American Paintings in the Metropolitan Museum of Art

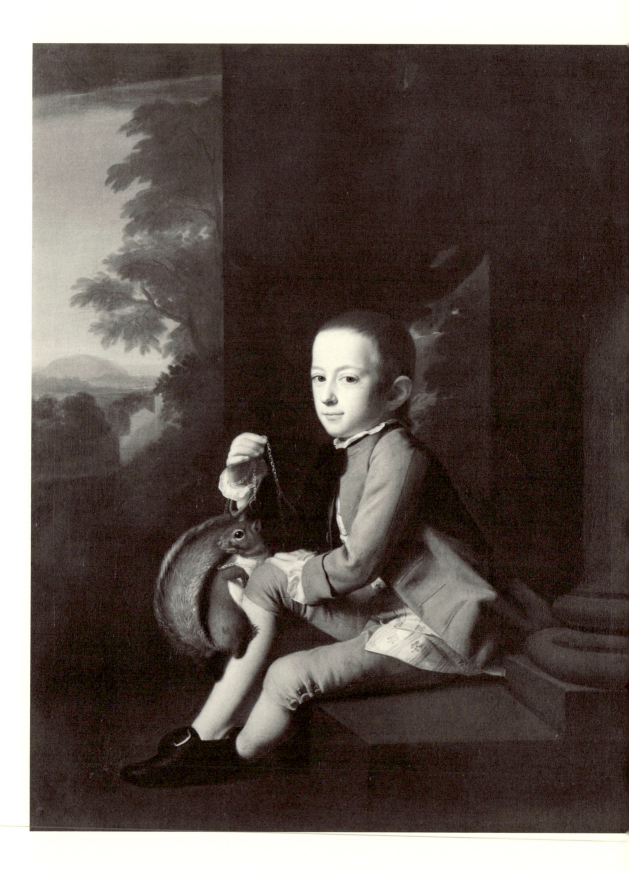

American Paintings in the Metropolitan Museum of Art

Volume I

A Catalogue of Works by Artists
Born by 1815

By JOHN CALDWELL *and*
OSWALDO RODRIGUEZ ROQUE

With Dale T. Johnson

Edited by Kathleen Luhrs

*Assisted by Carrie Rebora
and Patricia R. Windels*

THE METROPOLITAN MUSEUM OF ART
IN ASSOCIATION WITH PRINCETON UNIVERSITY PRESS

JACKET ILLUSTRATION:
The Sortie Made by the Garrison of Gibraltar
by John Trumbull.
Photograph by Geoffrey Clements.

FRONTISPIECE:
Daniel Crommelin Verplanck (detail)
by John Singleton Copley.

Copyright © 1994 by The Metropolitan Museum of Art

LIBRARY OF CONGRESS CATALOGING-IN-PUBLICATION DATA
(Revised for. v. 1)

Metropolitan Museum of Art (New York, N.Y.)
American paintings in the Metropolitan Museum of Art.
Includes bibliographies and indexes.
Contents:
v. 1. A catalogue of works by artists born by 1815 / by John
Caldwell and Oswaldo Rodriguez Roque with Dale T. Johnson—
v. 2. A catalogue of works by artists born between 1816 and 1845/
Natalie Spassky—v. 3. A catalogue of works by artists born
between 1846 and 1864.
I. Luhrs, Kathleen, 1941— II. Caldwell, John, 1941-1993.
III. Rodriguez Roque, Oswaldo, 1949-1989. IV. Title.

ND205.N373 1980 759.13′074′01471 80-81074
ISBN 0-870-99244-9
ISBN 0-870-99245-7 (pbk.)

Printed in the United States of America

TABLE OF CONTENTS

FOREWORD

An essential part of the museum's mission is to provide information on numerous levels and in varying degrees to its widespread and diverse public. One of the most effective means for such communication is through publications, more specifically complete and detailed assessments of the permanent collections. The Department of American Paintings and Sculpture has for some time been involved in such an endeavor. This three-volume catalogue is the realization of such work. Not only will the catalogue be of special use to the general public in its direct and easily comprehensible style and informative text but also it will be an invaluable tool for scholars because of the references and scholarly substance. In turn, the catalogue, the definitive and comprehensive publication of the museum's holdings in American paintings, gives the most current overview of the collection, its strengths and weaknesses.

We are indebted to the Ford Foundation for the funding that initiated the project and to the Surdna Foundation and the National Endowment for the Arts for their support. We would especially like to thank the William Cullen Bryant Fellows of the Metropolitan Museum of Art for their generous contribution to the production costs of this volume.

Philippe de Montebello, *Director*

PREFACE

T{HE} Metropolitan Museum of Art was established in 1870 following lengthy discussion and dedicated, organized activity by a diverse group of New York's social, religious, mercantile, academic, and artistic leaders. These men arranged the public and political support which allowed formation of the first general museum of art in this country. An early committee report of that year stated that the primary goal of the pioneering institution was to bring together and display "a more or less complete collection of objects illustrative of the history of Art from the earliest beginnings to the present time." Subsumed within this broader aim was the firmly held idea, stated by the leading spokesman for the founders, William Cullen Bryant, that New York City and the nation required "an extensive public gallery to contain the greater works of our painters and sculptors." In the meetings which led to the museum's foundation, the idea found ready support from a numerous group of painters, many of whose names are familiar today and most of whose works are represented in the museum's collection: George A. Baker, Albert Bierstadt, Walter Brown, Frederic E. Church, Vincent Colyer, Christopher Pearse Cranch, R. Swain Gifford, Sanford Gifford, Henry Peters Gray, William Hart, Daniel Huntington, Eastman Johnson, John F. Kensett, John La Farge, Louis Lang, Thomas Le Clear, Jervis McEntee, Aaron Draper Shattuck, Oliver William Stone, Arthur F. Tait, and Worthington Whittredge. Of these Church, Johnson, and Kensett became original trustees of the museum, insuring that the institution would actually collect and display paintings by American artists. The first American painting to enter the collection, Henry Peters Gray's *Wages of War*, was received in 1872. Since then over 1600 American paintings by about 800 artists have entered the collection through purchase, gift, and bequest. Of these, some 950 paintings by approximately 400 artists born before 1876 are the holding of the Department of American Paintings and Sculpture. The museum's collection of American paintings, given its overall quality and comprehensiveness, is perhaps the finest that exists in public or private hands.

The importance of the collection, and the fact that no scholarly catalogue of it existed, induced the Metropolitan, under the directorship of the late James Rorimer, to prepare one. The Ford Foundation awarded a grant in support of the project in 1963. The late Albert Ten Eyck Gardner, who had previously compiled *A Concise Catalogue of the American Paintings in the Metropolitan Museum of Art* in 1957, and Stuart P. Feld began the project aiming to produce a three-volume publication that would incorporate all American painters represented in the collection who were born before 1876. *American Paintings: A Catalogue of the Collection of the Metropolitan Museum of Art*, Volume I, which included painters born by 1815, prepared by Gardner and Feld, was published in 1965. Subsequently the staff and volunteers in the Department of American Paintings and Sculpture continued to do research and write entries, but with the steady growth of the collection and the rapid acceleration of research, publication, and revision of ideas in the field of American art history, it was determined some years ago to completely revise the existing Volume I and to select a new

larger format for the three volumes projected. The museum received two generous grants from the Surdna Foundation in 1976 and 1978, which made this major undertaking possible.

The three-volume *American Paintings in the Metropolitan Museum of Art* is arranged chronologically by the dates of the artists. Paintings by artists born by 1815 can be found in Volume I. Volume II consists of paintings by artists born from 1816 through 1845. Volume III is a catalogue of paintings by artists born from 1846 through 1864. We hope that a catalogue of the subsequent material, paintings by artists born after 1864 and paintings acquired since the publication of these volumes, can be prepared at a later time. Meanwhile some information on such works can be found in Henry Geldzahler's *American Paintings in the Twentieth Century* (1965) and in the museum's annual *Recent Acquisitions* publication. Paintings by American artists born from 1876 on are presently in the care of the Department of Twentieth Century Art.

A publication of this size and scope reflects the work of many people in the field and to a great extent the present state of scholarship. We hope that these volumes will add to the knowledge of American art and that where there are gaps, scholars will be inspired to fill them. We are extremely grateful for the generosity of the many people who assisted us in the preparation of these volumes, especially Kathleen Luhrs who oversaw and coordinated the project from beginning to end. We owe a debt of deep gratitude to the late Oswaldo Rodriguez Roque and the late John Caldwell, each of whom was blessed with a fine scholarly mind and a perceptive eye. It is sad indeed that they are not alive today to take pleasure in the appearance of this volume to which they contributed so much.

John K. Howat
Lawrence A. Fleischman Chairman
of the Departments of American Art

ACKNOWLEDGMENTS

The writing, editing, and publication of this catalogue has taken many years and the considerable efforts of a great many people. First of all, we are indebted to our colleagues on the museum staff. This three-volume American paintings catalogue began under former museum director Thomas P. F. Hoving and has proceeded with the warm support of our current director, Philippe de Montebello. James Pilgrim, former deputy director of the museum, and Inge Heckel, former manager of the Office of Development and Promotion, skillfully guided us through the initial planning phase. More recently, we have been encouraged by the guidance of Ashton Hawkins, executive vice president and counsel, Penelope K. Bardel, special advisor to the director, and Jennifer Russell, associate director for administration. Barbara Burn, executive editor, advised and assisted us on many occasions, and Jay Reingold and Richard Bonk, production associates, expedited production.

The past and present curatorial staff of the museum shared information on their areas of special interest. In American Decorative Arts, Frances Bretter, Alice Cooney Frelinguysen, Morrison H. Heckscher, Marilyn Johnson, Peter M. Kenny, Amelia Peck, Frances Gruber Safford, and Catherine Hoover Voorsanger offered their expertise on many occasions. Katharine Baetjer, Keith Christiansen, Walter Liedtke, Mary Sprinson de Jesus, Susan Alyson Stein, and Gary Tinterow of European Paintings gave their assistance in many instances, and James David Draper, James Parker, and Clare Vincent of European Sculpture and Decorative Arts kindly indentified sculpture, furniture, and decorative objects. Jean L. Druesedow and Kimberly S. Fink of the Costume Institute at times assisted in the dating of costumes. Dietrich von Bothmer in Greek and Roman Art and Helmut Nickel in Arms and Armor gave us the benefit of their wide knowledge on several occasions. David W. Kiehl and Elliot Bostwick Davis of Prints and Drawings shared their expertise of American prints.

We are grateful to many members of the museum's conservation staff. Hubert von Sonnenburg and his distinguished predecessor in Paintings Conservation, John M. Brealey, and their staff answered many questions regarding, technique and style. Dianne Dwyer, Dorothy Mahon, and Charlotte Hale examined a great number of paintings for this publication, and we are very grateful to them. Helen K. Otis, Margaret Holben Ellis, Betty Fisk, Margaret Lawson, and Marjorie N. Shelley in Paper Conservation all at some time kindly advised us about works within their expertise.

Others on the museum staff assisted in locating and verifying detailed information on the ownership and history of the paintings. Jeanie M. James, Barbara W. File, and Rebecca Lawson of the Archives Department made available letters and other records pertinent to the museum's acquisition of paintings. John Buchanan, Herbert M. Moskowitz, and Nina S. Maruca of the Office of the Registrar, and Marica Vilcek and her staff in the Catalogue Department have checked innumerable details about loans and exhibitions. We are also grateful to Barbara Bridgers, the late Mark Cooper, and the photography staff, especially Walter J. F. Yee and Christopher C. Holbrook, for their constant concern for quality.

This volume required the assistance of the capable staff of the museum's Thomas J. Watson Library. We thank William B. Walker, David Turpin, Doralynn Pines, Kenneth Dinin, the late Trevor Hadley, and Katria Czerwoniak for their efforts on our behalf, and Patrick F. Coman, Ronald Fein, Mark Chalfant, Benita Lehmann, and Alfred Torres for their daily assistance.

Many volunteers and interns in the Department of American Paintings and Sculpture have contributed to the completion of Volume I. In the early stages Marilyn Handler and then Jo-Nelle D. Long directed volunteers and interns with research. We thank Jane Bobbe, Barbara Buff, Katherine Cary, Jean Gridley, Elizabeth Quackenbush, Miriam Stern, Rebecca Tennen, and Virginia Thors, for their generous help with many tasks. Student interns included John Adler, Claudia Allen, William Bruno, Dana Hemmenway, Caroline Mortimer, Libby Russell, Gail Schecter, and Shira Silverman.

Scholars who have studied the work of individual artists and patrons responded generously to our requests for information. Most of them are acknowledged in the entries for which they shared their expertise, but we wish to thank them all collectively for their assistance and to mention several who were called upon often: Madeleine Fidell Beaufort, Davida Deutsch, William H. Gerdts, Carol Hevner, Lillian B. Miller, Merl Moore, Clifford W. Schaefer, Paul Staiti, and Marcia Briggs Wallace.

Various divisions of the Smithsonian Institution have facilitated this research. The Archives of American Art provided much of the manuscript material that was used and Arthur Breton and the staff in Washington as well as the staff in New York were especially helpful. Staff members of the Inventory of American Paintings and the Catalogue of American Portraits answered many queries. Special thanks also go to the library staff at the National Museum of American Art and the National Portrait Gallery.

Much of the detailed information included in this volume came from obscure exhibition catalogues, museum publications, books, and articles on little-known sitters and artists. These were provided by the staff of institutions and organizations throughout the country. Some, especially in New York, were relied on more often than others. In particular, we would like to thank: David Combs, Robert Rainwater, and Roberta Waddell at the New York Public Library; Betty H. Payne, at the New York Genealogical and Biographical Society, the late Thomas J. Dunnings, Richard J. Koke, Wendy J. Shadwell, Annette Blaugrund, Timothy Burgard, and Ella Foshay, at the New-York Historical Society; staff at the New York Society Library; Teresa Carbone, the Brooklyn Museum; Theresa La Bianca and other members of the staff at Greenwood Cemetery in Brooklyn; Jonathan Harding and Michael Wentworth at the Boston Athenaeum; the Connecticut Historical Society; the Frick Art Reference Library; Theodore E. Stebbins, Jr., Trevor Fairbrother, Carol Troyen, and Erica Hirschler at the Museum of Fine Arts, Boston; Abigail Booth Gerdts and Dita Amory at the National Academy of Design, New York; Nicolai Cikovsky, Jr., Deborah Chotner, and Franklin Kelly at the National Gallery of Art, Washington, D.C.; William Truettner at the National Museum of American Art, Washington, D.C.; Ellen Miles at the National Portrait Gallery, Washington, D.C.; Darrel L. Sewell, Philadelphia Museum of Art; Susan Danly at the Pennsylvania Academy of the Fine Arts; Elizabeth M. Kornhauser at the Wadsworth Athenaeum; and Helen Cooper at the Yale University Art Gallery.

We also thank staff members at: Addison Gallery of American Art, Phillips Academy, Andover, Massachusetts; Albany Institute of History and Art; Albright-Knox Art Gallery, Buffalo; American Academy of Art and Letters, New York; American Museum-Hayden Planetarium, New York; Art Gallery of Ontario, Toronto; Art Institute of Chicago; Art Museum, Princeton University; Art Students League of New York; Atlanta University Library; Avery Architectural Fine Arts Library, Columbia University, New York; Baltimore Museum of Art; Bar Harbor Historical Society, Maine; Beinecke Rare Book and Manuscript Library, Yale University, New Haven; Bennington Museum, Vermont; Berkshire Athenaeum Public Library, Pittsfield, Massachusetts; Boston Public Library; Bowdoin College Museum of Art, Brunswick, Maine; Brandywine River Museum, Chadds Ford, Pennsylvania; British Museum, London; Brooklyn Historical Society; Butler Library, Columbia University, New York; California Historical Society, San Francisco; California State Library, Sacramento; Cape Ann Historical Society, Gloucester, Massachusetts; Carmarthen Museum, Abergwili, Wales, Century Association, New York; Cincinnati Art Museum; City Museum and Art Gallery, Birmingham, England; Cleveland Museum of Art; Colorado Springs Fine Arts Center; Columbus Gallery of Fine Arts, Ohio; Cooper-Hewitt Museum of Decorative Arts and Design, Smithsonian Institution, New York; Corcoran Gallery of Art, Washington, D.C.; Cummer Gallery of Art, Jacksonville, Florida; Dallas Museum of Fine Arts; Delaware Art Museum, Wilmington; Detroit Institute of Arts; Enoch Pratt Library, Baltimore; Everson Museum of Art, Syracuse, New York; Fine Arts Museums of San Francisco; Fitzwilliam Museum, Cambridge; Folger Shakespeare Library, Washington, D.C.; Fogg Art Museum, Harvard University, Cambridge, Massachusetts; French Embassy, New York; Gibbs Art Gallery, Charleston; Harvard College Library, Cambridge, Massachusetts; High Museum of Art, Atlanta; Honolulu Academy of Arts; Huntington Library, Art Gallery, and Botanical Gardens, San Marino, California; Joslyn Art Museum, Omaha; Kresge Art Center Gallery, Michigan State University, East Lansing; Fine Arts Department, Library Association of Portland, Oregon; Library of Congress, Washington, D.C.; Los Angeles County Museum of Art; Maryland Historical Society, Baltimore; Massachusetts Historical Society, Boston; Mead Art Building, Amherst College, Massachusetts; Memorial Art Gallery of the University of Rochester; Minneapolis Institute of Arts; Mint Museum of Art, Charlotte, North Carolina; Mississippi Department of Archives and History, Jackson; Missouri Historical Society, Saint Louis; Montclair Art Museum, New Jersey; Museum of Art, Rhode Island School of Design, Providence; Museum of Fine Arts, Houston; Museum of Fine Arts, Springfield, Massachusetts; National Audubon Society, New York; National Portrait Gallery, London; National Society of Colonial Dames in the State of New York; National Trust for Historic Preservation, Washington, D.C.; Newark Museum, New Jersey; New Britain Museum of American Art, Connecticut; New Haven Colony Historical Society; New Haven Free Public Library; New Jersey Historical Society, Newark; Newport Historical Society; New York County Surrogate's Court; New York State Library, Albany; Oakland Museum; Onondaga Historical Society, Syracuse, New York; Oregon Historical Society, Portland; Parrish Art Museum, Southampton, New York; Peabody Institute of the Johns Hopkins University, Baltimore; Pennsylvania Historical Society, Philadelphia; Pierpont Morgan Library, New York; Portland Art Museum, Oregon; Portland Museum of Art, Maine;

Princeton University Library, New Jersey; Rensselaer County Historical Society, Troy, New York; Rhode Island Historical Society, Providence; Smith College Museum of Art, Northhampton, Massachusetts; Stanford University Libraries, California; Telfair Academy of Arts and Sciences, Savannah; Toledo Museum of Art; Trinity Church, New York; United States Military Academy, West Point, New York; United States Naval Academy, Annapolis, Maryland; Virginia Museum of Fine Arts, Richmond; Walker Art Center, Minneapolis; Walters Art Gallery, Baltimore; Washington County Museum of Fine Arts, Hagerstown, Maryland; Yale University Library, New Haven.

Commercial art galleries and auction houses were equally willing to cooperate with our research and have proven most helpful in the documentation of provenance. We are especially grateful to those persons who searched the records of auction houses and firms for material on the museum's paintings. The names of people and galleries who supplied information on provenance are given in the reference sections to the individual paintings. Several galleries, however, were often called on for assistance and made many efforts on our behalf. We would like to especially thank Christie's, Graham Gallery, Hirschl and Adler Galleries, Kennedy Galleries, M. Knoedler and Company, Sotheby's, Schwartz Galleries, and Vose Galleries for helping us on so many occasions. We also owe a special debt of thanks to Stuart P. Feld, the co-author of the first edition of this catalogue, for sharing his knowledge of the collection with us.

The problem of designing a book with such an unwieldy format was deftly handled by Klaus Gemming. He not only coped with many difficult problems in the layout but also constantly advised on schedules and production. To him we owe enormous gratitude. At Stamperia Valdonega, Verona, where the type was set with great care, we would like to thank Martino Mardersteig for his supervision of the project. David Lorczak, Paul Hoffmann, John Stinehour, and Stephen Stinehour at the Stinehour Press have been more than cooperative. Patricia Windels edited and proofread many of the early drafts for this book and helped in many ways to shape it. We are particularly grateful to her and to Elizabeth Gemming, who proofread the galleys for this book with great care. Jacolyn A. Mott also lent editorial assistance.

We are most grateful to our colleagues in the Department of American Paintings and Sculpture, all of whom participated in this project. As chairman John K. Howat ably supervised the changing staff at work on this volume and faithfully supported the project. Kevin J. Avery helped with the research and writing of several entries, and H. Barbara Weinberg offered her expertise and encouragement. Former members of this department made substantial contributions to the research, writing, and production of this volume: Lewis I. Sharp, Donna J. Hassler, and the late Stephen D. Rubin helped in many ways. The late Natalie Spassky and Doreen Bolger, authors of Volumes II and III, provided models of fine research. Contributors to those volumes, Linda Bantel, Meg Perlman, and Amy L. Walsh, were equally supportive. Various departmental assistants, Marilyn Handler, Kristine Schassler Waelder, Pamela Hubbard, Nancy Gillette, Emely Bramsen, Elisabeth Agro, Audrey Irwin, Jeanmarie Kraemer, and Irene Papanestor were a tremendous help in handling innumerable administrative details. In American Decorative Arts, Ellin Rosenzweig often lent support. Many drafts of this catalogue were typed and word-processed at different times; for this work we wish to thank Emily Umberger, Diane David, and Martha K. Lassiter.

Our departmental technicians George Asimakis, the late Ronald Brandt, Donald E. Templeton, Gary Burnett, Edward Di Farnecio, Sean Farrell, William Waelder, and Jason Weller patiently located, moved, and unframed each painting for examination.

In the early days of this project we all benefited greatly from the experience, wisdom, and good spirits of the late Margaretta M. Salinger, curator emeritus in the European Paintings Department. Miss Salinger gave us a sense of enormous continuity, for she had worked on many of these paintings before the museum had a separate department devoted to American paintings. She was both guide and support for several years.

Leslie P. Symington, whose skills in genealogical and art historical research are beyond compare, added considerably to this book. We thank her for her painstaking efforts to elucidate the identities of so many previously unidentified portrait subjects. The thorough provenance records for each painting are also due in great measure to her work. In the last phase of this catalogue project, Carrie Rebora, associate curator, brought her considerable knowledge to bear in updating entries, supplying new research, and then carefully weaving it into place. It was her administrative and scholarly skills that brought the project to completion.

The authors are most indebted to Kathleen Luhrs, the editor of the three-volume catalogue, for remaining devoted to this project over many years. Aside from editing and coordinating such a large project, she also brought to it her substantial knowledge of American art and her enthusiasm for this cataloguing effort. For this, and for so much more than can be stated here, we are very grateful.

INTRODUCTION

The works included in this catalogue form a comprehensive overview of American painting during the colonial and early republican periods. Remarkably enough, almost every artist of note working in this time span is represented here by either a masterpiece or a work of outstanding quality. Formed over many years, the Metropolitan Museum's collection of American paintings is probably the finest anywhere. It has its weaknesses, and the reader may notice a slant toward New York artists, but, in spite of this, no finer gathering is to be found.

The dependence of our early artists on European models is a leitmotif in this volume. The concept embodied in Robert Frost's famous phrase "the land was ours before we were the land's" applies to American painting with special force. In fact, almost the entire history of our art can be seen as a series of responses to European examples and styles. It was only about 1950, when the abstract expressionists made their final, transcendent Americanization of cubism and surrealism, that our painting ceased to function in more or less provincial terms in relation to that of Europe. It must be emphasized, however, that to note the essential provincialism of American art before the most recent period is in no way to denigrate its quality.

Little in the way of painting was produced in this country during the seventeenth century, and none of it is represented in the Metropolitan Museum's collection. The names of a number of men identified as painters in early documents have come down to us, but only a very few of the thirty or so surviving paintings from this period can be securely attributed to them. It is very likely that they pursued their craft only intermittently and did not derive their livelihood from it. The harsh demands of early colonization have usually been held responsible for the paucity of art, but other factors having to do with the settlers' lack of familiarity, mistrust, and scant appreciation of painting should share the blame. In the period of America's infancy, it was in the decorative arts that the qualities of embellishment, craftsmanship, and fantasy first betray the artistic sensibility at work. By comparison, only a very few paintings, notable among them the productions of the Freake Limner in the 1670s and Captain Thomas Smith in the early 1690s, reveal comparable ability. Significantly, the majority of pictures were painted in Massachusetts in the closing decades of the century when increased wealth, the arrival of the colonial governors, and the formation of Anglican congregations began to release the stranglehold of the early Puritan oligarchy.

With the coming of the eighteenth century, portrait painting was firmly established in the more prosperous and populated areas of the colonies. By 1729, when the arrival of John Smibert began a new era in American painting, significant achievements in the art had been registered in Maryland by Justus Engelhardt Kühn (d. 1717), in New England by the Pierpont Limner and the portrayer of Anne Pollard, 1721 (Massachusetts Historical Society, Boston), and in New York City and the Hudson River valley by a group of prolific "patroon painters." The latter form a very special chapter in the early history of American painting. Despite the

clumsiness and lack of professional training evident in the majority of their works, they are the first native-born artists who can be considered as a school. Their portraits, some based on Dutch prototypes (see *Portrait of a Lady*, p. 7), some on English mezzotints, and some on the works of other patroon painters (see *Boy with a Fawn*, p. 11), are colorful, lively, and often insightful apings of fashionable late baroque portraiture. At their best, they possess a decorative two-dimensionality, a bluntly direct representation of character, and a distinct, difficult-to-define, but very real, awkwardness. These characteristics are prophetic in view of later developments in eighteenth-century American painting. The artists' reliance on formulas, the flatness of the images, and the boisterous coloring have led some to think of these paintings as folk art. This is something of a misunderstanding; for the sitters depicted are usually members of wealthy New York Dutch families, and the stylistic variety in the paintings reveals an all-too-conscious attempt to keep up with the latest fashion. These portraits are more judiciously viewed as colonial art, embodying the ambitious ideals and taste characteristic of a wealthy colonial society yet falling far short of the standards of professional accomplishment sustained in any of the European art capitals. By about 1750, most of these patroon artists had ceased to work, their style rendered obsolete by the presence and influence of immigrant artists capable of producing more convincing, if altogether less interesting, images.

Certainly, the most important immigrant painter to work in the American colonies was the Englishman John Smibert. A London-trained portraitist of considerable talent, Smibert brought to this country the late baroque portrait style of Sir Godfrey Kneller, official painter to George I. The painterly treatment of faces and draperies that had assured Smibert the patronage of prominent Londoners quickly made him the most sought-after portraitist in Boston (see *Mrs. Francis Brinley and Her Son Francis*, p. 14). But this polished style was in fact more than was required to satisfy the needs of the New Englanders. Smibert thus became the first in a long line of foreign-trained artists, whose style underwent a distinct provincialization upon contact with the relaxed standards of the American cities. Yet in the case of Smibert (as with many of the others), this was not altogether a bad thing. An unmitigated forthrightness, manifested early on in the relative informality of his *Francis Brinley* (p. 13), distinguishes many of his later American works, none more so than his incisive portrayal of old age in *Nathaniel Byfield* (p. 16).

As the first academically trained painter to work in America, Smibert's influence was great. His works set a new standard of artistic achievement, and his acceptance by prominent Bostonians increased his wealth and made him the first American artist to achieve social respectability. His studio—containing the casts of classical and antique sculpture, prints, and copies after old master paintings, gathered during a trip to Italy—became a center for the dissemination of artistic information in this country. Intact at least until the early 1800s, his studio effects silently but effectively propagated the ideals defined by seventeenth-century academic doctrine long after Smibert's death in 1751. One wonders if the driving ambition for history painting exhibited by John Singleton Copley and John Trumbull, as well as their respect for baroque painting, was not nurtured in this teacherless school they frequented in their youth.

More direct and obvious, however, was Smibert's influence on the native-born Robert

Feke, whose first known work, *Isaac Royall and His Family*, 1741 (Harvard Law Art Collection), is a paraphrase of Smibert's 1729-1731 group portrait of Bishop Berkeley and his entourage (Yale University). Here, especially in the figure of Royall, are already present the accuracy of characterization, the linearity, the adventurous contrasted coloring, and the restrained compositional arrangements that were to become hallmarks of his best works. How Feke was able to produce a painting that, on the one hand, reveals his lack of formal training and his debt to Smibert, and, on the other, so accurately points to the transformation of rococo portraiture, now recognized as colonial America's outstanding achievement in painting, remains an unsolved mystery. By and large, Feke's style has been viewed as the natural offspring of the union of English painting, transmitted by Smibert and by mezzotint engravings, with the native primitive manner, exemplified by the works of the anonymous New York and New England limners. This is a likely speculation but more intriguing is the equally justifiable supposition that at some point in his well-traveled career Feke was exposed to the colorful, more linear rococo portrait style favored in Italy and Spain. Such an exposure would go a long way toward explaining his palette as well as his penchant for depicting men in ostentatiously ornamented clothing. While these features are not well illustrated in the relatively sober portrait of Tench Francis of 1746 (p. 21), they are readily apparent in Feke's portraits of James Bowdoin, William Bowdoin, and General Samuel Waldo, all of 1748 (Bowdoin College Museum of Art). In any case, the origins of the first clearly identifiable American painting style are not well understood and preclude any easy generalizations.

The extent of Feke's genius and the singularity of his development in the American colonies become instantly clear when we compare his background with that of other painters working in America at about the same time. In Boston, Joseph Badger acknowledged Smibert's lead and attempted to follow it but, unlike Feke, was unable to apprehend the style very well. Instead, he primitivized it and in many of his portraits (see *James Badger*, p. 37), there is a rawness, which has earned him some reputation as an uncompromisingly honest painter. Actually, whether this was a result of psychological penetration or of technical maladroitness is not readily discernible, but it is revealing indeed that many of Boston's elite continued to patronize him until Copley arrived on the scene.

Badger's style had no exact counterpart in the other colonies: still, artists such as Gustavus Hesselius in Philadelphia, Jeremiah Theüs in Charleston, and William Williams in Philadelphia resemble him in that their derivative and rigid styles crystallized early in their careers and then underwent no further development. They drew on different traditions: Hesselius on late continental baroque formulas, Theüs on early Franco-Swiss rococo portraiture, and Williams on the developing English conversation piece. Most of their works are pleasing or charming enough to prevent the memory of their makers from being erased, but, in light of later events, they must be seen as the stunted offspring of robust European stock which, for a while, survived on foreign soil but could not, in the final analysis, engender progeny. With the death of Smibert in 1751 and the disappearance of Feke about 1750, the progress of American painting would have been determined to a great degree by these men and others like them had not the desire for money brought John Wollaston and Joseph Blackburn to these shores. Without them, the transition from Feke to Copley in Boston and from Hesselius and Williams to Benjamin West in Philadelphia would have been considerably more disjunct.

Essentially, what Blackburn brought to New England in 1754 and Wollaston to the middle colonies in 1749 was the fashionable rococo portrait style then being practiced in England by painters such as John Vanderbank, Joseph Highmore, and Thomas Hudson. Wollaston's *William Axtell* (p. 27) and Blackburn's portraits of Mr. and Mrs. Samuel Cutts (pp. 33-36) show the artists' talent for rendering strong likenesses within the canon of contemporary British portraiture. Although the styles of Blackburn and Wollaston are easily distinguishable and reveal different artistic personalities, their careers in America followed a similar course. Both filled considerable artistic vacuums on their arrival and were consequently swamped with commissions. Both were excellent drapery painters but not portraitists of great depth. Both came to America to make money and moved from one city to another whenever patronage in a given locality was exhausted. Finally, both men left America when it became convenient for them to do so. Of the two artists, Wollaston was the more prolific and the more superficial. In spite of their shortcomings, however, Blackburn and Wollaston introduced up-to-date standards of style that significantly elevated American taste. Thus, it is not surprising that the young Copley felt obliged to imitate the shiny fabrics and fashionable compositions of Blackburn's Boston portraits and that it was the elegance of Wollaston's Philadelphia works that was held up to the young West as worthy of emulation.

Both Copley and West, the first American artists to achieve international reputations, were born in the year 1738. They were members of a generation of self-confident Americans that included George Washington, Thomas Jefferson, and John Adams—men who grew to maturity in the climate of prosperity and national feeling following the successful outcome of the French and Indian wars. Had they not been artists, the middle-class backgrounds of these men would in all likelihood have insured their unswerving commitment to living and working in America. Being as ambitious and talented in their professions as the patriots were in theirs, they were forced to look abroad to find the optimal opportunities for the development of their careers. West, surely the more adventurous of the two, took his chances early in life and left at age twenty-one. Copley, as persevering and desirous of certainty in his personal life as in his painting, waited until circumstances practically forced him to go. He was almost thirty-six when he left for London.

By and large, West's American works can be regarded as juvenilia, even though a number of them, such as the portraits of Sarah Ursula Rose (p. 66) and Thomas Mifflin, ca. 1758–1759 (Historical Society of Pennsylvania, Philadelphia), reveal a sense of compositional design in advance of the models available to him in Philadelphia. Probably the most interesting of his early works is *The Death of Socrates*, ca. 1756 (Historical Society of Pennsylvania), a primitive-looking affair based on an engraving. It marks the beginning of a consuming passion for history painting. The picture already discloses the linearity, planarity, and strong coloring —as well as the thematic content—that were to put the young West perfectly at ease with the embryonic neoclassical style he encountered in Rome in 1760 and which he subsequently espoused. In 1768, already in England for seven years, he further defined this style in a recognized masterpiece, *Agrippina Landing at Brundisium with the Ashes of Germanicus* (Yale University) and thereby propelled himself to the center stage of European artistic developments. Had he stopped there he would have achieved a lasting reputation as a precursor of Jacques Louis David; instead he went on to expand the range of history painting to include

contemporary events and to produce some of the first romantic pictures painted anywhere. Appropriately enough, he became president of the Royal Academy, painter to George III, and a powerful figure in English art circles. Although so much of West's work is English, enough of America remained with him to prevent the English from ever considering him as one of their own, and Americans were always predisposed to claim him as their countryman.

Aside from his own productions, West also played a crucial role in the development and training of aspiring American artists. From the time he settled in London until the end of his life he stood ready to assist all American artists desirous of obtaining some training in a European studio. Practically every American painter of note from Matthew Pratt to Samuel F. B. Morse either worked with West or was in one way or another aided by him. No better index of the manner in which his generosity was dispensed exists than the strongly individual styles developed by most of the Americans who proudly acknowledged their debt to him. Not a single statement accusing West of attempting to force his style on a student has come down to us, unusual behavior indeed for a man who was unquestionably in a position to do so.

In contrast to West's, Copley's career in America was not only significant, it was the signal achievement of American colonial art. An abiding respect for exacting craftsmanship and a familiarity with the history of the visual arts were the two most important things he learned from his stepfather, the Boston mezzotint engraver Peter Pelham. Copley's knowledge of reading, writing, and mathematics were in all likelihood also the result of Pelham's instruction. This informal education at home contrasts dramatically with West's classical training at the hands of the learned William Smith, provost of the College of Philadelphia. This difference in background is well worth noting, for it helps to explain the radically divergent approaches to art adopted by the two artists: West nearly always insisted on the primacy of moral and intellectual aims, often at the expense of good technique, while Copley usually attended to pictorial values first and never compromised his high standards of craftsmanship.

At first, quite naturally, Copley took his cue from the paintings he could readily see in Boston, that is, works by Smibert, Feke, and Feke's pupil John Greenwood (1727–1792). He saw that they derived their ideas of fashionable portraiture from mezzotints after English works and followed their example. Early paintings dealing with mythological subjects taken from prints and a series of careful anatomical drawings copied from a published book established that he was aware of the traditional academic curriculum and the values it fostered. None of these early works is particularly outstanding, but they are comparable in quality to the works then being produced by Badger and Greenwood, and, in the case of the mythological subjects, far more ambitious. Only the portraits of Feke and Blackburn were of higher quality. Between 1754 and 1758 Copley, deliberately it seems, set out to learn what he could from the example of these two artists. With the double portrait of Mary and Elizabeth Royall of about 1758 (MFA, Boston), he conclusively demonstrated that he had not only learned well, but had surpassed his models. He achieved a greater psychological penetration into the character of his sitters as well as a more adventurous definition of composition and color. In about 1760, he painted the finest American colonial portrait up to that time, the remarkable *Epes Sargent* (National Gallery of Art, Washington, D.C.). There followed a series

of portraits, both oils and pastels, which, though not of even quality, contains a goodly number of consummate masterpieces. These are the faces of America's past, which have been treasured and which, even today, speak to us directly, forcefully, and with all the vitality of actual presences. Because of this, Copley has always been regarded as a realist who preferred to paint exactly what he saw. Certainly, it cannot be denied that whatever he painted, whether seen or copied, was carefully thought out. Yet his compositional and coloristic schemes border on the abstract. His remarkable ability to conceptualize a portrait as a painting, that is, independent of subject matter, is the major reason why, in his best works, the eye is seldom bored or dissatisfied in spite of improbable color combinations (*Joseph Sherburne*, p. 90), faulty anatomy (*Gulian Verplanck*, p. 96), and awkward relationships between foreground and background (*Daniel Crommelin Verplanck*, p. 92). Time after time, in his American portraits, Copley's faultless formalism veils his faulty representation of reality and ironically enough helps reinforce the mistaken notion that he was primarily a realistic painter. Actually, the most that can be said is that his faces are so expressive and individualized as to look real and that, at times, his fabrics approach trompe l'oeil. Copley probably relied on printed sources in arriving at his compositions and in choosing the staffage surrounding his sitters far more than has heretofore been suspected. There are good reasons for coming to this conclusion, including poses repeated in portraits of different sitters, costumes repeated, and ample depictions of extravagant furniture, which he almost certainly never saw, and once this is accepted, the question of his realism becomes a subject for investigation and ceases to be an article of faith.

Copley's career in America was an absolute triumph. He gained wealth, seems to have compelled Blackburn to leave the country, and achieved a legendary reputation throughout the colonies. His style of portraiture became canonical and was echoed in the works of Charles Willson Peale, John Trumbull, Ralph Earl, and a host of other lesser known painters such as Joseph Steward and William Johnston. Unfortunate for American painting, but fortunate indeed for the history of American art, was his move to England, prompted by the mounting political turmoil, in 1774. After a few weeks in the mother country, he determined to fulfill a long-standing ambition and went on a general tour of France and Italy, which included a considerable stay in Rome. His first religious painting, *The Ascension*, 1775 (MFA, Boston), his ambitious portrait of Mr. and Mrs. Ralph Izard, 1775 (MFA, Boston), and letters to his brother detailing his experiences in Italy reveal that he was profoundly affected by the milieu of this spawning ground of artistic innovation. Back in London, where he spent the rest of his life, he was predisposed to follow in West's footsteps and to accept the premise that recent events were fit subjects for history painting. Perhaps as a result of increasing rivalry between him and West, Copley's first painting in this genre, *Watson and the Shark* (1778, first version, National Gallery of Art, Washington, D.C.; a later version, p. 99), went beyond what West had accomplished in his *Death of General Wolfe*, 1770 (National Gallery of Canada, Ottawa), and further extended the acceptable limits of history painting. The episode depicted there, aside from the fact that it involved a man who would one day become lord mayor of London, had no particular historical significance. In addition, the persons involved, including a black man, were obviously of the lower class. Indeed, the point of the painting was not primarily to edify, ennoble, or improve the moral character

of the viewer, as was expected of the genre, but rather to confront the viewer with the horror of a shark attacking a helpless man. In the hands of Copley, English history painting become more monumental drama and less accurate history. His concept may have been irreverent and even improper but it commanded an enthusiastic response from the general public and set the course he was to follow in *The Death of the Earl of Chatham*, 1779-1781, and *The Death of Major Peirson*, 1783 (both Tate Gallery, London). In all these works, Copley's experience as a portraitist in America helped him immeasurably and determined his general approach. Just as do the American portraits, the English history paintings depict a reality that has been tampered with and made subservient to pictorial and psychological ends. In *Watson and the Shark*, for example, the shark is convincing as an agent of destruction but not as a shark; in *The Death of the Earl of Chatham*, the lords are shown in ceremonial dress though this was contrary to the facts of the event; in *The Death of Major Peirson*, the group of fleeing women and children is gratuitous. Just as in the American portraits, the emotions and reactions of the faces in the English history paintings are so humanly authentic and the composition and color of the canvases are so visually compelling that it is difficult for the viewer to imagine that these events might have occurred in a manner different from the way Copley painted them. Copley's history paintings, therefore, continue the approach to painting he established so successfully in his colonial portraits. By contrast, his English portraits, decidedly influenced by Sir Joshua Reynolds and Thomas Gainsborough, seem intended more to flatter than to explore character and are usually regarded by those who have grown accustomed to his American portraits as a bit contrived. In fact, they are by and large better painted than the American ones and seldom display the awkwardness in anatomy or in the arrangement of visual props that are characteristic of his colonial works. The best among them, such as *Midshipman Augustus Brine* (p. 105) and the portrait of Lord Mansfield, 1783 (National Portrait Gallery, London), are masterpieces of characterization equal to the portraits of Epes Sargent or Paul Revere, 1768–1770 (MFA, Boston).

Although Copley and West went abroad seeking liberation from the limitations imposed upon them at home, it was their native experience that preconditioned them to look at European painting with more or less unprejudiced eyes and which, by way of compensating for it, inclined them toward history painting as a vehicle for the conveyance of drama, emotion, and grand statements. Logically enough, in the end both artists found inspiration for their works, as well as confirmation of their ambitions, in the outdated baroque *machines*, which had never found an auspicious reception in England. By seeking to go beyond the civilities of English rococo portraiture and establish the respectability of the baroque, they laid the groundwork for romanticism and influenced key European artists of the younger generation—Delacroix in the case of West and Gericault in the case of Copley. A comparable American involvement in the development of an international style did not occur until a century and a half later.

While West and Copley were transforming history painting in Europe between about 1770 and 1790, two important artistic developments occurred at home. The first was the coming to maturity of a generation of native-born painters, most of whom had received some training abroad. The second was the recognition by most of these artists, in spite of their European training, that Copley's American works defined a style of portraiture particularly

suited to this country and one that they wished to emulate. Copley's influence, of course, had reached a number of American painters before his departure. Several works in this collection, for example, Matthew Pratt's *Cadwallader Colden and His Grandson Warren De Lancey* (p. 61), John Mare's *Jeremiah Platt* (p. 108), and Charles Willson Peale's *Margaret Strachan (Mrs. Thomas Harwood)* (p. 117), adequately illustrate this. More important from the standpoint of history, however, was the immense authority Copley's portraits continued to exert on native painting after his removal to London. John Trumbull's early portraits of members of his family, Ralph Earl's *Roger Sherman*, ca. 1775 (Yale University), as well as portraits by older painters such as Henry Benbridge, who had worked abroad, owed an inestimable debt to Copley. The spell Copley cast on American portraiture did not begin to wear off until a taste for things neoclassical took hold after the adoption of the federal constitution, more specifically in terms of painting, until the return from England of Trumbull in 1789 and of Gilbert Stuart in 1793.

Of the painters active in this country during the years of the revolution and of the critical period following it, Charles Willson Peale was the ablest and most influential. A man of wide interests and knowledge, Peale continued to adhere to Copley's compositional formulas and linearism but could not command either Copley's psychological penetration or his crisp representation of fabrics. Nevertheless, Peale's portraits, painted in relatively light colors, are lively, good-humored, and pleasing. For the most part they present Americans at ease with themselves and their surroundings, in a sense reflecting their contentment with a lifestyle they were determined to preserve. Insofar as they generally lack the air of aristocratic polish with which Copley endowed most of his portraits, Peale's appear less pretentious and more democratic. Very likely Peale was more in tune with the *Weltanschauung* of the people he painted than any of his portrait-painting contemporaries. To be sure, his life was marked by the energy, optimism, and innovative spirit prevalent in the early days of the republic. Peale fought in the revolutionary war, befriended Washington, engendered a whole dynasty of painters, excavated mastodons, and founded museums. A stay in London from 1767 to 1769 familiarized him with fashionable English portraiture, and a number of his works, such as *Benjamin and Eleanor Ridgely Laming*, 1788 (National Gallery of Art, Washington, D.C.), reflect this knowledge. Unlike most of his contemporaries, his good sense kept him from the painful pursuit of history painting in a country that was not ready for it. This did not mean he was a painter without ambition; on the contrary, it freed him to do such trompe-l'oeil works as *The Staircase Group*, 1795 (Philadelphia Museum of Art), and portrait miniatures, and to encourage his children's considerable achievements in portraiture and still-life painting.

From the mid–1780s on, Peale had increasingly devoted his energies to the operation of his museum, which by then included natural history specimens and stuffed animals, as well as paintings. This feature was a great success. It was not only among the country's first permanent displays of art; it did much to persuade America's elite of the need for the establishment of such institutions. The progeny of Peale's museum were the American Academy of the Fine Arts, founded in New York in 1802, and the Pennsylvania Academy of the Fine Arts, founded in Philadelphia in 1805, both of which eventually mounted annual exhibitions of European and American art.

Though overshadowed by the accomplishments of Peale and his family, two other native

painters working at this time deserve attention, Matthew Pratt and Henry Benbridge. Pratt studied with West and produced a now-famous conversation piece *The American School* (p. 57), which, aside from its debt to his teacher's early manner, made public an intention to achieve artistic independence some years in advance of comparable political developments. Pratt's American portraits are often Copleyesque. They are painted in a softer, almost reticent way, dominated at times by dark harmonies featuring purple. Those painted in the late 1780s and early 1790s, however, reveal poses and fashions derived from more recent English formulas. Benbridge spent a number of years in Rome and is thought to have studied under Anton Raphael Mengs and Pompeo Batoni. He thus developed a colorful, linear portrait style which in some works coincided remarkably with Copley's (see *Portrait of a Gentleman*, p. 132) but which originated at the source of early neoclassicism. He was moderately successful in London, counting among his patrons James Boswell, but after his return his style degenerated quickly. He settled in Charleston, where he filled the artistic vacuum created by the death of Theüs and painted works so variable in quality and style that attributions to him still pose tremendous difficulties. Given his talent, his background, and the promising quality of his early works, his disappointing career must be regarded as one of the great lost opportunities in American painting.

After about 1790, the conventions associated with the late works of Reynolds and Gainsborough and with the portraits of such younger English artists as Henry Raeburn and John Hoppner were embraced by three young Americans who lived and worked in London in the late 1770s and 1780s: Ralph Earl, John Trumbull, and Gilbert Stuart. Returned to the United States at various times between the signing of the peace treaty with Great Britain and Washington's second term (Earl in 1785, Trumbull in 1789, and Stuart in 1793), these three artists had an enormous impact on American painting.

Ralph Earl, though the least technically proficient of these artists, painted the most ambitious portraits. At times he devised complex compositions with many figures (see *Mrs. Noah Smith and Her Children*, p. 146). At his best, for example, in the well-known portrait of Elijah Boardman (p. 144), he succeeded in using his considerable powers of coloring and arrangement to create a persuasive likeness and character. Probably an impatient craftsman, Earl produced his usually life-sized portraits with great speed. He either did not see the artistic need for, or did not think his patrons could subsidize, portraits finished to the extent demanded by the English academic practice he so obviously emulated. Consequently, his works are inevitably characterized by two-dimensionality and colorism that gives them a primitive quality. Earl's work has entry into many an exhibition of American folk art. His works, however, were enthusiastically received by the Connecticut country aristocracy for whom he practically defined a local style. His influence on later provincial painters of Connecticut and Massachusetts, whose output can more justifiably bear the folk art label, was nothing less than seminal.

Though at first somewhat encumbered by the influence of Copley's American portraits, John Trumbull developed into an artist of considerable ability under the tutelage of Benjamin West. The son of a Connecticut governor and a graduate of Harvard accustomed to the life of a gentleman, Trumbull never quite reconciled himself to the vicissitudes of an artist's life. West's influence, moreover, reinforced Trumbull's belief in the moral purpose

of art and nourished his ambition to be more than just a portrait painter. Consequently, on more than one occasion, his commitment to his art wavered under pressure. During the American Revolution he served as an aide to various generals, including Washington, and engaged in speculative business ventures with his brother. Between 1793 and 1794 he was deeply involved in the negotiation of the Jay Treaty with England and in the commission set up under it to adjudicate naval claims. During these years he also imported old master paintings into England. Such interruptions did not benefit his art.

Trumbull's great contributions to American painting were the revolutionary war episodes he began painting in England between 1786 and 1788 and his ambitious *The Sortie Made by the Garrison of Gibraltar*, 1789 (p. 205). With these works, all of which he brought to the United States and most of which were exhibited here at various times, the innovations in history painting shaped by West and Copley in England were introduced to a new generation of American artists. At first little notice was taken of his history paintings, and Trumbull was forced to earn his livelihood from portraiture. Some years later, however, after having painted additional scenes in this country and finishing others he had begun abroad, his efforts were recognized, and he received a commission to paint large-scale replicas of four works for the rotunda of the Capitol at Washington. Since then the images of such landmark events in American history as the signing of the Declaration of Independence and the surrender of Cornwallis at Yorktown have been largely determined by Trumbull's painting.

In portraiture, Trumbull scored a number of significant achievements during his residence in the United States beween 1789 and 1793. It was at this time that he painted a large number of outstanding small oil portraits (see *Giuseppe Ceracchi*, p. 217, and *Thomas Mifflin*, p. 214) as well as impressive full-length portraits of George Clinton, 1791 (New York City Hall), and George Washington, 1790 (New York City Hall; 1792, Yale University). In the twelve portraits commissioned by the City of New York and hung at City Hall, Trumbull displayed to this country the soft pastel shades, loose brushwork, and ruddy complexions typical of the latest fashion in English portraiture. In later years this appealing style, brought to its apogee in the United States by Trumbull's competitor Gilbert Stuart, gave way to harsh-looking portraits with a more linear treatment of forms and an overly generous use of dark colors, including black (see portraits of Mr. and Mrs. John Murray, pp. 220–221). Practically ignored today by all except specialists are the artist's history paintings concerned with literary, religious, mythological, and landscape subjects. Many of these were recurring features at the annual exhibitions of the American Academy of the Fine Arts between 1816 and 1836, where Trumbull was president of the board of directors. Their quality was not high, and they found few purchasers. Largely derived from Benjamin West's proto-romantic formulas, they exerted little influence on the younger New York painters, most of whom, at that time, were emulating more up-to-date styles and practically all of whom resented Trumbull's despotic and self-serving handling of the affairs of the academy over which he presided.

Rather than Trumbull, it was Gilbert Stuart who became the most successful and influential of federal period painters. Neither well-born, formally educated, nor diversified in his artistic interests, he possessed enormous natural talent. Stuart could easily have ranked with the great English portraitists of the day had financial circumstances not made it expedient for him to return to the United States. Once home, he quickly established himself as the

country's best and most widely respected artist. Like Copley, he was the purveyor of likenesses that not only skillfully distilled the character of a sitter but also captured something of the general atmosphere of the period.

Although he painted a number of portraits prior to his departure in 1775, Stuart's artistic formation really took place in England. Little is known about this crucial developmental phase of his career: he worked under Benjamin West and presumably learned something from him. By 1779, however, his style had gravitated to the fluid, decorative, and urbane manner of the leading English masters, particularly Gainsborough. Perhaps this is not surprising in view of what is known about his character. Unlike West, who was irreproachably moral, private, religious, and a model of decorum, Stuart was witty, secular, gregarious, and a bon-vivant. It was thus predictable that he would shun the ideological preachiness of history painting and devote himself to the analysis of the human personality. Beginning about 1780, his portraits—specifically, in the faces of his subjects—betray a snapshot-like entrapment of character, a psychological incisiveness quite distinguishable from the gentler, more civilized aims of his English contemporaries. (See, for example, *Man in a Green Coat*, p. 164, *Portrait of the Artist*, p. 165, and *Thomas Smith*, p. 166.) In his greatest work of this period, for example, *The Skater (Portrait of William Grant)*, 1782 (National Gallery of Art, Washington, D.C.), the intensity of the character portrayal dominates the other no less brilliant aspects of the painting so that personality gains the upper hand of social grace. This would not have been possible had Stuart been mostly interested in pleasing his patrons or had his analytical bent been readily susceptible to their influence. As far as we know, and as the works bear out, exactly the opposite was true: with the exception of Washington, Stuart appears never to have been overwhelmed by the status of his subject. Regardless of their qualities as works of art, therefore, his characterizations usually strike us as revealingly accurate. We instinctively trust the suggestion of sycophancy in his portrait of Sir Joshua Reynolds, 1784 (National Gallery of Art, Washington, D.C.), the hint of lofty character in his stylish depiction of John Singleton Copley, 1783–1784 (National Portrait Gallery, London), and the evident grasping selfishness in the full-length of John Fitzgibbon, earl of Clare, 1789 (Cleveland Museum of Art).

For an artist to whom painting was predominantly a vehicle for the revelation of, and at times for passing judgment on, human character, formal considerations necessarily took second place. Accordingly, after his arrival in New York in 1793, Stuart readily diminished the broad handling of paint he had mastered abroad and began producing works remarkable for their unembellished forthrightness, such as *Matthew Clarkson* (p. 167) and *Mrs. Richard Yates*, 1793–1794 (National Gallery of Art, Washington, D.C.). There seems to have been no particular artistic or ideological conviction behind this change of style, although he may have felt the need to compete with Copley, whose portraits still set the standard for portraiture in New York. Stuart just as readily reverted either wholly or partially to his "English" manner whenever he thought it appropriate (see, for example, *Horatio Gates*, p. 172; *Matilda Stoughton de Jáudenes*, p. 170). His view of painting as a means rather than an end also helps to explain why he claimed portraits were finished when only the head had been painted and why he frequently lost interest in particular sitters and never completed their commissions.

After New York, Stuart worked in Philadelphia, Washington, and Boston. It was in Philadelphia that he fulfilled the goal he officially gave out as the cause of his return home: the portrayal of George Washington. He painted several types of bust-length and full-length portraits of the first president, but it is only the third portrait painted from life, the famous unfinished Athenaeum portrait (1796, MFA, Boston, and National Portrait Gallery, Washington, D.C.) that reveals Stuart at ease with his subject and captures the humanity of the great hero. The awesomeness of Washington's presence, the necessity for supplying the country with state portraits, and the immense profitability of producing them quickly operated singly or in combination to make most of Stuart's portraits of Washington unsatisfying performances both psychologically and artistically.

Still, during this time, Stuart managed to paint some outstanding portraits of men and to infuse his portraits of women with an appealing sensuousness never before attempted by a native painter (see *Mrs. Joseph Anthony, Jr.*, p. 181). He was recognized as the finest portraitist working in the United States and became something of a sacred cow. People, however important, considered it a privilege to have their commissions accepted by Stuart and took their chances on whether he would ever fulfill them. In Boston, despite his intemperance and moodiness, he found wholehearted indulgence and perfected a type of portrait that, if not ambitious enough for some of his patrons, was good enough for Stuart—empty background and strong delineation of character (*Henry Rice*, p. 190; *David Sears, Jr.*, p. 191). Even when sympathy for his subjects or respect for their achievements prompted him to do something more than the usual, the auxiliary elements of the portrait are unoriginal and executed without great care (*James Monroe*, p. 194; *Josiah Quincy*, 1824, MFA, Boston; and *Mrs. Andrew Sigourney*, p. 193). On the other hand, some of the simple or unfinished works of this period, such as the portraits of John Adams, 1825–1826 (National Museum of American Art, Washington, D.C.), and Washington Allston (p. 195) are, like the earlier unfinished portrait of Mrs. Perez Morton, ca. 1802 (Worcester Art Museum), utterly magical.

Stuart's impact on the course of American painting can hardly be overstated. He was the first to move effectively away from linearity and toward a freer handling of paint, thus paving the way for the more pronounced painterliness of Thomas Sully, John Neagle, and Henry Inman. He popularized a type of simple portraiture that found ready imitation throughout the country in the work of portraitists such as James Frothingham, Matthew Harris Jouett, Ezra Ames, and Waldo and Jewett. Finally, his self-willed nature and his ability to do artistically as he pleased set a standard of professional independence that was certainly admired by younger artists such as John Vanderlyn and Washington Allston, who viewed painting as an exalted calling. It was to Stuart's great credit that, even in the closing years of his career, when he was still working in a fundamentally eighteenth-century manner, his primacy remained unquestioned, his judgment unimpeachable, his influence undiminished.

Stuart became a paragon during the first decades of the nineteenth century because most artists were still portraitists, despite their ambitions to paint landscapes and historical scenes. The initiation of government commissions for portraits of American heroes for newly erected public spaces, however, added a much needed measure of prestige to the otherwise taxing business of portrait painting. The seminal example of public sponsorship for the arts followed the War of 1812, when the City of New York engaged a number of artists to commemorate

military heroes for the walls of City Hall. For many painters, including John Wesley Jarvis, Samuel Waldo, and Thomas Sully, these commissions led to other government projects and private commissions. Sully, a master of characterization, was very prolific, painting somewhere in the neighborhood of 2,500 pictures during his long and fruitful life. He brought the latest style of English portraiture, as practiced by Sir Thomas Lawrence, to Philadelphia. His palette and technique, which have been damned as shallow by some, may be judged a salutary native transformation of the Englishman's approach. His works in this collection should convince critics that his style was actually quite sophisticated. The attraction of patrons and artists to Sully's style is made clear by the sheer number of his commissions and the influence he brought to bear on John Neagle, Henry Inman, Charles Cromwell Ingham, Chester Harding, and others.

Although portraiture remained the dominant strain in American painting through the 1830s, the American artistic horizon changed radically during the early decades of the nineteenth century. Annual exhibitions at the Pennsylvania Academy as of 1811 and at the American Academy as of 1816—where European paintings on loan from local collectors hung side by side with American ones—compelled artists to show their best, most inspired work. Artists returning from study in London took the opportunity to produce works for exhibition, without specific commissions. At first, Philadelphia painters took the lead in exploring new subject matter, with, for example, James and Raphaelle Peale in still-life painting and Thomas Birch (1779–1851) in landscapes. The Peales produced still lifes of great charm and originality, inspired followers, such as John A. Woodside, and provided an alternative to the Dutch still lifes that were entering the growing collections of Robert Gilmor in Baltimore and Luman Reed and Thomas Jefferson Bryan in New York. Birch, the son of the engraver and miniaturist William Russell Birch (1755–1834), painted landscapes that were models of light-filled clarity and which acknowledged the picture-worthiness of the countryside around Philadelphia.

The two artists most responsible for turning American painting to new paths were John Vanderlyn and Washington Allston. Although their characters and art differed markedly, Allston and Vanderlyn were nevertheless comparable in many respects: they went to Europe early on and achieved considerable success there, they considered themselves educators of the public and embraced history painting wholeheartedly, and both paid a heavy price for their refusal to forsake that ideal. After returning home, both became entrapped by large, unwieldy projects in their later years.

Vanderlyn was the protégé of Aaron Burr and, given the zealous francophilia of this Jeffersonian Democrat, was sent to France in 1796 to obtain academic training. He was the first American-born artist to train in France and the first to adopt an unmistakably French manner; yet there is little indication that his countrymen took note of this. It is possible, however unlikely it may seem, that the linearity and severity of a portrait such as *Mrs. Marius Willett and Her Son, Marinus, Jr.* (p. 254), an early work painted in the United States around 1802 between stays in France, struck its viewers as reminiscent of Copley or Peale and not as a work in the height of French fashion. In 1803, perhaps dismayed by the provincial taste of Americans and sensing he had still much to learn, Vanderlyn accepted a commission to paint copies of old masters for the American Academy in order to return to

Europe. This period, certainly the crucial one in terms of his artistic formation, included a two years' stay in Rome and was a resounding personal success. His acknowledged master-pieces, *Marius Amid the Ruins of Carthage*, 1807 (San Francisco Museums of Fine Art), and *Ariadne Asleep on the Island of Naxos*, 1812 (Pennsylvania Academy of the Fine Arts), were painted at this time and were very favorably received in Europe.

Unfortunately for Vanderlyn, his very success gave him an overly rigid idea of himself as a history painter and cut him off from the artistic life of his native land. Upon his return to the United States in 1815, he found not only that history painting had no market in this country but that some aspects of painting readily accepted in Europe, such as nudity in the representation of mythological scenes, were frowned upon by his compatriots. His huge panorama of the palace and gardens of Versailles (p. 257), inspired by the extremely popular and profitable panoramas he had seen in London and Paris, failed to attract much attention, and his mismanagement of the building erected in New York to display it reduced him to poverty. Unwilling to blame himself, he blamed everyone else; he quarreled with art patrons, city officials, artists, and, perhaps most vociferously, with Trumbull, who received the government commission Vanderlyn coveted. By the 1820s, Vanderlyn had few friends in the city's established artistic circles, and from then on, until his death in 1852, his life was one of poverty, bitterness, and professional mediocrity.

Far more difficult to understand as an artistic personality than Vanderlyn was Washington Allston, widely held to be the country's first romantic artist. Born to a wealthy southern family, Allston settled in Boston after graduating from Harvard College. It was not long, however, before he embarked for England, also intending to visit the Continent, especially Rome. This trip lasted from 1801 to 1808. He absorbed various influences, among which were J. M. W. Turner, assorted old masters, and Dutch landscape and marine painters, but Allston seemed incapable of sorting them out. He was intelligent, well educated, and aristo-cratic—the English considered him a gentleman. His works were exhibited at the British Institution, and he was the friend of well-known artists and writers. Upon his return to Boston he was embraced by that city's intellectual circle as one of their own. They sang his praises with great local pride, and Allston responded by producing some outstanding pictures of a type never before attempted in this country. Among them were such brooding, mysterious, coloristic, and disturbing works as *Elijah in the Desert*, 1817–1818 (MFA, Boston), and the ambitiously large *Dead Man Restored to Life by Touching the Bones of the Prophet Elisha*, 1811–1814 (Pennsylvania Academy of the Fine Arts), all evidence of his considerable learning.

As these works appeared, and as they were noticed by younger artists, his reputation among them also grew. They regarded him as an oracle and frequently sought his advice. Allston's opinions were seldom contradicted, but even as he attained such high status, his pictures failed to exercise a direct influence. He was clearly out of touch with the artistic milieu, such as it existed, and the fact that he painted some of his best pictures after a second trip to England from 1811 to 1818—for example, *Moonlit Landscape* (MFA, Boston) and *Flight of Florimell* (Detroit Institute of Arts), both from 1819—did not seem to help. In the end he became psychologically and aesthetically bogged down in the painting of a large, complicat-ed work, *Belshazzar's Feast*, 1817–1834 (Detroit Institute of Arts). Allston never completed the painting, but finished enough for us to see today the disaster that had befallen him.

If Allston's talent was not sufficient to set the future course of American painting, it was nevertheless indicative of a felt need among artists by the turn of the nineteenth century to break through the barrier of portraiture, which had for so long confined them. The person who did the most to bring artists together to advance their art collectively was Samuel F. B. Morse. As Allston's student and traveling companion in Europe, Morse had high ambitions to become a great artist. His first important paintings, *The Dying Hercules*, 1812–1813, and *The Judgment of Jupiter*, 1814–1815 (both Yale University), show not only the influence of his mentor but also reveal his debt to the classicizing teachings of West and his admiration for the old masters. He returned to the United States as if on a crusade to expand Americans' taste for art and pursued this course even while forced to support himself painting portraits. Thus, while earning a respectable living accepting commissions for portraits, including the prestigious job of taking Lafayette's likeness for New York City Hall in 1825, Morse spoke and wrote about the higher branches of art. Social gatherings of artists at Morse's home eventually developed into the New York Drawing Association, which became the National Academy of Design in 1826. The establishment of an artists' academy, which competed with the American Academy by exhibiting only the work of living artists, was a turning point in the history of American art. Critical coverage of exhibitions by newspapers and journals, such as the *New-York Mirror* and the *Knickerbocker*, increased, and writers extolled historical and genre paintings and landscape painting as the product of a movement to create a truly national art.

This artistic climate set the stage for the astonishingly rapid success of the English-born Thomas Cole. Cole's emphasis on a detailed rendering of natural forms, developed through painstaking outdoor sketching during his brief residence in Pittsburgh in 1823, compares to efforts of earlier landscape painters, such as William Guy Wall, Joshua Shaw, and especially Thomas Doughty. Doughty's landscapes were the first to capture identifiable American qualities of light, atmosphere, and color, and were honest attempts to portray the American land in which he spent much time hunting, fishing, and walking. What set Cole apart from Doughty and other early landscapists was that he made his art a perfect vehicle for the expression of pent-up feelings of nationalism. He realized that the wilderness had not been exploited as an effective subject for landscape painting. Associating the wilderness with the presence of God, Cole recognized, from studying works by Salvator Rosa, that he could exaggerate and alter his subject matter to increase its appeal. In 1825, Cole moved to New York, where he met a local collector who financed him on a sketching trip to the Catskill Mountains. From this point on, the course of American landscape painting would not be the same. Many saw in Cole only the realist side of his style, but, even at this early stage of his career, the painter insisted on "composing" his works and in asserting his mission to give voice to "higher paths." These attitudes, in fact, increased his rising popularity in New York. Trumbull bought one of Cole's paintings and then organized the young artist's public debut at the American Academy because he knew his landscapes would appeal to New York's elite art collectors. Within months, Cole was enlisted to show his work at the National Academy, where the artists praised his ingenious compositions.

In 1829 Cole went to England, where he was exposed to John Constable and J. M. W. Turner, yet Cole could not understand the premises of their style. He left England for Italy in 1831; there he was overwhelmed not so much by Italian art as by the grandeur of the

remnants of ancient Roman civilization. The experience set him to thinking about the rise and fall of great nations, and he conceived of a grand five-part series, *The Course of Empire*, 1836 (New-York Historical Society), which he produced after his return to New York. These paintings, showing the rise and fall of a great civilization, established him as a serious artist with a perceptive, contemporary sense of the meaning of landscape painting. His new interest in allegory spilled over into his American subjects. It is not surprising that his finest native views, of which this collection is fortunate enough to possess three, are imbued with the idealizing spirit of his grand series.

No other American landscape painter was able to challenge Cole during the 1830s and 1840s. His technical ability and synthetic approach seemed to lie beyond the capabilities of others. His influence was so strong that in 1835 his older friend, Asher B. Durand, decided to give up a highly successful career as an engraver to follow his lead. At first an uncertain artistic talent, Durand, thanks to his previous occupation, developed a technique that surpassed Cole's in precision and detail. But Durand did not share Cole's disposition toward the expression of "higher truths." Durand thought that the American landscape painter did not need to go outside of his country for subject matter, and he emphasized a humble attitude before Nature, the work of God. He perfected his style in the late 1840s, and after Cole's death in 1848 assumed the master's mantle. He made clear his talent to the world in *Kindred Spirits*, 1849 (New York Public Library), which memorialized Cole's friendship with the poet William Cullen Bryant. A highly composed and idealized painting full of the most realistically executed details, this picture was unmistakably American in subject matter and attitude. Although Durand was acknowledged as the leader of what was rapidly becoming a New York landscape school, his example was not inhibitory. The younger artists Frederic E. Church, Jasper F. Cropsey, and John F. Kensett, to name only the most important, emulated his painstaking methods and his reverent outlook (somewhat belatedly articulated in his "Letters on Landscape Painting," which appeared in the art journal *The Crayon* beginning in 1855), but they each arrived at decidedly individual styles. Their works are included in the second volume of this series of catalogues.

If the development of landscape in New York was largely the result of the vision and appeal of one man, Cole, the same holds for genre painting and William Sidney Mount. Beginning his career in New York as a sign painter, Mount quickly graduated to portraiture. By the time he moved back to Long Island, where he was born and his family resided, he may have seen a number of Dutch genre paintings both in New York's commercial galleries and private collections. Mount's extraordinarily clear and convincing approach, however, appears to have been the result of close observation of the country life that was all around him in Stony Brook and Setauket, rather than of any close study of foreign models. It might be argued that his forte was the deceptive simplicity of his compositions, in which seemingly straightforward transcriptions of mundane activities (see *The Raffle* (*Raffling for the Goose*), p. 513, and *Cider Making*, p. 516) are actually complex vehicles for political and personal comment.

The same can be said of Mount's colleagues in narrative painting, John Quidor and George Caleb Bingham, who also turned from careers in portraiture to become chroniclers of American stories, habits, and occupations. Quidor may have derived his initial inspiration from a

multiplicity of European artists, but his rather eccentric approach to art upstaged his sources. His portrayal of popular dramatic scenes, primarily from the writings of Washington Irving, bordered on the bizarre and transformed literary satire into caricatures of American life. Bingham, who was less imaginative than Quidor and more inventive than Mount, was perhaps the country's most shrewd narrative artist. He was a skilled painter who devoted his talent to scenes of frontier life, which he knew would be of considerable interest to urban viewers at the National Academy, Apollo Gallery, and American Art-Union. The pictures he sent to New York for exhibition, such as *Fur Traders Descending the Missouri* (p. 540), told tales of the West with such clarity of color and composition that they seemed true. In later pictures on the subject of country elections and country politicians, he commemorated topical conflicts and promoted stereotypical characters in scenes that can be read in relation to his own campaigns for public office. Yet, for all Bingham's disguised messages, his compositions were, above all, poignantly entertaining.

By the 1850s, the collective work of American artists represented a rich pageant of styles and subject matter that provided the impetus for many years to come. Indeed, the growth of taste and talent between the late eighteenth and mid-nineteenth centuries was not only remarkable, but also exhilarating. Succeeding generations of artists had a strong lively base on which to build.

<div align="right">Oswaldo Rodriguez Roque</div>

READER'S GUIDE TO THE CATALOGUE

THE same format, methods, and procedures have been followed in the three American paintings catalogues, and the reader can use the following guideline for all of them. The general intention in the arrangement of the catalogues has been to trace the history of American painting, and thus the basic organizing principle is a chronological one. Rather than place each painting strictly according to date, however, paintings are grouped by artist, and within each artist's work they are arranged in chronological sequence with the earliest painting first. The order of artists is by birth and death dates. Thus when two or more painters have the same year of birth, the one who died first precedes. Works by unidentified artists are placed according to their period, style, and subject matter. There is a brief biography with a selected bibliography on every artist after which the entries on the individual paintings in the collection follow. After each discussion of a painting specific information is arranged in the following order: medium, support, and dimensions; inscription and canvas stamp; related works; references; exhibitions; on deposit; ex collections; credit line; and accession number. All works in the catalogues are illustrated, each one with a caption giving artist and title. Illustrations of related works, details, artist's signatures, canvas stamps, radiographs, autoradiographs, and photographs showing a painting's previous condition are included where appropriate. Every attempt has been made to check the physical condition of each painting during the cataloguing process, but since some were out of the museum on extended loan, such an examination was not always possible. While there is no separate discussion of condition for each work, severe problems and irreversible conditions are noted and discussed in the text of an entry.

Each volume has two indexes: one for artists and titles of paintings and another for provenance. For the convenience of the reader an alphabetical list of all artists represented in the three catalogues appears at the end of each volume, indicating in which volume the main entry on a particular artist is to be found. No absolute cutoff date has been used regarding new acquisitions, but only a few major works received after January 1979 have been included. Paintings not catalogued in Volumes I, II, or III but held by the Department of American Paintings and Sculpture appear at the end of Volume I (p. 623).

These catalogues were begun following the same style as the department's earlier Volume I (1965) by Gardner and Feld, which was in turn based on the museum's European paintings catalogues. As work progressed, however, some changes and additions seemed desirable. Rather than revise the basic format completely, we decided to continue with the tried system and add some new features. There are four basic additions.

In the early volume the sources for quotations in a painting entry were not always indicated; some were given in the reference section, which basically was (and is) limited to works that discuss the museum's painting. Now the sources for all quotations and specific information on an artist's work in general or on his other works are given in parentheses immediately following such information. Thus, the reader should be aware that there is a dual system at work. Where the source for a quotation also mentions the painting, it is listed in the references, and the year

of the publication or item is indicated in the text. The reader can then find the work readily in the reference section, which is organized chronologically. Otherwise, the full bibliographical information appears in parentheses in the text itself.

Under the old method, a similar shortcoming existed regarding information in the artists' biographies. There was often no indication of where the material had been obtained. For this reason a selected bibliography has been added to the biographies to show where most of the information on an artist was found and where further details are available. Here, too, if a particular quotation comes from a work not listed in the bibliography, its origin is indicated in the text in parentheses.

Another new section is one on related works. Although by no means inclusive, it has been added to aid the scholar in sorting out studies, copies, prints, and other versions of a work. It was thought that compiling this information in one place would be helpful.

Finally, it should be noted that attempts have also been made to give the present location of all works of art mentioned in the catalogues. When the present location of a work is not known or the work is not readily available to the public, we have tried to cite a publication where a reproduction of it can be found. Many American paintings have changed hands rapidly in recent years, and it has not always been easy to keep track of them; sometimes the best we could do was to give the place and year in which a work was offered for sale.

No matter how hard one tries to anticipate every possibility in devising a catalogue format, the cataloguer is bound to discover some unexpected but useful information concerning a painting for which there is no proper niche. In such cases we have preferred to be a little inconsistent rather than exclude an interesting item merely because it did not exactly fit the format. As a whole, we have tried to make the catalogues useful to scholars without excluding readers whose interest in American painting is more general and without sacrificing visual design. The following is an explanation of the various categories and editorial procedures used in the catalogues.

Biography of the Artist

The first facts provided on an artist are birth and death dates; these are based on the most recent respected authorities, or in a few cases the discovery of new evidence. Each essay attempts to give pertinent information regarding background, training, stylistic development, influence, and significance. Sources for quoted matter are given in full in the text unless the material comes from one of the publications in the bibliography, in which case only the author's name or a short title and the page number are given. The basic information is derived from works cited in the bibliography.

Cross References

The following method has been used both in biographies and painting entries to indicate a cross reference. When the name of an American painter who is not the subject of that particular entry but whose biography and paintings can be found in the catalogues is first used, it is given in full in small capital letters. For an American painter whose work is not represented in the

catalogues, birth and death dates follow the first mention of the name. This is true only for American painters, not sculptors or engravers, or European artists. To find the volume in which a painter is discussed the reader can consult the complete alphabetical list of artists at the end of each volume. When paintings that have their own entries in the catalogues are mentioned under other entries they are followed by (q.v.).

Bibliography

The bibliography is selective and limited to five items arranged chronologically (obituaries are grouped as one item). Reference works were chosen on the basis of their usefulness in providing the information given in the biography and their reliability as sources for further information. In some cases, however, they are simply all that is available. There are brief annotations to guide the reader.

Titles of Paintings

When known, the original title the artist gave the picture or the title under which the painting was first exhibited or published has been used. For paintings that are obviously portraits, the subject's proper name is given as the title. In some cases, a painting has become so well known by a certain title that to change it would cause considerable confusion, so the popular one has been retained. When, however, a title has been changed, this is indicated in the text of the entry; varying titles appearing over the years are noted in "references" and "exhibited." Where the original title is in a foreign language, it appears in parentheses following the English translation.

Medium and Support

Works have been classified as paintings on the basis of medium and/or support. All works in oil done on canvas, wood, metal, leather, or paperboard supports are included; so too are works in wax, tempera, or mixed media on canvas or wood. In general, works on paper are not included except for a few oils.

Measurements

The dimensions of the support are given in inches followed by centimeters in parentheses. Height precedes width.

Inscriptions

The artist's signature, inscriptions, and their location on the support are given. Inscriptions not in the artist's hand are recorded and indicated as such. Canvas and manufacturers' stamps are also included. Certain labels or stickers are noted when they provide information (e.g., on ex collections or exhibition history) that is not available elsewhere, but they are usually

mentioned where that information is relevant, for example, in the text, or under "exhibited," or "ex coll."

Related Works

A work is considered "related" to a painting in the collection if it is thought to be a preliminary drawing or study, a replica, a variant by the artist, a copy by another artist, or a high quality print based on the painting. There are many cases where artists have painted the same scene or subject repeatedly; such occurrences are generally stated in the text of an entry, but works that just treat the same theme are not included under related works unless there is good reason to consider the museum's picture to be based on one of them.

We do not suggest that the related works noted in this section provide a complete listing. Represented are examples known to our authors through publications or brought to their attention by scholars or the owners of such works. In many cases, our authors have not had the opportunity to examine the related works and have had to rely on previously published information or on the owners for attributions and physical descriptions. A reference to a published illustration is given wherever possible, and some related works are illustrated in the catalogues.

Information on related works is listed as follows: Artist (if other than the artist of the museum's work), Title or Description, Medium, Size, Date, Collection, and City (except in the case of prints), Accession number (only where needed, for example, in the case of drawings in large collections), Reproduction (cited as "ill." in Author, Title, Date, Page or Plate number).

References

For the most part these are sources that refer directly to the painting under discussion. Sometimes, however, sources for the biography of a subject or information on settings or items shown in the paintings are included, but they are always annotated as such. The references are selective: contemporary sources on the paintings are included, as are newspaper and periodical reviews of their exhibitions; more recent books, articles, manuscripts, and spoken accounts appear when they offer new information, interpretations, or in general add to the knowledge of the works. Where a painting is not included in an exhibition but is *discussed* in an exhibition catalogue, the exhibition catalogue appears in the reference section. Otherwise all information from exhibition catalogues is given under "exhibited." Illustrations are noted in the references, and special attempts have been made to mention at least one reproduction in color. At times too, the authors have indicated that an illustration shows the work in a different condition from the present one.

The standard form for a reference is as follows: the writer's first initials and last name, the main title of the book or periodical (subtitles are usually excluded) or a description of the document, the first date of the writing (with the date of later or revised editions following), the volume in arabic numbers, the page number, and possibly a brief annotation. References are separated from one another by the symbol // unless two works by the same writer happen to come one after the other, in which case a semicolon is used. Newspaper and manuscript refer-

ences follow the method prescribed in the twelfth edition of the Chicago *Manual of Style*. A few abbreviations are used and they are listed at the end of these notes.

Material from the Archives of American Art, Smithsonian Institution, has been cited repeatedly, and the reader should know how we distinguish collections owned by the archives from those owned by others but available on microfilm at the archives. When the Archives of American Art has the collection, the item is described, and the date, collection, and archive number is given, followed by "Arch. Am. Art" (e.g. A. H. Thayer to G. de F. Brush, Jan. 6, 1917, Thayer Papers, D200, Arch. Am. Art). When the material is only on microfilm there, the item is described, and the date, the collection, and the place where the collection is to be found are given, followed by the microfilm number used by the Archives of American Art and its name (e.g. J. S. Sargent to I. S. Gardner, August 18, 1894, Isabella Stewart Gardner Museum, Boston, microfilm 403, Arch. Am. Art).

Documents in the museum's possession are also cited frequently, and they are found either in the files of the Department of American Paintings and Sculpture (Dept. Archives) or in the Archives office of the museum (MMA Archives).

Exhibited

The listing of exhibitions in which the painting has appeared is selective. Efforts have been made, however, to include all known exhibitions of a painting before its acquisition by the museum. Also one-man shows, memorials, retrospectives, and major group shows are given. In cases where a catalogue for an exhibition provides new information or places the museum's painting in a new interpretive context, this exhibition, too, is included.

In the listings, the institution, gallery, or exhibition hall is given first, followed by the city (when not already indicated in the name of the institution), the year, the title of the exhibition and catalogue. We then list the author of the catalogue or entry, the number assigned to the painting there, and the title under which the painting was exhibited if it is the first known exhibition or the title is different from the present one. A brief annotation summarizing the information supplied (lender, price, or discussion of the work where significant) is placed last. In the case of regular annual exhibitions the title is dropped (e.g. *Fifteenth Annual Exhibition. . .*) and only the institution or its abbreviation is given (e.g. NAD, 1831, no. 181, as Portrait of a Gentleman, lent by M. E. Thompson).

Exhibitions, like references, are separated from one another by the symbol //. When the same institution appears consecutively, a semicolon is used and the name is not repeated. The places to which an exhibition traveled are listed, except in the case of ones that had many stops, then usually the names of the organizing institutions are given, followed by "traveling exhibition" (e.g. MMA and American Federation of the Arts, traveling exhibition, 1975–1977, *The Heritage of American Art*, cat. by M. Davis, no. 77, ill. p. 172; p. 173).

On Deposit

Paintings are considered as on deposit when they have been housed in, or placed on long-term loan to, an institution or agency that does not own them. Depending on the circumstances,

they may or may not have been available to the general public. Deposits made before the Metropolitan Museum's acquisition of works have been included when known and verifiable.

Ex Coll.

The names of previous owners of a painting from the earliest known to the last are given with their city of residence and the years when they are known to have held the painting. (Dates are usually derived from exhibition information, and owners' death dates are sometimes supplied for the terminal date.) The family relationship of one owner to another is given when known. When a work was owned by, or consigned to, a dealer the preposition *with* appears before the name; a person who simply negotiated the sale or gift of a painting is further described "as agent." Auction information is always given in parentheses. A semicolon is used between the listings of various transactions, except where a painting passed directly from its known owner to an auction sale. A semicolon is also used, however, if we do *not* know or cannot verify the owner at the time of the auction. For example in ". . . Bertha Beckwith, New York, 1917–1926 (sale, Silo's, New York, Nov. 19, 1926, no. 389, as Chase's Wife on the Lake in Prospect Park, 13½ × 19½, $250). . . ." we know that the painting was sold by Mrs. Beckwith at Silo's; if we did not know for sure that she was the owner when Silo's sold the painting, a semicolon would appear before the parenthesis and sale.

Great effort has been made to verify the information we have on previous ownership, but this has not always been successful. In some cases, therefore, a listing may be qualified by "probably," "possibly," or with a question mark. Very often information comes to the museum secondhand, and sometimes there is only family tradition to rely on. The sources for the information we have received are usually found under "References" or "Exhibited"; otherwise a statement on the source follows the name of the former owner, e.g. James Smith (according to a label on the back). The artist's name is sometimes given in this section when the work remained in his possession for a long period after it was known to have been completed and of course if it later reverted to him.

We have given the names of all collections known to us except in the case of anonymous donors to the museum where the person's intent or legal stipulations prevent such disclosure.

Kathleen Luhrs, *Editor*

ABBREVIATIONS AND SHORT TITLES

Am. Acad. of Arts and Letters	American Academy of Arts and Letters, New York
Arch. Am. Art	Archives of American Art, Smithsonian Institution, Washington, D.C.
Arch. Am. Art. Jour.	*Archives of American Art Journal*
DAB	*Dictionary of American Biography* (New York, 1926–1936)
FARL	Frick Art Reference Library, New York
Gardner and Feld	Albert Ten Eyck Gardner and Stuart P. Feld, *American Paintings: A Catalogue of the Collection of the Metropolitan Museum of Art. Volume I: Painters Born by 1815* (New York, 1965)
Groce and Wallace	George C. Groce and David H. Wallace, *The New-York Historical Society Dictionary of Artists in America, 1564-1860* (New Haven, 1957)
MFA, Boston	Museum of Fine Arts, Boston
MMA	Metropolitan Museum of Art, New York
MMA Bull.	*Metropolitan Museum of Art Bulletin*
MMA Jour.	*Metropolitan Museum Journal*
NAD	National Academy of Design, New York
NYHS	New-York Historical Society
NYPL	New York Public Library
PAFA	Pennsylvania Academy of the Fine Arts

THE CATALOGUE

GERRIT DUYCKINCK

1660–about 1712

Evert Duyckinck (1621–ca. 1703), first of a line of four generations of New York painters and the father of Gerrit Duyckinck, was born in Borcken, Holland. By 1640 he had emigrated to New Netherland and was established as a glazier in New Amsterdam in 1648. Although he probably worked as a glass painter or etcher quite early, only one surviving document, a deed dated 1693, mentions him as a painter. His son Gerrit, on the other hand, was considered a painter early in his career. In 1679, when he was nineteen, he was listed in the records of the Dutch Church in New York as "Schilder," or painter, a profession he appears to have practiced at least intermittently throughout his life.

Gerrit Duyckinck's marriage in 1683 to Maria Abeel of Albany associated him with several of the wealthiest and most politically powerful Dutch families in the colony. Perhaps in part because of these connections, Duyckinck became involved with Jacob Leisler, an extremely controversial figure who served as self-appointed governor of New York during the aftermath of the Glorious Revolution. Although he served Leisler's government as a militia captain and apparently as a member of the court of admiralty, Duyckinck escaped Leisler's fate—hanging. He also evidently retained his property, because the tax records for 1695 show that he owned three houses in New York City. In a deed, also dated 1695, Duyckinck is referred to as a glazier, implying that he must have taken over his father's shop. This business was probably very much like that of his son Gerardus (1695–ca. 1745), who advertised in 1735:

> Lookin-glasses new Silvered, and the Frames plaine Japan'd or Flowered, also all sorts of Picktures, made and Sold, all manner of painting Work done. Likewise Lookinglasses, and all sorts of painting Coullers and Oyl sold at reasonable Rates, by Gerardus Duyckinck at the Sign of the two Cupids, near the Old Slip Market. N. B. Where you may have ready Money for old Lookinglasses (Belknap, p. 119).

Gerrit Duyckinck should probably be considered more a craftsman than an artist. He would undoubtedly have regarded painting a portrait as an activity not fundamentally different from decorating windowpanes or even resilvering mirrors. There would have been little reason for innovation on the part of the painters of the Duyckinck family, since the principal issue was to please their patrons. Only the demand for a more fashionable image would have prompted individual stylistic developments. Not surprisingly, then, distinguishing between the works of the Duyckincks is a difficult task, complicated by a general lack of signed or dated paintings and their usually rather poor state of preservation. The body of work attributed to Gerrit Duyckinck depends on a portrait traditionally said to be of him that was recognized by John Hill Morgan in 1921 as having the characteristics of a self-portrait. Under such circumstances, the attribution of paintings is chancy, at best, and the task of building up a coherent body of work for Gerrit Duyckinck or the other members of his family is still to be done.

BIBLIOGRAPHY: John Hill Morgan, *Early American Painters* (New York, 1921), pp. 19, 28–31. Calls painting of Gerrit Duyckinck in New-York Historical Society a self-portrait, an attribution on which

all others are based // Waldron Phoenix Belknap, Jr., *American Colonial Painting: Materials for a History*, ed. Charles Coleman Sellers (Cambridge, Mass., 1959), pp. 63–128. Notes only, mostly genealogical, but contains the basic information on the Duyckincks.

ATTRIBUTED TO GERRIT DUYCKINCK

Mrs. Augustus Jay

Anna Maria Bayard Jay (1670–after 1747) was the daughter of Balthazar and Maria Bayard and the grandniece of Peter Stuyvesant, governor of New Netherland from 1646 to 1664. She was the grandmother of Chief Justice John Jay. The Bayard family was a part of the merchant and landholding aristocracy that dominated New York politics and society throughout most of the eighteenth century. Mrs. Jay's husband, Augustus, to whom she was married in 1697, was a Huguenot merchant who fled to America from La Rochelle after the revocation of the Edict of Nantes in 1685. After their marriage Jay's business prospered, probably because of his wife's family connections. Their great-grandson, Peter Jay, married Sarah Duyckinck, the daughter of the last member of the Duyckinck family active as a painter, Evert IV.

Another, very similar, portrait of Mrs. Jay, attributed to Gerrit Duyckinck and dated about 1710, is in the New-York Historical Society. As the Metropolitan's portrait shows a somewhat younger subject, it may have been painted about 1700. The condition of the painting, however, raises several complicated issues. Although the style of the sitter's bodice suggests a later date, about 1720, pentimenti below the neck suggest that the bodice was repainted to reflect a later style. Exactly what happened is difficult to determine because at some point the panel on which the portrait was painted suffered two vertical splits, one running to the right of the sitter's nose and the other a few inches from the left edge of the painting. Severe paint loss around the damaged areas necessitated extensive repainting in modern times, especially in portions of the face and around the bodice, rendering the authorship and date highly problematical.

The pose is based on a 1695 mezzotint of the countess of Essex by John Smith after Sir Godfrey Kneller.

Oil on wood, 31¾ × 22½ in. (80.6 × 57.1 cm.).
EXHIBITED: Chrysler Art Museum, Provincetown,

Mass., 1970, *American Naive Painting of the 18th and 19th Centuries: 22 Masterpieces from the Collection of Edgar William and Bernice Chrysler Garbisch*, no. 22.
Ex COLL.: Walter Wallace, by 1953, Edgar William and Bernice Chrysler Garbisch, Cambridge, Md., 1953–1970.
Gift of Edgar William and Bernice Chrysler Garbisch, 1970.
1970.283.5.

Portrait of a Lady

This portrait has been associated with Gerrit Duyckinck for some years, but its condition is such as to render a definitive attribution almost impossible. At some time in the past large areas of the figure were repainted, possibly by the artist in an effort to accord with the wishes of his patron, or perhaps by an early restorer. Unrepainted portions of the panel, for example the landscape at the left, are much abraded, so that the work as a whole is difficult to evaluate.

With so little of the original remaining, the key issue is the date the painting was executed. The most authoritative scholar on early New York portraits, Waldron Phoenix Belknap, Jr., who attributed the work to an unknown New York artist, was of two minds about the date, calling it about 1710 at one point and about 1720 at another. In any event, Belknap associated the pose with that in two other portraits painted in New York and Albany during the same period, *Mrs. Anthony Van Schaick*, 1720, which is attributed to the SCHUYLER LIMNER, and *Ariaantje Van Rensselaer*, ca. 1720, which is unattributed (both Albany Institute of History and Art). All three works exhibit billowing drapery behind the sitter, and Belknap convincingly demonstrated that they must be derived from an as yet unknown print.

Oil on wood, 41¼ × 32¾ in. (104.8 × 83.2 cm.).
REFERENCES: *Old Print Shop Portfolio* 3 (Oct. 1943), p. 47, assigns it to Gerrit Duyckinck and dates ca. 1700 // W. P. Belknap, Jr., *American Colonial Painting* (1959), p. 303; no. 32c, p. 304, as Young Lady by New York painter, ca. 1710, says it is derived from a print and has been attributed to Gerrit Duyckinck; p. 324, dates ca. 1720; pl. XXXII, dates it ca. 1710 // O. Larkin,

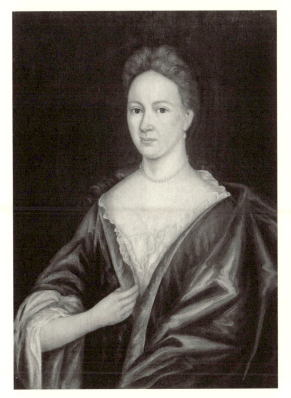 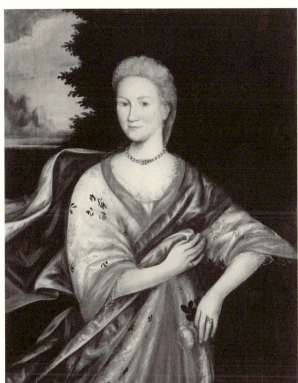

Attributed to Duyckinck, *Mrs. Augustus Jay*. Attributed to Duyckinck, *Portrait of a Lady*.

Art and Life in America (rev. ed., 1966), p. 23, as by a New York limner.

EXHIBITED: National Gallery, Washington, D.C., 1954, *American Primitive Paintings from the Collection of Edgar William and Bernice Chrysler Garbisch*, part 1, p. 13, as attributed to Gerrit Duyckinck, ca. 1710.

EX COLL.: with the Old Print Shop, New York, by 1943–1948; Edgar William and Bernice Chrysler Garbisch, Cambridge, Md., 1948–1972.

Gift of Edgar William and Bernice Chrysler Garbisch, 1972.

1972.263.1.

SCHUYLER LIMNER

active about 1715–1725

There are numerous extant early eighteenth century portraits from the Hudson Valley area around Albany. All of them are unsigned and most are undocumented. Clearly several different artists were at work; yet efforts to distinguish the style of individual painters, based necessarily on purely technical evidence, have proved both controversial and inconclusive. An exhibition of many of these works, "Merchants and Planters of the Upper Hudson Valley, 1700–1750," held in 1967, appears to have deepened disagreements between scholars rather than resolved them, and discussion of these paintings remains fraught with difficulty and uncertainty.

The existence of the artist now called the Schuyler Limner was first proposed by James Thomas Flexner (*First Flowers of Our Wilderness* [1947]). The name is derived from the many portraits of members of the Schuyler family of Albany that have been attributed to the same painter. Active in Albany as early as 1715, he worked for the next ten years there and in nearby Schenectady, and perhaps in Kingston and New York as well. At some point he may have gone to Newport, where he may have painted a portrait of Governor Richard Ward of Rhode Island (Redwood Library and Athenaeum, Newport), and he possibly went as far afield as Virginia; for portraits of members of the Broadnax and Custis families of Jamestown, painted about 1722 to 1723, resemble his style. After that, he may have worked again in Albany, although this is uncertain, and no works by him painted after 1725 have been found.

Some scholars ascribe as many as eighty portraits to the Schuyler Limner, while others discern in this body of work at least four and as many as nine different hands. Part of the difficulty stems from varying painting techniques, such as the use of different pigments and grounds. Another problem is the state of preservation and the additions made by restorers over the years. Also, the Schuyler Limner's development appears to have followed a somewhat unusual course. His early work, for example the portrait of Pieter Schuyler, about 1715 (City of Albany), is markedly more sophisticated than later paintings like that of Mrs. Thomas Van Alstyne, 1721 (NYHS). A comparable development is found in JOHN SMIBERT's work—paintings of his that can now be conclusively dated show an equally quick and sharp falling away from academic standards toward a two-dimensional appearance. One cannot say, however, that increasing "primitivism" necessarily constitutes an artistic failure. Some of the Schuyler Limner's late portraits have a blunt honesty and a timeless, almost iconic, quality that make them powerful and memorable works of art.

Recently, Mary Black has discovered a document that establishes that some of the works of the Schuyler Limner are by Nehemiah Partridge (1683–ca. 1729 or 1737), who was born in Portsmouth, New Hampshire, and worked in Boston as a japanner, painter, and paint merchant from about 1712 to about 1714. In this document is a statement that Partridge pledged to paint four portraits of the Evert Wendell family who were previously identified as the subjects of portraits attributed to the Schuyler Limner.

BIBLIOGRAPHY: Robert G. Wheeler and Janet R. MacFarlane, *Hudson Valley Paintings, 1700–1750, in the Albany Institute of History and Art* (Albany, N.Y., n.d.). Somewhat outdated, but still invaluable source reproduces a number of portraits by the Schuyler Limner // Abby Aldrich Rockefeller Folk Art Collection, Williamsburg, Va.; Museum of American Folk Art, New York; Albany Institute of History and Art; and NYHS, *Merchants and Planters of the Upper Hudson Valley, 1700–1750*, checklist (1967). Includes forty-three portraits attributed to the Schuyler Limner, with dates where possible, and is the most complete treatment thus far // Mary Black, "The Case Reviewed," *Arts in Virginia* 10 (Fall 1969), pp. 12–20. Assimilates Schuyler painter and Flexner's Aetatis Sue Limner into Aetatis Suae Limner, attributes twelve portraits painted in Jamestown to him // Mary C. Black, "Pieter Vanderlyn and Other Limners of the Upper Hudson," in *American Painting to 1776: A Reappraisal*, ed. Ian M. G. Quimby (Winterthur, Del., 1971), pp. 218–234, 247–248. Summarizes career of Aetatis Suae Limner, argues for viewing body of work as by single artist, says Flexner agrees, states that S. Lane Faison, John Davis Hatch, Agnes Halsey Jones, Eleanor S. Quandt, and Russell J. Quandt believe same works are by four to nine artists // Mary C. Black, "Contributions toward a History of

Early Eighteenth-Century New York Portraiture: Identification of the Aetatis Suae and Wendell Limners," *American Art Journal* 12 (Autumn 1980), pp. 4–31. Identifies Schuyler Limner as Nehemiah Partridge.

ATTRIBUTED TO THE
SCHUYLER LIMNER

Portrait of a Lady
(possibly Tryntje Otten Veeder)

Little is known of Tryntje Otten Veeder beyond the fact that she was married to Gerrit Symonse Veeder, a prominent citizen of Schenectady, New York, on August 3, 1690. That she may be the subject of this portrait is largely deduced from the proposed provenance given in the references below and by the general similarity of the painting to a portrait of Gerrit Veeder (Munson-Williams-Proctor Institute, Utica, N.Y.). Although the portraits are similar in style and size, the subjects do not face each other, as would be expected of companion portraits. Both portraits and two others of residents of Schenectady were at one time attributed to a painter called the Veeder Limner, named after the portrait of Gerrit Veeder. However, it seems improbable to maintain a separate identity for a

painter with such a scant body of work in a small area so close to Albany, given the presence of the Schuyler Limner in Albany and Schenectady at the same period and the high degree of similarity of the present portrait to certain paintings attributed to him. For example, the portraits of Mrs. Thomas Van Alstyne, 1721 (NYHS), and Lavinia Van Vechten, 1719 (Brooklyn Museum), have in common with the present one a similar treatment of drapery, eyes, and especially lips, as well as faces so stark and impassive as to remind one of the eighteenth-century portraits of American Indians by Gustavus Hesselius (1682-1755). When the portrait first came to the museum it was thought that the sitter might be Anneke Jans Bogardus, painted by PIETER VANDERLYN. It should, however, be assimilated with the body of work ascribed to the Schuyler Limner and dated about 1720 to 1725.

Oil on canvas, 28 × 24½ in. (71.1 × 62.2 cm.).
REFERENCES: O. Curran, "A Study of Portraits of Schenectady Residents, 1715–1750," M. A. thesis, State University of New York at Oneonta at its

Attributed to the Schuyler Limner, *Portrait of a Lady (possibly Tryntje Otten Veeder)*.

Schuyler Limner, *Gerrit Veeder*. Munson-Williams-Proctor Institute, Utica, N. Y.

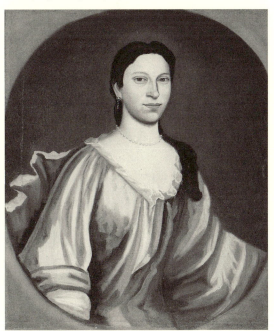

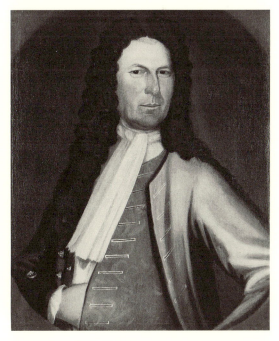

Cooperstown Graduate Programs, 1966, pp. 60–61, 131–133, summarized in *Schenectady County Historical Society Bulletin* 10 (Sept. 1966), pp. [2–8], discusses portrait of Gerrit Symonse Veeder and attributes to Veeder Limner; copy of letter in Dept. Archives, July 25, 1967, suggests the portrait is by the same hand as the portraits of Gerrit Veeder, Caleb Beck, and Anna Beck, who were neighbors, and proposes that subject is Tryntje Otten Veeder, postulating provenance as follows: Tryntje Otten Veeder and Gerrit Symonse Veeder; their son, Helmers Veeder; his daughter, Catherine Veeder Van Eps; her son, Jan Baptist Van Eps; his son, Abraham Truax Van Eps; his daughter, Mary Margaret Van Eps Davis; her granddaughter, Anna Davis Yates; her husband, De Forest Yates, by 1926; his nephew, Lester Yates Baylis.

EXHIBITED: Abby Aldrich Rockefeller Folk Art Collection, Williamsburg, Va.; Albany Institute of History and Art; Museum of Early American Folk Art, New York; and NYHS, 1967, *Merchants and Planters of the Upper Hudson Valley, 1700–1750*, no. 82, attributed to the Schuyler Limner, position in checklist suggesting date of 1720-1721 || MMA, Art Institute of Chicago, and Los Angeles County Museum of Art, 1976, *The World of Franklin & Jefferson* (not in cat.), shown in New York only.

ON DEPOSIT: Schenectady County Historical Society, 1915–1924 || MMA, 1958–1976.

EX COLL.: Anna Davis Yates; her husband, De Forest Yates, by 1926; his nephew, Lester Yates Baylis; his wife, Elizabeth (Eddie) Thornton Baylis, later Mrs. Alfred Wheeler, Darien, Conn., by 1957–d. 1970; estate of Mrs. Alfred Wheeler, 1970-1975; the picture was left to a sister-in-law and a niece, Mrs. Suzanne W. Thornton and Mrs. Phyllis M. Woodward, 1975–1976, who donated the portrait to the museum in memory of their relative, choosing to use her earlier married name on the credit line, probably to indicate the family in which the painting descended.

Anonymous Gift, in memory of Elizabeth Thornton Baylis, 1976.

1977.135.

UNIDENTIFIED ARTIST

Portrait of a Lady
(possibly Hannah Stillman)

The information that accompanied this portrait suggests that it may represent Hannah Stillman, daughter of George and Jane Pickering Stillman of Wethersfield, Connecticut, who was married to Neil McLean, a Hartford physician, in 1737. Originally attributed to PIETER VANDERLYN, the painting bears little resemblance to his work as currently defined. Although it is superficially similar to other portraits by unidentified artists of the same period, 1720–1730, for example that of Mrs. Johannes Van Brugh, about 1729 (NYHS), other works by this particular hand have not yet been located. As so often is the case, the source for the composition is a British mezzotint, the countess of Ranelagh by John Smith after Sir Godfrey Kneller, but the meaning of the composition has been entirely transformed. Kneller painted a young, attractive woman in a pastoral setting, her hand held to her breast in a gesture of modesty. In the present portrait, which has no background, all traces of baroque sensuality and coyness have vanished,

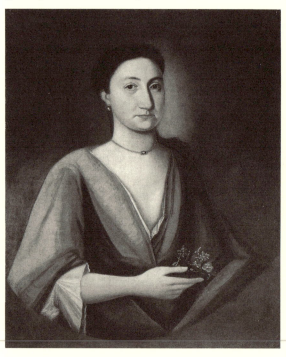

Unidentified artist, *Portrait of a Lady* (*possibly Hannah Stillman*).

despite the sitter's deep décolletage. Her hand, at a rather rigid right angle to her body, holds a tight little spray of flowers, rather than a fold of her dress, and her face is that of a middle-aged, highly respectable woman. She looks piercingly at the viewer, and the planar construction of her face and her large dark eyes suggest solidity and even a certain poignance.

Oil on canvas, 29½ × 24½ in. (74.9 × 62.2 cm.).
REFERENCES: H. L. Coger, letter in Dept. Archives, June 8, 1962, traces provenance as follows: Hannah Stillman McLean, Hartford; her son, Neil McLean, Jr.; his daughter, Anna McLean Wadsworth, Buffalo, N.Y., by 1815, then Springville, N.Y., until 1833; says purchased from her descendant there in 1962; another hand on letter says painting is in period frame by the Pollard Limner.
Ex COLL.: with Henry L. Coger, 1962; Edgar William and Bernice Chrysler Garbisch, Cambridge, Md., 1962–1972.
Gift. of Edgar William and Bernice Chrysler Garbisch, 1972.
1972.263.4

PIETER VANDERLYN

about 1687–1778

Pieter Vanderlyn was born in the Netherlands. He came to New York from Curaçao in 1718, apparently after serving in the Dutch navy in the West Indies. Early in 1722 he was in Albany, and in that same year, in Kingston, New York, he married Geertruy Vas, daughter of the minister of the Kingston Dutch Church. From 1724 until at least 1730 he lived in Albany, returning to Kingston in 1734, where he seems to have spent most of the rest of his life. His second son, Nicholas, was the father of the important early nineteenth century artist JOHN VANDERLYN.

The earliest reference to Vanderlyn's having been a painter comes in an 1848 manuscript biography of his grandson John. Like many other colonial artists, he seems to have also worked as a house and sign painter. In the absence of any signed canvases, the several attempts at building up a body of work for him have produced contradictory results. Although each approach has something to recommend it, the most recent research is probably the most convincing. It attributes a group of some twenty portraits to Vanderlyn. Most are of children, painted in the Albany area and in Kingston from 1730 to about 1745, when Vanderlyn appears to have given up portrait painting. Despite his Dutch ancestry and that of most of his subjects, he used poses based on English mezzotints, as did other colonial artists. In style he tended to simplify his models rather drastically, often outlining his subjects' features and filling in the contours with flat areas of paint. His line, however, was graceful, and his portraits of children, even though repetitive in pose, are especially distinguished by careful observation and individuality.

BIBLIOGRAPHY: Robert Gosman, "Biographical Sketch of John Vanderlyn, Artist," 1848, R. R. Hoes Collection, Senate House Museum, Kingston, N.Y., typescript in NYHS, pp. 11, 13 // Charles X. Harris, "Pieter Vanderlyn, Portrait Painter," New-York Historical Society Quarterly 5 (Oct. 1921), pp. 59–73. Summarizes extant documents on Vanderlyn, assembles body of work, most of which is now given to the Schuyler Limner // James Thomas Flexner, "Pieter Vanderlyn, Come Home,"

Antiques 75 (June 1959), pp. 546–549, 580. Makes a good case for the portrait of Mrs. Petrus Vas as key work but assembles body of work now generally ascribed to the De Peyster Limner // Mary Black, "The Gansevoort Limner," *Antiques* 96 (Nov. 1969), pp. 738–744. Before identifying as Vanderlyn, expands Flexner's discussion in *First Flowers of Our Wilderness* (1947) of works by Gansevoort Limner and lists eighteen paintings // Mary C. Black, "Pieter Vanderlyn and Other Limners of the Upper Hudson," in *American Painting to 1776: A Reappraisal*, ed. Ian M. G. Quimby (Winterthur, Del., 1971), pp. 234–241. Identifies Gansevoort Limner as Vanderlyn; best source to date.

ATTRIBUTED TO PIETER VANDERLYN

Young Lady with a Rose

This portrait is very similar in composition and pose to five others attributed to Pieter Vanderlyn. It is also strikingly similar in pose to a portrait by an unknown painter of Mrs. Jacobus Stoutenburg, about 1720 (Museum of the City of New York), which is derived from a mezzotint of Louise, duchess of Portsmouth, by Paul van Somer after Sir Peter Lely. This pose was used by a number of colonial artists, including JOHN SMIBERT and the SCHUYLER LIMNER. Vanderlyn, however, by simplifying his source, in effect transformed it. His subject stands in an abstractly conceived space, unlike Lely's duchess, who sits gracefully in a landscape. The resulting change is not simply a matter of pose but also of style and apparent meaning. The elegant informality of Lely's portrait has given way and instead there is a rigid, iconic quality. The subject's outsized right hand is held palm outward, while the left, which in the Lely portrait rests easily in the sitter's lap, here toys awkwardly with the end of the belt. With her serious face and meaningful glance, the young lady seems unconcerned with the rose, despite its apparently significant presentation. It is as though a baroque image has been made into an almost medieval one, resulting in an air of strangeness, of an incomplete message.

Oil on canvas, $32\frac{1}{2} \times 27$ in. (82.6 × 68.6 cm.).

Inscribed at lower left: [illegible] / Geschil[derd] [painted] 1732.

REFERENCES: M. Black, *Antiques* 96 (Nov. 1969), p. 738; ill. p. 741, attributes the portrait to the Gansevoort Limner.

EXHIBITED: MMA, 1961–1962, and American Federation of Arts, traveling exhibition, 1962–1964, *101 Masterpieces of American Primitive Painting from the Collection of Edgar William and Bernice Chrysler Garbisch*, color pl. 9, attributes the painting to Pieter Vander-

lyn // Abby Aldrich Rockefeller Folk Art Collection, Williamsburg, Va.; Albany Institute of History and Art; Museum of Early American Folk Arts, New York; and NYHS 1967, *Merchants and Planters of the Upper Hudson Valley, 1700–1750*, no. 57, attributed to the Gansevoort Limner // Los Angeles County Museum of Art and M. H. de Young Memorial Museum, San Francisco, 1966, *American Paintings from the Metropolitan Museum of Art*, p. 15; no. 78, ill. p. 93, as by an unknown Hudson Valley painter // MMA and American Federation of Arts, traveling exhibition, 1975–1977, *The Heritage of American Art*, cat. by M. Davis, no. 3, ill. p. [27], as by the Gansevoort Limner.

EX COLL.: Edgar William and Bernice Chrysler Garbisch, Cambridge, Md., 1958–1962.

Gift of Edgar William and Bernice Chrysler Garbisch, 1962.

62.256.1.

Attributed to Vanderlyn,
Young Lady with a Rose.

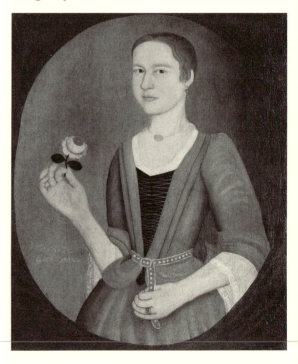

UNIDENTIFIED ARTIST

Boy with a Fawn

Although an attribution of this portrait to a known hand has not been possible, it is quite certain that it was painted by a Hudson Valley limner about 1720. The costume of the unidentified boy and the inclusion of a deer call to mind similar elements in the portrait of *De Peyster Boy with Deer*, about 1735 (NYHS). Both these works are part of a group of representations of children with deer painted by Hudson Valley limners at this time, all mostly derived from a mezzotint by John Smith of Godfrey Kneller's portrait of Lord Buckhurst and Lady Mary Sackville published in 1695. (W. P. Belknap, Jr., *American Colonial Painting* (1959), p. 313, identifies the source.)

It has long been assumed that the fawns in these portraits were included only because they were fashionable pets. While this may be the case, it is just as likely that they, and other animals, served an emblematic function. Deer, in particular, were strongly associated with longevity. Cesare Ripa's depiction of "Long Life" as an old woman accompanied by a stag was certainly known in England and on the continent through the various translations of his work published during the seventeenth and eighteenth centuries (*Iconologia or Moral Emblems* [London, 1709], no. 324). The renowned English physician and author Sir Thomas Browne noted that "the common opinion concerning the long life of Animals, is very ancient, especially Crows, Choughs and Deer." In his chapter on the deer, Browne also stated that "the ground and authority of this conceit was first Hieroglyphical, the Aegyptians expressing longaevity by this animal" (*Enquiries into Vulgar and Common Errors* [London, 1686], pp. 98–101). It seems appropriate, then, that in an age in which infant mortality was all too common, portraits of children should include fawns. In *Boy with a Fawn*, the toy-like representation of the animal, miniaturized and unrealistic, which renders completely puzzling the spatial relationship between the boy and the landscape to his left, calls attention to the fawn's function as emblem more than as a real animal.

Like many other Hudson Valley limners, the painter of this portrait compensated for his lack of training by emphasizing color and two-dimensional pattern. Although certain conventions like the landscape in the background, the formal pose of the child, and the inclusion of the iconographically significant element accord with established practice, the work is fundamentally nonacademic and provincial.

Oil on canvas, 39⅜ × 27⅝ in. (100 × 70.2 cm.).

EXHIBITED: American Federation of Arts, traveling exhibition, 1968–1970, *American Naive Painting of the 18th and 19th Centuries*, pl. 2, dated about 1700.

ON DEPOSIT: Gracie Mansion, New York, 1974–1978.

Ex COLL.: with John F. Schenck, Flemington, N.J., by 1967; Edgar William and Bernice Chrysler Garbisch, Cambridge, Md., 1967–1969.

Gift of Edgar William and Bernice Chrysler Garbisch, 1969.

69.279.1.

Unidentified artist, *Boy with a Fawn*.

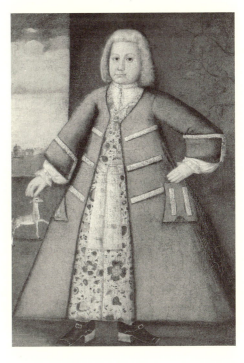

JOHN SMIBERT

1688–1751

The first important academically trained artist to work in America, John Smibert was born and brought up in Edinburgh. He served an apprenticeship to a house painter before leaving in 1709 for London, where he worked as a carriage painter. In 1713 he joined the Queen Street Academy. According to the engraver George Vertue, who knew Smibert and whose diary is an important source of information about him, he then returned to Edinburgh, where he pursued his career as a portrait painter. As Smibert's own notebook, published in 1969, makes clear (p. 73), he was back in Edinburgh by 1719, and the same year he departed for Italy. Following the tradition among northern European artists, he spent most of his time in Rome and around Florence, where he is said to have numbered among his patrons Grand Duke Cosimo III. Like many painters before and since, he supported himself by copying works by artists such as Raphael and Titian and by painting portraits of his countrymen on the grand tour. While in Italy, he made the acquaintance of George Berkeley, later bishop of Cloyne, the great philosopher of idealism, who was responsible for his coming to America.

Late in 1721, or early the next year, Smibert left Italy. He may have stayed for a while in Edinburgh, but then went to London, where he soon established himself as a successful portrait painter. In 1728, however, he joined Berkeley's rather unrealistic project to establish a college for British colonists and Indians in Bermuda. Berkeley planned first to buy a farm in Rhode Island to serve as a source of food for the college. Smibert sailed with him in September 1728, and they arrived in Newport the following January. Here Berkeley remained for a year and a half, waiting in vain for the funds Parliament had voted for the college, but Smibert left for Boston, where he was painting portraits by May.

As the first artist of any eminence to settle in the colonies, Smibert was an immediate success. During his first eight months in Boston he painted twenty-six portraits, earning the considerable sum of £760. In 1730 he showed his work, along with portraits and copies of paintings by other artists, in what was apparently the first art exhibition held in the American colonies. As a result, he was hailed as a "Great Master" in a poem by Cotton Mather's nephew, Mather Byles. Smibert decided to remain in America, although his patronage diminished somewhat as the pent-up demand for portraits began to be satisfied. According to Vertue, "he was not contented here [London], to be on a level with some of the best painters, but desir'd to be w[h]ere he might at the present, be lookt on as at the top of his profession then, & here after in which no doubt, he there succeeded in" (vol. 3, p. 161).

Having left London in 1728, Smibert missed the revolution in British art led by Hogarth in the second quarter of the eighteenth century. The style he transmitted to the American colonies was therefore somewhat *retardataire*, a continuation of the by-then threadbare tradition of Sir Godfrey Kneller. In America, however, Smibert was a major figure. At the moment of his arrival in 1729, he was unquestionably the best-trained and most able painter at work in the colonies, and his early portraits, such as those of Francis Brinley and his wife

and son (qq.v.) established a new standard in American portraiture. Although his style deteriorated after a few years, even as late as 1740, when he was painting portraits in New York and Philadelphia, his work was competent, if not accomplished.

Throughout much of the eighteenth century, Smibert's influence on American artists was considerable. ROBERT FEKE's work clearly progressed during the 1740s under his stimulus. After Smibert's death in 1751, his studio remained intact, and his collection of paintings, especially the copies he had made of European masters, served as models for several generations of artists. JOHN SINGLETON COPLEY, CHARLES WILLSON PEALE, and JOHN TRUMBULL are among the most important of the artists who profited from the study of Smibert's collection, and it is probable that their rapid mastery of the neoclassical style when they went abroad owed something to their careful attention to Smibert's copies of seventeenth-century paintings. In his autobiography, written between 1837 and 1840, Trumbull recalled his study of Smibert's collection, describing him as "the patriarch of painting in America" (ed. T. Sizer, 1953, p. 44).

BIBLIOGRAPHY: *The Notebook of John Smibert with Essays by Sir David Evans, John Kerslake, and Andrew Oliver and with Notes Relating to Smibert's American Portraits by Andrew Oliver* (Boston, 1969). Essential information on Smibert's life and work from 1705 to 1747 // George Vertue, *The Note-Books of George Vertue Relating to Artists and Collections in England*, ed. Sir Henry Hake (6 vols.; Oxford, 1936–1955), 3, pp. 11, 14, 24, 29, 36, 42, 161. Entries from 1713 until the author's death in 1756 // Henry Wilder Foote, *John Smibert, Painter, with a Descriptive Catalogue of Portraits and Notes on the Work of Nathaniel Smibert* (Cambridge, Mass., 1950). For many years the standard work // R. Peter Mooz, "Colonial Art," in *The Genius of American Painting*, ed. John Wilmerding (New York, 1973), pp. 45–50. Good discussion of Smibert's place in English art, his architectural projects, and the changes in his style // Richard H. Saunders III, "John Smibert (1688–1751): Anglo-American Portrait Painter," Ph.D. diss., Yale University, 1979. The definitive work on the artist.

Francis Brinley

Although Francis Brinley (1690–1765) was born in London and educated at Eton, his parents were Americans; his mother was a Bostonian and his father came from Newport. In order to inherit his grandfather's considerable fortune, Brinley came to America in 1710 and eventually settled in Boston, where he married Deborah Lyde, granddaughter of Nathaniel Byfield, whose portrait Smibert later painted (q.v.). After his grandfather's death in Newport in 1719, Brinley built Datchet House in Roxbury, Massachusetts, one of the most splendid residences in the colony at that time. A wealthy landowner, he appears to have passed his life rather uneventfully. He served as colonel in the Roxbury militia during the French and Indian War and held the posts of assistant surveyor and justice of the peace in the colonial government.

An entry in Smibert's notebook states that "Francis Brinley Esqr." was painted "at Boston May 1729." The portrait is thus one of his earliest American paintings, and it has about it the air of suavity and assurance that Smibert achieved only in the work he did immediately after his arrival in the colonies. The sitter's clothing is rendered with more attention to tactile values than is usually the case in Smibert's work, and the face and hands are strongly characterized and carefully modeled. Brinley is ensconced in a stylish Queen Anne armchair, specifically positioned to show a back cabriole leg, thereby implying an expensive version of the usual chair with cabriole legs only in the front. One senses in his heavy face and figure a man of repose and quiet self-satisfaction. The landscape at the right, representing the view of Boston from his country-seat four miles away, is one of the earliest American landscapes by a trained artist. Smibert is known to have painted pure landscapes at several periods in his career, but only one, a 1738 view

of Boston, has been located (Boston art market, 1988, ill. in Corcoran Gallery of Art, Washington, D. C., *Views and Visions* [1987], p. 111, pl. 105). The landscape background in the Brinley portrait is important because it shows what the first landscapes painted in America may have looked like. Although the city of Boston is depicted realistically, with recognizable landmarks such as King's Chapel (Brinley's church) and Old South Meeting House, the landscape itself serves a largely symbolic purpose. In the foreground are rather awkwardly represented haystacks in the meadows beside the Charles River. May, the month in which Smibert noted that the portrait was painted, is not an unlikely time for the first hay crop in New England. But the depiction of haystacks in conjunction with the evening sky also recalls seventeenth- and eighteenth-century European landscape cycles with autumn harvests under early evening skies, a conventional reference to nature's bounty that both Smibert and his sitter would have understood. More directly, as in portraits by other New England artists, Brinley is shown next to the source of his wealth, in this case his extensive landholdings.

Oil on canvas, 50 × 39¼ in. (127 × 99.7 cm.).
REFERENCES: *The Notebook of John Smibert* (1969), 1729 entry, pp. 87, 104 // N. Brinley to F. Brinley, June 24, 1790, Dept. Archives, asks his brother to pick up "Father & Mothers Pictures" from unnamed third party // A. T. Perkins, *Proceedings of the Massachusetts Historical Society* 16 (1878), p. 394, dates it 1729, gives owner as Edward L. Brinley, Philadelphia // T. Bolton, *Fine Arts* 20 (August 1933), pp. 11-12, dates it ca. 1729–1730 // H. W. Foote, *John Smibert, Painter* (1950), pp. 64, 71, 136, dates it 1731–1732 // S. P. Feld, *MMA Bull.* 21 (May 1963), pp. 297–308, discusses Brinley, dates it to a visit made by Bishop Berkeley to Brinley in September 1731 // Gardner and Feld (1965), p. 3 // R. P. Mooz, in *The Genius of American Painting*, ed. J. Wilmerding, (1973), p. 47 // T. E. Stebbins, Jr., letter in Dept. Archives, June 20, 1977, says that haystacks are quite possible in May // R. H. Saunders III, "John Smibert (1688–1751)," Ph. D. diss., Yale University, 1979, pp. 127–128, say Brinley's "matter-of-fact expression is a significant change in emphasis for Smibert. Normal concessions and appropriate gestures . . . are superseded, if only temporarily, by a style based more on direct observation. Few London sitters would have permitted themselves to be painted with their hands folded and consequently *Francis Brinley* is not as typically English as suggested by others"; identifies buildings in landscape.
EXHIBITED: MMA, 1909, *Hudson-Fulton Celebration*,

no. 35, lent by Mrs. Henry Wharton // Yale University Art Gallery, New Haven, 1949, *The Smibert Tradition*, no. 5, lent by Mrs. Henry Wharton // Wilmington Society of the Fine Arts, 1951, *Portraits in Delaware, 1700–1850*, no. 40, lent by David Stockwell, Wilmington // MMA and American Federation of Arts, traveling exhibition, 1975–1977, *The Heritage of American Art*, cat. by M. Davis, no. 1, color ill. p. [24]; rev. ed. (1977), dates it 1729.
EX COLL.: Francis Brinley, Roxbury, Mass., by 1790; his great-grandson, Edward L. Brinley, Philadelphia, by 1878; his daughter, Mrs. Henry Wharton, Philadelphia, by 1909–ca. 1924; her son, Henry Wharton, Philadelphia, 1926; his wife, Mrs. Henry Wharton, by 1949; with David Stockwell, Wilmington, by 1951; with James Graham and Sons, New York, by 1962.
Rogers Fund, 1962.
62.79.1.

Mrs. Francis Brinley and Her Son Francis

When Deborah Lyde (1698–1761), daughter of Edward and Catherine Lyde of Boston, was married to Francis Brinley in 1718, she was a woman of wealth and social prominence. Her grandfather Nathaniel Byfield (see below) was one of the most important and best-connected men in the colony. The various dates previously suggested for the present painting indicated several possible identities for the baby Mrs. Brinley holds in her lap, but the discovery of Smibert's notebook has now resolved the question. Here the portrait is entered under the date of May 1729 as "Mrs. Brinly & son Fras." Young Francis was born in 1729 and died in 1816.

Mrs. Brinley holds a sprig of orange blossoms, which, as Stuart Feld pointed out (1963, p. 305), Smibert may have taken from an eighteenth-century print by Sir Peter Lely. Ultimately, the gesture goes back at least as far as the early sixteenth century, when Leonardo's student Francesco Melzi painted Pomona, the Roman goddess of fruit trees, with an identical gesture. One would doubt, however, that Smibert, who appears to have been visually sophisticated rather than learned, was consciously referring to the classical goddess in his painting. Yet it is curiously appropriate that next to Mrs. Brinley is an orange tree bearing fruit.

In Western Europe since the Crusades the orange blossom has been associated with marriage, the white flower symbolizing purity. The

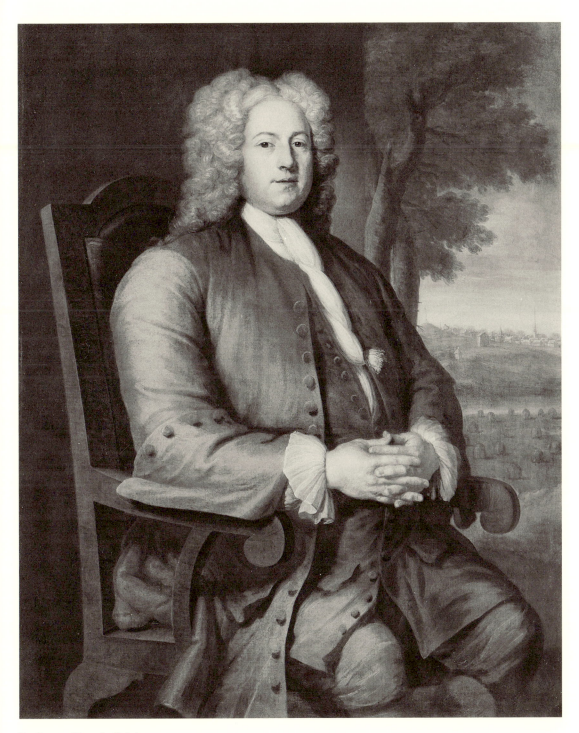

Smibert, *Francis Brinley*.

fruit, however, was generally a sign of fecundity, and Smibert may have been emphasizing both Mrs. Brinley's purity and her role as a mother (she eventually had seven children). At the same time, the orange tree serves as an expression of the subject's wealth. Although cultivated in England as early as the sixteenth century, the trees became fashionable only in the late seventeenth century when Louis XIV had a giant orangery built at Versailles. Like most fashions at the court of the Sun King, the cultivation of orange trees became a vogue all over Europe, but since they required expensive, heated greenhouses in the cold climates of northern Europe, their cultivation was confined for the most part to the very rich. Although it is not known whether orange trees were grown at Datchet House, even the single tree shown next to Mrs. Brinley would have been quite costly and certainly a rarity in early eighteenth century Massachusetts. Thus, as in the companion portrait of Francis Brinley (see above), Smibert has given evidence of the great wealth of the sitter and at the same time linked her to fashionable society in Britain.

Oil on canvas, 50 × 39¼ in. (127 × 99.7 cm.).

REFERENCES: *The Notebook of John Smibert* (1969), 1729 entry, pp. 21, 87, 104 // N. Brinley to F. Brinley, June 24, 1790, letter in Dept. Archives, asks brother to pick up "Father & Mothers Pictures" from unnamed third party // A. T. Perkins, *Proceedings of the Massachusetts Historical Society* 16 (1878), p. 394, identifies child as Francis // T. Bolton, *Fine Arts* 20 (August 1933), pp. 11–12, identifies child as Francis // H. W. Foote, *John Smibert, Painter* (1950), pp. 64, 137, identifies child as Henry // S. P. Feld, *MMA Bull.* 21 (May 1963), pp. 303–306, suggests child was Edward, cites Lely prototype for Mrs. Brinley's pose and Italian or Flemish Madonna and Child compositions as general source for pose // Gardner and Feld (1965), pp. 3–4 // R. P. Mooz, in *The Genius of American Painting*, ed. J. Wilmerding (1973), p. 47, discusses Smibert's technique // R. H. Saunders III, "John Smibert (1688–1751)," Ph.D. diss., Yale University, 1979, pp. 128–129, says pose is closest to Sir Peter Lely's portrait of Elizabeth, countess of Kildare, 1679 (Tate Gallery, London), of which no engraving is known, and that it resembles poses in Smibert's painting of Sir Francis Grant and his family (coll. Lady Grant, Monymusk, Scotland) painted eleven years earlier; notes that Mrs. Brinley, more than her husband, is painted in Smibert's London manner.

EXHIBITED: MMA, 1909, *Hudson-Fulton Celebration*, no. 36, lent by Mrs. Henry Wharton // Yale University Art Gallery, New Haven, Conn., 1949, *The Smibert Tradition*, no. 6, lent by Mrs. Henry Wharton //

Wilmington Society of the Fine Arts, 1951, *Portraits in Delaware, 1700–1850*, no. 41, lent by David Stockwell, Wilmington // Los Angeles County Museum of Art and M. H. de Young Memorial Museum, San Francisco, 1966, *American Paintings from the Metropolitan Museum of Art*, p. 9; no. 1, color ill. p. 33 // MMA and American Federation of Arts, traveling exhibition, 1975–1977, *The Heritage of American Art*, cat. by M. Davis, no. 2, color ill. p. [25]; rev. ed. (1977), dates it 1729.

EX COLL.: same as preceding entry.

Rogers Fund, 1962.

62.79.2.

Nathaniel Byfield

Nathaniel Byfield (1653–1733) was born in Long Ditton, Surrey, the twenty-first child of the Reverend Richard and Sarah Juxon Byfield. He came to Boston in 1674 and the next year married Deborah Clarke, daughter of Captain Thomas Clarke. They settled in Bristol, Massachusetts. His second wife was Sarah Leverett, whom he married in 1718. Byfield was a member of the Massachusetts General Court in 1697 and 1698 and its speaker in 1699. He served as the first judge of the vice-admiralty court from 1699 to 1700, 1703 to 1715, and 1728 to 1733, the year of his death. Strongly opposed to the Salem witch trials, Byfield was firm in his convictions, apparently overbearing in character, exceedingly pious, and generous in his charity. His legal opinions were said to be so sound that he never had a decision reversed on appeal. After his death, the *Boston Weekly News-Letter* of June 14, 1733, gave "An Account of the Deceased," with the following description of his character:

He was greatly valued and honoured by those acquainted with him, for his superior Genius and Abilities; his great natural Courage, Vigour and Activity; his plain, unaffected chearful and instructive way of Conversation; his catholic Spirit; his Zeal against Sin, and to maintain public Peace and good Order; his strict Regard to the Worship of God, and constant, devout and exemplary Attendance on it, both in Public and Private; and in one word, his love to the Ministry, the Churches, and Civil and Religious Interests of this People.

Before the discovery of Smibert's notebook, this picture was assumed to be his original portrait of Byfield. "Coll. Byfield" appears in the notebook under the date August 1729, but the

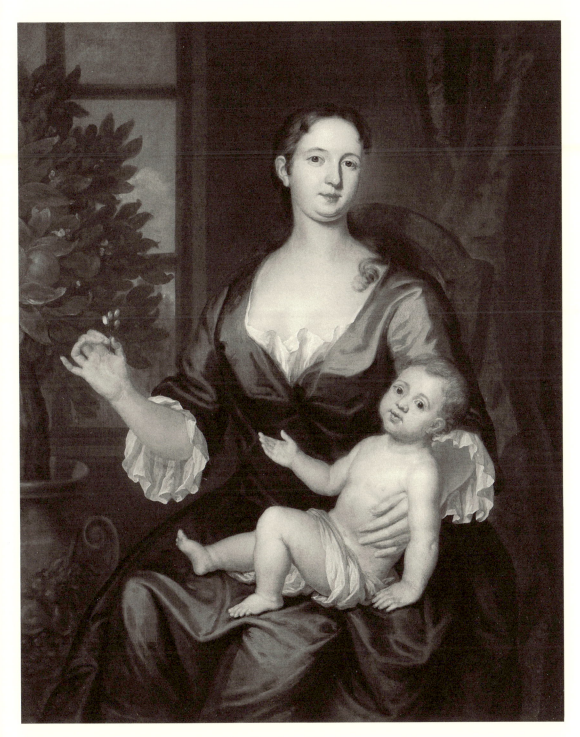

Smibert, *Mrs. Francis Brinley and Her Son Francis.*

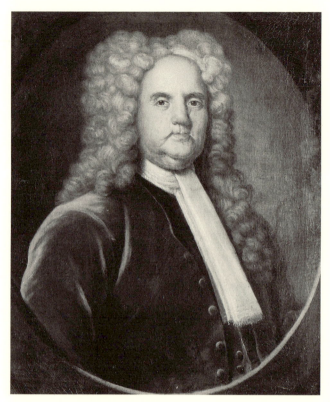

Smibert, *Nathaniel Byfield.*

Oil on canvas, 30 × 25 in. (76.2 × 63.5 cm.).
Inscribed at lower left: ÆTatis 78. 1730.

RELATED WORKS: oil on canvas, ca. 50 × 40 in.
(127 × 101.6 cm.), 1729, unlocated, probably lost //
oil on canvas, 30 × 25 in. (76.2 × 63.5 cm.), 1730?,
private coll., ill. in R. H. Love Galleries, Chicago,
Selections of American Art (1986), p. 4, no. 76. // oil on
canvas, 29 × 24 in. (73.7 × 96.4 cm.), 1730?, Byfield
Parish, Mass., on loan to the Essex Institute // copy by
Jane Stuart, oil on canvas, 34 × 25 in. (96.4 × 63.5
cm.), Byfield School, Bristol, Conn.

REFERENCES: C. Chauncy, *A Sermon on the Death of
the Hon. Nathanael Byfield, Esq.* (1733), discusses the
subject's character // H. B. Wehle, *MMA Bull.* 20
(Jan. 1925), p. 20 // C. K. Bolton, *The Founders* (1919),
2, p. 360, gives information on subject; p. 636, discuss-
es other versions; (1926), 3, p. 741, gives provenance //
T. Bolton, *Fine Arts* 20 (August 1933), p. 42 // O.
Hagen, *The Birth of the American Tradition in Art* (1940),
p. 54 // H. W. Foote, *John Smibert, Painter* (1950), pp.
53, 55, 57, 70–71, 115, 140–141, dates 1730, identifies
as Byfield portrait in Byles's poem, mentions other
versions // Gardner and Feld (1965), p. 2 // *The Note-
book of John Smibert* (1969), p. 105, A. Oliver notes
inscription "clearly wrong" as to subject's age // R.
H. Saunders III, letter in Dept. Archives, Dec. 12,
1977, agrees that this painting is replica by Smibert
of larger original, cites other replicas of portraits by
Smibert, some not listed in notebook; "John Smibert
(1688–1751)," Ph.D. diss., Yale University, 1979, pp.
133–134, says original (1729) portraits of Byfield and
his wife do not survive, states that this portrait is a
replica painted the following year, notes that in this,
as in later replicas by Smibert, light and dark contrasts
are more pronounced than in his portraits from life,
and calls it "a remarkably satisfactory image of a
stalwart colonial patriarch."

EXHIBITED: Newark Museum, N.J., 1947, *Early
American Portraits*, no. 28 // Yale University Art Gal-
lery, New Haven, Conn., 1949, *The Smibert Tradition*,
unpaged, no. 9, foreword by J. M. Phillips calls it
"realistic character portrayal akin to Hogarth" // Yale
University Art Gallery, New Haven, Conn., and Vic-
toria and Albert Museum, London, 1976, *American
Art, 1750–1800*, pp. 69, 275, no. 1, states age inscrip-
tion incorrect, possibly added later, gives provenance.

EX COLL.: Sir William Pepperell, Kittery Point,
Me.; his daughter, Mrs. Nathaniel Sparhawk; her
daughter, Mrs. William Jarvis; her daughter, Mrs.
Hampden Cutts; her daughter, Anna Holyoke Cutts
Howard; her daughter, Mary C. (Mrs. R. W.) King,
Montclair, N.J., 1919; Charles Allen Munn, West
Orange, N.J., 1919–1924.

Bequest of Charles Allen Munn, 1924.
24.109.87.

size of the canvas as indicated, about fifty by
forty inches, and the high price seem to preclude
its being the portrait in the Metropolitan. The
latter bears the date 1730 and is undoubtedly a
replica by Smibert, as evidently are two other
similar portraits of Byfield (see Related Works).
The portrait of Byfield said to have been ex-
hibited by Smibert in 1730 and referred to by
Mather Byles as "Fixt strong in thought" was
probably the larger, more impressive, canvas of
1729 (unlocated).

Smibert's portrait of Byfield differs from many
of his other works in its concern with character
rather than fashion, depicting the sitter as a rigid
man of intense pride, even hauteur. If compared,
however, to Smibert's best portraits, for example
that of Samuel Sewall, 1729 (MFA, Boston),
there is a slightly mechanical aspect to the paint-
ing consistent with its being a replica of another
work and not a painting from life.

Hannah Pemberton

In May of 1734, Smibert was commissioned to paint Samuel Pemberton (Bayou Bend Collection, Museum of Fine Arts, Houston), son of James Pemberton, a well-to-do merchant and landowner for whom Pemberton Square in Boston was named. Two months later he was asked to paint, in the same size and format, Samuel's sisters Mary (also Bayou Bend Collection) and Hannah (1715–1774). Nineteen years old at the time of this portrait, Hannah became, in August 1739, the second wife of Benjamin Colman, a Boston merchant, whom Smibert painted a month after the marriage took place. Colman's portrait (New Britain Museum of American Art, Conn.), a large three-quarter length, was evidently not intended to serve as a companion to the small half-length portrait of Hannah, which was probably still in the possession of her parents. Hannah's portrait is almost the mirror image of her sister Mary's, and it is likely they were painted to hang together.

In the present portrait, Smibert's style clearly shows the flatness and crude modeling that had by 1732 become usual in his work. Hannah Pemberton is in a sense the typical Smibert woman, with regular features and aristocratic demeanor, yet at the same time characterless and somewhat stereotyped.

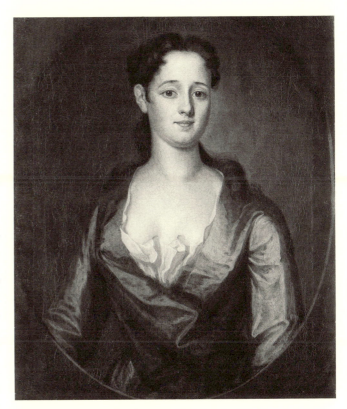

Smibert, *Hannah Pemberton*.

Oil on canvas, 30 × 25 in. (76.2 × 63.5 cm).
REFERENCES: *The Notebook of John Smibert* (1969), 1734 entry, pp. 92, 111 // A. T. Perkins, *Proceedings of the Massachusetts Historical Society* 17 (1879), p. 95, calling it a portrait of Mrs. Benjamin Colman, says possibly by Blackburn and in the possession of Henry Davenport, Boston // H. H. Edes, *Publications of the Colonial Society of Massachusetts* 6 (1904), p. 89, states that the portrait, "erroneously said to belong to the late Henry Davenport" by A. T. Perkins, is in the possession of Ellen M. Ward, Boston, in custody of Colman Ward Cutler, New York, and is believed to be by Blackburn // T. Bolton, *Fine Arts* 20 (August 1933), p. 42, as by Smibert, gives Dr. Colman W. Cutler as owner // L. Burroughs, *MMA Bull.* 3 (Dec. 1944), pp. 98–99, cites Kneller portrait of so-called Princess of Hanover as source for composition // H. W. Foote, *John Smibert, Painter* (1950), pp. 177–178, dates it ca. 1734–1735 // Gardner and Feld (1965), pp. 4–5 // D. B. Warren, *Bayou Bend* (1975), p. 125, notes similar size and format of portraits of Hannah, Mary, and Samuel Pemberton, says perhaps conceived to hang together // L. C. Luckey, letter in Dept. Archives, July 14, 1977, clarifies loan to MFA, Boston // R. H. Saun-

ders III, "John Smibert (1688–1751)," Ph.D. diss., Yale University, 1979, pp. 178–179, says portraits of Pemberton sisters illustrate how difficult it is to judge ages of Smibert's subjects.

EXHIBITED: MFA, Boston, 1878, lent by Henry Davenport, returned to Colman Ward Cutler in 1896.

EX COLL.: the subject's daughter, Mary Colman Ward, d. 1809; her daughter, Phebe Ward Cutler; her grandson, Henry Davenport, Boston, 1878; his first cousin, Ellen Maria Ward, Boston; on loan to her cousin, Colman Ward Cutler, New York, by 1896 (owner by 1933–1935); his son, Paul C. Cutler, Rocky River, Ohio, 1935–1938; with William Macbeth, as agent, 1938–1943.

Rogers Fund, 1943.
43.51.

ROBERT FEKE

about 1708–about 1751

Robert Feke was born at Oyster Bay, Long Island, the second son of the Baptist minister and blacksmith Robert Feke. Although the exact date of his birth is not known, it has been established that an older brother, John, was born in 1706 and a younger sister in 1710. Nothing is known of how he acquired his training as a painter, though his ambitious group portrait of Isaac Royall and his family (Harvard Law School, Cambridge, Mass.) places him in Boston in 1741, already an accomplished artist and very much under the influence of JOHN SMIBERT.

On September 23, 1742, Feke married Eleanor Cozzens of Newport. It was there that the itinerant diarist Dr. Alexander Hamilton of Annapolis, Maryland, visited him in 1744. According to Hamilton, Feke possessed "exactly the phizz of a painter, having a long pale face, sharp nose, large eyes with which he looked upon you stedfastly, long curled black hair, a delicate white hand, and long fingers," a description which accords exactly with Feke's own self-portraits. Dr. Hamilton also thought that Feke was "the most extraordinary genius" he ever knew, doing pictures "tollerably well by the force of genius, having never had any teaching" (C. Bridenbaugh, ed., *Gentleman's Progress: The Itinerarium of Dr. Alexander Hamilton, 1774* [1948], p. 102).

Only eight portraits by Feke are known to have been painted between 1741 and 1745, presumably all in Newport. After 1746, when he was working in Philadelphia, he completed fifteen or twenty paintings per year, earning a substantial two to three hundred pounds annually. Like JOHN WOLLASTON and JOSEPH BLACKBURN, Feke traveled in search of commissions: signed and dated works locate him back in Boston in 1748 and once more in Philadelphia in 1749–1750. It is possible that he then went to Virginia, as portraits of Virginia subjects have been found that resemble his later style. Throughout this period he produced portraits of consistent excellence that introduced new standards of accomplishment in their realism, expressiveness, and decorative qualities. The last mention of his name occurs in a list of witnesses present at the wedding in Newport of his brother-in-law, Joseph Cozzens, in August 1751. He left five children, of whom only two daughters had descendants.

It is now widely acknowledged that Robert Feke was the first exponent of a recognizably American style. His elegant portraits, characterized by accurate likenesses, two-dimensional abstraction, and sharply bounded areas of color, influenced John Greenwood (1727–1792), who was to become the teacher of JOHN SINGLETON COPLEY, as well as JOHN HESSELIUS, the first master of CHARLES WILLSON PEALE. Feke thus stands at the head of a native artistic tradition that eventually embraced all the major American painters of the late eighteenth century.

BIBLIOGRAPHY: Henry Wilder Foote, *Robert Feke* (Cambridge, Mass., 1930). Still the basic biography although now somewhat dated // Waldron Phoenix Belknap, Jr., *American Colonial Painting: Materials for a History*, ed. Charles Coleman Sellers (Cambridge, Mass., 1959), pp. 3–28. Presents documentary evidence establishing the American identity of Feke // R. Peter Mooz, "New Clues

to the Art of Robert Feke," *Antiques* 94 (Nov. 1968), pp. 702–707 // R. Peter Mooz, "Robert Feke: The Philadelphia Story," in *American Painting to 1776: A Reappraisal*, ed. Ian M. G. Quimby (Winterthur, Del., 1971), pp. 181–216. Gives new information bearing on the birth and death dates of the artist and discusses in detail his Philadelphia works.

Tench Francis

This portrait, one of the two signed and dated works that establish Feke's presence in Philadelphia in 1746, occupies a prominent position in the development of his style. Thinly painted in elegant rococo pastel colors, its detailed realism balanced by a geometrical organization of silhouetted shapes, the portrait is the first masterful synthesis of elements that would henceforth become hallmarks of Feke's art.

Born in Ireland, probably in Dublin, Tench Francis (1690?–1758) was the son of the Very Reverend John Francis, rector of St. Mary's Church, Dublin, and dean of Lismore. His mother's maiden name was Tench. He received his education in England, studied law in London, and came to America before 1720 to serve as attorney for Lord Baltimore. He settled in Kent County, Maryland, where he opened a law office. From 1726 to 1734 he was clerk of the Talbot County Court and in the last year of his tenure

Feke, *Tench Francis.*

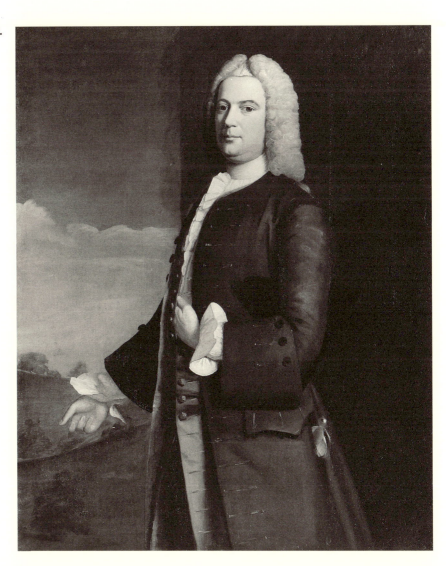

was elected burgess from Talbot County to the Maryland assembly. In 1736 he became commissary general and registrar of wills of Talbot County, a post he continued to fill until 1738 when he moved to Philadelphia with his wife, the former Elizabeth Turbutt, whom he had married in 1724. He moved his law practice to Philadelphia in 1738.

Francis's talents as an orator and his broad knowledge of the law won him an extensive practice, so that by 1741, when he was appointed attorney general of Pennsylvania, he had become the undisputed leader of the Pennsylvania bar. While occupying this office, he worked to insure the effective and impartial administration of the law. In 1750 he acted as a member of the commission appointed to settle the Pennsylvania-Maryland boundary. In the same year, he was made recorder of Philadelphia. In 1755, his health much impaired, he resigned all his offices. When Francis died three years later, the *Pennsylvania Gazette* noted that he had served the province "with the highest Reputation" (August 24, 1758).

In his portrait, Feke represented Francis at the height of his career, a successful and sober man, a pillar of society, and an appealing person. Reflecting the values of Quaker Philadelphia, his dress is plain but of quality. His hat and sword are equally modest. Feke has not concealed the fact that Francis lacked a finger on his right hand.

Another portrait of Francis by Feke, executed in 1749 during his second trip to Philadelphia, is now in a Rhode Island private collection.

Oil on canvas, 49 × 39 in. (124.5 × 99.1 cm.).
Signed and dated at lower right: R. Feke / Pinx 1746.

REFERENCES: J. F. Fisher, *Dawson's Historical Magazine* 3 (Nov. 1859), p. 348, publishes a letter requesting information about Feke, the painter of a "kit-kat (size of life) of a gentleman in the handsome full dress of the time, 1746," almost certainly this portrait, then owned by Fisher. The replies initiated a search for facts about the painter that has continued to the present day // W. C. Poland, *Robert Feke* (1907), p. 20, cites this portrait as proof of Feke's visit to Philadelphia in 1746 and identifies it as that described by Fisher // H. W. H. Knott, *DAB* (1931; 1959), s.v. "Francis, Tench," gives biographical information // T. Bolton and H. L. Binsse, *Antiquarian* 15 (Oct. 1930), ill. p. 37, with a companion portrait of Mrs. Tench Francis; p. 82, lists it as owned by Henry Middleton Fisher // H. W. Foote, *Robert Feke* (1930), pp. 148–149, lists it as no. 2; ill. opp. p. 38 together with another portrait of Tench Francis (no. 1), then considered a work of Feke's // L. Burroughs, *MMA Bull.* 30 (May 1935), pp. 114–116, gives brief biographical details about Feke and Francis // Gardner and Feld (1965), pp. 7–8 // J. D. Prown, *John Singleton Copley* (1966), 1, p. 21 // R. P. Mooz, in *American Painting to 1776*, ed. I. M. G. Quimby (1971), pp. 187–191; in *The Genius of American Painting*, ed. J. Wilmerding (1973), pp. 52, 57, says the landscape background is intended to suggest Francis's farm in Willingboro, N.J. // *MMA Bull.* 33 (Winter 1975–1976), ill. no. 6.

EXHIBITED: PAFA, 1910 // MMA, 1939, *Life in America*, no. 11 // Whitney Museum of American Art, New York; Heckscher Art Museum, Huntington, N.Y.; MFA, Boston, 1946, *Robert Feke*, no. 13 // PAFA, 1971, *Philadelphia Painting and Printing to 1776*, no. 6 // MMA, 1975–1976, *A Bicentennial Treasury* (see *MMA Bull.* 33 above).

EX COLL.: the subject, until 1748; his son, Tench Francis; his grandson, J. Francis Fisher, Philadelphia, by 1859; his son, Dr. Henry M. Fisher, Jenkintown, Pa., until 1934; with Macbeth Gallery, New York, 1934.

Maria DeWitt Jesup Fund, 1934.
34.153.

JOHN WOLLASTON

active 1733–1775

Little is known about John Wollaston's career before his arrival in New York, where his presence was first reported in 1749. It is possible that he was the son of T. Woolaston, a portrait painter mentioned by Horace Walpole in his *Anecdotes of Painting* (1876 ed., 2, p. 236), one of whose sons "followed his father's profession," but this is conjectural. Although CHARLES

WILLSON PEALE, in a letter of 1812 to his son Rembrandt, stated that Wollaston "had some instructions from a noted drapery painter in London" before coming to America, a number of Wollaston's English works, such as his portraits of Sir Thomas Hales, 1744, and Thomas Appleford, 1746 (both NYHS), reveal an artist far better acquainted with the conventions of rococo portraiture than any mere apprentice to a drapery specialist.

Once in America, Wollaston became a much sought after artist. He worked in New York from 1749 to 1752, in Annapolis and other parts of Maryland from 1753 to 1754, and in Virginia from about 1755 to 1757. On November 11, 1757, he was appointed a "writer," or clerk, for the Bengal establishment of the British East India Company. First, however, he went to Philadelphia, where he painted about a dozen portraits in 1758, and then sailed to India in the spring of 1759. By 1760 he had become a magistrate in a court of Calcutta and was deciding cases involving substantial sums of money. He returned to America by 1767 and painted about twenty portraits in Charleston, South Carolina, from January to May of that year, at which time he left for London. Charles Willson Peale, in the letter mentioned above, reported that Wollaston "had returned from the East Indies very rich" and that, "soon after he arrived in London, went to Bath where I believe he died."

Altogether, John Wollaston painted about three hundred portraits in America. He became, in fact, in the words of Bolton and Binsse, a "portrait manufacturer" whose sitters were depicted in similar poses and in similar dress time after time. Still, his likenesses, with the subjects' fine apparel lovingly rendered, were the finest examples of fashionable English rococo portraiture yet seen in the middle and southern colonies. Little wonder, then, that a list of Wollaston's sitters reads like a register of members of prominent American families. The painter's praises were sung in the press of the day. In the *Maryland Gazette*, March 15, 1753, a Dr. T. T., "on seeing Mr. Wollaston's pictures in Annapolis," rhymed:

> Nature and We must bless the hand,
> that can such heavenly Charms portray.
> And Save the Beauties of this Land
> From envious Obscurity.

Francis Hopkinson of Philadelphia, later a signer of the Declaration of Independence, published his "Verses inscribed to Mr. Wollaston" in the *American Magazine* of September 1758.

The fact that his subjects invariably have almond-shaped eyes has long been singled out as a characteristic feature of Wollaston's work and a mark of its provincial character. However, this stylization, perhaps a manifestation of rococo chinoiserie, was entirely in keeping with English portrait fashion in the 1740s, as may be observed in various works by Thomas Hudson, Richard Wilson, and Allan Ramsay. Hopkinson in his poem to Wollaston may well have given voice to his contemporaries' opinion on this matter when he noted:

> The sparkling eyes give meaning to the whole,
> And seem to speak the dictates of a soul.

Although in retrospect much of Wollaston's work does appear mechanical and repetitive, there can be no doubt that his portraits did much to elevate American colonial taste and strongly influenced the early work of BENJAMIN WEST, MATTHEW PRATT, and JOHN HESSELIUS.

BIBLIOGRAPHY: Theodore Bolton and Harry Lorin Binsse, "Wollaston, an Early American Portrait Manufacturer," *Antiquarian* 16 (June 1931), pp. 30–33, 50, 52. Includes extract of Peale's 1812 letter and contains a list of many, but not all, of Wollaston's paintings // George C. Groce, "John Wollaston: A Cosmopolitan Painter in the British Colonies," *Art Quarterly* 15 (Summer 1952), pp. 132–148 // Wayne Craven, "Painting in New York City, 1750–1775," in *American Painting to 1776: A Reappraisal*, ed. Ian M. G. Quimby (Winterthur, Del., 1971), pp. 256–265 // Wayne Craven, "John Wollaston's Early Career in England and New York City," *American Art Journal* 7 (Nov. 1975), pp. 19–31.

Cadwallader Colden

Cadwallader Colden (1688–1776), although born in Ireland, was of Scotch parentage and spent most of his youth in Scotland. His father, Alexander Colden, a minister in Duns, Berwickshire, Scotland, wanted him to follow in his footsteps, but the young Colden, after receiving a degree from the University of Edinburgh, decided to study medicine in London. In 1710 he arrived in Philadelphia, where he practiced as a physician and carried on a mercantile business for the next five years. In 1715, while on a brief trip to Scotland, he married Alice Christie of Kelso (see below), and published his first scientific treatise, on animal secretions. Soon after, he returned to Philadelphia and stayed there until 1718, when he moved with his family to New York, having been promised the surveyor- generalship of the province. This appointment took place in 1720 and marked the beginning of Colden's lengthy career in public service. In 1721 he was named to the governor's council, and, finally, in 1761, he became lieutenant governor of the colony, an office he held until his death.

A learned and versatile man, Colden wrote many treatises dealing with history, applied mathematics, botany, medicine, and philosophy. He also carried on a correspondence with many of the finest minds of his day, including Linnaeus, Benjamin Franklin, Samuel Johnson, and the Dutch philologist Jakob Gronovius. Colden's *History of the Five Indian Nations Depending on the Province of New York*, perhaps his best-known work, appeared in 1727 and was subsequently enlarged and revised. Despite its shortcomings, it remains an authoritative source and one of the pioneer works of anthropological science.

Colden introduced into America Linnaeus's system of botanical classification and sent the Swedish scientist a description of nearly four hundred plants found in the vicinity of his Or-

ange County estate, Coldengham. These were published in 1749 by Linnaeus, who named a species of plant *Coldenia* in honor of one of the discoveries. Colden's interest in medicine never flagged, and he wrote many articles on the fever epidemics that then periodically ravaged American cities, as well as on throat distemper, the treatment of cancer, and the medical properties of tar water.

Colden's career in politics did not make him many friends. He had strong royalist inclinations and sought to break the power of New York's large landowners. As lieutenant governor, he served as the province's highest executive official for fourteen years, except for the brief administrations of several governors. During this tenure, he attempted to halt smuggling, control the judiciary, and enforce the Stamp Act. On November, 1, 1765, at the height of the Stamp Act crisis, a mob burned his effigy with one of the devil on Bowling Green. After the Boston Port Bill and the convening of the Continental Congress in Philadelphia, British authority virtually ceased in the colonies, and Colden retired to his Long Island estate, Spring Hill, near Flushing, where he died.

This portrait and its companion were almost certainly painted between 1749 and 1752 when Wollaston was in New York. They descended in the family until they were bequeathed to the Metropolitan.

Stiff and formularized, compared to the portrait of Joseph Reade (q.v.), the picture is nevertheless a competently executed work that presents the sitter as a confident, urbane gentleman of some means. It was clearly intended to flatter, and, to realize how much of a cosmeticized likeness the picture really is, one need only observe the excessive use of reds in the face and recall that when he sat for this portrait Colden was at least sixty-one. That the sitter is in fact Cadwallader Colden may be established by comparing this work to MATTHEW PRATT's full-length por-

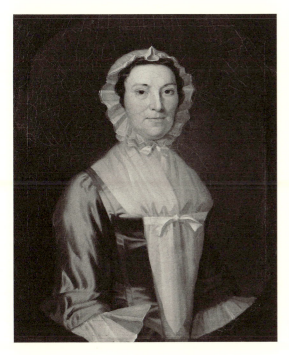

Wollaston, *Mrs. Cadwallader Colden.*

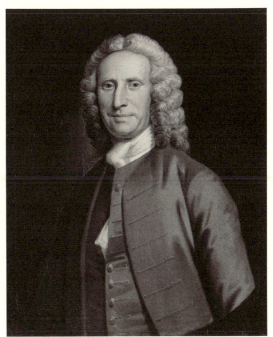

Wollaston, *Cadwallader Colden.*

trait of Colden painted in 1772 (Chamber of Commerce, New York, on loan to NYHS) and his double portrait of Colden with his grandson Warren DeLancey painted about 1771–1775 (q.v.).

The paneling from the parlor of Coldengham, Colden's country house, is now in the collection of this museum, in the Verplanck Room.

Oil on canvas, 30 × 25 in. (76.2 × 63.5 cm.).

REFERENCES: E. R. Purple, *Genealogical Notes of the Colden Family in America* (1873), p. 7, gives biographical data // *DAB* (1930; 1957), s.v. "Colden, Cadwallader," gives biographical information // T. Bolton and H. L. Binsse, *Antiquarian* 16 (June 1931), p. 50, list this painting // J. Downs, *MMA Bull.* 36 (Nov. 1941), pp. 218–224, states that the portraits of the Coldens were painted about 1760 // A. T. Gardner, *MMA Bull.* 17 (April 1959), pp. 205–208, ill. p. 207 // Gardner and Feld (1965), pp. 9–10 // W. Craven, *American Art Journal* 7 (Nov. 1975), p. 27, ill. p. 28.

ON DEPOSIT: Gracie Mansion, New York, 1966–1974; Allentown Art Museum, Pa., 1975–1976.

EXHIBITED: Museum of the City of New York, 1934 (no cat.) // MMA, 1936, *Benjamin Franklin and His Circle,* no. 82.

EX COLL.: descended to the subject's great-grandson, David Cadwallader Colden, New York, d. 1850; his wife, Frances Wilkes Colden, New York, d. 1877; her sister, Anne Wilkes, New York, d. 1890, who owned the portrait jointly with her nieces Harriet K. Wilkes, d. 1887, and Grace Wilkes, d. 1922.

Bequest of Grace Wilkes, 1922.
22.45.6.

Mrs. Cadwallader Colden

Alice Christie, or Christy (1690–1762), is said to have been born at Kelso, Scotland, where her father, David, was a clergyman. In 1715 she was married to Cadwallader Colden (see above) and accompanied him to Philadelphia the following year. She assisted her husband with his accounts and in copying his papers and correspondence and supervised the education of their ten children. Among these, a daughter, Jane, became the first woman in the new world to be distinguished as a botanist, and a son, David, was a scholar of recognized standing. Alice Colden died at Government House, Fort George, New York, in March 1762.

When Wollaston arrived in New York he became the first resident European-trained artist in the city since Hendrick Couturier, who had worked there from about 1673 until 1674. Wollaston's seventy-five or so portraits of New Yorkers set a standard for portraiture in the colony

and became symbols of wealth and status. Their similarity of pose, costume, and expression (see the portraits of Mr. and Mrs. Joseph Reade below) endow them with an iconic regularity that, in all likelihood, was perfectly acceptable to a relatively young colonial aristocracy seeking to perpetuate itself on canvas.

Oil on canvas, 30 × 25 in. (76.2 × 63.5 cm.).

REFERENCES: E. R. Purple, *Genealogical Notes of the Colden Family in America* (1873), p. 7, gives biographical data // *DAB* (1930; 1957), s.v. "Colden, Cadwallader," gives date of subject's marriage and mentions her children // T. Bolton and H. L. Binsse, *Antiquarian* 16 (June 1931), p. 50, list this painting // J. Downs, *MMA Bull.* 36 (Nov. 1941), pp. 218–224, states that the portraits of the Coldens were painted about 1760 // A. T. Gardner, *MMA Bull.* 17 (April 1959), pp. 205–208, ill. p. 207 // Gardner and Feld (1965), p. 10.

ON DEPOSIT: same as preceding entry.
EXHIBITED: same as preceding entry.
EX COLL.: same as preceding entry.
Bequest of Grace Wilkes, 1922.
22.45.7.

Joseph Reade

Joseph Reade (1694–1771), the son of Lawrence Reade, who settled in New York in the early part of the eighteenth century, was im-

portant in New York social, political, and business circles. He became a member of the vestry of Trinity Church in 1715, serving variously as vestryman or warden for more than fifty years. In 1725 he was elected an assessor of the East Ward. That same year he signed a petition to ban the sale and export of spoiled flour, a practice that threatened to ruin the credit of the city. He was a member of the grand jury that examined the cases arising from the slave riots in 1741. Robert Monckton appointed him to the governor's council in 1761, describing him as "a gentleman of fortune and in every way qualified for the trust" (M. J. Lamb [1877; 1921], p. 692). It was in his capacity as council member that, in 1765, he advised Governor Sir Henry Moore and Lieutenant Governor Cadwallader Colden, whose portrait by Wollaston is also in the Metropolitan (q.v.), to delay the issuance of the stamped paper required by the unpopular Stamp Act. Reade continued on the council until his death, when his seat was given to William Axtell, whose portrait by Wollaston is also in the collection (q.v.). At the time of his death, Reade possessed substantial holdings in minerals and ores. Reade Street in New York City was named after him.

This portrait and that of Mrs. Reade (see below) were probably painted during Wollaston's stay in New York from 1749 to 1752. Reade's

Wollaston, *Mrs. Joseph Reade*.

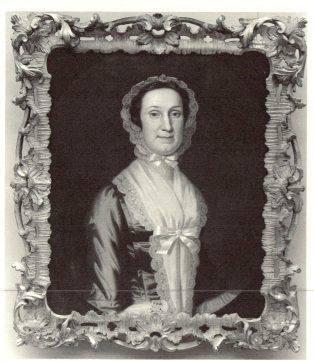

Wollaston, *Joseph Reade*.

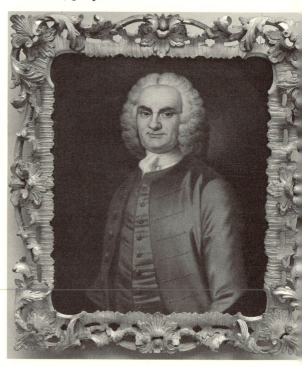

costly brown coat, beautifully curled wig, and pleated stock are carefully and realistically depicted, while his face, uncharacteristically expressive for a Wollaston portrait, is a model of assertiveness and self-assurance. Both of the Reade portraits retain their original carved and gilded rococo frames, which are of unusually high quality.

Oil on canvas, 30 × 25 in. (76.2 × 63.5 cm.).

REFERENCES: M. J. Lamb, *History of the City of New York* (1877; 1921), 1, pp. 582, 627, 692, 725, 730–731, 756; 2, p. 209, note 2; provides biographical information // B. Burroughs, *Catalogue of Paintings in the Metropolitan Museum* (1931), p. 405, lists the picture as lent by A. F. Street since 1925 // "Information given to Mrs. George Eustis Corcoran by her father, the late Mr. William A. Street, concerning the portraits of Mr. and Mrs. Joseph Reade, painted by John Wollaston," June 30, 1948, typescript in Dept. Archives, gives biographical information // Gardner and Feld (1965), p. 11 // W. Craven, *American Art Journal* 7 (Nov. 1975), p. 27.

EXHIBITED: MMA, 1965, *Three Centuries of American Painting* (checklist arranged alphabetically).

ON DEPOSIT: MMA, 1925–1948, lent by Arthur Frederick Street until 1946 and then by William S. E. Corcoran.

EX COLL.: Joseph Reade, until 1771; his wife, Anna Reade, until 1778; her son, John Reade; his daughter, Anna (Mrs. Robert Kearney), New York, d. 1853; her daughter, Susan Watts (Mrs. William Ingram Street), New York; her son, William Augustus Street, Seabright, N. J., and New York, d. 1924; his son, Arthur Frederick Street, New York, 1925–1946; his nephew, William Street Eustis Corcoran, New York, 1946–1948.

Purchase, Gift of Mrs. Russell Sage, by exchange, 1948.

48.129.1.

Mrs. Joseph Reade

Anna French (1701–1778) was the daughter of Annetje Philipse and Philip French. She was married to Joseph Reade in 1720; they had seven children. Mrs. Reade's dress and pose are of a type frequently seen in Wollaston's portraits of women painted during his New York sojourn of 1749 to 1752. The format was well established in British painting, a good example being Allan Ramsay's portrait of Jean Nisbet, 1748 (coll. Lady Eleanor Abercromby, Forglen House, Aberdeenshire; ill. in D. and F. Irwin, *Scottish Painters* [1975], fig. 13).

Oil on canvas, 30 × 25 in. (76.2 × 63.5 cm.).
REFERENCES: same as preceding entry.
EX COLL.: same as preceding entry.
Purchase, Gift of Mrs. Russell Sage, by exchange, 1948.

48.129.2.

William Axtell

William Axtell (1720–1795), born in the West Indies, arrived in New Jersey about 1746 to dispose of some two thousand acres of land in Somerset County, which his father, Daniel, had purchased a few years before. Just when he moved to New York is not known, but by the time this portrait was painted, probably sometime during Wollaston's New York stay of 1749 to 1752, Axtell had married Margaret De Peyster and established himself as a merchant and landowner. He maintained two homes in New York, a town house at 221 Broadway, above Vesey Street, and a country estate in Flatbush, Long Island. The house there, Melrose Hall, where this portrait is said to have hung, was long after considered to be haunted by a mistress of Axtell's.

After the death of Joseph Reade (q.v.), Axtell, whose wife was the sister of Reade's son-in-law James De Peyster, took his place on the governor's council. Some years previous, Abraham De Peyster, Axtell's father-in-law, had served as treasurer of this body. As the Revolution approached, Axtell's leanings became more loyalist. Most of his property, it seems, was in England and the West Indies. In June of 1776 he was brought before the Committee of Conspiracy of the New York provincial congress but was released on parole. The committee reported that they believed him to be a gentleman of high honor and integrity. After the Battle of Long Island, with New York City firmly in British hands, Sir William Howe commissioned him colonel of a corps of Long Island loyalists called the Nassau Blues. During this period he was made responsible for granting licenses to all the public houses in the county and passes over the Brooklyn Ferry, both sources of a large revenue.

When the British evacuated New York, Axtell went to Nova Scotia and from there made his way to England. In 1784 his American property was confiscated, and in 1788 his estate was disposed of. He died at Beaumont Cottage, Surrey, England, in 1795, at the age of seventy-five.

Axtell's wife, who died in 1780, bore him no

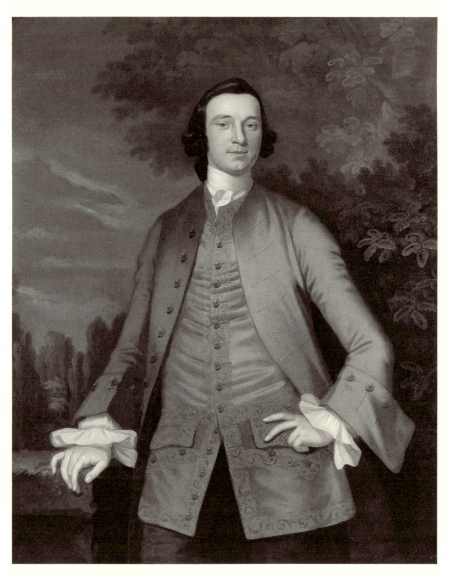

Wollaston, *William Axtell*.

children, but the couple did adopt Elizabeth Shipton, Mrs. Axtell's niece. Miss Shipton later married Aquila Giles, a general in the Continental Army. They purchased Axtell's Flatbush house in 1784 and lived there until 1809. This portrait probably came into their possession at that time. It remained in the Giles family until 1918.

A superb example of Wollaston's large paintings, the portrait presents Axtell as a handsome, charming dandy. He is seen outdoors, as befitted a gentleman with large landholdings, and his confident pose is among the most common in eighteenth-century European portraiture. The fabrics of his garments are realistically painted, with a soft sheen reminiscent of the manner in which Wollaston's Scottish contemporary Allan Ramsay executed drapery. The likeness of the subject is mask-like, stylized, and somewhat impersonal, but the overall effect of the portrait is one of stylishness, well-being, and perfect balance. It is as if the most attractive aspects of Axtell's status had been emphasized, but not his character. As might be expected, the painting complements the companion portrait of Mrs. Axtell (NYHS) rather well.

Oil on canvas, 50 × 40 in. (127 × 101.6 cm.).

REFERENCES: H. D. S[leeper], "Portrait of Colonel William Axtell by John Wollaston," 1929, bound typescript in Dept. Archives, an early inaccurate account of the history of this portrait // T. Bolton and H. L. Binsse, *Antiquarian* 16 (June 1931), p. 50, list this painting // C. A. Axtell, *Axtell Genealogy* (1945), pp. 12–13, gives full biography of subject // *Catalogue of American Portraits in the New-York Historical Society* (1974), 1, ill. p. 29, shows companion portrait of Mrs. Axtell; p. 30.

Ex COLL.: William Axtell, Flatbush, N.Y., until 1784; his adopted daughter, Mrs. Aquila Giles, Flatbush; her son, George Washington Giles, until 1855; William Ogden Giles, New York, 1855; his wife, Catherine C. Giles, New York, until 1917; Silas Blake Axtell, New York, 1917–1926; with Vose Galleries, Boston, 1926–1927; Clarence Dillon, Far Hills, N.J., 1927–1976.

Gift of Clarence Dillon, 1976.
1976.23.1.

JOSEPH BLACKBURN

active 1752–about 1778

The earliest known mention of Blackburn as an artist was made in 1834 by William Dunlap, who called him a painter of "very respectable portraits in Boston." In 1878, Augustus T. Perkins published the first checklist of his works and put forward the proposal that he was born in Wethersfield, Connecticut, about 1700. This was accepted by H. W. French in *Art and Artists of Connecticut* (1879), who also stated that the painter had signed most of his works "J. B. Blackburn." Subsequently, this was amplified to "Jonathan B. Blackburn," the name under which several Blackburn portraits were exhibited at the Metropolitan Museum in 1909 and 1911. Between 1917 and 1919 three discoveries established Blackburn's correct name: Frank W. Bayley found in a list of unclaimed letters published in the *New Hampshire Gazette* of October 30, 1761, one for a "Jos. Blackburn"; Lawrence Park came upon a portrait signed "Jos. Blackburn" in a house in Brooklyn; and a bill for a portrait was discovered that bore the signature "Jos. Blackburn," dated July 12, 1762, at Portsmouth, New Hampshire.

In 1898 Thomas Addis Emmet, in his history of the Emmet family, stated that Blackburn had painted several members of the Tucker family of Bermuda. Since then about twenty pictures attributed to him, some signed and dated 1752 or 1753, have been discovered there. The earliest paintings of American subjects are dated 1754. By 1755 he was established in Boston and for the next eight years was active as a portrait painter, principally in and around Boston and Portsmouth, New Hampshire. Then he seems to have disappeared from New England. A bill paid to him in London in January 1764 by Jonathan Warner of Portsmouth, New Hampshire, indicates that he had settled in England, perhaps the country of his origin. A number of portraits, signed and dated after this year, all apparently painted in England, suggest that he remained active there.

Blackburn's portraits painted in Bermuda and New England indicate that he had previously received some training abroad, probably in England, and that he was familiar with the works of such English painters as Thomas Hudson and Joseph Highmore; yet his manner is not altogether a reflection of contemporary English rococo portraiture. Elements of the

more formal baroque portrait survive and may be observed in this collection in the pose of Mrs. David Chesebrough and in the wind-tossed shawl of Mary Sylvester (qq.v.). Still, Blackburn, together with JOHN WOLLASTON, can be credited with popularizing in America the more delicate, decorative, pastel-shaded style of portraiture usually considered rococo. In fact, other parallels exist between Wollaston and Blackburn: both specialized in fashionable portraiture with an emphasis on drapery and were fast workers.

Blackburn's arrival in New England could not have occurred at a more opportune moment. More graceful, informal, and erotically tinged than the works of his American contemporaries, his pictures found special favor among members of the merchant aristocracy, who commissioned about sixty percent of his portraits, many of them full size (J. D. Prówn, 1, p. 26). Certainly, his were the best paintings produced in New England in the years immediately after the disappearance of ROBERT FEKE, about 1750, and the death of JOHN SMIBERT in 1751. Only JOSEPH BADGER, John Greenwood (1727–1792), and the young JOHN SINGLETON COPLEY offered Blackburn any competition. Their less sophisticated portraits, however, did not compare very favorably with the stylish productions of Blackburn. Copley, who had been painting for only two years when Blackburn arrived in Boston, quickly realized this, and his portraits of 1756 to 1757 strongly reflect Blackburn's influence. By 1758, however, Copley had effected a highly personal synthesis of Blackburn's style with the more native approach of Feke and had begun to emerge as the major figure in American colonial painting. It is likely that his rapid success prompted Blackburn to seek his fortune elsewhere in 1763. His last known signed and dated work is a 1778 English portrait.

BIBLIOGRAPHY: Lawrence Park, "Joseph Blackburn: A Colonial Portrait Painter, with a Descriptive List of His Works," *Proceedings of the American Antiquarian Society* 32 (Oct. 1922), pp. 270–329. Reprint. Worcester, Mass.: American Antiquarian Society, 1923. Gives a history of the discoveries establishing Blackburn's identity and lists eighty-eight portraits // John Hill Morgan and Henry Wilder Foote, "An Extension of Lawrence Park's Descriptive List of the Works of Joseph Blackburn," *Proceedings of the American Antiquarian Society* 46 (April 1936), pp. 15–81. Reprint. Worcester, Mass.: American Antiquarian Society, 1937. Disagree with Park regarding the exact date of several discoveries, add thirty-eight works to Park's list, and correct other errors // C. H. Collins Baker, "Notes on Joseph Blackburn and Nathaniel Dance," *Huntington Library Quarterly* 9 (Nov. 1945), pp. 33–42. Says Blackburn's style is provincial and unlike the London manner of Joseph Highmore or Thomas Hudson, but this opinion is not altogether convincing // Jules D. Prown, *John Singleton Copley* (2 vols.; Cambridge, Mass., 1966), 1, pp. 23–27. Clarifies the stylistic relationship between Copley and Blackburn.

Mrs. David Chesebrough

Margaret Sylvester (1719–1782) was born at Southold, Long Island. She was the daughter of Brinley and Mary Sylvester of Sylvester Manor, Shelter Island, New York, and the older sister of Mary Sylvester (see below). In October 1749 she became the second wife of "King David" Chesebrough, a wealthy and prominent Newport merchant. They had two children. The Chese-broughs lived in Newport until the coming of the Revolution, at which time they moved to Stonington, Connecticut. They both died there in 1782.

Family tradition has it that this portrait and that of Mary Sylvester were painted in New York City, but no evidence exists that Blackburn ever worked in New York or that the Chesebroughs ever lived there. Accordingly, it seems wiser to assume that the picture, which is dated 1754,

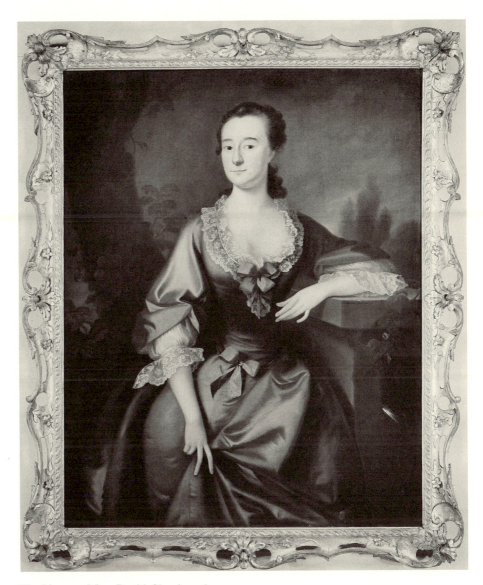

Blackburn, *Mrs. David Chesebrough.*

was executed in Newport, and that it was there, and not in New York, that Blackburn painted his first American portraits.

As did many painters active in America at the time, Blackburn often relied on British mezzotints for his compositions. Although no exact source for this portrait is known, it is very similar to the mezzotint portrait of Lady Mary Douglas engraved by John Smith in 1707. Blackburn would have been capable on his own of modifying such a pose.

Further evidence of Blackburn's sophistication is revealed by his inclusion of iconographical elements alluding to Margaret Chese-

brough's married state. The ivy twining around the tree in the background and clinging to a ledge whence pours the water that sustains it was a long-established symbol for the dependence of the wife upon the husband, their inseparability, and their mutual growth.

The portrait retains its original carved and gilded frame.

Oil on canvas, 49$\frac{7}{8}$ × 40$\frac{1}{8}$ in. (126.7 × 101.9 cm.).
Signed and dated on the ledge at right center: I. Blackburn Pinxit 1754.

REFERENCES: H. T. Tuckerman, *Book of the Artists* (1867), p. 45, says that this portrait was much admired for its artistic merit and was exhibited at the

American Academy at the request of John Trumbull // A. T. Perkins, *Proceedings of the Massachusetts Historical Society* 16 (1878), p. 388, says this picture was owned by Dr. Deering [*sic*], Utica, N.Y. // A. C. Wildey, *Genealogy of the Descendants of William Chesebrough* (1903), pp. 27–28, gives biographical information on the subject // B. Burroughs, *MMA Bull.* 11 (June 1916), ill. cover; p. 132, incorrectly calls the artist Jonathan Blackburn // L. Park, *Art in America* 7 (Feb. 1919) pp. 70–79, calls the picture the earliest known dated work by Blackburn in America, states that it is traditionally said to have been painted in New York, and notes that it is very similar to his portrait of Mrs. William Greenleaf; *Proceedings of the American Antiquarian Society* 32 (1922), p. 294, no. 24 // F. W. Bayley, *Five Colonial Artists of New England* (1929), p. 85 // T. Bolton and H. L. Binsse, *Antiquarian* 15 (Nov. 1930), p. 90 // A. Burroughs, *Limners and Likenesses* (1936), pp. 55–56 // J. H. Morgan and H. W. Foote, *Proceedings of the American Antiquarian Society* 46 (1936), pp. 19–20, say it was painted at Newport, that no known works suggest that Blackburn was ever active in New York // O. Hagen, *The Birth of the American Tradition in Art* (1940), p. 96 // C. H. C. Baker, *Huntington Library Quarterly* 9 (Nov. 1945), p. 36 // Gardner and Feld (1965), pp. 13–14 // J. D. Prown, *John Singleton Copley* (1966), 1, p. 23, says it influenced Copley's portrait of Anne Gardiner.

EXHIBITED: American Academy of Fine Arts, New York, 1833, as Portrait of a Lady, lent by Dr. Dering // MMA, 1895, *Retrospective Exhibition of American Paintings*, no. 191, lent by General Sylvester Dering, Utica, N.Y.

Ex COLL.: descended to the subject's grandnephew, Dr. Nicoll Havens Dering, Rome, N.Y., by 1833– d. 1867; his son, Sylvester Dering, Utica, N.Y., until 1916.

Gift of Sylvester Dering, 1916.

16.68.3.

Mary Sylvester

Mary Sylvester (1725–1794) was the sister of Mrs. David Chesebrough (see above). She was married to Thomas Dering, a Boston merchant, in March 1756 in Newport, where she had been educated. In 1760 they moved to Shelter Island, New York, where Dering took charge of the family estate that his wife had inherited. She died at East Hampton, Long Island, in 1794. Although her portrait is not dated, it is likely that Blackburn painted it in 1754, the year in which he painted the portraits of her sister and Abigail Chesebrough (Stonington Historical Society, Conn.), the daughter of David Chesebrough by a previous marriage.

In accordance with her unmarried status, Blackburn depicted Mary Sylvester as a shepherdess, the lamb at her side a symbol of purity and innocence. The rest of her flock, visible in the lower right corner of the painting, is well tended, indicating her attention to the maidenly virtues.

It has often been assumed that Blackburn derived this allegorical representation from a British mezzotint, but as in the case of the preceding portrait a source has not yet been identified. The representation of virtuous ladies as shepherdesses was well established in English rococo portraiture, and Blackburn must have been familiar with this convention.

The exceptionally fine carved, painted, and gilded frame is original to the portrait.

Oil on canvas, 49⅞ × 40 in. (126.7 × 102.1 cm.).
Signed on the shaft of the crook: I. Blackburn Pinx.

REFERENCES: H. T. Tuckerman, *Book of the Artists* (1867), p. 45, says that this portrait was much admired for its artistic merit and was exhibited at the NAD at the request of John Trumbull // A. T. Perkins, *Proceedings of the Massachusetts Historical Society* 16 (1878), p. 388, says this picture was owned by Dr. Deering [*sic*], Utica, N. Y. // B. Burroughs, *MMA Bull.* 11 (June 1916), p. 132, ill. p. 133, incorrectly calls the artist Jonathan Blackburn // L. Park, *Proceedings of the American Antiquarian Society* 32 (1922), p. 317, no. 68, says the picture was probably painted in New York in 1754 // F. W. Bayley, *Five Colonial Artists of New England* (1929), p. 125 // T. Bolton and H. L. Binsse, *Antiquarian* 15 (Nov. 1930), p. 92 // A. Burroughs, *Limners and Likenesses* (1936), p. 57, says the picture shows Blackburn's usual shopworn gestures; fig. 50, illustrates it in conjunction with Copley's shepherdess portrait of Ann Tyng of 1756, which Burroughs thinks is derived from it // J. H. Morgan and H. W. Foote, *Proceedings of the American Antiquarian Society* 46 (1936), p. 19, say it was painted at Newport in 1754 or Boston in 1756 // O. Hagen, *The Birth of the American Tradition in Art* (1940), p. 98 // C. H. Collins Baker, *Huntington Library Quarterly* 9 (Nov. 1945), p. 36 // Gardner and Feld (1965), pp. 14–15 // J. D. Prown, *John Singleton Copley* (1966), 1, p. 23, says relationship to Copley portrait of Ann Tyng has often been noted.

EXHIBITED: American Academy of the Fine Arts, New York, 1833, as Portrait of a Lady, lent by Dr. Dering // MMA, 1895, *Retrospective Exhibition of American Paintings*, no. 200k, as The Shepherdess, a Portrait of Miss Mary Sylvester, 1754, lent by General Sylvester Dering, Utica, N.Y. // Los Angeles County Museum of Art and M. H. de Young Memorial Museum, San Francisco, 1966, *American Paintings from the Metropolitan Museum of Art*, p. 10; no. 2, ill. p. 17 // MMA

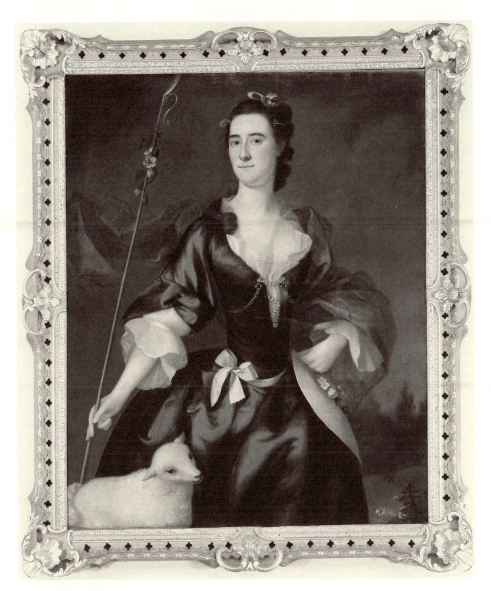

Blackburn, *Mary Sylvester*.

and American Federation of Arts, traveling exhibition, 1975–1977, *The Heritage of American Art*, cat. by M. Davis, no. 5, ill. p. [30] // Society for the Preservation of Long Island Antiquities, Setauket, N.Y., 1976, *Long Island Is My Nation*, cat. by D. Failey, no. 66, ill. p. 61.

EX COLL.: same as preceding entry.
Gift of Sylvester Dering, 1916.
16.68.2.

Samuel Cutts

Samuel Cutts (1726–1801) was born in Portsmouth, New Hampshire. He was the son of Eunice Curtis and Richard Cutts. After he received training in the countinghouse of Nathaniel Sparhawk in Kittery, Maine, Samuel returned to Portsmouth where he became a prosperous merchant in the East India trade. He was also active in politics, serving as a representative to the New Hampshire General Court, a member of the provincial congress, and later the New Hampshire assembly. In November of 1762, he married Anna Holyoke (see below) in Cambridge, Massachusetts.

Blackburn depicts the prosperous Portsmouth merchant in typical eighteenth-century fashion. There is a view of the harbor out the window

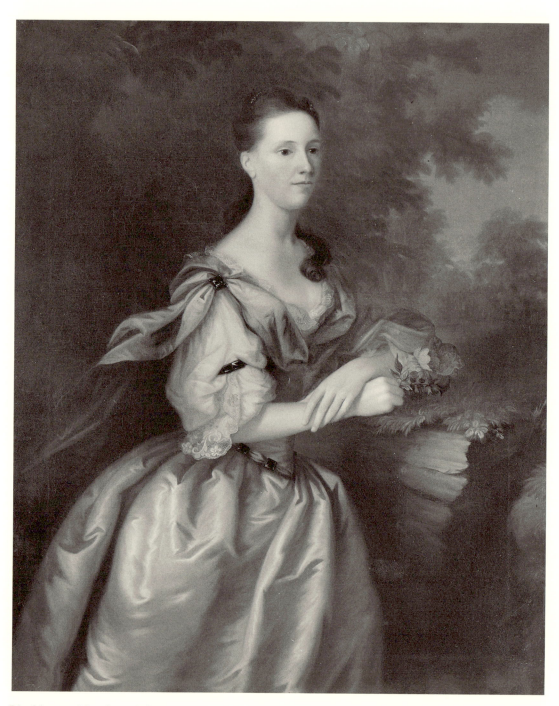

Blackburn, *Mrs. Samuel Cutts*.

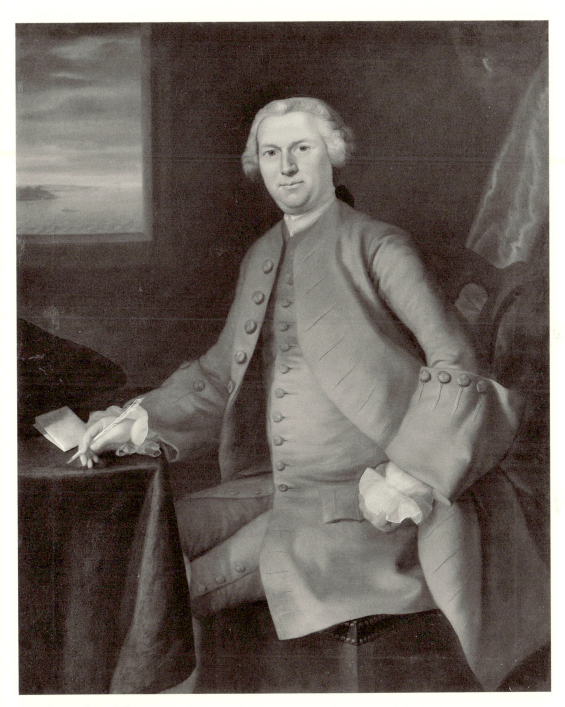

Blackburn, *Samuel Cutts*.

and what may be one of Cutts's trading vessels on the horizon. Lawrence Park dates the pictures 1763, insisting that they must have been done after the Cuttses' wedding. It is, of course, just as likely that they were done in 1762 before their impending marriage. Either way, they are likely wedding portraits and probably among the last works Blackburn painted before leaving America.

As is readily evident from his portraits of Mary Sylvester and Mrs. David Chesebrough (qq.v.), strong characterization was not Blackburn's forte. In this pair of portraits, however, he proved that his ability to render strong likenesses was not inconsiderable. This aspect of the Cuttses' portraits, in combination with the masterful drapery painting that is more typical of Blackburn's American works, place these portraits among the most successful of his productions. Whether the high social rank of his sitters, or their ability to pay well, prompted Blackburn's extra efforts, the result was a most happy one: It is easy to think that the portraits show the subjects and the artist at their best.

Oil on canvas, 50¼ × 40⅜ (127.6 × 102.6 cm.).
REFERENCES: A. S. Cutts, will, Nov. 25, 1919, copy in Dept. Archives, bequeaths "antique portraits of the Cutts family" to Louise Cutts Powell // L. Park, *Proceedings of the American Antiquarian Society* 32 (Oct. 1922), p. xx, dates portrait about 1763 // H. D. S[leeper], "Portraits of Mr. and Mrs. Cutts," typescript 1928, in Dept. Archives, provides biography of subjects and complete provenance.
EX COLL.: the subject, Portsmouth, N. H., d. 1801; his son, Edward Cutts, Portsmouth, d. 1824; his son, Hampden Cutts, Brattleboro, Vt., d. 1885; his son, Edward Holyoke Cutts, Faribault, Minn., d. 1887; his widow, Hannah (Annie) Sherwood Cutts, Omaha, until 1919; her granddaughter, Louise Cutts Powell, Boston, 1919; with Vose Galleries, Boston, 1919-1926; Clarence Dillon, Far Hills, N. J., 1926–d. 1979.
Bequest of Clarence Dillon, 1979.
1979.196.1.

Mrs. Samuel Cutts

Anna Holyoke (1735–1812), the daughter of the Reverend Edward Holyoke, was born at Marblehead, Massachusetts. Her father was president of Harvard College from 1737 to 1769, and her mother, the former Margaret Appleton, was from a distinguished New England family.

In November of 1762 Anna Holyoke became the wife of Samuel Cutts (see above). It is presumed that they met through Miss Holyoke's relations, the Havens family in Portsmouth. After their marriage, the Cuttses took up residence in a new house on Market Street that became one of the showplaces of Portsmouth. The house burned in 1802, and, according to family tradition, these portraits were among the household items that were saved from the fire. Mrs. Cutts outlived her husband by eleven years and died in Kennebunk, Maine.

Blackburn has placed Mrs. Cutts in a woodsy outdoor setting, typical of English rococo portraiture. Her elaborate dress is in the Van Dyck style, which was enjoying a revival in England at this time. Blackburn probably copied it from a mezzotint, a common practice among eighteenth-century American portrait painters.

The frames on the pictures appear to be the original ones. In the rococo style and of English make, they show traces of having once been gilded.

Oil on canvas, 50¼ × 40½ (127.6 × 102.9 cm.).
REFERENCES: same as preceding entry.
EXHIBITED: same as preceding entry.
EX COLL.: the subject, d. 1812, Portsmouth, N. H.; her son, Edward Cutts, Portsmouth, d. 1824; his son, Hampden Cutts, Brattleboro, Vt., d. 1885; his son, Edward Holyoke Cutts, Faribault, Minn., d. 1887; his widow, Hannah (Annie) Sherwood Cutts, Omaha, until 1919; her granddaughter, Louise Cutts Powell, Boston, 1919; with Vose Galleries, Boston, 1919–1926; Clarence Dillon, Far Hills, N. J., 1926–d. 1979.
Bequest of Clarence Dillon, 1979.
1979.196.2.

JOSEPH BADGER

1708–1765

One of the least-known colonial portraitists, Joseph Badger was identified by art historians in the early part of the twentieth century. The son of an impecunious tailor of Charlestown, near Boston, Badger, like the Duyckincks in New York, was more a craftsman than an artist. Unlike them, however, he was ambitious, and his career is replete with efforts at self-improvement. Initially imitative of ROBERT FEKE and JOHN SMIBERT, Badger later turned to JOHN SINGLETON COPLEY, who was thirty years younger, as an exemplar, and in fact several of his works were for some time believed to be early Copleys. In a sense, however, Copley was Badger's nemesis; his work surpassed Badger's in popularity almost immediately after he began painting in the 1750s, and Badger produced very little after 1760, when Copley had reached maturity. At his death in 1765, Badger was still better known in Boston as a glazier than as a painter.

Almost nothing is known of Badger's personality, but judging from the sparse surviving records his career was not marked by great success. His paintings, which mostly date from about 1740 to about 1763, appear to have brought him very little money. After his death his wife was forced to sell his relatively meager real-estate holdings to cover his debts. Nevertheless, there is about his work a kind of straightforward honesty that connects him with the best tradition of American painting, and his biographer Lawrence Park was quite right in saying:

> In spite of their faults, one feels, I think, in looking at his portraits, that he endeavored conscientiously to produce a likeness with no deception in the method, and when one considers the difficulties under which he worked, his lack of adequate instruction, the almost utter absence of good pictures from which to study, the scarcity of books on art subjects, and that throughout his life he lived in an atmosphere not particularly congenial to art, it must be conceded that he had talents which, under different influences and more inspiring surroundings, would have given him a much higher place in the history of art in this country (p. 7).

BIBLIOGRAPHY: Lawrence Park, *Joseph Badger (1708–1765) and a Descriptive List of Some of His Works* (Boston, 1918), reprinted from *Proceedings of the Massachusetts Historical Society* 51 (Oct. 1917 – June 1918). Most complete treatment to date // James T. Flexner, *First Flowers of Our Wilderness* (Boston, 1947). Brief, well-written account // Jules David Prown, *John Singleton Copley* (2 vols.; Cambridge, Mass., 1966), 1, pp. 14, 16. Discusses Badger in terms of Copley // Louisa Dresser, "The Orne Portraits by Joseph Badger," *Worcester Art Museum Bulletin* (Feb. 1972), pp. 1-16. Discussion of the only documented Badger portraits.

James Badger

James Badger (1757–1817), shown at the age of three in this 1760 portrait by his grandfather, was born in Boston and is said to have moved to Charleston, South Carolina, in 1777, at the age of twenty. Not much more is known of him than what is recorded on his tombstone: "as a Teacher of Sacred Music he indefatigably laboured to promote that useful science." Also, he was to be remembered "as a husband tender, as a Father affectionate, as a master indulgent, as a friend sincere, . . . [and] exemplary in his piety."

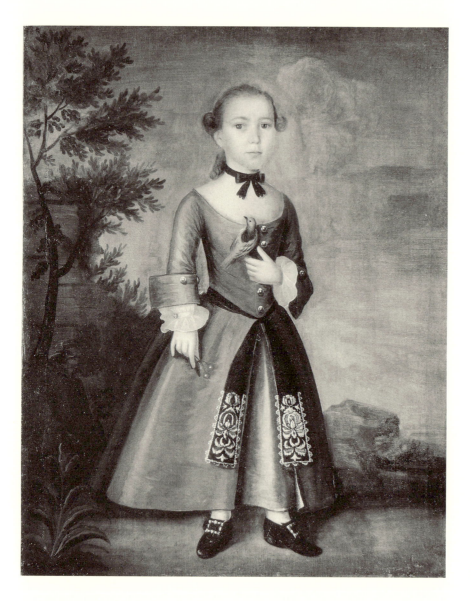

Badger, *James Badger*.

This portrait, done in Badger's usual muted colors, fits the characterization made of his work by Lawrence Park: "Stiff and formal as these children's portraits are, they nevertheless well express the primness of the time, and have a quaintness and a naive and piquant charm which is irresistible" (*Joseph Badger* [1918], p. 6). Like many of his other portraits, this one gives ample evidence of Badger's difficulty with drawing. The boy's head and upper body obviously presented problems for the artist: they appear to be surrounded by a nimbus of pentimenti, creating an effect that E. P. Richardson termed "strangely ghostly" and "wraithlike" (*Painting in America* [1956], p. 44). Badger painted very thinly, and over the years, as the film of paint on his canvases has been reduced by repeated cleaning and rendered transparent by age, the areas that he painted out have become more visible.

James Badger's pose is a variation of the one in the artist's portrait of John Gerry, ca. 1745 (Bayou Bend Collection, Museum of Fine Arts, Houston), and is derived from paintings by Sir Godfrey Kneller. It is most likely based on a mezzotint. The bird and cherries invite speculation as to their meaning, but one suspects that, although Badger was aware of the formal tradition, the iconographic content of such symbols had probably been forgotten. He certainly knew the work of JOHN SINGLETON COPLEY, whose

38

portrait of Thomas Aston Coffin, about 1757–1759 (Munson-Williams-Proctor Institute, Utica, N.Y.), shows a somewhat similar pose, with cherries in the subject's left hand and two doves near his right. The enhanced sense of individuality in the present portrait, as compared to Badger's earlier works, again may owe something to Copley, particularly to his *Unknown Boy*, about 1758–1759 (Bayou Bend Collection, Museum of Fine Arts, Houston). In any case, Badger reused the composition in a portrait of Rebeckah Barrett, about 1765 (Daughters of the American Revolution Museum, Washington, D. C.).

Oil on canvas, 42½ × 33⅛ in. (108 × 84.1 cm.).
Inscribed on the back: July 8th 1760.
REFERENCES: C. Lee, *Early American Portrait Painters* (1929), p. 201 // H. B. Wehle, *MMA Bull.* 26 (August 1931), p. 190, gives James Badger's epitaph // M. B. McGraw, *The Child in Painting* (1941), no. 32 // J. T. Flexner, *First Flowers of Our Wilderness* (1947), pp. 198–200, 344 // V. Barker, *American Painting* (1950),

p. 124, says young Badger "has the face of a real child above his doll-like figure and harshly modeled costume" // Gardner and Feld (1965), pp. 15–16 // J. D. Prown, *American Painting* (1970), p. 31, describes as "charming but unskilled."

EXHIBITED: MMA, 1939, *Life in America*, no. 15 // NYHS, 1948–1949, *Up from the Cradle (Early American Portraits of Children)*, no. 10 // MMA, 1958–1959, *Fourteen American Masters* (no cat.) // Los Angeles County Museum of Art and M. H. de Young Memorial Museum, San Francisco, 1966, *American Paintings from the Metropolitan Museum of Art*, p. 10; no. 2, ill. p. 17 // National Gallery, Washington, D. C.; City Art Museum of St. Louis; and Seattle Art Museum, 1970–1971, *Great American Paintings from the Boston and Metropolitan Museums*, no. 6 // Santa Barbara Museum of Art and University of Arizona Museum of Art, Tucson, 1976, *First Flowers of Our Wilderness*, pl. 63, miscaptioned as Jeremiah Theüs's Gabriel Manigault.

EX COLL.: descended in the Badger family to Kate Bull McIver, Charleston, by 1929.

Rogers Fund, 1929.
29.85.

JEREMIAH THEÜS

1716–1774

Jeremiah Theüs was born in the small village of Chur, in the easternmost Swiss canton of Grisons, into what may have been an artistic family. He came to America, probably with his own family, sometime between 1735 and 1739. For many years the only competent artist in Charleston, he evidently remained there most of his life. Remarkably eclectic, his style shows the influences of artists as varied as the Genevan pastel portraitist Jean Etienne Liotard, the British painters Sir Godfrey Kneller and Thomas Hudson, and the Anglo-American JOHN WOLLASTON. Yet Theüs's work lacks conviction, and one senses that he picked up each style casually and without real understanding. On occasion, in such portraits as that of Mrs. Thomas Lynch, 1775 (Reynolda House, Winston-Salem, N.C.), his deft use of color makes up for his formal weaknesses. In his portraits of children, Theüs produced work that approaches the best of American folk, or country, art in the almost abstract qualities of its design. In his lovely painting of Peggy Warner, undated (Telfair Academy, Savannah), the child's lips and cheeks, her beads, and the fruit she is holding are painted in precisely the same unlikely shade of orange, and the resultant image has something of the finesse one associates with artists like JOHN DURAND or even JOSHUA JOHNSON. In general, however, the judgment of his work expressed by James Thomas Flexner is probably accurate, if harsh:

Occasionally in a male face we suspect a yearning toward character study, but usually he made use of stereotyped features, brightly complexioned. Gleaming clothes cover the cast-iron shapelessness of the sitters' bodies. He was a painter without dash or inspiration or any natural ability, except perhaps as a colorist, but he had learned his lessons in the Old World well enough to turn out portraits that made a handsome show of elegance. This knack paid off so well that he dominated South Carolina art for thirty-four years. When he died in 1774, he left a fortune (*First Flowers of Our Wilderness* [1947], p. 108).

BIBLIOGRAPHY: Virgil Barker, *American Painting: History and Interpretation* (New York, 1950), pp. 106–109. Summarizes known material at that time, quotes and discusses views of Theüs held by William Dunlap and Charles Fraser in the early nineteenth century // Margaret Simons Middleton, *Jeremiah Theüs, Colonial Artist of Charles Town* (Columbia, S.C., 1953). Lists works by Theüs and has an introduction by Anna Wells Rutledge comparing Theüs to a variety of European artists // Louisa Dresser, "Jeremiah Theüs: Notes on the Date and Place of His Birth and Two Problem Portraits Assigned to Him," *Worcester Art Museum Annual* 6 (1958), pp. 43–44. Establishes birth dates of Theüs and his brothers from local church records and says he came to America in 1735 // Augustin Maissen, "Jeremiah Theüs (1716–1774), il grond artist american," *Annalas* (1959), pp. 26–27 (written in Romansh). Gives Theüs's birth date, says he left Switzerland in 1739 // R. Peter Mooz, "Colonial Art," in *The Genius of American Painting*, ed. John Wilmerding (New York, 1973), pp. 40-41. Links Theüs's early style to that of Justus Engelhardt Kühn (d. 1717) and calls later work "almost Rococo."

Gabriel Manigault

Gabriel Manigault (1704 – 1781) was the wealthiest man in the colony of South Carolina. The son of a French Huguenot merchant, he was noted for his charitable activities and his patriotism. He supported the revolutionary cause with large sums of money, and in 1779, when the British were attacking Charleston, Manigault, who was then seventy-five, volunteered the services of both himself and his fifteen-year-old grandson to the forces defending the city.

The portrait is in the relatively standard style and format of works by Sir Godfrey Kneller and his followers. The fascinated stare that Theüs has given to Manigault and to his wife in the companion portrait (see below) is, however, remarkable. It would appear that he was trying to imitate prints by or after Jean Etienne Liotard, one of the most fashionable European portraitists of the eighteenth century. Unfortunately, Theüs's effort to show his sitter looking out directly as if to engage the viewer's attention is awkwardly carried out: the eyes seem slightly crossed and at the same time too sharply focused. At some point in the past this must have distressed a former owner, because the eyes were partially scratched off the canvas and repainted in a more conventional matter (the picture has since been restored to its original state). Yet Theüs presumably succeeded in fulfilling what was surely the primary aim of his commission, a recognizable likeness, in which he has projected an image of solidity, sobriety, and even benevolence.

Oil on canvas, 30 × 24 in. (76.2 × 62.2 cm).

Signed and dated at lower left: Theüs. 1757. Inscribed on the back: Gabriel Manigault / b. 1704– d. 1781 / Theüs pinxit / 1757.

RELATED WORKS: copy by unidentified artist, 30 × 25 in. (76.2 × 63.5 cm.), South Carolina Society, Charleston. Exhibited in South Carolina Hall, this is believed to be a copy after the copy Gilbert Stuart made in 1794, which was destroyed at Columbia, S. C., during the Civil War.

REFERENCES: J. H. Morgan, *Brooklyn Museum Quarterly* 11 (1924), p. 49 // H. B. Wehle, *MMA. Bull.* 26 (August 1931), pp. 188-189 // A. W. Rutledge, *Artists in the Life of Charleston* (1949), p. 114 // M. S. Middleton, *Jeremiah Theüs* (1953), pp. 9, 145-146 // C. M. Mount, *Gilbert Stuart* (1964), pp. 175-176, says the South Carolina Society commissioned Stuart to paint a copy of this portrait in 1794; "Stuart quickly constructed, from this head and shoulders, a posthumous three-quarter-length of the merchant seated at his desk; p. 371, says Stuart's copy destroyed in Civil War // Gardner and Feld (1965), p. 17 // H. G. McCormack, *Antiques* 98 (Nov. 1970), pp. 787-788, gives biographical data on sitter, says Theüs made all sitters look like first cousins // E. L. Willcox, South Car-

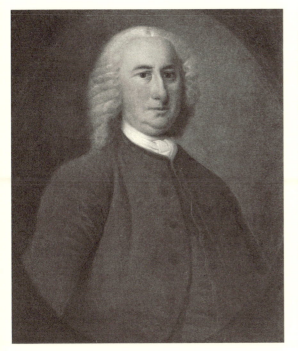

Theüs, *Gabriel Manigault.*

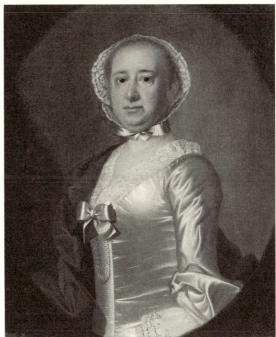

Theüs, *Mrs. Gabriel Manigault.*

olina Society, letter in Dept. Archives, Nov. 16, 1977, suggests provenance and discusses copy.

EXHIBITED: Gibbes Art Gallery, Charleston, 1970, *Art in South Carolina, 1670–1970,* no. 27 // Santa Barbara Museum of Art and University of Arizona Museum of Art, Tucson, 1976, *First Flowers of Our Wilderness,* p. 2, miscaptioned as Joseph Badger's portrait of James Badger.

EX COLL.: descended in the Manigault family to Dr. Gabriel Manigault, Charleston, d. 1874; with Webbs Art Store, Columbia, S.C.; with Macbeth Gallery, New York, 1928.

Fletcher Fund, 1928.

28.126.1.

Mrs. Gabriel Manigault

Well known for her journal, which is one of the most important sources for the social history of South Carolina in the eighteenth century, Anne Ashby (1705–1782) was the daughter of a wealthy South Carolina landowner. In 1730 she became the wife of Gabriel Manigault (see above). In her diary she recorded the sittings for their portraits by Theüs in 1757 rather laconically: "April 14. Sat for my picture. April 15. Mr. M. and my daughter sat for their picture. April 22. Sat again for my picture. April 23,

d[itt]o. Mr. Manigault [May] 19. Sat for my picture [July] 16. Our pictures came home." The sparsity and timing of the sittings imply that Theüs first painted the faces of his subjects from life and then painted the rest in his studio, with a few additional sittings in between. That this was indeed his method of working is further supported by his habit of repeating the same dress, as well as pose, in different portraits. This portrait, for example, is markedly similar in these respects to that of Elizabeth Rothmaler in the Brooklyn Museum, painted the same year. Mrs. Manigault's pose, which suggests that she was very tightly corseted, is, like her staring eyes, probably the result of Theüs's somewhat misguided attempts at copying the conventions of Jean Etienne Liotard, transmitted in prints by or after his work. That Theüs was inspired by a print is also indicated by his treatment of Mrs. Manigault's pearls, which differ very little in color or tactility from the gray satin of her dress.

Oil on canvas, 30 × 24¾ in. (76.2 × 62.9 cm.).

Signed and dated at lower left: Theüs. 1757. Inscribed on the back: Mrs. Gabriel Manigault / (Anne Ashby) / b. 1705—d. 1782 / Theüs pinxit / 1757.

REFERENCES: A. Manigault, copy of her diary entries for April 14, 15, 22, 23, May 19, and July 16,

1757, in M. L. Webber, *South Carolina Historical and Genealogical Magazine* 20 (April 1919), pp. 128–129, mentions the sittings for her portrait and her husband's (quoted above) // J. H. Morgan, *Brooklyn Museum Quarterly* 11 (1924), p. 49 // H. B. Wehle, *MMA Bull.* 26 (August 1931), pp. 188–189 // J. T. Flexner, *First Flowers of Our Wilderness* (1947), pp. 109, 354 // A. W. Rutledge, *Artists in the Life of Charleston* (1949), p. 114, gives extracts from sitter's diary, discusses and illustrates portraits of daughter-in-law by Theüs, fig. 4, and of son by Allan Ramsay, fig. 5 // M. S. Middleton, *Jeremiah Theüs* (1953), pp. 9, 145–146 // Gardner and Feld (1965), pp. 17–18 // H. G. McCormack, *Antiques* 98 (Nov. 1970), pp. 787–788.

Ex COLL.: same as preceding entry.
Fletcher Fund, 1928.
28.126.2.

John Dart

When this portrait and its companion (see below) came to the museum in 1967, the subjects were unknown, but subsequent research has revealed that they are Mr. and Mrs. John Dart of Charleston, South Carolina. Little is known of John Dart (1750–1782) beyond the facts that he was a lawyer, the son of Benjamin Dart, who served the province as secretary of the senate, and was married in 1772 to Henrietta Sommers.

It has been suggested that Theüs painted the Darts at the time of their marriage, even though Dart's elaborate coat and waistcoat belong to the period of about 1760 to 1770. Theüs, however, often gave his sitters clothing he copied from mezzotints, so costume dating is not a reliable method of dating his pictures. The treatment of the face and especially the eyes strongly suggests the influence of JOHN WOLLASTON, who was working in Charleston from January to May of 1767. It is most likely that the portraits were executed between 1772 and 1774, the year of Theüs's death. The subject's pose and demeanor seem to suggest a fastidious withdrawal from excessive contact with the world. Nevertheless, the portrait is rather generalized in expression and lacking in character. Theüs has concentrated instead on the graceful curves of the face and clothing and on the meticulous rendering of the highly ornamental attire. Indeed, the profusion of embroidered gold thread is quite remarkable, so much so as to suggest that Theüs's subject was at least as interested in displaying his wealth as in preserving his likeness. Dart's face is noticeably high in color, possibly from the use of rouge,

a practice not uncommon among fashionable men of the eighteenth century. Although not especially well painted, the portrait is refined and skillful in coloration, with the dark blue of the coat beautifully balanced by the brown background.

Oil on canvas, 30 × 25 in. (76.2 × 63.5 cm.).

REFERENCES: M. S. Middleton, *Jeremiah Theüs* (1953), p. 126, says probably painted at time of subject's marriage in 1772, owned by Richard Bryan, Johns Island, S. C. // M. R. Severans, Gibbes Art Gallery, Charleston, letter in Dept. Archives, Dec. 30, 1977, supplies information on provenance // J. A. Williams, letter in Dept. Archives, Jan. 4, 1978, identifies as John Dart, formerly coll. Richard Bryan // R. J. Bryan, letter in Dept. Archives, April 25, 1978, confirms identity of subject, gives information on family // J. D. Long, Dec. 1981, memo in Dept. Archives, discusses date of costume.

Ex COLL.: Dart-Roper-Bryan family; Richard R. Bryan, Johns Island, S.C., by 1953–1958; with James Arthur Williams, Savannah, 1958; with Harry Arons, Ansonia, Conn., 1958; Edgar William and Bernice Chrysler Garbisch, Cambridge, Md., 1958–1967.

Gift of Edgar William and Bernice Chrysler Garbisch, 1967.
67.268.1.

Mrs. John Dart

Henrietta Isabella Sommers (1750–1783) was the daughter of Humphrey Sommers, a successful building contractor in Charleston, South Carolina. The large wooden house he built there for his family and in which she grew up is still standing at 128 Tradd Street. She was married to John Dart (see above) in December 1772 and bore him three children. Like her husband, Mrs. Dart died young, after what was described as a "long and tedious illness."

In this portrait, the costume is quite probably based on a print. It is unlikely that the subject possessed a robe trimmed in ermine or owned such a profusion of pearls. As in the portrait of Mrs. Manigault (q.v.), whose diary supports this conclusion, Theüs undoubtedly painted the face from life and the clothing in his studio, with a mezzotint before him. A number of his other portraits of women show costumes very similar to this one. Mrs. Dart's attire, like that of her husband, may be a demonstration of her wealth, a function of portraiture evidently popular with South Carolina's burgeoning aristocracy, but

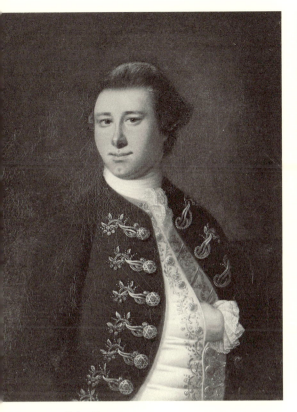

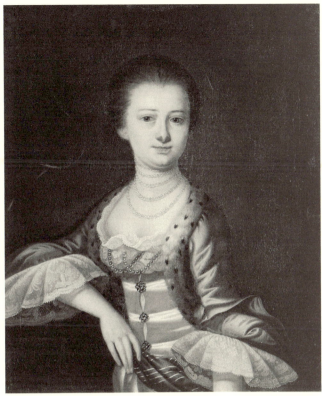

Theüs, *John Dart*. Theüs, *Mrs. John Dart*.

here the richness of the costume is such as to approach a parody, albeit unintentional, of rococo elegance in dress. The sitter's face, pretty in spite of a large nose, is sympathetically conceived. Her shoulders, however, seem too small in proportion and droop excessively. Instead of producing the image of a sophisticated young woman, doubtless his intent, Theüs created an oddly boneless, overdressed doll. Nevertheless, the coloristic refinement is characteristic of rococo portraiture at its best. The delicate blue robe is a resonant contrast to the brown background, against which it forms a series of graceful S-shaped curves.

Oil on canvas, 30 × 25 in. (76.2 × 63.5 cm.).

REFERENCES: M. S. Middleton, *Jeremiah Theüs* (1953), pp. 126–127 // *South Carolina Historical and Genealogical Magazine* 18 (July 1917), p. 145, notes death of subject and gives biographical information (quoted above) // J. A. Williams, letter in Dept. Archives, Jan. 4, 1978, identifies as Mrs. John Dart // R. J. Bryan, letter in Dept. Archives, April 25, 1978, confirms subject's identity // M. R. Severans, Gibbes Art Gallery, Charleston, Nov. 27, 1978, letter in Dept. Archives, mentions other Theüs portraits in which women have same jewels and dress.

EX COLL.: same as preceding entry.

Gift of Edgar William and Bernice Chrysler Garbisch, 1967,
67.268.2.

WILLIAM WILLIAMS

1727–1791

A good deal of confusion exists concerning the identity of William Williams. At least three painters with that name worked in America in the latter half of the eighteenth century, and biographical data concerning any one of them has sometimes been interpreted as pertaining to another. The work of the William Williams under discussion here is gradually being sorted out from that of his namesakes.

The first important artist so named to work in America was born in Bristol, England, most likely in 1727, because his baptism was registered on June 14 of that year. He was probably the son of one William Williams, mariner, entered in the Bristol burgess book in 1734. At the age of twenty, he appeared in Philadelphia carrying one of his pictures under his arm. A Quaker named Samuel Shoemaker saw it, commissioned another from him, and introduced him to his friend Edward Pennington, a local merchant, who was the cousin of BENJAMIN WEST. Nine years old at the time, West was soon brought to Williams, who gave him two books on painting to read and allowed the boy to visit his studio.

Williams's history before this time is somewhat nebulous, but it seems that he ran away to sea as a young man, became a privateersman, was shipwrecked in the Caribbean, settled on the Mosquito Coast, now part of Nicaragua, where he twice married Indian women and had several children, and eventually made his way to Philadelphia. His novel, *The Journal of Llewellin Penrose, a Seaman*, published posthumously (Edinburgh, 1815), draws on these experiences, but though it has been accepted by some as largely autobiographical, it is patently a work of fiction.

In Philadelphia in the 1750s Williams painted portraits, landscapes, and scenery for the stage, his work in the latter category making him the first professional painter of theatrical scenery in America. On January 13, 1763, his advertisement in the *Pennsylvania Journal* announced that he had just returned from the West Indies and would once again carry on "his Business, viz. Painting in General," at the sign of Hogarth's Head in Loxley's Court. He also offered to instruct "Polite Youth" in all branches of drawing and in playing "the Hautboy, German and common Flutes" (oboe, recorder, and flute). It was during the 1760s that Williams appears to have arrived at his peak, producing portraits of high quality, mostly full-length, fashionably dressed figures painted in a tight manner, anatomically awkward from the waist down, and surrounded by stage-like elements that at times literally enclose them. By 1769 he had moved to New York, staying there until about 1776, when he returned to London. In 1778, West painted him in *The Battle of La Hogue* (q.v.), showing him as an older sailor, naked from the waist up, sitting in one of the attacking boats. One or more sons, born in America from one or more marriages, stayed behind and supported the Revolution.

Eventually, Williams made his way back to his native Bristol, where he attempted to continue working as a painter, apparently with little success. If he married again, his wife had certainly died when he applied to Thomas Eagles, a prominent gentleman of Bristol,

for a pass to St. Peter's Hospital. Instead of acceding to his request, Eagles personally aided him until 1786, when a place became available in the more comfortable Merchants' and Sailors' Almshouse in King Street, Bristol. There he died on April 27, 1791.

Eagles, who inherited Williams's scant estate, probably consisting of no more than a few paintings besides the manuscript for *The Journal of Llewellin Penrose*, published the latter and attempted to gather as much biographical information about Williams as possible. Obviously, the attractive and picturesque character who had captured West's attention as a youth continued to interest people until the end.

BIBLIOGRAPHY: David H. Dickason, *William Williams, Novelist and Painter of Colonial America, 1727–1791* (Bloomington, Ind., 1970). A biography that accepts as factual many of the events narrated in Williams's novel and makes use of the recollections of Benjamin West, Thomas Eagles, and his son John Eagles concerning Williams // Edgar P. Richardson, "William Williams—A Dissenting Opinion," *American Art Journal* 4 (Spring 1972), pp. 5–23. Reviews all the literature on Williams's career and arrives at a biography based only on proven facts; also identifies other painters named William Williams and defines their individual styles.

Portrait of a Boy, probably of the Crossfield Family

This painting has long been called a portrait of Master Stephen Crossfield even though the available information makes any definite identification impossible. Although the dealer from whom the work was acquired was certain that it descended in the Crossfield (sometimes Crosfield) family, the information provided by his source was partially in error because the portrait was thought to be of Stephen Crossfield, the New York shipbuilder and landowner, and to have been painted about 1730 to 1740. Once the attribution to William Williams had been made and the date amended to about 1770–1775 on stylistic grounds, it was assumed that the subject was more likely the son of this Crossfield, also named Stephen, knowledge of whom is limited to the facts that he was born on July 10, 1765, and died on May 8, 1790, "a young gentleman of great worth" (American Antiquarian Society, *Index of Marriages and Deaths in the New York Weekly Museum, 1788–1817* [1952]). This identification remains necessarily tentative. A portrait of another boy of the Crossfield family, by JOHN DURAND, is in the museum's collection (q.v.).

Surely one of Williams's finest works, the portrait well illustrates his tendency to locate figures in a stage-like space surrounded by elements reminiscent of theater props. The landscape background, like the foliage and rocks, is imaginary, which further contributes to the impression that the boy is posing amidst completely artificial studio surroundings. Obviously born into a wealthy family, he holds a battledore and shuttlecock for playing the eighteenth-century equivalent of badminton, then a genteel sport engaged in by women and children. The equipment illustrated was probably imported from England and, as in so many examples of rococo portraiture, it establishes the informality of the occasion as well as the fashionableness of the subject. A similar use of the battledore and shuttlecock was made by JOHN SINGLETON COPLEY in his portrait of Thomas Aston Coffin, 1757–1759 (Munson-Williams-Proctor Institute, Utica, N.Y.), and in *Boy Called Master Hancock*, 1758–1759 (Bayou Bend Collection, Museum of Fine Arts, Houston).

Oil on canvas, 52¼ × 35¾ in. (132.7 × 91 cm.).

REFERENCES: J. Biddle, *Antiques* 91 (April 1967), p. 485, calls it Master Stephen Crossfield and discusses briefly // W. H. Gerdts, *Winterthur Portfolio 4* (1968), p. 161, calls it Master Stephen Crossfield and says it is the most significant portrait by Williams to have come to light in recent years // D. H. Dickason, *William Williams, Novelist and Painter of Colonial America, 1727–1791* (1970), pp. 173–175; ill. p. 174, as Master Stephen Crossfield.

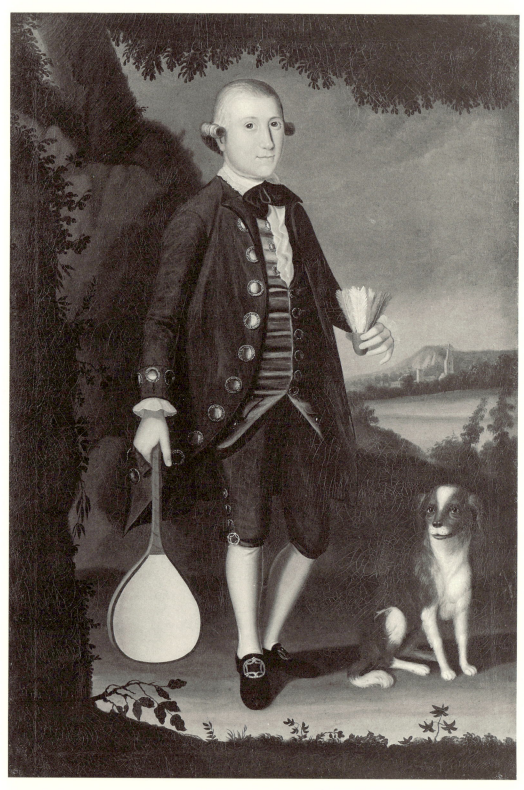

Williams, *Portrait of a Boy, probably of the Crossfield Family.*

JOHN HESSELIUS

1728–1778

Gustavus Hesselius (1682–1755), the father of John, was himself an American painter of considerable importance. He was born in Sweden into a family of intellectuals that included Emanuel Swedenborg. After working in London under the Swedish painter Michael Dahl, he came, in 1712, to Wilmington, Delaware, then a Swedish colony, and was one of the first trained artists to work in this country. Shortly after, he went to Philadelphia, where he remained until about 1720, then moved to Maryland, where he lived until about 1726, and finally returned to Philadelphia, where he settled more or less permanently. John Hesselius was probably born there in 1728. Although one would assume that he had some training from his father, the earliest painting that is certainly by him, a portrait of Lynford Lardner, 1749 (private coll.; ill. in Philadelphia Museum of Art, *Philadelphia: Three Centuries of American Art*, p. 48), is heavily, almost overwhelmingly, influenced by the work of ROBERT FEKE. In fact, so strikingly close to Feke are the younger Hesselius's early works as to suggest to Feke's biographer, R. Peter Mooz, that he was Feke's student. Gustavus Hesselius's work also appears to have been strongly affected by Feke's presence in Philadelphia.

By the summer of 1750 John Hesselius was in Virginia and Maryland, perhaps with Feke, painting portraits. The large number of these is evidence that he was an almost immediate success. After 1750 he returned to Philadelphia and lived with his father until the latter's death in 1755. From 1756 through 1758 he appears to have worked as an itinerant portrait painter in Virginia, Maryland, Delaware, and New Jersey. From about 1755 on his work shows the influence of JOHN WOLLASTON, then active in the South, and after Hesselius's return to Philadelphia in 1758, where Wollaston was then working, the influence is even more marked. His new manner is described by Edgar P. Richardson as a change from "the dignified Baroque pose and luminous color of Feke's Philadelphia portraits" to the rococo elegance characteristic of Wollaston (*Painting in America* [New York, 1956], p. 43). This development was not an entirely happy one. Although Hesselius gained proficiency in painting lace and drapery, he also adopted Wollaston's mannerisms. James T. Flexner remarks of his work from this time: "His style of painting little children makes them all look like the baby in 'Alice in Wonderland' who was on the point of turning into a pig" (*Magazine of Art* 38 [Dec. 1945], p. 290).

By 1760 Hesselius had moved to Maryland, settling in Anne Arundel County. Fairly well

off financially, he married Mary Young Woodward, a wealthy Annapolis widow, in 1763. No works by him have been found from these years, until 1764, when he painted the portrait of Mrs. Richard Galloway (see below). For the remainder of his career, Hesselius appears to have combined painting with managing his large estate. In style he moved away from the lush informality he had learned from Wollaston, although he occasionally resumed it. Instead he produced a more searching and serious exploration of character, as in the portrait of Mrs. Thomas Gough, 1777 (Washington County Museum of Fine Arts, Hagerstown, Md.).

Hesselius's influence on other artists, though not of overwhelming importance, was quite real. His Philadelphia works were evidently assimilated by the young BENJAMIN WEST, and he served as CHARLES WILLSON PEALE's first teacher (in exchange for a saddle), his influence being particularly reflected in Peale's early works. Perhaps more important, his success and his life as a cultivated country gentleman (he was a musician, art collector, and amateur scientist) must have encouraged West and Peale to pursue careers in art.

BIBLIOGRAPHY: Richard Keith Doud, "John Hesselius: His Life and Work," M.A. thesis, University of Delaware, 1963. Most complete treatment to date // Richard K. Doud, "John Hesselius, Maryland Limner," *Winterthur Portfolio* 5 (1969), pp. 129–153. Catalogues Maryland portraits // R. Peter Mooz, "Robert Feke: The Philadelphia Story," in *American Painting to 1776: A Reappraisal*, ed. Ian M. G. Quimby (Winterthur, Del., 1971), pp. 211-213. Discusses Hesselius in relation to Feke // Philadelphia Museum of Art, *Philadelphia: Three Centuries of American Art*, exhib. cat. (1976). Includes "John Hesselius," by Dorinda Evans, pp. 48-49, which illustrates earliest documented work by Hesselius and discusses his influence on West.

Mrs. Richard Galloway

When this portrait came to the museum it was believed, on the basis of family tradition, to represent Ann Galloway (1632–1723) and to have been painted by Gustavus Hesselius in 1721. In 1928 one of her descendants called that identification impossible, and in 1938 William Sawitzky stated that the painting was by John, not Gustavus, Hesselius and suggested a later date. Finally, an old lining canvas was removed in 1940, revealing John Hesselius's signature, the date 1764, and the identity of the subject. Sophia Galloway (1697–1781) was the daughter of William and Margaret Richardson, prominent Quakers of West River, Anne Arundel County, Maryland. She was married to Richard Galloway in 1715, and they lived at his family home, Cedar Park, where their daughter Elizabeth was born in 1721.

The painting has been described as marking the beginning of the third stage of Hesselius's stylistic development, lasting from 1764 until his death. Certainly it shows a marked lessening in his desire to emulate the rococo elegance of JOHN WOLLASTON. In composition it is very close to several portraits by ROBERT FEKE, who derived the pose from a 1735 British print by Alexander van Haecken after a portrait of Catherine Clive by Joseph van Haecken. The treatment of drapery also recalls Feke's style, but the striking characterization of the face is unlike the work of either Feke or Wollaston and may represent an oddly delayed influence of the work of Hesselius's father, Gustavus. The utterly direct and unconventional treatment of the subject's face is perhaps closest to the elder Hesselius's painting in his self-portrait of about 1740 (Historical Society of Pennsylvania, Philadelphia).

The canvas seems to have been cut down at some point; for it lacks the characteristic scalloping at the top and bottom that is usually caused by the original tacks. In pose and composition the portrait is so similar to that of Hesselius's portrait of Mrs. Gavin Lawson, 1770 (Colonial Williamsburg), that it is probably safe to assume that it was of similar dimensions (49½ × 38½ in.) and that it was cut down at the left and, possibly, also at the right, as well as at top and bottom.

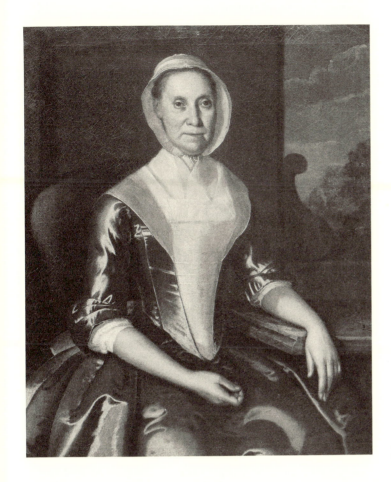

Hesselius, *Mrs. Richard Galloway.*

Oil on canvas, 36¾ × 30 in. (93.3 × 76.2 cm.).

Inscribed on back before lining: Sophia Galloway Aetat. 67 / J. Hesselius Pinx 1764.

REFERENCES: *MMA Bull.* 18 (Feb. 1923), pp. 46–47, says it is a portrait of Mistress Ann Galloway of Tulip Hill, Md., painted according to family tradition by Gustavus Hesselius in 1721, and notes that the painting was copied by S. George Phillips in 1928 for a descendant of the Galloway family // L. J. Morris, letter in Dept. Archives, March 8, 1928, refutes this attribution, believing the subject referred to was the granddaughter (1725–1756), also named Ann Galloway, of the woman thought to be the sitter and cites two other portraits of her // W. Sawitzky, note in Dept. Archives, Dec. 5, 1939, says not by Gustavus Hesselius but by his son John, dates to 1750s, says therefore not a portrait of Ann Galloway (1632–1723 // L. Burroughs, *Art Quarterly* 4 (1941), pp. 110–114, corrects the attribution and identity of the sitter, gives provenance // R. K. Doud, "John Hesselius: His Life and Work," M. A. thesis, University of Delaware, 1963, pp. 16, 42–44, 47, 74–75 // Gardner and Feld (1965), p. 19 // R. K. Doud, *Winterthur Portfolio 5* (1969), pp. 134, 138–139, says "The strong, gentle face is rendered with a sensitivity rare not only in American painting but also in Western art of the period," says portrait marks beginning of third phase in Hesselius's development; p. 147, catalogues it.

EXHIBITED: American-Scandinavian Foundation, Stockholm, and Ny Carlsberg Glyptothek, Copenhagen, 1930, *Exhibition of American Art*, no. 48, and no. 77, as by Gustavus Hesselius // Philadelphia Museum of Art, 1938, *Gustavus Hesselius*, no. 2 // MMA, 1939, *Life in America*, no. 6 // Art Institute of Chicago, 1949, *From Colony to Nation*, no. 70 // Los Angeles County Museum of Art and M. H. de Young Memorial Museum, San Francisco, 1966, *American Paintings from the Metropolitan Museum of Art*, p. 10; no. 4, ill. p. 19 // MMA and American Federation of Arts, traveling exhibition, 1975–1977, *The Heritage of American Art*, cat. by M. Davis, no. 6, ill. p. [32].

EX COLL.: the subject's daughter, Elizabeth Galloway Sprigg; her son, Richard Sprigg; his daughter, Sophia Sprigg Mercer, d. 1821; her son, John Mercer; his son, Thomas Swann Mercer; his son, Carroll Mercer; his wife, Mrs. Carroll Mercer, by 1922.

Maria DeWitt Jesup Fund, 1922.

22.206.

WILLIAM JOHNSTON

1732–1772

William Johnston was the son of Thomas Johnston of Boston, one of the most important early American artist-craftsmen, a figure of note in fields as diverse as printmaking, furniture japanning, and organ making. He is said to have painted portraits as well. As a boy, William Johnston undoubtedly visited the studios of his neighbors JOHN SMIBERT and Peter Pelham (1697–1751). He was a friend of JOHN SINGLETON COPLEY, Pelham's stepson, and he must have known Copley's half brother Henry Pelham (1749–1806). John Greenwood (1727–1792) was an apprentice to Thomas Johnston. Thus, it is in no way surprising that the younger Johnston, living in such a milieu, elected to follow an artistic career.

Until recently there were no portraits identified as having been painted by Johnston in Boston before he left to become an itinerant artist. Not many documents concerning him survive, but a letter written by him to Copley in 1770 implies that he painted portraits in Portsmouth, New Hampshire, probably in 1760 and 1762. It can now be stated that the portraits of Mr. and Mrs. Jacob Hurd (see below), probably painted in Boston, are undoubtedly his work. This attribution is based on their similarity to the portrait of Dr. Hall Jackson, tentatively dated 1760 or 1762 (Mead Art Gallery, Amherst College, Amherst, Mass.), which is now generally accepted as being by Johnston. These three portraits show him to have been heavily influenced by his friend Copley. In fact, in the past, all were mistakenly attributed to Copley. They are based on poses used by Copley and also share the stylistic characteristics of his early work: sharp side lighting, strong modeling, careful attention to fabrics and details, and accurate likenesses. Johnston's early portraits, however, lack the strong presence of the sitter that distinguishes all but Copley's earliest work.

Documented or securely attributed pictures by Johnston reveal that by 1762 he had left Boston. One may speculate that among the reasons for his departure was the insurmountable competition of Copley. In any case, in 1762 and 1763 he was painting portraits in New London, Connecticut, and in 1763 and 1764 in New Haven and Hartford. At some point he returned to Boston, where on December 2, 1766, he married Christy Bruce, the widow of Samuel Bruce. By 1770, when he wrote to Copley, he was in Barbados, and from the fact that he made no mention of his wife or her two children by her previous marriage it has been inferred that they were no longer living. Also, he did not bother to describe his situation in Barbados in any detail, and one may conjecture that he had been there some time, as such information would have been given in earlier communications. He did, however, mention that he was working as an organist for seventy-five pounds a year. As a young man in Boston he had played the organ at Christ Church from 1750 to 1753. Johnston died, apparently of a sudden illness, at Bridgetown, Barbados, in 1772. His half brother John continued the family tradition, becoming one of the best artists in post-revolutionary Boston. A still life by him, done in 1810, is among the most beautiful of the period (Saint Louis Art Museum).

With the exception of the Boston and Portsmouth portraits discussed above, all the paintings now known to be by Johnston are from the period he was in Connecticut. In general,

they reveal a lessening of his dependence on Copley, although several are based on poses found in Copley's work, for example Johnston's portrait of Mrs. Nathaniel Shaw, 1763 (New London County Historical Society, Conn.), which follows very closely Copley's painting of Mrs. Daniel Rogers, 1762 (private coll.; ill. in Prown, no. 100). At the same time, away from the relatively sophisticated art he knew in Boston, Johnston's paintings assumed more the quality of work by a country or folk artist. His forms look flatter and more two-dimensional, and the features of his subjects tend to have more abstract, almost geometrical, shapes. Modern viewers tend to prefer these provincial works to his earlier portraits for precisely these qualities, which give his pictures the charm so common in paintings by American folk artists.

BIBLIOGRAPHY: Massachusetts Historical Society, *Collections* 71 (Boston, 1914), pp. 88–92. Johnston's letter to Copley of May 4, 1770 // Frederick W. Coburn, "The Johnstons of Boston," *Art in America* 21 (Dec. 1932 and Oct. 1933), pp. 27–36, 132–139. Gives birth date as December 21, 1736 // Lila Parrish Lyman, "William Johnston (1732–1772): A Forgotten Portrait Painter of New England," *New-York Historical Society Quarterly* 39 (Jan. 1955), pp. 62–78. Most comprehensive biography to date // Susan Sawitzky, "The Portraits of William Johnston: A Preliminary Checklist," *New-York Historical Society Quarterly* 39 (Jan. 1955), pp. 79–89. Based on the research of the author's late husband, William Sawitzky, this is the most complete work on Johnston's paintings yet to appear; lists thirty-three portraits // MFA, Boston, *Paintings by New England Provincial Artists, 1775–1800*, exhib. cat. by Nina Fletcher Little (1976), pp. 142–145.

Jacob Hurd

When this portrait and its companion (see below) first came on the Boston art market in 1902, they were said to be of Isaac Hurd and his wife and were attributed to an unidentified artist. In 1930, Frank W. Bayley attributed both portraits to JOHN SINGLETON COPLEY, dating them about 1758. They were not, however, included in the catalogue of American portraits by Copley published by Barbara Neville Parker and Ann Bolling Wheeler in 1938. When they came to the Metropolitan in 1964 doubts arose as to the identity of the subjects as well as of the artist. The doubts about the painter were confirmed that same year by Jules Prown, who rejected the attribution to Copley. No record of an Isaac Hurd existed in the family genealogy. The portrait of the man shows him holding a letter with a barely decipherable inscription, but a radiograph of the painting revealed that it was addressed to Jacob Hurd, Halifax, making it almost certain that he is the subject.

Jacob Hurd (1726–1797) was the eldest of the fourteen children of Elizabeth Mason and the silversmith Jacob Hurd who moved from Boston to Halifax about 1751. He joined the Royal Navy about 1755 and served as clerk to the naval storekeeper in Halifax beginning in 1769. In 1760 he married Margaret Brown, and a few years later, probably on a visit to Boston, he and his wife sat for their portraits.

The painting is clearly the work of William Johnston. It shares a number of characteristics with the portrait of Dr. Hall Jackson, tentatively dated 1760 or 1762 (Amherst College, Amherst, Mass.), which is considered to be by Johnston. Both are strongly, if somewhat stiffly, modeled; each sitter has a similarly blurred hairline, the area between nose and mouth is defined in the same manner, and the mouth has the same rather geometrical curve. The almond shape of the eyes, a feature that appears in the work of the young Copley, is a stylistic trait common to Johnston portraits and is probably derived from British rococo mezzotints after works by such painters as Allan Ramsay. Hurd's portrait also resembles that of David Gardiner, painted by Johnston in 1762 or 1763 (coll. Rev. Sinclair D. Hart). In the treatment of the faces, there is the same line running down from the corner of the mouth and similar shading in the right cheek.

In general, however, the portrait is heavily dependent on Copley. Hurd's pose is similar to

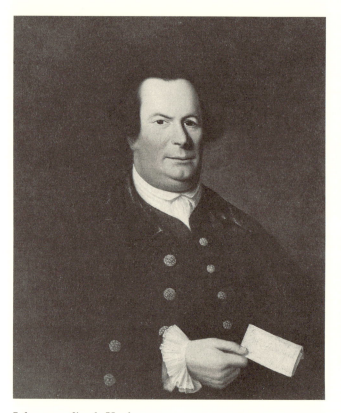

Johnston, *Jacob Hurd.*

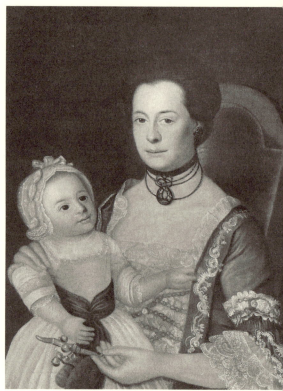

Johnston, *Mrs. Jacob Hurd and Child.*

that of Thomas Greene in Copley's portrait dated 1758 (Cincinnati Art Museum), and the treatment of the face resembles that of James Otis, which Copley probably painted in the same year (Wichita Art Museum). Hurd's portrait may have been painted a few years later. Yet Johnston could not match Copley's style. Instead of the latter's sharp particularity of likeness, one sees a generalized resemblance, and in place of the real sense of skin and fabric, which Copley was already able to produce by 1758, there is only a competent, though rather dull, treatment of face and clothing.

Oil on canvas, 30 × 25 in. (76.2 × 63.5 cm.).

Inscribed on letter at lower right: To / Mr Jacob Hurd / Halifax.

REFERENCES: C. F. Libbie and Co., Boston, *Catalogue of the . . . Library of the Late William H. Whitmore . . .*, sale cat., Nov. 11–14, 1902, no. 2763, as Isaac Hurd and his wife // Goodspeed's Book Shop, Boston, *Catalogue No. 11* (Jan. 1903), calls this picture and its companion portraits of Isaac Hurd, wife, and child, of Charlestown, Mass. // F. W. Bayley to Ehrich Galleries, New York, June 30, 1930, letter in MMA Archives, attributes to Copley, with a date of about 1758 // J. D. Prown, letter in Dept. Archives, August 10, 1964, rejects attribution to Copley // Gardner and

Feld (1965), pp. 52–53, as by unknown artist // B. C. Cuthbertson, Public Archives of Nova Scotia, Halifax, Feb. 3, 1978, letter in Dept. Archives, gives information on the subject // M. Elwood, Nova Scotia Museum, Halifax, April 17, 1978, identifies child in companion portrait.

EXHIBITED: Slater Memorial Museum, Norwich, Conn., 1968, *A Survey of American Art*, no. 1.

ON DEPOSIT: City Art Museum, Saint Louis, 1930, from Ehrich Galleries, New York, agent for Lee M. Hurd // Lyman Allyn Museum, New London, Conn., 1933, from Ehrich Galleries, agent for Lee M. Hurd // Museum of the City of New York, 1946 // Federal Reserve Bank of New York, 1972–1982.

Ex COLL.: William H. Whitmore (sale, C. F. Livvie and Co., Boston, Nov. 14, 1902, no. 2763, as Isaac Hurd and his Wife, $15 each); with Goodspeed's Book Shop, Boston, 1902–1903; Lee M. Hurd, New York, from 1903; on consignment with Ehrich Galleries, New York, 1930–1933; anonymous owner.

Anonymous gift, 1964.

64.114.1.

Mrs. Jacob Hurd and Child

This portrait of Mrs. Hurd, who was Margaret Brown of Boston, and her child, is like that

of her husband in being related to Copley's paintings of the late 1750s. In pose and composition it somewhat resembles his portrait of Mrs. Daniel Rea and her daughter, dated about 1757 (Butler Art Institute, Youngstown, Ohio), but the dress is in a style that was current a few years later. The manner is more typical of Copley's paintings of 1759 to 1761, for example, his portrait of Dorothy Murray, which is dated during that period (Fogg Art Museum, Cambridge, Mass.). However, Johnston was clearly less advanced than Copley. Spatially, the painting is somewhat confusing, and the lace, though meticulously painted, gives the effect more of surface pattern than of actual material.

Johnston was also indebted in this portrait to another Boston artist. Mrs. Hurd sits in a chair almost exactly like the one shown in the portraits of Mr. and Mrs. Francis Brinley (qq.v.) by JOHN SMIBERT. No chair of that type is known to exist in America today, and it is possible that it was actually a prop in Smibert's studio, the contents of which remained intact for many years after his death in 1751. If so, Johnston may well have used the chair as a prop himself on occasion. It could also be an example of what might be termed "painters' furniture," that is, a chair invented by one artist which was simply copied by others and in reality never existed.

The child is probably the Hurds' son Jacob, said to have been born about 1762, a reasonable date for this portrait. As nothing is known of a visit by Johnston to Halifax, Nova Scotia, where the Hurds lived, it is more likely that he painted them when they returned to Boston on a visit.

The attribution of this painting to Johnston seems relatively secure. Not only does it have the same characteristic features as those in the portrait of Dr. Hall Jackson mentioned in the description of Jacob Hurd's portrait (see above) but the lace on Mrs. Hurd's dress is painted in the same finely detailed, though somewhat unreal, manner as that in the portrait of Mrs. Ralph Isaacs of 1763 (New London County Historical Society, Conn.), which has been accepted as Johnston's work.

Oil on canvas, 30 × 25 in. (76.2 × 63.5 cm.).
REFERENCES: same as preceding entry.
EXHIBITED: same as preceding entry.
ON DEPOSIT: same as preceding entry.
EX COLL.: same as preceding entry.
Anonymous gift, 1964.
64.114.2.

Samuel Gardiner

This portrait and its companion (see below) descended in the Gardiner family of Gardiners Island, Suffolk County, New York. According to the last owner in the family they represent Samuel Gardiner (1724–1776) and his wife, Abigail. Samuel was a great-great-grandson of Lion Gardiner, who purchased the island in 1639 from the Montauk Indians. In 1746 he married his first cousin, the daughter of his uncle David Gardiner, fourth proprietor of the island. Samuel and Abigail were both born in East Hampton, where the family had large landholdings; they moved at some point to New London, Connecticut, originally the home of Samuel's mother, Elizabeth Coit. In this portrait, Samuel Gardiner is shown holding a letter addressed to him as a merchant at New London. In this profession he was very successful for a while. In 1772 he also served as town treasurer. His business failed, however; a letter written by his wife to one of her brothers in 1773 "complains of being poor" and requests money (J. T. Gardiner, *Gardiners of Gardiner's Island* [1927], p. 141). Samuel Gardiner died in March 1776, about a year after his wife's death.

The descent of the portraits is unclear. Of the Gardiners' children, three were daughters, who lived in Norwich, Connecticut, only one of whom had children. There was also a son, Samuel, who was feebleminded; he returned to East Hampton to live with his uncle Colonel Abraham Gardiner and after the uncle's death with his son, Captain Abraham Gardiner. As the portraits were subsequently in the possession of the family in East Hampton, they may have passed from the son of Samuel and Abigail to his cousin's family.

The pose William Johnston chose for Samuel Gardiner is strikingly similar to that of *Moses Gill*, painted in 1764 (Museum of Art, Rhode Island School of Design, Providence), and *Epes Sargent*, assigned the same date (coll. Joyce and Erving Wolf), both painted by Copley. Gardiner's right arm and hand closely resemble Gill's, and his left is almost exactly like Sargent's. As the portrait of Gardiner bears the date 1763, on a letter on a shelf behind him, the close correspondence with the Copley portraits of 1764 is somewhat puzzling. It is possible that Johnston had used the same pose for a Boston portrait and that Copley was following his example. It is more likely, however, that both

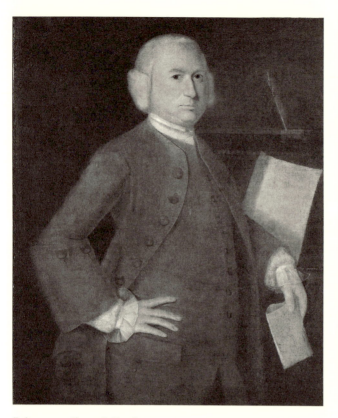

Johnston, *Samuel Gardiner.*

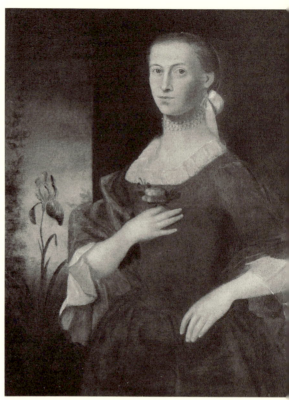

Johnston, *Mrs. Samuel Gardiner.*

artists were working from the same source, probably a British mezzotint that has yet to be identified.

When the Gardiner portraits entered the Garbisch collection they were heavily and disfiguringly overpainted. When the overpainting was removed, it became evident that the portraits had been damaged by excessive heat, and a great deal of the surface had been lost. Although this is apparent throughout, it is particularly significant in the backgrounds and in the clothing. Enough remains, however, to render the attribution to Johnston possible. Gardiner's face shows the same characteristic peculiarities as those in the portrait of Jacob Hurd (see above). The pose is very similar to that of Eleazer Wheelock Pomeroy, painted by Johnston in 1763 or 1764 (ill. in S. Sawitzky, *New-York Historical Society Quarterly* 39 (Jan. 1955), p. 87). Also the cuff on the right sleeve of both Pomeroy and Gardiner are treated in a similarly emphatic manner. The treatment of the wig and the modeling of Gardiner's face is very similar to Johnston's portrait of Eliphalet Dyer of 1764 (Connecticut Historical Society, Hartford). Moreover, Johnston is known to have painted portraits in New London in 1763, the year this painting is dated.

Oil on canvas, 36 × 29 in. (91.4 × 73.6 cm.).

Inscribed on letter in subject's hand: To— / Mr Sam1: Gardiner / Mercht: / In / New Lond[on]. Inscribed on letter behind him: New London [illeg.] 1763 / Sir.

REFERENCES: J. Abbe, Jr., to E. W. Garbisch, Nov. 15, 1960, in Dept. Archives, gives biographical information and provenance, speculates that both subjects may have died in Norwich, Connecticut, where two of their daughters lived // P. P. Kiehart, April 1962, report in Dept. Archives, describes condition of the portraits before conservation.

EX COLL.: possibly the subject's son, Samuel Gardiner, East Hampton, N.Y., d. 1789; possibly his first cousin, Abraham Gardiner, East Hampton; descended to Lion Gardiner, East Hampton, d. 1936; his wife, Mrs. Lion Gardiner, East Hampton, until about 1959; with James Abbe, Jr., East Hampton, 1959–1960; Edgar William and Bernice Chrysler Garbisch, Cambridge, Md., 1960–1970.

Gift of Colonel Edgar William and Bernice Chrysler Garbisch, 1970.

1970.283.2.

Mrs. Samuel Gardiner

Abigail Gardiner (1724–1775), daughter of David Gardiner, the fourth proprietor of Gardiners Island, was married in 1746 to her first cousin Samuel, the son of her father's younger brother. Her brother David married Samuel's sister Elizabeth, and their portraits were also painted by William Johnston (coll. Rev. Sinclair D. Hart), quite possibly in 1763 during a visit to the Samuel Gardiners in New London.

The subject's pose, derived from Sir Godfrey Kneller, was favored by a great many American painters, for example JOHN SMIBERT. It was especially popular during the 1760s in America to depict ladies standing next to their gardens. Just as her husband's letter identifies him as a merchant, Mrs. Gardiner's garden, with iris and hollyhocks, identifies her as a woman of refinement and good taste. The three strands of pearls around her neck attest to her wealth, as well as to her sense of style, as wearing pearls high on the neck was very fashionable at this time. Like so many women in American paintings of this period she holds a rose.

This portrait suffered even more than its companion from what was apparently heat damage and subsequent restoration, probably in the nineteenth century. The repainting, which had an oddly comical effect on the subject's face, has been removed, but the original surface of the painting cannot be recaptured. Mrs. Gardiner's dress was very badly affected; here, the lighter tones that Johnston used to give a sense of modeling have been lost almost entirely except for small areas in the right sleeve. The general effect of the portrait is much flatter and more two-dimensional than it undoubtedly was originally. Enough remains, however, for it to be identified as the work of William Johnston. It is very similar to the portrait of Mrs. Nathaniel Shaw, Jr., 1763 (New London County Historical Society, Conn.), a documented work by Johnston, the frame of which bears his initials. The faces of both women show mannerisms characteristic of Johnston. The poses are almost the same, although the subjects face in opposite directions, and the right arms, hands, fingers, and ribbons in the hair are virtually alike. The canvases are each divided in the same proportion of dark backdrop and light landscape. Mrs. Shaw's dress, with its elaborate modeling, gives a good indication of the way Mrs. Gardiner's may once have looked.

Oil on canvas, 36 × 29 in. (91.4 × 73.6 cm.).
REFERENCES: same as preceding entry.
EX COLL.: same as preceding entry.
Gift of Edgar William and Bernice Chrysler Garbisch, 1970.
1970.283.3.

MATTHEW PRATT

1734–1805

Matthew Pratt was born in Philadelphia on September 23, 1734, the son of Henry Pratt, a goldsmith, and Rebecca Claypoole Pratt, the daughter of a local cabinetmaker. Between 1744 and 1747 he attended Stephen Vidal's school in Philadelphia and from 1749 to 1756 was apprenticed to his uncle James Claypoole (1720–1786), from whom he learned the painter's craft. After his apprenticeship, he formed a partnership with a Francis Foster, but in 1757 he abandoned it and set off on a trading voyage to Jamaica, a venture which turned out unsuccessfully. By 1758 he was back in Philadelphia painting portraits on his own. Even though Dunlap and Tuckerman state that he was in New York from 1760 to 1764, Pratt's own autobiographical notes indicate that he continued to work in his native city

until 1764. In 1760, he married Elizabeth Moore, the daughter of a Philadelphia drygoods merchant.

Pratt's career entered a new phase in 1764, when he went to London with his cousin Betsy Shewell, who was to marry BENJAMIN WEST. For almost four years, Pratt remained in England, where he studied under West, worked for eighteen months in Bristol, and gained admission to the Society of Artists of Great Britain as a still-life painter. After his return to Philadelphia in 1768, he found himself well patronized by many of the city's wealthy families. He was, by all accounts, a well-educated and urbane man who mixed easily with the best society even though he himself was not part of it. In 1770 family business took him to Ireland, where he met Archdeacon Isaac Mann and painted a portrait of him (unlocated), which he exhibited at the Dublin Society of Artists. He then worked briefly in England, and again in Ireland, before returning to America. He may have painted in Philadelphia for a time, but by 1771 he was in New York; for it was there that he met JOHN SINGLETON COPLEY, who visited the city in that year. On November 6, 1771, Copley wrote to his half brother, Henry Pelham (1749–1806), that Pratt had seen and admired his portrait of Mrs. Thomas Gage, 1771 (Timken Art Gallery, San Diego):

> Mr. Pratt says of it, It will be flesh and Blood these 200 years to come, that every Part and line in it is B[ea]utifull, that I must get my Ideas from Heaven, that he cannot Paint (*Letters & Papers of John Singleton Copley and Henry Pelham, 1739–1775* [1914], p. 174).

Shortly afterwards, Pratt's fortunes took a turn for the worse. He traveled south in search of customers, arriving at Williamsburg in 1773, where he offered for sale "a small but very neat collection of paintings," including some of his copies of old masters and "a few copies of some of Mr. West's best portraits" (*Virginia Gazette*, March 4, 1773). In 1787 an advertisement in a Philadelphia newspaper announced that Pratt was teaching "the art of Drawing and Colouring, in all the different methods now in use" (*Pennsylvania Packet*, June 18, 1787). Nine years later, he joined George Rutter, William Clarke, and Jeremiah Paul in a business designed to supply all kinds of painting and painted decoration (*Philadelphia Aurora*, Feb. 15, 1796). During these years Pratt painted many shop signs in Philadelphia, which, according to those who saw them, were of outstanding quality, but none that we know of has survived. He died on January 9, 1805, leaving behind his wife and six children.

Although what is known of Matthew Pratt would indicate that his artistic output was considerable, only about forty paintings can with confidence be assigned to his hand. By and large, these are somewhat stiff provincial interpretations of late English rococo portraiture in the manner of Reynolds, the early West, and Joseph Wright of Derby, all of whom were also members of the Society of Artists of Great Britain. Pratt preferred to surround his sitters with a tenebrous atmosphere and often used dark colors in the clothing and drapery. In spite of his obvious drawbacks, his portraits are usually charming works in which the subjects have an appealingly benevolent spirit.

BIBLIOGRAPHY: William Dunlap, *History of the Rise and Progress of the Arts of Design in the United States* (2 vols.; New York, 1834), 1, pp. 98-103 // "Autobiographical Notes of Matthew Pratt, Painter," *Pennsylvania Magazine of History and Biography* 19 (Jan. 1896), pp. 460–466 // Theodore Bolton and Harry Lorin Binsse, "Pratt, Painter of Colonial Portraits and Signboards," *Antiquarian* 17 (Sept.

1931), pp. 20–24, 48, 50. Lists seventeen works by the artist // Frederick W. Coburn, *DAB* (1935; 1964), s.v. "Pratt, Matthew" // William Sawitzky, *Matthew Pratt, 1734–1805* (New York, 1942). The definitive monograph by the most thorough student of Pratt's work, with a catalogue of thirty-five located paintings.

The American School

When Matthew Pratt arrived in London in 1764, BENJAMIN WEST, who had been working there for only a year, had already become a well-known artist. As Pratt noted, West "had a very elegant house, completely fitted up to accomodate a very large family, and where he followed his occupation in great repute" (*Pennsylvania Magazine of History and Biography* 19 [Jan. 1896], p. 462). Pratt lodged with West and was the first of many American artists who, over the years, flocked to his studio to acquire the skills of professional training.

The American School, painted in 1765 and exhibited with this title at the Spring Gardens Exhibition of the Incorporated Society of Artists of Great Britain the following year, is Pratt's homage to West's generosity. Here, in one of the paneled and brocaded rooms of his house, West, standing at the left, is singled out as the leader of a school of artists who, though strongly associated with Great Britain, insisted on their American identity. In this respect, Pratt's painting is not so much a report on the state of affairs in 1765 as a vision of the future course of events.

Although showing the influence of traditional representations of academies and artists' shops such as Baccio Bandinelli's *Academy in the Artist's House*, engraved by Agostino Veneziano in 1531, and Stradanus's *Color Olivi*, engraved by Joannes Gallé in the early 1580s, *The American School* is still a relatively uncluttered domestic scene that owes much to the British conversation piece as illustrated by John Hamilton Mortimer's *The Artist, Joseph Wilton, and a Student*, about 1765 (Royal Academy, London), which deals with a similar theme, and Benjamin West's *The Cricketers*, 1763–1764 (private coll., England; ill. in Allentown Art Museum, Pa., *The World of Benjamin West*, exhib. cat. [1962], no. 5). West's picture, in particular, though treating an entirely different subject, may be considered the immediate precursor of *The American School*; for, in addition to having very similar dimensions (38⅞ × 49 in.), it shows five Americans abroad, their oddly proportioned figures displayed across the

length of the canvas in much the same manner as Pratt's. Both works, furthermore, possess the "legginess" for which Sawitzky (1942, p. 8) faulted *The American School*. This is also a characteristic of Nathaniel Dance's *Conversation Piece, Group Portrait*, 1760 (Philadelphia Museum of Art), which may, in turn, be considered an antecedent of West's *Cricketers*. However, in spite of other infelicities, including errors in foreshortening and scale, numerous pentimenti, and obfuscated forms, *The American School* creditably synthesizes two pictorial traditions to make its point that a small but vigorous school of American artists was forming in London, under a youthful host and master, in an atmosphere of friendship and informality.

Since 1887, when the painting was exhibited in Philadelphia and Charles Henry Hart first attempted to identify the figures, many others have contributed their speculations. The consensus now seems to be that West is the figure standing on the left. This is based on similarities to Angelica Kauffmann's 1763 chalk portrait of him (National Portrait Gallery, London) and Pratt's portrait of about 1765 (PAFA). Because Pratt put his signature on the lower left of the painting shown on the easel, the artist sitting before it would logically appear to be Pratt, but comparison with his self-portrait of 1765 to 1766 (National Portrait Gallery, Washington, D.C.) indicates that Pratt is the figure sitting next to West and showing him a drawing on blue paper. Although Abraham Delanoy (1742–1795) of New York, the only other American artist known to have studied with West at about this time, has sometimes been thought to be one of the unidentified figures in the group, all that can be said with certainty is that Delanoy, who was about twenty-three years old when the picture was painted, could not possibly be either of the two youths in the background. The boy drawing at the table, however, does bear a striking resemblance to an unidentified artist painted around the same time by Pratt (Detroit Institute of Arts).

While the reception of *The American School* at the 1766 Spring Gardens Exhibition was probably favorable, it ought to be kept in mind that

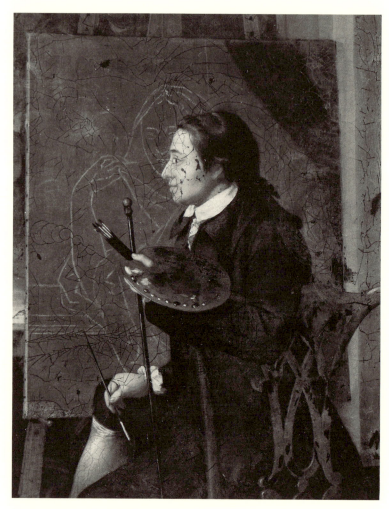

X-ray photograph reveals the drawing on the easel
in Pratt's *The American School*.

JOHN SINGLETON COPLEY's *Boy with a Squirrel*, 1765
(MFA, Boston), sent from Boston and exhibited
the same year as Pratt's picture, won him im-
mediate election to the Society of Artists, whereas
Pratt's membership was not approved until the
following year.

A recent cleaning has revealed that a chalk
underdrawing for a portrait of a lady was re-
presented on the painting on the easel. It is now
only visible under a black light. Although it is
impossible to identify the sitter, the abundant
drapery accords more with West's portraits of
this period than with Pratt's. It would seem,
therefore, that in spite of the signature, the
canvas must have been intended by Pratt to re-

present a portrait by West being worked on by a
studio assistant who was, perhaps, just beginning
to paint the drapery. As a result of the cleaning,
The American School can now be seen to have been
painted in very high-keyed colors, with the scene
bathed in a cool silvery light reflected in the
faces of all the figures.

Oil on canvas, 36 × 50¼ in. (91.4 × 127.6 cm.).
Signed and dated at lower left of the painting on
the easel: M. Pratt / ad. 1765.
REFERENCES: E. Edwards, *Anecdotes of Painters Who
Have Resided or Been Born in England* (1808), p. 22,
states "The last picture which he [Pratt] exhibited,
was entitled, The American School; it consisted of
small whole-length figures, which were the portraits of

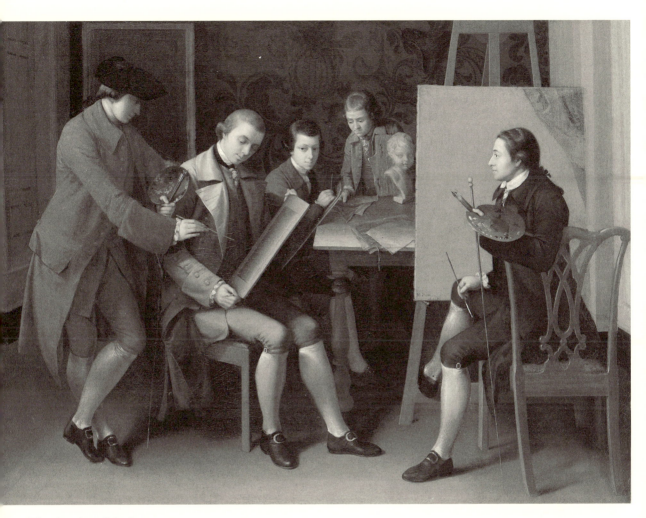

...att, *The American School*.

himself, Mr. West, and some others of their country-men, whose names are unknown to the author" // W. Dunlap, *History of the Rise and Progress of the Arts of Design in the United States* (1834), 1, p. 101, quotes the painter Thomas Sully, who reported, "This picture was exhibited in our academy some years ago, and was so well executed that I had always thought it was a copy from West" // C. H. Hart, *Harper's Weekly* 40 (July 4, 1896), p. 665, rejects his earlier identification of the subjects (see below under exhibited, PAFA, 1887–1888) and claims the figure at the easel is prob-ably Delanoy // W. T. Whitley, *Artists and Their Friends in England* (1928), 1, p. 200 // T. Bolton and H. L. Binsse, *Antiquarian* 17 (Sept. 1931), p. 48, include it in a list of the artist's work // W. Sawitzky, *Matthew Pratt* (1942), pp. 35–38, thinks Delanoy may be the boy standing behind the table // E. P. Richardson,

Painting in America (1956), p. 78, calls it the most fam-ous of American conversation pieces // Gardner and Feld (1965), pp. 21–22 // J. D. Prown, *American Paint-ing* (1970), p. 38, thinks Pratt is probably the artist sitting before the easel // *MMA Bull.* 33 (Winter 1975–1976), color ill. no. 16 // J. Wilmerding, *American Art* (1976), p. 47, says the colonial tradition was brought to a new level of sophistication with this painting // M. Brown, *American Art to 1900* (1977), p. 185, does not think the painting shows a strong influence of West.

EXHIBITED: Incorporated Society of Artists of Great Britain, London, 1766, Spring Gardens Exhibition, no. 130, as The American School // Society of Artists, Philadelphia, 1811, no. 105, as School of West // PAFA, 1887–1888, *Loan Exhibition of Historical Por-traits*, cat. by C. H. Hart, no. 459, as West's School of

Painters in London, lent by Mrs. R. V. Tiers Jackson, incorrectly identifies the artist seated before the easel as Gilbert Stuart and the two youths in the center as possibly John Trumbull and Joseph Wright // MMA, 1896, *Retrospective Exhibition of American Paintings*, no. 241, lent by S. P. Avery // M. H. de Young Memorial Museum, San Francisco, 1935, *Exhibition of American Painting*, no. 20 // Philadelphia Museum of Art, 1938, *Benjamin West*, no. 63 // MMA, 1939, *Life in America*, no. 18 // Carnegie Institute, Pittsburgh, 1940, *Survey of American Painting*, no. 50 // Museum of Art, Rhode Island School of Design, Providence, 1945, *Old and New England*, no. 45 // Tate Gallery, London, 1946, *American Painting*, no. 169 // Art Institute of Chicago, 1949, *From Colony to Nation*, no. 96 // Corcoran Gallery of Art, Washington, D.C., 1950, *American Processional*, no. 38 // MMA, 1958–1959, *Fourteen American Masters* (no cat.) // MFA, Boston, 1970, *Masterpieces of Painting in the Metropolitan Museum of Art*, p. 102 // National Gallery, Washington, D.C.; City Art Museum of St. Louis; and Seattle Art Museum, 1970-1971, *Great American Paintings from the Boston and Metropolitan Museums*, no. 18 // MMA, 1975–1976, *A Bicentennial Treasury* (see *MMA Bull.* 33 above) // Yale University Art Gallery, New Haven, Conn., and Victoria and Albert Museum, London, 1976, *American Art, 1750–1800*, no. 18.

Ex coll.: the artist's son, Nathan Pratt, Philadelphia, until 1805; the artist's great-granddaughter, Rosalie V. Tiers Jackson, Philadelphia, by 1887; Samuel P. Avery, New York, by 1896–1897.

Gift of Samuel P. Avery, 1897.

97.29.3.

Mrs. Peter De Lancey

Mrs. Peter De Lancey (1720–1784) was born Elizabeth Colden, the eldest daughter of Cadwallader and Alice Christie Colden, whose portraits by JOHN WOLLASTON are in the museum (qq.v.). What is known about her has come down to us in the form of correspondence with her father (NYHS), most of it dealing with domestic family matters. She was a sensitive and strong woman, at times subject to nervous disorders but a conscientious wife and mother. After her marriage to Peter De Lancey in January 1737, she moved to his large estate near West Farms on the Bronx River, then part of Westchester County, which included De Lancey's mills, extensive farmlands, and the old family mansion (a site now in the New York Zoological Park, near 181st Street). There she raised twelve children, of whom ten reached maturity.

After her husband's death in 1770, Mrs. De Lancey saw her large family divided by the political storm gathering over the question of American independence. Her loyalist son James, for example, from 1770 to 1776 sheriff of Westchester County, led an infamous cavalry troop known as the "Cowboys" and had to seek exile in Nova Scotia at the conclusion of the war, while her daughter Alice espoused the political views of her husband, Ralph Izard, the prominent South Carolinian patriot. The De Lancey home near the mills was destroyed, Mrs. De Lancey's house at Union Hill was plundered (a site now near the intersection of Fordham Road and the Grand Concourse), and she spent the closing years of her life at her father's estate at Spring Hill, near Flushing, Long Island, where she died on September 22, 1784.

This portrait, for some time attributed to JOHN SINGLETON COPLEY, was perhaps the picture of the same dimensions sold in the John Fenning sale in 1913 (accepted by F. W. Bayley as a Copley). Since 1917, when Charles Henry Hart conclusively attributed it to Pratt, it has been accepted as one of the painter's autograph works. William Sawitzky, Pratt's biographer, thought that the painting, "exhibiting all of the essential characteristics of Pratt's work during the 1770s, can be taken as a prototype for the later pictures, and, together with Cadwallader Colden's full-length, forms perhaps the best key to Pratt's general technique of any portrait from his hand" (1942, pp. 11, 12).

Pratt's partiality to long, flowing headscarves in his portraits of women provides the occasion here for some particularly painterly passages, though the features of Mrs. De Lancey's face are in his usual, more linear, vein. The bold curve traced by the scarf admirably accommodates the figure in the oval field, which, despite its rarity in American portrait painting at this time, does not appear to have been pared down from a rectangular canvas.

The portrait is not dated but may have been painted in 1771 or thereabouts, when Pratt is known to have been in New York working on the full-length portrait of Cadwallader Colden (Chamber of Commerce, New York, on loan to NYHS).

Oil on canvas, 29¾ × 25 in. (75.6 × 63.5 cm.).

REFERENCES: M. J. Lamb, *History of the City of New York* (1877; 1921), pp. 297, 709, gives biographical information // Fifth Avenue Art Galleries, New York, *Catalogue of the Collection of Oil Paintings Belonging*

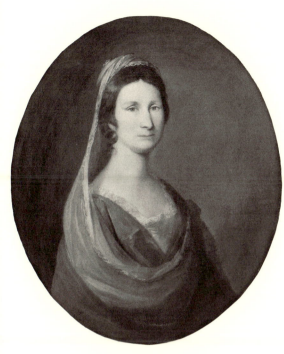

Pratt, *Mrs. Peter De Lancey*.

to Mr. *John Fenning of 428 Fifth Avenue, New York*, sale cat. (March 27–28, 1913), no. 153, sold for $700, probably the picture listed by Bayley in 1915 // Macbeth Gallery disposition card, Dec. 4, 1914, Jan. 12, 1915, William Macbeth Papers, Arch. Am. Art, notes purchase from Dr. Watts and sale to H. L. Pratt // F. W. Bayley, *The Life and Works of John Singleton Copley* (1915), p. 94, lists a portrait of Mrs. Elizabeth De Lancey (probably this one), 25 × 30 in., "sold at auction in 1912" // C. H. Hart, *Historical, Descriptive and Critical Catalogue of the Works of American Artists in the Collection of Herbert L. Pratt, New York* (1917), no. 1, calls it "unmistakably the work of Matthew Pratt," although acquired as a Copley // C. W. Spencer, *DAB* (1931; 1959), s.v. "De Lancey, James," gives biographical information // T. Bolton and H. L. Binsse, *Antiquarian* 17 (Sept. 1931), p. 48, include it in list of works // A. Burroughs, *Limners and Likenesses* (1936), p. 83, says it shows the influence of Charles Willson Peale // W. Sawitzky, *Matthew Pratt* (1942), pp. 11, 12, 52–54 // S. Sawitzky, letter in Dept. Archives, Dec. 3, 1957, gives information on provenance // A. T. Gardner, *MMA Bull.* 17 (April 1959), pp. 205–208, dates it between 1770 and 1772 // Gardner and Feld (1965), pp. 22–24.

EXHIBITED: Brooklyn Museum, 1917, *Early American Paintings*, no. 77, as by Pratt, lent by Herbert L. Pratt // National Gallery of Art (now National Museum of American Art), Washington, D. C., 1925–1926, *Exhibition of Early American Paintings, Miniatures*

and Silver, no. 51, as by Pratt, lent by Mr. Herbert Pratt // Museum of the City of New York, 1936, *Portraits of Ladies of Old New York, 18th and 19th Centuries* (no cat.) // M. Knoedler and Co., New York, 1936, *Masterpieces of American Historical Portraiture*, no. 26, lent by Herbert L. Pratt // Grey Art Gallery, New York University, New York, 1976, *Circa 1776*, p. 12.

EX COLL.: the subject, New York, d. 1784; James De Lancey Watts; possibly John Fenning (sale, Fifth Avenue Art Galleries, New York, March 28, 1913, no. 153, $700); Dr. Robert Watts, New York, by 1914; with Macbeth Gallery, New York, 1914–1915; Herbert Lee Pratt, Glen Cove, N. Y., 1915–ca. 1944; his daughter, Mrs. Edith Pratt McLean (later Mrs. Howard Maxwell), Glen Cove, N. Y., by 1944–1957.

Bequest of Edith Pratt Maxwell, 1957.

57.38.

Cadwallader Colden and His Grandson Warren De Lancey

Though neither signed nor dated, this portrait has long been accepted as one of the "few either well-documented or otherwise convincing key pictures" by Matthew Pratt (Sawitzky [1942], p. 8). The expression and execution of the old man's features are strongly reminiscent of Pratt's full-length portrait of Colden painted in 1772 (Chamber of Commerce, New York, on loan to NYHS), and the likeness of his grandson exhibits strong similarities with other known portraits of children by Pratt.

Warren De Lancey (1761–1842), who according to family tradition is the boy depicted here, was the twelfth and youngest child of Peter De Lancey and his wife Elizabeth (see above), who was Cadwallader Colden's daughter. He was born on May 3, 1761, at his parents' estate near West Farms, now part of the Bronx, New York, and died on July 24, 1842, in New York City. As did many other members of his family, he became a loyalist and joined the British army at the time of the Revolution, gaining special distinction for heroism at the battle of Chatterton's Hill, Westchester County, in 1776, when he was only fifteen. For his bravery he was finally rewarded in 1780 with a cornetcy in the 17th Dragoons, commanded by his uncle Oliver De Lancey. After the war, he continued to live in New York, quietly managing his property in Westchester and Madison counties. He married three times and at his death left six children.

Cadwallader Colden is sympathetically shown here as grandfather and teacher (for biography

see under portrait by JOHN WOLLASTON). He held strong views regarding the education of his grandchildren. Shortly after the birth of his daughter Elizabeth's first child, he advised her:

You should endeavor to educate your children to different kinds of business, for thereby their several interests will not clash with one another but on the contrary, they will thereby become more useful to each other by promoting their mutual benefits and advantage.

He also offered his services as a tutor, assuring her that when her son

shall have made some advance in the things commonly learned at schools, it will give me much pleasure to assist him in making a further progress than is commonly made in this country (*The Papers of Cadwallader Colden*, ed. D. Barck [1918], 4, pp. 339-340).

Still intellectually active in his old age, Colden is shown with a globe at his side, his hand on a diagram dealing with some aspect of the motion of planets around the sun, perhaps an eclipse. These allude to his continuing interest in the fundamental laws of the universe, first treated by him in *An Explication of the First Causes of Action in Matter, and, of the Cause of Gravitation* (New York, 1745 [actually appeared 1746]). Colden's argument in that book had quickly come under attack by European scientists, including the great Swiss mathematician Leonhard Euler, who noted that Colden's understanding of orbital motion "entirely disqualifies the Author from establishing the True Forces requisite to the motion of the planets" (quoted in B. Hindle, *William and Mary Quarterly* 13 [Oct. 1956], p. 471). Colden's reputation as a physicist never recovered from this criticism, yet he continued to toy with his ideas until he died.

Although Sawitzky thought that this portrait was painted about 1774 to 1775, it is more accurate to date it sometime between Copley's visit to New York in 1771 and the outbreak of revolutionary unrest in 1775. In fact, it is likely that Pratt's favorable reaction to Copley's New York work accounts for many of the qualities of this ambitious double portrait, a type that is rare in the history of colonial painting. The poses and the highly realistic facial expressions are related to Copley's New York paintings, including the portrait of Daniel Crommelin Verplanck

(q.v.), whose stylized features Pratt emulates in his portrayal of Warren De Lancey. Two other portraits by Pratt, which he painted in Virginia in the summer of 1773, *James Balfour, with His Son, George* and *Mary Jemima Balfour* (Virginia Historical Society, Richmond), also strongly reflect Copley's influence. That of James Balfour and his son has the same composition as the Colden, albeit in reverse.

Oil on canvas, 50 × 40 in. (127 × 91.6 cm.).

RELATED WORKS: attributed to Matthew Pratt, but possibly a copy, *Cadwallader Colden with a Little Girl*, oil on canvas, 56¾ × 36⅞ in. (144.1 × 93.7 cm.), ca. 1772, coll. Mrs. John W. Titcomb, on loan to the Tacoma Art Museum // Unidentified artist, *Cadwallader Colden*, oil on canvas, 49 × 40 in. (124.5 × 101.6 cm.), NYHS, probably a nineteenth-century copy, shows Colden alone, seated in a different posture, but the face and cravat obviously copied from Pratt, ill. in *New-York Historical Society Quarterly* 52 (Oct. 1978), p. 270.

REFERENCES: E. R. Purple, *Genealogical Notes of the Colden Family in America* (1873), p. 16 // A. J. Wall, *New-York Historical Society Quarterly* 8 (April 1924), p. 19, as by Copley but also attributed to Pratt // D. A. Story, *The de Lanceys* (1931), p. 65 // T. Bolton and H. L. Binsse, *Antiquarian* 17 (Sept. 1931), p. 48, list it // W. Sawitzky, *Matthew Pratt* (1942), pp. 8, 46-48, says that since the exhibition of the painting at the Museum of the City of New York, 1927, students of early American painting have agreed on the Pratt attribution // J. T. Flexner, *The Light of Distant Skies* (1954), pp. 24-25 // B. Hindle, *New-York Historical Society Quarterly* 45 (July 1961), ill. p. 240 // *MMA Bull.* 28 (Oct. 1969), ill. p. 53.

EXHIBITED: Museum of the City of New York, 1926-1927, *Old New York* (no cat.); 1932, *Inaugural Exhibition* (no cat.), lent by de Lancey Kountze // MMA, 1939, *Life in America*, no. 67 // Hudson River Museum, Yonkers, N.Y., 1970, *American Paintings from the Metropolitan*, no. 36 // National Maritime Museum, Greenwich, England, 1976, *1776: The British Story of the American Revolution*, no. 352.

ON DEPOSIT: Museum of the City of New York, 1946-1963.

EX COLL.: Mrs. Peter De Lancey, New York, d. 1784; her descendants to O. de Lancey Coster, New York; Harry A. Coster, New York; de Lancey Kountze, New York, by 1932; his grandson, Peter de Lancey Swords, Mt. Kisco, N.Y., until 1969.

Morris K. Jesup Fund, 1969.

69.76.

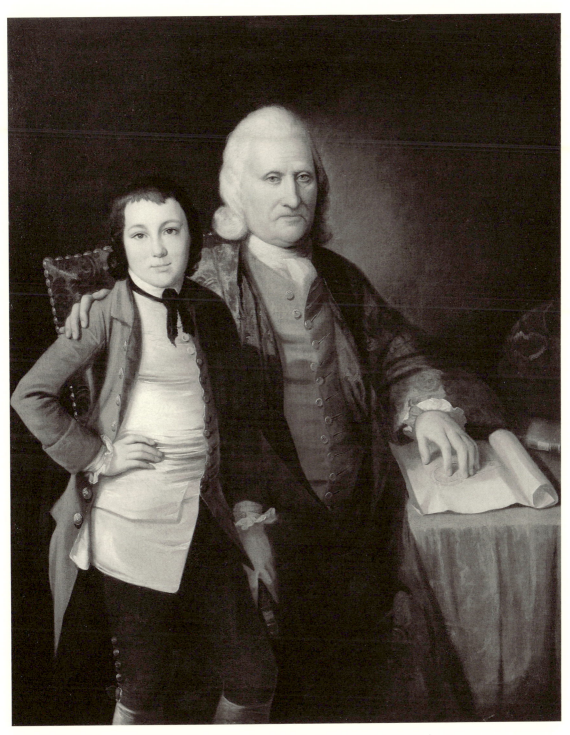

Pratt, *Cadwallader Colden and His Grandson Warren De Lancey*.

BENJAMIN WEST

1738–1820

Benjamin West was born on October 10, 1738, near Springfield, Pennsylvania, in a house now on the campus of Swarthmore College. He was the youngest of the ten children of Sarah Pearson West and John West, an innkeeper who is said to have been a cooper and a hosier as well. His talent for painting was manifested early and was nurtured by his parents. Many romantic tales of his early career—receiving his first colors from the Indians, executing his first portrait sketch at the age of six, discovering independently the principle of the camera—were recorded by his first biographer, John Galt, who knew him intimately. When West was about nine, his cousin Edward Pennington, a Philadelphia merchant, bought him his first artist's supplies and introduced him to WILLIAM WILLIAMS, who lent him treatises on painting by Charles Alphonse du Fresnoy and Jonathan Richardson and let him visit his studio.

West's career as a painter began at the age of fifteen when he was commissioned to paint a portrait of a woman in Lancaster, Pennsylvania. He quickly became something of a local celebrity. One of his patrons, William Henry, urged him to become a history painter rather than a portraitist, and it was for him that the young West executed *The Death of Socrates*, ca. 1756 (private coll.), one of the earliest expressions of neoclassicism in Anglo-American art and the precursor of his many innovative works in this genre. In 1756, West attracted the attention of Dr. William Smith, provost of the College of Philadelphia, who enrolled him in his school and devised a program of studies suited to a painter. Although he never graduated, his exposure to classical learning fueled his determination to become a history painter and travel abroad. As Galt put it: "The true use of painting, [West] early thought, must reside in assisting the reason to arrive at correct moral inferences, by furnishing a probable view of the effects of motives and of passions" (1, p. 157). His portraits of this time, despite their provincialism, show that he was well aware of the conventions of English portraiture. These were transmitted to him through prints and the works of Williams and JOHN WOLLASTON. In a poem published in the *American Magazine* for September 1758, Francis Hopkinson singled out the latter as worthy of West's emulation:

> Hail sacred genius! may'st thou ever tread
> The pleasing paths your Wollaston has led.
> Let his first precepts all your works refine.
> Copy each grace, and learn like him to shine
> *(American Magazine and Monthly Chronicle for the*
> *British Colonies* 1 [Sept. 1758], pp. 607-608.)

After painting many portraits in Philadelphia and achieving the status of a local wonder, West went to New York in 1758 in search of new sitters, new surroundings, and higher earnings. There he painted William Kelly, a generous merchant, who gave him the fifty guineas that made possible his long-envisioned trip to Europe. With this money and his own life's savings, West sailed for Italy in 1760 on a journey that would lead him to the pinnacle of artistic success.

As the first American artist to study in Italy, West became a sort of picturesque curiosity, heartily welcomed by the colony of English connoisseurs, dandies, and Italophiles who lived there during the second half of the eighteenth century. In Rome, West studied antiquities, painted assiduously, and met Cardinal Albani and the painter Anton Raphael Mengs; he was seen at the right places with the right people. His view of art as the handmaiden of virtue and morality was completely in tune with the embryonic neoclassical movement then developing in Rome and soon to sweep over all of Europe. He visited Florence, Venice, and Bologna, made a special study of Raphael, and was very probably influenced by Gavin Hamilton's historical paintings, although he never acknowledged this. Thus, by the time he reached London in 1763, West had been exposed to the newest trends in European art. His ability, his ambition, his modernity, his willingness to experiment, and his social presentability soon earned him widespread patronage. Through his friend Robert Drummond, archbishop of York, for whom he painted the revolutionary picture *Agrippina Landing at Brundisium with the Ashes of Germanicus*, 1766 (Yale University, New Haven, Conn.), West met George III. They soon became good friends. In 1768 the king appointed him a charter member of the Royal Academy of Arts, and by 1772 he had made him his historical painter.

As an artist committed to the grand manner and to the representation of moral truths, West chose subjects from the Bible, the classics, and medieval history. It was in the representation of contemporary events, however, that he earned for himself an important position in the annals of Western art. In his monumental *Death of General Wolfe*, 1769 (National Gallery of Canada, Ottawa), probably his best-known work, he achieved a specificity of time and place (including contemporary dress for the figures) that generated a good deal of controversy; yet his adherence to long-established conventions of pose, expression, and composition so ennobled the work that the misgivings of Sir Joshua Reynolds and others were readily overcome. *Saul and the Witch of Endor*, 1777 (Wadsworth Atheneum, Hartford), another of West's landmark works, embodied the romantic notions of sublime beauty before artists such as Henry Fuseli, James Barry, and William Blake took up the standard of romanticism. For the most part, however, West's output consisted of uninspired pastiches of enormous size, which enjoy little admiration today. During the period from 1780 to 1810, he spent much time planning and executing pictures for a Chapel of Revealed Religion to be installed at Windsor Castle. This vast project, for which he painted over thirty-five pictures, was never brought to completion, to the artist's great distress. Yet his position at the top of the hierarchy of British painters, once achieved, was never in question. He was elected president of the Royal Academy, succeeding Sir Joshua Reynolds, and held the post, save for one year, from 1792 until his death in 1820.

After royal patronage was cut off in 1811, owing to George III's declining health, West painted two huge religious pictures, *Christ Healing the Sick*, 1815 (Pennsylvania Hospital, Philadelphia), and *Christ Rejected*, 1814 (PAFA), both of which earned him small fortunes from their exhibition and the sale of engravings. Thereafter, his powers declined rapidly. He died in 1820, mourned as one of the great painters of England. His burial in Saint Paul's Cathedral was attended by all the important artists and patrons of his day.

West's influence on the course of American painting was enormous, and it is certain that without him the achievements of most of the major American artists of that time would

never have been possible. As soon as he had established himself in London, he opened the doors of his home and studio to any and all American painters wishing to acquire experience abroad. Among those who studied with him, or were befriended by him, were WASHINGTON ALLSTON, HENRY BENBRIDGE, MATHER BROWN, JOHN SINGLETON COPLEY, Abraham Delanoy (1742–1795), WILLIAM DUNLAP, RALPH EARL, Robert Fulton (1765–1815), Charles R. Leslie (1794–1859), SAMUEL F. B. MORSE, CHARLES WILLSON PEALE, REMBRANDT PEALE, MATTHEW PRATT, GILBERT STUART, THOMAS SULLY, JOHN TRUMBULL, and Joseph Wright (1756–1793).

BIBLIOGRAPHY: John Galt, *The Life, Studies, and Works of Benjamin West, Esq.*, (2 pts.; London, 1816–1820) ‖ John Dillenberger, *Benjamin West: The Context of His Life's Work* (San Antonio, 1977). Pays particular attention to paintings with religious subject matter ‖ Robert C. Alberts, *Benjamin West: A Biography* (Boston, 1978). A thorough biographical account ‖ Dorinda Evans, *Benjamin West and His American Students* (Washington, D. C., 1980). A catalogue for an exhibition held at the National Portrait Gallery and the Pennsylvania Academy of the Fine Arts, it assesses West's influence on American painting ‖ Helmut von Erffa and Allen Staley, *The Paintings of Benjamin West* (New Haven, 1986). A catalogue raisonné of his paintings and important drawings, it also contains an overview of West's career.

Sarah Ursula Rose

Sarah Ursula Rose (1744–1823) was born and died in Lancaster, Pennsylvania. Her father, Joseph, was a Dublin-trained lawyer who immigrated to America. Her mother, Ursula, was the former Mrs. Abraham Wood. Ann, a daughter by the mother's previous marriage, lived in the Rose household before her marriage in 1756 to William Henry and was also painted by the young Benjamin West (Historical Society of Pennsylvania, Philadelphia).

In 1770, Sarah Ursula Rose was married to Henry Miller, who later became a lieutenant colonel on Washington's staff. He served with distinction for three years but was forced to leave the army because his family required his presence at home. During the Whiskey Rebellion of 1794 he was quartermaster general in the federal force organized by President Washington to suppress the uprising.

Painted in the Rose home in Lancaster in 1756 when Sarah was twelve, this small portrait is among the earliest known works by West. Rather roughly painted and displaying only a rudimentary ability in the representation of drappery and anatomy, the painting still manages to convey a sympathetic characterization of an alert, self-possessed, and stylish young girl. West, though unable to achieve a realistic three-dimensional illusion, clearly possessed a natural feel for the beauty of line. The varied and balanced outlines of the eyes, neck, face, hand, and drapery give the portrait its considerable visual

West, *Sarah Ursula Rose.*

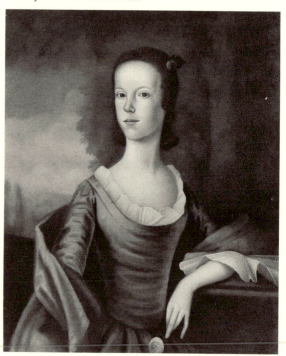

appeal. The rose, one shown in the sitter's hand and another in her hair, is a traditional symbol of feminine virtue. Here it is also a witty allusion to her family name.

Oil on canvas, 29 × 23⅜ in. (73.7 × 59.4 cm.).

REFERENCES: H. M. Watts, statement written Jan. 1, 1873, and attached to old photographic negative of this portrait, in Dept. Archives, notes "Portrait of Sarah Ursula Rose at the age of 12 years. Born on the 27 May A. D. 1744. Painted by Benjamin West, late President of the Royal Academy, London, Engld., in the house of her father the late Joseph Rose esq., in Lancaster, Penna. in the year 1756. Joseph Rose, being a Barrister at law in Dublin Ireland, emigrated to the colony of Pennsylvania and died in Lancaster A. D. 1777. Sarah Ursula Rose became the wife of Genl. Henry Miller and the maternal Grand Mother (inter alios) of the undersigned Henry Miller Watts" // W. Sawitzky, *Pennsylvania Magazine of History and Biography* 62 (Oct. 1938), p. 462, no. 15, lists the painting as an unlocated work attributed to West // H. L. Cooke, Jr., *National Geographic* 122 (Sept. 1962), p. 367 // A. Neumeyer, *Geschichte der Amerikanischen Malerei* (1974), p. 81, says it shows the influence of Wollaston's manner // H. von Erffa and A. Staley, *The Paintings of Benjamin West* (1986), p. 494, says pose is the same as in Mrs. Samuel Boudé portrait, 1755–1756; p. 518; p. 548, no. 690, catalogues this work; ill. p. 549.

EXHIBITED: PAFA, 1887–1888, *Loan Exhibition of Historical Portraits*, no. 367, lent by John S. Watts // MMA and American Federation of Arts, traveling exhibition, 1961–1964, *101 Masterpieces of American Primitive Painting from the Collection of Edgar William and Bernice Chrysler Garbisch*, color pl. 15 // American Federation of Arts, traveling exhibition, 1968–1970, *American Naive Painting of the 18th and 19th Centuries*, color pl. 11 // MMA and American Federation of Arts, traveling exhibition, 1975–1977, *The Heritage of American Art*, cat. by M. Davis, no. 7, ill. p. [35].

EX COLL.: the subject, Lancaster, Pa., d. 1823; her daughter, Mrs. David Watts; her son, Henry Miller Watts, Philadelphia, by 1873; his son, John Schonberger Watts, by 1887; Mrs. Henry D. Sedgwick, Stockbridge, Mass., 1960; Edgar William and Bernice Chrysler Garbisch, Cambridge, Md., 1960–1964.

Gift of Edgar William and Bernice Chrysler Garbisch, 1964.

64.309.2.

Hagar and Ishmael

The painting illustrates the miraculous rescue of the dying Ishmael after he and his mother had been turned out of Abraham's household:

And God heard the voice of the lad; and the angel of God called to Hagar out of heaven, and said unto her, What aileth thee, Hagar? fear not; for God hath heard the voice of the lad where he is. Arise, lift up the lad, and hold him in thine hand; for I will make him a great nation. And God opened her eyes, and she saw a well of water; and she went, and filled the bottle with water, and gave the lad drink (*Genesis* 21: 14-19).

Painted in 1776 and exhibited at the Royal Academy that year, the picture was immediately purchased by Lord Cremorne, apparently because the face of Ishmael resembled that of his son. The child died, however, and the painting was sold to another collector. Eventually it was acquired by West, who, after making substantial changes, resubmitted it to the Royal Academy in 1803. This action set off a storm of controversy, which can only be explained in the light of events that had taken place shortly before.

JOHN SINGLETON COPLEY, becoming more antagonistic toward West, had applied the same year to the governing council of the Royal Academy for an extension in presenting his group portrait of the Knatchbull family for exhibition. His request was granted, but West, absent from the deliberations because of illness, opposed it and shortly thereafter forced the matter to come before the academy's general assembly. This body then revoked the council's permission and instructed Copley to submit his picture on time. Copley complied, and matters seemed to have quieted down when *Hagar and Ishmael* arrived for the exhibition. Copley, who sat on the council, remembered that the painting had been exhibited at the academy before and noted that it was against the rules to show a work twice. The council then decided not to accept West's painting. Before notification reached him, the story was leaked to the press, so that West became aware of the council's action only by reading about it in the newspapers. Accused in print of attempting to circumvent the academy's regulations, West was outraged and immediately wrote the council that *Hagar and Ishmael* had been so altered as to become an entirely new picture: the angel had been eliminated and a new one substituted, the figures of both Hagar and Ishmael had been changed, new draperies had been introduced, and the background was completely different.

Shortly thereafter, the academy attempted to pacify West by passing a resolution absolving him of acting with malicious intent, but by that

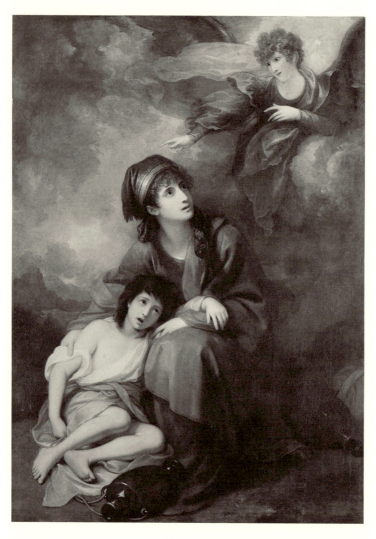

West, *Hagar and Ishmael.*

time the issue had become too controversial and the painting could not be exhibited. In 1804, however, with West once again firmly in control as president of the academy, it was shown there in its new state. At that time it was well received. Later, in 1806, when it appeared at the exhibition of the British Institution, one bedazzled writer was so impressed as to claim that it was not unworthy of Leonardo da Vinci.

A number of drawings by West dealing with the theme of Hagar and Ishmael are known. A highly finished preparatory drawing, signed and dated 1776, probably depicting the earlier state of the painting, is in the Victoria and Albert Museum. A small sketch in the Morgan Library may illustrate an early idea for the picture. Two other drawings, horizontal in format, in all likelihood represent later thoughts for another version of the same subject (one in the Addison Gallery of American Art, Andover, Mass., dated 1788, the other New York art market, 1968). A mezzotint showing the picture in its revised state was made by Valentine Green.

Radiographs have confirmed West's claims regarding the alterations. After being reworked, *Hagar and Ishmael* remained in the possession of the artist and his family. It was among the paintings once offered for sale to the United States government by the painter's sons as the nucleus for a national museum. Like two other West paintings in the Metropolitan's collection (*The Damsel and Orlando* and *Omnia Vincit Amor*) this

picture came into the possession of the Seguin family, English singers who immigrated to the United States in 1838. According to the executor of Mrs. Arthur E. S. Seguin's estate, she did not own the paintings but held them as collateral for a loan (O. B. Smith to L. Cesnola, March 12, 1881, MMA Archives). Title to the paintings was legally given in 1923 to Clara Seguin, the widow of Mrs. Arthur E. S. Seguin's grandson, after many years of attempts to find the original owners or their heirs in England.

Oil on canvas, 76 × 54½ in. (193 × 138.4 cm.).

Signed and dated at lower right: B. West 1776; at lower left: B. West 1803.

RELATED WORKS: *Hagar and Ishmael*, black and white chalk, with white, blue, and red body color, on gray paper, signed and dated B. West, 1776, 12⅛ × 8⅞ in. (30.8 × 22.5 cm.), Victoria and Albert Museum, London, ill. in R. S. Kraemer, *Drawings by Benjamin West and His Son Raphael Lamar West* (1975), p. 9, fig. 4, probably drawing for the picture as first painted // *Hagar and Ishmael*, black chalk, 5⅛ × 3¹¹⁄₁₆ in. (13 × 9.4 cm.), Pierpont Morgan Library, New York, ill. ibid., pl. 4, no. 9, a first sketch or idea for the painting // Valentine Green, mezzotint, 26⁵⁄₁₆ × 20⅞ in. (66.8 × 53 cm.), 1805.

REFERENCES: B. West, letter to the council of the Royal Academy, London, April 16, 1803, in extra-illustrated edition of J. Galt, *Life of . . . West*, 1, p. 76, Historical Society of Pennsylvania, Philadelphia // J. Farington, *The Farington Diary*, ed. J. Greig (1923), 2, pp. 92, 167, discusses the controversy in 1803; pp. 216, 226, discusses West's desire to exhibit the painting in 1804 // "A Correct Catalogue of the Works of Benjamin West, Esq.," *Port Folio* 6 (1811), p. 554, says this picture was painted for Lord Cremorne and was later in the possession of a nobleman in Ireland (this is a reprint from *La Belle Assemblée* 4 [London, 1808]) // "Letter from the Sons of Benjamin West . . . Offering to Sell to the Government of the United States Sundry Paintings of that Artist," Dec. 11, 1826, *House Documents*, 19th Cong., 2d sess., Doc. No. 8, p. 5, no. 21, lists it // George Robins, London, *A Catalogue Raisonné of . . . the Works of . . . Benjamin West*, sale cat. (May 22, 23, 25, 1829), no. 135 // W. Sandby, *The History of the Royal Academy of Arts* (1862), 1, pp. 264–265, discusses the controversy of 1803 // W. T. Whitley, *Art in England, 1800–1820* (1928), pp. 54–56 // H. W. Williams, Jr., "West's Hagar and Ishmael Rediscovered," 1942, MS in Dept. Archives, presents most of the data in this entry // G. Evans, *Benjamin West and the Taste of His Times* (1959), pp. 52–53, says the composition of the picture recalls the works of the Carracci and their Bolognese followers // J. D. Prown, *John Singleton Copley* (1966), 2, pp. 365–369, discusses the controversy of 1803 in the light of the rivalry between Copley and West // Gardner and Feld (1965), pp. 28–29 // A. T.

Gardner, *MMA Bull.* 24 (March 1966), pp. 234, 236 // W. D. Garrett, *MMA Journal* 3 (1970), p. 322 // J. Dillenberger, *Benjamin West* (1977), pp. 24–25; p. 187, no. 490, gives sources listing the work // R. C. Alberts, *Benjamin West* (1978), pp. 280–284, 302, gives a full account of the 1803 controversy // H. von Erffa and A. Staley, *The Paintings of Benjamin West* (1986), color ill. p. 137; pp. 288–289, no. 239, catalogues it; p. 342.

EXHIBITED: Royal Academy, London, 1776, no. 318; 1804, no. 211 // British Institution, London, 1806, no. 94 // PAFA, 1851, no. 16; 1852, no. 338; 1853, no. 378; 1854, no. 360; 1855, no. 425; 1856, no. 245; 1859, no. 297.

ON DEPOSIT: PAFA, 1851–1863; MMA, 1881–1923; Virginia Museum of Fine Arts, Richmond, 1954–1964.

EX COLL.: Lord Cremorne, 1776; unknown Irish owner, until about 1803; the artist, 1803–1820; his sons, Raphael and Benjamin West (sale, George Robins, London, May 25, 1829, no. 135, £52.10); Armstrong, 1829; held by Arthur E. S. Seguin, Philadelphia, by 1851–d. 1852; held by his wife, Ann Childe Seguin, New York, 1852–d. 1888; held by her daughter, Maria C. Seguin, New York, 1888–d. ?; her nephew's widow, Clara (Mrs. Edward S. R.) Seguin, New York, by 1923.

Maria DeWitt Jesup Fund, 1923.

95.22.8.

The Battle of La Hogue

The Battle of La Hogue, actually a number of separate encounters, took place off Cape La Hogue (or La Hougue), near Cherbourg, from May 19 to 24, 1692. It was the decisive naval battle of the War of the Grand Alliance, which broke out after the Glorious Revolution of 1688 forced the exile of the Catholic James II and brought William and Mary to the English throne.

A combined French and Irish army financed by Louis XIV for the purpose of invading England had been assembled at La Hogue under the command of the exiled King James and the maréchal de Bellefonds. They expected the crossing to England to meet with few difficulties because the officer in command of the British fleet, Admiral Edward Russell, was known to sympathize with James II and the English and Dutch admirals in charge of guarding the channel were thought to be severely at odds. It was accordingly decided by the invaders that Vice-Admiral Tourville's fleet of forty-four ships at Brest would suffice to cover the transportation and landing of the troops. They were surprised, indeed, when, on May 19, a combined English and Dutch fleet

with ninety-nine ships of the line appeared off Cape Barfleur. Misjudging the size of the Anglo-Dutch force because of weather conditions and, in any case, under orders to engage the enemy, Tourville attacked, fought with distinction, and inflicted some damage, though neither side suffered losses. Still heavily outnumbered, he attempted to withdraw but could not escape the pursuing Admiral Russell. After negotiating the treacherous Race of Alderney, about half of Tourville's fleet arrived safely at Saint-Malo. The other ships, however, were caught by the flood tide and swept back to the east, some to Cherbourg, others to La Hogue. The vessels at Cherbourg, including the damaged *Soleil Royal*, the pride of the French fleet, were attacked by an English force under Sir Ralph Delavall and burned on May 21. Those at La Hogue, although under the protection of the guns of Fort Lisset and Fort Saint-Vaast, fared no better. On the night of May 23, and again the following day, about two hundred small boats and frigates under the command of Vice-Admiral Sir George Rooke set fire to them, destroying all but nine. This victory secured the supremacy of Britain at sea and made an invasion impossible. It is still regarded as one of the greatest triumphs of the British fleet (on the battle and its significance see J. Ehrman, *The Navy in the War of William III, 1689–1697* [1953], pp. 395–399).

When West painted these events in 1778, political and military conditions in Great Britain had reached a point of crisis. In America, the year before, General Burgoyne had surrendered 5,700 men at Saratoga. Rumors that France was about to join the war on the side of the colonies materialized with a declaration of war in February 1778. Fears of a French invasion were widespread. Later that year, in June, British peace offers were rejected by Congress, Washington scored a victory at Monmouth, and, in July, the French fleet arrived off Delaware. For West, who was widely thought to be in sympathy with the American cause, the painting of the Battle of La Hogue must have been a political as well as an artistic statement. The picture was bound to be interpreted as an avowal of his loyalty and as a patriotic attempt to boost the morale of a rather despondent Britain. When finally exhibited at the Royal Academy in 1780 it brought forth nearly unanimous praise. The *Morning Chronicle and London Advertiser* (May 2, 1780) said that it exceeded "all that ever came from Mr.

West's pencil," while the *London Courant* (May 6, 1780) thought that it did "infinite honour to the artist." The *Morning Post* (May 4, 1780) was exceptional in objecting to "the disgraceful attitude of the French officer in the boat, and the sailor aiming a blow with his fists at a drowning man . . . as circumstances too ludicrous for the sublimity of such a composition."

It has often been thought that West was historically in error in representing the *Soleil Royal* in the background and Sir George Rooke prominently in the foreground next to the trumpeter (both imagined circumstances, as the *Soleil Royal* had already been burnt by the time of Rooke's attack and he did not personally take part in the combat); it is likely, however, that what West intended was a conflation of the separate important episodes of the battle as well as a heroization of Rooke. The combination of realism in the particulars, such as dress and likeness, with idealization in the composition of the events was characteristic of West's innovative approach to history painting, first formulated in *The Death of General Wolfe*, 1769 (National Gallery of Canada, Ottawa).

Two paintings by West of this subject are known. The first version, executed for Lord Grosvenor in 1778 and probably the picture shown at the Royal Academy in 1780, is now at the National Gallery of Art, Washington, D.C. The Metropolitan's version, slightly larger, was painted to hang in West's gallery as a companion to a copy of *The Death of General Wolfe* and is probably the work referred to several times in the writings of JOHN TRUMBULL. In an account of work done in London in 1784 Trumbull noted:

The Battle of LaHogue. Copied for Mr. West, from his original picture. — the Same size, but on a Cloth — 12 inches longer, & 6 inches higher: — this extra size is left equally on every side, with a view to enlarge the Composition for a Companion to the Copy of Wolfe. — This Copy was painted up entirely at once, and will only be retouched and harmonized by Mr. West; — the universal Shadow was blue black prepared by Jenkins, by means of which the union and Silvery tone were obtained — this picture was begun by Mr. Raphael LeMar West, who was soon fatigued and gave it up; — it was finished by me in less than Sixty days, and given to Mr. West.

In 1813 Trumbull added: "It now hangs in his [West's] painting Room, having been continued to the whole surface of the Cloth by him, and is valued at Guineas 600." Some years later, in his

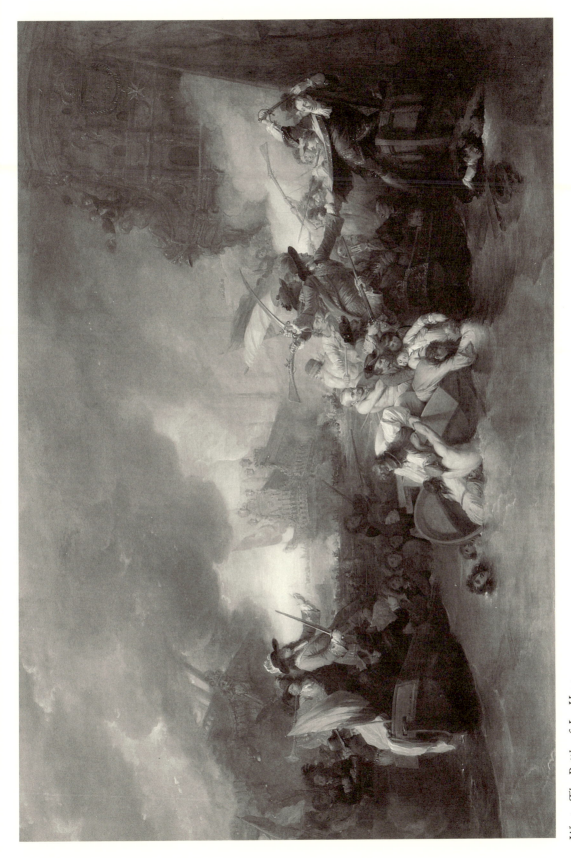

West, *The Battle of La Hogue.*

autobiography, Trumbull wrote that he had finished the picture in the summer of 1785 and admitted that this work had been of "inestimable importance" to him.

As might be expected of a studio copy, the picture is executed with considerably less vigor and spontaneity than the first version. The brilliant passages of drapery that characterize the Washington picture are absent here, as is its brighter and more contrasted palette, this perhaps due to the dulling effect of the blue-black shadow of which Trumbull speaks. Still, the painting cannot truly be said to be by Trumbull. Many of the figures were clearly retouched by West, as well as substantial parts of the sky and parts of the water. In these areas a greater freedom of execution is apparent, and strict adherence to the model of the original is abandoned. It must be assumed, therefore, that the picture satisfied West as a competent product of his workshop, so much so that he could exhibit it as his painting without compunction.

Although the picture is inscribed "B. West 1778, Retouched 1806," Trumbull's writings indicate that the work was largely done from about 1784 to 1785. West's inclusion of the year in which he completed the first version probably indicates that this copy was begun at that time, most likely by his son Raphael, as Trumbull stated. In 1806, when the entire inscription seems to have been added, West had borrowed the earlier version from Lord Grosvenor in order to exhibit it in his gallery together with the recently painted *Death of Lord Nelson* 1806 (Walker Art Gallery, Liverpool). The presence of the original must have decided him on making further alterations to the copy. It is interesting to note, however, that in doing so, he chose not to duplicate the original exactly, but rather to capture more of its spirit.

Oil on canvas, $64\frac{1}{2} \times 96$ in. (163.9 × 243.8 cm.). Signed, dated, and inscribed on transom of boat, at left center: B. West 1778, Retouched 1806.

RELATED WORKS: *The Battle of La Hogue*, oil on canvas, $60\frac{1}{8} \times 84\frac{3}{8}$ in. (152.7 × 214.3 cm.), 1778, National Gallery, Washington, D. C., the first version (for engravings of this version see H. von Erffa and A. Staley, *The Paintings of Benjamin West* [1986], p. 209) // *The Battle of La Hogue*, pen, brown ink, and gray wash on cream-colored paper, $6\frac{7}{16} \times 9\frac{13}{16}$ in. (16.4 × 24.9 cm.), 177[?], British Museum, London, a detailed compositional study // Naval Battle, black chalk on cream-colored paper, $15\frac{1}{2} \times 12\frac{5}{8}$ in. (39.4 × 32.1 cm.), British Museum, London, a detailed compositional

study // Naval battle, $3\frac{1}{16} \times 5\frac{13}{16}$ in. (7.8 × 14.8 cm.), preliminary studies, Pierpont Morgan Library, New York, ill. in R. Kraemer, *Drawings by Benjamin West and His Son Raphael Lamar West* (1977), nos. 17, 18 // George Chambers, *The Battle of La Hogue*, oil on canvas, 60 × 85 in. (152.4 × 215.9 cm.), National Maritime Museum, Greenwich, England, a copy // Several other copies by unidentified artists are known, one at Swarthmore College and others in private collections.

REFERENCES: J. Trumbull, account book, in entries for 1784 and 1813, details his work on the painting, printed in T. Sizer, *Yale University Library Gazette* 22 (1948), pp. 121–122 (quoted above) // J. Farington, diary entries for May 11, and July 8, 1806, in *The Farington Diary*, ed. by J. Greig (1924) 3, pp. 227, 272 // "A Correct Catalogue of the Works of Benjamin West, Esq.," *Port Folio* 6 (1811), p. 548, lists "the second picture of the Battle of La Hogue, with alterations" among the "pictures painted by Mr. West for his own Collection" // J. Galt, *The Life, Studies and Works of Benjamin West* (1816-1820), 2, p. 220, lists a painting of this subject; p. 225, lists the "first and second pictures of the Battle of La Hogue" // C. Smart, *West's Gallery* (1823), p. 17, no. 69, lists a painting of this subject, probably this picture, hanging in the Great Room // "Letter from the Sons of Benjamin West . . . Offering to Sell to the Government of the United States Sundry Paintings of that Artist," Dec. 11, 1826, *House Documents*, 19th Cong., 2d Sess., Doc. No. 8, p. 5, no. 8, lists it // George Robins, London, *A Catalogue Raisonné of . . . the Works of . . . Benjamin West*, sale cat. (May 22, 23, 25, 1829), p. 32, no. 101, describes this picture // W. Dunlap, *History of the Rise and Progress of the Arts of Design in the United States* (1834), 1, p. 65, says that when West was painting the picture "an admiral took him to Spithead, and to give him a lesson on the effect of smoke in a naval engagement, ordered several ships of the fleet to manoeuvre as in action, and fire broadsides, while the painter made notes;" pp. 88-90, says he has "heard [it] praised as *the best* historic picture of the British school" and notes that a print after Langendyk probably follows West's composition and not vice versa; p. 103, notes that the picture sold in 1829 must have been a copy // J. Trumbull, *Autobiography* (1841), p. 92 // L. Fagan, *A Catalogue Raisonné of the Engraved Works of William Woollett* (1885), pp. 52–53, lists eight states of Woollett's engraving after the original as well as copies by Klauber and Voysard // M. S. Robinson, National Maritime Museum, to W. P. Campbell, National Gallery, Washington, D. C., Jan. 11, 1960, copy in Dept. Archives // W. P. Campbell, letter in Dept. Archives, 1964 // Gardner and Feld (1965), pp. 29–32 // A. T. Gardner, *MMA Bull.* 24 (March 1966), pp. 229, 236 // H. von Erffa, *American Art Journal* 1 (Spring 1969), p. 28, says the composition is "based on a painting by Langendyk" // A. Lehman, "Benjamin West's Battle of La Hogue," 1971, unpublished MS in Dept. Archives, emphasizes the political context of the painting and

says that West's representation of the events of different days in one canvas is in accord with academic tenets of history painting; notes that a print by Dirk Langendyk postdates West's picture and appears to rely on an engraving of it // I. Jaffe, *John Trumbull* (1975), pp. 69–70, 316, considers it a copy by Trumbull // R. C. Alberts, *Benjamin West* (1978), p. 326, gives details concerning West's borrowing of the first version in 1806 // H. von Erffa and A. Staley, *The Paintings of Benjamin West* (1986), p. 102; ill. p. 210, no. 91, catalogues it and discusses date.

EXHIBITED: West's Gallery, London, 1785–1829, Great Room, no. 69 // Royal Academy, London, 1888, no. 154, lent by Edward P. Monckton // James Graham and Sons, New York, 1962, *Benjamin West*, no. 5 // MMA, 1965, *Three Centuries of American Painting* (checklist arranged alphabetically) // Bronx Council on the Arts, New York 1971, *Paintings from the Metropolitan*, no. 1.

Ex COLL.: the artist, until 1820; his sons, Raphael and Benjamin West (sale, George Robins, London, May 23, 1829, no. 101, 370 gns.); Hon. John Monckton, London, and Fineshade Abbey, Stamford, from 1829; Edward Philip Monckton, Fineshade Abbey, d. 1916; his son, George Edward Monckton, Fineshade Abbey (sale Sotheby's, London, Feb. 10, 1921); with Sutton; with Sigmund Samuel, Toronto, by 1952; Mr. and Mrs. William B. Chapoton, Leamington, Ontario, 1952–1958; with Bernard Feldman, Philadelphia; with James Graham and Sons, New York, 1958–1964.

Harris Brisbane Dick Fund, 1964.

64.57.

The Damsel and Orlando

The painting depicts an episode from Ludovico Ariosto's famous epic poem *Orlando Furioso*, first published in 1532. Count Orlando, having arrived at a herdsman's cottage in search of lodging, is told the story of a maid who had once brought her wounded lover there, nursed him tenderly, and subsequently married him. As proof of the veracity of the tale, a bracelet given to the herdsman by the maid as an expression of gratitude is produced. Orlando immediately recognizes it as the same one he had once given his beloved Angelica. He can no longer doubt the meaning of the many carvings on trees he has just seen, proclaiming the love of Angelica and Medoro.

This revelation

proved to be the axe which took his head off his shoulders at one stroke, now that Love, that tormentor, was tired of raining blows upon him. Orlando tried

to conceal his grief, but it so pressed him, he could not succeed: willy nilly the sighs and tears had to find a vent through his eyes and lips (L. Ariosto, *Orlando Furioso* [1532]; trans. G. Waldman [1974], canto 23, par. 121).

Orlando goes mad, and his grief drives him to superhuman violence: he uproots trees at one jerk, decapitates men as if he were plucking flowers, and kills cattle and horses with his bare hands. His subsequent exploits form the core of Ariosto's poem.

Never out of fashion despite Cervantes's scathing satire in *Don Quixote*, Ariosto's epic enjoyed a revival toward the end of the eighteenth century, no doubt because its tales of chivalry, love, and war held great appeal for proto-romantic sensibilities. In London, an edition published by the printer John Baskerville appeared in 1773, and another, by John Hoole, was published in 1783 with engraved plates after Angelica Kauffmann and other contemporary artists.

In West's painting, it is the melodrama of Orlando's undeceiving that is emphasized, even though the pose of the herdsman and the architectural setting are more evocative of a subject like the Nativity or the Adoration of the Shepherds. Orlando's expression reveals the intensity of his grief, as does his recoiling pose, later employed by West in *Thetis Bringing the Armor to Achilles*, 1806 (New Britain Museum of American Art, Conn.). Even his horse's eyes and mouth reflect the mood of horror.

Although the picture is neither signed nor dated, a very similar version of equal size, now at the Toledo Museum of Art, is signed and dated 1793. Because that work is a finished painting, in contrast to this one which is sketchily executed in a number of areas, it is likely to be the work listed as *The Damsel and Orlando* in the list of West's paintings published in *Public Characters of 1805*. The Metropolitan's version must then be the one cited in the same source as the "second picture of a Damsel and Orlando," then in West's painting room.

How West arrived at the iconography of these pictures is a bit of a mystery; for Ariosto's poem does not actually say that it is a woman who brings the bracelet to Orlando. The possibility that the subject depicted refers to another source besides Ariosto or that the Toledo and Metropolitan pictures might be associated with others listed in the early compilations of West's works, however, is very slim.

Like *Hagar and Ishmael* (q.v.) the painting was in the possession of, but not owned by, the Seguin family until 1923.

Oil on canvas, 36 × 28 in. (91.4 × 71.1 cm.).

RELATED WORK: *Scene from Orlando Furioso* (formerly *The Hero Returned*), oil on canvas, 36 × 28 in. (91.4 × 71.1 cm.), 1793, Toledo Museum of Art, Ohio, ill. in *Toledo Museum of Art News*, no. 36 (May 1920), unpaged.

REFERENCES: "A Correct Catalogue of the Works of Mr West," *Public Characters of 1805* (London, 1804), p. 566, listed as the "second picture of a Damsel and Orlando" in West's painting-room // Joel Barlow, *The Columbiad. A Poem* (Philadelphia, 1807), p. 434, lists it as The Damsel and Orlando // "A Correct Catalogue of the Works of Benjamin West, Esq.," *La Belle Assemblée or Bell's Court and Fashionable Magazine* 4 (1808), suppl., p. 17, as the "second picture of the Damsel and Orlando" // John Galt, *The Life, Studies, and Works of Benjamin West, Esq. . . .* (London, 1820), p. 228, lists the "second picture of Angelica and Madora / Do. of a Damsel and Orlando" // A. T. Gardner, *MMA Bull*, 24 (March 1966), ill. p. 233 // Gardner and Feld (1965), pp. 32–33 identify the iconographical source as Ariosto's poem but mistakenly associate the picture with the Angelica and Medora

listed as no. 44 in the "Letter from the Sons of Benjamin West" offering to sell West's paintings to the U. S. government // John Dillenberger, *Benjamin West* (San Antonio, 1977), p. 172 // H. von Erffa and A. Staley, The *Paintings of Benjamin West* (1986), pp. 263–264, no. 194.

EXHIBITED: PAFA, 1851, no. 249; 1852, no. 247; 1854, no. 202; 1855, no. 212; 1856, no. 218, as Scene from Shakespeare's The Tempest, in all these // MMA, 1965, *Three Centuries of American Painting* (checklist arranged alphabetically) // Montreal Museum of Fine Arts, 1967, *The Painter and the New World*, no. 209.

ON DEPOSIT: PAFA, 1851–1863 // MMA, 1881–1923 // Allentown Art Museum, Pa., 1975–1976.

EX COLL.: the artist, until 1820; his sons Raphael and Benjamin West (sale, George Robins, London, June 20-22, 1829, 64, as Composition from Ariosto); Henry P. Bone (sale, Christie's, London, March 12, 1847, no. 126, as A Scene from the Tempest—a sketch); with W. [I.?] Smith, London, 1847; held by Arthur E. S. Seguin, Philadelphia, by 1851–d. 1852; held by his wife Ann Childe Seguin, New York, 1852–d. 1888; held by her daughter, Marie C. Seguin, New York, 1888–d. ?; her nephew's widow, Clara (Mrs. Edward S. R.) Seguin, New York, by 1923.

Maria DeWitt Jesup Fund, 1923.
95.22.5.

West, *The Damsel and Orlando.*

West, *Scene from Orlando Furioso.*
Toledo Museum of Art.

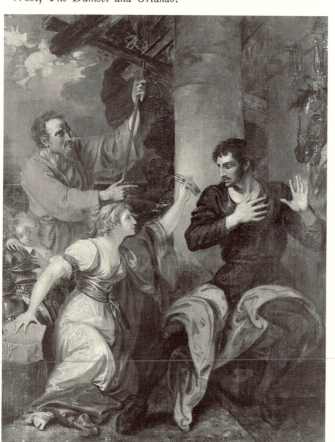

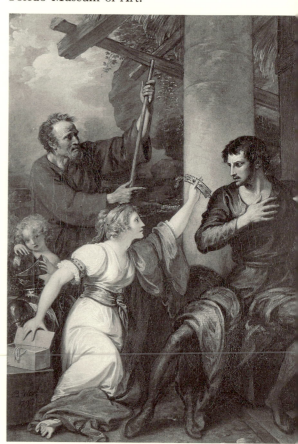

Peter Beckford

Peter Beckford (died 1735) was born in Jamaica and lived there all his life. His father, Peter Beckford, held public office for a few months in 1702 as lieutenant-governor of the island but seems to have amassed his wealth through piracy and other dubious means at a time when Jamaica served as a haven for buccaneers preying on Spanish commerce. His estate, consisting of rich sugar plantations, slaves, silver plate, cash, and other property, totaled about £800,000 at the time of his death and was left entirely to his son. Young Peter Beckford married the heiress Bathshua Herring and further increased his fortune. Their son, William, was sent to England for his education and eventually served as an alderman and then twice lord mayor of London. Their grandson, also named William, was reputedly the richest man of his time in Britain. A well-known eccentric and the author of the Arabian tale *Vathek*, he used the family fortune to acquire a large collection of art and construct one of the greatest of all architectural fantasies, Fonthill Abbey.

It was in one of the vast halls of neo-Gothic Fonthill that the portraits of Peter Beckford and his wife (see below) were intended to hang. Each one was placed over a doorway, and with two other portraits by West of William Beckford's mother and aunt (National Gallery of Art, Washington, D. C.), they formed part of a decorative ensemble designed to memorialize, as well as to aggrandize, Beckford's ancestry.

Painted in 1797, long after their deaths, West's portraits of Mr. and Mrs. Beckford were once reported to be copies of originals owned by their grandson. While this is probably true in part, the existence of compositional drawings and detailed studies for these works by West establishes that they are largely the result of his imagination. He was doubtless intrigued by the opportunity to paint portraits in the baroque style, something he had already attempted in a less ambitious way in his portrait of *John Sawrey Morritt*, 1765 (private coll., ill. in von Erffa and Staley, 1986, p. 26), exhibited at the Society of Artists in 1765). He undertook his task seriously. In this respect, it should be remembered that the fashion for portraits showing subjects dressed in the style of the mid-seventeenth century was in vogue in England at this time. One of the most famous English paintings, Thomas Gainsborough's *Blue Boy* (Huntington Library, San Marino, Calif.), was part of this current. This enthusiasm for baroque portraiture may account in part for the looseness and freedom with which West executed the Beckford portraits. In general, however, the sketchiness of these works is probably the reflection of the patron's taste; for Beckford is known to have preferred West's oil sketches to his finished paintings.

The relative predominance of red in this portrait may well indicate a desire to experiment with color, recalling Gainsborough's similar interests. In his right hand Peter Beckford holds a French map of Jamaica, an appropriate acknowledgment of his birthplace and the source of his enormous wealth.

Oil on canvas, 57 × 45½ in. (144.8 × 115.6 cm.). Signed and dated at lower right: B. West / 1797.

RELATED WORK: *Study for Peter Beckford*, black chalk with white highlights on blue paper, 11⅛ × 9¼ in. (28.3 × 23.5 cm.), Friends Historical Library, Swarthmore College, Pa., ill. in M. Hamilton-Phillips, *MMA Jour.* 15 (1980), fig. 6.

REFERENCES: J. Britton, *Beauties of Wiltshire* (1801), I, p. 230, reports that the portraits then hanging at Fonthill were copies of earlier ones // "A Correct Catalogue of the Works of Benjamin West, Esq.," *Port Folio* 6 (1811), p. 545, lists "four half lengths" painted for William Beckford (this list is a reprint of the one in *La Belle Assemblée* 4 (London, 1808) // John Galt, *The Life, Studies, and Works of Benjamin West, Esq. . . .* (London, 1820), p. 220 // A. T. Gardner, *MMA Bull.* 13 (Oct. 1954), pp. 41–49, discusses these portraits at Fonthill Abbey // Gardner and Feld (1965), pp. 34–35 // M. Hamilton-Phillips, "Drawings for Projects by Benjamin West for William Beckford of Fonthill," unpublished article, 1979, copy in Dept. Archives, gives thorough account of the intent of Beckford's project, notes that he preferred West's oil sketches, and discusses these portraits in detail; *MMA Jour.* 15 (1980), pp. 158–60, fig. 2; pp. 161–164, discusses and illustrates drawings for portraits // H. von Erffa and A. Staley, *The Paintings of Benjamin West* (1986), ill. p. 491; pp. 490, 492, no. 592, catalogues it and pp. 492–493, no. 593, catalogues the portrait of Mrs. Beckford.

ON DEPOSIT: Bartow-Pell Mansion, Bronx, N.Y., 1964–1974.

EX COLL.: William Beckford, Fonthill Abbey, Wiltshire, and Bath, d. 1844; his daughter, Susan Euphemia, tenth duchess of Hamilton, Hamilton Palace, Lanarkshire, Scotland, d. 1859; her son, William Alexander Archibald, eleventh duke of Hamilton, Hamilton Palace, d. 1863; his son, William Alexander Louis Stephen, twelfth duke of Hamilton, Hamilton Palace, d. 1895; estate of the twelfth duke of Hamilton

(sale, Christie's, London, Nov. 5, 1919, no. 75; portrait of Mrs. Beckford, no. 76); with Tooth Brothers, London, 1919; John R. Morron, New York, d. 1950.

Bequest of John R. Morron, 1950.

50.232.1.

Mrs. Peter Beckford

Bathshua Herring Beckford was the daughter and heir of Colonel Julines Herring. She was born in Jamaica and died there about 1750.

This portrait, painted in the same broad manner as its companion (see above), is not so uniformly red. The sitter's blue dress and white head dress vary the color scheme somewhat, although the background drapery and overall tonality remain reddish. It is interesting to note that Mrs. Beckford's pose and expression do not complement those in the portrait of her husband and she appears to be much older than he. There is the possibility that, as one chronicler of the treasures of Fonthill noted, the portraits were copied from earlier ones. They could have been painted at different times in the sitters'

lives, thus accounting for the disparity between the portraits by West. In all likelihood, he made relatively free use of his sources and, for reasons unknown to us, chose not to paint the portraits as companion pieces.

Oil on canvas, 57 × 45½ in. (144.7 × 115.6 cm.).

Signed and dated at lower right: B. West / 1797.

Inscribed on lining canvas: Busbua [*sic*] Beckford / wife of Peter Beckford Esq.ʳ and / Daughter & Heir of Colonel Jutives [*sic*] Hering.

RELATED WORKS: Hand in sleeve holding an open book, black chalk study heightened with white on blue-gray paper, $5\frac{15}{16} \times 8\frac{9}{16}$ in. (15.1 × 21.7 cm.), Pierpont Morgan Library, New York, ill. in M. Hamilton-Phillips, *MMA Jour.* 15 (1980), fig. 8 // Drapery study, black chalk heightened with white on blue-gray paper, $15\frac{1}{16} \times 9\frac{3}{4}$ in. (38.2 × 24.9 cm.), Pierpont Morgan Library, New York, ill. ibid., fig. 9 // Study for Mrs. Peter Beckford, black chalk heightened with white on blue paper, 11 × 9 in. (27.9 × 22.8 cm.), Friends Historical Library, Swarthmore College, Pa., ill. ibid., fig. 7.

REFERENCES: same as preceding entry.

EX COLL.: same as preceding entry.

Bequest of John R. Morron, 1950.

50.232.2.

West, *Peter Beckford.*

West, *Mrs. Peter Beckford.*

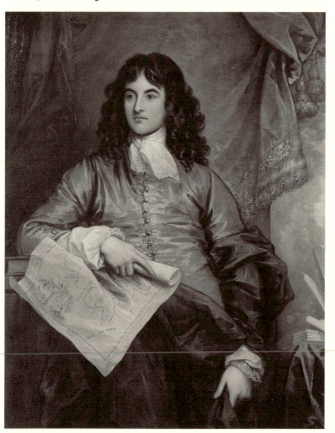

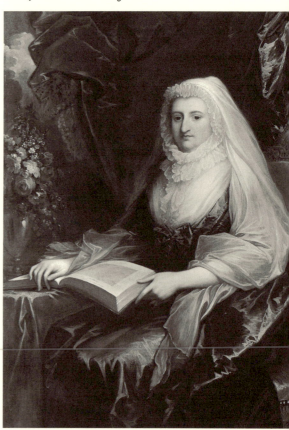

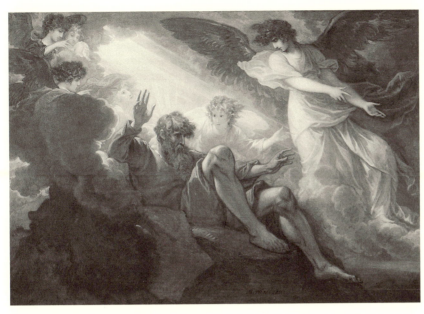

West, *Moses Shown the Promised Land*.

Moses Shown the Promised Land

And Moses went up from the plains of Moab unto the mountain of Nebo, to the top of Pisgah, that *is* over against Jericho. And the Lord shewed him all the land of Gilead, unto Dan, and all Naphtali, and the land of Ephraim, and Manasseh, and all the land of Judah, unto the utmost sea, and the south, and the plain of the valley of Jericho, the city of palm trees, unto Zoar. And the Lord said unto him, This *is* the land which I sware unto Abraham, unto Isaac, and unto Jacob, saying, I will give it unto thy seed: I have caused thee to see *it* with thine eyes, but thou shalt not go over thither (Deut. 34:1–4).

Signed and dated 1801, this small panel was in all probability intended as a study for a much larger picture to be installed in the Chapel of Revealed Religion at Windsor Castle. That project, designed to illustrate the history of the Christian faith from the Creation to the end of the world (as prophesied in the book of Revelation), had occupied West off and on since 1780. He meant it to stand as a monument to the tenets of Christianity accepted by all denominations and as a grand statement of his art at the service of morality. The project, however, was halted in 1810, after a period of vacillation on the part of the crown, and the completed pictures were kept by West, who put them on view at his Newman Street gallery.

In all the paintings dealing with Moses and the Mosaic law intended for the chapel, West gave free rein to his baroque tendencies, employing strong diagonal movement, painterly execution, and sharp contrasts of light and shadow. His desire to evoke the spirit of baroque painting is particularly demonstrated in the present picture by the Michelangelo-like representation of Moses, as well as by the Rubenesque use of oil on wood in the preparation of a study. West's concern with light as a symbol for God and as the driving emotional element led him to locate its source behind the figures, thus anticipating, as he often did, a characteristic device of later Romantic art.

Oil on wood, 19¾ × 28¾ in. (50.2 × 73 cm.).

Signed and dated on the rock at lower center: B. West 1801.

RELATED WORKS: *Moses Shown the Promised Land from the Top of Mount Pisgah*, oil on canvas, dimensions variously listed as 9 × 6 ft. and 6 × 10 ft., unlocated, perhaps never completed // Henry Moses, *Moses Viewing the Promised Land*, line engraving after the present picture, 6⅞ × 9¾ in. (17.5 × 24.7 cm.), ill. in H. Moses, *The Gallery of Pictures Painted by Benjamin West Esqr.* (1817).

REFERENCES: J. Galt, *The Life, Studies and Works of Benjamin West* (1820), pt. 2, p. 211, no. 16, lists "Moses sees the Promised Land from the top of Mount Abarim, and Death, a sketch in oil colours," probably

this picture // C. Smart, *West's Gallery* (1823), Entrance Gallery, p. [2], no. 4, lists "Moses Viewing the Promised Land," possibly this picture but could also be the large version // "Letter from the Sons of Benjamin West . . . Offering to Sell to the Government of the United States Sundry Paintings of that Artist," Dec. 11, 1826, *House Documents*, 19th Cong., 2d sess., Doc. No. 8, p. 6, no. 56, lists this painting // George Robins, London, *A Catalogue Raisonné of . . . the Works of . . . Benjamin West*, sale cat. (May 22, 23, 25, 1829), p. 11, no. 29. describes this picture as "wrought in the noble gusto of the great Italian school" // K. Ahrens, *Antiques* 103 (April 1973), p. 746 // J. D. Meyer, *Art Bulletin* 57 (June 1975), p. 261, discusses this picture and notes the emotionally charged character and diagonal movement of West's paintings illustrating the Mosaic Dispensation for the Windsor chapel; ill. p. 262 // J. Dillenberger, *Benjamin West* (1977), ill. p. 69, states that it is a small oil study for the large painting, now lost; p. 145, no. 82, lists sources documenting existence of large painting // H. von Erffa and A. Staley, *The Paintings of Benjamin West* (1986), color ill. p. 104; pp. 308–309, no. 269, catalogues it as Moses Shown the Promised Land, noting that no larger version was probably ever painted.

EXHIBITED: Royal Academy, London, 1801, no. 243, as Moses, from the Top of Mount Pisgah, is Shown the Promised Land . . . (either this work or the large version) // West's Gallery, London, until 1829, Entrance Gallery, no. 4 (either this work or the large version) // M. Knoedler and Co., New York, 1969, *American Paintings, 1750–1950*, checklist no. 6 // National Gallery, Washington, D. C.; City Art Museum of St. Louis; and Seattle Art Museum, 1970–1971, *Great American Paintings from the Boston and Metropolitan Museums*, no. 17 // MMA, 1975, *Notable Acquisitions, 1965–1975*, p. 13.

EX COLL.: the artist, until 1820; his sons, Raphael and Benjamin West, until 1829 (sale, George Robins, London, May 22, 1829, no. 29, £25.4); with Albert, 1829; (sale, Sotheby and Co., London, July 7, 1965, no. 132, as "Let There Be Light," £750); with Julius Weitzner, New York; with M. Knoedler and Co., New York, by 1969.

Gift of Mr. and Mrs. James W. Fosburgh, by exchange, 1969.

69.73.

Omnia Vincit Amor, or The Power of Love in the Three Elements

A recent cleaning of this work has uncovered the inscription "B. West — 1809 —" at the lower righthand corner of the canvas, making it virtually certain that this was the painting exhibited at the Royal Academy in 1811 with the above title. Either West was extremely fond of this work and did not wish to sell it, or, more likely, it was not readily marketable. In 1823 it was listed as hanging in West's Gallery under the name *Omnia Vincit Amor*, without the secondary title. In 1826, however, it was called *The Triumph of Love over Animated Nature* in the letter from the sons of Benjamin West in which they offered to sell a large number of his works to the United States government. Later, in 1829, it was among the works by West auctioned by George Robins in London, this time with the title *Omnia Vincit Amor*. Then, from the time it was first exhibited at the Pennsylvania Academy of the Fine Arts in 1851 until 1895, it was again called *The Triumph of Love*. The reasons for these various changes in title are not known, but it seems probable that a discrepancy between the title *Omnia Vincit Amor* and the actual iconography of the painting is responsible for the confusion. Probably that was why West gave it a more relevant secondary title.

Virgil's phrase in *Eclogue* 10:69, "omnia vincit amor" (love conquers all), possesses a fairly specific iconography. In the history of art, works known by this title usually depict the god Cupid (Amor in Latin) subduing the god Pan, whose name in Greek means *all*. (For listings of numerous examples of the theme by many different artists see A. Pigler, *Barockthemen* [1974], 2, p. 19, and A. T. Lurie, *Bulletin of the Cleveland Museum of Art* 62 [Dec. 1975], p. 284.) For this reason, it is certain that West's painting, with the prominent figures of Venus and the animals, is derived from different precedents, ones far more detailed in representing the triumph of love over all beings and things. An early example is Otho van Veen's frontispiece to his *Amorum Emblemata* (Antwerp, 1608), a book later translated into many languages and its plates frequently pirated. In van Veen's frontispiece, Venus descends from the clouds in a chariot pulled by two doves. She is accompanied by Cupid, who holds a flaming torch and whose arrows have pierced a representative assortment of creatures of land, sea, and air, humans included. The element fire is also present, as are the sun and the moon. Jan Goeree's *Venus Genetrix*, engraved in London in 1712 as a frontispiece to Lucretius's *De Rerum Natura*, is a later stage in this tradition. There Venus is accompanied not only by Cupid but also by the Three Graces. Instead of attempting

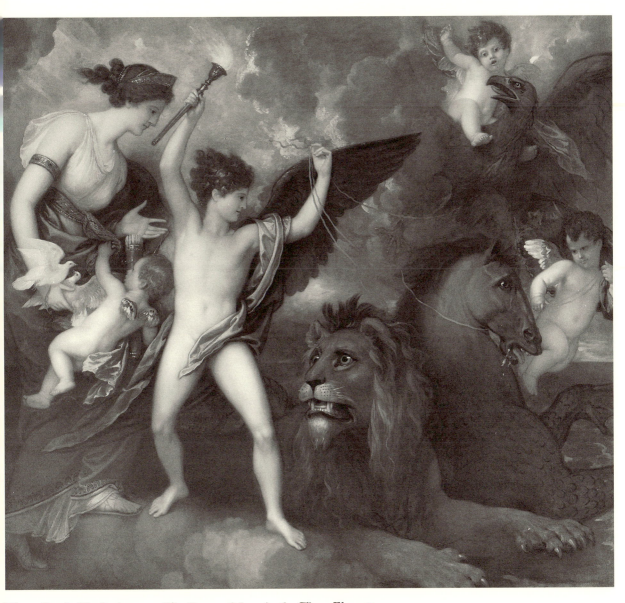

West, *Omnia Vincit Amor, or The Power of Love in the Three Elements.*

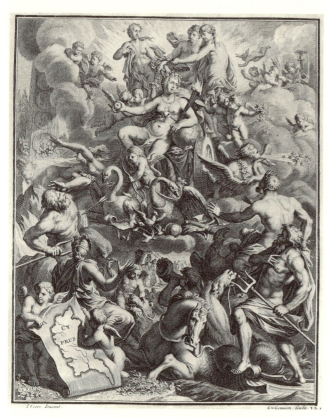

Jan Goeree, *Venus Genetrix*, 1712, frontispiece to
Lucretius, *De Rerum Natura*.

to depict as many living creatures as possible,
like van Veen, Goeree opted for a more symbolic
approach. Here love is seen triumphing over
Jupiter (air) accompanied by the eagle, Neptune
(water) accompanied by a hippocampus, Cybele
(earth) with a lion, and Pluto (fire) surrounded
by flames. These clearly stand for the universe
in all its aspects: the four elements that make up
all matter, the living creatures that inhabit them,
and the divine entities that preside over them.

Whether West was aware of these specific
sources is impossible to say, but the similarity in
iconography permits us to conclude that he was
at least familiar with the pictorial tradition. Ac-
cordingly, his painting may be given a broader
reading. The lion, hippocampus, and eagle stand
for all the creatures of land, sea, and air, re-
spectively. By virtue of their association with the
classical gods, the animals also allude to the div-
ine aspect of creation. Love, on the other hand,
is represented by a group of figures consisting of
Venus with doves, Cupid, clinging to Venus's
skirt and carrying a bow and arrows, and
Hymen, the god of marriage, with a torch. The
element fire is not represented by an animal,

for no creature can live in it, but its presence in
Hymen's torch indicates that it, too, is controlled
by the forces of love. As is made clear by the
ribbons restraining the three animals, which are
held together in Hymen's left hand, love in all
its aspects, divine and earthly, lustful and con-
jugal, ties together all of creation. This was a
philosophical concept with venerable anteced-
ents in the Neoplatonic thought of the Renais-
sance and was admirably expressed by Marsilio
Ficino: "Love is the perpetual knot and link of
the universe" (*De Amore* [written in 1457; pub-
lished in 1561], III, iii). While it is not known
whether West knew Ficino's text, the similarity
of concept suggests that the painting may be
based on an as yet unidentified literary work in
the same tradition.

Painted in the Venetian manner in colors
reminiscent of Titian's later pictures, *Omnia Vin-
cit Amor* displays West's facility in applying im-
pastos with broad brushstrokes. Grose Evans
proposed, in 1959, that the figures were darken-
ed on purpose in accordance with Edmund
Burke's tenets of the sublime, but recent cleaning
and restoration, including removal of a great
deal of later overpainting, especially in the area
of the eagle's wings, have revealed a vibrantly
colored work. Similarly, the idea that West de-
rived Hymen's pose from the Laocoön group is
also unconvincing. At this point in his career he
was borrowing mostly from his own work. The
pose of Hymen is a reversal of that of the angel in
his *Archangel Gabriel*, 1798 (unlocated, ill. in von
Erffa and Staley, 1986, p. 392), while the pose
of Venus is a reprise of the figure of Thetis in his
Thetis Bringing the Armor to Achilles, 1806 (New
Britain Museum of American Art, Conn.).

Like *Hagar and Ishmael* (q.v.) the painting
was in the possession of, but not owned by, the
Seguin family until 1923.

Oil on canvas, 70⅜ × 80½ in. (178.8 × 204.5 cm.).
Signed and dated at lower right: B. West — 1809 —.
RELATED WORKS: Study for Venus's doves, black
chalk on blue paper, 12¼ × 5 ¹³⁄₁₆ in. (30.8 × 14.8 cm.),
Pierpont Morgan Library, New York, ill. in R. S.
Kraemer, *Drawings by Benjamin West and His Son
Raphael Lamar West* (1977), no. 148v. // Study for Cu-
pid's arm, pencil on paper, ca. 6 × 5 in. (ca. 15.2 ×
12.7 cm.), London art market, 1978 // Charles R.
Leslie, *Omnia Vincit Amor*, copy, unlocated, exhibited
at American Academy of Fine Arts, New York, 1816,
no. 52, lent by Major General [Winfield] Scott.
REFERENCES: C. Smart, *West's Gallery* (1823), p.
27, no. 86, lists it as hanging "over the arch" in the

Inner Room // "Letter from the Sons of Benjamin West . . . Offering to Sell to the Government of the United States Sundry Paintings of that Artist," Dec. 11, 1826, *House Documents*, 19th Cong., 2d sess., Doc. No. 8, p. 5, no. 9, as The Triumph of Love over Animated Nature // W. Dunlap, *Diary of William Dunlap* (1931), 3, entry for June 23, 1833, p. 70, notes that Sully told him that West painted the picture in 1809 // W. Dunlap, *History of the Rise and Progress of the Arts of Design in the United States* (1834), 2, p. 124, says that Thomas Sully saw it in West's studio in England in 1809 and that C. R. Leslie made a copy of it that was later brought to America // G. Evans, *Benjamin West and the Taste of His Times* (1959), p. 77, says the pose of Hymen is derived from the Laocoön group; pp. 79–80, discusses the darkness of the painting as in keeping with Burke's concept of the sublime // Gardner and Feld (1965), pp. 35–36 // A. T. Gardner, *MMA Bull.* 24 (March 1966), p. 236 // B. Coffey, letter in Dept. Archives, May 16, 1978, gives information on provenance and says that this is the 1811 Royal Academy painting // H. von Erffa and A. Staley, *The Paintings of Benjamin West* (1986), color ill. p. 138; color ill. detail p. 139; pp. 403–404, no. 422, catalogue it.

EXHIBITED: Royal Academy, London, 1811, no. 63, as Omnia Vincit Amor, or The Power of Love in the Three Elements // West's Gallery, London, until 1829, Inner Room, no. 86 // PAFA, 1851, no. 241; 1852, no. 243; 1853, no. 241; 1854, no. 206; 1855, no. 230; 1856, no. 235; 1856 (fall), no. 147; 1857, no. 207; 1859, no. 262; 1860, no. 184; 1863, no. 284, in all these as The Triumph of Love, property of S. Seguin // MMA, 1896, *Retrospective Exhibition of American Paintings*, no. 208, as The Triumph of Love // Los Angeles County Museum of Art and M. H. de Young Memorial Museum, San Francisco, 1966, *American Paintings from the Metropolitan Museum of Art*, no. 7, ill. p. 20.

ON DEPOSIT: PAFA, 1851–1863, and MMA, 1881–1923.

EX COLL.: the artist, until 1820; his sons, Raphael and Benjamin West, 1820–1829 (sale, George Robins, London, May 25, 1829, no. 143, £63); Henry Bone, 1829–1834; his son, Henry P. Bone (sale, Christie's London, March 12, 1847, no. 124); with W. [I.?] Smith, London, 1847; held by Arthur E. S. Seguin, Philadelphia, by 1851–d. 1852; held by his wife, Ann Childe Seguin, New York, 1852–d. 1888; held by her daughter, Maria C. Seguin, New York, 1888–d. ?; her nephew's widow, Clara (Mrs. Edward S. R.) Seguin, New York, by 1923.

Maria DeWitt Jesup Fund, 1923.
95.22.1.

JOHN SINGLETON COPLEY

1738–1815

The greatest artist in America in the eighteenth century, John Singleton Copley was born July 3, 1738, probably in Boston, where his family had recently emigrated from Ireland. His father, a tobacconist, died while Copley was still a child, and in 1748 his mother was married to Peter Pelham (1697–1751), a mezzotint engraver and sometime painter and schoolmaster who had left London for Boston in 1727. Three years after this marriage, Pelham died, and at the age of thirteen Copley took up his trade of engraving. His first extant work is a print. Young Copley was, however, extremely ambitious, and at sixteen he began to imitate the works of the most important artists which were readily at hand. In Boston in the 1750s, these were prints by European artists, the copies of European paintings JOHN SMIBERT had brought there in 1729, and Smibert's own work as well. Even though Smibert's style deteriorated in the course of his long and important career, it still remained unsurpassed except by ROBERT FEKE's paintings done in Boston in 1748. Recognizing the old-fashioned nature of Smibert's late style, Copley turned to Feke, who had developed the first identifiably American style, and to John Greenwood (1727–1792), who was active in

Boston until 1752. Only Copley's earliest work, however, suffers from comparison with theirs, and by 1755, when JOSEPH BLACKBURN arrived in Boston, Copley was prepared to encounter a fully trained practitioner of the English rococo style. Again he surpassed his model and, within three years, had assimilated all he could learn from Blackburn. His portrait of Epes Sargent, about 1760 (National Gallery, Washington, D.C.), is the first of his works that can be called a masterpiece. That it was the first painting produced in the colonies unequivocally deserving such a term serves to emphasize Copley's importance to the history of American art.

In the late 1750s, perhaps in reaction to his absorption of Blackburn's style, Copley developed a rather blunt manner, but in the early 1760s, probably influenced by his patrons' demands, he turned to a more uninhibited expression of rococo elegance. In doing so he returned, as Jules David Prown has pointed out, to the manner of Blackburn. The more restrained portrait of Henry Pelham, *Boy with a Squirrel*, 1765 (MFA, Boston), was apparently Copley's own favorite of this period. He sent it to London, where both Sir Joshua Reynolds and BENJAMIN WEST praised it in terms that must have been utterly exhilarating for him. His friend Captain R. G. Bruce passed along Reynolds's comments:

> He says of it "that in any Collection of Painting it will pass for an excellent Picture, but considering the Disadvantages" I told him "you had laboured under, that *it was a very wonderfull Performance.*" "That it exceeded any Portrait that Mr. West ever drew." "That he did not know one Painter at home, who had all the Advantages that Europe could give them, that could equal it, and that if you are capable of producing such a Piece by the mere Efforts of your own Genius, with the advantages of the Example and Instruction which you could have in Europe, You would be a valuable Acquisition to the Art, and one of the first Painters in the World, provided you could receive these Aids before it was too late in Life, and before your Manner and Taste were corrupted or fixed by working in your little way at Boston. He condemns your working either in Crayons or Water Colours." . . . At the same time he found Faults. He observed a little Hardness in the Drawing, Coldness in the Shades, An over minuteness, all which Example would correct. "But still," he added, "*it is a wonderful Picture* to be sent by a Young Man who was never out of New England, and only some bad Copies to study" (*Letters & Papers of Copley*, pp. 41–42).

Reynolds, who had a superb eye, was, of course, correct. Yet perhaps he did not realize that Copley had turned to French, not British, art for inspiration, basing the pose on a print by Jean Baptiste de Poilly after Jacques Courtin's *Young Girl with a Squirrel* (ill. in A. Neumeyer, *Gazette des Beaux-Arts* 69 [May 1967], suppl., p. 22). In a sense, as R. Peter Mooz has pointed out, Copley was continuing in the old-fashioned tradition of Chardin (see *The Genius of American Painting*, ed. J. Wilmerding [1973], p. 69). At the same time, the *Boy with a Squirrel*, with its directness, strong side lighting, and clear modeling, which Reynolds regarded as lacking in rococo refinement, foreshadowed neoclassical portraits of twenty years later like Jacques Louis David's *Antoine Laurent Lavoisier and His Wife*, 1788 (MMA). Copley's best works of the next few years, for example, *Nicholas Boylston*, 1767 (Harvard University), have about them an icy clarity and coloristic daring found later in David's work. From Reynolds's point of view as a master of a fully developed rococo style, Copley's paintings, especially the *Young Lady with a Bird and Dog*, 1767 (Toledo Museum of Art, Ohio), which he sent to London that same year, necessarily appeared to be outmoded. Yet Reynolds's own position was contradictory. His actual practice was in conflict with the ideals expressed in his *Discourses*,

especially the sixth lecture, which clearly reached for something like the works done by the pioneer neoclassical painters Gavin Hamilton, George Romney, and Henry Fuseli in Rome at this time. That Copley, in Boston, should independently proceed along the same avant-garde lines was at once paradoxical and totally predictable, when one considers the young American's sheer genius and what might be called eighteenth-century American art's predilection for certain aspects of the neoclassical style.

Both Reynolds and West strongly urged Copley to come to Europe. He was reluctant, however, because of the remarkable success he was achieving in Boston and his uncertainty about his reception in Europe. He wrote in 1767, "I make as much as if I were a Raphael or a Correggio; and three hundred guineas a year, my present income, is equal to nine hundred a year in London" (Prown, 2, p. 51). For the time being, at least, he decided to stay put. During this period, he was mastering two new and difficult media, watercolor and pastel. In these, his most successful work was done in 1769, when he painted in watercolor on ivory a miniature self-portrait (Manney coll., New York) and drew in pastel another self-portrait (Henry Francis du Pont Winterthur Museum, Winterthur, Del.). The stylishness and brio of these works, and the visible self-esteem they reflect, may have had something to do with Copley's marriage in that year to Susanna Farnham Clarke, the daughter of a Boston merchant and granddaughter of a silversmith. This marriage connected him to one of the most prominent merchant families in Boston.

In the late 1760s Copley's style changed once again; he dramatically heightened contrasts between light and shadow, simplified his backgrounds, and at times radically reduced his former coloristic brilliance. This style perhaps reached a peak during his visit to New York in 1771, and in the first months after his return to Boston. His stark, simple portraits of Samuel Verplanck (q.v.) and Samuel Adams (City of Boston, on deposit at MFA, Boston) also appear to presage certain developments in French painting during the last quarter of the eighteenth century. The New York portraits are interesting as well in that they depict a different social milieu. The Verplancks seem to inhabit a world different from Copley's New England patrons; restrained and even withdrawn, they appear to lack the confidence and drive of the Boston subjects. Mrs. Thomas Gage, 1771 (Timken Art Gallery, San Diego), and the woman once called Mrs. Thrale, 1771 (Los Angeles County Museum of Art), actually seem weary, as if the demands of their lives had proven somehow insupportable.

Back in Boston, Copley continued to paint with coloristic restraint, but his subjects were even more dramatically lit from the side against increasingly simple, abstract backgrounds. On occasion, however, as in his portrait of Mrs. Richard Skinner, 1772 (MFA, Boston), he returned to the rich colors of earlier years. He also painted some double portraits, which he had not done since his youth. One of these, of Mr. and Mrs. Thomas Mifflin, 1773 (Historical Society of Pennsylvania, Philadelphia), is perhaps his last American masterpiece. The unsettled political conditions in Boston in the pre-revolutionary period, during which his wife's family was threatened with violence and his own commissions declined, prompted him to take the journey to Europe that he had long contemplated.

After arriving in London in July 1774, Copley set off for Italy in August. Passing through Paris and Florence on his way to Rome, he wrote to his half brother, Henry Pelham, detailed descriptions of the works of art he had seen. In Rome, he was befriended by the neoclassical

painter Gavin Hamilton, and while studying antique art he produced paintings that were clearly influenced by Hamilton's work. In the *Ascension*, 1775 (MFA, Boston), the first history painting done since his youth, he added another element to his developing neoclassical style, the influences of Raphael and Poussin. Joining his family in London in October 1775, Copley at first supported himself by painting portraits, but by 1778, with his famous painting *Watson and the Shark* (q.v. for version in MMA), he proved himself as a history painter. This painting was in itself a revolution in the history of art. A few years before, Benjamin West had confounded tradition by painting *The Death of General Wolfe* (National Gallery of Canada, Ottawa) with figures in contemporary clothing, but Copley went a step further in showing an extraordinary event in the life of an ordinary person. At the same time, he extended the style that has been called the neoclassic horrific to such a degree that it definitely foreshadowed Géricault's *The Raft of the Medusa*, first exhibited in 1819.

After his success with *Watson*, Copley was elected a member of the Royal Academy, and the next year he began another, very different, type of history painting. *The Death of the Earl of Chatham*, 1779-1781 (Tate Gallery, London), is a large picture recording the actual moment in the House of Lords when William Pitt the elder was stricken, during a debate over American independence. By depicting in detail an important contemporary event, Copley advanced history painting even further along the road toward realism that West had pioneered. The painting, which he exhibited for a fee and for which he solicited subscriptions for an engraving, brought him fame and fortune. Rather than repeating his success with a similar composition he turned to an outdoor battle scene for his next important history painting, *The Death of Major Peirson*, 1782-1784 (Tate Gallery, London). Almost universally judged to be his finest work, the painting commemorates the British victory in driving the French invaders from the Channel island of Jersey during the European fighting occasioned by the American Revolution. Although based to some degree on compositions by Rubens and Raphael, Copley's achievement is his own. The painting is brilliant with light and color and full of dramatic incident. As intensely real as his American portraits and as artistically complex and sophisticated as the work of any of his European contemporaries, *The Death of Major Peirson* represents the greatest achievement in eighteenth-century British or American history painting.

Copley's portraits of this period, such as *Midshipman Augustus Brine* (q.v.) and *The Three Youngest Daughters of George III*, 1785 (Her Majesty the Queen, Windsor Castle), as Prown has said, proceed from, rather than break with, his American style. Like the Boston portraits, that of Midshipman Brine has sharp side lighting and a strong feeling of intense reality. The brushwork is looser and the palette lighter, but what seems to be a wide divergence in style can be explained by the change of scene. One cannot imagine the occasion arising in America for the rococo extravagance of the delightful portrait of George III's daughters, with its carriage, flowers, birds, dogs, and beautifully painted dresses in white and delicate shades of yellow, blue, and pink.

The Death of Major Peirson marked the high point of Copley's career. Although he produced other history paintings, some of them quite successful, and a number of superb portraits, his career slowly declined. He had considerable public success with *The Siege of Gibraltar*, 1783–1791 (Guildhall Art Gallery, London), but he failed to secure the royal patronage he sought

and became embroiled in a series of bitter quarrels with Benjamin West about the affairs of the Royal Academy. Toward the end of his life, paintings like *George IV as Prince of Wales*, 1804–1815 (MFA, Boston), and *The Battle of the Pyrenees*, 1812–1815 (MFA, Boston), show a real decline in his powers, probably the result of old age and ill health.

BIBLIOGRAPHY: *Letters & Papers of John Singleton Copley and Henry Pelham, 1739–1776*, Massachusetts Historical Society, *Collections* 71 (Boston, 1914). Contains most of Copley's letters and family papers, 1739–1776 // Barbara Neville Parker and Anne Bolling Wheeler, *John Singleton Copley: American Portraits in Oil, Pastel, and Miniature, with Biographical Sketches* (Boston, 1938) // Jules David Prown, *John Singleton Copley* (2 vols.; Cambridge, Mass., 1966). The definitive work, it includes a catalogue raisonné // Alfred Frankenstein and the editors of Time-Life Books, *The World of Copley, 1738–1815* (New York, 1970). Engaging text, excellent color illustrations // Trevor J. Fairbrother, "John Singleton Copley's Use of English Mezzotints for His American Portraits: A Reappraisal Prompted by New Discoveries," *Arts* 55 (March 1981), pp. 122–130. The most complete treatment of Copley's reliance on print sources.

The Return of Neptune

For many years largely denigrated, paintings like Copley's *Return of Neptune* and BENJAMIN WEST's *Death of Socrates*, ca. 1756 (private coll.), now are recognized as having real art historical significance, not as provincial and obvious period pieces but as early examples of the stylistic developments that led to the formation of the neoclassical and romantic styles. Copley derived the present painting, like his *Galatea*, about 1754 (MFA, Boston), from a print, in this case an engraving by Simon François Ravenet after a design by Andrea Casali. Interestingly, however, in both cases he selected rather old-fashioned historical art; both sources look back to the seventeenth century and ultimately to Raphael and his researches into classical art. Copley's choice,

which was probably made from the collection of prints assembled for sale by his stepfather, Peter Pelham, is significant in a number of ways. For example, the subject is unusual for the time and place. The print sources of both the *Return of Neptune* and to an even greater degree *Galatea* show nude women who are coyly alluring. One wonders whether in some sense his choice was dictated by an adolescent sexual interest. More important, the choice of subjects indicates the remarkable level of Copley's ambition at this time. As Jules Prown has pointed out (1966):

from the beginning he seems to have had a vision of achieving a place for himself in the pantheon of art alongside those heroes of whom he had read—Raphael, Rubens, Titian, Guido The playful figures cavorting in the water in *Galatea* and *The Return of Neptune*

Copley, *The Return of Neptune*.

would someday become the tortured victims in *Watson and the Shark* and *The Siege of Gibraltar*.

It is important to remember that this painting was the work of a fifteen-year-old American boy. For Copley, who lived on the Long Wharf, a pier jutting almost three hundred yards out into Boston's harbor, the sea must have seemed the source of everything out of the ordinary. He saw soldiers, merchants, admirals, generals, slaves from all over the world arriving on the wharf and passing the house he had lived in from his earliest youth, as G. B. Warden has pointed out (*Museum of Fine Arts Bulletin* 91 [Jan. 1976], p. 52). It is not surprising, then, that he chose to see the even more exotic figures of pagan gods and goddesses as, in effect, arriving by boat. Other consequences of his upbringing are apparent in the painting as well. Neptune's anatomy is relatively well understood. The bodies of the mermaids, in contrast, are constructed almost abstractly; the line of the buttocks could have been drawn with a French curve, and the breasts lack nipples. Yet one has to remember that there was no academy in Boston in the 1750s, and Copley, if he wished to draw from life, would have had to do without female models. He did, however, have at his disposal a Dutch and an Italian text on anatomy.

Oil on canvas, 27½ × 44½ in. (69.9 × 113 cm.).
RELATED WORKS: *The Return of Neptune*, smaller and reversed in composition, unlocated (formerly coll. Mrs. C. B. Raymond, Boston, 1872).
REFERENCES: A. T. Perkins, *A Sketch of the Life and a List of Some of the Works of John Singleton Copley* (1873), p. 89, describes this painting and mentions a smaller version with the composition reversed // A. T. Gardner, *MMA Bull.* 20 (April 1962), pp. 257–263, identifies and reproduces the engraved source, says the Ravenet engraving was based on a theatrical transparency that ornamented a machine for the display of fireworks in London to celebrate the signing of the treaty of Aix-la-Chapelle in 1748, says that the color, which Copley had to make up, is "in some strange way . . . typical of much of his later work" // Gardner and Feld (1965), pp. 38–39 // W. H. Gerdts, *Burlington Magazine* 108 (May 1966), p. 281 // J. D. Prown, *John Singleton Copley* (1966), I, pp. 17–18, says works as pendant to Galatea, discusses as example of early interest in history painting, relates to later work (quoted above); p. 236.
EXHIBITED: National Gallery, Washington, D.C.; MMA; and MFA, Boston, 1965–1966, *John Singleton Copley, 1738–1815*, cat. by J. D. Prown, no. 2, pp. 14–15.
EX COLL.: Jonathan Simpson, Boston, by 1774; Miss Simpson, until at least 1873; Mr. and Mrs. J.

Nelson Borland; their daughter, Mrs. Orme Wilson.
Gift of Mrs. Orme Wilson, in memory of her parents, Mr. and Mrs. J. Nelson Borland, 1959.
59.198.

Mrs. Jerathmael Bowers

Based on family tradition the subject of this portrait is identified as Mary Sherburne Bowers (1735-1799). She was the daughter of Joseph Sherburne (see below) by his first wife, Mary Watson, and was married to Jerathmael Bowers, of Swansea, Massachusetts, in 1763, when she was twenty-eight. Tradition has it that the portrait was painted about the time of her marriage. The identification of the sitter has been questioned several times, the alternative suggestion being that the portrait is of Joseph Sherburne's third wife Mary Plaisted (1721-1785). The reason given is that the sitter appears older than Mary Bowers might have looked in the early 1760s, and that the execution of the work is more in keeping with Copley's style of the late sixties. This then could make it a companion portrait to Joseph Sherburne, which some scholars have found highly plausible. The difference in quality alone, however, should separate these two works; for the portrait of Joseph is far superior.

Furthermore, the record of a Boston Athenaeum label formerly attached to the original frame of the picture gives strong support to the family tradition. In 1837 Mrs. Bowers's daughter, Elizabeth Sherburne Bowers (1779–1851), who had married Thomas Danforth of Boston, lent the painting to an exhibition at the Boston Athenaeum, where it was simply listed as Mrs. Bowers by Copley, lent by Mrs. Danforth. It would be hard to believe that Mrs. Danforth did not know her own mother, who died when she was twenty. The portrait descended to Mrs. Danforth's daughters Mary and Elizabeth who again lent it to the Athenaeum, in 1871, but this time it was listed somewhat confusingly as Mrs. Elish. Browning Bowers. Unless the family had a Copley portrait of Mrs. Bowers that has since disappeared, and whose frame was switched with another Copley at some point, it is likely that the subject of the museum's portrait is Mrs. Bowers.

Following her father's death, Mrs. Bowers, who was his sole survivor, inherited a considerable estate. Her husband was also a well-to-do

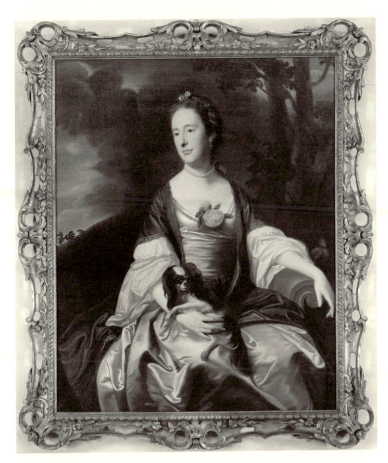

Copley, *Mrs. Jerathmael Bowers.*

merchant, and the couple moved into an elaborate house in Somerset, Massachusetts, soon after their marriage. Several rooms from that house, which survived until 1957, are installed in the Henry Francis du Pont Winterthur Museum, Delaware. Jerathmael Bowers was a Tory during the American Revolution, and this caused him some difficulty when he later sought public office. The couple had one son, John, who died fairly young, and three daughters: Mary, who married Joseph Jenckes of Newport; Elizabeth, who married Thomas Danforth of Boston; and Hannah, who married Dr. Francis Boorland of Somerset. The portrait of Joseph Sherburne descended in Mary's family as did this one, after it was received from their Danforth cousins in the 1880s.

Copley based the portrait on a mezzotint by James McArdell of Sir Joshua Reynolds's 1759 portrait of Lady Caroline Russell, later duchess of Marlborough. As has often been noted, he copied Reynolds's portrait line for line, even to the markings of the dog on the sitter's lap. Yet his handling of the print is innovative in terms of eighteenth-century American art. He understood Reynolds's "tender and sympathetic approach to a character," which gave to the subject "a certain gracious shyness, a momentary quality, as of being caught unobserved" (E. Waterhouse, *Painting in Britain, 1530–1790* [1953], p. 167). To some extent, he has brought Reynolds's charm down to earth. The ethereal mist behind the sitter becomes a solid mass of clouds, the sitter's face loses some of its gentle wistfulness to gain an aristocratic calm, and the dress is more solid and less artfully wrinkled. Yet, even working at a stage removed from the original, Copley seems to have retained Reynolds's effect of informality and sensitive perception of the sitter's gentle, human qualities. The frame of the painting is believed to be the original.

Oil on canvas, 49⅞ × 39¾ in. (126.7 × 101 cm.).
Label of the Boston Athenaeum, formerly on the frame: Elish Bowers by Copley. Owner, The Misses Danforth.

REFERENCES: "Alien Pictures Received at Athenaeum," May 8, 1871, MS, p. 205, records: "Stuart, Dr. Saml Danforth Delivered Sept 11 The Misses Danforth / Copley Mrs. Elish. Browning Bowers Delivd Oct. 9th [The Misses Danforth] // A. T. Perkins, *A Sketch of the Life and a List of Some of the Works of John Singleton Copley* (1873), p. 37, says this painting was then owned by Mrs. Bowers's granddaughter, Mary Danforth, Boston // F. W. Bayley, *The Life and Works of John Singleton Copley* (1915), p. 63, implies owner unknown // M. I. Jenckes, Indianapolis, Dec. 4, 1915, says the sitter is Mary Sherburne Bowers and supplies history of ownership // B. Burroughs, *MMA Bull.* 11 (Jan. 1916), cover ill., p. 21; (March 1916), pp. 76–77, says it was based on McArdell engraving after Reynolds's Lady Caroline Russell; (April 1916), p. 94 // *Antiquarian* 12 (April 1929), ill. p. 48, notes the "natural posing of the head and hands" // *Connoisseur* 85 (June 1930), p. 397, says sitter "could scarcely have been less than about thirty-four or thirty-five when this portrait was executed" // T. Bolton and H. L. Binsse, *Antiquarian* 15 (Dec. 1930), p. 116, tentatively date it about 1765 // J. H. Morgan, *Antiques* 31 (March 1937), ill. p. 117, shows this painting and Reynolds's mezzotint // B. N. Parker and A. B. Wheeler, *John Singleton Copley* (1938), pp. 41–42, say it was "probably painted in 1763 or 1764 shortly after the sale of British mezzotints in Boston in 1762" // J. H. Morgan, *John Singleton Copley* (1939), p. 13 // J. T. Flexner, *First Flowers of Our Wilderness* (1947), ills. pp. 218–219, compares it to the mezzotint of the Reynolds; p. 345, dates it ca. 1763–1764 // F. A. Sweet, *Art Quarterly* 14 (Summer 1951), pp. 151–152 // W. P. Belknap, Jr., *American Colonial Painting* (1959), pp. 274, 313, 315, dates it about 1763 // S. Tillim, *Arts Magazine* 37 (Feb. 1963), p. 48, says it "is suffused with that aristocratic impersonality and ritualized elegance which Copley, like Reynolds, equated with Fine Art" // A. S. Roe, Cornell University, letter in Dept. Archives, April 15, 1964, says that the subject may be Mary Plaisted who became the third wife of Joseph Sherburne and gives biographical data // Gardner and Feld (1965), pp. 39–41 // J. D. Prown, Yale University, March 31, 1965, letter in Dept. Archives, says he thinks Mrs. Bowers may be Mrs. Sherburne; *John Singleton Copley* (1966), 1, p. 60, gives arguments for Mrs. Sherburne as subject, concludes " the possibility must be acknowledged," and says it stylistically "fits better into the later rather than the early 1760s"; p. 197; p. 210, lists as Mrs. Jerathmael Bowers // J. Harding, Boston Athenaeum, June 9, 1986, letter in Dept. Archives, supplies information from original catalogues and records regarding the picture's early loan.

EXHIBITED: Boston Athenaeum, 1837, no. 38, as Portrait of Mrs. Bowers, J. S. Copley, Mrs. Danforth, Proprietor; 1871, no. 246, as Mrs. Elish. Browning Bowers, by Copley, owned by the Misses Danforth // MMA, 1958–1959, *Fourteen American Masters* (no cat.) // National Gallery, Washington, D. C.; MMA; and MFA, Boston, 1965–1966, *John Singleton Copley, 1738–1815*, cat. by J. D. Prown, no. 38; color ill. p. 54; p. 55, as Mrs. Jerathmael Bowers, dates it 1767–1770, and says it ranks "among the highest achievements of Copley's American career" // Los Angeles County Museum of Art, and National Portrait Gallery, Washington, D. C., 1981–1982, *American Portraiture in the Grand Manner*, exhib. cat. by M. Quick, color ill. no. 13 // National Portrait Gallery, Washington, D. C., 1987, *American Colonial Portraits, 1700–1776*, exhib. cat. by R. H. Saunders and E. G. Miles, no. 75, as Mrs. Jerathmael Bowers (or Mrs. Joseph Sherburne), ca. 1767.

EX COLL.: the subject, Somerset, Mass., d. 1799; her daughter, Elizabeth Sherburne Bowers (Mrs. Thomas Danforth), Boston, d. 1851; her daughters Mary and Elizabeth S. B. Danforth, Boston, by 1873; their second cousin, Rev. Dr. Joseph Sherburne Jenckes, Indianapolis, d. 1910; his wife, Mrs. Joseph Sherburne Jenckes, Indianapolis, until 1915.

Rogers Fund, 1915.

15.128.

Mrs. Sylvanus Bourne

Mercy Gorham (1695–1782) was born and brought up on Cape Cod, as was her husband, Sylvanus Bourne of Falmouth, Massachusetts, to whom she was married in 1718. They settled in Barnstable after 1720, where Bourne soon became a very prosperous merchant. His wife bore him eleven children. A member of the king's council for more than twenty years and a judge on the court of common pleas, Bourne was chief justice of the Massachusetts Bay Colony at the time of his death in 1763. Copley painted his widow three years later, in 1766, when she was seventy-one, presenting her as a rather good-humored woman who does not quite look her age. Sylvanus Bourne came from Puritan stock, and several of his ancestors had served as missionaries to the Indians. Yet his wife is shown here holding a book, described by a descendant, Colonel Samuel Swett, as being an Anglican prayer book, an anomaly he explained in 1851 as follows:

A number of her family, . . . became Episcopal; and probably the sweet face of Mercy allured her husband from the Puritanic fold into the domain of the Church of England, which, in the opinion of our ancestors,

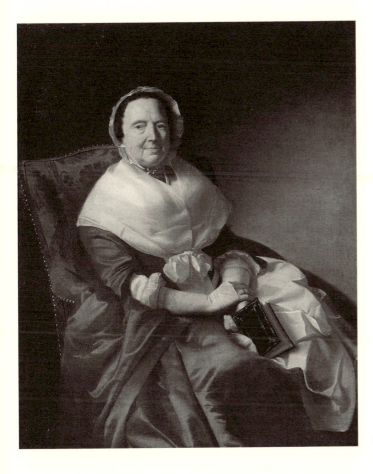

Copley, *Mrs. Sylvanus Bourne.*

was no better than the domain of the scarlet lady of Babylon.

He also mentioned that in one of her letters she praises some wine presented to her "and remarks that her taste in wine had been commended by Judge Dudley."

Although less delicately painted than some of Copley's portraits of the period, this painting exhibits to a remarkable degree what Jules Prown has characterized as "a sense of presence, of the physical entity and personality of the sitter, which is conveyed across the span of two hundred years. The subject of the portrait appears as a distinct, knowable human being" (1966, 1, p. 53). Strongly lit from the side, Mrs. Bourne's face is intensely observed, her eyes focus directly on the viewer, and the highlights of her vigorously modeled brown dress are convincingly rendered. Small deficiencies in Copley's drawing, such as a lack of three-dimensionality in the head, are hardly noticeable, and the viewer's

attention is drawn instead to the expressive face and finely modeled hands.

Mrs. Bourne is painted with such apparent realism that one would naturally suppose that the entire portrait was painted from life. Her dress and underskirt, however, are exactly the same, line for line and fold for fold, as those worn by Mrs. James Russell in a portrait by Copley that has been dated 1770 or 1771 (private coll., ill. in Prown, 1, fig. no. 275). Not only are their dresses identical but they sit on what would appear to be the same chair, with the same pattern in its upholstery. The poses are the same as well, and in fact the portraits differ only in the faces of the sitters and in the presence of lace on the border of Mrs. Russell's fichu. It is thus necessary to assume that Copley based both portraits on a common source. Although he might conceivably have used a drawing he had made for one portrait in painting the other, the fact that he is known to have copied a num-

ber of portraits almost slavishly from mezzotints after the work of European artists (see *Mrs. Jerathmael Bowers* above) renders a print source more likely. The exact source in this case has not been identified.

Oil on canvas, 50¼ × 40 in. (127.6 × 101.6 cm.).
Signed and dated at right center: Jn⁰: S: Copley / Pinˣ 1766.

REFERENCES: A. T. Perkins, *A Sketch of the Life and a List of Some of the Works of John Singleton Copley* (1873), suppl., p. 1, says owned by Col. Samuel Swett, a descendant of the sitter // F. W. Bayley, *The Life and Works of John Singleton Copley* (1915), pp. 60–61, says location of the painting unknown // H. B. Wehle, *MMA Bull.* 19 (Nov. 1924), p. 270, gives biographical information on the sitter, says painting bought from the sitter's great-great-great grandson, J. Barnard French, Bristol, R.I., and prior to that, painting was in Florence for forty years // T. Bolton and H. L. Binsse, *Antiquarian* 15 (Dec. 1930), p. 118, includes it in checklist // S. Tillim, *Arts Magazine* 37 (Feb. 1963), p. 48, calls it a "brownish classless portrait of an individual" // Gardner and Feld (1965), pp. 41–42 // J. D. Prown, *John Singleton Copley* (1966), 1, p. 54, note 3, says similar in composition to five other Copley portraits; pp. 76, 80, 124, 160, 209 // R. P. Mooz, *The Genius of American Painting*, ed. J. Wilmerding (1973), p. 69, says Copley had found Reynolds's solution to Hudson's "fixed stare" on his own.

EXHIBITED: Cape Cod Association, Boston, 1851, *Constitution . . . with an Account of the Celebration of Its First Anniversary*, p. 73, says it "hangs in our hall tonight," apparently lent by Samuel Swett // MMA, 1936–1937, *An Exhibition of Paintings by John Singleton Copley*, no. 18 // MMA, 1939, *Life in America*, no. 20, p. 14, says it expresses a "republican veracity . . . as striking as Roman portrait busts" // Art Institute of Chicago, 1949, *From Colony to Nation*, no. 34 // MMA, 1958, *Fourteen American Masters* (no cat.) // Hirschl and Adler Galleries, New York, 1975–1976, *American Portraits by John Singleton Copley*, no. 23.

EX COLL.: descended to Colonel Samuel Swett, by 1851–d. 1866; Mrs. Alexander, Florence, until 1921; her grandnephew, J. Barnard French, Bristol, R. I., 1921–1924.

Morris K. Jesup Fund, 1924.
24.79.

Joseph Sherburne

Joseph Sherburne (1710–1779) was born in Portsmouth, New Hampshire, the son of Mary Lovell and Joseph Sherburne, a well-to-do landowner and justice of the state supreme court. By 1728 he was living in Boston, where he was listed as a member of the Brattle Street Church.

At first engaged in the East India trade, he later became a successful hardware merchant. He owned a great deal of property on Beacon Hill, and at his death his estate was appraised at the very considerable sum of £19,400. Sherburne married three times.

A portrait by Copley dated 1767, whose subject has been tentatively identified as Daniel Rogers (MFA, Boston), is very similar in composition to the portrait of Sherburne, but as the latter is more advanced in technique, it should probably be dated slightly later, between 1767 and 1770. Shown informally in a cap and banyan, Sherburne is portrayed in a daring and effective color scheme of fully saturated brown, blue, and red. Probably the most extraordinary aspect of the portrait is the vivid feeling of reality, which Copley achieved by a number of means. One is the extremely careful attention to detail. Every fold of cloth and bit of pattern in Sherburne's silk robe is meticulously delineated; every wrinkle on his face and hands is clearly indicated. Another is the strong side lighting, which heightens the semblance of actuality in space, and, by its specificity, conveys the impression of a particular moment in time.

Unlike such European-trained artists as JOHN SMIBERT and JOHN WOLLASTON, Copley developed an extraordinary ability to suggest three-dimensional form through the use of highly contrasting lights and shadows. It would seem that he derived this ability to render objects in space—one of the most characteristic and powerful elements of his style—from a variety of European sources. Among other things, there is evidence that he was familiar with European tenebrist painting. In a letter to Myles Cooper, president of King's College, New York, in 1768, Copley agreed to sell him a painting of "Candle light" (unlocated), or as Cooper had called it in an earlier letter of August 5, 1768, "The Nun with the Candle before her" (*Letters & Papers of Copley*, pp. 70–71). But even ten years before, Copley's portrait of Henry Pelham, 1758–1761 (private coll., ill. in Prown, 1, fig. 95), shows a boy reading, his face bathed in the glow of a light before him. Jules Prown has proposed that Copley may have been trying to reproduce effects found in seventeenth-century paintings influenced by Gerrit van Honthorst and Georges de la Tour. Another possibility is the work of Poussin. Copley's sharply side-lit figures bear a marked resemblance to those in Poussin's *Seven Sacraments*, which he mentioned having seen in Paris in a letter to Henry

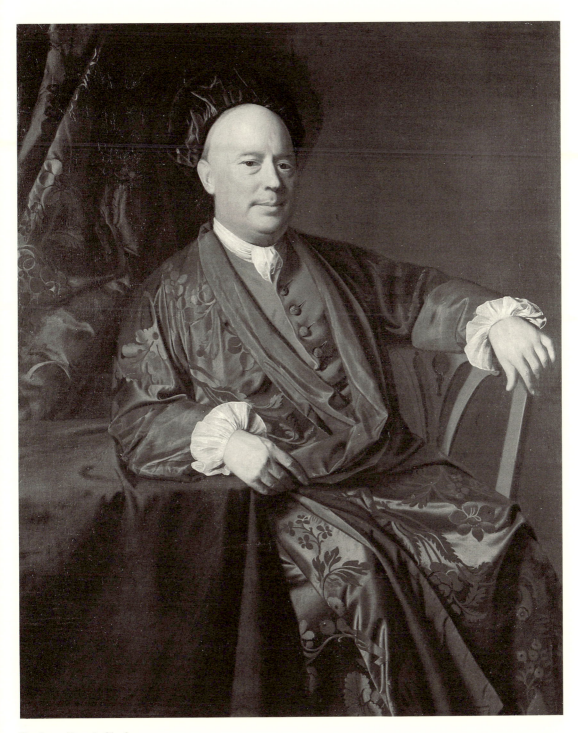

Copley, *Joseph Sherburne*.

Pelham of September 2, 1774, but which he had first known from engravings in a Boston collection (*Letters & Papers of Copley*, p. 245).

Oil on canvas, 50 × 40 in. (127 × 101.6 cm.).

REFERENCES: J. M. Lansing, *MMA Bull.* 18 (Sept. 1923), pp. 208–209, dates the portrait about 1770 // F. W. Bayley, *Five Colonial Artists of New England* (1929), ill. p. 271 // T. Bolton and H. L. Binsse, *Antiquarian* 15 (Dec. 1930), p. 118 // Gardner and Feld (1965), pp. 42–43 // J. D. Prown, *John Singleton Copley* (1966), 1, p. 60, notes similarity to portrait of Daniel Rogers; pp. 113, 117, 122, 124, 125, 127, 141; pp. 196–197, dates it 1768–1770; p. 229, fig. 218, dates it 1767–1770 // M. Mead, *Arts Magazine* 45 (May 1971), p. 34, the well-known anthropologist says that Copley "gives no sense of a back" in the portrait.

EXHIBITED: MMA, 1958–1959, *Fourteen American Masters* (no cat.) // Los Angeles County Museum of Art and M. H. de Young Memorial Museum, San Francisco, 1966, *American Paintings from the Metropolitan Museum of Art*, p. 10; p. 36, color ill. no. 5 // M. Knoedler and Co., New York, 1971, *What Is American in American Art*, no. 7 // Tokyo National Museum and Kyoto Municipal Museum, 1972, *Treasured Masterpieces of the Metropolitan Museum of Art*, no. 109 // MMA and American Federation of Arts, traveling exhibition, 1975–1977, *The Heritage of American Art*, cat. by M. Davis, no. 8, ill. p. [37].

ON DEPOSIT: Cincinnati Art Museum, 1889–1923, lent by Miss Sarah Wheelwright, Toledo.

EX COLL.: descendants of Joseph Sherburne; his great-great-great-granddaughter, Mary Bowers Wheelwright, Cincinnati, by 1923.

Amelia B. Lazarus Fund, 1923.

23.143.

Daniel Crommelin Verplanck

No documents have been found to indicate the order in which Copley painted portraits of members of the Verplanck family. In addition to Daniel (1762–1834), his father, Samuel, and his uncle Gulian (see below), he also painted Samuel's sister Mary, Mrs. Charles McEvers (coll. Mrs. Alfred Renshaw, Old Lyme, Conn.), and possibly Gulian's wife, Mary Crommelin Verplanck, and their daughter Anne, later Mrs. Gabriel Ludlow. The sheer number of the portraits shows that the Verplancks were thoroughly pleased with Copley's work. Considering that these members of New York's Anglo-Dutch colonial aristocracy had broad European experience and probably were excellent judges of quality, this constituted high praise indeed.

The portrait of Daniel may well have been the first of the Verplancks Copley painted after his arrival in New York in mid-June of 1771; for the landscape background, traditionally said to represent the family estate at Fishkill, New York, seems to show a summer scene. That it was the first of these portraits to be painted is further suggested by Copley's choice of composition, that of a little boy with a pet squirrel, the very subject that had won him the approbation of Sir Joshua Reynolds six years before, and which he would doubtless have expected to appeal to prospective patrons in New York. The combination of such an informal subject with a formal landscape at least indicates that he was attempting something in the nature of a tour de force, an effort more likely to have been made early in his visit rather than near its end, when he was struggling to finish the work he had started.

Ever since WILLIAM DUNLAP's *History of the Rise and Progress of the Arts of Design in the United States* appeared in 1834, this portrait has been singled out as a work of exceptional quality and interest. Partly this may be because of the presence of the pet squirrel. Copley's first use of one was in his portrait of John Bee Holmes, 1765 (coll. H. Richard Dietrich, Jr., Philadelphia), which follows a print by Jean Baptiste de Poilly after Jacques Courtin's *Young Girl with a Squirrel*, about 1737 (ill. in *Gazette des Beaux-Arts* 69 [May-June 1966], p. 308, fig. 10; see suppl. May-June 1967, p. 22, for identification by A. Neumeyer of Copley's source). Copley, however, has transformed the rococo sensuality of Courtin's portrait into a traditional picture of a child with a pet. Copley's well-known portrait of Henry Pelham, *Boy with a Squirrel* (MFA, Boston), is a more distant derivative, as is, finally, the portrait of Daniel Verplanck. Here, however, instead of the small, close-up interior scenes of his earlier paintings, Copley has portrayed his subject in a more imposing setting, against the rather grandiose columns of what is said to be the Verplanck house at Fishkill, with a portion of the estate in the background. The realistic landscape, probably an attempt to imitate Gainsborough's combination of topographical landscapes with portraits, is contrasted with the formal, traditional columns at the right. The light is dramatic, almost theatrical. Although the time would appear to be sunset, the figure of the boy is very brightly lit against a dark background, from a

direction not at all consistent with that of the sunset in the sky. The resulting sense of unreality, combined with the boy's sidelong gaze and knowing expression, imparts to the portrait the feeling of a strange, yet intimate, moment in time.

The eldest son of Samuel and Judith Crommelin Verplanck, Daniel grew up in the family house on Wall Street. While attending Columbia College he married Elizabeth Johnson, who was both the granddaughter and daughter of presidents of the college. She died in 1789, the year after her husband graduated. One of their two children, Gulian Crommelin Verplanck (1786–1870), became an important figure in New York political and artistic circles, serving, for example, as vice president of the American Academy of Fine Arts and publishing a scholarly edition of Shakespeare. Daniel Verplanck later married Ann Walton, by whom he had seven children, and in 1804 they moved to Mount Gulian, the family estate at Fishkill. A representative to Congress from Dutchess County from 1803 to 1809, he spent most of the remainder of his life as a gentleman farmer, and was known as a connoisseur of wine and a collector of silver.

Copley, *Daniel Crommelin Verplanck.*

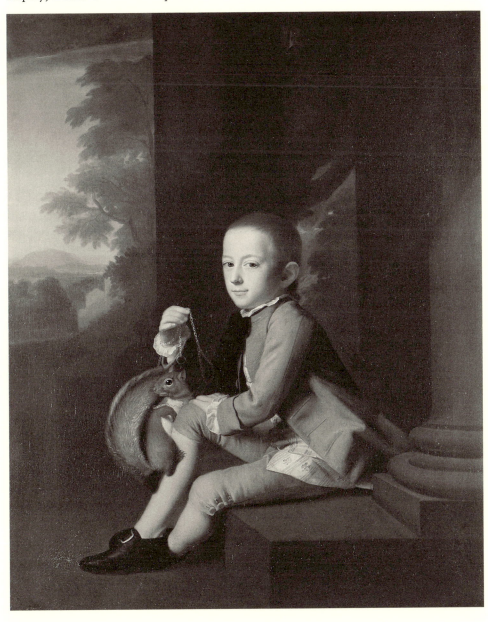

Oil on canvas, 49½ × 40 in. (127.3 × 101.6 cm.).

REFERENCES: W. Dunlap, *History of the Rise and Progress of the Arts of Design in the United States* (1834), 1, p. 109, quotes letter by sitter's son, Gulian C. Verplanck, saying, of Copley, "The introduction of a squirrel . . . was a favourite idea with him. I have a large full length of my father when a child, playing with a squirrel" // A. T. Perkins, *A Sketch of the Life and a List of Some of the Works of John Singleton Copley* (1873), pp. 114–115, says painted in New York in 1773, owned by estate of Gulian C. Verplanck // W. E. Verplanck, *The History of Abraham Isaacse Ver Planck* (1892), p. 15, says belongs to author; says Dunlap misdates Copley's New York visit as 1773 // F. W. Bayley, *The Life and Works of John Singleton Copley* (1915), p. 246, says owned by W. E. Verplanck, Fishkill, New York // T. Bolton and H. L. Binsse, *Antiquarian* 15 (Dec. 1930), p. 118, say painted in 1771, owned by W. E. Verplanck // B. N. Parker and A. B. Wheeler, *John Singleton Copley* (1938), pp. 194–195, say undoubtedly painted in 1771 on Copley's trip to New York, hung in Verplanck house, Mount Gulian, until about 1932, when it burned down, owned by sitter's great-great-grandson, W. Everett Verplanck, Salem, Mass. // V. D. Andrus, *MMA Bull.* 7 (June 1949), pp. 261–265 // B. Hogarth, *American Artist* 25 (Dec. 1961), color ill. p. 40 // Gardner and Feld (1965), pp. 44–45, color ill. on cover // *American Artist* 30 (Feb. 1966), p. 4, color ill. on cover // J. D. Prown, *John Singleton Copley* (1966), 1, pp. 81, 115, 233 // *MMA Bull.* 33 (Winter 1975–1976), ill. p. 238.

EXHIBITED: Brooklyn Museum, 1917, *Early American Paintings*, no. 19, as Daniel Crommelin Verplanck, lent by William Verplanck // Society of Colonial Dames, New York, 1930, lent by William E. Verplanck // MFA, Boston, 1938, *John Singleton Copley Loan Exhibition*, no. 75, lent by W. Everett Verplanck // MMA, 1958–1959, *Fourteen American Masters* (no cat.) // MMA, 1939, *Life in America*, no. 24, lent by W. Everett Verplanck // MMA, 1965, *Three Centuries of American Painting* (checklist arranged alphabetically) // MMA, 1976–1977, *A Bicentennial Treasury* (see *MMA Bull.* 33 above).

EX COLL.: the subject's son, Gulian Crommelin Verplanck, Fishkill, N.Y., 1834–d. 1870; W. E. Verplanck, Fishkill, by 1892–1935?; W. Everett Verplanck, Salem, Mass., by 1938–1949; with M. Knoedler and Co., New York, 1949; Bayard Verplanck, Fishkill, 1949.

Gift of Bayard Verplanck, 1949.

49.12.

Samuel Verplanck

Samuel Verplanck (1739–1820) was an interesting and important member of New York's colonial aristocracy. Born in New York, he graduated from King's College (later Columbia) in 1758. Soon thereafter he went to Amsterdam, where he worked in the large banking house of his uncle, Daniel Crommelin, himself a transplanted New Yorker. While there he married Crommelin's daughter Judith and in 1763 returned, with his wife, to America. He inherited from his father, Gulian, a large house at what is now 30–32 Wall Street, and it was probably there that Copley painted his portrait. Verplanck was a serious connoisseur of art. His American furniture, some of which is in the museum's Verplanck Room, was the best obtainable in New York, and he seems as well to have had what for the place and time was a remarkable collection of art, both American and European. Part of his collection undoubtedly came from his father, whose house Peter Kalm mentions visiting in 1748, writing that "the walls were quite covered with all sorts of drawings and pictures in small frames" (*Travels into North America* [1770], p. 250). Verplanck's wife, too, was something of a collector; according to family tradition she received from her friend Sir William Howe, the commander of the British forces in America from 1775 to 1778, two paintings by Angelica Kauffmann and a French porcelain tea set. The paintings, along with a Dutch landscape with Noah's Ark of about 1700 and a miniature apparently of Verplanck himself, done about 1760, are sometimes shown in the museum's Verplanck Room and are evidently all that can be identified of the Verplancks' European paintings.

During the Revolution, Judith Verplanck, who apparently had Tory sympathies, remained in the Wall Street house, while her husband stayed on his estate at Fishkill, New York. Verplanck had played a part in the events leading up to the Revolution, serving as a member of the Committee of One Hundred and a delegate to the first New York Provincial Congress, where he signed the Declaration of Association and Union against Great Britain. During the war he was evidently neutral. Described on a deed as a "merchant, Gentleman, Citizen of New York, Burgher of Amsterdam, and a Governeur of King's College," he was also one of the twenty-four founders of the New York Chamber of Commerce. When Copley visited New York, he wrote to Henry Pelham in Boston on November 24, 1771, that he had "just come back from Mr. Verplanck's where we have spent the Even'g" (Massachusetts Historical Society, *Collections* 71

[1914], p. 175). This shows that Copley's rapid rise in fortune and advantageous marriage had resulted in his being accepted in the same social circles as his patrons.

As Edward Morris noted, Copley, in the portraits of this period, forsook the lively colors, carefully elaborate poses, and richly depicted fabrics of his earlier work, preferring, in effect, the neoclassical to the rococo style (Walker Art Gallery, Liverpool, *American Artists in Europe, 1800–1900*, exhib. cat. [1976], p. 16). The composition of this portrait is radical in its simplicity, and the colors are extraordinarily muted, both characteristics that are usually thought of as neoclassical. How Copley in New York could have learned of what was then Europe's most advanced style is something of a mystery. Members of the Verplanck family were well-traveled, cultivated, and astute connoisseurs of painting; it is possible that one of them or some other person in New York, such as General Thomas Gage, whose wife's portrait Copley painted, possessed a work in the newly emerged style. Unfortunately, too little is known about eighteenth-century art collections in New York to provide any definite answer. The presence of a painting by BENJAMIN WEST, for example, might reasonably be assumed, but in this type of portrait Copley seems closer to French than to British neoclassicism, and it is very unlikely that works by painters such as Jacques Louis David existed in New York or Boston around 1770. Even with Copley's unquestioned genius, one hesitates to credit him with the independent invention of the neoclassical style. Clearly, though, the characteristic qualities of this and other Copley portraits of the period contradict the theory that neoclassicism emerged in America as a response to the Revolution.

Perhaps only in Copley's well-known portrait of Samuel Adams, 1770–1772 (City of Boston, on deposit at MFA, Boston), are the composition and color so simple. In both portraits the pose is similar, with the shoulders awkward and not well drawn. The different personalities of the sitters, however, result in strikingly different effects. Verplanck is represented as a man of considerable reserve, and his portrait is so restrained that it perhaps lacks a high degree of interest for the viewer of our day. Adams, on the other hand, Copley knew very well as a charismatic, even violent, man, and his character comes through in his portrait like a whiplash.

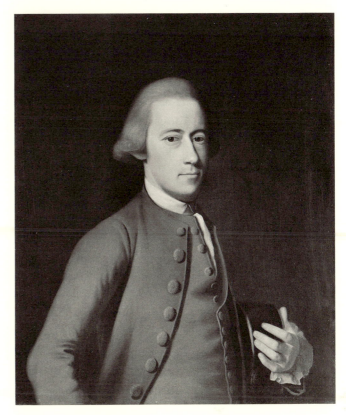

Copley, *Samuel Verplanck*.

Oil on canvas, 30 × 25 in. (76.2 × 63.5 cm.).

Inscribed on old stretcher: Portrait of Samuel Verplanck by Copley / owner Samuel VerPlanck, Fishkill on the Hudson / N.Y.

RELATED WORKS: Two copies of the portrait were made for members of the Verplanck family at the time it was given to the museum. One of them is now in the New-York Historical Society.

REFERENCES: L. F. Fuld, *Columbia University Quarterly* 9 (Sept. 1907), p. 489, says portrait owned by sitter's great-grandson, Samuel Verplanck, Fishkill, N.Y. // S. Verplanck, letter in Dept. Archives, Nov. 12, 1907, offers to lend it to the MMA for six months // F. W. Bayley, *The Life and Works of John Singleton Copley* (1915), p. 247, dates ca. 1770, says owned by Samuel Verplanck, Fishkill // B. N. Parker and A. B. Wheeler, *John Singleton Copley* (1938), pp. 196–197, say painted in New York in 1771, owned by James De Lancey Verplanck, Fishkill // J. Downs, *MMA Bull.* 36 (Nov. 1941), p. 220, gives description on deed quoted above // V. D. Andrus, *MMA Bull.* 7 (June 1949), pp. 261–265 // E. P. Richardson, *Winterthur Portfolio* 2 (1965), pp. 9–10 // Gardner and Feld (1965), pp. 43–44 // J. D. Prown, *John Singleton Copley* (1966), I, p. 81, says of this and portrait of Gulian Verplanck, "the drawing is crisp, the light-dark contrasts very strong, and the heads placed low on the canvas"; pp. 84, 115, 223.

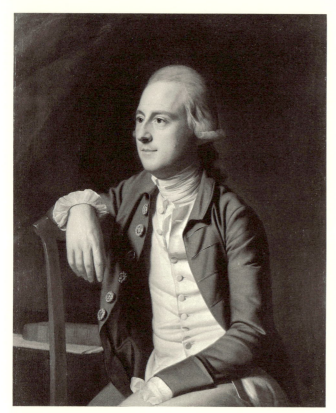

Copley, *Gulian Verplanck.*

EXHIBITED: MMA, 1958–1959, *Fourteen American Masters* (no cat.) // MMA, 1965, *Three Centuries of American Painting* (checklist arranged alphabetically).

Ex COLL.: great-grandson of the subject, Samuel Verplanck, Fishkill, N.Y., by 1907–after 1915; probably his wife, Matilda C. Verplanck, Fishkill, N.Y., 1921; James De Lancey Verplanck, by 1938–1939.

Gift of James De Lancey Verplanck, 1939.

39.173.

Gulian Verplanck

The youngest brother of Samuel Verplanck (see above), Gulian Verplanck (1751–1799) also attended King's College, from which he graduated in 1768, and learned his trade as merchant and banker in Amsterdam at his uncle's firm. After returning to New York, he turned his attention to politics and banking. Verplanck was a fluent debater in the state assembly, to which he was elected in 1788. He served as speaker in 1791 and again in 1796. In 1791 he succeeded Isaac Roosevelt as president of the Bank of New York and supervised its move to its present location on Wall Street. In 1792 he was one of the founders of the Tontine Association, which later became the New York Stock Exchange. Verplanck also served as one of the regents of the University of the State of New York. He married Cornelia Johnston in 1784, and they had seven children.

Like his brother Samuel, to whom he was close and who evidently supervised his education, Gulian Verplanck was a man of wealth and taste. In 1834, Gulian Crommelin Verplanck, his grandnephew, in sending to WILLIAM DUNLAP some passages from letters Gulian had written to Samuel about American artists, described him as one "whom you doubtless recollect as . . . a gentleman of much taste and cultivation" (Dunlap, *History of the Rise and Progress of the Arts of Design in the United States* [1834], 1, p. 110). The passages themselves demonstrate a lively interest in art and a good deal of confidence in his own judgment. The first, written from London in 1773, relays BENJAMIN WEST's high opinion of Copley and forthrightly asserts that *The Death of General Wolfe* is West's finest painting. Then on March 12, 1775, he writes again to Samuel from Rome:

I have the satisfaction of finding Mr. Copeley in Italy Whom I persuaded to go to Naples with Me, He has just finished two excellent Portraits of Mr & Mrs Izard who are likewise here, from the Improvements He has already made in his Manner, & will continue to make from studying the Works of the greatest Masters I have no doubt but that He will soon rank with the first Artists of the Age. (Citation is from G. C. Verplanck to S. Verplanck, Verplanck Papers, Box 8, V no. 71, NYHS).

Copley's interests are clear from the many references to classical antiquity in his painting of the Izards, 1775 (MFA, Boston), as are Verplanck's from his persuading Copley to join him on the trip to Naples to see the ruins of Pompeii. Perhaps even more noteworthy, however, is the pride Verplanck took in the achievements of his fellow American.

Copley painted the present portrait during his New York visit of 1771, when the subject was twenty years old. Almost as restrained as the portrait of his brother, that of Gulian shows him in a pale blue coat. Copley's intention here was not, however, to dazzle with rich, fully saturated colors, as he had in the portrait of Joseph Sherburne (q.v.) and would again in the one of Mrs. John Winthrop (q.v.), but rather to portray his subject's personality. Thus, although similar in pose to the portraits of Ezekiel Goldthwaite

(MFA, Boston) and Joseph Hooper (coll. Mr. and Mrs. Jacob Blaustein, Pikesville, Md.), Gulian's portrait is closest in spirit to those of Mrs. Thomas Gage (Timken Art Gallery, San Diego) and the unidentified woman once called Mrs. Thrale (Los Angeles County Museum of Art). In all three Copley seems to have approached his subjects with human warmth rather than with his characteristic stark forthrightness, and one senses on the part of the sitters a gentle reserve (in the two women even a suggestion of fatigue) that is rare in his work.

Oil on canvas, 36 × 28 in. (91.4 × 71.1 cm.).

REFERENCES: A. Nevins, *History of the Bank of New York and Trust Company* (1934), p. 29, says painting reproduced courtesy of Verplanck Quillard // V. D. Andrus, *MMA. Bull.* 7 (June 1949), pp. 261–262, says painted in New York in 1771 // E. P. Richardson, *Winterthur Portfolio* 2 (1965), p. 9 // Gardner and Feld (1965), pp. 45–46 // J. D. Prown, *John Singleton Copley* (1966), 1, pp. 81, 115, 233.

EXHIBITED: MMA, 1958–1959, Fourteen American Masters (no cat.) // MMA, 1965, *Three Centuries of American Painting* (checklist arranged alphabetically).

EX COLL.: the subject, d. 1799; his daughter, Emily (Mrs. Claude Quilliard), d. 1869; her son, Gulian Verplanck Quilliard; his four children, 1948; with John Levy Galleries, New York, 1948; with M. Knoedler and Co., New York, 1948–1949; Mrs. Bayard Verplanck, 1949.

Gift of Mrs. Bayard Verplanck, 1949.

49.13.

Mrs. John Winthrop

Hannah Fayerweather (1727–1790), the daughter of Hannah Waldo and Thomas Fayerweather, was baptized at the First Church in Boston, February 12, 1727. She was married twice, in 1745 to Parr Tolman and in 1756 to John Winthrop, great-great-grandson of the governor of Massachusetts and the second Hollis Professor of Mathematics and Natural Philosophy at Harvard College. Winthrop carried out important investigations concerning sunspots and earthquakes, earning the distinction of being America's first prominent astronomer. Mrs. Winthrop shared her husband's intellectual interests; in her later years she spoke of being "lonely for Cambridge and the delights of intellectual companionship."

It has often been suggested, though never in print, that Copley's portrait of Mrs. Winthrop has been cut down from a larger canvas. Quite

probably this idea arose from its resemblance to such portraits by Copley as that of Mrs. Ezekiel Goldthwaite, 1770-1771 (MFA, Boston), which shows a great deal more of the figure and the background. However, a careful examination reveals that the canvas at both top and bottom retains the scalloped pattern imparted by the original tacks with which it was fixed to its stretcher. That the canvas was cut down the sides is unlikely, as the usual format Copley chose for his portraits of single sitters was rectangular. The size of the canvas, $35\frac{1}{2} \times 28\frac{3}{4}$ inches, is very close to that of his portrait of Paul Revere (MFA, Boston), which is $35 \times 28\frac{1}{2}$ inches, and to ten other extant pictures. Among these, perhaps the most interesting in relation to this picture are the portraits of Charles Pelham, Copley's stepbrother, and a man who may be Peter Pelham, another stepbrother (both private coll., ill. in Prown, 1, figs. 27, 28), painted very early in his career at a time when he was much influenced by John Greenwood (1727–1792) and ROBERT FEKE. In the second of these portraits, dated 1753, Copley adapted the pose from a mezzotint after Sir Godfrey Kneller of Thomas Newport, Lord Torrington. In the portrait of Charles, tentatively dated 1754, the precocious young artist transformed his source by enlarging the table to cover almost the entire foreground. Mrs. Winthrop is seen in very nearly the same pose, also holding a still-life element, a nectarine sprig in one hand and a piece of the red-orange fruit in the other. Yet despite similarities in pose and composition, Mrs. Winthrop inhabits a different world. The portraits of the Pelhams are emblematic and conceptual, whereas that of Mrs. Winthrop, painted in 1773, the year before Copley departed for Europe, exhibits the refined realism he had developed over twenty years. The fabrics of her clothes, the wrinkles in her face, and the colors of the fruit she holds are rendered with the almost magical skill that is characteristic of Copley at the height of his powers. Perhaps the most astonishing aspect of the portrait, beyond even the truly vivid presentation of Mrs. Winthrop, is the complicated and beautiful interaction of her hands with their reflection in the highly polished table. As an artist who at least once, in *Corkscrew Hanging on a Nail*, 1766–1774 (MFA, Boston), attempted a trompe-l'oeil still life, Copley appears to have been interested in the contradiction between

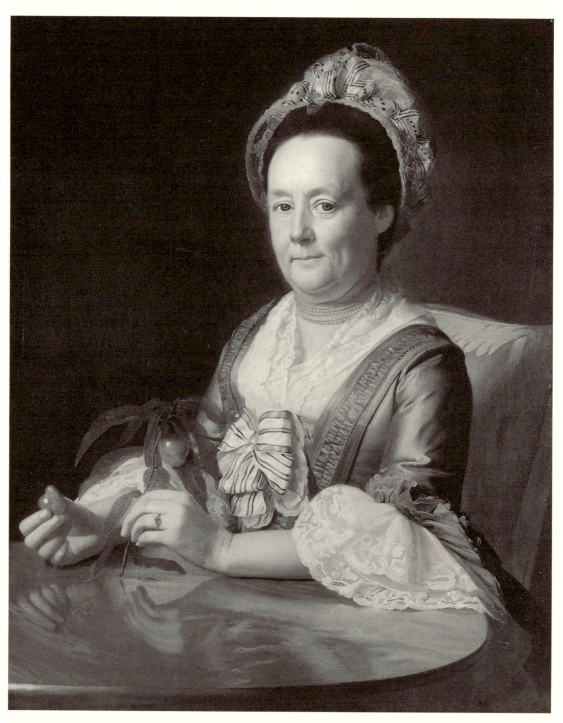

Copley, *Mrs. John Winthrop.*

appearance and reality, explored in Western art from the time of the classical Greeks. Mrs. Winthrop's hands are rather self-consciously posed, not for their own effect but in order to produce an extraordinarily graceful interaction with their reflection. In the table top, they assume an oddly independent existence; the still-life element of the fruit, as well as the ring on her finger, has vanished, and one is in the presence of an almost balletic refinement of form that far surpasses similar elements in Copley's earlier portraits.

Oil on canvas, 35½ × 28¾ in. (90.2 × 73 cm.).

REFERENCES: Inventory of Dr. Winthrop's estate, 1790, Rare Books and Manuscripts, Boston Public Library, lists a portrait of Mrs. Winthrop valued at £36 (probably this picture) // A. T. Perkins, *A Sketch of the Life and a List of Some of the Works of John Singleton Copley* (1873), pp. 124–125, says the painting was then owned by a descendant, Mrs. Harris, of Cambridge // F. W. Bayley, *The Life and Works of John Singleton Copley* (1915), p. 259, says it was painted in 1774 and was then owned by Edward D. Harris, Yonkers, N.Y. // J. M. Lansing, *MMA Bull.* 27 (Feb. 1932), pp. 52–54 // B. N. Parker and A. B. Wheeler, *John Singleton Copley* (1938), p. 210, quote receipt for 10 guineas paid June 24, 1773, for the portrait // Gardner and Feld (1965), pp. 46–48 // J. D. Prown, *John Singleton Copley* (1966), 1, p. 89, says it relates to portrait of Mrs. Samuel Waldo; pp. 98, 116, 235 // *MMA Bull.* 33 (Winter 1975–1976), ill. no. 22.

EXHIBITED: MMA, 1936–1937, *An Exhibition of Paintings by John Singleton Copley*, no. 34 // MFA, Boston, 1938, *John Singleton Copley Loan Exhibition*, no. 86 // MMA, 1958, *Fourteen American Masters* (no cat.) // MMA, 1965, *Three Centuries of American Painting* (checklist arranged alphabetically) // Pushkin Museum, Moscow, and Hermitage, Leningrad, 1975, *100 Kartin iz muzeia Metropolitan* [*100 Paintings from the Metropolitan Museum*], no. 80, color ills. pp. 224–225; pp. 224, 226 // MMA, 1975–1976, *A Bicentennial Treasury* (see *MMA Bull.* 33 above).

EX COLL.: descended to Mrs. Harris, Cambridge, Mass., by 1873; Edward D. Harris, Cambridge, Mass., and Yonkers, N.Y., by 1915–1931.

Morris K. Jesup Fund, 1931.

31.109.

Watson and the Shark

The original painting of this subject is one of the best known works in the history of Anglo-American painting. It was commissioned by Brook Watson, a successful London merchant who had spent a number of years in America with the British army and who was acquainted with Copley's brother-in-law, Jonathan Clarke. As a young boy, in 1749, Watson lost his leg, and very nearly his life, when he was attacked by a shark while swimming in Havana harbor. Copley's presentation of the event is unusual in a number of ways, first of all conceptually. Traditionally, history painters, even when they dealt with contemporary events, depicted their subjects in the clothes of classical Greece and Rome. It was the much discussed "revolution" of BENJAMIN WEST to show contemporary heroes in the clothing they might actually have worn. West, however, did not break with the tradition entirely; he continued to define history painting in terms of great events in which outstanding men and women played the chief parts. In *Watson and the Shark*, Copley carried West's innovation one step further: he painted an ordinary man in an extraordinary event of no great historical importance. When Copley exhibited the first version of the painting (National Gallery, Washington, D.C.) at the Royal Academy in 1778, it bore the title "A Boy Attacked by a Shark, and Rescued by Some Seamen in a Boat; Founded on Fact which Happened in the Harbour of Havannah." As James Flexner said, "We are asked to sympathize with a tragedy not because it involved a great man or a significant occasion, but because the victim was a human being like the rest of us. The aristocratic emphasis on eminent people has given way to an interest in the common man" (*MMA Bull.* 7 [Oct. 1948], p. 68).

Yet, it must be stressed that stylistically Copley's *Watson and the Shark* is history painting in the grand manner. The sources for his work, as Jules Prown demonstrated, include West, Rubens, and, in the figure of Watson, antique sculpture. More recently, Roger Stein has suggested that Copley was basing his work on even grander sources, Raphael's *Transfiguration* and the tapestries he designed for the Sistine Chapel, which Copley must have seen on his visit to Italy in 1774 and 1775 (*Discoveries & Considerations*, ed. by C. Israel [1976], pp. 101–102). After his return to London, he may also have seen Raphael's famous cartoons for the tapestries, which were in the royal collection (that he knew what they looked like, at any rate, is confirmed by the presence of a complete set of engravings of them in his possession at the time of his death). As one example of such a derivation, the two men reach-

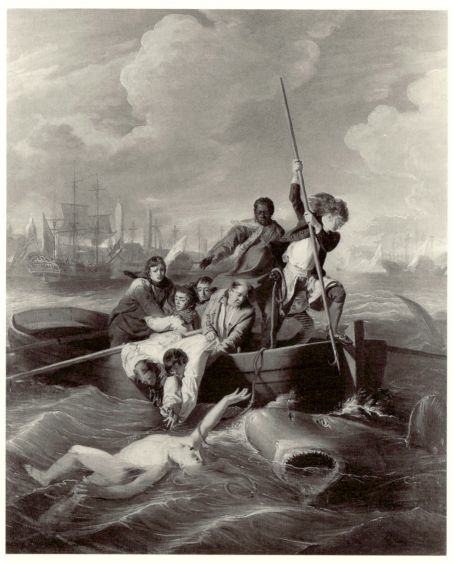

The Detroit Institute of Arts version of Copley's *Watson and the Shark*.

ing out of the boat to Watson are quite similar to two of the fishermen in *The Miraculous Draught of Fishes*, one of the Raphael designs. (I. B. Jaffe, *American Art Journal* 9 [May 1977], p. 22, cites comparisons with another work with the same title painted by Rubens in 1618, in the Cathedral of Notre-Dame, Malines, Belgium, and still another, attributable to Rubens or Van Dyck, in the National Gallery, London. Jaffe also says [p. 19] that Watson's pose is close to that of the Laocoön in the Vatican Museums.) It might be observed that Raphael's boat is hardly large

enough to hold one man, not to say three, while Copley's boat is more credible in size. Even so, a critic in the London *Morning Chronicle* thought that the boat did not tilt as it perhaps should (J. D. Prown [1977], 2, p. 267).

The generally horrific nature of the event has often been linked to Edmund Burke's theory of the sublime, but it may also have something to do with works of earlier British artists of the 1760s, for example, Nathaniel Dance's *Death of Virginia*, 1761 (now unlocated). Paintings like these have been called precocious examples

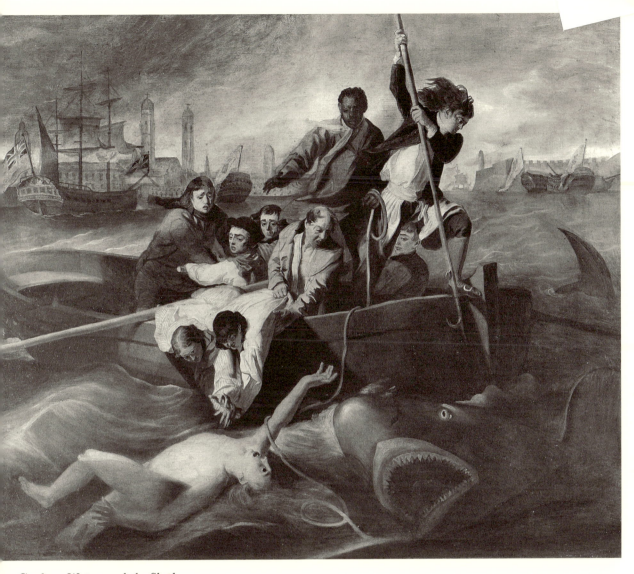

Copley, *Watson and the Shark*.

of neoclassicism by scholars such as Robert Ro-
senblum (*Transformations in Late Eighteenth-Cen-
tury Art* [1967], p. 65). As Rosenblum makes
clear, neoclassicism and romanticism are not
mutually exclusive, and Copley's work may also
be regarded as the first in a long line of great
romantic sea paintings that includes Géricault's
Raft of the Medusa, Turner's *Slave Ship*, and
WINSLOW HOMER's *Gulf Stream*. Copley has paint-
ed a highly charged event totally without the
distancing device of the classical past and has
given it the same almost incredible immediacy

and sense of presence that are in his American
portraits. The drama and the extreme emotions
of the situation are strengthened by his attention
to the actual appearance of such things as facial
expressions and fabrics.

A number of versions of *Watson and the Shark*
exist, of which three are generally accepted as
authentic. The first, at the National Gallery in
Washington, is the one exhibited at the Royal
Academy in 1778. Another, signed and dated
the same year, very close in size and of the same
horizontal format, is at the Museum of Fine

Study for the figure in the rear of the boat.
Detroit Institute of Arts.

Arts, Boston. The third, signed and dated 1782, in the Detroit Institute of Arts, is vertical in format and less finished in execution. The relationship of the Metropolitan's painting to these works is difficult to establish. So thinly painted as to be little more than a colored drawing, obviously unfinished, as several of the ships are without masts or rigging (which precludes its having been used by the engraver), the painting totally lacks the groping, unsure quality usually associated with a study. Various of its details differ from those in the other versions, such as the architecture of the buildings in the background, but as each figure is in precisely the same pose as in the Washington painting, the picture has been called a copy or replica, made before the original was finished, conceivably by Copley's half-brother Henry Pelham (J. D. Prown [1966], 2, p. 459). However, it has a feature hardly ever found in a copy—a conspicuous pentimento, in the area of the shark's tail. This is also present in the Washington and Boston paintings, indicating that the artist was finding it difficult to deal with the anatomy of the shark, a fact one of Copley's critics noted in a review of the first painting (J. D. Prown [1966], 2, p. 267). The final form of the shark's tail in the Metropolitan's painting resembles that in the Boston version, whereas the penti-

The first version of Copley's *Watson and the Shark*.
National Gallery of Art, Washington, D. C.

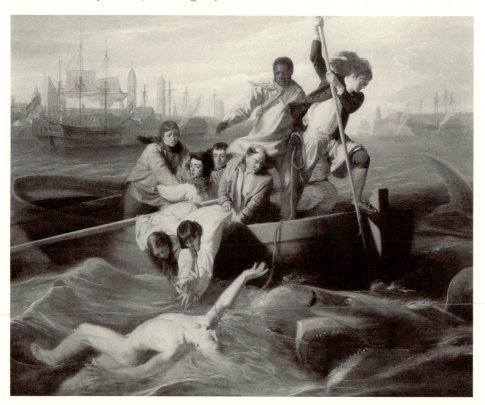

mento is related to the form in the Washington canvas, giving rise to the theory that the Metropolitan's work is a rapid study of the original composition to record it for use in making the second version, the one in Boston, and perhaps, a few years later, the Detroit painting as well.

That Copley at some point needed such a record, and kept it in his possession, from which it passed into the collection of his son, Lord Lyndhurst, might have been ignored because the only painting called *Watson and the Shark* sold at the Lyndhurst auction was believed to be the one now in Boston. The price, £11.11, extremely low compared to others in the sale (£1,600 for *The Death of Major Peirson*), indicates, however, a small, not very impressive, and possibly unfinished work like the Metropolitan's rather than the large and beautiful Boston painting. Furthermore, its buyer was a man named Cox, who is known to have acted as the agent for Copley's granddaughter, Martha Babcock Amory of Boston, in whose collection the Metropolitan's painting once was.

The question of who actually painted the picture is less easily resolved. In many respects it resembles other works from Copley's hand. It is similar in execution to his study for the 1776 portrait of his family (ill. in Hirschl and Adler Galleries, New York, *Adventure & Inspiration* [1988], p. 16), in which the visible underdrawing is very much like that seen in the Metropolitan's painting. Some of the faces in these two works are crude, almost smudged, as they are in the Detroit painting, and also in the drawings for the original. Infrared photography of the Detroit and New York paintings reveals that the underdrawing in both appears to be by the same hand. As the former is generally accepted as being by Copley, one can assume that its underdrawing and that of the Metropolitan's as well are by him. It is possible that Copley did just the drawing on the Metropolitan's canvas and another artist added the colors. It is more likely that Copley himself added the paint, quickly and rather summarily. He was not a facile artist, producing over his lifetime relatively few canvases (compared to a painter like West), and there are numerous references to how painstakingly he built up his finished paintings. For use simply as a record, however, he might easily have produced just such a painting as this, and the close similarity of its execution to that of the version in Boston, which is accepted by everyone as Copley's work, makes attribution of this painting to him plausible.

Infrared photographs show the underdrawing of a detail of the Metropolitan painting (left) and the Detroit painting (right).

Oil on canvas, 24⅞ × 30⅛ in. (63.2 × 76.5 cm.).

RELATED WORKS: Study for harpooner and oarsman, black and white chalk, 13½ × 15⅝ in. (34.2 × 39.6 cm.), 1777–1778, Detroit Institute of Arts, ill. in Prown (1966), 2, no. 375 // Study of figure on left, black and white chalk, 12 × 10 in. (30.4 × 25.4 cm.), 1777–1778, Detroit Institute of Arts, ill. in Prown (1966), 2, no. 376 // Study for oarsmen, black and white chalk, 9¾ × 11⅞ in. (24.7 × 30.1 cm.), 1777–1778, Detroit Institute of Arts, ill. in Prown (1966), 2, no. 377 // Study for rescue group, black, white, and red chalk, 14½ × 21⅞ in. (36.8 × 55.5 cm.), 1777–1778, Detroit Institute of Arts, ill. in Prown (1966), 2, no. 378 // Study, possibly for head of Brook Watson, pencil and white chalk, 14 3/16 × 22 9/16 in. (36 × 57.3 cm.), 1777–1778, MFA, Boston, ill. in Prown (1966), 2, no. 374 // Head of a black man, possibly a study for this picture, oil on canvas, 21 × 16¼ in. (53.3 × 41.2 cm.), 1777–1783, Detroit Institute of Arts, ill. in Prown (1966), 2, no. 381 // Watson and the Shark, oil on canvas, 71¾ × 90½ in. (182.2 × 229.8 cm.), 1778, National Gallery, Washington, D.C., ill. in Prown (1966), 2, no. 371 // Watson and the Shark, oil on canvas, 72⅛ × 90¼ in. (183.2 × 229.2 cm.), 1778, MFA, Boston, ill. in Prown (1966), 2, no. 372 // Watson and the Shark, oil on canvas, 36 × 30½ in. (91.4 × 77.4 cm.), 1782, Detroit Institute of Arts, ill. in Prown (1966), 2, no. 373 // possibly by Copley, Watson and the Shark, oil on canvas, 35½ × 30 in. (90.1 × 76.2 cm.), Bayou Bend Collection, Museum of Fine Arts, Houston // Valentine Green, A Youth Rescued from a Shark, mezzotint, 1779, 18¼ × 23¾ in. (46.4 × 60.3 cm.) probably copy after Copley, Watson and the Shark, oil on canvas, 50 × 68 in. (127 × 172.7 cm.), formerly coll. Copley Amory, Jr. // probably copy after Copley, Watson and the Shark, oil on copper, 19½ × 23½ in. (49.5 × 59.6 cm.), Beaverbrook Art Gallery, Fredericton, New Brunswick // probably copy after Copley, Watson and the Shark, 35 × 20½ in. (88.9 × 52 cm.), now unlocated // unidentified artist after Copley, Watson and the Shark, oil on metal, 22 × 27½ in. (55.8 × 59.8 cm.), now unlocated, ill. in Antiques 67 (Jan. 1955), p. 24 // Henry S. Sargent after Copley, Watson and the Shark, oil on canvas, 23¼ × 18¼ in. (60 × 46.3 cm.), MFA, Boston.

REFERENCES: A. T. Perkins, A Sketch of the Life and a List of Some of the Works of John Singleton Copley (1873), p. 9; p. 128, says this picture, then in Boston, is an original sketch and mentions the Washington painting as The Boy and the Shark; p. 132, lists what is apparently this painting in Lyndhurst sale catalogue of March 5, 1864, no. 61, calls it Youth Rescued from a Shark and finished painting a Boy Saved from a Shark // M. B. Amory, The Domestic and Artistic Life of John Singleton Copley (1882), p. 74; the author, Copley's granddaughter, calls it an "original sketch or . . . small finished picture in oils" and says it is owned by the artist's descendants // F. W. Bayley, The Life and Works of John Singleton Copley (1915), pp. 253–254, calls it

the original sketch, owned by Mrs. F. Gordon Dexter, Boston // M. Jeffrey, MMA Bull. 1 (Dec. 1942), pp. 148–150 // E. P. Richardson, Art Quarterly 10 (1947), p. 213, calls it the first small sketch in oil; p. 217, compares finished painting to works of major artists // J. T. Flexner, MMA Bull. 7 (Oct. 1948), p. 68, mentions this painting, cites title of finished painting when exhibited at the Royal Academy, and discusses subject (quoted above) // J. S. Newberry, Jr., Bulletin of the Detroit Institute of Arts 28, no. 2 (1949), pp. 32–35, calls it "a small oil sketch dating from the year 1778" and reproduces two drawings related to the subject // W. H. Gerdts, Burlington Magazine 108 (May 1966), p. 278 // Gardner and Feld (1965), pp. 49–51, as attributed to Copley // J. D. Prown, John Singleton Copley (1966), 2, pp. 267–274, quotes extensively the reaction to the finished painting by British critics, discusses it in relation to West, neoclassicism, and the tradition of history painting, discusses drawings for it, cites Copley's debt to Rubens and antiquity, discusses related paintings; p. 459, says museum's painting, a copy after Copley, "is apparently of eighteenth-century origin," "has a certain aura of originality," tentatively identifies it as the one in the Lyndhurst sale, speculates that Henry Pelham may have painted it after Copley's unfinished painting, says it differs too much from the engraving by Valentine Green to be a copy after it.

EXHIBITED: Athenaeum Gallery, Boston, 1873, no. 126; 1874, no. 137, as Youth Rescued from a Shark, calls it "Original picture of the large one," lent by "C. Amory" // Gallery of Fine Arts, Columbus, Ohio, 1947, The Colonial Americans, no. 1 // Montreal Museum of Fine Arts; National Gallery of Canada, Ottawa; and Toledo Museum of Art, Ohio, 1957–1958, British Painting in the Eighteenth Century, cat. by D. Farr, no. 2, calls it the first oil sketch for the finished painting // MMA, 1958–1959, Fourteen American Masters (no cat.) // Bowdoin College Art Museum, Brunswick, Me., 1964, The Portrayal of the Negro in American Painting, cat. by S. Kaplan, unpaged, no. 2, compares the black man to Queequeg and Ishmael in Melville's Moby Dick.

EX COLL.: the artist's son, Lord Lyndhurst (sale, Christie, Manson and Woods, London, March 5, 1864, no. 61, as A Youth Rescued from a Shark); with Cox as agent; the artist's granddaughter, Martha Babcock (Mrs. Charles) Amory, Boston, ca. 1864–d. 1880; her daughter, Susan (Mrs. Franklin Gordon) Dexter, Boston, 1915; her son, Gordon Dexter, Nassau, d. 1937; his wife, Mrs. Gordon Dexter, 1937-1942.

Gift of Mrs. Gordon Dexter, 1942.
42.71.1.

Midshipman Augustus Brine

Augustus Brine (1769-1840) was the son of Admiral James Brine of Dorset and his first wife, Jane Knight. The elder Brine had a distinguished career, which included the command of the ship *Belliqueux* at Yorktown during the American Revolution. Copley painted this portrait of his son in 1782, when, at the age of thirteen, he was appointed midshipman in the Royal Navy, serving initially on his father's ship. From the portrayal, young Brine appears to have started his naval career with a good deal of self-confidence. Yet the life of a young man in the British navy, even the son of an admiral, was not without its dangers, and this Copley

Copley, *Midshipman Augustus Brine*.

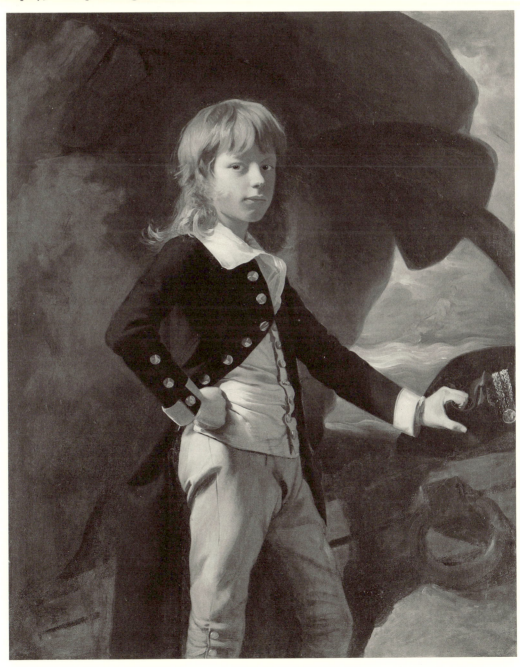

implies by showing in the background a ship in heavy weather. In addition to the treachery of the sea, there were the hazards of mutiny: Augustus Brine's half-brother George, also a midshipman, would have perished if a mutiny plotted on board his father's ship *Glory* had not been foiled by one of the mutineers, who, not wishing to kill the boy along with the officers, informed on the others. Augustus pursued his career steadily; he was commissioned lieutenant in 1790, rising to commander in 1798, post-captain in 1802, and finally rear admiral in 1822. During the War of 1812, as commander of the *Medway*, he captured the American brig *Syren*. He retired shortly before his death. His wife, whom he married in 1803, was Maria Martha Dansey, daughter of William Dansey of Dorset and granddaughter of Odber Knapton of Lymington, Hampshire. She seems to have inherited the Knapton estate, for the Brines lived at Boldre Hill in Lymington and their son, Augustus James, assumed the name and arms of Knapton by royal license in 1860.

It was traditional in the eighteenth century to portray naval officers beside a cliff at the edge of the sea, with a ship sailing away in the background. The upturned fluke of an anchor, in the upper right of Copley's picture, is also seen in a portrait of the type by Gainsborough of Augustus John, earl of Bristol (National Trust, Ickworth, Suffolk), which was engraved in 1773. In pose and general composition, Copley's portrait is close to that of Henry, duke of Gloucester, by Adriaen Hannemann (National Gallery, Washington, D.C.), which was once thought to be William of Orange by Van Dyck.

The present portrait is a fine example of Copley's English work at its best. In comparison to his American paintings, his palette had become considerably lighter and his style freer and looser. The landscape background, especially the rendering of the sea, demonstrates a delight in the qualities of paint itself. The composition is quite sophisticated, with the massive anchor fluke balancing by its thrust the dark expanse of rock that serves as a foil for the sharply lit figure of the boy. Other elements, however, are strikingly similar to those in Copley's American portraits, particularly that of Daniel Crommelin Verplanck (*q.v.*). Both figures are brightly lit from the side, and in both portraits there is a clearheaded understanding and expression of

the subject's character. If Daniel Verplanck is knowing, Midshipman Brine appears arrogant, though sensitive withal, and in both portraits the impression of physical reality is strongly felt.

Oil on canvas, 50 × 40 in. (127 × 101.6 cm.).
Signed and dated at left center: J. S. Copley Pin-[xit] / 1782.

REFERENCES: Christie, Manson and Woods, London, *Catalogue of Pictures by Old Masters . . .*, sale cat. (Dec. 12, 1924), no. 111, erroneously says dated 1783 // *International Studio* 96 (August 1930), cover ill., as coll. Richard de Wolfe Brixey // J. L. Allen, *MMA Bull.* 11 (May 1944), pp. 260–262, discusses painting and naval career of subject // Gardner and Feld (1965), pp. 48–49 // J. D. Prown, *John Singleton Copley* (1966), 2, pp. 294–295, calls it "superlative," cites "strong light and dark contrasts," "brilliance of the colors, and the bravura of the brushwork"; pp. 345, 413 // A. Frankenstein and the editors of Time-Life Books, *The World of Copley* (1970), color ill., p. 150, call it "highly accomplished" // *MMA Bull.* 33 (Winter 1975–1976), color ill. no. 24 // T. J. Fairbrother, letter in Dept. Archives, April 25, 1979, suggests that it may represent a nocturnal scene.

EXHIBITED: Reinhardt Gallery, New York, 1929 (no cat.) // Art Institute of Chicago, 1933, *Century of Progress Exhibition of Paintings and Sculpture*, no. 413 // Montreal Museum of Fine Arts, 1950, *The Eighteenth Century Art of France and England*, no. 2 // MMA, 1958–1959, *Fourteen American Masters* (no cat.) // National Gallery, Washington, D.C.; MMA; and MFA, Boston, 1965–1966, *John Singleton Copley, 1738–1815*, cat. by J. D. Prown, color ill. p. 100, pp. 101, 140 // MFA, Boston, 1970, *Masterpieces of Painting in the Metropolitan Museum of Art*, cat. by E. A. Standen and T. M. Folds, color ill. p. 103 // National Gallery, Washington, D.C.; City Art Museum of St. Louis; and Seattle Art Museum, 1970–1971, *Great American Paintings from the Boston and Metropolitan Museums*, p. 13; color ill. p. 39, no. 12 // MMA and American Federation of Arts, traveling exhibition, 1975–1977, *The Heritage of American Art*, no. 9, color ill. p. [38] // MMA, 1975–1976, *A Bicentennial Treasury* (see *MMA Bull.* 33 above).

Ex COLL.: the subject's son, the Rev. Augustus James Brine (who assumed the name and arms of Knapton in 1860), Boldre House, Lymington, Hampshire, d. 1879; his son, Augustus L. K. Knapton, Rope Hill, Lymington; Mrs. Knapton, Stanwell House, Lymington; Lord Duveen of Milbank, London; (sale, Christie, Manson and Woods, Dec. 12, 1924, no. 111, £1,627.10); with Frank T. Sabin, London, 1924; with Duveen Brothers, London, 1924; Richard De Wolfe Brixey, by 1930–1943.

Bequest of Richard De Wolfe Brixey, 1943.
43.86.4.

JOHN MARE

1739–1802 or 1803

John Mare was the son of John Mare of New York, who emigrated from England, and Mary Bes Mare, who was probably of Dutch origin. Nothing is known of his artistic training. By 1759 he was in Albany in search of portrait commissions. At about that time he married Ann Morris, who with her infant son must have died early, for there is no mention of them in Mare's will, made in 1761. As the same will does not identify him as living in Albany, it may be assumed that he had returned to New York. In 1766 he was paid by the common council of the city to paint a portrait of George III (now lost), which was probably based on a print. From 1762 to 1767 his only competitor in New York was Lawrence Kilburn (1720–1775), a painter of no particularly striking talent, but after that a number of other artists, including JOHN DURAND and Abraham Delanoy (1742–1795), a student of BENJAMIN WEST's, arrived in the city.

There is some evidence that Mare was in Boston around 1767, when he was commissioned by Dr. James Lloyd of Boston to copy a portrait of his father, Henry Lloyd, painted a decade earlier by JOHN WOLLASTON (now unlocated). Mare's picture (coll. Mrs. Orme Wilson, New York), appears to be a competent copy. It was probably in Boston, in 1768, that he painted a portrait believed to be of John Torrey (coll. Frederick H. Metcalf, Melrose, Mass.). Early in 1772 he was back in Albany seeking commissions, but in 1773 or 1774 he returned to New York, where he did his last known works, a portrait of Dr. Benjamin Youngs Prime, 1774 (NYHS), and his only known pastel, a portrait of John Covenhoven, 1774 (Shelburne Museum, Shelburne, Vt.).

Last recorded as being in New York in 1777, Mare moved by 1778 to Edenton, North Carolina, where for some time he prospered as a merchant. In 1784 he married his second wife, Mrs. Marion Boyd Wells. He was active in politics, serving three times as a member of the council of state, a group of seven men who were the governor's closest advisers, and in 1789 he represented Edenton at the convention to ratify the Constitution of the United States. Mare was a prominent member of the Anglican church. He played an important role in the early history of the Masons in North Carolina and is said to have written the constitution of their state organization. During this period he apparently did not practice his art. He died sometime between June 1802 and April 1803.

Although his portrait of John Keteltas, 1767 (NYHS), has often been cited as among the earliest examples of trompe-l'oeil painting in America (because of a fly on the sitter's cuff), Mare was not an innovative or influential artist. William Sawitzky, in a lecture given in 1942, characterized his paintings as stiff and awkward, yet placed him on a higher level than some of his contemporaries (see H. B. Smith and E. V. Moore, p. 33). His finest work, the portrait of Jeremiah Platt (q.v.), was not discovered until 1954, and as Helen Burr Smith and Elizabeth V. Moore pointed out, "No matter how dependent he was on a set formula for composition, he painted faces with individuality. It is honest work, straightforward, . . .

unstained by flattery. These are portraits of real persons and irrefutable proof of his professional success" (p. 33).

BIBLIOGRAPHY: Helen Burr Smith, "John Mare (1739–c. 1795), New York Portrait Painter: With Notes on the Two William Williams," *New-York Historical Society Quarterly* 35 (Oct. 1951), pp. 355–399. Summarizes all that was then known about Mare, includes catalogue of signed or attributed works // Helen Burr Smith and Elizabeth V. Moore, "John Mare: A Composite Portrait," *North Carolina Historical Review* 44 (Jan. 1967), pp. 18–52. Summarizes and updates previous article, conclusively places Mare in New York and North Carolina, describes in detail his later years // Helen Burr Smith, "A Portrait by John Mare Identified: Uncle Jeremiah" *Antiques* 103 (June 1973), pp. 1185–1187. Gives the results of sixteen years of brilliant detective work on Mare's finest portrait, that of Jeremiah Platt (see below).

Jeremiah Platt

When this portrait came to the museum in 1955, the subject was unknown. At that time there was speculation that the painting might be a self-portrait and, because the chair shown at the right is so prominent, that Mare might have been a cabinetmaker as well as an artist. In 1973, eighteen years later, Helen Burr Smith, Mare's biographer, published the results of her persistent and successful research on the painting, identifying the subject and establishing the painting's history. Jeremiah Platt (1744–1811) was born in Huntington, Long Island, the son of Dr. Zophar and Rebecca Wood Platt. His father combined the careers of surgeon, landowner, merchant, and miller. Platt's first wife, Mary Ann Vanderspiegel, whom he married in 1769, died in 1775; their three children died in early childhood. He was a member of the mercantile firm of Broom, Platt and Company in New York and a founder of the Tontine Coffee House, which later became the New York Stock Exchange. In 1775 Platt and his firm moved to New Haven and equipped privateers, many of which they owned, to fight the British during the Revolution. In 1780 he married Abigail Pynchon of Springfield, Massachusetts, by whom he had three children. He died in 1811 and was buried in the Grove Street Cemetery in New Haven. Although he was penniless at his death, his estate was that of a well-to-do man. Along with an extensive amount of furniture and silver, it included "One large framed Picture—$1.00" that was identified by Helen Burr Smith as this painting.

Mare's portrait of Jeremiah Platt, painted in 1767, is the most sophisticated of his known works. The color is extraordinarily subtle and refined, with the rich reddish pink of the drapery picked up in the subject's face and hands and in the pinkish cast of his purplish-blue coat. One can even see traces of red in the brown background. Platt's right hand is beautifully painted, as is his crisply modeled clothing. Mare has presented him as the proud, wealthy merchant he no doubt was at that time, posed beside an intricately carved Chippendale chair beneath elegant damask drapery. The viewer's attention focuses on Platt's sharply lit face, with its piercing eyes and unusually long chin, on which traces of beard are carefully indicated. The gray wig is finely detailed.

The unusually elaborate composition suggests that Mare may have been emboldened to attempt more difficult effects by the commission he had received the previous year for a portrait of George III, which must have included suitably regal attire and trappings. Mare's intensely realistic treatment of Platt may well have been derived from JOHN SINGLETON COPLEY; for he was probably in Boston in 1767. In its pose and composition, carefully and realistically painted face and hands, and sharp side lighting, Mare's portrait of Platt resembles several Copleys made about the same time, those of Epes Sargent, about 1764 (coll. Joyce and Erving Wolf), Woodbury Langdon, 1765–1766 (coll. Mrs. Thomas B. Foster, New York), and John Gray, 1766 (Detroit Institute of Arts). Although Mare could have developed these stylistic elements on his own, the only artist in America he could have learned them from was Copley.

Oil on canvas, 48½ × 38½ in. (123.1 × 97.7 cm.). Signed and dated on chairback: Jnᵒ Mare. / Pinx.ᵗ / 1767.

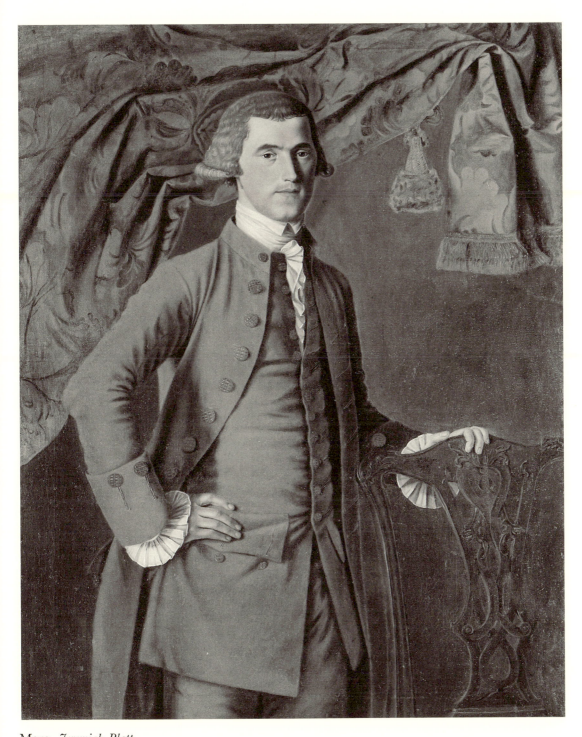

Mare, *Jeremiah Platt*.

REFERENCES: Inventory of the estate of Jeremiah Platt of New Haven, May 17, 1811, Connecticut State Library, quoted in H. B. Smith, *Antiques* 103 (June 1973), p. 1187 // E. E. Gardner, *MMA Bull.* 14 (Nov. 1955), pp. 61–63, speculates on identity of subject, calls portrait Mare's masterpiece // A. Winchester, *Antiques* 68 (Nov. 1955), pp. 458-459, says chair portrayed probably not a specific chair // Gardner and Feld (1965), pp. 54–55, call it "among the best paintings of the colonial period" // H. B. Smith and E. V. Moore, *North Carolina Historical Review* 44 (Jan. 1967), pp. 19, 23, 33, 51, note that it is the only known portrait by Mare in which the subject is shown at more than waist length, with both hands visible, and with a background // E. V. Moore, *Antiques* 98 (Nov. 1970), p. 808 // R. P. Mooz, in *The Genius of American Painting*, ed. J. Wilmerding (1973), p. 73, calls it a *portrait d'apparat*, says color extraordinary, cites definite rococo tendency in palette, says chair vies for attention with subject // H. B. Smith, *Antiques* 103 (June 1973), pp. 1185–1187, identifies subject, summarizes all that is known about him, gives history of painting, quotes from inventory of his estate // *MMA Bull.* 33 (Winter 1975–1976), color ill. no. 14.

EXHIBITED: MMA, 1965, *Three Centuries of American Painting* (checklist arranged alphabetically) // Pushkin Museum, Moscow, and Hermitage, Leningrad, 1975, *100 Kartin iz muzeya Metropoliten* [*100 Paintings from the Metropolitan Museum*], no. 79, ill. p. 222 // MMA, 1976-1977, *A Bicentennial Treasury* (see *MMA Bull.* 33 above).

EX COLL.: the subject, New Haven, Conn., 1767–1811; his brother, Ebenezer Platt, Huntington, N. Y., 1811–d. 1839; his son, Isaac Watts Platt, d. 1858; his son, Ebenezer Platt, Elizabeth, N. J., d. 1878; his son, Charles D. Platt, d. 1923; his brother, William Clifford Platt, Pleasantville, N. Y., d. 1946; his wife, Helen Doane Platt, Pleasantville, N. Y., 1946–1954; John Fremery (sale, Coleman Auction Galleries, New York, March 10, 1955); with Jon Nicholas Streep, New York, 1955.

Victor Wilbour Memorial Fund, 1955.
55.55.

JOHN DURAND

active 1765–1782

John Durand is thought to have come from Connecticut and is said to have been in Virginia by 1765. He is recorded the following year in New York, where he completed the six portraits of the children of the merchant James Beekman that are now in the New-York Historical Society. A payment of nineteen pounds, entered into Beekman's account book (NYHS), identifies the artist as "Monsier Duran," a spelling which many have interpreted as indicative of French, probably Huguenot ancestry. In 1767 Durand married Margaret McKinney in New York and advertised in the *New York Journal* that "Any young Gentleman inclined to learn the Principles of Design, so far as to be able to draw any objects and shade them with Indian ink or Water-colors, which is both useful and ornamental may be taught by John Durand . . . at his house in Broad Street, near the City Hall, for a reasonable Price" (quoted in William Kelby, *Notes on American Artists, 1754–1820* [1922], p. 6). The following year he placed another advertisement in the *New York Gazette* which provides an unusually direct glimpse into the psychology of the colonial artist. In it Durand solicited commissions for history paintings and confessed that "tho' he is sensible, that to excel (in this Branch of Painting especially) requires a more ample Fund of universal and accurate Knowledge than he can pretend to, in Geometry, Geography, Perspective, Anatomy, Expression of Passions, ancient and modern History, &c., &c. Yet he hopes from the good Nature and Indulgence of the Gentlemen and Ladies who employ him that his humble Attempts, in which his best Endeavours will not be wanting, will meet with Acceptance, and give Satisfaction; and

he proposes to work at as cheap Rates as any Person in America" (quoted in Rita S. Gottesman, *The Arts and Crafts in New York, 1726–1776* [1938], 1, pp. 1–2). Like many other artists working in America at this time, Durand aspired to the highest level of artistic achievement as defined by the European academies, although he himself may have had little idea of what traditional academic training involved.

Sometime in 1768, Durand went to Connecticut. He probably painted there until 1770, when two of his ads appeared in the Williamsburg *Virginia Gazette*. Abandoning his earlier pretensions, he now offered to paint "almost anything at a reasonable price" (Thomas Thorne, *William and Mary Quarterly* 6 [Oct. 1949], p. 567). From this time until 1782, when the last known reference to him appears in the Dinwiddie County, Virginia, tax list, Durand is believed to have remained in Virginia. There are signed portraits in the New Haven County Historical Society, all dated 1772, of two couples in New Haven, indicating that he went back to Connecticut sometime that year.

In the past the possibility that John Durand was the artist of the same name who exhibited landscapes at the Royal Academy in 1777 and 1778 has been entertained, but it is not likely; for no landscapes by him are known and the backgrounds of his portraits do not include detailed landscapes. WILLIAM DUNLAP, the earliest American writer to take notice of Durand's achievements, received his data on the artist from Thomas Sully's nephew, Robert Sully, and quoted him as saying: "He painted an immense number of portraits in Virginia; his works are hard and dry, but appear to have been strong likenesses, with less vulgarity of style than artists of his *calibre* generally possess." Whether Durand ever came under the direct influence of Copley is difficult to determine. He was surely aware of contemporary trends in fashionable portraiture but since the poses and props in his portraits are not borrowed from Copley, the linear quality of his works may simply be the result of a lack of training. Despite his obvious handicaps, Durand must be ranked among the most original American artists of the eighteenth century. His likenesses are usually appealing and his colors are at times truly remarkable.

BIBLIOGRAPHY: William Dunlap, *The History of the Rise and Progress of the Arts of Design in the United States* (1834, ed. 1918), 1, p. 169. Contains the earliest remarks on Durand's work // Wayne Craven, "Painting in New York City, 1750-1775," *American Painting to 1776: A Reappraisal*, ed. Ian M. G. Quimby, Winterthur Conference Report 1971, pp. 281-287. Emphasizes Durand's contribution to painting in New York during this period // Vals Osborne, unpublished paper, 1975, in MMA Department Archives. Gathers many of the known facts on the career of John Durand // Carolyn J. Weekley, "Artists Working in the South, 1750–1820," *Antiques* 110 (Nov. 1976), pp. 1046–1048. Suggests Durand was working in Virginia by 1765. // Franklin W. Kelly, "The Portraits of John Durand," *Antiques* 122 (Nov. 1982), pp. 1080–1087.

Boy of the Crossfield Family (possibly Richard Crossfield)

As in *Portrait of a Boy (probably of the Crossfield Family)* by WILLIAM WILLIAMS (q.v.), which was said to represent Stephen Crossfield, the identity of the sitter in this Durand portrait has not been substantiated. It was traditionally thought to represent Richard Crossfield. Although the portrait descended in the Crossfield (sometimes Crosfield) family as a depiction of the elder brother of Stephen Crossfield, no reference to a son of Stephen Crossfield, Sr., named Richard has been found. It is possible, of course, that the

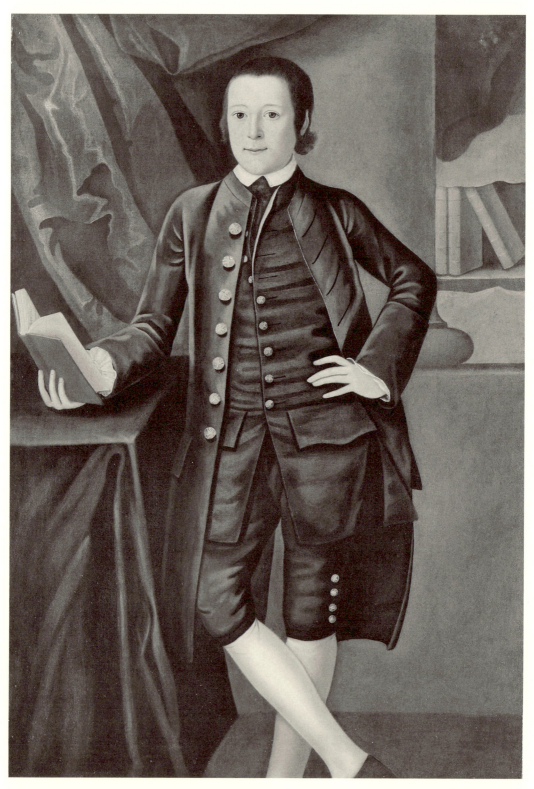

Durand, *Boy of the Crossfield Family* (*possibly Richard Crossfield*).

English-born shipbuilder Stephen Crossfield and Mary Kerbyle, who were married in New York on June 21, 1758, had a child in 1759. If so, the child would have been eight or nine years old at the time of Durand's residence in New York from 1766 to 1768. This is when the portrait was most likely painted. A son of the Crossfields, born in 1759, would be the same age as the boy in this portrait. Whether the identity of the subject is ever satisfactorily settled or not, the portrait is certainly one of the masterpieces of Durand's art. Unusual because of the ankle-length format and the exceptionally well-preserved condition in which it has survived, the picture emphasizes in a charming way the easy grace and aristocratic mien of an obviously well-bred youngster.

As in Durand's 1766 portraits of *Jane Beekman* and *William Beekman* (NYHS), the Crossfield boy is surrounded by books. In the case of the Beekmans these are clearly titled works by Erasmus, Ovid, and Vergil, which affirm the importance of a liberal, classical education in colonial times. In this portrait, however, there are no real titles, just a kind of pseudoscript.

Though handicapped by a lack of formal training, Durand made a virtue of his linearism in the way he arranged his compositions, which are extremely well-balanced and employ some highly original color combinations. In this work, the seriousness of the boy's attitude is appropriately complemented by a palette of dark and heavy reds, blues, and greens, all within the same tonal range.

Oil on canvas, 50¼ × 34½ (127.6 × 87.6 cm.).

REFERENCES: *MMA Bull.* 29 (Oct 1970), ill. p. 57, as Richard Crossfield, dated ca. 1770 // R. Davidson, *Antiques* 99 (March 1971), ill. p. 344 // MMA, *Notable Acquisitions, 1965–1975* (1975), p. 12.

EXHIBITED: MMA and American Federation of Arts, traveling exhib., 1968–1970, *American Naive Painting of the 18th and 19th Centuries*, pl. 12, as Richard Crossfield // Yale University Art Gallery, New Haven, and Victoria and Albert Museum, London, 1976, *American Art, 1750–1800*, no. 17, as Richard Crossfield // MMA and American Federation of Arts, traveling exhib., 1977, *The Heritage of American Art*, cat. by M. Davis, rev. ed. 1977, no. 10.

EX COLL.: descendants of the Crossfield family, until 1965; with Nathan Liverant and Sons, Colchester, Conn., 1966; Edgar William and Bernice Chrysler Garbisch, Cambridge, Md., 1966–1969.

Gift of Edgar William and Bernice Chrysler Garbisch, 1969.

69.279.2.

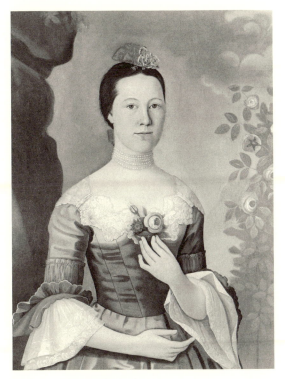

Durand, *Mary Bontecou.*

Mary Bontecou

Mary Bontecou was born on September 13, 1747, the daughter of the New Haven silversmith Timothy Bontecou and his second wife, Mary Goodrich. A craftsman of local prominence, Timothy Bontecou was the son of Huguenot parents, although he himself was an Anglican. It is said that he learned his trade in France. According to the records of the North Haven Church, Mary Bontecou was married to John Lathrop (sometimes spelled Lothrop) on January 13, 1774. She would have been thirty years old at this time. Lathrop is identified in the Bontecou genealogy (1885) as a New Haven furniture maker. Not very much else is known about him. He was probably a partner in the firm of Houghton and Lathrop, New Haven cabinetmakers, which advertised its business in 1784 and 1787 (see *Connecticut Historical Society Bulletin* 32 (Oct. 1967), p. 130). Mary Bontecou was his second wife; they had no children.

Since the pose in this portrait indicates that it was probably not one of a pair and because Mary Bontecou appears to be so young, it is likely

that Durand painted her before her marriage, during his 1768 to 1770 period in Connecticut. At the time the subject would have been in her early twenties. The existence of a matched pair of portraits by Durand, found in New Haven and traditionally known as Mr. and Mrs. John Lathrop (National Gallery of Art, Washington, D. C.), raises the possibility that Durand painted Mary Bontecou again after her marriage in 1774. It is difficult, however, to be certain it is the same woman; it could be Mr. Lathrop's wife of his first marriage.

In the portrait of Mary Bontecou, Durand's abilities are clearly evident. The outlines of the subject's face, shoulders, and arms are particularly pleasing, and the background elements compensate for her position to the left of the center of the canvas, thus balancing the work. Most remarkable, however, is Durand's palette, which is primarily shades of rose pink and aquamarine blue. Parts of the sky, the leaves of the rosebush, and the dress are painted in this pastel shade of blue, while the roses, the lace, and the flesh tints are varying strengths of pink. Durand's reliance on mezzotint prototypes always poses a problem when considering the iconography of his portraits; for it is difficult to know whether he meant specific motifs to refer to the sitter or whether he just copied what pleased him. In this case, the presence of roses may primarily refer to Miss Bontecou's womanly virtue or may be a decorative device. Certainly, the association of the rose, appealingly beautiful but difficult to pluck, with virtuousness is an old one.

A photograph of this painting taken before restoration shows that there was extensive damage and paint loss in several areas but mostly these were peripheral to the figure of the sitter. The family genealogy mentions a story that may well account for this.

An oil portrait . . ., torn and defaced, is in the possession of Mrs. Elisha Peck . . . of New Haven. Its dilapidated condition was thought by its possessor to be due to ill-treatment by the British in their raid on New Haven in 1779, but old Capt. Peter Storer . . . [said] that he and "Tom Bontecou" . . . found it in the garret when they were boys, and used it as a target for their arrows.

Clearly, their marksmanship was poor.

Four other portraits by Durand of members of the Lathrop family of Norwich, Connecticut, are known (Mary Perkins, *Old Houses of the Ancient Town of Norwich, 1660–1800*), 1, opp. pp. 134, 148) and indicate that the New Haven Lathrops were related to the families in Norwich.

Oil on canvas, $35\frac{1}{2} \times 27\frac{5}{8}$ in. (90.2 × 70.2 cm.).
REFERENCES: J. E. Morris, *The Bontecou Genealogy: A Record of the Descendants of Pierre Bontecou* [1885], p. 47 (quoted above) // R. W. Thomas, New Haven, letters in Dept. Archives, July 16, 1952, gives the provenance of this picture as provided by Mrs. Lage and information about the sitter; Sept. 30, 1963, gives further information on the sitter from records of North Haven Church // Gardner and Feld (1965), p. 56.
EXHIBITED: MMA and American Federation of Arts, traveling exhib., 1961–1964, *101 Masterpieces of American Primitive Painting from the Collection of Edgar William and Bernice Chrysler Garbisch*, color pl. 16, name mistakenly given as Mary Boticon Lathrop // MMA, 1968–1970, *American Naive Painting of the 18th and 19th Centuries*, color pl. 16; 1975–1977, *The Heritage of American Art*, exhib. cat. by M. Davis, no. 10.
EX COLL.: the subject, New Haven; her niece, Grace Bontecou (Mrs. Elisha Peck), New Haven, by 1885; her daughter, Mrs. William Whittemore Low, New Haven, her granddaughter, Charlotte Low Lage, Madison, Conn., by 1952; Edgar William and Bernice Chrysler Garbisch, Cambridge, Md., 1960 to 1962.
Gift of Edgar William and Bernice Chrysler Garbisch, 1962.
62.256.6.

CHARLES WILLSON PEALE

1741–1827

Charles Willson Peale, artist, inventor, scientist, writer, and museum founder was born in Queen Anne County, Maryland, one of five children of a country schoolteacher who died when Charles was nine. Mrs. Peale took her family to Annapolis where she worked as a seamstress to support them. Showing his artistic bent early, Charles drafted patterns for his mother's needlework and copied prints. At fourteen, he was apprenticed to a saddlemaker, and by the age of twenty, when he married Rachel Brewer from nearby South River, he had established his own shop.

Peale's first known commission was to paint portraits of a Maryland planter and his wife, for which he received the handsome sum of ten pounds. This success led in 1762 to a trip to Philadelphia where he visited the painting rooms of a Mr. Steele and of James Claypoole (1720–ca. 1796). With a copy of Robert Dossie's *The Handmaid to the Arts* and a supply of colors, Peale returned to Annapolis and advertised as a sign painter. In exchange for a fine saddle he was given further instruction by JOHN HESSELIUS, whose strong rococo style can be seen in one of Peale's earliest extant paintings, *Joshua Carter*, 1765 (private coll., ill. in Sellers, *Peale* [1969], p. 46).

At this time he began to take a strong interest in politics. His activities as one of the Sons of Liberty angered his Tory creditors, and they pressed him for repayment of his debts. To escape them, Peale fled to Boston, where he remained throughout the winter of 1765. It was there that he discovered the "high art" of JOHN SMIBERT, which featured, he wrote, whole groups of figures in "a style vastly superior" to any he had seen in Maryland (Sellers, *Peale* [1969], p. 45). He also sought out JOHN SINGLETON COPLEY, who received him kindly and lent him a portrait of a candlelit subject to copy as a test of skill. The picture is thought to have been *Henry Pelham*, 1765 (MFA, Boston), which was in Copley's studio at the time. The "highly finished" quality and naturalistic poses of Copley's work greatly impressed the young Peale and had a lasting effect on his work. When he returned to Annapolis he abandoned the formal rococo style of Hesselius and took up the fashionable and naturalistic one characteristic of Copley.

Impressed with his maturing skill, Charles Carroll (known as the Barrister) and John Beale Bordley formed a group of backers to finance a trip to London to further Peale's education. He arrived in England in February 1767 with a letter of introduction to BENJAMIN WEST, whose studio had become a home away from home for many American artists. Peale studied under West for two years and regarded him as the best painter in England, admiring both his technical ability and the grand scale of his history paintings. Nonetheless, Peale was not comfortable with the sophisticated painterliness of the English style. Much of his time was spent in painting miniatures, then greatly in demand, and this gave him the means to stay in London longer. He also learned to work in a number of mediums other than painting, including etching, mezzotint, and clay. His work was twice exhibited at the Society of Artists, where he was elected to membership.

In June 1769, the twenty-eight-year-old artist, having acquired a substantial amount of

artistic polish, returned to Annapolis, where he found ready employment painting portraits. He was soon established as one of the foremost artists in the colonies. In his works of this period Peale's own affability is always evident. Domesticity and family life is a constant theme. In each portrait there is a hint of provincial naiveté. Though their faces are solidly painted, Peale's sitters tend to have thin lips, small eyes, and hands that are awkwardly rendered. But typical of naive work, accessories of dress—jabots, shirt ruffles, and lace are meticulously drawn. There is usually a background landscape or a personal item that relates to the identity of the sitter. Peale treated light in a generalized broad and simple manner, and his palette was harmonious, dominated by soft local color. In a letter he wrote to Bordley in November of 1772, he admitted that some New Yorkers familiar with Copley's style had praised his work saying "that I paint more certain and handsomer likenesses than Copley" (Bolton, *Art Quarterly* 2 [1939], p. 367). Thus, after Copley's departure for England in 1774, Peale became, one might say by default, the leading painter in America. His canvases of this period portray many of the important men and women of the Revolution. His work was now in great demand, and the success he found in Philadelphia encouraged him to settle there permanently in 1776.

This was also the year war broke out, and Peale, like many other Americans, enlisted in the militia. He was commissioned a first lieutenant and following his participation in the battles at Trenton and Princeton, he was made a captain. But he was not at heart a fighter and spent as much time as possible painting miniatures of his fellow officers. He remained active during the campaign that drove the British from Philadelphia, but in 1779 he returned home. After one term as a representative to the General Assembly of Pennsylvania, he withdrew from politics and embarked on his most active years as a painter. His portraits during this middle period tended toward a sharp realism.

In October 1780 Peale moved his family from their home on Market Street to a larger house at Third and Lombard to which he added a gallery to show his portraits of revolutionary war heroes. His enthusiasm and inventiveness soon manifested itself in other ways. By 1784 he had begun collecting specimens for a museum of natural history. In time the collection grew to over 100,000 objects related to art and nature; it included an enormous variety of birds, animals, and reptiles, preserved by Peale and mounted in natural attitudes and painted habitat settings. His next project was the establishment of the Columbianum or American Academy of Fine Arts, the antecedent of the present-day Pennsylvania Academy of the Fine Arts. For the first exhibition, Peale produced his famous *Staircase Group*, 1795 (Philadelphia Museum of Art), an inventive trompe-l'oeil painting that violated every convention of eighteenth-century portraiture.

Always alert to the acquisition of any new specimen for his museum, Peale rushed to Newburgh, New York, in 1801 when news reached him of the discovery of some giant bones there. *The Exhumation of the Mastodon*, 1806–1808 (Peale Museum, Baltimore), is his celebration of the event. It includes nearly seventy-five figures, about two dozen of whom are identifiable friends, relatives, and scientists. Central to the composition is a great wooden tripod with special buckets designed and built by Peale to empty the pit. Within three months two mastodons were assembled by Peale—one installed at the American Philosophical Society in Philadelphia and the other sent on a tour of Europe.

For approximately the next twenty years Peale divided his time between administrative duties at the museum and his estate, Belfield, where he did experimental farming. At the age of seventy-four, he began to paint once more. These late works are distinct in both style and technique from the earlier pictures. There is a greater degree of characterization and more realistic delineation of features. His interest in lighting effects not only gives more contrast to the compositions but more substance to the subjects. He was most probably influenced by the style of his son REMBRANDT PEALE, who had studied in Paris in 1810. One of the great works from this period is a full-length self-portrait commissioned by the trustees of Peale's Museum. *The Artist in His Museum*, 1822 (PAFA), shows him drawing back a curtain in front of the museum gallery to reveal "his world in miniature." Near at hand are the symbols of his many interests: a stuffed bird, taxidermist tools, mastodon bones, and his palette.

Throughout his long life Peale continued to work as an inventor and craftsman. He received the first United States patent for a truss bridge. He invented a fireplace that consumed its own smoke, an improved kitchen chimney, a portable steam bath, and a perpetual oven to conserve heat. He made porcelain false teeth, ground lenses for spectacles, took silhouettes with a physiognotrace, improved the polygraph for copying documents, and made a milk cart that swung like a mariner's compass so that it was always level. In addition to his memoirs he wrote several practical essays.

Peale outlived three wives who bore him sixteen children, many of whom became artists. Together with his younger brother JAMES PEALE and his children, Charles Willson Peale and his offspring formed an extraordinary dynasty of artists.

BIBLIOGRAPHY: Charles Coleman Sellers, *Charles Willson Peale* (2 vols., Philadelphia, 1947). The most complete treatment of the artist's life // Charles Coleman Sellers, *Portraits and Miniatures by Charles Willson Peale*, vol. 42, part 1 of *The Transactions of the American Philosophical Society* (Philadelphia, 1952). An illustrated catalogue of some 1046 portraits by the artist // Charles Coleman Sellers, *Charles Willson Peale* (New York, 1969). Based on the 1947 book by Sellers, but includes new information // Charles Coleman Sellers, *Mr. Peale's Museum: Charles Willson Peale and the First Popular Museum of Natural Science and Art* (New York, 1980) // Edgar P. Richardson, Brooke Hindle, and Lillian B. Miller, *Charles Willson Peale and His World* (New York, 1983). Catalogue of a traveling exhibition held at the National Portrait Gallery, Washington, D. C., Amon Carter Museum, Dallas, and the Metropolitan Museum of Art.

Margaret Strachan
(Mrs. Thomas Harwood)

Margaret Strachan (1747–1821) was the youngest daughter of William and Mary Strachan of London Town, Anne Arundel County, Maryland. In 1772 she was married to Thomas Harwood who several years later became the first treasurer of the Western Shore of Maryland under the council of safety. They had two sons, William born in 1772 and Richard born in 1774.

Peale recorded a portrait of Miss Strachan in his 1770–1775 list of paintings which he drew up in an effort to collect outstanding fees when he was preparing to move from Annapolis to Philadelphia. Miss Strachan is listed as "M[iss] Peggy 3/4 5/5/-" (that is, three-quarter length for five guineas). Her name appears directly under her mother's, "Mrs. Streachan & copy 3/4 9.9.0." Peale had his own system of determining sizes and prices for his canvases. His half-length is the traditional three-quarter length, while his three-quarter is actually

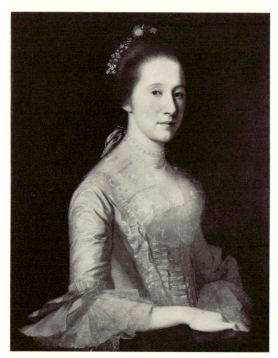

C. W. Peale, *Margaret Strachan*
(Mrs. Thomas Harwood).

a small half-length. Although the portraits are
undated, Sellers determined the date as about
1771, two years after Peale's return from London
and prior to the subject's marriage on January
16, 1772. Peale's later portrait of Thomas Har-
wood (Henry Francis du Pont Winterthur Mu-
seum, Winterthur, Del.) is recorded in his diary
(p. 155): "Mr. Harwood 3/4 5.5.0," where it is
noted as finished on November 12, 1775.

The gold tone, seen in the flickering high-
lights of Margaret Strachan's satin gown and
repeated in the lemon verbena crown in her
hair, serves to unify the picture. The placement
of her arm on the table forms a base to support
the composition. This pose is one Peale may
have first seen in the studio of JOHN SINGLETON
COPLEY and then later in London. Slightly rigid
and not as accomplished in handling when com-
pared to a Copley, Peale's portrait shows an
intimate and direct involvement between sitter
and painter. Here, he presents Margaret
Strachan as a self-possessed young lady, but he
also instills her portrait with a romantic feeling
and sensitivity. Sellers designated this work "the
most vivid and charming of Peale's portraits of
women, a personification of feminine grace and
dignity."

The success of this composition encouraged
Peale to use it several times. One sees the same
pose in *Mrs. Charles Carrollton*, 1771 (Brooklyn
Museum) and in the postmortem portrait *Mrs.
Charles Greenberry Ridgely*, 1773 (private coll.,
Dover, Del., ill. in Sellers, [1959], no. 734),
among others.

Oil on canvas, 31 × 24½ in. (78.7 × 62.2 cm.).
REFERENCES: *Arts* (May 1923), p. 333 // L. Bur-
roughs, *MMA Bull.* 28 (July 1933), cover ill; pp. 118–
119, discusses, gives subject as Mrs. Richard Har-
wood // *Art Digest* 19 (Aug. 1, 1933), gives subject as
Margaret Hall Harwood, ill. p. 12 // T. Bolton, *Art
Quarterly* 2 (1939), p. 426, fig. 15 // C. C. Sellers,
Portraits and Miniatures by Charles Willson Peale (1952),
pp. 4, 20, 21, 101, no. 370; ill. p. 285 // R. B. Hale,
MMA Bull. 12 (March 1954), p. 170, ill. p. 171 //
Gardner and Feld (1965), p. 59 // M. W. Brown et al.
American Art (1979), ill. p. 133; p. 134, says it "is strik-
ingly close to Copley in its intensity of focus, feeling
for material reality, and presence of personality."
EXHIBITED: PAFA, 1923, *Catalogue of an Exhibition
of Portraits by Charles Willson Peale, James Peale, and
Rembrandt Peale*, no. 43 (1st ed. lists as Margaret Hall
Harwood, 2nd ed. changes to Mrs. Margaret Strachan
Harwood, lent by Mr. Blanchard Randall // NAD,
1951, *The American Tradition*, no. 111 // Century As-
sociation, New York, 1953, *Exhibition of Paintings by
Members of the Peale Family*, no. 20 // PAFA, 1955,
The One Hundred and Fiftieth Anniversary Exhibition, no.
6, ill. p. 5; p. 17 // MMA, 1965, *Three Centuries of
American Painting* (checklist arranged alphabetically) //
Allentown Art Museum, Pa., 1976, *American Paint-
ings from the Metropolitan Museum of Art*, no cat. // Na-
tional Portrait Gallery, Washington, D. C.; Amon
Carter Museum, Dallas, MMA, *Charles Willson Peale
and His World*, cat. by E. P. Richardson, B. Hindle, and
L. Miller, color ill. no. 9, p. 43, say it is a fine example
of the precise drawing and delicate muted color of the
artist's Maryland style after his return from London;
p. 244, gives incorrect provenance // National Por-
trait Gallery, Washington, D. C., 1987, *American
Colonial Portraits, 1700–1776*, exhib. cat. by R. H.
Saunders and Ellen G. Miles, ill. no. 101; p. 292,
compares to portraits by Reynolds.
EX COLL.: the subject, d. 1821; probably her son,
Richard Harwood, Annapolis, d. 1835; his daughter,
Elizabeth (Mrs. George Fitzhugh Worthington),
Baltimore, d. 1887; her son, Hobart Worthington,
Baltimore, until about 1918; Blanchard Randall,
Baltimore, about 1918 to 1933.
Morris K. Jesup Fund, 1933.
33.24.

Portrait of a Man

The identity of this man and woman (see below) are unknown. Sellers (1952) dates the portraits about 1775 and refers to them as "unusual both for their size and vivid characterization." Indeed, their oval format and size give them the appearance of enlarged miniatures. Peale is known to have painted cabinet-size oils during revolutionary campaigns, but the only one located is his self-portrait in uniform, 1777–1778 (American Philosophical Society, Philadelphia).

Portrait of a Man has the warmth and immediacy that Peale captured in his portraits of close friends and relatives. With delicate brushwork, he depicts a man with an expression of great sensitivity. Painted precisely, yet quickly, the picture is notable, as Sellers says, for the subject's alertness and "apparent unawareness of posing." These two portraits do not appear on Peale's list of early works, which includes size and price—another indication that they were probably painted for a friend or family member for whom there would have been no charge.

The man's pose is similar to that in Peale's 1771 portrait of his brother-in-law David Ramsay (private coll. New York; ill. in Sellers, [1952], p. 282). There is also a facial resemblance to members of the Ramsay family. The work could perhaps be a portrait of Nathaniel Ramsay (1741–1817), husband of Peale's sister Margaret

Jane. Another possibility is the husband of his sister Elizabeth Digby Peale. This, however, cannot be verified because the only recorded portrait of Robert Polk (1744–1777) was destroyed by fire.

Oil on canvas, oval, 9¾ × 7⅞ in. (24.8 × 20 cm.).
REFERENCES: B. Burroughs, *The Metropolitan Museum of Art Catalogue of Paintings* (1931), describes subject as an elderly man // C. C. Sellers, *Portraits and Miniatures by Charles Willson Peale* (1952), p. 256, no. 1019; ill. p. 260, no. 1019 // Gardner and Feld (1965), pp. 59–60, note man's resemblance to the 1805 Peale portrait of Gilbert Stuart (NYHS).
EXHIBITED: Grey Art Gallery, New York University, 1976, *Circa 1776*, p. 13.
EX COLL.: Graham F. Blandy, New York, d. 1926; his wife, Mrs. Graham F. Blandy, New York, 1926.
Fletcher Fund, 1926.
26.129.1

Portrait of a Woman

This is a companion portrait to that of the man above. Here too the sitter bears certain characteristics similar to those of relatives of Charles Willson Peale. There are distinct facial similarities between this woman and Margaret Jane Peale (Mrs. Nathaniel Ramsay, 1743–1788) as she appears in *The Peale Family*, 1773 and 1808 (NYHS). The same is true for Peale's sister

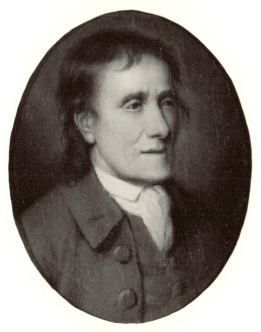

C. W. Peale, *Portrait of a Man.*

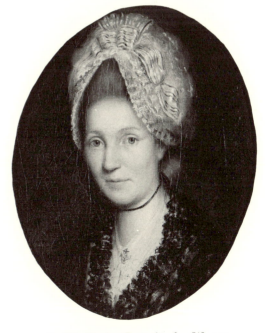

C. W. Peale, *Portrait of a Woman.*

Elizabeth Digby Polk (1747–ca. 1776). Certain other things could also point to Elizabeth, for instance, the sitter is wearing a gold anchor stickpin, and Mrs. Polk's husband, Robert, was a shipmaster. The woman also appears to be in delicate health, as was Mrs. Polk, who died about 1776, which could account for the sad expression on the man's face. But again, this is all speculative.

The woman is wearing the fashionable muslin Dormeuse cap which often varied in size according to one's coiffure. It has a ruched edge with a black and white striped satin ribbon encircling the crown, and its shape indicates a date in the late 1770s or early 1780s. The sitter wears a black shawl over a white modesty piece, which is fastened by the gold anchor stickpin.

Besides indicating that someone in her family might have been a seafarer, the anchor is an emblem of hope. The sitter's face lacks the meticulous handling one finds in her costume. By and large, the characterization is not as strong as in the portrait of the man.

Oil on canvas, oval, 9¾ × 7⅞ in. (24.8 × 20 cm.).
REFERENCES: B. Burroughs, *The Metropolitan Museum of Art Catalogue of Paintings* (1931), p. 272 // C. C. Sellers, *Portraits and Miniatures by Charles Willson Peale* (1952), p. 256, no. 1020 (quoted above); p. 260, listed, ill. p. 290, no. 1020 // Gardner and Feld (1965), p. 60 // P. Ettesvold, Costume Institute, MMA, 1979, memo in Dept. Archives, describes cap and notes when it was in fashion.
EXHIBITED: same as preceding entry.
Ex COLL.: same as preceding entry.
Fletcher Fund, 1926.
26.129.2.

Samuel Mifflin

Samuel Mifflin (1724-1781), the eldest son of Sarah Robinson and Jonathan Mifflin, was a prominent Philadelphia merchant. He was also influential in the city's political life. Mifflin held various offices, including justice of the peace, 1750, member of the common council, 1755, associate justice of the city court, 1756, and from 1773 to 1776, president of the court of common pleas. At the outset of the Revolution, Colonel Mifflin commanded three battalions of artillery in northern New Jersey. In 1778, he declined the commission of commodore of the Pennsylvania navy and returned to ci-

vilian life. Nonetheless, a year later he subscribed five thousand pounds to help re-equip the Continental Army. He died in Philadelphia on May 16, 1781.

Mifflin, a portly middle-aged man, is shown in civilian dress. The inclusion of elegant furnishings emphasizes his affluent status. He sits in a large damask upholstered Chippendale chair, his arm resting on a red tablecloth beside two calf-bound books. The drapery and the view of a ship from the window, an allusion to his mercantile pursuits, are standard conventions. The portrait is painted in Peale's best manner. The relaxed pose, forthright demeanor, and keen observation clearly indicate his indebtedness to Copley. In fact it is very similar to two of Copley's portraits that Peale may have seen on his visit to Boston in 1766: *James Otis*, ca. 1758 (Wichita Art Museum) and *John Murray*, ca. 1763 (New Brunswick Museum, Saint John). Peale, however, does not display Copley's talent for characterization or his great ability in handling fabrics. The pose too is not quite up to Copley's standard; it is, nonetheless, well-executed. Instead of the robust coloring typical of Copley's sitters the skin tones are pale, milky tints more characteristic of BENJAMIN WEST and the neoclassical English tradition.

The portraits of Samuel Mifflin and of Mrs. Mifflin and her granddaughter were at one time assumed to be by Copley and were published as such. Doubt was apparently cast on the attribution by Charles Henry Hart, who was proven correct when the paintings were cleaned in the 1920s, and the signature and date were revealed: "C W Peale pinxit 1777." According to Charles Coleman Sellers, Peale often dated his portraits by the year of the commission and not that of completion. Indeed in a letter of July 25, 1780, Peale wrote to Mifflin concerning payment for the two portraits, indicating that they were only half done. He was at this time trying to raise money to buy a house on Third and Lombard streets in Philadelphia; for the house he had rented on Market Street had been sold. Thus he explained to Mifflin:

I am . . . under the necessity of calling in the most pressing manner on those for whom I have done any painting, was money to be had on Interest I should not be so importunate but as it is, I do expect where the work is half finished, that at least I shall receive my half price agreeable to the Card enclosed I ought to have at the beginning. Your price which you

have to pay is by the Cheaper Card and I will finish your pictures amediately [sic] after I receive my first payment.

He included a notation that he regarded the portraits as half-lengths, for which his normal charge was £14. 14. each, and the charge for the inclusion of the child was another eight guineas.

Oil on canvas, 49⅞ × 39¾ in. (126.4 × 101 cm.).
Signed and dated at right: CWPeale pinxit 1777.
REFERENCES: C. W. Peale to S. Mifflin, July 25, 1780, Papers of Charles Willson Peale, American Philosophical Society, Philadelphia (quoted above) // A. T. Perkins, *John Singleton Copley* (1873), p. 86, attributes to Copley and gives owner as Dr. Charles Mifflin, Boston // C. W. Bowen, ed., *History of the Celebration of the Inauguration of George Washington as President of the United States* (1892), p. 509, quotes C. H. Hart as saying the portrait, formerly attributed to Copley, is by Peale and is in the collection of Mr. McMurtrie of Philadelphia // A. E. Rueff, August 5, 1922, letter in MMA Archives, says the frames on this and the companion portrait are original // J. H. Morgan to B. Burroughs, Nov. 10, 1922, says this picture and its companion were originally shown to him as by Copley, but he thought they were by Peale; notes that subsequent cleaning disclosed the signatures // J. M. Lansing, *MMA Bull.* 18 (Jan. 1923), p. 13-16; ill. p. 14 // A. E. Rueff, August 25, 1923, letter in MMA Archives, gives information on the provenance // B. Burroughs, *Catalogue of Paintings* (1931), p. 272 // W. A. Orton, *America in Search of Culture* (1933), p. 99 // B. N. Parker and A. B. Wheeler, *John Singleton Copley* (1938), p. 255, says attributed to Copley but unlocated since 1873 // *Magazine of Art* 39 (Nov. 1946), p. 278 // Gardner and Feld (1965), pp. 60-62 // T. Bolton, *Art Quarterly* suppl. to 2 (1939), p. 431 // C. C. Sellers, *Portraits and Miniatures by Charles Willson Peale* (1952), no. 547, pp. 141-142, gives biography of sitter, says 1777 is date of commission not completion // J. Wilmerding, *A History of Marine Painting* (1968), ill. no. 14, p. 22; p. 25, discusses it.
EXHIBITED: PAFA, 1923, *Exhibition of Portraits by Charles Willson Peale, James Peale, and Rembrandt Peale*, no. 118 // Century Association, New York, 1953, *Exhibition of Paintings by Members of the Peale Family*, no. 21 // Hudson River Museum, Yonkers, N. Y., *American Paintings from the Metropolitan Museum* (1970), no. 33 // MMA and American Federation of Arts, traveling exhibition, 1975-1977, *The Heritage of American Art*, cat. by M. Davis, no. 11, p. 42, ill. p. 43.
EX COLL.: the subject's daughter, Sarah (Mrs. Turbutt Francis); her daughter, Rebecca (Mrs. Matthias Harrison), Philadelphia; her daughter, Rebecca McMurtrie, Philadelphia; possibly in possession of her cousin, Dr. Charles Mifflin, Boston, 1873; Mrs. McMurtrie's son, James McMurtrie, Philadelphia, by

1876; his daughter, Sarah Josephine Wistar McMurtrie (Mrs. N. Dubois Miller), until 1922; with André E. Rueff, Brooklyn, as agent, 1922.
Egleston Fund, 1922.
22.153.1.

Mrs. Samuel Mifflin and Her Granddaughter Rebecca Mifflin Francis

Mrs. Mifflin was born Rebecca Edgell, daughter of Simon and Rebecca Edgell of Philadelphia. Her father died in 1742 and her mother in 1750. At that time Jonathan Mifflin was made executor of the family estate and guardian of Rebecca and her brother William. In the same year, Rebecca became the second wife of Mifflin's son Samuel. They had three children. The eldest, Sarah, was married in 1770 to Colonel Turbett Francis, son of Tench Francis. Of their four children, the second daughter, Rebecca Mifflin Francis, is portrayed here with her grandmother. Rebecca Francis was later married to Matthias Harrison of Philadelphia and had three children.

Mrs. Mifflin is shown instructing her grandchild from an emblem book illustrating the virtues of "CONJUGAL CONCORD / FELIAL LOVE / LOVE OF VIRT[UE] / DUTY TO [?]." The book is probably Peale's own copy of *Emblems, for the Entertainment and Improvement of Youth* (London, 1735). The child points to the central rondel, which illustrates a composition similar to this portrait inscribed "FELIAL LOVE."

The influence of Copley, so noticeable in the portrait of Samuel Mifflin (see above), is apparent here as well. Peale places Mrs. Mifflin in a damask upholstered chair and fills the entire bottom of the painting with the rich fabric of the dresses. The anatomy of both subjects becomes lost in the clothing, much as in Copley's *Mrs. Sylvanus Bourne* (q. v.). Indeed, there is a great show of finery. Mrs. Mifflin wears a pale mauve robe over a quilted blue petticoat of satin (which is now in the collection of the Philadelphia Museum of Art, 43-17-1). About her shoulders is a fichu edged in lace. She also wears a fancy shawl, an apron, and a ruched cap. The child's dress is a soft salmon color, which has a layer of sheer white embroidered material on top. Much like Copley, Peale shows a great deal of skill in rendering various fabrics and textures.

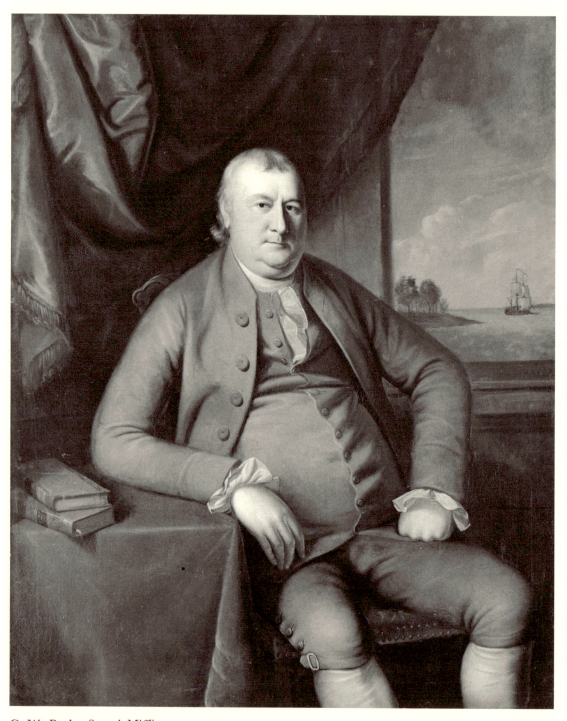

C. W. Peale, *Samuel Mifflin*.

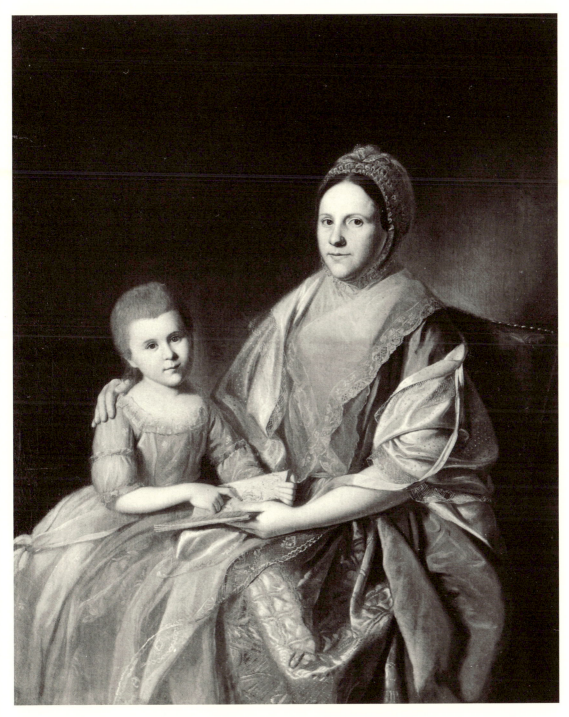

C. W. Peale, *Mrs. Samuel Mifflin and Her Granddaughter Rebecca Mifflin Francis.*

As Charles Coleman Sellers noted, the picture "is, in its grace and serenity, its comfortable softness and luxurious detail, a contrast to the strong, simple pose" of its companion piece, *Samuel Mifflin*. Characteristic of Peale, both subjects look directly at the viewer. In this scene of domestic tranquility, Sellers notes that Peale "achieved a more natural, harmonious grouping than this insistence upon a subject-spectator relationship generally allowed." Compared to a similar composition of a grandmother and child with a book, *Mrs. James Smith and Grandson*, 1776 (ill. Sellers [1952], p. 293), the Mifflin picture is more successful because of the smooth continuous curve of Mrs. Mifflin's left arm, which holds the book. The tender relationship is further emphasized by the hand on the child's shoulder and the forward lean of her body in response.

Oil on canvas, 50⅛ × 40¼ in. (127 × 101.8 cm.).

REFERENCES: A. T. Perkins, *John Singleton Copley* (1873), p. 86, lists it as by Copley, gives incorrect surname for granddaughter, and says it is owned by Dr. Charles Mifflin, Boston // B. C. Mifflin, *Charles Mifflin, M. D.* (1876), ill. opp. p. 19, from an old photograph; p. 30, says that it is by Copley and was in possession of the McMurtries // C. W. Bowen, ed., *Celebration of the Inauguration of George Washington* (1892), p. 509, says that it had previously been attributed to Copley but is now attributed to Peale, and is in the possession of Mr. McMurtrie of Philadelphia // J. M. Lansing, *MMA Bull.* 18 (Jan. 1923), pp. 13–16, ill. p. 14 // *New York Times*, April 8, 1923, ill. and discusses this picture in a review of PAFA show // B. N. Parker and A. B. Wheeler, *John Singleton Copley* (1938), p. 255, list as unlocated since 1873 // T. Bolton, *Art Quarterly* 2 (1939), p. 373, fig. 11; suppl. to 2 (1939), p. 431 // *Antiques* 43 (June 1943), ill. p. 281, and notes that Mrs. Mifflin's petticoat was recently acquired by the Philadelphia Museum of Art // C. C. Sellers, *Portraits and Miniatures by Charles Willson Peale* (1952), no. 548, p. 142; p. 261, dates between 1777 and 1780; ill. p. 295 // Gardner and Feld (1965), p. 62.

EXHIBITED: PAFA, 1923, *Exhibition of Portraits by Charles Willson Peale, James Peale, and Rembrandt Peale*, no. 169 // MMA, 1931, *Catalogue of Paintings*, by B. Burroughs, no. 6 // Newark Museum, 1947, *Early American Portraits*, no. 20 // Century Association, New York, 1953, *Exhibition of Paintings by Members of the Peale Family*, no. 22 // National Gallery of Art, Washington, D. C., City Art Museum of Saint Louis, Seattle Art Museum, 1970–1971, *Great American Paintings from the Boston and Metropolitan Museums*, exhib. cat. by T. N. Maytham, no. 13, p. 38; ill. p. 39 // Los Angeles County Museum of Art; M. H. de Young Memorial Museum, San Francisco, 1966, *American*

Paintings from the Metropolitan Museum of Art, no. 8 // MMA and American Federation of the Arts, traveling exhibition, 1975–1976, *The Heritage of American Art*, cat. by M. Davis, no. 11.

Ex COLL.: same as preceding entry.
Egleston Fund, 1922.
22.153.2.

George Washington

In 1779 Congress, in a jubilant mood, summoned George Washington to Philadelphia. The enemy had been expelled from New England, New Jersey, and Pennsylvania, and the French alliance was buttressing the American cause. Victory was near at hand. Eager to honor Washington, the Supreme Executive Council of Pennsylvania commissioned Charles Willson Peale to paint a portrait of him to hang in its chambers. For Peale it was the opportunity to do a monumental public commission at a handsome price. He later painted at least twelve full-length and five three-quarter-length copies, some of which went to major European collections. No other American artist's work had been so widely honored.

Painted between 1779 and 1781, all the full-length portraits are in a courtly style, which Thomas Jefferson described as "easy, erect, and noble" (quoted in Sellers, [1959], p. 225). The tall figure of Washington stands in a relaxed position, leaning slightly, with one hand on a cannon. In the first of these portraits (PAFA), Washington pauses after the Battle of Princeton, specifically indicated by the inclusion of Nassau Hall in the background. In other examples, Princeton is also shown, and later the scene is Yorktown. The background depicted in the Metropolitan painting, however, is Trenton. Of the eighteen known works, this is the only one with that view.

As Sellers notes, this painting "seems to have been painted for someone who preferred to memorialize that famous Christmas night, rather than the culminating and strategically more brilliant action at Princeton." Though the Battle of Princeton was a more decisive victory, the Battle of Trenton was the turning point of the war. It was the first American victory after a long series of humiliating defeats. An important moral victory, it encouraged the soldiers whose enlistments were to expire on December 31 to re-enlist.

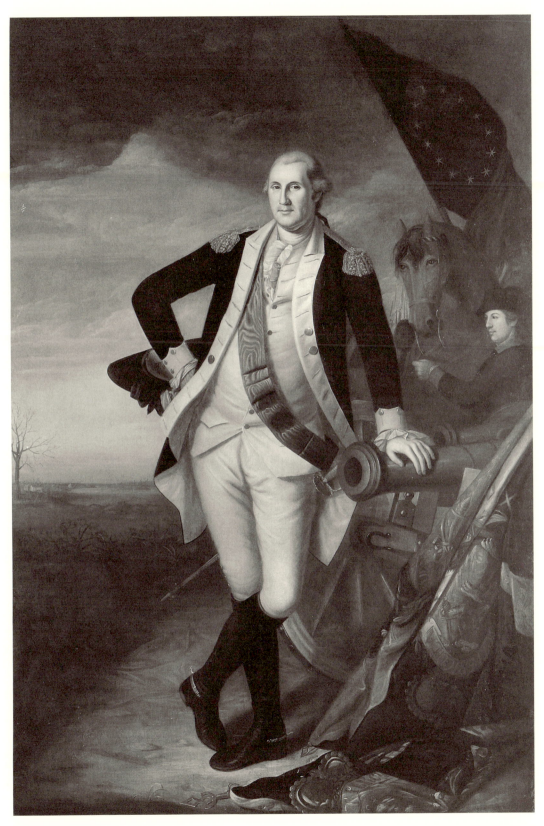

C. W. Peale, *George Washington*.

On February 22, 1779, Peale set out from Philadelphia on a tour of the Trenton and Princeton battlefields to sketch appropriate and specific backgrounds for his paintings. In the Metropolitan portrait Washington is shown standing on a knoll overlooking the Delaware River, from which he made his famous crossing to Trenton on Christmas night 1776. Close examination of the wintry-looking scene reveals a large structure with some houses directly behind it, a smaller one farther downriver, and beyond that a brick house with a cupola (the Trent House). A recent study of foundations dating back to about 1776 and a map of Trenton drawn by William S. Yard in that year reveal that most of the buildings Peale chose to depict remain intact as historic sites today. The large structure is the Old Barracks built in 1758 to house British soldiers during the French and Indian War. The Battle of Trenton took place within a short distance of the barracks. There is a small building beyond the barracks, which may be the mill indicated on Yard's map. The Trent House, named for its original owner (after whom Trenton is also named), was built in 1719.

The different paintings also show variations in Washington's uniform, each recording changes according to the date it was painted. The Metropolitan portrait was probably done between June and August 1780. In it Washington wears a blue silk sash, an example of which is in the collection of the Peabody Museum. Officers of lesser stature wore pink or green at this time. In June 1780, Washington ordered that officers discontinue the wearing of sashes and that silver stars replace the gilt rosettes on their epaulettes. In this picture the commander in chief wears three silver stars. Peale, however, included the blue sash in the portraits he painted until August 1780, perhaps for the grace and color it added to the composition.

Sellers suggested that the Metropolitan portrait may have been painted on Mrs. Washington's order because of its different background and because it is the only portrait in which Washington wears his elegant state sword (now at Mount Vernon)—also, of course, because the painting descended in the Washington family. The meticulous rendering of the chased hilt on the state sword indicates that Peale worked from the original. All the other portraits show Washington with a heavy battle sword at his hip.

The cannon on which Washington leans sym-

George Washington's dress sword, which Peale depicts in the portrait. Mount Vernon Ladies' Association.

bolizes the victory that is being celebrated, as do the captured Hessian flags that lie at his feet. The flag of the United States, which before June 1777 was blue with a circle of thirteen stars, plays a progressively more important role in the composition of these pictures. In the first work, the flag is farther to the right than it is here and on a plane parallel with Washington's head. In this picture, Peale has increased the sense of drama by placing the flag on a strong diagonal above Washington's head so that all the upward lines meet at that point.

The type of pose Peale chose was probably influenced by various English works he had seen. While different aspects can be related to the works of several English painters, the pose bears a close resemblance to two portraits of Admiral Edward Boscawen by Allan Ramsay. Peale's Washington combines elements from both these works. The first portrait, which was engraved by John Faber, Jr., in 1751, is similar not only in the posture of the figure but in the

placement of the hands. The second, or Badminton portrait, of about 1758, shows a full-length figure, knees crossed, leaning on a cannon.

Despite the monumental size and courtly pose, the picture is strongly realistic. Washington is portrayed with a small head and eyes—an ungainly figure with sloping shoulders, protruding stomach, and thin legs. Irrespective of this, the attitude conveyed is one of confidence and stoicism. Contemporary critics called the portrait a striking likeness. It was Peale's most successful official commission. While the pose is typical of English court paintings of its time, it is imbued with an American freshness. Peale's vigorous and realistic style evokes a sense of immediacy. Washington lacks the air of stern command; he is sensible and forthright, amiable and at ease—even slightly amused. In this series of paintings, Peale portrays him with more fidelity than most other well-known portraitists.

The Metropolitan's collection also includes a miniature on ivory of Washington by Charles Willson Peale. It was painted in 1779 for Martha Washington, while the general was en route to Trenton. Like this full-length painting, it descended in the family of Washington's niece Harriet.

The artist's brother JAMES PEALE painted a work similar to this large oil portrait. It is smaller and has Yorktown as the background (q.v.).

Oil on canvas, 95 × 61¾ in. (241.3 × 154.9 cm.).
RELATED WORKS: There are at least twenty similar portraits by Charles Willson Peale, see Sellers, (1959), pp. 225–233. Peale also did a mezzotint after the version in the PAFA, 14 × 10 in. (35.6 × 25.4 cm.), 1780, in which the pose is in reverse.
REFERENCES: *Collector* 8 (March 15, 1897), p. 145, 146, quotes C. P. Huntington's letter to MMA, announcing gift of this painting to MMA; discusses sash; gives information on provenance; (April 1, 1897), p. 167, C. H. Hart, writes correcting information on sash and says it was not included on the paintings Peale sent abroad // *Paintings in the Metropolitan Museum of Art* (1905), p. 134, gives provenance // *Picture and Art Trade* 50 (July 1, 1915), ill. p. 13, compares to version in PAFA // J. H. Morgan and M. Fielding, *The Life Portraits of Washington and Their Replicas* (1931), no. 11, p. 29 // G. A. Eisen, *Portraits of Washington* (1932), 2, pp. 349, 353 // T. Bolton, *Art Quarterly* 2 (Autumn, 1939), suppl., pp. 438–439, catalogued as replica no. 7 of the original full-length painted from life in 1779 // C. C. Sellers, *MMA Bull.* 9 (Feb. 1951), ill. on cover; p. 152, discusses changes

in uniform; says Peale must have had original sword to work from // C. C. Sellers, *Portraits and Miniatures by Charles Willson Peale* (1952), no. 914, pp. 230–231, dates it before August 1780, says probably painted "on Mrs. Washington's order," discusses sword; fig. 360 // A. T. Gardner, *MMA Bull.* 23 (April 1965), p. 271, fig. 11; p. 272 // Gardner and Feld (1965), pp. 62–64 // L. B. Wright et al., *The Arts in America, the Colonial Period* (1966), p. 213, pl. 146 // C. C. Sellers, *Charles Willson Peale* (1969), p. 169 // *MMA Bull.* 33 (Winter 1975–1976), ill. p. 239.

EXHIBITED: MMA, 1932, *Exhibition of Portraits of George Washington*, no cat. // Alabama State Fair, Birmingham, 1951, no. cat. // MMA, 1965, *Three Centuries of American Painting* (checklist arranged alphabetically); 1976, *A Bicentennial Treasury* (see *MMA Bull.* 33 above).

EX COLL.: the subject's niece, Harriet (Mrs. Andrew Parks), until 1822; her daughter, Mary Parks (Mrs. Milton Hansford); her cousin, Miss Bell, Tooting, Surrey; with Samuel P. Avery, Jr., New York, 1896; Collis P. Huntington, New York, 1896–1897.

Gift of Collis P. Huntington, 1897.
97.33.

Thomas Willing

The first president of the United States Bank and a leading merchant, Thomas Willing (1731–1821) was born in Philadelphia, where his father, Charles Willing, was a prosperous merchant and later mayor of the city. Thomas Willing was educated in England from the age of eight and studied law there briefly. He returned home in 1749 and worked in his father's countinghouse until his father's death in 1754. He then assumed control of the business and a year later formed a partnership with Robert Morris. The firm of Willing, Morris and Company eventually became the leading mercantile firm in the city. Willing was also active in political affairs. He was secretary of the Pennsylvania delegation at the Albany Congress in 1754. Beginning in 1757 he was a member of the common council, later a judge, and in 1763 mayor of Philadelphia. In 1767 he was appointed justice of the Supreme Court of Pennsylvania.

Willing was the first to sign the nonimportation agreement in 1765, which declared the Stamp Act unconstitutional. Yet, in 1774, an amicable settlement of English and colonial differences was foremost in his mind. At this time, Willing was president of the first Provincial Con-

gress of Pennsylvania, and a year later he was elected to the Second Continental Congress. Although he steadfastly championed colonial rights, he opposed those who were seeking separation from Great Britain. In July 1776, he voted against the resolution for independence and was not included in the new Pennsylvania delegation to Congress. He remained in Philadelphia during the British occupation. Morris, however, left and helped organize the new government.

Despite his earlier opposition to independence, when the Continental Army was on the brink of financial dissolution in 1780, Willing subscribed $25,000 to help re-equip its forces. A year later, when the Bank of North America was founded to provide funds for the revolutionary cause, Willing was chosen its president and served until 1791, when he was appointed head of the first Bank of the United States. Due to his sound financial judgment and steady application to tasks, Willing became known as the "Old Regulator."

Willing married Anne McCall in 1763, and they had thirteen children before her death, in 1781. In 1807 he suffered a paralytic stroke and resigned the presidency of the bank. He recovered, however, and in his ninetieth year died at his home in Philadelphia.

Charles Willson Peale painted this portrait in 1782, probably to celebrate Willing's recent election as president of the Bank of North America. Both Willing and Morris had been among Peale's early political opponents and were of the class with whom he sought to make amends in order to receive more portrait commissions. He seems to have accomplished this readily. He was commissioned to paint *Mrs. Thomas Willing and Son* in 1780 (private coll., Wilmington, Del.). This portrait of Thomas Willing and five commissions for Robert Morris were completed between 1782 and 1783. He also did miniatures of Willing's daughter and son-in-law Mr. and Mrs. William Bingham.

Peale portrays Willing as a dignified and successful man. A few months previous, Willing's

C. W. Peale, *Thomas Willing*.

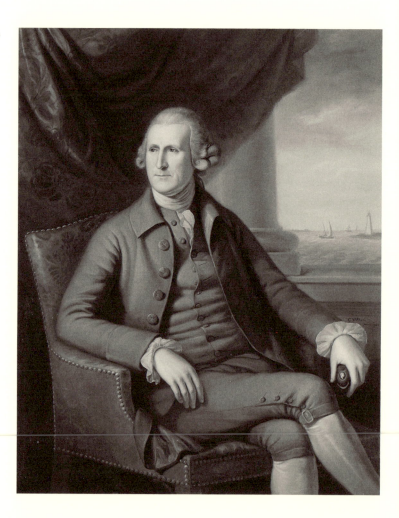

wife had died in childbirth, and in his expression Peale has captured both sensitivity and sadness. The pose is adapted from a mezzotint of Sir Isaac Newton by John Faber after the 1726 portrait by John Vanderbank (see Sellers, *Art Quarterly* 20 (Winter 1957), p. 424). Faber made two variants after Newton's death in 1727, and it is the final one, in which the sitter's head is turned sharply to the left, that Peale has followed here. In a richly upholstered Philadelphia armchair, Willing is seated before a conventional neoclassical column and a drawn-back drapery. To his left is a marine view, but rather than the standard view of a schooner, we see a pilot boat off a lighthouse. Peale has chosen a specific scene—the channel between Delaware's Cape Henlopen and Cape May, New Jersey. A crude lighthouse equipped with a whale oil lamp had been built at Cape Henlopen in 1725, the second to be built on the Atlantic Coast. In 1765 a more permanent hexagonal tower replaced it. The money to build it was raised by a lottery to which Willing was a major subscriber. The lighthouse was damaged by the British during the Revolution, but it was restored in 1784, probably again with funds raised by Willing.

Another personal effect in the painting is the snuffbox Willing holds in his left hand. It is oval in shape with a silver thumbpiece and appears to be made of tortoiseshell and jasperware. It bears a portrait medallion of George Washington, which is identical to ones produced by Josiah Wedgwood. Wedgwood based the head on a medal designed by Voltaire in 1778. Given Peale's careful inclusion of symbolic objects, it is likely that the snuffbox was a special gift to Willing. Washington is known to have presented such mementos to close friends; in fact, he gave a small watercolor portrait of himself to Willing's daughter in 1791, which is now in the collection at Mount Vernon.

Oil on canvas, 49½ × 39¾ in. (128.3 × 101 cm.). Signed and dated at right below ledge: C WPeale / pinxt 1782.

REFERENCES: B. A. Konkle, *Thomas Willing and the First American Financial System* (1937), ill. p. 40, gives owner as E. S. Willing // J. Biddle, *Antiques* 91 (April 1967), ill. p. 485, calls it one of Peale's "most penetrating studies of character" // R. C. Alberts, *The Golden Voyage*, ill. p. x // C. C. Sellers, *Antiques* 99 (March 1971), p. 405 // V. Osborne, April 24, 1973, letter in Dept. Archives, supplies information on provenance.

EXHIBITED: National Portrait Gallery, Washington, D. C., 1974, *In the Minds and the Hearts of the People* (not in cat.) // Roberson Center for Arts and Sciences, Binghamton, N. Y., 1975, *William Bingham*, ill. p. 20.

EX COLL.: the subject, Philadelphia, d. 1821; his son, Richard Willing, Philadelphia, d. 1858; his daughter, Ellen Willing; her brother, Edward Shippen Willing, Bryn Mawr, Pa. (according to a label on the stretcher); his daughter, Ava Lowle Willing (Mrs. John Jacob Astor, later Lady Ribblesdale), d. 1925; her grandson, Ivan Obolensky, by 1964 until 1966; with Robert G. Osborne, New York, 1966.

Purchase, Gift of Dr. Ernest G. Stillman, by exchange, 1966.
66.46.

Elie Williams

Elie Williams (1750–1822) was born in Prince Georges County, Maryland, to Prudence Holland and Joseph Williams. His older brother, Otho Holland Williams, later became a general and hero of the American Revolution. The family moved to what is now Williamsport, Maryland, soon after Elie Williams's birth. When he was twelve both of his parents died.

Williams joined the Frederick County Militia in January 1776 and attained the rank of colonel. After the war, until 1791, he served as quartermaster and from then until 1794 with Robert Eliot as agent for the United States Provision Department. Williams also served as chief clerk of the Washington County circuit court and in 1800 was succeeded in that post by his son Otho Holland Williams. In 1806 President Jefferson appointed Elie Williams road commissioner, during which time he helped to plan the Cumberland route west. In 1811 he formed a business partnership with David and Charles Carroll which consisted of paper mills and a grain distillery in the District of Columbia. It did not, however, prove profitable and was sold in 1819, at which time Williams retired from business. While surveying a route for the proposed Potomac Canal in 1822, he contracted yellow fever and died at his home in Georgetown. Williams had married Anna Barbara Grosh of Maryland and had a large family. His eldest daughter married United States Chief Justice John Buchanan.

Peale painted this portrait of Williams in 1789 during a period which, according to Charles Coleman Sellers, "was perhaps the most fin-

ished and assured of his whole career." He dispensed with all background detail. Painted in firm and crisp lines, Williams appears informally posed. Seated sideways in a Windsor chair, he holds a document in one hand, a quill in the other, and gestures to the viewer. Peale used this basic pose many times between 1788 and 1790, for example, in his portraits of John Swan, 1788, and Richard Tilghman, 1790 (see ills. no. 209 and 229 in Sellers, [1959], pp. 319, 325).

As a result of his incessant experimentation, Peale had problems with this picture. In search of brighter colors, he used untried materials. In his diary for July 26, 1791, he wrote that he was working to

repair the damage which had been done . . . by my using a new color, turpath mineral, very bright yellow, and which I had fondly imagined would give me great advantage in the strength and force of my coloring, but I consider it a great blessing that in the time of my using this color I did not paint many pictures, and I have now nearly retouched all the pieces where I had used it. Mr. Williams and Mrs. Ramsey were all that I remember to have painted from home. The effect of this color was that whenever it was used those places became of a lead color and . . . by many people those spots were thought to be caused by a dirty brush.

Peale's search for greater vibrancy indicates his direction away from the pastel palette of his earlier years. His portrait of Elie Williams emphasizes his success, especially in the robust flesh tints. He treated the costume in bold contrasts: Williams wears a deep blue-green jacket with brass buttons and a yellow waistcoat. At the same time Peale's realistic rendering also increased. The Philadelphia Windsor chair, with green paint worn down to the grain, is convincingly rendered. The sense of volume, careful detailing, and naturalism evident in this portrait anticipate Peale's *The Staircase Group* of 1795 (Philadelphia Museum of Art).

Oil on canvas, 36¼ × 27⅝ in. (92.1 × 69.4 cm.).
REFERENCES: C. C. Sellers, *Portraits and Miniatures by Charles Willson Peale* (1952), p. 90, no. 308, gives extract from Peale's diary July 26, 1791, in which Peale mentions repainting this picture (quoted above); p. 249, no. 983, dates the painting 1789, says it "is almost certainly the portrait of 'Mr. Williams,' painted in 1789 and repainted soon after because of the use of faulty pigments," gives owner as Arthur G. Camp; ill. p. 320, no. 213 // N. A. Goyne, *Antiques* 95 (April 1969), ill. p. 539, and describes the chair as a Philadelphia style, fan-back Windsor side chair.

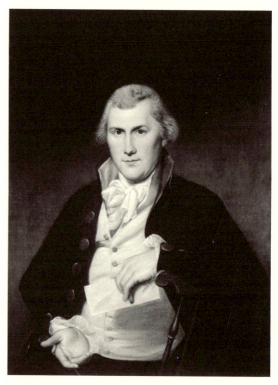

C. W. Peale, *Elie Williams.*

EXHIBITED: Rhode Island School of Design, Providence, 1936, *American Portraiture, 1750–1850*, as Eli Williams, lent by Macbeth Gallery // Macbeth Gallery, New York, 1937, *Portraits by Eleven American Artists*, no. 7 // Washington County Museum of Fine Arts, Hagerstown, Md., 1937, *American Painting before 1865*, p. 14, no. 4, mistakenly as Otho Holland Williams, lent by Mrs. Coralie L. Bell Douglas; ill. p. 15 // Ferargil Galleries, New York, 1938, *Early American Portraits*, no. 9, as Col. Eli Williams // American Federation of the Arts and MMA, traveling exhibition, 1975–1977, *The Heritage of American Art*, cat. by M. Davis, no. 12.

Ex COLL.: the subject, Georgetown, District of Columbia, d. 1822; his son, Otho Holland Williams, d. 1869; his daughter, Sarah S. Williams (Mrs. William Ragan), Hagerstown, Md.; her daughter, Ellen Williams Ragan (Mrs. Henry Bell), Hagerstown, Md., her daughter, Coralie Livingston Bell (Mrs. J. Wyeth Douglas), Washington, D. C., 1936; with Macbeth Gallery, New York, by 1936; Arthur G. Camp, Litchfield, Conn., by 1941–1957; with Kennedy Galleries, New York, 1957; I. Austin Kelly, III, New York, 1957–1967.

Gift of I. Austin Kelly III, 1967.
1967.242.

HENRY BENBRIDGE

1743–1812

Henry Benbridge was born into a moderately well-to-do family in Philadelphia. His early work seems strongly influenced by JOHN WOLLASTON, who visited Philadelphia in 1758 and may have given him some instruction. The young Benbridge was extremely ambitious and like many other American artists wished to proceed directly with history painting, which he had read was the highest art a painter could create. In a letter discussing the early artists in this country, CHARLES WILLSON PEALE recalled: "Mr. Benbridge born in Phi[l]a: his Mother lived in lodge Alley which Mr. Benbridge covered with paintings as large as life coppied chiefly from Raphaelle's prints" (C. W. Peale to Rembrandt Peale, Oct. 28, 1812, L. B. Miller, ed., *The Collected Papers of Charles Willson Peale and His Family* [Washington, D. C., 1980]).

Benbridge's efforts to imitate Raphael must have presented an unusual appearance, judging from his painting done from a print after a Rubens tapestry, *Achilles among the Daughters of Lycomedes* (private coll., ill. in Stewart [1971], p. 15, fig. 2), which has oddly sharp lighting and confused anatomy.

In 1765, having received his inheritance from his father's estate, Benbridge was in Rome, sharing quarters with the Irish sculptor Christopher Hewetson. There he is said to have studied with Pompeo Batoni and Anton Raphael Mengs, although no actual evidence of this has been found. Clearly their influence is apparent in his portrait of General Pascal Paoli (Fine Arts Museums of San Francisco), which he painted in Corsica at the request of James Boswell, the biographer of Samuel Johnson. Paoli, the Corsican patriot, was a celebrity among eighteenth-century intellectuals in England, and when Benbridge's portrait was exhibited in London in 1769 it was widely discussed. The *London Chronicle* (May 6–9, 1769) noted: "all who had seen the general thought it a striking likeness The painter has taken great pains, and has finished the face in a very masterly manner." Later in 1769 Benbridge went to London, where he exhibited two other portraits at the Royal Academy that are now unfortunately lost. With the encouragement of BENJAMIN WEST, he seems to have considered setting up in the practice of portrait painting in London, but he returned to Philadelphia in 1770, carrying letters of recommendation from West and Benjamin Franklin. At about this time, he married Letitia Sage, a miniature painter.

The portrait of an unknown gentleman of 1771 (National Gallery, Washington, D. C.), the first of only two known dated works done by Benbridge after his return to America, indicates that he had assimilated West's latest portrait style. Yet in this and other portraits apparently from the 1770s, he seems to have also developed something of his own manner. Edgar P. Richardson pointed out: "As Benbridge saw these men, there is no *panache*, no cheerful sense of adventure: their faces are brooding, almost melancholy, as if they faced a troubled future with determination but also with foreboding" (*American Art Journal* 7 [May 1975], pp. 31–32).

Benbridge moved from Philadelphia to Charleston in 1772, two years before the death of the leading portrait painter in that city, JEREMIAH THEÜS. Imprisoned by the British after

the fall of Charleston in 1780, Benbridge was exiled to Saint Augustine, Florida. After the war he returned briefly to Philadelphia. Then, in 1784, he resumed painting portraits in Charleston and remained there until at least 1788. By 1801, his health had failed, and he was living with his son in Norfolk, Virginia, where, according to WILLIAM DUNLAP, he was seen by THOMAS SULLY. By this time, he appears for the most part to have ceased painting; for only two works, both self-portraits, are known from these last years. He may have moved with his son to Baltimore around 1810. His death in Philadelphia in 1812 attracted so little attention that Peale later wrote in his autobiography that Benbridge had died in Charleston.

Of the portraits he painted in Italy, his biographer Robert G. Stewart has written that Benbridge "apparently never studied or took an interest in anatomy and he never learned to draw. In all four of these paintings Benbridge's tendency to enlarge the forehead of the subjects and to diminuate the bodies is evident" ([1971], pp. 17–18). His work is very uneven in quality and shows a multiplicity of stylistic influences ranging from Mengs and Batoni, Gainsborough, West, and the British caricaturist Thomas Patch to Charles Willson Peale and even JOHN SINGLETON COPLEY. His use of very dark shadows, a practice much frowned upon by Dunlap and later by the Charleston artist Charles Fraser (1782–1860), may have had its origins in Copley's portrait of John Bee Holmes, 1765 (coll. H. Richard Dietrich, Jr., Philadelphia), which probably came to Charleston in 1765. Benbridge's self-portrait of about 1793 (private coll., ill. in Stewart [1971], p. 28) is strikingly like the Copley in pose and exaggerated side lighting. With few of his portraits dated, it is hard to follow his artistic development after his return to America. His works of the early 1770s, such as *Charles Cotesworth Pinckney* (National Portrait Gallery, Washington, D. C.) and *Benjamin Loring* (coll. Mr. and Mrs. Samuel P. Sax, ill. in Stewart [1971], no. 35), are elegantly colored and sharply modeled. Some of his works of the 1780s, such as the cabinet picture of the Enoch Edwards family (Philadelphia Museum of Art) are harshly lit and almost primitive.

BIBLIOGRAPHY: Henry Benbridge Papers, Gordon Saltar Collection, Henry Francis du Pont Winterthur Museum, Winterthur, Del. // Anna Wells Rutledge, "Henry Benbridge (1748–1812?), American Portrait Painter," *American Collector* 17 (Oct. and Nov. 1948), pp. 8–10, 23; 9–11, 23 // Robert G. Stewart, "The Portraits of Henry Benbridge," *American Art Journal* 2 (Fall 1970), pp. 58–71 // National Portrait Gallery, Washington, D. C., *Henry Benbridge (1743–1812): American Portrait Painter*, exhib. cat. by Robert G. Stewart (1971). Illustrated catalogue of known or recorded works by Benbridge, includes bibliography.

Portrait of a Gentleman

This is one of Benbridge's finest works. Its history is unknown beyond a previous owner's statement that it was purchased in New Hope, Pennsylvania. It is very close in style to Benbridge's portrait of an unknown gentleman in the National Gallery, Washington, dated 1771. The general assurance and refinement of the work suggest a similar date, soon after Benbridge's return from Europe in 1770, and its purchase in Pennsylvania also suggests that it might have been painted in Philadelphia, indicating a date of 1770 to 1772, when Benbridge left for Charleston. It has been suggested (1971) that the portrait was painted in South Carolina or Georgia, based on the "hint of Spanish moss" in the background. Close examination, however, shows this not to be Spanish moss but trailing vines with green leaves, which do not restrict the location to the South. In fact, it is likely that the landscape is imaginary.

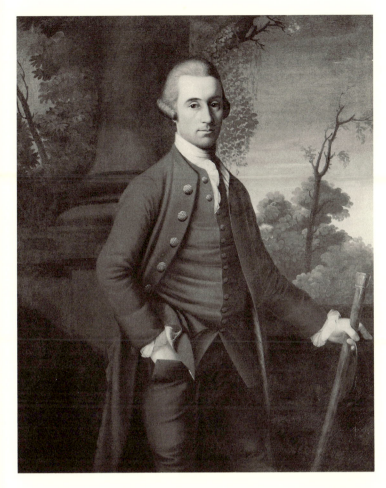

Benbridge,
Portrait of a Gentleman.

As in some other Benbridge portraits there is a gentleness to the subject's gaze and a calm, almost melancholy, air. The most remarkable aspect of the picture is the confidence and elegance with which it is painted. Benbridge's study in Italy clearly had paid off for him as an artist. The rich reddish brown of the clothing is subtly echoed in the column and even slightly in the sky, and the coloring of the subject's face is carefully and beautifully rendered. The composition is well balanced with the figure placed exactly in the center of the canvas and the column behind countered by the walking stick and upthrust of the tree at the right. The landscape is delicately and beautifully painted in shades of green and brown. The subject's legs, however, are awkwardly drawn and diminutive.

Although the composition and pose of this portrait can be traced back at least as far as Anthony Van Dyck, a more likely source is to be found in the work of Thomas Gainsborough, which was fashionable when Benbridge was in London. Moreover, the shading of the left side of the head is so close to Gainsborough's characteristic manner as to suggest that Benbridge may have based this painting on a print after a Gainsborough portrait.

Oil on canvas, 49¼ × 39½ in. (125.1 × 100.3 cm.).

REFERENCES: undated note in Dept. Archives, says portrait was bought in New Hope, Pa. || *MMA Bull.* 29 (Oct. 1970), p. 57, dates it in the early 1770s || *Antiques* 99 (Feb. 1971), p. 208.

EXHIBITED: National Portrait Gallery, Washington, D. C., 1971, *Henry Benbridge (1743–1812)*, exhib. cat. by R. G. Stewart, no. 55.

EX COLL.: Albert Duveen, New York, by 1965; with Anton Rudert, New York, 1969.

Morris K. Jesup Fund, Maria DeWitt Jesup Fund, and Louis V. Bell Fund, 1969.

69.202.

Mrs. Benjamin Simons

When this portrait came to the museum, the subject, according to family tradition, was identified as Mrs. Benjamin Simons (ca. 1675–1737), the former Marie Esther Du Pré of Charleston, South Carolina. A descendant, Charles Lennox Wright, who had specialized in the family genealogy, pointed out in 1942 that since Benbridge first visited Charleston in 1771 or 1772, long after the death of that Mrs. Simons, the subject of this portrait was probably her daughter-in-law Mrs. Benjamin Simons (ca. 1710–1776), the former Ann Dymes Dewick. The same year, Anna Wells Rutledge, an authority on Charleston artists, suggested that the sitter might be the younger Mrs. Simons's sister-in-law. In 1955, Wright reported to the museum his very thorough and painstaking research indicating that the younger Mrs. Benjamin Simons was indeed the subject. In 1755, when she became Simons's second wife, she was a widow with four children. He was the owner of a large plantation, Middleburg, near Charleston, where he was a rice and slave merchant. The family lived in Charleston, and Mrs. Simons was a supporter of Saint Philip's Church, where she is buried.

The date of the portrait is sometime between 1771, when Benbridge first visited Charleston, and 1776, the year of the subject's death. It forms a striking contrast to *Portrait of a Gentleman* (see above). Whereas that work is smoothly and elegantly painted, the present one is by comparison almost crudely rendered. The face is painted with broad, undifferentiated strokes, and the color in the cheeks is unconvincingly applied. The pink chair and drapery are badly modeled, and their color entirely lacks the subtlety of the other work. The landscape, too, is rough and unappealing, consisting of daubs of dark green paint applied in a fashion almost completely unlike the beautifully painted and colored landscape background of *Portrait of a Gentleman*. Like many other American artists trained in Europe, Benbridge seems to have been unable to sustain the high style he had acquired there, and it became a progressively thinner veneer over the provincialism with which he had begun.

Benbridge, *Mrs. Benjamin Simons.*

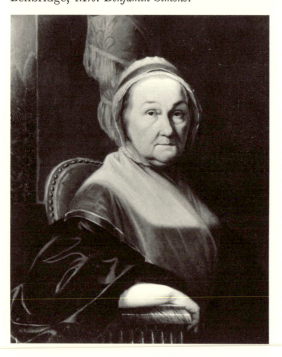

Oil on canvas, 29⅞ × 25 in. (75.5 × 63.5 cm.).

REFERENCES: C. L. Wright, letters in Dept. Archives, 1942, refutes previous identification of sitter as Marie Esther Du Pré, wife of Benjamin Simons, suggests that she might be Ann Dewick, second wife of his son Benjamin // A. W. Rutledge, letter in Dept. Archives, March 21, 1942, proposes another identity for the subject // *American Collector* 17 (Oct. 1948), ill. p. 10, as portrait of an unidentified lady, and (Nov. 1948), p. 11, as "Mrs. Simons (?)" // C. L. Wright, letter in Dept. Archives, Jan. 25, 1955, establishes identity of sitter as Ann Dewick Simons, gives provenance // Gardner and Feld (1965), p. 65 // R. G. Stewart, *American Art Journal* 2 (Fall 1970), p. 67, says shows Benbridge's sympathy with older women.

EXHIBITED: World's Fair, New York, 1940, *Masterpieces of Art*, no. 177, as Mrs. Simons (née Dupré), but says painted about 1790 // MMA, 1965, *Three Centuries of American Painting* (checklist arranged alphabetically), as Mrs. Benjamin Simons II // National Portrait Gallery, Washington, D. C., 1971, *Henry Benbridge (1743–1812)*, exhib. cat. by R. G. Stewart, ill. no. 51, calls it one of Benbridge's "most sympathetic and impressive pictures of an old lady," and dates it shortly before her death in 1776.

EX COLL.: the subject, Charleston, d. 1776; her son, Robert Simons, 1776–1807; his widow, Mary Harlbeck Simons; Benjamin Bonneau Simons, Charleston, until 1845; his daughter, Maria Simons, 1845–1886; her sister, Jane Van der Horst Simons Bowly; her sons, George Hollins Bowly and E. Heyward Bowly, 1922–1929.

Fletcher Fund, 1929.

29.58.

JAMES PEALE

1749–1831

James Peale, the youngest brother of CHARLES WILLSON PEALE, was born at Chestertown, Maryland, the son of an immigrant schoolteacher. He spent his early years in Annapolis as an apprentice to Charles in the saddlery trade. Later he also worked as a carpenter and a cabinetmaker. About 1770, again under the guidance of Charles, he learned to paint in oils and watercolors and was grounded in the principles of portraiture. Essentially an assistant in his brother's studio, he turned out copies and painted a little from life. It is known that he made a copy after his brother's copy of a BENJAMIN WEST *Venus* after Titian. James Peale thus benefited from the training his brother had received in London under West. This accounts for much of his sophistication as an artist, that is to say, his awareness of stylistic trends, his versatility in technical matters, and his interest in different genres.

During the American Revolution, Peale saw active military service and reached the rank of captain before his resignation on June 1, 1779. This event was precipitated by a dispute over the date of his promotion and recalls the behavior of JOHN TRUMBULL under similar circumstances. On leaving the army, James Peale went to Philadelphia, where he helped his brother with the many portraits of George Washington he was commissioned to do at that time. James is believed to have made a trip to Yorktown in 1781. This would account for his interesting attempt at history painting, *The Generals at Yorktown*, ca. 1781–1790 (two versions, Colonial Williamsburg, Va., and private coll.), and for the Yorktown background in some of his brother's Washington portraits. Except for these, James Peale gave little indication of his own artistic preferences at this time. After his marriage to Mary Claypoole, daughter of the painter James Claypoole (1720–ca. 1796), in November of 1782, however, the situation changed.

Now living in his own house and possessing his own studio, James Peale began to produce works in a distinct style, among them small portraits of Washington at Yorktown (q.v.). In October of 1786, James and Charles Willson Peale ran an advertisement to announce that they were dividing their painting business. James was to concentrate on miniatures and Charles on oil portraits. But it is clear that this promised division of labor was not rigidly followed. James Peale's *The Ramsay–Polk Family*, ca. 1793 (private coll.), a conversation piece in the English style, and *The Fight between Captain Allan McLane and the British Dragoons*, 1803, a history painting of a fairly contemporary scene of which there are two versions (both private colls.; ill. M. Snyder, *City of Independence* [1975], p. 265, fig. 180), demonstrate his eagerness to experiment. After this time, James Peale's oil portraits reflect the influence of French neoclassicism. His painting technique proved to be particularly suited to this style. His *Madame Dubocq and Her Children*, 1807 (J. B. Speed Art Museum, Louisville, Ky.), though slightly stiff, must be ranked with the finest and most ambitious American neoclassical portraits. It was probably his excellent painting of miniatures, however, that kept James Peale alive. For this talent he was assiduously sought after until 1818 when his eyesight began to fail. From then on, he specialized in still-life painting, again bringing to his work

an inquisitive intellect and a keen imagination. A painting such as *Still Life: Balsam Apple and Vegetables* (q.v.) clearly establishes him as one of the master still-life painters of this period.

BIBLIOGRAPHY: *DAB* (1934; 1962), s. v. "Peale, James" || Charles Coleman Sellers, "James Peale," in Maryland Historical Society, Baltimore, *Four Generations of Commissions: The Peale Collection of the Maryland Historical Society* (1975), exhib. cat., pp. 29–33. Gives a sensitive evaluation of his career || John I. H. Baur, "The Peales and the Development of American Still Life," *Art Quarterly* 3 (Winter 1940), pp. 81–92.

George Washington

After the completion of the full-length portrait of Washington commissioned by the Supreme Executive Council of Pennsylvania in 1779, CHARLES WILLSON PEALE was besieged with orders for copies of the work. (For further information, see entry on Charles Willson Peale, *George Washington*.) To meet this demand in the ensuing years he was assisted by his brother James and other family members. Thus a large number of copies emerged from his studio. These works exhibit significant variations in details and

in background composition. They are not all comparable in quality, and, given the fact that only a few are signed, a number of them must bear uncertain attributions. The present work is an unsigned copy. It was once thought to have been painted by Charles Willson Peale, but for some time now students of the Peales have agreed that the bright palette and crisp outlines indicate that it is more likely the work of James.

Other qualities of the painting buttress this attribution. To begin with, the representation of the sky as filled with light and not quite convincing cloud forms is typical of James Peale's

James Peale, *George Washington*.

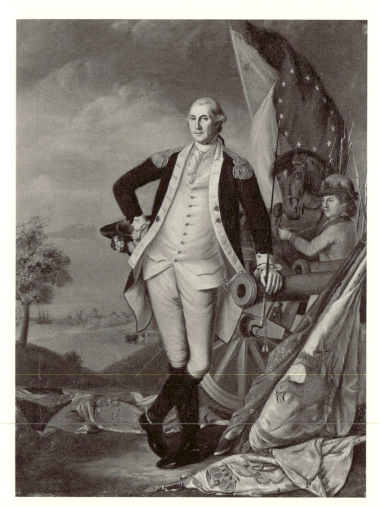

Washington at the Battle of Princeton, signed and dated 1804 (Henry Francis du Pont Winterthur Museum, Winterthur, Del.). It is also similar to *Horatio Gates* (Maryland Historical Society, Baltimore), which is unsigned but securely given to James on the basis of its close affinity to the 1804 Washington portrait. Both paintings depict the sky in the same way. The tree at the left in the Metropolitan picture is very similar to the one in the Gates portrait. Furthermore, the size of the painting is the same as the works by James Peale just mentioned as well as his half-length portraits of Washington (see J. H. Morgan and M. Fielding, 1931, pp. 125-127). According to Charles Coleman Sellers (1952), James Peale painted all these works after leaving his brother's house in November of 1782.

Shortly after the defeat of the British by combined Franco-American land and sea forces in October of 1781 at Yorktown, James Peale made a trip there to become acquainted with the topography. He then included a view of the harbor at Yorktown featuring sunken ships in *The Generals at Yorktown*, ca. 1781–1790 (two versions, Colonial Williamsburg, Va., and private coll.). The same view appears in the Metropolitan painting and in a portrait of Washington sold by Charles Willson Peale to the comte de Rochambeau in July 1782 (probably painted by both brothers, see Sellers, 1952, p. 232). This choice of site explains the presence of the blue Bourbon flag next to the American standard, as well as the flags of various British regiments lying at Washington's feet. These variations, together with the unusual representation of Washington holding a riding stick, are probably the result of James Peale's intervention and are sufficiently important to establish this work as something more than a mere copy of the Charles Willson Peale original.

Oil on canvas, 36 × 27 in. (91.4 × 68.6 cm.).

REFERENCES: J. H. Morgan and M. Fielding, *The Life Portraits of Washington and Their Replicas* (1931), p. 32, no. 18, attribute this work to C. W. Peale // J. H. Morgan, letter in Dept. Archives, Feb. 9, 1932, says it is by James Peale // C. C. Sellers, *Portraits and Miniatures by Charles Willson Peale* (1952), p. 232, states, "It should be noted that it was not until November [1782] that James Peale married and set up for himself, an event followed by the emergence of Washington full lengths of a distinctly different flavor and a smaller size which may with some plausibility be ascribed to him" // Gardner and Feld (1965), pp.

66–67 // W. D. Garrett, *MMA Journ.* 3 (1970), p. 327, ill. p. 328.

EXHIBITED: MMA, 1896, *Retrospective Exhibition of American Paintings*, no. 201, as by C. W. Peale; 1958, *Fourteen American Masters* (no cat.) // MMA and American Federation of Arts, traveling exhibition, 1975–1977, *The Heritage of American Art*, cat. by M. Davis, no. 13, as by Charles Willson Peale.

EX COLL.: William H. Huntington, Paris, d. 1885. Bequest of William H. Huntington, 1885.

85.1.

Still Life: Balsam Apple and Vegetables

This is one of the acknowledged masterpieces of American still-life painting and one of Peale's most ambitious works in this genre. Given the variety of textures and shapes depicted, it must be considered something of a tour-de-force. Peale includes a pyramidally arranged and carefully balanced assortment of vegetables. They are identified, from left to right, as okra, blue-green cabbage, crinkly Savoy cabbage, Hubbard squash, eggplant, balsam apple, tomatoes, and purple-red cabbage. These are presented by themselves, without kitchen utensils, porcelain baskets, or other man-made objects, in a lavish horticultural display that denotes the fertility of the land, possibly in the warm, southern part of the country where okra and balsam apples naturally grow. The balsam apple, a kind of gourd long used in treating wounds, is suggestive of the healing power of nature.

In many ways the present work departs from Peale's usual formulas for still-life painting, and therefore may be considered somewhat experimental. In place of the typical somber coloring, we find a liberal use of orange-yellow: it colors the table, the squash, the balsam apple and its flowers. The same tone is reflected in many of the highlights and in the background. In addition, the execution is juicy and painterly as opposed to the linearity of many of Peale's other works. Finally, in this painting, the light uniformly emanates from the upper left, something which is at variance with the usual Peale practice of representing the light as coming from one direction in the foreground and from the opposite direction in the background. The result is a heightened realism that borders on trompe-l'oeil painting.

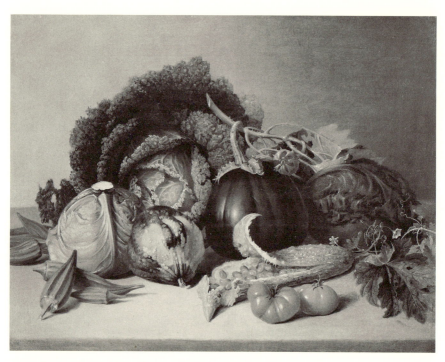

James Peale, *Still Life: Balsam Apple and Vegetables.*

This work probably dates from the 1820s, when James Peale mainly painted still-lifes. It may be the picture listed in the 1827 catalogue of the Pennsylvania Academy of the Fine Arts annual exhibition as "Still-Life—Cabbage, Balsam Apple, &c." Little attention has been given to the possible stylistic sources of this remarkable painting or, indeed, to the sources of the considerable number of still lifes painted by James Peale. It is apparent, however, that his works, as one scholar has recently noted, "are far from the elaborate and richly appointed still lifes of the Dutch seventeenth-century painters, closer to the simpler and more architectonic arrangements of Chardin, although neither so sensuous nor so sophisticated, and perhaps closest to the more naive still lifes of the Spanish school" (M. Brown, *American Art to 1900* [1977], p. 209). Although it does not seem plausible to postulate a direct relationship between this picture and such an outstanding example of Spanish still-life painting as Luis Melendez's *Still Life with Bread, Bacon and Vegetables*, ca. 1772 (MFA, Boston), the formal parallels are provocative and deserve some attention.

Oil on canvas, 20¼ × 26½ in. (51.4 × 67.3 cm.).

RELATED WORKS: *Still Life*, oil on canvas, approximately 20 × 26 in. (51 × 66 cm.), coll. Peter Trowbridge Gill, New York // attributed to James Peale (once considered a copy by Sully; in this version the table is grained) *Still-Life*, 20 × 26 in. (51 × 66 cm.), Arizona State College, Tempe, ill. in P. R. Kloster, *The Arizona State College Collection of American Art* (1954), ill. p. 19.

REFERENCES: J. L. Allen, *MMA Bull.* 34 (Nov. 1939), identifies the vegetables in this painting // M. Walker, letter in Dept. Archives, June 24, 1963, says this picture came to him with others owned by Clifton Peale, great-grandson of James Peale // Gardner and Feld (1965), p. 67 // E. H. Dwight, letter in Dept. Archives, March 24, 1966, suggests that the painting at Tempe is the copy of our work long attributed to Sully and allegedly painted for his sister, which was formerly in the coll. of T. H. Willis, Charleston, S. C. // *MMA Bull.* 33 (Winter 1975–1976), color ill. no. 34 // K. C. Hodges, Phoenix, May 7, 1983, letter and unpublished paper in Dept. Archives, supplies information and research on the Tempe painting // R. Gill, August 27, 1986, orally provided information received from E. H. Dwight in 1973 regarding related works.

EXHIBITED: PAFA, 1827, no. 192, Still-Life— Cabbage, Balsam Apple & c. (possibly this picture) //

Walker Galleries, New York, 1939, *Paintings and Water Colors by James Peale and His Family*, no. 3 // Century Association, New York, 1953, *Exhibition of Paintings by Members of the Peale Family*, no. 23 // National Gallery of Art, Washington, D. C.; City Art Museum, Saint Louis; Seattle Art Museum, 1970–1971, *Great American Paintings from the Boston and Metropolitan Museums*, no. 23 // MMA, 1976–1977, *A Bicentennial Treasury* (see *MMA Bull.* 33).

Ex coll.: the great-grandson of the artist, Clifton Peale; with Walker Galleries, New York, 1939.

Maria DeWitt Jesup Fund, 1939.

39.52.

Martha Stewart Wilson

Martha Stewart (1757-1852) was born at Sidney, her father's estate, near Clinton, New Jersey. She was the daughter of Mary Oakley Johnston and Charles Stewart, commissary general of the Continental Army from 1776 to 1783. On February 1, 1776, she was married to her cousin Robert Wilson, who was a captain in the army and fought at the Battle of Monmouth. He subsequently died of tuberculosis on August 29, 1779. They had only one daughter, Margaretta, but Mrs. Wilson also raised two orphaned sons of her brother. In a series of encouraging letters to one of these adopted sons, Charles S. Stewart, she once wrote (Feb. 16, 1811): "True, there is no near male friend in your family to extend a fostering hand to you and lead you onward to fame and fortune. Let not this circumstance, however, discourage you, but rather let it stimulate you to fresh industry and exertion" (quoted in E. F. Ellet, *Women of the Revolution* [1900], 2, p. 71). Besides supervising the education of these children, she also managed her father's estate in New Jersey. She was well known as a conversationalist and hostess and was a close friend of George and Martha Washington. In 1808 she moved to Cooperstown, New York, where her daughter, then the wife of John M. Bowers, was living. She died there at the age of ninety-four.

Painted in 1814, this portrait reflects the neoclassical stylistic traits that distinguish James Peale's portraits after about 1800. Always given to painting relatively sharp outlines and to flattening forms, he found himself in tune with the aesthetic principles of the latest style and produced portraits that at times rank in quality with those of the French-trained JOHN VANDERLYN. The linearity of Peale's later portraits is in contrast with such paintings as *The Ramsay-Polk Family*, ca. 1793 (private coll.), which appears provincial because of the rococo-style composition. The museum's picture is one of those happy portraits in which Peale's technique and style complement each other.

The predominant colors, red, brown, and black, though certainly productive of a somber mood, are enlivened somewhat by the delicately painted patterns of the white lace *fanchon* and neck ruffle. Mrs. Wilson's face and her one visible hand are reddish in tone, but Peale has failed to create the impression of living flesh that one finds in the contemporary portraits of GILBERT STUART. Smoothly painted, her face remains impassive and a bit forbidding, even though the beauty of this lady of advancing years is clearly represented. A label indicates that the frame, which was manufactured in New York, dates from a slightly later period, about 1830.

Oil on canvas, 28½ × 24 in. (72.3 × 61 cm.).

Signed and dated at lower right: Jas. Peale/1814.

Label on frame: Parker & Clover, / Looking-Glass / Manufacturers, / No. 180 Fulton-Street. / Picture Frames, Curtain Orna- / ments and Brackets, of the neat- / est and most approved patterns.

James Peale, *Martha Stewart Wilson*.

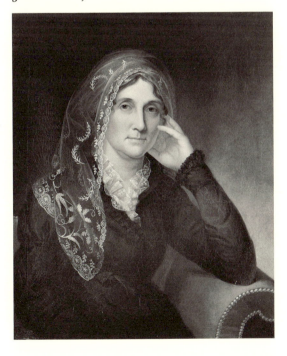

RELATED WORK: oil on canvas, 29 × 24 in. (73.7 × 61 cm.), 1814, New York art market, 1979.

EX COLL.: the Hoyt family; the McKim family; Mrs. Maud S. McKim, until 1933; William L.

McKim, New York and Palm Beach, 1933–1972. Gift of Mr. and Mrs. William L. McKim, 1972. 1972.191.

RALPH EARL

1751–1801

The birth of Ralph Earl, son of Phoebe Whittemore and Ralph Earle, on May 11, 1751, is recorded in two towns, Leicester and Shrewsbury, Massachusetts. He was descended from a family of Worcester County farmers and craftsmen who originally hailed from Rhode Island. Young Earl is known to have attended the school in Leicester, but just how he acquired his early artistic training is still a mystery. Samuel King (1749-1819) and WILLIAM JOHNSTON have been put forward as possible masters, but they are conjectures. A younger brother, James Earl (1761–1796), also became a painter.

In 1774 Earl married his cousin Sarah Gates and established a studio in New Haven, Connecticut. There he met the young engraver Amos Doolittle, with whom he collaborated in the production of four prints illustrating the battle of Lexington and Concord, the sites of which they visited in the summer of 1775. Earl's paintings of these encounters of the American Revolution provided the designs engraved by Doolittle and were later judged by WILLIAM DUNLAP as "the first historical pictures, perhaps, ever attempted in America" (pp. 263–264). About this time Earl painted the major picture of his early career, the portrait of the Connecticut statesman Roger Sherman (Yale University, New Haven). Though wooden and two dimensional, it is a masterpiece of characterization and speaks highly of Earl's ability as a portraitist before his studies in England.

Despite his father's allegiance to the American cause, Earl became an ardent loyalist. He cooperated with the British and was often brought before the local committees of safety. When his father became a colonel in the Continental Army, Earl refused to serve under him and was consequently disinherited. In 1778, presented with the choice of imprisonment at home or banishment abroad, he fled to England and eventually found his way into the studio of BENJAMIN WEST. His wife and family were left behind.

How long Earl studied with West is not known with certainty. Their relations, however, seem to have been friendly and close. Earl painted in London but was often in other parts of England, including Norwich and Windsor. During his seven years abroad he exhibited five portraits at the Royal Academy and acquired a more graceful and fashionable style. He was certainly looking closely at the works of Gainsborough, Reynolds, West, and other English masters, but he never lost the primitive manner he had developed in America. In 1784, believing his first wife dead, he married Ann Whiteside of Norwich, a union that was later regarded as bigamous.

Earl returned to the United States in 1785 with his new wife and their two children. By November 7 of that year he was in New York painting portraits of important patriots like General Frederic Wilhelm Augustus, baron von Steuben, 1786 (2 versions, New York State Historical Association, Cooperstown, and Yale University). Shortly thereafter records indicate that Earl had become dependent on liquor and was in debtor's prison, where he remained until sometime in 1788. He then left New York for Connecticut, where he traveled from town to town painting admirable full-sized portraits. He worked in New Milford, Greenfield, Litchfield, Hartford, Fairfield, Windsor, and Sharon. In the early 1790s Earl was often back and forth between Connecticut and Long Island. In 1794 he again worked in New York City. Then from 1799 to 1801 he was in Northampton, Massachusetts, where he took on several students, among them his son RALPH W. E. EARL. The many paintings Earl produced in the period just before 1800 indicate that he was at the height of his powers and doing well, but soon all this changed. On August 16, 1801, at the age of fifty, Ralph Earl died at the home of Dr. Samuel Cooley, a physician in Bolton, Connecticut. Dunlap attributed his demise to intemperance.

The works Earl produced after his return to the United States rank among the most accomplished of American provincial paintings. Awkward in modeling and perspective, they are knowledgeable variations of fashionable English portraits. Following Reynolds and Gainsborough, Earl's execution was unusually direct and full of bravura. His portraits were among the most ambitious done in America after the departure of Copley. They set a new standard for American provincial work, and many artists from the interior of Connecticut and Massachusetts emulated Earl's style.

BIBLIOGRAPHY: William Dunlap, *A History of the Rise and Progress of the Arts of Design in the United States* (*New York*, 1834, Boston ed. 1918), I, pp. 263-264 // William Sawitzky, *Ralph Earl, 1751–1801* (New York, 1945). Catalogue of an exhibition at the Whitney Museum of American Art, Oct. 16–Nov. 21, 1945, and at the Worcester Art Museum, Dec. 13, 1945–Jan. 13, 1946 // Laurence B. Goodrich, *Ralph Earl, Recorder for an Era* (Albany, N. Y., 1967) // William Benton Museum of Art, University of Connecticut, Storrs, *The American Earls* (Oct. 14–Nov. 12, 1972) Contains a good summary of available knowledge // Elizabeth Mankin Kornhauser, "Ralph Earl, 1751–1801: Artist-Entrepreneur" (Ph.D. diss., Boston University, 1988). The most recent and thorough account of Earl's career.

Lady Williams and Child

This portrait was once considered to be *Lady Williams and Child* by George Romney. The Romney attribution was obviously in error. For lack of any further information on the sitters, however, the painting's traditional title has been retained. William and Susan Sawitzky (1961) suggested that the lady might be Mary Riley, second wife of Sir Edward Williams, baronet, of Eltham, Kent, and Gwernevet, Wales, but this is unlikely.

The picture is competently executed and has an intimate, informal manner that Earl's previous American portraits lack. *Lady Williams and Child*, however, cannot be said to rank among the best works of his English period. Still, the painting illustrates the progress he had made during the five years he spent there. The draperies are lovingly and crisply rendered, the figures appear in an up-to-date pose, and conventional elements, such as an inkstand and an envelope, are included. Just what the paper and ink are meant to convey in the context of this work is not clear. It is possible that the sitter's name was once on the envelope. In some of

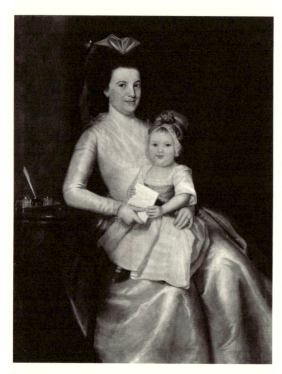

Earl, *Lady Williams and Child.*

Early American Paintings (1918), pp. 38–39 // D. C. Rich, *International Studio* 96 (1930), p. 37 // L. B. Goodrich, *Antiques* 74 (Nov. 1958), p. 418 // W. S. Sawitzky, *Worcester Art Museum Annual* 8 (1960), pp. 24–25 // Gardner and Feld (1965), pp. 71–72 // E. M. Kornhauser, "Ralph Earl, 1751–1801" (Ph. D. diss., 1988), pp. 82, 336–337, says it shows influence of Copley.

EXHIBITED: Ehrich Galleries, New York, 1906, "*Old Masters*" *Portrait Show,* no. 20, as Lady Williams and Child // Whitney Museum of American Art, New York, and Worcester Art Museum, 1945, *Ralph Earl,* no. 5, says purchased by New York art dealer in England about 1905 or 1906 // Dallas Museum of Fine Arts, 1946, *Two Hundred Years of American Painting,* no. 2 // MMA, 1965, *Three Centuries of American Art* (checklist arranged alphabetically) // William Benton Museum of Art, University of Connecticut, Storrs, 1972, *The American Earls,* no. 2.

EX COLL.: with Ehrich Galleries, New York, by 1906.

Rogers Fund, 1906.

06.179.

Master Rees Goring Thomas

This painting came to the museum as a portrait of Master Goring Thomas by Thomas Gainsborough. It remained in the European Paintings Department, where it came to be regarded as the work of an unidentified artist, until 1978, when it was thought that the portrait very much resembled the work of Ralph Earl. Several experts (1978) concurred with this attribution. One scholar later wrote (1983), after examining Earl's portraits of Sophia and Marianne Drake (private coll., Switzerland, ill. Goodrich, *Ralph Earl,* pp. 29, 31), painted in England in 1783 and 1784, that she found very strong stylistic similarities between those works and the museum's portrait.

If the subject of the painting, "Master Goring Thomas," is correct, then the person most likely represented is Rees Goring Thomas (1769–1821), the son of Morgan Thomas and Frances Goring. Frances Goring was the only child of Henry Goring of Fradley Hall, Staffordshire, a direct descendant of Edward III, and it is probably because she inherited her father's estate that the surname Goring Thomas came into use. It was not hyphenated until 1878. Morgan Thomas was from Llannon, county Carmarthen, Wales, where his family were landowners. Their eldest son, Rees, was the first person in the family to bear the Goring Thomas name. In all likelihood

Earl's portraits of this period, for example *Marianne Drake* (private coll. Switzerland, ill. in Goodrich, *Ralph Earl,* p. 29), anecdotal objects refer to the sitter's accomplishments. Miss Drake has both a paintbox and a harpsichord.

In spite of some advances, Earl continued to paint in the stiff manner of his earlier American works. The portraits he painted in England at this time and after his return to the United States possess the unlikely combination of academic convention and primitive execution, which probably accounts for a good deal of their appeal.

We have no record of how much Earl charged for a portrait of this size, but it is known that a smaller one (38½ by 28 inches) of Sophia Isham painted the same year cost £5.5. (See Goodrich, *Ralph Earl* [1967], p. 22.)

Oil on canvas, 50¼ × 39¾ in. (127.3 × 101 cm.).

Signed and dated at lower left: R. Earl Pinxit 1783.

REFERENCES: *American Art News* 4 (Feb. 24, 1906), pp. 6–7, notes that when this picture was first discovered in England it was believed to be by George Romney // R. T. H. Halsey, *MMA Bull.* 1 (1906), pp. 83–86 // H. L. and W. L. Ehrich, eds., *One Hundred*

the portrait was painted about 1783 or 1784, during Earl's stay in England. At that time the subject would have been a schoolboy of about fourteen or fifteen. In 1799 Rees Goring Thomas married Sarah Hovel of Norfolk. In 1811 he purchased the manor of Tooting Graveney and lived in Tooting Lodge in Surrey. He is also referred to as the patron of the chapel of Llan Gennych in the church in Llanelly in Wales. He died on September 21, 1821, and his estates passed to his son Rees Goring Thomas (1801–1863).

The painting is one of several portraits of young people painted by Earl while in England. Besides the nineteen-year-old Drake sisters of Middlesex, there is the portrait of Sophia Isham (private coll., England, ill. Goodrich, *Ralph Earl*, p. 23), age eleven, who was painted at the Misses Dutton school in Windsor in 1783. It is possible that Earl received a fair amount of patronage from schools as did several artists in this period. For example, both BENJAMIN WEST and George Romney painted boys at Eton in the late 1770s. Such portraits were often commissioned by the school but paid for by the student's family.

Perched on a rock in a landscape setting, Master Goring Thomas is posed very much in the manner of Gainsborough. The painting is large, and the sitter almost life size. For all its trappings and careful work, however, the portrait still bears the stamp of a provincial painter, especially in the awkward handling of the body. It is not surprising that it passed as the work of an unidentified British painter for so many years.

Oil on canvas, 66 × 47⅝ in. (167.6 × 121 cm.).
REFERENCES: *Burke's Landed Gentry* (1939), p. 2229, gives information on the sitter // O. Rodriguez Roque, American Painting and Sculpture Dept., orally, Oct. 1978, noted that portrait was probably by Earl // J. D. Prown, Yale University, Nov. 28, 1978, letter

Earl, *Master Rees Goring Thomas.*

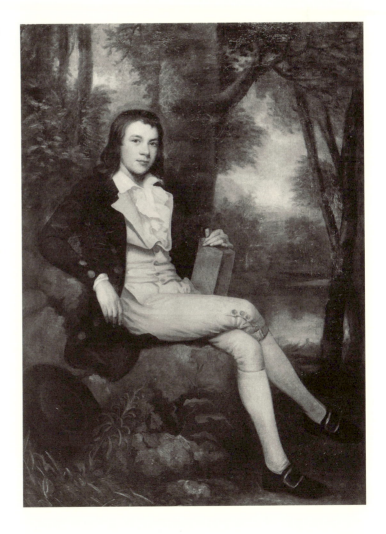

in Dept. Archives, says that the handling of the clothing and the general composition look right for Earl, questions whether the condition of the painting may have something to do with the way the head and hands appear // T. E. Stebbins, MFA Boston, letter in Dept. Archives, Dec. 28, 1978, says he thinks the Earl attribution is on the right track // Memo in Dept. Archives, April 12, 1979, requests the transfer of the painting from European Paintings to American Paintings // E. M. Kornhauser, May 25, 1983, says she thinks the reattribution to Earl is just and that there are strong similarities to the Drake portraits.

Ex COLL.: Mr. and Mrs. Morris K. Jesup, New York, by 1914.

Bequest of Maria DeWitt Jesup, from the collection of her husband, Morris K. Jesup, 1914.

15.30.35.

Elijah Boardman

Elijah Boardman (1760–1823) was born in New Milford, Connecticut, on March 7, 1760, the son of Sarah Bostwick and Sherman Boardman, both of old Connecticut stock. An enthusiastic believer in the cause of American independence, he enlisted in a regiment of the Connecticut line in 1776, at the age of sixteen, shortly after the outbreak of hostilities. He reenlisted in 1780 and served for the duration of the war, when his last commission was as a sergeant in Colonel Samuel Blatchley Webb's Connecticut regiment. Following the war, in partnership with his brother Daniel, he became a drygoods merchant in New Milford and attained great success in business. In 1792, he married Mary Ann Whiting of Great Barrington, Massachusetts. They had three sons and three daughters.

Boardman was also politically active and served in the Connecticut state legislature, first as a representative, then as a senator. From 1821 until the time of his death, he was a member of the United States Senate. In his later years Boardman became interested in the development of land in Connecticut's Western Reserve, which later became part of Ohio. There he founded the town of Boardman, which is where he died on August 18, 1823, while on a visit to his children.

The portrait of Elijah Boardman is one of Earl's finest works and one of the masterpieces of American portraiture. He has placed his knowledge of the aristocratic English style of Joshua Reynolds and Thomas Gainsborough at the service of an American republican ideal—

the working elite. The bolts of cloth, the source of Boardman's wealth—printed cottons, linens, and muslins, as well as solid silks—are displayed unashamedly through the open door, while on the shelves of the desk, a variety of titles attest to his wide reading. Boardman is thus identified as a man of business as well as a man of learning. His clothes and his hairstyle, with its long queue, or pigtail wig, further identify him as a man of fashion. Of towering stature, handsome and alert, Boardman engages the viewer with his attitude of supreme confidence. Earl's awkward rendering of the room and the subject's anatomy seems to enhance the effect of directness, rather than distract from it.

Earl clearly pleased his patron. About eight years later, Boardman commissioned a somewhat larger portrait of his wife with their son William Whiting Boardman (Huntington Library, San Marino, Calif.; ill. *Antiques* 123 [Feb. 1983], p. 415). A view of Boardman's house in New Milford, designed by William Sprats and completed in 1793, showing the drygoods store next to it, was painted by Earl about 1796 (coll. Cornelia Boardman Service, on loan to the MMA). In all, Earl painted about nineteen members of the Boardman family.

The books in Boardman's desk with legible titles on their spines are as follows: top shelf, "JUNIUS/LIBERTY," and volumes 2, 3, and 4 of "MOORE'S/TRAVELS"; middle shelf, volumes 4 and 5 of "SHAKE/SPEARE," "MILTON/PARADISE LOST," and another volume, "HUD . . ./DRA . . ."; bottom shelf, "MARTIN'S/GRAMMAR," "JOHNSON'S DICTIONARY," "GUTHRIE'S GEOGRAPHY," "LEX MERCATORIA," several volumes of the "DICTIONARY OF ARTS AND/SCIENCES," the "LONDON/MAGAZINE/1786," "ANSON'S VOYAGE," and "COOK VOY . . ." There is also the number 3 after a slash, perhaps a price of three shillings, written on a label that hangs from the last bolt of cloth on the bottom shelf in the storeroom.

Oil on canvas, 83 × 51 in. (210.8 × 129.5 cm.).

Signed and dated at lower left: R. Earl pinxt 1789.

REFERENCES: F. F. Sherman, *Art in America* 22 (June 1934), p. 88; 27 (Oct. 1939), p. 173, gives owner as C. Boardman Tyler // L. B. Goodrich, *Magazine of Art* 39 (Jan. 1946), p. 4, says it indicates he had forgotten his English style; ill. p. 5, as coll. Mrs. Cornelius Boardman Tyler // S. P. Feld, *MMA Bull.* 23 (April 1965), p. 282, lent by Mrs. Cornelius Boardman Tyler; p. 283 // L. B. Goodrich, *Ralph Earl*

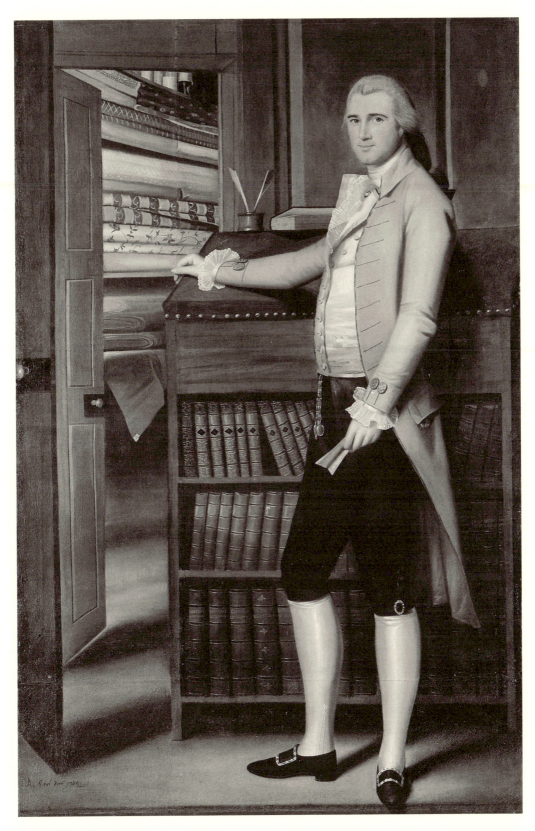

Earl, *Elijah Boardman*.

(1967), p. 60, fig. 25, ill. p. 61 // A. Neumeyer, *Geschichte der Amerikanischen Malerei* (1974), pl. 86 // MMA, *Notable Acquisitions, 1979–1980* (1980), p. 54, entry by M. M. Salinger // F. M. Montgomery, *Textiles in America, 1680–1870* (1984), color frontis. // M. M. Salinger, *Masterpieces of American Painting in the Metropolitan Museum of Art* (1986), pp. 34–35 (color ill.).

EXHIBITED: Whitney Museum of American Art, New York, and Worcester Art Museum, 1945–1946, *Ralph Earl, 1751–1801*, exhib. cat. by W. Sawitzky, no. 15, lent by Cornelius Boardman Tyler // MMA, 1965, *Three Centuries of American Painting* (checklist arranged alphabetically), lent by Mrs. Cornelius Boardman Tyler.

ON DEPOSIT: MMA, 1966–1979, lent by Mrs. Cornelius Boardman Tyler.

EX COLL.: descended to Cornelius Boardman Tyler, Plainfield, N. J., d. 1955; his wife, Susan W. Tyler, Fairfield, N. J., d. 1979.

Bequest of Susan W. Tyler, 1979.

1979.395.

Mrs. Noah Smith and Her Children

This complex group portrait represents Mrs. Noah Smith (1757–1810) and her five children, from left to right, Henry, Daniel, Noah, Eliza, and Celia. Mrs. Smith, the former Chloe Burrall, was the daughter of Colonel Charles Burrall and his wife Abigail of Canaan, Connecticut. On November 4, 1779, she was married to Noah Smith (1756–1812), a native of Suffield, Connecticut, a member of the Yale College class of 1778, and a practicing attorney before the Supreme Court of Vermont. She went to live with her husband in Bennington, Vermont, where he held a succession of public offices, including state attorney and county clerk, prior to his election to the General Assembly in 1789. He later served until 1791 as a judge of the state supreme court, then as federal excise commissioner (a post assigned to him by President

Earl, *Mrs. Noah Smith and Her Children.*

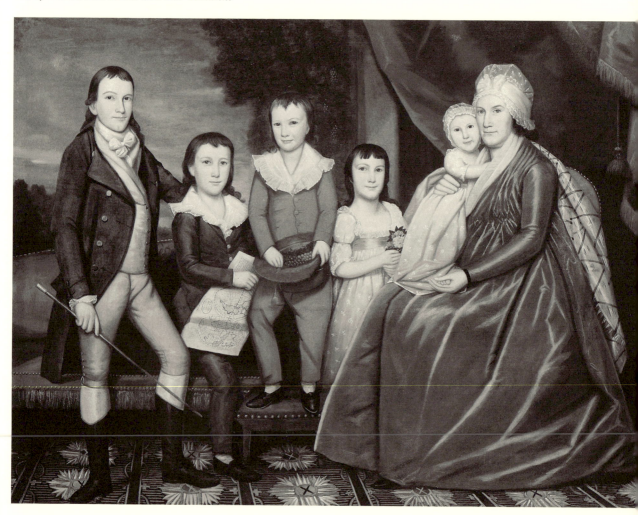

Washington), and from 1798 to 1801 he was the chief judge of the state supreme court. Soon after this, Smith and his family moved to Milton, Vermont, where he owned vast tracts of land. The family was responsible for building the Congregational Church there. After a few years, Smith's business failed, and he was cast into debtor's prison. On his release in 1811, he was a broken man and in a state of mental derangement. He died soon after. His wife had died two years earlier.

Painted in Bennington in 1798, the present work, together with an accompanying portrait of Noah Smith (Art Institute of Chicago), forms one of the most interesting and ambitious portrait groups in the history of American painting. That the two pictures form a pair can scarcely be doubted: the works are the same height and share the identical chair, carpet, and background draperies. In fact the same interior is depicted in both. While most companion portraits are painted to hang next to each other, it is clear that in this case, the intention was for the pictures to hang opposite each other. Perceived this way, the absence in the group portrait of the pater familias and of a counterbalancing drapery would be made up for by the portrait of Noah Smith on the opposite wall. Such a placement would not only create a balanced visual effect but would also establish a continuity of illusionistic space, especially given the size of the portraits. Thus surrounded, the viewer would be drawn into the circle of this happy, prosperous family.

In the portrait of *Mrs. Noah Smith and Her Children*, familial well-being is emphasized by a number of significant iconographic elements. Henry's riding costume, his mother's dress of costly fabrics, and the upholstered cabriole sofa are in the latest styles. The book held by Daniel,

The companion portrait, Earl's *Noah Smith*.
Art Institute of Chicago.

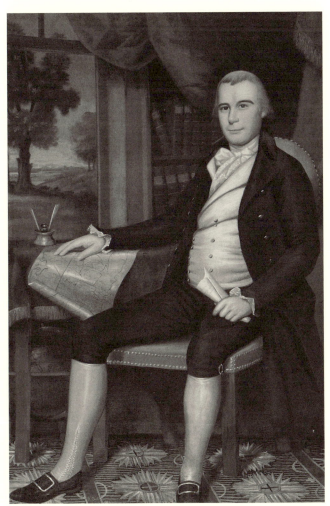

147

opened to a chart of the world, alludes to the children's educational training, while in the hat held by little Noah, the grapes picked from the vine visible behind him are a reminder of the richness of the family's land. Eliza's flowers, perhaps chrysanthemums, are symbolic of her virtue and ladylike qualities.

Although these children went on to lead useful lives, perhaps none achieved the degree of success or affluence that they seem to have enjoyed when Ralph Earl painted them. Henry, who married Phoebe Henderson, died young, at the age of twenty-seven. He had one son, Daniel (1789–1820), who became a minister and president of Marietta College in Ohio. Noah (1794–1825) graduated from Middlebury College and became a teacher in Louisville, Kentucky. He died unmarried. Eliza became the wife of a Dr. Huntington in Vergennes, Vermont, and had one daughter, Ann Eliza Huntington, who once owned this picture. Celia (1797–1876) was married to Hiram Painter, who owned a hotel business in Vergennes. Her descendants received this painting after the death of Ann Eliza Huntington and kept it in the family until 1957.

Oil on canvas, 64 × 85¾ in. (162.6 × 217.8 cm.).
Signed and dated at lower left: Ralph Earl pinxit 1798.

RELATED WORKS: Unidentified artist, *Mrs. Noah Smith and Her Children*, copy, ca. 1874, oil on canvas, 65¼ × 84⅛ in. (165.8 × 213.7 cm.), Art Institute of Chicago.

REFERENCES: W. H. Crockett, *Vermont, the Green Mountain State* (1923), pp. 63–64, gives biographical information about Noah Smith // Mrs. J. Barnes to J. Winterbotham, Jr., June 9, 1934, copy in Dept. Archives, says copy of the painting was probably done in Albany, New York, about 1874 and gives biographical information regarding Mrs. Smith and her five children // S. P. Feld, *MMA Bull.* 23 (April 1965), p. 300; *Antiques* 87 (April 1965), p. 441, says it is the most ambitious picture by Earl that has been recorded // L. B. Goodrich, *Ralph Earl* (1967), pp. 90–91, says that while it is "not the most populous of his canvases," it is "certainly one of the most colorful" // *Interiors* 126 (June 1967), p. 8, says it is among the museum's finest acquisitions // S. P. Feld, Hirschl and Adler Galleries, New York, Dec. 14, 1977, letter in Dept. Archives, gives information on provenance // E. M. Kornhauser, "Ralph Earl, 1751–1801" (Ph.D. diss., 1988), pp. 249–250, 320–321.

EXHIBITED: American Federation of Arts, traveling exhibition, 1961–1964, *101 Masterpieces of American Primitive Painting from the Collection of Edgar William and Bernice Chrysler Garbisch*, no. 31 // MMA, 1965,

Three Centuries of American Painting (checklist arranged alphabetically) // Los Angeles County Museum of Art; M. H. de Young Memorial Museum, San Francisco, 1966, *American Paintings from the Metropolitan Museum of Art*, no. 10 // National Gallery of Art, Washington, D. C.; City Art Museum, Saint Louis; Seattle Art Museum, 1970–1971, *Great American Paintings from the Boston and Metropolitan Museums*, exhib. cat. by T. N. Mayham, no. 14 // William Benton Museum of Art, University of Connecticut, Storrs, 1972, *The American Earls*, no. 12 // MMA and American Federation of Arts, traveling exhibition, 1975–1977, *Heritage of American Art*, cat. by M. Davis, no. 14, color ill.

EX COLL.: Mr. and Mrs. Noah Smith, Milton, Vt., until 1812; their daughter, Mrs. Eliza Smith Huntington, Vergennes, Vt.; her daughter, Ann Eliza Huntington, Vergennes, until 1876; her cousin, Mrs. Ruth Keller Goss, d. 1940; her daughter, Ruth (Mrs. J. Warren Barnes), Troy, N. Y., and Mrs. Barnes's son, Wentworth H. Barnes, Salisbury, Conn., until Dec. 1957; with Hirschl and Adler Galleries, New York, Dec. 1957–Jan. 1958; Edgar William and Bernice Chrysler Garbisch, Cambridge, Md., Jan. 1958–1964.

Gift of Edgar William and Bernice Chrysler Garbisch, 1964.
64.309.1.

Marinus Willett

Marinus Willett (1740–1830) was the son of Aletta Clowes and Edward Willett and a descendant of Thomas Willet, the first English mayor of colonial New York. He was born in Jamaica, Long Island, and resided in New York for most of his life. He attended King's (Columbia) College, worked as a cabinetmaker, and eventually became a wealthy merchant and landowner. In 1758, during the French and Indian War, Willett obtained a commission as second lieutenant in Oliver De Lancey's New York regiment and fought in the unsuccessful expedition against the French at Fort Ticonderoga. Later he took part in the campaign against Fort Frontenac. During the years of intense political activity preceding the outbreak of the American Revolution, Willett became a well-known radical and leader of the Sons of Liberty. In 1775 and 1776 as a captain in the First New York Regiment he participated in the invasion of Canada. At the end of November 1776, Willett was placed in command of Fort Constitution in New York City. He led a successful sortie against the enemy the following

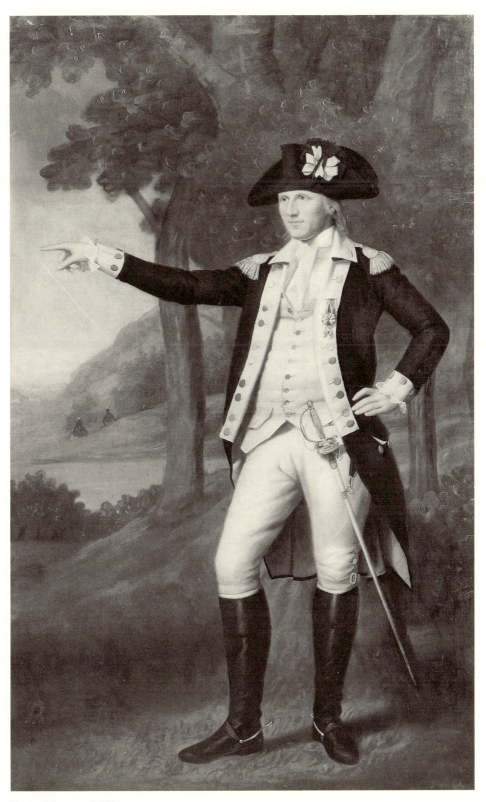

Earl, *Marinus Willett*.

May at Fort Stanwix, for which the Continental Congress voted to present him with an "elegant sword." This is the same sword (marked by Liger, Rue Coquillière, Paris) Willett wears in this portrait, and it too is in the museum's collection (Department of Arms and Armor).

In 1778 Willett joined Washington's army and saw action at the battle of Monmouth. The following year, he took part in the Sullivan-Clinton Expedition against the Iroquois Indians. He continued to serve for the next three years as an officer of the New York Regiment. On October 25, 1781, he led the attack in the successful battle of Johnstown. At the end of hostilities, he was elected to the New York assembly, a post he resigned in 1784 to accept an appointment as sheriff of the city and county of New York.

Since Willett had spent most of his life serving in frontier posts and dealing with Indians, it was only natural for Washington to turn to him in 1790 to deal diplomatically with the hostile Creek Indians of Georgia and Alabama. So successful was Willett as an envoy that in August of 1790 he turned up in New York with the Creek chief Alexander McGillivray, ready and willing to conclude a treaty with the federal government. In 1792 Willett declined an army appointment because he thought it unwise for the government to launch an Indian war at that time. Instead he accepted another four-year appointment as sheriff of New York. His political career culminated in 1807 when he was appointed mayor of the city. Four years later, after he was defeated in a bid to become lieutenant governor of the state, Willett retired from public life. He was married three times, first in 1760 to Mary Pearse, who died in 1793; then in 1793 to Mrs. Susannah Vardill, who obtained a divorce in 1799, and lastly, in 1799 or 1800, to Margaret Bancker, who bore him five children. He died on August 22, 1830, at his home in Cedar Grove, New York City. A portrait of his third wife with their son Marinus, Jr., by JOHN VANDERLYN, is also in the collection of this museum.

Willett appears in military uniform, and on his lapel is the order of the Society of the Cincinnati. His commanding stance is characteristic of English military portraits of this period with which, of course, Earl would have been familiar. A good example is Joseph Wright of Derby's *Colonel Charles Heathcote*, which was exhibited at the Society of Artists in London in 1772, where Earl easily could have seen it (private coll., ill. in Benedict Nicolson, *Joseph Wright of Derby* [1968], no. 79).

Although Willett's portrait was exhibited in New York in 1838 as by "Earle of Connecticut," it was not until 1935 that the association with Ralph Earl was reestablished. In preparation for a catalogue raisonné, William Sawitzky (1945) dated the portrait about 1791, some six years after Earl's return from England.

Oil on canvas, 91¼ × 56 in. (231.5 × 142.2 cm.).

REFERENCES: *DAB* (1930, 1957), s. v. Willett, Marinus, gives biographical information on the sitter // D. Wager, *Col. Marinus Willett* (1891), ill. p. 48, mistakenly says the picture was painted by Trumbull when Willett was thirty-five years old // G. W. Van Nest, letter in Dept. Archives, April 23, 1906, says "it was made by an English painter who came here" // F. Morris, *MMA Bull.* 12 (1917), p. 158, says it was painted by an unknown artist, 1790–1800 // B. Burroughs, *Catalogue of Paintings in the Metropolitan Museum* (1931), p. 5, as American school, painted about 1790–1800 // *Magazine of Art* 39 (Nov. 1946), p. 277 // *Magazine of Art* 39 (Nov. 1946), p. 277 // Gardner and Feld (1965), pp. 72–74 // L. B. Goodrich, *Ralph Earl* (1967), pp. 76–77, dates it 1791, notes that "apprehensive redskins in the offing recall the patriot's prowess as an Indian fighter" // E. M. Kornhauser, "Ralph Earl, 1751–1801" (Ph.D. diss., 1988), pp. 159–160, 335–336, notes that Willett had been responsible for Earl's arrest in 1785.

EXHIBITED: Stuyvesant Institute, New York, 1838, *Exhibition of Select Paintings by Modern Artists* (Dunlap Benefit Exhibition), no. 148, as by Earle of Connecticut, lent by Mrs. Willett // MMA, 1922, *Duncan Phyfe Exhibition*, no cat.; 1935, *Exhibition of Portraits of Original Members of the Society of the Cincinnati*, no. 32, as probably a contemporary copy after Ralph Earl; 1939, *Life in America*, no. 42, as by Earl // Whitney Museum of American Art, New York, and Worcester Art Museum, 1945–1946, *Ralph Earl, 1751–1801*, exhib. cat. by W. Sawitzky, no. 28, dates it about 1791 // Amon Carter Museum of Western Art, Fort Worth, 1975–1976, *The Face of Liberty*, exhib. cat. by J. T. Flexner and L. B. Samter, pp. 57, 148; ill. p. 149 // National Maritime Museum, Greenwich, England, 1976, *1776: The British Story of the American Revolution*, no. 257.

ON DEPOSIT: Museum of the City of New York, 1933–1934 // Chase Manhattan Bank, New York, 1960–1961.

EX COLL.: probably the subject, d. 1830; his wife, Mrs. Marinus Willett, New York, by 1838–d. 1867; descended to her grandnephew, George Willett Van Nest, New York, by 1906–d. 1916.

Bequest of George Willett Van Nest, 1916.
17.87.1.

ADOLPH ULRICH WERTMÜLLER

1751–1811

Adolph Ulrich Wertmüller was born in Stockholm on February 18, 1751. (His Christian names are also variously given as Adolf Ulrik and Ulric.) The sixth of nine children of a prosperous apothecary, he studied drawing and sculpture as a youth and in 1771 took up painting. He enrolled in the Swedish Art Academy for a year, and then in 1772 went to Paris where his cousin Alexandre Roslin was a well-known portraitist. A member of the French Royal Academy since 1753, Roslin exercised his influence and found a place for Wertmüller in the studio of Joseph Marie Vien. By 1773 Wertmüller had progressed sufficiently to enter the academy as a student and, a year later, won its second medal. When Vien was appointed director of the French Academy in Rome in 1775, he accompanied him. He then traveled throughout Italy, visiting collections, drawing and sketching, and earning some money by painting portraits. Many years later, when he settled in the United States, these works were shipped to him and shown to his friends the Peales and probably other artists as well.

In 1779, Wertmüller arrived in Lyon, where he remained for about a year painting portraits in a manner reminiscent of Louise Elisabeth Vigée-Lebrun. After his return to Paris in 1781, he met the Swedish envoy to France, Count Gustaf Creutz, who immediately became his benefactor. It was Creutz who took his work to the Swedish monarch and obtained an appointment for Wertmüller as painter to the king. By this time, Wertmüller had become a member of the French Academy and was exhibiting regularly at the Paris Salon. In 1785 he started work on his most famous picture, *Danaë and the Shower of Gold*, 1787 (National Museum, Stockholm). A painting executed in the severe linear style characteristic of Jacques Louis David, it is set in a classical context but endowed with an erotic allure that is more in keeping with rococo sensibility. When the picture was exhibited in Philadelphia in 1806, its forthright nudity brought about a storm of controversy. This did not keep the crowds away, and the exhibition of the picture became a sure source of income for Wertmüller.

Wertmüller left Paris in 1788 and worked in Bordeaux. Then came the turmoil of the French Revolution, and he sought commissions in Madrid and Cadiz before sailing to the United States on March 8, 1794. He settled in Philadelphia, where he began to turn out portraits of President George Washington (q.v.). Attracted to Elisabeth Henderson, a granddaughter of the painter Gustavus Hesselius (1682-1755), Wertmüller decided to remain in this country. In 1796, however, business affairs called him back to Europe, where he discovered that his life's savings had been squandered. As a result he was unable to return to the United States until 1800. The following year in Philadelphia, he married Elisabeth Henderson, and due to new responsibilities of farming and land management, his interests shifted away from painting. After 1803, he and his wife lived on a farm along the Delaware River at Naaman's Creek, about twenty miles south of Philadelphia. It is believed that during his years in the United States, he painted some eighteen to twenty oil canvases, close

to forty small works, and an undetermined number of miniatures and small ovals. He died at Naaman's Creek, Pennsylvania, on October 5, 1811.

BIBLIOGRAPHY: Michel Benisovich, "The Sale of the Studio of Adolph-Ulrich Wertmüller," *Art Quarterly* 16 (Spring 1953), pp. 21–39. Gives details regarding the 1812 sale of the artist's works, many of them drawings and sketches executed in Europe as well as casts and old master paintings owned by him // Franklin D. Scott, *Wertmüller—Artist and Immigrant Farmer* (Chicago, 1963). The most complete study of the artist's life, it also includes a translation of the diary he kept at Naaman's Creek from 1803 to 1811 (Wertmüller Samling, Royal Library, Stockholm) // Gunnar W. Lunberg, *Le Peintre Suédois Adolf Ulrik Wertmüller à Lyon, 1779–1781* (Lyon, 1972). The author, who is the biographer of Wertmüller's cousin Alexandre Roslin, comments on Wertmüller's work at Lyon and catalogues forty-one portraits he painted there.

George Washington

According to Wertmüller's register and cash book, his original portrait of Washington, of which this is a replica, was executed during August 1794 "in the Senate chamber where the Congress assembles at Philadelphia" (Benisovich, 1956, p. 41). It has long been assumed that Washington sat for the painter. A number of early writers, including REMBRANDT PEALE, while critical of the work, believed that it was painted from life. However, George Washington Parke Custis, the president's adopted son who lived with him in Philadelphia at this time, thought that Wertmüller did not have more than one sitting, if he had any at all (Custis, *Recollections and Private Memories of Washington by his Adopted Son*, ed. B. J. Lossing (1860), p. 627). More recent writers have also questioned whether Washington actually sat for the Swedish artist. The reason is that the president's face appears wooden and generalized, displaying a glossy, inexact likeness different from portraits of him executed by other painters at this time. In pose and dress, the work is a rusty repetition of a formula the artist first developed in Lyon in 1780, which found frequent and happier expression throughout his European career (see his portraits of Pierre Nicolas Grassot, 1780, ill. Lunberg [1972], pl. 4, and Count Jacob de Rechteren, 1790, Prado, Madrid).

On November 8, 1794, Wertmüller recorded the completion of his first *Washington*: "Fini le portrait du General Washington, prem. Président du Congress, un habit de velour noir, but quaré de 15, ce port. est pour moi" (Benisovich, 1956, p. 58). From this portrait Wertmüller painted all known copies, including the Metropolitan's. The first version was sold with the

contents of his studio in 1812 to John Wagner of Philadelphia for fifty dollars together with at least twenty-two straining frames with prepared canvas, all of which had been readied to become copies.

Although the museum's portrait is clearly dated 1795, several nineteenth-century writers, including Peale, mistook it for the first portrait of 1794. Since the museum's picture is known to originally have been owned by Théophile Cazenove (1740–1811), financier and American agent for the Holland Land Company who was in Philadelphia from 1790 to 1799, it must be the work Wertmüller entered in his account book on March 18, 1795: "Fini une copie de Portrait du gen. Washington, pres. du Congrès, en habit de velour noir, pour Mr. Cazenowe, toile de 15 quaré" (Benisovich, 1956, p. 59). The accounts also reveal that the artist received 406 livres for the portrait from Cazenove himself, contrary to Peale's claim that Washington had presented the portrait to Cazenove.

Wertmüller's portrait of Washington, with its fussy lace ruff and powder-speckled coat, was the object of widely diverging judgments regarding its fidelity as a likeness of the president. A number of persons claiming to have known Washington pronounced it one of the finest portraits of him, while others disavowed any similarity whatsoever. Rembrandt Peale, who in later years claimed to be the only artist still living who had painted Washington from life, thought Wertmüller's portrait "a highly finished laborious performance" with "a German Aspect" (1858). This characterization, with its pejorative cast, was essentially accurate. Very much in the late French rococo style, the portrait was an anomaly, produced at a time when the more

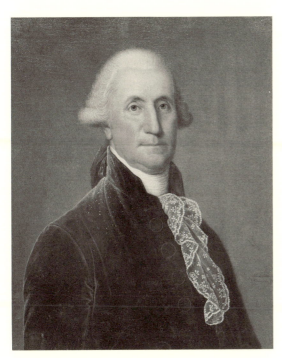

Wertmüller, *George Washington.*

painterly art of GILBERT STUART and the linear neoclassicism of JOHN VANDERLYN were beginning to define the possibilities of American portraiture. It was to be expected that Peale would find it precious and foreign.

Oil on canvas, $25\frac{3}{4} \times 21\frac{1}{8}$ in. (65.4×53.7 cm.). Signed and dated at lower right: A. Wertmüller, S. Pt. / Philadelphia 1795.

RELATED WORKS: *George Washington,* oil on canvas, 25×21 in. (63.5×53.3 cm.), 1794, formerly estate of Samuel T. Wagner, Philadelphia, the original portrait // *George Washington,* oil on wood, an oval format, copy, $6\frac{1}{8} \times 5$ in. sight (15.6×12.7 cm.), 1794, formerly coll. Thomas Lamont, ill. in J. H. Morgan and M. Fielding, *Life Portraits of Washington,* between pp. 206–207, no. 7 // *George Washington,* oil on canvas, 25×21 in. (63.5×53.3 cm.), formerly coll. Dr. John P. Mann, New York // *George Washington,* oil on canvas, 25×21 in. (63.5×53.3 cm.), 1795, National Museum, Stockholm // *George Washington* oil on canvas, unfinished, $25\frac{1}{4} \times 20\frac{3}{4}$ in. (64.1×52.7 cm.), Historical Society of Philadelphia, ill., Morgan and Fielding, between pp. 204–205, no. 5 // *George Washington,* oil on canvas, unfinished, 25×21 in. (63.5×53.3 cm.), 1795, formerly coll. S. R. Slaymaker, Lancaster, Pa. // Elizabeth B. Johnson, *Original Portraits of Washington* (1882), listed one, cabinet size and in military dress, formerly coll.

Cornelius Bogart, New York; a 1797 bust-portrait, and another, formerly the coll. Benjamin F. Beale // Henry Bryan Hall, *George Washington,* stipple engraving after the MMA replica, $7\frac{1}{4} \times 5\frac{3}{8}$ in. (18.4×13.7 cm.), 1859, ill. in Washington Irving, *Life of Washington* (New York, 1859), frontis.// John Chester Buttre, *George Washington,* stipple engraving, $6\frac{5}{8} \times 4\frac{1}{2}$ in. (16.8×11.4 cm.), 1859, ill. in *Lives of Illustrious Men of America* (Cincinnati, 1859).

REFERENCES: A. Wertmüller, Register of Payments, 1780–1802, Wertmüller Samling, Royal Library, Stockholm (quoted above) // *Analectic Magazine* 3 (June 1815) // R. Peale, *Crayon* 2 (Oct. 3, 1855), p. 207; "Washington and His Portraits," 1858, p. 15, MS, Charles Roberts Autograph Collection, Haverford College (quoted above) // H. T. Tuckerman, *The Character and Portraits of Washington* (1850), pp. 65–68, discusses the painting, notes two versions, and quotes Jared Sparks, Washington's biographer, as saying "Judging from the engraving...I remember no one which appears to me to represent Washington's features and character more imperfectly"; ill. opp. p. 66, shows the Hall engraving after the portrait // E. B. Johnston, *Original Portraits of Washington* (1822), pp. 50–53, mistakenly considers this portrait Wertmüller's original (as did Peale), notes several others and engravings, and quotes a writer in the *Washington National Intelligencer* who remembered seeing Washington on several occasions: "It has been my privilege to see the best likenesses of the chief. The one of all others most resembling him is that prefixed to the first volume of Irving's 'Life of Washington.' All the rest wanted the animation I perceived in his features"; ill. opp. p. 50, is the Hall engraving after the portrait // C. A. Munn, *American Magazine of Art* 10 (1919), p. 279, gives a history of the portrait // H. B. Wehle, *MMA Bull.* 20 (Jan. 1925), ill. p. 21; p. 22, says this is one of five known replicas // J. H. Morgan and M. Fielding, *The Life Portraits of Washington and Their Replicas* (1931), pp. 204–206, lists six replicas, including this one // G. A. Eisen, *Portraits of Washington* (1932), 2, p. 479 // M. Benisovich, *Art Quarterly* 16 (Spring 1953), pp. 21–24, discusses Wertmüller estate auction that included the original portrait; *Gazette des Beaux-Arts* 48 (July/August 1956), p. 68; *Art Quarterly* 26 (Spring 1963), ill. p. 26; p. 37; p. 59, in transcript of Wertmüller's account book, under March 18, 1795, notes this copy of portrait completed (quoted above) // F. D. Scott, *Wertmüller* (1963), pp. 8–9, ill. between pp. 26–31 // Gardner and Feld (1965), pp. 75–77 // M. N. Benisovich, *Art Quarterly* 26 (Spring 1963), p. 14, says it is still unknown whether Washington sat to Wertmüller // A. Palmer, "Adolph Ulric Wertmüller," M. A. thesis, University of Delaware, May 1972, pp. 36–42, copy in Dept. Archives, presents evidence for and against the portrait's being painted from life and quotes the historical accounts.

EXHIBITED: MMA, 1965, *Three Centuries of Ameri-*

can Painting (checklist arranged alphabetically) // Montreal, Museum of Fine Arts, 1967, *The Painter and the New World*, cat. no. 129 // Ackland Art Center, University of North Carolina, Chapel Hill, 1968, *Age of Dunlap*, exhib. cat. by H. Dickson, no. 56, p. 25 // Pennsylvania State University Museum, State College, 1976, *Portraits USA, 1776–1976*, p. 22.

ON DEPOSIT: Staten Island Institute of Arts and Sciences, 1971–1974.

EX COLL.: Théophile Cazenove, Philadelphia and Paris, 1795–d. 1811; his estate; Charles A. Davis, New York, by 1858–d. 1867; his daughter, Madame Gentil (sale, Hotel Drouot, Paris, 1880); William F. Morgan, New York, 1880; Charles Allen Munn, West Orange, N. J., by 1924.

Bequest of Charles Allen Munn, 1924.
24.109.82.

JOSEPH STEWARD

1753–1822

The preacher and painter Joseph Steward was born in Upton, Massachusetts. He was educated at Dartmouth College, graduating in the class of 1780. After studying for the ministry with the Rev. Dr. Levi Hart of Preston, Connecticut, he was licensed to preach in Newport, Rhode Island. A letter written to Hart in 1786 notes that Steward was still in Newport but had been ill for the last two years and unable to work. It is very likely that his illness, which seems to have been of a chronic respiratory nature, was the factor that led him to pursue portrait painting. Long hours of preaching evidently were not conducive to his health. He did, however, go to Hampton, Connecticut, in 1788, where he assisted the minister there, the Rev. Samuel Moseley, who had been stricken with paralysis. He married Moseley's daughter Sarah in 1789 but did not succeed to her father's position. Three of the Steward children were born in Hampton before 1796, when the family moved to Hartford. Steward was a deacon in the First Church of Hartford, and, with the Rev. Dr. Nathan Strong and Rev. Abel Flint, he published *The Hartford Selection of Hymns* (1799), which went through eight editions. Although he sometimes preached and filled in for other clergymen in the neighborhood, he appears to have earned his living as a painter.

In 1797 he proposed to the legislature that he open a museum in the state house, which he did in June of that year. It contained among other things portraits of well-known Americans, usually copied by Steward, paintings of natural history subjects, especially birds, which were highly praised but none of which are now known. There were natural history displays of such specimens as crystals, ores, and shells. There were also an organ, wax works, and, beginning about 1805, a physiognotrace for taking silhouettes. In 1808 the museum was moved to larger, improved quarters. One of the few such establishments in this country at the time, it was a popular place and remained so for many years after Steward's death.

Joseph Steward also advertised himself as an instructor in the "polite accomplishments of Drawing & Instrumental Music" for young ladies. Other than Sarah Perkins (working ca. 1790), it is not known how many young ladies came to him for lessons, but it is known that he was the teacher of the deaf and dumb artist John Brewster, Jr. (1766–1854), whose style is very close to his, and he was also the early instructor of SAMUEL L. WALDO.

Steward is not known to have signed his paintings, but at least one is inscribed on the stretcher. It is only in recent years that a fair sized body of work, over sixty portraits, has been attributed to him. He probably learned to draw at Dartmouth, if not earlier, but in painting he appears to have been self-taught. His style may be primitive, but his portraits drawn from life are carefully rendered and show a great deal of sensitivity and insight. At his death, the Hartford *Connecticut Mirror* (April 22, 1822) described his character: "Possessing a mild and peaceable temper, an amiable and friendly disposition, a sound and discriminating mind, and exhibiting in every department of life an uniform and consistent course of conduct, he was highly esteemed and respected as a citizen, a minister, and a christian."

BIBLIOGRAPHY: [Thompson R. Harlow], "Joseph Steward and the Hartford Museum," *Connecticut Historical Society* 18 (Jan.–April 1953), pp. 1–16. Includes a biography and illustrates thirteen portraits by him // Thompson R. Harlow, "The Life and Trials of Joseph Steward," *Connecticut Historical Society Bulletin* 46 (Oct. 1981), pp. 97-164. Published for an exhibition at the Connecticut Historical Society in Hartford, it contains a biography, with discussions of Stewart's art, the museum he founded, and a checklist of sixty-six portraits.

ATTRIBUTED TO JOSEPH STEWARD

Jonathan Dwight

Jonathan Dwight (1743-1831) was the great grandson of Jonathan Edwards and the uncle of Timothy Dwight, a president of Yale College. Born in Boston, he was raised in Halifax, Nova Scotia. At the age of ten, he was sent by his father to live with an uncle, Colonel Josiah Dwight, in Springfield, Massachusetts. Starting as a clerk in his uncle's store, he eventually took over its management. The store, which handled primarily dry goods, had a reputation as a local gathering place. It was highly profitable. In the early nineteenth century Dwight established branches in Boston and several other cities and towns in Massachusetts and Connecticut. He is mentioned in phrases of high regard both by his family and in several histories of Springfield. According to his son Henry, later a minister in Geneva, New York, he was "active and industrious, prudent and economical, judicious and persevering," as well as "a kind and excellent father" (B. W. Dwight, *History of the Descendants of John Dwight of Dedham, Mass.* [1874], 1, p. 863). In 1819, when the liberal faction of Springfield's Congregational church broke away from the main body, Dwight, who was a leader of the group, donated the money to build a new church. He was married three times, first to Margaret Ashley of Westfield, Massachusetts, who died

in 1789, then Margaret Van Veghten Vanderspiegel of New Haven, whom he married in 1790; she died in 1795, and he married Hannah Buckminster of Brookfield, Massachusetts, in 1796. There were seven Dwight children who lived to maturity, all of them from his first marriage.

Attributed to Stewart, *Jonathan Dwight.*

Joseph Steward

The subject's features are reproduced sensitively and honestly, even including three moles, one of them hairy. In the background is a river, probably the Connecticut, which runs through Springfield, and a church, which may be the First Congregational, of which Dwight was an important member. The red house at the left may represent his store, which was identified in a nineteenth-century local history as the "Old Red House," and the white building opposite it could be his house, identified in the same source as "a conspicuous white House" across Main Street from the store (M. A. Green, *Springfield, 1636–1886* [1888], p. 337). The canvas bears the stamp of James Poole's London art supply house, with the address High Holborn, indicating that it was sold between 1785 and 1803, when the business was located there. The portrait appears to have been painted about 1790.

The attribution of this portrait has long posed difficulties and is still speculative, based mainly on stylistic evidence. Early on, when the picture was first acquired by the museum, it was suggested by several scholars that it might be by Joseph Steward, mainly due to its similarity in format to the portrait of Captain Thomas Newson (private coll., ill. *Connecticut Historical Society Bulletin* 46 [Oct. 1981], no. 35), which is accepted as by Steward but not a documented work. There are aspects of the Dwight portrait, however, that are very like the style of Steward's student John Brewster, namely the light palette and the flatness of the figure. Comparing the treatment of the face in Dwight, however, to the large portraits of John Phillips and Eleazar Wheelock, commissioned from Steward by Dartmouth College in 1793 (Hood Museum of Art, Dartmouth College, Hanover, N. H.), one finds the same narrow mouth and the same kind of highlighting of the features. The treatment of the eyes and hair is very like that in the portrait of Wheelock's granddaughter Maria Malleville Wheelock, ca. 1793 (coll. Bertram K. and Nina Fletcher Little). This work, painted at Hanover, New Hampshire, and firmly attributed to Steward, also has an oval format with the subject standing before a landscape, and the landscape features are similarly drawn.

The portrait of Jonathan Dwight is very much in the Connecticut Valley tradition of RALPH EARL, WILLIAM JENNYS, and REUBEN MOULTHROP, in which the artist captures the dignity of his subjects and renders them in their everyday settings with honesty and directness.

Oil on canvas, 29½ × 26¼ in. (75 × 66.7 cm.).
Canvas stamp: I POOLE / HIGH HOLBORN / LINNEN.
REFERENCES: W. L. Warren, New Haven County Historical Society, letter in Dept. Archives, Dec. 4, 1962, suggests that it is by Steward // Gardner and Feld (1965), p. 74, as by an unknown painter // M. Black and J. Lipman, *American Folk Painting* (1966), p. 20, say that the pale palette used was usually employed in pastels and watercolors; ill. no. 27, date it ca. 1790 // N. F. Little, letter in Dept. Archives, March 6, 1978, points out resemblance to Steward's landscapes but is uncertain about the treatment of the face // C. P. Bickford, Connecticut Historical Society, letter in Dept. Archives, July 27, 1981, says he thinks the portrait is by Steward and requests it for exhibition.
EXHIBITED: MMA, 1965, *Three Centuries of American Painting*, as by an unknown painter (checklist arranged alphabetically) // Los Angeles County Museum of Art and M. H. de Young Memorial Museum, San Francisco, 1966, *American Paintings from the Metropolitan Museum of Art*, no. 11, ill. p. 24, as by an unknown painter // Connecticut Historical Society, Hartford, 1982, *The Life and Trials of Joseph Steward*, exhib. cat. by T. R. Harlow, published in *Connecticut Historical Society Bulletin* 46 (Oct. 1981), no. 16, p. 115; ill. p. 140 // Wadsworth Atheneum, Hartford, 1985, *The Great River*, no. 52, dates it about 1793–1795.
ON DEPOSIT: Museum of the City of New York, 1934–1935, lent by Mrs. Jonathan Dwight // MMA, 1958–1961, lent by Barbara Mercer Adam and Charlotte Adam Coate.
EX COLL.: descended to the subject's great-great grandson, Jonathan Dwight V; his wife, Mrs. Jonathan Dwight, New York, by 1934–1958; her half-sisters, Barbara Mercer Adam and Charlotte Adam Coate.
Gift of Barbara Mercer Adam and Charlotte Adam Coate, 1961.
61.90.

FREDERICK KEMMELMEYER

ca. 1755–1821

Frederick Kemmelmeyer arrived in this country, probably from Germany, about 1788; he was naturalized on October 8 of that year in Annapolis, Maryland. He was active as a painter in the Baltimore area from about 1788 to 1803. His earliest known advertisement, which appeared in the *Maryland Gazette* of June 3, 1788, announced the opening of his drawing school for young gentlemen (sessions held at his house) and ladies (sessions held at Mrs. Alcock's Academy). He also offered to "paint miniatures and other sizes, in oil and water colours, and Sign Painting upon moderate terms."

Thereafter, his advertisements appeared periodically in Baltimore newspapers until 1803, when he turns up in Alexandria, Virginia. By October of that year he had opened a school in Georgetown. In 1805 notices in both the Fredericktown and Hagerstown newspapers indicate that Kemmelmeyer had gone back to Maryland. In 1806 advertisements appeared in Chambersburg, Pennsylvania, papers, but some of Kemmelmeyer's family still seem to have been living in Hagerstown, where their name is found in the baptismal records of the German Calvinist Church. Other towns where the painter shows up after this time are Winchester, Virginia, and Shepherdstown, West Virginia. On November 13, 1816, he advertised the establishment of a drawing school in Hagerstown, Maryland. According to Bryding Adams Henley (1986), the last known contemporary notice of him is of his death on November 13, 1821, in the *Franklin Repository* of Chambersburg, Pennsylvania. He would have been at least sixty-six years old at this time.

Although Kemmelmeyer's works reveal that he had little formal training, he was nevertheless an ambitious artist eager to attempt copies of historical subjects. Two such paintings, *First Landing of Christopher Columbus*, 1806 (National Gallery of Art, Washington, D. C.) and another, *Battle of Cowpens, 17th January 1781*, 1809 (Yale University, New Haven), indicate the extent of his aspirations. His best known history paintings, however, represent Washington reviewing the western army at Fort Cumberland. In these, as in the *Battle of Cowpens*, the emphasis on contemporary events probably owes something to JOHN TRUMBULL and his scenes of the American Revolution.

BIBLIOGRAPHY: Alfred C. Prime, *The Arts and Crafts in Philadelphia, Maryland and South Carolina* (Topsfield, Mass., 1932). Some Kemmelmeyer advertisements are reprinted on pages 17 and 51 // *Antiques* 65 (April 1954), p. 291. Includes biographical data and discusses Kemmelmeyer's historical paintings // E. Bryding Adams, "Frederick Kemmelmeyer, Maryland Itinerant Artist," *Antiques* 125 (Jan. 1984), pp. 284–292. Contains new information on the artist and illustrates many of his pastel portraits as well as history paintings // Bryding Adams Henley, "Frederick Kemmelmeyer, Maryland Itinerant Artist," *Maryland Antiques: Show & Sale 1986* (Baltimore, 1986), pp. 77–78.

The American Star
(George Washington)

This picture has been dated about 1795 but may now be regarded as a later work by Kemmelmeyer, executed no earlier than 1803. The careful representation of seventeen stars in the firmament surrounding the head of the eagle as well as in the national flag next to the original American standard, with thirteen stars and "US" inscribed in the field, is strong evidence that Kemmelmeyer's picture could not have been painted before the admission of Ohio into the Union as the seventeenth state on March 1, 1803. The eighteenth star was not added until after the admission of Louisiana in 1812. Because a similar portrait by Kemmelmeyer (NYPL) is dated between 1800 and 1803, a date closer to 1803 is also more likely for this work.

Essentially an agglomeration of iconographical elements assembled for their narrative value rather than their visual plausibility, the picture glorifies Washington's achievements as a soldier, statesman, and Freemason by surrounding his portrait with artillery weapons, symbols of nationhood, and a Masonic medal. His characterization here as a star also identifies him as a

provider of secure guidance, a source of light in darkness, and a heavenly presence. Thus, as in votive images of a more directly religious character, Washington is presented as a subject worthy of veneration and respect, a man whose wonder-working virtues should be a source of inspiration and a model to all. The intended message is no different from that of Parson Weems's hagiographical *Life and Memorable Actions of George Washington*, first published about 1800 and much read at this time. The inscriptions on the painting are: (on the banner in the eagle's mouth) SEMPER ACTA PROBATA; (over the portrait of Washington) THE AMERICAN STAR; (under the portrait) GENL: GEOE: WASHINGTON; (on the face of the monument) First in War. / First in Peace. / First in defence / of / our Country; (on the scroll at the base of the monument) Independence / of / AMERICA / July 4th 1776; (on a flag at the left) US.

A number of similarities between this painting and a 1798 engraving by Cornelius Tiebout after Charles Buxton, published by Charles Smith, and popularly known as *The Bowling Green Washington*, reveals that Kemmelmeyer's work is actually a manifestation in colored oils of an established print tradition that repeatedly glorified Washington, and, after his death in 1799, memorialized him. (See I. N. P. Stokes, *The Iconography of Manhattan Island* [1915], 1, p. 413, ill. pl. 52.)

There are two similar works which on the basis of the Metropolitan's picture are attributed to Kemmelmeyer. A painting in the Museum of Early Southern Decorative Arts looks as though it could be an earlier depiction of the bust of Washington that appears in the Metropolitan's painting. The other, which is 9¾ by 8 inches, oil and gilt on paperboard, is in the Charles W. McAlpin Collection, in the print room of the New York Public Library. This work, like the Metropolitan's, shows Washington in a circle of bellflowers, but with a hat and a different grouping of flags. The number of stars on the flag in that work is sixteen. This fact together with the inscription "first in War, first in Peace, first in Defence of his country," a paraphrase of the funeral oration Henry Lee delivered to Congress on December 26, 1799, dates this particular work between about 1800 and 1803, before the Metropolitan version.

Kemmelmeyer, *The American Star (George Washington)*.

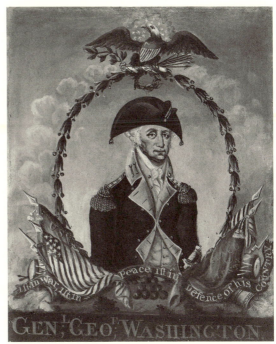

Kemmelmeyer, *George Washington*.
Museum of Early Southern Decorative Arts,
Winston-Salem, N.C.

Kemmelmeyer, *General George Washington*.
McAlpin Collection, Prints Division, NYPL.

Oil and gilt on paper, 22 × 17¾ in. (55.9 × 45.1 cm.).

Signed at lower right: F. Kemmelmeyer / Pinxit.

RELATED WORK: Attributed to Kemmelmeyer, *George Washington*, 21¾ × 17¾ in. (55.3 × 45.1 cm.), oil on paper mounted on linen, Museum of Early Southern Decorative Arts, Winston-Salem, N. C.

REFERENCES: Gardner and Feld (1965), p. 78; D. Deutsch, *Antiques* 120 (July 1981), p. 171, attributes a similar portrait of Washington in the NYPL to Kemmelmeyer, illustrates both works and discusses their motifs and the sources of the inscriptions // D. Deutsch, Nov. 1981, orally, supplied information on another work similar to this and the one in the NYPL.

EXHIBITED: MMA, 1961–1962, and American Federation of Arts, traveling exhibition, 1962–1964, *101 Masterpieces of American Primitive Painting from the Collection of Edgar William and Bernice Chrysler Garbisch*, no. 26, dates the painting about 1795; MMA, 1965, *American Paintings from the Metropolitan Museum of Art*, unnumbered checklist, dates painting about 1800 // Los Angeles County Museum of Art; M. H. de Young Memorial Museum, San Francisco, 1966, *American Paintings from the Metropolitan Museum of Art*, no. 82 // Monmouth Museum, Red Bank, N. J., 1968, *Flags of Freedom*, ill. and listed as exhibited at the entrance to the exhibition.

EX COLL.: Massachusetts art market, 1959 // Edgar William and Bernice Chrysler Garbisch, 1959–1962.

Gift of Edgar William and Bernice Chrysler Garbisch, 1962.
62.256.7.

ATTRIBUTED TO
FREDERICK KEMMELMEYER

Washington Reviewing the Western Army at Fort Cumberland, Maryland

In 1794 a rebellion against the federal government of the United States broke out in a number of counties in western Pennsylvania. The conflict was precipitated by the excise laws of March 3, 1791, and May 8, 1792, affecting the sale of distilled spirits. To inhabitants of this part of the nation, mostly Scotch-Irish immigrants for whom whisky was an important economic commodity, indeed almost a kind of currency, the tax was a discriminatory measure detrimental to their liberty and economic welfare. Protests ensued which eventually turned into full-scale riots. On August 7, 1794, President Washington issued a proclamation commanding the population to cease its opposition by September 1,

but it proved ineffectual. The president then called up the militias of Pennsylvania, New Jersey, Maryland, and Virginia to put down the uprising. On Washington's arrival in western Pennsylvania resistance vanished, and the entire episode went down in history as one of the crucial early tests of the power and effectiveness of the central government.

This painting shows Washington reviewing the assembled militia troops at their place of gathering, Fort Cumberland, Maryland, October 16, 1794. On that day Washington wrote in his diary:

After an early breakfast we set out for Cumberland—and about 11 Oclock arrived there.

Three Miles from the Town I was met by a party of Horse under the command of Major [George] Lewis (my Nephew) and by Brigr. Genl. [Samuel] Smith of the Maryland line, who Escorted me to the Camp; where, finding all the Troops under Arms I passed along the line of the Army (*The Diaries of George Washington*, ed. by J. C. Fitzpatrick [1925], 4, pp. 219–220).

Neither signed nor dated, the painting has been attributed at various times to Edward Savage, Kemmelmeyer, and James Peale. The probability that it is by Savage is slight; for the likeness of Washington is very different from that in the Savage portrait at Harvard and in his Washington family portrait at the National Gallery of Art, Washington. Also no other similar works by Savage are known. Whether the painting is by Peale or Kemmelmeyer, however, is a more difficult question. On the one hand, it is certain that in composition and execution the work is more sophisticated than are the two simplified versions of this scene that bear Kem-

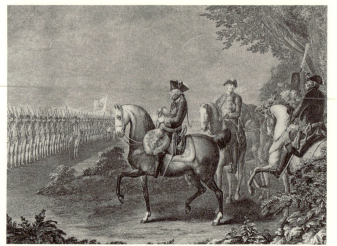

Daniel Nikolaus Chodowiecki, engraving, *König Friedrich's II. Wachtparade in Potsdam.* Prints Division, Library of Congress, Washington, D. C.

melmeyer's signature (Henry Francis du Pont Winterthur Museum, Wilmington, Del., and private coll., Baltimore, ill. in A. Winchester and J. Lipman, *The Flowering of American Folk Art* [1974], p. 91). On the other hand, it is difficult to believe that James Peale could have produced a painting that so misconstrues the anatomy of the horse, the likenesses of the principal figures, and the relationship of the figures to the landscape. His history paintings, such as *Washington at the Battle of Princeton*, 1804 (Henry Francis du Pont Winterthur Museum), while not masterpieces of veristic representation, are far more true-to-life than this painting. In particular, Peale never stylized the curve of the horse's neck, or painted faces in so generalized a way as is seen in this work. Furthermore, his background figures are not as clumsy or stiff, for example, as the long lines of soldiers in this picture. Finally, the horses and figures in paintings by Peale, though at times badly proportioned and somewhat flat in appearance, usually look as if they are actually standing on the ground and do not give the impression of floating slightly above it, as may be observed in this work.

The very qualities that render an attribution to James Peale implausible, however, call to mind the characteristics of Kemmelmeyer's work as seen *not* in the other depictions of this subject but in one of the more ambitious works that bear his signature, *First Landing of Christopher Columbus*, 1806 (National Gallery of Art, Washington, D. C.). Here we can observe that Kemmelmeyer was capable of rendering a complex composition and could handle coloring with some degree of sophistication. In that painting the representation of the foreground, the faces of the figures with their protuberant noses, and the convincing effects of atmosphere and spatial recession are very reminiscent of the museum's picture and no longer permit us to state that it is not by Kemmelmeyer because it exhibits these qualities. More recently, a print source for this painting has been discovered, and since it is by a very popular German artist, Daniel Nikolaus Chodowiecki (1726–1801), it is much more likely that a German immigrant such as Kemmelmeyer would have been familiar with his work and probably also would be in possession of his engravings.

Accordingly, this work is now once again attributed to Kemmelmeyer because of the comparable degree of accomplishment evident in it

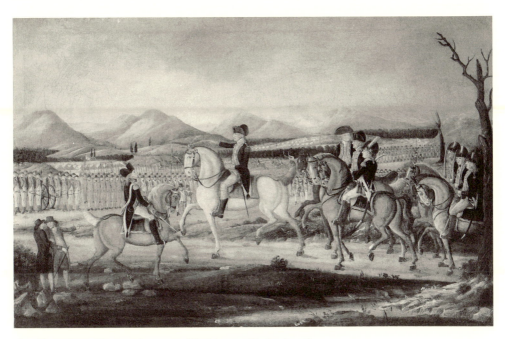

Attributed to Kemmelmeyer, *Washington Reviewing the Western Army at Fort Cumberland, Maryland.*

and in the National Gallery picture and because the previous alternative attributions are simply untenable. If this is the case, it is likely that the present work is Kemmelmeyer's original rendering of the Fort Cumberland scene and that the other two small pictures, which show only Washington in the foreground, are copied from this one.

The painting has been extensively restored and is still much abraded and worn. A photograph of the condition before treatment reveals serious losses and damages but does not disclose any radical changes that would invalidate the argument presented here.

Oil on canvas, 22¾ × 37¼ in. (57.8 × 94.6 cm.).

RELATED WORK: Daniel Nikolaus Chodowiecki, *König Friedrich's II. Wachtparade in Potsdam*, engraving, 1777, 9 5/16 × 12 7/16 in. (23.8 × 31.5 cm.), ill. in J. H. Bauer, *Daniel Nikolaus Chodowiecki: Das druckgraphische Werk* (1982), no. 409.

REFERENCES: E. B. Johnston, *Original Portraits of Washington* (1882), p. 142, refers to another depiction of the scene, noting that an "itinerant artist named Kemmelmyre [*sic*] sketched Washington from life while 'Reviewing the Western Troops, Cumberland, Md., October 2, 1794' " // Mrs. C. F. Quincy, letter to W. Lanier Washington, Nov. 2, 1927, in the possession of Victor Spark, says that C. F. Quincy be- lieved the picture to be by Savage // J. H. Morgan and M. Fielding, *The Life Portraits of Washington and Their Replicas* (1931), p. 199, as by Kemmelmeyer // C. A. Hoppin, *Washington Post*, May 8, 1932, says painted by Savage for his museum and picture gallery in Philadelphia // G. A. Eisen, *Portraits of Washington* (1932), 2, p. 435, lists it as by an unknown artist but notes that some have attributed it to Savage; states that Jonce I. McGurk thinks that it is the original Kemmelmeyer version; gives early prov- enance; p. 659, pl. 143, shows condition of the paint- ing in 1932 // Gardner and Feld (1965), pp. 67–69, reject the Savage attribution and change it to James Peale on the basis that it is too well painted to be by Kemmelmeyer // E. B. Adams, *Antiques* 125 (Jan. 1984), ill. p. 288, says naive attention to detail and awkward painterly manner indicate it is by Kemmel- meyer // B. A. Henley, Birmingham Museum of Art, letter in Dept. Archives, Jan. 15, 1987, supplies information on print source which William Gerdts brought to her attention in July of 1984.

EXHIBITED: M. H. de Young Memorial Museum, San Francisco, Los Angeles County Museum of Art; Wadsworth Atheneum, Hartford; Museum of Art, Rhode Island School of Design, Providence, 1942– 1943, *Twenty-five American Paintings from the Revolution to the Civil War*, no. 19 (Hartford catalogue), as the Cumberland Review by Edward Savage, lent by Victor Spark through Newhouse Galleries, New York; ill. p. 23 // National Gallery of Art, Wash- ington, D. C., and the Museum of Modern Art, New

York, 1944, *American Battle Painting, 1776–1918*, cat. p. 55, as attributed to Edward Savage, lent by Victor Spark // Corcoran Gallery of Art, Washington, D. C. 1950, *American Processional*, no. 84, attributed to Kemmelmeyer and dated about 1794; ill. p. 85, shows condition in 1950 (there is overpaint on the tree at the right) // Denver Art Museum, 1951, *Art in America*, as by Kemmelmeyer // National Gallery of Art, Washington, D. C., 1954, *American Primitive Paintings from the Collection of Edgar William and Bernice Chrysler Garbisch*, part 1, cat. p. 31, as by Kemmelmeyer // MMA and American Federation of Arts, traveling exhibition, 1961–1964, *101 Masterpieces of American Primitive Painting from the Collection of Edgar William and Bernice Chrysler Garbisch*, no. 29, as by Kemmelmeyer // MMA, 1965, *Three Centuries of American Painting* (checklist arranged alphabetically), as attributed to James Peale // Lytton Gallery, Los Angeles County

Museum of Art and M. H. de Young Memorial Museum, San Francisco, 1966, *American Paintings from the Metropolitan Museum of Art*, no. 81 // American Federation of Arts, traveling exhibition, 1968–1970, *American Naive Painting of the 18th and 19th Centuries, 111 Masterpieces from the Collection of Edgar William and Bernice Chrysler Garbisch*, color ill. no. 25.

On Deposit: Jumel Mansion, New York, before 1927, lent by C. F. Quincy.

Ex coll.: Charles Frederick Quincy, Newton, Mass., New York, and Scarsdale, N. Y., until 1927; with Victor Spark, New York, by 1942 until 1945; Edgar William and Bernice Chrysler Garbisch, 1945–1963.

Gift of Edgar William and Bernice Chrysler Garbisch, 1963.

63.201.2.

GILBERT STUART

1755–1828

Gilbert Stuart was born in North Kingston, Rhode Island, on December 3, 1755. He was the son of a Scottish millwright and a Rhode Island farm girl. His childhood friend Benjamin Waterhouse told WILLIAM DUNLAP that Stuart was about thirteen years old when he began to copy pictures and that his pencil portraits in this youthful period were quite successful. Thus, by 1769, when the wandering Scottish painter Cosmo Alexander (1724-1772) took an interest in him, Stuart had already manifested his talents. At about this time, he became Alexander's pupil and informal apprentice. In 1771 he accompanied him to Edinburgh, where he probably hoped to join the studio of an established painter. The following year, however, when Alexander died, Stuart was left virtually stranded. The American artist rarely spoke about this unhappy episode, but it seems that it was only with the greatest difficulty that he managed to stay alive and make his way home in 1773 or 1774.

As is to be expected, Stuart's portraits from this time are primitive looking and reveal Alexander's influence. His *John Bannister* of about 1774 (Redwood Library and Athenaeum, Newport), for example, clearly derives from the *Alexander Grant* of Cosmo Alexander (Art Institute of Chicago, ill. *Antiques* 94 [Sept. 1978], p. 500) in the background arrangement and the painting of the face. Yet, it is evident from Stuart's most ambitious work of the period, the double portrait of Francis Malbone and his brother Saunders (private coll.), that he realized Alexander's stylistic shortcomings and recognized the preeminence of Copley in colonial portraiture. His indebtedness to Copley is revealed in the portrait of Dr. Benjamin Waterhouse, of about 1776 (Redwood Library and Athenaeum), which he began shortly after his arrival in London in late 1775.

Stuart went to London probably because he realized there would be little opportunity for a painter in revolutionary America. He had no resources and was apparently in difficult straits when BENJAMIN WEST, who was always generous to his compatriots, took him into his studio in 1777. Stuart developed rapidly but he was not at all disposed to adopt West's style. The portrait of James Ward, 1779 (Minneapolis Institute of Arts), in Van Dyck costume and with his dog, discloses Stuart's new ideal—urbane fashionable portraiture in the manner of Thomas Gainsborough and Joshua Reynolds as practiced at this time by younger British artists. In 1781, realizing he was a far better face painter than West, he abandoned that artist's studio and set up his own. In 1782 he sent the remarkable full-length portrait of William Grant, known as *The Skater* (National Gallery of Art, Washington, D. C.) to the Royal Academy and established his reputation as the peer of such English portraitists as John Hoppner, George Romney, and Henry Raeburn. From this time on he never lacked patrons. An intelligent and witty man, Stuart began to gratify his taste for good company, good food, and lavish surroundings. He entertained and became a cosmopolite. In 1786 he married Charlotte Coates, the daughter of an English physician. They had twelve children.

In 1787, hounded by creditors, Stuart left England for Ireland, doubtless to avoid prison. In Dublin he painted a large number of notable people and once again established himself in luxury. In general his style of painting remained unchanged, although such full-length portraits as *John Fitzgibbon, Earl of Clare*, 1789 (Cleveland Museum of Art), and *The Right Honorable John Foster*, 1791 (Nelson Atkins Museum of Art, Kansas City), possess a coloristic brilliance that surpasses his most elaborate English portraits. Only after 1793, when, insolvent again, he left Ireland and returned to the United States, did his approach to painting begin to change. His countrymen, especially those residing in New York, where Stuart first settled, were not ready for the flashy mannerisms of the English high style. Copley had been the finest portrait painter to work in New York, and the lingering influence of his painstaking realism once again exercised an effect on Stuart. Even though Stuart's reputation in London was higher than Copley's had been, he decided to indulge the taste of his patrons. A number of works executed at this time, including *Mrs. Richard Yates* (National Gallery of Art, Washington, D. C.) and *Matthew Clarkson* (q.v.), are masterpieces of straightforward, unembellished character-painting and distinctly echo Copley's American manner. Others like the equally masterful portraits of John Jay, 1794 (U. S. Department of State, Washington, D. C.), and of Josef de Jáudenes y Nebot and his wife (qq.v.) are more painterly and elegant, doubtless because the subjects were well-traveled and aware of European standards of style.

In late 1794, Stuart moved to Philadelphia, then the federal capital, and quickly became the painter of its political and mercantile elite. Particularly noteworthy among the pictures he produced at this time are the various portraits he painted of George Washington and a number of fashionable women. His *Mrs. Joseph Anthony* (q.v.), for example, displays his London training as well as a new and engaging seductiveness. In 1803 he left Philadelphia in order to work in Washington, perhaps thinking that proximity to the seat of government would insure an active social life and a steady flow of commissions. The new capital, however, was hardly an urban center, and in 1805 Stuart moved to Boston, where he remained until his death in July 1828.

During these later years, Stuart's technique did not really change (especially not with

respect to capturing a likeness), but he did develop a new portrait type, which in composition and coloring was more in tune with the tenets of neoclassicism. Featuring remarkably life-like heads and solidly executed busts placed against a plain, roomy background, these portraits are models of realism and simplicity and may be regarded as his most original contributions to American portraiture. During this period, he also exercised great influence on younger American painters. While JAMES FROTHINGHAM, THOMAS SULLY, and MATTHEW HARRIS JOUETT benefited directly from his teachings, many other portraitists, realizing his importance, emulated his style.

BIBLIOGRAPHY: Lawrence Park, *Gilbert Stuart*, ed. by William Sawitzky (New York, 1926). The indispensable catalogue raisonné, it provides hundreds of illustrations // John Hill Morgan, *Gilbert Stuart and His Pupils* (New York, 1939). Assesses Stuart's influence // James Thomas Flexner, *Gilbert Stuart: A Great Life in Brief* (New York, 1955). Gives a very good account of Stuart's early years // Charles Merrill Mount, *Gilbert Stuart* (New York, 1964). Has a more up-to-date listing of works than is found in Park // National Gallery of Art, Washington, D. C. and Museum of Art, Rhode Island School of Design, Providence, *Gilbert Stuart, Portraitist of the Young Republic*, exhib. cat. (1967). Contains an excellent introduction by E. P. Richardson and informative entries on individual paintings.

Man in a Green Coat

Several identities have been suggested for the subject of this portrait, including Benjamin Waterhouse and William Temple Franklin. In both these cases, comparisons with other Stuart portraits of the same men fail to establish the identification. The portrait appears to be an early work. Although executed with bravura, in a lush painterly fashion, it still displays uncertainties of execution typical of an artist not fully confident of his powers. To begin with, it is clear that the portrait was originally intended to fill the rectangular canvas but subsequently was changed to an oval format. In addition, the outline of the wig was corrected by covering part of it with the same black pigment used in the background. While this is normal practice, it was done in an obviously intrusive way. Finally, the sharp division of the upper background into light and dark halves, which pick up blues, reds, greens, pinks, and whites at the edges, produces a confused welter of illegible forms. Even if they are regarded as abstractions, these forms do not relate well to the figure in the portrait.

Such infelicities of execution raise a difficult question: does this painting antedate Stuart's similar-sized portrait of James Ward, 1779 (Minneapolis Institute of Arts), which shows a decidedly more assured performance but is not so appealing a work? If the problems of *Man in a Green Coat* are to be attributed to inexperience, then the portrait probably was done before the one of Ward because Stuart's work after about 1779 displays masterful ability, for example, *The Skater*, 1782 (National Gallery of Art, Wash-

Stuart, *Man in a Green Coat.*

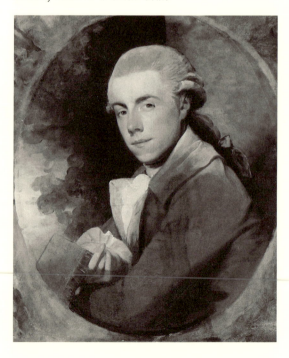

ington), and the oval *John Singleton Copley*, 1783-1784 (National Portrait Gallery, London). If, however, the picture is considered unfinished, as may well be the case, then the traditional dating of about 1780 or 1785 would still hold. In any event, the portrait remains one of Stuart's finest English works and illustrates how quickly and naturally he adopted the free and elegant manner of fashionable London portraitists, such as Joshua Reynolds and more particularly Thomas Gainsborough.

Oil on canvas, 28½ × 23½ in. (72.3 × 59.7 cm.).
REFERENCES: L. Park, *Gilbert Stuart* (1926), 2, no. 656, p. 610, lists it as Portrait of a Gentleman and says it was painted in London about 1785 // E. Clare, Knoedler and Co., New York, letter in Dept. Archives, Dec. 14, 1964, supplies information on the provenance // C. M. Mount, *Gilbert Stuart* (1964), p. 64; p. 362, lists it as a portrait of Waterhouse // C. M. Mount, letter in Dept. Archives, Sept. 16, 1965, notes that he identifies the sitter as Waterhouse and believes it is one of Stuart's earliest London efforts // S. Feld, memo in Dept. Archives, Sept. 14, 1965, notes that Elizabeth Clare at Knoedler suggested W. T. Franklin as the subject // Gardner and Feld (1965), p. 80 // *MMA Bull.* 33 (Winter 1975/1976), no. 25 (color ill.) // R. McLanathan, *Gilbert Stuart* (1986), ill. p. 26; p. 27.
EXHIBITED: MMA, 1933, *Paintings from the Harkness Collection* (no cat.); 1958–1959, *Fourteen American Masters* (no cat.) // Los Angeles County Museum of Art; M. H. de Young Memorial Museum, San Francisco, 1966, *American Paintings from the Metropolitan Museum*, no. 14, p. 27 // Pushkin Museum, Moscow, and Hermitage, Leningrad, 1975, *100 kartin iz muzeya Metropoliten* [*100 Paintings from the Metropolitan Museum*], pp. 227–228, no. 81 // MMA, 1976, *A Bicentennial Treasury* (see *MMA Bull.* 33 above).
EX COLL.: George Sitwell Campbell Swinton, London, 1920; with M. Knoedler and Company, London, 1920; Edward S. Harkness, New York, 1920–1940; his wife, Mary Stillman Harkness, 1940–1950.
Bequest of Mary Stillman Harkness, 1950.
50.145.37.

Portrait of the Artist

Preserved on a label found on the back of this picture are excerpts from a letter, dated December 6, 1884, in which Jane Stuart, the artist's youngest daughter, wrote: "He painted a small sketch in oil of himself for my mother (in London, after great persuasion) but could not be induced to finish it. Some years since I

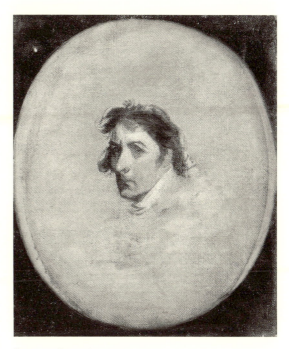

Stuart, *Portrait of the Artist*.

gave this Head to the late Mrs. H. G. Otis, which she left to her son Harry, who died quite recently, in some part of Europe." This self-portrait, then, represents Stuart about age thirty, shortly after his marriage to Charlotte Coates on May 10, 1786.

Executed with great economy and absolute assurance, the portrait captures the artist's likeness in a vague though coloristically well-defined way, as Stuart thought portraits should: "the true and perfect image of the man is to be seen only in a mist or hazy atmosphere" (G. C. Mason, *The Life and Works of Gilbert Stuart* [1879], p. 67). Thus, regardless of its unfinished state, the picture is so well-balanced, so fresh, and such an accomplished study of a proud and irritable character that in terms of Stuart's own philosophy of portraiture it must be considered a finished product. Little wonder that he could not be induced to "finish" it.

Even though the portrait is much larger than a miniature, its bright turquoise background suggests that Stuart was attempting something more in the aesthetic vein of miniature and petit boudoir portraits than was usually his practice. There is nothing, however, of the smooth, delicate quality of such works here. On the contrary, Stuart's knowing application of the oil pigments

on the coarse weave of the canvas, using it to give a palpable texture to the likeness, justifies his enthusiasm for the possibilities of his preferred medium, oil on canvas.

Oil on canvas, 10⅝ × 8⅞ in. (29 × 22.5 cm.).

REFERENCES: L. Park, *Gilbert Stuart* (1926), 2, no. 797, p. 718–719, says the portrait was painted in London about 1786–1788 but misdates the Jane Stuart letter December 16, 1885 // H. B. Wehle, *MMA Bulletin* 21 (March 1926), pp. 76–77 // T. Maytham, MFA, Boston, June 10, 1963, letter in Dept. Archives, gives information on loan of painting // C. M. Mount, *Gilbert Stuart* (1964), p. 375 // Gardner and Feld (1965), pp. 80–81.

EXHIBITED: Museum of Art, Rhode Island School of Design, Providence, 1936, *Rhode Island Tercentenary Celebration*, no. 27 // Dayton Art Institute, Ohio, 1950, *The Artist and His Family* (no cat.) // MMA, 1958–1959, *Fourteen American Masters* (no cat.); 1965 *Three Centuries of American Painting* (alphabetical checklist) // National Gallery of Art, Washington, D. C.; Museum of Art, Rhode Island School of Design, Providence, 1967, *Gilbert Stuart*, no. 13, p. 55 // Yale University Art Gallery, New Haven; Victoria and Albert Museum, London, 1976, *American Art, 1750–1800*, no. 45, pp. 108–109.

ON DEPOSIT: MFA, Boston, 1883–1922, lent by the estate of Mrs. Harrison Gray Otis.

EX COLL.: Mrs. Gilbert Stuart; her daughter, Jane Stuart, Boston; Mrs. Harrison Gray Otis, Boston, d. 1873; possibly her son, Harrison Gray Otis, d. about 1883; estate of Mrs. Harrison Gray Otis, Boston, 1883–1922; Albert Rosenthal, Philadelphia, 1925–1926; with Ehrich Galleries, New York, 1926.

Fletcher Fund, 1926.

26.16.

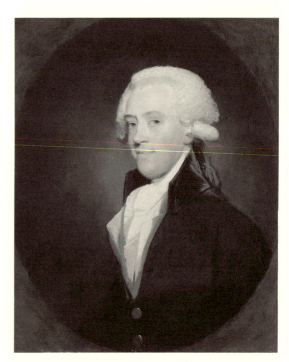

Stuart, *Thomas Smith.*

Thomas Smith

Biographical facts regarding Thomas Smith (ca. 1747–1829) are not abundant. He was the son of William Smith of Change Alley in London and was apprenticed as a bookbinder to Abraham Jefferies of Blackfriars on October 6, 1761. If we assume he was fourteen years old at that time, then he was born about 1747. On November 1, 1768, he was made a member of the Worshipful Company of Stationers in London. He obviously prospered as a manufacturer of books; for by about 1790 he owned two houses: Castlebar House in Ealing, Middlesex, and Bolton House in Piccadilly. On June 30, 1810, Smith was elected under warden of the Stationers' Company, then upper warden in 1811, and fi-

nally master in 1812. He died at Alençon, France, in 1829.

Since Smith was a Londoner and the style of the work is clearly that of Stuart's English period, the portrait may be dated about 1785. The actual date may be 1787, if the *Musical Memoirs* (London, 1830) of the oboist William Thomas Parke refer to this sitter and this painting. He does not give the day or the month, but entered under the year 1787, he notes:

This year I became acquainted with Stuart the well-known and admired portrait painter, who was infallible in his likenesses, though not equally remarkable for the elegance of his draperies . . . A few days afterwards I dined at the house of the same artist with a large party: among whom were Mr. T. Smith, a gentleman of fortune, and a very particular friend of mine, who had that day been sitting to Stuart for his portrait (pp. 86, 87).

The drawing of Smith's head, in particular, recalls Stuart's portrait of Copley painted in 1784 (National Portrait Gallery, London). In both cases the defining elements, such as the eyebrows and nose, are outlined in bold, rough strokes, while areas demanding strong modeling, such as

the cheeks and the area below the eyebrows, are so tinted as to give the impression that the subject is wearing makeup. Furthermore, in both portraits the distant side of the mouth is anatomically confusing as a result of heavy brushwork.

Smith is depicted in a blue coat, dark in tone, against an equally dark, brown background. In this manner his head becomes the sole focus of attention. The prettified face with its instant appeal is typical of Stuart's best English works and is an example of the kind of fashionable portraiture he felt compelled to abandon after his return to America.

Oil on canvas, 30 × 25 in. (76.2 × 63.5 cm.).

REFERENCES: C. M. Mount, *Gilbert Stuart* (1964), p. 362, lists an unlocated portrait of T. Smith mentioned in the memoirs of William Thomas Parke (possibly this painting) // Jacques Coe, letter in Dept. Archives, Nov. 3, 1967, gives information on the subject and provenance // J. R. Moon, Worshipful Company of Stationers and Newspaper Makers, London, letter in Dept. Archives, March 10, 1978, furnishes extracts from the company records relating to Thomas Smith.

EX COLL.: the subject, d. 1829; his son, Captain H. N. Smith; his daughter, Amy, Lady Burgoyne, d. 1895; her husband, Sir John Montagu Burgoyne, Sandy, Bedfordshire, d. 1921; probably his second wife, Katherine, Lady Burgoyne; with John Levy Galleries, New York, by 1939; Jacques Coe, New York, November 1939–1967.

Gift of Mr. and Mrs. Jacques Coe, 1967.
67.220.

Matthew Clarkson

Matthew Clarkson (1758–1825) was born in New York, the son of Elizabeth French and David Clarkson. His great-grandfather and namesake, the patriarch of the family in America, came to New York from England in 1690 as secretary of the province. His descendants intermarried with members of prominent local families, and the Clarksons continued to have a strong voice in the political and commercial affairs of the colony. During the American Revolution, they sided with the patriot cause.

In 1776 Matthew Clarkson fought at the Battle of Long Island. At Fort Edward, while aide-de-camp to General Benedict Arnold, he was wounded; later, he distinguished himself at the Battle of Saratoga. He then became em-

Gilbert Stuart

broiled in a controversy with Thomas Paine over the Silas Deane affair. In 1779 he was reprimanded by the Continental Congress for refusing a summons from the Executive Council of Pennsylvania. Congress, however, granted his request to serve in the South, and he joined the staff of General Benjamin Lincoln as aide-de-camp. He remained in that post until the end of the war and served as Lincoln's assistant when he was secretary of war from 1781 to 1783. Later Clarkson joined the New York state militia where he rose to the rank of major general.

After retiring from active military duty about 1788, Clarkson devoted his energies to a number of political, business, and civic projects. He became a regent of the State University of New York; served in the state assembly for one term, 1789–1790, during which he introduced a bill for the abolition of slavery; and was a member of the state senate for two terms, 1794 and 1795. Clarkson was president of the Bank of New York from 1804 to 1825. De Witt Clinton, who defeated him in 1802 for a seat in the United States Senate, said of him: "Whenever a charitable or public-spirited institution was about to be established Clarkson's presence was deemed essential. His sanction became a passport to public ap-

Stuart, *Matthew Clarkson.*

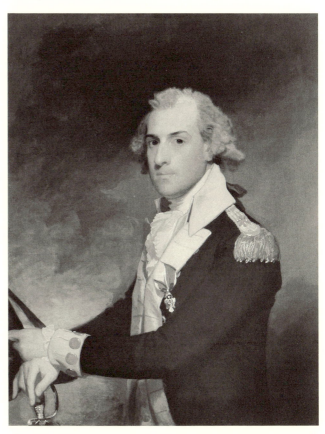

probation" (quoted in Gardner and Feld, p. 82). Clarkson was married twice, to Mary Rutherfurd in 1785 and Sarah Cornell in 1792.

Painted in New York about 1794, this portrait is an example of how Stuart adjusted his style to a different class of patrons when he returned to America. Although his familiarity with the techniques of the English school is still in evidence, brilliant brushwork effects have been eliminated; the cosmetic appearance, the florid and rouged countenances of his British subjects, has given way to quieter and more realistic representations, and his color in general has become more harmonious. Here, in fact, as in many of Stuart's New York works, one can sense the influence of Copley. It is not amiss to attribute Stuart's straightforward and uncompromising characterization of Matthew Clarkson to Copley's appealing realism of some twenty years previous.

Though long since retired from active military duty, Clarkson is dressed in the uniform of the Continental Army and proudly displays the badge of the Order of the Cincinnati. He is represented as a handsome and virile military officer, but he lacks the urbanity, ease, and style that characterize Stuart's English and Irish subjects.

Another portrait of Clarkson, painted by SAMUEL L. WALDO and WILLIAM JEWETT in 1823, is also in the Metropolitan's collection (q.v.).

Oil on canvas, 36 1/16 × 28 1/4 (91.6 × 71.8 cm.).

RELATED WORKS: James Frothingham, copy, oil on canvas, 36 × 29 in. (91.4 × 73.7 cm.), ca. 1840, coll. John Jay // Samuel L. Waldo, copy, oil on canvas, unlocated // Mrs. Peter A. Jay (the subject's daughter), copy, oil on canvas, unlocated // G. Mason (1879) notes that John Trumbull copied this portrait for the head of Clarkson in *The Surrender of General Burgoyne at Saratoga*, 1817–1821 (Rotunda of the Capitol, Washington, D. C.).

REFERENCES: *DAB* (1930; 1957), s. v. Clarkson, Matthew, gives biographical information on the subject // G. Mason, *The Life and Works of Gilbert Stuart* (1879), p. 159, gives Matthew Clarkson as owner of the portrait and lists a number of copies // C. W. Bowen, ed., *The History of the Centennial Celebration of the Inauguration of George Washington* (1892), p. 438, says it was painted in 1793–1794 // L. Park, *Gilbert Stuart* (1926), I, p. 217, no. 159, dates it 1793 or 1794; p. 218, lists copies // J. Allen, *MMA Bull.* 33 (June 1938), pp. 144–146 // C. M. Mount, *Gilbert Stuart* (1964), p. 175; p. 348, in a note says it is derived from Francis Cotes's Portrait of a Man in the Tate Gallery, London; p. 366, lists it // Gardner and Feld

(1965), pp. 81–82 // R. McLanathan, *Gilbert Stuart* (1986), p. 79, color ill. p. 82.

EXHIBITED: John Herron Art Museum, Indianapolis, 1942 *Retrospective Exhibition of Portraits by Gilbert Stuart*, no. 10 // MMA, 1958–1959, *Fourteen American Masters* (no cat.) // World's Fair, New York, *Four Centuries of American Masterpieces*, no. 6 // MMA, 1965, *Three Centuries of American Painting* (checklist arranged alphabetically) // Lytton Gallery, Los Angeles County Museum of Art; M. H. de Young Memorial Museum, San Francisco, 1966, *American Paintings from the Metropolitan Museum of Art*, no. 15 // National Gallery of Art, Washington, D. C.; Art Museum, Rhode Island School of Design; American Federation of Arts, 1967, *Gilbert Stuart, Portraitist of the Young Republic*, cat. no. 22 // MFA, Boston, 1970, *Masterpieces of Painting in the Metropolitan Museum of Art*, text by T. Folds, color ill. p. 104 // National Gallery of Art, Washington, D. C.; City Art Museum of Saint Louis; Seattle Art Museum, 1970–1971, *Great American Paintings from the Boston and Metropolitan Museums*, exhib. cat. by T. N. Maytham, no. 20.

EX COLL.: the subject, d. 1825; his son, David Clarkson, until 1867; his son, Matthew Clarkson, New York, by 1879; his son, Banyer Clarkson, New York, by 1926; his wife, Helen Shelton Clarkson, d. 1937.

Bequest of Helen Shelton Clarkson, 1937.
38.61.

Josef de Jáudenes y Nebot

Josef de Jáudenes y Nebot (1764–before 1819) was born in the city of Valencia, Spain, on March 25, 1764, the son of Antonio de Jáudenes y Amat and Emilia Nebot. According to the United States Department of State's historical register, he was commissioned Spanish chargé d'affaires to the United States on February 12, 1791, together with José Ignacio de Viar. A passage in a letter written by President Washington on July 20, 1791, however, informs us that Jáudenes had been present in this country before his diplomatic appointment: "I yesterday had Mr. Jaudenes, who was in this country with Mr. Gardoqui and is now come over in a public character, presented to me for the first time by Mr. Jefferson." Both Jáudenes and Viar were involved in negotiations regarding the boundaries between the United States and Spanish Louisiana and navigation on the Mississippi River, but sometime in mid-1794, Jáudenes began to act independently of his colleague. In that year, too, he married Louisa Carolina Matilda Stoughton (see below), daughter of the

wealthy John Stoughton, Spanish consul in Boston.

The Jáudeneses set up house in Philadelphia and are reported to have lived in great style and beyond their means. He aspired to an appointment as his country's full-fledged envoy to the United States, but his hopes were dashed when Don Carlos Maria Martinez d'Yrujo arrived in 1796 with the rank of envoy extraordinary and minister plenipotentiary. Superseded in his post, Jáudenes sailed with his wife for Spain aboard the *Governor Mifflin* on July 24, 1796, never to return to this country.

Little is known of Jáudenes's career after his departure, but it is likely that he did more than simply retire to his family vineyards near Palma, Majorca. Perhaps his service as "comisario ordenador" or quartermaster in the royal armies, noted in the inscription at the upper right, dates from this period. In any case, on July 14, 1803, he was created a knight of the order of Charles III. He died sometime before 1819.

Painted in New York in 1794 about the time of his wedding, the portrait of Jáudenes ranks as a tour de force in Stuart's oeuvre. The attention lavished on the execution of costume details and accessories, as well as the baroque formality of the pose, both uncommon in Stuart's art, appropriately reflect his sitter's concern with rank and status. The painting looks to the continental baroque portrait tradition as interpreted by late eighteenth century English painters. Joshua Reynolds's portrait of *Alexander, Lord Loughborough* (Honorable Society of Lincoln's Inn, London), exhibited at the Royal Academy in 1785 and engraved by J. Grazer in 1786, a work surely known to Stuart, may be cited as a possible source, though here Reynolds went back to older models with which Stuart was also familiar. In this respect it should be noted that Stuart was quite capable of using baroque sources on his own, and, in fact, did so when he so closely followed Hyacinthe Rigaud's portrait of Bishop Bossuet for his full-length *George Washington*, 1796 (PAFA). Thus, the similarity to Reynolds's portrait may be the result of Stuart's reliance on similar antecedents rather than a direct imitation.

As in many other works painted by Stuart in New York after his return from England, the handling of paint in the Jáudenes portrait is relatively tight, following in the tradition of Copley. This quality becomes more apparent when one compares the Jáudenes picture with

Stuart's portrait of Joshua Reynolds, painted in England in 1784 (National Gallery of Art, Washington, D. C.) and with a representative Copley portrait like that of Isaac Smith, 1769 (Yale University, New Haven, Conn.). Curiously enough, this emphasis on linearity, combined with the rococo-like decorativeness of the costume, was probably quite in keeping with the taste of Jáudenes, whose concepts of grand portraiture were in all likelihood shaped by the works of eighteenth-century Spanish artists who were heavily influenced by Anton Raphael Mengs. Thus, an unexpectedly complex meeting of art historical influences takes place in this portrait, and, in retrospect, it does not seem unreasonable that a perceptive student of Stuart's portraiture like Charles Henry Hart mistakenly took it to be a copy by a Spanish artist after Stuart's original.

The inscription and coat of arms, which includes those of the sitter's four grandparents, Jáudenes, Nebot, Amat, and Rius, were added by another hand in Spain.

Oil on canvas, 50¾ × 39¾ in. (128.9 × 101 cm.).

Inscribed by a later hand at lower right: G. Stuart, R. A. New York, Sept. 8, 1794. Inscribed by a later hand below coat of arms, at upper right: Don Josef de Jaudenes, y Nebot/Comisario Ordenador de los / Reales Exercitos y Ministro Em / biado de Su Magestad Catholi / ca cerca de los Estados Unidos / de America. / Nació en la Ciudad de Valen– / cia Reyno / de España el 25, de / Marzo de 1764.

REFERENCES: K. Cox, *MMA Bull.* 2 (April 1907), p. 64 // C. H. Hart, letter in Dept. Archives, June 5, 1907, says it is a copy by a Spanish artist after a Stuart portrait // *New York Herald*, August 19, 1907, p. 3, questions its authenticity // S. Isham, *McClure's Magazine* 31 (June 1908), pp. 176–178, gives biographical information on sitter, quotes Washington's letter of July 20, 1791, and, after discussing the attribution controversy, concludes that it is a characteristic work by Stuart // M. Fielding, *Pennsylvania Magazine of History and Biography* 38 (1914), p. 325, no. 71, lists it as Josef de Jaudens [*sic*] and mistakenly adds under no. 72 that the figures were added "by some assistant or local artist" // L. Park, *Gilbert Stuart* (1926), 1, p. 432, no. 434, says the coat of arms, signature, and inscriptions are later additions // A. and A. Garcia Carraffa, *Enciclopedia Heráldica y Genealógica Hispano-Americana* (1933), 47, pp. 74–75, gives biographical information on sitter // A. T. Gardner, *MMA Bull.* 6 (March 1948), p. 190, gives further biographical information // C. M. Mount, *Gilbert Stuart* (1964), pp. 179–181, discusses the work and says it was painted during the summer of 1794; pp. 181, 349, discusses sources of the composition; p. 349, expresses view

that signature and inscription are by Stuart // Gardner and Feld (1965), p. 82–83 // *Apollo* 104 (Sept. 1976), p. 162, notes Stuart's "success in shrewdly catching the spirit and nationality of his sitter" // M. Brown, *American Art to 1900* (1977), p. 189 // N. Little, Knoedler and Co., New York, March 1986, supplied information on provenance // R. McLanathan, *Gilbert Stuart* (1986), pp. 81, 84, 92, 105, 107; color ill., p. 91.

EXHIBITED: MMA, 1958–1959, *Fourteen American Masters* (no cat.); 1965, *Three Centuries of American Painting* (checklist arranged alphabetically) // National Gallery of Art, Washington, D. C.; Museum of Art, Rhode Island School of Design, Providence, 1967, *Gilbert Stuart, Portraitist of the Young Republic*, no. 23 // Yale University Art Gallery, New Haven; Victoria and Albert Museum, London, 1976, *American Art, 1750–1800*, no. 48, pp. 110–111.

Matilda Stoughton de Jáudenes

Matilda Stoughton de Jáudenes (b. 1778) was the daughter of John Stoughton, who served as Spanish consul in Boston for thirty years before his death in 1820. She was born in New York and in 1794, at the age of sixteen, was married to

Stuart, *Matilda Stoughton de Jáudenes*.

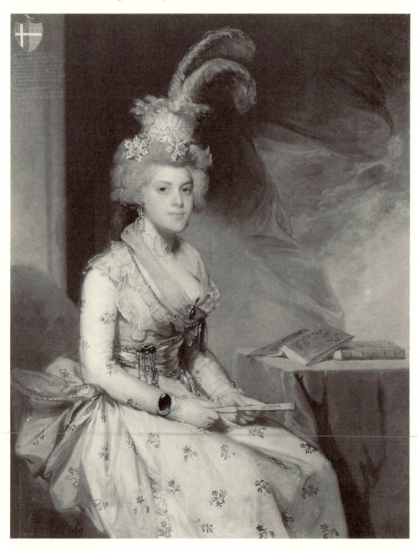

Josef de Jáudenes y Nebot (see above). This portrait, painted about the time of her marriage, captures the material splendor she was accustomed to and which was noted by her contemporaries. Mrs. Gabriel Manigault, who met the Jáudeneses at a party at the house of Mrs. John Jay in New York, wrote in her diary (July 4, 1794): "Mr. and Mrs. Jaudenes were there, as fine as little dolls." The following year, on April 2, 1795, a guest at a dinner given by President and Mrs. Washington in Philadelphia stated that Mrs. Jáudenes and the Portuguese minister's wife were "brilliant with diamonds."

Although it has been inferred by some that Mrs. Jáudenes's excessively ornamented appearance reveals a satiric intent on Stuart's part, in reality the plenitude of bejeweled accessories is in keeping with her newly acquired nationality. The diamond hairpins or *piochas* adorning her coiffure, the gold fob and chains encircling her waist, as well as the ivory fan (which points toward her husband when the portraits are exhibited side by side) are typical Hispanic costume accessories. Clearly intended to complement the portrait of her husband, this work was nevertheless conceived by Stuart as an independent work: while certain objects depicted in both these pictures, such as the armchairs, the table, and the draperies, appear in black and white reproductions to be part of the same interior, they are in fact painted in different colors.

Stuart, *Josef de Jáudenes y Nebot*

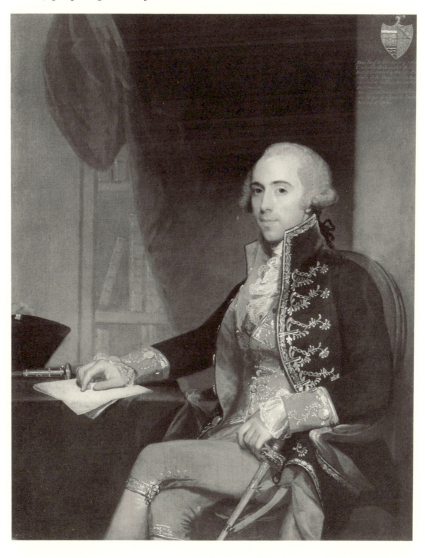

The coat of arms displays the arms of Stoughton on the left (see J. Guillim, *Display of Heraldry* [1724], sec. 6, p. 422) and those of Jáudenes on the right. It was painted by a later hand as was the inscription.

Oil on canvas, 50⅝ × 39½ in. (128.6 × 100.3 cm.).

Inscribed by a later hand at lower left: G. Stuart, R. A. New York Sept. 8,/1794. Inscribed by a later hand below coat of arms, at upper left: Doña Matilde Stoughton, / de Jaudenes—Esposa / de Don Josef de Jaudenes, / y Nebot Comisario Ordena— / dor de los Reales Exercitos, / de Su Magestad Catholica / y su Ministro Embiado cerca / de los Estados Unidos de / America— / Nació en la Ciudad de / Nueva-York en los Estados / Unidos el 11 de Enero de / 1778.

REFERENCES: K. Cox, *MMA Bull.* 2 (1907), p. 64 // C. H. Hart, letter in Dept. Archives, June 6, 1907, says he thinks Stuart painted the face and sky on the right but that a local Spanish artist finished the rest of it // *New York Herald*, August 19, 1907, p. 3, questions its authenticity // S. Isham, *McClure's Magazine* 31 (June 1908), pp. 176–178, calls it a characteristic work by Stuart and discusses the controversy over the attribution // M. Fielding, *Pennsylvania Magazine of History and Biography* 38 (1914), p. 325, no. 72, lists it as Matilde Stoughton Jaudens // L. Park, *Gilbert Stuart* (1926), p. 433, no. 435, says that the coat of arms, inscription, and signature are later additions // A. T. Gardner, *MMA Bull.* 6 (1948), p. 190 // C. M. Mount, *Gilbert Stuart* (1964), pp. 179–181, discusses the work and says it was painted during the summer of 1794; p. 182, discusses sources; p. 349, further discusses sources and expresses the opinion that the signature and inscription are by Stuart // Gardner and Feld (1965), p. 84 // B. N. O'Doherty, *Art News* 66 (Summer 1967), p. 80, says the elaborate paraphernalia of dress and jewelry is . . . surprisingly dry and unfeeling // M. H. Grandal, *Goya* 105 (Nov./Dec. 1971), p. 172, says Stuart found inspiration for this portrait in the painting of Charles Le Brun // *Apollo* 104 (Sept. 1976), pp. 159–162 // *Burlington Magazine* 118 (Sept. 1976), p. 661 // R. McLanathan, *Gilbert Stuart* (1986), p. 89; color ill. p. 90.

EXHIBITED: MMA, 1958–1959, *Fourteen American Masters* (no cat.); 1965, *Three Centuries of American Painting* (checklist arranged alphabetically) // National Gallery of Art, Washington, D. C.; Museum of Art, Rhode Island School of Design, Providence, 1967, *Gilbert Stuart, Portraitist of the Young Republic*, no. 24, ill. p. 70 // National Gallery of Art, Washington, D. C.; City Art Museum, Saint Louis; Seattle Art Museum, 1970–1971, *Great American Paintings from the Boston and Metropolitan Museums*, exhib. cat. by T. N. Maytham, no. 19 // Yale University Art Gallery, New Haven; Victoria and Albert Museum, London, 1976, *American Art, 1750–1800*, no. 47, pp. 110-111.

EX COLL.: same as preceding entry.

Rogers Fund, 1907.
07.76.

Horatio Gates

General Horatio Gates (1728–1806), the hero of Saratoga, was born at Maldon, Essex, England. Not much is known about his family background except that his father had a number of professions and trades, including army officer and greengrocer, and that his mother was probably a housekeeper to the duke of Leeds. He entered the British army early in life and served in a number of important campaigns in America during the Seven Years' War, including the assault on Fort Duquesne (now Pittsburgh) in July of 1755, in which he was severely wounded. At the end of the war he returned to England. In 1772, however, probably because his old friend George Washington had written him about land opportunities in Virginia, he decided to take up the life of a southern planter in Berkeley County, Virginia. There he lived quietly until the outbreak of hostilities against Great Britain in 1775. Largely because he perceived better advantages for himself, he backed the patriot cause and was promptly commissioned a brigadier general in the Continental Army.

Gates's service during the Revolution was marked by some real successes, one bitter defeat, and an inordinate number of squabbles and controversies. He was with Washington at Boston in 1775, then, after losing the command of the northern department to Philip Schuyler in 1776, he assumed control of the troops in Philadelphia. Early in 1777 he was ordered back to Ticonderoga to replace Schuyler, but the Board of War changed its mind in the matter a number of times, creating much ill feeling. By the time the American army met the British under Burgoyne at Saratoga in 1777, however, Gates was in control. His victory there was an impressive accomplishment though marred by a bitter quarrel with Benedict Arnold and by lack of judgment in negotiating Burgoyne's surrender. By the Articles of the Convention, signed on October 17, 1777, Burgoyne's army was granted the right to return to England provided that it would not serve in the war again. On November 4, 1777, Congress voted its thanks to Gates and ordered a medal struck to commemorate the victory.

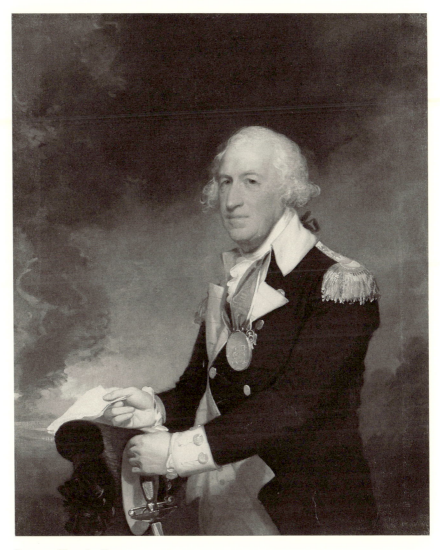

Stuart, *Horatio Gates*.

Gates then quarreled with Washington over the return of Continental troops and played into the hands of the anti-Washington faction in Congress. When a plot to replace Washington with Gates failed, he fell out of favor and was unable to secure another important command. He served in the now quiet northern department of the army once more in 1778 and in the eastern department in 1778 and 1779, where he was occupied with obtaining supplies. By the winter of 1779-1780, he was back at his plantation, but then, as the situation in the South steadily worsened, Congress ordered him to take command of the southern department. Unfortunately for Gates, he was not up to the task. With a disorganized army and his generals opposed to his strategy, he met Cornwallis's troops at Camden, South Carolina, and suffered a humiliating defeat. Congress immediately replaced him and ordered an inquest, which, however, did not take place; he was obliged to retire without obtaining the acquittal he thought he deserved. Eventually, Congress repealed its resolve ordering the inquest, and the general returned to active service under Washington and served until the end of the war.

Gates lived in Virginia until 1790. Not long after marrying his second wife, the wealthy Janet Montgomery, he moved to New York. There he established a fashionable estate at Rose Hill Farm, just below Murray Hill. Before his death in 1806, he served one term in the New York legislature, from 1800 to 1801.

This portrait, painted in New York in 1793 or 1794, makes for an interesting comparison with a somewhat similar one of Matthew Clarkson (q.v.). It also further illustrates Stuart's concerns after returning from England. Although the portrait is certainly an attempt at a monumental representation, the relatively hard and stiff execution of the uniform as well as the pose of the sitter are very much like that of the Matthew Clarkson portrait. In the head of Gates, however, Stuart produced a likeness more characteristic of his European works. Loosely painted and soft in focus, the face has a cosmetic ruddiness. With white hair executed in bold, visible strokes, the head is closer in style to that of Dr. William Samuel Johnson (ill. in L. Park, 3, no. 448, p. 268), reportedly the first portrait Stuart painted in New York, than it is to that of Clarkson. There is no chronology for Stuart's New York portraits of 1793-1794, so it is difficult to chart the stylistic development in these works, but it seems safe to say that their variable character at least reveals his ken in adapting his style to the individual needs of his patrons.

Since Copley's brand of realism was probably the major artistic force that confronted Stuart in New York, it was only natural that, when representing the majority of his sitters, he should follow the forthright manner Copley had popularized while reserving his best London style for those sophisticated patrons familiar with English fashion. If this hypothesis holds, the combination of a flattering, painterly head with a conservatively posed, restrained body in this portrait is an appropriate pictorial interpretation of the general's character, which was an amalgam of Englishness, provincialism, and recent fashionableness.

Painted long after the battle that made him famous, Gates is presented by Stuart as the hero of Saratoga. He wears the uniform of a brigadier general, decorated with the medal Congress ordered struck for him to commemorate the victory, as well as the Order of the Cincinnati. In his hand is a copy of the Saratoga Convention. The painting descended in the family of Gates's good friend Colonel Ebenezer Stevens, who

seems to have commissioned the work. An 1854 exhibition catalogue states that the portrait was painted for Stevens in 1804, but we know that he had such a portrait by December 1796 when Gates wrote asking him to lend it to the engraver Cornelius Tiebout.

Oil on canvas, 44¼ × 35⅞ in. (112.4 × 91.1 cm.).

RELATED WORKS: Cornelius Tiebout, stipple engraving (oval), 1798, 9⅛ × 7⅛ in. (23.2 × 18.1 cm.); second state is incorrectly identified as James Madison // Daniel Huntington, a copy, unlocated but mentioned in G. W. Sheldon, *American Painters* (1879), p. 104.

REFERENCES: H. Gates to E. Stevens, Dec. 22, 1796, private coll. on deposit, No. 9667, Box cf, Manuscript Department, University of Virginia Library, Charlottesville, writes: "I request the Favour you will let the Bearer Mr. Tiebout, have the picture Mr. Stewart painted of me, for about three Weeks, one Month, at His House, No. 36 Pearl Street, as he is an Artist of great Merit, there is no Danger but he will be particularly carefull of the Picture, and Deliver it again into your Hands perfectly unsullied, & Safe // G. C. Mason, *The Life and Works of Gilbert Stuart* (1879), p. 183, calls it superb and one of Stuart's most remarkable paintings; ill. opp. p. 183 // L. Park, *Gilbert Stuart* (1926), 1, pp. 340–341, describes and gives provenance; 3, ill. p. 189.

ON DEPOSIT: MMA, 1937–1977, lent by Lucille S. Pfeffer.

EXHIBITED: American Art-Union, New York, 1853, *Washington Exhibition*, no. 2, refers to it as one of Stuart's best works // New York Gallery of Fine Arts, 1854, no. 2, lent by Horatio Gates Stevens, notes "This picture was taken from life, for the late Gen. Ebenezer Stevens in 1804, and it is considered one of the artist's best productions // MMA, 1895–1896, *Retrospective Loan Collection of Paintings by American Artists*, no. 183, lent by Mrs. John R. Stevens.

EX COLL.: Ebenezer Stevens, New York, d. 1823; his son, Horatio Gates Stevens, New York, d. 1873; his son, John Rhinelander Stevens, New York, d. 1898; his daughter, Lucille Stevens (Mrs. Edward Elwell Spafford), New York, d. 1914; her daughter, Lucille Spafford (Mrs. Charles A. Pfeffer, Jr.), New York, until 1977.

Gift of Lucille S. Pfeffer, 1977.
1977.243.

Charles Wilkes

Charles Wilkes (1764–1833), a nephew of the famous Whig parliamentary leader and promoter of American liberty John Wilkes, was born in London. He came to America toward the end

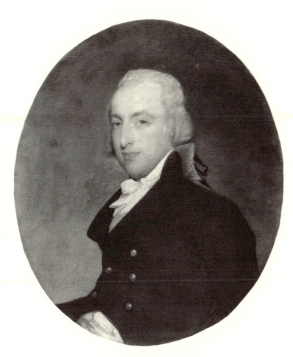

Stuart, *Charles Wilkes.*

London manner and produced a society portrait much closer in form and spirit to his *Thomas Smith* (q.v.) than to *Matthew Clarkson* (q.v.). The hazy quality of the face, the aristocratic turn of the head, and the informal posture of the figure seated on a small side chair are characteristic traits of Stuart's English period. The restrained execution throughout, however, betrays the profound transformation taking place in his style following his return to America.

Originally rectangular, the portrait was at some point clumsily cut down to its present oval shape, and consequently Wilkes's head appears to lean a little too far forward.

Oil on canvas, oval, 30 × 25 in. (76.2 × 63.5 cm.).
REFERENCES: L. Park, *Gilbert Stuart* (1926), 2, p. 813, no. 909, says this portrait was painted in New York about 1794 // C. M. Mount, *Gilbert Stuart* (1964), p. 377, lists it // Gardner and Feld (1965), pp. 84–85.
EXHIBITED: MMA, 1958–1959, *Fourteen American Masters* (no cat.).
EX COLL.: Charles Wilkes, New York, d. 1833; his widow, subject to a life interest, she died 1851; their children, George, d. 1876, Frances (Mrs. David Cadwallader) Colden, d. 1877, and Anne, d. 1890, who after 1877 held the portrait jointly with George Wilkes's daughters, Harriet K., d. 1887, and Grace, d. 1922.
Bequest of Grace Wilkes, 1922.
22.45.1.

of the Revolution and became associated with the Bank of New York when it was organized in 1784. His brother John, a well-known lawyer, also lived in New York. In 1794, Charles Wilkes was elected principal teller of the bank and in 1825 succeeded Matthew Clarkson as its president. A wealthy gentleman, Wilkes took part in the organization of several New York charitable and educational institutions. In 1805 he became the first treasurer of the New-York Historical Society, serving until 1818, and in 1808 he was among the original founders of the Free School Society of the City of New York, the forerunner of the present public school system. Also in 1808 he helped establish the American Academy of Fine Arts of which he was a director. In 1802 Wilkes went to England to claim estates he had inherited; he returned with a number of old master paintings, said to have been in the collection of John Wilkes. They formed one of the earliest collections of European paintings in New York. These descended in his family, and a number of them, together with several family portraits and JOHN TRUMBULL'S *Washington before the Battle of Trenton* (q.v.), were bequeathed to the Metropolitan.

In his portrait of Charles Wilkes, painted about 1794, Stuart reverted somewhat to his

George Washington

This portrait of President Washington, called the Gibbs-Channing-Avery portrait, is one of a group of eighteen similar works known as the Vaughan group. The first of this type, presumed to have been painted from life and then copied in all the others, originally belonged to Samuel Vaughan, a London merchant living in Philadelphia and a close friend of Washington's. It descended in Vaughan's family until about 1850, when it was acquired by the distinguished Philadelphia collector Joseph Harrison, in whose family it remained until 1912. It then passed to Thomas B. Clarke of New York, then to a New York dealer, and subsequently to Andrew Mellon, who donated it to the National Gallery of Art in Washington. While in Harrison's possession, the Vaughan portrait was copied by the aging Rembrandt Peale who pronounced it "the first original portrait painted by Stuart, in Sep-

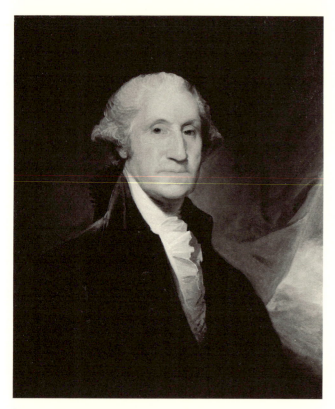

Stuart, *George Washington*.
The Gibbs-Channing-Avery portrait.

The portrait of "Gibbs" Washington in my possession was sold by Stuart to his warm personal friend—my uncle,—Col. George Gibbs of New York, with the statement that it was one of two or three pictures on the easel while Washington was sitting, and was touched from life. Col. Gibbs subsequently purchased from Stuart a complete and uniform set of his portraits of the Presidents, and then sold the picture of Washington which I have to his sister—my mother—Mrs. William E. Channing, who gave it to me twenty-five years ago. The picture, therefore, has never been out of our family since it left Stuart's hands.

While it is true that the Gibbs-Channing-Avery portrait is characterized by a looseness of the flesh more appropriate to Washington's age than the rejuvenating Vaughan portrait, there can be no doubt that it is a monumentalized, iconic representation, better understood as an interpretive copy. The masterfully applied shadows in the face are of a steel, blue-gray tone also used to color the eyes and the wig. As a result, the entire face takes on a unified marble-like effect that is cold and distant. This gives the likeness an authoritative and aristocratic air which is further reinforced by the exaggerated arching of the eyebrows. In addition, the greater detail visible in the president's coat, in the folds of the background drapery, and in the rapidly painted sawtooth queue ribbon (unique among Vaughan-type portraits) makes this the most formally presented Washington of all eighteen in the group. Finally, the combination of colors—green for the background, brown for the coat, and an unrealistic blend of yellows, blues, and pinks in the sky at the lower right—produces a lively effect setting off the coolly lit head. The result is a striking image of an apotheosized man.

Oil on canvas, $30\frac{1}{4} \times 25\frac{1}{4}$ in. (76.8×64.1 cm.).
RELATED WORKS: *George Washington*, oil on canvas, $29 \times 23\frac{3}{4}$ in. (73.5×60.5 cm.), 1795, National Gallery of Art, Washington, D. C.; the original portrait of which the Metropolitan painting and sixteen others are copies; others are catalogued in J. H. Morgan and M. Fielding, *The Life Portraits of Washington* (1931), pp. 250–259, nos. 1–16, ten are illustrated; see also C. M. Mount (1964), p. 378 // The Vaughan canvas was first engraved in London by Thomas Holloway, $10\frac{5}{8} \times 7\frac{1}{4}$ in. (27×18.4 cm.), Nov. 2, 1796.
REFERENCES: G. Mason, *The Life and Works of Gilbert Stuart* (1879), p. 90, calls this picture "the finest beyond all comparison" // E. B. Johnson, *Original Portraits of Washington* (1882), pp. 93–94, includes

tember 1795, at the same time that Washington sat to me." Although Peale's account elsewhere falls into grievous error, nearly all subsequent students of Stuart's art have accepted this opinion. No doubt, this is largely due to the Vaughan portrait's naturalistic, direct, and appealing likeness, qualities not evident in the other portraits of the Vaughan group.

Precisely when in 1795 Stuart began work on the first portrait of Washington is not known. Rembrandt Peale consistently claimed that it was in September of that year, but a list of thirty-two "gentlemen who are to have copies of the portrait of the President of the United States" drawn up by Stuart on April 20 indicates that he had begun work earlier, at least in March. In any case, the Metropolitan's portrait is considered one of the earliest and best replicas, and at least one modern commentator has agreed that "there are enough differences between the portrait and the Vaughan one to make it reasonable to suppose that the artist had had a fresh look at his subject" (J. Allen, 1957). This speculation had long been part of the tradition surrounding the portrait and was noted in a letter from William F. Channing (1882).

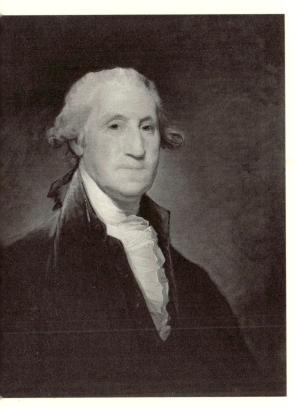

Stuart, *George Washington*.
The Phillips-Brixey portrait.

a letter from Channing discussing the portrait (quoted above) || S. P. Avery, *Some Account of the Gibbs-Channing Portraits of Washington* (1900), quotes letters from Channing, G. Mason, C. H. Hart, and W. S. Baker among others || S. Isham, *MMA Bull.* 2 (July 1907), pp. 118–121 || M. Fielding, *Gilbert Stuart Portraits of George Washington* (1923), p. 115, states that this portrait was painted in Philadelphia in September 1795 and "possesses all the artistic perfection of Stuart's brush" || J. H. Morgan and M. Fielding, *The Life Portraits of Washington and Their Replicas* (1931), p. 236, notes it in a discussion of the Vaughan type, says sixteen are known and all were probably painted between 1795 and 1796; p. 251, no. 2; p. 348, includes letter from R. Peale to J. Harrison (quoted above); pp. 352–353 || G. A. Eisen, *Portraits of Washington* (1932), 1, p. 44 || J. Allen, *MMA Bull.* 15 (Feb. 1957), opp. p. 141; color ill. on cover || C. M. Mount, *Gilbert Stuart* (1964), p. 378, includes it in a list of seventeen replicas || Gardner and Feld (1965), pp. 85–87 || *MMA Bull.* 33 (Winter 1975–1976), color ill. no. 29.

EXHIBITED: MFA, Boston, 1880, *An Exhibition of Portraits Painted by Gilbert Stuart*, no. 303 || Century Association, New York, 1888 || Metropolitan Opera House, New York, 1889, *Loan Exhibition Commemorating the Centennial of Washington's Inauguration*, cat. no. 31 || NAD, 1893–1894, no. 131 || MMA, 1895–1896, *Retrospective Exhibition of American Paintings*, no. 172 ||

Union League Club, New York, 1897 (no cat.) || Grolier Club, New York, 1899, *Engraved Portraits of Washington*, no. 274 || MMA, 1939, *Life in America*, no. 38; 1958–1959, *Fourteen American Masters* (no cat.) || National Gallery of Art, Washington, D.C.; City Art Museum, Saint Louis; Seattle Art Museum, 1970–1971, *Great American Paintings from the Boston and Metropolitan Museums*, exhib. cat. by T. N. Maytham, no. 21 || Pushkin Museum, Moscow, and Hermitage, Leningrad, 1975, *100 Kartin iz muzeya Metropoliten* [*100 Paintings from the Metropolitan Museum*], no. 82, pp. 229–230 || MMA, 1976–1977, *A Bicentennial Treasury* (see *MMA Bull.* 33 above).

EX COLL.: George Gibbs, from 1795; his sister, Mrs. William E. Channing, Boston, before 1833–1857; her son, William F. Channing, Providence, from 1857 until 1889; Samuel P. Avery, New York, 1889–d. 1904; his son, Samuel P. Avery, Jr., New York, 1904–1907.

Rogers Fund, 1907.
07.160.

George Washington

Like the preceding portrait (see above), this work, known as the Phillips-Brixey Washington, also belongs to the Vaughan group and demonstrates the range of interpretation Stuart achieved in his copies of that image. Compared with the Gibbs-Channing-Avery portrait, the present picture appears to have been rather carelessly executed, but since the effect produced is so totally different, Stuart can perhaps be given credit for deliberately calculating it. Still, it should be pointed out that in this portrait the shadows in the face are indiscriminately applied and blur the forms around the mouth and eyes, the wig is a rather incoherent mass of pigment, and the varied facial textures Stuart achieved in the Vaughan portrait are absent. Yet these shortcomings have not prevented this work from commanding an enthusiastic following. Gustavus A. Eisen, who reproduced it in color as the frontispiece to his volume on Stuart, was the most eloquent of its supporters:

It is a slightly idealized Vaughan, and one of the most satisfactory and sympathetic creations of the painter's brush. In this portrait Stuart reached the climax of his art, and his portraiture its noblest expression. The greatest portrait of the greatest of men, fascinating and hypnotic as no other, lovable and supreme. It introduces us to the spiritual qualities of the finest type any man can possess and in a manner perhaps not discoverable in any other painted portrait.

Unlike the Gibbs-Channing-Avery portrait, the Phillips-Brixey Washington shows the president in a black coat against a generalized Venetian red background. The details of the coat are not elaborated. The jabot appears to have been painted with great speed, as does the queue ribbon. The greater focus in the face, brought about by the suppression of peripheral detail, must be judged one of the painting's virtues; Washington's alert and benign appearance possesses great appeal. The picture was painted in the last few years of the eighteenth century and was originally owned by the Phillips family of Manchester, England, Whig sympathizers of the American Revolution, in whose possession it remained until 1924.

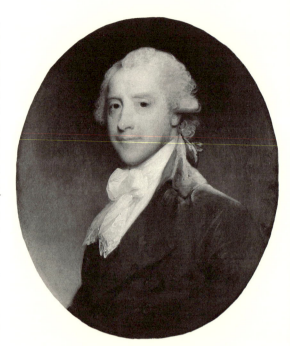

Stuart, *William Kerin Constable*.

Oil on canvas, 29 × 23¾ in. (73.7 × 60.3 cm.).
RELATED WORKS: see preceding entry.
REFERENCES: *Art News* 23 (Feb. 21, 1925), p. 6 // L. Park, *Gilbert Stuart* (1926), 2, p. 825, no. 15 // J. H. Morgan and M. Fielding, *The Life Portraits of Washington and Their Replicas* (1931), p. 258, no. 15 // G. A. Eisen, *Portraits of Washington* (1932), 1, pp. 40–43, includes quoted opinion // C. M. Mount, *Gilbert Stuart* (1964), p. 378, lists it.
EXHIBITED: Corcoran Gallery of Art, Washington, D. C., 1932, *Washington Bicentennial Exhibition*, no. 7 // MMA, 1958–1959, *Fourteen American Masters* (no cat.); 1965, *Three Centuries of American Art* (checklist arranged alphabetically) // Los Angeles County Museum of Art; M. H. De Young Museum, San Francisco, 1966, *American Paintings from the Metropolitan Museum of Art*, pp. 11, 40, no. 17 // Tokyo National Museum and Kyoto Municipal Museum, 1972, *Treasured Masterpieces of the Metropolitan Museum of Art*, no. 110.
EX COLL.: descended in the Phillips family, Manchester, England, to Morton Phillips, Haybridge, Staffordshire, until 1924; with Duveen Brothers, New York, 1924; Richard De Wolfe Brixey, 1924–d. 1943.
Bequest of Richard De Wolfe Brixey, 1943.
43.86.1.

William Kerin Constable

William Kerin Constable (1752–1803) was born in Dublin. His father, who had served as a surgeon with the British army in Canada during the French and Indian War, eventually settled in Schenectady, New York, where Constable spent most of his youth. He attended Trinity College in Dublin and then returned to New York, where he joined his brother-in-law James Phyn in the West Indian trade. In 1773 Con-

stable went to England. The war prevented his return until 1777, when he made his way to Philadelphia. During the British evacuation of that city, he remained behind and swore an oath of allegiance to the United States. At the end of the war, he established his own firm specializing in trade with the West Indies and the South. He married Ann White of Philadelphia in 1782. In 1784 he moved to New York, where he founded Constable, Rucke and Company.

This firm outfitted the first American vessel to trade with China and India and owned the six-hundred-ton vessel *America*, one of the finest ships built in New York. A short time after its founding, the company contracted with the British government to supply their troops in the West Indies. Meanwhile, Constable became increasingly involved in land speculation. In 1791 he and two associates bought from the State of New York a tract of four million acres known as Macomb's Purchase for eight pence an acre. Soon after, much of this land was sold at advantageous prices ranging up to two dollars an acre. Until the time of his death on May 22, 1803, Constable's energies were spent promoting the settlement of this area. He also owned half a million acres of land in Ohio, Kentucky, Virginia, and Georgia. In New York State his Northern Inland

Lock Navigation Company succeeded in conveying boats of ten tons from Schenectady to Lake Ontario with only one portage; its waterways eventually became part of the Erie Canal.

The distinguished jurist Ogden Edwards summarized Constable's personality as follows (1883):

William Constable was truly one of nature's noblemen. He was a man of sound comprehension and fruitful mind, of high-toned feelings and vivid imagination. He saw clearly, felt keenly and expressed himself pungently. He was endowed with all the qualities necessary to constitute an orator; and was, in truth, the most eloquent man in conversation I ever heard.

A bill in Stuart's hand lists his account with William Constable and contains charges of $100 for a "portrait of said WC" dated November 1796, as well as charges of $500 and $250 respectively, for a full-length and a half-length of George Washington. The portrait of Constable is probably this picture. It was apparently intended for his son and for many years hung at Constable Hall in Constableville, New York.

Executed in Philadelphia, when Stuart had established himself as America's premier portraitist, it is essentially a further refinement of the formula he had already applied in the portrait of *Charles Wilkes* (q.v.). The likeness is softly painted in ruddy tones, but the traces of painterly execution have by and large disappeared. The background color is darker around the head, setting it off with greater precision, and the emphasis is on the face. The style is simple, direct, and at times unflattering. In the coming years Stuart would produce hundreds of portraits of this type, altering the course of American portraiture. The present work was probably cut down from a rectangle some time ago.

Oil on canvas, oval, 28⅝ × 23½ in. (72.7 × 59.7 cm.).

RELATED WORKS: unidentified artist, *William Constable*, copy, oil on canvas, 29 × 24⅛ in. (73.7 × 61.3 cm.), National Gallery of Art, Washington, D. C., ill. in National Gallery of Art, *American Paintings* (1980), p. 239.

REFERENCES: G. Stuart, receipt, July 13, 1797, photostat in Dept. Archives, lists Nov. 1796 payment of $100 for portrait of Constable // G. Mason, *The Life and Works of Gilbert Stuart* (1879), p. 161, claims Henry Inman called it: "the finest portrait ever painted by the hand of man," // F. B. Hough, *History of Lewis County* (1883), pp. 564–570, gives biographical information on sitter; p. 569, includes statement by Ogden Edwards (quoted above) // L. Park, *Gilbert Stuart* (1926), 1, p. 232, no. 179 // F. J. Mather, Jr., *Estimates in Art* (1931), 2, p. 7, mistakenly lists it as one of Stuart's best British portraits // C. M. Mount, *Gilbert Stuart* (1964), pp. 207, 216; p. 366, lists it // Gardner and Feld (1965), pp. 88–89 // R. Watson, *Quarterly Bulletin of the Irish Georgian Society* 12 (April-June, 1969), p. 60, n. 10 // Richard McLanathan, *Gilbert Stuart* (1986), p. 97.

EXHIBITED: MFA, Boston, 1880, *An Exhibition of Portraits Painted by Gilbert Stuart*, no. 295, lent by John Constable, Constableville, N. Y. // American Art Galleries, New York, 1929, *Loan Exhibition for the Benefit of the National Council of Girl Scouts*, no. 845 // MMA, 1958–1959, *Fourteen American Masters* (no cat.); 1965, *Three Centuries of American Painting* (checklist arranged alphabetically).

EX COLL.: the subject's son, William Constable, Constableville, N. Y., d. 1821; his son, John Constable, Constableville, N. Y., d. 1887; his nephew's wife, Mrs. William Constable, New York, d. 1922; her husband's relative, William Constable, New York, until 1925; Richard De Wolfe Brixey, New York, from 1925 until 1943.

Bequest of Richard De Wolfe Brixey, 1943.
43.86.2.

Joseph Anthony, Jr.

Joseph Anthony, Jr. (1762–1814), Gilbert Stuart's first cousin, was born in Newport, Rhode Island, where his father was a successful sea captain and tradesman. Young Anthony was trained as a silversmith, a craft with which his family had been associated since Francis Anthony worked as a goldsmith in Queen Elizabeth's jewel office. About 1783, the Anthonys moved to Philadelphia, where Joseph Anthony, Jr., opened a shop on Market Street. His lengthy newspaper advertisements catalogue the extensive range of wares he sold and disclose that he imported large quantities of English silver (see A. C. Prime, *The Arts & Crafts in Philadelphia, Maryland and South Carolina* [1929; 1932], 1, pp. 42-43; 2, pp. 85-87). His prospering business, as well as his family's continued involvement in shipping and trade, enabled him, like his Boston contemporary Paul Revere, to make the transition from craftsman to entrepreneur. He became prominent in local society and was one of the original subscribers to the Philadelphia City Dancing Assembly Fund. On December 29, 1785, Anthony married Henrietta Hillegas, daughter of Michael Hillegas, first treasurer of the United States.

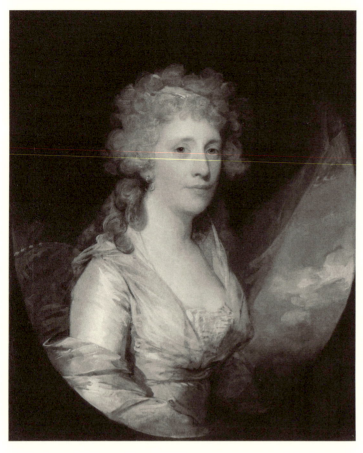

Stuart, *Mrs. Joseph Anthony, Jr.*

Although no great silver masterpieces by him are known today, Anthony was an accomplished silversmith conscious of the latest trends in design. Many of his productions are now in the collections of American museums, including the Philadelphia Museum of Art and the Metropolitan. Anthony's two sons were apprenticed in his shop, and in 1810 they became partners in the business. Joseph Anthony, Jr., died on a visit to Harrisburg, Pennsylvania, on August 5, 1814.

This portrait, one of the few known representations of an American silversmith, was executed in Philadelphia between 1795 and 1798. It is a sympathetic likeness in Stuart's typical Philadelphia manner and makes for an interesting comparison with the superior portrait of his wife (see below).

Oil on canvas, 30 × 24½ in. (76.2 × 62.2 cm.).

REFERENCES: G. Mason, *The Life and Works of Gilbert Stuart* (1879), p. 129, lists it as Judge Anthony, owned by the Clement family || Buffalo Fine Arts Academy, *Academy Notes* 1 (Sept. 1905), pp. 74–75, notes its acquisition by the MMA || Mrs. M. F. Fisher, Huntingdon, Pa., Dec. 1907, Dept. Archives, gives information on provenance and sitter's dates || L. Park, *Gilbert Stuart* (1926), 1, p. 107, no. 26, says it was painted in Philadelphia about 1798, gives incomplete provenance || H. B. Smith, *New York Sun*, July 9, 1938, gives biographical information and says Anthony was not a judge || C. M. Mount, *Gilbert Stuart* (1964), p. 191, suggests that it was painted about 1795; p. 364, lists it || Gardner and Feld (1965), pp. 89–90 || Philadelphia Museum of Art, *Philadelphia: Three Centuries of American Art*, exhib. cat. (1976), pp. 150–151, gives biographical data.

EXHIBITED: Ehrich Galleries, New York, 1918, *One Hundred Early American Paintings*, ill. p. 107 || MMA, 1958–1959, *Fourteen American Masters* (no cat.).

EX COLL.: the subject, d. 1814; his daughter, Henrietta Hillegas Anthony (Mrs. William Patton, later Mrs. Samuel Clement), Huntingdon, Pa., d. 1868; her daughter by first marriage, Rachel Patton (Mrs. James Gwin), Huntingdon, Pa., d. 1885; her half-sister, Elizabeth Tylee Clement, Huntingdon, Pa., and Brooklyn, until 1904; with Ehrich Galleries, New York, 1904–1905.

Rogers Fund, 1905.

05.40.1.

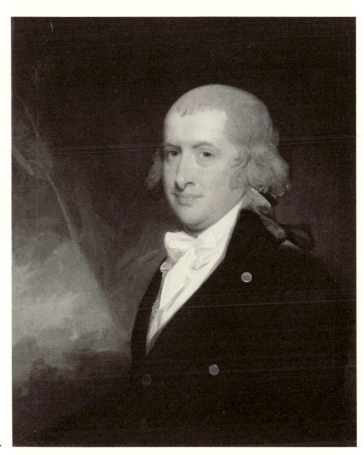

Stuart, *Joseph Anthony, Jr.*

Mrs. Joseph Anthony, Jr.

Mrs. Joseph Anthony, Jr. (1766-1812), was born Henrietta Hillegas, one of the ten children of Michael and Henrietta Hillegas of Philadelphia. Her father amassed a considerable fortune in sugar refining and iron manufacturing and, shortly after the Declaration of Independence, was made the first treasurer of the United States. She was married to Mr. Anthony (see above) at Christ Church, Philadelphia, on December 29, 1785. They had eleven children of whom four survived to adulthood. She died on October 3, 1812.

This picture, painted in Philadelphia, probably between 1795 and 1798, compares favorably with many other portraits of women Stuart painted in that city: *Elizabeth Parke Custis*, ca. 1796 (private coll.); *Elizabeth Beale Bordley*, ca. 1797 (PAFA); and *Ann Penn Allen*, ca. 1795 (Allentown Art Museum). In pose, execution, and sensibility, all these portraits of women recall Stuart's London manner and are in sharp con-

trast to the portraits of men he painted at this time. Certainly among his finest works, they possess a sensuality rare in American portraiture. As long ago as 1925, Frank Jewett Mather, a leading historian of American art, noted the difference between Stuart's portraits of men and his portraits of women:

To the American man he gave what the American man wanted, a most resolute and resemblant face-painting. . . . Towards the American woman Gilbert Stuart's attitude was that of all perceptive foreigners. She was a marvel, a puzzle, and a delight. She was irresistibly herself, an independent and unconditioned existence, in a sense that the American man busied with nation making could not be. So Stuart read her, confessed her, and most gallantly celebrated her, with the result that the mothers and daughters of the early Republic are today about twice as alive as the fathers and sons (F. J. Mather, Jr., *Estimates in Art* (1931), ser. 2, pp. 9–10).

Oil on canvas, 30 × 23⅜ in. (76.2 × 59.4 cm.).
REFERENCES: G. Mason, *The Life and Works of Gilbert Stuart* (1879), p. 129 // E. S. Whitney, *Michael*

Hillegas and His Descendants (1891), pp. 37–38, gives biographical information on the subject // L. Park, *Gilbert Stuart* (1926), 1, p. 108, no. 27, says it was painted in Philadelphia about 1798 // C. M. Mount, *Gilbert Stuart* (1964), p. 191, suggests it was painted in 1795; p. 194, lists it // Gardner and Feld (1965), pp. 90–91.

EXHIBITED: Ehrich Galleries, New York, 1918, *One Hundred Early American Paintings*, p. 106 // MMA, 1958–1959, *Fourteen American Masters* (no cat.); 1965, *Three Centuries of American Paintings* (checklist arranged alphabetically).

Ex COLL.: same as preceding entry.
Rogers Fund, 1905.
05.40.2.

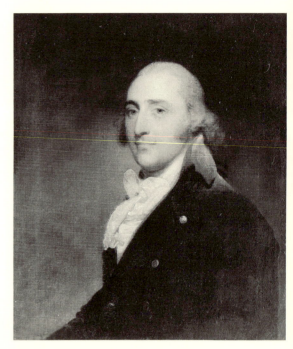

Stuart, *Charles Lee or Gentleman of the Lee Family*.

Charles Lee or Gentleman of the Lee Family

This portrait, which descended in the family of Charles Lee (1758–1815), of Virginia, was once said to represent him. Lee, a noted Virginia lawyer, was attorney general from 1795 to 1801, during the Washington and Adams administrations. Doubt seems to have been cast on the identity of the sitter for a number of reasons. In the 1920s, it was thought that contemporary engravings did not support the identification. There are, however, no such engravings that are genuine. To add to the problem, Charles Lee the lawyer has continually been confused with the revolutionary war general Charles Lee (1731–1782), who was born in England and of whom many spurious engravings were once issued. This may be the reason that the donor of the picture, Charles Allen Munn, who said it was obtained from Charles Lee's granddaughter, later referred to it in his will as the so-called Charles Lee.

Yet a different problem arose when another portrait of Charles Lee, from the same family another generation later, was given to the National Portrait Gallery in 1964. That work was mistakenly thought by the donor to be a Stuart but was subsequently (1966) attributed to Cephas Thompson. It purportedly shows the sitter at about the age of fifty-two or fifty-three, a few years before his death, when he was already known to be in poor health. (A copy of the painting taken in 1870 hung for many years in the Justice Department and was engraved in 1891 by Max Rosenthal.) The Thompson portrait little resembles Stuart's image. Given the age difference and accounting for poor health, it is not inconceivable that they could be of the same man, but this seems unlikely.

A portrait of Charles Lee by Gilbert Stuart, presumably this one, was exhibited in the Stuart exhibition at the Museum of Fine Arts, Boston, as early as 1880. It was lent by Charles Lee's daughter by his second wife and hung next to the unfinished Stuart portrait of the first wife, Anne Lee (1790–1804), which is now unlocated. The daughter from the second marriage, Elizabeth Gordon Lee Pollock (1813–1890), was only two when her father died, but her mother lived until 1843, so it seems unlikely that she would have been confused about the subject of the portrait. Without more information, it is impossible to identify the sitter in the museum's portrait with certainty, but, at the same time, it seems unnecessary to completely discount the possibility that he may indeed be Charles Lee.

The portrait is much abraded and has unfortunately been stripped of the layer of glazes that was so important a part of Stuart's technique. It was probably painted between 1794 and 1803 when Stuart resided in Philadelphia. Charles Lee would have been in Philadelphia until 1801, when he returned to Virginia to practice law.

Oil on canvas, 30 × 25 in (76.2 × 63.5 cm.).

REFERENCES: G. C. Mason, *The Life and Works of Gilbert Stuart* (1879), pp. 213–214, says the portrait is owned by Lee's daughter Mrs. Pollock // Charles Allen Munn, will, filed 1924, copy, MMA Archives, bequeaths to "the Metropolitan Museum of Art. . . . the portrait (so-called) of Charles Lee by Gilbert Stuart" // *MMA Bull.* 19 (July 1924), p. 182, lists it as Charles Lee portrait from Munn bequest // H. B. Wehle, *MMA Bull.* 20 (Jan. 1925), p. 22, questions identity of the subject and suggests he may be "the same Charles Ogden of whom Saint-Memin made an engraving in 1798 [1789]" // L. Park, *Gilbert Stuart* (1926), 1, p. 469, no. 481, quotes Wehle but says there is no Charles Ogden [there is, but there is not much to support Wehle's contention]; 3, p. 289, ill. no. 481 // C. M. Mount, *Gilbert Stuart* (1964), p. 207, says Charles Lee was painted by Stuart in Philadelphia; p. 370, lists museum's painting as Charles Lee (?) // B. Burroughs, *Catalogue of Paintings in the Metropolitan Museum* (1931), p. 343, says the "face does not bear a convincing resemblance to the known portrait of Charles Lee // Gardner and Feld (1965), p. 91, as Portrait of a Man, formerly called Charles Lee // R. G. Stewart, National Portrait Gallery, Washington, Nov. 3, 1966, letter in Dept. Archives, says their portrait came with the tradition it was a Gilbert Stuart but that it is by Cephas Thompson; he concludes, "I believe the confusion . . . was due to there being a Gilbert Stuart portrait in the same family. Putting the photographs . . . together, I think they could be the same man interpreted by two different artists working twenty years apart."

ON DEPOSIT: Gracie Mansion, New York, 1966–1970; 1970–1985.

EXHIBITED: MFA, Boston, 1880, *Exhibition of Portraits Painted by Gilbert Stuart*, no. 362, as Charles Lee, lent by Mrs. Pollock // Palace of Fine Arts, San Francisco, 1940, *Golden Gate International Exposition*, no. 1219 // MMA, 1958–1959, *Fourteen American Masters* (no cat.).

EX COLL.: the subject's daughter, Elizabeth Lee (Mrs. Abraham Pollock), Warrenton, Va., by 1880–d. 1890; her daughter, Anne Lee Pollock (Mrs. Charles Janney), Leesburg, Va., until 1922; Charles Allen Munn, West Orange, N. J., 1922–d. 1924.

Bequest of Charles Allen Munn, 1924.

24.109.85.

Louis-Marie, Vicomte de Noailles

Unrecorded and virtually unknown until its appearance at auction in 1970, Gilbert Stuart's portrait of the vicomte de Noailles is the most important work by the artist to have come to light in recent years.

Louis-Marie, vicomte de Noailles (1756–1804), was the second son of Philippe, duc de Mouchy. A dandy in the French court, Noailles, nevertheless, genuinely sympathized with the political aims of the American Revolution. At first, his government would not consent to his going to America, but later, in 1779, he was attached as colonel of cavalry to the comte d'Estaing's expedition against the British in the West Indies and the Carolinas.

Back in France in 1780, Noailles soon obtained a commission as lieutenant colonel in the Royal-Soissonnais regiment about to embark for America under Rochambeau. As the real commander of this regiment, he played a key role in the Yorktown campaign and represented the French at the negotiation of General Cornwallis's surrender.

Following the cessation of hostilities in America, Noailles returned to France and further distinguished himself in the events leading to the fall of the ancien régime. He was elected to the Estates General in May of 1789 and quickly allied himself with those members of the third estate and the clergy who declared themselves a National Assembly. Speaking before this body on the night of August 4, 1789, Noailles eloquently proposed that the nobility give up their ancient feudal rights. He argued that taxes be paid by individuals according to income, that all feudal estates be purchasable by the community for a fair price, and that seigneurial labor, inalienable tenures, and other personal servitudes be abolished outright. By the end of the night, the assembly had agreed to dismantle the old order, at least on paper.

Thereafter Noailles, now a Jacobin, served on the assembly's military committee, helped establish a national gendarmerie, and on February 26, 1791, became president of the assembly. In May of that year, he was called to put down an insurrection at Colmar, succeeded, and returned to Paris in time to witness the collapse of the monarchy and the beginnings of general anarchy. In early 1792 he served at Sedan, but when France declared war on the Austro-Prussian alliance he was transferred to the Belgian border. Disenchanted with developments in the capital and sensing the coming reign of terror, Noailles decided to leave the country.

After a short sojourn in England, Noailles arrived in Philadelphia on May 3, 1793. He joined the banking house of Bingham and Company as

a partner, speculated successfully on the stock exchange, and promoted the sale of land to French émigrés. About this time he met Gilbert Stuart and posed for the figure of George Washington in the full-length "Lenox portrait" (NYPL). In 1800 Noailles's French properties were restored to him, and his name was erased from the list of émigrés, but he still remained in America. Three years later, however, he offered his services to the Napoleonic government and received a commission to serve in Santo Domingo. Despite the French loss of that colony, Noailles covered himself with glory once more when the ship he commanded captured an English corvette en route to Havana. During the fierce fighting Noailles sustained severe wounds from which he died a few days later, on January 5, 1804.

Painted in Philadelphia in 1798, at a period when Stuart was at work on a number of monumental full-length portraits of Washington, the portrait of Noailles is one of only two known full-lengths by Stuart in small format. The other picture, a portrait of Noailles's business partner William Bingham (coll. Baring Brothers and Company, London) was painted about the same time, and, like the portrait of Noailles, displays a neoclassical severity not usually associated with Stuart's Philadelphia works.

Although Stuart was probably aware of the small full-length portrait *George Washington before the Battle of Trenton* (q.v.) that JOHN TRUMBULL had produced in Philadelphia in 1792, it is more likely that he was following European precedents when he painted the vicomte de Noailles six years later. Full-length portraits of small size are not uncommon in late eighteenth-century English art, and the formula of representing a cavalry leader about to mount his horse, with attendant present and battle raging in the distance, had been well explored by English painters. As early as 1766, Joshua Reynolds had exhibited a portrait of *John Manners, Marquess of Granby* (John and Mable Ringling Museum of Art, Sarasota, Fla.) incorporating all these elements, and, while Reynolds's work may not be a direct source for Stuart's picture, it must at least be considered a likely antecedent, especially since it was copied numerous times and engraved twice before 1798.

Shown in the uniform of a colonel in the Chasseurs à Cheval d'Alsace and wearing a non-regulation *karabela* saber, Noailles stands on a bluff overlooking a cavalry charge in progress, probably a reference to his service at Colmar in 1791 or Sedan in 1792. The leader of this charge, who is mounted on a white horse, the same color as that depicted in the foreground, and who carries a saber, may in fact be a reference to Noailles in action. At the lower right edge of the canvas lies an emblematic grouping of skeletal bones, a thistle, and a serpent. These symbols, associated with death, barrenness, and evil, are probably included as *memento mori* or allusions to the ravages of war.

Given the variety of its component parts, including a landscape setting and carefully portrayed horses, Stuart's painting of the vicomte de Noailles must be regarded as one of his more complex works. In spirit it is far less cluttered and more neoclassical than his full-lengths of Washington. The presence of pentimenti around the vicomte's chest and shoulders indicates that Stuart experienced some indecision in delineating the figure, but the rest of the work has been painted with great assurance. The attendant, sensitively depicted and constituting a second portrait, turns as if to acknowledge the presence of the viewer and thus establishes a degree of intimacy unusual in highly formal portraits of this type.

Oil on canvas, 50 × 40 in. (127 × 101.6 cm.).

Signed and dated lower left: G. Stuart 1798.

REFERENCES: J. K. Howat, *MMA Bull.* 29 (March 1971), pp. 327–340, fully discusses this work; color ill. on back cover // P. de Noailles, duc de Mouchy, to D. Dillon, June 9, 1971, copy in Dept. Archives, gives information on provenance // Col. J. R. Elting, July 30, 1971, letter in Dept. Archives, identifies Noailles's uniform // MMA, *Notable Acquisitions*, 1965–1975 (1975), p. 12.

EXHIBITED: MMA, 1972, *Recent Acquisitions* (no cat.) // Amon Carter Museum of Western Art, Fort Worth, Texas, 1975–1976, *The Face of Liberty*, exhib. cat. by L. Samter, p. 224, pl. 79.

EX COLL.: the subject, d. 1804; his son, comte Alexis de Noailles, until 1835; his son, comte Alfred de Noailles, until 1895; his son, comte Alexis de Noailles; his nephew, La Croix-Laval, d. about 1940; his nephew, comte Christian de la Croix-Laval (sale, Hôtel des Ventes de Nice, May 28, 1970); with Julius H. Weitzner, London.

Purchase, Henry R. Luce Gift, Elihu Root, Jr., Bequest, Rogers Fund, Maria DeWitt Jesup Fund, Morris K. Jesup Fund, Charles and Anita Blatt Gift, 1970.

1970.262.

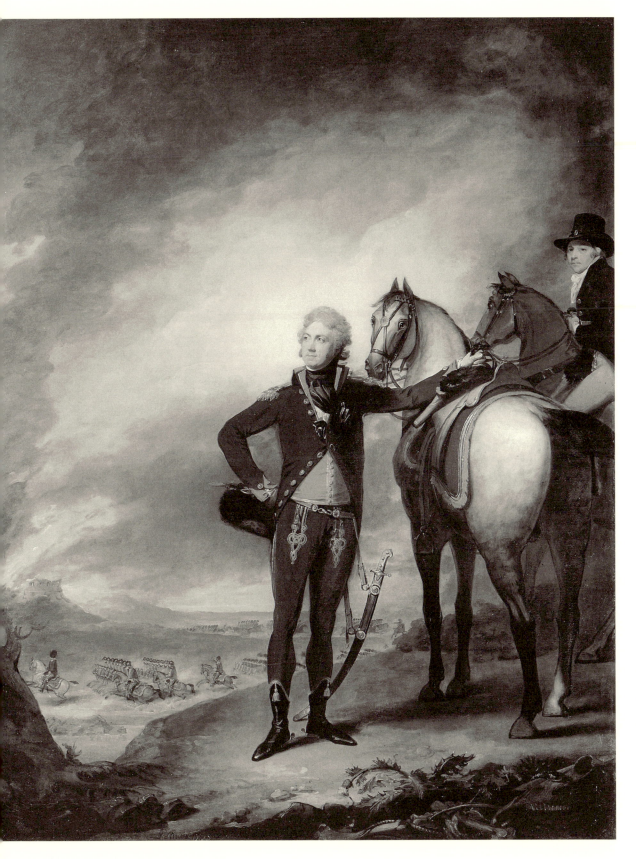

Stuart, *Louis-Marie, Vicomte de Noailles.*

John R. Murray

John R. Murray (1774–1851) was born in New York, the son of the wealthy merchant and landowner John Murray, whose portrait was painted by JOHN TRUMBULL (q.v.). Young Murray developed a lifelong interest in art. In addition to his regular schooling, he took drawing lessons from Alexander Robertson (1772–1841). His interest was further strengthened during an extensive grand tour of Europe from 1799 to 1800, when he visited Berlin, Potsdam, Prague, Vienna, Warsaw, and Saint Petersburg. After his return to New York, he became a successful merchant and was involved in a number of civic activities. In 1807, the year in which he married his second wife, Harriet Rogers, daughter of Colonel Nicholas Rogers of Baltimore, he became a governor of New York Hospital, a post he held until 1837. He was among the founders of the American Academy of the Fine Arts, and, after the establishment of the artist-controlled National Academy of Design, he was made an honorary member there.

Murray was among the earliest American patrons of the arts. His collection of old masters was well known and included copies of, or works

Stuart, *John R. Murray.*

attributed to, Correggio, Gaspar and Nicolas Poussin, Andrea del Sarto, Rembrandt, and Teniers. He also owned works by such American artists as JOHN SINGLETON COPLEY, GILBERT STUART, and JOHN VANDERLYN. A view of New York Hospital drawn by Murray and engraved by W. S. Leney in 1811, attests to his abilities as an amateur artist (ill. in I.N.P. Stokes, *The Iconography of Manhattan Island* [1918], 3, pp. 570–571, pl. 88).

His portrait by Stuart, though sensitively painted and with striking chiaroscuro effects, bears the traces of an overly quick execution. Areas of the cravat and coat are carelessly painted, and Murray's hand is anatomically unconvincing. According to Park, the portrait was painted in Philadelphia about 1800, when Murray was twenty-six years old.

Oil on canvas, 29⅜ × 24⅛ in. (74.6 × 61.3 cm.).
REFERENCES: G. Mason, *The Life and Works of Gilbert Stuart* (1879), p. 229, says the portrait was painted about 1800 and is owned by a son, mistakenly gives name as John R. Morris // L. Park, *Gilbert Stuart* (1926), 2, p. 542, no. 569 // N. Oakman, letters in MMA Archives, July 31, Oct. 29, Dec. 27, 1950, says the painting was bequeathed to her and her sister but that Mrs. Burr requested that it be given to the Metropolitan at some point, gives information on provenance // C. M. Mount, *Gilbert Stuart* (1964), p. 372, lists it // Gardner and Feld (1965), pp. 91–92 // L. B. Miller, *Patrons and Patriotism* (1966), ill. opp. p. 144; pp. 146–148, gives biographical information on the sitter with sources.

Ex coll.: John R. Murray, Mount Morris, N. Y., d. 1851; his son, John Rogers Murray, Mount Morris, N. Y., d. 1881; his adopted sister, Elizabeth duBois Vail (Mrs. L. Wolters Ledyard), Cazenovia, N. Y., d. 1901; her daughter, Murray Ledyard (Mrs. J. H. Ten Eyck Burr), Cazenovia, N. Y., and Washington, D. C., d. 1950; her cousins, Anna Hubbard (Mrs. Walter) Oakman and Helen L. Hubbard, 1950.

Gift of Mrs. Walter Oakman and Miss Helen L. Hubbard, 1950.

50.213.

George Washington

This portrait, known as the Carroll-Havemeyer *Washington* is a copy by Stuart after his unfinished portrait of George Washington painted some time in 1796 (now jointly owned by the Museum of Fine Arts, Boston, and the National Portrait Gallery, Washington, D. C.). That painting, together with its companion portrait of

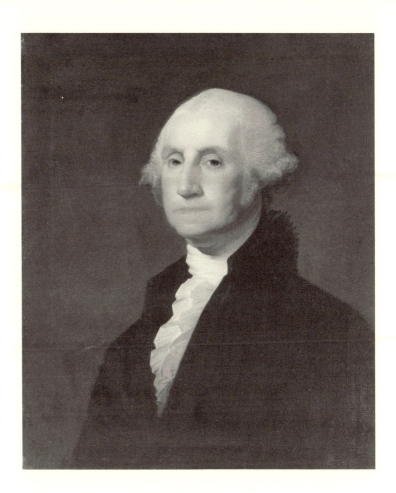

Stuart, *George Washington.*
The Carroll-Havemeyer portrait.

Martha Washington, was in Stuart's possession until his death. It was purchased in 1831 by the Washington Association in Boston, which presented it to the Boston Athenaeum. Accordingly, all replicas of this work are said to be of the Athenaeum type. Some controversy still persists as to whether the Athenaeum portrait was painted in April of 1796, when Washington is known to have sat to Stuart for a portrait commissioned by William Bingham of Philadelphia, or whether it was a separate work also done from life. The distinction is important; for, if the Athenaeum head was executed for the Bingham commission (now PAFA), then the likenesses in the full-length Lansdowne-type portraits produced at this time derive from it; whereas, if the Athenaeum portrait is another work done from life, the full-lengths must be considered as a separate group after Bingham's original. In any case, the present work is unquestionably a copy of the Athenaeum portrait, one of about seventy-two such works painted by Stuart with varying degrees of competence and called by him his "hundred dollar bills."

Although MATTHEW HARRIS JOUETT is known to have helped Stuart in the production of this series of Washington portraits, and although other artists of ability copied Stuart's work, thus complicating the attribution of a number of copies, this picture has always been accepted as an original Stuart. It was painted about 1803, either in Philadelphia or Washington, for Daniel Carroll of Duddington Manor in the District of Columbia and descended in his family. In 1888 it was bought by Henry O. Havemeyer and was the first of a large number of superb works of art given to the museum by him. It is competently executed, but the modeling of Washington's face has been done quickly and summarily, with little subtlety. The shadows lack graduation, and the highlights are somewhat monochromatic. In 1923 Gustavus Eisen, however, approvingly called it "superior to the Athenaeum portrait in expression, and probably one of the earliest replicas."

Oil on canvas, $29\frac{1}{8} \times 24\frac{1}{8}$ in. (74 × 61.3 cm.).
RELATED WORKS: See C. M. Mount, *Gilbert Stuart* (1964), pp. 378–379, for the most complete list of copies.

REFERENCES: E. B. Johnston, *Original Portraits of Washington* (1882), p. 101, states that it was painted in Washington for Daniel Carroll and mentions a replica painted by G. P. A. Healy taken to London // *Art Interchange* 20 (June 2, 1888), p. 178, says it was painted in Washington and discusses provenance // *International Studio* (Feb. 1923), ill. p. 392 // M. Fielding, *Gilbert Stuart Portraits of George Washington* (1923), p. 166, says it was painted in Washington in 1803 // G. Eisen, *International Studio* 76 (Feb. 1923), p. 392, discusses it (quoted above) // L. Park, *Gilbert Stuart* (1926), 2, p. 870, no. 46, dates it 1803 // J. H. Morgan and M. Fielding, *The Life Portraits of Washington and Their Replicas* (1931), p. 280, no. 45, says it was probably painted in Philadelphia and later taken to Washington // G. A. Eisen, *Portraits of Washington* (1932), 1, p. 181, // C. M. Mount, *Gilbert Stuart* (1964), p. 378, lists it // A. T. Gardner, *Antiques* 87 (April 1965), p. 436; *MMA Bull.* 23 (April 1965), ill. p. 267; p. 270 // Gardner and Feld (1965), pp. 92–93 // W. D. Garrett, *MMA Journal* 3, (1970), p. 327.

EXHIBITED: Museum of the City of New York, 1944, *Exhibition in Honor of the 160th Anniversary of the Founding of the Society of the Cincinnati* (no cat.) // M. H. de Young Memorial Museum, San Francisco, 1957, *Painting in America— The Story of 450 Years* (no cat.) // MMA and American Federation of Arts, traveling exhibition, 1975–1977, *The Heritage of American Art*, exhib. cat. by M. Davis, no. 15.

ON DEPOSIT: Corcoran Gallery of Art, Washington, D. C., 1884–1888 // Colonial Williamsburg, Va., 1945–1946.

EX COLL.: Daniel Carroll, Duddington Manor, District of Columbia, about 1803–d. 1849; descended to his daughter and to the Carroll family, until 1888; Henry O. Havemeyer, New York 1888.

Gift of Henry O. Havemeyer, 1888.

88.18.

Albert Gallatin

Albert Gallatin (1761–1849) was born into an aristocratic Swiss family in Geneva. He was orphaned at the age of nine but received an extraordinary education at the home of a distant relative and at the academy in Geneva, where he came under the influence of the doctrines of Jean Jacques Rousseau. In 1780 he immigrated to the United States, partly out of curiosity about the New World and partly to escape from the confining conventions of his family. His coming to America had little to do with politics, and he did not take part in the Revolution. In 1784 he settled on land he had bought in western Pennsylvania, and there his political career began to take shape. From 1790 to 1792 he was a member of the Pennsylvania legislature, where he acquired a reputation as an expert on finance. A believer in democracy, a supporter of Jefferson, and an advocate of agricultural interests, he was elected to the United States Senate in 1793 but was prevented from serving his term because his eligibility was questioned on the grounds that he had not been a citizen for the requisite number of years. In 1794 he dissuaded many supporters of the Whiskey Rebellion from resorting to violence. Probably as a result of this, he was elected to the House of Representatives where he served three terms. He favored strict financial accountability by the Treasury and founded the Committee on Ways and Means to watch over public finances. Given his expertise, it was only natural that President Jefferson should appoint him secretary of the treasury in 1801.

During the first five of his thirteen years in the Treasury, Gallatin reduced the national debt, financed the Louisiana Purchase, and still managed to have surplus funds. The War of 1812, however, made havoc of his program, and by 1813 Gallatin opted to become a diplomat, quickly assuming the leading role in the negotiations for the Treaty of Ghent. Later, although asked to resume his post at the Treasury, he pre-

Stuart, *Albert Gallatin*.

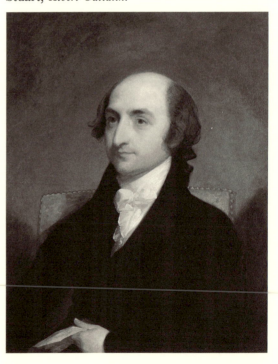

ferred to serve as ambassador to France, from 1816 to 1823. In 1826, he was made minister to Britain, but he resigned the following year. He returned to live in New York and in 1831 accepted the presidency of the National (later Gallatin) Bank. From about this time on Gallatin's interest in the Indians of North and Central America increased steadily. His treatises on the subject were models of organization and scholarship. In 1842 he founded the American Ethnological Society, and in 1843 he assumed the presidency of the New-York Historical Society. He died at the age of eighty-eight.

Henry Adams, Gallatin's biographer, stated that this portrait was painted about 1803 in Washington and that Mrs. Gallatin complained that Stuart had softened and enfeebled her husband's features until the character of his face was lost. She was probably right: here with an unusually smooth technique Stuart has rendered the brushstrokes invisible and blended the various flesh tones so imperceptibly that a certain lifeless quality results. The focus is on Gallatin's forehead, which is brightly spotlighted and appears to radiate light. It is the only brilliantly painted passage in an otherwise dry work.

In his will Gallatin bequeathed "my portrait by Stuart" to his daughter Frances, and, after her death, to his grandson Albert, son of James Gallatin. Albert, however, predeceased his aunt, and so the portrait passed to Albert's widow, who sold it to another of Gallatin's grandsons, Frederic W. Stevens. He, in turn, presented it to the Metropolitan.

Oil on canvas, 29⅜ × 24⅞ in. (74.6 × 63.2 cm.).
RELATED WORK: Dominick Canova, *Albert Gallatin*, lithograph, published by Anthony Imbert, ca. 1830, 5¹³⁄₁₆ × 6½ in. (14.8 × 16.5 cm.) // Draper, Toppan, Longacre and Co., *Albert Gallatin*, engraving, ca. 1838, 1⅛ × 1 in. oval (2.9 × 2.5 cm.) // There are several late nineteenth century engravings as well, see L. Park, (1926), I, p. 334.
REFERENCES: A. Gallatin, will, Surrogate's Court, New York County, liber 98, p. 128 // H. Adams, *Life of Albert Gallatin* (1880), p. 301 // A. E. Gallatin, *The Portraits of Albert Gallatin* (1917), pp. 4–5, quotes Albert Gallatin's will; *Gallatin Iconography* (1934), p. 14, no. 3 // L. Park, *Gilbert Stuart* (1926), I, p. 333, no. 309; ill., p. 182 // C. M. Mount, *Gilbert Stuart* (1964), p. 251; p. 368, lists it // Gardner and Feld (1965), pp. 93–94 // R. McLanathan, *Gilbert Stuart* (1986), pp. 106–107.
EXHIBITED: MFA, Boston, 1880, *An Exhibition of Portraits Painted by Gilbert Stuart*, cat. no. 242, as owned by Albert H. Gallatin, New York // MMA, 1939,

Life in America, no. 57 // Palace of Fine Arts, San Francisco, 1940, *Golden Gate International Exposition*, no. 1218 // National Gallery of Art, Washington, D. C., 1943, *Thomas Jefferson Bicentennial*, no. 21 // M. Knoedler and Co., New York, 1946, *Washington Irving and His Circle*, no. 44 // Valentine Museum, Richmond, Va., 1948, *Makers of Richmond*, cat. pl. 15 // National Gallery of Art, Washington, D. C., 1950, *Makers of Historical Washington*, no. 14 // National Portrait Gallery, Washington, D. C., 1968, *This New Man*, p. 47 // Library of Congress, Washington, D. C., *James Madison and the Search for Nationhood*, 1981–1982 (no cat.).
ON DEPOSIT: U. S. Delegate to the United Nations, New York, 1968–1974.
EX COLL. the subject, New York, d. 1849; his daughter, Frances (Mrs. Byam Kerby Stevens); her nephew's wife, Mrs. Albert Gallatin; Mrs. Stevens's son, Frederic W. Stevens, New York, until 1908.
Gift of Frederic W. Stevens, 1908.
08.90.

William Eustis

William Eustis (1753–1825), the son of Benjamin and Elizabeth Eustis, was born in Cambridge, Massachusetts. He attended the Boston Latin School and graduated from Harvard in 1772. He then studied medicine under the patriot Dr. Joseph Warren and helped care for the wounded at the battle of Bunker Hill. Subsequently, he served as a surgeon in the Continental Army. At the end of the war he established a medical practice in Boston. In 1786 Eustis joined the expedition sent to suppress Shays's Rebellion in western Massachusetts. By this time he was a confirmed Anti-Federalist, and his political views led him to seek public office.

For six years, from 1788 to 1794, Eustis sat on the Massachusetts General Court, then, in 1800, he defeated Josiah Quincy for a congressional seat which he held until 1804. In 1807, President Jefferson named Eustis secretary of war, and in that capacity he attempted to reorganize the military establishment for a possible war with England. His efforts proved fruitless. When war broke out in 1812, Eustis was blamed for the disorganized state of the army and resigned amidst a storm of criticism. He survived his disgrace, however, and in 1814 President Madison appointed him minister to Holland, a post he held until 1818. From 1820 to 1823 he once more represented Massachusetts in Congress, but by then his real ambition was to become governor of the state. He ran for that office unsuccessfully

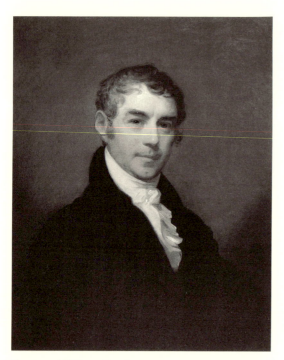

Stuart, *William Eustis.*

several times, in 1820, 1821, and 1822. In 1823, however, he defeated Harrison Gray Otis and achieved his goal. He died during his second gubernatorial term, on February 6, 1825, at the age of seventy-one. His wife, the former Caroline Langdon of Portsmouth, New Hampshire, whom he married in 1810, survived until 1865. They had no children.

The Eustis picture was probably painted in Boston about 1806. Like many of the works Stuart painted after his arrival in Boston in 1805, this portrait reveals his awareness of the conventions of French neoclassical portraiture. He never achieved the sharp focus and clear outlines characteristic of that style, but portraits such as this betray a neoclassical inflection in pose and coloring. The fairly uniform background tone, painted in a smoother manner than was previously characteristic, as well as the turn of the head and direction of the gaze (as if the sitter were looking at the artist from a slightly higher position) are hallmarks of Stuart's new manner and may also be observed in the Metropolitan's portrait of David Sears, Jr. (q.v.).

Oil on canvas, $28\frac{3}{4} \times 23\frac{7}{8}$ in. (73 × 60.6 cm.).
RELATED WORK: The Frick Art Reference Library

lists a late nineteenth century copy of the portrait by Asa W. Twitchell (unlocated).

REFERENCES: F. S. Drake, *Memorials of the Society of the Cincinnati of Massachusetts* (1873), ill. opp. p. 299, an engraving of the portrait by George Perine // L. Park, *Gilbert Stuart* (1926), 1, p. 314, no. 283, says it was painted in Boston about 1806 // *DAB* (1930, 1958), s.v. "Eustis, William" gives biographical information // C. M. Mount, *Gilbert Stuart* (1964), p. 367, lists it // Gardner and Feld (1965), p. 94.

ON DEPOSIT: Federal Reserve Bank of New York, 1972-present.

EX COLL.: the subject, Boston, d. 1825; probably his wife, d. 1865; Frances Appleton Langdon Haven (probably a niece of Mrs. Eustis), d. 1924; the subject's great-grandnephew, Eustis Langdon Hopkins, 1924–1945.

Bequest of Eustis Langdon Hopkins, 1945.
46.28.

Henry Rice

Major Henry Rice (1786–1867) was born at Marlborough, Massachusetts, on January 15, 1786, the son of Noah Rice and Hannah Cole of Boston. He was a descendant of Edmund Rice who came to America from England in 1638 and was one of the first settlers of Marlborough.

Stuart, *Henry Rice.*

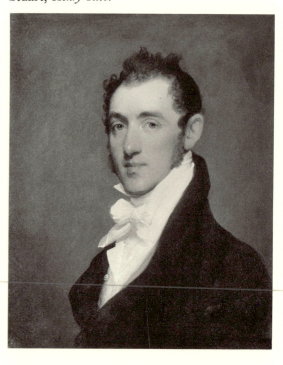

Although his family was well-established and owned property in that town, Henry's great success as a merchant was largely the result of his own resourcefulness. In 1816 he married Maria Burroughs of Boston, also a member of an old wealthy Massachusetts family.

During the War of 1812, Henry Rice served as a major with the state militia and was involved in the defense preparations in Boston. In a letter to his sister Sarah in 1812, he described the confusion in the city caused by the anticipation of a British attack and vouched for the patriotism of the Boston Federalists:

I have ... great confidence that Boston will not be attacked, should it be, the British will find that they are not opposed by Democrats, but by Federalists who though they disapproved of the iniquitous war and despise the authors of it will not tamely surrender as has been done in almost every instance by those who have assisted in making the war. *Boston will be saved* (H. Rice to S. C. Rice, Sept. 12, 1812, notarized copy in Dept. Archives).

Retiring from active mercantile pursuits in 1846, Rice became a stock and real estate broker. His winter home at 8 Bulfinch Place in Boston was designed by the great Boston architect Charles Bulfinch. A number of his fine Dutch paintings were exhibited at the Boston Athenaeum at various times. He died at the old family homestead in Marlborough in 1867.

Painted about 1815, presumably about the time of Rice's wedding, this portrait possesses the strength of characterization, as well as the appealing simplicity, of Stuart's less pretentious Boston portraits. Although formularized, as is evident when one compares it with the very similar *Captain Charles Knapp*, also of about 1815 (Yale University), it is redeemed as is the Knapp portrait by Stuart's superb execution of the face. Possibly because of the difficulty of obtaining imported canvas at this time, both these works have been painted on wood panel textured to resemble canvas.

Oil on wood, 26½ × 21½ in. (67.3 × 54.6 cm.).

REFERENCES: M. Fielding, *Pennsylvania Magazine of History and Biography* 38 (1914), p. 331, no. 112 // L. Park, *Gilbert Stuart* (1926), 2, p. 642, no. 703, misidentifies sitter as a captain probably from New York State, says the portrait was painted in Boston about 1815 // L. A. Rice, May 1, 1931, letter in Dept. Archives, encloses information on the sitter correcting Park // C. M. Mount, *Gilbert Stuart* (1964), p. 374, list it // Gardner ard Feld (1965), p. 95.

EXHIBITED: MMA, 1895–1896, *Retrospective Exhibition of American Paintings*, no. 200i, lent by Miss Lita A. Rice // Museum of Art, Rhode Island School of Design, Providence, 1936, *Rhode Island Tercentenary Celebration*, no. 26, as Captain Henry Rice // John Herron Art Institute, Indianapolis, 1942, *Retrospective Exhibition of Gilbert Stuart*, no. 26.

EX COLL.: the subject, d. 1867; his son, Henry Rice, Jr., by 1867; his daughter, Lita A. Rice, Springdale, Conn., until 1896.

Purchase, 1896.

97.39.

David Sears, Jr.

David Sears, Jr. (1787–1871), was the only son of the Boston merchant David Sears and his wife Anne Winthrop Sears. His father's investments in the East India and China trade and in local land were highly profitable, and young Sears inherited a considerable fortune. He attended the Boston Latin School and graduated from Harvard College in 1807. Afterwards, he studied law in the office of Harrison Gray Otis but did not practice in the profession. An extended tour of Europe on which he embarked in 1811 included lengthy stays in London and Paris, where among his acquaintances was the former Empress Joséphine. He returned to Boston in 1814 but in subsequent years made many trips, visiting Paris from 1829 to 1830; Cuba in 1832; and Italy in 1834. He was in Europe again from 1836 to 1838 and in 1853. As a result of his exposure to European art, he became one of the earliest patrons of WASHINGTON ALLSTON. Sears and his wife, Miriam Mason, whom he married in 1809, had ten children.

David Sears, Jr., contributed greatly to the support of the poor. He was responsible for developing large areas of Brookline and Back Bay, Boston. His stone house on Beacon Street, designed by Alexander Parris and built in 1816, is one of the monuments of American neoclassical architecture. He also had a villa in Newport, Rhode Island, where he spent his summers after 1845. He served as an overseer of Harvard College from 1853 to 1858, contributed to the astronomy department there and at Amherst College, and was a member of the Boston Athenaeum and the Massachusetts Historical Society. He served in the Massachusetts legislature, first in the House of Representatives from 1816 to 1820, then from 1824 to 1825, and again in 1828;

he also served in the state senate in 1826 and 1851.

Gilbert Stuart is known to have painted two portraits of David Sears, Jr., and two portraits of his father, which have sometimes caused confusion. Besides the Metropolitan's portrait of David Sears, Jr., an 1806 portrait is recorded (unlocated), but only the head of that work is by Stuart; THOMAS SULLY completed the rest of it in 1831. The Metropolitan's portrait is entirely the work of Stuart, although it has often been stated that it was the one begun by Stuart and completed by Sully.

Painted in Boston about 1815, the portrait reveals the extent to which Stuart's style had been influenced by French neoclassical portraiture. A comparison of this portrait and the self-portrait of JOHN VANDERLYN (q.v.), painted in France, for example, discloses many similarities in pose, composition, and tonal contrasts. Stuart, however, never aimed for the hard-edged precision that Vanderlyn adopted from Jacques Louis David and his followers; instead his late portraits consist for the most part of a synthesis of new trends from abroad and his own Americanized version of late eighteenth century English style. This amalgam, especially in Stuart's portraits of men, proved influential and continued long after his death in the work of such artists as SAMUEL L. WALDO, WILLIAM JEWETT, and JOHN WESLEY JARVIS.

Oil on canvas, 27¼ × 23½ in. (69.2 × 59.7 cm.).
REFERENCES: G. Mason, *The Life and Works of Gilbert Stuart* (1879), p. 253, discusses two Stuart portraits of Sears, notes one was painted in 1806 and then gives the provenance of this work // R. C. Winthrop, Jr., *Memoir of the Honorable David Sears* (1886), gives biographical data // C. H. Hart, *A Register of Portraits Painted by Thomas Sully* (1909), p. 147, no. 1490, says under 1831, Sully added "Drapery etc. to Stuart's head of Mr. Sears"; says it is probably the Metropolitan portrait // E. Biddle and M. Fielding, *The Life and Works of Thomas Sully* (1921), p. 269, no. 1561, assume this is painting Sully worked on // L. Park, *Gilbert Stuart* (1926), 2, p. 671, no. 740, says portrait was painted in Boston about 1815; 4, ill. p. 453 // B. Burroughs, *Metropolitan Museum of Art Catalogue of Paintings* (1931), p. 341, says Charles Henry Hart believed that Sully worked on this painting about 1830 // J. T. Flexner, *Gilbert Stuart* (1955), p. 164, discusses, calls it "a beautiful picture. . . . it satisfies to perfection Stuart's ideal of emphasizing not accessories but the likeness itself" // C. M. Mount, *Gilbert Stuart* (1964), p. 374, includes it in checklist // Gardner and Feld (1965), pp. 95–96 // W.

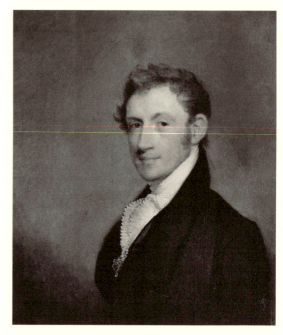

Stuart, *David Sears, Jr.*

D. Garrett, *MMA Journal* 3 (1970), p. 323 // R. McLanathan, *Gilbert Stuart* (1986), p. 141.

EXHIBITED: Boston Artists' Association, 1843, no. 27 (probably this painting) // MFA, Boston, 1880, *Exhibition of Portraits Painted by Gilbert Stuart*, no. 537, lent by Mrs. William Amory (probably this painting; no. 536, another version of the subject was lent by Mr. Knyvet Sears) // MMA, 1895–1896, *Retrospective Exhibition of American Paintings*, no. 204 // Museum of Art of the Rhode Island School of Design, Providence, 1936, *Rhode Island Tercentenary Celebration*, no. 4 // Art Association of Newport, Rhode Island, 1936, *Retrospective Exhibition of the Work of Artists Identified with Newport*, no. 15 // Saginaw Museum, Michigan, 1948, *An Exhibition of American Painting from Colonial Times until Today*, no. 55 // Slater Memorial Museum, Norwich, Conn., 1968, *A Survey of American Art*, no. 3.

ON DEPOSIT: Bartow-Pell Mansion, Bronx, New York, 1968–1972 // Federal Reserve Bank of New York, 1972–present.

EX COLL.: the subject, Boston, d. 1871; his daughter Anna (Mrs. William Amory), Boston, until 1881; subscribers to a fund for its presentation to the museum (Cyrus W. Field, Henry F. Spaulding, William E. Dodge, Collis P. Huntington, Joseph W. Drexel, Robert Gordon, William Loring Andrews, Richard Butler, Samuel Sloan, Tracy R. Edson), 1881.

Gift of Several Gentlemen, 1881.
81.12.

Mrs. Andrew Sigourney

Mrs. Andrew Sigourney (1765–1843), née Elizabeth Williams, was the eldest daughter of Elizabeth Bell and Henry Howell Williams. Her father owned property in Roxbury and on Noodle's Island, now East Boston. In 1797 she was married to Andrew Sigourney, a prominent Bostonian whose family was of Huguenot origin. He was at various times treasurer of the Ancient and Honorable Artillery Company, treasurer of the town of Boston, and representative to the Massachusetts state legislature.

Mrs. Sigourney, wearing a turban of white dotted muslin, a black silk dress with neck ruffles, and a white ruffled fichu, is presented in this portrait of about 1820 as an elegant middle-aged lady of determined character. The sensuality evident in the portrait of Mrs. Joseph Anthony, Jr. (q.v.), is missing here, instead Stuart has given his subject an intelligent knowing look. Like Copley before him, Stuart was able to portray his Boston sitters as they saw themselves: well-to-do but hardly foolish or ostentatious. As in his other late Boston portraits in this collection, the brushwork is controlled and economical. It is also very accurate, manifesting Stuart's ability to make his technique respond to the taste of his patrons.

Oil on canvas, 27 × 22 in. (69.6 × 55.9 cm.).

REFERENCES: G. C. Mason, *The Life and Works of Gilbert Stuart* (1879), 3, p. 256 // L. Park, *Gilbert Stuart* (1926), 2, pp. 691–692, no. 766, describes and gives provenance; 4, ill. no. 766 // C. M. Mount, *Gilbert Stuart* (1964), p. 375, lists it.

EXHIBITED: Boston Athenaeum, 1828, *An Exhibition of Portraits by the Late Gilbert Stuart*, no. 214, not in printed catalogue but listed as such in manuscript additions in copy at MFA, Boston // City Art Museum, Saint Louis, 1915, *Fifth Annual Exhibition of Paintings Owned in St. Louis*, no. 64.

ON DEPOSIT: Carnegie Library, Fort Worth, Texas, 1916, lent by Samuel Moore Gaines.

EX COLL.: the subject, Boston, d. 1843; her grandson, Andrew John Cathcart Sigourney, Baltimore, d. 1869; his widow, later Mrs. William M. King, Norfolk, Va., d. 1893; her daughter, Martha Sigourney Harmon, Norfolk; her son, Andrew Sigourney Harmon, Norfolk, until March 1915; sold to Samuel Moore Gaines, Fort Worth, March 1915–1916; Herbert Lee Pratt, New York and Glen Cove, N. Y.; his daughter, Harriet (Mrs. Donald F. Bush), New York, d. 1978; her husband, Donald F. Bush, New York, 1978.

Gift of Donald F. Bush in memory of Harriet P. Bush, 1978.

1978.380.

Stuart, *Mrs. Andrew Sigourney*.

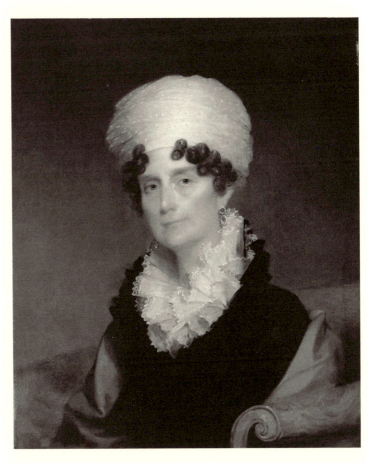

James Monroe

James Monroe (1758–1831), the fifth president of the United States, was born in Westmoreland County, Virginia. He studied law with Thomas Jefferson from 1780 to 1783 and became his political protégé. Monroe fought in the American Revolution, served in the Virginia legislature, and was elected to the Confederation Congress. From 1790 to 1794 he was a senator from Virginia, a post he left in order to become minister to France. In 1799 he was elected governor of Virginia for four years and subsequently served in a number of diplomatic posts. He tried to obtain the presidency in 1808 but was defeated by Madison who, nonetheless, later solicited his political support and made him secretary of state in 1811, and concurrently, secretary of war in 1814. Monroe's successes in these offices during the last years of the War of 1812 secured him the support of a majority of Republicans, and in 1816 he was elected president. His eight years in that office saw the passage of the Missouri Compromise, steady economic progress, and the acquisition of Florida. In 1823, confident of the increasing power of the United States, he issued the statement now known as the Monroe Doctrine, in which he warned foreign powers that further colonial expansion in the western hemisphere would not be tolerated. Although not of the intellectual caliber of Jefferson or Madison, Monroe was a better administrator than either of them.

This picture originally belonged to a set of half-length portraits of the first five presidents of the United States commissioned from Stuart by John Doggett, a Boston framemaker and art dealer, about 1820. It was completed sometime before June 20, 1822, when the exhibition of the set was announced in the *Boston Daily Advertiser*. Monroe's likeness, highlighted in tones of gray and white that give it a marble-like appearance, was taken from a life portrait Stuart painted in Boston in 1817 (now PAFA). The composition and details in the Metropolitan portrait, however, are more complex than those of its predecessor, which is only about half the size.

Stuart had long experimented with portraits of dignitaries seated at tables, and it is not surprising to find close analogies in a number of his previous works including *Thomas Jefferson* and *James Madison*, both painted in 1805–1807 (Bowdoin College Museum of Art, Brunswick, Maine). As in those works, the color of the tablecloth,

Stuart, *James Monroe*.

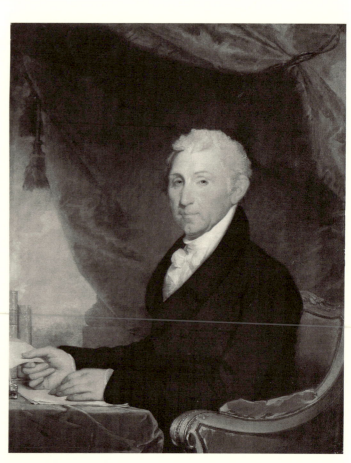

chair, and background drapery is a bright cardinal red, which can be viewed as Stuart's presidential equivalent of the blue associated with the French Bourbon kings. Although the composition has its roots in the late eighteenth century English portraiture of Reynolds, Romney, and Gainsborough, the very smooth handling of pigment as well as the relative flatness that characterizes the arrangement of props and the draperies may be regarded as concessions to the neoclassical aesthetic. These qualities combined with the impassive whiteness of the face and the strong contrasts achieved by the large zones of red and black endow this portrait with an abstract, hieratic quality that brings to mind Stuart's Gibbs-Channing-Avery portrait of Washington (q.v.). Monroe appears as the powerful and efficient administrator which he, in fact, was.

Doggett's complete set was considered for purchase by the United States government, but the appropriation bill, introduced in Congress in 1846, was never passed. In 1851, a fire in the Library of Congress, where the paintings were housed, destroyed the first three pictures of the set. The portrait of Madison, subsequently owned by Herbert L. Pratt, is now at the Mead Art Museum, Amherst College.

Oil on canvas, 40¼ × 32 in. (102.2 × 81.3 cm.).
RELATED WORKS: *James Monroe*, oil on wood, 26½ × 21½ in. (67.3 × 54.6 cm.), 1817, PAFA, ill. in Park, [1926], 3, no. 553 || *James Monroe*, replica, oil on wood, 25⅝ × 21½ in. (65.1 × 54.6 cm.), unlocated, ill. in Park, [1926], 3, no. 554 || Vistus Balch, three engravings after MMA version: half-length, 5⅛ × 3¹³⁄₁₆ in. (13 × 9.7 cm.); oval, 4½ × 3¹¹⁄₁₆ in. 11.4 × 9.4 cm.); reversed, 3¾ × 2¾ in. (9.5 × 7 cm.).
REFERENCES: G. Mason, *The Life and Works of Gilbert Stuart* (1879), p. 229 || L. Park, *Gilbert Stuart* (1926), 2, p. 529, no. 555 || H. B. Wehle, *MMA Bull.* 24 (August 1929), pp. 198–199 || M. M. Swan, *The Athenaeum Gallery, 1827–1873* (1940), pp. 27, 69 || C. M. Mount, *Gilbert Stuart* (1964), p. 311, dates it about 1820; p. 314; p. 372, lists it || Gardner and Feld (1965), pp. 96–97 || *Time* 80 (Sept. 21, 1962), p. 9; cover, ill. in color || R. McLanathan, *Gilbert Stuart* (1986), color ill. p. 132; p. 133.
EXHIBITED: Athenaeum Gallery, Boston, 1827, no. 115; 1828, *Stuart Benefit Exhibition*, no. 31 || PAFA, 1831, no. 97, as for sale by Messrs. Doggett, Farnsworth and Co. || Stuyvesant Institute, New York, 1838, *Exhibition of Select Paintings by Modern Artists*, no. 199, possibly this painting || MFA, Boston, 1880, *An Exhibition of Portraits Painted by Gilbert Stuart*, no. 424 ||

Toledo Museum of Art, 1913, *Perry Victory Centennial Exhibition*, no. 14 || Panama-Pacific Exposition, San Francisco, 1915, no. 2765 || Museum of Art of the Rhode Island School of Design, Providence, 1936, *Rhode Island Tercentenary Celebration*, no. 21 || MMA, 1939, *Life in America*, no. 69 || Art Institute of Chicago, 1949, *From Colony to Nation*, no. 115 || MMA, 1958–1959, *Fourteen American Masters* (no cat.); 1965, *Three Centuries of American Painting* (checklist arranged alphabetically) || National Gallery of Art, Washington, D. C.; Museum of Art, Rhode Island School of Design, Providence, 1967, *Gilbert Stuart, Portraitist of the Young Republic*, no. 45 || MMA, 1970, *Nineteenth Century America*, no. 4 || Hudson River Museum, Yonkers, N. Y., 1970, *American Paintings from the Metropolitan Museum*, no. 45 || MMA and American Federation of Arts, traveling exhibition, 1975–1977, *The Heritage of American Art*, cat. by M. Davis, no. 16.
ON DEPOSIT: White House, Washington, D. C., 1971–1975.
EX COLL.: John Doggett, Boston, until 1839; Abel Phillips, Boston, by 1839; Hon. Peter A. Porter, Niagara Falls, N. Y., 1851–1856; A. B. Douglas, Brooklyn, until 1857; Abiel Abbot Low, Brooklyn, 1857–d. 1893; his son, A. Augustus Low, Brooklyn; his wife, Mrs. A. Augustus Low; sold to her brother-in-law, Seth Low, Brooklyn, and Bedford Hills, N. Y., d. 1916; his wife, Mrs. Seth Low, New York, subject to a life estate, d. 1929.
Bequest of Seth Low, 1916.
29.89.

Washington Allston

This portrait of the famed American painter WASHINGTON ALLSTON (1779–1843) was commissioned by Edmund Dwight of Boston, one of his friends and admirers. According to family tradition, Mr. Dwight retrieved the picture from Stuart's studio, together with a portrait of Daniel Webster, immediately after hearing of the painter's death. It is one of a number of works begun about 1827–1828. Among them are the unfinished portraits of Nathaniel Bowditch (private coll.) and Jared Sparks (New Britain Museum of American Art, Conn.), which share this portrait's special appeal and can be viewed as the finest expression of the artist's aesthetic. Allston's features, lightly sketched in with transparent flesh tints and browns and blacks, have barely begun to emerge from the gray-brown background. It is an eerie, somewhat romantic image of great expressive power, and it prompted Allston's brother-in-law, the novelist Richard Henry Dana, to remark: "It is a mere head, but such

Stuart, *Washington Allston.*

Rhode Island Tercentenary Celebration, no. 12 // NAD, 1951, *The American Tradition*, no. 128 // MMA, 1958, *Fourteen American Masters* (no cat.); 1965, *Three Centuries of American Painting* (checklist arranged alphabetically) // National Gallery of Art, Washington, D. C.; Museum of Art, Rhode Island School of Design, Providence, 1967, *Gilbert Stuart, Portraitist of the Young Republic*, no. 54.

Ex coll.: Edmund Dwight, Boston, d. 1849; his daughter, Mary Dwight (Mrs. Samuel Parkman), Boston, 1849–d. 1879; her daughter, Ellen T. Parkman (Mrs. William W. Vaughan), Boston, by 1880; her daughter, Mary Eliot Vaughan (Mrs. Langdon P. Marvin), New York, until 1928.

The Alfred N. Punnett Endowment Fund, 1928. 28.118.

COPIES AFTER STUART

Commodore Isaac Hull

Isaac Hull (1773–1843) began his seafaring career at the age of fourteen as a cabin boy. Before reaching twenty-one he had already commanded a ship and made several long voyages. In March of 1798 he was made a lieutenant in the United States Navy and served aboard the *Constitution*, which protected American commerce in the Atlantic. In 1804 he took part in the expedition against the Barbary pirates of Tripoli. Promoted to the rank of captain two years later, he was given the command of the *Constitution* and supervised the overhauling of the ship for service in the War of 1812. On August 19 of that year, the *Constitution* engaged the British frigate *Guerrière* in waters off Boston and reduced her to a hulk within forty-five minutes. This victory, the first important naval battle of the war, gave American morale a much needed boost and made Hull a hero overnight.

For the next few years, Hull commanded the Boston and Portsmouth navy yards. Then, in 1824 he was made a commodore and put in charge of the Pacific station. Until 1827 he was mostly at Callao, Peru, protecting American interests in South America at a time when the Spanish colonies were struggling for their independence. From 1829 to 1835 he served as commandant of the Washington Navy Yard. He was made chairman of the Board of Revision, organized in 1838 to revise the table of allowances for navy vessels, and, subsequently, commandant

a head! and so like the man!'' Allston's vivacious eyes and youngish features belie his age, about forty-eight or forty-nine years, and show him at the peak of his artistic powers, before difficulties with his *Belshazzar's Feast* ruined him.

The work bears comparison with the museum's other unfinished painting by Stuart, his self-portrait of 1786 (q.v.); for it not only reveals his remarkable abilities at the age of seventy-one but also how little his fundamental approach to portraiture had changed in the intervening years.

Oil on canvas, 24 × 21½ in. (61 × 54.6 cm.).

References: G. Mason, *The Life and Works of Gilbert Stuart* (1879), p. 127, gives Dana's remark (quoted above) // J. Winsor, *Memorial History of Boston* (1881), 4, ill. p. 393, a wood engraving of the portrait // L. Park, *Gilbert Stuart* (1926), 1, p. 98, no. 13 // M. E. V. Marvin, New York, letter in Dept. Archives, April 29, 1928, relates family tradition about the painting // H. B. Wehle, *MMA Bull.* 23 (1928), pp. 263–264 // *International Studio* 92 (1929), p. 60 // A. T. Gardner, *MMA Bull.* 3 (1944), p. 56 // C. M. Mount, *Gilbert Stuart* (1964), p. 363, lists it // Gardner and Feld (1965), pp. 97–98 // R. McLanathan, *Gilbert Stuart* (1986), p. 145; ill. p. 146.

Exhibited: MFA, Boston, 1880, *An Exhibition of Portraits Painted by Gilbert Stuart*, no. 276, as lent by Miss Ellen T. Parkman, Boston // Art Museum, Rhode Island School of Design, Providence, 1936,

of the Mediterranean station. Hull held this post until his retirement in 1841. The following year he bought a house in Philadelphia, where he lived until his death on February 13, 1843.

This portrait was once thought to be a copy by Stuart of the 1807 work he painted in Boston (now unlocated, ill. in Park, [1926], 3, no. 419). In 1914 George Story said he had been told the painting was commissioned from Stuart by Harrison Gray Otis, the prominent Bostonian, after whose death it was acquired by Parker C. Chandler. But even if this provenance is accurate, the claim to authenticity cannot be entertained; for the picture's style is certainly not Stuart's. Yet, the portrait is not the product of mechanical copying or of an untrained hand. Comparison with the 1807 portrait of Hull (now unlocated), which descended in the Platt family and was considered to be either the original Stuart or an autograph replica, reveals that the painter of the museum's work chose to represent Hull with a slightly more friendly, jovial demeanor than had Stuart. The copiest opted for a tighter, more linear execution. In fact the treatment of each curl and strand of hair is so close to the 1813 engraving that it must have served as a model for this work.

Oil on canvas, 30 × 25 in. (76.2 × 63.5 cm.).

Inscribed on the stretcher by a later hand: This picture was painted for Harrison Gray Otis in Boston 1813–1814.

RELATED WORKS: Gilbert Stuart, *Commodore Isaac Hull*, 1807, oil on canvas, 27½ × 22 in. (68.6 × 55.9 cm.), now unlocated, ill. in Park, *Gilbert Stuart* (1926), 3, no. 419 // David Edwin, *Commodore Isaac Hull*, stipple engraving, 3¾ × 3¼ in. (9.5 × 8.3 cm.), in the *Analectic Magazine* 1 (March 1813), opp. p. 266, after the Stuart original // Waldo and Jewett, *Commodore Isaac Hull*, 1834, oil on wood, 28⅜ × 22⅞ in. (72.1 × 58.1 cm.), Yale University, after the Stuart original.

REFERENCES: G. H. Story, letter in Dept. Archives, Jan. 7, 1914, gives provenance // L. Park, letter in Dept. Archives, Aug. 16, 1924, says the MMA portrait is probably a replica // L. Park, *Gilbert Stuart* (1926), 1, p. 419, no. 420, accepts it as by Stuart // C. M. Mount, *Gilbert Stuart* (1964), p. 369, lists it as a copy by Stuart // Gardner and Feld (1965), pp. 98–99, reject attribution to Stuart.

ON DEPOSIT: Bartow Mansion, Pelham Bay, New York, 1964–1979.

EX COLL.: possibly Harrison Gray Otis, Boston, d. 1848; possibly his wife, d. 1873; possibly Parker C. Chandler, Boston; Isabella P. Francis, New York, about 1905 to about 1914; George H. Story, New

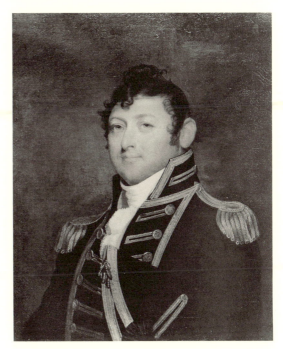

After Stuart, *Commodore Isaac Hull*.

York, by 1914; Charles Allen Munn, West Orange, N. J., about 1914 to 1924.

Bequest of Charles Allen Munn, 1924.
24.109.84.

Commodore Stephen Decatur

Stephen Decatur (1779–1820) was born at Sinepuxent, on the eastern shore of Maryland, studied at the Episcopal Academy in Philadelphia, and after a year at the University of Pennsylvania, joined a local shipping firm. In 1789 he became a midshipman in the navy, where, thanks to his courage and leadership, he quickly achieved success. He gained fame as a hero during the war with Tripoli in 1803 by blowing up the frigate *Philadelphia*, then in enemy hands, and by leading a number of intrepid raids and boardings that effectively demoralized the enemy. For his uncommonly brave actions, he was made a captain. Later, during the War of 1812, he led a squadron of three vessels and scored impressive victories against the British vessels *Macedonian* in 1812 and *Endymion* in 1815. In the last encounter he fell prisoner to the enemy, but since hostilities were practically over, he was soon released. A few months later he led an ex-

pedition against the Algerian pirates and forced the dey of Algiers to accept a peace treaty. Thereafter he served on the Board of Navy Commissioners, invested heavily in real estate in Washington, and was socially well-known in that city. The renowned architect Benjamin H. Latrobe designed his house on Lafayette Square, which still stands today. Decatur died on March 22, 1820, near Bladensburg, Maryland, of a wound received in a duel with Captain James Barron.

The portrait after which this copy was painted was long thought to be the version at the National Museum of American Art, Smithsonian Institution, Washington, D. C. More recently, however, a picture in the collection at the Independence Hall National Historical Park, Philadelphia, has been claimed as the original portrait by Stuart. That portrait was painted in 1806 but was considerably altered by a repainting of Decatur's uniform sometime between 1813 and 1847. In all probability, the Metropolitan painting was copied from it before the repainting; for X-rays indicate the uniform in the Philadelphia portrait was originally more like the one depicted in the Washington portrait and in this copy. Of course, it is still possible that the Metropolitan's painting was done from another copy, but this is unlikely because the resemblance is much closer to the Philadelphia work than to the Washington painting or other known versions.

After Stuart, *Commodore Stephen Decatur*.

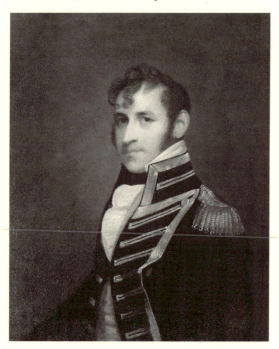

In any case, the museum's portrait is the product of a relatively competent but uninspired artist. It was once in the collection of a descendant of Oliver Hazard Perry, a close friend of Decatur's who may have been the original owner.

A condition problem has caused the surface of the painting to appear grainy, abraded, and lifeless.

Oil on canvas, 30⅛ × 25 in. (76.5 × 63.5 cm.).
RELATED WORKS: Gilbert Stuart, *Commodore Stephen Decatur*, oil on canvas, 29¼ × 24 in. (74.3 × 61 cm.), 1806, Independence Hall National Historical Park, Philadelphia, ill. in *Connoisseur* 171 (August 1969), p. 264 // Attributed to Stuart, *Commodore Stephen Decatur*, oil on canvas, 30⅛ × 25¼ in. (76.5 × 64.1 cm.), ca. 1813, National Museum of American Art, Smithsonian Institution, Washington, D. C., ill. ibid., p. 267 // Gilbert Stuart, *Commodore Stephen Decatur*, oil on canvas, 30¼ × 25¼ in. (76.2 × 63.8 cm.), ca. 1815, coll. Jonathan Bryan III, Richmond, Va., ill. ibid., p. 270 // Copy after Stuart, *Commodore Stephen Decatur*, oil on canvas, 29⅞ × 24⅞ in. (75.9 × 63.2 cm.). coll. Mr. and Mrs. William F. Machold, Wayne, Pa., ill. ibid., p. 270 // James A. Simpson, *Commodore Stephen Decatur*, oil on canvas, 25 × 21 in. (63.5 × 53.3 cm.), Georgetown University Art Collection, Washington, D. C. // David Edwin, *Stephen Decatur, Esq.*, stipple engraving, 3¾ × 3⅛ in. (9.6 × 7.9 cm.), *Analectic Magazine* 1 (May 1813), opp. p. 369 // Another oil on canvas copy after Stuart was in the collection of Harry Stone, New York, as late as 1941 but is now unlocated.
REFERENCES: S. D. Parson (son of subject's niece), New York, letter in Dept. Archives, June 26, 1924, suggests that our portrait may have been copied from his (now at National Museum of American Art, Washington, D. C.) when it was photographed by the Mathew Brady studios in New York about 1865 or 1866 // *MMA Bull.* 19 (July 1924), p. 182, lists it as by Stuart in Munn bequest // H. B. Wehle, *MMA Bull.* 20 (Jan. 1925), p. 22, questions Stuart attribution and suggests it is a copy by John Trumbull or Rembrandt Peale // L. Park, *Gilbert Stuart* (1926), 1, p. 274, mentions it as a copy // B. Burroughs, *The Metropolitan Museum of Art Catalogue of Paintings* (1931), p. 344, as copy after Stuart // Gardner and Feld (1965), p. 99 // W. H. Truettner, *Connoisseur* 171 (August 1969), pp. 271–272.
ON DEPOSIT: Bartow-Pell Mansion, Pelham Bay, New York, 1964–present.
EX COLL.: Lucretia Perry (Mrs. Henry Fairfield Osborn), New York; with Jonce McGurk, Baltimore, about 1919; Charles Allen Munn, West Orange, N. J., about 1919–1924.
Bequest of Charles Allen Munn, 1924.
24.109.83.

JOHN TRUMBULL

1756–1843

John Trumbull was born in Lebanon, Connecticut, on June 6, 1756, the son of Jonathan Trumbull, later governor of the colony, and of Faith Robinson Trumbull. He received a classical education, first at a local school and later at Harvard College, from which he graduated in 1773. He showed an early interest in art, which his father, who wished him to become a lawyer or a minister, discouraged. Nevertheless, Trumbull read treatises on art, learned to draw, and copied engravings.

At the outbreak of the American Revolution, Trumbull became an adjutant to General Joseph Spencer of the First Connecticut Regiment, and shortly thereafter served on Washington's staff as second aide-de-camp. In August of 1775, he became a major of brigade and saw action at Dorchester Heights. The next year he served as a colonel under General Horatio Gates in New York and Pennsylvania and under General Benedict Arnold in Rhode Island. In February of 1778, upon receiving his signed commission from Congress, Trumbull discovered it was dated three months after he had assumed his duties. Indignant, he resigned. He then took up his artistic career once more, painting portraits of his relatives in Lebanon as well as historical subjects inspired by prints. In June of 1778, he moved to Boston, where he lodged in the house once occupied by JOHN SMIBERT. Some of that painter's works, his copies after old masters, plaster casts, and engravings were still on the premises.

Trumbull had long been an admirer of another Boston artist—JOHN SINGLETON COPLEY. Now more than ever exposed to Copley's portraits, he enthusiastically assimilated his style. This is evident in the posthumous portrait of his brother *Joseph Trumbull*, 1778 (Connecticut Historical Society, Hartford). Trumbull remained in Boston until May of 1780 when he sailed for Europe. The exact nature of this trip has never been revealed. After a brief time in France he arrived in London in July and immediately made his way to the studio of BENJAMIN WEST.

Trumbull's studies in London were interrupted abruptly in November of 1780 when he was arrested and imprisoned by the British on the suspicion of treason. Released about eight months later, he left England for Holland and eventually returned home. There he engaged in business with his brother David until 1783. In that year, the war officially over, Trumbull went again to England and West's studio. His technique now improved considerably, and he began work on history paintings representing scenes from the recent war. In these pictures, as well as in two versions of *The Sortie Made by the Garrison of Gibraltar*, 1786–1789 (q.v.), Trumbull combined Copley's detailed realism with West's romanticism and achieved an individual style that was compellingly direct. His history paintings, together with the portrait heads done in preparation for them, are considered his finest works.

Trumbull returned to the United States in 1789 and continued to make progress on his scenes of the Revolution. He traveled extensively in search of documentation for these works, promoted subscriptions for engravings to be made from them, and painted portraits of many prominent men. In 1793, however, he accepted an appointment as secretary to John Jay, then envoy extraordinary to Great Britain, and in 1794 left for Europe. There he

took up his diplomatic chores and involved himself in several business ventures, among them dealing in old master paintings. It was not until about 1800 that he again began to paint. In that year he married Sarah Hope Harvey. She has often been described as a neurotic woman who proved to be a social liability to her husband. Trumbull, however, was deeply attached to her. They left England in 1804 and soon settled in New York, where Trumbull found work as a portraitist. Generally uninspired, his work from this period is characterized by a dark tonality.

Trumbull's social background and his deep understanding of art made him an ideal choice for the board of the new American Academy of the Fine Arts, founded in 1805 and financed by wealthy New York merchants. He was appointed vice president of this organization in 1808. His position, however, did not do much to increase his patronage, and later that same year he went back to London. There his declining powers and the political problems that soon ushered in the War of 1812 led to difficulties. He returned to New York in 1816, a bitter man predisposed to care more about his own well-being than artistic excellence. In 1817 he received a commission from Congress to paint four large-sized replicas of his revolutionary war pictures for the rotunda of the Capitol. Since only eight pictures were to decorate the rotunda, the awarding of four to Trumbull caused resentment among many of his fellow painters, especially in view of his dwindling artistry. In 1826 the younger students at the academy, over which Trumbull now presided, revolted against his despotic and self-serving rule and founded the artist-run National Academy of Design. From this time on, Trumbull was regarded as an ogre by New York artists, and it is in that light that WILLIAM DUNLAP relates his career in *A History of the Rise and Progress of the Arts of Design* (1834). Trumbull became increasingly isolated and was rescued from insolvency by his nephew through marriage, the noted professor of chemistry and geology at Yale Benjamin Silliman. Silliman persuaded the college to acquire all of Trumbull's works and build a gallery to house them, in exchange for which the artist would receive an annuity of a thousand dollars. The gallery which opened in New Haven in 1832 became Trumbull's personal monument and the first college art museum in the country. Trumbull and his wife were later interred there.

Had Trumbull remained in England, or met with more extensive patronage at home, the quality of his painting, which was substantial in the years from 1785 to 1789, might have continued to improve. The lack of a sophisticated artistic climate in the United States, however, and after about 1808, his deteriorating eyesight, contributed to an abrupt decline in the caliber of his work. His pictures became dark, metallic, and lifeless, and he failed to command the respect he so ardently sought. He was probably the most knowledgeable painter of his generation, and his many works with religious, literary, mythological, and historical themes, as well as his landscape views, reveal the depth of his learning.

BIBLIOGRAPHY: Trumbull Papers, Yale University Library, New Haven. The major collection of letters and manuscripts // William Dunlap, *A History of the Rise and Progress of the Arts of Design in the United States* (2 vols., New York, 1834), 1, pp. 340-393. A biased account but representative of views held by many of Trumbull's contemporaries // John Trumbull, *Autobiography, Reminiscences and Letters of John Trumbull from 1756 to 1841* (New York and London, 1841; ed. 1953, *The Autobiography of Colonel John Trumbull*, by Theodore Sizer). Contains indispensable though at times inaccurate information; Sizer's edition provides copious scholarly notes that correct and amplify Trumbull's account // Irma B. Jaffe, *John Trumbull: Patriot-Artist of the American Revolution* (Boston,

1975). The first modern appraisal of the painter's life and works with new information, new interpretations, and a learned point of view || Yale University Art Gallery, *John Trumbull: The Hand and Spirit of a Painter* (New Haven, 1982). Catalogue of a major exhibition of Trumbull's work organized by Helen A. Cooper with essays by Patricia Mullan Burnham, Martin Price, Jules David Prown, Oswaldo Rodriguez Roque, Egon Verheyen, and Bryan Wolf.

George Washington

John Trumbull arrived in London for the first time in July of 1780. Shortly thereafter he must have begun work on this portrait, which was completed before his arrest in the middle of November. The likeness of Washington was painted from memory, influenced perhaps by the CHARLES WILLSON PEALE portrait of 1776 (Brooklyn Museum) that Trumbull had copied in Boston in 1778 (Yale University, New Haven, Conn.). The new work was an immediate success, and a mezzotint of it was published by Valentine Green on January 15, 1781. On the plate Green identified it as "engraved from the original picture in the possession of M. De Neufville, of Amsterdam." Passing through that city on his way to London, Trumbull had met the senior member of the banking firm John de Neufville and Son. Later, in London he met de Neufville's son, who may have bought the portrait and taken it to Amsterdam.

Since it was one of the first authoritative representations of Washington available in Europe, the portrait was soon copied throughout the continent. In 1781 it appeared in Hilliard d'Auberteuil's *Essais Historiques et Politiques sur les Anglo-Américains*, published in Brussels. In 1817 an engraving by Maria Misa, showing Washington in the same pose but in a tropical setting, appeared in J. B. Nougaut's *Beautés de l'Histoire des Etats-Unis*, published in Paris. Variations of the portrait also appeared in a number of printed textiles.

For Trumbull the full-length Washington portrait represented a distinct improvement over his only previous portrait of a standing figure, that of Jabez Huntington executed in 1777 (Connecticut State Library, Hartford). Primitive and awkward, the Huntington portrait reflected the rococo ideal in military portraiture, familiar to Trumbull from European engravings or, more importantly, from such works painted in America as John Smibert's *Sir William Pepperell*, ca. 1746 (Essex Institute, Salem, Mass.) and Joseph Badger's *John Larrabee*, ca. 1760

(Worcester Art Museum). In contrast, the portrait of Washington incorporates elements of fashionable English portraiture of a more recent date. The presence of the horse and the turbaned black attendant (usually identified as Washington's manservant Billy Lee) recalls Sir Joshua Reynolds's *Frederick, Count of Schaumburg-Lippe*, ca. 1764–1767 (Her Majesty Queen Elizabeth) and *John Manners, Marquess of Granby, R. A.*, 1766 (John and Mable Ringling Museum of Art, Sarasota, Fla.). Similarly, the more naturalistic pose is reminiscent of English portraits like Joseph Wright of Derby's *Robert Shore Milnes*, ca. 1771–1772 (coll. Mrs. Lawrence Copley Thaw, ill. in B. Nicolson, *Joseph Wright of Derby*, pl. 114). Like so many contemporary English portraits of military figures with horses, the precedent is Sir Anthony Van Dyck's *Charles I with Groom and Horse*, 1635 (Louvre).

Whether Trumbull actually saw these works at this time is not documented, but it is likely that he was exposed to the latest trends in English portraiture as soon as he set foot in the studio of BENJAMIN WEST. In this respect, it should be pointed out that certain aspects of the portrait, including the use of black lines to reinforce outlines in the head and neck of the horse as well as the very free application of highlights in the boots indicate West's influence and may be compared to his execution of similar forms in *Scene from Orlando Furioso*, 1793 (Toledo Museum of Art; unfinished version, *The Damsel and Orlando*, MMA, q.v.).

Although the background is slightly sketchy, it has been identified as depicting West Point on the Hudson River. In September of 1780 Washington was headquartered at nearby Tappan, New York, and it is likely that Trumbull, knowing of Washington's whereabouts, attempted to paint a realistic scene. In a certain sense, his choice of West Point was ironic; for later that month Benedict Arnold's plan to betray that fortress was uncovered, and his British supporter, Major John André, was hanged. Trumbull always suggested that his imprisonment in London was a direct reprisal for this incident.

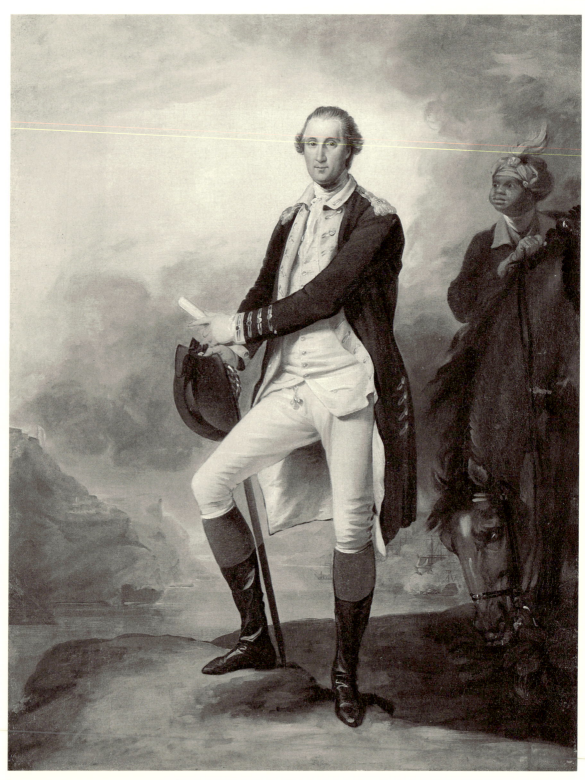

Trumbull, *George Washington*.

The red and white striped banner flying atop the fortress may be the navy ensign adopted in 1775, though the snake and the words "Don't tread on me" that also form part of that banner are not visible.

Oil on canvas, 36 × 28 in. (91.4 × 71.1 cm.).

RELATED WORKS: Valentine Green, *General Washington*, 1781, mezzotint, 24 13/16 × 15 7/8 in. (63 × 40.3 cm.), ill. in W. C. Wick, *George Washington, an American Icon*, p. 27. This was the source for many illustrations of Washington (Green later did a bust-length version also).

REFERENCES: T. Digges, London, to B. Franklin, Paris, Dec. 29, 1780, in C. C. Sellers, *Benjamin Franklin in Portraiture* (1962), p. 376, says that Trumbull finished the portrait before going to jail // E. G. Kennedy to J. F. Weir, Nov. 7, 25, and Dec. 5, 1898, Dept. Archives, offers to sell the painting, says it was painted for de Neufville, and came from the Netherlands to England // C. A. Munn, *Three Types of Washington Portraits* (1908), pp. 4–9, identifies a number of engravings and printed cottons after this painting // H. B. Wehle, *MMA Bull.* 20 (1925), p. 20 // J. H. Morgan and M. Fielding, *The Life Portraits of Washington and Their Replicas* (1931), pp. 172–173, say it must have been done in West's studio before Trumbull's arrest // G. A. Eisen, *Portraits of Washington* (1932), 2, pp. 470–471 // T. Sizer, *The Works of Colonel John Trumbull* (1950, rev. ed. 1967), p. 81, says that the groom is Billy Lee and that the background represents West Point // Gardner and Feld (1965), pp. 101–102 // I. B. Jaffe, *John Trumbull* (1975), pp. 47, 314 // H. Cooper et al., *John Trumbull* (1982), p. 96; ill. p. 97, fig. 51.

EXHIBITED: MMA, 1932, *Exhibition of Portraits of Washington*, p. 3 // Wadsworth Atheneum, Hartford, 1956, *John Trumbull, Painter-Patriot*, no. 17, pl. 1 // Monmouth Museum, Red Bank, N. J., 1968, *Flags of Freedom*, no. 37 // National Portrait Gallery, Washington, D. C., 1973, *The Black Presence in the Era of the American Revolution*, exhib. cat. by S. Kaplan, no. 38; p. 33.

EX COLL.: de Neufville family, the Netherlands, from 1780 or 1781 until about 1890; London art market; with E. G. Kennedy, New York, by 1898; Charles Allen Munn, West Orange, N. J., 1908–1924.

Bequest of Charles Allen Munn, 1924.
24.109.88.

Thomas Jefferson

Thomas Jefferson (1743–1826), third president of the United States, author of the Declaration of Independence, political economist, and architect, was born April 1743, in Goochland now Albemarle County, Virginia. After graduating from the College of William and Mary in 1762, he studied law. As a member of the Virginia House of Burgesses from 1769 to 1775, he advocated the patriot cause, and in 1775–1776, he was a delegate to the Second Continental Congress. In 1779 he succeeded Patrick Henry as governor of Virginia and in 1785 was appointed American minister to France. On his return to the United States in 1790, he became Washington's first secretary of state. His opposition to the conservative and centralizing policies of Alexander Hamilton and the Federalists eventually led to the formation of the Democratic-Republican party, which in 1800 captured the presidency. As president, Jefferson steered the country through the difficult years of the Napoleonic wars and pushed through the Louisiana Purchase. After 1809, he lived in retirement at Monticello, the Palladian masterpiece he designed and erected on his Virginia estate. There he devoted much of his time to the building and establishment of the University of Virginia. At his death, he was revered as one of the greatest American patriots and a man of undisputed genius.

John Trumbull met Thomas Jefferson for the first time in the summer of 1785 when Jefferson, then American minister in Paris, visited London on official business. The two men became good friends, and Jefferson, eager to encourage Trumbull's artistic ambitions, invited him to be his guest in Paris. Trumbull made two trips to the French capital, one in the summer of 1786 and another in December of 1787. On his first visit he introduced Jefferson to the beautiful Maria Cosway, wife of the celebrated English miniature painter Richard Cosway and a woman for whom the American minister developed a strong romantic attachment. On the second trip, he accompanied Angelica Schuyler Church, who was also presented to Jefferson and quickly became his friend. At this time, Trumbull painted from life the portrait of Jefferson in his small version of *The Declaration of Independence*, 1787-1797 (Yale University). Maria Cosway and Angelica Church knew each other well, and from London each of them carried on a flirtatious correspondence with Jefferson in which they represented themselves as rivals for his affections. It is not surprising then that, when Trumbull arrived in England in February of 1788 with *The Declaration of Independence*, both ladies expressed the desire for copies of his depiction of Jefferson.

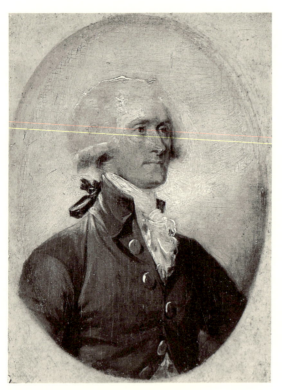

Trumbull, *Thomas Jefferson.*

On March 6, 1788, Mrs. Cosway wrote to Jefferson: "Will you give Mr. Trumbull leave to make a coppy of a certain portrait he painted at Paris ... It is a person who hates you that requests this favor." On July 21, Angelica Church wrote to him: "Mr. Trumbull has given us each a picture of you. Mrs. Cosway's is a better likeness than mine, but then I have a better elsewhere, and so I console myself." On August 19, Mrs. Cosway wrote: "Wish me joy for I possess your picture. Trumbull has procured this happiness which I shall ever be grateful for."

The present picture is the portrait painted for Angelica Church. It is the only such portrait of Jefferson to have descended in her family and makes it highly probable that the passage in her letter referring to a better likeness elsewhere alludes to the vividness of her memory and not to another picture. Maria Cosway's copy, long in the possession of the girls' school she founded in Lodi, Italy, is now in the White House collection and on loan to the National Gallery of Art in Washington. Since the only portrait of Jefferson that Trumbull painted in Paris appears

to be the one in the *Declaration*, it has always been assumed that these two pictures, as well as a third one the artist painted for Jefferson's daughter Martha (Monticello, Thomas Jefferson Memorial Foundation, Charlottesville, Va.) are direct copies even though Jefferson appears much younger in these works. The influence of other portraits of Jefferson on these small portraits, however, cannot be excluded, and, in the case of the Church and Cosway pictures, in which Trumbull attempts to depict a bewigged, fashionable cosmopolite, close parallels exist between them and Mather Brown's 1786 portrait of Jefferson, a copy of which hung in John Adams's house in London and which Trumbull often saw (now coll. Charles F. Adams, Dover, Mass.).

The Jefferson portraits are among the earliest of Trumbull's small oil portraits on wood, most of which were painted in the United States between 1790 and 1794. They are executed with impastos and transparent glazes in a manner that produces contrasting textures completely unlike the effect of the watercolor on ivory technique used for true miniature portraits.

Oil on mahogany, $4\frac{1}{2} \times 3\frac{1}{4}$ in. (11.4 × 8.3 cm.).

RELATED WORKS: *The Declaration of Independence*, oil on canvas, $21\frac{1}{8} \times 31\frac{1}{8}$ in. (53.7 × 79.1 cm.), 1787–1820, Yale University, New Haven, ill. in H. A. Cooper et al., *John Trumbull* (1982), p. 77 || *Thomas Jefferson*, oil on wood, $4\frac{1}{2} \times 3\frac{1}{4}$ in. (11.4 × 8.3 cm.), White House, Washington, D. C., on loan to the National Gallery of Art || *Thomas Jefferson*, oil on wood, $4\frac{7}{8} \times 3\frac{3}{4}$ in. (12.4 × 9.5 cm.), 1787 or 1788, Thomas Jefferson Memorial Foundation, Charlottesville, Va.

REFERENCES: M. Cosway to T. Jefferson, March 6, 1788, and. A. S. Church to Jefferson, July 21, 1788, in *The Papers of Thomas Jefferson*, ed. by J. P. Boyd (1954), 12, p. 645, and 13, p. 391 (quoted above) || J. Trumbull, *Autobiography* (1841), pp. 150–151 || H. B. Wehle, *American Miniatures* (1927), p. 28, mistakenly reports that this portrait was painted in Paris in the autumn of 1787 || F. F. Sherman, *Art in America* 19 (Oct. 1931), p. 258, incorrectly notes that it was painted in Paris in 1787; p. 259, lists it || F. Kimball, *Proceedings of the American Philosophical Society* 88 (1944), p. 503 || T. Sizer, *Art Bulletin* 30 (Dec. 1948), p. 503, mistakenly says it was painted in Paris in 1786 || E. Cometti, *William and Mary Quarterly* 9 (April 1952), p. 152 || *The Papers of Thomas Jefferson*, ed. by J. P. Boyd (1954), 10, p. xxix, calls it a replica of the portrait in the Declaration of Independence at Yale || A. L. Bush, *The Life Portraits of Thomas Jefferson* (1962), pp. 17–19, says it is a replica after the portrait in the Declaration || Gardner and Feld (1965), pp. 102–103 || T. Sizer, *The Works of Colonel John Trumbull* (1950;

rev. ed. 1967), p. 46, says it was painted in London in 1788 after the portrait in the Declaration // I. Jaffe, *John Trumbull* (1975), pp. 140, 310 // H. A. Cooper et al., *John Trumbull* (1982), p. 117.

EXHIBITED: MMA, 1927, *Miniatures Painted in America, 1720–1850*, exhib. cat., p. 55 // Smithsonian Institution, Washington, D. C., 1943, *Thomas Jefferson Bicentennial Exhibition*, no. 14.

EX COLL.: Angelica Schuyler Church (Mrs. John Church), London and New York 1788–d. 1814; her daughter, Catherine Church (Mrs. Bertram P. Cruger), New York and Paris, d. 1839; her son, John Church Cruger, New York, and Cruger's Island, N. Y., d. 1879; his daughter, Cornelia Cruger, Cruger's Island, N. Y., d. 1922.

Bequest of Cornelia Cruger, 1923.

24.19.1.

The Sortie Made by the Garrison of Gibraltar

This work, which according to Theodore Sizer (1950), is Trumbull's "most successful large-scale picture of a historical scene," depicts the events of the night of November 26, 1781, when British troops, long besieged by Spanish forces at Gibraltar, made a sortie against the encroaching enemy batteries to the north and set fire to them. Although in the long siege of Gibraltar this was only one episode among many, it was an important victory and helped to secure the position of the British garrison there. The painting is the largest and last version of the three paintings on that subject Trumbull executed from 1786 to 1789. (Much later he made two copies, so all told there are five paintings.)

In a letter to his brother Jonathan on May 24, 1786, Trumbull acknowledged that BENJAMIN WEST had suggested a scene depicting the victory at Gibraltar, "a subject of the History of this Country, at once popular, sublime, & in every respect perfect for the pencil, . . . hitherto untouched & which alone, if properly treated is sufficient to establish my Reputation." Trumbull may have seen the work as a way of redressing the offense his paintings of the American Revolution had given in England. Yet he must have known that at that moment JOHN SINGLETON COPLEY was at work on a painting of the Gibraltar theme commissioned by the Court of Common Council of London in 1783. In addition, he must have known that Copley, West's rival, had won that commission only because he reduced his fee considerably after rejecting West's

John Trumbull

idea that rather than compete for a single commission they convince the council that two different works, depicting different scenes from the history of the siege, were needed. Trumbull must have been aware too that Copley was then encountering difficulties with his monumental canvas, and, consequently, that if West suggested such a subject to him now, it was probably in the hope that a student of his would complete the subject and send it to the engraver's before Copley.

Significantly, two dated drawings by Trumbull have survived which imply that he was not only aware of the situation but chose a diplomatic solution. The earlier of the drawings, *General Elliot at Gibraltar* (Connecticut Historical Society, Hartford), dated May 20, 1786, is a compositional study depicting *The Siege of Gibraltar* precisely Copley's subject, and one which dealt with the relief of the garrison on September 13-14, 1782. The second drawing, dated May 23, 1786, illustrates *The Sortie Made by the Garrison of Gibraltar* (Boston Athenaeum Sketchbook, sheet 2), an iconographically distinct topic but, still, one guaranteed to tap the same audience as Copley's work. The change of subject thus permitted the artist to compete with Copley without appearing to insult him.

According to Trumbull, it was the engraver Antonio di Poggi, a witness at the scene, who first told him the story of the sortie and of the tragic death of the Spanish officer Don José de Barboza. Abandoned by his fleeing troops, the Spaniard charged the attacking column alone, fell mortally wounded, and, refusing all aid, died near his post. Trumbull began a series of preparatory drawings, some of which he gave to the

Trumbull, small compositional study for the *Sortie*, May 23, 1786, sheet 2, Trumbull Sketchbook, Boston Athenaeum.

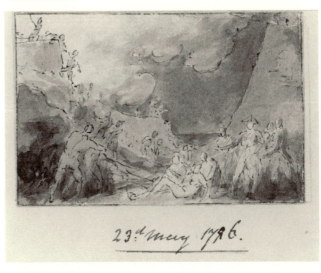

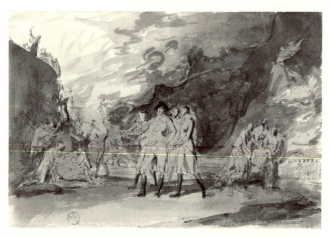

Trumbull, compositional study showing the English officers in the center, sheet 4, Trumbull Sketchbook, Boston Athenaeum.

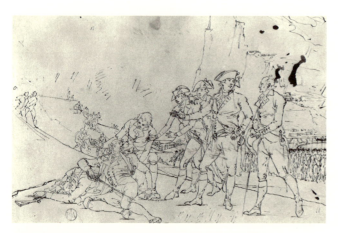

Trumbull, compositional studies, sheet 6 (above) and sheet 11 (below), Trumbull Sketchbook, Boston Athenaeum.

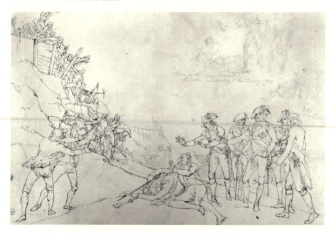

Boston Athenaeum in 1828 when that institution purchased the painting. Beginning with the ink and wash study dated May 23, 1786, the drawings reveal Trumbull's attempts to resolve the considerable problems of composition presented by a complex scene. From the first, he determined to depict the attack on the batteries to the left and to give the central position to the dying Spaniard. Only once (Boston Athenaeum Sketchbook, sheet 4) did he deviate from this arrangement by placing the group of English officers at the center of the composition. Clearly, this alternative was too static for him and too unimpressive for the confrontation between the Spanish officer and the English. Trumbull then became dissatisfied with the original arrangement of the dying Spaniard as illustrated in that drawing and turned the figure at the right perpendicular to the group of officers, placed it against the corpse of a soldier, and provided a supporting redcoat behind (Boston Athenaeum Sketchbook, sheet 6). Later the supporting figure disappears and the defiant refusal of aid by the dying Don José begins to find expression in the artist's hands (Boston Athenaeum Sketchbook, sheet 11). Finally, two drawings (Boston Athenaeum Sketchbook, sheet 3 and 9 top) appear to be studies that were later included in the final compositional study (sheet 12), which, as Trumbull noted on the sheet, "is nearly the same as the first small painted study which was given to Mr. West." Here, the confrontation between Don José and the English officers is made more direct, dead bodies litter the center of the composition, and the sky itself is rendered to reflect the drama of the moment. Meanwhile the number of men attacking the batteries has increased considerably. The drawings thus establish a determined progression toward movement, complexity, and drama, intensified by stronger gestures and poses. The result is not unlike the baroque effects of the first scene Trumbull painted of the American Revolution, *The Death of General Warren at the Battle of Bunker's Hill* (Yale University), completed in 1786 about the time he began to think of painting *The Sortie*.

Trumbull's first painted version of the scene (Corcoran Gallery of Art, Washington, D. C.) was completed sometime in 1787. According to his own account, he made a great error in dressing the Spaniard in white and scarlet rather than in blue and scarlet. Instead of correcting the original work, he undertook, on the advice of West, a larger version on a canvas twenty by

thirty inches. In retrospect this account appears unlikely, especially in view of the small size and unfinished quality of the first version. If, as he had written his brother, he believed that a painting based on the events of Gibraltar was sufficient to establish his reputation, he could not possibly have thought this achievable through a mere study of a history painting. Accordingly, a large version was inevitable.

For the second version (now in the Cincinnati Art Museum), he set about taking portraits of the officers engaged in the action and conceived further changes in the composition. The dying Spaniard was moved once again; this time he assumed an attitude of raging defiance as he recoiled from his would-be benefactors. The arrangement of officers became more frieze-like and included eight instead of five figures. Two more English officers and a soldier swinging a crowbar were added, framing the composition at the extreme right and left. The trend toward greater formal and emotional complexity was therefore continued in this second version. It was not an unqualified success. As Trumbull tells it: "This picture pleased, but I was not satisfied with all its parts; my Spanish hero seemed to express something approaching to ferocity, and several other parts appeared to me not well balanced" (*Autobiography*, [1841], p. 149). He sold the painting to Sir Francis Baring for five hundred guineas, a very large sum at the time and one which suggests that he did not need to paint a still larger version of the scene. Furthermore, the artist was not obliged to paint a work more than ten times the size of the second version in order to correct its aesthetic shortcomings. Clearly other motives drove him to paint this monumental picture. Like West and Copley, Trumbull possessed that peculiarly American ambition— to become a history painter in the grand manner.

Although at first glance the third version does not seem to differ from the second so much as the second from the first, the large *Sortie* incorporated a number of significant changes. Trumbull altered Don José's pose, working it out carefully in a compositional sketch (coll. Jonathan Isham). The emotions conveyed by his death changed drastically when the figure was given the pose of the *Dying Gladiator* (Louvre) and the likeness of the young Thomas Lawrence (shortly to become one of Britain's renowned portraitists). The foreground was deepened and cleared up, another figure was placed at the far right, the sky was toned down considerably, and

John Trumbull

Trumbull, figure study for the group with the dying Spaniard, sheet 3, Trumbull Sketchbook, Boston Athenaeum.

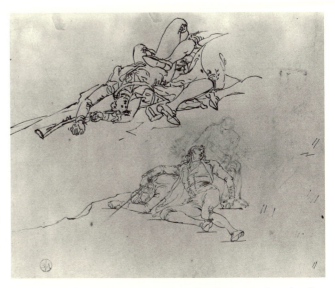

Trumbull, studies for the dying Spaniard and a dead soldier, sheet 9 (above), and chiaroscuro study for the entire composition, sheet 12 (below), Trumbull Sketchbook, Boston Athenaeum.

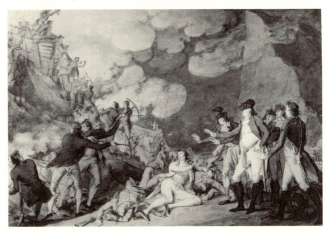

the entire scene was suffused with a reddish glow. The last effect was in accord with published accounts of the action that reported "the column of fire and smoke which rolled from the works, beautifully illuminated the troops and neighbouring objects, forming all together a *coup-d'oeil* not possible to be described" (John Drinkwater, *A History of the Late Siege of Gibraltar* [1786], p. 201). By far the most significant change took place in the execution of the work, which now became smoother, more linear, and more restrained, even though it incorporates significant material Trumbull added over the years of work. The third version of *The Sortie* appears simpler, tighter, and less cluttered—in effect, more neoclassical than the other versions.

Completed early in 1789, this version of *The Sortie* was shown in May of that year at a private exhibition organized by Trumbull at Spring Gardens. The public appears to have received it well, although the newspaper critics remained silent. Horace Walpole, the noted connoisseur and chronicler of the age, is reported by Trumbull to have considered it the finest picture that had been painted on the northern side of the Alps. Sometime afterward, Trumbull received an offer of twelve hundred guineas for the work but refused it. It remained in his possession until he sold it to the Boston Athenaeum in 1828, save for about three years, 1824 to 1827, when it is supposed to have been in an English collection.

Trumbull's arrangement of the composition in three parts (the destruction of the batteries, the dying Spaniard, and the group of officers) clearly presented difficulties; yet it enabled him to represent various aspects of the historical event and, more importantly, to explore the various moods of the occasion. In this respect the painting is a more ambitious work than its forerunners in Anglo-American contemporary history painting. West's *Death of Wolfe*, 1770 (National Gallery of Canada, Ottawa), Copley's *Death of Major Peirson*, 1782–1784 (Tate Gallery, London), and, Trumbull's own paintings of the American Revolution *The Death of General Warren at the Battle of Bunker's Hill* and *The Death of General Montgomery in the Attack on Québec* (Yale University) depicted unified scenes partaking of the same well-defined psychological atmosphere. *The Sortie*, on the other hand, not only pretends to take the viewer into the fray of the attack but also requires him to witness simultaneously the

emotionally charged death of an enemy hero, as well as to admire the majesty and magnanimity of the commanding English officers. Accordingly, Trumbull chose his sources carefully. In representing the destruction of the batteries, he relied on solutions he had already arrived at for *The Battle of Bunker's Hill*. The strong diagonal movement to the upper left, the density of the figures, the agitation created by their bold gestures, and the strong contrasts of light and dark had all been previously used to great effect in that work. For the dying Spaniard, as Trumbull notes, the classically restrained but moving form of *The Dying Gaul*, also a defeated captive, provided the model. Next to him, the sharply foreshortened figure of the dead redcoat repeats the pose of a similar figure placed in the center foreground of Copley's *Death of Major Peirson*. Finally, in conveying the benign grandeur of the English commander General Elliot and his officers, Trumbull followed the precedent West had established in *Agrippina Landing at Brundisium with the Ashes of Germanicus*, 1768 (Yale University), and relied on Roman relief sculpture. Trumbull must have seen a number of such works in European collections or reproduced in engravings so it is difficult to pinpoint a direct link with a particular work, though the appearance of the emperor in the Domitianic relief from the Palazzo della Cancelleria in Rome (Vatican) well illustrates the parallels between the painting and sculptures of that type both in the poses of the figures and their grouping.

Still other antecedents may be cited with respect to the rendering of the appearance of the picture as a night scene illuminated by fires. In Trumbull's *Death of General Montgomery* a steel-blue light is as pervasive in that dark scene as is the reddish tonality of *The Sortie*. In Joseph Wright of Derby's *View of Gibraltar during the Destruction of the Spanish Floating Batteries* (Milwaukee Art Center), exhibited at Robin's Rooms, Covent Garden, in April 1785, the fires caused by the burning of the batteries on the water at night were very successfully exploited in a work of large size.

After the completion of the third *Sortie*, Trumbull refrained from painting contemporary historical subjects on this scale until 1817. In that year, he began four copies of his revolutionary war paintings for the rotunda of the United States Capitol. By that time, however, his eyesight had deteriorated badly, and he had met

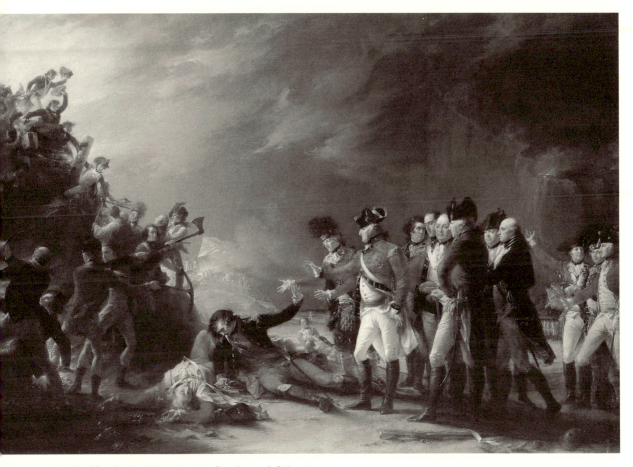

Trumbull, *The Sortie Made by the Garrison of Gibraltar.*

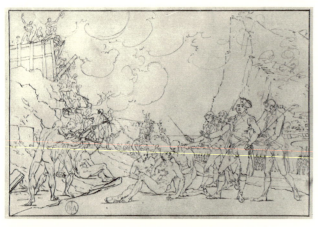

Trumbull, compositional study with many nude
figures, sheet 5, Trumbull Sketchbook,
Boston Athenaeum.

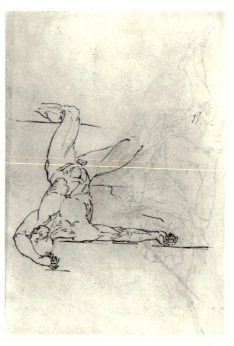

Trumbull, anatomical study for a
figure of a dead man, sheet 3 verso,
Trumbull Sketchbook, Boston Athenaeum.

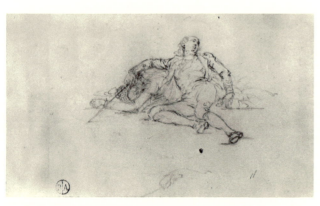

Trumbull, study for the dying Spaniard, sheet 7,
Trumbull Sketchbook, Boston Athenaeum.

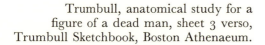

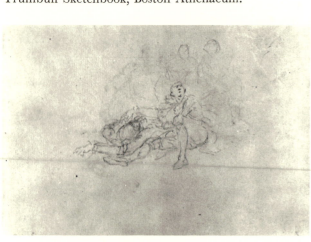

Trumbull, sketches for figures of officers,
sheet 8, Trumbull Sketchbook,
Boston Athenaeum.

Trumbull, sketch for the dying Spaniard,
sheet 7 verso, Trumbull Sketchbook,
Boston Athenaeum.

Trumbull, Thomas Lawrence as the dying
Spaniard, sheet 16, Trumbull Sketchbook,
Boston Athenaeum.

Trumbull, sketch for foreground figures,
sheet 10, Trumbull Sketchbook,
Boston Athenaeum.

Trumbull, general sketch for entire
composition, sheet 13, Trumbull Sketchbook,
Boston Athenaeum.

Trumbull, drawing for top ornament of the frame,
sheet 14, Trumbull Sketchbook, Boston Athenaeum.

Trumbull, general sketch of the picture in its frame,
sheet 15, Trumbull Sketchbook, Boston Athenaeum.

Sheet 16

Sheet 14

Sheet 10

Sheet 15

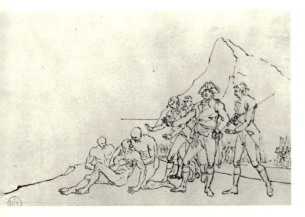

Sheet 13

with serious reverses as an artist in his own country. It is not surprising that these later works lack the quality of the pictures he painted in England from 1785 to 1789, when he was at the height of his powers and responsive to the stimulating influences of the artistic milieu in London. *The Sortie Made by the Garrison of Gibraltar* thus occupies a special place in Trumbull's career. It is the only work that reveals the magnitude of his ambition at his best moment. More important, it is the only work by him that can justifiably claim a spot alongside the recognized monuments of Anglo-American contemporary history painting.

Oil on canvas, 71 × 107 in. (180.3 × 271.8 cm.).
Signed and dated at lower left: John Trumbull / 1789.
RELATED WORKS: *General Elliot at Gibraltar* (compositional sketch), 6⅜ × 8⅝ in. (16.2 × 21.9 cm.), May 20, 1786, Connecticut Historical Society, Hartford // Fifteen preliminary drawings in Sketchbook, 1786–1789, Boston Athenaeum: sheet 2, compositional study, pen and ink with wash, 1¾ × 2½ in. (4.4 × 6.4 cm.), May 23, 1786; sheet 3, figure study for group of the dying Spaniard, graphite, pen and ink, 7⅜ in. × 9⅛ in. (18.7 × 23.2 cm.); sheet 3 verso, anatomical study for a figure of a dead man, pen and ink, 7⅜ × 9⅛ in. (18.7 × 23.2 cm.); sheet 4, compositional study with group of officers in center, pen and ink with wash, 5¹¹⁄₁₆ × 8⁷⁄₁₆ in. (14.5 × 21.4 cm.); sheet 5, compositional study with many nude figures, pen and ink, 5⁵⁄₁₆ × 7¹³⁄₁₆ in. (13.5 × 19.8 cm.); sheet 6, compositional study, pen and ink, 6⅛ × 9¼ in. (15.6 × 23.5 cm.); sheet 7, study for the dying Spaniard, graphite, 4⅝ × 7⅜ in. (11.8 × 18.7 cm.); sheet 7 verso, sketch for the dying Spaniard, graphite, 4⅝ × 7⅜ in. (11.8 × 18.7 cm.); sheet 8, sketches for figures of officers, graphite, 7⅛ × 8⅝ in. (18.1 × 21.9 cm.); sheet 9, study for dying Spaniard and a sketch of a dead soldier, graphite, pen and ink, 7⁷⁄₁₆ × 9¼ in. (18.9 × 23.5 cm.); sheet 10, sketch for foreground figures, pen and ink, 4⅞ × 7⅜ in. (12.4 × 18.7 cm.); sheet 11, compositional study with figures clothed, graphite, pen and ink, 11⅞ × 17¾ in. (30.2 × 45.1 cm.); sheet 12, chiaroscuro study for entire composition, wash, pen and ink, 11⅞ × 17⅝ in. (30.2 × 44.8 cm.); sheet 13, general sketch for entire composition, graphite, 11½ × 18⅜ in. (29.2 × 46.2 cm.); sheet 14, drawing for top ornament of the frame with description of its iconography, graphite, pen and ink, 7¹¹⁄₁₆ × 16½ in. (19.5 × 41.9 cm.); sheet 15, general sketch of the picture in its frame, graphite, 7¾ × 8¾ in (19.7 × 22.2 cm.); sheet 16, Thomas Lawrence as the dying Spaniard, black and white chalk on blue paper, 14 × 11⅜ in. (35.6 × 28.9 cm.) // *The Sortie Made by the Garrison of Gibraltar*, oil on canvas, 15⅛ × 22⅛ in. (38.4 × 56.2 cm.), 1787,

Corcoran Gallery of Art, Washington, D. C., ill. in I. Jaffe, *John Trumbull* (1975), p. 136, fig. 109 // *The Sortie Made by the Garrison of Gibraltar*, oil on canvas, 20 × 30 in. (50.8 × 76.2 cm.), 1788, Cincinnati Art Museum, the second version, ill. in T. Sizer, *The Works of Colonel John Trumbull* (1950; rev. ed. 1967), fig. 197 // compositional study (pose of the dying Spaniard is altered), ink, gray washes, and graphite, 1790, coll. Jonathan Isham, 1⅞ × 2¾ in. (4.8 × 7 cm.), ill. in H. A. Cooper et al., *John Trumbull* (1982), p. 62, fig. 35 // *The Sortie Made by the Garrison of Gibraltar*, oil on canvas, 35½ × 54 in. (90.2 × 137.2 cm.), ca. 1840, Yale University, New Haven, a replica by Trumbull, probably after the engraving // *The Sortie Made by the Garrison of Gibraltar*, oil on canvas, 37½ × 58½ in. (95.3 × 148.6 cm.), ca. 1840, Caldwell Colt Robinson, Newport, on loan to the Lyman Allyn Museum, New London, Conn. // *References [Key] to The Sortie*, pen and brown ink, 7⁵⁄₁₆ × 17⅜ in. (18.6 × 44.1 cm.), n.d., Yale University, ill. in T. Sizer, *The Works of Colonel John Trumbull* (1950; rev. ed. 1967), fig. 199 // William Sharp, engraving, 23¹⁄₁₆ × 31⅜ in. (58.5 × 79.7 cm.), 1799, ill. in Wallraf-Richartz-Museum der Stadt Köln, *Triumph und Tod des Helden* (1988), p. 412.

REFERENCES: J. Trumbull, "Record of Paintings of before 1789," no. 33, Trumbull Papers, Yale University, New Haven // John Trumbull to Jonathan Trumbull, May 24, 1786, Trumbull Papers (quoted above) // W. Allston to C. Fraser, August 24, 1801, in J. B. Flagg, *Life and Letters of Washington Allston* (1892), pp. 45–46 // *New-York Evening Post*, Dec. 3, p. 3, and Dec. 28, 1804, p. 1 notes its exhibition in New York // *New-York Gazette and General Advertiser*, Dec. 27, 1804, mentions its exhibition in New York // J. Murray to J. Trumbull, Dec. 19, 1810, Trumbull Papers, NYHS, estimates value of the paintings at $5,000 // J. Trumbull to J. Murray, April 5, 1811, ibid., thanks him for sending the painting from New York to London, says it arrived too late for the exhibition at the British Institution // John Neal, *Randolph, a Novel* (1823), 2, pp. 123–124, "Let us now look in upon Mr. Trumbull. You have seen his *Sortie of Gibraltar*; and nothing that I could say of it now, would be of any avail, to elevate it in your opinion. It is his best picture. Indeed, his Death of Montgomery; Battle of Lexington; Bunker Hill, and all of his late pictures, are, altogether, not worth so much as that—so vigorous, and so full of action, as it is" // J. Elmes, *Arts and Artists* (1825), 3, pp. 199–200, criticizes Trumbull but then says: "Yet Mr. T. *was* a man of considerable power. His well-known "Sortie of Gilbraltar," the original sketch of which has lately been exhibited at the Suffolk Street exhibition, was a very fine picture, but worth, it is true, every thing else that he has ever done" // *New York Commercial Advertiser*, Oct. 20, 1827; June 2, 5, 6, 28, 1828, lengthy article discusses it // Boston Athenaeum, Report of Committee on Fine Art, July 1, 1828, approves purchase of painting

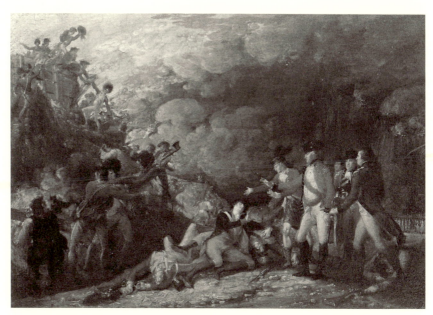

Trumbull's small early version of *The Sortie Made by the Garrison of Gibraltar*, 1787. Corcoran Gallery of Art, Washington, D. C.

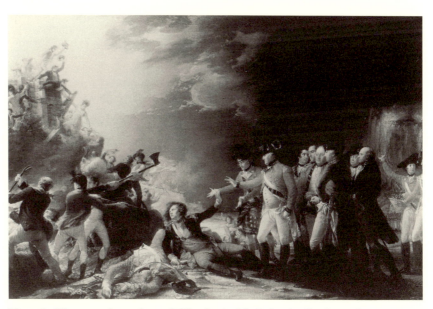

Trumbull's second version of *The Sortie Made by the Garrison of Gibraltar*, 1788. Cincinnati Art Museum.

Trumbull, small study for the composition gives the dying Spaniard the same pose as in the Metropolitan's painting. Coll. Jonathan Isham.

from proceeds of the First Exhibition if it can be obtained for $2,000 // J. Trumbull to T. Sully, July 30, 1828, Trumbull Papers, NYHS, outlines plan of a lottery to sell the picture (requires 100 subscribers at $50 each, all to receive a print of the work and one person to win the painting // J. Trumbull to F. Dexter, Sept. 11, 1828, Boston Athenaeum, replies to Dexter's letter of July 17 and accepts offer of $2,000 // J. Quincy to J. Trumbull, Sept. 24, 1828, ibid., arranges for payment and delivery of the picture // J. Trumbull to J. Quincy, Sept. 27, 1828, ibid., sends receipt for payment // J. Trumbull to J. Quincy, Sept. 30, 1828, ibid., says he is sending whatever sketches and studies for the painting he has been able to gather // J. Quincy to J. Trumbull, Oct. 20, 1828, acknowledges receipt of the drawings // W. Dunlap, *A History of the Rise and Progress of the Arts of Design in the United States* (1834), 1, pp. 360–361, says that to make up for the offense the painting of Bunker Hill had given, "he determined to paint one subject from British history," gives an account of the various versions and says this one received great applause at its exhibition; p. 371, mentions its exhibition in New York; 2, p. 458 // *Boston Courier*, May 28, 1834, p. 2, says "there is a striking reality about it" // J. Trumbull, *Autobiography* (1841), pp. 147, 148–150, 158–159 // C. E. Lester, *The Artists of America* (1846), p. 152 // H. T. Tuckerman, *Book of the Artists* (1867), pp. 85, 90 // J. Durand, *American Art Review* 2 (1881), 2nd part, pp. 186, 188–189, 221, 225, 227, 230 // W. H. Downes, *Atlantic Monthly* 62 (July 1888), p. 96, no. 369 // J. Durand, *American Art and American Art Collections* (1889), 2, pp. 668, 672, 675, 688 // J. F. Weir, *John Trumbull* (1901), pp. 44, 49, 53–54, 74–75 // W. T. Whitley, *Artists and Their Friends in England, 1700–1799* (1928), 2, pp. 109, 110–111, says Trumbull credited idea to Poggi who had made a drawing of the scene of the sortie when he was at Gibraltar in 1783, doubts some of Trumbull's later claims, such as the fact that Baring paid him 500 guineas for the small picture and the Walpole comment // J. L. Brockway, *Art Bulletin* 16 (March 1934), pp. 5–13 // M. M. Swan, *The Athenaeum Gallery, 1827–1873* (1940), pp. 16, 50, 89, 111–116, quotes many of the letters and documents dealing with the purchase of the painting by the Boston Athenaeum // T. Sizer, *The Works of Colonel John Trumbull* (1950; rev. ed. 1967), pp. 2, 100–101, 138–139 // H. W. Williams, *Corcoran Gallery of Art Bulletin* 16 (Nov. 1967), pp. 15–21 // *American Paintings in the Museum of Fine Arts, Boston* (1969), 1, pp. 271–272; 2, p. 101 // H. E. Dickson, *American Art Journal* 5 (May 1973), pp. 8–9 // I. B. Jaffe, *John Trumbull* (1975), pp. 128–129, 131–138, 140, 148, 188, 208, 310, 318, 321–322, fully discusses the history of the painting and notes the rivalry between West and Copley as a factor in its creation // O. Rodriguez Roque, *Apollo* (May 1980), pp. 375–377 // C. Rebora, memo in Dept. Archives, Dec. 12, 1988, gives references from New York newspapers.

EXHIBITED: Studio of Benjamin West, London, Spring, 1789 // Great Room, Spring Gardens, London, 1789 // Park Theatre, New York, 1804–1805 // 31 Argyle Street, London, 1811 // British Institution, London, 1812, no. 26 // American Academy of the Fine Arts, New York, 1828, no. 45 // Boston Athenaeum, 1829, *Third Exhibition of Paintings*, no. 86 // Apollo Association, New York, 1841, *October Exhibition*, no. 65 // MFA, Boston, 1879, *Contemporary Art*, no. 209, pl. 12 // Thomas Birch's Sons Art Auction Rooms, Philadelphia, 1896, *Very Important Collection of Studies and Sketches Made by Col. John Trumbull*, pp. vi, 14 // Brooklyn Museum, New York, 1917, *Early American Paintings*, no. 121 // Addison Gallery of American Art, Andover, Mass., 1939, *William Dunlap, Painter and Critic*, p. 31 // World's Fair, New York, 1939, *Masterpieces of Art*, no. 178 // Hirschl and Adler Galleries, New York, 1976, *The American Experience*, no. 9, entry lists bibliography and exhibition history // Yale University Art Gallery, New Haven, Conn., 1982, *John Trumbull*, exhib. cat. by H. A. Cooper et al., no. 12, p. 35, J. Prown discusses it; pp. 56–62, catalogue entry by O. Rodriguez Roque, discusses picture in depth and illustrates several related works // Wallraf-Richartz-Museum, Cologne, Kunsthaus, Zurich, Musée des Beaux-Arts, Lyon, 1988, *Triumph und Tod des Helden*, p. 353, no. 101; color ill. p. 354.

ON DEPOSIT: MFA, Boston, 1876–1976, from the Boston Athenaeum.

EX COLL.: John Trumbull, 1789–May 1824; unknown English owner, 1824–1827; John Trumbull, 1827–Sept. 1828; Boston Athenaeum, 1828–1976; with Hirschl and Adler, New York, 1976.

Purchase, Pauline V. Fullerton Bequest; Mr. and Mrs. James Walter Carter and Mr. and Mrs. Raymond J. Horowitz Gifts; Erving Wolf Foundation and Vain and Harry Fish Foundation, Inc., Gifts; Gift of Hanson K. Corning, by exchange; and Maria DeWitt Jesup and Morris K. Jesup Funds, 1976.

1976.332.

Thomas Mifflin

Thomas Mifflin (1744–1800) was born in Philadelphia, the son of a wealthy merchant. At the age of sixteen he was graduated from the College of Philadelphia, now the University of Pennsylvania. He spent a year in Europe in 1764 and returned to Philadelphia during the agitation over the Stamp Act. He immediately became active in politics and was one of the most radical members of the first Continental Congress. After his election to the second Congress, he turned his attention to recruiting and training troops for the Continental Army. In May of 1775, Mifflin became a major and the following month

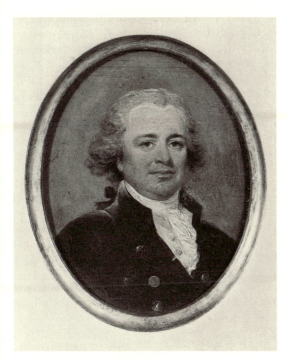

Trumbull, *Thomas Mifflin.*

an aide-de-camp to General George Washington, a position he gave up in August when he was appointed quartermaster general of the army. With one interruption he served in this capacity until 1778. Mifflin saw action at the important battles of Trenton and Princeton, and, by February of 1777, he had achieved the rank of major general.

After 1778 Mifflin was once more involved in politics, first as a member of the Pennsylvania assembly until 1779, and then as president of Congress from 1783 to 1784. At the federal convention of 1787, he strongly supported the Constitution. From 1788 until 1790 he sat on the Executive Council of Pennsylvania and shortly thereafter became chairman of the state constitutional convention. He served three terms as governor, 1790 to 1799. He ran for governor on his own ticket in 1799 and beat his opponent by a margin of ten to one. When he died the following year he was penniless. His wife, the former Sarah Morris, whom he had married in 1767, predeceased him in 1790.

This portrait is not dated, but it is almost identical to one of Mifflin at Yale University that is signed and dated 1790. The Metropoli-

tan's portrait must have been painted in Philadelphia at a time when Trumbull was gathering material for his historical works. Mifflin occupies a prominent spot in two of Trumbull's paintings commemorating the American Revolution. In *The Death of General Mercer at the Battle of Princeton,* completed about 1831 (Yale University, New Haven), Mifflin is depicted as a brigadier general leading a cavalry charge. In *The Resignation of General Washington,* the earlier version of which was completed in 1824 for the rotunda of the United States Capitol, he appears as president of Congress. In both cases, however, the likeness was taken from Trumbull's small portrait at Yale. The Metropolitan's portrait depicts Mifflin more frontally than the Yale picture. In style it is painted in a tighter manner than the earlier Jefferson portrait, but the paint is not as thinly or as smoothly applied as in Trumbull's portrait of Ceracchi (q.v.). The painting is a good example of the conscientious and painstaking preparations Trumbull made in documenting his historical works.

Oil on mahogany, 4 × 3 in. (10.2 × 7.6 cm.).

RELATED WORK: *Thomas Mifflin,* oil on wood, 3⅝ × 3 in. (9.2 × 7.6 cm.) (oval), 1790, Yale University, New Haven, ill. in H. A. Cooper et al., *John Trumbull* (1982), p. 139.

REFERENCES: F. F. Sherman, *Art in America* 19 (Oct. 1931), p. 260, no. 68, lists it as owned by Ernest L. Parker since 1927 // *DAB* (1933; 1961), s. v. Mifflin, Thomas, gives biography of the subject // T. Sizer, *The Works of Colonel John Trumbull* (1950; rev. ed. 1967), p. 53, ill. fig. 120 // T. Sizer to W. Middendorf II, letters in Dept. Archives, August 4, 7, 15, 1962, gives information on the provenance // *Art-gallery Magazine* 11 (Oct. 1967), p. 26.

EXHIBITED: PAFA, 1926, *A Gallery of National Portraiture* (no cat.) // MMA, 1927, *Catalogue of an Exhibition of Miniatures Painted in America, 1720–1850,* p. 55, as lent by Ernest L. Parker; 1963, *American Art from American Collections,* no. 232 // Baltimore Museum of Art and MMA, 1967, *American Paintings and Historical Prints from the Middendorf Collection,* no. 10 // National Collection of Fine Arts, Washington, D. C., 1974, *In the Minds and Hearts of the People* (not in cat.).

EX COLL.: estate of Gilbert S. Parker, Philadelphia, 1927; his brother, Ernest Lee Parker, Philadelphia, by 1927–d. 1938; with the Old Print Shop, New York, by 1962; J. William Middendorf II, New York, from 1962–1968.

Gift of J. William Middendorf II, 1968.
68.222.15.

George Washington before the Battle of Trenton

This portrait is a small-size replica of one Trumbull painted from life at Philadelphia in 1792 (now at Yale University, New Haven). As Trumbull tells it (though mentioning Princeton when his description clearly refers to Trenton), he intended the original picture to depict Washington's

military character, in the most sublime moment of its exertion—the evening previous to the battle of Princeton; when viewing the vast superiority of his approaching enemy, and the impossibility of again crossing the Delaware, or retreating down the river, he conceives the plan of returning by a night march into the country from which he had just been driven, thus cutting off the enemy's communication, and destroying his depot of stores and provisions at Brunswick (*Autobiography*, [1841], pp. 166–167).

Unfortunately, William L. Smith, the congressman from South Carolina, who commissioned the work on behalf of the city of Charleston, thought that a calm matter-of-fact likeness would be more suitable to the taste of Charlestonians and asked Trumbull to paint another portrait.

Trumbull, *George Washington before the Battle of Trenton*.

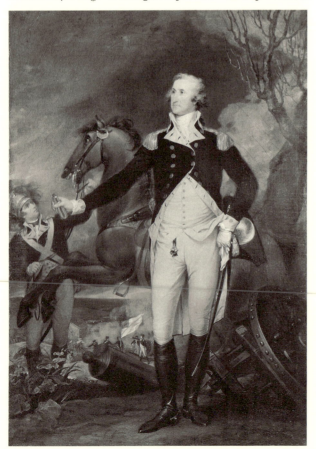

Accordingly, Trumbull asked Washington for more sittings, a request to which he proved agreeable. Washington instructed the painter to keep the first portrait for himself and finish it to his own taste. Thus Trumbull was certainly in possession of his original work when he painted this smaller version before leaving for England in 1794. It was probably done for his close friend the New York banker Charles Wilkes in whose family it descended.

The portrait varies from the original in a number of ways that make it a less romantic picture: the blasted tree at the upper right has been restored to life, the rocks at the lower left have given way to a clump of shrubbery, while the sky has been lightened considerably, and the horse has changed from a pale white charger to a brown one.

The last of a series of full-length portraits of Washington as a general, this picture well illustrates Trumbull's achievement as an artist. The portrait of 1780 (q.v.), though a stiff performance, showed an attempt to assimilate accepted English models of heroic portraiture, relying particularly on the example of Sir Joshua Reynolds. In 1790 Trumbull's second full-length portrait of Washington (two versions, Henry Francis du Pont Winterthur Museum, Winterthur, Del., and City Hall, New York) reflected the naturalistic informality of Thomas Gainsborough's *Colonel St. Leger* (Royal Collections, Buckingham Palace, London) and *George, Prince of Wales* (Waddesdon Manor, Buckinghamshire), both of which had been exhibited at the Royal Academy in 1782. The Yale portrait of 1792, however, is planned according to the highly original conventions Trumbull developed in his battle pictures. To be sure, the strong diagonals, the clutter of forms superimposed on one another, the agitated horse, and expressive sky owe something to BENJAMIN WEST's romantic battle paintings of the 1780s, such as, the *Battle of Crécy* and *Edward III Crossing the Somme*, both 1788 (Royal Collections, London), but they are more directly descended from Trumbull's own earlier works, such as, *The Capture of the Hessians at Trenton*, 1786–ca. 1828, and *The Death of General Mercer at the Battle of Princeton*, 1787–ca. 1831 (both at Yale), which furnish close parallels. Washington is posed in the Roman *ad locutio* gesture, not the gesture of a dynast in which the arm is raised above the shoulder but that of a magistrate, later used by GILBERT STUART in his

full-length Lansdowne *Washington* of 1796 (PAFA). Then too, the horse restrained by the groom repeats the general style of classical representations of the Dioscuri, in which Castor appears as a tamer of horses. Such a mixture of elements is entirely characteristic of Trumbull at the peak of his powers and must have contributed to his belief that his portrait of Washington was "the best certainly of those which I painted, and the best, in my estimation, which exists, in his heroic military character" (*Autobiography*, [1841], p. 166). While the larger portrait has suffered from surface abrasion and damage, this replica has survived in excellent condition.

Oil on canvas, 26½ × 18½ in. (67.3 × 47 cm.).

RELATED WORKS: *General George Washington at the Battle of Trenton*, oil on canvas, 92½ × 63 in. (235 × 160 cm.), 1792, Yale University, New Haven, color ill. in H. A. Cooper et al., *John Trumbull* (1982), frontis. // John Trumbull, *George Washington*, oil on canvas, 90 × 60 in. (228.6 × 152.4 cm.), 1792–1793, or 1794, Marquess of Bute, Dumfries House, Ayrshire, Scotland // A small whole length replica, now unlocated, was left by Trumbull at Benjamin West's gallery, Newman Street, London in 1797 // Thomas Cheesman, *General Washington*, engraving, 27¾ × 17½ in. (70.5 × 44.5 cm.), 1796, ill. in W. C. Wick, *George Washington, an American Icon* (1982), p. 50. Many other engravings follow this example // Unidentified artist, oil on academy board, 24⅞ × 19¾ (63.2 × 50.2 cm.), thought to be a copy after the Cheesman engraving, formerly MMA, ill. in Gardner and Feld, p. 108.

REFERENCES: G. A. Eisen, *Portraits of Washington* (1932), 2, p. 472, lists it as Equestrian with Brown Horse // T. Sizer, *The Works of Colonel John Trumbull* (1950, rev. ed. 1967), p. 83, lists it // Gardner and Feld (1965), pp. 103–104 // J. K. Howat, *MMA Bull.* 29 (March 1971), p. 339, says it prefigures Gilbert Stuart's portraits of the vicomte de Noailles (q. v.) and William Bingham (Baring Bros., London) // I. Jaffe, *John Trumbull* (1975), p. 158, cites classical sources for Washington's pose and for the horse and soldier in a discussion of the larger version.

EXHIBITED: Art Institute of Chicago, 1949, *From Colony to Nation*, no. 123 // MMA, 1965, *Three Centuries of American Painting* (checklist arranged alphabetically).

EX COLL.: Charles Wilkes, New York, d. 1833; his widow, subject to a life interest, she died 1851; their children George, d. 1876, Frances (Mrs. David Cadwallader Colden), d. 1877, and Anne, d. 1890, who after 1877 held the portrait jointly with George Wilkes's daughters, Harriet K., d. 1887, and Grace, d. 1922.

Bequest of Grace Wilkes, 1922.

22.45.9.

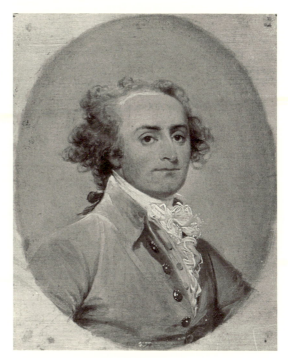

Trumbull, *Giuseppe Ceracchi.*

Giuseppe Ceracchi

Trumbull's portrait of the Italian sculptor Giuseppe Ceracchi (1751–1801) was probably painted in Philadelphia in 1792, the place and year in which a similar portrait, now in the Trumbull collection at Yale, is known to have been painted. As are most of Trumbull's later portraits of this type, the museum's picture is more smoothly and thinly painted than the Jefferson portraits (q.v.). The purple-tinted shadows in the face, the charcoal-colored hair, and the robin's-egg blue background lend it a delicate air more in keeping with the decorative qualities of a miniature. As the eminent Trumbull scholar Theodore Sizer noted, it remains "one of the happiest productions of the colonel's work" (1948).

It is likely that the Metropolitan portrait, found by Samuel P. Avery in Brussels in 1873, had been taken by Ceracchi to Europe and that the Yale version was kept by Trumbull as a memento. A large number of small oil on wood portraits of important Americans were painted by Trumbull in the 1790s, primarily as preparation for his history paintings but also as a kind of gallery of the famous men with whom he had

come in contact. In a sense, Trumbull's portrait of Ceracchi is an indication of the stature he enjoyed as the most gifted sculptor to work in America since Jean Antoine Houdon in 1785.

Ceracchi was born in Rome. He studied sculpture in his native city and received a prize at the Accademia di San Luca in 1771. From about 1774 to 1779 he was in London. Trained in the neoclassical style, he, nevertheless, developed a high degree of lively realism. He worked first in the London studio of Agostino Carlini, exhibited portrait busts at the Royal Academy, and later executed a number of important commissions, including two of the statues for the façade of Somerset House. He then traveled to Vienna, Mannheim, Rome, Berlin, and Amsterdam, searching for commissions commensurate with his large ambitions and producing portrait busts of many eminent people as he went. With the idea of designing an equestrian statue of George Washington, Ceracchi arrived in Philadelphia in 1790. He obtained sittings from Washington and tried to get Congress to underwrite a colossal monument to American liberty. In 1792 he returned to Europe. Involved in political unrest in Rome, he soon fled to Florence and from there went to Munich and then to Amsterdam. By 1794 he was back in Philadelphia attempting once more to raise money for his liberty monument, which he estimated would cost $300,000. He sought sittings from a number of prominent statesmen, including Adams, Madison, and Hamilton. He often presented portrait busts gratis in the hope of obtaining the backing of various politicians for his project. His efforts led nowhere, and in 1795, frustrated and bankrupt, he left the United States. In Europe he became increasingly involved in political agitation, first against the papal government in Rome, then against the rule of Napoleon in France. In 1800 he was accused of plotting the assassination of Napoleon at the Opéra in Paris and was brought to trial. The guillotine ended his life on January 31, 1801. The Metropolitan Museum owns a marble bust of Ceracchi's *Washington* that was done in 1795. It exhibits a high degree of academic finish. This was also the case with Houdon's work, which raised the general standards of American sculpture.

Trumbull is known to have exchanged portraits with other artists, and that may have been the intention in this case. Ceracchi did model a terra-cotta bust of Trumbull, which along with several other such busts Trumbull was searching for in 1818:

When Cerracchi [*sic*] was in this country, He executed Busts in Terra Cotta of many of our principal people—He took them to Europe generally—if by any means you can find them, I would wish that they would be purchased for me and shipped to me here—I particularly recollect a Head of President Adams—bald and resembling the Busts of Scipio—One also of myself, the ancient corslet on the Breast, and a pallet & pencils scratched upon that (J. Trumbull to Mr. Ivins [?], Feb. 24, 1818, Trumbull Papers, Yale University Library).

Oil on wood, $3\frac{7}{8} \times 3\frac{3}{16}$ in. (9.8 × 8.1 cm.).

RELATED WORKS: *Giuseppe Ceracchi*, 1792, oil on mahogany, $3\frac{7}{8} \times 3$ in. (9.8 × 7.6 cm.) (oval), Yale University, New Haven, ill. in T. Sizer, *The Works of Colonel John Trumbull* (1950; 1967), fig. 110.

REFERENCES: S. P. Avery, diary, July 26, Sept. 5, 1873, Watson Library, MMA, notes "Brussels. . . . saw miniature by Trumbull" and later, Van Hinsberg [dealer in Brussels], "to buy Cat—also head of Trumbull for 500 f" (probably this painting), quoted in M. F. Beaufort et al., *The Diaries 1871–1882 of Samuel P. Avery, Art Dealer* (1979), pp. 189, 211 // C. Cook, *Art and Artists of Our Time* (1888), 3, pp. 188–189, states that this picture was discovered by Avery in a shop in the Hague // *Studio* 4 (Nov. 1889), ill. p. 178; p. 180, says Avery bought it in the Hague // J. F. Weir, *John Trumbull* (1901), p. 76 // T. Bolton, *Early American Portrait Painters in Miniature* (1921), p. 163, no. 63 // L. Burroughs, *MMA Bull.* 31 (1936), p. 85 // A. T. Gardner, *MMA Bull.* 6 (1948), ill. p. 196 // T. Sizer, *The Works of Colonel John Trumbull* (1950; rev. ed. 1967), p. 24 // U. Desportes, *Art Quarterly* 26 (Summer 1963), ill. p. 179 // G. Hubert, *Les Sculpteurs Italiens en France sous le Révolution, l'Empire et la Restauration* (1964), pp. 24–37, contains biography of the subject // Gardner and Feld (1965), p. 105.

EXHIBITED: MMA, 1895, *Retrospective Exhibition of American Paintings*, no. 3; 1909, *Hudson-Fulton Celebration*, no. 45 // Wadsworth Atheneum, Hartford, 1956, *John Trumbull, Painter-Patriot*, no. 69.

EX COLL.: probably with Van Hinsberg, Brussels, 1873; with Samuel P. Avery, New York, 1873; John Taylor Johnston, New York, by 1876 (sale, Somerville Art Gallery, New York, Dec. 19, 1876, no. 109, $90); with Samuel P. Avery, New York, 1876; Robert W. de Forest, New York, 1876–1936 (sale, American Art Association, New York, Jan. 29, 1936, no. 226); with M. Knoedler and Company, New York, 1936.

Morris K. Jesup Fund, 1936.

36.35.

Alexander Hamilton

Alexander Hamilton (1757–1804) was born on Nevis in the British West Indies. In 1773 he entered King's, now Columbia, College in New York, where his enthusiasm for the revolutionary cause propelled him headlong into the political arena. Despite his youth, he acquired a reputation as a thinker and pamphleteer. In 1776 he joined the Continental Army and was promptly made secretary and aide-de-camp to General George Washington. Toward the end of the war, however, he quarreled with Washington, left his staff, and took up a post as head of an infantry regiment under General Lafayette. He distinguished himself by capturing a British defense at the Battle of Yorktown. After the war, Hamilton practised law in New York. He served in the Continental Congress, where he became an eloquent advocate of a strong central government. He was a delegate from New York to the Constitutional Convention, and although he played a secondary role in the drafting of the Constitution, his authorship with James Madison and John Jay of the Federalist papers greatly facilitated its adoption by the states. In 1789

Trumbull, *Alexander Hamilton.*

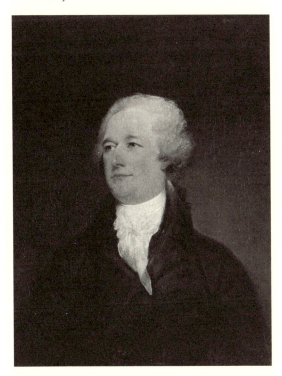

The full-length 1792 version of Trumbull's *Alexander Hamilton.* Coll. Donaldson, Lufkin, and Jenrette, New York.

President Washington made Hamilton secretary of the treasury, a position which enabled him to straighten out the country's finances, establish a national bank, and encourage industrial development. Early in 1795 he returned to a lucrative law practice in New York and continued to be active in the Federalist party. In the presidential contest of 1800–1801, his support secured the election of Thomas Jefferson over Aaron Burr, whom Hamilton distrusted. In 1804, Hamilton again stood in the way of Burr's political advancement, insuring his defeat in the race for the governorship of New York. Over a slur in the press, Burr challenged Hamilton to a duel. At Weehawken, New Jersey, on the banks of the Hudson, on July 11, 1804, Hamilton fell at the first shot. He died the following day.

Hamilton's death prompted the commissioning of many copies of his portrait. This is one of four known replicas Trumbull painted after

an earlier 1792 portrait. The first, the so-called Jay original, is thought to be the one now in the National Gallery of Art in Washington. Trumbull is believed to have painted it from life for John Jay, in whose family it descended. This conclusion, however, is based on stylistic not documentary evidence. Many years later Trumbull himself, when describing the copy now at Yale, stated that it had been done "from an original, painted at Washington in 1792, now in the possession of the family of the late Gov. Wolcott" (*Autobiography*, [1841], p. 433). Yet Trumbull's statement has been called into question; for in 1792 the city of Washington hardly existed, and it seems impossible that he could have painted Hamilton's portrait there at that time. Also, when he made the statement he was over eighty. In any case, Trumbull's original portrait, whether the National Gallery's picture or another work, was in existence by 1792; for on July 4 of that year the *New-York Daily Advertiser* announced the exhibition in City Hall of Trumbull's full-length portrait (now coll. Donaldson, Lufkin and Jenrette, New York), painted for the Chamber of Commerce of the State of New York, a work which can only be understood as an embellished copy.

Because it is a replica of an earlier work, the Metropolitan's portrait very much reflects Trumbull's manner of the early 1790s. The colors have been smoothly blended, and the execution is somewhat dry, but fundamentally the style of the picture recalls that of the portrait miniatures Trumbull was painting in the 1790s.

Other bust-length portraits of Hamilton by Trumbull, painted from one of the marble busts executed by Giuseppe Ceracchi (and therefore referred to by Sizer as the Ceracchi type), are known. Most of these works, in which Hamilton's head is at a different angle, were done about the same time as the copies made from the 1792 original, that is about 1804–1806. They lack, however, the vitality of the copies that are informed by Trumbull's earlier, more accomplished style.

Oil on canvas, 30¾ × 24¾ in. (77.6 × 62.4 cm.).
RELATED WORKS: *Alexander Hamilton*, oil on canvas, 30¼ × 24⅜ in. (76.8 × 61.3 cm.), early 1792 or before, National Gallery of Art, Washington, D. C., ill. in National Gallery of Art, *American Paintings* (1980), p. 249 // *Alexander Hamilton*, oil on canvas, 86¼ × 57½ in. (219.1 × 146.1 cm.), 1792, Donaldson, Lufkin, and Jenrette, New York, a full-length painted after

the National Gallery version, if that is the original, or after a lost original, ill. in *Catalogue of Portraits in the Chamber of Commerce of the State of New York* (1924), no. 50 // *Alexander Hamilton*, oil on canvas, 30¼ × 20 in. (76.8 × 50.8 cm.), 1832, Yale University, New Haven, ill. in T. E. Stebbins and G. Gorokhoff, *American Paintings at Yale University* (1982). no. 1590 // *Alexander Hamilton*, after 1792, oil on canvas, 30 × 24 in. (76.2 × 61 cm.), Essex Institute, Salem, Mass.

REFERENCES: *DAB* (1931, 1960), s. v. Hamilton, Alexander, gives biographical information // T. Sizer, *The Works of Colonel John Trumbull* (1950; rev. ed. 1967), p. 37, dates it after 1804 // Gardner and Feld (1965), pp. 105–106 // W. D. Garrett, *MMA Journal* 3 (1970), p. 322.

EXHIBITED: MMA, 1880, *Loan Collection of Paintings*, no. 109, lent by H. G. Marquand; 1881, *Loan Collection of Paintings*, no. 250; 1895–1896, *Retrospective Exhibition of American Paintings*, 1896, no. 177; 1939, *Life in America*, ill. no. 48 // Wadsworth Atheneum, Hartford, 1956, *John Trumbull, Painter-Patriot*, no. 90 // MMA, 1965, *Three Centuries of American Painting* (checklist arranged alphabetically) // Los Angeles County Museum of Art, M. H. de Young Memorial Museum, San Francisco, 1966, *American Paintings from the Metropolitan Museum of Art*, no. 13 // MMA and American Federation of Arts, traveling exhibition, 1975–1977, *The Heritage of American Art*, exhib. cat. by M. Davis, no. 17.

EX COLL.: Henry G. Marquand, New York, by 1880–1881.

Gift of Henry G. Marquand, 1881.
81.11.

John Murray

John Murray (1737–1808) settled in New York in 1758 and became a prominent importing merchant. In 1788 he was elected vice-president of the New York Chamber of Commerce, which he later served as president from 1798 to 1806. In 1792 he was made a director of the Bank of New York. For a long time, he was the treasurer of the board of governors of New York Hospital and a director of both the United States Bank and the Humane Society of New York. In 1797 he was one of the commissioners in charge of building Newgate prison. He owned the area in New York now known as Murray Hill and had a country house on East 20th Street. His estate at the time of his death was calculated at about half a million dollars.

When the Murray portraits were acquired by the museum, the subjects were thought to be John Murray's older brother Robert and his

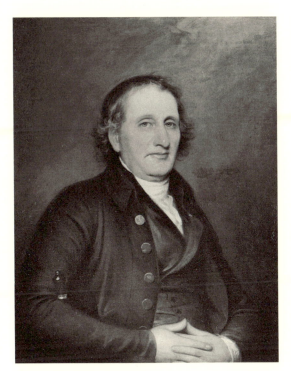

Trumbull, *John Murray*.

tenebrous aspect reminiscent of baroque painting. In total contrast, the face has the bright ruddiness typical of late eighteenth century English portraiture.

Besides this portrait and the one of Mrs. Murray (see below), the Metropolitan also has a portrait of the couple's son John R. Murray painted by GILBERT STUART (q.v.).

Oil on canvas, 30 × 24 in. (76.2 × 61 cm.).

RELATED WORK: Daniel Huntington, *John Murray*, oil on canvas, 1865, copy with variations, formerly New York Chamber of Commerce, ill. in *Catalogue of Portraits in the Chamber of Commerce* (1924), no. 11.

REFERENCES: Secretary of the Chamber of Commerce, New York, Oct. 5, 1865, New York Chamber of Commerce Records, notes that Huntington's portrait is "after an original by John Trumbull, in the possession of Mr. John R. Murray of Cazenovia, late of New York // J. Scoville [W. Barrett], *The Old Merchants of New York City* (1885), 1, pp. 293–295; 2, p. 342, gives biographical information on the sitter // B. Burroughs, *Catalogue of Paintings in the Metropolitan Museum* (1931), p. 363, gives the subject as Robert Murray // E. Gardner to T. Sizer, March 25, 1948, copy in Dept, Archives, reidentifies subject // C. Greenberg, *Art Digest* 28 (Jan. 1, 1954), p. 7, says this portrait and its companion "raise faithful likenesses to an intensity of art all the more convincing because the means are so reserved" // Gardner and Feld (1965), pp. 106–107 // T. Sizer, *Art Bulletin* 31 (March 1949), p. 23, says it was painted in New York about 1806; *The Works of Colonel John Trumbull* (1950; rev. ed. 1967), p. 55.

EX COLL.: the subject, New York, d. 1808; his son, John R. Murray, Mount Morris, New York, d. 1851; his son, John Rogers Murray, Mount Morris, New York, d. 1881; his adopted sister, Elizabeth duBois Vail (Mrs. L. Wolters Ledyard), d. 1901, Cazenovia, N. Y.; her daughter, Murray Ledyard (Mrs. J. H. Ten Eyck Burr), Cazenovia, N. Y. and Washington, D. C., until 1922.

Morris K. Jesup Fund, 1922.

22.76.1.

wife. In 1948, however, Elizabeth Gardner discovered that a portrait known to be of John Murray, painted by Daniel Huntington, was in the New York Chamber of Commerce. It was actually a copy after the Trumbull picture with some variations. This evidence, coupled with the fact that the costumes of the subjects and the style of execution in both works were more in keeping with a date of about 1806, twenty years after Robert Murray's death, led to a reidentification of the subjects.

The colorless, stiff style of this work is entirely characteristic of Trumbull's portraits at that time. Although in the face he successfully conveys an impression of character, the clothes and hands have been summarily painted and appear formless and blurred. The coat and waistcoat, painted in shades of brown, blend with the somewhat lighter brown of the background and lose definition. In addition, traces of black pigment appear everywhere, with the result that the portrait takes on a somewhat monochromatic quality. Perhaps what Trumbull was aiming for was the muted tonalities of French neoclassical portraiture. His painterly tendencies, however, remained unchecked, and the picture possesses a

Mrs. John Murray

Mrs. John Murray (1746–1835) was Hannah Lindley of Philadelphia before her marriage. She was a niece of the wife of Robert Murray, John's older brother. Of her, the Murray family genealogy (1894) notes: "She was a truly Christian lady . . . Her habits were simple, her manners courteous and dignified, and in her tongue was the law of kindness." Mrs. Murray survived her

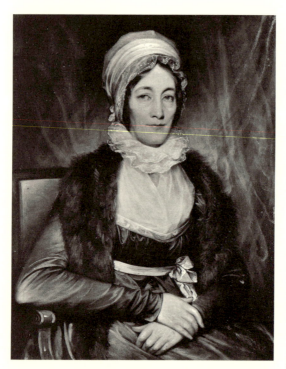

Trumbull, *Mrs. John Murray.*

pearance require that it be considered an independent work. Like *John Murray*, this portrait is painted in shades of brown, but the highlights display yellowish tones that are evocative of Dutch seventeenth century portraiture. Other elements of the picture, such as the pose, the ruffled collar, and the fur stole, further establish Trumbull's debt to the Dutch school and recall, for example, Ferdinand Bol's *Elisabeth Bas*, ca. 1641 (Rijksmuseum, Amsterdam; ill. in B. Haak, *Rembrandt* [1969], p. 165). Despite its obvious eclecticism, the portrait must be ranked among Trumbull's finest late works.

Oil on canvas, 30 × 24 in. (76.2 × 61 cm.).
REFERENCES: S. S. Murray, *A Short History of the Descendants of John Murray* (1894), pp. 23–24, gives biographical data (quoted above) // B. Burroughs, *Catalogue of Paintings in the Metropolitan Museum* (1931), p. 363, gives the sitter as Mrs. Robert Murray // C. Greenberg, *Art Digest* 28 (Jan. 1, 1954), p. 7 // Gardner and Feld (1965), p. 107 // T. Sizer, *The Works of Colonel John Trumbull* (1950; rev. ed. 1967), p. 55, says it was painted in New York about 1806 // I. Jaffe, *John Trumbull*, pp. 209, 311.
EXHIBITED: Wadsworth Atheneum, Hartford, 1956, *John Trumbull, Painter-Patriot*, no. 95 // Yale University Art Gallery, New Haven, *John Trumbull*, exhib. cat. by H. A. Cooper et al., no. 121, pp. 166–167, catalogue entry by O. Rodriguez Roque, says Trumbull must have known the Murrays well since he stored sixty-five boxes and works in Murray's warehouse after departing for London in 1808.
Ex COLL.: same as preceding entry.
Morris K. Jesup Fund, 1922.
22.76.2.

husband by twenty-seven years, and seven of their children lived to adulthood.

This picture has always been considered a companion to the portrait of John Murray, but its more ambitious composition, more accomplished execution, and noncomplementary ap-

MATHER BROWN

1761–1831

Mather Brown, who was a direct descendant of the seventeenth-century puritan divine Increase Mather, was born in Boston. His father, Gawen Brown, was a clockmaker and his mother was the daughter of the Reverend Dr. Mather Byles, who took over Mather Brown's care when she died. According to family tradition, Brown's entry into the world was greeted joyously by his grandfather's friend JOHN SINGLETON COPLEY, who two years later, in 1763, painted two portraits of Brown's mother, one in oil (New York art market, 1982, ill. in

Prown, *John Singleton Copley* [2 vols., 1966], 1, fig. 111) and one in pastel (Bayou Bend Collection, Museum of Fine Arts, Houston).

Mather Brown's teachers included some of the most illustrious American artists. In 1773 GILBERT STUART, then eighteen years old, passed through Boston on his way back from Scotland and gave the twelve-year-old Brown drawing lessons. At sixteen Brown was pursuing the career of an itinerant portrait painter. Having learned to paint miniatures, he traveled as far from home as Peekskill, New York. In 1780, after spending half a year in the West Indies painting miniature portraits, he had amassed sufficient funds to go to Paris. He had a letter of introduction from the Reverend Byles to Benjamin Franklin, whose guest he was for two months. Franklin then wrote a letter recommending him to BENJAMIN WEST. In London, because of Franklin's recommendation, West gave him free instruction.

In addition, Brown enrolled in the Royal Academy school in 1782, supposedly the first American to do so. He began to exhibit there the same year. In 1784 he opened his own studio. "I have just removed into a very elegant House," he wrote, "where I have genteel Apartments for my pictures, and cut a respectable Appearance which is of great Consequence for one of my Profession." And later, "my great object is to get my Name established and to get Commissions from America, to paint their Friends and Relations here" (quoted in Coburn, p. 254). His portrait of Thomas Jefferson, dated 1786 (coll. Charles Francis Adams, Jr.), though still somewhat indebted to the portrait style of Stuart, shows West's influence in its pearly tone and generalized treatment of fabric. Yet the portrait *Lady with a Dog* (see below), painted in the same year, has the characteristically muted and almost unpleasant colors he used in many of his subsequent works and which he probably also derived from West.

For a brief period in the late 1780s and early 1790s Brown's work had an enormous vogue. By 1788 he had moved to a large house in fashionable Cavendish Square. At the end of that year he was appointed portrait painter to the duke of York. He later became painter to the duke of Clarence as well. The extraordinary success enjoyed by Copley, West, and Brown in the London art world at this time aroused jealousy on the part of many English artists. In 1789 one London painter wrote:

> Mr. West paints for the Court and Mr. Copley for the City. Thus the artists of America are fostered in England, and to complete the wonder, a third American, Mr. Brown of the humblest pretenses, is chosen portrait painter to the Duke of York. So much for the Thirteen Stripes—so much for the Duke of York's taste (quoted in W. T. Whitley, *Artists and Their Friends in England, 1700–1799* [London, 1928], 2, p. 160).

A work perhaps typical of Brown in this period is his very large portrait of George IV when prince of Wales, 1789 (coll. Her Majesty Queen Elizabeth II), which has an almost rococo treatment that may have been requested by the sitter. Several years later, about 1795, Brown's history painting *Thomas, Earl of Surrey, Defending His Allegiance to Richard III after the Battle of Bosworth Field, 1485* (coll. duke of Norfolk, Arundel Castle), which is thought to be part of a series commissioned for Arundel Castle, shows him working once more in a somewhat outdated style based on the work of West.

Brown's success was short-lived. In one of his letters to his Boston aunts in 1801, he described his situation as "extremely distressing and embarrassing owing to my failure in busi-

ness and the distresses brought on by the War (Coburn, p. 257)." In 1808 he gave up on London and tried to make his living elsewhere. He wrote from Liverpool two years later: "from London I went to teach a School in Buckinghamshire—from thence I went to Bath and Bristol and followed portrait painting, from thence to Staffordshire." In another letter home he confessed, "I sometimes sit down in despair, and scarcely know where to go next. Some persons think I had better go to New York" (Coburn, p. 258). During the next thirteen years Brown taught and painted in Liverpool, Manchester, and elsewhere in Lancashire. Some of his portraits, for example, that of John Bridge Aspinall, 1810 (Walker Art Gallery, Liverpool), show him to be an entirely competent, if unexciting, artist. Evidently his work varied in terms of quality.

In 1824 Brown returned to London. He exhibited ten paintings, six of them religious subjects, at the newly formed Society of British Artists. An account of his last years by his friend William Henry Back, a drawing teacher, describes him as an artist hopelessly out of fashion: "[He] pursued his painting with unremitting application; yet with no pecuniary profit whatever; his only recompense for his pursuit was his intense enjoyment of it . . . he was mortified at finding his pictures stuck to him like burrs." Finally, in a touching description of Brown's death, in 1831, Back said that he had had his bed moved to his painting room where, "amidst the offspring of his choicest friend, the only solacer of lone hours . . . he laid himself down, and died surrounded by his pictures (W. H. Back, "A Biographical sketch of an old friend," Nov. 22, 1846, in Autograph Letters from Mather Brown, MMA Library). His reputation suffered even after his death. In the early 1830s the Anglo-American artist C. R. Leslie (1794–1859) wrote to WILLIAM DUNLAP:

> I was once in Mather Brown's rooms, and a more melancholy display of imbecility I never witnessed. Imagine two large rooms crowded with pictures, great and small, historical and portrait—in some places several files deep. I thought of Gay's lines:
>
> > In dusty piles his pictures lay,
> > For no one sent the second pay.
>
> And in all this waste of canvas not one single idea, nor one beauty of art. He seemed to possess facility, but nothing else. Those of his canvasses that looked most like pictures, exhibited a feeble imitation of the manner of West, but wholly destitute of any one principle of his master (quoted in W. Dunlap, *History of the Rise and Progress of the Arts of Design in the United States* [2 vols., New York, 1834], 1, p. 229).

Some fifty years after his death, however, we find a more apt summary of Brown's work:

> As there is character and considerable variety of expression in Brown's portraits, we are encouraged to conclude that he was successful in preserving the likenesses of those who sat to him. Had he painted with greater richness of colour, and given more force and impasto to the draperies and accessories of his portraits, they would hold a higher place in the estimation of the lovers of our early English School (Frederick P. Seguier, *A Dictionary of the Works of Painters* [2 vols., London, 1870], p. 29).

BIBLIOGRAPHY: Mather Brown and Byles Family Papers, Massachusetts Historical Society, Boston. Includes typescripts of material owned by a Byles descendant, among them Brown's letters to his aunts Mary and Catherine Byles and an 1835 biography by the latter // Frederick W. Coburn, "Mather Brown," *Art in America* 2 (August 1923), pp. 252–260. Quotes extensively from Brown's

letters // Dorinda Evans, "Twenty-six Drawings Attributed to Mather Brown," *Burlington Magazine* 114 (August 1972), pp. 534–541. Establishes a group of drawings as being by Brown and shows that he sometimes based portraits on drawings instead of painting them from life // National Portrait Gallery, Washington, D.C., *Benjamin West and His American Students* (1980), exhib. cat. by Dorinda Evans, pp. 74–83, 93–102 // Dorinda Evans, *Mather Brown: Early American Artist in England* (Middletown, Conn., 1982). The definitive account to date of the artist's life and career with a checklist of his known works.

Lady with a Dog

The subject of this portrait has not been identified. It was painted in 1786, two years before Brown had established himself in Cavendish Square and had begun his rise to renown. He painted the details of the sitter's elaborate dress with great care and precision, but the skirt is more broadly painted, with long, free brushstrokes modeling the folds of material. The woman looks out very directly from the canvas, and her brightly lit face against the dark drapery background draws the viewer's attention. The green of her skirt is of an unpleasant, sickly hue that is in dull contrast with the red of the chair. At the right, the conventional landscape with a stream is gracefully painted, but again the color lacks refinement.

Yet, despite the roughness of Brown's execution, which, as Charles Bulfinch noted about the portrait Brown had painted of him, was in "the modish stile of painting, introduced by Sir Joshua Reynolds," the *Lady with a Dog* is not without sophistication (quoted in Evans, 1982, p. 54). It is similar to the Copley said to be *Mrs. Seymour Fort* (Wadsworth Atheneum, Hartford), which may have been exhibited at the Royal Academy in 1778 and which Brown could have seen later. Like Copley, Brown weds a strongly characterized likeness, perhaps reflective of his American background, to the loose handling of paint typical of London portraiture. Copley's ability with color and texture, however, far exceeded Brown's, whose sketchy strokes and dull tones are closely in keeping with West's practice.

Oil on canvas, 49½ × 39½ in. (125.7 × 100.3 cm.). Signed and dated at lower right: M. Brown / 1786.
RELATED WORK: *Lady with a Dog*, oil on canvas, 35½ × 27½ in. (90.2 × 69.9 cm.), coll. Stanley K. Jernow, a half-length replica showing the sitter without the landscape and holding the dog in her lap with both hands.
REFERENCES: Gardner and Feld (1965), p. 110 //

Mather Brown

S. P. Feld, *Antiques* 87 (April 1965), p. 440, says Brown's style, said to be an imitation of Stuart's, is actually closer to West's and that ruddy complexion and bold treatment of drapery are characteristic of Brown // D. Evans, *Mather Brown* (1982), ill. pp. 54–55; pp. 146–157, compares style to Portrait of a Young Girl (q.v.).
EXHIBITED: Los Angeles County Museum of Art and M. H. de Young Memorial Museum, San Francisco, 1966, *American Paintings from the Metropolitan Museum of Art*, ill. p. 25, no. 12 // Mansfield Art Center, Ohio, 1986, *The American Animal*, no. 2.
EX COLL.: unidentified owner (sale, Christie, Manson and Woods, London, June 16, 1950, no. 109, sold to "James" for 14gns. 14s.); Mrs. Martin H. Flett, Boston, by 1963; with Vose Galleries, Boston, 1963–1964.
Purchase, Bertram F. and Susie Brummer Foundation, Inc., Gift, 1964.
64.129.

Brown, *Lady with a Dog*

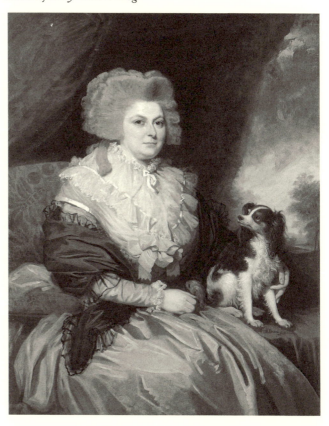

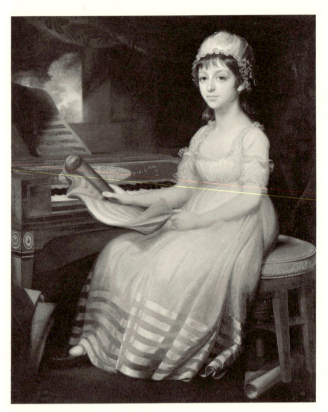

Brown, *Portrait of a Young Girl*

Portrait of a Young Girl

This portrait of an unidentified girl was painted by Mather Brown in 1801, the year in which he wrote his aunts in Boston about his failure in business. It suggests some of the reasons for his difficulties in that it is a far less assured performance than his *Lady with a Dog* (see preceding entry). By comparison, the girl's dress is a little flat, and her arms are merely areas of flesh-colored paint, with no attempt at modeling at all. The background is murky, and the green curtains behind the sitter are unconvincing. Somehow the entire image lacks specificity; the face seems scarcely to be a likeness, and the wood of the piano lacks a sense of texture, just as the gilt ornamentation on it hardly glitters. Brown appears to have lost the sophistication and panache of his earlier painting and to have assumed a provincial style.

The sitter is portrayed before a small square piano bearing the label "1797 / Kirkman Fecit / London." The depiction is of interest because, although the prestigious London harpsichord firm of Josephus Kirkman and Sons began to produce square pianos beginning in 1775, no example of them appears to have survived. The instrument keyboard is incorrectly rendered, and the sheet music is mostly suggestive, reading: pi[a] / [illegible] / [Velti] Subita.

Oil on canvas, 50 × 40¼ in. (127 × 102.2 cm.).
Signed and dated at lower left: M. Brown. / 1801.
ON DEPOSIT: Gracie Mansion, New York, 1974–1978.
REFERENCES: D. Evans, *Mather Brown* (1982), pp. 146–147, compares it to Lady with a Dog, noting that Brown stresses linearity and that "the paint is flatter and thinner, tending toward brownish blends"; p. 239, no. 219, gives provenance.
EX COLL.: with Michael Harvard, London; J. Mitchell, London, until 1953; with Schweitzer Gallery, New York, 1953–1957; Mr. and Mrs. Theodore Newhouse, New York, 1957–1965.
Gift of Caroline Newhouse, 1965.
65.235.

REUBEN MOULTHROP

1763–1814

Reuben Moulthrop was baptized in East Haven, Connecticut, on July 24, 1763. Nothing is known of his early life and consequently of his artistic training, but the technical execution of his work makes it doubtful that he received any formal instruction in painting. In all probability his formative models were pictures by such provincial painters as JOHN DURAND, RALPH EARL, and Abraham Delanoy (1742–1795), all of whom worked in and around New

Haven in the 1770s. He seems to have pursued painting only as a side interest, his main occupation being that of a modeler in wax. Numerous newspaper advertisements identify him as a kind of early American Madame Tussaud, going from town to town displaying wax figures such as Louis XVI at the guillotine, an Indian, and the president of the United States. Moulthrop's obituary, printed in the Hartford *Connecticut Courier* on August 9, 1814, only identified him as "a celebrated artist in wax-work." Unfortunately, his wax figures are unknown today.

Although Moulthrop's painting style always remained primitive, his ability to convey character singles him out as one of the most remarkable members of what is now loosely termed the Connecticut school. Equally remarkable in a number of his works is his evident familiarity with the conventions of English portraiture as followed by Hoppner, Reynolds, and Romney. How he came to such knowledge is not known, but it may have come from studying the works of Ralph Earl, who was English-trained, as well as from English prints. Moulthrop's manner was obviously pleasing, and many important Connecticut merchants and divines, including the formidable Ezra Stiles, president of Yale, favored him with their patronage.

The influence of a number of Connecticut painters, including Winthrop Chandler (1747–1790) and JOSEPH STEWARD, has been discerned in a number of portraits attributed to Moulthrop. Whether or not he knew their work, however, is not known. Since many of the attributions to Moulthrop are tenuous and only a few signed pictures by him have survived, the pattern of his artistic development remains extremely uncertain. He married Hannah Street of New Haven on November 18, 1792. She and six children survived him at his death on July 29, 1814.

BIBLIOGRAPHY: "Reuben Moulthrop," *Connecticut Historical Society Bulletin* 20 (April 1955), pp. 44–51. Gathers biographical material from a number of primary sources // William and Susan Sawitzky, "Portraits by Reuben Moulthrop," *NYHS Quarterly Bulletin* 39 (Oct. 1956), pp. 385–404. A checklist of works attributed to Moulthrop by the Sawitzkys // Ralph W. Thomas, "Reuben Moulthrop, 1763–1814," *Connecticut Historical Society Bulletin* 21 (Oct. 1956), pp. 97–111. Contains an interpretation of Moulthrop's work as well as a catalogue (with a number of new attributions) of an exhibition held at the Connecticut Historical Society Gallery, Hartford // Samuel M. Green, II, "Some Afterthoughts on the Moulthrop Exhibition," *Connecticut Historical Society Bulletin* 22 (April 1957), pp. 33–45. Questions many works previously given to Moulthrop.

Job Perit

Not much is known about the life of Job Perit (1751–1794). He was the son of Peter Perit and Abigail Shepard Perit of Milford, Connecticut. Born in Milford, he moved at some point to New Haven with his wife Sarah (see below), whom he married in 1782. The presence in the portrait of an inkwell and what appears to be a ledger suggests he was engaged in business.

Among the very few signed and dated portraits by Reuben Moulthrop, this portrait and its companion serve as chronological anchors for a number of stylistically similar but undated works and shed some light on Moulthrop's development as an artist. Abraham Delanoy (1742–1795) and Moulthrop were once thought to have collaborated on the portraits of John Mix and Ruth Stanley Mix (Abby Aldrich Rockefeller Folk Art Collection, Williamsburg, Va.), but that idea was doubted once the Perit portraits were discovered. Although the Mix portraits are now listed as by an unidentified artist, the discovery of the Perit portraits in 1965 led to other works being securely attributed to Moulthrop. The portrait, for example, of Brad-

ford Hubbard (New Haven Colony Historical Society), more or less generally accepted as a Moulthrop, was taken with virtually complete assurance to be his work. In addition, the portraits of the Perits push back by about a year or so the time when Moulthrop's distinct style was thought to have emerged. As these portraits demonstrate, Moulthrop's empty backgrounds, strong representation of character, and largely monochromatic color were already hallmarks of his style by 1790.

Although both canvases were heavily soiled and seriously damaged when found, these problems luckily did not affect any important areas of the pictures. In fact, the paint surfaces, though crazed as is usual in Moulthrop's works, have survived rather well. Once cleaned the pictures revealed the subtle use of color that is one of the virtues of Moulthrop's art. Job Perit's apparel as well as the fashionable bow-back Windsor chair on which he sits are rendered in shades of pastel blue that are picked up by the shadowing in the face and the inkwell on the table. Whether

Moulthrop learned this kind of coloring from an artist such as JOHN DURAND, whose *Mary Bontecou Lathrop* (q.v.) exhibits similar color qualities, or whether he arrived at it on his own is not known. The results, however, approach the severe neo-classical qualities found in the pastel portraits drawn by members of the Sharples family. Moulthrop also shares with them a strong reliance on the monochromatic and the color blue.

No information regarding the actual commission of this portrait has come to light, but a few facts regarding Moulthrop's practice are known in relation to his portrait of the president of Yale, Ezra Stiles, 1794 (Yale University). According to his daughter, Stiles was "pleased with [Moulthrop's] genius" and had his picture painted "partly to please my mother and to gratify his daughters, and partly to encourage an amiable and industrious young man." In his diary, Stiles recorded sitting for Moulthrop only on September 25, 1794, which suggests that one day's sitting was sufficient for him to take the likeness. After Stiles's death in 1795, the portrait

Moulthrop, *Job Perit*

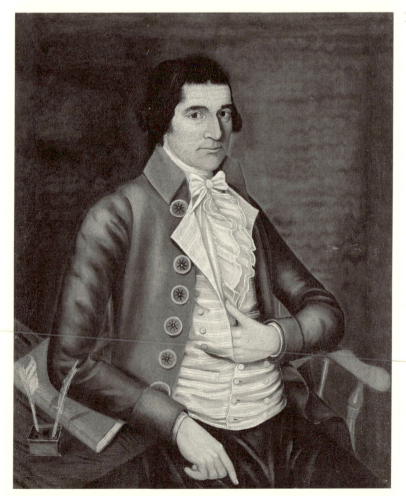

was valued in the inventory of his estate at three pounds (J. Setze, *Bulletin of the Associates in Fine Arts at Yale University* 23 [Sept. 1957], p. 7).

Oil on canvas, 36⅛ × 29¾ in. (91.8 × 75.6 cm.).

Inscribed on the back before lining: Job Perit. Ætat. 38. / A. D. 1790. Ruben Molthrop. Pinxit.

REFERENCES: R. W. Thomas, New Haven, to E. W. Garbisch, July 10, 1957, copy in Dept. Archives, says Mrs. Sawitzky noted that Moulthrop often inscribed the backs of the canvases and used variant spellings of his name // R. W. Thomas, New Haven Colony Historical Society, to S. P. Feld, Feb. 3, 1965, ibid., supplies biographical data on the subjects // S. P. Feld, *MMA Bull.* 23 (April 1965), p. 281.

EXHIBITED: American Federation of Arts, traveling exhibition, 1961-1964, *101 Masterpieces of American Primitive Painting from the Collection of Edgar William and Bernice Chrysler Garbisch*, no. 24, color ill., p. 143 // MMA, 1965, *Three Centuries of American Painting* (checklist arranged alphabetically) // American Federation of Arts, traveling exhibition, 1968–1970, *American Naive Painting of the 18th and 19th Centuries*, pl. 20 // MMA and American Federation of Arts, traveling exhibition, 1975–1977, *The Heritage of American Art*, cat. by M. Davis, no. 18.

Ex COLL.: with Ralph W. Thomas, New Haven, Conn., 1957; Edgar William and Bernice Chrysler Garbisch, 1957–1965.

Gift of Edgar William and Bernice Chrysler Garbisch, 1965.

65.254.1.

Mrs. Job Perit

The portrait of Sarah Stanford Perit (1760–1829) was painted in 1790 as a companion to that of her first husband, Job Perit (see preceding entry). After his death she was married to Dr. Eneas Munson, one of the founders of the Yale Medical School. The miniature of a little girl that she displays in her right hand is said to portray her daughter Elizabeth Perit, who was about five when the Perit portraits were painted. In 1806 Elizabeth was married to Elihu Munson, her stepfather's son from his previous marriage.

As in the portrait of Job Perit, blue tonalities against a maroon-brown background dominate

Moulthrop, *Mrs. Job Perit*

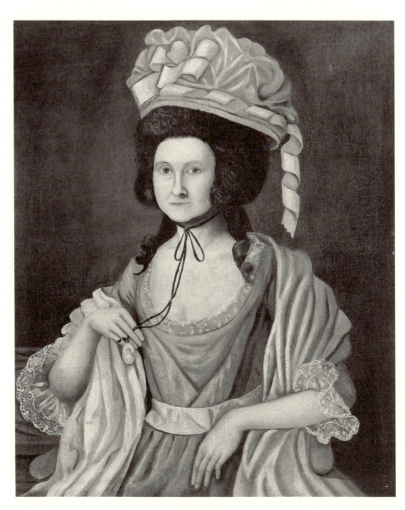

the color scheme. More than the other portrait, however, this one seems to reflect Moulthrop's awareness of fashionable English portraiture of the 1780s and 1790s, a knowledge he must have acquired from prints or from seeing the works of RALPH EARL. Earl's portrait of Mrs. Alexander Hamilton (Museum of the City of New York), 1787, for example, a work strongly influenced by the style of George Romney, exhibits striking parallels to the portrait of Mrs. Perit. One almost never finds, however, in Earl's subjects the kind of emphasis on fashionable hairdo and headdress that is displayed in the portrait of Mrs. Perit. Such an overstatement seems to be more closely related to contemporary fashion prints published in books such as James Stewart's *Plocacosmos: or the Whole Art of Hair Dressing* (London, 1782), in which styles in coiffures and hats are consistently exaggerated in portraits of women.

Oil on canvas, 36¼ × 29¾ in. (92.1 × 75.6 cm.). Inscribed on the back before lining: Sally Perit. Ætat. 29. / A. D. 1790. Ruben Molthrop. Pinxit.

REFERENCES: same as preceding entry.

EXHIBITED: American Federation of Arts, traveling exhibition, 1961–1964, *101 Masterpieces of American Primitives from the Collection of Edgar William and Bernice Chrysler Garbisch*, no. 25, color ill., p. 143 // MMA, 1965, *Three Centuries of American Painting* (checklist arranged alphabetically) // American Federation of Arts, traveling exhibition, 1968–1970, *American Naive Painting of the 18th and 19th Centuries*, pl. 21 // MMA and American Federation of Arts, traveling exhibition, 1975–1977, *The Heritage of American Art*, cat. by M. Davis, no. 19.

Ex COLL.: same as preceding entry.

Gift of Edgar William and Bernice Chrysler Garbisch, 1965.

65.254.2.

JOSHUA JOHNSON

active 1796–1824

There is not much information on the early life of Joshua Johnson (sometimes spelled Johnston), who is the first black painter in America with a known body of work. He may have been a native of the French West Indies and possibly a slave in Maryland. In the 1817 Baltimore directory, he is listed under a special section "Free House holders of Colour," and there is also an oral tradition among some of his sitters' descendants that he was a black man. Since J. Hall Pleasants's pioneer work on Johnson, a growing number of paintings have been attributed to him over the years. It was long thought that his early work was influenced by CHARLES WILLSON PEALE, who was painting in Baltimore in the early 1790s. According to Carolyn J. Weekley's research (1987), enough evidence exists to indicate that Joshua Johnson was very likely a slave belonging to Peale's brother-in-law Robert Polk. It is believed that after Polk's death in 1777, Johnson became the serving boy who is mentioned in the Peale family papers of the 1780s. Even before Polk's death, his son, CHARLES PEALE POLK, had gone to live with Peale in Philadelphia. Baltimore records indicate that Johnson arrived there in the early 1790s, that he was a Catholic of French West Indian origin, and that by 1803, if not sooner, he was a free man and had been married for some years.

The closeness in style between Polk and Johnson is particularly noteworthy. Evidence of a network of patronage in Baltimore also links him with Charles Willson Peale and REMBRANDT PEALE. As the years went by, however, Johnson appears to have stopped trying

to model figures three-dimensionally in believable settings in the manner of the Peales. Instead he settled into his own naive style, and today he is considered one of this country's great folk artists. The flesh tones of his subjects often have a pearly pink glow that was probably derived from his study of Charles Willson Peale. Elsewhere, however, in lieu of Peale's pastel shades, Johnson used bright, strong colors, such as the red of the strawberries and the bird in the double portrait of Edward and Sarah Rutter (see below), which form a striking contrast to his dark backgrounds. He seems to have delighted in the literal treatment of certain details, making, for example, beautifully precise renderings of lace overlaying another fabric.

An advertisement in the *Baltimore Intelligencer* of December 19, 1798, claims Johnson is "a *self-taught genius*, deriving from nature and industry his knowledge of the Art; and having experienced many insuperable obstacles in the pursuit of his studies, it is highly gratifying to him to make assurances of his ability to execute all commands, with an effect, and in a style, which must *give* satisfaction." One imagines that the difficulties to which Johnson refers might in part have stemmed from his race. In addition, his somewhat flat, provincial style may not have fared well in competition with that of the other, better trained artists working in Baltimore. He was all but forgotten until about 1940, when his genuine aesthetic qualities became apparent to an audience that had become accustomed to modernist art.

BIBLIOGRAPHY: J. Hall Pleasants, *An Early Baltimore Negro Portrait Painter, Joshua Johnston* (Windham, Conn., 1940; reprinted from *The Walpole Society Note Book*, 1939). Summarizes documents relating to Johnson and catalogues thirteen pictures by him || J. Hall Pleasants, *Joshua Johnston: The First American Negro Portrait Painter* (Baltimore, 1942; reprinted from the *Maryland Historical Magazine* 37 [June 1942], pp. 121–149). Expands the body of Johnson's known work to twenty-one paintings || Peale Museum, Baltimore, *An Exhibition of Portraits by Joshua Johnson* (1948), cat. by J. Hall Pleasants. Expands list of his works to twenty-five || Abby Aldrich Rockefeller Folk Art Center, Williamsburg, Va., and Maryland Historical Society, Baltimore, 1987–1988, *Joshua Johnson: Freeman and Early American Portrait Painter*, cat. for traveling exhibition. Includes a chapter by Carolyn J. Weekley with information on the artist's life and a catalogue of eighty-three paintings attributed to Johnson.

Edward and Sarah Rutter

Edward Pennington Rutter (ca. 1798–1827) and Sarah Ann Rutter (1802–1843) were born in Baltimore, the eldest of five children born to Mary Pennington and Captain Joshua Rutter. Their father was a landowner and probably a ship's captain. Edward himself became a captain in later years, but little is known of him beyond the fact that he died at the age of about twenty-nine in Havana, where he was serving as master of the brig *Margaret*. His sister Sarah was married twice. Her first husband, to whom she was wed in 1820, was John Taylor of Baltimore. In 1825 she became the wife of John C. Hennick, whose various occupations over the years were saddler, superintendent of streets, constable, and employee in the customs house. The present painting was left to their son, Edward Rutter Hennick. They also had a daughter, Sarah Rebecca.

Based on the costumes and the ages of the children, the portrait is dated about 1804 or 1805. Johnson painted the Rutter children with characteristic simplicity and grace. His palette is very somber, accented with vivid touches of red in the bird at the left, the strawberries the children hold, and Sarah's shoes. The floor and the strawberry leaves are a rich dark green. The background is dark brown, against which the faces of the children stand out dramatically. As in all Johnson's work, there is in this portrait an air of stillness, of suspended action, which, from a contemporary standpoint, seems to give the

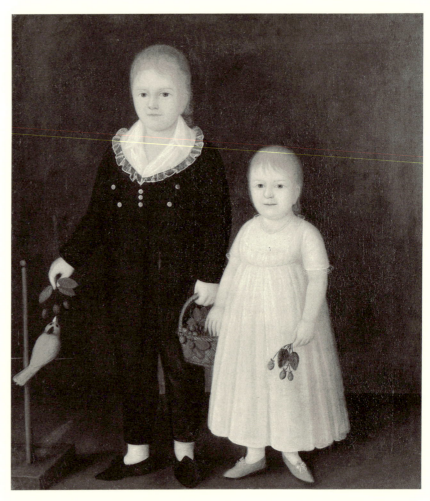

Johnson, *Edward and Sarah Rutter*

painting an unreal, almost magical air. It would seem that the bright red bird with the intensely white beak will always be aiming for, but never reaching, the strawberry above, and the children look out at the viewer with an odd gravity and the utter directness of figures in a dream.

The painting is believed to have its original gilt frame.

Oil on canvas: 36 × 32 in. (91.4 × 81.2 cm.).

REFERENCES: Joshua Rutter, will, Jan. 14, 1851, Register of Wills, Baltimore County, Md., states that his grandson Edward Rutter Hennick is to receive "the Likenesses of his Mother and Uncle Edward" // J. H. Pleasants, "Study in Maryland Painting, no. 3477," 1951, typescript, Maryland Historical Society, Baltimore, dates painting about 1805 and attributes it to Johnson, gives information on subjects and provenance // S. Keck, conservator, Brooklyn, Jan. 1957, report in Dept. Archives, discusses condition and treatment // S. P. Feld, *MMA Bull.* 23 (April 1965), p. 285 // *MMA Bull.* 33 (Winter 1975–1976), ill. p. [238] // Abby Aldrich Rockefeller Folk Art Museum, Williamsburg, Va., and Maryland Historical Society, Baltimore, *Joshua Johnson* (1987), pp. 121–122, no. 26, gives further information on Sarah Rutter and dates the picture 1804.

EXHIBITED: National Gallery of Art, Washington, D. C., 1957, *American Primitive Paintings from the Collection of Edgar William and Bernice Chrysler Garbisch*, part II, ill. p. 33 // MMA, 1961–1962, and American Federation of Arts, traveling exhibition, 1961–1964, *101 Masterpieces of American Primitive Painting from the Collection of Edgar William and Bernice Chrysler Garbisch*, color pl. 35 // MMA, 1965, *Three Centuries of American*

Painting (checklist arranged alphabetically), as lent by Edgar William and Bernice Chrysler Garbisch // American Federation of Arts, traveling exhibition, 1968–1970, *American Naive Painting of the 18th and 19th Centuries: 111 Masterpieces from the Collection of Edgar William and Bernice Chrysler Garbisch*, pl. 33 // Osaka, 1970, United States Pavilion, Japan World Exposition, *American Paintings* (no cat.) // Katonah Gallery, Katonah, N. Y., 1971, *American Folk Art of the 18th and 19th Centuries*, checklist, no. 3 // Pushkin Museum, Moscow, and Hermitage, Leningrad, 1975, *100 Kartin iz museia Metropoliten* [*100 Paintings from the Metropolitan Museum*], no. 84, ill. p. 233 // MMA, 1976–1977, *A Bicentennial Treasury* (see *MMA Bull.* 33 above) // American Federation of the Arts, traveling exhibition,

1985–1988 (shown in Toledo, Baltimore, Philadelphia, and Oklahoma City), *Hidden Heritage*, cat. by D. C. Driskell, no. 2.

Ex COLL.: Joshua Rutter, Baltimore, d. 1861; his grandson, Edward Rutter Hennick, by 1861; his sister, Sarah Hennick (Mrs. John Paul Mettee); her daughter, Ida Mettee (Mrs. Joseph Nicholas Huber), until 1936; her brother, Milton Harry Mettee; his son, Edwin Rutter Mettee, Pikesville, Md. 1951; with Norton Asner, Baltimore, by 1955–1956; Edgar William and Bernice Chrysler Garbisch, Cambridge, Md., 1956–1965.

Gift of Edgar William and Bernice Chrysler Garbisch, 1965.

65.254.3.

WILLIAM DUNLAP

1766–1839

The first historian of American art, William Dunlap was born into a fairly well-to-do family in Perth Amboy, New Jersey. His father, a storekeeper, was originally from the North of Ireland. He had come to America as a soldier and then stayed after the French and Indian War ended. At the time of the Revolution, the family were loyalists, and in 1777 they moved to the safety of New York. There, in a childhood accident, William Dunlap lost the use of his right eye. Despite this, he studied drawing and learned to paint, first from Abraham Delanoy (1742–1795) and then briefly from WILLIAM WILLIAMS. By 1782 he had begun to make his living as a portrait painter, and two years later he went to London, intending to study with BENJAMIN WEST. Although he stayed abroad for three years, he was, according to his own account, disinclined to serious study, even with West's encouragement. It is certainly the case that, after his return, his paintings, such as *The Dunlap Family*, 1788 (NYHS), though indebted to West in composition, differ little in style from those Dunlap did before he went abroad. In 1789 he married Elizabeth Woolsey, a member of an old New York family. Soon after, he became a partner in his father's hardware store. Dunlap continued to paint but by 1797 he was giving most of his energy to playwriting and managing theaters in New York.

Several years of business losses forced Dunlap into bankruptcy in 1805, and he resumed his artistic career, this time as an itinerant miniature painter. As he had only nominal preparation for this endeavor, Edward Greene Malbone (1777-1807), the preeminent American miniature painter, showed him the proper method of preparing the ivory. It would seem that Dunlap tried hard to overcome his deficiencies; for many of his miniatures represent a genuine achievement. He returned to the theater in 1806, managing the Park Theatre for Thomas Abthorpe Cooper and publishing a number of his own plays as well as translations

of works by others. At the end of 1811, he again withdrew from the theater, continuing, however, to publish plays and also taking on other literary projects.

In 1812 Dunlap resumed painting miniatures. Among his best are two self-portraits of about 1812 (Yale University, New Haven, Conn.), which reveal him as self-possessed and humorous. He returned to oil painting in 1813. According to his account, this was at the suggestion of GILBERT STUART, whose style he attempted to imitate. His best work as a painter probably dates from this time, although for two years, from 1814 to 1816, he painted very little. Instead he held the post of assistant paymaster general of the militia, which involved a good deal of traveling in upstate New York. In 1817, however, he was again painting portraits in New York, where he also served as keeper of the American Academy of Fine Arts. His moderate accomplishments combined with a limited market for art in New York in these years made it necessary for him to travel in search of commissions. Even then, he often had to barter portraits for lodging or produce, which he sent home to his family.

Dunlap's style through these years appears to have been based on Stuart's relatively tight, carefully colored work of the period. In the 1820s, however, Dunlap turned to the more fashionable, broadly painted style of THOMAS SULLY and Sir Thomas Lawrence, whose portrait of West (now in the Wadsworth Atheneum) had been purchased by the American Academy of Fine Arts. His efforts along these new lines were less successful. At the same time, he began a series of very large history paintings of incidents in the life of Christ, which he exhibited for a fee in various towns and cities.

In 1831 Dunlap was one of the founders of the National Academy of Design, where for several years he held the title of professor of historical paintings. When his health began to fail, he turned more to his pen for a livelihood, producing several major studies, for example, in 1832, the *History of the American Theatre* and then, in 1834, *History of the Rise and Progress of the Arts of Design in the United States*. In his extensive travels he had become acquainted with most of the artists of his day. His history of the arts, which is a series of chronologically arranged biographies, consists for the most part of letters from the artists describing the course of their lives, supplemented by the information Dunlap could add from his own memory or glean from the few contemporary art publications. His knowledge of artists in the early eighteenth century was perforce very limited, though he did what he could in the way of research. The work is limited, too, by his insistence on judging the artists' lives in moral terms. Yet the anecdotes he repeats in support of his opinions often give the reader a clear sense of the people he describes, and there are a number of lively passages. Dunlap's judgment of art was good. Despite his condemnatory treatment of JOHN TRUMBULL, he evaluated accurately the high quality of his early work and perceptively described the decline of his powers late in life. As an artist himself, his treatment of the work of others is for the most part sympathetic, and his history is an invaluable record of the difficulties as well as the ambitions of American artists in the eighteenth and early nineteenth century.

BIBLIOGRAPHY: William Dunlap, *History of the Rise and Progress of the Arts of Design in the United States* (2 vols.; New York, 1834), 1, pp. 243–311. Includes scattered references to himself throughout ∥ Oral Sumner Coad, *William Dunlap: A Study of His Life and of His Place in Contemporary Culture* (New York, 1917). A biography with primary focus on Dunlap's literary work ∥ *Diary of William Dunlap (1766–1839): The Memoirs of a Dramatist, Theatrical Manager, Painter, Critic, Novelist, and Historian* (3

vols.; New York, 1931). Intermittent but very full coverage from 1786 to 1834 // Charles M. Getchell, "The Mind and Art of William Dunlap (1766–1839)," Ph. D. diss., University of Wisconsin, 1946. Limited discussion of paintings // Charles H. Elam, "The Portraits of William Dunlap (1766–1839) and a Catalogue of His Works," M.A. thesis, New York University, 1952. The most serious art-historical treatment to date.

John Adams Conant

In March 1829, when his large *Calvary* (now unlocated) was exhibited in Washington, William Dunlap painted the portrait of Samuel S. Conant, an editor, who in turn recommended him to his father. Thus, in the summer of 1829, Dunlap went to Brandon, Vermont, to paint eight portraits of the family of John Conant. He later wrote:

Vermont is a rough country and newly settled. . . . Every man works and all prosper. . . . Mr. Conant was a first settler at Brandon, built his own house with his own hands, (and a very good one it is,) and by prudence and industry established a manufactory of ironware, and a family of children, together forming riches that princes might envy (*History of the Rise and Progress of the Arts of Design in the United States* [1834], 1, p. 304).

The subject of this portrait, John A. Conant (1800–1886), was the fourth child and third son of John Conant, and like his father, a prominent citizen of Brandon. In 1823 he became a partner in John Conant and Sons, whose various enterprises included a store, lumber business, iron furnace, brickworks, the production of pot and pearl ash, and the mining and treatment of manganese. He served in the state legislature from 1830 to 1831 and was president of the Brandon Bank. Conant retired from the family business in 1841 and set about establishing a railroad line, which by 1849 ran from Rutland to Burlington. He married twice, first Caroline D. Holton (see below) and later Adelia A. Hammond. There were no children of either marriage, and the portraits of John and Caroline Conant descended in the family of his sister Chara, wife of the Reverend Parcellus Church of Tarrytown, New York.

This portrait has often been called one of Dunlap's most successful works. His usual hardness of touch and awkward drawing are largely absent. The style is clearly based on that of THOMAS SULLY. There is, for example, something of Sully's luminosity, if not quite his sophistication. According to his own account, Dunlap

held the Conant family in high esteem, and this feeling is apparent in his warmly sympathetic portrayal of John Adams Conant.

Oil on wood, 30⅛ × 25 in. (76.5 × 63.5 cm.).

Signed and dated at lower right: W. Dunla[p] / 1829. Inscribed on a label on the back by another hand: John Adams Conant 1800–1886, / of Brandon, Vt. Painted by William Dunlap there in 1829. / Son of John Conant. See / Dunlap's "History of the Arts of Design." Vol. 1, p. 303 et seq. / his charge for a portrait was $25.00.

REFERENCES: W. Dunlap, *History of the Rise and Progress of the Arts of Design in the United States* (1834), 1, pp. 303, 304, mentions the commission and discusses Vermont (quoted above) // F. O. Conant, *A History and Genealogy of the Conant Family in England and America* (Portland, Me., 1887), pp. 299–300, gives information on the subject // J. A. Church, letters in MMA Archives, Nov. 14, 22, 1913, discusses six Dunlap portraits of the Conant family, offers the museum two, and notes: "Dunlap's work must have been satisfactory for the next year he went to Vermont again and painted ten in Castleton and others in Rutland and Orwell" // O. S. Coad, *William Dunlap* (1917), p. 124, says this portrait is among Dunlap's best, which are notable for their humaneness; p. 301, lists it // C. M. Getchell, "The Mind and Art of William Dunlap (1766–1839)," Ph. D. diss., University of Wisconsin, 1946, pp. 356, 361, calls it one of the best Conant portraits // C. H. Elam, "The Portraits of William Dunlap (1766–1839) and a Catalogue of His Works," M. A. thesis, New York University, 1952, p. 32, thinks it reveals influence of Sully and Sir Thomas Lawrence; pp. 37, 65, says the panel is scored to resemble canvas; p. 93, catalogues it // Gardner and Feld (1965), pp. 111–112.

EXHIBITED: Addison Gallery of American Art, Phillips Academy, Andover, Mass., 1939, *William Dunlap, Painter and Critic*, no. 12 // NAD and American Museum of Natural History, New York, 1950, *Samuel F. B. Morse Exhibition of Arts and Science*, not in cat.

EX COLL.: the subject, Brandon, Vt., d. 1886; his nephew, John A. Church, New York, by 1913.

Gift of John A. Church, 1913.

13.217.1.

Dunlap, *John Adams Conant*

Dunlap, *Mrs. John Adams Conant*

Mrs. John Adams Conant

Mrs. Conant was born Caroline D. Holton. Little else is known about her. She must have died before May 1869, when John A. Conant married for the second time. Although Dunlap's portrait of her husband has often been considered among his most successful, in her portrait his loosely applied brushstrokes, in a style derived from Sully and Lawrence, worked out rather badly. The paint that makes up Mrs. Conant's forehead and cheeks is too thickly applied and fails to blend well with the rest of the face. Similarly, the brushstrokes in her neck do not create a unified whole but remain simply streaks of paint. Dunlap's weak grasp of anatomy is seen in the excessive curve of the line of the shoulders and the almost two-dimensional appearance of the body.

Oil on wood, 30⅛ × 25 in. (76.8 × 63.5 cm.).
Signed and dated at lower right: w. d. / 1829.
Inscribed on back: wd / White Hall / Care of Mʳ.

Babcock. Inscribed on a label on the back by another hand: Caroline D. (Holton) Conant / wife of John Conant of / Brandon, Vt. Painted by William Dunlap in Brandon / in 1829 for $25.00.

References: W. Dunlap, *History of the Rise and Progress of the Arts of Design in the United States* (1834), I, pp. 303, 304, mentions the Conant commission // O. S. Coad, *William Dunlap* (1917), p. 301, lists it // C. M. Getchell, "The Mind and Art of William Dunlap," Ph. D. diss., University of Wisconsin, 1946, p. 356 // C. H. Elam, "The Portraits of William Dunlap (1766–1839) and a Catalogue of His Works," M. A. thesis, New York University, 1952, pp. 32, 37, 65; p. 93, catalogues it // Gardner and Feld (1965), p. 112.

Exhibited: NAD and American Museum of Natural History, New York, 1950, *Samuel F. B. Morse Exhibition of Arts and Science*, not in cat.

Ex coll.: the subject's husband, Brandon, Vt., d. 1886; his nephew, John A. Church, New York, by 1913.

Gift of John A. Church, 1913.
13.217.2.

CHARLES PEALE POLK

1767–1822

Born in Maryland, Charles Peale Polk was the son of Elizabeth Digby Peale and Robert Polk, a sea captain from Virginia. His mother died about 1773, and he went to live with his uncle CHARLES WILLSON PEALE in Philadelphia in 1776. The following year Polk's father died during a naval attack, and Peale continued to rear the boy, training him as a painter. Polk's earliest known work was done in 1783, and by 1785 he was practicing as a portrait painter in Baltimore and in Alexandria, Virginia. In between it seems he had gone to sea and not found it to his liking. In about 1785 he married Ruth Ellison of New Jersey, the first of his three wives, and the following year the first of his many children was born. His ambitions appear to have met with something of a check, because in 1787 in Philadelphia he advertised as a house, ship, and sign painter.

Polk never really prospered, and he was forced to travel widely in Maryland, Virginia, and Pennsylvania in search of commissions. He moved to Baltimore in 1791 and two years later opened a drawing school there. In 1795 he announced the opening of a drygoods store in Baltimore, but soon after he seems to have moved to Frederick, Maryland, whence he traveled to paint portraits in western Maryland and northwestern Virginia. Having obtained a commission from Thomas Jefferson, and later James Madison, Polk used his political connections to obtain a clerkship in the Treasury department in Washington, a job he held until about 1820, when he moved to a farm his third wife had inherited in Richmond County, Virginia.

Polk's early work definitely shows Peale's influence, but he never really assimilated his style. In fact, his portraits look like an attempt by a provincial or folk painter to imitate Peale. His drawing, rarely convincing, became with the years increasingly less so. His depiction of facial features grew progressively more stylized and his compositions flatter and less three-dimensional. Yet his portraits exhibited a strong decorative quality and attention to detail. His likenesses were often vivid, for example, the portrait of Mrs. Elijah Etting, 1792 (Baltimore Museum of Art), in which the subject's genial nature is immediately apparent. Occasionally, too, Polk turned his artistic failings into advantages. Such is the case in the portrait of Mrs. Isaac Hite, Jr., and her son James Madison Hite, of about 1799 (Maryland Historical Society, Baltimore), in which the folds of the lady's dress unite with the drapery behind her in a striking, two-dimensional pattern. This portrait is typical of his late period, which is characterized by stylized poses, dramatic presentation, and elongated limbs. Throughout his career Polk recorded the likenesses of many people, some rather well known.

BIBLIOGRAPHY: William R. Johnson, "Charles Peale Polk: A Baltimore Artist," *Baltimore Museum of Art Annual* 3 (1968), pp. 32–37. Gives life based on research by J. Hall Pleasants // Charles Coleman Sellers, *Charles Willson Peale* (New York, 1969). Mentions Polk occasionally, includes genealogy // Maryland Historical Society, Baltimore, *Four Generations of Commissions: The Peale Collection* (1975), exhib. cat. Includes "Charles Peale Polk, 1767–1822," by Stiles Tuttle Colwill, pp. 42–48. Short life of Polk with six portraits // Whaley Batson, "Charles Peale Polk, Gold Profiles on

Glass," *Journal of Early Southern Decorative Arts* 3 (Nov. 1977), pp. 51–57. A discussion of Polk's profiles in verre églomisé which he first advertised doing in Richmond in 1806 // Corcoran Gallery of Art, Washington, D.C., *Charles Peale Polk, 1767–1822: A Limner and His Likenesses* (1981), exhib. cat. by Linda Crocker Simmons. The most complete account to date, it includes a biography, a catalogue of 162 known works, and a comparative group of works by twelve of his contemporaries.

George Washington

Polk was almost as much an icon maker as a portrait painter. He produced a great many portraits of George Washington and several of Thomas Jefferson. In 1790 he wrote to Washington that in the previous year he had painted fifty portraits of him and requested a sitting to finish his most recent one from life. There is no evidence that Washington granted his request. To date Linda Crocker Simmons has documented some twenty-nine oil portraits of Washington by Polk, all of them derived from Peale's 1787 life portrait (PAFA). As Charles Coleman Sellers pointed out in 1951, Polk's image of the president is actually closer to Peale's mezzotint based on his life portrait than to the original work. Nevertheless, the museum's painting differs from both in numerous small ways, each evidently an effort by Polk to simplify the composition.

Although it is unsigned and has over the years been attributed to a number of members of the Peale family, Gustavus Eisen's attribution of the portrait to Polk in 1932 has not been successfully challenged. The painting has the flat, unmodeled simplicity, harsh outlines, and high coloring of Polk's work. The eyes, with the almost geometric drawing of the brows and lids, are especially characteristic of his style. As an image of Washington, the portrait makes up in directness for what it lacks in sophistication. The simplification of the uniform allows one's attention to concentrate on the face, with its hard mouth and directly engaging eyes. Although undated, it is close in style to Polk's early work and was probably done in the years around 1790.

When received from Charles Allen Munn, the painting was without provenance. Subsequently, it was said to have been painted by CHARLES WILLSON PEALE and purchased from him by Samuel Lee, in whose family it was alleged to have descended. In 1943, however, it was identified by Mrs. Harry Horton Benkard as having been in the collection of her grandfather Dr. Minturn Post, who she thought had probably got it at auction.

Polk, *George Washington*

Oil on canvas, 21¾ × 17⅞ in. (55.2 × 45.4 cm.).
REFERENCES: H. B. Wehle, *MMA Bull.* 20 (Jan. 1925), p. 20, says replica by C. W. Peale of his original of 1787 // J. H. Morgan and M. Fielding, *The Life Portraits of Washington and Their Replicas* (1931), p. 39, no. 37, as by C. W. Peale who sold it in 1797 to Samuel Lee, says it was sold by his descendants to the donor // B. Burroughs, *Catalogue of Paintings in the Metropolitan Museum* (1931), p. 272, lists under C. W. Peale as replica but says possibly a copy by James Peale // G. A. Eisen, *Portraits of Washington* (1932), p. 378, says by Polk, believes based not on Pennsylvania Academy portrait but on one in the collection of Henry E. Huntington; p. 405, says copied from a James Peale portrait in Charles Willson Peale's studio // J. H. Morgan, letter in Dept. Archives, Jan. 6, 1943, writes, "When Mr. Munn first owned this portrait it had no history. Later one was published tracing the canvas to Samuel Lee. Mrs. Harry Horton Benkard told me

that the portrait had belonged to her grandfather Minturn and had been sold at auction for $75 // Mrs. H. H. Benkard, letters in Dept. Archives, Jan. and Feb. 10, 1943, says painting belonged to her grandfather Dr. Minturn Post, who may have bought it at auction, it was subsequently owned for twenty years by her aunt, Miss Post, who, she claims, sold it at Plaza Art Galleries, spring of 1923, where bought by Mr. de Forest for $75 // J. H. Morgan, letter in Dept. Archives, Feb. 12, 1943, cites "strong probability that this portrait is by Peale Polk" // C. C. Sellers, letter in Dept. Archives, April 3, 1950, says by Rembrandt or Raphaelle Peale // H. B. Wehle, letter in Dept. Archives, April 11, 1950, says museum is changing attribution to James Peale // C. C. Sellers, *MMA Bull.* 9 (Feb. 1951), p. 155, says uniform in style of 1795–1800, notes resemblance to another portrait, specu-

lates that it is by Raphaelle Peale // S. P. Feld, letter in Dept. Archives, Dec. 13, 1962, suggests attribution to Charles Peale Polk // Gardner and Feld (1965), pp. 113-114, attributed to Polk.

EXHIBITED: Corcoran Gallery of Art, Washington, D. C., traveling exhib. 1981–1982, *Charles Peale Polk, 1776–1822*, cat. by L. C. Simmons, ill. pp. 3, 26, no. 12, catalogues it and notes that the details vary considerably from the Peale example and from Polk's other work of this type at Princeton.

Ex COLL: Dr. Minturn Post, New York, d. 1869; his granddaughter, Helen Minturn Post, New York, ca. 1900–1923 (possibly sale, Plaza Art Galleries, New York, 1923); with Robert W. de Forest, 1923; Charles Allen Munn, West Orange, N. J., by 1924.

Bequest of Charles Allen Munn, 1924.
24.109.81.

EZRA AMES

1768–1836

Born in Framingham, Massachusetts, Ezra Ames was the son of Jesse and Betty Bent Emes (he later changed the spelling of his last name). After living for a while in East Sudbury (now Wayland), Massachusetts, the family moved to Staatsburg, New York, in about 1790. By that time Ames had set up on his own; for his account book records that in 1790 he was working as a coach painter in Worcester, Massachusetts. He also records painting four portrait miniatures. In this same account book, he wrote in 1791 that he painted among other things thirteen signs, three stands of colors (flags with their cases and staffs, the latter with finials and ferrules), two sleighs, four chaises, three clockfaces, two fences, and a sun blind. In 1793, after a brief visit to New York, where he may have seen the work of GILBERT STUART, Ames settled in Albany, which was to be his home for the rest of his life. During his first years there, he continued to paint signs and carriages as well as portraits. It is evident from his surviving portraits, many of them bust-length works, that he did not receive any formal training.

Ames made a number of trips around Albany and into Massachusetts, where in Northbridge in 1794 he married Zipporah Wood. He did well in Albany, and the first sign of real artistic progress is his large painting of members of the family of John Fondey, Jr., 1803 (Albany Institute of History and Art), an ambitious work depicting seven figures somewhat in the manner of RALPH EARL. It was probably painted after Ames's trip to New York City in June of 1803. In 1806 he was commissioned to copy Gilbert Stuart's portrait of James Rivington (unlocated; Ames's copy, NYHS). At about this time Ames's style came to resemble Stuart's in some respects, and after this date, Ames's work lost much

of its previous naive quality. Whether or not this increase in sophistication was due entirely to copying Stuart's work is not known. On occasion, perhaps when he lacked a model to follow, Ames reverted to a naive style. This is especially evident in his portraits of children, for example, the group portrait of the children of Governor Daniel D. Tompkins, 1809 (Staten Island Institute of Arts and Sciences, New York).

Another artistic influence came about in 1809 or 1810, when Ames was commissioned to paint a copy of JOHN SINGLETON COPLEY's portrait of Elkanah Watson (Art Museum, Princeton University; Ames's copy, Albany Institute of History and Art). Its composition, pose, and something of Copley's manner are reflected in Ames's ambitious portrait of Henry Jones, 1810 (NYHS). His serious study of the leading American portrait painters of the eighteenth century must have been evident in one of his most successful works, the posthumous portrait of Governor George Clinton, which was exhibited in Philadelphia at the Pennsylvania Academy of the Fine Arts in 1812. It won considerable praise and was subsequently the first picture ever purchased by the academy, where it was probably destroyed by a fire in 1845. Judging from what appears to be a copy done in 1814 (NYHS), the Clinton portrait was a well-painted, sensitive likeness representing a combination of the styles of Copley and Stuart. The pose and composition are based on Copley's portrait of Elkanah Watson and Stuart's Lansdowne portrait of George Washington.

After his Philadelphia success, Ames began to receive portrait commissions from New York and elsewhere, and he largely abandoned the work of decorative painting with which he had begun his career. In 1813 the state assembly commissioned full-length portraits of Clinton and George Washington (State Capitol, Albany, New York). Unfortunately in these works Ames's ambition exceeded his skill. Painted with the full panoply of official portraiture, both are clearly based on the Stuart Lansdowne portrait, but Ames's weaknesses are revealed in the awkwardly drawn legs, the lack of perspective, and the incorrectly foreshortened furniture. In succeeding years, he continued to assimilate the styles of other artists practicing around him. On occasion he approached the neoclassical simplicity and dignity of JOHN VANDERLYN, and his later work is similar to that of the SAMUEL L. WALDO AND WILLIAM JEWETT partnership, with uncomplicated or nonexistent backgrounds and carefully rendered faces and clothing. Although true artistic achievement eluded him, Ames had a successful career. He was elected a member of the American Academy of the Fine Arts in New York in 1824 even though he never contributed to its exhibitions. He did so well financially that in 1834 he was elected president of the Mechanics and Farmers Bank of Albany, having been one of its directors since 1814. He passed his last years as a much respected citizen of Albany and a very prominent member of the Freemasons. At his death he left an estate valued at sixty-five thousand dollars.

BIBLIOGRAPHY: Theodore Bolton and Irwin F. Cortelyou, *Ezra Ames of Albany: Portrait Painter, Crafstman, Royal Arch Mason, Banker, 1768–1836* (New York, 1955). Complete biographical treatment includes catalogue of known works and entries regarding paintings from his account books in the New-York Historical Society // Irwin F. Cortelyou, "A Supplement to the Catalogue of Pictures by Ezra Ames of Albany," *New-York Historical Society Quarterly* 61 (April 1957), pp. 176–192.

Ames, *Philip Van Cortlandt*

Philip Van Cortlandt

Philip Van Cortlandt (1749–1831) was the eldest son of Joanna Livingston and Pierre Van Cortlandt, members of two of the most politically and socially prominent New York families. He was trained as a surveyor, and until the American Revolution he helped in the management of Van Cortlandt manor, including the operation of the gristmills and the sale of lands. Commissioned a lieutenant colonel in 1775, he took part in the battles of Saratoga and Yorktown, and when he retired in 1783 was given the rank of brigadier general. Van Cortlandt was active in politics; he served in the first New York provincial congress in 1775 and was a delegate to the New York convention that ratified the Constitution in 1788. From that year to 1793 he was a member of the state legislature and from 1793 to 1810 was a representative in the United States Congress. He was treasurer of the Society of the Cincinnati. In 1824, he accompanied his friend Lafayette on part of his tour of the United States. He never married, and this portrait passed to his nephew Philip Gilbert Van Wyck.

First attributed to Ames by William Sawitz-

ky, the portrait has been dated 1809 or 1810 by Bolton and Cortelyou (1955) on the basis of costume, hairstyle, and Van Cortlandt's apparent age. The dating also coincides with his retirement from Congress. The work is based on GILBERT STUART's portrait of James Rivington (unlocated), which Ames owned and copied in 1806 (NYHS). Like Rivington, who has a newspaper in his hand, Van Cortlandt holds a letter, with only a few words legible. Tradition holds that the letter is from Lafayette. With at least partial success, Ames attempted to match Stuart's painterly rendering of the subject's face, but in other areas he deviated from his manner. The striped waistcoat, for example, is very precisely and crisply rendered in a style quite different from Stuart's, as is the painting of the frilled jabot. Taken as a whole, the portrait demonstrates a fairly high level of skill and assurance, but the hands are anatomically unconvincing, and the painting is rather dull in terms of color.

On the reverse of the canvas is an incomplete sketch in black chalk of a man's head.

Oil on canvas, 36 × 28 in. (91.4 × 71.1 cm.).

REFERENCES: W. Sawitzky, n. d., note on back of photograph in Dept. Archives, identifies and says it is one of the most attractive paintings by Ames that has come to his attention // H. W. Williams, Jr., *MMA Bull.* 35 (July 1940), pp. 149–150 // T. Bolton and I. F. Cortelyou, *Ezra Ames of Albany* (1955), ill. p. xvi, say Sawitzky attributed to Ames; p. 49, date it 1809 or 1810; p. 138; p. 296, catalogue it // Gardner and Feld (1965), p. 115 // P. Van Wyck, *The Story of a Colonial Family* (1979), gives information on the subject.

EXHIBITED: NYHS and Albany Institute of History and Art, 1955–1956, *Paintings by Ezra Ames*, checklist no. 25 // MMA, 1965, *Three Centuries of American Painting* (checklist arranged alphabetically) // Amon Carter Museum of Western Art, Fort Worth, 1975–1976, *The Face of Liberty*, exhib. cat. by J. T. Flexner and L. B. Samter, p. 244, color pl. 89.

ON DEPOSIT: United States Tax Court, New York, 1943–1950; 1950–1958 // Independence National Historical Park, Philadelphia, 1982–1983.

EX COLL.: the subject's nephew (adopted son), Philip Gilbert Van Wyck, Croton, N. Y., d. 1870; his daughter, Ann Van Rensselaer Van Wyck (Mrs. Alexander Wells), Ossining, N. Y., d. 1919; her grandson, Schuyler Van Cortlandt Hamilton, Croton, N. Y., 1939; (sale, Parke-Bernet Galleries, New York, April 18, 1940, no. 50, $475); Eugene Delafield; Christian A. Zabriskie.

Gift of Christian A. Zabriskie, 1940.

40.94.

RUFUS HATHAWAY

1770–1822

Rufus Hathaway, the son of Mary Phillips and Asa Hathaway, was born in Freetown, Massachusetts. The family moved several times and by 1785 had settled in Bristol, Rhode Island. There is no record of Hathaway's having had any artistic training. However, he may have been apprenticed to a ship carver or decorator. His earliest known work is dated 1790. During the next few years he appears to have traveled in southern Massachusetts in the area around Plymouth and Taunton painting portraits. He signed his works both Hathaway and Hatheway. In 1795 he married Judith Winsor of Duxbury, having fallen in love with her, or so says family tradition, while painting her portrait. Joshua Winsor, Judith's father, was a prosperous owner of a fleet of fishing boats. It was reportedly at his suggestion that Hathaway forsook the somewhat chancy profession of artist to study medicine, becoming in later years Duxbury's only physician. Examples of his painting after 1795 are infrequent. There is an overmantel showing a pair of peacocks painted by him about 1800 (coll. Ann P. Vose), and he did at least one topographical landscape. That he also made wood carvings is learned from documentary evidence, but none has survived.

In 1822, the year he died, Hathaway was made an honorary fellow of the Massachusetts Medical Society. His wife outlived him by almost sixty-nine years, dying in 1881 at the age of a hundred and three. Hathaway's painting underwent little stylistic development. His portraits of Mr. and Mrs. Ezra Weston, Jr., of about 1793, and of their daughter Maria of about 1804 (all Abby Aldrich Rockefeller Folk Art Center, Williamsburg, Va.), hardly differ at all from his *Lady with Her Pets* of 1790 (see below), except perhaps for a slightly increased effect of three-dimensionality. Like all his works, they show Hathaway's power of intense observation combined with a charming, slightly humorous, sensibility, coloristic boldness, and mastery of two-dimensional design.

BIBLIOGRAPHY: Nina Fletcher Little, "Doctor Rufus Hathaway, Physician and Painter of Duxbury, Massachusetts, 1770–1822," *Art in America* 41 (Summer 1953), pp. 95–101. The first study on the artist // Nina Fletcher Little, "Rufus Hathaway," in Whitney Museum of American Art, New York, *American Folk Painters of Three Centuries* (New York, 1980), pp. 35–40 // Lanci Valentine, *Rufus Hathaway: Artist and Physician, 1770–1822* (Duxbury, Mass., 1987). Catalogue of an exhibition held at the Art Complex Museum in Duxbury, it includes new information on the artist and documents his known body of work.

Lady with Her Pets
(Molly Wales Fobes)

The identity of the subject of this portrait has not been established absolutely. According to one of the dealers from whom the work was purchased, a direct descendant of the subject stated that it represented Molly Whales Leonard of Marshfield, Massachusetts, but no other basis for this identification was given. Subsequent research, however, has turned up a reference by Lysander Richards, in *The History of Marshfield* (1905), to a quaint portrait of George Leonard's mother hanging in the Leonard estate in Marshfield Hills. George Leonard's mother was the former Molly (sometimes Polly) Wales Fobes (1772–1801), daughter of Prudence Wales and the Reverend Peres Fobes of Raynham, Mas-

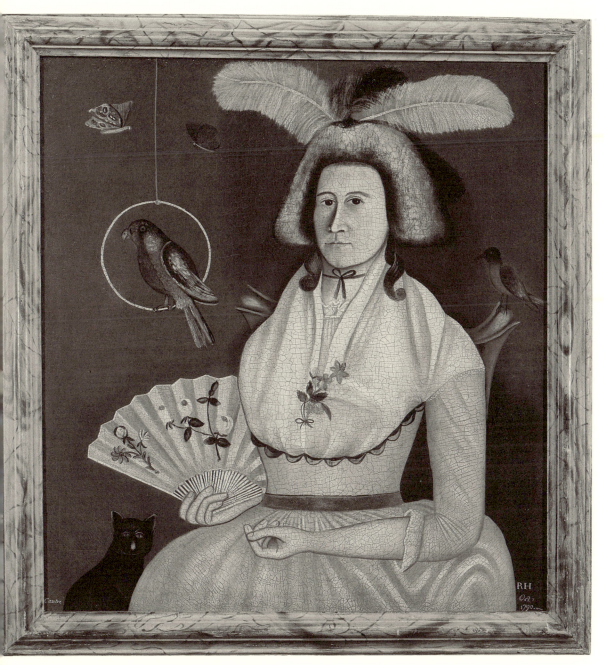

Hathaway, *Lady with Her Pets (Molly Wales Fobes)*

sachusetts. She married the Reverend Elijah Leonard (1760-1834), a 1783 Yale graduate, on May 13, 1792, and they had four children. This makes it possible that the sitter in this portrait is Molly Wales Fobes Leonard. Elijah Leonard was the minister of the Second Congregational Church in Marshfield and so later was his son George.

The painting is one of the best known por-

traits by an American country, or folk, artist, and for good reason. It has the exquisitely achieved design of the finest country art, and the sitter's striking accessories create an ambience of almost magical charm. Her figure is clearly outlined, and the folds of her fashionable dress assume a flat, abstract pattern. Her feathered headdress, springing out from the top of her *herisson*, or hedgehog style coiffure, is quite as-

Rufus Hathaway

tonishing—a version of the contemporary French fashion. The fan, which projects from behind and is held by a seemingly disconnected hand, is presented frontally, almost emblematically.

The pets, too, are positioned in a way that gives them the significance of emblematic figures. They consist of a black cat at the bottom left, perhaps named Canter, the word painted beside it, a parrot perched on a swing, and a robin on the back of the chair. Flying above are two insects, their thick bodies suggestive of moths. Such extensive use of animals as accouterments is found in French and Flemish portraits of the eighteenth century, which Hathaway could have known through prints. The rigid frontality and allover positioning of the figures, on the other hand, suggest medieval art. The forthright gaze of the lady and her pets seem to impart a symbolic meaning. The unnatural clarity, the pale colors, the unreal space, and the odd combination of animals give the impression that these creatures occupy a different, magical world, quite removed from a small town in Massachusetts.

The paint surface shows extensive crackling. The marbleized frame is the original.

Oil on canvas, $34\frac{1}{4} \times 32$ in. (87 × 81.3 cm.).

Signed and dated at lower right: RH / Octr / 1790. Inscribed at lower left: Canter.

REFERENCES: L. Richards, *History of Marshfield* (1905), 2, p. 204, notes a "quaint portrait" of George Leonard's mother hanging in the family house in Marshfield Hills (possibly this painting) // W. White, Duxbury, Mass., letters in Dept. Archives, Jan. 27, 1962, gives identity of sitter as Molly Whales Leonard, and Feb. 5, 1964, says identification was given to him by a direct descendant of Elijah Leonard who is now dead // C. R. Smith, Old Colony Historical Society, Taunton, Mass., letter in Dept. Archives, Feb. 15, 1964, says no Molly Whales Leonard in Leonard genealogy, suggests Polly Wales Leonard // S. P. Feld, *Antiques* 87 (April 1965), p. 440, says it is Hathaway's earliest known work and tentatively identifies subject as Molly Wales Leonard // Gardner and Feld (1965), pp. 116–117 // M. Black and J. Lipman, *American Folk Painting* (1966), p. 23, color pl. 48 // M. Black, *Art in America* 57 (May-June 1969), p. 59, calls it "an image almost medieval in its concept" // T. P. F. Hoving, *Art in America* 58 (March-April 1970), p. 62 // A. Goldin, *Art in America* 62 (March-April 1974), color. ill. p. 71 // *MMA Bull.* 33 (Winter 1975–1976), color ill. no. 20 // R. Vose, Vose Galleries, Boston, Oct. 19, 1981, gives information on the provenance.

EXHIBITED: MMA, 1961–1962, and American Federation of Arts, traveling exhibition, 1962–1964, *101 Masterpieces of American Primitive Painting from the Collection of Edgar William and Bernice Chrysler Garbisch*, color pl. 27 // Los Angeles County Museum of Art and M. H. de Young Memorial Museum, San Francisco, 1966, *American Paintings from the Metropolitan Museum of Art*, no. 79, ill. p. 96 // American Federation of Arts, traveling exhibition, 1968–1970, *American Naive Painting of the 18th and 19th Centuries: 111 Masterpieces from the Collection of Edgar William and Bernice Chrysler Garbisch*, color pl. 23 // Osaka, 1970, United States Pavilion, Japan World Exposition, *American Paintings* (no cat.) // National Gallery, Washington, D. C.; City Art Museum of Saint Louis; and Seattle Art Museum, 1970–1971, *Great American Paintings from the Boston and Metropolitan Museums*, no. 10 // Whitney Museum of American Art, New York, 1974, *The Flowering of American Folk Art*, cat. by J. Lipman and A. Winchester, no. 4, color ill. p. 18 // Pushkin Museum, Moscow, and Hermitage, Leningrad, 1975, *100 Kartin iz muzeia Metropoliten* [*100 Paintings from the Metropolitan Museum*], no. 83, ill. p. 231 // MMA, 1976–1977, *A Bicentennial Treasury* (see *MMA Bull.* 33 above) // New York State Museum, Albany, 1977–1978, *New York: The State of Art*, ill. p. 21 // Everson Museum of Art, Syracuse, N. Y., 1978, *The Animal Kingdom in American Art*, no. 1, ill. p. 7 // Whitney Museum of American Art, New York, *American Folk Painters of Three Centuries*, 1980, color ill. p. 37 // Art Complex Museum, Duxbury, Mass., 1987, *Rufus Hathaway: Artist and Physician, 1770–1822*, exhib. cat. by L. Valentine, p. 24, color ill. p. 25, gives new information on the subject, identifies hairstyle and discusses costume.

Ex COLL.: Marion Raymond Gunn, Newton, Mass., by 1957; her estate; with Vose Galleries, Boston, as agents, 1958; with Mary Allis, Fairfield, Conn., and Winsor White, Duxbury, Mass., 1958; Edgar William and Bernice Chrysler Garbisch, Cambridge, Md., 1958–1963.

Gift of Edgar William and Bernice Chrysler Garbisch, 1963.

63.201.1.

WILLIAM JENNYS

active 1793–1807

The origins of William Jennys are obscure. It has been speculated that he was related to the painter Richard Jennys (active 1766–1801), who came from Boston and painted portraits in the South, the West Indies, and Connecticut. Their styles are very close. In fact, it was long thought that they had collaborated. In recent years at least three paintings signed by both painters have confirmed this idea. Also the account book of one of their New Milford, Connecticut, subjects indicates payment to both for a portrait. (See E. Kornhauser, in Wadsworth Atheneum, *The Great River*, exhib. cat., 1986, nos. 52-53). Other suggestions are that William Jennys may be the man of that name listed among the crew of the privateer *Aurora* of Boston in 1781, his age given as twenty-three (see Warren, 1956, p. 40). According to traditions in several of the families who inherited his works, the portraits were said to have been painted by an Englishman. It has been thought that William Jennys could have been an English relative of Richard Jennys.

The earliest known date for the artist is 1793, when he advertised in the *Norwich Packet*. Among his earliest portraits, painted in the New Milford, Connecticut, area in 1795, are those of the Asa Benjamin family (National Gallery of Art, Washington, D. C.) and four members of the family of Asahel Bacon (Abby Aldrich Rockefeller Folk Art Center, Williamsburg, Va.). They are relatively assured, clearly the work of a painter with some training. Convincingly giving the illusion of three-dimensionality, they are close in style to paintings by Richard Jennys. In the portrait of Mrs. Bacon, the treatment shows the beginning of Jennys's fascination with facial modeling that became increasingly evident in his style. By 1798, for example, in his portrait of Mrs. Timothy Taylor (coll. Mr. and Mrs. Timothy Taylor Merwin, Jr., Wilton, Conn.), William Jennys's style, though still very much like Richard Jennys's, was moving in the direction of the hard lines typical of country or folk artists. Mrs. Taylor's body is conceived as a triangle, and her face shows the preoccupation with detail characteristic of William Jennys's later work.

In 1797 and 1798, William Jennys appears in the New York city directories as "portrait painter," but no New York subjects by him are documented. In 1801, he was painting portraits in Westfield, Becket, and Deerfield, Massachusetts. The following year he was in New Hampshire and Vermont and by 1807 in Newburyport, Massachusetts. It was during the years after 1800 that Jennys developed his last known style, one of the most individual in American art. His previous concern with realistic depiction of his sitters' faces seems to have become a passion, almost an obsession. For example, in his portrait of Mrs. Reuben Hatch of 1802 (Lyman Allyn Museum, New London, Conn.), the body has become a shapeless dark mass, but every detail of the face is accentuated in a manner that amounts to hyperrealism. The chin is a cluster of interlocking planes, each one so sharply differentiated that the face almost seems to have been carved out of wood. Jennys's clarity and control in rendering details of faces and fabrics, together with the peculiar airlessness of the space inhabited by his sitters, give his paintings an oddly surrealistic tone, quite appealing to the contempo-

rary viewer. Nothing is known of Jennys's work after 1807, the year of his last known dated canvas. Since the major research on him in the 1950s, many portraits have been attributed to him, but the only new information that has come to light is that confirming his collaboration with Richard Jennys.

BIBLIOGRAPHY: Frederick Fairchild Sherman, *Richard Jennys, New England Portrait Painter* (Springfield, Mass., 1941). Illustrates several works by William Jennys // William Lamson Warren, "The Jennys Portraits," *Connecticut Historical Society Bulletin* 20 (Oct. 1955), pp. 97–128. This exhibition catalogue gives the few facts known about both Jennyses // William Lamson Warren, "A Checklist of Jennys Portraits," *Connecticut Historical Society Bulletin* 21 (April 1956), pp. 33–64. Catalogues all portraits then known by both artists.

Gentleman of the Hale Family

When this portrait came to the museum the subject was identified, presumably by the vendor to the donor, as Joshua Hale of Newburyport, Massachusetts. There was in fact such a person, born in 1766 in Newbury, who settled in Newburyport after 1794. He would have been about forty years old when William Jennys is known to have been working there around 1807. This date is consistent with the sitter's costume, but he appears to be about twenty-five or thirty, which precludes his being that Joshua Hale, or his son, also Joshua, who would have been only

a child. Another Joshua Hale (1777–1818), who lived in Dracut, Haverhill, and Worcester, Massachusetts, would also have been about thirty years old at the time of the portrait. Thus, the sitter may be a different member of the Hale family whose identity became confused over the years.

Because of his relative youth, the man's rather full face offered Jennys few of the wrinkles and furrows he loved to depict. Nonetheless, the harshly modeled appearance of his late work is evident. The hand is awkwardly painted as is the coat, which does, however, form a sharp and elegant outline against the light greenish gray background. The pose was a favorite of Jennys's, and is found, for example, in his portrait of James Clarkson of Newbury, Massachusetts (private coll., ill. in Warren [1955], p. 99) to which this portrait is very close in style.

Jennys, *Gentleman of the Hale Family*

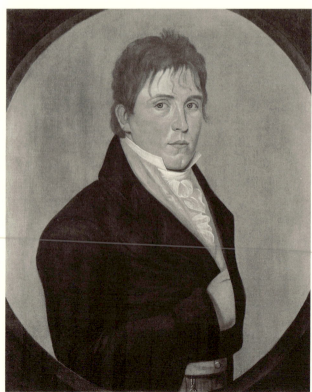

Oil on canvas, 30 × 24⅞ in. (76.2 × 62.8 cm.).

REFERENCES: A. P. Angeli, conservator, New York, to Col. and Mrs. E. W. Garbisch, July 1956, report in Dept. Archives, discusses condition (mainly areas of paint loss and abrasion) and restoration of the painting // C. R. Williams, Litchfield, Conn., letter in Dept. Archives, April 29, 1982, regrets that too much time has elapsed for her to recall the painting's history.

EX COLL.: with Thomas D. and Constance R. Williams, Litchfield, Conn., 1956; Edgar William and Bernice Chrysler Garbisch, Cambridge, Md., 1956–1966.

Gift of Edgar William and Bernice Chrysler Garbisch, 1966.
66.242.18.

RAPHAELLE PEALE

1774–1825

Raphaelle Peale was born at Annapolis, Maryland, the eldest son of Rachel Brewer and CHARLES WILLSON PEALE. Four other Peale children had died before his birth, and it is said that as a result Raphaelle, who was a sickly child, was spoiled and indulged to excess. This may account for his later inability to meet responsibilities. At the age of twelve he began to assist his father in the recently opened Peale's Museum. In 1793 he traveled to Mexico and South America to collect specimens for the museum, an indication both of his interest in the natural sciences and of his father's confidence in him. His portrait of his brother Rubens, executed in 1794 (private coll., ill. in C. C. Sellers, *Mr. Peale's Museum* [1980], p. 78), shows he had obviously learned a great deal about painting. After about 1794, Raphaelle and his brother REMBRANDT PEALE began to take over their father's portrait painting business. At the 1795 Columbianum exhibition in Philadelphia thirteen works by Raphaelle were shown: five portraits, five still lifes, and three trompe-l'oeil paintings (which he called "deceptions"). In the winter of 1795–1796, Raphaelle and Rembrandt traveled to Charleston to paint portraits and to exhibit copies of Charles Willson Peale's likenesses of American patriots. The next year they did the same in Baltimore, apparently with success. Raphaelle's marriage to the temperamental Martha ("Patty') McGlathery of Philadelphia in 1797, against his father's wishes, began well but in later years proved troublesome.

Following his marriage he turned his attention to other fields to supplement the meager income he earned as a portrait and miniature painter. He helped his father with heat experiments, filled in for him in the administration of the museum, and in 1798 patented a preservative for ship timbers. The next year he shared a sixty-dollar premium with his father for an essay on warming rooms. Nevertheless, his financial difficulties did not abate. In these circumstances the invention of the physiognotrace, a device for tracing silhouette profiles on paper, proved a godsend to him. Its inventor, John Hawkins, had given the Peale Museum free use of his device, and Raphaelle traveled all over the South in 1803 and 1804, taking thousands of these simple portraits. He earned a good deal of money from this, but when he attempted to bring the physiognotrace to Boston he was unsuccessful. Another trip to the South in 1805 met with the same fate. About this time, his health began to deteriorate. Peale now began to drink heavily and to neglect his wife and seven children. In 1809 he was admitted to the Pennsylvania Hospital where he was diagnosed as suffering from delirium.

Although he had always painted still-life and trompe-l'oeil pieces, Peale began to devote himself more exclusively to still lifes from about 1812 on. Painted rather fitfully between attacks of dementia, bouts of drinking, and domestic quarrels, the best of these paintings are clear, poetic, and well-balanced compositions endowed with a touch of melancholy and, perhaps, nostalgia. Together with the works of his uncle JAMES PEALE, they constitute the first significant body of still-life painting in America. As such their influence was far-reaching. Painters like JOHN A. WOODSIDE acknowledged them as stylistic models long after their maker

had died. The still lifes of both Peales contributed to a popularization of the genre, which continued to reflect their influence well past the middle of the century. In March of 1825, after years of continued financial failure and ill health, Raphaelle Peale died in Philadelphia at the age of fifty-one.

BIBLIOGRAPHY: John I. H. Baur, "The Peales and the Development of American Still Life," *Art Quarterly* 3 (Winter 1940), pp. 81–92. Assesses the importance of Raphaelle Peale's contribution to American still-life painting and assumes that his style is derived from the Dutch tradition // Charles Coleman Sellers, "The World of Raphaelle Peale," in Milwaukee Art Center and M. Knoedler and Company, New York, *Raphaelle Peale* (1959), exhib. cat. // Edward H. Dwight, "Raphaelle Peale," in Maryland Historical Society, Baltimore, *Four Generations of Commissions: The Peale Collection* (1975), exhib. cat., pp. 49–54. A biographical account and overall survey of Raphaelle Peale's artistic career // National Gallery of Art, Washington, D. C., and PAFA, *Raphaelle Peale Still Lifes* (Washington, D. C., 1988), exhib. cat. by Nicolai Cikovsky, Jr., with contributions by Linda Bantel and John Wilmerding. The most recent book on Raphaelle Peale, it includes some thirty-two still lifes by him and a small selection of others by his father and uncle // Phoebe Lloyd, "Philadelphia Story," *Art in America* 76 (Nov. 1988), pp. 154–203. Discusses Raphaelle Peale's still lifes in the context of his relationship with his father and his poor health.

Still Life with Cake

This work is essentially a more elaborate version of another still life by Peale, dated 1813, *Still Life with Raisin Cake* (private coll., ill. in *Raphaelle Peale Still-Lifes* [1988], p. 54, no. 42), which also features pieces of raisin cake on a plate, a glass of wine, and leaves in the background. Other paintings exhibiting variations of the elements shown here are in the Huntington Library and Art Gallery and the Brooklyn Museum, both dated 1819. This exploration of various different combinations of a few objects is typical of still-life painters. In this series, the fruits, cake, and wine suggest the dessert course of a well-planned meal and its association—the satisfaction of having been well fed.

The quietistic mood of this tenuously lit and rigorously balanced picture is typical of Raphaelle Peale's still lifes. The effect is achieved in part by tightly grouping the still-life elements in the center of the canvas and surrounding them with a good deal of space. It is also the result of the somber color scheme: gray for the tabletop and background, a warm sherry yellow for the wine, brown for the raisins, deep green for the leaves, and a yellowish beige for the cake. A few scattered passages of lively color, such as the bright yellow, orange, and green in the cake icing and the light green of the grapes, are also

part of this formula and serve to contrast with, and at the same time emphasize, the predominant mood of stillness. Although not tightly executed, Raphaelle Peale's still lifes are also not very painterly. He achieved a certain softness, scrupulously avoiding any semblance of exuberance. The sources of his practical, spare style have not been thoroughly investigated, but he probably studied Spanish still lifes in Mexico (Lloyd, *Art in America* 76 [Nov. 1988], p. 158) and the works of the Spanish master Juan Sánchez Cotán, which were exhibited at the Pennsylvania Academy in 1818 (Gerdts and Burke [1971], p. 31).

Oil on wood, 10¾ × 15¼ in. (88.3 × 38.7 cm.).
Signed and dated at lower right: Raphaelle Peale Feb 9: 1818.
REFERENCES: *Panorama* 5 (Dec. 1949-Jan. 1950), ill. p. 28 // *Art Digest* 24 (Feb. 1, 1950), p. 20 // *MMA Bull.* 19 (Oct. 1960), ill. p. 48; p. 55 // E. H. Dwight, Munson-Williams-Proctor Institute, Utica, N. Y., June 17, 1963, letter in Dept. Archives, provides information on exhibitions and provenance // E. Clare, M. Knoedler and Co., New York, orally 1964, gave information on the provenance // Gardner and Feld, 1965, p. 119, catalogues the painting // W. Gerdts and R. Burke, *American Still-life Painting* (1971), p. 31.
EXHIBITED: PAFA, 1819, no. 83, as Still Life—Wine, Cakes, Grapes, etc. (possibly this work) // Harry Shaw Newman Gallery, New York, 1949–1950 // Hewitt Galleries, New York, 1950, *The Tradition of*

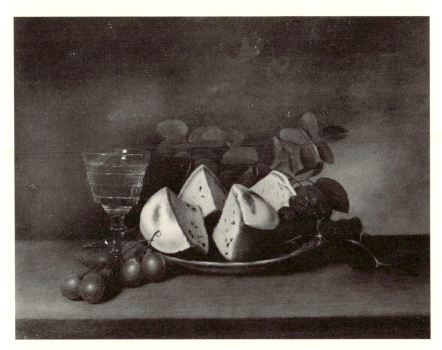

Peale, *Still Life with Cake*.

Trompe l'Oeil || MMA, *Three Centuries of American Painting*, 1965 (checklist arranged alphabetically); *19th Century America*, 1970 (not in cat.) || National Gallery of Art, Washington, D. C., and PAFA, 1988–1989, *Raphaelle Peale Still Lifes*, no. 50, color ill.

Ex coll.: Museum of the Harmony Society, Ambridge, Pa., until about 1850; Susannah (Mrs. John) Duss; Anderson Bouchelle; with M. Knoedler and Co., New York, sold through the Old Print Shop, New York, 1950; with Hewitt Galleries, New York, 1950–1959.

Maria DeWitt Jesup Fund, 1959.
59.166.

JOHN VANDERLYN

1775–1852

John Vanderlyn was born in Kingston, New York, the son of Nicholas Vanderlyn, a sign painter, and the grandson of PIETER VANDERLYN, who was active as a portrait painter in the Hudson River valley in the 1720s and 1730s. Like many other American painters, he turned first for inspiration to European art of the seventeenth century, making drawings after engravings of Charles Le Brun's *Passions*. Vanderlyn went to New York in 1792, where he worked for Thomas Barrow, a seller of prints and artists' materials, and in the evenings he attended the Columbian Academy, an art school run by the Robertsons, Archibald (1765–1835) and his brother Alexander (1772–1841). Although they advertised instruction in painting as well as drawing, this must have been fairly elementary, judging from Vanderlyn's

portrait of his brother Nicholas, about 1793 (Senate House Museum, Kingston, N.Y.). When GILBERT STUART returned to the United States in 1793, he started working in New York. Vanderlyn is known to have copied Stuart's portraits (one of Egbert Benson, see below, the other, of Aaron Burr, now unlocated). In his portrait of Edmund Bruyn of 1795–1796 (Senate House Museum) one can glimpse the first hint of his style as a mature artist; it is a work far exceeding in importance and refinement those he had done earlier. The copy by Vanderlyn of Stuart's portrait of Burr was brought to Burr's attention, and he became Vanderlyn's patron. He arranged for him to work for a few months as Stuart's assistant in Philadelphia. Although some signs of Stuart's influence are evident in Vanderlyn's work immediately after his apprenticeship, all traces of it were obliterated by his subsequent experience when he became the first American-born painter to study in France.

That Vanderlyn went to France and not England, the usual destination of American artists of the period, was undoubtedly due to Burr, who paid his expenses and whose Anti-Federalist party was sympathetic to Republican France. Arriving there in 1796 and studying with the neoclassical painter François André Vincent (1746–1816), Vanderlyn seems to have followed the traditional course of training. As he wrote to his brother Nicholas in December 1796:

> I am every day at drawing scholl (*sic*) from breakfast untill dinner w[h]ere I draw after chalk drawings, plaster figures of men & after living naked men who are kept for that business & 5 to 7 in the evening by candle light so that by next summer I shall be pretty well acquainted with the human figure which seems to be the only thing they draw in the schools (R. R. Hoes Collection, Senate House Museum, microfilm NYHS).

Vanderlyn studied with Vincent for at least two years, but it is hard to discern whether his developing neoclassicism was due to Vincent's example or to that of Jacques Louis David, whose style tended to dominate French art at this time. Vanderlyn's 1799 drawings of the Church family (MMA) have perhaps a little of the sweetness and simplicity of Vincent's work, but his self-portrait, probably painted the following year (q.v.), is stylistically dependent on David, as were the portraits he executed after his brief return to the United States in 1801, for example, that of Mrs. Marinus Willett and her son (q.v.). In his portraits of Aaron Burr, usually dated 1802 (NYHS and Yale University, New Haven, Conn.), Vanderlyn appears to have gone beyond David, following a group of his students, the Primitifs, in the search for even more radical simplicity. In the New-York Historical Society version, Aaron Burr, in fact, looks like a figure on a Roman coin.

In 1803 Vanderlyn went back to Europe to purchase plaster casts after antique and old-master sculptures and copies of paintings for the newly organized American Academy of the Fine Arts in New York. In 1805 he made a trip to Rome. Making a lengthy tour of Switzerland en route, he did not return to Paris until the beginning of 1808. He managed to extend his stay in Europe until 1815, producing some of his best work in portraiture and history painting. His 1805 portrait of Sampson Vryling Stoddard Wilder (Worcester Art Museum) is one of his most refined and assured performances, set firmly within the French neoclassical tradition. At the Salon in Paris in 1804 he exhibited *The Death of Jane McCrea* (Wadsworth Atheneum, Hartford), a violent image, in which an Indian is about to drive his tomahawk through the skull of a beautiful young woman. The choice of subject matter for this painting

and the voluptuousness and nudity of his *Ariadne*, about 1812 (PAFA), show how closely he was involved with the French art of this period, which, as Robert Rosenbloom has pointed out, was increasingly concerned with erotic and horrific subjects. In *Marius amid the Ruins of Carthage*, 1807 (Fine Arts Museums of San Francisco), Vanderlyn was influenced by such French neoclassical works as Jean Germain Drouais's *Marius at Minturnae*, 1784–1786 (Louvre). For his Marius, Vanderlyn received a gold medal at the Salon of 1808 and an offer to have the painting purchased for the Louvre, which he reportedly turned down.

When he returned to America in 1815, Vanderlyn was an extremely accomplished artist, from whom great things might well have been expected. Unfortunately, however, the portraits he painted after his return, for example, that of Zachariah Schoonmaker, dated 1816 (National Gallery of Art, Washington, D.C.), show a considerable decline from the standards set in his European work, and thereafter continue to exhibit a more or less steady falling off in quality, until finally, in works like the portrait of Francis Waddell (q.v.), they reach a level that can barely be called competent. In history painting, Vanderlyn attempted very little beyond replicas of his earlier works. His clumsy and uninspired painting of the *Landing of Columbus* (U.S. Capitol), which he worked on from 1839 to 1846 during a third stay in Paris, and his *Calumny of Apelles* (q.v.), a pallid copy of a drawing then believed to be by Raphael, represent almost his entire output of history painting after 1815.

The reasons for Vanderlyn's decline have often been discussed. Neil Harris, in a perceptive description of American artists returning from Europe, wrote that the contrast between the two social experiences "could be enormous and often produced a permanent inability to readjust and a nagging sense of grievance and maltreatment" (*The Artist in American Society* [1966], p. 81). Lillian Miller characterized Vanderlyn as "an ineffectual businessman who, unable to satisfy the public with which he was out of step, complained that it had no taste" (*New York History* 32 [Jan. 1951], p. 34). Most interestingly, Edgar P. Richardson, noting Vanderlyn's small output of history paintings, found that "his admirable early portraits suggest that his natural gifts were for an art of observation, rather than fancy. A conflict between what he was born to do and what he ought to do might account both for his small production and his unhappy nature" (*Painting in America* [1956], p. 92). Yet Vanderlyn's work appears to have dropped in quality from the moment he left Europe, both in 1801 and again in 1815, and it is certain that he found American artistic life thin and unnourishing. In 1810 he wrote a friend who was in Rome:

As a Painter give me Rome that is the place to conceive great & noble ideas from impressions the mind receives from surrounding objects & there I confess I wish to spend many years — & God grant that I may be permitted to return there in the course of a couple of years, after having spent some time in my native land but where neither caresses nor kind affections of friend[s] or relatives will be able to keep me (J. Vanderlyn to A. Day, Sept. 7, 1810, John Vanderlyn Misc. MSS, NYHS).

Many, if not most, American artists trained abroad in the eighteenth and early nineteenth centuries experienced a falling off in accomplishment after returning home. In the field of history painting, which most interested Vanderlyn, there was hardly anything available to him in this country either as a challenge or as a model.

There is, too, the question of Vanderlyn's conception of his vocation. Much of his time

was spent on planning exhibitions of his panoramas and lobbying in Washington for the creation of a national gallery of art, of which he wished to be director or keeper. In fact, Vanderlyn's place in the history of American art is secured by a remarkably small number of works. In all his years in Europe, when his accomplishment was at its highest, he produced very few paintings, and one wonders if he applied himself to his profession with much energy or persistence. As early as 1810, Aaron Burr wrote to his daughter, Theodosia, from Paris, "Vanderlyn has become a little lazy. He promised me a copy of your picture which has been in his hands for the purpose now five months" (Sept. 26, 1810, *The Private Journal of Aaron Burr*, ed. M. L. Davis [New York, 1838], 2, p. 69). Vanderlyn's own letters, more than those of most artists, seem filled with excuses for not painting. Whatever the reason, his career was in a sense abortive, and he never fulfilled his early promise. He died penniless in Kingston, New York, in 1852.

BIBLIOGRAPHY: John Vanderlyn Miscellaneous Manuscripts, NYHS. A large number of letters from all periods of the artist's life. Also includes a typescript copy of an 1848 biography by Robert Gosman (the original in the Museum of the City of New York) // Roswell Randall Hoes Collection, John Paul Remensnyder Collection, and Henry Darrow Collection, Senate House Museum, Kingston, N. Y. Together, these collections form the largest body of the artist's letters // Marius Schoonmaker, *John Vanderlyn, Artist* (1892; Kingston, N. Y., 1950). A short, nineteenth-century biography // Louise Hunt Averill, *John Vanderlyn, American Painter (1775–1852)* (Ph. D. diss., Yale University, 1949; published, Ann Arbor, 1984). Most complete treatment to date, it includes a catalogue of the artist's works and transcripts of many letters // University Art Gallery, State University of New York at Binghamton, *The Works of John Vanderlyn* (1970), exhib. cat. by Kenneth C. Lindsay. Catalogue of a very comprehensive exhibition, short but well-researched text.

Egbert Benson

Egbert Benson (1746–1833) was born in New York and educated at Kings (Columbia) College. While practicing law in Dutchess County, he became involved in the political events leading to the American Revolution and served on the provincial congress and the council of safety. He was attorney general of New York from 1777 to 1787, an influential member of the first state legislature, and the chief adviser to Governor George Clinton. An ally of Alexander Hamilton, Benson played an important part in the adoption of the federal constitution and served in the first and second congresses. He was appointed to the state supreme court in 1794 and to the United States circuit court in 1801 but soon after retired. A founder of the New-York Historical Society, he was its first president from 1805 to 1815 and published several historical accounts. Benson never married. When he died in Jamaica, New York, in 1833, the distinguished jurist James Kent characterized him as "acute, learned, interesting & inexorably honest & just"

(quoted in *New-York Historical Society Quarterly* 52 [April 1968], p. 218).

Vanderlyn's portrait of Benson is based on one GILBERT STUART painted in New York about 1794 (John Jay Homestead State Historic Site, Katonah, N. Y.), soon after Stuart returned to this country from Ireland. Vanderlyn probably painted his copy shortly after Stuart's portrait was finished. One of his earliest works, its flatness and two-dimensionality reflect his lack of training and experience. The subject is framed in a painted oval, an old-fashioned device barely visible in Stuart's original, and the placement is much higher on the canvas, as if the young artist were uncomfortable with the empty space above and at the sides. Although Vanderlyn attempted to reproduce Stuart's brushstrokes exactly in painting the face, his copy differs conceptually from the original. Where Stuart portrayed the sitter's clothing only in generalized fashion, Vanderlyn felt obliged to paint every detail. Instead of the indistinct, blurred outlines of the Stuart portrait, Vanderlyn's are sharp and almost geometric. This is especially evident

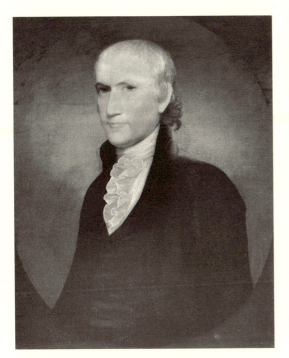

Vanderlyn, *Egbert Benson*.

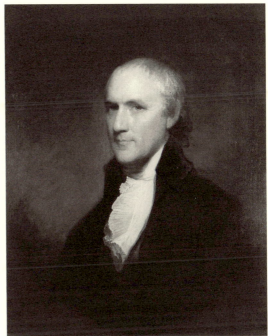

Stuart, *Egbert Benson*. John Jay Homestead. New York State Historic Site.

in the top of the subject's head, which is shaped like a segment of a globe. Vanderlyn also depicted Benson as a very thin man, which perhaps he actually was, but failed to give the figure the physical presence found in Stuart's version.

Oil on canvas, 29¾ × 23⅞ in. (75.6 × 60.6 cm.).

Inscribed on the back of the lining canvas (presumably by a restorer in imitation of signature on the back of the original canvas): *John Vanderlyn, pinxt.*

RELATED WORK: Gilbert Stuart, *Egbert Benson*, oil on canvas, 30 × 25 (76.2 × 63.5 cm.), John Jay Homestead State Historic Site, Katonah, N.Y.

REFERENCES: W. Dunlap, *History of the Rise and Progress of the Arts of Design in the United States* (1834), 2, p. 32 // M. Schoonmaker, *John Vanderlyn, Artist, 1775–1852* (1892; 1950), pp. 5–6, gives information on provenance // L. H. Averill, *John Vanderlyn, American Painter* (Ph. D. diss., Yale University, 1949; published, 1984), p. 17, dates it 1794, compares to Stuart original, and says it was probably Vanderlyn's first attempt at painting in oil; cat. no. 24; fig. 2 // L. B. Miller, *New York History* 32 (Jan. 1951), p. 34 // J. D. Hatch, *Actes du XIXe Congrès International d'Histoire de l'Art* (1959), p. 503 // Gardner and Feld (1965), p. 121 // S. Mondello, *New-York Historical Society Quarterly* 52 (April 1968), p. 163.

EXHIBITED: University Art Gallery, State University of New York, Binghamton, 1970, *The Works of*

John Vanderlyn, exhib. cat. by K. C. Lindsay, fig. 5, pp. 8, 9; p. 124, gives information on provenance.

EX COLL.: John Sudam, Kingston, N. Y.; d. 1835; his son, Harrison Sudam, 1890; Alphonso T. Clearwater, Kingston.

Bequest of Alphonso T. Clearwater, 1933.
33.120.619.

Portrait of the Artist

Unquestionably Vanderlyn's finest portrait, this painting ranks with such works as *Marius amid the Ruins of Carthage*, 1807 (Fine Arts Museums of San Francisco), and *Ariadne*, about 1812 (PAFA). Beautifully painted, with the refinement he evidently learned from his master, François André Vincent, the portrait also recalls the manner of Jacques Louis David in its side lighting, very crisp modeling, and particularly in its directness, which recalls David's own self-portraits. In a letter to his brother Peter on November 12, 1800, Vanderlyn reported that David admired this and the other portrait he exhibited in the Salon in 1800 and "said many flattering things of them, adding that we might raise their thoughts to a more lofty style when

one painted such portraits." Perhaps the most remarkable feature of the portrait is its coloring, which is simultaneously restrained and refined in the best neoclassical manner. Vanderlyn has presented himself in a light brown coat with a rich velvet collar of subtly modulated taupe and a bright plaid waistcoat of green, yellow, and orange, a successful dash of color. Antoine Jean Gros is said to have praised Vanderlyn "for his felicitous taste generally, and especially for the combination of colors in his attire" (quoted in R. Gosman, "Biographical Sketch of John Vanderlyn, Artist," 1848, typescript in John Vanderlyn Misc. MSS, NYHS, p. v.). The artist is shown at about the age of twenty-five, a handsome young man, proud, self-confident, and reserved.

Although the portrait has been dated as late as 1816, it is almost certainly the self-portrait Vanderlyn showed in the Salon of 1800, which, according to a letter he sent his brother Peter that year, he planned to present to Aaron Burr. The painting was, in fact, once in Burr's collection. Vanderlyn wrote to his brother Nicholas from New York in 1802 asking him "to send me down my Portrait by sloop," probably referring to this picture. Stylistically this painting is far closer to his 1799 drawings of the Church family (MMA) than to his later works.

The painting has suffered considerably from abrasion or overcleaning done in the past, especially the lower third of the canvas.

Oil on canvas, 25¼ × 20⅞ in. (64.1 × 53 cm.).

Signed, lower right: Vander[lyn] by him[s]el[f] / Pinxit.

RELATED WORK: Vanderlyn and an unidentified artist, *Portrait of the Artist*, pastel and charcoal on paper, 25⅜ × 20 in. (64.5 × 50.8 cm.), MMA. The badly rubbed face appears to be by Vanderlyn, but the clumsy charcoal strokes over it are by another hand.

REFERENCES: J. Vanderlyn, Paris, to P. Vanderlyn, Kingston, N. Y., Nov. 12, 1800, R. R. Hoes Collection, Senate House Museum, Kingston (quoted above) // J. Vanderlyn, New York, to N. Vanderlyn, Kingston, June 19, 1802, ibid. (quoted above) // *Collector* 5 (May 15, 1894), p. 209 // J. E. Stillwell, *The History of the Burr Portraits* (1928), pp. 86–87, dates it 1811–1816; p. 99, gives provenance // H. E. Dickson, *Art Quarterly* 8 (Autumn 1945), p. 264, dates it ca. 1800 // L. H. Averill, *John Vanderlyn, American Painter* (Ph. D. diss., Yale University, 1949; published 1984), p. 28, identifies as painting in 1800 Salon; cat. no. 24, dates 1800; fig. 13 // A. T. Gardner, *The Panoramic*

View of the Palace and Gardens of Versailles (1956), color frontis. // J. D. Hatch, *Actes du XIXe Congrès International d'Histoire de l'Art* (1959), p. 507, identifies as self-portrait mentioned in 1800 letter // Gardner and Feld (1965), pp. 122–123, date ca. 1815 // D. Sutton, *Apollo* 85 (March 1967), p. 217, says it "could be by a French artist" // S. Mondello, *New-York Historical Society Quarterly* 52 (April 1968), p. 165.

EXHIBITED: Salon, Paris, 1800, under no. 386 "plusieurs portraits, sous le même numéro, parmi lesquels se trouve celui de l'auteur" // MMA, 1896, *Retrospective Exhibition of American Paintings, Loan Collections*, no. 200e, lent by Ann S. Stephens // Senate House Museum, Kingston, N. Y., 1938, *Exhibition of the Work of John Vanderlyn*, no. 1 // MMA, 1939, *Life in America*, no. 52, dates ca. 1800 // M. Knoedler and Co., New York, 1946, *Washington Irving and His Circle*, no. 10, dates ca. 1800 // NAD, 1954, *Memorabilia, 1800–1900*, no. 34, dates ca. 1801 // William Hayes Ackland Memorial Art Center, Chapel Hill, N. C., 1968, *Arts of the Young Republic*, cat. by H. E. Dickson, no. 55 // MMA, 1970, *19th-Century America* (not in cat.) // University Art Gallery, State University of New York, Binghamton, 1970, *The Works of John Vanderlyn*, exhib. cat. by K. C. Lindsay, fig. 1, p. 3; p. 123, accepts ca. 1800 date, cites two letters mentioning it // National Portrait Gallery, Washington, D. C., and Indianapolis Museum of Art, 1974, *American Self-Portraits, 1670–1973*, exhib. cat. by A. C. Van Devanter, no. 17, p. 48, notes influence of David, the jewel-like colors, and the lack of hard drawing.

ON DEPOSIT: MMA, 1894–1895, lent by Ann S. Stephens // Senate House Museum, Kingston, N. Y., 1951–1953.

EX COLL.: the artist, until at least 1802; Aaron Burr, New York, d. 1836; Mrs. Joshua Webb, New York, 1836; Mrs. Ann S. Stephens, New York, by 1882–d. 1886; her daughter, Ann S. Stephens, New York, 1886–d. 1918.

Bequest of Ann S. Stephens, in memory of her mother, Mrs. Ann S. Stephens, 1918.

18.118.

Mrs. Marinus Willett and Her Son Marinus, Jr.

Margaret Bancker (1774–1867) was the third wife of Marinus Willett, a revolutionary war colonel and New York political figure, whose portrait by RALPH EARL is in the museum's collection (q.v.). The daughter of Maria Smith and Christopher Bancker, a New York merchant, she was probably married to Willett in 1800. She bore him five children, the first of whom, Marinus (1801–1840), she holds in this portrait. Judging from the child's apparent age, the work

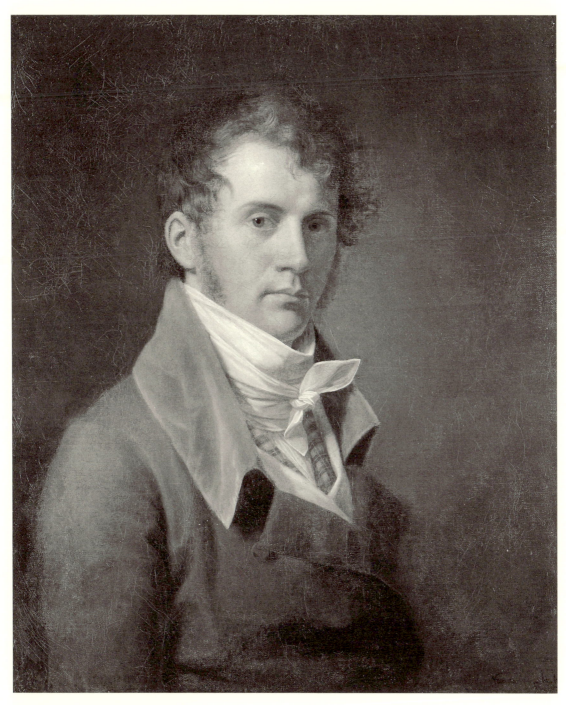

Vanderlyn, *Portrait of the Artist*.

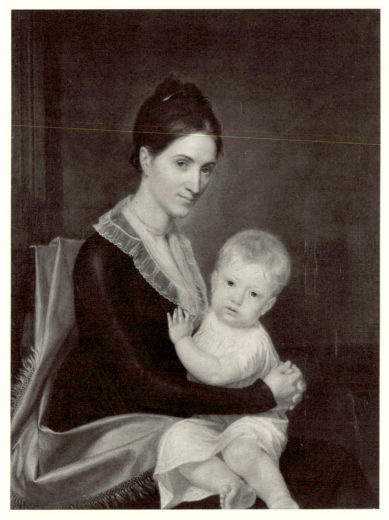

Vanderlyn, *Mrs. Marinus Willett and Her Son Marinus, Jr.*

was most likely painted about 1802. He grew up to become a physician and practiced in New York. Mrs. Willett did not marry again after her husband's death in 1830.

Marinus Willett was an Anti-Federalist and for a long time an ally of George Clinton. He subsequently switched to Aaron Burr's faction of the party, and Burr may well have had something to do with Vanderlyn's commission to paint Mrs. Willett's portrait. Vanderlyn chose a pose he had used before, in a drawing of Mrs. Edward Church and her child of 1799 (MMA), but reversed the composition. While Mrs. Church looks directly and engagingly out at the viewer, and appears somewhat sensuous, Mrs.

Willett is demure and has even a slightly pinched look. If Vanderlyn toned down his French style in some respects to satisfy American tastes, in others he pressed resolutely on. This painting is among the first neoclassical portraits painted in America. Lit from the side and portrayed in a narrow space against a wall with neoclassical molding, Mrs. Willett and her son are painted very much in the manner of Jacques Louis David. Vanderlyn's color is restrained and delicate, as in the golden beige shawl draped over the back of the Empire chair. Although the composition is based directly on his own work, there are several French prototypes for it.

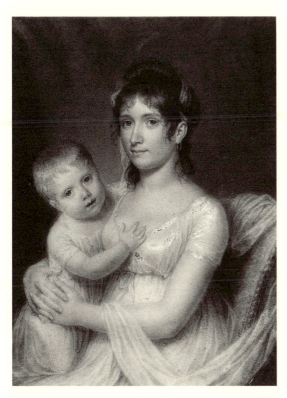

Vanderlyn's chalk drawing *Mrs. Edward Church and Child* (MMA) has similar pose.

Oil on canvas, 36⅞ × 28⅛ in. (93.7 × 71.4 cm.).

REFERENCES: G. W. Van Nest, letter in MMA Archives, April 23, 1906, says portrait was painted about 1801 and shows eldest Willett child // G. W. Van Nest, will, Jan. 14, 1910, copy in MMA Archives, bequeaths portrait, saying that he purchased it from Mrs. Edward M. Willett, his grandaunt // F. Morris, *MMA Bull.* 12 (July 1917), p. 160, mistakenly says child is Edward // *Antiques* 45 (June 1944), ill. p. 315 // J. T. Flexner, *Magazine of Art* 39 (Nov. 1946), ill. p. 280 // L. H. Averill, *John Vanderlyn, American Painter* (Ph. D. diss., Yale University, 1949; published, 1984), cat. no. 99, dates it ca. 1815; fig. 56 // A. T. Gardner, *The Panoramic View of the Palace and Gardens of Versailles* (1956), p. [10], says "it retains a note of restrained French elegance, simplified and modified perhaps by a sober American air" // Gardner and Feld (1965), pp. 121–122, date it ca. 1802, and say composition is reverse of drawing of Mrs. Church and child.

EXHIBITED: Stuyvesant Institute, New York, 1838, *Exhibition of Select Paintings by Modern Artists . . .* (Dunlap Benefit Exhibition), no. 149, as Portrait of a Lady and Child, lent by Mrs. Willet[t] // NAD, 1950, *Exhibition of the Founders* (no cat.) // MMA, 1965, *Three Centuries of American Painting* (checklist arranged alphabetically) // University Art Gallery, State University

of New York, Binghamton, 1970, *The Works of John Vanderlyn*, exhib. cat. by K. C. Lindsay, fig. 21, p. 128, compares to drawing of Mrs. Church and child, says Vanderlyn relinquished "French sophistication" for "rusticated severity."

EX COLL.: Mrs. Marinus Willett, New York, d. 1867; her daughter-in-law, Mrs. Edward M. Willett, New York, d. 1875; probably her husband, d. 1888; his grandnephew, George Willett Van Nest, New York, d. 1916.

Bequest of George Willett Van Nest, 1916.
17.87.2.

The Palace and Gardens of Versailles

When Vanderlyn first visited Versailles in 1797, he wrote his brother Peter on August 14 a rapt description of the palace and its gardens:

this grand palace is elevated & airy with large [fountains of] water in front of it & with statues in the middle representing Sea . . . Monsters [& c.] which spout water out of their Mo[uths] when the waters play which is on Days of public rejoicing. There are a thousand statues at least of marble scattered about in groves, gardens, avenues & labyrinths which are formed of [boskets] or thickets & the beauty & grandeur I cannot discribe [*sic*] you. The immagination [*sic*] can not conceive any thing so inchanting, surrounded by so many gods & goddesses though of marble that on[e] expects nothing else but to see Nymphs sporting every minute, so is the immagination warmed (R. R. Hoes Collection, Senate House Museum, Kingston, N. Y.).

By 1807, Vanderlyn was contemplating painting a panorama for public exhibition. It was not until about September of 1814, before returning to the United States, that he made a number of sketches of Versailles and its gardens, evidently with the intent of painting a panoramic view of them for exhibition back home. In 1816 he was discussing these plans and raising money from investors for a building in New York in which to show panoramas. The following year the city granted him land in City Hall Park for nine years, and Vanderlyn built a rotunda, an imposing neoclassical structure possibly designed by James O'Donnell, an Irish architect who had come to New York in 1812. The city had seen panoramas before, but they had been shown for popular entertainment. Vanderlyn presented his as high art, the educational equivalent of visiting Versailles itself, and his Rotunda, probably the first building in New York specifically designed for the exhibition of art, was an

expensive structure—so expensive, in fact, that it put Vanderlyn in debt for many years.

In 1818 Vanderlyn started to paint the panorama. The canvas, originally about 18 feet high and 165 feet long, consisted of 42-inch strips sewn together to make a continuous surface. The work was done in a barn near Kingston, New York, and he expected to finish it that summer with the aid of two assistants, one of whom, already arrived, he referred to as "a Swiss" (see Refs., J. Vanderlyn to H. Vanderlyn, June 28, 1818). This Swiss artist has been identified as Johann Heinrich Jenny, a topographical painter. The following spring, Vanderlyn was still at work on the painting, which he had set up in New York. That he was continuing to be aided by other artists is indicated by a letter of April 5, 1819, to his nephew Henry, in which he complained of the incompetence of the help he was able to get. Finally, on about July 1, the panorama could be exhibited, though Vanderlyn kept the Rotunda closed in the mornings "to retouch & introduce some figures & it still wants some more" (J. Vanderlyn to C. B. King, July 26, 1819). According to the artist, the painting generally met with praise, but already he had started what was to become a litany of complaints about the poor receipts from showing it.

A long series of travels with the panorama in fruitless search of substantial profits began as early as 1820. Only a partial itinerary can be determined from Vanderlyn's correspondence. After its showing in New York, the painting was exhibited in Philadelphia, then subsequently in Charleston, Montreal, Washington, and Boston. When Vanderlyn went to New Orleans in 1828 seeking a commission from the city to paint Andrew Jackson at the Battle of New Orleans, he took the panorama with him. He also planned to exhibit it in Havana in 1829, but presumably he could not find a proper site there to display it. It was shown in Savannah in 1833 and in Saratoga Springs, New York, in 1834, in a structure he had built especially for the purpose. In 1835, he sent it to Charleston with his nephew, the minor artist John Vanderlyn, Jr. (1805–1876). After this, it was shown at the "playhouse" of Eliza Jumel's summer house in Saratoga, New York. By 1848 the panorama seems to have been put in storage in Philadelphia, but that same year Vanderlyn, at the age of seventy-three, was contemplating another trip to New Orleans to exhibit it. Even in 1852, the year of

his death, he was writing to his friend Emile B. Gardette about plans to show the painting in Washington and Kingston. The panorama was in Washington when Vanderlyn died and was stored for many years in the crypt of the Capitol.

In a sense, the panorama of Versailles was Vanderlyn's undoing, as *Belshazzar's Feast* had been for his friend WASHINGTON ALLSTON. The Rotunda he built to house it was often unoccupied, and the efforts of other artists to use the space were an important cause of his increasingly embittered relations with the artistic community in New York. After the city took over the building, he embarked on a lifelong effort to get it back or at least receive some financial compensation for its loss. Moreover, the debts he had incurred in building it caused him serious embarrassment. Perhaps more important, however, the panorama and its exhibitions diverted Vanderlyn's energies from artistic efforts and into entrepreneurial ventures, which, as he was evidently a poor businessman, increased his financial woes and contributed significantly to the bitterness that characterized him in his later years.

An observer's initial reaction to the painting may be one of amazement at its size. Surrounded by an immense landscape, lit by the late afternoon sun, the viewer is stationed between the upper and lower part of the formal gardens, at the top of the steps that descend to the huge circular basin on one side, with the palace and water gardens on the other. An extremely wide and mostly empty brown avenue leads between large geometric pools to the severe, long brown facade of the palace; opposite, beyond the Bassin de Latone, seemingly enormous because of the spectator's proximity, a series of avenues bisects the vast area of wooded plantings, ending with the Grand Canal. There are small groups of figures scattered about the grounds, fashionably dressed, but static. Some are officers in the uniforms of the European powers that defeated Napoleon and brought about the restoration in 1814, at the time when Vanderlyn was making his sketches. Included are a few recognizable people: Czar Alexander I and King Frederick William II of Prussia. Vanderlyn himself is seen pointing out the monarchs to a companion. The only excitement introduced in the painting is the appearance of the Bourbon king, Louis XVIII, in white wig and blue-sashed uniform, at a second-story window in the center of the

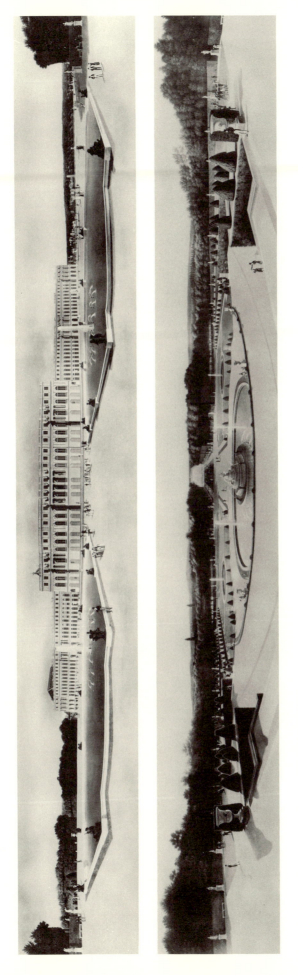

Vanderlyn, *The Palace and Gardens of Versailles.*

Alexander J. Davis, 1828 drawing of the Rotunda built to display the panorama in New York. NYHS.

palace. A small crowd below looks up, and four children at the left run forward for a closer view. Aside from this, the landscape, dotted at regular intervals with trees, sculptures, and fountains, lacks drama and interest and has no real visual focus, only expanses of space.

Although Vanderlyn seems to have been faithful to the actual appearance of the scene, his choice of it was perhaps not a good one. Unlike other panoramas, which showed urban or natural landscapes and battle scenes with a great variety of details, this is a restrained, neo-classical image of royal splendor, hardly the sort of subject to attract a large paying audience of Americans. Vanderlyn himself finally became aware of its limited appeal; for he wrote his friend, the diplomat David Bailie Warden, on August 2, 1824:

Had I bestowed my time and attention in painting a view of N. York, instead of Versailles I should I am now convinced have reaped more profits—but I was not aware of the general ignorance here respecting Versailles and its former brilliant court (R. R. Hoes Collection, Senate House Museum, Kingston, N. Y.).

The Palace and Gardens of Versailles is the only remaining full-scale panorama by an American artist. When it came to the museum in 1952, it needed considerable restoration. This was car-

Detail of the right section of Vanderlyn, *Gardens of Versailles*. Identified at the left is Vanderlyn and a companion. In the center group is Alexander I of Russia (holding a lorgnette) and standing next to him (hands clasped) is Frederick William III of Prussia.

Vanderlyn, perspective drawing for the *Gardens of Versailles* (view to the north). Senate House State Historic Site, Kingston, N. Y.

ried out by Laurence J. Majewski with funds contributed by Emily Crane Chadbourne, who was instrumental in arranging the gift of the painting to the Metropolitan from the Senate House Museum, of which she was a trustee. Rolled up and stored for many years on long thin spools, the canvas was curved and buckled, as well as coated with dirt and suffering from paint loss. There were twenty-four odd sections, none longer than fifteen feet, and although not much of the total length had been lost, large pieces were missing from the top and bottom of various sections, probably to enable their being used as individual decorative panels. Before its installation in a new gallery in 1982-1983, the painting was further restored under the direction of Gustav Berger and Peter Fodera of Berger Art Conservation. Gustav Berger devised a flexible fiberglass backing to support the great weight of the canvas and prevent it from buckling. Based on Vanderlyn's original drawings and on photographs of Versailles, missing portions of the panorama were added.

Oil on canvas, 12 × 165 ft. (3.6 × 50 m.).

RELATED WORKS: Sketches of sculptures that appear in the painting, ca. 1814–1815, Senate House Museum, Kingston, N. Y.: Study of Allegorical Figure Poema Lyricum, pencil, squared, 10⅝ × 4¾ in. (27 × 12.1 cm.), 1975, ill. in University Art Gallery, State University of New York at Binghamton, *The Works of John Vanderlyn*, exhib. cat. (1970), no. 46; Study of Hermes with the Infant Dionysos and of a nude standing male figure, pencil, 11¾ × 9 in. (29.9 × 22.9 cm.), 1975–706; Study of a standing nude male figure (Hermes?), pencil, 12 × 9 in. (30.5 × 22.9

cm.), 1975–707; Study of a reclining woman and child, pencil on gray paper, 7½ × 5¼ in. (19.1 × 13.3 cm.), 1975–703; Two studies of a putto and sphinx on a pedestal, pencil, 9¼ × 12 in. (23.5 × 30.5 cm.), 1975–741; Study of a god and chained reclining woman and child, 12⅞ × 8 in. (32.7 × 20.3 cm.), 1975–705; Study of a herm with cornucopia, pencil, 8 × 4½ in. (20.3 × 11.4 cm.), 1975–700; Study of three herms, pencil, 11⅛ × 5½ in. (28.3 × 14 cm.), 1975–751; Study of a nude reclining female figure, pencil on brown paper, 8½ × 8 in. (21.6 × 20.3 cm.), 1975–702; Study of a standing male figure, pencil, 12 × 3¾ in. (30.5 × 9.5 cm.), 1975–704; Study of two classical figures, pencil, 8 × 9 in. (20.3 × 22.9 cm.), 1975–701 // Study of two putti on pedestal, inscribed "Bassin de Droite n° 5," pen and black ink, brush and gray wash on blue paper, 5¼ × 4½ in. (sight) (13.3 × 11.4 cm.), coll. Fred. J. Johnston // Study of a woman with putti, black and white chalk on gray paper, 6¾ × 5¼ in. (17.2 × 13.3 cm.), ibid. // Study of three putti on pedestal, inscribed "Bassin de Gauche n° 8," pen and black ink, brush and gray wash on green paper, 5¼ × 4¼ in. (13.3 × 10.8 cm.), ibid., ill. in University Art Gallery, State University of New York at Binghamton, *The Works of John Vanderlyn*, exhib. cat. by K. C. Lindsay (1970), no. 47 // Study of three putti with wreath, inscribed "bassin de Droite n° 2," black and white chalk on brown paper, 7 × 5 in. (sight) (17.8 × 12.7 cm.), ibid., ill. ibid., no. 48 // Study of a group of officers, charcoal on tan paper, 18⅛ × 22 13/16 in. (46 × 57.9 cm.), Senate House Museum, 1975–583 // Studies of forty-five figures on façade of palace, numbered, pencil, 17 × 11¾ in. (sight) (43.2 × 29.9 cm.), coll. Fred J. Johnston // Studies of reclining male nude figure (possibly for this painting), black chalk, 11¾ × 17⅞ in. (29.9 × 45.4 cm.), Senate House Museum, 1975–708 // Attributed to John Vanderlyn, *Oil Sketch for Versailles Panorama: View to West*,

oil on paper mounted on cardboard, 11 × 15½ in. (27.9 × 39.4 cm.), coll. Fred J. Johnston // Pencil drawings for the painting, squared for transfer, all in the Senate House Museum: View of the gardens, 13 9/16 × 38¼ in. (34.5 × 97.2 cm.); View of the palace, 11 7/8 × 39 in. (30.2 × 99.1 cm.); View of the pool and avenue of statues, 13 15/16 × 35¼ in. (35.4 × 89.5 cm.); View of the fountain and woods, 32½ × 14¾ in. (82.6 × 37.5 cm.); View of the fountain and canal, 35 3/8 × 14¼ in. (89.9 × 36.2 cm.).

REFERENCES: H. Vanderlyn to J. Vanderlyn, August 2, 1807, Henry Darrow Collection, Senate House Museum, Kingston (hereafter cited as Darrow coll.), says he is pleased with Vanderlyn's "Panorama scheme" (possibly referring to this picture) // W. Lawrence to S. A. Lawrence, April 15, 1816, Darrow coll., mentions Vanderlyn's desire to set up a place in New York to show a panorama (presumably this painting) // J. Vanderlyn to H. Vanderlyn, June 6, 1818, John Vanderlyn Misc. MSS, NYHS (hereafter cited as Vanderlyn Misc. MSS) // J. Vanderlyn to J. Brown, June 27, 1818, R. R. Hoes Collection, Senate House Museum, Kingston (hereafter cited as Hoes coll.), says he has "just commenced" this painting // J. Vanderlyn to H. Vanderlyn, June 28, 1818, Vanderlyn Misc. MSS, gives dimensions, says he is preparing canvas for the painting in Kingston, has one assistant "(a Swiss)," expects another // J. W. Jarvis to J. Vanderlyn, Nov. 5, 1818, Darrow coll., says he thinks panorama will succeed, urges Vanderlyn to finish it // J. Vanderlyn to R. Earl, April 2, 1819, letter owned in 1931 by Harry Bland, photostat, Vanderlyn Misc. MSS, says he is engaged in finishing the painting // J. Vanderlyn to H. Vanderlyn, April 5, 1819, ibid., says he has put the canvas in New York in the "Circus," complains about his assistants, expects to finish in May // J. Vanderlyn to C. B. King, July 26, 1819, ibid., says Versailles has been exhibited for last three weeks in afternoon; continuing to work on it (quoted above); notes that business is slow // J. Vanderlyn to J. Vanderlyn, Jr., March 1820, ibid., writes from Washington to inquire about panorama's receipts in New York // J. Vanderlyn, Jr., to J. Vanderlyn, Nov. 22, 1820, Darrow coll., gives receipts of exhibition in Philadelphia // J. Gardette to J. Vanderlyn, June 5, 1821, ibid., says panorama has arrived in Philadelphia // T. Field to J. Vanderlyn, Sept. 18, 1821, ibid., discusses Vanderlyn's plans to exhibit painting in Raleigh, Fayetteville, Charleston, and New Orleans // J. Gardette to J. Vanderlyn, Nov. 6, 1821, ibid., says painting being exhibited in Philadelphia as a benefit but receipts are poor // J. Vanderlyn to J. Vanderlyn, Jr., March 18, 1822, ibid., plans to close exhibition of Versailles in Charleston on April 1 // J. Vanderlyn to N. Vanderlyn, Oct. 8, 1823, Vanderlyn Misc. MSS, plans to exhibit panorama in Boston // J. Gardette to J. Vanderlyn, Oct. 15, 1823, Darrow coll., tells Vanderlyn he is sorry exhibition of painting in Canada did not succeed // J. Vanderlyn to J. Vanderlyn, Jr.,

March 8, 1824, Hoes coll., says he has left painting in Washington // J. Vanderlyn to D. B. Warden, August 2, 1824, Hoes coll. (quoted above) // L. Jarvis to J. Vanderlyn, Nov. 15, 1824, Vanderlyn Misc. MSS, discusses costs of building to exhibit painting in New Orleans // H. Barron to J. Vanderlyn, March 18, 1826, Darrow coll., gives receipts for exhibition in Washington // J. Vanderlyn to J. Townsend, August 23, 1828, Vanderlyn Misc. MSS, says exhibiting Versailles in New Orleans // J. Vanderlyn to J. Vanderlyn, Jr., July 10, 1829, Darrow coll., plans to exhibit the painting in Baltimore // New-York Mirror, and Ladies' Literary Gazette 7 (Sept. 26, 1829), p. 1, describes exhibition of this and other panoramas, says they "have given great and general satisfaction, and reflected much honour on the tasteful and indefatigable artist" // J. Vanderlyn to J. Vanderlyn, Jr., Feb. 27, 1831, Darrow coll., discusses sending it to Savannah; says in order to fit in limited exhibition area "Versailles might be contracted in its circumference 10 or 12 feet as I have done in one or two instances" // J. Vanderlyn, Jr., to J. Vanderlyn, April 3, 1833, ibid., is in Savannah with it // J. Vanderlyn, Jr., to J. Vanderlyn, May 28, 1833, Hoes coll., tells him exhibition is "a dead loss" // J. Vanderlyn to J. Vanderlyn, Jr., 1833, ibid., plans to exhibit it again in Philadelphia // J. Vanderlyn, Jr., to J. Vanderlyn, June 22, 1834, Darrow coll., reports belief that Saratoga Springs exhibition will be popular // J. Vanderlyn, Jr., to J. Vanderlyn, August 7, 1834, ibid., reports poor receipts there // J. Vanderlyn to R. Burford (copy), Nov. 14, 1834, Darrow coll., has just sent panoramas of Versailles and Geneva to Charleston // W. Dunlap, History of the Rise and Progress of the Arts of Design in the United States (1834), 2, pp. 39–41, says expected cost of Rotunda $8,000, actual cost between $13,000 and $14,000, lists paintings exhibited there by Vanderlyn, including this one, describes vicissitudes of scheme // J. Vanderlyn, Jr., to J. Vanderlyn, May 22, 1835, Darrow coll., has just put up Versailles in Charleston // J. Vanderlyn, Jr., to J. Vanderlyn, June 13, 1835, ibid., reports Versailles exhibition a failure // J. P. Sherwood to J. Vanderlyn, Feb. 5, 1836, Vanderlyn Misc. MSS, reports that Versailles has just been taken down in Charleston // J. Vanderlyn to L. Vanderlyn, Jan. 18, 1837, Hoes coll., says has left Versailles to John Vanderlyn, Jr. // [J. Vanderlyn], Review of the "Biographical Sketch of John Vanderlyn, Published by William Dunlap, in His "History of the Arts of Design"; with Some Additional Notices Respecting Mr. Vanderlyn as an Artist, By a Friend of the Artist (1838), p. 556, says taken to New Orleans in 1828, implies it was there in 1820 // J. Vanderlyn to L. Vanderlyn, July 26, 1839, Vanderlyn Misc. MSS, says John Vanderlyn, Jr., showing it in Saratoga // J. Vanderlyn to J. Vanderlyn, Jr., April 26, 1840, Hoes coll., says the painting was exhibited in "the old playhouse of Mrs. Jumel" and he wishes "the canvas was better preserved" // J. Vanderlyn to G. Le Row, Feb. 27, 1844, Remensnyder Collection,

Senate House Museum, Kingston, says he showed Versailles in New Orleans for six weeks beginning in mid-March 1828 // J. Vanderlyn to E. B. Gardette, June 2, 1847, Vanderlyn Misc. MSS, plans to exhibit it in Saratoga Springs // J. Vanderlyn to E. B. Gardette, June 29, 1847, ibid., says exhibition drawing poorly // J. Vanderlyn to E. B. Gardette, Oct. 24, 1847, ibid., says Saratoga exhibition was a failure // J. Vanderlyn to E. B. Gardette, Oct. 26, 1848, ibid., says he is going to New Orleans and may exhibit this painting, says he will write Gardette for it // J. Vanderlyn to E. B. Gardette, March 26, 1852, ibid., plans to exhibit "my panorama" in Washington, thinking of showing it in Kingston // R. Gosman to Commissioner of Public Buildings, Washington, D. C., Oct. 13, 1852, asks whereabouts of painting; reply at bottom, says rolled up in Capitol // R. Gosman to Commissioner of Public Buildings, Washington, D. C., Nov. 10, 1853, asks that painting be sent to John Vanderlyn, Jr., in New York // R. Gosman, lectures on Vanderlyn, ca. 1850-1860, MS in the Museum of the City of New York, pp. 31–33, refers to Jenny as "a young French artist" who accompanied Vanderlyn to America and assisted with the painting // I. N. P. Stokes, *Iconography of Manhattan Island* 5 (1926), p. 1610, quotes notice from *New York Evening Post*, May 26, 1820, that the Versailles panorama, "covering 3,000 sq. ft of canvas," is on view in the Rotunda // L. H. Averill, *John Vanderlyn, American Painter* (Ph. D. diss., Yale University, 1949, published 1984), pp. 115–117; pp. 120–121, says it cost $2,000 to paint; pp. 133–134, gives receipts; pp. 139, 173; cat. no. 14, dates it 1818; fig. 35, shows detail // L. B. Miller, *New York History* 32 (Jan. 1951), pp. 37, 39–40, says Vanderlyn's panoramas of European scenes were out of date // A. T. Gardner and L. J. Majewski, in *The Panoramic View of the Palace and Gardens of Versailles* (1956), unpaged, describe the history of the painting and the Rotunda, give a detailed account of the restoration, and include large foldout photographic reproduction // T. Bolton, *Art News* 55 (Nov. 1956), pp. 42–44 // Gardner and Feld (1965), pp. 123–125 // S. Mondello, *New-York Historical Society Quarterly* 52 (April 1968), pp. 172, 176–179 // University Art Gallery, State University of New York at Binghamton, *The Works of John Vanderlyn*, exhib. cat. by K. C. Lindsay (1970), pp. 57–59, 135–136, discusses related works // L. Parry, *Art in America* 59 (Nov.-Dec. 1971), pp. 55–56 // W. T. Oedel, letter in Dept. Archives, July 10, 1979, refers to three drawings for this painting in Senate House Museum and gives information // S. Oettermann, *Das Panorama: Die Geschichte eines Massenmediums* (1980), pp. 253–255, gives historical context // W. T. Oedel, *John Vanderlyn* (Ph. D. diss., University of Delaware, 1981), pp. 413–416, discusses the beginnings of the project, notes that Vanderlyn used a camera obscura to make drawings; pp. 427–434, discusses the execution of the work, noting that the Swiss artist probably did most of the

Vanderlyn, drawing of three putti, the "Bassin de Gauche, No. 8." Coll. Fred J. Johnson, Kingston, N. Y.

landscape; says it was installed in the Rotunda in June of 1819, main problem is it has too much empty space; notes that it exhibits all the attributes of neoclassicism // Foundation for the Preservation of the Centenarian Mesdag Panorama, The Hague, *The Panorama Phenomenon*, exhib. cat. (1981), pp. 73–74 // K. Avery, MMA, orally, June 30, 1988, supplied correct name of Swiss artist and identified figures in the panorama // K. J. Avery and P. L. Fodera, *John Vanderlyn's Panoramic View of the Palace and Gardens of Versailles* (New York, 1988), discuss the history and reinstallation of the panorama.

EXHIBITED: Rotunda, New York, July 1819–after Oct. 1820, *Description of the Panorama of the Palace and Gardens of Versailles*, 1821, cat. by J. Vanderlyn // Philadelphia, Nov. 1820–after Nov. 1821 // Charleston, by March 1822 // Montreal, 1823 // Washington, D. C., 1826 // Boston, 1827 // New Orleans, by August 1828 // Savannah, by April-May 1833 // Saratoga Springs, N. Y., June-August 1834 // Charleston, May 1835–Feb. 1836 // "Tuileries," estate of Eliza Jumel, Saratoga Springs, between 1836 and 1839 // Saratoga Springs, June-August 1847 // Senate House Museum, Kingston, N. Y., 1938, *Exhibition of the Works of John Vanderlyn*, nos. 42–46, as fragments.

John A. Sidell

Born in New York, John Augustus Sidell (1794–1850) married Marilla Adeline Noxon in 1820. Vanderlyn probably knew Sidell, who was an attorney and master in chancery, as early as July 1829 and is thought to have painted this portrait of him shortly after, perhaps the following year. In 1832 Sidell was serving as Vanderlyn's agent during the latter's extended periods away from New York, and in 1834 he was his attorney in one of the artist's recurring legal battles with the city of New York. At about this time, Vanderlyn lent Sidell approximately two thousand dollars (quite possibly the proceeds of his commission to paint a portrait of George Washington for the United States Congress) and accepted as security some building lots in Harlem. For a while Sidell appears to have made payments on the loan, and he continued to act as Vanderlyn's lawyer and agent. Starting in 1838, however, when Vanderlyn was in Paris, Sidell began to experience financial difficulties and was unable to repay him. By 1844, Vanderlyn, still in Paris, was writing of him in increasingly embittered tones:

It is this wretch Sidell who is the cause of my lingering here so long. I lost all last summer of the want of funds unable to work at my picture ... every step taken by him should be looked upon with distrust & profoundly examined (J. Vanderlyn to J. H. Shegogue, Feb. 6, 1844, Darrow Collection, Senate House Museum, Kingston, N. Y.).

As late as 1848, Vanderlyn was suing Sidell, but there is no evidence that he was ever successful.

Vanderlyn's portrait of Sidell was probably the portrait of a gentleman shown in the National Academy of Design's exhibition of 1830 as lent by "I. Sidel." In style and manner of execution, it is similar to his other works of the period, for example, the portrait of John Sudam of 1830 (National Gallery of Art, Washington, D. C.) and that of Philip Hone, 1827 (Art Commission, City of New York). As in Vanderlyn's

Vanderlyn, *John A. Sidell.*

French-influenced portraits of the years just after 1800, Sidell is depicted in a narrow space before wall paneling that is neoclassical in style. His face is sharply lit from the side, with the light focused on it in a manner adopted from Jacques Louis David. In execution, however, the portrait is markedly different from otherwise similar ones Vanderlyn painted a quarter of a century earlier. As opposed to his previous technique with its crisp handling and subtly modulated colors, the brushstrokes here, especially in the neckcloth, are looser and more sketchily applied, and the details of the dull black coat are scarcely visible. Even the face, in comparison with his earlier work, seems slightly blurred and the execution less assured and refined. No doubt this represents in part a slackening in Vanderlyn's artistic effort and even ability, but it might also be an attempt to accommodate himself to the popular style of portrait painting in New York as practiced by SAMUEL L. WALDO and WILLIAM JEWETT.

Oil on canvas, 30 × 24 in. (76.2 × 61 cm.).

Inscribed on the back: By *J. Vanderlyn / Died* 1852.

REFERENCES: L. H. Averill, *John Vanderlyn, American Painter* (Ph. D. diss., Yale University, 1949; published 1984), pp. 142–143, says the portrait shows

Vanderlyn's declining powers, notes poor placement of figure and lack of sureness in handling; cat. no. 80, dates it between 1825 and 1830; fig. 42 // A. T. Gardner, in *The Panoramic View of the Palace and Gardens of Versailles* (1956), dates it ca. 1830–1835 // Gardner and Feld (1965), p. 125, date it ca. 1830 // W. T. Oedel, letter in Dept. Archives, July 10, 1979, gives information about the sitter.

EXHIBITED: NAD, 1830, no. 19, as Portrait of a Gentleman, lent by I. Sidel.

Ex COLL.: John A. Sidell, d. 1850; his son, C. V. Sidell, 1850–1899.

Bequest of C. V. Sidell, 1899.
02.25.

Francis Lucas Waddell

Born into a wealthy New York family, Francis Lucas Waddell (1808–1859) married Louisa Smith, the daughter of Thomas H. Smith, a rich merchant in the East India trade. They lived on 17th Street near Gramercy Park, possibly with Waddell's father-in-law. In 1851 they moved to 84 East 18th Street, where they lived until 1859, the year of Waddell's death. Francis Waddell published four volumes of now-forgotten poetry: *Texas, Fall of San Antonio, Death of Milan, Goliad, and Other Poems* (1844), *The Drift Wood Spar* (1853), *An Autumn Dream* (1857), and *Old Buck's Feast; or, The Power of Office* (1859), the latter a satirical poem attacking James Buchanan. His personality was vividly summarized as follows:

Francis L. Waddell . . . probably the most widely known young man in his day . . . possessed a gentlemanly impudence that was sublime. Upon our rich nabobs, who possessed no other shining quality than money, Frank absolutely looked down. There were men in the city that Frank would not have borrowed money of in the days of his hardest need, and Frank did see some tough times. It was a curious trait about Frank, that he would spend his money as free as water when he had it. He had no selfishness. He was clever in every sense and meaning of the word. He was a shining light in our highest society. He was courted by every one, and when he died, no one in our great living crowd was ever more missed . . . No one was better known at our celebrated watering place, Saratoga, than Frank Waddell. He never failed to be at Marvin's United States Hotel, as the season came round, and probably no person was ever more identified with the gayeties of a fashionable resort—like this,—than our friend Frank. He was the Beau Brummel of the place Frank was a *bon vivant* of the first order. He was the most remarkable man for wit

Vanderlyn, *Francis Lucas Waddell.*

and humor at the table that we ever saw (W. Barrett [J. Scoville], *The Old Merchants of New York*, 4 [1885], pp. 72–73).

Vanderlyn depicts Waddell with partly open collar and informal tie, attire that suggests his poetic aspirations. The portrait has a looser, less precise style than that of Vanderlyn's earlier work, and it could represent an attempt to adopt the more painterly style popular in the second quarter of the nineteenth century. Unfortunately, it is unsuccessful; the paint is awkwardly applied, and the subject's features, especially the right eye, seem distorted. On the whole, the portrait appears flat and unconvincing, showing a rather sharp decline in quality from the level of Vanderlyn's earlier work. It should probably be dated about 1837, when Waddell served as the artist's agent. A later date is unlikely, because in 1838 Vanderlyn instituted a suit against Waddell for an unpaid debt of $195. He held Waddell's note in that amount for a painting, presumably by him, that is otherwise unknown, a "picture of man between vice & virtue" (J. Vanderlyn to L. Vanderlyn, Jan. 18, 1837, Darrow Collection, Senate House Museum, Kingston, N. Y.).

Oil on canvas, 25¼ × 21 in. (64.1 × 53.3 cm.).

REFERENCES: L. H. Averill, *John Vanderlyn, American Painter* (Ph. D. diss., Yale University, 1949; published 1984), cat. no. 94, as Frank Waddell, ca. 1840; fig. 65 // Gardner and Feld (1965), pp. 125–126, date it between 1825 and 1835, based on the subject's age.

EXHIBITED: NAD, 1950, *Exhibition of the Founders* (no cat.).

EX COLL.: Mrs. Ann S. Stephens, New York, d. 1886; her daughter, Ann S. Stephens, New York, 1886–1918; her heirs, 1918–1919.

Gift of Mrs. M. Howard Hoopes and Miss Grace H. Patterson, in memory of Miss Ann S. Stephens, 1919.

19.18.

The Calumny of Apelles

Vanderlyn described the subject of this monochrome in a letter of July 26, 1852, to his friend C. H. Van Gaasbeek:

Apelles[,] says Lucian, implicated without cause in a conspiracy against Ptolomy [*sic*], king of Egypt, painted [this] to revenge himself of his persecutors, Credulity characterized by long ears; seated between Ignorance and Suspicion, receives Calumny, who in the fair form of a woman richly dressed advances towards the chair dragging by the hair Innocence, whose arms and hands are raised towards heaven, imploring assistance. Envy with cross eyes and pale and haggard face guides the steps of Calumny, who has for companions Fraud and Artifice occupied in decking her. Behind them follows slow Repentance in a long mantle of mourning tearing her hair, and biting her fingers at the sight of Truth, who shows herself without veil or cover in all her loveliness.

That it was painted in Washington in the early months of 1849 was indicated by Vanderlyn in a letter from there dated April 9 of that year to an unidentified correspondent, probably his friend Emile B. Gardette of Philadelphia. At the same time, he made clear the source of his composition as well as the purpose for which he intended the painting:

A portion of my time has been employed in making a copy, somewhat enlarged of a drawing I had in my portfolio, copied after a sketch in bister by Raphael out of the collection of sketches in the Louvre by the old Masters—made now about 50 years ago, the subject is Calumny Whilst engaged in this work it was suggested to me that it would make a good engraving or print, and I thought the suggestion a good one, and intend to pursue it if I can get a person to engrave it in a decent manner, perhaps Sart[a]in

of your City would do. The figures have much of the grace of spirit of the great Master, which must be preserved in the engraving. . . . You may, if convenient, speak to Sart[a]in the Engraver if he could undertake it.

Vanderlyn's *Calumny of Apelles* was never engraved, and his thinking a print of it might be popular indicates the degree of his estrangement from the American taste of the period, when popular paintings were those of the Hudson River school and genre scenes by artists like GEORGE CALEB BINGHAM and WILLIAM SIDNEY MOUNT. It is ironic, too, to find Vanderlyn saying of his work that "the figures have much of the grace of spirit of the great Master," when they seem so ill drawn. In this case, however, the fault was not entirely his, as much of the clumsiness of the painting is present in the sketch that was his model. In the drawing in the Louvre, now no longer attributed to Raphael, the head of Repentance, the second figure from the left, appears to be unattached to her body, just as it does in Vanderlyn's painting. Actually, he often corrected defects in the original, for example, in the figure of Truth at the far left, he altered her awkwardly foreshortened left arm and oversized hand and also corrected the drawing of her right hip. Otherwise, except to add a bit of drapery to the figure of Innocence, Vanderlyn changed the figures very little. Overall, however, he lightened the composition considerably, eliminating the mysterious shadows and giving it a neoclassical clarity.

Although he had made the drawing after the Louvre sketch some fifty years before, Vanderlyn's choice of subject matter for this painting probably had much to do with his later years, when he believed himself to be beset by enemies, frequently other artists. His *Landing of Columbus*, 1839–1846 (U. S. Capitol), had occasioned several reports that he had paid a French artist to execute it, a charge that was at least partially true. Whether or not the Columbus was painted with the aid of assistants, not an unusual practice for a work of that size, Vanderlyn certainly felt himself to be a victim—not unlike Apelles. On July 25, 1850, he wrote Gardette from New York, "I have experienced so much of calumny and vituperation from the rascally clique of artists & their allies here & in other parts of our Country that I shall be obliged to come out with a justification & Vindication."

Vanderlyn wrote in March 1852 to Van

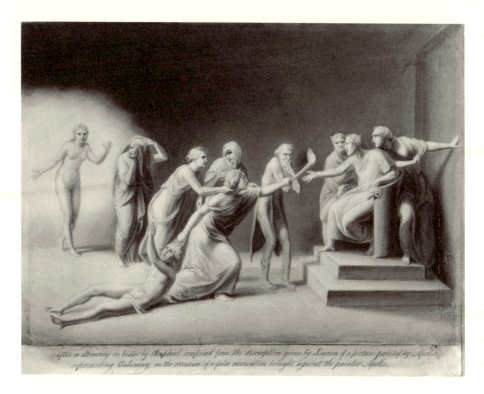

Vanderlyn, *The Calumny of Apelles*, and (below), Vanderlyn, drawing of two figures for *The Calummy of Apelles*. Senate House State Historic Site, Kingston, N. Y.

Gaasbeek that two hundred dollars would be an inadequate price for the painting. He sold it, however, to a Mr. Elmendorf for fifty-one dollars. Vanderlyn apparently exercised an option to replace it with a portrait a few months later; for the painting was subsequently bought from his niece, who presumably inherited it from him.

Oil on canvas, $22\frac{1}{2} \times 28\frac{1}{2}$ in. (57.2 × 72.4 cm.), including an added strip of oil on paper at the right, measuring $1\frac{3}{4}$ in. (4.5 cm.).

Inscribed by the artist on a strip of paper attached to the bottom of the canvas: After a drawing in bister by Raphiel composed from the description given by Lucien of a picture painted by Apelles / representing Calumny, on the occasion of a false accusation brought against the painter Apelles.

Canvas stamp: PREPARED BY / EDW. DECHAUX / NEW YORK.

RELATED WORKS: Study for two figures, pencil, $3\frac{3}{8} \times 4\frac{7}{8}$ in. (8.6 × 12.4 cm.), ca. 1800, Senate House Museum, Kingston, N. Y., 1975.600.13 // School of Raphael, *Calumny*, ink and bister wash, $12\frac{3}{8} \times 18\frac{7}{16}$ in. (31.4 × 46.8 cm.), 16th century, Louvre, 3878, ill. in Louvre, *Les Dessins de Raphaël* (n.d.), cat. by G. Rouchès, no. 12.

REFERENCES: J. Vanderlyn to E. B. Gardette?, April 9, 1849, and July 25, 1850, John Vanderlyn Misc. MSS, NYHS (quoted above) // J. Vanderlyn to C. H. Van Gaasbeek, Sept. 18, 1850, Hoes Col-

lection, Senate House Museum, Kingston, N. Y., says he is leaving painting in Kingston to sell by subscription // Vanderlyn to Van Gaasbeek, March 26, 1852, John Vanderlyn Misc. MSS, NYHS, says, "I am also at a loss to dispose of my small picture of Calumny for anything like a decent compensation, $200 would be an inadequate sum—and this I fear I shall not be able to get" // Vanderlyn to Van Gaasbeek, July 12, 1852, Hoes Collection, Senate House Museum, offers to sell it for fifty or sixty dollars and exchange it in August or September for a portrait; July 23, 1852, says he is absolutely dependent

John Vanderlyn

267

upon sale of Calumny; July 26, 1852, identifies figures (quoted above) // Van Gaasbeek to Vanderlyn, July 31, 1852, ibid., informs him he has sold it to Elmendorf for fifty-one dollars // M. Schoonmaker, *John Vanderlyn, Artist* (1892; 1950), p. 72 // L. H. Averill, *John Vanderlyn, American Painter* (Ph. D. diss., Yale University, 1949; published 1984), pp. 180–181, says it was finished at the same time as unlocated painting called Suicide of Cleopatra but no immediate buyer was found, considers it heavy and clumsy, calls modeling hard and dry, and notes Vanderlyn's description of its subject to Van Gaasbeek; cat. no. 112, dates it 1850, gives information on provenance; fig. 54 // A. T. Gardner, in *The Panoramic View of the Palace and Gardens of Versailles* (1956), p. [10], says based on engraving by Normand in C. P. Landon's *Vies et oeuvres des peintres les plus célèbres de toutes les écoles* (1808), 7, pl. 472, and not on Raphael drawing, but gives no evidence for this, implies that it dates to Vanderlyn's student days in Paris // Gardner and Feld (1965), pp. 126–127, quote passage in Lucian, date after 1829 or after 1845, say after Raphael drawing, not Normand engraving // W. T. Oedel, letter in Dept. Archives, July 14, 1979, supplies photograph and information on drawing in the Senate House Museum.

EXHIBITED: University Art Gallery, State University of New York, Binghamton, 1970, *The Works of John Vanderlyn*, exhib. cat. by K. C. Lindsay, fig. 16, p. 26; pp. 126–127, says after Raphael, who based his drawing on Botticelli's painting of the same subject in the Uffizi, dates after 1835 on the basis of canvas stamp, says it may have been painted in Paris between 1839 and 1845 or in this country in 1845–1846.

Ex COLL.: the artist, 1849–1852; Mr. [Nicholas] Elmendorf, Kingston, N. Y., 1852; probably the artist, d. 1852; probably his nephew, John Vanderlyn, Jr., Kingston, 1852–d. 1876; his sister, Catherine Vanderlyn, Kingston, 1876–d. 1892; George H. Sharpe, Kingston, 1892–d. 1900; his family.

Gift of the family of General George H. Sharpe, 1924.

24.186.

JACOB EICHHOLTZ

1776–1842

Jacob Eichholtz was always pleased that he arrived in this world the year the Declaration of Independence was signed. He was born in Lancaster, Pennsylvania, to a family of German descent. Although he had some early instruction from a sign painter, he supported himself at first as a copper- and tinsmith. According to the autobiographical sketch he sent WILLIAM DUNLAP, who later quoted it in his work on American artists, "Chance . . . threw a painter into the town of my residence. This in a moment decided my fate as to the arts" (2, p. 229). Eichholtz's early work consists largely of rather crude profile portraits. In 1808, however, THOMAS SULLY visited Lancaster and gave Eichholtz some paint brushes, encouragement, and instruction as well. He said that he was later gratified to see Eichholtz's improvement. Although Eichholtz continued to do business as a smith as well as a painter, his artistic ambition remained strong. In 1810 he made a careful copy of a portrait by GILBERT STUART, and the following year he went to Boston to pay him a visit, receiving "sound lectures and hope" (Dunlap, 2, p. 230). Eichholtz appears to have benefited considerably from this experience; in fact, his painting in the years afterward was a sort of small-town version of Stuart's style tinctured with a substantial admixture of Sully's. At the same time, he retained something of the directness and even naiveté of the country or folk artist. If his sitter's face was too thin or his nose too short, he made no attempt to hide the fact, and

consequently his likenesses often have a good deal of charm and, on occasion, humor. His fidelity to appearances, however, could result in images of dramatic intensity, even power, such as his 1820 portrait of Abraham Freeman (Cincinnati Historical Society). This painting, showing a wrinkled, toothless old man lost in thought, is a work that recalls the realistic depictions of such eighteenth-century artists as JOHN SINGLETON COPLEY and CHARLES WILLSON PEALE.

To some extent, Eichholtz was an itinerant artist, traveling as far afield as Baltimore and Pittsburgh. In about 1823 he moved to Philadelphia and remained there until 1831, when he had earned enough money to buy a house for his large family in Lancaster. He often returned to Philadelphia and seems to have lived there again from 1838 to 1841. As might be expected from his links with that city, Eichholtz's later work continued to show an increasing debt to Sully. That artist's taste for the sentimental appears from time to time in Eichholtz's portraits.

BIBLIOGRAPHY: William Dunlap, *History of the Rise and Progress of the Arts of Design in the United States* (2 vols.; New York, 1834), 2, pp. 228–230. A short autobiography // W. U. Hensel, *Jacob Eichholtz, Painter: Some "Loose Leaves" from the Ledger of an Early Lancaster Artist* (Lancaster, Pa., 1912). The artist from the point of view of a local historian, includes a partial list of his works // John Calvin Milley, "Jacob Eichholtz, 1776–1842, Pennsylvania Portraitist," M. A. thesis, University of Delaware, 1960. A careful account of the artist's stylistic development // Rebecca J. Beal, *Jacob Eichholtz, 1776–1842: Portrait Painter of Pennsylvania* (Philadelphia, 1969). An extensive catalogue of the artist's work, it includes a short essay by E. P. Richardson.

Eichholtz, *Samuel Humes.*

Samuel Humes

Like many of Eichholtz's sitters, Samuel Humes (1754–1836) was born in Lancaster, Pennsylvania. A member of that small city's prosperous middle class, he was treasurer of the Sun Fire Company from 1798 to 1822 and served as assistant city burgess in 1803 and 1804. In 1799 he married Mary Hamilton. They had five children, all of whom, with their spouses, were painted by Eichholtz, some of them several times.

When this portrait came to the museum, the subject was identified as Samuel Humes's son, Dr. Samuel Humes (1788–1852). Because the previous owner had also had a companion portrait of the sitter's wife (now unlocated), and the younger Humes never married, the original identification was dropped. Rebecca J. Beal, the author of the Eichholtz catalogue, recognized that the subject must be the elder Humes and convincingly based her identification on a very similar likeness of him by Eichholtz dated 1810 (private coll., ill. in Beal, 1969, p. 287). She has dated the museum's portrait about 1825.

Stylistically, the painting recalls the work of

GILBERT STUART and THOMAS SULLY. The rendering of the face, and especially the ruddy coloring, resembles Stuart's style, but the hair is in the more broadly stroked manner of Sully. Neither painter, however, would ordinarily have shown his sitter wearing his spectacles and holding the case, nor would they have delineated the outline of the coat so sharply. Thus, despite the artistic influences evident in Eichholtz's work, his literal and direct style remains his own.

Oil on canvas, 29 × 24⅛ in. (73.7 × 61.3 cm.).

REFERENCES: E. P. Richardson, *Art in America* 27 (Jan. 1939), pp. 21–22, identifies as portrait of Dr. Samuel Humes (1788–1852), recorded in Eichholtz's account book on Sept. 10, 1836, but notes stylistic incongruity with other work of 1830s // R. J. Beal, letters in Dept. Archives, June 29, July 8, Sept. 15, 1964, gives evidence for believing the subject not to be Dr. Samuel Humes // Gardner and Feld (1965), p. 130, identify the subject as man of the Humes family, ca. 1815, exhibited at Woolworth Building, Lancaster, Pa., 1912 // R. J. Beal, letter in Dept. Archives, Oct. 6, 1965, says painting exhibited in 1912 is now in Lancaster Free Public Library // R. J. Beal, letter in Dept. Archives, Sept. 4, 1968, identifies sitter as Samuel Humes (1754–1836) // R. J. Beal, *Jacob Eichholtz, 1776–1842* (1969), p. 115, no. 378; ill. p. 326.

EXHIBITED: MMA, 1965, *Three Centuries of American Painting* (checklist arranged alphabetically).

EX COLL.: Oliver Phelps, 1939; his son, Oliver Phelps, Detroit; with the Old Print Shop, New York, 1959.

Maria DeWitt Jesup Fund, 1959.

59.163.

THOMAS THOMPSON

1776–1852

Thomas Thompson was born in London, the fourth child of a Huguenot family from Kent. He received training as an artist at the Royal Academy school and in the studio of Sir Joshua Reynolds. From 1793 until 1810 with the exception of 1794, Thompson exhibited annually at the academy. His early participation appears to have been confined to miniature portraits. In 1797, however, he exhibited several marine subjects: *Admiral Sir John Jervis' Fleet Taking Possession of the Spanish Prizes*; *The Glatton, after the Action*; and *The Glatton, Captain Trollope, Engaging Six French Frigates*, none of which are presently located. With the exception of one group portrait Thompson showed in 1798, all twenty-five works he exhibited at the academy after 1797 were marines, a preference that continued throughout his career.

Thompson's descendants reported that his interest in America was aroused by popular descriptions of the beauties of the Susquehanna Valley, and that "relatives and some friends of the family, the Taggarts, were likewise interested, and . . . purchased land in the new settlements" (DeLuce, p. 72). Intent on seeing for himself what America had to offer, Thompson sailed to Baltimore in 1818. He then returned to England and convinced his wife of eighteen years to emigrate with their seven children. The family settled in the Susquehanna Valley, at Carbondale, Pennsylvania, but after two years chose instead the comforts of life in Baltimore, and yet later, Philadelphia. By 1829, the date of a lithograph by Thompson, it is presumed that he was in New York, and by 1831 he is recorded in the city directory at Third Street near Bowery. He remained in this area of the city until 1841 when he moved

to Brooklyn, where at his death in 1852 he was living at 18 Clinton Street with his wife and five of his children.

Thompson's beginnings in this country have been described as "unproductive in the art sense" (DeLuce, p. 73). The earliest known American painting by him is thought to be *Portrait of a Young Man* (coll. Nina Fletcher Little, ill. in *Antiques* 15 (Feb. 1949), p. 121) which is signed and dated 1819. Starting in 1831, however, Thompson's participation in New York art organizations and exhibitions is well documented, and once again he appears to have specialized in the depiction of ships. His descendants report the existence of three notebooks of drawings, dated 1833, 1835, and 1838, which "give detailed descriptions and sketches of the rigging of ships in New York Harbor," including "the name of each vessel, with the captain, the tonnage, where bound for, or where from, and details of the complicated rigging" (DeLuce, p. 74). Thompson exhibited his marine subjects at the American Academy of Fine Arts (1833), the Apollo Association (1841), the American Art-Union (1848–1851), and the Pennsylvania Academy of the Fine Arts (1850–1851). From 1831 until his death in 1852 he showed almost annually at the National Academy of Design, where he was elected an associate member in 1834. Judging from his exhibition record at the academy, it appears that Thompson painted scenes not only along the East Coast but as far west as Wisconsin. In 1835 he did not show any pictures, and the following year all his titles were those of English scenes; presumably he made a return visit to England about this time. English scenes turn up again in 1849 and 1851. Thompson was a founder of the Brooklyn Art Union and a member of the Brooklyn Institute of Arts and Sciences (now the Brooklyn Museum). A portrait he painted of his friend Augustus Graham, the Brooklyn Institute's president, is in the collection of the Brooklyn Museum.

Thompson is noted for one excellent print, a colored lithograph of *The Battery and New York Harbor*, 1829, considered by I. N. P. Stokes as "a fine example of early American lithography, and one of the largest lithographs known" (*The Iconography of Manhattan Island* [1918], 3, pl. 100a, p. 593). Its crisp linearity reveals the artist's sophistication, and it stands as one of the few indications of his artistic achievement in this field. Thompson died in Brooklyn on November 15, 1852.

BIBLIOGRAPHY: Olive S. DeLuce, "Percival DeLuce and His Heritage," *Northwest Missouri State Teachers College Studies* 12 (June 1, 1948), pp. 71–132. Written by a Thompson descendant, this is the most complete account of his life and career; it lists exhibitions and extant works // Nina Fletcher Little, "Thomas Thompson," *Antiques* 15 (Feb. 1949), pp. 121–123. Discusses his marine subjects and a rare lithograph.

The U. S. Ship Franklin, with a View of the Bay of New York

Neither signed nor dated, this panoramic view of New York harbor has traditionally been accepted as Thomas Thompson's portrait of the seventy-four gun ship-of-the-line *Franklin*. The basis for this information, which there is little reason to doubt, is from the donor who is said to have bought the picture from Thompson's son. The view contains what is believed to be the only known contemporary depiction of the *Franklin*, the first ship built in the Philadelphia Navy Yard. A three-masted, triple-decked vessel, she was constructed in 1815 under the direction of Samuel Humphreys and made her maiden voyage to the Mediterranean in 1817 under the command of H. E. Ballard. The painting has

Thompson, *The U. S. Ship Franklin, with a View of the Bay of New York.*

generally been dated sometime between the artist's completion of a print of New York harbor in 1829 and the exhibition of a work with this title at the American Academy of the Fine Arts in 1833. The *Franklin*, however, was recorded in New York harbor on two specific occasions: in April of 1820, soon after which she was laid up in ordinary to be fitted out for a cruise to the Pacific, departing in October of 1821; the ship returned in 1824, after which time she was again laid up in ordinary until 1843. While it is possible that Thompson sketched the *Franklin* when she was in dry dock, it is just as likely that he painted her in the harbor as we see her. Thus the picture may date as early as the 1820s.

When one looks closely at the *Franklin*, it is evident that some major celebration is taking place on board. The deck is crammed with people. At the stern stand two ladies and a gentleman. Obviously, this is an occasion when a great many people visited the ship. Perhaps she was sailing off or had just returned. On September 28, 1821, we know that the mayor and the common council made a special visit to the U.S.S. *Franklin* before her departure for the coast of South America en route to the Pacific (*Minutes of the Common Council of the City of New York* 12 (1917), p. 35). A notice in the *New-York Gazette* on October 1, 1821, alerted New Yorkers that "This ship being under sailing orders, we understand that visitors can no longer be permitted to

go on board—She will sail in a few days on her destined cruise." It is not certain, however, what particular year or occasion in the history of the *Franklin* Thompson depicted.

When a work with this title was exhibited in the 1833 exhibition at the American Academy, one reviewer noted: "The shipping is extremely well executed, and the grouping very masterly, but the sea is infinitely too green and the waves

A detail of the *Franklin* showing visitors on board.

wooden." Whether or not this was the same picture Thompson later showed at the National Academy of Design in 1838 is not known, but the opinions of the reviewers were similar.

Thompson's panoramic view of New York harbor includes Castle William on Governor's Island at the far left and Staten Island in the center. The ambitious size and composition of the picture make it one of the most accomplished American marine paintings of the period.

Oil on canvas, 30 × 65 in. (76.2 × 165.1 cm.).

REFERENCES: *New York Mirror*, June 15, 1833, p. 390, in a review of the 1833 exhibition, calls it "Correct and well coloured" || *American Monthly Magazine* 1 (August 1833), p. 403 (quoted above) || *New York Mirror*, June 16, 1838, p. 406, in a review of the NAD exhibition, says it is "Accurately drawn, but too opake in colour" || N. F. Little, *Antiques* 15 (Feb. 1949), p. 22, says it is "an excellent example of Thompson's fine views of New York" and indicates that it was purchased by Arnold in 1917 from a son of the artist || *Dictionary of American Naval Fighting Ships* (1963), 2, p. 443, gives the history of the ship || Gardner and Feld (1965), ill. p. 128; p. 129, as Scene from the Battery, with a Portrait of the Franklin, 74 Guns, say it was shown in 1838 and that the hardness of the drawing and purity of color relate it to primitive paintings of the period || J. Wilmerding, *A History of American Marine Painting* (1968), p. 113, as Scene from the Battery, with a Portrait of the "Franklin," dates it ca. 1838, places it in the context of marine painting of the time and compares to the work of Thomas Birch, calling it "an achievement that Birch seldom attempted" || C. Rebora, New York, Feb. 1988, supplied references for 1833 exhibition || J. Cheever, United States Naval Academy Museum, Annapolis, June 14, 1988, letter in Dept. Archives, supplies information on the history of the ship, says the general appearance of the major vessel fits the design of the *Franklin*, but no other contemporary likeness is known, and confirms that the women and the crowd indicate some special occasion, which could be just prior to departure on, or arrival from, one of her two major cruises.

EXHIBITED: American Academy of the Fine Arts, New York, 1833, no. 84, as The U. S. Ship Franklin, with a View of the Bay of New-York, no. 84 (possibly this picture) || NAD, 1838, no. 160, as Scene from the Battery, with a Portrait of the Franklin, 74 Guns (possibly this picture) || Santa Barbara Museum of Art and Art Center in La Jolla, 1955, *The Era of Sail*, no. 40 || MMA, 1965, *Three Centuries of American Painting* (checklist arranged alphabetically) || Los Angeles County Museum of Art and M. H. de Young Memorial Museum, San Francisco, 1966, *American Paintings from the Metropolitan Museum of Art*, no. 29.

ON DEPOSIT: Museum of the City of New York, 1939–1963, lent by Edward W. C. Arnold and MMA || Allentown Art Museum, Pa., 1975–1976.

EX COLL.: probably the Thompson family, until 1917; Edward W. C. Arnold, New York, 1917–1954.

The Edward W. C. Arnold Collection of New York Prints, Maps, and Pictures. Bequest of Edward W. C. Arnold, 1954.

54.90.289.

JOSHUA SHAW

ca. 1777–1860

Born in Bellingborough, Lincolnshire, Joshua Shaw was the son of a farmer. He was apprenticed to a sign painter, a trade which he followed in Manchester while studying art. According to WILLIAM DUNLAP, he painted still lifes, portraits, flower paintings, and landscapes, though few of these early works are known today. By 1802, he was in Bath, producing primarily landscape paintings, if we are to judge from his entries at the Royal Academy, which began in that year. In succeeding years he sometimes came to London for the exhibitions at the academy and the British Institution, and in 1813 he apparently moved there, at least for a while. Nothing is known about the extent or nature of his production or patronage, but from his exhibiting only landscapes in London one may conclude that he worked mainly in that genre.

In 1817 Shaw immigrated to the United States, bringing BENJAMIN WEST'S *Christ Healing the Sick in the Temple* to Philadelphia, where he supervised its unpacking and installation in the Pennsylvania Hospital. His prospects here must have been encouraging, because the next year his wife came to join him. By 1818 he was traveling through the South and Middle West making sketches for *Picturesque Views of American Scenery*, which was first published in Philadelphia in 1819 with engravings by John Hill (1770–1850). Making use of his experiences in gathering these views, he published his *United States Directory for the Use of Travelers and Merchants* in 1822.

Shaw lived in Philadelphia for much of his life, although he seems to have traveled occasionally, perhaps in search of fresh landscape subjects. An inventor as well as an artist, he returned to Europe at least once in connection with an improved gunlock, probably about 1833, when he exhibited paintings at the Royal Society of British Artists. He is said to have received a prize from the Czar for his inventions in the field of naval warfare. In about 1843 he moved from Philadelphia to Bordentown, New Jersey, where he continued to paint until 1853, when he was paralyzed by a stroke. He died seven years later in Burlington, New Jersey.

Shaw's known output consists almost entirely of landscapes, but he did on occasion paint genre and history subjects. Although not an innovative artist, he was well trained and accomplished. Most of his English works resemble landscapes by eighteenth-century artists such as Richard Wilson and Philip de Loutherbourg. Occasionally he painted rural scenes with peasants and cattle in the manner of Thomas Gainsborough. When he came to this country, his style changed little in terms of composition, and he continued to paint landscapes with broad expanses, often of water, framed at each side with trees. In execution his American works are drier and more detailed, generally lacking the precisely observed contrasts between light and shade found in his earlier work. Throughout his active career, Shaw exhibited in Philadelphia at the Pennsylvania Academy of the Fine Arts and in New York at the National Academy of Design and the Apollo Association. Although some of his landscapes are American in location, the overwhelming majority of identifiable scenes are British. Perhaps for this reason, or because he had what was said to be an irascible temper, Shaw seems to have played a relatively minor role in the rise of an American school of landscape painting in the years after 1825.

BIBLIOGRAPHY: William Dunlap, *History of the Rise and Progress of the Arts of Design in the United States* (2 vols.; New York, 1834), 2, p. 320. Very brief and uninformative // John Sartain, *The Reminiscences of a Very Old Man, 1808–1897* (New York, 1899), pp. 176–180. Brief personal memoir by the Philadelphia engraver who knew Shaw well // Groce and Wallace (1957), pp. 573–574. In the absence of any monograph on the artist, this is the best source, gives references detailing his participation in exhibitions.

The Deluge, towards Its Close

When this painting was presented to the museum by the artist WILLIAM MERRITT CHASE it was identified as the work of WASHINGTON ALLSTON. At that time, the noted playwright Guy Bolton brought into the museum a watercolor sketch for the painting inscribed with the name of Joshua Shaw, and the ensuing controversy over the attribution was reported in the press (1909). Despite strong evidence to the contrary, the painting appeared in the literature of American art for many years as Allston's work. In the museum's 1965 catalogue of American paintings it was convincingly identified as the work of Shaw on both stylistic and documentary grounds.

The picture is derived from Nicolas Poussin's famous painting *Winter*, or *The Flood* from his cycle of *The Four Seasons*, 1660–1664 (Louvre). Shaw undoubtedly knew this work from prints and probably from copies as well; one by Robert Strange, for example, was in London in 1769. More specifically, the painting is based on a work by BENJAMIN WEST, possibly dated 1804 (now unlocated) and known today from a drawing (MFA, Boston) and from another version of 1790–1803 (private coll., ill. in H. von Erffa and A. Staley, *The Paintings of Benjamin West* [1986], p. 122). Shaw borrowed the main element of the picture from West: the piece of timber with a dangling snake, which is surrounded by drowned bodies. The clear shape of Noah's ark in the middle ground in the West drawing suggests that the shiplike object in the same place in Shaw's work also represents the ark. Shaw has, however, chosen to represent a slightly different moment in the biblical narrative (Genesis 7:21). West's composition, which has been titled *The Abating of the Waters after the Deluge*, shows the ark beginning to emerge from the flood, with the human and animal figures in the foreground all dead. Shaw's painting, originally and now once again titled "The deluge, towards its close," represents a slightly earlier episode. His ark is still afloat on stormy seas, and in the foreground a serpent and a large doglike animal are alive. Restricted for the most part to beautifully modulated shades of gray, the work depicts a moment in which human life is extinguished, leaving behind only some disturbed and equally doomed animals. Shaw's context is more emotional and romantic than religious; the ark is shadowy and unreal, and the overwhelming impression is one of horror and death.

Shaw exhibited his *Deluge* at the British Institution in 1813, probably soon after he had completed it. Judging from one review, reaction appears to have been favorable:

Mr. J. Shaw has several good specimens of this kind of finishing. His picture of The Deluge towards its close is a daring subject, and the portion of success with which it is performed, justifies the Artist's choice of subject. The gayest hearted spectator, the most "heedless, rambling impulse," would experience a check, and be set thinking at sight of its grey solemnity, its rainy cataract, and heaving inundation of the great deep, burying the creation in a watery wreck; the terror inspiring effect of the deluge is expressed by a novel and very natural circumstance of a dog standing on an elevated piece of ground near a drowned family, and howling as he looks up at the watery gloom.

Shaw apparently even managed to hold his own, in the opinion of the public at least, with J. M. W. Turner, who exhibited a painting of the same subject (Tate Gallery, London) that year at the Royal Academy. According to William T. Whitley (1923):

Turner's composition, *The Deluge*, ... did not attract much notice and some considered it as inferior in certain respects to Joshua Shaw's version of the same subject, shown not long before at the British Institution.

Benjamin West, who evidently viewed Shaw's imitation of his own work as a compliment, wrote to him in 1818:

You say that a gentleman in the City of Philadelphia has evinced a love for your Picture of the Deluge, which I had so much admired in London: it is very true, I did admire it, and so did all the Professors in Painting who saw it, as a work of genious [*sic*] and that the subject was painted with energy [,] truth of character, and [is] a superior [work] of art in its Class. I congratulate any person who may possess that picture, as having a Classical and a fine work of art.

Oil on canvas, 48¼ × 66 in. (122.6 × 167.6 cm.).

REFERENCES: London newspaper review, 1813, provided by J. P. Harthan in a letter, June 11, 1964, MMA Archives (quoted above) // B. West to J. Shaw, March 20, 1818, Misc. MSS Benjamin West, NYHS (quoted above) // B. Burroughs, *MMA Bull.* 4 (May 1909), p. 89, calls the painting an important picture of Allston's // *New York American*, Dec. 5, 1909, quotes Guy Bolton on attribution to Shaw, quotes

various museum authorities, quotes W. M. Chase on attribution to Allston // W. T. Whitley, *Art in England, 1800–1820* (1928), pp. 210–211 (quoted above); p. 280 // A. Burroughs, *Limners and Likenesses* (1936), p. 130; in this and all subsequent references prior to 1965 the painting is given to Allston // E. P. Richardson, *American Romantic Painting* (1944), p. 23 // A. T. Gardner, *MMA Bull.* 3 (Oct. 1944), pp. 57–58 // E. P. Richardson, *Washington Allston* (1948), p. 64; pp. 66–67, says subject goes back to Poussin and Annibale Carracci; p. 189, no. 34, says barnlike shape on horizon may be the ark // J. T. Flexner, *MMA Bull.* 7 (Oct. 1948), p. 70 // V. Barker, *American Painting* (1950), p. 341, says "snakes and howling wolf now seem insufficient . . . and the drowned bodies are ill drawn" // J.T. Flexner, *The Light of Distant Skies* (1954), pl. 57; p. 133 // Gardner and Feld (1965), pp. 131–133, attribute to Shaw for the first time since 1909, give details of early controversy over attribution // J. Wilmerding, *A History of American Marine Painting* (1968), pp. 48–49; p. 53, says reflects Burke's concept of the sublime; p. 83 // D. Piper, ed., *The Genius of British Painting* (1975), p. 205 // R. Verdi, *Burlington Magazine* 123 (July 1981), p. 398, mentions it in relation to Poussin's Deluge // L. R. Matteson, *Pantheon* 34 (July, Aug./Sept. 1981), ill. p. 225, and compares to Turner's Deluge; p. 226.

EXHIBITED: British Institution, London, 1813, no. 134, as "The deluge, towards its close," gives dimensions including frame as 5.7 × 7 ft., and includes quote from Genesis 7:21 // Carnegie Institute, Pittsburgh, 1940, *Survey of American Painting*, no. 103, lists as by Allston, as do subsequent exhibitions until 1965 // Museum of Modern Art, New York, 1943, *Romantic Painting in America*, no. 1 // Detroit Institute of Arts, 1944–1945, *The World of the Romantic Artist*, no. 33 // Brooklyn Museum, 1945, *Landscape*, no. 44 // Art Institute of Chicago and Whitney Museum of American Art, New York, 1945, *The Hudson River School and the American Landscape Tradition*, no. 3 // Tate Gallery, London, 1946, *American Painting*, no. 2 // Detroit Institute of Arts and MFA, Boston, 1947, *Washington Allston*, no. 3 // Whitney Museum of American Art, New York, 1954, *American Painting in the Nineteenth Century*, no. 46 // Carnegie Institute, Pittsburgh, 1965, *The Seashore*, no. 31, as by Joshua Shaw, ca. 1813 // University Art Museum, Berkeley, Calif., National Collection of Fine Arts, Washington, D. C., Dallas Museum of Fine Arts, and Indianapolis Museum of Art, 1972–1973, *The Hand and the Spirit*, exhib. cat. by J. Dillenberger and J. C. Taylor, no. 18, p. 60, dates it ca. 1805 // Lowe Art Museum, University of Miami, Coral Gables, Fla., 1974–1975, *19th Century American Topographical Painters*, no. 122.

EX COLL.: Mrs. W. W. Lawton, Charleston, S. C. (sale, Fifth Avenue Art Galleries, New York, 1909), William Merritt Chase, New York, 1909.

Gift of William Merritt Chase, 1909.
09.14.

West, drawing, *The Waters Subsiding after the Deluge*, MFA, Boston.

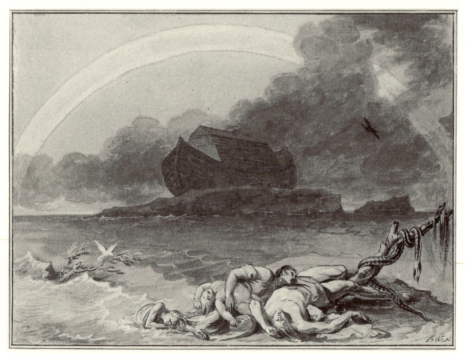

Shaw, *The Deluge, towards Its Close*.

JOSEPH WOOD

ca. 1778–1830

Joseph Wood was born on a farm near Clarkstown, New York. Despite his father's objections, he decided to become an artist. When he was about fifteen, Wood ran off to New York where he apprenticed himself to a silversmith and painted portrait miniatures on the side. In about 1801, presumably after his apprenticeship expired, he announced himself in the city directory as a portrait and miniature painter. Although he continued to practice independently, the next year he also began to work in partnership with JOHN WESLEY JARVIS making portraits on glass in the *verre églomisé* style and profiles on paper with a physiognotrace. According to Wood's biographers, his work was rather crude until about 1805 when he received some instruction in miniature painting from Edward Greene Malbone (1777–1807), the leading practitioner of that art in the country. Thereafter, he became very successful, producing miniatures and small oil portraits in a clear, luminous, rather fastidious style. His partnership with Jarvis lasted until about 1810, when that artist went South. Three years later Wood moved to Philadelphia, where he is listed in the city directory only as a miniature painter. He did, however, paint standard-sized portraits, including a series of the heroes of the War of 1812 for illustration in a number of Philadelphia magazines.

Wood's Philadelphia paintings are perhaps his most assured. Polished and neoclassical in style, they are similar to the early portraits of JOHN VANDERLYN, whose work he would have known. He may also have been influenced by the many French émigré artists who were active in Philadelphia. His wash drawings, as evidenced by a group of portraits that were in a private collection in Germantown, Pennsylvania, in 1932, are elegant performances by an artist sure of his powers. At some point after 1816, when he moved to Washington, the quality of his work declined abruptly. One reason for this is probably to be found in his personal life. Wood's early years in New York had been spent with the convivial Jarvis, and, doubtless, like Jarvis, he drank more than was good for him. At some later point his habits led to alcoholism. His difficulties were so well known that his life was the basis for a temperance tract published in 1834.

Wood's artistic decline can also be attributed to a change in his style. By about 1820 he began to adapt the methods of the miniature painter to painting in oil, constructing faces with small dots of paint in a manner similar to the stippling technique used on ivory. The unfortunate result is that his subjects often appear to have spotted, mottled faces. In painting his sitters' bodies, he also changed his technique, going from small, very precise, brushstrokes to larger, rather crude, applications of paint, which sacrificed to a great extent the three-dimensionality he had achieved in his earlier work. This effect became more noticeable after 1825, when perhaps influenced by the work of THOMAS SULLY, he adopted a freer, more romantic style, but his execution was crude and perfunctory instead of broad and dashing.

Although he spent most of his remaining years in Washington, Wood lived off and on in Baltimore and may have traveled for a while in the South. His patronage declined to such an extent that by 1829 he was forced to advertise in the Washington city directory as a draftsman for patent applications. He died a year later.

BIBLIOGRAPHY: James K. Paulding, "Sketch of the Life of Mr. Wood," *Port Folio* 5 (Jan. 1811), pp. 64–68. Based on the slightly fanciful memories of the artist, reprinted as *Sketch of the Early Life of Joseph Wood, Artist, by J. K. Paulding, of New York, also Wood's Latter Days, and His Death, by S. A. Elliot, of Washington* (Washington, D. C. 1834), with two additional pages about Wood's alcoholism || William Dunlap, *History of the Rise and Progress of the Arts of Design in the United States* (2 vols.; New York, 1834), 2, p. 97. Adds little to other account || George C. Groce, Jr., and J. T. Chase Willet, "Joseph Wood: A Brief Account of His Life and the First Catalogue of His Work," *Art Quarterly* 3 (Spring 1940), pp. 149–161, suppl. to 3, pp. 393–418. Most complete treatment to date, catalogue restricted to documented works.

Thomas Macdonough

Thomas Macdonough (1783–1825) was born at the Trap (now Macdonough), Delaware. His father was a physician whose Irish Protestant family had emigrated from county Kildare about 1730. Macdonough joined the navy in 1800 and served in the West Indies. Later he participated in actions against the pirates at Tripoli. He was made a lieutenant in 1805, an appointment that was confirmed two years later. In 1810, he requested a furlough in order to serve as a captain of merchant ships, and as such he made at least one voyage to India. He married Lucy Ann Shaler of Middletown, Connecticut, in

Wood, *Thomas Macdonough.*

1812. After the War of 1812 broke out, Macdonough returned to active duty and took command of the American fleet on Lake Champlain, where he occupied himself in fitting out the fleet. In September of 1814, a strong force of British troops advanced from Canada to Plattsburg, New York, supported by a fleet superior to that of the Americans. Nevertheless, by skill and planning, Macdonough prevailed in one of the most important naval battles in the history of this country. After his victory at the battle of Plattsburg, the British army retreated to Canada, and thus Great Britain had no basis for territorial claims at the Treaty of Ghent that ended the war. Macdonough was promoted from master-commandant to captain. While commander of the Mediterranean squadron in 1825, his health, which had been severely affected by the War of 1812, began to fail rapidly, and he took passage for New York. He died at sea during this voyage and was buried in Middletown, Connecticut, his home since 1806.

The subject's pose, with one arm over the back of a chair, was a favorite of Wood's; it also appears in an undated watercolor by JOHN VANDERLYN and in a number of works by Wood's friend Jarvis. In terms of style, the portrait fits well with Wood's later work; for the face is executed in the stippled technique common in his portraits after about 1820, and it is perhaps closest to his portrait of Judge Jeremiah Townley Chase of about 1819 to 1824 (Court of Appeals, Annapolis, Md.).

Macdonough appears to be considerably older than in his portrait by GILBERT STUART (National Gallery of Art, Washington, D. C.), which is usually dated 1818. Yet, it is presumably the Wood portrait that is listed in a *Prospectus of Delaplaine's National Panzographia for the Reception of the Portraits of Distinguished Americans*, published in December of 1818. This was a rather elaborate scheme of Joseph Delaplaine's to exhibit por-

traits of noted people for the edification of his countrymen and the enhancement of his own fortune. According to the prospectus, "Statesmen will occupy one department; military genius, another; naval heroes, a third; divines, a fourth; physicians, a fifth; legal talents, a sixth; distinguished mechanics, a seventh, &c" (pp. 13–14). The exhibition was to open in Philadelphia on January 1, 1819. Delaplaine's collection, which he had amassed for the most part to illustrate various publishing schemes, was bought in 1825 by Rubens Peale for Peale's Museum in New York, which closed in 1837. The collection was purchased that year by P. T. Barnum for his American Museum, and this painting was sold with that collection in 1863. From then until about 1915 its location is obscure.

Oil on wood, 9⅞ × 6¾ in. (25.1 × 17.2 cm.).

REFERENCES: J. Delaplaine, *Prospectus of Delaplaine's National Panzographia for the Reception of the Portraits of Distinguished Americans* (1818), p. 15, lists portrait of Macdonough (presumably this picture) as part of the collection // [Old Print Shop] *Portfolio* 5 (Aug.–Sept.

1945), ill. p. 16, says probably painted between 1819 and 1825 in Washington or Baltimore // unknown writer on behalf of Mrs. W. Murray Crane, letter in Dept. Archives, Nov. 21, 1949, says Mrs. Crane bought the picture in Washington about 1915 // Gardner and Feld (1965), pp. 134–135 // Mrs. R. Hecker Barnett, Old Print Shop, New York, letter in Dept. Archives, July 18, 1978, says had the picture on consignment from Mrs. W. Murray Crane in 1945 and returned it to her.

EXHIBITED: Delaplaine's Gallery, Philadelphia, 1819, no. 101, as Captain Macdonough by Wood, $10, probably this picture. Presumably, it was also exhibited in New York at Peale's Museum and the American Museum.

EX COLL: Joseph Delaplaine, Philadelphia, ca. 1818–1825, presumably this picture; Rubens Peale, New York, 1825–1837; P. T. Barnum, New York, 1837–1863 (sale, Henry H. Leeds and Co., New York, Oct. 30, 1863, no. 11, presumably this picture); Washington, D. C., art market, about 1915; Mrs. W. Murray Crane, New York, by about 1915–1949; with the Old Print Shop, New York, 1945.

Gift of Mrs. W. Murray Crane, 1949.
49.146

REMBRANDT PEALE

1778–1860

Rembrandt Peale, the second son of the painter CHARLES WILLSON PEALE, was born during the American Revolution on a farm in Bucks County, Pennsylvania. After the British evacuation of Philadelphia, the family moved back to the city. Under his father's careful eye, Rembrandt pursued an artistic vocation, painting portraits in oil by the time he was thirteen. In May of 1795, he participated in the pioneering public exhibition of works of art at the Columbianum in Philadelphia. He had already painted his first of many portraits of George Washington. Soon after, he made a trip south with his brother RAPHAELLE PEALE, seeking portrait commissions and exhibiting copies of his father's portraits of distinguished Americans. Later the two young Peales opened their own museum in Baltimore. Rembrandt continued an active association with his father, aiding him in the excavation of two mastodon skeletons in 1801 and then taking one of the specimens on tour abroad. At the same time he intended, like his father before him, to study with BENJAMIN WEST. He set off for London in 1802 with his brother Rubens Peale (1784-1865). There the display of the mastodon met with less enthusiasm than anticipated. Rembrandt did, however, study drawing from life with a group of other students under West's tutelage. In 1803

he exhibited two portraits at the Royal Academy, one entitled *Self-Portrait with a Mammoth Bone* (said to have been painted over later). Late that same year, imminent war between France and England sent the Peale brothers back to the United States. Rembrandt spent a few months in search of portrait commissions in Savannah, Charleston, and Baltimore before settling in Philadelphia. Again he joined his father in local art activities, becoming one of the founders of the Pennsylvania Academy of the Fine Arts in 1805. He continued to paint portraits in Philadelphia and assisted his father in recording the faces of the country's most famous men. Trips to Washington and Boston produced several collaborative portraits, notably that of GILBERT STUART (NYHS), with whom Rembrandt Peale had corresponded on the subject of contemporary European painting techniques.

Not satisfied with experimentation on his own he decided to continue his studies abroad. Armed with a commission from his father for portraits of the great men of France, he spent part of 1808 and from 1809 to 1810 in Paris. He took a studio convenient to the Louvre and studied the spoils of Flanders and Italy assembled by Napoleon. His portraits of important Frenchmen like the writer Jacques Henri Bernardin de Saint-Pierre, 1808 (Corcoran Gallery of Art, Washington, D.C.) and the painter Jacques Louis David (PAFA) were apparently well-received in Paris; for he was escorted to the studios of some of the most prestigious painters by Napoleon's minister Dominique-Vivant Denon. His portraits done in France document his adoption of French stylistic conventions, one of which was to give his paintings a high finish. His letters to his father tell of his experiments with the fashionable encaustic technique of using hot wax as a medium.

> My encaustic leaves me nothing to desire, in addition to the advantage of a canvass that will not crack or burn up, and the preservation of the colours that will not embrown . . . there is a facility of inestimable advantage, no waiting for the colours to dry, no dust spoiling my black—the advantage of miniature, fresco, oil-painting combined. I have produced the most brilliant effects—my tints surpass the fairest complexions and equal what the imagination can conceive (*Port Folio* 4 [Sept. 1810], pp. 275–279).

When he returned to Philadelphia, Rembrandt Peale demonstrated his familiarity with French history painting in a series of large compositions including an equestrian portrait of Napoleon, 1811 (unlocated), and a painting called *The Roman Daughter*, 1812 (National Museum of American Art, Washington, D.C.), which was poorly received at the Pennsylvania Academy exhibition in 1812. Portraiture was not enough to satisfy Peale's ambitions even though it was the area in which he did his best work. Not all of his portraits are of equal quality, but many are excellent characterizations full of power and grace. While his work became less naturalistic and more neoclassical following his studies in France, he managed to accommodate both styles.

Peale moved his picture gallery to Baltimore at the end of 1814. There he included a "gallery of heroes" as well as exhibits on science and manufacturing. One of his major technological interests was in gas-lighting, and a project to illuminate the city added to his financial burden. In 1822, a tour of his largest and best received history painting, *The Court of Death*, 1820 (Detroit Institute of Art), provided him with some funds. He then sold the Baltimore museum to his brother Rubens and moved to New York. In the following years he exhibited his work at the American Academy of the Fine Arts in New York, and was elected

its president. He also spent time in Boston, where he devoted himself to lithography. The financial success of his portraits of George Washington enabled him to make several more trips to Europe, including a stay in Italy. After about 1837 until his death in 1860, Rembrandt Peale lived in Philadelphia, where he taught art and concentrated his energy on the best known of all his images—the porthole portrait of George Washington. Among his various publications is the drawing manual *Graphics* (1834). He frequently lectured on Washington portraits, advertising himself as "the only painter living who ever saw Washington." Rembrandt Peale's second wife, Harriet Cany (ca. 1800–1869), also painted and often copied works by her husband. There are known works too by his daughter Rosalba Carriera (1799–1874), and his son Michael Angelo (1814–1833), who died young. All were his students.

BIBLIOGRAPHY: Charles E. Lester, *The Artists of America* (New York, 1846), pp. 99–231. Autobiographical sketch sent by Peale to Lester from Philadelphia on March 8, 1846 // Rembrandt Peale, "Reminiscences," *Crayon* 1 (1854), pp. 22, 81, 124, 161, 226, 290, 469; 2 (1855), pp. 127, 175, 207, 232; 3 (1856), pp. 5, 37, 100, 163; 4 (1857), pp. 44, 278, 307, 339, 370; 5 (1858), p. 47; 7 (1860), pp. 24–25. The artist's recollections of his life and career // John A. Mahey, "The Studio of Rembrandt Peale," *American Art Journal* 1 (Fall 1969), pp. 20–40. Discusses the artist's stylistic development in depth // Charles Coleman Sellers, *Charles Willson Peale* (Philadelphia, 1947). Documents Rembrandt's relationship with his father // Historical Society of Pennsylvania, Philadelphia, *Rembrandt Peale, 1778–1860: A Life in the Arts* (1985), exhib. cat. with essays by Carol Eaton Hevner and Lillian B. Miller. The most recent research on Rembrandt Peale with an excellent evaluation of his life and work by Ms. Hevner.

Peale, *Marquis de Lafayette.*

Marquis de Lafayette

This portrait of the French soldier and politician Marie Joseph Paul Yves Roche Gilbert du Motier, marquis de Lafayette (1757–1834) was painted in 1825 during his return visit to the United States. Lafayette, who had played a key role in obtaining French assistance during the American Revolution, was himself one of the heroes of that conflict. At the request of President Monroe, he returned to the United States in 1824 and made a triumphal tour of the country. Most of the well-known artists were eager to paint him. The commission for the portrait for the city of New York was given to SAMUEL F. B. MORSE (City Hall, New York).

Rembrandt Peale was among the many who petitioned the city fathers for the honor, writing on August 18, 1824:

it is particularly my ambition to paint a Portrait of *Lafayette* in the style of, and as a companion to, my *Washington* I would propose to make a highly finished Portrait of the Marquis de le Fayette in the same style, at the price which I have fixed for Copies of my Washington, one thousand Dollars. Being already in possession of an Original Portrait of Lafayette which I painted when I was last in Paris in 1810, it

is probable my acquaintance with his physiognomy will enable me to make a valuable & interesting delineation of his character (Peale to the Mayor and Corporation of the City of New York, August 18, 1824, MSS coll., Museum of the City of New York).

A year later in a letter dated August 10, 1825, in which he comments on a lifemask of Lafayette (New York State Historical Association, Cooperstown) taken by the sculptor John Browere (1790–1834), Rembrandt Peale noted that he "had twice painted the general's portrait from life, once at Paris, and recently at Washington" (quoted in C. H. Hart, [1899], p. 67).

Lafayette was in Washington on three occasions during his American tour, first in October 1824, then from November 22, 1824, until February 1, 1825, and from August 1 to September 6, 1825. His continually busy schedule would account for an undated letter addressed to Peale:

I am once more to apologize for want of punctuality—but this time I may be earlier than my word—It becomes necessary for me to leave you at half past eleven—I shall be at your house about ten, unless you bid me not to come, and so we can have the sitting as long as you had intended it (Lafayette to R. Peale, MMA Library).

Several years later, in 1831, when the painting was exhibited in Peale's gallery in Philadelphia, the catalogue firmly stated that the portrait was painted during the last winter of Lafayette's visit (which would be January or February of 1825). It would appear, however, that it was painted over several months. Since Peale indicates in August of 1825 that the work is finished, perhaps the note he wrote from New York on July 11, 1825, requesting Lafayette to sit for him was an attempt to make the final touches on the portrait.

The porthole format in which the subject has been placed follows the formula Peale developed around 1823 for his standard copy of George Washington (q.v.). Like that work, it is possible that this portrait too is a composite image, despite the subject's sittings for it. The rather mannered elongation of the features bears a resemblance to Morse's *Lafayette* and more so to his bust-length version (NYPL). Then, too, the portrait shares the idealized manner of the 1824 Ary Scheffer portrait of Lafayette, a gift to the United States, which hung in the nation's Capitol by early January of 1825. As is usual with Peale at this time, he has avoided extraneous detail, concentrating on the face and head and sharply delineating Lafayette's hairstyle and facial features.

The marquis's penetrating glance is a hallmark of Rembrandt Peale's heroic style.

Peale may have exhibited the painting in New York as early as 1826 when the *New York Evening Post* (May 12, 1826) noted that he had introduced the practice of showing his recent works to the public:

[He] has opened a room adjoining his painting room, where ladies and gentlemen can have an opportunity of witnessing the efforts of his pencil. It contains at present several fine portraits of gentlemen of celebrity residing in this city, and recently painted by Mr. Peale; and also, the portrait of Washington.

Oil on canvas, $34\frac{1}{2} \times 27\frac{3}{8}$ in. (87.6 × 69.5 cm.).
Signed at lower right (no longer visible): R. Peale pinxit.

REFERENCES: R. Peale to Lafayette, July 11, 1825, coll. Lafayette College, Easton, Pa., writes: "I am waiting with the hope that you will favour me with a sitting before your departure from this city [New York]" || Lafayette to Peale, n.d., MMA Library, discusses a sitting for the portrait (quoted above) || Peale, letter, August 10, 1825, in C. H. Hart, *Browere's Life Masks of Great Americans* (1899), p. 67 (quoted above) || *Crayon* 4 (July 1857), p. 220, reviews the portrait in the NAD exhibition: "Mr. Peale's truthfulness and fidelity ensure the value of this picture as a representation of Lafayette's countenance. The picture was painted in 1825" || B. Burroughs, *Catalogue of Paintings in the Metropolitan Museum of Art* (1931), p. 273, mistakenly says the painting was probably painted when Peale was in Paris || MMA, *Eminent Americans* (1930), no. 4, says it represents the mature Lafayette who returned to visit the United States in later years || F. E. H. Folsom, Newport, R. I., March 16, 1921, says painting originally belonged to George Folsom, her father-in-law || Gardner and Feld (1965), pp. 136–137, catalogues it and dates 1825 || C. Hevner, Peale Family Papers, National Portrait Gallery, Washington, D. C., memo in Dept. Archives, supplies information on early exhibitions.

EXHIBITIONS: Peale's New York Museum and Gallery of the Fine Arts, 1825, no. 207, as Lafayette, an original portrait not yet copied, for sale || Sully and Earle's Gallery, Philadelphia, 1831, *Peale's Italian Paintings*, no. 326 || Peale Museum, Philadelphia, *Peale's Italian Pictures*, 1831, no. 26, pp. 16–17, notes the portrait of Lafayette was "painted during the last winter of his visit" || R. Peale's Painting Room, 1837, Philadelphia, *Exhibition of the Court of Death*, no. 2 [in 1830 broadside catalogue of the exhibition] || NAD, 1857, no. 187, as General La Fayette (painted in 1825), lent by G. Folsom || Washington Art Association, Washington, D. C., 1859, no. 97, as owned by G. Folsom, Esq. || Maison Française, New York, *Lafayette Centenary Exhibition*, 1934, n. p. || Musée de

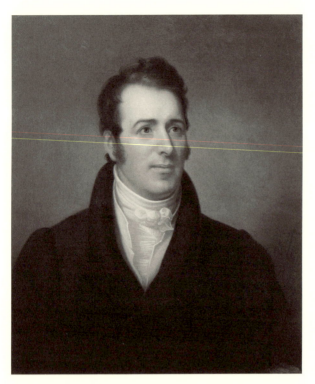

Peale, *John Johnston.*

partnership with James Boorman. Boorman and Johnston, Merchants, became one of the leading firms in the city. Among many products, they dealt in wine, tobacco, and iron. Johnston remained a member of the firm for some thirty-one years. In 1817 he married the widow Margaret Taylor Howard; they had five children, one of whom, John Taylor Johnston, was a founder of the Metropolitan Museum of Art.

The portrait of Johnston is said to have been commissioned in 1826, when he paid Rembrandt Peale fifty dollars on account. Some two years later, Peale had evidently not yet completed the work; for Johnston paid one hundred dollars "for which painting to be finished." Presumably, that was done before 1829 when Peale left on a trip to Italy. The work is a very fine example of his portrait style at this time. Johnston appears robust and lively against a plain gray-green background. He has the dreamy, far-away look that is typical of many of Peale's sitters, among them the heroes of the War of 1812. Although very simple in composition, the portrait is a highly polished performance.

Oil on canvas, 30¼ × 26 in. (76.8 × 66 cm.).
EXHIBITIONS: MMA, 1909, *Hudson-Fulton Exhibition*, no. 32, lent by J. Herbert Johnston.
REFERENCES: E. J. De Forest, *John Johnston of New York, Merchant* (1909), frontis. ill.; pp. 123–124, gives information about the subject and the portrait commission (quoted above) // MMA, *Annual Report for the Year 1979–1980*, p. 21.
Ex COLL.: the subject, New York, d. 1851; his son, John Taylor Johnston, New York, d. 1893; his son, J. Herbert Johnston, New York, by 1909–d. 1935; his wife, Mrs. J. Herbert Johnston, New York; her daughter, Noel Johnston Appleton King, New York, d. 1979.
Bequest of Noel Johnston King, 1979.
1980.77.

l'Orangerie, Paris, 1934, *Exposition du centenaire de La Fayette*, cat. by A. Girodie, no. 211, implies that it was painted in France // Municipal Museum of Baltimore [Peale Museum], 1937–1938, *An Exhibition of Paintings by Rembrandt Peale*, no. 28 // MMA, 1965, *Three Centuries of American Painting* (checklist arranged alphabetically) // Montreal Museum of Fine Arts, 1967, *The Painter and the New World*, no. 159.
Ex COLL.: George Folsom, New York and Stockbridge, Mass., by 1857; his son, George W. Folsom, Newport, R. I., d. 1915; his wife, Frances E. H. Folsom, Newport, R. I., with Folsom Galleries, New York, by 1921.
Rogers Fund, 1921.
21.19.

John Johnston

John Johnston (1781–1851) was born at Barnboard Mill, Galloway, Scotland. He trained as an accountant in Kirkcudbright and came to New York in 1804. He first worked in the banking house of James Lenox and William Maitland. Beginning in 1809 he took charge of the first of two voyages he was to make to India for the firm. In March of 1813 he formed a

George Washington

It has been said that Rembrandt Peale was obsessed with the image of George Washington. He certainly produced a great many portraits of him. Besides his own first oil portrait in 1795 (Historical Society of Pennsylvania, Philadelphia), of which there are at least ten replicas with minor variations, he is responsible for at least twenty copies of GILBERT STUART'S 1795 portrait and over thirty-nine copies of the portrait

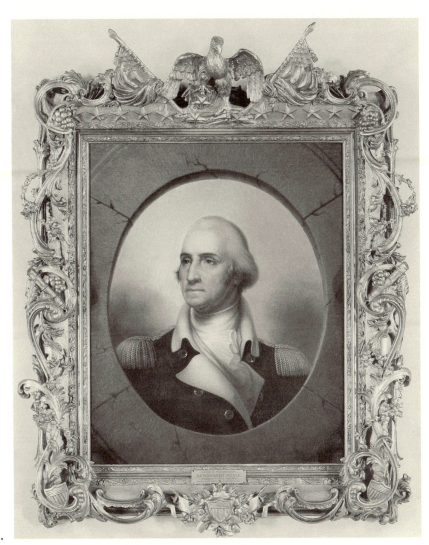

Peale, *George Washington.*

painted that same year by his father, CHARLES WILLSON PEALE. In an autobiographical note Rembrandt Peale once wrote:

When I was but a schoolboy I knew no other [besides himself] who was born on the birthday of Washington, and it was this childish motive which impelled me to seek every occasion of seeing him. This was necessarily followed by the greatest veneration for his character as well as his sublime aspect. My post had been behind my father's chair when he painted him in 1786—I was the bearer of every message from my father to him—I met him every Sunday as he went to church—crossed the street, returned, and met him again It will not be difficult, therefore, to believe that I longed for no greater honor than to paint his portrait (C. Lester, *The Artists of America* [1846], p. 240).

For Rembrandt Peale, his most important

Washington portrait was doubtless his "Pater Patriae." This work, painted about 1824 (PAFA), is monumental, measuring about four and one-half by six feet. It is after the *Pater Patriae* that all of the smaller, so-called porthole portraits, including this one, were done. Peale referred to them as his Washington copies, or the standard likeness, and said that he completed seventy-nine of them. The date when he produced the first of these portraits is not known, but it is thought that he began to paint them in large numbers beginning about 1846. (See below for another copy with a companion portrait of Martha Washington).

Rembrandt Peale based the image of Washington on the portrait done by his father in 1795 (NYHS). He later recalled: "I subsequently made many studies in efforts to combine my

own and my father's portraits, but never satisfied myself nor my father . . . till many years after, in the seventeenth attempt" (Lester [1846], p. 205). Besides that work, however, he relied on many others as well. In 1823, when he was first contemplating his large Washington, he tells us that he went into seclusion for three months and assembled "every Portrait, Bust, Medallion and Print of Washington" he could find (ibid., p. 210). The result was an idealized Washington that even Peale's father regarded as exceptional.

The faces of the Washington copies, some looking left and some right, are nearly all identical. The president's dress is alternately civilian, with a jabot of either linen or lace or, as in this case, military. Shown bust-length, Washington appears in an oval trompe-l'oeil stone frame, often cracked, as here, and sometimes festooned with a wreath. His cloak frequently protrudes from the lower edge of the oval. In some versions the inscription "Pater Patriae" appears at the bottom. The popular designation "porthole" is said to have been mistakenly applied by a Brooklyn catalogue maker in printing announcements of Peale's later commercial venture, in which he produced replicas of the portrait with minor variations for $250 each (see PAFA, *Catalogue of Portraits by Charles Willson Peale and James Peale and Rembrandt Peale* [1923], p. 117).

The idea of enclosing the subject in an oval format most likely resulted from Peale's study of European portraiture. There was a style, popular in seventeenth-century Europe, in which portraits were enclosed in trompe-l'oeil stone casements. For example, Cornelius Johnson, an Anglo-Dutch artist, sometimes surrounded his portraits of the 1620s with an imitation marble oval.

Whatever the stylistic derivation of Peale's porthole Washington, the portrait was looked upon as exceptional. One version was displayed in the Capitol in 1824 and bought by the government in 1832 for two thousand dollars. Peale spent a great deal of time promoting the sale of the portraits. Going from city to city in 1859 and 1860, he delivered a lecture entitled "Washington and His Portraits."

Oil on canvas, 36⅛ × 29⅛ in. (91.76 × 73.98 cm.).
Signed at lower left: *Rembrandt Peale.*
REFERENCES: H. B. Wehle, *MMA Bull.* 20 (Jan. 1925), ill. p. 21, refers to the work as a composite // J. H. Morgan and M. Fielding, *Life Portraits of Wash-*ington (1931), no. 21, p. 380 // B. Burroughs, *Catalogue of Paintings in the Metropolitan Museum of Art* (1931), p. 273 // Gardner and Feld (1965), pp. 138–139 // M. Brown, *American Art to 1900* (1977), no. 275, ill. p. 194, dates it about 1823.

ON DEPOSIT: Brooklyn Museum, 1974–1977.

EXHIBITED: Ehrich Galleries, New York, 1909, *Exhibition of Colonial and Early American Portraits*, ill. on titlepage, no. 30; 1910, *Early American Paintings*, probably no. 21 or 22; 1920, *George Washington as Depicted by His Contemporaries*, no. 4 (porthole type), possibly this picture // Maison Française, New York, 1934, *Lafayette Centenary Exhibition* (not in cat.) // MMA, 1965, *Three Centuries of American Painting* (checklist arranged alphabetically).

EX COLL.: with Ehrich Galleries, New York, 1909–possibly until 1920s; Charles Allen Munn, West Orange, N.J., before 1924.

Bequest of Charles Allen Munn, 1924.
24.109.86.

George Washington

This is another of Rembrandt Peale's Washington copies (see above). Stiff and very detailed, it was probably done later than the museum's other George Washington porthole portrait. It is not as good. The buttons on the uniform are carefully delineated as is each and every strand of the tassels, but Peale's brushwork is not as controlled, and the result is not as finely polished. The portrait is still very much a heroic image, it brings to mind Rembrandt Peale's own ode to the portrait:

At length an artist 'mong the last to whom
the hero sat, a great impulse obeyed,
(For faithful memory triumphed o'er the tomb),
And o'er his canvas spreading light and shade,
With full impulse heart and pencil, one
Proud effort wrought the form of WASHINGTON
Magazine of American History 52 (August 1880), p. 134.

Oil on canvas, 36 × 29 in. (91.5 × 73.7 cm.).
Signed at lower left: *Rembrandt Peale.*
REFERENCES: Gardner and Feld (1965), p. 239.
EXHIBITED: Los Angeles County Museum of Art and M. H. de Young Memorial Museum, San Francisco, 1966, *American Paintings from the Metropolitan Museum of Art*, no. 30, p. 49, ill. // MMA and American Federation of Arts, traveling exhibition, 1975–1976, *The Heritage of American Art*, exhib. cat. by M. Davis, p. 61, no. 20, catalogues the work.

ON DEPOSIT: El Paso Museum of Art, 1960 // Library of Presidential Papers, New York, 1966–1972 // New York City Department of Parks, 1973–1974.

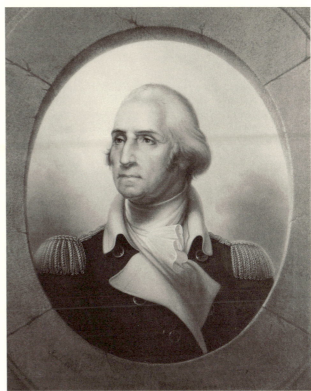

Peale, *Martha Washington*.

Peale, *George Washington*.

Martha Washington

The wife of the first president of the United States, Martha Dandridge (1731–1802), was born in New Kent County, Virginia. She was descended from an eminent family whose members were among the earliest settlers of Virginia. At eighteen she was married to a wealthy landowner, Daniel Parke Custis. When he died, in 1757, she was left to raise their two surviving children and to manage a large estate and fortune. She was married to George Washington in January of 1759. At their Potomac River home, Mount Vernon, she was an accomplished hostess. Washington took command of the colonial army in June of 1775, and thereafter she was often at

his side, watching over him and boosting the morale of the American troops. As first lady in 1789, she joined her husband in New York and later Philadelphia, the country's early capitals. She presided over weekly receptions, and guests often commented on her warm and gracious manner. When Washington retired from the government in 1797, the couple returned to Mount Vernon, where Martha survived her husband by two and a half years.

Martha Washington's image, like the president's, became a familar one. She never did, however, sit for a portrait to Rembrandt Peale. This work, which closely follows the format of the porthole *George Washington* (see above), is directly copied from CHARLES WILLSON PEALE'S 1795 portrait of her (Independence Hall National Park, Philadelphia). The likeness, somewhat modified from the original, betrays the style of Rembrandt Peale mainly in the luminous flesh tones.

A letter written in 1853 by the artist to a Mrs. Campbell, who had commissioned companion portraits of George and Martha Washington (now NYHS), indicates how much of an after-

thought the portrait of Martha was: "You are the first lady in America to possess the portrait of Mrs. Washington, which I am happy to say pleases all who have seen it" (R. Peale to Mrs. Campbell, Nov. 28, 1853, Peale Misc. MSS, NYHS). Since it is possible that Peale could have painted one or more portraits of Mrs. Washington for one or more gentlemen patrons before he produced Mrs. Campbell's, it is difficult to know exactly when he began these companion pieces. But the 1853 portrait may well be the first; about six others are recorded. The Metropolitan Museum formerly had another Rembrandt Peale portrait of Martha Washington; it is now in the collection of the National Portrait Gallery in Washington.

Oil on canvas, 36 × 29 in. (91.5 × 73.7 cm.).
REFERENCES: Gardner and Feld (1965), p. 140.
EXHIBITED: Museum of the City of New York, 1936, *Portraits of Ladies of Old New York, 18th and 19th Centuries* (no cat.), lent by Mrs. William Graves Bates // Cincinnati Art Museum, 1954, *Paintings by the Peale Family*, no. 78 // Dallas Museum of Fine Arts, 1956, *Mr. President* (no cat. available) // Los Angeles County Museum and M. H. de Young Memorial Museum, San Francisco, 1966, *American Paintings from the Metropolitan Museum of Art*, no. 31 //// Amon Carter Museum of Western Art, Fort Worth, 1976–1977, *The Face of Liberty*, exhib. cat. by J. T. Flexner and L. B. Samter, p. 230.
ON DEPOSIT: same as preceding entry.
EX COLL.: same as preceding entry.
Bequest of Frances Mead, 1926.
54.15.2.

WASHINGTON ALLSTON

1779–1843

Washington Allston was born in Georgetown, South Carolina, where his family were wealthy landowners. At the age of eight, he was sent to Newport, Rhode Island, to be educated. There it is known that he received some artistic instruction from the portrait painter Samuel King (1749-1819). In 1800, Allston graduated from Harvard, returned to South Carolina, and sold his share of the family property to raise money to study art abroad. In 1801, together with a friend from Newport, the miniature painter Edward Greene Malbone (1777–1807), Allston sailed for England. In London he studied at the Royal Academy and exhibited several paintings at the British Institution. His early works, many executed while he was still in college, consist largely of landscapes. Like those he later painted in London, they reveal his study of prints after such European artists as Salvator Rosa. Allston went to Paris in 1803. There he painted what is probably the first work of his mature style, *Rising of a Thunderstorm at Sea*, 1804 (MFA, Boston). This picture shows a different sensibility, strongly influenced by the works of J. M. W. Turner that Allston had seen in London and to a lesser degree by paintings of similar subjects by Joseph Vernet.

In Rome, where he lived from 1805 to 1808, Allston became friendly with a group of German artists, with whom he often exchanged ideas. Some of his landscapes from this time bear a striking resemblance to ones by the German painter Joseph Anton Koch, who was then living in Rome. In this particular case it is not known whether Allston and Koch knew each other. Allston was also very much aware of the older art of Rome; his severely neoclassical *Jason Returning to Demand His Father's Kingdom*, 1807–1808 (Lowe Art Museum, University of Miami, Coral Gables, Fla.), is clearly dependent on paintings by Nicolas

Poussin, as is *Italian Landscape* of 1805 (Addison Gallery of American Art, Andover, Mass.) He continued to study glazing techniques, which he had begun in London, and his Roman portraits show an increasing mastery of them.

Allston returned to Boston in 1808 and married Ann Channing. (She died in 1815, and in 1830 he married Martha Dana). He painted a few portraits of friends and several landscapes, among them *Coast Scene on the Mediterranean*, 1811 (Columbia Museum of Art and Science, S.C.). In this picture he combined his memories of paintings by Turner with Italian influences to produce what was unquestionably the most accomplished landscape yet painted by an American and one that seems to foreshadow the paintings of FITZ HUGH LANE a generation later. Despite his foreign training and evident skill, Allston apparently received little in the way of patronage, and in July of 1811 he sailed again for England. There he resumed his friendship with Samuel Taylor Coleridge, whom he had come to know in Rome, and again began to produce history paintings. These included *The Dead Man Restored to Life by Touching the Bones of the Prophet Elisha*, 1811-1814 (PAFA), which won a prize of two hundred guineas at the British Institution, and *The Angel Releasing Saint Peter from Prison*, 1814–1816 (MFA, Boston), commissioned by the eminent collector and connoisseur Sir George Beaumont. In these, as in *Uriel in the Sun*, 1817 (Boston University), Allston was striving to equal the monumental history paintings he had seen in Italy and England. In *Elijah in the Desert Fed by the Ravens*, 1817–1818 (MFA, Boston), he perhaps came closest to success. Although based in part on precedents set by Turner, the work is in Allston's own style, an immense landscape masterfully composed and subtly colored in cool blue and shades of brown. By 1818, Allston had become very much a part of the British cultural and artistic world; nevertheless, he decided that year, notwithstanding the strong misgivings expressed by his friends Beaumont, Coleridge, and William Wordsworth, to return home.

In retrospect, it would appear that Allston's friends were right. Except for the mysterious *Moonlit Landscape*, 1819 (MFA, Boston), which is probably his masterpiece, Allston's work after 1818 never equaled what he had produced abroad. The central problem of his career after returning to the United States was his inability to complete *Belshazzar's Feast* (Detroit Institute of Arts), a large painting he had begun in England in 1817 and on which he worked until his death. The innumerable changes and revisions he made to it have been attributed to a kind of artistic insecurity caused by his attempt to paint in this country a picture for which there were no models or tradition. With no one in Boston to turn to for advice except GILBERT STUART, who was apparently responsible for the initial changes in the painting, Allston seems to have been at a loss as to how to proceed. As in the case of JOHN VANDERLYN, an artistic career that had flowered in Europe became tragically blighted in America. Allston was not, however, completely preoccupied with *Belshazzar's Feast*. He painted a number of other works, many of them much admired by contemporaries, such as *The Spanish Girl in Reverie* (q.v.), in which an idealized figure is seen through a mist against an ethereal landscape, and occasionally history paintings, though these are generally considered minor works. The landscapes after 1819 are hazy and insubstantial, entirely lacking the earlier vigor. Despite his disappointments, Allston was a much loved and admired figure. He was generally considered the country's leading artist from 1828, when Stuart died, until his own death in 1843.

BIBLIOGRAPHY: Washington Allston, *Lectures on Art, and Poems*, ed. R. H. Dana, Jr. (New York, 1850). Contains his theory of art // Jared B. Flagg, *Washington Allston: Life and Letters* (New York, 1893). A full biography written by his half-nephew // Edgar Preston Richardson, *Washington Allston: A Study of the Romantic Artist in America* (Chicago, 1948). The definitive treatment up to that time, it includes a catalogue raisonné // William H. Gerdts, "Washington Allston and the German Romantic Classicists in Rome," *Art Quarterly* 32 (Summer 1969), pp. 166–196. Very thorough and perceptive study of Allston's early life and artistic influences // William H. Gerdts and Theodore E. Stebbins, Jr., *"A Man of Genius": The Art of Washington Allston (1779–1843)* (Boston, 1979). A catalogue for an exhibition held at the Pennsylvania Academy of the Fine Arts and the Museum of Fine Arts, Boston, it contains the most recent and best overall treatment of Allston.

A Study from Life *and* Study for the Angel Releasing Saint Peter from Prison

Allston produced many paintings of idealized female figures, particularly in his later years. *A Study from Life* is an early example. As his contemporaries were aware, all these women resembled each other to some degree. The writer William Ware noted in 1852:

There was no subject, perhaps, of which he was so fond, (and it agreed with the delicacy and refinement of his mind,) and repeated so often, as ideal female heads; ... while all the accidents of the picture varied ... the type was the same ... an inexpressive countenance, or at most, a ruminating, introspective one (*Lectures on the Works and Genius of Washington Allston* [1852], pp. 64–65).

In 1948 the painting was dated 1802–1803 by Edgar P. Richardson, based on his belief that the immature technique indicated the time of Allston's first London period from 1801 to 1803 and on the statement by Allston's brother-in-law Richard Henry Dana, Jr., that it was painted from life in London. Richardson at that time, however, was unaware of the study on the verso for a much later project, *The Angel Releasing Saint Peter from Prison* of 1812–1816, which was also used for the figure at the left in Allston's *Dido and Anna* (Lowe Art Museum, University of Miami, Coral Gables, Fla.). William H. Gerdts has redated *Dido and Anna* from 1805–1808 to about 1815, and thus the *Study from Life* should be dated at about that time as well. In style it fits better with Allston's later work, in which the mixing of colors under many glazes gives an impression of color without being definitely of a single hue. The woman's dress is composed of shifting, indeterminate shades of red, blue, and green. Her hair shines a dark reddish brown

through the hazy atmosphere that so often characterized Allston's work from 1815 on. Her delicate pink lips, almost hidden in a shadow, are a strikingly realized effect that may suggest a reason for his contemporaries' unending praise of him as a colorist.

The painting remained in Allston's possession throughout his life. Many years later, he appears to have returned to *A Study from Life* or to *Dido and Anna* as the source for Jessica's face in *Lorenzo and Jessica*, 1832 (coll. Elizabeth von Wentzel, ill. in MFA, Boston, "*A Man of Genius*," exhib. cat. [1979], no. 64).

The Angel Releasing Saint Peter from Prison was commissioned in 1812 by the well-known connoisseur and art patron Sir George Beaumont for the parish church of Cole Orton, near Ashby-de-la-Zouch, Leicestershire. (The painting was later returned to the Beaumont family and ultimately made its way to the MFA, Boston.) The study differs from the finished painting, in which the angel's left arm is extended somewhat further and there are additional folds of drapery. Because it was quickly, though carefully, painted and does not have Allston's usual painstaking application of glazes, the study is fresh and immediate in a way that his work rarely is, and its clear, unobscured outlines demonstrate how accomplished a draftsman he was with paint.

Oil on paperboard, 36¼ × 26¾ in. (92.1 × 67.9 cm.).

RELATED WORKS: (For A Study from Life): *Dido and Anna*, 1813–1815, oil on millboard, 24 × 18⅛ in. (61 × 46 cm.), Lowe Art Museum, University of Miami, Coral Gables, Fla., ill. in MFA, Boston, "*A Man of Genius*" (1979), p. 45, no. 26.

(For Study for the Angel Releasing Saint Peter from Prison): *Study for the Angel Releasing Saint Peter*, ca. 1813–1814, graphite on paper, 6½ × 6¼ in. (16.5 × 15.9 cm.), MFA, Boston, ill. in MFA, Boston, "*A Man*

Allston, *A Study from Life.*

Allston, *Study for the Angel Releasing Saint Peter from Prison.*

of Genius" (1979), ill. p. 225, fig. 77 || *Study for the Head of Saint Peter,* 1814–1815, oil on millboard, 26 × 23½ in. (66 × 59.7 cm.), coll. Eleanor A. Bliss, ill. ibid., p. 184, no. 27 || *The Angel Releasing Saint Peter from Prison: Sketch,* ca. 1814, oil on canvas, 29 × 25⅛ in. (73.7 × 63.8 cm.), private coll., ill. in E. P. Richardson, *Washington Allston* (1948), pl. 27 || *The Angel Releasing Saint Peter from Prison,* 1814–1816, oil on canvas, 124½ × 108½ in. (316.2 × 275.6 cm.), MFA, Boston, ill. in MFA, Boston, *"A Man of Genius"* (1979), p. 185, no. 28.

REFERENCES: *The Journal of Richard Henry Dana, Jr.,* ed. R. F. Lucid (1968), 1, p. 176, entry of July 12, 1843, speaks of "two unfinished female heads one of which was large, somewhat open & low dressed in the bosom & the face averted. This was painted in London, & he had life to paint from," says "the picture painted in London presented the right side," presumably referring to Study from Life; says R. W. Weir particularly mentioned as praiseworthy the "female figure from life, with bare arm and neck" || M. Sweetser, *Allston* (1879), p. 188, lists Study from Life as ideal female figure, in the collection of Richard H. Dana, Jr. || A. T. Gardner, *MMA Bull* 3 (Oct. 1944), p. 54 || E. P. Richardson, *Washington Allston*

(1948), p. 188, says Study from Life was used for figure of Anna in Dido and Anna || Gardner and Feld (1965), pp. 142–143, publish verso for first time || W. H. Gerdts, letter in Dept. Archives, April 5, 1979, says the studies were probably painted during Allston's second rather than first London visit, redates Dido and Anna, ca. 1815, pointing out its similarity to descriptions of Allston's Hermia and Helena (ill. Hirschl and Adler Galleries, New York, *The Art of Collecting* [1984], p. 13, no. 5), which is known to have been painted during his second visit || MFA, Boston, *"A Man of Genius,"* exhib. cat. (1979), pp. 92–93, W. H. Gerdts, dates Study for the Angel 1813–1815; p. 94, gives same date for Study from Life.

EXHIBITED: Boston Athenaeum, 1850, no. 64, as Study from Life — (Painted in London), lent by Mrs. Allston || MFA, Boston, 1881, *Exhibition of the Works of Washington Allston,* no. 268, lent by Richard H. Dana, Jr., says painted before 1818.

ON DEPOSIT: MMA, 1924–1931, from Richard Henry Dana, Jr.; 1931–1956, from the Allston Trust || Allentown Art Museum, Allentown, Pa., 1975–1977.

EX COLL.: Mrs. Washington Allston, Cambridge, Mass., 1843–1862; her brother, Richard Henry Dana,

Jr., Cambridge, by 1879–1931; Allston Trust, Boston, 1931–1956.

Gift of the Allston Trust, 1956.

56.53.

The Spanish Girl in Reverie

Allston explained the subject of this painting in a poem he wrote to accompany its first exhibition in 1831 at the Boston Athenaeum. "Sweet Inez" is sitting at the spot where her betrothed, Isidor, pledged her his love and from which five months ago he departed for a war. She dreams about his return, little guessing that, the battle already won, he is on his way back to her. At the poem's close he rides up, and the pair are blissfully reunited. Characteristically, Allston chose to depict the moment before action occurs, when, fearing for her lover's safety, Inez thinks back to when she first fell in love. This quiet, but emotional, moment of reflection, or reverie, as it was often termed, was a favorite subject for Allston and one which he shared with his friends the English romantic poets Coleridge and Wordsworth. The Spanish girl, with her generalized, luminous features, is the descendant of many of Allston's romantic heroines They are etherealized beauties who seem to inhabit a special, totally inactive, world.

In 1979, a drawing from the Massachusetts Historical Society was identified as a life study

Allston, *Seated Young Woman Holding Flowers.* Courtesy of the Fogg Art Museum, Harvard University, Cambridge, Mass. Washington Allston Trust.

Allston, *Life Study of Ann Channing.* Massachusetts Historical Society.

of Allston's first wife, Ann Channing, who died in 1815. Theodore Stebbins dated the drawing about 1812 and suggested that the same woman appears in a study for *The Angel Releasing Saint Peter from Prison*, 1814 to 1816 (MFA, Boston), *Rebecca at the Well*, 1816 (Washington Allston Trust, Fogg Art Museum, Harvard University), and *Beatrice*, 1819 (MFA, Boston). The drawing, however, is closest to *The Spanish Girl in Reverie*, with almost every detail corresponding. While it is by no means impossible that Allston would have turned to a drawing done some fifteen or so years before as a model for this painting, it is also likely that the identification of the subject

and the dating of the drawing are incorrect. In any event, the drawing clearly served as the source for the present painting.

Despite the Spanish girl's rather sentimental charm, Allston's contemporaries appear to have focused their attention on the landscape, being particularly fascinated by his technique. Speaking of the picture, the writer and painter Henry Greenough (1807–1883) asked Allston how "you give a certain mellowness of tone which I can only describe by saying that your mountains look as if one could with a spoon help himself easily to a plateful." Allston (1893) is said to have replied:

Allston, *The Spanish Girl in Reverie*.

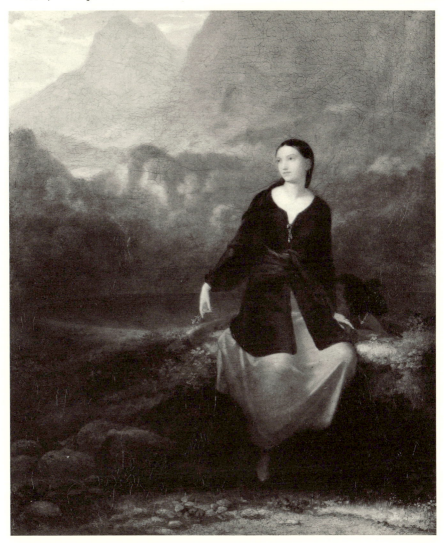

I am glad you like *that* picture, for I thought I had been happy in the very effect, and I will tell you how I painted it. I first conceived the process when studying Mount Pilot, in Switzerland. I painted the mountain with strong tints of pure ultramarine and white of different tints, but all blue. Then to mitigate the fierceness of the blue I went over it, when dry, with black and white, and afterward with Indian red and white, not painting out each coat by the succeeding one, nor yet scumbling, but going over it in parts as seemed necessary. You know that if you paint over a red ground with a pretty solid *impasto* you get a very different effect of color from one painted on a blue or yellow ground. Whatever be the color of the ground it *will* show through and have its effect on the eye, unless with *malice prepense* you entirely bury it with opaque color. In this way I went over that mountain, I suppose, *at least twenty times*, and that is the secret of the diaphanous effect which you mention.

For many years, the landscape that so pleased contemporary viewers was difficult to assess. The varnish in the glazes had become yellowed and much less transparent over the years. In 1980, the old varnish was slowly removed with particular care taken not to disturb the layers of glazes. The picture turned out to be remarkably well preserved, and Allston's colors exhibit the diaphanous effect he so diligently sought.

Oil on canvas, 30 × 25 in. (76.2 × 63.5 cm.).
RELATED WORKS: *Life Study of Ann Channing*, ca. 1812–1815?, graphite on paper, 5¼ × 8¼ in. (13.3 × 21 cm.), Massachusetts Historical Society, Boston, ill. in MFA, Boston, "*A Man of Genius*" (1979), no. 87 // *Seated Young Woman Holding Flowers*, graphite on paper, 4⅛ × 3⅜ in. (12.2 × 9.7 cm.), n.d., Washington Allston Trust, Fogg Art Museum, Harvard University, ill. in *Winterthur Portfolio* 12 (1977), p. 15, fig. 14.
REFERENCES: F. Dexter, *North American Review* 33 (Oct. 1831), pp. 506–510, writes in a review that "In atmospheric effect, we do not believe it has ever been surpassed"; includes Allston's poem // *Remarks on Allston's Paintings* (1839), pp. 16–18, refers to her as the Castilian maiden // J. Huntington, *Knickerbocker* 14 (August 1839), pp. 163–174, mentions it in a review in which the picture did not appear // W. Allston, *Lectures on Art, and Poems*, ed. R. H. Dana, Jr. (1850), pp. 333–335, quotes poem; regrets the picture's absence from 1839 exhibition and describes background landscape "among which you see and *hear* a sweet little cascade falling into a stream whose quiet tune it hardly disturbs" // W. Ware, *Lectures on the Works and Genius of Washington Allston* (1852), pp. 77–78, calls it "one of the most beautiful and perfect of Mr. Allston's works" because of the landscape // *Crayon* 6 (Dec. 1859), p. 381, says the painting "now at the Astor Library" is for sale // S. Clarke, *Atlantic Monthly* 15 (Feb. 1865),

pp. 135–136 // H. T. Tuckerman, *Book of the Artists* (1867), p. 149 // M. Sweetser, *Allston* (1879), p. 112; p. 190, says painted after 1818 // J. B. Flagg, *Life and Letters of Washington Allston* (1893), p. 194 (quoted above) // E. L. Cary, *International Studio* 35 (Sept. 1908), pp. xci–xcii // A. T. Gardner, *MMA Bull.* 3 (Oct. 1944), p. 57 // E. P. Richardson, *Washington Allston* (1948), p. 149, calls it Allston's best-known work; p. 157; p. 210, no. 135, dates it 1831 // H. W. L. Dana, in Cambridge Historical Society Publications, *Proceedings for the Year 1943* 29 (1948), p. 49 // Gardner and Feld (1965), pp. 143–144 // W. H. Gerdts, *Art Quarterly* 32 (Summer 1969), p. 167, cites it as an example of Allston's move from dynamism to reverie in figure painting; p. 192 // B. Novak, *American Painting of the Nineteenth Century* (1969), p. 58, says example of single figure dreaming in a landscape depends for success on qualities of light, color, and atmosphere // R. A. Welchans, "The Art Theories of Washington Allston and William Morris Hunt," Ph. D. diss., Case Western Reserve University, 1970, pp. 38, 53–54 // W. H. Gerdts, *Art in America* 61 (May–June 1973), p. 62, calls it culmination of "lovely, poetic images of women and youths" // E. B. Johns, "Washington Allston's Theory of the Imagination," Ph. D. diss., Emory University, 1974, pp. 103–104 // E. Johns, *Winterthur Portfolio* 12 (1977), p. 12, says Allston's main concern "seems to be the figure's attitude, both literal and symbolic, of quiet receptivity"; ill. p. 13 // Lowe Art Museum, University of Florida, Coral Gables, Fla., *The Paintings of Washington Allston*, exhib. cat. (1975), pp. 9, 16 // S. B. Webster, MS in Dept. Archives, 1978, gives references to the painting // MFA, Boston, "*A Man of Genius*," exhib. cat. (1979), pp. 125, 130, 139, 140, 167; pp. 225–229, T. E. Stebbins, Jr., discusses drawing of Ann Channing // D. Dwyer, Paintings Conservation, 1980 report in Dept. Archives, describes condition and conservation.
EXHIBITED: Boston Athenaeum, 1831, no. 135, lent by E. Clark; 1862, no. 303, lent by Mrs. Clark // MFA, Boston, 1881, *Exhibition of the Works of Washington Allston*, no. 241a, lent by Mrs. Daniel Thompson (noted on a label on the back) // MMA, 1965, *Three Centuries of American Painting* (checklist arranged alphabetically) // Los Angeles County Museum of Art and M. H. de Young Memorial Museum, San Francisco, 1966, *American Paintings from the Metropolitan Museum of Art*, pl. 32 // Slater Memorial Museum, Norwich, Conn. 1968, *A Survey of American Art*, no. 4 // MMA and American Federation of the Arts, traveling exhibition, 1975–1977, *The Heritage of American Art*, cat. by M. Davis, no. 21, color ill. p. [62], says modeled on outdoor figure compositions of Titian.
EX COLL.: E. Clark, Boston, by 1831; Mrs. Clark, by 1862; Mrs. Daniel Thompson, Northampton, Mass., by 1881; Lyman Bloomingdale, New York, by 1901.

Gift of Lyman G. Bloomingdale, 1901.
01.7.2.

JOHN WESLEY JARVIS

1780–1840

Jarvis was born in England, although he came from a family that had settled in America by the middle of the eighteenth century. His grandfather, a hatter, was one of the early members of the first Methodist Society in New York. At the time of his grandfather's death, Jarvis's father was sent to England, and he later married there. John Wesley Jarvis was born in South Shields. In 1783, his father returned to the United States, and the rest of the family followed in 1786. They first lived in Philadelphia, where in 1795 John Wesley Jarvis was apprenticed to the English artist Edward Savage (1761-1817), who taught him engraving. Jarvis accompanied Savage to New York in 1801 and soon set up his own business. About 1804 or 1805 he began a partnership, painting portraits and miniatures, with another young artist, JOSEPH WOOD. Both received instruction in the technique of miniature painting from Edward Greene Malbone (1777–1807). Besides miniatures on ivory and paper, they produced silhouettes on glass and profiles in gilt. In 1810 the partnership was dissolved, and Jarvis made the first of his many winter trips south, first stopping in Baltimore and then going on to Charleston. He undertook anatomical studies with Dr. John Augustine Smith, who followed the theories of phrenology. WILLIAM DUNLAP writes that Jarvis may have been the "first painter in this country who applied phrenological science to the principles of the art of portrait painting" (2, pp. 77–78).

In 1811 Jarvis moved his studio to Baltimore, where "his convivial talents, his storytelling, his untiring capability of remaining at the table, as well as his talents as an artist" (ibid., p. 79) procured him commissions. He remained there for at least two years and exhibited at the Pennsylvania Academy of the Fine Arts, in Philadelphia. Although his work was uneven, Jarvis was one of the most sought-after portraitists of his day. He was back in a studio in New York by 1813. In 1814, he was commissioned by the Corporation of the City of New York to paint portraits of six leading military heroes of the War of 1812, among them Thomas McDonough and Oliver Hazard Perry (City Hall, New York). To help him in this undertaking, Jarvis engaged HENRY INMAN as his apprentice. These large full-length portraits are among Jarvis's most ambitious works.

Inman reports that by 1820 Jarvis was receiving as many as six sitters a day. He gave each an hour and often completed six portraits a week. It seems that Jarvis would paint the face and figure and then turn the canvas over to Inman to do the background and drapery.

Jarvis was noted for his flamboyant personality and behavior, strolling the streets accompanied by two enormous dogs and dressed in "a long coat trimmed with furs like a Russian prince" (Dunlap, 2, p. 217). His studio was described as "chaotic . . . inextricable confusion, sometimes picturesque, but rarely comfortable" (Tuckerman, p. 59).

He continued to travel to make his living and in the winters painted in Charleston, Mobile, or New Orleans. In 1834 he was crippled by a stroke, which ended his career. He lived out his last years cared for by his sister in New York, and there he died on January 12, 1840.

Married twice, he had several children, one of whom, CHARLES WESLEY JARVIS, also became a portrait painter.

Although Jarvis was probably for some years one of the country's preeminent portraitists, his work, as has been noted, was uneven. It is not always easy to distinguish his style from that of other New York portraitists of the period. Among his finest achievements are the many portrait miniatures he did in the early years of the nineteenth century. Unlike his oil portraits, where his inability to draw well is often evident, the miniatures exhibit his ability to render a face without any such flaws.

BIBLIOGRAPHY: William Dunlap, *A History of the Rise and Progress of the Arts of Design in the United States* (2 vols., New York, 1834), 2, pp. 72–96. Details major events in the artist's career, some of them supplied by Henry Inman // Henry T. Tuckerman, *Book of the Artists* (New York, 1867), pp. 57–61 // Theodore Bolton and George C. Groce, "John Wesley Jarvis, an Account of His Life and the First Catalogue of His Work," *Art Quarterly* 1 (Autumn 1938), pp. 299–321. Includes a discussion of his technique // Harold E. Dickson, "Day vs. Jarvis: With Notes on the Early Years of John Wesley Jarvis," *Pennsylvania Magazine of History and Biography* 63 (April 1939), pp. 169–188 // Harold E. Dickson, *John Wesley Jarvis* (New York, 1949). A biographical study that includes a checklist of the artist's works.

Mrs. Robert Dickey

This early Jarvis portrait and its companion (see below) are thought to have been painted as wedding portraits. The young woman wears a simple white empire style gown with a veil, which could be a wedding or an evening dress.

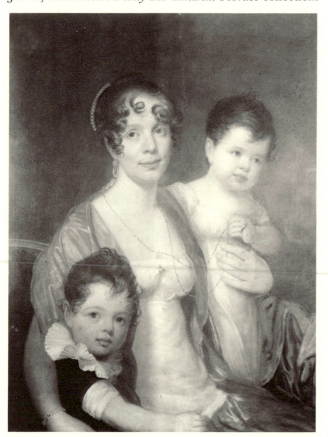

Jarvis, *Mrs. Robert Dickey and Children*. Private collection.

Her arm is placed over the back of the chair in such a way as to make her wedding ring especially evident. When the portraits came to the museum, they were unidentified, but the young woman is obviously the same subject as in a later Jarvis portrait, *Mrs. Robert Dickey and Her Children* (private coll.), which shows her wearing the same bracelet, earrings, and pearl comb. Her bright red hair is dressed in the antique style that became popular about 1803.

The subject, Anne Brown Dickey (1783–1846), was the daughter of Dr. and Mrs. George Brown. She was born in Northern Ireland and immigrated with her family to Baltimore as a child. She was married to Robert Dickey (see below) in Baltimore in 1807, and came to live in New York. She is said to have had ten children. Mrs. Dickey's aunt was the wife of the wealthy banker Alexander Brown, who in 1824 bought Mrs. Dickey a house on Greenwich Street in New York, which we know from the codicil to her will (Liber No. 14, Proceedings to Probate Wills of Real Estate, New York Surrogate's Court). She died on March 26, 1846, five years before her husband, and was buried in Laurel Hill Cemetery in Philadelphia.

Jarvis also painted portraits of Mrs. Dickey's parents, Dr. and Mrs. George Brown (private coll.). Both sets of portraits, all on wood panel, appear to be painted from about 1807 to 1810. In these early portraits, Jarvis's poor ability to render the human body is offset by the animation and interest he gave to the faces.

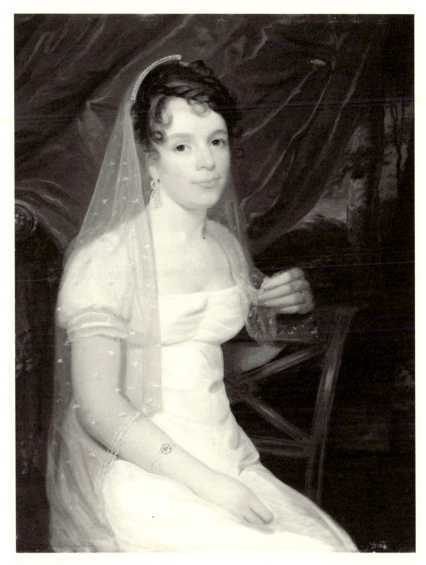

Jarvis, *Mrs. Robert Dickey*.

Oil on wood, 34½ × 27¹¹⁄₁₆ in. (87.6 × 70.3 cm.).

ON DEPOSIT: Gracie Mansion, New York, 1974–1975.

REFERENCES: M. Rotan, FARL, Sept. 1969, note on FARL photograph mount, suggests that subject is Mrs. Dickey based on Jarvis portrait of Mrs. Robert Dickey with Her Children // memo in Dept. Archives, 1984, notes that M. Rotan at FARL identified the sitter based on the Jarvis portrait of Mrs. Robert Dickey with Her Children, which is in a private collection.

EXHIBITED: Adams, Davidson and Co., Washington, D. C., *American Portraits* (1964), pp. 2–3, as Portrait of a Woman by J. W. Jarvis, ca. 1810; *American Portraits* (1967), p. 36, no. 47, ill. p. 7, as Portrait of a Woman, ca. 1810; Hirschl and Adler, New York, Dec. 4, 1967–Jan. 13, 1968, *American Paintings for Public and Private Collections*, no. 24, as Portrait of a Lady, dated ca. 1810–1815 // MMA, 1970, *19th Century America*, exhib. cat. by J. K. Howat and N. Spassky (not in cat.); 1986–1987, *Dance*, no cat.

EX COLL.: with Adams, Davidson and Co., Washington, D. C., 1963–1967; with Hirschl and Adler, New York, 1967–1969.

Bequests of Oliver Burr Jennings and George D. Pratt, by exchange, 1969.

69.22.1.

Robert Dickey

Since this portrait is the companion piece to the one above, it is assumed that it is a likeness of Robert Dickey (1777–1851). There are two other portraits of him known, a pencil drawing by JOHN VANDERLYN, done in Paris in 1800, and a miniature by Edward Greene Malbone (1777–1807) of 1802 (both private coll.). Although the features of the Jarvis portrait correspond to those in the other portraits, the resemblance is not as close as one would expect. It is possible that the two other works are romanticized images and Jarvis's a more realistic one.

Robert Dickey was born in Northern Ireland, the son of Ann Thompson and John Dickey of Cullybacky, county Antrim. Like the Browns, the Dickeys immigrated to the United States. John Dickey died in Newcastle, Delaware, in 1795. Robert Dickey became a New York merchant. He is listed in the city directories as early as 1802. For most of his seventy-four years, he made his home on Greenwich Street, and, according to the minutes of the common council, owned land on Varick and Chapel streets in the

1820s. One of his grandsons, Charles Denston Dickey, reported (1909) that Robert Dickey failed in business about 1835.

Holding a bamboo walking stick in his lap, the subject of this bold portrait gazes intently at the viewer; from his waist hangs a gold seal and in his shirt is a jeweled stickpin. There is a great deal of awkwardness in the painting of the figure, especially the neck, which is unnecessarily elongated. Jarvis seems to have had trouble with the man's height, barely fitting him on the canvas. Despite this, Jarvis imbued Mr. Dickey with a spirited and pleasant countenance. The coloring is lively as well. The landscape background, painted in a very free style with loose brushwork, is typical of Jarvis's portraits of this period. Like the portrait of Mrs. Dickey, the date of this work is probably about 1807 to 1810.

Oil on wood, 34½ × 27⅝ in. (87.6 × 70.2 cm.).

ON DEPOSIT: Gracie Mansion, New York, 1974–1975.

REFERENCES: J. C. Brown, *A Hundred Years of Merchant Banking* (1909), p. 329, gives brief biographical information on the subject obtained from C. D. Dickey // M. Rotan, FARL, Sept. 1969, note on FARL photograph mount, suggests that subject is Mr. Dickey based on two other portraits and one of his wife // Memo in Dept. Archives, 1984, notes that M. Rotan at FARL identified the sitter based on portraits of him and his wife.

EXHIBITED: Adams, Davidson and Co., Washington, D. C., *American Portraits* (1964), pp. 2–3, as Portrait of a Man, by J. W. Jarvis, ca. 1810; *American Portraits* (1967), p. 36, no. 47, ill. p. 7, as Portrait of a Man, ca. 1810 // Hirschl and Adler Galleries, New York, Dec. 4, 1967–Jan. 13, 1968, *American Paintings for Public and Private Collections*, no. 25, as Portrait of a Gentleman, ca. 1810–1815 // MMA, 1970, *19th Century America*, exhib. cat. by J. K. Howat and N. Spassky (not in cat.).

EX COLL.: with Adams, Davidson and Co., Washington, D. C.; 1963–1967; with Hirschl and Adler Galleries, New York, 1967–1969.

Bequests of Oliver Burr Jennings and George D. Pratt, by exchange, 1969.

69.22.1.

Vanderlyn, *Robert Dickey*. Private collection.

Mrs. William Thomas (Ann Hampton)

For some years, confusion existed over the identity of the subject in this portrait. She was once thought to be Mrs. Wade Hampton, although the donor originally stated that the por-

Jarvis, *Robert Dickey.*

trait was of Ann Hampton, a maternal ancestor. A careful tracing of her family genealogy has revealed that her maternal great-great-grand-mother was Ann Hampton Thomas (1762–1840), whose dates and circumstances, indeed, match those of the lady in the Jarvis portrait. Ann Hampton was married to William Thomas, Jr., at Trinity Church in New York, on November 17, 1781. The couple had ten children. Thomas, who came from Halifax, Yorkshire, England, is listed in the New York city directories first as a grocer and by 1791 as a merchant. He died on

October 20, 1810, at the age of sixty at his home, Poplar Hill, in Greenwich Village. By 1820, the Thomas estate there consisted of twelve lots on Broadway near Art Street (later Astor Place), which in those years had the character of a residential area with fine brick houses. Mrs. Thomas died November 3, 1840, and was buried in the family vault in Trinity Church.

It is unusual in American portraits of this period to depict sitters in outdoor settings. Here the brown tones in the trees indicate an autumn scene. Bundled up in dark heavy clothing, Mrs.

Jarvis, *Mrs. William Thomas (Ann Hampton).*

Thomas also wears a black shawl with a wide decorative floral border, which was fashionable mourning attire. While she does not appear to be young, the curls poking out from beneath her black bonnet are still reddish in color. Thus, Mrs. Thomas was probably painted after 1810, the year she was widowed, but closer to 1813, when Jarvis returned to New York after almost two years in Baltimore. The portrait is very close in style and feeling to Jarvis's portrait of De Witt Clinton (MFA, Boston), which also shows the sitter against a dramatic sky. Typical of Jarvis's New York portraits of this period, Mrs.

Thomas is neither carefully drawn nor flattered, but comes across as a lively person.

Oil on canvas, 34⅛ × 27⅛ in. (86.5 × 68.7 cm.).
REFERENCES: K. Bonner, letter in MMA Archives, June, 6, 1954, says the portrait is of Ann Hampton // Memo in MMA Archives, June 16, 1954, reports that the donor identified the sitter as an ancestor in the maternal line of Griffith // K. Bonner, will, Nov. 17, 1959, probated 1962, calls it a portrait of Ann Hampton by J. W. Jarvis // Gardner and Feld (1965), pp. 146–147, catalogue it as Portrait of an Old Lady, mistakenly say the donor thought the subject was

Mrs. Ann Hampton, note that Mrs. Wade Hampton (Anne Fitz Simmons) would have been too young, and say the dashing brushwork is characteristic of Jarvis // L. P. Symington, 1986, note in Dept. Archives, establishes the ancestor of the donor as Ann Hampton Thomas.

Ex coll.: the subject, New York, d. 1840; probably descended to her granddaughter, Ann Thomas (Mrs. Edward) Griffith, New York, d. 1871; her daughter, Kate Helena Griffith (Mrs. Robert Bonner), New York and Lenox, Mass., d. 1927; her daughter, Kate d'Anterroches Bonner, New York, until 1962.

Bequest of Kate d'A. Bonner, 1962.
62.183.1.

Alexander Anderson

Alexander Anderson (1775–1870) was the first important wood engraver in the United States. He was born in New York, the son of a Scottish printer who published a newspaper, the *New York Constitutional Gazette*. He studied medicine and became a physician, continuing, however, a boyhood interest in drawing and engraving. Anderson was particularly taken with the work of the English wood engraver Thomas Bewick, whose white-line engraving style he imitated. When the yellow fever epidemic of 1798 claimed the lives of Anderson's wife, infant son, and several other members of his immediate family, he abandoned his medical practice. During a recuperative stay on Saint Vincent in the West Indies, he spent a good deal of time drawing and experimenting with printmaking. When he returned to New York, he made wood engraving his full-time profession. Among the many illustrations he did were ones for the Bible, the works of Shakespeare, books for young people, and medical texts. His achievements also included the engravings for the American edition of Bewick's *General History of Quadrupeds* (1804).

Anderson and Jarvis were friends and collaborated on book illustrations. Their association began about 1808 when John R. Desborough Huggins sought artists to illustrate a collection of musings, *Hugginiana* (1808), that he wished to publish. Jarvis drew the illustrations and Anderson engraved them. They continued to work together, and in 1809 Anderson assisted Jarvis in taking the death mask of his friend the political revolutionary Tom Paine (NYHS). Also, prior to the War of 1812, they collaborated on some political caricatures relating to the embargo. About 1814–1815, Anderson was chosen to en-

grave the plates for paper money issued in New York when currency became scarce. According to family tradition, it was about this time that Jarvis painted Anderson's portrait.

Very few could match Alexander Anderson's wood cutting skills, and he continued to engrave illustrations up to the age of ninety-three, when he produced the cuts for the second edition of John Warner Barber's *Historical Collections of New Jersey* (1868).

This portrait by Jarvis is thought to be one of the few depictions of Alexander Anderson. A certificate, signed by Anderson's grandson, which accompanied the portrait states that it was painted in 1815: "Dr. Anderson was forty years of age at the time of the sitting." Often identified as a sketch, the picture was more likely once a fully realized composition; for the surface reveals several pentimenti, indicating that the image was developed beyond the sketching stage. The portrait, acquired by the museum in the early 1880s, was considered a problem by various conservators over the years. Evidently there had been many later additions to it. An attempt to clarify the background first led to the portrait being overpainted in the 1890s. The

Jarvis, *Alexander Anderson.*

present state of the picture reflects at least four attempts at cleaning and restoration. A photograph taken in 1914, before the removal of extensive overpaint, shows that little but the face could be distinguished. In 1951, Albert Ten Eyck Gardner expressed the suspicion that the portrait might even have been worked on by Anderson himself. At that time, the attempt was made to remove most of the overpaint. Despite this rather drastic approach, the subject retains much of the vitality and characterization that one looks for in Jarvis's successful portraits. Arms resting on an artist's portfolio, Anderson surveys his world with an expression of interest and amusement.

Oil on canvas, 34 × 27 in. (86.4 × 68.6 cm.).
REFERENCES: B. J. Lossing, *A Memorial of Alexander Anderson, M. D.* (1872), p. 85, n. 1, notes that "Mrs. Lewis, Dr. Anderson's youngest daughter, has a fine portrait of her father painted at middle age by his friend John Wesley Jarvis" // E. C. Lewis, grandson of the subject, certificate in MMA Archives, n.d., "This portrait of Dr. Anderson was painted in 1815 by John Wesley Jarvis, the eccentric artist. Dr. Anderson was forty years of age at the time of the sitting. They were intimate friends, and the picture remained in the possession of the family until the present time. It has never been copied" // R. Hoe, Oct. 23, 1881, letter in MMA Archives, says he purchased the portrait from one of Anderson's descendants and thinks it should be in a public gallery in New York // T. Bolton and G. C. Groce, *Art Quarterly* 1 (Autumn 1938), p. 311 // H. E. Dickson, *John Wesley Jarvis* (1949), p. 343, no. 2, dates it ca. 1804 to 1806 // A. T. Gardner, *MMA Bull.* 9 (April 1951), pp. 218–224, discusses the subject, his relationship to Jarvis, and the problems of restoring the portrait; *MMA Bull.* 23 (April 1965), ill. p. 267, fig. 4, p. 270, discusses // Gardner and Feld (1965), p. 146 // W. D. Garrett, *MMA Journal* 3 (1970), ill. p. 323, p. 325, discusses it.
EXHIBITED: MMA 1958–1959, *Fourteen American Masters*, no cat.; 1965, *Three Centuries of American Painting*, (checklist arranged alphabetically) // Los Angeles County Museum of Art and M. H. de Young Memorial Museum, San Francisco, 1966, *American Paintings from the Metropolitan Museum of Art*, no. 21 // MMA, 1970, *19th Century America*, exhib. cat. by J. K. Howat and N. Spassky (not in cat.).
EX COLL.: the subject, d. 1870; his daughter, Jane (Mrs. Edwin) Lewis, Jersey City, N. J.; her son, Dr. E. C. Lewis, Jersey City, N. J., until 1881; Robert Hoe, Jr., New York, 1881.
Gift of Robert Hoe, Jr., 1881.
81.16.

General Andrew Jackson

Andrew Jackson (1767–1845), the seventh president of the United States, 1829–1837, was born at Waxhaw, on the border of North and South Carolina. He served in the army briefly during the American Revolution and was imprisoned by the British. Later, he went on to study law and was admitted to the bar in 1787. He moved to Nashville in 1788 and practiced there successfully, also speculating in land until the panic of 1795 caused him financial problems. Jackson was elected Tennessee's first congressman in 1796, and the next year he became U. S. senator, a post he would take up again in 1823. He served as a superior court judge in Tennessee from 1798 to 1804. During the War of 1812, Jackson defeated the Creek warriors at Horseshoe Bend and rose to the rank of major general. He won a decisive victory over the British at New Orleans, which made him one of the heroes of the war. His exploits as a military leader against the Indians, the British, and the Spanish led to great popularity. That and political events gave him a sweeping victory in the 1828 presidential election. His two terms in office were marked by great turmoil, mainly struggles over the federal tariff and the national bank.

Andrew Jackson was probably one of the most often painted of United States presidents. This portrait by Jarvis dates from about 1819. The Metropolitan owns another portrait of him from about the same time by SAMUEL L. WALDO (q.v.). In the Jarvis portrait, Jackson wears the uniform of a major general. In 1819, when Jackson was made an honorary citizen of New York, the city council commissioned JOHN VANDERLYN to paint a full-length portrait of him (City Hall, New York). On February 23, 1819, the merchant John Pintard noted in a letter to his daughter:

I have just returned from seeing Gen. Jackson sworn in as a citizen of this City. I had a short but distinct view of his hard features suff[icien]t to qualify me to judge of the fidelity of the Portraits of two of our artists Vanderlyne & Jarvis, the first appointed to take the picture for the Cor[poratio]n [of the City] the second for himself. V. is not happy. His portraits are too stiff & minutely labored. Jarvis executes with spirit & is very successful in giving character to his performances. He ought to have been the artist.

On April 26, 1819, one of the general's political allies, Samuel Swartwout of New York,

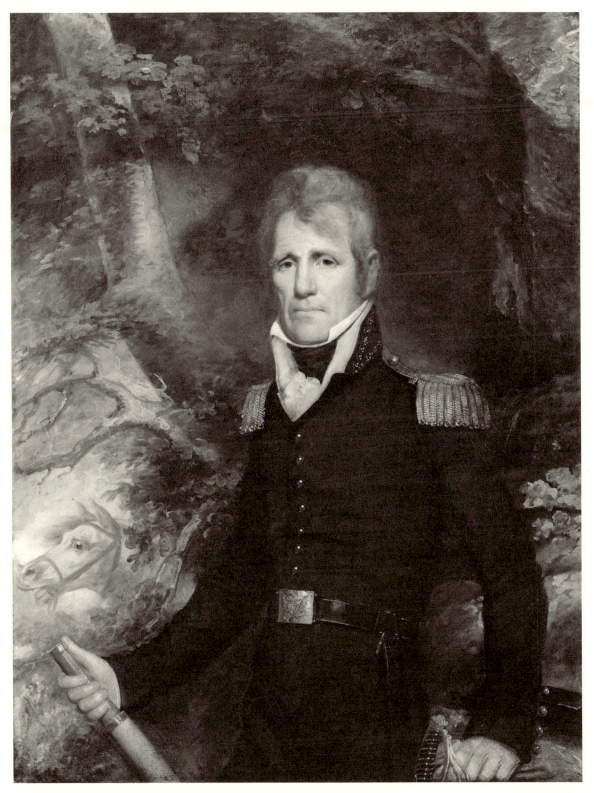

Jarvis, *General Andrew Jackson*.

who may have commissioned the portrait now in the museum, wrote to him:

I have just been to see Jarvis' portrait of you. It is inimitable. He has already made five copies for different gentlemen. You perceive that your friends do not forget you. My picture of you, is to be a three quarter full size. Jarvis has a full-length for himself.

Based on this information Harold Dickson (1949) surmised that Jarvis painted at least seven or eight portraits of Jackson. There is a bust-length portrait of Jackson by Jarvis (White House, Washington, D. C., ill. in Dickson, 1949, no. 78), which Dickson dated about 1819, but it could be earlier. It certainly appears to pre-date the Metropolitan's painting (which was unknown to Dickson in 1949); for not only is the hairstyle an earlier one, but Jackson's hair is not as gray. Another bust-length portrait by Jarvis, recorded in a Colorado collection (FARL 37211), is closer to the Metropolitan's portrait, but Jackson is shown facing in the opposite direction and in civilian dress.

Oil on canvas, 48½ × 36 in. (123.2 × 91.4 cm.).
REFERENCES: J. Pintard to E. Pintard, Feb. 23, 1819, in *Letters from John Pintard to His Daughter, Eliza Noel Pintard Davidson, 1816–1833*, ed. by D. C. Barck (1940), 1, pp. 168–169, possibly this picture (quoted above) // S. Swartwout to A. Jackson, April 26, 1819, in *Correspondence of Andrew Jackson* ed. by J. S. Bassett (1933), 6, p. 471 (quoted above) // H. E. Dickson, *John Wesley Jarvis* (1949), pp. 213–215, notes, "A fortnight after Jarvis' wedding in 1819 the town witnessed a belated celebration of the kind that had accompanied the arrival of heroes during the war Jackson, fresh from the military campaign in Florida was greeted, paraded, dined, presented the freedom of the City in a gold box, and painted for the portrait gallery and according to Joseph Rodman Drake's poem in the *New York Evening Post* he sat "an hour or so with Jervis [*sic*]"; quotes Swartwout // S. Feld, *Antiques* (April 1965), ill. p. 441, says this is probably the portrait painted for Swartwout // Gardner and Feld (1965), pp. 147–149.
EXHIBITED: MMA, 1970, *19th Century America*, exhib. cat. by J. K. Howat and N. Spassky (not in cat.) // National Gallery of Art, Washington, D. C.; City Art Museum, Saint Louis; Seattle Art Museum, 1970–1971, *Great American Paintings from the Boston and Metropolitan Museums*, exhib. cat. by T. N. Maytham, no. 30 // MMA, 1977, *The Heritage of American Art*, exhib. cat. by M. Davis, p. 65, dates it probably 1819, ill. no. 22.
EX COLL.: possibly Samuel Swartwout, New York,

d. 1856; Manhattan Club, New York, until 1964, when it was auctioned.
Harris Brisbane Dick Fund, 1964.
64.8.

ATTRIBUTED TO JARVIS

Augustus Washington Clason

The subject of this portrait, Augustus Washington Clason (1799–1853), was the youngest of eight children of Catherine Matthewman and Isaac Clason, who originally came from Stamford, Connecticut. The father, who died in 1815, was one of New York's wealthiest merchants; he began as a grocer and made a fortune in the China trade, much of which he lost in 1814, when the price of tea fell considerably. That same year, he is said to have lent the government $500,000. He was a director of the Manhattan Bank and was known as a good friend of Aaron Burr's. The area known as Clasons Point, which is now part of the Bronx, was purchased by Isaac Clason in 1793, and remained the family estate for many years. Augustus W. Clason was also a merchant, and until about 1836, he was in business with his brother-in-law John F. Delaplaine. Like his father, Clason was a member of the New York Chamber of Commerce. In 1819 he married Maria Wood of New York; she died in 1822 leaving behind her husband and two children.

A portrait by an unidentified artist of Mrs. Clason, which was once attributed to John Wesley Jarvis, is in the collection of the New-York Historical Society. While Mrs. Clason's portrait does not appear to be a companion piece to that of Mr. Clason, it should be noted that its attribution to Jarvis was removed partly because, in 1965, the Jarvis attribution of the Metropolitan's portrait had been removed. The reasons for discounting the Augustus W. Clason portrait as by Jarvis are understandable. The painting has been so overcleaned that very little of the distinguishing marks of an artist's style are apparent. The brushwork and certain other telling characteristics are no longer evident. There are, however, certain similarities to other works of Jarvis, such as the highlighting and coloring of the features, that make it more likely that it is by him rather than some other New

York portraitist of the period. Since the portrait was donated as a Jarvis by the sitter's son and referred to as a Jarvis by other members of the family, there is a strong possibility that he did in fact paint it. Part of the problem with Jarvis's work is that it varies so much in quality. Although this portrait may not be typical of Jarvis's style, if one can be defined as typical, it does not seem sensible to so readily remove the original attribution.

The donor's granddaughter, who thought the painting was by Jarvis, noted that the portrait was painted when the subject was twenty-one, which would place it about 1820, shortly after Mr. Clason's marriage.

Oil on canvas, 29 15/16 × 25 (76 × 63.5 cm.).

REFERENCES: W. Scoville [W. Barrett, pseud.], *The Old Merchants of New York City* (1862), I, p. 331, V, pp. 151–155, gives information on the subject and his family // A. W. Clason, letter in MMA Archives, March 9, 1909, discusses portrait donated by his father // E. C. Mallison, granddaughter of donor, letters in MMA Archives, Sept. 4, 14, 1925, Dec. 6, 1928, Dec. 2, 1938, discusses family paintings, an undated note in her hand, says that the portrait was painted when Clason was twenty-one // H. E. Dickson, *John Wesley Jarvis* (1949), p. 347, no. 39, lists it as by Jarvis // Gardner and Feld (1965), p. 149, change attribution on stylistic grounds from Jarvis to unknown artist.

EX COLL.: the subject, New York, d. 1853; his

Attributed to Jarvis, *Augustus Washington Clason.*

son, Augustus Wood Clason, New York, until 1875.
Gift of Augustus Wood Clason, 1875.
75.8.

EDWARD HICKS

1780–1849

Born on April 4, 1780, in Attleborough, now Langhorne, Pennsylvania, Edward Hicks was the youngest son of Isaac Hicks, a British official in America, and his wife Catherine. As the American Revolution drew to a close, Isaac Hicks's situation became increasingly precarious, and he was forced to flee, leaving his home and family. Shortly thereafter Catherine Hicks died, and Edward was left a virtual orphan at the age of two.

Hicks was taken in by David and Elizabeth Twining, close friends of his mother's, and was brought up by them as a Quaker. He showed little interest in formal education, and at thirteen was apprenticed to William and Henry Tomlinson, carriage makers at Four Lanes End, Pennsylvania. In 1801, having proved himself a painter of some ability, he moved to

Milford, Pennsylvania, where he became a partner in the coachmaking and painting business of Joshua Canby. He was soon primarily concerned with the painting aspect of the business, not only decorating coaches, but also painting street, shop, and tavern signs. By 1810 he had moved to Newtown, Pennsylvania, where he established his own shop, and, in the following year, produced his first elaborate signs. He later expanded his production to include painted furniture, alphabet blocks (of which he may have been the originator), and fireboards.

The professional career of Edward Hicks fluctuated, but there always appears to have been a demand for his work. At times he directed a large and active shop with many assistants, among them, for a time, his nephew THOMAS HICKS as well as MARTIN JOHNSON HEADE. The reason for the unsteady development of Hicks's painting business was the direct result of his formal acceptance as a Quaker preacher by the Middletown Meeting in Pennsylvania in the autumn of 1812.

Acknowledged as a preacher of extraordinary gifts, he traveled to New York, New Jersey, Canada, and as far as Virginia and the Midwest. The Quaker's general disapproval of painting as too worldly an occupation prompted Hicks to abandon his lucrative sign-painting business in 1814 and try his hand at farming. The result was hardship for his family (he had married Sarah Worstall in 1803 and in 1816 their fifth child was born), mounting debts, and the breakdown of his health. After being rescued financially by a number of friends, Hicks went back to painting about 1820. He resolved his doubts of conscience by concentrating on subjects of obvious moral import. His most popular theme was the Peaceable Kingdom. Based on the prophecy of Isaiah 11, it represents a personal, political, and religious call for peace. Other works depict historical subjects such as *Washington Crossing the Delaware*, *Penn's Treaty with the Indians*, and the *Signing of the Declaration of Independence*. Toward the end of his life, Hicks also portrayed farms belonging to friends and family.

Although Hicks's paintings were well-known within Quaker communities, his fame as a preacher exceeded his renown as an artist during his lifetime. After his death in 1849, his works lapsed into near oblivion until 1932 when one of his Peaceable Kingdoms received considerable notice. Today, he is one of the best known American folk artists. Although the two-dimensional and decorative quality of his paintings reflect his lack of training, as does his reliance on print sources, Hicks's adept use of color and his skill at rendering atmospheric perspective and facial half-tones reveal a talent far beyond that of a mere sign painter.

BIBLIOGRAPHY: Edward Hicks, *Memoirs of the Life and Religious Labors of Edward Hicks, Late of Newtown, Bucks County, Pennsylvania, Written by Himself* (Philadelphia, 1851). Begun in 1843, *Memoirs* also includes a diary and two previously published sermons, "A Little Present for Friends and Friendly People," and "A Word of Exhortation to Young Friends" // Alice Ford, *Edward Hicks: Painter of the Peaceable Kingdom* (Philadelphia, 1952). An informative biography, based on the artist's *Memoirs*, family records, and memorabilia, it is the first to note the Richard Westall print as the source for the Peaceable Kingdom and to assemble Hicks's basic body of works // Abby Aldrich Rockefeller Folk Art Collection, Williamsburg, Va., *Edward Hicks, 1780–1849*, exhib. cat. by Alice Ford (1960). In this first major Hicks exhibition Alice Ford discusses his work in terms of a proposed chronology // Eleanor Price Mather and Dorothy Canning Miller, *Edward Hicks: His Peaceable Kingdoms and Other Paintings* (Newark, Del., 1983). Offers the most up-to-date treatment of the artist's career.

The Falls *of* **Niagara**

Above, below, where'er the astonished eye
Turns to behold, new opening wonders lie,

With uproar hideous'first the *Falls* appear,
The stunning tumult, thundering on the ear.

This great o'erwhelming work of awful Time
In all its dread magnificence sublime,

18

Rises on our view, amid a crashing roar
That bids us kneel, and Time's great God adore.

25

Hicks, *The Falls of Niagara*.

The Falls of Niagara

Only two versions of this subject by Hicks are presently known, this one on canvas, dated 1825, and another on wood, undated (Abby Aldrich Rockefeller Folk Art Center of Colonial Williamsburg). The ownership of the one at Williamsburg can be traced back to Dr. Joseph Parrish of Philadelphia, a prominent Quaker physician active in the abolitionist cause, who treated Hicks's daughter in 1836. The Metropolitan's painting has no comparable history. It is unlikely, however, that it is the sign with the scene of Niagara that Hicks is known to have painted for the Temperance House of Newtown, Pennsylvania.

Hicks based his 1825 painting of *The Falls of Niagara* (as seen from the Canadian side) directly on a vignette from a map of North America published in Philadelphia by Henry S. Tanner in 1822. The moose, beaver, rattlesnake, and eagle—all traditional emblems of North America—and the tree appear in an identical configuration in Tanner's vignette. As usual with Hicks's works, *The Falls of Niagara* is not without relation to his own experience. In his *Memoirs*, he recounts a trip he had made with Isaac Parry and Mathias Hutchinson to Niagara Falls in the autumn of 1819. The Quakers of the Philadelphia Meeting had long been active in missionary work among the Indians of upstate New York, and Hicks, who claimed

A Map of North America (detail) by H. S. Tanner.
Library of Congress.

that "the Heavenly Shepherd in mercy and goodness laid upon me a concern to travel" (*Memoirs*, p. 72), went north to preach. His route from Pennsylvania to Niagara Falls closely followed and was possibly inspired by that described in Alexander Wilson's long, narrative poem *The Foresters*. The poem by the famous American ornithologist was first serialized in the Philadelphia periodical *The Port Folio* between June 1809 and March 1810 and was published by Simeon Siegfried in Hicks's hometown, Newtown, Pennsylvania, in 1818, the year before Hicks's trip. Hicks, who described the falls as "the mighty wonder of the world" (*Memoirs*, p. 74), inscribed on the borders of his painting several lines from the poem.

Oil on canvas, $31\frac{1}{2} \times 38$ in. (80 × 96.2 cm.).

Inscribed and dated at four corners: The / Falls / of / Niagara / 18 / 25 /. Inscribed along the sides: With uproar hideous' first the *Falls* appear, / The stunning tumult thundering on the ear. / Above, below, where'er the astonished eye / Turns to behold, new opening wonders lie, / This great o'erwhelming work of awful Time / In all its dread magnificence sublime, / Rises on our view, amid a crashing roar / That bids us kneel, and Time's great God adore.

RELATED WORKS: Vignette from Henry S. Tanner, *A Map of North America, Constructed According to the Latest Information* (Philadelphia, 1822), ill. *Antiques* (Feb.

1976), p. 366, fig. 1a // *Falls of Niagara*, oil on wood, $37\frac{3}{4} \times 44\frac{1}{2}$ in. (96.5 × 111.8 cm.) including frame, ca. 1825–1826, Abby Aldrich Rockefeller Folk Art Center, Williamsburg, Va., ill. Mather and Price, *Edward Hicks* (1983), p. 203, no. 114. This picture is said to be a companion to a Peaceable Kingdom of the Branch, 1822–1825 (Yale University), which descended in the Parrish family.

REFERENCES: Gardner and Feld (1965), p. 149 // M. Black and J. Lipman, *American Folk Painting* (1966), p. 143, discuss both versions; p. 149, imply Rockefeller version was a fireboard given to Dr. Parrish // M. Black, *Art in America* 57 (May 1969), ill. p. 55 // E. P. Mather, *Edward Hicks, A Peaceable Season* (1973), n. p., ill., says use of new world animals shows the "intense Americanism of the artist" // *MMA Bull.* 33 (1975–1976), ill. p. [239] // J. Ayres, *Antiques* 109 (Feb. 1976), p. 366, ill. p. 368, fig. 2, identifies Tanner map vignette as source for the scene // E. P. Mather and D. C. Miller, *Edward Hicks* (1983), p. 23, color ill. opp. p. 144; pp. 202–203, catalogue both versions.

EXHIBITIONS: MMA, 1961–1962, and American Federation of Arts, traveling exhibition, 1962–1964, *101 Masterpieces of American Primitive Painting from the Collection of Edgar William and Bernice Chrysler Garbisch*, 1961, no. 478, ill. p. 73, listed 144; new ed. 1962, no. 47, p. 146, ill. pl. 47, lent by Edgar William and Bernice Chrysler Garbisch // MMA, 1965, *Three Centuries of American Painting* (checklist arranged alphabetically) // Los Angeles County Museum of Art, Lytton Gallery; M. H. de Young Memorial Museum, San Francisco, 1966, *American Paintings from the Metropolitan Museum of Art*, p. 95, no. 83 // American Federation of Arts, traveling exhibition, 1968–1970, *American Naive Painting of the 18th and 19th Centuries: III Masterpieces from the Collection of Edgar William and Bernice Chrysler Garbisch*, p. 149, no. 42 // Osaka, 1970, United States Pavilion, Japan World Exposition, *American Paintings* (no. cat.) // National Gallery of Art, Washington, D. C.; City Art Museum, Saint Louis; Seattle Art Museum, 1970–1971, *Great American Paintings from the Boston and Metropolitan Museums*, no. 16 // Pushkin Museum, Moscow; Hermitage, Leningrad, 1975, *100 Kartiniz muzeya Metropoliten* [100 Paintings from the Metropolitan Museum], pp. 235–236 // MMA, 1976, *A Bicentennial Treasury* (see *MMA Bull.* above) // New York State Museum, Albany, 1977, *New York — The State of Art* (no cat.) // Whitney Museum of American Art, New York, 1980, *American Folk Painters of Three Centuries*, entry by E. P. Mather, color ill. p. 89; p. 92.

EX COLL.: Indiana art market; with Argosy Gallery, New York, 1957; Edgar William and Bernice Chrysler Garbisch, Cambridge, Md., 1957–1962.

Gift of Edgar William and Bernice Chrysler Garbisch, 1962.

1962.256.3.

Peaceable Kingdom

This is one of approximately sixty versions of the Peaceable Kingdom subject painted by Edward Hicks beginning about 1820. These paintings represent the messianic prophecy of chapter 11 of Isaiah, verse 6:

The wolf also shall dwell with the lamb, and the leopard shall lie down with the kid; and the calf and the young lion and the fatling together; and a little child shall lead them.

Common to all these paintings is the image of a child emerging from the woods into a peaceful gathering of wild and domestic animals. One arm extended over the neck of the lion, the child holds a grapevine or olive branch in the other. Hicks derived this image from an engraving after a drawing by the English artist Richard Westall. The print was easily accessible; for it was a popular illustration in both English and American Bibles in the early nineteenth century. A drawing of a standing lamb, which Hicks

made on the back of an envelope, is very likely a study for the lamb at the right of the composition in many of these paintings, including the Metropolitan's version. The lamb, as well as other animals, is probably derived from zoological illustrations. As Julius Held has pointed out: "Hicks's method of work seems to have been the assembling, in ever new variations, of certain stock figures and poses" (J. Held, *Art Quarterly* 14 [Summer 1951], p. 126).

Hicks often inscribed his own versification of the Old Testament prophecy around the borders of his paintings. On the Metropolitan's painting, he inscribed the book and chapter references below the leopard's paw at the lower right: "Isaiah 11 chap 6 7 8." The additional verses account for the inclusion of an enlarged animal population and of the two children at the left:

And the cow and the bear shall feed; their young ones shall lie down together. And the lion shall eat straw like the ox. And the nursing child shall play

icks, *The Peaceable Kingdom*.

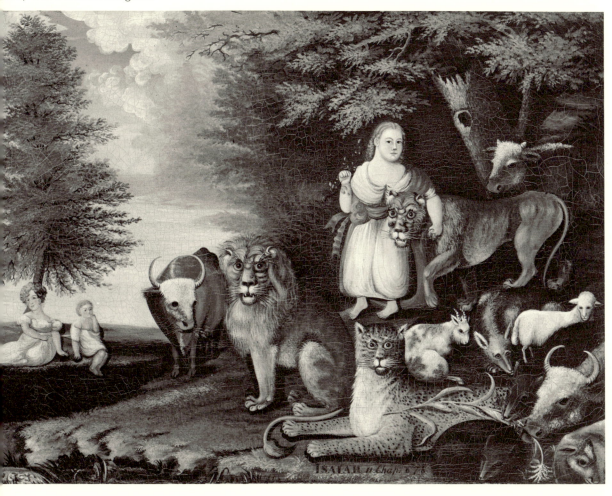

on the hole of the asp, and the weaned child shall put his hand on the adder's den.

Verses on a badly obliterated sheet of paper originally pasted to the back of the stretcher appear to have been a copy of the poem Hicks composed based on the biblical verses, and "had . . . printed to present to friends along with the canvas" (Ford, *Edward Hicks* [1952], p. 41).

In this painting, as in a number of other versions, Hicks gives central prominence to the straw-eating lion and his companion the ox. The image of the lion eating straw was for him a favorite expression of submission. By accepting God, man, like the lion, would abandon his selfish ways: "the lion will eat straw like the ox, and . . . ambitious fiery men and women . . . may become the most distinguished and useful disciples of Jesus Christ" (Edward Hicks, *Memoirs* [1851], p. 326). Thus, for Hicks, the image of the lion eating straw with the ox was similar to the grapevine—a symbol of redemption. The Metropolitan's painting, in which the child holds an olive branch, is probably one of the very first versions in which Hicks monumentalized the image of the passive lion. Therefore it is considered a transitional work and dated 1830 to 1832 by Mather and Miller (1983).

Julius Held has related Hicks's Peaceable Kingdom theme to a long tradition of representing peace as a group of animals living harmoniously together. Incorporated within this tradition is the association of each animal with a different nation. Hicks's Peaceable Kingdoms may also refer to the Hicksite schism of 1827, as well as to the political climate in the United States following the War of 1812. Versions that include scenes of Penn's treaty with the Indians in place of the two children often have additional lines of verse that elucidate Hicks's acceptance of the popular belief that Penn's religious community was a fulfillment, at least in part, of the biblical prophecy. The mahogany veneer frame is old, but according to the Garbisch collection records, it is not the original one.

Oil on canvas, $17\frac{7}{8} \times 23\frac{7}{8}$ in. (45.4 × 60.6 cm.).
Inscribed at lower right: ISAIAH 11 Chap 6 7 8.
RELATED WORKS: *Peaceable Kingdom*, oil on canvas, $17\frac{1}{2} \times 23\frac{1}{8}$ in. (44.5 × 59.7 cm.), Regis Collection,

Minneapolis, ill. in Mather and Miller, no. 27 // *Peaceable Kingdom*, oil on canvas, $16\frac{1}{2} \times 20\frac{3}{4}$ in. (41.9 × 52.7 cm.), formerly Sidney Janis, New York (1983), ill. in Mather and Miller, no. 25 // *Lamb*, pencil on paper, $5 \times 5\frac{1}{2}$ in. (15.2 × 16.5 cm.), ca. 1825, private coll., ill. in A. Ford, *Edward Hicks*, p. 139, no. 4.

REFERENCES: Garbisch collection, data sheet, Dec. 1970, Dept. Archives, describes frame as contemporary but not original // E. P. Mather, *Quaker History* 62 (Spring 1973), pp. 7–9, groups painting with a Peaceable Kingdom once in the collection of Sidney Janis (ill. in Mather and Miller, no. 25) and another in the Regis Collection, Minneapolis, Minn. (ill. in Mather and Miller, no. 27) as transitional works; notes advance of lion and ox into foreground and appearance of branch without grapes; notes MMA painting usually dated about 1835, but suggests date of 1833–1834; *Art Quarterly* 36, no. 1 and 2 (1973), p. 90, compares MMA painting to one now in Regis coll., which the author calls transitional // E. P. Mather and D. C. Miller, *Edward Hicks* (1983), p. 119, no. 26, catalogue MMA painting as Peaceable Kingdom in Transition, date it 1830–1832, mistakenly say the frame is original, and supply early provenance.

EXHIBITIONS: Milwaukee Art Institute, 1951, *Primitive Art Exhibition*, lent by Edgar William and Bernice Chrysler Garbisch // National Gallery of Art, Washington, D. C., 1954, *American Primitive Paintings Exhibition, Part I, Collection of Edgar William and Bernice Chrysler Garbisch* (not in cat.); 1957, *American Primitive Paintings Exhibition, Part II, Collection of Edgar William and Bernice Chrysler Garbisch* (not in cat.) // American Federation of Arts, traveling exhibition, 1968–1970, *American Naive Painting of the 18th and 19th Centuries: 111 Masterpieces from the Collection of Edgar William and Bernice Chrysler Garbisch* (not in cat.) // Bronx County Courthouse, New York, 1971, *Paintings from the Metropolitan Museum of Art*, no. 2 // ACA Galleries, New York, 1972, *Four American Primitives*, no. 2, ill. as frontispiece to Hicks section, gives incorrect measurements // MMA, 1972, *Recent Acquisitions, 1967–72* // Andrew Crispo Gallery, New York, 1975, *Edward Hicks: A Gentle Spirit*, no. 7 // Queens Museum, New York, 1976, *Cows*, no cat. // Everson Museum, Syracuse, N. Y., 1978, *The Animal Kingdom in American Art*, no. 52.

EX COLL.: Burton family, Edgely, Pa.; with Robert Carlen, Philadelphia; with Edith Gregor Halpert, New York; with Valentine Gallery, New York, 1945; Edgar William and Bernice Chrysler Garbisch, Cambridge, Md., 1945–1970.

Gift of Edgar William and Bernice Chrysler Garbisch, 1970.

1970.283.1.

JOHN A. WOODSIDE

1781–1852

John Archibald Woodside was born in Philadelphia, where his father worked as an engrossing clerk, copying documents, and his mother ran a millinery shop on Arch Street. It is thought that he received his training in painting from MATTHEW PRATT or one of his partners in the sign-painting business, William Clarke, Jeremiah Paul, Jr., or George Rutter. In 1805 Woodside opened his own studio and from 1809 on advertised himself as an ornamental or sign painter. It was as a sign painter that WILLIAM DUNLAP listed him in his *History* (1834), but with the comment that he possessed "talent beyond many who paint in the higher branches." A number of works by Woodside in these "higher branches" has survived; they include emblematic pictures, animal subjects, patriotic scenes, copies after English engravings, and even a miniature. In addition, his talent in still-life painting, although greatly indebted to the pioneering work of the Peale family, was substantial. From 1817 to 1836, he exhibited still lifes as well as pictures of animals at the Pennsylvania Academy of the Fine Arts. In 1854 one of his works was shown at the Boston Athenaeum.

After Woodside's death on February 26, 1852, the *Philadelphia Public Ledger* noted: "He was one of the best sign painters in the state, and perhaps in the country, and was the first to raise this branch of the art to the degree of excellence here which it has now attained. He was quiet and unobtrusive in his deportment and passed his long life in the pursuit of his favorite art with credit to himself and profit to all who had any intercourse with him." Much of his business was in decorating fire engines. A collection of panels by Woodside executed for Philadelphia fire companies is now in the museum of the Insurance Company of North America, Philadelphia. Woodside's youngest son, Abraham Woodside (1819-1853), was also a painter in Philadelphia. The eldest son and his father's namesake, whose dates are not known, was a wood engraver.

BIBLIOGRAPHY: William Dunlap, *A History of the Rise and Progress of the Arts of Design in the United States* (2 vols., New York, 1834), 2, p. 471 // Frederic Fairchild Sherman, "Some Recently Discovered Early American Miniaturists," *Antiques* 11 (April 1927), pp. 294–295. Gives a brief account of the artist and illustrates a miniature by him // Joseph Jackson, "John A. Woodside, Philadelphia's Glorified Sign-Painter," *Pennsylvania Magazine of History and Biography* 57 (Jan. 1933), pp. 58–65. The most complete biographical account // Joan Dolmetsch, "Four Children, Three Artists," *Antiques* 91 (April 1967), pp. 500–502. Discusses a genre painting Woodside copied from an English engraving and a similar painting by Jeremiah Paul, Jr.

Still Life: Peaches and Grapes

This painting, probably done in the 1820s, is one of the few known examples of Woodside's work in still life. He has composed his objects, including a Chinese export porcelain bowl, in a symmetrically balanced, pyramidal fashion, lit by a strong raking light that diminishes in intensity from front to back, recalling the formulas of Rubens Peale (1784-1865). The picture, however, possesses a harder, metallic quality that is not evident in Peale's work. Woodside's

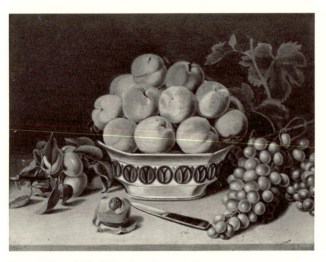

Woodside, *Still Life: Peaches and Grapes*.

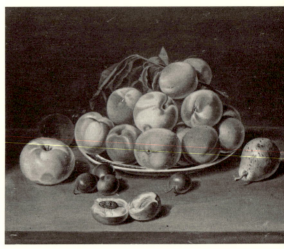

Woodside, *Still Life: Peaches, Apple and Pear*.

choice of grapes and peaches—fruits often painted by the Peale family—further evinces the derivation of his still-life style.

Wolfgang Born, the pioneer historian of American still-life painting, classed Woodside with the many Philadelphia artists who, although they primitivized the style of the Peales, contributed to the establishment of a deeply rooted local still-life tradition. This tradition in turn influenced such later artists as John F. Francis (1808–1886), whose works possess a vivid colorism and an awkwardness already present in the works of Woodside.

Oil on wood, 9¾ × 12¼ in. (24.8 × 31.1 cm.).
REFERENCES: M. Jeffery, *MMA Bull.* 37 (Feb. 1942), pp. 43–44, says the "firm drawing and clear, warm colors . . . are characteristic of Woodside's work in the twenties" // W. Born, *Antiques* 50 (Sept. 1946), ill., p. 158 // Gardner and Feld (1965), p. 153 // W. H. Gerdts and R. Burke, *American Still-life Painting* (1971), p. 48, compare to work of James and Rubens Peale; ill. pp. 42, 239.
EXHIBITED: PAFA, 1829, no. 11, as Peaches, Grapes &c., for sale (possibly this picture).
EX COLL.: heirs of the artist, Anna W. F. Trout and Rosealba Trout, Philadelphia, until about 1940; with Arnold Seligmann, Rey and Co., New York, 1941.
Rogers Fund, 1941.
41.152.1.

Still Life: Peaches, Apple and Pear

In this companion piece to *Still Life: Peaches and Grapes* (see above), Woodside again attempts to represent the varied colors and textures of fruit; peaches, plums, an apple, and a pear. His use of a strong generalized light, the source of which is disclosed by the shadows as being in the upper left, as well as his reliance on crisp outlines and sharply colored details give this work a primitive hardness reminiscent of the works of Levi W. Prentice (1851–1935), another American still-life painter who successfully combined bright coloring, primitive execution, and academic composition. As was often the case in the still-life paintings of the Philadelphia school, particularly those of the Peale family, the background is lit from a direction opposite that of the foreground.

Oil on wood, 9¾ × 12¼ in. (24.8 × 31.1 cm.).
REFERENCES: M. Jeffery, *MMA Bull.* 37 (Feb. 1942), pp. 43–44, dates it in the 1820s // Gardner and Feld (1965), p. 153 // W. H. Gerdts and R. Burke, *American Still-life Painting* (1971), p. 48.
EXHIBITED: PAFA, 1829, no. 15 as Peaches, &c., for sale (possibly this picture).
EX COLL.: same as preceding entry.
Rogers Fund, 1941.
41.152.2.

UNIDENTIFIED ARTIST

The Plantation

Landscapes by folk artists generally depict a particular location, and this scene of a large rural house with a number of subsidiary houses, a mill, and a warehouse may have actually existed. The painting is said to have been found in Virginia, and it was once suggested that the main house was one that was built by William Randolph on his Turkey Island Plantation on the James River near Richmond. A nineteenth-century description of that house, however, based on its then visible ruins indicates that it had two rather than three stories. In any case, the painting appears to be at least in part a fantasy. The placement of two large windows on the lower story of the main building is unlike any known to have existed in this country and is very likely a product of the artist's imagination; so too it would appear

are other elements in the picture, including the naval vessel at the bottom.

The whole basis of the painting is conceptual. The two trees on each side of the composition are greatly enlarged, as are the grapes that ornament the area in front of the mansion. The landscape proceeds up the picture plane rather than back into space. The houses are all painted in scale with each other, rather than diminishing in size to indicate distance. Vegetation appears only at the sides of the landscape, where it functions as a decorative fringe, and the leaflike forms of the small trees at the edges of the hill are separated by geometrically shaped clumps of grass. Everything is symmetrical, and considerations of line overrule reality. It is the imaginative aspects of the painting, however, that are responsible for much of its appeal.

In some respects the work relates to needle-

Unidentified artist, *The Plantation.*

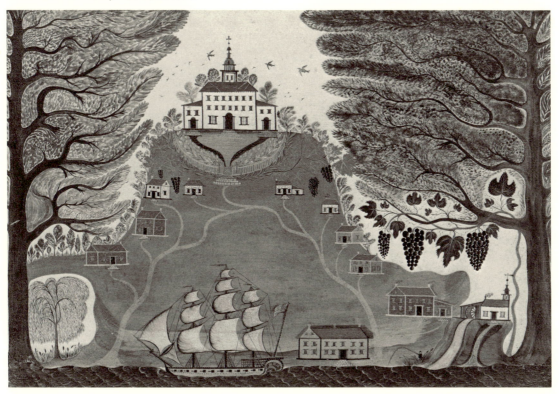

work samplers. For there one finds images of houses surrounded by trees, vines, and other landscape elements in similar designs that cover most of the field. Indeed, it has often been remarked that the strokes of paint in this picture resemble stitches.

The painting's date is unknown. The architecture of the buildings suggests the late eighteenth century, but the ship could have been built far earlier or later. It is probable that the landscape was painted during the first quarter of the nineteenth century.

Oil on wood, 19⅛ × 29½ in. (48.6 × 74.9 cm.).
REFERENCES: R. E. Stivers, letter in Dept. Archives, Feb. 13, 1964, suggests that Turkey Island Plantation is probable site // I. N. Hume, Colonial Williamsburg, letter in Dept. Archives, Feb. 20, 1964, says unlike any known site in Virginia // S. G. Stoney, Carolina Art Association, Charleston, letter in Dept. Archives, Feb. 29, 1964, says unlikely to represent South Carolina location // R. E. Stivers, "Turkey Island Plantation (1679–1874)," Jan. 10, 1965, transcript in Dept. Archives, gives information on possible location // Gardner and Feld (1965), pp. 151–152 // J. Wilmerding, A History of American Marine Painting (1968), says more like a map than an in-depth view // MMA Bull. 33 (Winter 1975–1976), color ill. no. 38 // J. A. Tilley, Mariner's Museum, Newport News, Va., letter in Dept. Archives, Dec. 16, 1981, says vessel resembles an American frigate or sloop of war from any time between 1730 and 1850.

EXHIBITED: National Gallery of Art, Washington, D. C., 1954, American Primitive Paintings from the Collection of Edgar William and Bernice Chrysler Garbisch, part 1, p. 44 // Corcoran Gallery of Art, Washington, D. C., 1960, American Painters of the South, no. 87 // MMA, 1961–1962, and American Federation of Arts, traveling exhibition, 1962–1964, 101 Masterpieces of American Primitive Painting from the Collection of Edgar William and Bernice Chrysler Garbisch, color pl. 46, dates the painting about 1825, says it was painted in Virginia // American Federation of Arts, traveling exhibition, 1968–1970, American Naive Painting of the 18th and 19th Centuries: 101 Masterpieces from the Collection of Edgar William and Bernice Chrysler Garbisch, color pl. 41 // M. Knoedler and Co., New York, 1971, What Is American in American Art, no. 24 // Cummer Gallery of Art, Jacksonville, Fla., 1972, 1822 Sesquicentennial Exhibition, Part I, no. 17 // Queens County Art and Cultural Center, New York; MMA; Memorial Art Gallery of the University of Rochester, N. Y.; and Sterling and Francine Clark Art Institute, Williamstown, Mass., traveling exhibition, 1972–1973, 19th Century American Landscape, cat. by M. Davis and J. K. Howat, no. 1 // Whitney Museum of American Art, New York, Virginia Museum of Fine Arts, Richmond, and Fine Arts Museums of San Francisco, traveling exhibition, 1974, The Flowering of American Folk Art, 1776–1876, cat. by J. Lipman and A. Winchester, no. 72, color ill., 57, date ca. 1835 // MMA, 1976–1977, A Bicentennial Treasury (see MMA Bull. 33 above), dates ca. 1825.

EX COLL.: Edgar William and Bernice Chrysler Garbisch, Cambridge, Md., 1948–1963.

Gift of Edgar William and Bernice Chrysler Garbisch, 1963.
63.201.3.

JOHN PARADISE

1783–1833

The son of a saddler, John Paradise was born in Pennington, New Jersey. After receiving a country school education, he followed for a time his father's trade. It is said that he played the violin and the flute and enjoyed drawing, and by the time he was eighteen had taken up portrait painting. Almost all that has been written about him comes from WILLIAM DUNLAP (1834), who appears to have received his information from Paradise's son shortly after the artist's death. Despite the fact that he was well-known in New York, a member of the American Academy of the Fine Arts and a founder of the National Academy of Design, there are few references to him. ASHER B. DURAND, who engraved many of Paradise's portraits of Methodist ministers, makes a few occasional remarks. There are indications that Paradise

was often ill and unable to paint. Dunlap refers to him as having "affections of the head, which at times rendered him incapable of business." Paradise's earliest known documented works are dated 1806 and 1807, and were painted in the nearby vicinity of Hopewell, New Jersey.

For a short time, he studied in Philadelphia with the French émigré artist Denis A. Volozan (b. 1765) who had trained in Paris at the Ecole des Beaux-Arts before coming to Philadelphia in 1799. The neoclassical style that Paradise acquired from Volozan stayed with him throughout much of his career. His training, however, does not seem to have been very intense because he never entirely lost the awkward traits of a self-taught artist. His sense of anatomy was poor, and he did not always manage to fit his sitters easily on the canvas. His strength, however, was that he was a good face painter. His works have simple, realistic qualities about them that transcend time.

Dunlap claims that Paradise was in New York by 1810, but he is not listed at an address in the city until 1813. He is often known as a painter of Methodist ministers; for they were the subjects of many of his commissions in his early years in New York. Over thirty such portraits were engraved by ASHER B. DURAND for the *Methodist Quarterly Review*. More interesting, however, are the portraits he painted of New York tradespeople, many of them parishioners of the Old Dutch Church in the Bloomingdale section of New York. The most elaborate of these is the life-size depiction of Richard A. Striker, 1830 (Museum of the City of New York). The portraits of Paradise's own family, particularly the ones of his children (NYHS), are especially charming. Unlike his later New York works, they are lighter in palette and have a distinctly folk-art quality about them. Similar to many American artists, Paradise moved from a simple untutored style to a more sophisticated one, experiencing along the way the influences of several of his contemporaries. He exhibited at the National Academy of Design fairly regularly from 1826 until 1833, when in November he died at the home of his sister in Springfield, New Jersey.

His wife, Elizabeth Stout, bore him nine children, one of whom, John Wesley Paradise (1809-1862), became a well-known engraver; another son, Andrew Wheeler Paradise, was a portrait photographer.

BIBLIOGRAPHY: William Dunlap, *A History of the Rise and Progress of the Arts of Design in the United States* (2 vols., New York, 1834), 2, pp. 204–205. From an account probably provided by Paradise's son John (see Dunlap, *Diary* [1931], 3, p. 768) // Alice Blackwell Lewis, *Hopewell Valley Heritage* (Hopewell, N. J., 1973), pp. 75–79. Gives background on the artist's early years // Kathleen Luhrs and Leslie P. Symington, unpublished notes and catalogue on John Paradise.

Mrs. Warren Rogers

Julie Françoise Gabrielle d'Anterroches (1794–1888) was the daughter of Joseph Louis, chevalier d'Anterroches, and the former Mary Vanderpoel of Elizabethtown, New Jersey. Her father, a distant relation of Lafayette, had come to America at the time of the American Revolution. Miss d'Anterroches was first married in 1811 to Edward Griffith, a pottery maker who came from Newcastle, Staffordshire, England. There were five children from this marriage. Mrs. Griffith was widowed in January of 1820, and in August of 1821 she became the wife of Warren Rogers, a New York flour merchant, and had two more children. She died in New Jersey at the age of ninety-four.

This portrait appears to be one of Paradise's

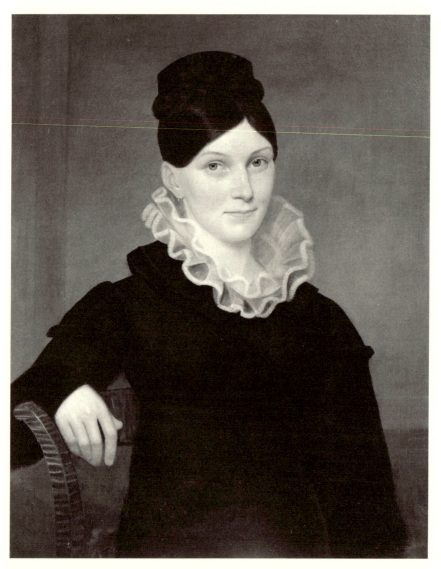

Paradise, *Mrs. Warren Rogers*.

New York works, probably done at the time of the subject's second marriage in 1821, when she was twenty-seven. This accords with her demeanor, which is that of a young matron, and the style of her clothing. She wears a simple, dark high-waisted dress with a white ruff, and her hair is swept up and decorated with a braid and a tortoise-shell comb. Typical of many of Paradise's subjects, she is positioned off-center against the corner of a plain wall with a chair rail. The chair in which she sits is painted to resemble tiger maple.

The evidence of Paradise's early neoclassical

training, coupled with his primitive tendencies, make this one of his most interesting portraits. Perhaps because of the sitter's French background, he stressed the linear neoclassical style, which is reminiscent of Jacques Louis David and also similar to that of JAMES PEALE, who was painting in Philadelphia at this time. With her dark hair and gray eyes, Mrs. Rogers is one of Paradise's most appealing subjects.

The museum also has miniatures of Mrs. Rogers and her husband, painted in 1839 by Theodore Lund (active 1836–1843).

Oil on canvas, $30\frac{1}{2} \times 24\frac{1}{2}$ in. (76.7×61.5 cm.).

REFERENCE: Gardner and Feld (1965), p. 154, as Julie Griffith, date it 1811, when the subject was seventeen.

EX COLL.: the subject, New York, and Elizabeth, N. J., d. 1888; her son, Edward Griffith, New York, d. 1901; his daughter, Kate H. Griffith (Mrs. Robert E.) Bonner, New York and Lenox, Mass., d. 1924; her daughter, Kate d'Anterroches Bonner, Lenox, Mass., and New York, d. 1962.

Bequest of Kate d'A. Bonner, 1962.
62.83.2.

SAMUEL L. WALDO

1783–1861

This very prolific portrait painter was born in Windham, Connecticut, the son of a farmer. He attended a country school, and when he was sixteen he went to Hartford, where he took painting lessons from the folk artist JOSEPH STEWARD. Opening his own studio in Hartford in 1803, Waldo first made a living painting signs and a few portraits. By 1804 he was charging twenty dollars for quarter-length and one hundred dollars for full-length portraits. He had little business in Hartford, however, and at the suggestion of a friend, he went to Litchfield, Connecticut. There he painted members of the Gould family and through them met the Hon. John Rutledge, who invited him to Charleston. He painted portraits in Charleston and for nearly three years met with success. In 1806, after several gentlemen agreed to sponsor his studying abroad Waldo left for England. In London he shared a room with Charles Bird King (1785-1862) and worked under BENJAMIN WEST. He also studied at the Royal Academy and succeeded in showing a portrait there in 1808. While in England, Waldo married, and in January of 1809 he returned home to make his living in New York.

Waldo soon became a hardworking portraitist with a respectable following. He took on the young painter WILLIAM JEWETT as an apprentice in 1814, and they became partners in July of 1817. The firm of WALDO AND JEWETT began to thrive, capturing important commissions from celebrities and distinguished citizens of the city. The firm continued until Jewett's retirement in 1854.

Waldo was obviously the more talented artist. The work he produced with Jewett was competent; only occasionally did it go beyond a certain level of honest, factual, and fashionable portraiture. Indeed Waldo's early portraits from just before the partnership show a flamboyance and bravura that soon leveled off. Perhaps because of his business-like approach to art, interest in Waldo was never very strong, and there has not been a great deal written about him. A director of the American Academy of the Fine Arts and later an associate member of the National Academy of Design, he seems to have had a considerable influence in New York's cultural life. Besides painting, he also engaged in art criticism. Unlike many of his fellow artists, he was on good terms with JOHN TRUMBULL and seems to have been well thought of by such contemporaries as WILLIAM DUNLAP, whose biographical sketch of him has been the basis of much of what we know. Waldo made a return visit to Europe three years before his death. When he died in New York at the age of seventy-seven, the National

Academy of Design honored him by including a special group of his works in their annual exhibition.

BIBLIOGRAPHY: William Dunlap, *A History of the Rise and Progress of the Arts of Design in the United States* (2 vols., New York, 1834), pp. 205–206 // "Samuel L. Waldo," *Crayon* 8 (May 1861), pp. 98–100. A biographical sketch written shortly after his death // William H. Downes, *DAB* (1936; 1957), s.v. Waldo, Samuel Lovett.

Portrait of the Artist

This self-portrait of Samuel L. Waldo (1783–1861) has the same forceful style that is evident in *Old Pat* (see below). It is very different from the more staid style that was to become the hallmark of the work of Waldo and Jewett for thirty-seven years. Since the portrait depicts a man in his thirties, there seems little reason to doubt the traditional dating of about 1815.

Waldo presents himself as the successful, established painter that we know him to have been by this time. Well-dressed, he sports an elaborate watch fob and looks off to the side as though carefully studying his subject. The romantic style of the painting's execution reflects Waldo's exposure to contemporary English portraiture. In particular, it reminds us of his admiration for Sir Thomas Lawrence, whose full-length portrait of BENJAMIN WEST Waldo helped acquire for

Waldo, *Portrait of the Artist.*

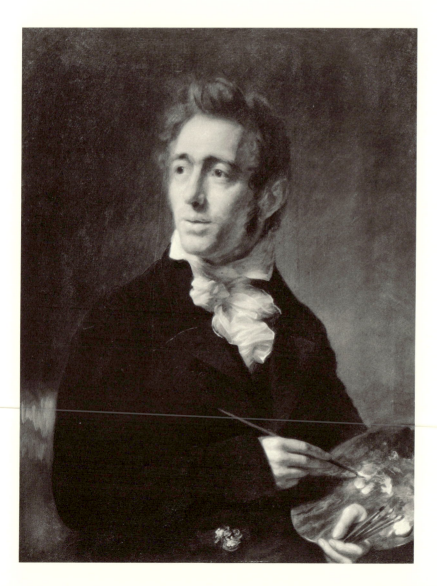

Waldo, *Study for Arm and Fist*, verso of *Portrait of the Artist*.

General Andrew Jackson

(For biographical information on Andrew Jackson [1767–1845], see the entry under JOHN WESLEY JARVIS.) Among Waldo's own collection of paintings at the time of his death was a portrait head of Andrew Jackson described as "original from life." Waldo painted several portraits of Jackson; most of them are half-length views in a painted oval. The details of the stock and uniform, however, vary. The portrait in the Metropolitan's collection has been described as painted from life and may be the original study that Waldo kept for himself and the one on which his later portraits of Jackson were based. The major portrait, which Waldo exhibited at the American Academy of the Fine Arts in 1819, was done for the city of New Orleans. Described

the American Academy of the Fine Arts. (The picture is now in the Wadsworth Atheneum, Hartford.) The loose, painterly execution is also reminiscent of THOMAS SULLY.

There are three unfinished studies, presumably by Waldo, on the back of the wood panel: a brush drawing of crossed knees, an extended arm with rolled sleeve, and a clenched fist. To what these studies may have related is not known.

Oil on wood, 33 × 22½ in. (83.8 × 57.2 cm.).
REFERENCES: W. Lincoln, *Genealogy of the Waldo Family* (1902), 1, ill. p. 390 // A. E. Rueff, letter in MMA Archives, Nov. 9, 1922, says it was painted about 1815 // C. F. Sullivan to Rueff, letter in Dept. Archives, Dec. 28, 1922, notes that the portrait is of his grandfather and gives provenance // H. B. Wehle, *MMA Bull.* 18 (March 1923), ill. p. 63, notes acquisition and gives provenance // F. Sherman, *Art in America* 18 (1930), pp. 81–86 // Gardner and Feld, (1965), pp. 171–172.

EXHIBITED: MMA, *Loan Collections and Recent Gifts to the Museum* (1897), p. 43, no. 140, lent by Charles Sullivan; MMA, *Life in America* (1939), p. 53, no. 73; *Three Centuries of American Painting* (checklist arranged alphabetically).

Samuel L. Waldo

Waldo, *General Andrew Jackson*.

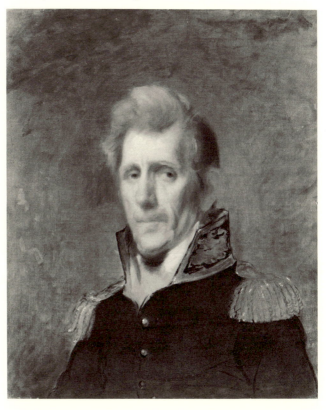

as "Portrait of Major General Jackson on Horseback, before the battle of New Orleans, size of Life," its whereabouts is no longer known.

Although the inscription on the museum's portrait says it was painted in New York in 1817, Jackson is not known to have visited New York until 1819. Since it also gives Jackson's age at the time as fifty-four, which is how old he was in 1821, we can probably assume that the inscription is inaccurate and was added at a later time. Like the museum's portrait by Jarvis, the work was most likely painted in 1819, shortly after Jackson was made an honorary citizen of New York.

Waldo depicted Jackson at the period when he was turning from a military career to one in national politics. It is easy to see in this unfinished head how Waldo deftly outlined the general's salient features, creating a powerful character study. The work is basically a quick study of Jackson's strong features; the throat and collar remain unfinished. A contemporary description of Jackson by an English traveler notes: "His face is unlike any other. Its prevailing expression is energy; but there is, so to speak, a lofty honorableness in its worn lines. His eye is of a dangerous fixedness, deep set, and overhung by bushy gray eyebrows. His features long, with strong ridgy lines running through his cheeks. His forehead a good deal seamed, and his white hair stiff and wiry, brushed obstinately back" (quoted in Hart, 1897, p. 795).

Oil on canvas, 25¾ × 21 in. (64.3 × 53.3 cm.).
Inscribed on the back (probably at a later date): Gen'l Andrew Jackson AE 54 / original sketch from life / by S. L. Waldo / New York 1817.
RELATED WORKS: *Andrew Jackson*, a life-sized full-length portrait, 1819 (now lost), once hung in the Custom House, New Orleans // *Andrew Jackson*, 33 × 25¼ in. (83.8 × 64.1 cm.), oil on wood, 1819, shows the sitter in the correct uniform, wearing a black stock and a belt, Addison Gallery of American Art, Phillips Academy, Andover, Mass., ill. in *Antiques* 53 (May 1948), p. 365, no. 3 // *Andrew Jackson*, slightly unfinished, the sitter wears a white stock and a red sash, oil on canvas, 33¼ × 26¼ in. (84.5 × 66.7 cm.), Historic New Orleans, ill. in *Antiques* 53 (May 1948), p. 364, no. 2 // Attributed to or after Waldo, *Andrew Jackson*, oil on canvas, 35⅝ × 27½ in. (90.5 × 69.8 cm.), Tennessee State House, Memphis, ill. in Hirschl and Adler, New York, *25 American Masterpieces* (1968), no. 6 // Peter Maverick, after Waldo, *Major General Andrew Jackson*, engraving, ca. 1819, appears closest to the Addison portrait, 8¼ × 6½ (21 × 16.5 cm.).

REFERENCES: Leeds and Miner, New York, *Executor's Sale of Four Private Collections*, sale cat. (1866), p. 19, no. 106, as "Original from life," part of Waldo estate // C. H. Hart, *McClure's Magazine*, 9 (1897), p. 795, says this picture, owned by Hoe, was "wholly painted in the presence of the sitter," dates it 1817, says from it Waldo painted a full-length portrait, and gives description of Jackson (quoted above) // B. Burroughs, *Catalogue of Paintings in the Metropolitan Museum* (1931), pp. 386–387 // A. T. Gardner, *MMA Bull.* 2 (Oct. 1943), ill. p. 105 // R. W. Thorpe, *Antiques* 53 (May 1948), pp. 364–365, dates it 1817, discusses other portraits // Gardner and Feld (1965), pp. 172–173, date it 1819.
EXHIBITIONS: NAD, 1861, no. 186, as Gen'l Andrew Jackson, a Study from Life—painted in 1817 // MMA, 1895, *Retrospective Loan Collection of . . . American Artists*, p. 38, no. 119, lent by John M. Hoe, New York // Toledo, 1913, *Perry Victory Centennial Exhibition*, no. 16 // MMA, 1965, *Three Centuries of American Painting* (checklist arranged alphabetically) // Los Angeles County Museum of Art and M. H. de Young Memorial Museum, San Francisco, 1966, *American Paintings from the Metropolitan Museum of Art*, ill. no. 27, pp. 11–12.
ON DEPOSIT: United States Mission to the U. N., 1973–1977.
EX COLL.: probably the artist, d. 1861; his estate (sale, Leeds and Miner, New York, 1866); John M. Hoe, New York, 1895–at least 1897; George H. Story, until 1906.
Rogers Fund, 1906.
06.197.

Portrait of a Man

When this portrait was given to the museum in 1906, the donor believed it to be by THOMAS SULLY. Then in 1934, on the basis of strong stylistic similarities to Waldo's portrait of Alexander Macomb of 1815 (Art Commission, City of New York), it was attributed to Waldo. The portrait has the simplicity and elegance of the works he painted in New York before he formed his partnership with Jewett in 1817. *Portrait of a Man* is a particularly fine work. There is a certain amount of neoclassical influence and a breath of romanticism about the painting, but it is all very low key.

Although nothing is known about the identity of the sitter, it is possible that he was a miniature painter in New York. Like the Waldo and Jewett portrait of John Trumbull, ca. 1821 (Yale University), in which the objects pictured refer to Trumbull's professional accomplishments as a

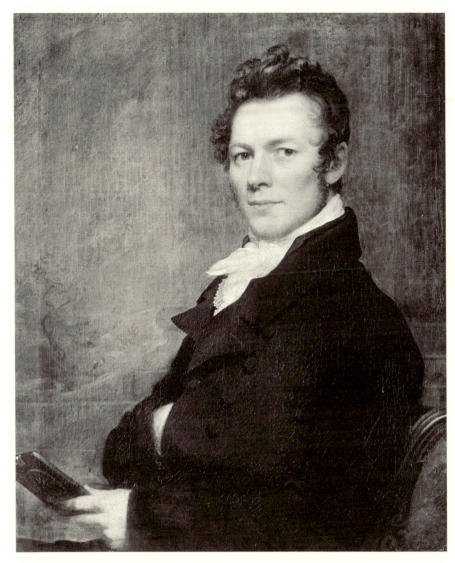

Waldo, *Portrait of a Man*.

painter, soldier, and man of affairs, the miniature in this portrait may be an allusion to the sitter's profession rather than a portrait of a loved one, especially since the likeness in the miniature is not visible. In 1817, Waldo exhibited a portrait of a Mr. Gimbrede at the American Academy of the Fine Arts. The engraver Thomas Gimbrede (1781–1832) was painting miniatures in New York at this time, but no likeness of him is presently known to which this portrait can be compared.

Oil on canvas, 30⅛ × 25⅛ in. (76.5 × 63.8 cm.).

REFERENCES: B. Burroughs, *Catalogue of Paintings in the Metropolitan Museum* (1931), p. 345, lists it as Portrait of a Man, by Thomas Sully // H. B. Wehle, MMA, Nov. 1, 1934, note in Dept. Archives, reattributes to Waldo // Gardner and Feld (1965), pp. 170–171, catalogues it as by Waldo.

ON DEPOSIT: United States Tax Court, New York, 1943–1953 // Bartow Mansion, Pelham Bay Park, New York, 1970–present.

Ex COLL.: George H. Story, New York, by 1906. Gift of George H. Story, 1906.
06.200.

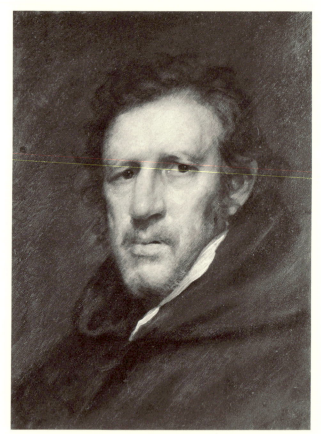

Waldo, *Old Pat, the Independent Beggar.*

Old Pat, the Independent Beggar

Not much is known about the subject of this painting, Old Pat, the independent beggar, as he is styled on the back of the panel. Presumably a well-known character, he is believed to have been Patrick MacGregor, a ne'er-do-well who lived in New York during the early part of the nineteenth century. It is said that Old Pat earned a bit of money modeling for artists. Waldo did several portraits of him, one of which was engraved by ASHER B. DURAND, who probably thought the portrait would have a fairly wide appeal. Commenting on the Metropolitan's picture, which he noted was painted on wood scored to look like twilled canvas, William Sawitzky (1934) wrote: "The man's face is not without intelligence His eyes are searching, but shrewd, resentful, and suspicious His long upper lip is slightly drawn up, in a faint snarl . . . the appearance of the whole man is altogether unkempt and actually dirty."

The painting is a strong characterization,

more forthright and spontaneous than Waldo's standard formal portraits. It is freely painted in the style of Sir Thomas Lawrence, whose work Waldo greatly admired. Probably, as Sawitzky suggested, it was a study for Waldo's larger portrait *Old Pat, the Independent Beggar,* 1819, which is in the Boston Athenaeum; for it certainly has the character of a sketch from life done as a model for a more finished portrait. More recently, the theory has been advanced that the Metropolitan version was painted specifically for Durand to use in making his engraving of the subject, about 1819. Although the partially legible inscription on the back of the painting indicates that this could have been the case, the engraving is as different from this portrait as it is from the other known versions.

It is said that *Old Pat* was the first plate Durand engraved directly from a painting and that, as the inscription on the back of the Metropolitan's painting may imply, his success with it led to a commission the next year to engrave Trumbull's *Declaration of Independence.*

The large version of *Old Pat* was exhibited at the Boston Athenaeum in 1829. It is very

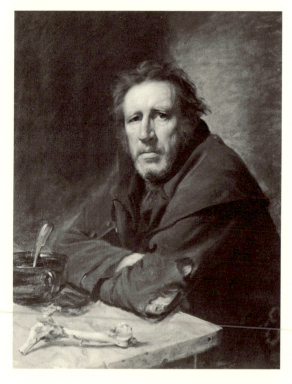

Waldo, *Old Pat, the Independent Beggar.*
Boston Athenaeum.

likely that the same work, listed in the catalogue as *The Beggar's Dessert*, was exhibited at the American Academy of the Fine Arts in 1819, the year Waldo painted it. One reviewer noted: "we cannot refrain from noticing . . . the Beggar of Waldo (no. 92), which is full of truth, effect and strongly-marked character" (*New-York Evening Post*, May 29, 1819, p. 2). Since still lifes, or in the reviewer's words "a humbler walk of art," are discussed elsewhere, *The Beggar's Dessert* must be the work we now know as *Old Pat*.

Oil on wood, 19⅞ × 14¾ in. (50.5 × 37.5 cm.).

Inscribed on the back, possibly by a later hand: Old Pat / The Independent Beggar / S. L. Waldo pinxt / New York / Mr. A. B. Durand in 1819 [illegible] / [illegible] his engraved portrait [illegible] / Received the engraving of Trumbull's / Declaration of Independence.

RELATED WORKS: *Old Pat, the Independent Beggar*, oil on wood, 32¾ × 25½ in. (64.8 × 83.2 cm.), 1819, Boston Athenaeum, ill. in J. Harding, *The Boston Athenaeum Collection* (1984), pl. 48 // Waldo, *Pat, the Independent Beggar*, oil on wood, 20 × 15½ in. (50.8 × 39.4 cm.), New Britain Museum of American Art,

Conn., ill. in *Antiques* 25 (March 1934), p. 93 // Attributed to Waldo or John Wesley Jarvis, *Old Pat*, oil on wood (scored to look like canvas), 18⅞ × 14¼ in. (47.9 × 36.2 cm) ca. 1819, Cleveland Museum of Art, ill. in Sawitzky, *Antiques* 25 (March 1934), p. 95 // Asher B. Durand, *Old Pat*, engraving, 4 × 3⅞ in. (10.2 × 9.8 cm.), ca. 1819 // Boston Athenaeum exhibition records imply that the British-American artist Joseph Gear (1768–1853) made a watercolor or miniature copy of the version there (1830, no. 41, *Independent Beggar Boy*, after Waldo).

REFERENCES: *Catalogue of Paintings . . . Presented to the Metropolitan Fair in Aid of the U. S. Sanitary Commission*, New York, April 19, 1864, no. 81, as The Independent Beggar, by Waldo (probably this picture), notes "works . . . have been given to the Fair, by those Artists whose names are attached, except otherwise specified // J. Durand, *The Life and Times of A. B. Durand* (1894), p. 25, notes Durand's print of Old Pat was his "first original work" engraved directly from a painting, says it resulted in Trumbull's commissioning to engrave the *Declaration of Independence* // W. Sawitzky, *Antiques* 25 (March 1934), pp. 93–95, says this is a study for version in Boston Athenaeum, describes it at some length (quoted above), and discusses the New Britain study // E. P. Richardson, *Magazine of Art* 39 (Nov. 1946), p. 283, cites it as an example of

Waldo, *Old Pat*. Cleveland Museum of Art.

Waldo, *Old Pat, the Independent Beggar*. New Britain Museum of Art.

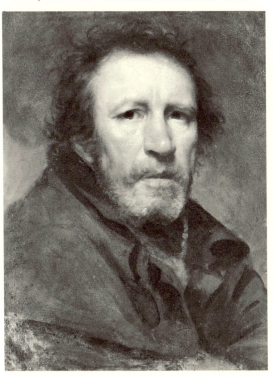

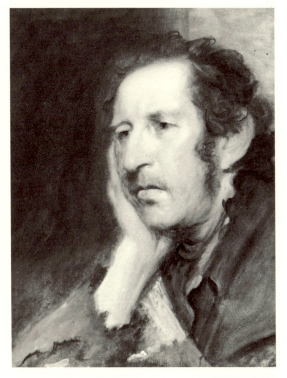

Waldo's "portraits at their best," which "have the rare combination of freshness and sustained vigorous study" || Gardner and Feld (1965), p. 173 || D. B. Lawall, *Asher Brown Durand* (Ph. D. diss., Princeton University, 1966; published 1977), pp. 55, 56, 57–58 || G. Hendricks, *American Art Journal* 3 (Spring 1971), p. 66, n. 26, suggests that it was "painted especially for Durand's use for his engraving" || M. Goldberg, memo in Dept. Archives, Jan. 11, 1989, discusses Cleveland painting || C. Rebora, memo in Dept. Archives, March 14, 1989, notes that large version of this painting was probably the work shown at the American Academy in 1819 as the Beggar's Dessert and supplies review.

EXHIBITED: MMA, 1958–1959, *Fourteen American Masters*, no. cat.

EX COLL.: presumably the artist's family, until 1864 (sale, Metropolitan Fair, New York, April 19, 1864, no. 81, The Independent Beggar) (probably this picture); John M. Falconer, Brooklyn, d. 1903 (sale, Anderson, New York, April 28–29, 1904, no. 639); Samuel P. Avery, New York, 1904.

Gift of Samuel P. Avery, 1904.

04.29.3.

Mrs. Samuel L. Waldo

This is an unfinished portrait of the artist's second wife, Deliverance Mapes (ca. 1797–1865). The couple were married in 1826, the year following the death of Waldo's first wife, Josephine

Waldo, *Mrs. Samuel L. Waldo.*

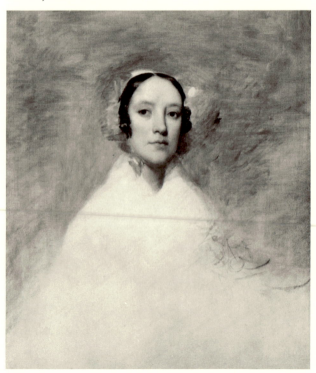

Eliza (or Elizabeth) Wood. Seven children were born to Deliverance and Samuel L. Waldo, three of whom died young. The Metropolitan's portrait is thought to have been painted about the time of their marriage in 1826.

Because the painting is unfinished, it gives us an excellent chance to see something of Waldo's working methods. For example, he has prepared the wood panel to look like canvas by scoring it. Either because of a scarcity of twilled canvas in the United States in the early part of the nineteenth century or because they preferred the effect, some artists worked on wood treated to look like twilled canvas; the earliest American practitioner of this technique is thought to be GILBERT STUART.

There is another portrait by Waldo of his wife Deliverance, shown with their son and a dog, in the Karolik Collection at the Museum of Fine Arts, Boston, which dates from 1830–1831.

Oil on wood, 30¼ × 25⅝ in. (76.8 × 65.1 cm.).

Inscribed on the back by a later hand: Samuel L. Waldo N. A. / 1783–1861.

REFERENCES: A. E. Rueff, letter in MMA Archives, Nov. 9, 1922, says picture has never been exhibited or reproduced || C. F. Sullivan to Rueff, letter in Dept. Archives, Dec. 28, 1922, notes that the portrait is of his grandmother and gives provenance || H. B. Wehle, *MMA Bull.* 18 (March 1923), ill. p. 63, notes acquisition and gives provenance || Gardner and Feld (1965), p. 174, says this is the state of a Waldo portrait before it would be given to Jewett.

EXHIBITED: M. H. de Young Memorial Museum, San Francisco, 1935, *Exhibition of American Painting*, no. 230 || Detroit, 1945, *The World of the Romantic Artist*, p. 10, no. 7 || MMA, 1965, *Three Centuries of American Painting* (checklist arranged alphabetically).

EX COLL.: the artist, New York, d. 1861; his wife, Deliverance Waldo, New York, d. 1865; their daughter Clara's husband, Charles Sullivan, New York; his son Charles Frank Sullivan, New York, by 1902–1922; with André E. Rueff, Brooklyn, as agent, 1922.

Amelia B. Lazarus Fund, 1922.

22.217.2.

ATTRIBUTED TO WALDO

Unidentified Woman

This portrait came to the museum identified as Abigail Smith. A torn note pasted on the back says ". . . gail daughter of John Quincy

Adams, / wife of Colonel Wm. S. Smith / [illegible]." The Abigail Adams (1765–1813) who married Colonel William Stephens Smith was the daughter of John Adams, not John Quincy Adams, and she died long before this portrait was ever painted. Judging by the woman's clothing and the chair, the portrait dates from about 1850. If the subject is an Adams, she is presumably from some other branch of the family than is indicated. Attempts to establish her identity and that of the child (see below) have so far proven futile.

Such a small intimate portrait is unusual for Waldo, especially at this period. The signature, however, seems correct, at least it appears to have been added at the time the picture was painted, and there are some other examples in which Waldo printed his name (usually he chose script). Because work done on such a small scale usually involves different painting techniques and there is so little miniature work by Waldo to compare it to, this portrait and its companion cannot certainly be given to Waldo. He could very well, however, be the painter of these two strongly realistic portraits. The size of the pictures and the appearance of the subjects suggest that they may be commemorative works. It is likely that either the mother, who appears ill and grieving, or the child are post-mortem portraits. The woman is dressed in black with a plaid blouse and a figured belt-purse. The chair is in the Gothic-revival style which reached its height in popularity in the 1850s.

Oil on wood, 5¼ × 4⅛ in. (13.3 cm. × 10.5 cm.).
Signed at lower right: SAMUEL L. WALDO.
REFERENCES: *The Erskine Hewitt Collection*, Parke-Bernet Galleries, New York, Oct. 21, 1938, sale cat., no. 898 (child is no. 899), says purchased from "descendants of the family in Brooklyn" by Clapp and Graham // M. Goldberg, New York, letter in Dept. Archives, Oct. 15, 1987, notes that although it is not usual she has seen other printed Waldo signatures; says the mood of the pictures implies that the portrait of the child is posthumous // R. B. Cox and C. Hale, MMA Paintings Conservation, Jan. 30, 1989, say signatures on this and the companion painting appear to be original.
EXHIBITED: MMA, 1950, *Four Centuries of Miniature Painting*, cat. by H. B. Wehle, p. 14.
Ex COLL.: with Clapp and Graham, New York, 1938; Erskine Hewitt, Ringwood, N.J., 1938 (sale, Parke-Bernet Galleries, New York, Oct. 21, 1938).
Fletcher Fund, 1938.
38.146.5.

Unidentified Girl

A companion to the portrait above, this small panel has written on the back: "Elizabeth Quincy/Smith." The handwriting of this in-

Attributed to Waldo, *Unidentified Woman*.

Attributed to Waldo, *Unidentified Girl*.

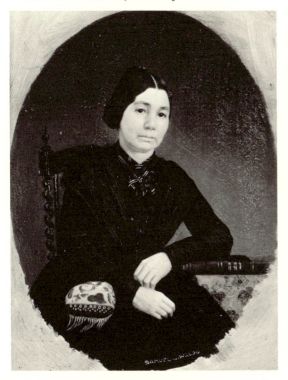

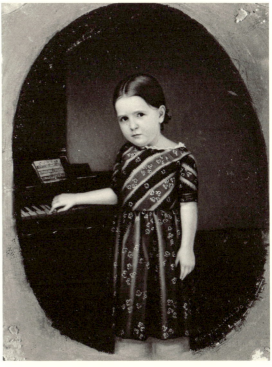

scription is different from that on the companion piece. But here, too, it has so far not been possible to verify the subject's identity.

The child, who is probably between four and six years of age, stands next to a miniature-sized melodeon. The instrument has a lyre-base made up of facing C scrolls and is in the rococo-revival style of the 1850s. The girl's dress is calf-length, striped in muted shades of grape, gray-green, and beige, with a fleur-de-lys design. She also wears white drawers. Although rendered in a starkly realistic manner, the little girl has a very endearing expression and demeanor.

Oil on wood, 4⅝ × 3¾ in. (11.2 × 9.5 cm.).
Signed at lower right: SAMUEL L. WALDO.
REFERENCES: same as preceding entry.
EXHIBITIONS: same as preceding entry.
EX COLL.: same as preceding entry.
Fletcher Fund, 1938.
38.146.5.

WILLIAM JEWETT

1792–1874

William Jewett was born in East Haddam, Connecticut, on January 14, 1792. While still a youngster he worked on his grandfather's farm, but at age sixteen he was apprenticed to a coachmaker in New London. Since decorative painting was part of the coachmaker's craft, he probably learned to grind colors, mix paint, and execute ornamental designs. It is not known with certainty how or where Jewett first met SAMUEL L. WALDO, but about 1812, according to WILLIAM DUNLAP (1834), Jewett came to New York in order to become Waldo's assistant. He was released from his indenture to the coachmaker only after signing an interest-bearing note compensating the man for loss of services.

From the beginning of their professional association, Jewett seems to have gotten along with Waldo extremely well. Their initial agreement was that Jewett would work for Waldo for three years in exchange for instruction. After two years, however, Jewett "proved so useful as to induce his teacher to give him a salary in addition to his board and lodging" (Dunlap, 1834). At this time, besides assisting his master, Jewett also drew from the collection of antique casts belonging to the American Academy of the Fine Arts. Either by design or simply as the natural outcome of events, Jewett, after several years of study under Waldo, became his partner. On July 26, 1817, he signed the following contract:

> I William Jewett do agree to live with Samuel L. Waldo and to give him my time and professional services for three years from and after the first of May 1818, on the following terms, viz., S. Waldo shall board and lodge me, and have my washing done, and pay me for the first year Four hundred dollars, for the second year Five hundred and for the third year, ending in the year of our Lord Eighteen hundred and twenty-one, Six hundred dollars, deducting at the same rates for the time I may be absent from business excepting two or three weeks annually for the benefit of health, and it is also agreed that the business shall be conducted in the name of the firm of Waldo and Jewett (quoted in *New York Herald Tribune*, Jan. 17, 1943, p. 5).

Thus was born one of the most prolific and enduring partnerships in the history of American portrait painting. It is thought that Jewett worked very much in the manner of a drapery

painter; his domain being the clothing, accessories, and backgrounds of the portraits.

During the years of their association, both Waldo and Jewett continued to paint on their own, though infrequently. In 1819 Waldo noted in a letter to his friend THOMAS SULLY: "I have this day returned from an excursion up the North River where Jewett and I have been making sketches and painting landscapes for five weeks past" (Waldo to Sully, August 8, 1819, Dreer Collection, D5, Arch. Am Art). Although Jewett exhibited some genre and still lifes at the American Academy of the Fine Arts, pure landscape painting by him is not presently known. He became an associate at the National Academy of Design in 1848.

For their jointly painted portraits, Waldo and Jewett earned a sound reputation and a steady stream of patrons. Their lucrative association lasted until Jewett's retirement in 1854 to a farm he had purchased twelve years earlier in Bergen Hill, New Jersey. He died in nearby Jersey City on March 24, 1874. At the time, his estate, which was probably a good index of his professional success, was valued at $150,000.

BIBLIOGRAPHY: William Dunlap, *A History of the Rise and Progress of the Arts of Design in the United States* (2 vols., New York, 1834), 2, p. 207. Gives a brief account of the formation of the partnership // Frederic Fairchild Sherman, "Samuel L. Waldo and William Jewett, Portrait Painters," *Art in America* 18 (Feb. 1930), pp. 81-86 // *DAB* (1932, 1961), s.v. Jewett, William. The best biographical account available.

WALDO AND JEWETT

The Reverend John Brodhead Romeyn

The Reverend John Brodhead Romeyn (1777–1825) was one of the most popular and influential Presbyterian ministers of his day. He was born in Marbletown, New York, the son of the Reverend Dirck Romeyn, academic founder of Union College. Educated at the Schenectady Academy and Columbia College, from which he graduated in 1795, he was licensed to preach in 1798 and became pastor of the Dutch Reformed Church at Rhinebeck, New York. He was later minister to Presbyterian congregations in Schenectady and Albany and in 1808 took charge of the Cedar Street Presbyterian Church in New York, where he remained the rest of his life. He married Harriet Bleecker in Albany in 1799. Their only child died in infancy, and Mrs. Romeyn died the same year as her husband.

Romeyn was known as an inspiring minister. He frequently preached in Dutch and always propounded traditional Calvinist theology. His great influence resulted not from the sophistication of his ideas but from his commanding personality. In spite of generally frail health, he held a number of important posts. In 1810 he was elected moderator of the general assembly of the Presbyterian church. He was also a college trustee at both Columbia and Princeton. He helped found the Princeton Theological Seminary in 1812 and served on its board of directors until his death on February 22, 1825. His sermons were published in two volumes in 1816.

Four virtually identical versions of this portrait by Waldo and Jewett are known, and the same image was engraved by ASHER B. DURAND in 1820. Since it is in keeping with the working methods of Waldo and Jewett, it is possible that all the portraits were painted at about the same time, that is, between 1817, when the artists began their partnership, and 1820, when Durand used one of the portraits as a model for his engraving.

Compositionally, the artists relied on formulas made popular by GILBERT STUART in his late years. Thus Romeyn's figure may be compared

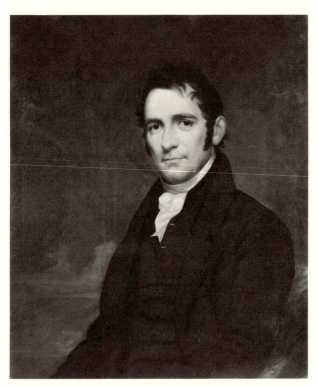

Waldo and Jewett, *The Reverend John Brodhead Romeyn.*

alogue of Paintings in the Metropolitan Museum (1931), p. 388, lists it as Dr. Romaine // R. Feigenbaum, *American Portraits, 1800–1850* (1972), pp. 43–46, discusses it in relation to portrait at Union College // Gardner and Feld (1965), pp. 175–176.

EXHIBITED: MMA, 1965, *Three Centuries of American Painting* (checklist arranged alphabetically).

ON DEPOSIT: Bartow Mansion, Pelham Bay Park, New York, 1946–1961 // Federal Reserve Bank, New York, 1972–1979 // Gracie Mansion, New York, 1987–present.

Ex COLL.: probably Mr. and Mrs. Robert Buloid, New York and New Rochelle, N. Y., d. 1885; Mrs. Buloid's sister-in-law, Grace (Mrs. Lawrence) Davenport, New Rochelle, N. Y., d. 1890; her granddaughter, Grace Davenport Thorne, New Rochelle, d. 1919, subject to a life estate; her sister, Elizabeth H. J. (Mrs. Francis) Cowdrey, New Rochelle, d. 1929.

Bequest of Elizabeth H. J. Cowdrey, 1929.
29.148.1.

Matthew Clarkson

This portrait of Matthew Clarkson (1758–1825) was painted in June 1823, almost thirty years after GILBERT STUART executed a portrait of Clarkson (q.v.). It is a good example of the formularized but highly successful portrait style perfected by Waldo and Jewett several years after they established their partnership. Waldo admired the works of English portraitists, especially Sir Thomas Lawrence, and after his return to the United States painted works that reveal their influence. The portraits he executed jointly with Jewett, however, differ markedly from that style. As may be observed here as well as in the portraits of Henry L. de Groot and Edward Kellogg (qq.v.), dark tonalities are predominant, the modeling of the face is smooth, and the sitter's features are thrown into relief by light and dark contrasts almost baroque in character. To a great extent, this emphasis on chiaroscuro is simply a reflection of a general trend toward romanticism in European portraiture. The combination of chiaroscuro and realism in the works of Waldo and Jewett, however, is very original and gives their portraits a Caravaggesque air quite unlike that of any other American portraitists working at this time.

As is the case with most portraits of men painted by this partnership, the representation of drapery is achieved by first painting broad masses of a determined color—in this case grayish black for the coat and red for the curtain—

with that of James Madison's in the portrait by Stuart (q.v.), and the turn of the head recalls that in Stuart's portrait of William Eustis (q.v.). As is clear in this and in the following works, however, the likeness of the sitter in portraits by Waldo and Jewett is more sharply defined by means of light and dark than is the case with Stuart.

Oil on canvas, 30¼ × 25¼ in. (76.8 × 64.1 cm.).

RELATED WORKS: *Rev. John Brodhead Romeyn*, oil on canvas, 30 × 25¼ in. (76.2 × 64.1 cm.), 1818–1820, Union College, Schenectady, N. Y., ill. in R. Feigenbaum, *American Portraits, 1800–1850* (1972), p. 42 // two other versions, both oil on canvas mounted on wood, 30 × 24¼ in. (76.2 × 62.2 cm.), ca. 1820, Fifth Avenue Presbyterian Church, New York // Asher B. Durand, *Rev. J. B. Romeyn D. D.*, engraving, 8 × 6½ in. (20.3 × 16.5 cm.), 1820.

REFERENCES: W. B. Sprague, *Annals of the American Pulpit*, (1858), 4, pp. 216–220, gives biographical information on the subject // G. D. Thorne, will, Oct. 15, 1919, Liber 202, p. 80, Surrogate's Court, White Plains, N. Y., notes seven oil portraits by Waldo that she wishes to leave to MMA // E. H. J. Cowdrey, will, Feb. 25, 1929, copy in MMA Archives, says portrait hangs in dining room of her house, the Grange, Davenport Neck, New Rochelle, N. Y. // B. Burroughs, *Cat-*

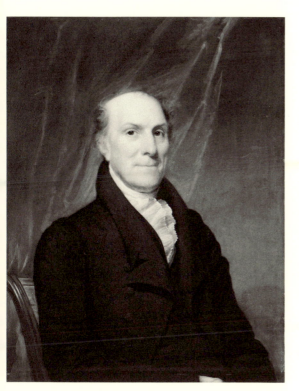

Waldo and Jewett, *Matthew Clarkson*.

and then giving shape to it by painting highlights and shadows with a few well-placed strokes. This approach to drapery painting is, of course, perfunctory, but in view of the overriding emphasis these painters placed on an authoritative likeness it is perhaps excusable. It was certainly one of the methods that permitted them to turn out portraits of good quality in large numbers. This picture was given to the museum with a collection of Clarkson family heirlooms.

Oil on wood, 33 × 25⅝ in. (83.8 × 65.1 cm.).

Inscribed on the back: This likeness was taken by Messrs. Waldo and Jewett in June 1823. General Clarkson was aged 64 years 8 months at that time.

RELATED WORKS: *Matthew Clarkson*, oil on canvas, 33 × 41 in. (83.8 × 104.1 cm.), New York Hospital. A portrait usually assigned to just Waldo showing Clarkson in the same pose as our painting but in more elaborate surroundings.

REFERENCES: C. W. Bowen, ed., *The History of the Centennial Celebration of the Inauguration of George Washington* (1892), p. 438, mentions the existence of several portraits of Clarkson by Waldo // Gardner and Feld (1965), p. 176.

EX COLL.: descended to Mr. and Mrs. William H. Moore, New York.

Gift of Mr. and Mrs. William H. Moore, 1923. 23.80.80.

Edward Kellogg

Edward Kellogg (1790–1858) was born in the small village of Northfield, Connecticut. In 1793 his family moved to Dutchess County, New York, where he received some formal education. Nine years later, they returned to Northfield, where Kellogg began a career as a businessman. He married Esther Fenn Warner in 1817, and three years later moved to New York, where he founded the wholesale drygoods firm of Edward Kellogg and Company. During the panic of 1837, he was unable to make collections and though his assets were ample he was forced to suspend business. This crisis prompted him to turn his attention to problems connected with money and finance, the study of which increasingly consumed his energies.

Kellogg became convinced that money should be regulated by government, not by private banks, and that interest rates should be sharply reduced and controlled. In 1843 he retired from business in order to devote himself to this subject. At this time, his essay *Currency, the Evil and the Remedy* was published in pamphlet form by Horace Greeley and had a wide circulation. In 1849, the same general arguments, much refined, appeared in an expanded form in *Labor and Other Capital: The Rights of Each Secured and the Wrongs of Both Eradicated*. When Kellogg died on April 29, 1858, he was at work on a new edition of this book. In the 1860s his daughter and longtime assistant, Mary Kellogg Putnam, brought out many editions of his work under the title *A New Monetary System*. His ideas were championed by American pro-labor forces and thus directly influenced the adoption of a system of paper currency. In effect, Kellogg was the father of the American greenback.

When Mary Kellogg Putnam gave the portraits to the museum in 1899, she wrote: "I desire to present the two portraits of my father and mother painted about the year 1830 by Waldo and Jewett, partly that the pictures may be preserved and also that my father's work for his fellow creatures may be held in remembrance by those whom he sought to benefit." The pose is one Waldo and Jewett used frequently; in his right hand, Mr. Kellogg holds a pair of black gloves. According to the inscription on the back,

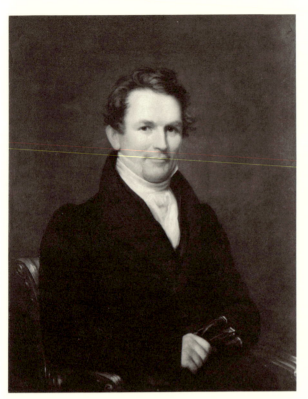

Waldo and Jewett, *Edward Kellogg*.

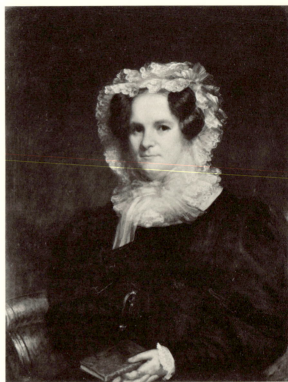

Waldo and Jewett, *Mrs. Edward Kellogg*.

the portrait was painted in 1831–1832. The work successfully portrays the intellectual liveliness and personal assurance of a self-made businessman and man of letters. Similar to many of the works of Waldo and Jewett, this portrait is painted on wood.

Oil on wood, 33⅜ × 25⅜ in. (84.8 × 64.5 cm.).

Signed, dated, and inscribed on the back: Edward Kellogg / painted by Waldo and Jewett / New York 1831–1832.

REFERENCES: M. K. Putnam, letter in MMA Archives, March 23, 1899 (quoted above), gives biographical data // *DAB* (1932, 1960), s.v. "Kellogg, Edward" // Gardner and Feld (1965), p. 178.

EX COLL.: Edward Kellogg, New York, 1832–1858; his wife, Esther Kellogg, 1858–1872; their daughter, Mary Kellogg Putnam, Elizabeth, N.J., 1872–1899.

Gift of Mary E. Kellogg Putnam, 1899.

99.29.1.

Mrs. Edward Kellogg

Esther Fenn Warner (1794–1872) was born in Plymouth, Connecticut. She was married to Edward Kellogg (see above) at Northfield, Connecticut, in 1817, and they later lived in New York.

As in the companion portrait of Mr. Kellogg, the infelicities of a somewhat hurried execution are noticeable here, perhaps, more so because of the complicated attire of a lady. Mrs. Kellogg's face and hair appear overly labored and without grace. The heavy application of paint and the uncertain definition of details prefigure the more obvious appearance of these qualities in later portraits by Waldo and Jewett. The chair or settee on which Mrs. Kellogg sits, like the armchair occupied by her husband, is awkward and poorly defined.

Oil on wood, 33⅜ × 25⅜ in. (84.8 × 64.5 cm.).

REFERENCES: M. K. Putnam, letter in MMA Archives, March 23, 1899, gives biographical data // Gardner and Feld (1965), pp. 178–179.

Henry La Tourette de Groot

Henry La Tourette de Groot (1789–1835) was born in Bound Brook, New Jersey, the son of Ann La Tourette and William de Groot, who was a lieutenant in the Continental Army and scion of an old New York Dutch family. Henry became a prosperous importer in New York with extensive business interests in England. He is last listed as a homeowner in New York in 1831, probably the year in which he moved his family to London where he lived in elegant style. He owned a house in Regent's Park, had coaches and liveried servants, and sent his children to an exclusive academy. He died in 1835 and was buried in the vault of Saint Marylebone Church, London. After his death, his wife returned to New York with their three children. One of them, Fanny de Groot, later married Dr. Thomas S. Hastings, president of Union Theological Seminary. Their son Thomas Hastings became a well-known New York architect whose firm, Carrère and Hastings, designed many important buildings including the New York Public Library at Fifth Avenue and 42nd Street. Another grandchild of the sitter's was Adelaide Milton de Groot (1876–1967), a painter and collector who bequeathed a number of masterpieces of modern painting to the Metropolitan Museum.

This portrait, basically a reprise of the Waldo and Jewett formula used for the portraits of Reverend John Romeyn and Matthew Clarkson (qq.v.), is a somewhat more ambitious performance: the sitter's hands have been painted with greater care, and the letter held by de Groot constitutes a fairly well-executed still-life passage. The vertical emphasis, derived from the works of GILBERT STUART, which Waldo and Jewett often gave to compositional arrangements, is here readily apparent. This was an important development in New York portraiture and was often echoed in the works of such emulators of Waldo and Jewett's style as WILLIAM SIDNEY MOUNT (see his portraits of Mr. and Mrs. Gideon Tucker).

This work is painted in the relatively tight and smooth manner typical of Waldo and Jewett portraits produced between 1820 and 1830. Since

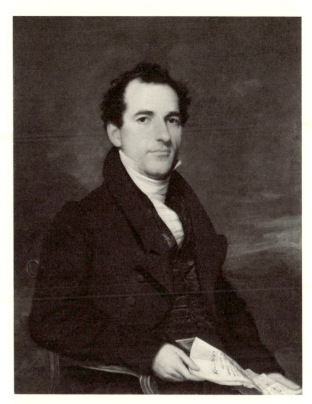

Waldo and Jewett, *Henry La Tourette de Groot.*

de Groot appears to be in his early thirties it seems reasonable to date the portrait about 1825.

Oil on wood, 33 × 25⅝ in. (83.8 × 65.1 cm.).

REFERENCES: A. M. de Groot, genealogical and biographical notice regarding H. L. de Groot, Nov. 14, 1936, MS in Dept. Archives // J. Allen, *MMA Bull.* 32 (Jan. 1937), p. 16, says it was painted by Waldo // Gardner and Feld, 1965, pp. 176–177, attribute it to Waldo and Jewett and date it about 1825–1830.

EX COLL.: Henry L. de Groot, New York and London, d. 1835; his daughter, Fanny (Mrs. Thomas S.) Hastings, New York, d. 1963; her son, Thomas Hastings, New York, d. 1929; his wife, Mrs. Thomas Hastings, until 1936.

Bequest of Mrs. Thomas Hastings, 1936.
36.114.

Portrait of a Lady (probably of the Buloid Family)

The identity of the sitter is not known beyond the indication in the donor's will that she was the aunt of Robert Buloid, a wealthy New York

merchant and a relation of the donor. The portrait and that of the Rev. John B. Romeyn came from the New Rochelle estate of the Davenport family, which had remained intact up until 1929. Robert Buloid was the husband of Elizabeth Davis Davenport in whose family the portrait descended. To date, genealogical research on the Buloid family has not produced any one candidate for this subject, who was painted in 1832. It is also possible that the sitter was Mrs. Buloid's aunt.

Except for the woman's hands, which are summarily painted and awkward, the portrait is one of the happiest productions of the Waldo and Jewett workshop. Interrupted in her reading, the elderly lady gazes benignly at the viewer with a look of recognition. The impression is one of informality and spontaneity, quite unlike the formality of the portrait of Mrs. Edward Kellogg (q.v.), which is more representative of the Waldo and Jewett style at this time. Coloristically, the picture is bright and lively with none of the tenebrousness of the preceding portraits. It is painted in a free, juicy manner. The empty background, the position of the subject in the chair, and the gesture of turning from the

Waldo and Jewett, *Portrait of a Lady*
(*probably of the Buloid Family*).

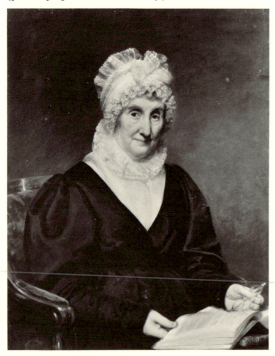

work at hand to confront the viewer directly is reminiscent of a number of GILBERT STUART portraits of elderly women, most notably *Mrs. Richard Yates*, 1793–1794, and *Mrs. John Adams*, 1815 (both National Gallery of Art, Washington, D. C.). Curiously enough, this attempt on the part of Waldo and Jewett to closely emulate Stuart's technique and style appears to take place in the 1830s, that is, just a few years after his death. From this period on, Waldo and Jewett portraits of women generally display freer execution, livelier coloring, and a greater sense of urbanity than previously.

Oil on wood, 33 × 25⅜ in. (83.8 × 64.5 cm.).

Signed and dated with a stamp on the back: WALDO & JEWETT / 1832 / NEW YORK. Inscribed on the back: Buloide / no. 5.

REFERENCES: G. D. Thorne, will, Oct. 15, 1919, Liber 202, p. 80, Surrogate's Court, White Plains, N. Y., notes seven oil portraits by Waldo that she wishes to leave to MMA // E. H. J. Cowdrey, will, Feb. 25, 1929, copy in MMA Archives, describes this picture as a portrait of Mr. Buloid's aunt, "old lady with cap . . . hanging in yellow room" // B. Burroughs, *Catalogue of Paintings in the Metropolitan Museum* (1931), p. 388, incorrectly dates it 1852 // Gardner and Feld (1965), p. 179.

Ex COLL.: Mr. and Mrs. Robert Buloid, New York and New Rochelle, N. Y., d. 1885; Mrs. Buloid's sister-in-law, Grace (Mrs. Lawrence) Davenport, New Rochelle, d. 1890; her granddaughter, Grace Davenport Thorne, New Rochelle, d. 1919, subject to a life estate; her sister, Elizabeth H. J. (Mrs. Francis) Cowdrey, New Rochelle, d. 1929.

Bequest of Elizabeth H. J. Cowdrey, 1929.
29.148.2.

The Knapp Children

One of the most ambitious works by Waldo and Jewett, this group portrait depicts the four sons of Shepherd Knapp (1795–1875) and his wife, the former Catherine Louisa Kumbel (1793–1872). They are, from left to right, Gideon Lee Knapp (1821–1875), Shepherd Fordyce Knapp (1832–1886), William Kumbel Knapp (1827–1877), and Peter Kumbel Knapp (1825–1871). If we assume that in the portrait Shepherd Fordyce Knapp is no older than two, the work would have been painted about 1833–1834, a dating which agrees with the somewhat loose execution of the faces and with the less pronounced contrasts of light and dark in the work

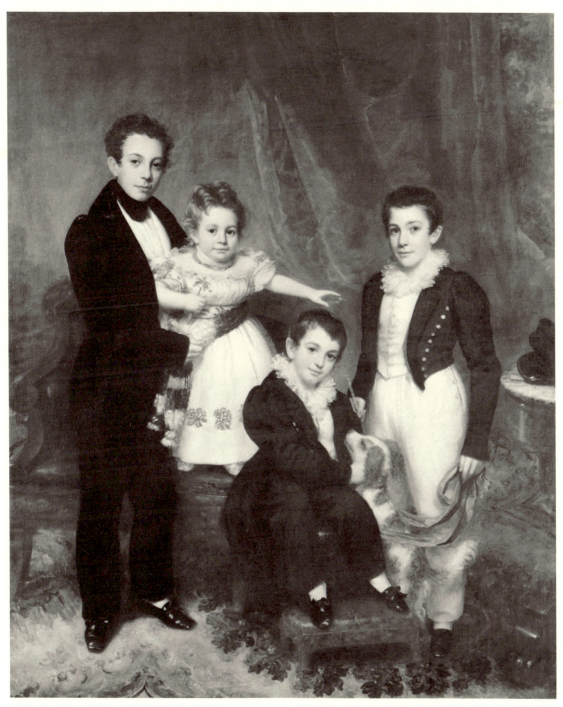

Waldo and Jewett, *The Knapp Children*.

as a whole, both characteristics of the partnership's production in the early 1830s. In any case, it is unlikely the portrait was painted after 1835, the year in which another son, Addison Melvin Knapp (1835–1874), was born.

As the painting clearly indicates, the Knapp children were born into a well-to-do family. Their father, Shepherd, who came from Cummington, Massachusetts, was one of New York's merchant aristocrats. In 1855 his fortune was estimated at three hundred thousand dollars, and the following notice about him appeared: "Has been long established as a leather and hide merchant, carrying it on in every department, as importer, tanner, etc. He has realized a handsome fortune, and is in every respect an excellent citizen. He is also president of the Merchants' Bank, and somewhat known in the political world" (M. Y. Beach, *The Wealth and Biography of the Wealthiest Citizens of the City of New York* [1855], pp. 43–44). Not a great deal is known about the lives of the children. Gideon became the owner and manager of the Greenpoint Ferry, operating from lower Manhattan to Long Island. He married Augusta Murray Spring, daughter of the well-known Reverend Gardiner Spring (whose portrait by Waldo and Jewett is owned by the Presbyterian Brick Church, New York); they had seven children. Shepherd married Kate Floyd Smith and had at least two children. William married Maria Meserole and had three or more children. Their grandson John Knapp Hollins inherited this portrait, and it was his widow who donated it to the museum in 1959. Peter married Anne Amelia Baker and had at least seven children (Shepherd Knapp, *Family Memories* [1946], p. 66).

Although the children's clothing as well as the sitting room furniture and rug depicted in the work are clearly contemporary, the overall composition of the painting harks back to late eighteenth century English portraiture. In particular, the poses of the children, the falling curtain used as a backdrop, the garden views beyond it, and the inclusion of a pet dog are reminiscent of the BENJAMIN WEST portrait of Prince Adolphus, later duke of Cambridge, with Princess Mary and Princess Sophia, painted in 1778 for their father, George III (Royal Collections, Buckingham Palace). While Waldo was in London in 1806–1809, that painting hung in the dining room of the queen's private apart-

ments at Windsor Castle, so it seems unlikely that he actually saw it (see O. Miller, *The Later Georgian Pictures in the Collection of the Queen* [1969], no. 1147, ill. pl. 112). The similarities between the painting and West's portrait, however, are so close as to suggest that Waldo may have seen a similar picture, or a drawing after the royal portrait, in West's studio.

Painted in the lighter tonalities and exhibiting the freer brushwork characteristic of Waldo and Jewett portraits of the 1830s, this painting, despite the awkwardness of the children's hands and the implausibly rendered armchair and dog, is the most successful group portrait by these artists presently known. The muted tones of red, black, white, and yellow that predominate in the picture create an ambiance of aristocratic restraint very much in keeping with the sensitive characterizations of the children as little gentlemen. As was the custom at the time, the youngest boy, being still a baby, wears a dress. He holds in his right hand a silver and coral rattle and wears a coral necklace, both amulets to ward off evil. His brother Peter appears to be holding a drumstick in his right hand, and it is probable that the soldier's cap lying on the marble-topped table at the right is also his.

Oil on canvas, 70 × 57½ in. (177.8 × 146.1 cm.).
REFERENCES: S. Knapp, *Family Memories* (1946), gives information on the subjects // Gardner and Feld (1965), pp. 180–181, misidentify the children as the sons of Gideon Lee Knapp and thus date the painting about 1849–1850 // G. A. Vondermuhll, Jr. (great-grandson of Gideon Knapp), letter in Dept. Archives, Jan. 11, 1976, correctly identifies the children as the sons of Shepherd Knapp and gives biographical information on them // Mrs. J. K. Hollins (donor of the painting), letter in Dept. Archives, Dec. 27, 1978, quotes information received from her mother-in-law, Mrs. Evelina Knapp Hollins, daughter of William Kumbel Knapp, suggesting that the portrait was painted in the sitting room of Shepherd Knapp's old colonial home at West 162nd Street in New York; also quotes information received from husband, John Knapp Hollins, stating that it was painted by Waldo and Jewett.
EXHIBITED: MMA, 1965, *Three Centuries of American Painting*, (checklist arranged alphabetically) // Wildenstein and Co., New York, 1966, *Three Hundred Years of New York City Families*, no. 19, as the Knapp Sons // Lytton Gallery, Los Angeles County Museum of Art, and M. H. de Young Memorial Art Museum, San Francisco, 1966, *American Paintings from the Metropolitan Museum of Art*, no. 28 // Worcester Art Museum, 1973, *The American Portrait*, no. 13.

Ex coll.: Shepherd Knapp, New York, d. 1875; his son William Kumbel Knapp, d. 1877; his daughter Evelina Knapp (Mrs. Henry B.) Hollins; her son John Knapp Hollins, Beaufort, S. C.; his wife Sallie Hitchings Hollins, Beaufort, S. C., until 1959.

Gift of Mrs. John Knapp Hollins, in memory of her husband, 1959.

59.114.

Portrait of a Girl with Flowers

The young girl represented in this portrait was identified by the donor as her husband's grandmother. (So far we know that his parents were John H. Wray and Elizabeth Sloane, both of the New York area.) Unfortunately, genealogical research has so far failed to shed any more light on her identity. The portrait is signed and dated on the back with the Waldo and Jewett stamp, but the last two digits of the given year are difficult to read: the third number from the left could be either a three or a five, while the fourth is completely illegible. It is now believed that the Waldo and Jewett stencil was not used after the 1830s. That and a number of other factors establish fairly conclusively that this picture was painted in the mid- to late 1830s. To begin with, the style of the dress worn by the girl was the height of fashion at that time. Also, the manner of painting is characteristic of Waldo and Jewett works of the 1830s: the brushstrokes are relatively free and loose, and the treatment of the girl's face is very similar to the way in which the faces of William and Peter Knapp are handled in the *Knapp Children* (q.v.) from about the same time.

Not very many portraits of children by Waldo and Jewett are known, and it is probable that they felt some uneasiness in painting them. In the portrait of the Knapp children, for example, they reverted to a well-established if somewhat dated formula. In this case, they attempted to emulate the stylistically more advanced conventions of children's portraiture employed by New York's leading younger artists. Thus, the fuzzy execution and the soft, sentimentalized quality of the girl's face are very much in the manner of HENRY INMAN, and the representation

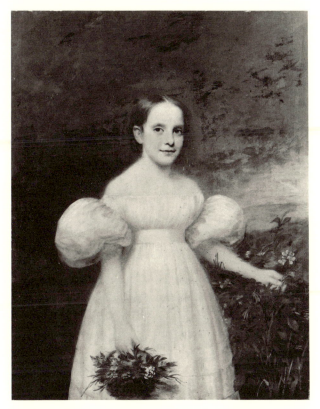

Waldo and Jewett, *Portrait of a Girl with Flowers.*

of the subject in an outdoor setting, holding freshly picked flowers, recalls CHARLES CROMWELL INGHAM'S *Amelia Palmer* (q.v.).

Like many Waldo and Jewett works on wood, this panel is scored to give the appearance of canvas.

Oil in wood, 40⅞ × 31¾ in. (103.8 × 80.6 cm.).

Signed and dated with a stencil on the back: WALDO & JEWETT / 18[3?] // New York.

REFERENCES: E. W. Wray, codicil to will, April 27, 1956, Monmouth County Surrogate's Court, Book 599, bequeaths portrait of "husband's grandmother painted by Waldo and Jewett" to the MMA // M. Goldberg, New York, Jan. 11, 1989, gave information regarding date of Waldo and Jewett stencil.

Ex coll.: Charles S. Wray, Navesink, N. J., d. 1953; his wife, Elsa Welles Wray, Navesink, N. J., 1953-1973.

Bequest of Elsa Welles Wray, 1973.

1973.123.

UNIDENTIFIED ARTIST

Mrs. George Pine

Portia Charlotte Cheetham (1805–1893) was married to George W. Pine, a surveyor and civil engineer, about 1831 and had two sons and three daughters. At various times, the Pines lived in New York City, Walton, New York, Saint Louis, and Brooklyn. Mr. Pine was employed by Cornelius Vanderbilt to survey a road for the development of the Nicaragua route to the West Coast. Shortly after completing this work, he died of a fever.

Sometime after her husband's death in 1852, Portia Charlotte Pine followed her son George to Marysville, California. He later served as Yuba County treasurer from 1889 until 1912. Mrs. Pine died in Yuba City, California, at the age of eighty-eight.

When the portrait of Mrs. Pine was given to the museum following the death of her daughter in 1926, the artist was not identified. According to a pencil inscription once visible on the back before the canvas was lined, this portrait was painted in New York in 1835. Previously attributed first to CHESTER HARDING and then to SAMUEL L. WALDO, both fashionable portrait painters of the day, the picture is presently considered unidentified. A note (1945) in the files indicates that portions of the initials J. L. were once visible and that the work might be by J. L. Harding (working 1835–1882). This cannot be substantiated. The picture is in poor condition; the glazes have been broken into, and there has been paint loss and abrasion. Amazingly enough, the sitter is still attractive. The portrait recalls the late style of GILBERT STUART, though it lacks the sophisticated blending of tints that made his faces so lifelike. There is also an awkwardness in execution, mainly in the subject's left shoulder.

Oil on canvas, 30¼ × 25¼ in. (76.8 × 64.1 cm.).

Inscribed on the back before lining: Taken December 1835, N. Y. City.

REFERENCES: J. M. Quinn, *The History of the State of California and Biographical Record of the Sacramento Valley, California* (1906), p. 820, gives information on the subject in a biography of her son George // B. Burroughs, *Catalogue of Paintings in the Metropolitan Museum* (1931), p. 153, as by Chester Harding // E. R. Lewis, Public Library of Washington, D. C., letter in Dept. Archives, June 2, 1945, says she thinks it was done by John L. Harding, says it is signed J. L. // Memo in Dept. Archives, Dec. 13, 1946, notes that painting was cleaned and lined // Gardner and Feld (1965), pp. 174–175, attribute it to Waldo // R. Cox, Painting Conservation, March 8, 1989, notes poor condition and that presence of initials can no longer be determined // J. Stark, Memorial Museum of Sutter County, Yuba City, Calif., letter in Dept. Archives, March 23, 1989, supplies biographical information // F. B. Lane, Walton, N. Y., May 3, 1989, letter in Dept. Archives, gives biographical data.

ON DEPOSIT: Museum of the City of New York, 1931–1946 // Bartow-Pell Mansion, Pelham Bay Park, New York, 1961–1978.

Ex COLL.: The subject's daughter, Carolyn M. Pine, Yuba City, Calif., and Long Beach, N. Y., 1926.

Bequest of Carolyn M. Pine, 1926.

26.185.

Unidentified artist, *Mrs. George Pine.*

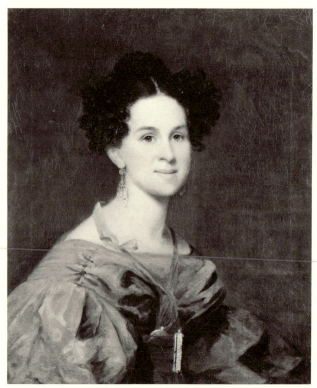

THOMAS SULLY

1783–1872

Thomas Sully, son of the actors Matthew and Sarah Sully, was born at Horncastle, England, in 1783. In 1792 the family emigrated to Richmond, Virginia, and two years later settled in Charleston, South Carolina. His earliest teacher in art was one of his schoolmates, Charles Fraser (1782–1860), who went on to become a well-known miniaturist. Sully also received instruction from another miniature painter in Charleston, the Frenchman Jean Belzons (active 1794–1812), who had married one of Sully's sisters. It seems, however, that the two men did not get along. Sully went to Richmond in September of 1799 to learn miniature painting from his elder brother, Lawrence (1769–1804), who was fairly successful. Lawrence and Thomas moved to Norfolk in 1801. There Thomas Sully painted his first miniature from life, and a year later his first oil painting. He began at this time to keep a register of works that he was to continue to the end of his life. (It is now in the Historical Society of Pennsylvania.) On its pages, ruled in columns, he entered the date on which a picture was begun, the size, the subject's name if it were a portrait, an occasional explanatory note, the price, and the date of completion. It does not contain, however, all the works he ever did.

In September 1804, Lawrence Sully died, and Thomas assumed the responsibility for supporting his widow and three children. On June 27, 1806, he married his sister-in-law. Their union was an unusually happy one; they had six daughters and three sons. In November 1806, on the advice of Thomas Abthorpe Cooper, the distinguished actor and theatrical manager, Sully moved to New York. He was eager to work, and by the end of 1807, as his register indicates, he had painted at least seventy works and received over three thousand dollars in recompense. In that same year he traveled to Boston in order to meet GILBERT STUART, who let him watch while he worked on a portrait and consented to criticize one that Sully had been commissioned to paint. Soon after this visit, Sully settled in Philadelphia, which was to remain his home.

Very little has been written about Sully's early works, but it is clear from a number of them, for example *Portrait of a Young Man*, ca. 1804 (private coll., ill. in M. Fabian, exhib. cat. [1983], p. 43), and *Self-Portrait at Age 25* (Philadelphia Museum of Art), that his style was loose and free from the beginning, but his handling of anatomy, drawing, and modeling were weak. He must have recognized his shortcomings, and, certainly after meeting Stuart, he realized that it was imperative for a painter with his gifts to study abroad. In June 1809, therefore, he set sail for England and the studio of BENJAMIN WEST. At the time West had all but abandoned portraiture in favor of history painting, but Sully benefited from his help and gained access to the studios of the best English portrait painters. He was particularly impressed with and tried to emulate the works of Thomas Lawrence, with whom he became friendly. In Lawrence, Sully found his pole star. Even later in his career, when he was a successful painter in his own right, he continued to keep up with Lawrence's works through engravings.

Following his return to Philadelphia in 1810, Sully was soon recognized as the finest portrait painter working in that city. He also tried his hand at history painting, for example,

Washington Crossing the Delaware, 1818 (MFA, Boston), but only as an occasional departure from his main occupation. His best pictures of this period are beautifully colored, stylish works that seldom fail to please. Among them are the full-length portrait of Samuel Coates, 1812–1813 (Pennsylvania Hospital, Philadelphia, ill. in M. Fabian, exhib. cat. [1983], p. 61), and *Lady with a Harp: Elizabeth Ridgely*, 1818 (National Gallery of Art, Washington, D. C.). They are not astute analyses of individual character but flattering, good-humored, and at times overly sentimental portrayals of middle-class people. After the deaths of CHARLES WILLSON PEALE in 1827 and of Stuart in 1828, Sully had no serious competitors either in Philadelphia or elsewhere in the country. His professional triumph was complete when in 1837 he obtained sittings from Queen Victoria for a portrait commissioned by a Philadelphia benevolent society (q.v.). After his return to the United States he was more than ever recognized as the country's leading portraitist.

Sully remained a popular artist until the end of his life, but after about 1845 his powers began to decline. His modeling of form was weak, and he often displayed anatomies that were less than credible. In 1842 he was offered the presidency of the Pennsylvania Academy of the Fine Arts but turned it down. He died in Philadelphia on November 5, 1872, having painted upwards of 2,600 works. His *Hints to Young Painters*, first prepared for the press in 1851, was published posthumously in 1872. It fully describes his general approach to portraiture and offers technical advice, but appearing so long after it was written, *Hints* did not have a substantial effect on American painters. Throughout his life, Sully actively sought to become acquainted with the history of art and constantly made sketches after acknowledged masterpieces of paintings and sculpture (one such sketchbook, dated 1810 to 1819, is in the Metropolitan's collection). Many of his portraits reflect his learning and often contain allusions to past masters as well as iconographically significant details.

BIBLIOGRAPHY: Edward Biddle and Mantle Fielding, *The Life and Works of Thomas Sully (1783–1872)* (Philadelphia, 1921). This is the standard biography with a listing of works // Pennsylvania Academy of the Fine Arts, Philadelphia, *Catalogue of the Memorial Exhibition of Portraits by Thomas Sully*, exhib. cat. (1922) // Bedford Gallery, Longwood College, Farmville, Va., *Thomas Sully, 1783–1872*, exhib. cat. (1973) // National Portrait Gallery, Washington, D. C., *Mr. Sully, Portrait Painter: The Works of Thomas Sully (1783–1872)*, exhib. cat. by Monroe Fabian (1983). Includes some eighty works dating from 1801 to 1865 // Steven E. Bronson, "Thomas Sully: Style and Development in Masterworks of Portraiture, 1783–1839," Ph. D. diss., University of Delaware (1986).

Mrs. Katherine Matthews

When this portrait came to the museum in 1906, it was identified as Mrs. Katherine Matthews of Philadelphia by Ehrich Galleries of New York, who said it came from direct descendants. In Sully's register an entry describing the portrait gives the following information: "Mrs. Matthews Sister to Mrs. Mallon. Begun Dec. 1, 1812—finished Jan. 29, 1813. Bust. Price, $70." Unfortunately, not much else is known about Mrs. Matthews or her sister, who also sat to Sully

for a portrait in December 1812, nor is it certain that Mrs. Matthews's first name was actually Katherine. There was a Mrs. Mallon from Dublin who ran a well-known ladies academy in Philadelphia in the early nineteenth century. Her first name was Catherine, but it is not known if she was related (it is unlikely, however, she had a sister of the same name).

Painted after Sully's English trip of 1809–1810, the portrait reveals the extent to which he assimilated the example of Sir Thomas Lawrence in representing women. The fashionable

fur wrap, the gesture of the right hand, the turn of the head and the bravura brushwork are all elements Sully borrowed from Lawrence, more specifically, from his portrait of *Elizabeth Farren, Countess of Derby*, painted in 1790 (now in MMA) and engraved by Bartolozzi in 1803. Sully, however, transformed Lawrence's full-length portrait into a bust-length one and in so doing lost the compositional vitality and sensuality of Lawrence's forward-leaning figure. He attempted to compensate for this by placing Mrs. Matthews to the right of the canvas, a solution that creates a certain imbalance and hints at the forward movement of the figure. Unable to achieve the spontaneous quality of Lawrence's aesthetic, he filled the large space to the left with a raking light. The portrait, although a bit awkward, possesses a good deal of charm. Sully's conservative portrayal of Mrs. Matthews, enhanced by his restrained palette, reveals that his view of womanhood was in keeping with American values. Whereas Lawrence's portrait endows the figure with an unmistakable sexual allure, Sully's presents a picture of correctness befitting a Philadelphia lady of charm. As Tuckerman perceptively observed of Sully's women, they "have an air of breeding, a high tone, and a genteel carriage . . . One always feels at least in good society among his portraits" (H. T. Tuckerman, *Book of the Artists* [1867], p. 159).

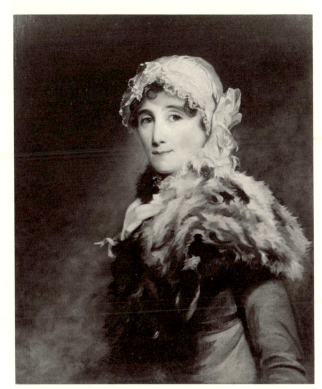

Sully, *Mrs. Katherine Matthews.*

Rogers Fund, 1906.
06.178.

Oil on canvas, 27½ × 23 in. (69.9 × 58.4 cm.).
REFERENCES: T. Sully register, 1813, Dreer Collection, Historical Society of Pennsylvania, Philadelphia, as Mrs. Matthews (quoted above) // H. L. and W. L. Ehrich, eds., *One Hundred Early American Paintings* (1918), pp. 126–127, as Mrs. Katherine Matthews, state that the picture came "from direct descendants" // E. Biddle and M. Fielding, *The Life and Works of Thomas Sully* (1921), p. 227, no. 1206, give information from Sully's register // Gardner and Feld (1965), pp. 156–157.
EXHIBITED: Ehrich Galleries, New York, 1906 // MMA, 1965, *Three Centuries of American Painting* (checklist arranged alphabetically) // Lytton Gallery, Los Angeles County Museum of Art; M. H. de Young Memorial Museum, San Francisco, 1966, *American Paintings from the Metropolitan Museum of Art*, cat. no. 18 // MMA, 1970, *Nineteenth-Century America*, not in cat. // Hudson River Museum, Yonkers, N. Y., 1970, *American Paintings from the Metropolitan Museum*, no. 46.
ON DEPOSIT: Allentown Art Museum, Allentown, Pa., 1975–1976.
EX COLL.: descendants of the subject; with Ehrich Galleries, New York, by 1906.

Major John Biddle

John Biddle (1792–1859) was born in Philadelphia the son of Charles and Hannah Biddle. His brother Nicholas became an important Philadelphia banker and financier. At the outbreak of the War of 1812, John Biddle joined the army as a second lieutenant in the Third artillery and served in Colonel Zebulon Montgomery Pike's regiment on the Canadian frontier. He then became, successively, first lieutenant, captain and, in 1817, assistant inspector general of the artillery corps with the rank of major. This last post he resigned in 1821 in order to serve a brief stint as United States Indian agent at Green Bay, Wisconsin, then part of the Michigan territory. Later that year he moved to Detroit to became head of the land office and settled there.

Active in politics, Biddle served as territorial delegate to Congress from 1829 to 1831. In 1835 he presided over the convention that formulated Michigan's first state constitution. His scholarly

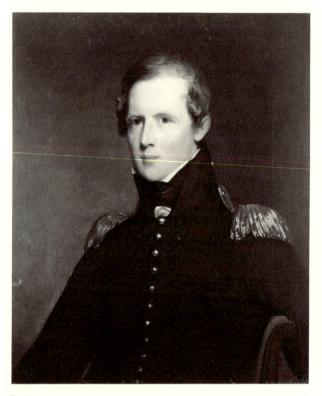

Sully, *Major John Biddle*.

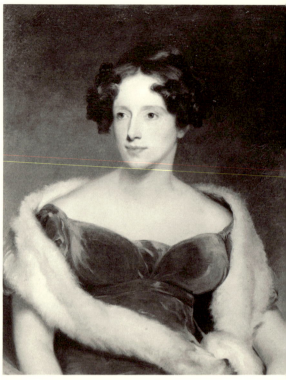

Sully, *Mrs. John Biddle*.

papers on Michigan history were numerous, his travels in Europe extensive. He died on August 25, 1859, at White Sulphur Springs, Virginia. Sully's register states that this portrait was painted in April 1818 and that he charged one hundred dollars for it. Although in a number of other portraits he painted of the Biddle family, Sully employed the loose, painterly technique he mastered after his trip to England, in this work he chose to depict Major Biddle in a tighter manner, which is reminiscent of GILBERT STUART. Sully, of course, was familiar with Stuart's work and had even taken informal lessons from him when he visited Boston in 1807. This portrait, however, lacks the variety of brushwork as well as the careful build-up of skin tones and glazes that characterizes Stuart's pictures.

Oil on canvas, 30 × 25 in. (76.2 × 63.5 cm.).
RELATED WORKS: Samuel Sartain, *Major John Biddle*, engraving.
ON DEPOSIT: PAFA, 1855, lent by Miss Biddle, according to sticker formerly on the back // National Gallery, Smithsonian Institution, Washington, D. C., 1914–1916, lent by Colonel John Biddle, West Point, New York // Executive Mansion, Albany, N. Y.,

1975–1976 // Staten Island Institute of Arts and Sciences, Staten Island, N. Y., 1977–1978 // Gracie Mansion, New York, 1978–1979.

REFERENCES: T. Sully register, 1818, Dreer collection, Historical Society of Pennsylvania, Philadelphia, as Major John Biddle, U. S. Army, "Begun April 13. Finished April 30, 1818" // *Appleton's Cyclopaedia of American Biography* (1900), p. 256, gives information on the subject // E. Biddle and M. Fielding, *The Life and Works of Thomas Sully* (1921), p. 99, no. 135, give information from Sully's register // H. Wehle, *MMA Bull.* 19 (July 1924), p. 180 // Mrs. C. H. Hart, n. d., biographical information recorded at FARL 121–15N3 // Gardner and Feld (1965), pp. 157–158.

EX COLL.: John Biddle, Detroit, d. 1859; probably his son, William Shepard Biddle, d. 1901; his daughter, Susan D. Biddle, Detroit, d. 1915, and his son, Major General John Biddle, until 1924.

Gift of General John Biddle, 1924.
24.115.1.

Mrs. John Biddle

Eliza Falconer Bradish (1795–1865) was the daughter of Margaretta and James Bradish of New York. Her father, who was a merchant,

died when she was about four; her mother was a music publisher. Eliza married Major John Biddle in January 1819 and became the mother of eight children, five of whom survived to adulthood. According to Sully's register, this portrait was painted in December 1821 and cost one hundred dollars. Unlike the portrait of her husband, painted three years earlier, it shows the subject in a more up-to-date and fashionable style, combining an informal quality in the pose and likeness with the more staid effect of the costly velvet dress and fur boa. With the exception of the face, which was painted with some care, the portrait appears to have been executed with great rapidity, a fact which may account for the poor rendering of the left side of Mrs. Biddle's body. Although in size the portrait corresponds to that of Mr. Biddle, the color scheme and composition are not complementary, so that it is unlikely that the work was intended as a companion piece.

Oil on canvas, 30 × 24⅞ in. (76.2 × 63.2 cm.).
RELATED WORK: Alvah Bradish, *Mrs. John Biddle*, oil on canvas, unlocated, a copy after this painting (noted in FARL).
REFERENCES: T. Sully register, 1821, Dreer collection, Historical Society of Pennsylvania, Philadelphia, as Mrs. J. Biddle "Miss Bradish of New York, Begun Dec. 1—Finished Dec. 24, 1821. Price, $100. Bust" // E. Biddle and M. Fielding, *The Life and Works of Thomas Sully* (1921), p. 99, no. 136, give information from Sully's register // H. Wehle, *MMA Bull.* 19 (July 1924), p. 180 // C. J. Biddle, letter in Dept. Archives (July 17, 1956), gives biographical information on the subject // Gardner and Feld (1965), p. 158.
EXHIBITED: NAD, 1951, *The American Tradition*, no. 130 // MMA, 1986-1987, *Dance*, no cat.
ON DEPOSIT: National Gallery, Smithsonian Institution, Washington, D. C., 1914-1916, lent by Miss Susan Biddle, Detroit, 1914-1915 and from 1915-1916 by Colonel John Biddle, West Point, N. Y. // Staten Island Institute of Arts and Sciences, Staten Island, N. Y., 1977-1978 // Gracie Mansion, New York, 1978-1979.
EX COLL.: the subject, Detroit, d. 1865; probably her son, William Shepard Biddle, d. 1901; his daughter, Susan Dayton Biddle, Detroit, d. 1915, and his son, Major General John Biddle, 1915-1924.
Gift of General John Biddle, 1924.
24.115.2.

Portrait of the Artist

This work, among the most appealing of Sully's self-portraits, was one of several portraits he painted for the Baltimore broker Henry Robinson, including those of John Finley and William Gwynn (qq.v.). It has been said that Robinson commissioned Sully to paint several of his Baltimore friends, but these three portraits, all painted in 1821, were most likely gifts from Sully to Robinson. Sully states in his journal on July 5, 1821, that he "presented" them to Robinson. Also, when one adds up the prices he entered in his account book for his pictures during this period and then compares it with his total income, just the amount at which he valued these pictures is missing. Sully stayed at Robinson's home in Baltimore from the winter of 1820 to the summer of 1821, so it is very likely the paintings were a way of thanking him for his hospitality. Henry Robinson is best-known as a patron of REMBRANDT PEALE. He was a major backer of Peale's Museum in Baltimore, an early investor in Peale's Baltimore Gas Light Company, and later a founder and president of the Boston Gas Company.

According to his register, Sully began this painting on May 8, 1821, and completed it on May 15. The self-portrait is carefully executed and displays brushwork that is unusually restrained for him. The lighting creates a dramatic effect in the face, which is further emphasized by the pointing brush that establishes his occupation.

The artist is shown momentarily interrupted at his work. This spontaneous pose, combined with Sully's speedy execution and painterly technique, creates a sense of immediacy which straightaway engages the spectator. This is a common type of self-portrait. For example, Jean Siméon Chardin used it in his self-portrait of 1775 (Louvre). Certain affinities, however, exist between Sully's self-portrait and that of BENJAMIN WEST from about 1776 (Baltimore Museum, ill. von Effa and Staley, p. vi), in which the artist looks up from his drawing. In this respect it should be noted that Sully's portrait of himself painting his wife (two versions, Yale University Art Gallery and PAFA) is also heavily indebted to a similar composition by West of 1806 (PAFA). Certainly Sully would have seen these works in London; for West encouraged him to study his portraits.

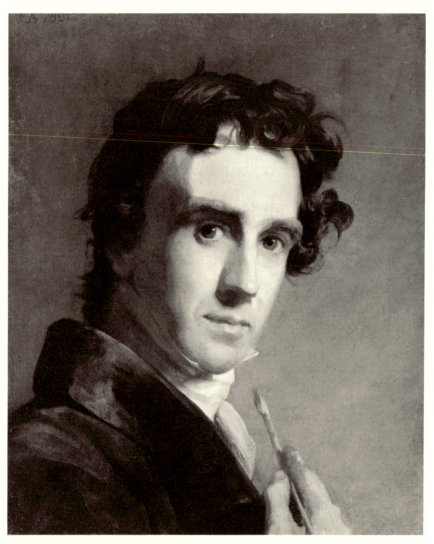

Sully, *Portrait of the Artist.*

Oil on canvas, $17\frac{1}{8} \times 14$ in. (43.5×35.6 cm.).

Signed and dated at upper left: TS (monogram) 1821.

REFERENCES: T. Sully, register, Dreer Collection, Historical Society of Pennsylvania, Philadelphia, says portrait begun May 8, 1821, and finished May 15, $50 // T. Sully, journal, copy NYPL, entry for July 15, 1821, says "portrait of myself presented to H. Robinson" // C. H. Hart, *A Register of Portraits Painted by Thomas Sully* (1909), no. 1650 // E. Biddle and M. Fielding, *The Life and Works of Thomas Sully* (1921), p. 290, no. 1731 // A. T. Gardner, *MMA Bull.* 23 (April 1965), ill. p. 273 // Gardner and Feld (1965), pp. 159-160.

EXHIBITED: Peale Museum, Baltimore, 1822, no. 142 // MMA, 1939, *Life in America*, p. 52, no. 74; ill. p. 53 // Peale Museum, Baltimore, 1956, *Rendezvous for Taste, Peale's Baltimore Museum, 1814–1830*, no. 122, p. 14 // MMA, 1958–1959, *Fourteen American Masters*, no cat.; 1965, *Three Centuries of American Painting* (checklist arranged alphabetically); 1970, *19th Century America* (not in cat.) // Cummer Gallery of Art, Jacksonville, Fla., 1972, *1822 Sesquicentennial Exhibition*, I, no. 16 // Bedford Gallery, Longwood College, Farmville, Va., 1973, *Thomas Sully, 1783–1872*, frontis. ill.; p. 25, no. 17 // National Portrait Gallery, Washington, D. C., *Mr. Sully, Portrait Painter*, color cover, cat. by M. Fabian, no. 33, says made in Baltimore

May 8–15, 1821, and that Sully notes in his journal that it was a gift to Robinson.

Ex coll.: Henry Robinson, Baltimore and Boston, 1821–d. 1848; his daughter, Rosa C. (Mrs. Mark M.) Stanfield, New York, by 1894.

Gift of Mrs. Rosa C. Stanfield, in memory of her father, Henry Robinson, 1894.

94.23.3.

William Gwynn

William Gwynn (1775–1854) was a distinguished Baltimore lawyer, journalist, wit, and litterateur. He was born in Ireland in 1775 and came to this country with his father at an early age. From 1812 to 1834 and again from 1835 to 1837 he edited the *Federal Gazette* in Baltimore. He also practiced law and was described by John H. B. Latrobe in his *Reminiscences of Baltimore* as "one of the most reliable counsellors of his day." He was a member of the Vaccination Society (1810), an incorporator of the Baltimore Gas Light Company (1817), and one of the managers in charge of laying the foundation of the Washington Monument in Baltimore. As a member of the Delphian Club, an exclusive gathering of urbane Baltimoreans, he helped shape *The Portico*, one of the most interesting American literary periodicals of the early nineteenth century. Toward the end of his life Gwynn returned to the full-time practice of law, but, worn by old age and the increasing competition of a younger generation, he soon retired. A bachelor all his life, he died on August 9, 1854, at his sister's home in Carroll County, Maryland.

According to Sully's register this portrait was begun on May 8, 1821 and completed on May 15, the exact same dates as the self-portrait (q.v.). Like that work and the portrait of John Finley, this portrait was painted for Henry Robinson, a friend of Sully's whose 1846 portrait is now in the Bayou Bend collection (Museum of Fine Arts, Houston).

Certainly among Sully's most felicitous portraits of men, the portrait of William Gwynn exhibits the artist's familiarity with the conventions of romantic portraiture. Leaning forward with Byron-like tousled hair and lit dramatically from above, Gwynn's figure is strongly delineated in terms of light and shadow. The highlighted parts of his face are painted in delicate shades of pastel pinks, and the shadowed zones are in a gray tone that echoes the color of the background. Overall the portrait appears to have been more carefully painted than the portrait of Finley. The picture is now displayed in an oval frame.

Oil on canvas, $23\frac{1}{4} \times 19\frac{1}{2}$ in. (59.1 × 49.5 cm.).

Signed and dated at upper left: TS (monogram) 1821.

References: T. Sully, register, Dreer Collection, Historical Society of Pennsylvania, Philadelphia, says painting begun May 8, 1821, finished May 15, $100 // T. Sully, journal, copy NYPL, July 15, 1821, says "William Gwynn, port. presented to H. Robinson" // J. H. B. Latrobe, *Maryland Historical Magazine* 1 (June 1906), p. 120, gives passage cited above // *Paintings in the Metropolitan Museum of Art* (1905), catalogue, p. 166, incorrectly lists the subject as Mr. Gynn // C. H. Hart, *A Register of Portraits Painted by Thomas Sully* (1909), p. 75, no. 688 // E. Biddle and M. Fielding, *The Life and Works of Thomas Sully* (1921), p. 166, no. 710, gives information from Sully's register // J. H. Pleasants, "Studies in Maryland Paintings," no. 1672, MS (1933), Maryland Historical Society // Gardner and Feld (1965), pp. 159-160.

Exhibited: MMA, 1895–1896, *Retrospective Exhibition of American Paintings*, cat. no. 150 // MMA, 1965, *Three Centuries of American Painting* (checklist arranged alphabetically) // Louisiana State Museum, New Orleans, 1976–1977, *G. P. A. Healy, Famous Figures and Louisiana Patrons*, cat. no. 1.

Sully, *William Gwynn.*

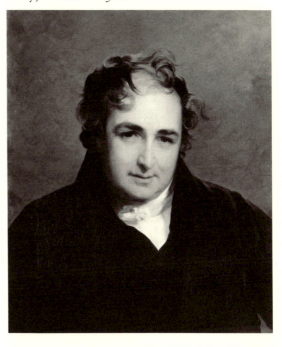

John Finley

When this portrait was given to the museum, the donor identified John Finley as a counselor at law in Baltimore. The only person with this name who resided in Baltimore in 1821, the year in which Sully's register records the execution of the portrait during the month of June, appears to be John McKnight Finley (1787–1850), who was born in York County, Pennsylvania, and died in New Orleans. He served in the War of 1812 and was a colonel in the Baltimore militia. His occupation was not law but business. His father, Ebenezer Finley, was the senior partner of Finley, Van Lear and Finley, Baltimore merchants, and young Finley joined this firm, which was located at the corner of Eutaw and Baltimore streets. His wife was Mary Van Lear (1790–1818). They had two children who died young.

Originally attributed to REMBRANDT PEALE, and published as such a number of times, the portrait was correctly given to Sully by Charles Henry Hart in 1909. Sully's monogram, as well as the date 1821, though once obscured by old varnish, is clearly visible in the upper left corner of the picture. It is a modest production intended to record a likeness and little else. Sully valued it at only fifty dollars. Nevertheless it is still well executed in his fashionable, broad manner. The hair, in tones of brown, gray, and earth colors, displays exceptionally lively brushwork, while the face is more smoothly painted in flesh tints, at times not sufficiently differentiated to adequately define the features, particularly the mouth, ear, and left brow. The result is a gauzy, soft-focus effect of great charm. The white cravat and black coat are competently but indifferently painted and serve to set off the face and call attention to it by means of lines leading to it. The close-up format of the portrait, with little space left between the top of the head and the edge of the canvas, was fashionable at this time. Sully had also used it in the self-portrait he painted in May (q.v.). Both were gifts from him to his friend Henry Robinson of Baltimore.

Sully, *John Finley.*

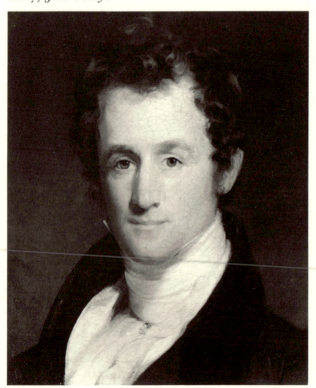

Oil on canvas, 17 × 14 in. (43.2 × 35.6 cm.).

Signed and dated at upper left: TS (monogram) 1821.

References: T. Sully, register, Dreer Collection, Historical Society of Pennsylvania, Philadelphia, says painted for H. Robinson, begun June 14, 1821, finished June 22, $50 // T. Sully, journal, copy NYPL, July 15, 1821, says "John Finley, port. presented to H. Robinson // W. H. Low, *McClure's Magazine* 20 (Feb. 1903), ill. p. 345, as by Rembrandt Peale // *Paintings in the Metropolitan Museum of Art* (1905), p. 134, no. 215, as by Rembrandt Peale // C. H. Hart, *A Register of Portraits Painted by Thomas Sully* (1909), p. 62, no. 525, gives it to Sully and points out previous error in attribution // E. Biddle and M. Fielding, *The Life and Works of Thomas Sully* (1921), p. 149, no. 551, give information from Sully's register // R. M. Torrance, *Torrance and Allied Families* (1938), p. 226, gives biographical information // J. H. Finley, letter in Dept. Archives, July 9, 1963, identifies sitter as a merchant and refers to 1938 genealogy // Gardner and Feld (1965), pp. 158–159.

Exhibited: MMA, 1965, *Three Centuries of American Painting* (checklist arranged alphabetically).

Ex coll.: Henry Robinson, 1821–d. 1848, Balti-

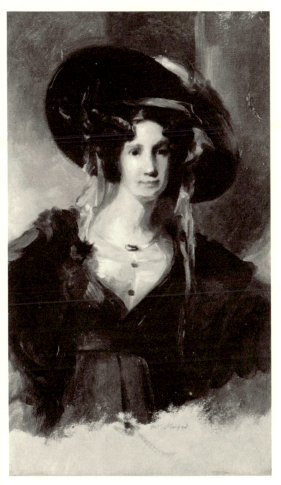

Sully, *Mrs. Huges*.

Sully, *Portrait of a Man*,
graphite on paper, verso of *Mrs. Huges*.

more and Boston; his daughter Rosa C. (Mrs. Mark M.) Stanfield, New York, by 1894.

Gift of Mrs. Rosa C. Stanfield, in memory of her father, Henry Robinson, 1894.

94.23.2.

Mrs. Huges

Although Sully did not return to England until 1838, works like this oil sketch demonstrate his continued interest in and indebtedness to the works of Sir Thomas Lawrence. A preparatory compositional study, the portrait is executed in shades of brown and white. A small ink and wash drawing in a private collection was once identified as a preparatory study for this portrait (ill. in Bedford Gallery, Longwood College, Farmville, Va., *Thomas Sully*, exhib. cat. [1973], p. 17). The drawing, however, is not a study but a copy by Sully of Lawrence's *Julia, Lady Peel*, 1827 (Frick Collection, New York), which Sully probably made from either the mezzotint published by Samuel Cousins in 1832 or the line engraving by Charles Heath that appeared as the frontispiece to the *Keepsake* in 1829. For his portrait of Mrs. Huges, Sully used the same three-quarter-length format and based the composition and fashionable costume on Lawrence's portrait of Lady Peel. Neither Sully's portrait nor drawing is dated, but based on their relationship to the Lawrence work, as well as on the elements of costume respresented, both may be assigned to around 1830.

Regrettably, nothing is known of Mrs. Huges, although according to the donor, the work descended in the artist's family. Given Sully's proclivity for phonetic spelling, it should be noted that he recorded a bust portrait in 1831 of "Mrs. Hughes, for her sister in England." Whether the subject's family name is Huges, Hughes, or even Huger is not certain.

On the back of the paper is a pencil sketch for a half-length portrait of a man.

Oil on paper, 13⅜ × 8⅛ in. (34 × 20.6 cm.).
Inscribed at lower center: *Mrs. Huges.*
REFERENCES: Gardner and Feld (1965), pp. 160–161 // S. Walker, response to letter in Dept. Archives, March 24, 1967, corrects an earlier mistake and suggests provenance.
Ex COLL.: probably Sully family, Brooklyn, N. Y.; with James Graham and Co., New York; Sybil Walker, New York.
Gift of Mrs. Sybil Walker, 1954.
54.181.

Sully, *Sarah Annis Sully.*

Sarah Annis Sully

Sarah Annis Sully (1779–1867) was born at Annapolis, Maryland. She was first married to Thomas Sully's elder brother, the portrait miniaturist Lawrence Sully (1769–1804) in Richmond, Virginia. Thomas Sully met her there in 1799, when at the age of sixteen, he became his brother's apprentice. He moved with them to Norfolk, where he executed his first miniature in 1801, and then back again to Richmond. When Lawrence died in 1804, Thomas continued to take care of the family, which included three daughters. Then, in June 1806, he married his brother's widow. Together they had three sons and six daughters. Through more than sixty years of marriage "Sally" Sully provided an exceptionally happy family life for her husband and children.

Some confusion regarding the date of this painting has been caused by the different years recorded on the front (1832) and back (1851) of the canvas. Sully's register indicates that on February 22, 1832, he finished painting a portrait of his wife, which he intended for himself. He did not note the format of the picture, but the catalogue of the Pennsylvania Academy of the Fine Arts annual exhibition held in May of 1832 includes a Sully portrait of his wife and notes that it was oval. Almost twenty years later a replica of the portrait of Mrs. Sully is listed in the artist's register as completed on October 20, 1851: "Bust, Copy from a former p't for Sully."

Evidence points to the portrait of Mrs. Sully now in the museum as being the original work. First, the very accomplished and spontaneous manner of execution evident in the museum's painting strongly argues in favor of the 1832 date, because Sully's powers had diminished a good deal by 1851. Secondly, the portrait is dated on the front, and it seems unlikely that he would have dated the replica in this manner.

Finally, a photograph of Sully's studio at the time of his death in 1872 shows a similar portrait of Mrs. Sully. The oval composition, which is painted on a square canvas, seems to be wider than the portrait now in the museum, which, according to the inscription on the back, should have been in the possession of Jane Sully Darley at that time.

The possibility exists that Sully painted yet other versions of this portrait that are not recorded, but it is most likely that the museum's picture was painted in 1832 and is his original version.

346

Thomas Sully's Philadelphia studio,
at the time of his death.

There is also a miniature portrait by Thomas
Sully of his wife, from about 1809, in the Metro-
politan's collection.

Oil on canvas, oval, 29½ × 22⅝ in. (74.9 × 57.5
cm.).

Signed and dated at lower right: TS (monogram)
1832. Signed, dated, and inscribed on the back before
lining: For my daughter / Jane Darlay [sic] / TS
(monogram) 1851.

RELATED WORK: see discussion above.

REFERENCES: T. Sully, Dreer Collection, Historical
Society of Pennsylvania, Philadelphia, says he began
a bust-length portrait on March 22, 1830, and fin-
ished it Feb. 22, 1832 (probably this picture); 1851,
notes he began a copy (quoted above) // C. H. Hart,
A Register of Portraits Painted by Thomas Sully (1909),
p. 160, no. 1639, says 1851 portrait is a "copy from a
former pt. for Sally [Sully]" // B. Burroughs, *MMA
Bull.* 9 (Dec. 1914), p. 250, says "it is one of Sully's
marked successes. The head is very attractive and the
handling most brilliant, reminding one in this direc-
tion of the work of John Sargent" // E. Biddle and
M. Fielding, *The Life and Work of Thomas Sully* (1921),
p. 288, no. 1715, give the information from Sully's
register and assign the picture to 1851 on the basis
of the dedicatory inscription; call it a replica of the
1832 portrait // A. T. Gardner, *MMA Bull.* 5 (Jan.
1947), p. 147, reproduces a photograph of Sully's
studio taken about 1872 showing another version of
this work // G. McDonald, Historical Society of Penn-
sylvania, letter in Dept. Archives, March 7, 1963,
gives transcription of Sully register and notes that the
1851 picture was a "copy from a former pt. for Sul-
ly" // Gardner and Feld (1965), p. 161, catalogues it
as 1832 picture.

EXHIBITED: PAFA, 1832, no. 55, as Portrait of
Mrs. Sully (in oval) (possibly this picture).

EX COLL.: the artist, until 1851; his daughter, Jane
Sully Darley, Philadelphia, d. 1877; her son, Francis
T. S. Darley, Philadelphia, d. 1914.

Bequest of Francis T. S. Darley, 1914.
14.126.3.

Musidora

Musidora is painted in the succulent, rich,
painterly style characteristic of Sully's best work.
It is his only known nude and presents a vision
that is both chaste and erotic, a combination
that had great appeal to Victorian audiences in
the first half of the nineteenth century. The
painting depicts an episode from James Thom-
son's poem *Summer* (1727), which is part of his
larger opus *The Seasons* (1726–1730). In the
poem, Damon, who has been courting Musidora,
comes upon her in the forest as she is bathing.
His delicacy and gentlemanliness on this oc-
casion so impresses her that she confesses her
love for him at once and thus dissipates his fears
that her previous coyness had been a sign of
disdain.

Two pictures of this subject are listed in Sul-
ly's register. The first, begun in April and fin-
ished in May of 1813, was done from a copy of a
picture by BENJAMIN WEST that Sully's friend
Charles Robert Leslie (1794–1859) exhibited at
the Pennsylvania Academy of the Fine Arts in
1813. This first copy by Sully was identified in
1980 by Caren F. Hammerman in a private col-
lection in Baltimore (now on loan to the Balti-
more Museum). It was once thought to be by
West (see H. von Erffa and A. Staley, *The Paint-
ings of Benjamin West* [1986], p. 229). Both the
West and the Leslie are now unlocated.

Although the pose is related, the Sully *Musi-
dora* in the Metropolitan is very different. It is
almost certainly the second one that he lists in
his register. According to that listing he began
work on the picture in 1813 but did not finish
it until 1835. (The inscription on the back of the

painting says it was begun in 1815, but the register is probably more reliable.) The picture remained in his possession until 1844 when he sold it to Mr. Lewis W. Gillet for two hundred dollars. The inspiration for this picture may have been another work by BENJAMIN WEST that is also now lost. Designated *Damon and Musidora*, from Thomson's *Seasons*, it was described in an 1829 sale catalogue of West's works as one of his finest specimens, its coloring "in the gusto of the Venetian school" (George Robins, London, sale cat., June 20-22, 1829, no. 66). To be sure there is no Damon in Sully's canvas, but his reliance on reds and yellows, as well as the pose of Musidora, discloses the clear, if somewhat indirect influence of Venetian painting that the writer detected in the West.

Besides the two Musidoras in Sully register, two other works by him of this subject have been recorded. One is an oil sketch, dated 1813, which descended in the Sully family and came on the market in New York in 1924, at which time it was described as a study for the Metropolitan's painting. The second, a work dated 1864 (photo in FARL), painted in the artist's late style, was held by the Anderson Art Galleries in New York in April 1929; its composition bears no resemblance to the museum's painting.

Oil on wood, $28\frac{1}{8} \times 22\frac{1}{2}$ in. (71.4 × 57.2 cm.).
Signed and dated on the embankment at the left: TS (monogram) 1835. Signed, dated, and inscribed on the back: Begun in 1815—fin[i]shed in 1835 TS (monogram).

Sully, *Musidora*.

RELATED WORK: oil study (possibly for this composition), $4 \times 5\frac{1}{2}$ in. (10.2 × 14 cm.), listed in Ehrich Galleries, New York, *Fifty Sketches and Studies for Portraits of Thomas Sully* (1924), no. 9.

REFERENCES: T. Sully, register, 1835, "After Benjamin West. Copy of former painting, begun in 1813, and finished 1835. Signed on face of picture... 25 × 30 ... $200," published in E. Biddle and M. Fielding, *The Life and Works of Thomas Sully* (1921), p. 372, no. 2440 // T. Sully to L. W. Gillet, April 9, 1844, copy in Dept. Archives, notes, "I have examined the picture, and will take advantage of your suggestions to endeavor its correction" // L. A. Gillet, letter in MMA Archives, Jan. 28, 1921 // H. B. Wehle, *MMA Bull.* 16 (April 1921), p. 83 // H. von Erffa, letters in Dept. Archives, Feb. 12, 1963, June 21, 1970, discusses West's unlocated work and notes that a Damon and Musidora appeared in the 1829 auction // Gardner and Feld (1965), pp. 161–162 // W. H. Gerdts, *The Great American Nude* (1974), p. 51, calls it "probably the most beautiful picture of a nude painted in American in the early nineteenth century" // W. H. Hunter, Peale Museum, Baltimore, July 29, 1971, believes a painting of Musidora in Baltimore attributed to West may be related to the museum's Sully // C. F. Hammerman, Baltimore, April 25, 1980, notes that she thinks she has identified Sully's first copy of Musidora in a private collection in Baltimore and notes that it had been considered a work by West // D. Dwyer, Painting Conservation, MMA, memo in Dept. Archives, 1981, notes that X-ray does not reveal that Sully made any changes in the composition, suggests that the painter may have had some difficulty defining the hip // H. von Erffa and A. Staley, *The Paintings of Benjamin West* (1986), no. 119, p. 229, under an unlocated picture by West called *Arethusa*, ca. 1802, discuss the Leslie and Sully *Musidora* copies, illustrate the Sullys, and note that the first one was probably closer to West.

EXHIBITED: Apollo Association, New York, 1839, no. 56, for sale // MMA, 1896, *Retrospective Exhibition of American Paintings*, no. 165, as lent by Mrs. L. W. Gillet // PAFA, 1922, *Memorial Exhibition of Portraits of Thomas Sully*, no. 55 // MMA, 1965, *Three Centuries of American Painting*, exhib. cat. by J. Howat and N. Spassky (checklist arranged alphabetically) // New York Cultural Center, traveling exhibition, 1975–1976, *Three Centuries of the American Nude*, no. 14.

EX COLL.: the artist, until 1844, Lewis Warrington Gillet, Baltimore and New York, by 1844–d. 1858; his wife, Ann Isabella, New York, by 1896; their grandson, Louis Allston Gillet, New York, by 1921.

Gift of Louis Allston Gillet, in memory of his uncles, Sully Gillet and Lorenzo M. Gillet, 1921.

21.48.

Queen Victoria

Alexandrina Victoria (1819–1901) was the daughter of the fourth son of George III, Edward Duke of Kent and Princess Mary Louise Victoria of Saxe-Coburg-Saalfeld. Her father died before she was a year old and her mother, realizing that Victoria might in the future become queen, raised her in a strict religious and moral environment. In 1830, upon the death of George IV, she was recognized as heir to the crown, and on June 20, 1837, she succeeded her uncle William IV as sovereign. She had just turned eighteen but already conducted herself with consummate grace and dignity. Her eminent biographer, Lytton Strachey, described her appearance at this time as "a countenance, not beautiful, but prepossessing—fair hair, blue prominent eyes, a small curved nose, an open mouth revealing the upper teeth, a tiny chin, a clear complexion, and, over all, the strangely mingled signs of innocence, of gravity, of youth, and of composure." When she died in 1901 she had ruled for sixty-three and a half years, the longest reign in British history.

Shortly before his departure for England in October 1837, Sully was approached by the Society of the Sons of Saint George, in Philadelphia, an organization established for the advice and assistance of Englishmen in distress, and commissioned to paint the young queen if she would agree to sit. The society drew up a formal request to Victoria to sit for Sully who "as the most finished artist, in portraits, in America ... would do ample justice to your Picture." According to this letter the portrait was to be placed "in a conspicuous situation, and be the means, at the meetings of our Society, of cherishing the recollections of the country from whence we sprung."

Immediately after arriving in London in November of 1837, Sully presented his request to the queen. Through the good offices of several influential friends of Sully's, she finally agreed to sit. At first Victoria set a date for the middle of February, but it was not until March 22, 1838, that her busy schedule permitted her to oblige the artist. At their first meeting in Buckingham Palace, according to Sully's journal, he made a sketch on a piece of bristol board which he held in his hand. The following day he began a sketch "in oil on a kit-kat canvas" and through a number of sittings in April it was this picture, now

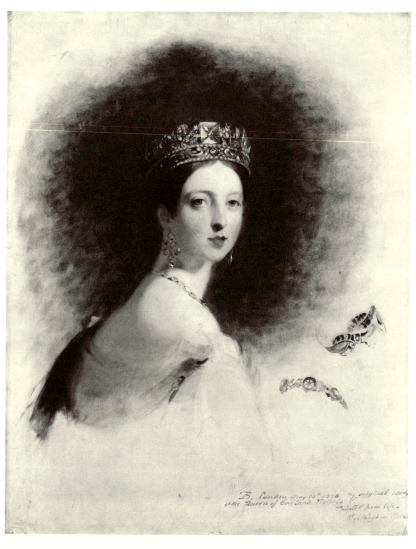

Sully, *Queen Victoria.*

owned by the museum, which he elaborated upon. On May 14 Victoria gave Sully a very long sitting which enabled him to finish the head; according to him "the likeness was much commended by all. The Queen quite approved of the style I had adopted and said it was a nice picture." On the following day the artist returned to the palace with his daughter Blanche, the queen having arranged that Sully's daughter "should sit with the crown jewels instead of herself." It is likely that at this time Sully painted the insignia of the Order of the Garter at the right of this canvas. The upper sketch represents the garter itself, worn by the queen on her left

arm about the elbow while the lower one depicts the collar of the greater George, as the medallion of Saint George slaying the dragon worn by all members is known. In completed versions of the painting this collar is not the necklace worn by the queen but the gold chain which hangs below the hood of her robe. Her headpiece is the diamond diadem called the Circlet.

Of the large versions of the portrait painted by Sully after the completion of our sketch, two survive. The three-quarter-length painted in London for the engraver Charles E. Wagstaff is in the Wallace Collection, London, and the full-length portrait for the Saint George Society is

in a private collection. Another full-length which Sully painted for himself and later presented to the Saint Andrew's Society in Charleston, S. C., was destroyed by fire in 1865. A near replica of the Metropolitan's study, which Sully painted for the poet Samuel Rogers, is in the collection of Queen Elizabeth II.

Unfortunately for Sully, the tremendous success of his portrait of the English queen created trouble for him at home. The Saint George Society, hoping to profit from it, wanted to display the picture to the public for a fee and sought to enjoin Sully legally from reproducing or exhibiting his copy of the portrait. Eventually, an arbitration panel of three lawyers awarded him the right to retain and duplicate the original sketch since he was "the author and exclusive owner of the invention and design." When the society unveiled its portrait to the public, it issued a pamphlet dated June 13, 1839, explaining

Sully, *Queen Victoria*. Private collection.

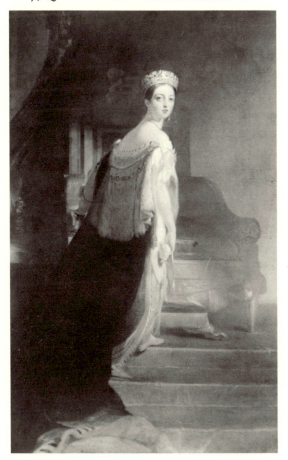

Sully, *Queen Victoria*.
Her Majesty Queen Elizabeth II.

the controversy and giving a lengthy rebuttal of the official opinion.

With its strong contrasts of light and shadow and its careful, tight execution, this oil sketch of Victoria has long been acknowledged as the most successful likeness of the queen that Sully painted. Its directness, freshness, and spontaneity are lacking in the larger versions in which Victoria's face is given a more idealized, sentimental cast. A few months after Sully painted this sketch, Victoria was to become embroiled in the major controversy of the early part of her reign. The queen, in an action of questionable constitutional validity, refused to dismiss her Whig ladies of the bedchamber after the Whig government lost its support in Parliament. The Tories refused to form a new government until Victoria acquiesced to their demands, but, deeming the composition of her household staff a matter of royal prerogative, she held fast to her views and asked the Whig cabinet to continue in office. The assertiveness and determination she showed at that time seriously worried many English politicians, and it is precisely the young queen's air of self-confidence and imperiousness that Sully sympathetically captured in this work.

Oil on canvas, 36 × 28⅜ in. (91.4 × 72.1 cm.).

Signed, dated, and inscribed at lower right: TS. (monogram) London May 15th 1838. My original study / of the Queen of England, Victoria 1st / Painted from life. / Buckingham House; on back before lining: Victoria Queen of England / from her person / May 15 1838 London / Tho's Sully.

RELATED WORKS: five preparatory drawings: three titled *Study of the Queen's Robes*, pencil on paper, 9 1/16 × 7⅜ in. (23 × 18.7 cm.), pencil on paper, 9 1/16 × 7⅜ in. (23 × 18.7 cm.), and pencil on paper, 7 1/16 × 10⅝ in. (18 × 27 cm.); *Study of the Throne in the House of Lords*, pencil on paper, 7 7/16 × 9 in. (18.8 × 22.8 cm.); *Study of the Queen's Train*, pencil on paper, 7 7/16 × 9 in. (18.8 × 22.8 cm.); *Diagram of Colors Used*, oil and ink on paper, 4⅞ × 7 11/16 in. (12.4 × 19.5 cm.), private coll., ill in M. Fabian, exhib. cat. (1983), pp. 94–95. (Pennsylvania Academy of the Fine Arts, *Catalogue of the Memorial Exhibition of Portraits, by Thomas Sully* [1922], lists five pencil sketches and a wash drawing for the portrait of Queen Victoria, nos. 248–253.) // *Victoria, Queen of England*, black ink on paper, 6⅜ × 9 in. (16.2 × 23 cm.), 1838, Christie's sale, June 1, 1984, ill. p. 11 // *Portrait of Her Majesty the Queen in Her Robes of State Ascending the Throne in the House of Lords*, oil on canvas, 54½ × 43½ in. (148.6 × 110.5 cm.), 1838, Wallace Collection, London. A three-quarter length portrait painted for the engraver Wagstaff. (A copy of this painting by Stephen Poyntz Denning, *Queen Victoria in Robes of State*, watercolor, 15⅛ × 11¾ in. (38.4 × 29.8 cm.), n. d., is also in the Wallace Collection.) // *Queen Victoria*, oil on canvas, 94 × 58 in. (238.8 × (147.3 cm.), 1838. Sully's copy, which he gave to the Saint Andrew's Society, Charleston, was destroyed by fire in 1865 // W. Warman, *Queen Victoria*, watercolor, 8½ × 6¼ in. (20.6 × 15.9 cm.), 1838, National Portrait Gallery, London // *Queen Victoria*, oil on canvas, 94 × 58 in. (238.8 × (147.3 cm.), 1838–1839, private coll., ill. in M. Fabian, exhib. cat. (1983), p. 97 // *Queen Victoria*, oil on canvas, 24 × 20 in. (61 × 50.8 cm.), 1839, Her Majesty Queen Elizabeth II, ill. in M. Fabian, exhib. cat. (1983), p. 99 // Charles E. Wagstaff, *Queen Victoria*, mezzotint, 15 × 12 in. (38.1 × 30.5 cm.), 1839 // *Queen Victoria*, oil on canvas, 30¼ × 25¼ in. (77 × 64.2 cm.), 1871, Christie's sale, May 30, 1986, ill. p. 9. Sully's copy of his original study // H. Grévedon, *Queen Victoria*, lithograph, 16¼ × 13 in. (41.3 × 33 cm.), n. d. // J. A. Leuchtlein, *Queen Victoria*, lithograph, 14⅞ × 11⅞ in. (37.8 × 30.2 cm.), n. d.

REFERENCES: T. Sully, journal, NYPL, Nov. 3, 1837, through July 29, 1838, include numerous references to the picture; entries for Nov. 23, 1838, through May 25, 1839, include information on his right to copy the picture // T. Sully, register, Dreer Collection, Historical Society of Pennsylvania, Philadelphia, as original study, begun March 22, finished May 15, 1838 // Society of the Sons of Saint George,

Philadelphia, *The Original Painting of Her Majesty, Queen Victoria the First, Painted by Mr. Thomas Sully* (1839), gives account of the commission (quoted above) and disputes the ownership of the design of the painting // C. C., *American Art Journal* 5 (August 16, 1866), pp. 268–269, describes Sully's studies and tells anecdote of Victoria's sitting to Sully // H. T. Tuckerman, *Book of the Artists* (1867), p. 161, says this picture was then hanging in Sully's studio // T. Sully, *Hours at Home* 10 (1869), p. 71 // C. H. Hart, *A Register of Portraits by Thomas Sully* (1909), no. 1749, lists it // *Century Magazine*, 5 (1883), frontis., woodcut by T. Johnson // B. Burroughs, *MMA Bull.* 9 (Dec. 1914), p. 250 // L. Strachey, *Queen Victoria* (1921), gives biographical information // E. Biddle and M. Fielding, *The Life and Works of Thomas Sully* (1921), p. 304, no. 1853, list it // Brooklyn Museum, *Exhibition of Portraits, Miniatures, Color Sketches, and Drawings by Thomas Sully* (1921), no. 35, lists wash drawings and pencil studies for it and an advertisement for the mezzotint engraving after the Wallace Collection portrait // Ehrich Galleries, New York, *Fifty Sketches and Studies for Portraits by Thomas Sully* (1924), no. 5, lists a wash drawing in sepia, which is called "the original study made from life by the artist and shown to the Queen for her approval before beginning her portrait" // A. T. Gardner, *MMA Bull.* 5 (January 1947), pp. 144–148, gives a full account of the history of the portrait and includes passages from Sully's manuscript journals quoted above // Gardner and Feld (1965), pp. 163–164 // H. Mitchell, *Washington Post*, March 19, 1973, ill. p. B1 // *MMA Bull.* 33 (Winter 1975–1976), ill. p. [240] // M. Brown, *American Art to 1900* (1977), p. 367 // O. Millar, surveyor of the Queen's pictures, London, letter in Dept. Archives, March 3, 1981, supplied information on related works // S. E. Bronson, "Thomas Sully," Ph. D. diss., University of Delaware (1986), pp. 221–246, gives account of the commission.

EXHIBITED: No. 155 Broadway, New York, June 1839 (according to a notice in the *New York Commercial Advertiser*, June 8, 1839, p. [2]) // Brooklyn Art Association, 1872, no. 98E, lent by the artist // MMA, 1965, *Three Centuries of American Painting* (checklist arranged alphabetically) // Bedford Gallery, Longwood College, Farmville, Va., 1973, *Thomas Sully*, no. 16 // MMA, 1976–1977, *A Bicentennial Treasury* (see *MMA Bull.* above) // National Portrait Gallery, Washington, D. C., *Mr. Sully, Portrait Painter*, no. 58, color ill. p. 36.

EX COLL.: the artist, Philadelphia, d. 1872; his daughter, Jane Sully Darley, Philadelphia, d. 1877; her son, Francis T. S. Darley, Philadelphia, d. 1914.

Bequest of Francis T. S. Darley, 1914.

14.126.1.

The Student (Rosalie Kemble Sully)

The artist's daughter Rosalie Kemble Sully (1818–1847) was the model for this picture of an art student with portfolio and drawing pencil in hand. The title "The Student" appears on the back in Sully's script, and is so identified in his register. It was begun on November 23, 1839, finished on the 30th, and intended for the Philadelphia publisher and art collector Edward L. Carey, who was later president of the Pennsylvania Academy of the Fine Arts. The painting, however, descended in the artist's family, thus raising the possibility that Carey never actually received it or that, if he did own it, it was eventually returned to Sully.

There is a persistent tradition that the hat worn by Rosalie was in reality a lampshade supplied by her father in order to obtain a special effect. More to the point, however, is the likelihood that Sully was aware of a strikingly similar composition of about 1779 by the English painter Henry Robert Morland depicting his son George Morland wearing a broad hat and sitting behind an easel (Yale Center for British Art, New Haven). In that work the artist's child is also presented as an art student, the atmosphere in which he works is an enveloping darkness, and the shadows cast upon his face are just like those in Sully's picture. Accordingly, the portrait of Rosalie may be more properly regarded as a somewhat belated, if altogether successful, representative of a type of lamplit, chiaroscuro picture popular in England in the late eighteenth century than as the fortuitous result of Sully's placing a lampshade on his daughter's head.

Sully's talented daughter exhibited landscapes in New York in 1839. She died young, and it is not surprising that her father painted several replicas of this painting. One is dated 1848 and is listed in the register as "The Student." Another, listed in the register for 1871, was formerly in the collection of the artist's daughter-in-law, Mrs. Alfred Sully, of Brooklyn. A picture called *The Fair Student*, exhibited at the Pennsylvania Academy in 1852, may have been yet another replica.

Oil on canvas, 23½ × 19½ in. (59.7 × 49.5 cm.). Signed and dated on portfolio at lower center: TS (monogram) 1834. Signed, inscribed, and dated on the back: The Student/TS (monogram) 1839.

RELATED WORKS: *The Student*, oil on canvas, 29½ ×

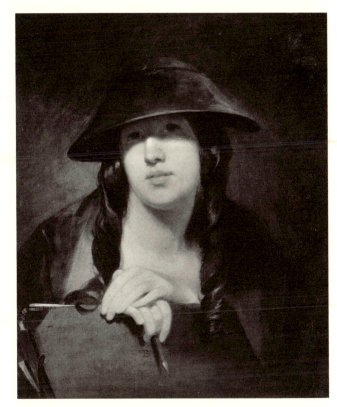

Sully, *The Student (Rosalie Kemble Sully).*

25½ in. (75 × 64.8 cm.), including frame, 1848, Raleigh N. C., art market, 1969. A replica // *Rosalie Kemble Sully*, oil on canvas, 32 × 24 in. (81.3 × 61 cm.), 1871, formerly coll. Mrs. Alfred Sully, Brooklyn, New York. A replica originally painted for Blanche Sully, the subject's sister // *The Fair Student*, oil on canvas, exhibited PAFA, 1852, as estate of J. Towne. Perhaps another replica (In his journal, Feb. 21, 1845, Sully noted: "Sent home the portrait of Rosalie's with a shade over the eyes to Mr. Towne who has purchased it" see M. Fabian, 1983, p. 102).

REFERENCES: T. Sully, register, Dreer Collection, Historical Society of Pennsylvania, Philadelphia, lists as begun Nov. 23, finished Nov. 30, 1839, 24 by 20, intended for E. Carey, $200 // B. Burroughs, *MMA Bull.* 9 (Dec. 1914), p. 250 // A. N. Lincoln, Dec. 12, 1919, note in Dept. Archives, says Rosalie's hat was a lampshade // E. Biddle and M. Fielding, *The Life and Works of Thomas Sully* (1921), p. 287, no. 1709, give the information from Sully's register, incorrectly list size as 23½ × 29½ in. // A. T. Gardner, *MMA Bull.* 5 (Jan. 1947), p. 147, reproduces a photograph of Sully's studio taken about 1872, showing a similar picture which may well be this one // Gardner and Feld (1965), pp. 166–167 // J. Wilmerding, ed., *The Genius of American Painting* (1973), pp. 87–88.

EXHIBITED: Philadelphia, U. S. Centennial Exposition, 1876, *Official Catalogue, Department of Art*, no. 147, as Miss Rosalie Sully, lent by Mrs. Darley || Santa Barbara Museum of Art, 1941, *Painting Today and Yesterday*, no. 120 || NAD, 1942, *Our Heritage*, no. 38, as The Artist's Daughter, Rosalie || MMA, 1946, *The Taste of the Seventies*, no. 153 || Dayton Art Institute, Ohio, 1950, *The Artist and His Family*, no cat. || MMA, 1965, *Three Centuries of American Painting* (checklist arranged alphabetically) || Lytton Gallery, Los Angeles County Museum of Art; M. H. de Young Memorial Museum, San Francisco, 1966, *American Paintings from the Metropolitan Museum of Art*, p. 11, no. 19 || Florence Lewison Gallery, New York, 1967, *The Creative Portrait in 19th Century American Painting*, no. 12 || Slater Memorial Museum, Norwich, Conn., 1968, *A Survey of American Art*, no. 7 || MMA, 1970, *19th Century America*, no. 17 || Indianapolis Museum of Art, 1970–1971, *Treasures from the Metropolitan Museum of Art*, p. 17, no. 5 || National Portrait Gallery, Washington, D. C., 1983, *Mr. Sully, Portrait Painter*, exhib. cat. by M. H. Fabian, p. 102, quotes from Sully's journal in 1845 regarding another possible version.

EX COLL.: the artist, Philadelphia, d. 1872; his daughter, Mrs. Jane Sully Darley, Philadelphia, d. 1877; her son, Francis T. S. Darley, d. 1914.

Bequest of Francis T. S. Darley, 1914.

14.126.4.

Mother and Son

Certainly among Sully's most ambitious paintings, this portrait depicts the artist's daughter Jane Cooper Sully Darley (1807–1877) with her son Francis Thomas Sully Darley (d. 1914). Jane Darley was a portraitist of good reputation in Philadelphia. From 1825 to 1869 she exhibited works at the Artist's Fund Society and at the Pennsylvania Academy of the Fine Arts. Her works were also seen at exhibitions at the Boston Athenaeum, the National Academy of Design in New York, and the Maryland Historical Society in Baltimore. In 1833 she was married to William Henry Westray Darley, a prominent music teacher and brother of the renowned illustrator F. O. C. Darley (1822–1888). Their son Francis became a well-known organist in Philadelphia.

According to Sully's register, this picture was begun on April 13, 1839, and completed on December 31 of that year. It is, however, dated January 1840 on the canvas. Sully valued it at a thousand dollars, a considerable amount in those days. He painted a much smaller copy of it in 1866.

Placed against a background composed of more or less standard romantic features—a very close seashore, mural structures resembling ruins, a classical marble urn—the grouping of the mother and son with a dog evokes a mood of tender feeling made all the more captivating by the pensive attitude of the mother and the conspicuous absence of the father. A number of these elements can be given a fairly precise iconographic reading. At the extreme upper right the spray of ivy clinging to the wall may be taken as an emblem for the faithfulness of a wife while the scene on the urn immediately below, representing Hermes bringing the infant Dionysos to be nurtured by the nymphs, probably alludes to the duties of motherhood. Jane Sully Darley is thus identified as a model wife and mother. Similarly, Francis T. S. Darley, lightly resting his foot on the pet dog, a much-used symbol of fidelity and loyalty in Western portraiture, is identified as a faithful son. Less susceptible to interpretation is the pose of the mother, strongly reminiscent of Dürer's *Melancholia*, and the positioning of the group against ruins by a seashore. An analogy with classical personages may well be intended, perhaps an identification of Jane Darley with Penelope, the ideal wife, and of young Francis with Telemachus, the ideal son who cared for his mother during his father's absence and cherished his memory. Certainly, the

Sully, *Figure Studies* (detail). MFA, Boston.

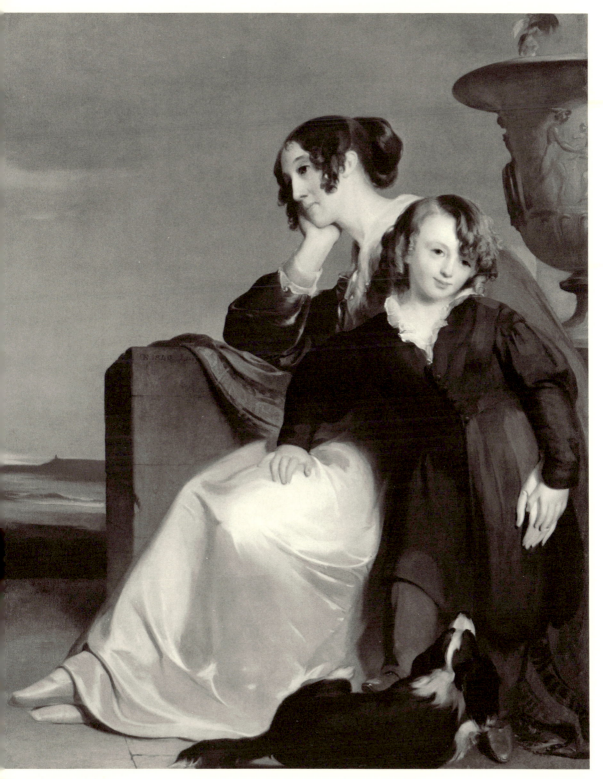

Sully, *Mother and Son.*

striking resemblance of Mrs. Darley's pose to that of the well-known early classical statue of Penelope at the Vatican Museum in Rome is a persuasive argument in favor of this view (see W. Amelung, *Die Sculpturen des Vaticanischen Museums* [1908], 2, p. 439, pl. 47). Nothing in the family history of the Darleys, however, directly relates to this interpretation. It may well be that what Sully intended was more the creation of a mood than of a grand, allegorically detailed portrait in the style popularized by Sir Joshua Reynolds.

Painted with great fluidity in rich, saturated tones, this picture is one of Sully's most accomplished feats of colorism. It vibrates with lively reds, browns, greens, and whites, and, despite a few typically Sullyesque misunderstandings in the representation of anatomy, displays a good command of form. A watercolor drawing for it is in the Museum of Fine Arts, Boston. Although other drawings on the same sheet appear unrelated to the final arrangement, they may well be alternative conceptions for the painting. Sully usually solved problems of composition by means of pen-and-ink and watercolor sketches of this type. The marble urn is a rendition of the well-known Salpion krater in the Museo Nazionale in Naples. The krater may have been known to Sully from a cast at the Pennsylvania Academy or from the many engravings of it published from the mid-eighteenth century on. Finally, it should be noted that at least one painting by Sir Thomas Lawrence, *Countess Grey and Her Daughters*, 1805 (private coll., ill. in National Portrait Gallery, London, *Sir Thomas Lawrence, 1769–1830*, 1979, no. 87), engraved in 1831 by Samuel Cousins, features a mother and two children shown against a low wall, though in that work the outdoor setting is an English garden.

Oil on canvas, 57 × 45⅜ in. (144.8 × 115.3 cm.).
Signed and dated on wall: TS (monogram) 1840. Jan.

RELATED WORKS: *Sheet of Figure Studies*, pen, wash and watercolor, 8½ × 10⅞ in. (21.6 × 27.6 cm.), n. d., MFA, Boston, 52.1634. Contains a compositional study for the painting // *Jane Darley and Her Son Francis*, oil on canvas, 18 × 14 in. (45.7 × 35.6 cm.), 1866, unlocated. This small copy is listed in his register as painted for Stanfield.

REFERENCES: T. Sully, register, Dreer Collection, Historical Society of Pennsylvania, Philadelphia, lists picture as begun April 13, finished Dec. 31, 1839, and valued at $1,000 // B. Burroughs, *MMA Bull.* 9 (Dec.

1914), p. 250 // E. Biddle and M. Fielding, *The Life and Works of Thomas Sully* (1921), p. 135, no. 432, give information from Sully's register as well as biographical data // Gardner and Feld (1965), pp. 165–167.

EXHIBITED: Artists' Fund Society, Philadelphia, 1840, no. 137, as full-length portrait of Mrs. Darley and Son, lent by W. H. W. Darley // MMA, 1943, *The Greek Revival in the United States*, no. 39; 1946, *The Taste of the Seventies*, no. 154 // Detroit Institute of Arts; Art Gallery of Toronto; City Art Museum, Saint Louis; Seattle Art Museum, 1951–1952, *Masterpieces from the Metropolitan Museum of Art*, no cat. // MMA, 1965, *Three Centuries of American Painting* (checklist arranged alphabetically) // American Federation of Arts, traveling exhibition, 1975–1977, *The Heritage of American Art*, cat. by M. Davis, no. 23.

EX COLL.: William H. W. Darley, Philadelphia; his wife, Jane Sully Darley, d. 1877, Philadelphia; their son, Francis T. S. Darley, until 1914, Philadelphia.

Bequest of Francis T. S. Darley, 1914.
14.126.5.

Child Asleep (The Rosebud)

This painting is recorded in Sully's register as Child Asleep, begun on June 7, 1841, and finished fourteen days later on the 21st. It does not appear to be an actual portrait of a child but rather a subject picture on an unabashedly sentimental theme. In his later years Sully produced many such works, though not always with such competence. Moreover, this picture is not merely a sentimental Victorian period piece but a reprise of a very old theme in Western art. Sculptural representations of the sleeping Eros are at the root of this tradition, and one need only compare this picture to a well-known antique bronze in the Metropolitan Museum (ca. 250–200 B. C., possibly from Rhodes, ill. in G. M. A. Hanfmann, *Classical Sculpture* [1967], fig. 253) to realize how similar in form and emotional content both works are. The painting may thus be linked to the sensibility of the classical revival, as much as to that of the Victorian age, demonstrating Sully's adeptness at choosing models from antiquity. In this respect, it is important to note that both this work and *The Sleeping Eros* celebrate restfulness, contentment, and the happy aspect of sleep, and do not have a funereal association, which was often the case with many drawings, paintings, and sculptures of children produced in the United States in the nineteenth century.

356

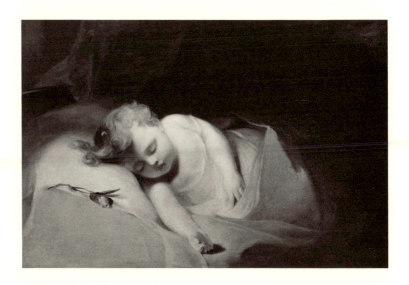

Sully, *Child Asleep (The Rosebud)*.

In 1848 this picture, bearing the title *The Rosebud*, appeared in engraved form in John Sartain's *The American Gallery of Art*, the first in a series of annual gift books intended to form "a gallery of characteristic specimens from the works of the Painters of America, where every artist of merit in the country will be represented." The owner of the painting was listed as M. W. Baldwin, and the engraving was accompanied by a long poem in seventeen stanzas expressly written for it by C. Chauncey Burr. Titled "The Infant Poet," the poem extols the beauty and innocence of a little boy's dream in images drawn chiefly from nature. At its close, four muses, as well as Apollo and Prometheus, bless the sleeping child, and Flora places a rosebud by his side, a symbol of virtue, youth, and promise.

Oil on canvas, 23⅞ × 36½ in. (60.6 × 92.7 cm.).
Signed and dated at lower right: TS (monogram) 1841.
Canvas stamp: T. BROWN / [High] Holborn.
RELATED WORK: John Sartain, *The Rosebud*, engraving, in *The American Gallery of Art* (1848), ill. opp. p. 11.
REFERENCES: T. Sully, register, 1841, Dreer Collection, Historical Society of Pennsylvania, Philadelphia, notes begun on June 7 and finished June 21, 1841, gives title as Child Asleep // B. Burroughs, *MMA Bull.* 9 (Dec. 1914), p. 250, conjectures, mistakenly, that the painting represents the artist's grandson Francis T. S. Darley at an early age // E. Biddle and M. Fielding, *The Life and Works of Thomas Sully* (1921), p. 340, no. 2137, list it as Child Asleep (The Rosebud), give the information from Sully's register // Gardner and Feld (1965), pp. 168–169 // W. Butler, Henry Francis du Pont Winterthur Museum, March 1981,

letter in Dept. Archives, relates picture to Sully's Little Nell, 1841, in the Free Library, Philadelphia.
EXHIBITED: Philadelphia, 1864, *Great Central Fair* (for the benefit of the U. S. Sanitary Commission), no. 230, as The Rosebud, lent by M. W. Baldwin // PAFA, 1922, *Memorial Exhibition of Portraits by Thomas Sully*, no. 131, as Child Asleep // Lytton Gallery, Los Angeles County Museum of Art; M. H. de Young Memorial Museum, San Francisco, 1966, *American Paintings from the Metropolitan Museum of Art*, p. 31, no. 20 // University of Michigan Museum of Art, Ann Arbor, 1972, *Art and the Excited Spirit*, no. 124, p. 9.
EX COLL.: Matthias William Baldwin, Frankford, Pa., by 1848 – d. 1866; the artist's grandson, Francis T. S. Darley, Philadelphia, d. 1914.
Bequest of Francis T. S. Darley, 1914.
14.126.6.

Mrs. John Hill Wheeler and Her Two Sons

Ellen Oldmixon Sully (1816–1896), a daughter of Thomas Sully, was born in Philadelphia. On November 8, 1838, she became the second wife of John Hill Wheeler, a well-known North Carolina lawyer, diplomat, and historian. The Wheelers had two children, Charles Sully (b. 1839) and Levi Woodbury (1842–1900), who are pictured here with their mother. John Hill Wheeler's *Historical Sketches of North Carolina*, published in 1851, though flawed and highly partisan, was one of the pioneering works dealing with the history of that state. As United States minister to Nicaragua from 1854 to 1857 he was at the center of the controversy that led to the United States's recognition of the govern-

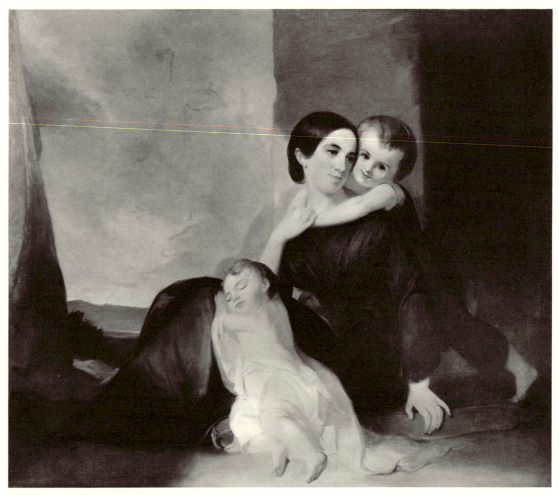

Sully, *Mrs. John Hill Wheeler and Her Two Sons.*

ment of the filibustering American William Walker. This later led to Wheeler's forced resignation. According to Sully's register this group portrait was begun on July 3, 1844, and finished on July 25. The painter valued it at a thousand dollars. The grouping of the mother and children in an undefined outdoor setting, with a massive stonewall to the right and a falling curtain on the left, is strongly reminiscent of Renaissance depictions of the Virgin with Christ and Saint John the Baptist. Sully was a keen student of past art, and, as his sketchbook with figures and passages from the old masters well illustrates (now MMA), he did not hesitate to draw on it for inspiration. In this aspect of his work he differed somewhat from his English contempo-

raries, such as Thomas Lawrence, who either adhered to a more realistic specificity of costume, pose, and setting in group portraits or else opted for a relatively straightforward allegorical interpretation. Sully's approach, not truly realistic and not clearly allegorical, as is his portrait of Jane Darley and her son Francis, *Mother and Son* (q.v.), favors the evocation of a mood of harmony, security, and piety. The present work, painted when Sully was sixty years old, communicates a good deal of charm and appeal, but it also points up his declining abilities. The infelicities of anatomical representation as well as the monotonal, flat quality of the coloring are indications that in this case Sully's renowned skill had faltered.

Oil on canvas, 51¾ × 61¾ in. (131.4 × 156.8 cm.).
Signed and dated at lower right, below the cushion: TS (monogram) 1844.

REFERENCES: T. Sully, register, Dreer Collection, Historical Society of Pennsylvania, Philadelphia, lists the picture as begun July 3, finished July 25, 1844, and valued at $1,000 // C. H. Hart, *A Register of Portraits Painted by Thomas Sully* (1909), p. 178, no. 1848 // E. Biddle and M. Fielding, *The Life and Works of Thomas Sully* (1921), p. 317, no. 1959, give information from Sully's register and biographical data // *DAB* (1936), s. v. "Wheeler, John Hill," gives biographical information // J. R. Brasel, March 23, 1989, note in Dept. Archives, gives information on subjects and provenance.

ON DEPOSIT: MFA, Boston, 1932–1957, lent by William D. Wheeler, Washington, D. C. // Corcoran Gallery of Art, Washington, D. C., 1960–1966, lent by John R. Brasel; MMA, 1966–1967, lent by John R. Brasel.

EX COLL.: Mrs. John Hill Wheeler, Washington, D. C., d. 1896; her son, Charles Sully Wheeler, d. after 1913; his son, William D. Wheeler, Washington, D. C., by 1924; his cousins (the grandchildren of Woodbury Wheeler), Clara Smallen, Columbia, Md., and Capt. John R. Brasel, U.S.N.R., Bethesda, Md., and Larchmont, N. Y., by 1960.

Gift of Capt. John R. Brasel, U.S.N.R., 1967.
67.258.

Mrs. James Montgomery

Mrs. James Montgomery (ca. 1828 – before 1900), the former Eliza Kent, was probably born in England. She was married to James Montgomery, Jr. (1811–1889), a New York tea merchant, about 1844. He had established the New York firm of J. and J. R. Montgomery in 1838. There were three sons and a daughter from this marriage. After 1850, the family lived in Jersey City, where James Montgomery served as senior warden of Trinity Church. They later moved to New Brighton, Staten Island. Although the picture is not listed in Sully's register and is not signed, it is unquestionably in his inimitable style and may be dated about 1845. The saturated tones of the red-brown background, the coral necklace, dress and lips, the black eyes and eyebrows and the chestnut hair create a colorful impression, very much in keeping with the portrait style of Sir Thomas Lawrence whose palette at times approached the garish.

The art critic John Neal, who greatly admired Sully's portraits of women, noted: "His female portraitures are oftentimes poems, — full of grace

Thomas Sully

and tenderness, lithe, flexible, and emotional; their eyes, too, are liquid enough and clear enough to satisfy even a husband — or a lover. Nobody ever painted more beautiful eyes" (John Neal, "Our Painters," *Atlantic Monthly* 23 [March 1869], p. 337). This portrait, though somewhat standard and certainly unambitious, nevertheless bears out Neal's analysis and illustrates why Sully's reputation for painting women was unsurpassed in this country.

Oil on artist's board, 20 × 17 in. (50.8 × 43.2 cm.).

Label on the back: G. Rowney & Co / 51, Rathbone Place, London.

REFERENCES: U. S. Census, 8th Census 1860, New Jersey, roll 692, no. 644–645, pp. 172–173, gives subject's age and birthplace // Mrs. A. M. R. Hughes, relative of the donor, May 6, 1988, letter in Dept. Archives, supplies background on Montgomery family and says portrait was sent to her mother in 1937 // J. L. Allen, *MMA Bull.* 32 (Dec. 1937), p. 296, dates it about 1840 // Gardner and Feld (1965), p. 168.

ON DEPOSIT: Gracie Mansion, New York, 1947–1962.

EX COLL.: the subject's daughter, Rosalie Montgomery (Mrs. William S.) Gilbert, Kansas City, Mo., and San Diego, d. 1936; her cousin, Marguerite Soléliac (Mrs. John) Jay, New York, as a life estate, d. 1937.

Bequest of Rosalie M. Gilbert, 1937.
37.130.

Sully, *Mrs. James Montgomery.*

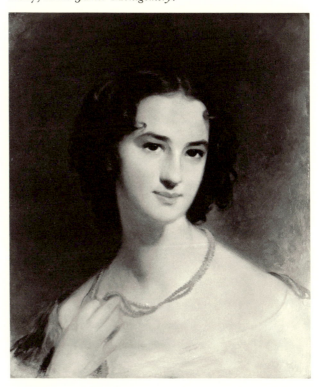

ROBERT PECKHAM

1785–1877

Robert Peckham was born in Petersham, Massachusetts, to William Peckham and Elizabeth Knapp Peckham. Little is known of his youth, but by the time he was in his early twenties he was painting portraits. In 1813 he married Ruth Wolcott Sawyer, from nearby Bolton, who bore him nine children before her death in 1842. By his second wife, Mahalath Griggs of Brimfield, whom he married in 1843, he had a daughter.

Peckham lived in Northampton for two years and then in 1815 moved to Bolton. In 1820 he moved again and settled in Westminster, where he remained for most of his life, except for a period of twelve years spent in Worcester. He had a business painting carriages and signs in Westminster, where he became an increasingly active and influential citizen. In 1828 he was appointed a deacon of the First Congregational Church, a post which he held for fourteen years. His clientele for portraits grew rapidly, and during the 1830s, he received commissions from many people throughout Worcester County.

In questions of morality, especially regarding temperance and slavery, Peckham's views were rigid and vocal. He believed in total abstinence, and his house became the local headquarters for antislavery lecturers and a station on the "underground railroad." Peckham and other local abolitionists were outspoken in their criticism of the members of their church who did not actively support the antislavery movement, and mounting resentment from the congregation led to his resignation in 1842. Peckham's subsequent role in recruiting radical abolitionists to speak at the local academy, which also served as the church vestry, led to his excommunication from the church in 1850. At this point he left town and for twelve years lived in Worcester. When Congress approved the Emancipation Proclamation in 1862, Peckham returned to Westminster and its church.

Although Peckham painted between 1809 and 1850, his most prolific period appears to have been in the thirties—after he became a deacon—and during the forties, before his excommunication. Very few of his paintings were signed. His first portraits were generally stylized and two-dimensional, but as his skill rapidly increased, his modeling became more realistic and his perspective more three-dimensional. Yet, for all his improvement, he never lost the naive characteristics of the self-taught artist. Peckham was preoccupied with the details of bonnets, collars, and jewelry. Typical of a folk artist, he delineated moles, wrinkles, and unflattering facial characteristics. "He was noted for the faithfulness of his portraits to the original. Indeed, it was once remarked 'his portraits are too truthful'" (S. F. Peckham, p. 400). The culmination of his style can be seen in his portraits of children from the late 1830s. Here his affection for his subjects is readily apparent. More than mere compositional arrangements, Peckham's interiors are careful delineations of his subjects' homes, in which they are surrounded by their prized possessions. The children are invariably placed in backgrounds that include favorite toys, pets, and books. An earthenware mug bearing the subject's name appears in several of these portraits (see below). Judging from several children's portraits, for example, Elizabeth Peckham in the *Peckham Sawyer Family* (MFA), *Mary L.*

Edgell (Whitney Museum of American Art, New York), and Joseph Sawyer Adams in *The Children of Oliver Adams* (private coll.), Peckham appears to have used a set pose for a deceased child. One Westminster lady remembered as a little girl going to his home next door to the schoolhouse for water as there was none at the school. She related that "he was a medium sized man, rather stooped, and wore his hair long with the ends curled under, a stern looking man, and his wife was a very small woman, but both were kind to children" (quoted in Sears, p. 84). This kindness is evident in the tender portrayal of Peckham's young subjects.

BIBLIOGRAPHY: William S. Heywood, *History of Westminster, 1728–1893* (Lowell, Mass., 1893), pp. 821–822 // Stephen F. Peckham, *Peckham Genealogy* (New York, n.d.), p. 400 // Ann Howard, "Notes on Deacon Robert Peckham." Unpublished material lent by a local Westminster writer, which contains the most thorough research to date on Peckham's life // Dale T. Johnson, "Deacon Robert Peckham: 'Delineator of the Human Face Divine'," *American Art Journal* 11 (Jan. 1979), pp. 27–36.

The Raymond Children

Anne Elizabeth Raymond and Joseph Estabrook Raymond, the children of Elizabeth Kendall and Joseph Raymond of Royalston, Massachusetts, were born in 1832 and 1834 respectively. Their father retired from business in 1844 but remained prominent in local affairs, holding the offices of town selectman, assessor, clerk, and representative to the state legislature. The first public library and the present public school in Royalston were named for him.

Anne became the second wife of John Low Choate of Boston in 1860. They lived in Chelsea, Massachusetts, and had two sons, Harry Raymond (who died in childhood) and Charles Buckingham. Joseph married Charlotte Louise Marshall of Fitchburg in 1861 and had one daughter, Martha Frances, born in 1871.

Painted about 1838, Anne and Joseph are an arresting pair, gazing directly at the viewer. Anne wears a bright orange dress, trimmed in dark blue with a broad neckline and full gigot sleeves, over white pantalettes. Her shoes are salmon-colored. Joseph is dressed in a dark-brown tunic with velvet collar and cuffs, a white shirt with a delicately fluted ruff, white muslin pants, and black shoes. Peckham's detailed depiction of the Raymond parlor makes this work an excellent document of a nineteenth-century room. Included are a Brussels carpet, a stenciled wall decoration, and an 1820s Pembroke table with turned legs. Also visible are a ceramic mug inscribed "A PR[E]SENT FOR JOSE[PH]," a china bisque doll, a stuffed-dog pull toy, and books (two of which can be identified as the Bible and Watts Psalms).

The painting, neither signed nor dated, was at one time believed to be by the Boston artist James Harvey Young (1830–1918). This attribution was based on its remarkable resemblance to an unsigned portrait, *Charles L. Eaton and His Sister* (Fruitlands Museum, Harvard, Mass.), which was then attributed to Young (now given to Peckham). However, a re-examination of the birth dates of the Raymond children and of Young made this implausible; for Young would have been only about eight years old at the time the picture was painted. Further research (1979) has connected the painting more surely with portraits done by Robert Peckham. Distinct similarities are apparent in an earlier painting owned by a descendant of the Peckham family, *The Children of Oliver Adams*, 1830 (private coll., ill. in D. Johnson [1979], p. 28). Numerous other known works by Peckham also support the attribution. Among the outstanding features of his style that are prevalent in *The Raymond Children* are: the direct gaze of the subjects, an impeccable attention to background detail, and certain facial characteristics, such as the delineation of the skull formation above the temple and the puffiness around the mouth. There is further evidence of a technical nature as well. It seems that Peckham had a distinct way of applying his ground color. He brushed it across the canvas diagonally from the lower left to the upper right (1988). Such a procedure is evident in this picture.

Oil on canvas 55¼ × 39 in. (140.3 × 99 cm.).

REFERENCES: E. G. Speare, *Child Life in New England, 1790–1840*, ed. C. Fennelly (1961), cover ill., as by unknown artist; ill. p. 3 // J. Biddle, *Antiques* 91 (April 1967), ill. p. 486, as about 1840 by an unknown artist // Hirschl and Adler Galleries, New York, *American Folk Art* (Nov. 1977), p. 9, mentions this picture as being by the same unknown artist as no. 6, Group of Children // D. Johnson, *American Art Journal* 11 (Jan. 1979), ill. p. 30 // L. Luckey, *Antiques* 134 (September 1988), ill. p. 557, rejects Peckham attribution // D. Chotner, National Gallery of Art, Washington, D.C., letter in Dept. Archives, Nov. 1, 1988, discusses the way in which Peckham applied his ground // C. Hale, MMA Paintings Conservation, memo in Dept. Archives, Dec. 1988, affirms that the same procedure of applying the ground appears in this painting.

EXHIBITED: National Gallery of Art, Washington, D. C., 1957, *American Primitive Paintings from the Collection of Edgar William and Bernice Chrysler Garbisch*, part II, ill. p. 68, as Joseph and Anna Raymond, artist unknown, ca. 1840 // Museum of American Folk Art, New York, 1966–1967, *American Dolls and Tin Toys* (no cat.) // MMA, 1967, *Collecting American Art for the Metropolitan* (no cat.) // American Federation of Arts, traveling exhibition, 1968–1970, *American Naive Painting of the 18th and 19th Centuries, 111 Masterpieces from the Collection of Edgar and Bernice Chrysler Garbisch*, no. 61, by unknown artist, about 1840.

ON DEPOSIT: National Gallery of Art, Washington, D. C., 1957–1966, lent by Edgar William and Bernice Chrysler Garbisch.

EX COLL.: with Harry Arons, Bridgeport, Conn., by 1956; Edgar William and Bernice Chrysler Garbisch, 1956–1966.

Gift of Edgar William and Bernice Chrysler Garbisch, 1966.

66.242.27.

JAMES FROTHINGHAM

1786–1864

The portraitist James Frothingham was born in Charlestown, Massachusetts. As a youth he worked with his father who was a coachmaker. His early attempts at painting were devoted to decorating carriages and capturing the likenesses of family members. In 1807, while on business in Lancaster, Massachusetts, Frothingham met the portrait painter Fabius Whiting (1792–1842). Whiting, who had once been a student of GILBERT STUART, showed him how to set a palette and mix colors. At the age of twenty, Frothingham read his first book on painting, Reynolds's *Discourses*, and having studied it completed a few pictures. At this point he decided to become a portraitist and abandoned carriage painting.

Frothingham often received guidance from Stuart, who was the leading portraitist of the time. After looking at a Frothingham portrait, Stuart is once quoted as saying, "except myself, there is no man in the United States can paint a better head" (Dunlap, 2, p. 216). The general compostition, pose, and background details of Frothingham's portraits show the strong influence of Stuart. A psychological presence is achieved through the use of direct eye contact, chiaroscuro, and loose brushwork. Frothingham tried, but never quite achieved Stuart's masterful luminous textures and colors. His likenesses, however, were often so derivative that the art historian John Hill Morgan once noted: "No one of Stuart's pupils absorbed more from Stuart's training nor more faithfully followed his master than did James Frothingham" (p. 54).

Frothingham established himself as a portraitist first in Salem, then in Boston. He moved to New York in 1826 and after 1844 lived in Brooklyn. He painted subjects from life and also

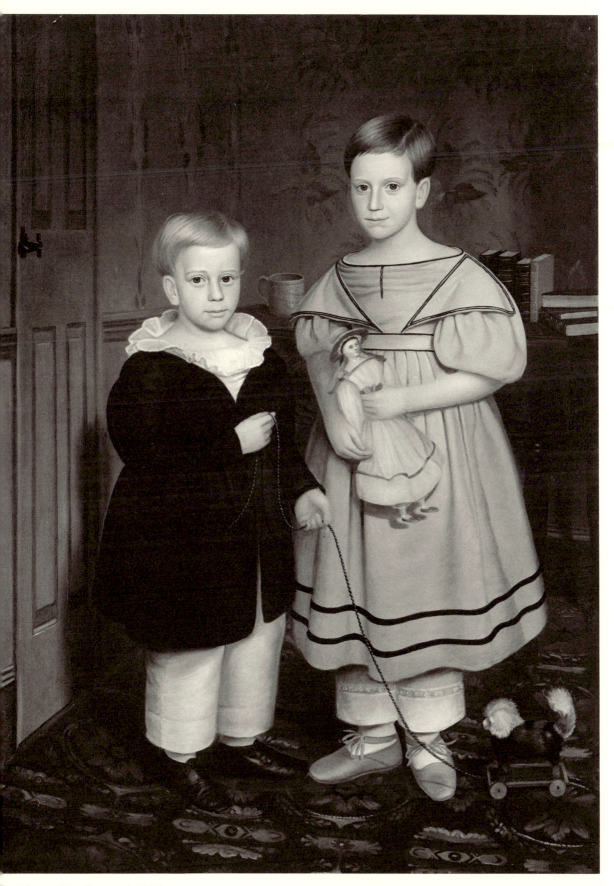

Peckham, *The Raymond Children*.

made copies after Stuart of which his George Washingtons were particularly successful (an example is in the Brooklyn Museum). He may not have achieved the popularity of Jarvis, Inman, and Morse, the leading New York portraitists of the time, but his work was good. Among his New York sitters were William Cullen Bryant, 1833 (MFA, Boston), Richard Riker, 1830 (NYHS), and Lorenzo Da Ponte, 1832. In 1834, William Dunlap recorded that Frothingham "remains [in New York] painting heads with great truth, freedom and excellence, but not with that undeviating employment which popular painters of far inferior talents at the same time find" (2, p. 216). In 1828 he became an associate member of the National Academy of Design and was elected an academician three years later. Besides exhibiting there, he showed his works at the Pennsylvania Academy of the Fine Arts, the Apollo Association, and the Boston Athenaeum. He remained active until his death in 1864. His daughter, Sarah C. Frothingham (1821–1861), was a miniature painter.

BIBLIOGRAPHY: William Dunlap, *A History of the Rise and Progress of the Arts of Design in the United States* (2 vols., New York, 1834), 2, pp. 212–216 // John Hill Morgan, *Gilbert Stuart and His Pupils* (1939), pp. 52–54 // Clara Endicott Sears, *Some American Primitives: A Study of New England Faces and Folk Portraits* (Boston, 1941), pp. 240–246.

Christopher Colles

Christopher Colles (1738–1816), inventor and engineer, was born in Dublin, the son of Richard Colles and Henrietta Taylor Colles. When his father died in 1750, he was sent to school in county Kildare where his mentor was the Reverend Dr. Richard Pococke, later bishop of Ossory, Elphin, and Meath. Colles's engineering talents, especially in hydraulics and canal-building, were evident early, but none of his fortune-building schemes were successful. In 1764, having completed his formal training, he married Anne Keough; they had eleven children, six born in Ireland and five in America.

The family came to Philadelphia in 1771, and Colles immediately immersed himself in a wide range of projects. Shortly after his arrival, he began to deliver lectures on geography and hydraulics, as well as a series on pneumatics in which he demonstrated one of his inventions, a new type of air pump. In 1773 he designed and started to build his first steam engine but abandoned it for lack of funds.

In 1774 Colles moved to New York in search of more profitable endeavors. He was the first to advocate the construction of inland locks to improve navigation on New York rivers, an idea that eventually came to fruition with the building of the Erie Canal. In 1774 he proposed the construction of a reservoir and waterworks for the city of New York. To this end, he directed the building of a pumping station east of Broadway, between Pearl and White streets, and began the installation of a series of water mains made from bored pine logs. Due to insufficient supplies and the interruptions caused by the Revolution, the enterprise was abandoned. Colles

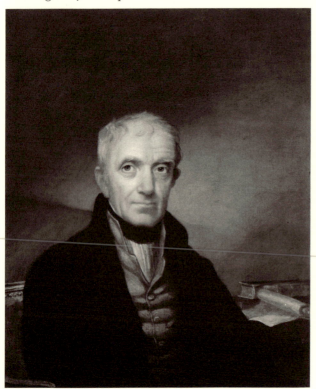

Frothingham, *Christopher Colles*.

served as an instructor in the artillery department of the Continental Army. After the war, however, he offered a new proposal for the building of more distant reservoirs to supply water to the city.

By 1783 Colles had approached George Washington about a plan to clear obstructions from the Ohio River to facilitate navigation to the Mississippi. Washington rejected the proposal as premature but, once again, Colles was ahead of his contemporaries in seeing the need for engineering projects. In 1789 he compiled and published his *Survey of the Roads of the United States of America*. Though it did not appear in completed form, it did encompass all points from Albany, New York, to Williamsburg, Virginia. The maps indicate all churches, houses, gristmills, taverns, and blacksmiths along each road.

During the War of 1812 Colles constructed and operated a semaphore telegraph system from the top of Castle Clinton in New York. The system involved numbered dials and a telescope as a means to communicate information about ship arrivals in the lower harbor. After the war, he manufactured a variety of items, including bandboxes, oil paints, rat traps, and fireworks. He also tested the specific gravity of imported liquors for the customs service. Though the scope of his endeavors proves him one of the most prolific jacks-of-all-trades in American history, none of his projects brought him financial success. He is known to have remarked that if he had been brought up a hatter, people would have come into the world without heads. In 1816 John Pintard, a close friend, obtained a position for Colles as keeper of the American Academy of the Fine Arts. He died that same year at the age of seventy-seven. The writer Gulian Verplanck said of him: "He was a man of the most diminutive frame and the most gigantic conceptions, the humblest demeanor and the boldest projects I ever knew" (O'Reilly [1928], p. 1).

Frothingham's portrait of Colles is an enlarged copy of a cabinet-sized picture painted by JOHN WESLEY JARVIS about 1812. Jarvis had pronounced Colles a genius and said "my pencil will render you hereafter better known; you have done too much to be forgotten." Frothingham's posthumous copy captures the same spirit and expression as the Jarvis portrait, but Colles is made to appear younger. In all it is a more flattering likeness. The features are softer, less pronounced; the eyes appear less cavernous and the face less wrinkled. To the black coat and collar Frothingham has added a gray vest and pleated stock, giving a more elaborate appearance to the costume. He has placed Colles in a Stuartesque pose, seated in a neoclassical-style armchair with the symbols of his inventiveness, his books, within easy reach on the table next to him. A hill appears in the background and the sky is painted in shades of light to deep salmon. Characteristically Frothingham has placed his subject considerably lower on the canvas than was typical of his mentor Stuart.

Oil on canvas: $30\frac{3}{8} \times 25\frac{1}{2}$ in. (77.2 × 64.8 cm.).

RELATED WORK: John Wesley Jarvis, *Christopher Colles*, oil on canvas, 12 × 10 in (30.5 × 25.4 cm.), ca. 1812, NHYS, ill. in *Catalogue of American Portraits in the New-York Historical Society* (1941) p. 60, no. 151.

REFERENCES: American Science and History Preservation Society, Twenty-third annual report, *Early Pipe Line Projects* (1918), p. 694, ill. no. 32 // E. J. De Forest, *James Colles, 1788–1883* (1926), ill. p. 11 // V. F. O'Reilly, *New York Irish World and American Industrial Liberator*, Feb. 27, 1928, ill. p. 1, discusses Colles's life // G. Bathe, *An Engineer's Miscellany* (1938), p. 130 // Gardner and Feld (1965), p. 184.

EXHIBITED: NAD, 1942, *Our Heritage*, no. 251.

EX COLL.: the subject's cousin, James Colles, Sr., New York; his great-grandson, Dr. Christopher J. Colles.

Gift of Dr. Christopher J. Colles, 1917.
17.160.

MATTHEW HARRIS JOUETT

1788–1827

Born April 22, 1788, on a farm near Harrodsburg, Kentucky, Matthew Harris Jouett was one of twelve children. He was chosen by his six brothers to be the one to use the family's slender resources for an education. After he graduated from Transylvania College in Lexington, Kentucky, in 1808, he served as law clerk to the chief justice of the state's appellate court and practiced law in Lexington from 1809 to 1812. During this period his principal artistic activity appears to have been as an amateur painter of portrait miniatures. At the time of the War of 1812, not long after he married, Jouett became a member of the Kentucky Mounted Volunteers. The following year he joined the Twenty-eighth United States Regiment, becoming a first lieutenant and then paymaster, a position in which his loss of some accounts took many years to repay. He left the army as a captain in 1815 and returned to Lexington, where he abandoned the law and turned to painting as his main profession.

In 1816 Jouett went to Philadelphia, intending perhaps to go from there to Europe, but instead he went to Boston and worked from June to October in the studio of GILBERT STUART. Jouett took careful notes of Stuart's comments about painting and described his techniques. These notes, which constitute the most complete record of Stuart's artistic practices, fortunately have been preserved (they are printed in John Hill Morgan, *Gilbert Stuart and His Pupils* [New York, 1939]). The time Jouett spent with Stuart was invaluable. To quote John Hill Morgan: "With the possible exception of Frothingham, no pupil absorbed more from Stuart than did Jouett, and the pity of it is that he was so circumstanced that full training at home or abroad was denied him" (ibid., p. 58).

Yet, as Morgan implied, training with Stuart did not compensate for deficiencies in drawing, and although Jouett imitated Stuart's compositions, and, with less success, his coloring, there is a notable awkwardness in his rendering of anatomy, particularly hands, and in the painting of backgrounds. He was generally at his best in simple bust-length portraits with plain drops, which allowed him to display his talents as a colorist to greatest advantage. His work was largely forgotten, however, until Charles Henry Hart selected several portraits by him for the World's Columbian Exposition of 1893 in Chicago and wrote some highly laudatory articles on him for *Harper's Monthly Magazine* in 1899 and 1900.

Tracing the course of Jouett's stylistic development is a difficult task. In general his earliest work is rather crude and appears to have been influenced by the succession of mostly minor artists who visited Lexington when he was a youth. The first and most important of these was the miniaturist Benjamin Trott (ca. 1770–1843). The months Jouett spent in Stuart's studio in 1816 were highly significant, and for many years he derived his composition and, in part, his technique from Stuart. Although he spent most of his time in Lexington, he traveled throughout the South. During the winters from 1820 to 1822, he was in New Orleans, where he became acquainted with JOHN WESLEY JARVIS. Jouett's portraits of the 1820s sometimes approach the realistic clarity of Jarvis's work. More significant, he visited Philadelphia on a number of occasions in the 1820s, and perhaps earlier as well, and made

friends with THOMAS SULLY. Paintings by Jouett that have been dated as early as 1819 appear to reflect Sully's influence. Even the most convincing treatment of Jouett, however, presents a chronology of his work that suggests either a need for revision or implies that Jouett was an extremely eclectic artist who used a variety of different styles at the same time. In general, one can say that he developed in the direction of greater forcefulness and technical proficiency.

BIBLIOGRAPHY: Samuel Woodson Price, *The Old Masters of the Bluegrass: Jouett, Bush, Grimes, Frazer, Morgan, Hart* (Louisville, 1902). Includes a list of about three hundred paintings compiled by Jouett's grandson R. Jouett Menefee // Edward A. Jonas, *Matthew Harris Jouett, Kentucky Portrait Painter (1787–1827)* (Louisville, 1938). Includes almost forty illustrations // Mrs. William H. Martin, *Catalogue of All Known Paintings by Matthew Harris Jouett* (Louisville, 1939). Lists some 529 paintings, but later sources have said that some are copies and others misattributions // William Barrow Floyd, *Jouett-Bush-Frazer, Early Kentucky Artists* (Lexington, 1968). Best treatment to date // William Barrow Floyd, "Portraits of Ante-Bellum Kentuckians," *Antiques* 105 (April 1974), p. 808.

John Grimes

John Grimes (1799–1837) was a student of Matthew Harris Jouett. His origins are somewhat obscure. He was probably born in Dayton, Kentucky, although some sources give his place of birth as Lexington. Various references in his will and that of his grandfather suggest that he was an orphan or, perhaps more likely, illegitimate. He was apprenticed to Thomas Grant, who had a tobacco and oil manufacturing business in Lexington, also dealing in varnish, wallpaper, and painted signs. Grimes appears to have become almost a member of the Grant family, and Grant's wife nursed him through his final illness. At some point while working in Grant's shop, which was a local gathering place for men with intellectual interests, Grimes came to Jouett's attention and became his pupil.

Adopting the trade of an itinerant portrait painter, Grimes is said to have ranged as far afield as Huntsville, Alabama, as early as 1820. From about 1825 to 1827 he was in Philadelphia, reportedly working as a drawing teacher, and he exhibited portraits at the Pennsylvania Academy of the Fine Arts from 1825 through 1829. He must have known THOMAS SULLY there, for he painted copies of Sully's work, and Sully made several copies of Grimes's portrait of Charles Wetherill. Judging from bequests in his will to several members of Philadelphia's artistic community, Grimes appears to have played a relatively active role in the city's cultural life. Later, he returned to the South and settled in Nashville, where a number of his portraits are in public collections and where he appears to

Matthew Harris Jouett

have painted several genre subjects. Shortly before his death from tuberculosis in 1837, he returned to Lexington.

The more authoritative sources on Jouett have dated this portrait around 1824, the year before Grimes is believed to have left for Philadelphia. Grimes would have been about twenty-five at that time. Jouett's chronology, however, with only one dated and few documented paintings, is insufficiently clear to permit the precise assignment of a date. The portrait is similar in

Jouett, *John Grimes*.

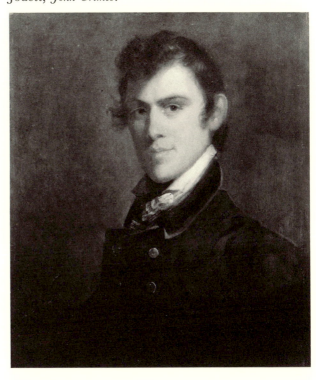

some respects to GILBERT STUART'S work, for example *Henry Rice* (q.v.), which Stuart painted about the time Jouett studied with him in Boston. Yet, although Jouett adopted the pose and to some extent the manner of the portrait from Stuart, he did not follow his technique of using translucent glazes of color for the subject's face. Instead he painted directly and, in comparison to Stuart, rather crudely. Similarly, Grimes's. dramatically side-lit head is uncharacteristic of Stuart and is probably derived from the more romantic portraiture of Sully.

Oil on wood, 28¼ × 21¾ in. (71.8 × 55.2 cm.).
REFERENCES: C. H. Hart, *Harper's Monthly Magazine* 98 (May 1899), p. 920, calls it Jouett's masterpiece // S. W. Price, *Old Masters of the Bluegrass* (1902), p. 66, no. 302, lists it // H. W. Henderson, *The Pennsylvania Academy of the Fine Arts* (1911), p. 118 // C. H. Hart, *Art in America* 4 (April 1916), pp. 175–176, says depicts painter in early stage of tuberculosis, and praises coloring // E. A. Jonas, *Matthew Harris Jouett* (1938), p. 5 // S. M. Wilson, *Filson Club History Quarterly* 13 (April 1939); reprinted as *Matthew Harris Jouett, Kentucky Portrait Painter* (1939), p. 90 // E. T. Whitley, *Kentucky Ante-Bellum Portraiture* (1956), pp. 682, 704 // E. Spangenberg, "A Critical Analysis of Matthew Harris Jouett's Painting Style," B. A. honors thesis, University of Louisville, 1956, pp. 38–40, places it among Jouett's "masterpieces," dates ca. 1824 // Gardner and Feld (1965), pp. 185–186 // W. B. Floyd, *Jouett-Bush-Frazer, Early Kentucky Artists* (1968), p. 54; ill. p. 57; p. 184, lists it in 1827 inventory of Jouett's estate valued at two dollars.

EXHIBITED: World's Columbian Exposition, Chicago, 1893, no. 2830, lent by Mrs. Menefee, *Official Catalogue, Department of Fine Arts*, p. 59, says portrait was painted in Lexington in 1824 // MMA, 1895, *Retrospective Exhibition of American Paintings*, no. 194.

EX COLL.: the artist, d. 1827; his daughter, Sarah Bell (Mrs. Richard H.) Menefee, Louisville, Ky., by 1893–1895.

Gift of Mrs. Richard H. Menefee, 1895.
95.23.

AMMI PHILLIPS

1788–1865

Born in 1788 into a temporarily impoverished family in Colebrook, Connecticut, near the Massachusetts border, Ammi Phillips had begun his career as an itinerant portrait painter by 1811, the date of his earliest signed works, portraits of Massachusetts residents Gideon Smith and Chloe Allis Judson (ill. B. C. and L. B. Holdridge, 1969, p. 21). Very few of the numerous portraits said to have been painted by Phillips over the next several years bear his signature. Most of them were at one time believed to be by an unidentified artist termed the Border Limner, who was active in the towns along the Massachusetts-Connecticut border from about 1810 to sometime in the 1820s. The theory that Phillips was the Border Limner was first advanced in 1965. Scholars have contested this attribution, but without definitive evidence. The issue is important because it concerns some of the finest paintings in American art. The portrait of Harriet Leavens, ca. 1815 (Fogg Art Museum, Harvard University), for example, which is attributed to Phillips, is a work of radical simplicity and great coloristic refinement, comparable to the works of more modern artists.

Phillips moved to Troy, New York, about 1817. His style, if the early works said to be by him are accepted as his, changed at this point. The early paintings show the possible influence of REUBEN MOULTHROP, whose work Phillips probably studied. These works are characterized by their light palette, lack of detail, and three-dimensional modeling, and most

of them are three-quarter or full-length compositions. The portraits of the 1820s, which were often bust-length, show the probable influence of EZRA AMES, who worked in nearby Albany. They typically depict sitters in dark clothing posed against dark backgrounds with meticulously rendered accessories, such as lace collars and bonnets. Some portraits, for example those of Phillips's cousins Gabriel Norton Phillips and Elizabeth Payne Phillips, both ca. 1824 (Connecticut Historical Society), show an increased understanding of light and shadow. Phillips traveled extensively throughout New York State during the 1820s and 1830s. In 1829, he moved to Rhinebeck, New York, and his style changed yet again, with flatter modeling and more stylized poses. These works are largely uncontroversial as to attribution.

Phillips's work of the 1830s is characterized by sharply drawn, elegant outlines and dramatic coloring. Some of these works, for example his *Boy with Primer, Peach, and Dog* of ca. 1836 (ill. L. Bantel, *The Alice M. Kaplan Collection* [1981], p. 166), are remarkably assured, refined performances. Although an untrained, country artist, Phillips projects a quality in his work that can only be termed urbane, so masterful is he in terms of design and color. During the 1840s, Phillips's style became more three-dimensional and realistic. In approaching the style of conventionally trained artists, he lost some of the vigor and confidence exhibited in his work of the previous decade. He continued to paint portraits until at least 1862, three years before he died in Curtisville (now Interlaken), Massachusetts.

BIBLIOGRAPHY: Barbara and Lawrence B. Holdridge, "Ammi Phillips, 1788–1865," *Connecticut Historical Society Bulletin* 30 (Oct. 1965), pp. 97–145. For the first time assign portraits of the Border Limner to Phillips, contains a checklist. // William Lamson Warren, "Ammi Phillips: A Critique," *Connecticut Historical Society Bulletin* 31 (Jan. 1966), pp. 1–18. Argues that Border Limner is not Phillips and rejects a number of attributions to him // Barbara C. and Lawrence B. Holdridge, *Ammi Phillips: Portrait Painter, 1788–1865* (New York, 1969). Expands artist's oeuvre to 308 portraits maintaining original attributions; includes a checklist and chronology // Mary Black, "The Search for Ammi Phillips," *Art News* 75 (April 1976), pp. 86–89 // Ruth Piwonka and Roderic H. Blackburn, *Ammi Phillips in Columbia County* (Kinderhook, N. Y., 1975). Catalogue for an exhibition at the Columbia County Historical Society covers the period from about 1814 to 1834.

Philip Slade

This portrait is inscribed on the back "PHILIP SLADE AGED 56 AD 1818." The subject was once identified as the Philip Slade who was minister at the nonsectarian Church of Christ in Swansea, Massachusetts, from 1801 to 1819. Slade's tombstone in South Swansea indicates that he died in 1828 at the age of sixty-eight, which would have made him fifty-seven or fifty-eight, not fifty-six, at the time this portrait was painted. Although the possibility exists that the subject's age was incorrectly recorded, Swansea is a considerable distance from the area where Ammi Phillips is known to have painted, which raises the possibility that another Philip Slade is represented in the portrait.

According to a former owner, the man represented was from Lansingburgh, New York. The Holdridges (1965) list him as from Hoosick, New York. Pending further research their suggested locale for the subject seems the most likely. Two years earlier, Phillips painted portraits of Joseph and Alice Slade (National Gallery of Art, Washington, D. C.) who may have been Philip Slade's brother and sister-in-law. Joseph Slade is posed sitting in an identical armchair. A three-quarter-length portrait of a woman in the same chair (1818, private coll., photograph in Dept. Archives) is said to be of Mrs. Philip Slade.

Slade is painted in the style of the works that were originally attributed to the Border Limner but were later considered the early work of Ammi Phillips. The portrait of Philip Slade

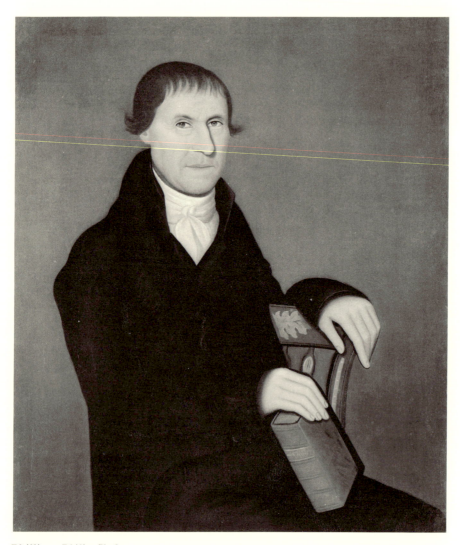

Phillips, *Philip Slade*.

could be viewed as a transitional work between the early style and that of the 1820s. The background is midway between the very light tones he used in his early works and the dark grounds he favored later on. Similarly, the portrait has a more modeled appearance than the works painted up to 1815. The elegant outline of Slade's body, with the left forearm and wrist making an unlikely but beautiful curve, appears remarkably simple against an unmodulated, almost abstract, gray background. His gaze is direct and penetrating, and although his body is anatomically unconvincing, Philip Slade has a considerable degree of presence.

Oil on canvas, 38½ × 32½ in. (97.8 × 82.6 cm.).

Inscribed on the back before lining: PHILIP SLADE AGED 56 YEARS AD 1818.

ON DEPOSIT: National Gallery of Art, Washington, D. C., 1955–1964, lent by Edgar William and Bernice Chrysler Garbisch.

REFERENCES: H. S. Newman, Old Print Shop, New York, letter in Dept. Archives, Dec. 5, 1957, says remembers painting was found on Cape Cod // W. P. Campbell, National Gallery of Art, Washington, D. C., letter in Dept. Archives, Dec. 12, 1957, identifies as Philip Slade of Swansea, Massachusetts // W. L. Warren, copy of letter in Dept. Archives, says it was purchased from Fred W. Fuessenich of Litchfield, Conn., who had identified the subject as Philip Slade of Lansingburgh, New York // B. C. and L. B. Hold-

ridge, *Connecticut Historical Society Bulletin* 30 (Oct. 1965), p. 100, attribute to Ammi Phillips, say Philip Slade brother of Joseph Slade of Hoosick, N. Y.; p. 110, no. 136 // W. L. Warren, *Connecticut Historical Society Bulletin* 31 (Jan. 1966), p. 8, rejects attribution to Phillips.

EXHIBITED: National Gallery of Art, Washington, D. C., 1957, *American Primitive Paintings from the Collection of Edgar William and Bernice Chrysler Garbisch*, Part II, p. 36, as by an unknown artist // Academy of the Arts and Talbot County Historical Society, Easton, Md., *Exhibition of American Art*, no. 16, as by Ammi Phillips // Museum of American Folk Art, New York, and Albany Institute of History and Art, 1968–1969, *Ammi Phillips*, exhib. cat. by B. C. and L. B. Holdridge, pp. 12, 31, give Slade's residence as Hoosick, N. Y., p. 46, no. 37 // MMA and American Federation of Arts, traveling exhibition, 1976–1977, *The Heritage of American Art*, cat. by M. Davis, p. 69, no. 24, identifies Philip Slade as of Swansea, Massachusetts.

EX COLL.: with Fred W. Fuessenich, Litchfield, Conn.; with the Old Print Shop, New York, 1954; Edgar William and Bernice Chrysler Garbisch, 1964.

Gift of Edgar William and Bernice Chrysler Garbisch, 1964.

64.309.3.

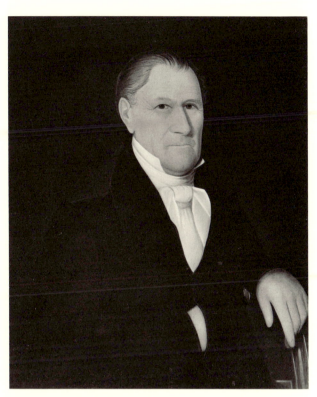

Phillips, *Thomas Storm*.

Thomas Storm

This portrait came to the museum identified as Thomas Storm of Stormville, New York. It was further noted that the village was named for his family and that he was a merchant of the house of Thomas Storm & Sons, dealers in tobacco, snuff, and dry goods. This information presumably came from the dealer who sold the painting to the Garbisches. Identifying the sitter is not actually as simple as the information might imply. The portrait probably dates from about 1830; it is painted in a dark palette with very little modeling and shows a pose that Phillips used early in his career and revived toward the end of the 1820s. At that time, however, the founder of the New York firm of Thomas Storm & Son (the son being Garrit) was in his eighties. He was born in Stormville in 1748, moved to New York City in 1784, and died there at Kips Bay in 1833. He is not likely the subject, being too old, and neither is his son Thomas Hall Storm, who died in Buenos Aires in 1818 at about age thirty-seven.

There are several other possibilities. Much of the area around Stormville, including East Fishkill and Hopewell, New York, was settled by the Storm family. Other Thomases of the period existed, for example, Thomas I. Storm (1766–1847), a cousin of the merchant and a farmer at Fishkill (see John Garrison Storm, comp. *Dirk Storm and His Descendants*, [1985], p. 53). He is a more promising candidate, being in his sixties when this portrait was painted. His sons were in business in New York City, one as a tobacco merchant. Quite possibly the confusion over who the sitter is may be the result of some slight misinformation or a combining of the facts regarding more than one family member. There is, of course, the possibility too that Phillips copied an earlier portrait of the first Thomas Storm noted in this entry. Considering the weakness of this work, that is not at all farfetched.

Oil on canvas, 32 × 26 in. (81.3 × 66 cm.).

EX COLL.: with Thurston Thacher, Hornell, N. Y., by 1949; Edgar William and Bernice Chrysler Garbisch, 1949–1979.

Bequest of Edgar William and Bernice Chrysler Garbisch, 1979.

1980.360.1.

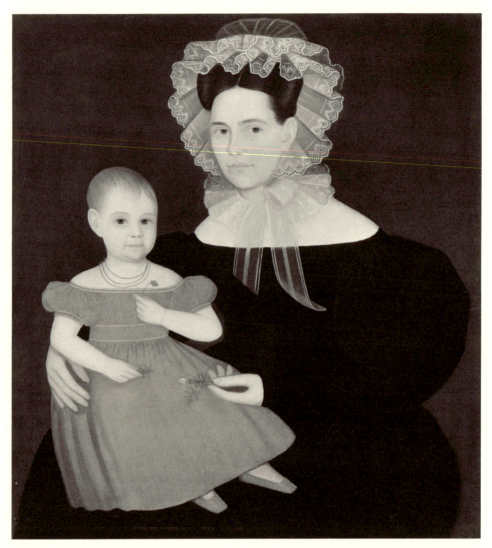

Phillips, *Mrs. Mayer and Her Daughter.*

Mrs. Mayer and Her Daughter

The subjects of this portrait are not known for certain. The title, *Mrs. Mayer and Her Daughter,* goes back only to 1959 when the Garbisches purchased the painting in Massachusetts. No information has been discovered since that time that permits the subjects to be more definitely identified. In fact, the child could just as easily be a son. In the literature on Ammi Phillips the portrait has been variously dated on the basis of style, ca. 1835, ca. 1836, and ca. 1835–1840. *Mrs. Mayer and Her Daughter* is close in appear-

ance to the artist's *Mrs. Horace Austin,* dated ca. 1826 (ill. B. C. and L. B. Holdridge (1969), p. 34), and his *Wife of the Journalist* (Art Museum, Princeton University), which is dated 1832. Generally the Mayer portrait is more fully modeled than the rather flattened and abstract forms one finds in Phillips's paintings of the late 1830s.

Phillips portrayed this mother and child with more than his usual care and effectiveness. The child is dressed in brilliant red, with shoes and necklace of the same color. The head and shoulders are strikingly outlined against a dark ma-

roon background, and the figure seems to float magically against the flat black of the mother's lap. The mother's face, too, projects vividly from the dark background, and her bluish-white bonnet is depicted in very delicate and meticulous detail. While the mother holds a pink rosebud, the child's is red. Altogether, as in many of Phillips's works, his strong and daring sense of color and design project an image that is not only charming but powerful as well.

Oil on canvas, 37⅞ × 34¼ in. (96.2 × 87 cm.).
REFERENCES: S. P. Feld, *Antiques* 87 (April 1965), p. 422 // Gardner and Feld (1965), pp. 186–187, date it about 1835–1840 // B. and L. B. Holdridge, *Connecticut Historical Society Bulletin* 30 (Oct. 1965),

p. 114, no. 98, date it about 1835 // B. C. and L. B. Holdridge, *Ammi Phillips*, p. 50, no. 183, say probably painted about 1836 in the area around Amenia, N. Y., and Kent, Conn.

EXHIBITED: American Federation of Arts, traveling exhibition, 1961–1964, *101 Masterpieces from the Collection of Edgar William and Bernice Chrysler Garbisch*, colorpl. 59, p. 147, as attributed to Ammi Phillips, ca. 1835; MMA, 1965, *Three Centuries of American Painting* (checklist arranged alphabetically), dates it about 1835–1840 // Grand Palais, Paris, 1968, *Peinture naïves americaines XVIIIe et XIXe siècles*, p. 73, no. 57 // Osaka World's Fair, 1970.

EX COLL.: Massachusetts art market, 1959; Edgar William and Bernice Chrysler Garbisch, 1959–1962.

Gift of Edgar William and Bernice Chrysler Garbisch, 1962.

62.265.2.

SAMUEL F. B. MORSE

1791–1872

Samuel Finley Breese Morse was born in Charlestown, Massachusetts, where his family was well established and distinguished. His father, the Rev. Jedediah Morse, was a Congregational minister and the famous author of the first American geography; his mother, Elizabeth Ann Breese, was the granddaughter of the Rev. Samuel Finley, president of Princeton College. As a youngster Morse attended Phillips Academy, Andover, and, in 1810, he received a bachelor's degree from Yale. During his last years in college he learned to paint portrait miniatures and began executing them for sale. He knew he wanted to become a painter and was further inspired by WASHINGTON ALLSTON, with whom he studied while holding a job with a Boston bookseller. His first ambitious painting, *The Landing of the Pilgrims at Plymouth*, ca. 1810–1811 (Boston Public Library), shows the influence of Allston and received the praise of GILBERT STUART. Morse's parents agreed that he could accompany Allston to Europe.

Morse arrived in London in 1811 and quickly set to work. He visited the studio of BENJAMIN WEST, drew at the Royal Academy school, and began a large painting showing Hercules in his last agonizing moments. This work, known as *The Dying Hercules*, 1812–1813 (Yale University, New Haven, Conn.), hung at the Royal Academy exhibition of 1813 and received laudatory reviews. Several plaster casts were made from the clay model Morse sculpted as a preparatory study for the painting, and one of these won a gold medal at the Society for the Encouragement of Arts, Manufactures, and Commerce in London in 1813. Over the next two years, Morse focused his studies on classical art and spent long hours drawing the Elgin marbles at Burlington House and other statuary at the British Museum. By 1815, he

was anxious to contribute to raising the quality of art in the United States, and he returned home.

Morse set up a studio in Boston, where he proudly displayed his history paintings. He quickly discovered, however, that Americans would only pay for portraits. He was thus forced to travel throughout New England in search of commissions. On one such journey, in Concord, New Hampshire, he fell in love with the sixteen-year-old Lucretia Pickering Walker, whom he married in 1818. For the next three winters, he painted portraits in Charleston, South Carolina, where he attracted numerous patrons. Many of the works he painted at this time are accomplished, innovative, and somewhat eclectic (see below, for example, *Mrs. Daniel deSaussure Bacot*). They often display baroque elements, either in the pose of the sitter, the arrangement of the drapery, or the use of heavy impasto. By early 1821, however, the number of his portrait commissions had flagged. On January 28 of that year, Morse wrote to his wife from Charleston: "I am conscious of painting much better portraits than formerly (which, indeed, stands to reason if I make continual exertion to improve), yet with all I receive no new commissions" (E. L. Morse, ed., 1, p. 235).

Later in 1821, Morse decided to invest his time and savings on a grand, national history painting. He should have scored a major success with his highly complex, multifigured *The Old House of Representatives*, 1822 (Corcoran Gallery of Art, Washington, D.C.), a detailed view of the interior of the domed chamber, reminiscent of Giovanni Paolo Pannini's views of the interior of the Pantheon. The extraordinary work, however, failed to please audiences in Boston and New York, where he arranged special exhibitions of the enormous canvas. To recover from his financial woes, Morse returned to portraiture and moved to New York. Within a few months of his arrival in late 1824, he won the city's commission for a full-length portrait of the marquis de Lafayette (Art Commission, City of New York), an honor coveted by many outstanding artists. Morse quickly gained several other important portrait commissions and became a respected member of the artistic community. His efforts to foster camaraderie among painters resulted in the establishment of the National Academy of Design, of which he was elected president.

Still, Morse had not achieved the artistic status he yearned for, and in 1829 he resolved to return to Europe to study the old masters and paint. During the next three years he visited France and Italy and painted a number of copies and original works; among the latter was his best landscape, *The Chapel of the Virgin at Subiaco*, 1830 (Worcester Art Museum). He could not resist undertaking another major project like *The Old House of Representatives* and set to work on *The Gallery of the Louvre*, 1832–1833 (Terra Museum of American Art, Chicago). After his return to New York in 1832, he planned to exhibit the painting around the country, but again he found the public apathetic. In the end, he was forced to sell the picture for much less than he had hoped.

From this time on, Morse spent more and more time on the invention of the telegraph. In 1835 he was appointed professor of the literature of the arts of design at New York University. This post carried no salary, and Morse, who had expected that at least the prestige would gain him more patrons, sank into poverty. During these years of struggle, he painted the well-known portrait of his daughter (q.v.), an ambitious combination of technical skill and fantasy, which he probably knew would be his last important work.

In 1837, having despaired of ever achieving success as an artist, Morse ceased to paint. His version of the electrical telegraph, however, eventually proved successful. Wealth and fame followed, and he was considered one of the important inventors of the nineteenth century. In an area still related to art, he fostered the use of the daguerreotype in the United States. Later in his life, he supported many artistic endeavors including the founding of the Metropolitan Museum, where he served as a trustee and, in his last year of life, as vice-president.

BIBLIOGRAPHY: William Dunlap, *A History of the Rise and Progress of the Arts of Design in the United States* (2 vols., New York, 1834), 2, pp. 308–319 // Edward Lind Morse, ed., *Samuel F. B. Morse: His Letters and Journals* (Boston and New York, 1914) // Carleton Mabee, *The American Leonardo* (New York, 1943). The first modern biography, it does not focus very much on Morse's artistic career // Paul J. Staiti and Gary A. Reynolds, *Samuel F. B. Morse* (New York, 1982). A catalogue of an exhibition held at the Grey Art Gallery of New York University with a thoughtful biographical essay // Paul J. Staiti, *Samuel F. B. Morse* (Cambridge and New York, 1989). The best work to date on Morse's artistic career, with a checklist of paintings, sculpture, drawings, and photographs.

Mrs. Daniel deSaussure Bacot

Eliza McKeever Ferguson (1796–1829), daughter of William Cattel Ferguson and the former Elizabeth Milner Colcock, was married in 1819. Her husband, Daniel deSaussure Bacot (1798–1839), was a member of a prominent South Carolina Huguenot family. For a number of years, he was an officer of the Bank of South Carolina. The Charleston directory for 1829 lists him as a teller and gives his address as 11 Lamboll Street. He moved to New Orleans in 1830 after Mrs. Bacot's death but later returned to Charleston and died there. The Bacots had six children.

According to family tradition, this picture was painted by Morse in 1820, at the time he executed the portrait of the sitter's grandmother Mrs. John Colcock II (Carolina Art Association, Gibbs Art Gallery, Charleston). Morse had been working winters in Charleston since 1818, and it was there that he scored his first success. His Charleston portraits reflect his search for an individual style and may be considered among the most innovative and sophisticated portraits produced in the United States at the time.

The portrait of Mrs. Bacot is one of his most successful experiments, in which the scope of his ambition was clearly within his grasp. The face is enlivened by the turn of the head and the large, liquid eyes, which are given a Rubensian cast probably best illustrated in *Susann Fourment* (Na-

tional Gallery, London) but also characteristic of many of Rubens's other portraits of women. Similarly, the painterly execution of the drapery is far more baroque in character than was usual for American exponents of loose brushwork such as GILBERT STUART and THOMAS SULLY. In other aspects, however, particularly in the placement of the figure against an almost empty, abstractly organized background dominated by cool whites, blues, and reds, Morse's awareness of contemporary French portraiture in the style popularized by Jacques Louis David's students is clear. Henry François Mulard's *Portrait of an Unknown Woman*, ca. 1810 (Kimbell Art Museum, Fort Worth), clearly underscores these formal similarities, made all the more striking by the Empire fashions worn by both women. Morse's portrait, then, is a learned reflection of his European experiences and a charming experiment in the history of American portraiture.

Oil on canvas, 30 × 24¾ in. (76.2 × 62.9 cm.).
REFERENCES: E. Chambers, July 8, 1931, letter in Dept. Archives, gives information on the subject // H. B. Wehle, *MMA Bull.* 26 (August 1931), p. 193, dates it about 1818–1821 // R. H. Colcock, letter in Dept. Archives, Nov. 6, 1931, says the picture was painted in 1820 // A. T. Gardner, *MMA Bull.* 4 (June 1946), pp. 264, 267 // R. B. Hale, *MMA Bull.* 12 (March 1954), pp. 170, 175 // Gardner and Feld (1965), p. 189 // M. Burns, Huguenot Society of South Carolina, Charleston, letter in Dept. Archives, June 14, 1978, provides genealogical information // P. J.

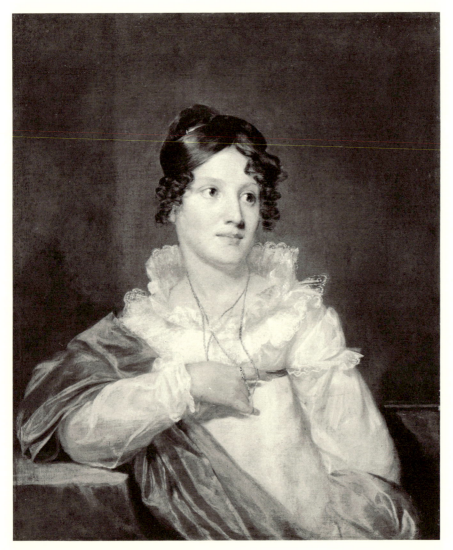

Morse, *Mrs. Daniel deSaussure Bacot.*

Staiti, *Samuel F. B. Morse* (1989), pp. 59–60, dates it ca. 1820 and says it exemplifies Morse's adaptation of "Sully's aristocratic language. . . . Mrs. Bacot's portrait glistens with harmonic variations on the tonalities of turquoise."

EXHIBITED: MMA, 1932, *Samuel F. B. Morse*, exhib. cat. by H. B. Wehle, pp. 15, 32 // Santa Barbara Museum of Art, 1941, *Paintings Today and Yesterday* (no cat.) // NAD, 1950, *Morse Exhibition of Arts and Science*, no. 10 // MMA, 1958–1959, *Fourteen American Masters*, no cat. // Corcoran Gallery of Art, Washington, D. C., *American Painters of the South*, no. 81 // Los Angeles County Museum of Art, 1966, *American Paintings from the Metropolitan Museum of Art*, ill. p. 3 // MMA, 1965, *Three Centuries of American Painting* (checklist arranged

alphabetically) // W. H. Ackland Memorial Art Center, University of North Carolina, Chapel Hill, 1968, *Arts of the Young Republic*, exhib. cat. by H. E. Dickson, no. 83 // Grey Art Gallery, New York University, *Samuel F. B. Morse*, essays by G. A. Reynolds and P. J. Staiti, fig. 33; p. 35, says it is an example of what exposure to Sully's art did for Morse, picture is lighter in palette, smoother in handling, and the pose is more casual than usual.

EX COLL.: descended in the family to Mrs. Cuthbert Bacot Fripp, Columbia, S. C., by 1928; with Eunice Chambers, Hartsville, S. C., 1930.

Morris K. Jesup Fund, 1930.

30.130.

De Witt Clinton

De Witt Clinton (1769–1828), one of the most colorful and capable statesmen in American history, was born in New York. His father, James Clinton, was of English descent and the brother of the first governor of New York State, George Clinton. His mother, Mary De Witt, was from an old New York Dutch family. Clinton graduated at the head of his Columbia College class in 1786 and, subsequently, studied law and gained admission to the bar. Naturally inclined to politics, he became secretary to his uncle as well as secretary of the state board of regents and of the board of fortifications. In 1795, with his party, the Anti-Federalists, out of power, he began to study the natural sciences, but by 1797 he was back in the political arena. In that year he was elected to the state assembly and in 1798 won a four-year term in the state senate. Clinton became a leader of the Republican factions in the senate and in 1801 gained control of the Council of Appointment, which at the time controlled about fifteen thousand offices. His power was immense, and in 1803, after serving for a brief time in the United States Senate, he accepted an appointment as mayor of New York, a post he held, with the exception of two annual terms, until 1815. Believing firmly in the destiny of the city, Clinton energetically set about providing it with all the institutions it lacked: he became the organizer of

Morse, *De Witt Clinton*.

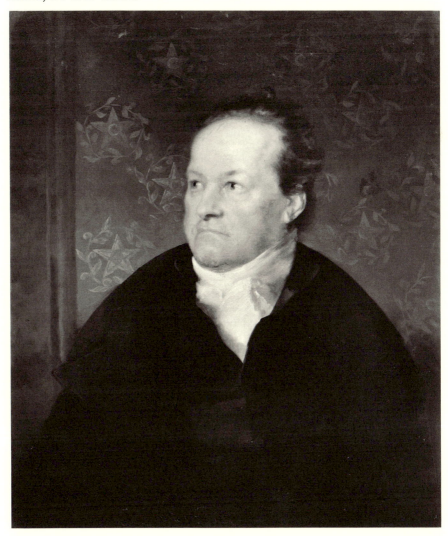

the Public School Society, the Orphan Asylum, the City Hospital, and lent his support and leadership to the New-York Historical Society, the Lyceum of Natural History, the Humane Society, the Society for the Promotion of Useful Arts, the American Academy of the Fine Arts, and many others, as well.

In 1812, backed by a coalition of New England Federalists and dissatisfied Republicans, Clinton ran for the presidency but was defeated. He then turned his energy to the idea of a canal linking the Hudson River and the Great Lakes. In 1817, after two years out of the political limelight, he was elected governor of New York, largely because of the popularity of this canal proposal. By 1822, having alienated the radical faction of the Republican party, Clinton found himself without support and had to give up the governorship. His political fortunes sank, and in 1824 he was removed from the office of Canal Commissioner, which he had held since 1810. The wave of public resentment, however, caused by this transparently political action swept him back into the governorship in 1824 as the candidate of an independent coalition. The following year the Erie Canal opened, and Clinton was completely vindicated. At the time of his death in 1828, he was the acknowledged elder statesman and benefactor of New York State.

De Witt Clinton was the subject of a goodly number of portraits, both painted and sculpted. This portrait, according to Henry N. Dodge, its last owner, was painted in 1826 for his father-in-law, the engraver Moseley I. Danforth. Danforth had planned to publish an engraving after it but failed to obtain the requisite number of subscribers. The portrait remained in the Danforth family until it was purchased by the museum. In presenting his subject as a man of formidable will and authority, Morse employed a compositional formula popular with romantic artists at the end of the eighteenth century. The frontal depiction of the figure with the head turned was used by a number of English painters of this period, but, more importantly, it was the formula chosen by JOHN TRUMBULL in the portraits he painted of Alexander Hamilton from 1792 on (q.v.). In 1822, JOHN NEAGLE repeated it in his portrait of the prominent businessman George Peabody (MFA, Boston). Thus, there were ample precedents in the Anglo-American tradition for Morse to draw upon. His portrait of Clinton, however, also possesses a certain French

flavor, best observed in the sharp contrasts between the areas of color, in the choice of flat tones, and in the patterning of the background. The background, in particular, featuring stars inscribed with a C and encircled by sprays of laurel, recalls the Napoleonic initial French artists used on all forms of decoration in the Empire period. The execution of the head in small, loose, feathery brushstrokes produces a painterly texture with a decidedly baroque air, not unlike the subtle technique employed by Velázquez in such late portraits as *Innocent X* (Galleria Doria-Pamphili, Rome).

How Morse arrived at such an eclectic combination of elements has not been explored. It may be supposed that his large ambitions, coupled with the frustrations of not being able to paint anything other than portraits, led him to look beyond the style of his contemporaries to the acknowledged past masters of face painting. In any case, his technique and style varied greatly. He did not always achieve results of such quality as in this painting, which, in its uncompromising verism, portrays Clinton, in the words of the historian Dixon Ryan Fox, as a man "to be admired and obeyed, but not loved" (*The Decline of Aristocracy in the Politics of New York* [1919], p. 200).

Oil on canvas, 30 × 25⅛ in. (76.2 × 63.8 cm.).
REFERENCES: *New York Evening Post* (May 6, 1826), mentions that Morse's "portraits of Clinton . . . and others" will be ready for the NAD exhibition // H. N. Dodge, letter in Dept. Archives, March 10, 1907, gives provenance and date of execution // A. T. Gardner, *MMA Bull.* 4 (June 1946), p. 267 // Gardner and Feld (1965), pp. 189–190 // W. Kloss, *Samuel F. B. Morse* (1988), ill. p. 102; p. 103 // P. J. Staiti, *Samuel F. B. Morse* (1989), pp. 126–127, describes the pose as "more aggressive" than that used for Lafayette and explains that "Morse's astute reading of Clinton's pugnacious character sets his image apart from contemporary portraits of the governor."

EXHIBITED: NAD, 1826, no. 106, as Portrait of his Excel. De Witt Clinton // MMA, 1932, *Samuel F. B. Morse*, exhib. cat. by H. B. Wehle, pp. 19, 33; 1939, *Life in America*, no. 91 // NAD, 1950, *Morse Exhibition of Arts and Science*, no. 9 // Detroit Institute of Arts; Art Gallery of Toronto; City Art Museum, Saint Louis; Seattle Art Museum, 1951–1952, *Masterpieces from the Metropolitan Museum of Art* (no cat.) // MMA, 1965, *Three Centuries of American Art* (checklist arranged alphabetically) // MMA and American Federation of Arts, traveling exhibition, 1975–1977, *The Heritage of American Art*, cat. by M. Davis, no. 25, color ill.

Ex coll.: Moseley I. Danforth, New York, 1826–d. 1862; his son-in-law, Henry N. Dodge, Morristown, N. J., until 1909.

Rogers Fund, 1909.
09.18.

Susan Walker Morse (The Muse)

Painted between 1836 and 1837, when Morse was occupied with the invention of the telegraph, this extraordinarily ambitious portrait depicts his eldest daughter, Susan Walker Morse (1819–1885), at about the age of seventeen. This is a work of marked eclecticism, the product of an extremely learned, ambitious, and able artist who at the very time of its execution was in the process of abandoning his art due to lack of patronage. The question whether the complexities of Morse's works were responsible for his professional failure may never be settled for sure, but it may at least be postulated that his most grandiose works, such as this portrait, must have appeared unfamiliar and somewhat strange to a visually unsophisticated public.

There are ample precedents for pictures of this type in the history of art, and it is not unusual to find in them such rich and opulent surroundings—such as we see in this portrait—as a way of emphasizing the dignity of the profession. Morse almost certainly saw, for example, Angelica Kauffmann's *Design* painted for the Central Hall of the Royal Academy, London. Although in the present work the architectural elements, the style of the furniture, and even the type of fabrics depicted unmistakably link it to the period of the Greek revival in America, the overall composition harkens back to the baroque era. In particular, it recalls the style of Peter Paul Rubens, who in a number of portraits (notably *Alethia Talbot and Her Train*, 1620, *Helene Fourment in Her Wedding Dress*, 1630–1632, both at the Alte Pinakothek, Munich, and *The Family of Balthasar Gerbier*, 1639–1640, original lost, a version at the National Gallery of Art, Washington, D.C.) posed his full-length figures before balustraded terraces opening onto landscape backgrounds and surrounded by falling drapery and sumptuous fabrics. Alternately, the tight, linear character of the execution is neoclassical in style, while the coloring again departs from contemporary conventions and reveals the influence of the works of Paolo Veronese, whose tonalities, according to WILLIAM DUNLAP, Morse attempted to emulate.

Morse's portrait of his daughter, which is certainly an idealized painting in the extreme, has been called *The Muse* even though the early exhibitions simply list it as a portrait of a lady or the artist's daughter. In 1837, however, a critic did note that Miss Morse, "but for the modern costume, might pass for a Clio by a master of by-gone days." Since then the informal title of *The Muse* has remained in use. A more perceptive commentator might have identified Morse's daughter as a personification of the art of drawing or design, but at least this early writer sensed that more was attempted here than straightforward portraiture unencumbered by iconographical meaning. The obvious allusion to the artist's craft made by the sitter's active engagement in drawing, the large-size folio in which she sketches, the magnifying glass attached to the ribbon on the couch, as well as the association with antiquity established by the presence of the classical vase are significant. Accordingly, an interpretation of this work as Susan Walker Morse personifying the art of design is here put forward as an alternative to the traditional identification of the sitter as a muse—which she cannot be since her attributes are not those of any one of the muses and since a muse of design was not known in antiquity.

According to the critic Henry T. Tuckerman, writing in 1867, this was the artist's last picture. Later (see MMA [1932]), it was pointed out that at least one other portrait, painted four years later, exists. It does seem, however, that this was Morse's last major painting intended for exhibition and meant to attract public attention. If so, the representation of his daughter personifying the art of design becomes especially meaningful. At this time Morse held the unpaid appointment of professor of the literature of the arts of design at New York University. Not without a degree of irony, he surrounded Susan Walker Morse with the material wealth he could not actually give her. Many years later, in 1849, after he had long given up painting, he wrote to James Fenimore Cooper, "I have no wish to be remembered as a painter, for I never was a painter. My ideal of that profession was perhaps too exalted—I may say is too exalted. I leave it to others more worthy to fill the niches of art" (quoted in E. L. Morse, ed., 2, p. 31). During his painting career, however, Morse, as his works

bear out, had attempted to live up to his ideals. This is nowhere more evident than in the portrait of his daughter, in retrospect, the artist's parting tribute to his first profession.

Susan Walker Morse, whose mother, Lucretia Pickering Walker Morse, died in early 1825, was brought up by her father and grandparents. (Her father did not remarry until 1848.) In 1839 she married Edward Lind, who eventually became the owner of his family's large sugar plantation in Puerto Rico. Their son, Charles Walker Lind, was born in 1842. Never particularly happy with life on the island, Susan often visited her now wealthy and eminent father at Locust Grove, his estate on the Hudson near Poughkeepsie, New York. In the early 1870s, with economic conditions at the plantation deteriorating steadily, Susan's family circle fell apart. In 1872 her father died; the next year, after an altercation with his father, her son shot himself. When her husband died in 1882, the plantation was entirely in the hands of creditors. She was permitted to remain in the mansion largely due to their respect for the memory of her famous father, but she led the life of a recluse. On December 7, 1885, she jumped overboard from a Spanish mail steamer on a journey from Puerto Rico to Havana.

This portrait hung at Locust Grove while Morse lived there and descended in his family until 1917.

Oil on canvas, 73¾ × 57⅝ in. (187.3 × 147.4 cm.).
REFERENCES: *New York Mirror* 14 (March 25, 1837), p. 312, mentions "the full-length portrait of a young lady . . . on the easel of Mr. Morse. We have seen it completed and it more than realises our expectations"; (April 29, 1837), p. 351, says it is the first picture "which catches the eye" upon entry into the NAD exhibition and describes it as "a portrait of a young lady, sitting with a port-crayon in her hand. Its principle charm is its simplicity and grace; but the drawing, keeping and colouring, are of the first grade." Also calls it a "classical production" // G. T. Strong, *The Diary of George Templeton Strong*, ed. by A. Nevins and M. H. Thomas (1952), p. 61, April 26, 1837, "Went to the Academy of Design . . . There's a portrait of the daughter of Morse of New Haven, a splendid painting" // *New York Mirror* (May 27, 1837), p. 383, in an extensive review, says that in this painting Morse "claims our admiration for combining with portraiture those qualities which belong to historical composition. We have, in this truly splendid full-length, a composition which, but for the modern costume, might pass for a Clio by a master of by-gone

days." Calls it "the most perfect full-length portrait that we remember to have seen from an American artist" // *Knickerbocker* 9 (June 1837), p. 620, "An exceedingly fine picture, and one upon which the eye rests long and often, with increasing pleasure. The graceful ease of the attitude, the general harmony of the coloring, and the clearness and firmness of the flesh tints are not exceeded by any portrait in the gallery. The sky is objectionable, both in the coloring, which is strangely coppery, and in the disposition of the clouds, which are moulded up into queer globular patches, such as we have never seen in nature. Mr. Morse may have seen such, however. Even with this draw-back, it is an uncommonly fine picture" // H. T. Tuckerman, *Book of the Artists* (1867), p. 169, "His last picture hangs in the drawing-room of 'Locust Grove,' his beautiful domain on the Hudson . . . it is an admirable full-length of his daughter // C. Mabee, *The American Leonardo* (1943), p. 294, says picture hung in the rotunda of the Capitol in 1845 // A. T. Gardner, *MMA Bull.* 4 (1946), pp. 267–268, "This portrait has sometimes been titled The Muse, but one feels that this classical allusion is inappropriately heavy and formal for a picture which is essentially a summing up of all that the genteel maiden of 1835 should be—unworldly and good, fashionably pale, a perfect expression of sheltered female virtue" // Gardner and Feld (1965), pp. 190–192 // J. T. Flexner, *Nineteenth Century American Painting* (1970), color ill. p. 11 // C. T. Overman (Lind family descendant), letter in Dept. Archives, March 21, 1973, gives biographical information // MMA, 1976, *A Bicentennial Treasury, American Masterpieces from the Metropolitan*, no. 45 // J. Wilmerding, *American Art* (1976), p. 68, claims that it is painted "in a fully neoclassical manner" // Grey Art Gallery, New York University, *Samuel F. B. Morse* (1983), exhib. cat. by P. J. Staiti and G. A. Reynolds, p. 77, discuss and point to antecedents by Reynolds and Rubens // W. Kloss, *Samuel F. B. Morse* (1988), p. 140, color ill. p. 141 // P. J. Staiti, *Samuel F. B. Morse* (1989), ill. p. 218, color ill. pl. xvi, pp. 215–222, calls it his "most spectacular late picture . . . [and] one of the most extraordinary full-length portraits in American art"; discusses antecedents by Guercino, Rubens, and Reynolds; describes subject as "imprisoned by concentric frames . . . at a divide between the natural world . . . and the highly structured interior world—the studio—where order and imagination collide."

EXHIBITED: NAD, 1837, no. 71, as Full Length of a Young Lady, Lent by S. F. B. Morse // Stuyvesant Institute, New York, 1838, *Exhibition of Select Paintings by Modern Artists* (Dunlap Benefit Exhibition), no. 9, as Full Length of a Young Lady, lent by S. F. B. Morse // Athenaeum Gallery, Boston, 1840, no. 71, as Portrait of the Artist's Daughter // Artist's Fund Society, Philadelphia, 1842, no. 72, as Full Length Portrait of the Artist's Daughter // U. S. Capitol, Washington, D. C., May 1845 // MMA, 1874, *Loan*

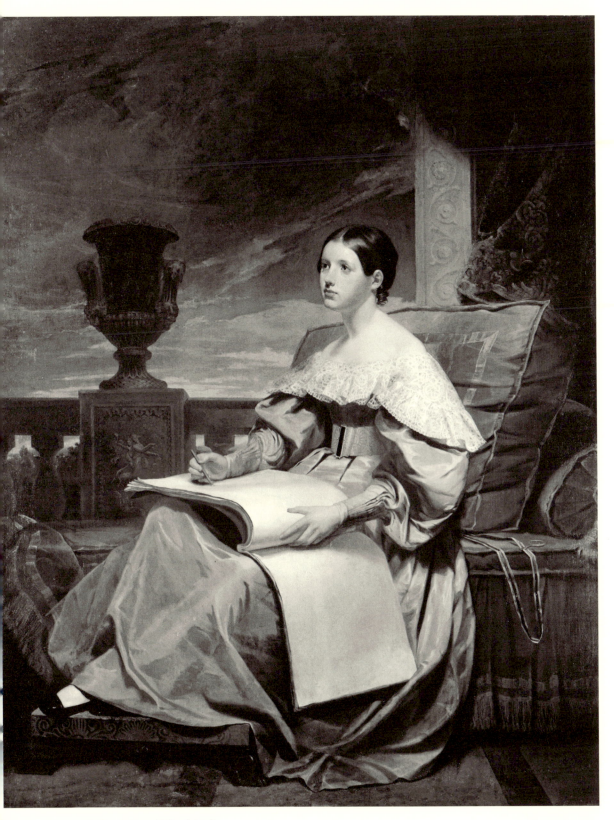

Morse, *Susan Walker Morse (The Muse)*.

Exhibition of Paintings, no. 119, as Portrait of Mrs. Lind, lent by Mrs. S. F. B. Morse; 1895, *Retrospective Exhibition of American Paintings*, no. 200t, as Portrait of Mrs. Lind, lent by Mrs. S. F. B. Morse // Brooklyn Museum, 1917, *Early American Paintings*, no. 56, as Susan Walker Morse, known as "The Muse," lent by H. L. Pratt // MMA, 1932, *Samuel F. B. Morse*, exhib. cat. by H. B. Wehle, p. 26, notes that the portrait of Mrs. Charles W. Morse was painted four years after this picture, p. 40, lists it; 1939, *Life in America*, no. 107 // World's Fair, New York, 1940, *Masterpieces of Art*, no. 292b // NAD, New York, 1950, *Morse Exhibition of Arts and Science*, no. 19 // MMA, 1965, *Three Centuries of American Paintings* (checklist arranged alphabetically) // Whitney Museum of American Art, New York, 1966, *Art of the United States, 1670–1966*,

exhib. cat. by L. Goodrich, no. 192, pp. 12, 31, color ill. // MMA, 1970, *Nineteenth Century America*, exhib. cat. by J. K. Howat and N. Spassky, no. 31 // National Gallery of Art, Washington, D. C.; City Art Museum, Saint Louis; Seattle Art Museum, 1970–1971, *Great American Paintings from the Boston and Metropolitan Museums*, exhib. cat. by T. N. Maytham, no. 34.

Ex COLL.: the artist, d. 1872; his second wife, Sarah Griswold Morse, Poughkeepsie, N. Y., d. 1902; his granddaughter, Susan Lind Morse (Mrs. George Kellogg Perry), d. 1910; George Kellogg Perry, until about 1917; Herbert Lee Pratt, Glen Cove, N. Y., by 1917 until 1945.

Bequest of Herbert L. Pratt, 1945.
45.62.1.

CHESTER HARDING

1792–1866

Chester Harding was born in Conway, Massachusetts, the fourth of twelve children born to Olive Smith and Abiel Harding. His father, a would-be inventor, did not adequately provide for his family, with the result that, at an early age and with hardly any formal schooling, Chester Harding was forced to look after himself. In 1806 the family moved to Madison County in central New York, where Harding learned chairmaking, cabinetwork, and other woodworking skills, as well as house and decorative painting. During the War of 1812 he served as a drummer boy. In 1815 he married Caroline Woodruff and settled in Caledonia, New York. Having incurred debts in his cabinetmaking business and later from a tavern he kept, Harding left town. He made his way to Pittsburgh, where he worked at a variety of jobs. Shortly thereafter he secretly returned to Caledonia for his wife and child.

Harding's first interest in portrait painting was in Pittsburgh, where he became acquainted with an ornamental sign and portrait painter by the name of Nelson. Harding immediately fancied the idea of "fixing likenesses," and though he could ill afford the ten dollars apiece, he commissioned Nelson to paint portraits of himself and his wife, hoping to see the portrait-painting process, but this Nelson did not allow. His own first attempt, a portrait of his wife, delighted him and he claimed that painting was like the "discovery of a new sense" (Dunlap [1834], p. 18)

Harding heard from his brother Horace, a chairmaker and amateur portrait painter who was living in Paris, Kentucky, that a local portrait painter there was receiving fifty dollars "a head." The local artist was probably MATTHEW HARRIS JOUETT. Impressed by this information, Harding packed up his family and went down the Ohio River to Paris, where he established himself, painting portraits at twenty-five dollars each. After completing about one hundred portraits, he found that he had sufficient funds to spend six weeks in Philadel-

phia studying the portraits of THOMAS SULLY and others. This was an important visit for him, for it was his first look at paintings by academic artists. He returned to Kentucky in 1820 with a critical view of his own work, realizing that as a self-trained artist his composition, drawing, and color lacked refinement.

Finding commissions difficult to obtain in 1820, Harding moved to Saint Louis, where he established a modest reputation. In June, he made a hundred-mile trip into the backwoods to paint one of the few known likenesses of Daniel Boone from life (Massachusetts Historical Society, Boston). In July 1821, having prospered, he took his family back to western New York. He then spent a successful winter in 1821 painting in Washington, D.C. The following autumn he went to Boston to meet GILBERT STUART, from whom he learned a good deal. Harding painted in Northampton, Massachusetts, during the summer of 1822 and was urged by several Bostonians to settle in their city. Though he was reluctant, due to the competition from Stuart, he finally yielded and "for six months rode triumphantly on the wave of fortune" (ibid., p. 34). The best of society came to be painted by this genial frontiersman who was noted for his keen perception of character. Not surprisingly Harding's portraits of this period show the influence of Stuart in the luminous flesh tones and character portrayal of the sitters. In six months of work in Boston he had saved enough to finance two years in Europe. After settling his family in Northampton, Massachusetts, he sailed for Liverpool in August 1823.

In England he developed a strong appreciation for the art of the past as well as for the current romantic vogue. Richard Rush, the American minister, gave him his first commission in London and introduced him to Sir Thomas Lawrence, whose work he particularly admired, and the duke of Sussex. Sussex sat for him, entertained him at Kensington Palace, and introduced him to the duke of Hamilton. Harding was invited to Hamilton Palace for extended visits and the duke sat for him several times. He was thus established and rarely at a loss for commissions. Other members of the nobility and dignitaries who sat for him were: the dukes of Gloucester and Norfolk, Lord Coke and Lord Aberdeen. Harding's success abroad, heightened by his entries in exhibitions at the Royal Society of British Artists and the Royal Academy, was nothing short of astonishing. By 1825 he had decided to settle in Glasgow and was wealthy enough to send for his family.

The following year, however, due to a depressed economy in Britain, he returned to Boston. After four prosperous years there he moved his family to Springfield. Harding continued to work in Boston, where he freely mingled with the city's leading citizens and painted prolifically until his death in 1866.

BIBLIOGRAPHY: William Dunlap, *A History of the Rise and Progress of the Arts of Design in the United States* (2 vols., New York, 1834) 2, pp. 65–72. Includes an account supplied by Harding. // Chester Harding, *My Egotistography* (Boston, 1866). An autobiography written for his children and later expanded by his daughter Margaret Eliot White and published as *A Sketch of Chester Harding, Artist, Drawn by His Own Hand* (Boston, 1929) // Leah Lipton, *A Truthful Likeness: Chester Harding and His Portraits* (Washington, D. C., 1985). The catalogue of an exhibition held at the National Portrait Gallery, it is the most complete historical treatment of Harding and includes a checklist of his known paintings.

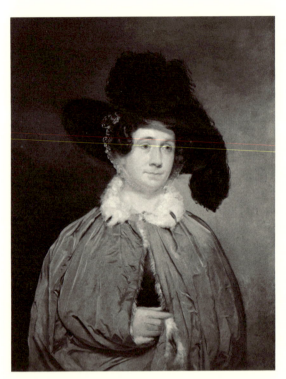

Harding, *Mrs. Thomas Brewster Coolidge.*

Mrs. Thomas Brewster Coolidge

Mrs. Thomas Brewster Coolidge (1791–1841) was born Clarissa Baldwin, daughter of Loammi Baldwin and his second wife, Margaret Fowle Baldwin, in Woburn, Massachusetts. Her father, a civil engineer of note, had been a colonel of the Twenty-sixth Regiment of the Continental Army at Boston and a commander at the Battle of Trenton. Clarissa was married to Thomas Brewster Coolidge in 1812, and they settled in Hallowell, Maine. The couple had one son.

Mrs. Coolidge's fashionable costume is that of the period between 1825 and 1830. She is enveloped by a voluminous, ermine-lined, silk taffeta cape, and wears a large hat laden with ostrich plumes.

The portrait was probably painted in 1827, not too long after Harding's return to Boston. Mrs. Coolidge's brother, the well-known civil engineer Loammi Baldwin, 2nd, had been painted by Harding in London in 1823. He was a member of the association formed to build a monument to commemorate the Battle of

Bunker Hill. Conceivably, Mrs. Coolidge is shown in the elaborate costume she wore at the cornerstone-laying ceremony late in 1825. Other similarly stylish portraits by Harding, *Mrs. Daniel Webster*, 1827 (Massachusetts Historical Society, Boston) and *Mrs. John Ball Brown*, ca. 1827 (MFA, Boston), are known to have been painted after the celebration, and, in the case of Mrs. Webster, she is shown in the gown she wore to this event (H. Backlin-Landman, *Oberlin College Bulletin* 28 (Spring 1971), pp. 194–200). All these portraits reflect the painterly and colorful mastery of Sir Thomas Lawrence, whose work Harding admired and studied while in England.

Despite the sophisticated dramatic placing of Mrs. Coolidge's figure against a stark background, Harding shows a lack of attention to anatomical correctness: the sitter's hand and arm appear implausible. Such a lapse was typical of Harding's style as were the alterations he made to simplify the composition and the costume. He omitted, for example, ties for Mrs. Coolidge's cap. Also, a pentimento is apparent along the bottom line of the hat where Harding made the brim narrower. Still, the rendering of the folds, creases, and highlights of the silk cloak is highly accomplished and gives the cloak added focus. The result is an example of Harding's best manner, in which he simply and directly captures the personality of the subject.

Oil on canvas, 36¼ × 28 in. (92.1 × 71.1 cm.).
RELATED WORK: Chester Harding, *Mrs. Thomas Brewster Coolidge*, ca. 1827, oil on canvas, 36¼ × 28 in. (92.1 × 71.1 cm.), New York art market, 1983, ill. in Lipton, *A Truthful Likeness* (1985), p. 146.
REFERENCES: American Art Galleries, New York, *Illustrated Catalogue of the Collection of the Late Frank Bulkeley Smith of Worcester, Mass.*, sale cat. (April 22–23, 1920), no. 147, as Mrs. Thomas Brewster Coolidge, gives provenance // B. Burroughs, *Catalogue of Paintings in the MMA* (1931) p. 153 // Gardner and Feld (1965), p. 193 // *The Britannica Encyclopedia of American Art* (1973), p. 266 // L. Lipton, *A Truthful Likeness* (1985), p. 65, ill. p. 146.
EXHIBITED: NAD, 1951, *American Tradition*, no. 60 // MMA, 1965, *Three Centuries of American Painting* (checklist arranged alphabetically) // Los Angeles County Museum of Art and M. H. De Young Memorial Museum, 1966, *American Paintings from the Metropolitan Museum of Art*, ill. no. 24 // Montreal Museum of Fine Arts, 1967, *The Painter and the New World*, no. 160 // MMA, 1970, *Nineteenth Century America*, ill. no. 36 // National Gallery of Art, Washington, D. C.; City Art

Museum, Saint Louis; Seattle Art Museum, 1970–1971, *Great American Paintings from the Boston and Metropolitan Museums*, exhib. cat. by T. N. Maytham, no. 29, discusses it.

ON DEPOSIT: MFA, Boston 1907–1916, lent by Baldwin Coolidge.

EX COLL.: the subject, Hallowell, Me., d. 1841; her son, Benjamin Coolidge, until 1871; his son, Baldwin Coolidge, by 1907–at least 1916; Boston art market; with Frank Bulkeley Smith, 1920 (sale, American Art Association, New York, April 22–23, 1920, no. 147).

Rogers Fund, 1920.

20.75.

Stephen Van Rensselaer

Stephen Van Rensselaer (1764–1839) was born in New York, the son of Catherine Livingston and Stephen Van Rensselaer. He was the eighth patroon of a vast family estate founded in 1630. At that time Kiliaen Van Rensselaer, a wealthy merchant from Amsterdam and director of the Dutch West India Company, formed Rensselaerswyck, twenty-four miles wide and forty-eight miles long, which included over seven hundred thousand acres of what are now Rensselaer, Albany, and part of Columbia counties.

After the completion of a large manor house in 1765, the reception room of which is now installed as a period room in the American Wing of this museum, Stephen Van Rensselaer's father brought his wife and infant son up the Hudson River to settle in their new quarters. Four years later, the elder Van Rensselaer died, leaving the estate to his infant son. Philip Livingston, young Stephen's maternal grandfather, then took charge of his education. After graduating from Harvard with honors in 1782, he married Margaret Schuyler, daughter of General Philip Schuyler, and began actively managing his own estates. He was drawn into public affairs by virtue of his prominence as well as by the encouragement of his new brother-in-law, Alexander Hamilton. In 1789 he was elected as a Federalist to the New York Assembly, in 1790 to the state senate, and in 1795 was chosen lieutenant governor under John Jay. Both men were reelected in 1799. In 1801 Van Rensselaer was unsuccessful as a candidate for governor against George Clinton. During the War of 1812 he was appointed major general in command of the state militia for the entire northern frontier.

Before the war, Van Rensselaer had been commissioned to designate the route for the Erie Canal, of which he was an early and ardent supporter. He served as a member of the canal board until 1824 and as its president until his death.

From 1823 to 1829 Van Rensselaer was a member of Congress. From 1819–1839 he was a regent of the University of the State of New York and chancellor from 1835 to his death. In 1824 he founded the first scientific school at Troy (later Rensselaer Polytechnic Institute). He was elected president of the Albany Institute and the Albany Lyceum of Natural History. He also served as president of the state's first board of agriculture.

Van Rensselaer insisted on managing his enormous patroonship along the strictly feudal lines on which it had been organized and refused to sell any part of it to his tenants. He was no despot, however, and his leniency was legendary. When he died in 1839 he was owed a half million dollars. According to his will, payments by his tenants were to be applied to his own debts, but many of the tenants refused to pay. A politi-

Harding, *Stephen Van Rensselaer.*

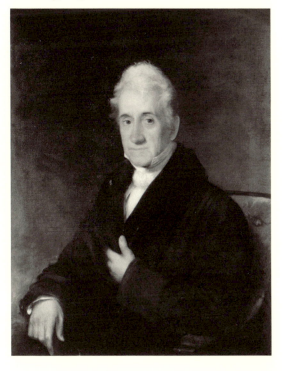

cal crisis was precipitated which was only re-solved when the amended constitution of the state abolished all feudal tenures in 1846.

Van Rensselaer's first wife, by whom he had three children, died in 1801. In 1802 he married Cornelia Paterson, daughter of Judge William Paterson. They had nine children.

After Chester Harding's return from England in 1826, he traveled extensively to cities all over the eastern United States. This portrait may have been painted in Albany or New York, where Van Rensselaer also had a home. In 1828 a portrait by Harding of General Van Rensselaer was exhibited at the American Academy of the Fine Arts. As this and two replicas are the only known portraits of Van Rensselaer by Harding, it is likely that it was painted prior to 1828. At that date the sitter's age was about sixty-three. The picture appears to be a sensitive and honest portrayal of the elderly patroon. A writer for the *Magazine of Art History* in 1884 is fully in accord with Harding's characterization and described Van Rensselaer as "a man of fine personal ap-pearance, tall, fully six feet, very straight and symmetrical, weighing perhaps one hundred and eighty pounds. He dressed plainly, but with scrupulous elegance, and had the graceful, cour-teous manners of the old school."

Oil on canvas: 36 × 28 in. (91.4 × 71.1 cm.).

RELATED WORKS: Chester Harding, *Stephen Van Rensselaer*, 1828, charcoal on paper, 21½ × 17 3/16 in. (54.5 × 44.2 cm.), Deerfield Academy, Deerfield, Mass., ill. in E. W. McClave, *Stephen Van Rensselaer III* (1984), p. 33 // Chester Harding, *Stephen Van Rensselaer*, 1828, oil on canvas, 35½ × 28 in. (90.2 × 71.1 cm.), Albany Institute of History and Art, a replica, ill. ibid., p. 15 // Chester Harding, *Stephen Van Rensselaer*, 1828, oil on canvas, 35½ × 28½ in. (90.2 × 72.4 cm.), Wyatt Collection, Geneva, Ill., a replica, ill. ibid., p. 38 // Daggett, Hinman and Company, after Harding, *Stephen Van Rensselaer*, ca. 1840 engraving, 4 × 3⅛ in. (10.2 × 8.1 cm.) frontis. to L. H. Sigourney, ed., *Religious Souvenir* (1840) // William Ver Bryck, *Stephen Van Rensselaer*, 1864, oil on canvas, 36 × 29 in. (91.4 × 73.3 cm.), Rensselaer Polytechnic Institute, Troy, N. Y., a copy.

REFERENCES: [J. Trumbull], *New York Commercial Advertiser*, June 28, 1828, p. [2], notes, "two very respectable portraits by Mr. Harding—not equal how-ever to our expectations, after all we had heard of his great success in London" (no. 60, probably this painting) // T. A. Glenn, *Some Colonial Mansions*, 1 (1898), ill. p. 161 // M. E. White, ed., *A Sketch of Chester Harding, Artist* (1929), ill. opp. p. 70 // Gardner

and Feld (1965), p. 194 // E. W. McClave, *Stephen Van Rensselaer, III* (1984), ill. p. 27 // L. Lipton (1985), p. 81, ill. p. 184.

EXHIBITED: American Academy of the Fine Arts, 1828, no. 60 (probably this picture) // MMA, *Three Centuries of American Painting*, 1965 (checklist arranged alphabetically).

EX COLL.: the subject's great great granddaughter, Louisa Robb (Mrs. Goodhue Livingston, Sr.), New York, by 1911.

Gift of Mrs. Goodhue Livingston, Sr., 1954. 54.51.

Mrs. Francis Stanton Blake

Mary Hubbard Nevins (1819–1844) was the daughter of Samuel Williamson Nevins of Ger-mantown, Pennsylvania. In 1840 she became the wife of Francis Stanton Blake, a Boston mer-chant. Before her death four years later Mrs. Blake had one daughter. For many years the subject was identified only as Mrs. Blake, a rela-tive of the donor. Genealogical research indicates that the donor's mother, the former Elizabeth West Nevins, was a niece of Mrs. Blake.

Since Mrs. Blake was married in German-town and lived out the few remaining years of

Harding, *Mrs. Francis Stanton Blake.*

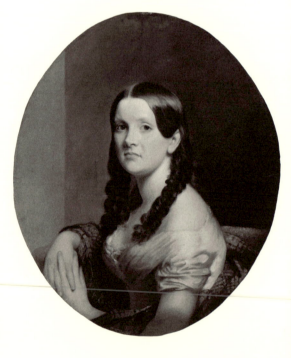

her life in Boston, it is likely that Harding painted her there between 1840 and 1844. She is dressed in a white satin gown with the short sleeves that replaced full gigots about 1840; a red plaid shawl is draped around her arms. Her hair is in the latest style.

Harding was appreciated for his fine depiction of character, or as one critic wrote, for capturing the "hints of temperament" that "lurk in the fine lines which nature draws upon the living face" (Samuel Bowles, *Atlantic Monthly* 19 [April 1867], p. 487). In this portrait there is the hint of a frown and a downward curl of the lip that betrays a haughty disposition.

Oil on canvas, oval, 30 × 25 in. (76.2 × 63.5 cm.).
REFERENCES: B. Burroughs, *Catalogue of Paintings in the Metropolitan Museum of Art* (1931), p. 153 // *The Britannica Encyclopedia of American Art* (1973) p. 266; ill. p. 267 // Gardner and Feld (1965), p. 195 // L. Lipton, *A Truthful Likeness* (1985), ill. p. 138.
EXHIBITED: NAD, 1942, *Our Heritage*, no. 4.
EX COLL.: probably the subject's niece, Elizabeth West Nevins (Mrs. Charles Perkins), Glen Cove, N.Y.; her daughter, Mary L. Perkins (Mrs. Waldron K. Post), New York.
Gift of Mrs. Waldron K. Post, 1925.
25.156.

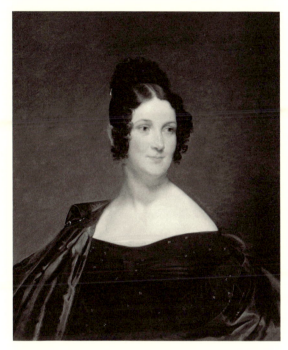

Harding, *Eunice Harriet Brigham*.

Eunice Harriet Brigham

Eunice Harriet Brigham (1813–1850) was a daughter of Levi Brigham and Eunice Monroe Brigham of Boston. Her father was a wine merchant there. In 1836 she was married to Samuel S. Ball, a partner in the Boston jewelry firm of Jones, Low, and Ball. Two years after their marriage, Mr. Ball died, leaving his wife and one daughter.

The portrait displays Harding's ability in handling a variety of textures—one juxtaposed upon another: folds of glossy taffeta over pleats of fine wool and delicate lace against smooth flesh. Skin tones of light to rose pink contrast with the subdued colors of the costume and olive background.

Miss Brigham's stylish maroon gown, flecked with tiny white and green dots, is gathered at the bodice and has wide gigot sleeves. Over her shoulder is draped a deep grayish-blue silk taffeta cape with a wide-edged collar. The style of her dress, coiffure, and apparent age indicate a date of about 1835. Most likely the portrait was painted just prior to her marriage. By 1830 Harding had moved to Springfield, Massachusetts, but he retained a studio in Boston and continued to work in the area.

Oil on canvas, 30 × 25 in. (76.2 × 63.5 cm.).
REFERENCES: Gardner and Feld (1965), p. 194 // L. Lipton, *A Truthful Likeness* (1985), ill. p. 140.
EXHIBITED: MMA, 1965, *Three Centuries of American Painting* (checklist arranged alphabetically).
EX COLL.: descended in the subject's family to Helen Winslow Durkee Mileham, until 1955.
Bequest of Helen Winslow Durkee Mileham, 1955.
55.111.10.

THOMAS DOUGHTY

1793–1856

Thomas Doughty was born in Philadelphia on July 19, 1793. Little is known about his family or their origins. When he was a child, his schoolmaster permitted him to draw one afternoon each week, but it is doubtful that he ever had any formal training. He seems to have been self-taught. Doughty first appears in the Philadelphia city directory in 1814 listed as a "currier" of leather, working in partnership with his brother Samuel. By 1816 this business had dissolved, and Thomas is listed as a painter. In May of that same year a landscape by him was shown at a special exhibition at the Pennsylvania Academy of the Fine Arts. But he evidently found it difficult to make his living as an artist; for in 1818 and 1819 he is again listed in the directories as a "leather currier," though now by himself. During this period he probably continued to paint. In any case, by 1820 he was working full-time as a painter. A number of landscapes from these early years survive, so it is certain he was receiving orders. His reputation grew, and in 1824 he was elected a member of the Pennsylvania Academy.

From the beginning, Doughty attempted to paint accurate views of recognizable American sites. Their specificity, achieved as a result of assiduous drawing outdoors, was greatly admired, especially during the early years of his career. Thus in 1826, when two of his paintings appeared in the first annual exhibition of the National Academy of Design, the *New York Mirror* called them "the most beautiful landscapes in the room." Yet Doughty's style was too rooted in eighteenth-century landscape conventions to prove durable. The influence of his earlier works on THOMAS COLE is recognized, but Cole quickly surpassed him and, by setting a new standard of accuracy, realism, and atmospheric effects in his own landscapes, made Doughty's seem obsolete.

In the summer of 1828 Doughty left Philadelphia, and by 1829 he was settled in Boston. He did not like the New England climate, however, and a year later was back in Philadelphia. There, between 1830 and 1832, he edited, with his brother John, *The Cabinet of Natural History and American Rural Sports*, a series to which he contributed many detailed representations of birds and animals. During this time he ceased working as a landscape painter. Then, from 1832 to 1837, he was again in Boston, where he seems to have made an adequate living. By now he had a large family to support, and he seems to have begun to paint more for profit than with artistic conviction. Ironically, it was during this period that he painted his best-known work, *In Nature's Wonderland*, 1832 (Detroit Institute of Arts). He also ran a painting school in order to earn extra income.

In 1837, at the age of forty-four, Doughty finally traveled to England. There he did not paint much of the local landscape but instead concentrated on producing American scenes from memory. He probably ran out of money quickly; for he was back in the United States by May 1838, this time in New York. His landscapes now began to reflect the influence of English landscapists, particularly of John Constable. These paintings, however, lacked much of the appeal of the earlier works. Doughty moved about quite a bit: he was in the area of

Albany, New York, in 1841; Washington, D.C., in 1842; Boston in 1843, and New Orleans in 1844. Eighteen forty-five saw the beginning of a two-year trip to Europe, where he painted a greater number of English views than previously; he also visited Paris. He returned to New York in 1848, but lack of patronage presumably forced him to move about once again, first to Long Island, then to New Jersey, and finally in 1852 to Owego, New York. He never regained his lost powers, and his last years were spent in poverty in New York, where he died on July 24, 1856. Dunlap's remark in 1834 is a fitting epitaph: "He was at one time the first and best in the country."

BIBLIOGRAPHY: William Dunlap, *A History of the Rise and Progress of the Arts of Design in the United States* (2 vols., New York, 1834) 2, p. 381 || *DAB* (1939), s.v. "Doughty, Thomas" || PAFA, *Thomas Doughty, 1793–1856: An American Pioneer in Landscape Painting*, exhib. cat. by Frank H. Goodyear, Jr. (1973). The indispensable work on Doughty.

On the Hudson

The exact location of this view along the Hudson is not known, but the combination of a wide expanse of water in the middle ground with the high mountains in the distance suggests the vicinity of the Catskills north of Newburgh, New York. In its relatively undifferentiated coloring and absence of dramatic effects, as well as in its tame execution, this painting recalls Doughty's early work. The attempt to represent a landscape view stretching toward a far horizon already reveals the influence of the early landscapes of THOMAS COLE and ASHER B. DURAND. Cole's *Winnipiseogee Lake* (Albany Institute of History and Art), engraved by Durand in 1830, makes use of a cone-like recession to a central area in the canvas that is frequently employed by Doughty in works dating from the 1830s. Another print by Durand of 1830, *Delaware Water Gap*, makes use of the same kinds of recession and, like the Cole, deploys flanking trees, the one on the right close to the picture plane and the one on the left a bit farther in, as repoussoir devices to frame the scene and articulate the depth of the foreground. The present work, accordingly, is assigned a date about 1830 to 1835.

At the beginning of his career, Doughty's plainer, more direct approach to landscape painting made him an innovator in this country, but by the 1830s it is clear that he was receptive to the advances achieved by younger artists who had once been influenced by him. Through prints and direct exposure to the works of Cole and Durand, Doughty began to reform his style which, however original, had been essentially eighteenth century in character and did not reflect the emerging romantic sensibility. He was by nature a conservative artist, and, in this pic-

Doughty, *On the Hudson*.

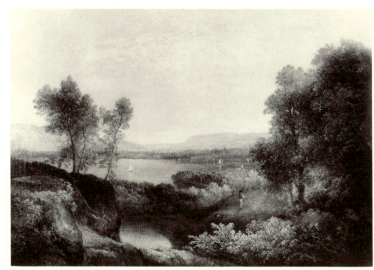

ture the tonalities employed—lightly tinted whites in the sky and monotonous yellow-greens in the foliage—still reflect his early technique. His observation of natural features is not very careful, foliage dissolves into masses of texturized colors mixed with glazes, and expressive contrasts of land, water, and sky are nonexistent. Thus, while the picture is pleasant, well-balanced, and unmistakably American, it still maintains a mood more characteristic of the English-inspired landscapes of JOSHUA SHAW and William Guy Wall (1792–after 1864).

Oil on canvas, 14¾ × 21½ in. (37.5 × 54.6 cm.). Signed at lower center: T. DOUGHTY.
REFERENCES: B. Burroughs, *Catalogue of Paintings*, *Metropolitan Museum of Art* (1931), p. 102, identifies the distant hills as those near West Point // Gardner and Feld (1965), p. 197.
EXHIBITED: Utah Centennial Exposition, Salt Lake City, 1947, *One Hundred Years of American Painting*, no. 1 // Phoenix Art Museum, 1967–1968, *The River and the Sea* // Lowe Art Museum, University of Miami, Coral Gables, 1974–1975, *Nineteenth Century American Topographic Painters*, no. 37.
ON DEPOSIT: New York State Historical Association, Cooperstown, N. Y., 1969–1970; Allentown Art Museum, Pa., 1975–1976.
EX COLL.: Samuel P. Avery.
Gift of Samuel P. Avery, 1891.
91.27.1.

Doughty, *River Glimpse*.

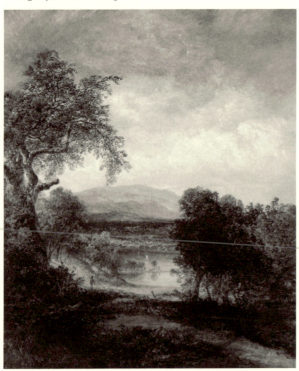

River Glimpse

In the fall of 1837 Doughty, already a well-known landscape painter in this country, traveled to England; he was then forty-four years old. Little is positively known of his activities abroad. His stay lasted only a few months, and by May of 1838 he was back in New York. To be sure, he observed recent developments in English landscape painting closely, and thenceforth many of his works reveal the various influences of the English picturesque landscape school and its leading light, John Constable. The master's bold brushwork, bright colors, dramatic clouds, and atmospheric depth of field obviously impressed Doughty and prompted him to paint works during the decade of the 1840s which, like *A River Landscape*, possess a vitality his earlier paintings lack. The silvery tone present here, singled out by Henry T. Tuckerman as one of Doughty's virtues (*Book of the Artists* [1867], p. 507), also derives from Constable; so does the overall composition, which in many respects echoes Constable's *Dedham Vale* (Royal Academy 1828; National Gallery of Scotland, Edinburgh), a work of which Doughty may have been aware.

The New York firm of Williams and Stevens, from whom Doughty purchased the canvas this work is painted on, first appears in the city directory in 1843. The painting may thus be dated with reasonable certainty about 1843–1850. As is often the case with Doughty's works painted after about 1837, there exists an almost identical version painted by him. In addition, there is a similar landscape that is oval in format (private coll., ill. in R. H. Love Galleries, *Selections of American Art* [Chicago, 1986], p. 14, no. 27).

Oil on canvas, 30¼ × 25 in. (76.8 × 63.5 cm.). Signed at lower center: T. DOUGHTY.
Canvas Stamp: WILLIAMS & STEVENS / 333 BROADWAY / NEW YORK.
RELATED WORK: *River Scene*, oil on canvas, 30 × 25 in. (76.2 × 63.5 cm.), formerly Knoedler and Co., New York. An almost identical version of this painting.
REFERENCES: E. E. Hale, *Art in America* 4 (1916), pp. 22–40 // B. Burroughs, *Catalogue of Paintings*, *Metropolitan Museum of Art* (1931), p. 102, identifies river as the Hudson; *Limners and Likenesses* (1936), pp. 145–146, dates this painting "1820–1821 at the earliest" // Gardner and Feld (1965), pp. 197–198 // M. K. Tally, memo in Dept. Archives, August 1978, fully discusses this work.
EXHIBITED: Baltimore Museum of Art, 1940, *Ro-*

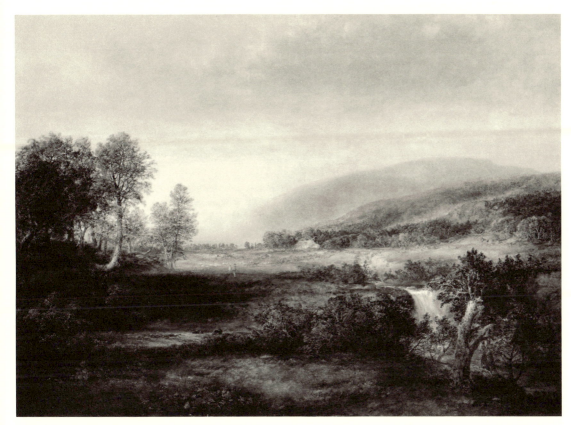

Doughty, *Spring Landscape*.

manticism in America*, not in cat. || MMA, 1965, *Three Centuries of American Painting* (checklist arranged alphabetically) || Hudson River Museum, Yonkers, N. Y., 1970, *American Paintings from the Metropolitan Museum*, no. 13 || Cummer Gallery of Art, Jacksonville, Fla., 1972, *1822 Sesquicentennial Exhibition*, part 1, no. 5 || R. W. Norton Art Gallery, Shreveport, La., 1973, *The Hudson River School*, p. 15, no. 10 || Shizuoka Prefectural Museum of Art, Japan, 1987, *Landscape Painting of the East and West*, no. 1.

Ex coll.: Samuel P. Avery.

Gift of Samuel P. Avery, 1895.

95.17.2.

Spring Landscape

In November 1852, Doughty moved with his family to Owego, New York, on the banks of the Susquehanna River. Shortly after settling there, he wrote the New York physician Uriah Levison of his intention to paint a series of landscape scenes depicting the four seasons: "Winter by Moonlight will be the first picture, . . . then Spring, Summer and Autumn, of course, I shall

do my best on these pictures, and if I have my health they will probably be finished by this time next year" (Doughty to U. Levison, Nov. 21, 1852, Graham Collection of Autograph Letters, Arch. Am. Art). The present work, once part of a series of the four seasons owned by Theodore B. Shelton, has been identified with the paintings Doughty mentioned in this letter, but it is possible that the Shelton set was painted later. Accordingly, this landscape is dated about 1853 to 1856, the year of the artist's death. The other three works belonging to the Shelton set are presently unlocated.

In the closing years of his life, Doughty's pictures were judged harshly by critics who were accustomed by this time to the detailed, highly realistic landscapes of THOMAS COLE, ASHER B. DURAND, and the young FREDERIC E. CHURCH. It was largely to escape their attacks that Doughty removed to western New York State in 1852. Works like this landscape, however, reveal his attempt to catch up with the rapidly evolving style of these painters and paci-

fy his detractors. The great detail in the observation of nature, the large size of the canvas, the panoramic vista opened up to the viewer, and the inclusion of varied landscape features, for example, a river, a waterfall, a blasted tree, mountains, sky, a farm, animals, or people— were all elements of the emerging monumental landscape mode that was taking shape in the United States. With the emphasis on the closely observed details on an expanded foreground, this painting calls to mind such early paintings of Frederic E. Church as *Mountains of Ecuador*, 1855 (Wadsworth Atheneum, Hartford). Doughty's ambitions, however, exceeded his abilities. He lacked the absolute mastery of perspective required to produce pictures in this grand manner. In addition, certain passages of *Spring Landscape* seem to be executed in the hasty, limp manner that characterized his early works and which never altogether disappeared from his landscapes.

Oil on canvas, 44 × 62 in. (111.8 × 157.5 cm.). Signed at lower center: T. DOUGHTY.

REFERENCES: F. H. Markoe, letter in MMA Archives, May 1921, says that Spring was part of a set of four pictures of the seasons and the other three, owned by his mother and his uncle, are in his cousin's house // Gardner and Feld (1965), p. 197 // J. K. Howat, *American Art Review* (Jan.–Feb. 1974), color ill. p. 105.

EXHIBITED: PAFA, 1973–1974, *Thomas Doughty 1793–1856*, exhib. cat. by Frank H. Goodyear, no. 53, p. 31, says that Doughty's *Early Winter* at the North Carolina Museum of Art (cat. no. 52) was part of the set to which our painting belonged // MMA and American Federation of Arts, traveling exhibition, 1975–1856, *The Heritage of American Art*, cat. by M. Davis, no. 75 // New York State Museum, Albany, 1977, *New York: The State of Art*, p. 28; checklist no. 5.

EX COLL.: Theodore B. Shelton, New York, d. 1899; his children, Madeline Shelton Markoe and George F. Shelton, New York, 1917.

Gift of George F. Shelton and Mrs. F. H. Markoe, in memory of their father, Theodore B. Shelton, 1917.
17.66.

ROBERT HAVELL, JR.

1793–1878

Robert Havell, Jr., born in Reading, England, was a member of a family of successful painters and aquatint engravers. His father and grandfather owned a London engraving business known as Daniel and R. Havell. One of their most successful ventures was a series of views of the river Thames based upon drawings by William Havell, Robert Jr.'s cousin. Despite the opportunities afforded by the family business, Robert Havell opposed his son's becoming an engraver. Beginning in 1825, Robert Havell, Jr., made an extensive sketching tour of Monmouthshire. A series of sketches of medieval ruins and other scenery made during the trip brought him to the attention of Colnaghi and Company, one of the most important publishers in London, and he went to work there.

After having met with difficulties in Edinburgh, John James Audubon (1785–1851) arrived in London in 1827 seeking a new aquatint engraver for the elephant-folio of *The Birds of America*. He engaged the elder Robert Havell, who, at Colnaghi's suggestion, had his son Robert Havell, Jr., join him. The father and son worked on the project until 1828; the younger Havell doing the engraving and the elder, the coloring. From then until the completion of the edition in 1838, Robert Havell, Jr., worked alone. He became well known as an aquatint engraver and also completed plates for *A Selection of Hexandrian Plants Belonging to the Natural Orders of the Amaryllis and Lilly*, published in Liverpool (1831–1834). For relax-

ation, Havell continued to make watercolor sketches of rural English scenery during the 1830s. In 1839 he disposed of his engraving business and sailed with his wife and daughter to New York. After a brief stay with Audubon, Havell lived for two years in Brooklyn. In 1842 he bought a house in Sing Sing (now Ossining), New York, where he lived until 1857, when he bought land and built a house in Tarrytown, New York, near Washington Irving, whose house, Sunnyside, he helped design. He remained there until his death in 1878.

Havell apparently came to the United States with the intention of sketching and publishing views of American scenery, which enjoyed enormous popularity. Soon after his arrival he began to take extensive sketching trips along the Hudson River in a horse-drawn carriage outfitted for sleeping. In September 1840, less than a year after his arrival, he exhibited four views painted in oils and an engraved panorama of New York at the Apollo Association. Throughout the 1840s Havell continued to engrave and paint river views and cityscapes, many of which he sold at the Apollo Association. After about 1850, he seems to have done little, if any, commercial printing. Instead he sketched in watercolors and painted in oils, perhaps for his own pleasure. His primary artistic importance was as a skillful engraver of aquatints. His landscape paintings, however, are of special interest because they are among the earliest large-scale views of American scenery. Such views later formed an integral part of the repertoire of the Hudson River school painters.

BIBLIOGRAPHY: Ruthven Deane, "The Copper-Plates of the Folio Edition of Audubon's 'Birds of America,' with a Brief Sketch of the Engravers," *Auk* 25 (Oct. 1908), pp. 401–413 // George Alfred Williams, "Robert Havell, Jr., Engraver of Audubon's 'The Birds of America,'" *Print-Collector's Quarterly* 6 (Oct. 1916), pp. 226–257. Includes information acquired from Havell family papers and conversations with family members // Howard Corning, ed., *Letters of John James Audubon, 1826–1840* (2 vols., Boston, 1930). Contains Havell correspondence // Margaret Sloane Patterson, *Views of Old New York: Catalogue of the William Sloane Collection* (New York, 1968), p. 36. Places Havell's work in the context of the scenographic print tradition // Waldemar H. Fries, *The Double Elephant Folio: The Story of Audubon's Birds of America* (Chicago, 1973).

View of the Bay and City of New York from Weehawken

The view of New York looking across the Hudson River from the New Jersey Palisades was painted in 1840 and is one of Havell's earliest landscape efforts in oil. During the time he lived in England his landscapes were either watercolors or prints. Since so few signed pictures by Havell are known, this work signed and dated 1840 is a key painting. It is one of the group of pictures Havell offered for sale at the Apollo Association not long after his arrival in New York from London.

Views of New York from Weehawken were popularized in prints after Alexander Hamilton's duel with Aaron Burr on the banks of the Hudson River below Weehawken. Visitors often walked up the path from Hoboken to Weehawken to enjoy the view of New York Harbor and the picturesque countryside of the Palisades. The physical beauty of the site made the setting a favorite with illustrators, poets, and travel writers. The series entitled *Hudson River Portfolio* (1820–1825), which included a view of New York from Weehawken by the English-born aquatint engraver John Hill (1770–1850) and the Irish-American painter and publisher William Guy Wall (1792–after 1864), further popularized the view.

Havell was surely familiar with the work of Hill and Wall, but his painting of the view from Weehawken displays a firsthand observation of the scene. Weehawken may have been one of the first sites he visited on his sketching trips along the Hudson River after his arrival in this country. He treated the subject in the standard man-

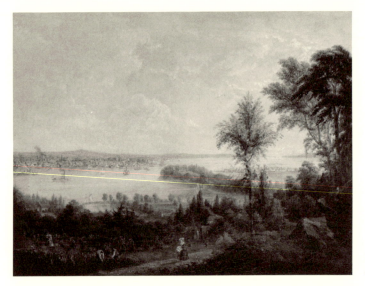

Havell, Jr., *View of the Bay and City of New York from Weehawken.*

ner of Dutch and English landscape scenes. The dark foreground plane is built up on the right side with trees and a rocky outcropping balancing the distant view of New York and Brooklyn on the left horizon. The vegetation is suffused with warm brown and brownish green tones that act as a foil for the vast open sky and water. The picture shows the same characteristic high vantage point with a vast landscape spread below as Havell's *View of the Hudson from near Sing Sing, New York* (NYHS) painted about 1850. This English formula of landscape painting, which he favored, was popular with the Hudson River school painters.

The inscription, which states that the view is from the "Mountain House," is in error. There were many Mountain Houses but none at this site, which was slightly to the south of the James Gore King estate, Highwood, in Weehawken. Dea's Point appears at left center before Havell's viewpoint, and Hoboken at the right center.

Oil on canvas, 24 × 33 in. (61 × 83.8 cm.).

Inscribed on the back: View of the Bay and City of New York / from Mountain House / Weehawken / by / Rob.ᵗ Havell / 1840.

Canvas Stamps: PREPARED BY / EDWARD DECHAUX / NEW YORK. Thompson Collection / New York–1870. GEO. P. ROWELL.

REFERENCES: Gardner and Feld (1965), pp. 199–200 // R. J. Koke, NYHS, memo in Dept. Archives, 1990, identifies the specific site.

EXHIBITED: Apollo Association, New York, 1840, no. 131, as View of the City of New York from Weehawken Heights, for sale.

ON DEPOSIT: Museum of the City of New York, 1935–1963.

EX COLL.: Thomas Thompson, Boston (sale, Leeds and Miner, New York, Feb. 7, 1870, no. 1074); George Presbury Rowell, New York, 1870–d. 1908 (according to stamp on the back); his wife, Jeanette Rigney Hallock Rowell, New York, 1908–1926; Edward W. C. Arnold, New York, by 1935–1954.

The Edward W. C. Arnold Collection of New York Prints, Maps, and Pictures. Bequest of Edward W. C. Arnold, 1954.

54.90.32.

UNIDENTIFIED ARTIST

View of New York from Weehawken

The scene of this painting is taken from close to the same spot as the one by ROBERT HAVELL, JR. (see above). This view, however, comes directly from a William H. Bartlett engraving *View of New York, from Weehawken*, which appeared in volume two of the widely circulated two-volume travel book *American Scenery*. With text by Nathaniel Parker Willis and illustrations by Bartlett, *American Scenery* was the best known of a number of travel books which provided both Eu-

ropean and American audiences with romantic descriptions and views of picturesque scenery. Illustrations from the volumes were a favorite source of inspiration for nineteenth-century American landscape painters.

In this copy of the Bartlett print, the artist has introduced an element of drama to the scene—a stormy sky above the New York skyline. Because it is copied from a print, the individual elements of the composition have a flat quality and there is a lack of cohesion, although the spatial recession across the water is deftly handled. The same print was the source for another very similar painting (NYHS) signed B. W. and dated 1840 (ill. in Koke, *American Landscape and Genre Paintings in the New-York Historical Society*, 3, p. 221). Many painters copied such scenes from print sources, for example, EDMOND C. COATES, whose large view of New York from Weehawken is in the New York State Historical Association at Cooperstown.

Oil on canvas, 24 × 29 in. (61 × 73.7 cm.).
RELATED WORK: William H. Bartlett, *View of New York, from Weehawken*, engraved by R. Wallis, in N. P. Willis, *American Scenery* (London, 1852), 2, opp. p. 30.
REFERENCES: Gardner and Feld (1965), p. 200 // R. J. Koke, NYHS, memo in Dept. Archives, 1990, discusses site and relationship to B. W. painting.
EXHIBITED: Shizuoka, Okayama, Kumamoto Pre-

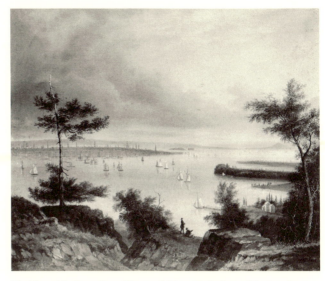

Unidentified artist, *View of New York from Weehawken*.

fectural Museums, Japan, 1988, *Nature Rightly Observed* (not included in cat.).
ON DEPOSIT: Museum of the City of New York, 1940–1963 // Gracie Mansion, New York, 1966–1970 // Parks Department, City of New York, 1971–1973.
EX COLL.: Edward W. C. Arnold, New York, by 1940–1954.
The Edward W. C. Arnold Collection of New York Prints, Maps, and Pictures. Bequest of Edward W. C. Arnold, 1954.
54.90.7.

UNIDENTIFIED ARTIST

View from Staten Island

View from Staten Island is a naive portrayal of the busy marine activity during the mid-nineteenth century at Tompkinsville Landing. The area, now Tompkinsville, is located on the east shore of Staten Island overlooking the Narrows of New York Harbor. On the left shore of the Narrows is Fort Hamilton. Adjacent to it is Fort Lafayette, located on Diamond Reef. Directly opposite Fort Lafayette is Fort Richmond, located on the beach at the base of Fort Tompkins. These fortifications at the Narrows were begun in 1808 to defend the entrance to New York Harbor from enemy invasion. The original Fort Richmond, as depicted here, was torn down in 1847. This

might indicate that the view was painted before that date, but there are other indications pointing to the 1850s. The canvas supplier was at 189 Chatham Street from 1826 to 1865, but the corner of Oliver designation does not appear in his address until the 1850s. The *Columbus* and the *Sylph*, the two paddle steamers shown and named in the painting, ran together from Whitehall Street to Tompkinsville in 1853 for Vanderbilt's Staten Island and New York Ferry Company, although both ships were in service earlier. The *Columbus* went out of service in January 1856. It is probably fair to consider the painting as having been painted about 1855.

The trees and shrubs and the minute details on the ships are skillfully rendered, but the lack

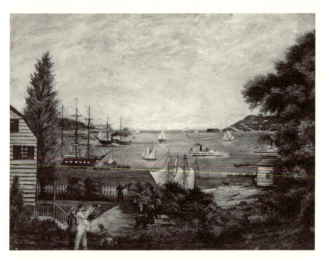

Unidentified artist, *View from Staten Island.*

of perspective and the discrepancies in the size of the objects indicate that the painter was untrained. The building in the left foreground appears to be a tavern. In front of it stands a portly man (possibly the tavernkeeper) looking through a telescope. A smaller man stands behind him. Pentimento indicate that the artist had originally placed the smaller man in front of the man with the telescope, then tried to re-

move him, replacing him with a hound. Two men are toasting each other at a table beyond and another man welcomes the arrival of a sloop.

The artist does not seem to have allowed sufficient room for the hull of the docked boat. The body of water is tilted up to show the maritime activity: an anchored clipper ship flying a burgee with a *U* on it (indicating the Union line); the two paddle steamers, the *Sylph* and *Columbus*; a sailer steamer; rowboats; and several boats under sail. The foreground colors are predominantly brown and green, water is depicted in bright turquoise, and there are touches of red throughout the composition.

In 1861 two new fortifications were completed, replacing the original Fort Richmond and Fort Tompkins. They became part of the Fort Wadsworth military reservation.

Oil on canvas, 30 × 40 in. (76.2 × 101.6 cm.).

Canvas stamps: c [g] ro[wn]ey & co., Manufacturers, 1 Rathbone [Park] London // s. n. dodge, Artist & Painters Supply Store, 189 Chatham c. Oliver. N. York.

Ex coll.: Edward W. C. Arnold, New York.

The Edward W. C. Arnold Collection of New York Prints, Maps and Pictures. Bequest of Edward W. C. Arnold, 1954.

54.90.181

CHARLES CROMWELL INGHAM

1796–1863

A native of Ireland, Charles Cromwell Ingham was born in Dublin in 1796. At the age of thirteen he began to attend drawing classes at the Dublin Institution. The following year he became a pupil of William Cuming, then one of Dublin's leading portraitists, with whom he studied for four years. In 1816 he came to New York, where his talent, intellect, and social grace quickly established him as the unrivaled painter of women and as a pillar of the art world. In spite of his contemporary fame, little information regarding his career has come down to us. His artistic development is shrouded in mystery and must be tentatively deduced from his surviving works. Whatever may have been his training in Ireland, Ingham espoused the neoclassical style early on and remained faithful to it for the rest of his life. His best portraits suggest that he must have studied the works of French painters before he came to the United States, although his mastery of line and smooth surface appears to have taken

place in this country. Thus two of his earliest known works, the portrait of Margaret Babcock of about 1820 (Newark Museum) and the 1824 portrait of De Witt Clinton (NYHS), reveal his stylistic proclivities but still possess a stiffness characteristic of an artist not in full command of his craft.

By 1830, however, as the remarkable portrait of Amelia Palmer (q.v.) clearly shows, this awkwardness had disappeared. The immense urbanity and artistic sophistication of this picture raise important questions about Ingham's rapid maturation as an artist. Even his contemporaries apparently had questions about how he achieved such technical and stylistic brilliance. In 1834, WILLIAM DUNLAP recorded that Ingham "produces a transparency, richness and harmony of colouring rarely seen in any country," and explained that he used a "process of successive glazings." Four years later, another writer, who obviously knew better, refuted Dunlap's assessment: "The author of the History of the Arts of Design, has attributed to Mr. Ingham successive *glazings* in his finish; whereas his practice is the use of colour without any glazings by repeated touches" (Stuyvesant Institute, New York, *Catalogue . . . of the Exhibition of Select Paintings by Modern Artists* [Dunlap Benefit Exhibition, 1838], p. 8, no. 18).

Beginning in about 1830, Ingham set the standard in New York for portraits of women. His highly finished, delicate works were consistently praised by contemporary reviewers, even though toward the end of his career the quality of his work became somewhat uneven. He also painted a number of landscapes, none of which has yet come to light. Ingham exhibited annually at the American Academy of the Fine Arts between 1816 and 1825, when he became a founding member of the National Academy of Design. As a representative on the National Academy's council and later its vice-president, Ingham played an important role in the institution's activities and exhibited numerous portraits every year. He also served as president of the Sketch Club. His friend and colleague Thomas Seir Cummings (1804–1894) described him as "an old-school gentleman; . . . warm in disposition and frank in manner, and always a pleasant companion." The quality and ambitiousness of his works entitle Ingham to be ranked as the most significant American artist to have followed the tenets of French neoclassicism after the decline of JOHN VANDERLYN. He died in New York on December 10, 1863.

BIBLIOGRAPHY: William Dunlap, *A History of the Rise and Progress of the Arts of Design in the United States* (2 vols., New York, 1834), 2, pp. 271–274 || Thomas Seir Cummings, *Historic Annals of the National Academy of Design* (1865), p. 353 || Henry T. Tuckerman, *Book of the Artists* (1867), pp. 69–70 || Albert Ten Eyck Gardner, "Ingham in Manhattan," *MMA Bull.* 10 (May 1952), pp. 245–253. In the only full-length article on Ingham to date, the author fundamentally misunderstands Ingham's style.

Mrs. David Cadwallader Colden

Frances Wilkes (1796–1877) was the daughter of Janet Shaw and Charles Wilkes, a prominent New York banker whose portrait was painted by GILBERT STUART (q.v.). On December 1, 1819, she was married to David Cadwallader Colden, scion of the Colden family and a highly successful New York lawyer. He was an active supporter of many public charities and a patron of the arts. They had no children, and after Mr. Colden's death in 1850, the large collection of Colden family papers in his possession passed to his wife who, two years later,

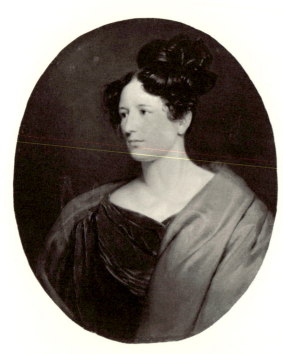

Ingham, *Mrs. David Cadwallader Colden.*

presented them to the New-York Historical Society. She died at Rye Beach, New Hampshire, on August 12, 1877, and was buried in Trinity Church Cemetery, New York.

Painted in 1830, this portrait exhibits the heavy, multi-layered surface and smooth execution that is characteristic of Ingham's work even in his early years. As in the portrait of Amelia Palmer (q.v.), the likeness displays a certain primitive, two-dimensional quality produced by the harshness of the lighting, the sharp outlines of the features, and the relative flatness of the coloring. Although Ingham by this time could reproduce fabrics masterfully, the drapery here has been hastily and indifferently handled, thus consigning this work to the lower ranks of his oeuvre. By endowing his likenesses with a soft modeling, combining innovative poses and bright colors, and by detailed renditions of drapery and accessories, Ingham would perfect his style in the next few years.

Oil on canvas, oval, 28¾ × 23¾ in. (73 × 60.3 cm.).

Signed, dated, and inscribed on the back before lining: By C. C. Ingham / 1830 / N. Y.

REFERENCES: E. R. Purple, *Genealogical Notes of the Colden Family in America* (1873), pp. 22–23, gives biographical data on the subject // A. T. Gardner, *MMA*

Bull. 10 (May 1952), p. 251, ill. p. 249 // Gardner and Feld (1965), p. 206.

Ex COLL.: the subject, d. 1877; her sister Anne Wilkes, New York, d. 1890, who owned the portrait jointly with her nieces Harriet K. Wilkes, d. 1887, and Grace Wilkes, d. 1922.

Bequest of Grace Wilkes, 1922.

22.45.2.

Mrs. Luman Reed

When this work was bequeathed to the museum the donor identified it as a portrait of Mrs. Luman Reed (1780–1869) by ASHER B. DURAND. It was presumed to be the companion to Durand's 1835 portrait of Luman Reed (q.v.). While comparison with another portrait of Mrs. Reed which descended in her family (private coll., FARL 122–12e) conclusively establishes the identity of the sitter, the attribution of the Metropolitan's portrait to Durand is no longer tenable. The hard-edged, glossy quality of the painting is completely uncharacteristic of his style, as is the meticulously realistic rendering of Mrs. Reed's dark-brown dress and fur boa. These traits, however, are signature features of the works of Charles Cromwell Ingham, and it is to him that this portrait is assigned with fair certainty.

The development of Ingham's distinctive portrait style is still unstudied, but his emphasis on closely observed reality, on crisp outlines, and on a rather abstract juxtaposition of color zones admits of the possibility that he was aware of the trends in late neoclassical French portraiture. If so, the works of the archetypal linearist of his times, J. A. D. Ingres, would naturally loom as prototypes. Yet Ingham's works cannot truly be said to derive from Ingres, and it may be that his portrait style was the result of a popularization of neoclassical ideals, similar to Ingres's own development, and not of any direct influence from the master. Specifically, Ingham's preference for softly focused modeling and his awkward retention of standard American portrait props, for example the red chair in this work, are symptomatic of an independent aesthetic sensibility.

Nowadays largely ignored, bust portraits of this type by Ingham were among the universally acknowledged signs of status in mid-nineteenth-century New York. His style was recognized as being particularly suitable for portraits of ladies. Although this portrait is not dated, the costume

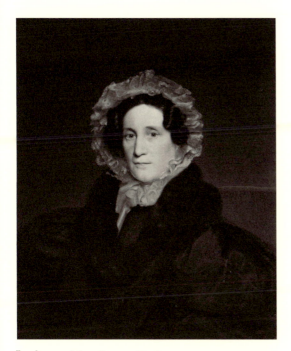

Ingham, *Mrs. Luman Reed.*

of the sitter indicates that it was painted about 1835. Mrs. Reed (née Mary "Polly" Barker) was the sister of Ralph Barker of Coxsackie, New York, in whose produce business Luman Reed apprenticed from about 1804 to 1808. She was married to Reed in 1808, and they had three children, two daughters and a son. After Reed's death in 1836, Mrs. Reed lived at Hyde Park, New York, with her daughter Mary (Mrs. Dudley Barber Fuller).

Oil on canvas laid down on composition board, 30⅛ × 25 in. (76.5 × 63.5 cm).
REFERENCES: D. B. Lawall, "Asher B. Durand" (Ph. D. diss., Princeton University, 1966), 3, p. 149, lists it as by Durand // O. Rodriguez Roque, 1979, orally, attributes to Ingham // E. M. Foshay, *Mr. Reed's Picture Gallery* (1990), ill. p. 24.
EXHIBITED: NYHS, 1990–1992, Luman Reed Gallery.
Ex COLL.: descended to the subject's great-grandson, Frederick Sturges, Jr., Fairfield, Conn., d. 1977.
Bequest of Frederick Sturges, Jr., 1977.
1977.342.2.

Amelia Palmer

This portrait of 1830 depicts Amelia Palmer (1819–1843), the only daughter of Amos Palmer (1788–1854) and Sarah Foster Palmer. Biographical facts about the subject are scarce and must be pieced together from a number of different sources. Her father was a successful drygoods merchant in New York, and his name appears in the city directories from 1812 to 1854. He was a member of the prominent Palmer family of Stonington, Connecticut, and son of Amos Palmer, a man of some wealth, representative to the Connecticut legislature on numerous occasions, and leader of the successful resistance against the British during the siege of August 1–12, 1814. On October 10, 1838, Amelia Palmer was married to Edward M. Cany, a member of a Philadelphia merchant family who settled in New York. She died without issue and was interred in Greenwood Cemetery. Her father's will lists no surviving children or direct descendants, which accounts for the ownership of this portrait by his brother's grandson when it was given to the museum (Register of wills, Liber 100, p. 396, Surrogate's Court, New York County).

Originally attributed to the British-American painter John T. Peele (1822–1897), the picture was correctly given to Ingham in 1952 on stylistic grounds. The crisp outlines of the young girl's figure, the highly finished porcelain-like quality of her face and arms, and finally, the obvious interest of the painter in the details of the flower-filled hat (in effect a complete still life within the portrait) are entirely characteristic of Ingham, whose painstaking working methods were much admired by his contemporaries but imitated by none. Further corroboration of this attribution was provided by the catalogue of the Dunlap Benefit Exhibition of 1838 which records a "Full length of a Lady, with a hat full of flowers and surrounded by a landscape" as painted by C. C. Ingham and owned by A. Palmer. In addition, it is virtually certain that this is the work listed as "Full Length Portrait of a Little Girl with Flowers" by Ingham in the National Academy of Design exhibition catalogues of 1830 and 1831. Amos Palmer is not named as the owner of this picture in the catalogues, but he was the named lender of another work by Ingham, a "Full Length Portrait of a Lady" (1830, no. 34; 1831, no. 11). In an

anonymous poem entitled *The National Academy of Arts and Design, Fifth Annual Exhibition, May 1830*, the "portrait of a Little Girl with Flowers" was called a companion to this other painting. Perhaps composed by New York's so-called mad poet MacDonald Clarke, this doggerel, after attacking Ingham's full-length portrait of a lady, notes:

> Standing in opposition mated,
> Sunlight, as some have stated;
> Comes forth a little girl with flowers
> From out the cool and shady bowers,
> Why washed she not her face and arms
> Before she thus exposed her charms?
> Bricky lights and shadows dun,
> Are but a libel on the sun;
> He never throws such dingy ray,
> When beauty meets him in the way.

Though basically nonsense, the poem retains some historical value as an indication of the hostility with which Ingham's style was viewed in some quarters. With the advantage of hindsight, however, one can see that it is precisely works such as the portrait of Amelia Palmer that clearly establish the individuality of Ingham's style and his considerable creativity in the context of American mid-nineteenth century portraiture. Here it is apparent that Ingham, early in his career, rejected the various modes of portrait painting then popular in this country (all ultimately derived from English precedents, whether interpreted by THOMAS SULLY, HENRY INMAN, or WALDO AND JEWETT) and, instead, held fast to a neoclassical ideal with a pronounced French accent. Thus, even though he did not venture into history painting, Ingham may

Ingham,
Amelia Palmer.

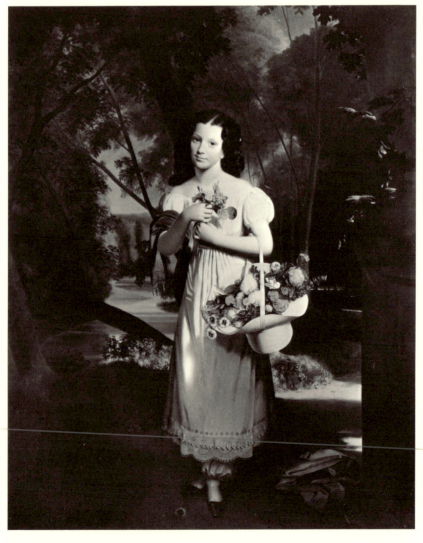

be considered the successor to JOHN VANDER-LYN in promoting the style of hard edges, crisp outlines, and smooth modeling. But, whereas Vanderlyn espoused the views and manner of Jacques Louis David, Ingham attempted to be more modern. The mysterious and somewhat unnatural use of light, the bright coloration of the flowers and the shawl, and the gentle eroticism which is evident in the painting of the girl's arms, shoulders, and face are characteristic of a genre of French painting, an early example of which is Anne Louis Girodet-Trioson's *Sleep of Endymion*, 1791 (Louvre). French works of a later date, such as Pierre Narcisse Guérin's *Iris and Morpheus*, 1811 (Hermitage, Leningrad), Claude Marie Dubufe's *Apollo and Cyparissus*, 1821 (Musée Calvet, Avignon), and Pierre Claude François Delorme's *Cephalus and Aurora*, 1822 (Musée Municipal, Sens), popularized this genre in the opening decades of the nineteenth century. (These pictures are all illustrated in MMA, *French Painting, 1774–1830*, exhib. cat. 1975).

Interestingly enough, all of the above-mentioned works, which show similar techniques to those Ingham used in the portrait of Amelia Palmer, are paintings dealing with mythological subjects. This association calls our attention to the Elysian setting depicted in Ingham's work as well as to the girl's idealized sprite-like pose. Obviously, Ingham aimed higher than straightforward, realistic portraiture, but just what precise meaning he wished to convey by the idyllic landscape and the presence of so many flowers as well as by the pedestal and vase to the right remains elusive. Since many of the flowers—cotton grass, bull thistles, phlox, violets, silkweeds, milkworts, and pinks—grow wild and since the outdoor setting is a kind of glade, including woods, a stream, and a classical-style monument, a link with one of the wood nymphs may be intended. In antiquity, these were thought of as young and fair maidens who often guarded the places they inhabited, a characterization more appropriate to Ingham's portrayal of Amelia Palmer than to the alternatively proposed identification of her as the goddess Flora. In any event, the identification of the flowers as general symbols of well-being and the season of growth was certainly made by the painter's contemporaries. For example, in a review of the 1831 National Academy exhibition, the *New-York Mirror* noted: "The figure is charming. Look at her hat filled with flowers. How light, fresh and full of summer association."

Unquestionably one of Ingham's very best works, if not his masterpiece, the portrait of Amelia Palmer has often been maligned, even in our own day, as being little more than mawkish. To be sure, the painting is sentimental in feeling and perhaps cloyingly sweet to modern eyes. On closer inspection, however, the balance and refinement of its execution and of the aesthetic principles behind it are far too cogitated to dismiss it offhandedly.

Oil on canvas, 67⅞ × 53¼ in. (172.4 × 135.3 cm.).

REFERENCES: *The National Academy of Arts and Design, Fifth Annual Exhibition* (1830), published anonymously, it contains satire in verse about the portrait (quoted above) // *New-York Mirror* 8 (May 7, 1831), p. 350, review (quoted above) notes: "A fair, fresh sweet face, and the form beautiful with the soft light shed down through the branches. The surrounding scenery is too sombre, and seems to have received little attention. It is to be regretted that the landscape could not be filled up and finished. . . .we do not pretend to judge whether these bright and highly finished portraits by Ingham are precisely what they ought to be; but as a colorist, he has no superior within our knowledge. His faces are not only perfectly soft and brilliant but animated and expressive" // A. T. Gardner, *MMA Bull.* 10 (May 1952), pp. 245–251, attributes the work to Ingham, notes early exhibitions and family tradition identifying the sitter, and quotes from the sources listed above // Gardner and Feld (1965), pp. 204–206 // M. Brown, *American Art to 1900* (1977), p. 369.

EXHIBITED: NAD, 1830, no. 136, as Full Length Portrait of a Little Girl with Flowers; 1831, *Retrospective Exhibition*, no. 5, as Full Length Portrait of a Little Girl with Flowers // Stuyvesant Institute, New York, 1838, *Exhibition of Select Paintings by Modern Artists* (Dunlap Benefit Exhibition), no. 34, as Full Length of a Lady, with a Hat Full of Flowers, and Surrounded by a Landscape, lent by A. Palmer // MMA, 1965, *Three Centuries of American Painting*, unnumbered checklist // Lytton Gallery, Los Angeles County Museum of Art; M. H. de Young Memorial Museum, San Francisco, 1966, *American Paintings from the Metropolitan Museum of Art*, no. 25 // W. H. Ackland Art Center, University of North Carolina, Chapel Hill, 1968, *Arts of the Young Republic*, exhib. cat. by H. E. Dickson, no. 85 // Worcester Art Museum, 1973, *The American Portrait*, exhib. cat. by W. J. Hennessey, pp. 22–23, ill. no. 14.

EX COLL.: Amos Palmer, New York, d. 1854; probably his wife, Sarah Palmer; her brother-in-law, Courtlandt Palmer, d. 1870; his grandson Courtlandt Palmer, until 1950.

Gift of Courtlandt Palmer, 1950.
50.220.1.

The Flower Girl

Certainly one of Ingham's best-known works, *The Flower Girl*, painted in 1846, ranks among the earliest and most important portrayals of young street vendors in American genre painting. Generally concerned with lower-class boys and girls engaged in a variety of enterprising activities, these pictures form a distinctive type in the history of nineteenth-century painting and give expression to a wide range of social and artistic attitudes toward the children of the burgeoning urban poor. Henry Inman's *The Newsboy* of 1841 (Addison Gallery of American Art, Phillips Academy, Andover, Mass.) was the first major work of this type to gain substantial public attention. It was engraved and published in the annual *The Gift* for 1843 and was considered important enough to prompt one critic to hope that "it might be the first of a Popular Portrait Gallery, for which the ever varying aspect of our crowded thoroughfares would supply an inexhaustible fund of subjects" (*Arcturus* [June 1841], p. 61). Significantly, Inman's painting was quickly purchased by the prominent New York collector Jonathan Sturges, who later owned *The Flower Girl*.

Inman's work was soon followed by WILLIAM PAGE's *The Young Merchants* in 1842 (PAFA), a more mature work depicting both a newsboy and a girl strawberry seller. Like Inman's picture, it was set in New York and was popularized in *The Gift* (1844), where an engraving of it was published to accompany a story written expressly for the picture. Other painters took up the theme, and thus it is not surprising to find Ingham turning to this type of picture in 1846 and choosing a character ideally suited to his well-known talents for painting women and flowers.

Formally, *The Flower Girl* may be considered a logical development of Ingham's style and, therefore, a work of some creativity and originality. It does not seem out of place, however, to mention the probable influence of the genre paintings of Gainsborough and Murillo in the composition of the work. Generally the picture's size, the isolation of the figure and its relationship to the flowers, and the attempt to create an individualized, expressive portrait may be linked with Gainsborough's "fancy pictures," many of which combine sensitive life-size portraits with interesting balancing features (for example, the cat in *Boy with a Cat—Morning*, 1787, MMA). More specifically, the background in Ingham's *The Flower Girl*, composed of a high wall and a view of a distant landscape, distinctly echoes a formula employed by Murillo in a number of his pioneer scenes, including his *Flower Girl* of about 1660–1670 (Dulwich Gallery, London), a painting repeatedly engraved in Victorian times and probably known to Ingham.

But far more interesting than these distant models are the technical aspects of *The Flower Girl* that give evidence of Ingham's considerable ability. The exquisitely finished execution, for which the artist was famous, has here lost its hard edge and acquired a softness, especially in the painting of the girl's face. The vividly contrasted colors of the flowers, clearer and brighter than those in Ingham's *Amelia Palmer* (q.v.), produce a chromatic lushness hardly matched by any American still-life painting of the period. Moreover the expression on the girl's face, is psychologically complex and effectively calls attention to the moral dilemma in which such lower-class young women often found themselves. In this respect the picture, despite its idealization and air of make-believe, is far more true-to-life than many other treatments of the theme. On the one hand, the poverty of the girl's circumstances is emphasized by the black bonnet with its obvious funereal associations and by her drab brown dress. On the other hand, her roseate cheeks, moist lips, and alluring beauty charge the picture with erotic overtones, as does the gesture with which she offers the fuchsias, often a symbol of love. It is as though the viewer were given the option of purchasing the flowers in her basket or the flower of her virtue while being simultaneously subjected to the most searching scrutiny. In this context, it is the expression on her face, innocent yet knowing, penetrating yet uncertain, that shifts the burden of moral decision from the vendor to the buyer and poses a valid question that prevents the work from completely sinking into mawkishness.

The symbolic association of fuchsias with love was fairly well established in American books dealing with the language of flowers, though in a rather imprecise and inconsistent manner. The most influential of these treatises assigned them, generally, the meaning "love lies-a-bleeding," alluding to disappointed or frustrated love (Elizabeth W. Wirt, *Flora's Dictionary* [1830], s.v. "Fuchsia"). Another American work used the

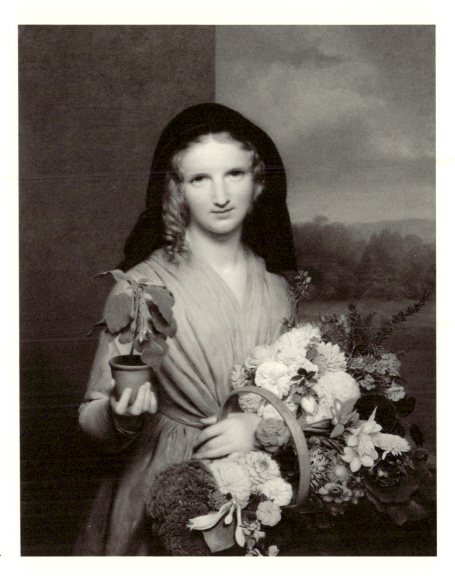

Ingham, *The Flower Girl.*

phrase "confiding love" but only with respect to the globe-flowered fuchsia (C. H. W. Elsing, *Flora's Lexicon* [1839], p. 86). Doubtless, the reason for the confusion in the meanings assigned to fuchsias was the result of the recent introduction of the plant as well as of the many kinds of hybrids and natural varieties that entered the market from about the 1820s on. The particular type of fuchsia depicted by Ingham, *Fuchsia fulgens*, was not grown in England, the country which pioneered the horticulture of these flowers, before the 1830s, and thus no specific meaning assigned to this species has been found in English or American flower books published before 1846 (see C. D. Mayne, *Practical Hints to a Young Florist on the Culture, Management, Propagation, etc., of the Fuchsia* [1843], s.v.

"F. fulgens"). It is likely that Ingham relied on the general associations of these exotic flowers as well as on the natural form of the *Fuchsia fulgens*, and not on the ready prescriptions of any book. The gesture of proffering flowers with the right hand, by itself, possesses a clear relationship to portraits of women personifying Flora, the goddess of flowers, and necessarily partakes of the erotic atmosphere of such pictures (see J. Held, "Flora, Goddess and Courtesan," in M. Meiss, ed., *De Artibus Opuscula* [1961], pp. 201-218, and especially, figs. 15, 23, 25, 26, and 27).

The model for the girl in this picture remains unidentified. She was at one time said to be Marie Perkins of New Orleans, but a search through the many published Perkins family genealogies failed to turn up a Marie Perkins

Charles Cromwell Ingham 403

who could plausibly have been the model. More-over, the picture was almost certainly not paint-ed as a portrait. A critic for the *Literary World*, who saw the picture at the National Academy in 1847, wrote that "the face seems to us to lack individuality, as if it had been made up from different models."

Oil on canvas, 36 × 28⅞ in. (91.4 × 73.3 cm.). Signed and dated on basket handle: C. C. Ingham. 1846.

REFERENCES: *Literary World* 1 (June 5, 1847), p. 418, review (quoted above) notes: "This is one of the most carefully finished pictures we have ever seen. It represents a blooming creature literally loaded with rich clusters of flowers. The face . . . appears to us slightly out of drawing. The flowers are painted with exceeding care, and yet they appear hard and waxen. They are so brilliant in color, and so prominent in position, as to destroy all interest in the figure" // *Crayon* 3 (Feb. 1856), p. 58, review of Sturges collection notes: "Ingham's celebrated 'Flower Girl' is also here —a picture characterized by a high degree of all the qualities which have given the artist his position, and really a wonderful work" // *Lights and Shadows of New York Picture Galleries* (1864), pl. 3 // T. S. Cummings, *Historic Annals of the National Academy of Design* (1865), pp. 141, 353, says that it represents "the perfection, perhaps, of those qualities which gave [Ingham] his high reputation" // H. T. Tuckerman, *Book of the Artists* (1867), pp. 69, 627, says it is one of three pictures by Ingham in the Sturges collection that are "good exemplars of his style and manner" // S. Isham, *The History of American Painting* (1905), ill. p. 195 // B. Burroughs, *MMA Catalogue of Paintings* (1931), p. 175 // E. E. Gardner, memorandum in Dept. Archives, Nov. 29, 1951, notes that "a member of the family came in and identified the subject (to J. Allen) as Marie Perkins, of New Orleans. This was a number of years ago" // A. T. Gardner, *MMA Bull* 10 (May 1952), pp. 245, 252–253, as "Miss Perkins" // J. C. Taylor, *William Page* (1957), pp. 37–38, describes it as an American rendition of "the English character piece" // Gardner and Feld (1965), pp. 206–207 // W. H. Gerdts and R. Burke, *American Still-life Painting* (1971), p. 104.

EXHIBITED: NAD, 1847, as The Flower Girl, lent by Jonathan Sturges // MMA and NAD, 1876, *Centennial Loan Exhibition of Paintings*, no. 262, as The Flower Girl, lent by Mrs. Jonathan Sturges // MMA, 1965, *Three Centuries of American Art* (checklist arranged alphabetically); 1970, *Nineteenth-Century America*, exhib. cat. by J. K. Howat and N. Spassky, color ill. no. 80 // Museum of Art, Pennsylvania State University, University Park, Pa., 1976, *Portraits USA, 1776–1976*, exhib. cat. by H. E. Dickson, pp. 50–51.

EX COLL.: Jonathan Sturges, New York, 1846–1872; his wife, Mary Pemberton Sturges, d. 1894; her daughter, Virginia Reed Sturges (Mrs. William H. Osborn), d. 1902; her son, William Church Osborn, 1902.

Gift of William Church Osborn, 1902.

02.7.1.

JOHN NEAGLE

1796–1865

Born in Boston, John Neagle grew up in Philadelphia and spent most of his life there. In his youth he was a friend of Edward F. Peticolas (1793–ca. 1853), whose father was a minia-turist. Neagle had some instruction from Pietro Ancora (working ca. 1800–1843) before becoming apprenticed (1813–1817) to Thomas Wilson, an ornamental sign painter. His first influential teacher, however, was the Philadelphia portrait painter Bass Otis (1784–1861). At the expiration of his apprenticeship to Wilson, Neagle set up to practice portrait painting in Philadelphia. Strongly lit and extremely linear, Neagle's earliest work is much like that of Otis, but he rapidly surpassed his teacher. Still, he evidently did not meet with much encouragement and soon set off on a trip west, visiting Lexington, Kentucky. Finding the field there occupied by MATTHEW HARRIS JOUETT, he moved on to New Orleans, where

he seems to have met with so little in the way of commissions that he quickly returned to Philadelphia.

During the 1820s, Neagle exhibited many portraits at the Pennsylvania Academy of the Fine Arts, where he was elected an academician in 1824. This honor also marked the beginning of his professional relationship with THOMAS SULLY, whose niece and stepdaughter, Mary Chester Sully, Neagle had married in 1820. Sully gave him technical and stylistic advice that he used throughout his career. For a brief period after he visited Boston in 1825 to learn what he could from GILBERT STUART, his portraits reflected the results of his study of Stuart's methods. By 1826, however, his best-known painting, *Pat Lyon at the Forge* (MFA, Boston), shows that Neagle had already replaced Stuart's influence with Sully's broader, more romantic style. Most of Neagle's portraits strongly recall Sully's manner. His best work, such as *Miss Anna Gibbon Johnson*, 1828 (PAFA), and *Dr. William Potts Dewees*, 1833 (University of Pennsylvania School of Medicine), are characterized by intense color, convincing light and shadow, rich textures, and strong compositions that show the influence of Sir Thomas Lawrence, whose work Sully encouraged Neagle to study.

In the late 1840s, Neagle's style changed yet again to a tighter, more realistic one. It has been suggested that this development shows the influence of the very fashionable portraitist CHESTER HARDING, although it may also indicate that Neagle was working from daguerreotypes. For the most part his portraits are brightly painted and somehow cheerful, especially his oil sketches, where a sort of joy in handling paint results in works of real panache. Generally his work, however, is lacking in inspiration. Neagle appears to have been a genial man, well liked by his fellow artists. He served as president of the Artist's Fund Society from 1835 to 1843.

BIBLIOGRAPHY: PAFA, *Catalogue of an Exhibition of Portraits by John Neagle* (1925), by Mantle Fielding. The most complete catalogue of Neagle's work // Virgil Barker, "John Neagle," *Arts* 8 (July 1928), pp. 7–23. A discerning estimate of Neagle's quality // Marguerite Linch, "John Neagle's Diary," *Art in America* 37 (April 1949), pp. 79–99. Excerpts from the artist's diary, which was then in an unnamed private collection // Bruce W. Chambers, "The Pythagorean Puzzle of Patrick Lyon," *Art Bulletin* 58 (June 1976), pp. 225–233. Discusses the iconography of Neagle's best-known work // Robert W. Torchia, *John Neagle, Philadelphia Portrait Painter* (Philadelphia, 1990). Catalogue based on extensive Neagle manuscript sources.

John Haviland

Born at Gundenham Manor, Somerset, John Haviland (1792-1852) was apprenticed in London at the age of fourteen to the architect James Elmes, a friend of his uncle, the painter Benjamin Robert Haydon. After supervising the construction of several of Elmes's projects, Haviland left England in 1815 for Saint Petersburg, where he briefly worked for another uncle, Count Morduinoff, in the Russian Imperial Corps of Engineers. In 1816 he came to Philadelphia and he soon developed into one of the country's greatest architects. In 1824 at the Franklin Institute he began the first formal courses in architecture taught in the United States and in 1836 was one of the founders of the Institution of American Architects, the forerunner of the present American Institute of Architects.

He was responsible for a number of buildings in Philadelphia, many of them considered important monuments of American architecture, such as the Deaf and Dumb Institute, built in 1824-1825 (now the Philadelphia College of Art), and other, more unconventional buildings such as the Moody House, about 1820, in Haverhill, Massachusetts. Although he had a pioneer-

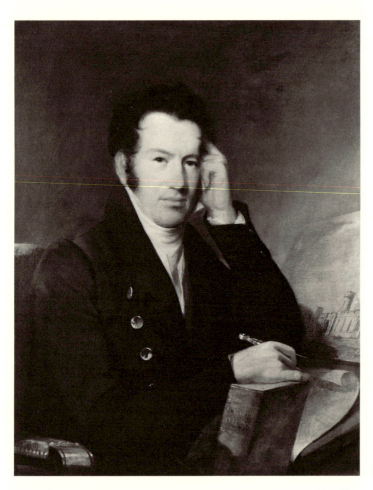

Neagle, *John Haviland.*

ing role in Greek revival architecture, his style was eclectic. In 1838 he contributed a refined Egyptian design for an office building of the Pennsylvania Fire Insurance Company in Philadelphia, and in the New York Hall of Justice (the Tombs), 1835-1838, he created what is perhaps the best-known American building in the Egyptian style. Haviland's most important building, which has been called both revolutionary and epochal, was the Eastern State Penitentiary at Philadelphia (1823–1829), with cells radiating out in wings from a central structure housing other prison functions. His innovative design was so strikingly successful that the British, French, and Russian governments sent commissioners to study the work, and subsequently adaptations of his radial prison appeared throughout the world.

Neagle shows Haviland sitting in front of a view of the neo-Gothic façade of the prison, with a plan of the building beside him. Although

Neagle could not have known in 1828, when the portrait was painted, of the subsequent worldwide fame and influence of the design, he portrays Haviland with the emblems of what was apparently already a considerable achievement. The construction of the prison, which Haviland was then supervising, was one of the largest building projects yet attempted in the United States and excited a good deal of notice. Haviland's right hand, holding a pair of calipers, rests on a volume of *The Antiquities of Athens* (1762–1816) by James Stuart and Nicholas Revett, which would seem incongruous in relation to the Gothic façade of the penitentiary. The book may refer to one of Haviland's other major achievements, *The Builder's Assistant* (1818–1819), which he wrote with the painter Hugh Bridport (1794–ca. 1869). This work, based in part on Stuart and Revett, was the first American handbook to include plates of the Greek orders, and it was an important pre-

cursor of the Greek revival style in American architecture.

Like his sitter, Neagle was fresh with success. *Pat Lyon at the Forge*, completed in 1827, had established his reputation as an important painter. In a thoughtful pose, the subject looks out at the viewer with the optimism that is found in so many of Neagle's portraits. The painting is competently and confidently executed, and the artist seems delighted with his technical ability, rendering the reflections of light on the subject's coat buttons and calipers. Although Neagle's visit to GILBERT STUART in Boston was two years past, Stuart's influence is visible in some rather subtle coloristic effects in the painting of Haviland's face and hands. Otherwise the portrait is in the broader style of THOMAS SULLY.

In terms of composition, Neagle, not an innovator like his subject, was looking backward to the work of CHARLES WILLSON PEALE, whose portrait of the architect William Buckland, begun 1774, completed 1787 (Yale University, New Haven, Conn.), shows the subject against a backdrop of a grand, supposedly imaginary, Greek revival building. Like Haviland, Buckland is holding an architectural drawing instrument, and on the table before him are plans for what is said to be his greatest achievement, the Hammond-Harwood house in Annapolis. Neagle must have known Peale's portrait, which hung for many years in that house. Indeed his portrait of the architect William Strickland (Yale University, New Haven, Conn.), painted the year after the Haviland portrait, is even closer to Peale's work in design and overall conception. For Haviland, Neagle elected to combine Peale's somewhat stiff eighteenth-century manner with the more informal pose and intimate presentation that he had learned from Sully.

Oil on canvas, 33 × 26 in. (83.8 × 66 cm.).

Signed and dated on the book: J.N.1828. Inscribed on the lining canvas: Portrait of John Haviland / Architect / Painted by John Neagle / Philada 1828. Inscribed on stretcher: Stuart's Athens. Inscribed on paper label on stretcher: These are to certify that John Haviland Esquire / Architect of Philadelphia U. S. is admitted / an Honorary and Corresponding Member / of the Royal Institute of / British Architects.

REFERENCES: J. P. Boyd, letter in Dept. Archives, May 12, 1939, identifies building as Eastern State Penitentiary // J. L. Allen, *MMA Bull.* 34 (July 1939),

John Neagle

pp. 182–184 // A. T. Gardner, *MMA Bull.* 14 (Dec. 1955), p. 103 // Gardner and Feld, (1965), pp. 201–202.

EXHIBITED: MMA, 1939, *Life in America*, no. 90 // NAD, 1942, *Our Heritage*, no. 12 // MMA, 1943, *The Greek Revival in the United States*, no. 37 // Saginaw Museum, Mich., 1948, *An Exhibition of American Painting from Colonial Times until Today*, no. 42 // Pennsylvania State University Museum of Art, University Park, 1955, *Pennsylvania Painters*, unnumbered // MMA, 1965, *Three Centuries of American Painting* (checklist arranged alphabetically).

EX COLL.: John F. Braun, Philadelphia, d. 1939; with Ferargil Galleries, New York, by 1938.

The Alfred N. Punnett Endowment Fund, 1938. 38.82.

John Walsh

Born in Dublin, John Walsh (1743–1828) immigrated to this country in 1765 with his wife, Catherine Seton, who was Scottish. They settled in Philadelphia, where Walsh joined the shipping business of his cousin Thomas Fitz-Simmons. During the Revolution he command-

Neagle, *John Walsh.*

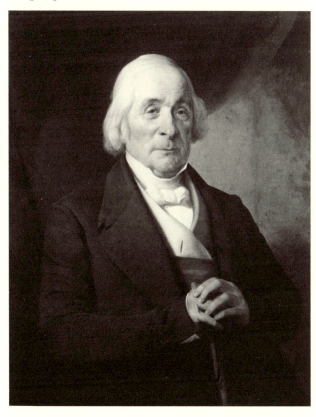

ed privateers, and in a battle with the British off Sandy Hook, New Jersey, he was seriously injured. He was confined by the British in a prison ship in Wallabout Bay, Long Island, but managed to escape and return to his family in Philadelphia. His daughter Mary became the wife of the Dublin-born architect Nicholas Fagan.

Although the subject is dressed in the style of the late 1820s, the painting is most like Neagle's work of the 1840s or later. One of Walsh's descendants claimed the portrait was based on a daguerreotype. The process, however, was not yet in use at the time of Walsh's death. Very likely the work was based on an earlier painting, perhaps a miniature portrait, done when Walsh was still alive.

Oil on canvas, 36 × 29 in. (91.4 × 73.7 cm.).

REFERENCES: L. E. Fagan, 2nd, letters in Dept. Archives, Oct. 12, 1924, says the portrait once belonged to subject's grandson, John Fagan of Philadelphia; March 20, 1925, says it was painted from a daguerreotype for Maurice Edward Fagan // Gardner and Feld (1965), pp. 202–203.

EXHIBITED: PAFA, 1925, *Catalogue of an Exhibition of Portraits by John Neagle*, cat. by M. Fielding, no. 96.

ON DEPOSIT: United States Tax Court, New York, 1951–1953.

EX COLL.: Fagan family, Philadelphia, until 1900; Philadelphia art market, 1900; New York art market, until 1906; Mr. and Mrs. Frederick S. Wait, New York, 1906–1908.

Gift of Mr. and Mrs. Frederick S. Wait, 1908. 08.229.

ASHER B. DURAND

1796–1886

Durand was born August 21, 1796, in Jefferson Village (now Maplewood), New Jersey. His father, John Durand, a descendant of a Huguenot surgeon, was a watchmaker, silversmith, farmer, and mechanic; he married Rachel Meyer Post, a widow, and Durand was the eighth of their eleven children. As a boy he is said to have helped in his father's shop, sometimes engraving his own designs on silver objects or copperplates. His career began in 1812, when he was apprenticed to the engraver Peter Maverick of Newark. In 1817, his five-year apprenticeship completed, he became Maverick's partner and ran the firm's New York branch. In 1820, when Durand accepted John Trumbull's commission to engrave his *Declaration of Independence* (Yale University, New Haven, Conn.), Maverick was offended and the partnership dissolved. The engraving, completed in 1823, and the sketchy drawing for it (NYHS) reveal Durand as an accomplished but rather conventional artist at this time. The print was much praised, and it established Durand as a successful engraver. Although he had worked very little as a painter, his stature as an engraver now assured him prominence in most of the art organizations of the period in New York. He was chairman of the founding meeting of the New York Drawing Association, which later became the National Academy of Design, as well as of the Sketch Club, which later evolved into the Century Association. Durand was married twice, first to Lucy Baldwin of Bloomfield, New Jersey, in 1821, and, after her death in 1830, to Mary Frank of New York in 1834.

During the late 1820s and early 1830s Durand gradually produced fewer engravings. His oil paintings, for the most part portraits, were well liked by his contemporaries, though they

have attracted limited attention in our own day. In 1834 he received the important, though brief, patronage of Luman Reed (see below), which enabled him to retire from engraving and devote himself entirely to painting. Initially confining his work to genre painting and portraits, he came very much under the influence of THOMAS COLE and in 1839 showed nine landscapes at the National Academy. In 1840, as he was approaching the age of forty-four, Durand, with the financial assistance of Jonathan Sturges (see below), set out for Europe with JOHN W. CASILEAR, JOHN F. KENSETT, and THOMAS P. ROSSITER.

The experience in Europe was crucial for Durand's development as an artist. In the period immediately before his departure he had experienced severe difficulties in his creative abilities, probably caused by an overly strong dependence on Cole. In Europe he carefully studied Claude Lorrain's pastoral scenes and John Constable's plein-air landscapes and familiarized himself with the work of Dutch artists like Paulus Potter and Aelbert Cuyp. On his return, in 1841, relying on drawings in his sketchbooks for standard picturesque subjects, Durand began to paint landscapes that combined Cole's meticulous depiction of natural elements with the idealizing light typical of the Claudian landscape. Included too were elements of religious iconography. In paintings such as *The Beeches* of 1845 (q.v) and *Early Morning at Cold Spring*, 1850 (Montclair Art Museum, N.J.), he explored the styles and manners of the European painters he admired. In so doing, he set a new level of sophistication in American landscape painting.

Durand was elected president of the National Academy in 1845. After Cole's death in 1848, he was generally regarded as the leading landscape painter in the country. The paintings for which he received this public acclaim tended to be large "machines," surprisingly akin in the emptiness of their sentiment to the salon paintings popular during the same period in Europe. The oil sketches from nature that Durand began to make in quantities in the 1840s are among the freest and freshest of his works. Comparison of Durand's oil sketches with the large canvases for which they often served as studies reveals that they have precisely those qualities lacking in his finished works, which can be dry and academic in execution. Other artists, notably FREDERIC E. CHURCH, who saw Durand's sketches in his studio, followed the same practice, probably derived from Constable, and raised it to high art.

From the forties onward Durand's life assumed a more or less regular pattern that continued past his retirement in 1869. That year he moved from New York to Maplewood, New Jersey. He spent the summers in mountainous areas of New York and New England making pencil and oil sketches and during the fall and winter painted from them the large finished canvases he exhibited every spring at the academy. In 1855 the *Crayon*, which was edited by his son John, published Durand's "Letters on Landscape Painting." He articulated the reverential attitude toward nature that he had previously expressed in visual terms and together his essays and paintings influenced an entire generation of landscape painters. A generally equable man, Durand was popular with other artists, and his always competent if not always inspired paintings were treasured by his patrons. His career, which lasted many years, was an unqualified success.

BIBLIOGRAPHY: Asher B. Durand Papers, NYPL, microfilm N19–21 Arch. Am. Art. Includes letters between 1830 and 1860 and the artist's European diary // John Durand, *The Life and Times of A. B. Durand* (New York, 1894). A biography by the artist's son // David B. Lawall, *Asher Brown*

Durand: His Art and Art Theory in Relation to His Times (Ph. D. diss., Princeton University, 1966; published New York, 1977). The most complete treatment of the artist to date // Montclair Art Museum, N. J., *A. B. Durand, 1796–1886*, exhib. cat. by David B. Lawall (Montclair, N. J., 1971) // David B. Lawall, *Asher B. Durand: A Documentary Catalogue of the Narrative and Landscape Paintings* (New York, 1978). An adjunct to Lawall's 1966 dissertation.

Mrs. Winfield Scott

Maria D. Mayo (1787–1862) was the daughter of Abigail De Hart and Colonel John Mayo of Richmond, Virginia. The family also lived for many years at their estate Hampton Place in Elizabethtown, New Jersey. Noted for her beauty and her wit, Miss Mayo was an accomplished harpist and singer. In 1817 she was married to Winfield Scott, a military hero of the War of 1812. (See his portrait by ROBERT W. WEIR.) The Scotts had seven children, only three of whom survived their parents. Mrs. Scott was an amateur poet and enjoyed traveling. She died in Rome in 1862 and was buried at West Point, where her husband died in 1866.

In its light tonality, Durand's portrait of Mrs. Scott is unusual for him. She wears a light brown dress, the gauzy white oversleeves of which are not very convincingly painted. Seated at a marble-top table she holds a mauve-colored dahlia; a red one lies on the table. The landscape background is not particularly identifiable, although both the Hudson Highlands of New York and Fort Snelling in Minnesota are areas that have been suggested.

Durand quit his engraving firm in 1831, and this portrait of Mrs. Scott probably represents one of his first efforts at supporting himself as a painter. Stiff in pose and very tightly painted, the portrait reveals him at a moment of artistic indecision, when he was evidently casting about for his own mode of portrait painting. The landscape background and overall tonality recall contemporary work by the fashionable New York portrait painter CHARLES CROMWELL INGHAM. Like Ingham, Durand may have flattered his subject. Although she was a noted beauty in her youth, Mrs. Scott looks much younger than the forty-four-year-old matron she was in 1831.

Durand, *Mrs. Winfield Scott.*

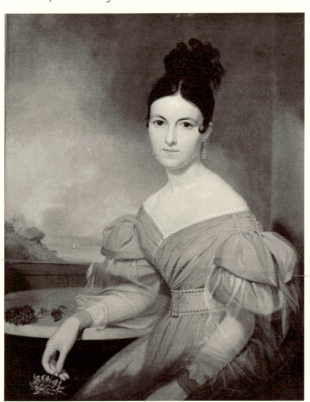

Oil on canvas, 34 × 27 in. (96.4 × 68.6 cm.).
Signed and dated at lower left: A. B. D / 1831.
REFERENCES: *Illustrated Catalogue of the . . . Collection . . . formed by . . . Frank Bulkeley Smith* (1920), sale cat., no. 150, describes, says the background suggests the Hudson Highlands or the Staten Island Hills // *American Art Annual* 17 (1920), p. 294, says purchased April 23, 1920, by William Randolph Hearst for $225 // *Kennedy Quarterly* 5 (Jan. 1965), ill. p. 96, no. 94; p. 97, discusses it // D. B. Lawall, University of Virginia Art Museum, says there are few portraits by Durand from this period by which to judge it.

EXHIBITED: Brooklyn Museum, 1917, *Exhibition of Early American Paintings*, no. 23, lent by Albert Rosenthal, Philadelphia // MMA, 1965, *Three Centuries of American Painting* (checklist arranged alphabetically), lent by Mrs. John C. Newington.

EX COLL.: Albert Rosenthal, Philadelphia, 1917; Frank Bulkeley Smith, Worcester, Mass., 1920 (sale, American Art Association, Plaza Hotel, New York, April 22–23, 1920, no. 150, for $225), William Randolph Hearst, San Simeon, Calif., 1920—d. 1951; with Kennedy Galleries, New York, by 1965; Mrs. John C. Newington, Greenwich, Conn., 1965.

Gift of Mrs. John C. Newington, 1965.
65.69.

Ariadne

After Ariadne, the Cretan princess, helped the Athenian hero Theseus escape from the labyrinth, he took her on his ship to Naxos and then deserted her while she slept. She was later found by Dionysos, who married her. The painting by JOHN VANDERLYN *Ariadne Asleep on the Island of Naxos* (PAFA) was exhibited in the Paris Salon of 1812. Vanderlyn brought the painting home with him in 1815 and exhibited it widely but failed to sell it, perhaps because of Ariadne's nudity, which shocked most Americans. On May 20, 1831, he sold the picture for six hundred dollars to Durand, who planned to make an engraving of it. Later, on December 5 of that year, he also sold him "an unfinished copy of Ariadne" for fifty dollars (Receipts, PAFA Archives).

According to the 1894 biography of Durand by his son John, "Notwithstanding that the original painting was always before him in his studio, he did not begin the work [his engraving] until he had made a reduced copy of it in color of the size of the intended engraving" (p. 76). This statement by Durand's son had always been accepted as accurate, and the museum's painting, which is much smaller than Vanderlyn's original, was considered Durand's work until 1970, when Kenneth C. Lindsay reported that it was the one Durand bought from

Vanderlyn for fifty dollars in December of 1831, arguing that the painting was probably unfinished when Durand got it and that he completed it. In 1975, however, it having come to Lindsay's attention that there was a larger, unfinished version of the painting in the New-York Historical Society that had descended in Durand's family, he published an article on Vanderlyn suggesting that the society's painting, not the Metropolitan's, was the one Durand had bought from Vanderlyn for fifty dollars.

It is known that in July 1882, Benson J. Lossing visited Durand's studio, and in an article published the following year said that he had seen "one exquisite copy in colors" by Durand of Vanderlyn's *Ariadne*, "the size of the engraving." The visual evidence of the museum's painting strengthens the conclusion that it is not Vanderlyn's work and therefore undoubtedly the copy by Durand described by his son John and by Lossing. Like Durand's engraving, it is less neoclassical and more romantic than any of the paintings of Ariadne known to be by Vanderlyn. The light is softer, less sharply focused, and the shadows are less harsh. The painting lacks as well the very crisp, almost hard, modeling of Vanderlyn's original, and in short, though a faithful copy, reflects the artistic sensibility of a different era. Durand's painting differs from both his own engraving, published in 1835 or 1836, and the Vanderlyn original

Durand, *Ariadne*.

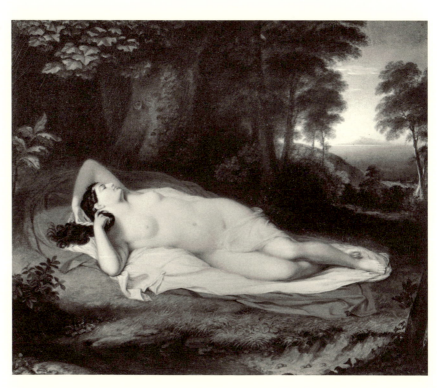

in only one, rather interesting, respect: the drapery over Ariadne's thigh is opaque, rather than partly transparent.

Oil on canvas, $17\frac{1}{8} \times 19\frac{3}{8}$ in. (43.5 × 49.2 cm.).

RELATED WORKS: J. Vanderlyn, *Ariadne Asleep on the Island of Naxos*, oil on canvas, 68 × 87 in. (172.7 × 221 cm.), 1810–1812, PAFA, ill. in University Art Gallery, State University of New York at Binghamton, *The Works of John Vanderlyn*, exhib. cat. by K. C. Lindsay (1970), pp. 82–83, no. 57 // J. Vanderlyn, *Ariadne*, oil on canvas, 70 × $87\frac{1}{2}$ (177.8 × 221.5 cm.), between 1813–1831, NYHS, ill. in NYHS, *Catalogue of the Collection Including Historical, Narrative, and Marine Art* (New York, 1982), 3, p. 209 // A. B. Durand, *Ariadne*, pencil, squared for transfer, $14\frac{1}{8} \times 17\frac{7}{8}$ in. (35.9 × 45.4 cm.), ca. 1831, NYHS // A. B. Durand, *Ariadne*, engraving, $14\frac{1}{16} \times 17\frac{3}{4}$ in. (36 × 45.1 cm.), 1835 // J. Vanderlyn, *Ariadne Half Length*, oil on canvas, 30 × 39 in. (76.2 × 99.1 cm.), Neville Public Museum, Green Bay, Wisc., ill. in University Art Gallery, State University of New York at Binghamton, *The Works of John Vanderlyn* (1970), p. 85, no. 62 // There are three known drawings by Vanderlyn relating to his *Ariadne*, two in charcoal, 1811, and one in watercolor, ca. 1812, but it is not likely that Durand based his versions on them (ibid., p. 80, nos. 55–56, and p. 81, no. 58).

REFERENCES: B. J. Lossing, *Harper's New Monthly Magazine* 66 (May 1883), p. 860 // J. Durand, *The Life and Times of A. B. Durand* (1894), p. 76, says Durand made a reduced copy (quoted above) // Grolier Club, New York, *Engraved Work of Asher B. Durand*, exhib. cat. (1895), p. 103 // *MMA Bull.*, suppl. to 12 (Oct. 1917), p. 4 // Gardner and Feld (1965), pp. 208–209 // D. B. Lawall, *Asher Brown Durand* (Ph. D. diss., Princeton University, 1966; partially published 1977), 1, pp. 124–128; ill. p. 64, no. 51, as by Durand, ca. 1835 // W. Craven, *American Art Journal* 32 (1971), p. 56, mentions smaller copy // Montclair Art Museum, N. J., *A. B. Durand*, exhib. cat. by D. B. Lawall (1971), p. 50, no. 30, mentions it as by Durand // K. C. Lindsay, *American Art Journal* 7 (Nov. 1975), p. 90, identifies large NYHS version as painting purchased from Vanderlyn for fifty dollars // D. B. Lawall, *Asher B. Durand* (1978), pp. 2–3, no. 4, as by Durand, ca. 1834, cites Lossing and John Durand references, says Ariadne in NYHS must be the one purchased for fifty dollars from Vanderlyn // W. T. Oedel, *John Vanderlyn* (Ph. D. diss., University of Delaware, 1981), pp. 397–398, n. 140–141, records that Durand purchased Vanderlyn's original and the unfinished copy now in NYHS in 1831 and painted the present "reduced copy" before he started the engraving // NYHS, *A Catalogue of the Collection, Including Historical, Narrative, and Marine Art* (1982), 3, pp. 208–210 // M. F. Beaufort, letter in Dept. Archives, Feb. 7, 1989, gives information on provenance.

EXHIBITED: San Francisco Art Association, 1872, no. 119, lent by B. P. Avery; 1873, no. 90, lent by B. P. Avery // Ortgies Art Gallery, New York, 1887, *Studies in Oil by Asher B. Durand...*, no. 393, as copy by Durand, no owner given // MMA, 1917, *Paintings of the Hudson River School* (see *MMA Bull.*, suppl. to 12, above) // Century Association, New York, 1943, *Exhibition of Paintings by Asher B. Durand*, no. 12 // NAD, 1950, *Exhibition of the Founders*, no cat. // University Art Gallery, State University of New York, Binghamton, 1970, *The Works of John Vanderlyn*, cat. by K. C. Lindsay, no. 60, ill. p. 84, as unfinished replica by Vanderlyn completed by Durand, identifies as copy sold by Vanderlyn to Durand for fifty dollars, quotes 1829 letter by Vanderlyn mentioning a small version // Los Angeles County Museum of Art, 1974, *American Narrative Painting*, cat. by N. W. Maure, no. 15, ill. p. 7, as by Vanderlyn and Durand.

ON DEPOSIT: M. H. de Young Museum, San Francisco, 1971–1974.

EX COLL.: Benjamin P. Avery, San Francisco, by 1872-d. 1875; his brother, Samuel P. Avery, New York, by 1897.

Gift of Samuel P. Avery, 1897.

97.29.2.

Luman Reed

One of the great patrons of American nineteenth-century art, Luman Reed (1785–1836), was born in Green River (now Austerlitz), a village in Columbia County, New York. In his boyhood he moved to Coxsackie, a small town on the Hudson south of Albany. There he worked in the family grocery business, taking produce from local farms to New York City by sloop. Having amassed a small amount of capital, he came to New York about 1815 and opened a wholesale and retail grocery business on the south side of Coenties Slip. By 1832 Reed had made his fortune and began to buy paintings, beginning with old masters but going on to the work of living artists. He commissioned a number of portraits from Durand and was instrumental in his taking up painting as a full-time profession. From THOMAS COLE he commissioned, in 1833, the series of paintings that is perhaps that artist's most important work, *The Course of Empire*, completed in 1836 (NYHS). He provided important support as well for WILLIAM SIDNEY MOUNT and George M. Flagg (1816–1897).

Reed's collection was housed in a specially constructed gallery in his Greenwich Street town house. A pivotal figure, Reed marks the

turning point in American patronage from aristo-crats to newly rich merchants. He was Durand's friend as well as his patron, and his illness in 1836 deeply distressed the artist, who wrote Cole a series of moving letters about the sudden de-cline in Reed's health. At his death Durand call-ed him, in one of these letters, "the man whose equal we shall never see again" (June 7, 1836, Asher B. Durand Papers, NYPL, microfilm N19, Arch. Am. Art).

Letters exchanged between Reed and Mount (A. Frankenstein, *William Sidney Mount*, 1975, pp. 68–73) are immensely revealing of the sincerity and generosity of Reed's interest in the work of artists around him, as shown by the following examples.

I feel as if your pictures were to be in the first rank of my Gallery of their kind as well as our friend Cole's. In Landscape your truth of expression and natural attitudes are to me perfectly delightful, and really every day Scenes where the picture tells the story are the kinds most pleasing to me and must be to every true lover of Art (July 25, 1835).

Not only was he sympathetic and openhanded in his relations with artists, he was an utterly avid collector as well.

The fact is I must have the best pictures in the Country (Sept. 24, 1835) . . . I say nothing about the picture you have in hand for me. I do not allow myself to think of it for if I do I shall want to see it so much that I shall hardly know how to wait until it is finish-ed. What pleasure you must take in painting (Oct. 29, 1835).

Moreover, Reed was aware that he was assist-ing at the birth of a new school of American painting.

I do not like to say too much before hand, but if these five pictures [Cole's *Course of Empire*] do not open the eyes of the Sticklers for old paintings, I shall be mistaken. This is a new era in the fine arts in this Country, we have native talent and it is coming out as rapidly as is necessary (Nov. 23, 1835).

There are several documented portraits of Reed by Durand. The first was mentioned by Reed in a letter to Durand of March 12, 1835, in which he described "my portrait taken for Mr. Sturges" (Jonathan Sturges was Reed's business partner, see below) and went on to say "He has got it home & hung up and it stands the test of the critics, even [Michael] Paff [a New York art dealer] says it is first rate & he you know spares nobody but the old masters."

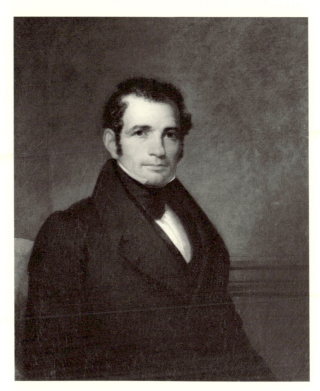

Durand, *Luman Reed*.

That portrait is very likely the one in this mu-seum, which descended in the Sturges family and was shown in the National Academy's annual exhibition in 1836. (Although listed in that cata-logue as a Portrait of a Gentleman by Durand, with no owner given, it was identified as a portrait of Reed by a writer in the *New-York Mirror*.) The second portrait of Reed by Durand is documented by a letter from the artist to Thomas Cole dated July 7, 1836, in which he stated, "I have nearly finished another portrait of our dead departed friend which satisfies me better than any other attempt" (Durand Papers, NYPL, microfilm N19 Arch. Am. Art). This may be the one that was given to the Chamber of Commerce of the State of New York by the chil-dren of Jonathan Sturges and is now in the Na-tional Portrait Gallery in Washington, D.C. It is freely painted in the manner typical of Durand's copies and quite close in spirit and style to the Metropolitan's portrait. However, it is not quite as strong. The third portrait of Reed by Durand, which is in the New-York Historical Society, is certainly the one presented by Durand to the New-York Gallery of Fine Arts, whose collection became part of the society's in 1864. It is docu-

mented in a letter to Durand from Sturges, a founder of the gallery, dated October 8, 1844, acknowledging Durand's gift of it to the gallery. Much further in style and execution from the 1836 version, it was probably painted about the time that Durand donated it. Yet another portrait of Reed descended in the Reed family and is still in a private collection.

Reed was married in 1808 to Mary Barker, the younger sister of Ralph Barker, his employer in Coxsackie. Her portrait by CHARLES CROMWELL INGHAM is also in the collection (q.v.).

Oil on canvas, 30⅛ × 25⅜ in. (76.5 × 64.5 cm.). RELATED WORKS: *Luman Reed*, oil on canvas, 36 × 27 in. (91.4 × 68.6 cm.), ca. 1836, National Portrait Gallery, Washington, D. C. (formerly at the Chamber of Commerce, New York), ill. in Montclair Art Museum, N. J., *A. B. Durand*, exhib. cat. (1971), no. 31, p. 7 // *Luman Reed*, oil on canvas, 30 × 25 in. (76.2 × 63.5 cm.), ca. 1844, NYHS, ill. NYHS, *Catalogue of American Portraits in the New-York Historical Society* (1974), 2, p. 655 // *Luman Reed*, oil on canvas, 30 × 25 in. (76.2 × 63.5 cm.), private coll., FARL 35033-5. REFERENCES: L. Reed to A. B. Durand, March 12, 1835, Asher B. Durand Papers, NYPL, microfilm N19, Arch. Am. Art (quoted above) // *New-York Mirror* 13 (June 25, 1836), p. 414, identifies the portrait of a gentleman, no. 154, in NAD 1836 exhibition as Luman Reed, says in it Durand "stamped himself as a portrait painter of the first order" // J. Durand, *The Life and Times of A. B. Durand* (1894), p. 114, quotes 1835 letter cited above // S. P. Feld, *Antiques* 87 (April 1965), p. 441 // Gardner and Feld (1965), pp. 209–210 // D. B. Lawall, *Asher Brown Durand* (Ph. D. diss., Princeton University, 1966; published 1977), p. 159; 3, p. 66, no. 57 // *Catalogue of American Portraits in the New-York Historical Society* (1974), 2, p. 654, describes the MMA portrait as a replica of the portrait now in the National Portrait Gallery, Washington, D. C. EXHIBITED: NAD, 1836, no. 154, probably this picture // Ortgies Art Gallery, New York, 1887, *Studies in Oil by Asher B. Durand...*, no. 372, as lent by Frederick Sturges // MMA, 1970, *19th-Century America*, exhib. cat. by J. Howat and N. Spassky, no. 60 // MMA, 1987, *American Paradise*, not in cat. Ex COLL.: Jonathan Sturges, New York, 1835-d. 1872; his son, Frederick Sturges, by 1887-d. 1917; his daughter, Mary Fuller Sturges Wilson. Bequest of Mary Fuller Wilson, 1962. 63.36.

The Beeches

The picture, which features meticulously rendered basswood and beech trees in the foreground, was simply titled *Landscape Composition* when Durand exhibited it at the National Academy of Design in 1846. The present title was first recorded in 1864, when the picture was shown at the Metropolitan Sanitary Fair, and was reiterated three years later by Henry T. Tuckerman. It was painted in 1845 for the New York collector Abraham M. Cozzens, who was then a member of the executive committee of the American Art-Union. It was Durand's first publicly exhibited work representing a new style in Hudson River school painting. The picture marked a significant departure from the romantic landscapes typical of his friend and former mentor THOMAS COLE. That it was a departure was recognized when it was shown at the National Academy. A critic for the *New-York Mirror* called it "incomparably the finest" of the two paintings Durand showed and perceptively noted that "there is no romance in his pictures, such as we see in Cole's. His scenes are quiet and gentle." The critic for the *Knickerbocker*, after praising the painting very highly, wrote along the same lines: "Then remember that all this is of the most every-day character. There is no attempt at grand composition."

In 1855, in the second of his "Letters on Landscape Painting," Durand implied that this new, realistic style had been inspired by John Constable:

If it be true—and it appears to be demonstrated, so far as English scenery is concerned—that Constable was correct when he affirmed that there was yet room for a natural landscape painter, it is more especially true in reference to our own scenery (*Crayon* 1 [Jan. 17, 1855], p. 34).

During his visit to England in 1840, Durand saw a good deal of Constable's work and was deeply impressed by it. He based the composition of *The Beeches* on *The Cornfield*, painted by Constable in 1826. Durand saw the picture in the National Gallery in London, where he spent much time studying and copying European pictures. From Constable's picture, he adopted the large trees at either side of the canvas, the sheep going along the road that winds into the middle distance, and even the figure with touches of red in his costume. The vertical format, which was highly unusual at the time

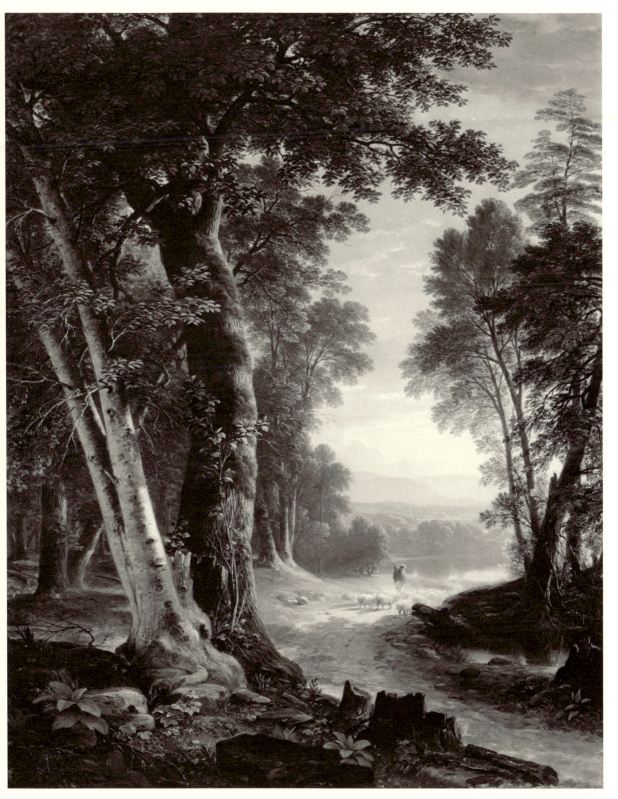

Durand, *The Beeches*.

in American landscape painting, is probably also derived from *The Cornfield*, which is similar in size. Indeed, despite what must be conceded to be painterly naïveté as compared to its model, *The Beeches* was a kind of artistic homage to Constable. More distantly, *The Beeches* reflects his study of Constable's series of paintings of Salisbury Cathedral (for example, *Salisbury Cathedral from the Bishop's Garden*, MMA), in which there is a Wordsworthian connection between the lines of the Gothic church and the arching forms of the tree branches framing it. (An earlier response to Constable's idea may be found in a sketch Durand made in Rome in 1840 of Saint Peter's framed by trees, NYHS). In *The Beeches*, the foreground landscape, perhaps significantly featuring a shepherd and his sheep, opens out into a peaceful scene, the focal point of which is a church steeple surrounded by beautiful, pinkish-yellow light.

In one respect, Durand's composition is more radical than one finds in Constable's works: the tops of the trees are cropped off, and the whole composition is brought nearer the viewer. Yet even here, Constable probably served as his model. Visiting the three important private collections of Constable's work, Durand must have seen his oil studies of trees in which the artist concentrated solely on the trunks and lower branches, which he often painted from nature and used as a basis for his large finished compositions. As far as is known, *The Beeches* is Durand's first landscape based on an oil sketch he had made on the spot: *Landscape with a Beech Tree* of 1844 (NYHS). (Cole also made oil sketches, but these appear to have been studio pieces painted in the manner common in British and American painting since the time of BENJAMIN WEST.) Based as it is on a plein-air sketch, *The Beeches* represents Durand's increased interest in accurately reproducing effects of light and shade, a practice that was taken up by later artists of the Hudson River school and one that has caused Durand to be called a proto-impressionist. It should be emphasized, however, that as much as this painting is concerned with reproducing the actualities of nature, it is primarily grounded in the work of other artists. Just as Durand took his composition from Constable, the delicate pinks, yellows, and blues of the sky reflect his study in Europe of paintings by Claude Lorrain.

Oil on canvas, 60⅜ × 48⅛ in. (153.4 × 122.2 cm.).

Canvas stamp: Theodore Kelley, 33½ Wooster Street.

Signed and dated at lower left: A. B. Durand / 1845.

RELATED WORK: *Landscape with a Beech Tree*, oil on canvas, 15¼ × 20¼ in. (38.7 × 51.4 cm.), 1844, NYHS, ill. in NYHS, *A Catalogue of the Collection Including Historical, Narrative, and Marine Art* (3 vols., New York, 1982), I, no. 629, p. 322.

REFERENCES: *Anglo-American* [New York] April 25, 1846, p. 22, calls it Landscape Composition, praises highly // *New-York Mirror* 4 (May 9, 1846), p. 74, compares to Cole (quoted above) // *Knickerbocker* 27 (May 1846), p. 464 (quoted above) // *Albion* 12 (March 19, 1853), p. 141, calls it Landscape Composition, says it is "one of his finest pictures" // E. A. Lewis, *Graham's Magazine* 45 (Oct. 1854), p. 321, as A Wood Scene, in collection of A. M. Cozzens // *Crayon* 3 (April 1856), p. 123, "It is, we believe, the first of his series of upright pictures, in which large trunks of trees are made prominent objects, and it is one of his happiest compositions" // H. T. Tuckerman, *Book of the Artists* (1867), pp. 193–194, calls it The Beeches saying "In the foreground are two noble trees, a beech and a linden—the latter with a fine mossy trunk," describes it, quotes lines from W. C. Bryant's poem *A Summer Ramble* as conveying the mood of the picture; p. 195, says it illustrates a line in Thomas Gray's *Elegy Written in a Country Churchyard*, "At the foot of yonder beech"; p. 623, lists it in collection of A. M. Cozzens // Leavitt, Strebeigh and Co., *Catalogue of the Entire Collection of Paintings...A. M. Cozzens*, sale cat. (1868), no. 29, as The Beeches—Sunset // S. A. Coale to A. B. Durand, July 27, 1870, Asher B. Durand Papers, NYPL, microfilm N21 Arch. Am. Art, refers to Durand as "the illustrious painter of 'The Beeches.' " // D. O'C. Townley, *Scribner's Monthly* 2 (June 1871), p. 43, lists it as among works that attracted most attention at NAD // D. Huntington, *Asher B. Durand: A Memorial Address* (1887), p. 33, says it was painted for Cozzens, is now in the collection of Morris K. Jesup, and that it won high praise from artists when exhibited // J. Durand, *The Life and Times of A. B. Durand* (1894), p. 173, calls it Passage through the Woods and dates 1846, says it was first of landscapes in upright format, says bought at Cozzens sale by Morris K. Jesup // *MMA Bull.* 10 (April 1915), p. 64, says it is not so successful as Durand's Summer Afternoon // *MMA Bull.* suppl. to 12 (Oct. 1917), p. 4, ill. p. 5 // Gardner and Feld (1965), pp. 210–211 // D. B. Lawall, *Asher B. Durand* (Ph. D. diss., Princeton University, 1966; published 1977), p. 384, says first example of Durand's regarding atmospheric perspective as subject to proportion; p. 468; p. 472, calls it first of his forest interiors; p. 486, says sublimity of this picture "marred by too obvious a penchant for curved and serpentine lines, for tender plants, smooth water, and limpid

light"; p. 489; 3 (unpublished), p. 116, no. 213, gives references and exhibitions // J. Caldwell, "Asher B. Durand's Travels in Europe," M.A. thesis, Hunter College, New York, 1973, p. 14, says coloring based on Claude paintings Durand had seen in Europe; p. 20, says composition based on Constable's The Cornfield // M. W. Brown, *American Art to 1900* (1977), p. 328, color ill. pl. 34 // D. B. Lawall, *Asher B. Durand* (1978), pp. 51–53, no. 99, gives references and exhibitions, quotes extensively from contemporary reviews // O. Rodriguez Roque, *Antiques* (Nov. 1987), color ill., p. 1101, calls it an "overt homage to John Constable."

EXHIBITED: NAD, 1846, as Landscape Composition (which indicates that the scene depicted was not a real one), lent by A. M. Cozzens // American Art-Union, New York, 1853, *The Washington Exhibition in Aid of the New-York Gallery of Fine Arts*, no. 42, as Landscape Composition, lent by Cozzens // Metropolitan Sanitary Fair, 1864, *Catalogue of the Art Exhibition at the Metropolitan Fair*, no. 27, as The Beeches, Sunset, lent by A. M. Cozzens // MMA, 1917, *Paintings of the Hudson River School* (see *MMA Bull.*, suppl. to 12, above) // MMA, 1946, *The Taste of the Seventies*, no. 93 // Los Angeles County Museum and M. H.

de Young Memorial Museum, San Francisco, 1966, *American Paintings from the Metropolitan Museum of Art*, no. 39, color ill. p. 45 // MMA, 1970, *19th-Century America*, exhib. cat. by J. Howat and N. Spassky, no. 61 // Montclair Art Museum, N. J., 1971, *A. B. Durand*. exhib. cat. by D. B. Lawall, no. 50, color ill., says that although Tuckerman and the Cozzens sale catalogue mention this painting in connection with a line from Gray's *Elegy*, it "has no connection with the painting," says this is earliest known studio composition based on oil study made out of doors // MMA and American Federation of Art, traveling exhibition, 1975–1977, *The Heritage of American Art*, exhib. cat. by M. Davis, color ill., no. 28, p. 26 // MMA, 1987, *American Paradise*, color ill. p. 105; pp. 104–106, entry by B. D. Gallati.

EX COLL.: Abraham M. Cozzens, New York, 1845-d. 1868 (sale, Leavitt, Strebeigh and Co., New York, May 22, 1868, no. 29, as The Beeches—Sunset, $4,000), Morris K. Jesup, New York, 1868-1908; his wife, Maria De Witt Jesup, New York, 1908-1914.

Bequest of Maria De Witt Jesup, from the collection of her husband, Morris K. Jesup, 1914.

15.30.59.

Mathew B. Brady, photograph of *The Beeches* at the Metropolitan Fair, New York, April 1864. NYHS.

Durand, *Jonathan Sturges*.

Jonathan Sturges

Jonathan Sturges (1802–1874) was born in Southport, Connecticut, the son of Barnabas and Mary Sturges, who were of relatively modest circumstances. About 1821, he joined the grocery business of Luman Reed (see above) in New York, becoming a partner in 1828 and, after Reed's death in 1836, buying his share of the business, with two other partners, from the estate. The firm prospered considerably, its profits for 1862 being put at $800,000. Sturges made a number of other investments as well. He was founder and director of the Bank of Commerce, a director of the Illinois Central Railroad, serving for a while as its acting president, and an important stockholder in the New York, New Haven and Hartford Railroad. He was a founding member of the Union League Club and an active member of the Century Association. One of Sturges's daughters, Amelia, married J. P. Morgan in 1862 but died a year later; another daughter, Virginia, married William Henry Osborn, who was later president of the Illinois Central Railroad; and his son Frederick married Luman Reed's granddaughter Mary Reed Fuller.

This portrait shows Sturges as a serious, rather phlegmatic man. In addition to his business activities, he was one of the more important patrons of American art, its institutions as well as the painters themselves. He appears to have acquired this interest from Luman Reed. In 1844, eight years after the latter's death, Sturges led a group who bought Reed's collection and set it up, in part as a memorial to him, as the New-York Gallery of the Fine Arts. It eventually became part of the New-York Historical Society's collections. Sturges was described by WILLIAM SIDNEY MOUNT as "an unchanging friend" (autobiographical sketch dated 1854, in A. Frankenstein, *William Sidney Mount* [1975], p. 19).

To Durand, Sturges was both friend and patron. His admiration for the young artist led him to accompany him on one of his sketching expeditions. He advanced him the funds for his trip to Europe from 1840 to 1841, agreeing to accept copies of European paintings and original works of art by Durand as repayment. Sturges commissioned Durand's best-known painting, *Kindred Spirits* (NYPL), in 1848, as a gift to William Cullen Bryant in gratitude for his eulogy of THOMAS COLE. Sturges's art collection was a remarkable one. According to an article published in the *Crayon* in February 1856, it contained three paintings by Cole, two by ROBERT W. WEIR, *The Flower Girl* by CHARLES CROMWELL INGHAM (q.v.), two paintings by FRANCIS W. EDMONDS, three by Mount, including one of his finest genre paintings, *Farmers Nooning*, 1836 (Museums at Stony Brook, N.Y.), about ten by Durand, including *In the Woods* (q.v.), and examples of the work of HENRY INMAN, DANIEL HUNTINGTON, HENRY PETERS GRAY, JOHN GADSBY CHAPMAN, and FREDERIC E. CHURCH.

Although in pose and coloring the present portrait is very close to a number of other works by Durand, it is so inferior in the quality of its brushwork to such portraits as the one of Luman Reed in the museum's collection as to suggest that it is a replica. Like the replicas of Reed's portrait, this portrait can tentatively be dated in the late 1830s or early 1840s.

Oil on canvas, 30½ × 25 in. (77.5 × 63.5 cm.).
EXHIBITED: Ortgies Art Gallery, 1887, *Studies in Oil by Asher B. Durand . . .*, no. 373, as lent by Frederick Sturges.
Ex COLL.: the grandson of the subject, Frederick

Sturges, New York, by the 1890s; his son, Frederick Sturges, Jr., Fairfield, Conn., d. 1977.

Bequest of Frederick Sturges, Jr., 1977.
1977.342.1.

Landscape—Scene from "Thanatopsis"

Although Durand occasionally painted large landscapes with philosophical content early in his career, they were rare in his work of the 1840s, one probable reason being that such paintings were generally considered the specialty of THOMAS COLE. With Cole's death in 1848 Durand became the acknowledged leader of the Hudson River school, and he turned again briefly to the elaborate depiction of moral messages in landscapes, relying on Cole's paintings as models. This picture was inspired by William Cullen Bryant's poem "Thanatopsis" (1811, 1817). Painted in 1850, it shows that Cole's influence extended to the incorporation of specific details: the large, aged tree at the right is a more realistic version of the twisted and gnarled tree he often placed in a foreground corner, the castle and mountain in the middle ground are very similar to a motif in his *Landscape—the Fountain of Vaucluse*, 1841 (Dallas Art Museum), and the medieval castle and Gothic church recall similar elements in Cole's pair of narrative paintings *The Departure* and *The Return* of 1837 (Corcoran Gallery of Art, Washington, D.C.). The composition resembles that of *The Arcadian or Pastoral State*, the second painting of Cole's famous series *The Course of Empire*, 1836 (NYHS). Parallels between *Thanatopsis* and Cole's *Oxbow*, 1836 (q.v.), are perhaps the most interesting. Both show strong contrasts between large areas: the left side of *The Oxbow*, including the foreground, is wild and stormy, and the right is bright, cultivated, and peaceful, whereas in *Thanatopsis* the right side, foreground, and middle ground are dark and gloomy and the left is pastoral, serene, and aglow with light.

Although Durand closely followed Cole's precedents, he did so with his characteristic modesty and lack of flamboyance. As the *Albion*'s critic noted (1850), the allegorical elements are "so toned into the pure landscape features of this picture, that they become of no importance." In fact, from 1911, when the painting came to the museum, until 1963, it was called *Imaginary Landscape*, and its association with Bryant's poem was unrecognized. When it was exhibited at the National Academy in 1850, Durand included in the catalogue the following lines from the poem:

> The hills,
> Rock-ribbed and ancient as the sun; the vales
> Stretching in pensive quietness between;
> The venerable woods; rivers that move
> In majesty, and the complaining brooks,
> That make the meadows green; and, poured
> round all,
> Old ocean's gray and melancholy waste,—
> Are but the solemn decorations all
> Of the great tomb of Man!

Other lines are reflected in the painting, those dealing with the reversion of the earth to earth, the loss of individual being

> To mix forever with the elements;
> To be a brother to the insensible rock,
> And to the sluggish clod, which the rude swain
> Turns with his share, and treads upon. The oak
> Shall send his roots abroad, and pierce thy mould.

In the foreground are Egyptian, classical, and medieval ruins ("Thou shalt lie down / With patriarchs of the infant world,—with kings, / The powerful of the earth,... / All in one mighty sepulchre"). In the middle ground a funeral is taking place, an illustration of the final passage, exhorting man not to dread his end but to "approach thy grave / Like one who wraps the drapery of his couch / About him, and lies down to pleasant dreams." Although Bryant's ocean was a "gray and melancholy waste," and Durand's is a shining expanse, to which the entire composition leads, the painting is faithful to the spirit and content of the poem. There are other symbolic elements in the painting: two goats at the edge of the graveyard scene mark the limits of the doleful area of the landscape; below them, on the sun-bathed meadow sloping down to the river, is a flock of grazing sheep, beyond which the ploughman toils in solitary peace.

Thanatopsis is like other works by Durand and his colleagues such as FREDERIC E. CHURCH—large, impressive canvases conveying philosophical sentiments which Barbara Novak has termed paintings of "the Hudson River Salon style" (1967, p. 92). Like the "machines" of the nineteenth-century salon, *Thanatopsis* is a rather overwhelming canvas that looks today somewhat empty and listless. It is in striking contrast to an oil study Durand evidently made for it, *Classical Landscape (Imaginary Landscape)*, ca. 1850 (Delaware Art Museum, Wilmington). The study is

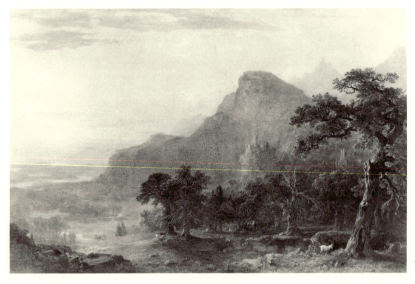

Durand, *Landscape—Scene
from "Thanatopsis"* before
1932 restoration.

dramatic, focusing on one structure and a single figure; its strong light effects seem to have been directly observed, even though the painting was probably done in the studio, and its mountains, though less grand, are more immediate and convincing. By comparison, the finished landscape painting is lacking in focus and blurred by a haze of ideality, a practice Durand learned from studying Claude Lorrain. In 1850, however, the reception of *Thanatopsis* was enthusiastic, and it continued to be praised for many years thereafter.

In 1862 Durand repainted the near range of mountains at the request of B. F. Gardner, who

then owned it, making the sheer drop of the mountain behind the castle into a more gradual decline. These additions were removed by the museum's conservators in 1932.

Oil on canvas, 39½ × 61 in. (100.3 × 154.9 cm.).
Signed and dated at lower left: A. B. Durand, 1850.
RELATED WORKS: *Classical Landscape* (*Imaginary Landscape*), ca. 1850, oil on canvas, 14⅞ × 20¾ in. (37.8 × 52.7 cm.), Delaware Art Museum, Wilmington. Although this served as a model, the subject matter is apparently not the same.
REFERENCES: *New-York Evening Mirror* 12 (April 13, 1850), p. [2], says it is "on the moral theme or

Durand, *Classical Landscape*
(*Imaginary Landscape*).
Delaware Art Museum.

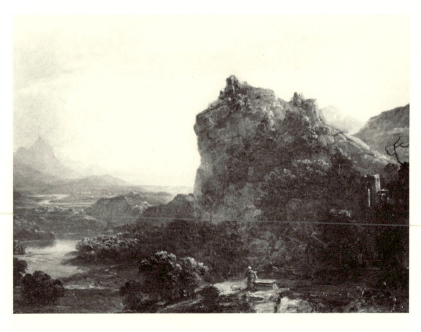

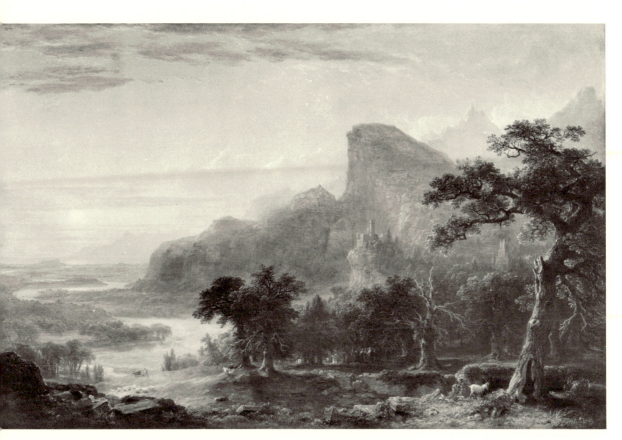

Durand, *Landscape—Scene from "Thanatopsis."*

Thanatopsis, which never struck us a subject suggestive of pictures, but the artist has made a truly fine picture out of it" // *Albion* 9 (April 27, 1850), p. 201 (quoted above) // *Bulletin of the American Art-Union* (May 1850), p. 22, says that the painting "would be more highly enjoyed by itself, and in the studio of its author" than in the gallery at the National Academy; (Dec. 1850), p. 171, records that it was distributed to Frank Moore, New York // H. T. Tuckerman, *Book of the Artists* (1867), p. 196, mistakenly records that the picture was sold at the Artists' Fund Sale in 1865 for $1,350 // Townley, *Scribner's Monthly* 2 (June 1871), p. 43, calls it Thanatopsis // Ortgies Art Gallery, New York, *Studies in Oil by Asher B. Durand...*, sale cat. (1887), p. 4, lists it among Durand's leading works // J. Durand, *The Life and Times of A. B. Durand* (1894), p. 174, gives its history, says "now in the possession of Mr. Pierpont Morgan" // E. P. Richardson, *Magazine of Art* 39 (1946), p. 284, calls it the museum's "best example of Durand" and "an outstanding example" of Durand's "romantic reveries" // E. P. Richardson, *Art Quarterly* 12 (1949), p. 12, describes it as "a reverie upon the scenery of the Old World as seen in retrospect by a romantic imagination" // A. T. E. Gardner, *A Concise Catalogue of the American Paintings in the Metropolitan*

Museum of Art (1957), p. 13, as Imaginary Landscape // Columbia Museum of Fine Arts, Ohio, and Ohio State University, *Romantic Painting, Romantic Prints*, exhib. cat. by D. B. Lawall and W. K. Samore (1963) under no. 11, J. F. Cropsey's *Return from Hawking* (coll. John C. Newington, Greenwich, Conn.), says the latter was influenced by Thanatopsis // Gardner and Feld (1965), pp. 211–212 // D. B. Lawall, *Asher Brown Durand* (Ph. D. diss., Princeton University, 1966; published 1977), pp. 408, 468; p. 487, says it is "probably Durand's most successful synthesis of a sublime foreground and beautiful distance"; pp. 530-537, interprets landscape as a correction of a stoic pessimism of Bryant's poem to correspond to optimistic expectation of salvation in his later poetry // B. Novak, *American Painting of the Nineteenth Century* (1969), p. 84, ill. p. 83 // M. W. Brown, *American Art to 1900* (1977), p. 327, likening Durand's work to Claude's, calls this "a programmatic picture," with even the Claudian "mythic details and nostalgic overtones" that Durand "usually avoided" // D. B. Lawall, *Asher B. Durand* (1978), pp. 81–83, no. 142, gives extensive references and information on provenance, says "Most or all of Durand's repainting" done for Gardner in 1862, "which filled in the interval between the two peaks above and slightly to the left

of the castle, has been removed," and gives related work || Wayne Craven, *Antiques* 116 (Nov. 1979), pp. 1123–1124.

EXHIBITED: NAD, 1850, p. 138, as Landscape, Scene from "Thanatopsis," with lines from Bryant's poem quoted above || American Art-Union, New York, 1850, no. 198, as The Thanatopsis, gives size as 39 × 60 in. || Century Association, New York, 1843, *Exhibition of Paintings by Asher B. Durand*, no. 14, as Imaginary Landscape || Art Institute of Chicago and Whitney Museum of American Art, New York, 1945, *The Hudson River School and the American Landscape Tradition*, no. 95, as Imaginary Landscape || Hudson River Museum, Yonkers, N. Y., *The Hudson River School, 1815–1865*, no. 23 || Montclair Art Museum, N. J., 1971, *A. B. Durand*, cat. by D. B. Lawall, no. 60, ill. p. 96, as Landscape, Scene from "Thanatopsis" || Delaware Art Museum, Wilmington, 1972, *American Painting, 1840–1940*, p. [11], ill. p. [12], as Landscape, A Scene from Thanatopsis || Spokane World's Exposition, 1974, no cat. || MMA and American Federation of Arts, traveling exhibition, 1975–1977, *The Heritage of American Art*, exhib. cat. by M. Davis, no. 29, ill. p. 78 || Shizuoka, Okayama, and Kumamoto Prefectural Museums of Art, 1988, *Nature Rightly Observed*, color ill. pp. 94–95, 181–182.

ON DEPOSIT: Virginia Museum of Fine Arts, Richmond, 1947–1952.

EX COLL.: American Art-Union, New York, 1850; by lottery to Frank Moore, New York, 1850; B. F. Gardner, Baltimore, by 1862; on consignment to S. P. Avery (sale, Leeds' Art Gallery, New York, *Catalogue of a Remarkably Fine Collection of Oil Paintings, by the Best American Artists, . . . Consigned to Mr. S. P. Avery. . .*, Dec. 28, 1866, no. 47a, $1,350); J. Pierpont Morgan, New York, by 1894–1911.

Gift of J. Pierpont Morgan, 1911.

11.156.

High Point: Shandaken Mountains

This painting, commissioned by Nicholas Ludlum of New York, was first shown at the National Academy's annual exhibition in April 1853. Durand spent the summers of 1853 and 1855 in Olive Township near Kingston, New York, close to High Point Mountain, the site depicted here. The painting, however, is probably based on drawings or sketches made on an earlier visit, perhaps the one Durand mentioned in a letter of September 18, 1847, to his son John (Asher B. Durand Papers, NYPL, microfilm N20 Arch. Am. Art). High Point was one of his favorite subjects, and a number of studies of it exist (see D. B. Lawall, *Asher B. Durand* [1978], nos. 391-394).

In contrast to Durand's large "historical landscapes," such as *Thanatopsis* (q.v.), where nature is overwhelming in its grandeur, the view of High Point Mountain is more modest and realistic. The season is early fall, as indicated by a tree with red foliage in the foreground and another in the middle ground. The treatment of light is quite specific, with the background in full sunlight and the remainder in mottled patches of sunlight and shadow. The stream beautifully reflects the varied light in shades of blue and gray-green with touches of white. At the left is a group of brown and white cattle, and at the right a man dressed in shades of blue and gray, which match those in the landscape, adds another fish to a stringer held by a woman with Durand's customary touch of red in her dress. The scene is bucolic, depicting the quiet joys

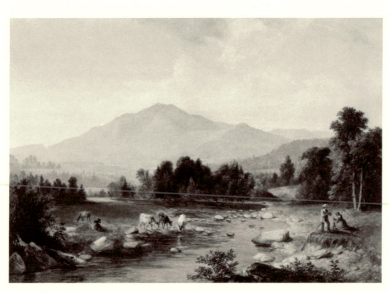

Durand, *High Point: Shandaken Mountains.*

and bounty of nature. It was the type of picture responsible for Durand's immense popularity and prestige in the years preceding the Civil War, a reassuring view of an America that was becoming increasingly urban.

Oil on canvas, 32¾ × 48 in. (83.2 × 121.9 cm.). Signed and dated at lower left: A. B. Durand 1853.

REFERENCES: J. Durand, *The Life and Times of A. B. Durand* (1894), p. 175 || Gardner and Feld (1965), pp. 212–213 || D. B. Lawall, *Asher B. Durand* (Ph. D. diss., Princeton University, 1966; partially published 1977), p. 408; pp. 469–470, discusses as example of beautiful, as opposed to sublime, in painting || W. D. Garrett, *MMA Journal* 3 (1970), p. 319 || U. S. Embassy, Moscow, *Amerikanskaya Zhivopis, 1830–1970* [*American Painting, 1830–1970*] (1974), p. 9, lists it; color ill. p. 14 || D. B. Lawall, *Asher B. Durand* (1978), p. xxxvi, mentions fisherman as example of foodgathering in Durand's landscapes; p. 98, no. 175, says topography modeled on Mountains and Stream (Yale University, New Haven, Conn.).

EXHIBITED: NAD, 1853, no. 390, lent by N. Ludlum || Newark Museum, 1930, *Development of American Paintings, 1700 to 1900* || Century Association, New York, 1943, *Exhibition of Paintings by Asher B. Durand*, no. 13 || MMA, 1965, *Three Centuries of American Painting* (checklist arranged alphabetically) || Los Angeles County Museum of Art and M. H. de Young Memorial Museum, San Francisco, 1966, *American Paintings from the Metropolitan Museum of Art*, no. 40, ill. p. 57 || MMA, 1970, *19th-Century America* (not included in catalogue) || Hudson River Museum, Yonkers, N. Y. 1970, *American Paintings from the Metropolitan*, checklist, no. 14 || De Cordova Museum, Lincoln, 1972, *Man and His Kine* (no cat.) || Shizuoka, Okayama, and Kumamoto Prefectural Museums of Art, 1988, *Nature Rightly Observed*, no. 3, color ill. p. 96; p. 82.

ON DEPOSIT: Bartow-Pell Mansion, Bronx, N. Y., 1946; U. S. ambassador's residence, Spaso House, Moscow, 1974–1978.

EX COLL.: Nicholas Ludlum, New York, 1853-d. 1868; his wife, Sarah Ann Ludlum, New York, d. 1876.

Bequest of Sarah Ann Ludlum, 1877.

77.3.1.

River Scene

Durand first used cattle as an important element in *The Solitary Oak* (*The Old Oak*), 1844 (NYHS), ten years previous to *River Scene*. (The oak, like those on the left in *River Scene*, was based on a drawing from one of his Swiss sketchbooks [NYHS]). Although *The Solitary Oak* seems related to paintings of the Barbizon school, it was actually a response to Paulus Potter's *The Young Bull*, 1647 (Mauritshuis, The Hague), which Durand had praised on a visit to The Hague in 1840. His emphasis on animals continued to increase to the point where such works as *Farmyard Summer*, about 1850 (IBM Corporation, ill. in Lawall [1978], fig. 75), could warrant the term animal painting rather than landscape. In this respect, he was influenced by the paintings of Cuyp and Potter he had seen in Europe in 1840 and 1841. By 1854, in his *Landscape with Cattle Crossing a Bridge* (University of Virginia Art Museum, Charlottesville, ill. in Lawall [1978], fig. 94), the cattle are active, moving elements, in contrast to their static

Durand, *River Scene.*

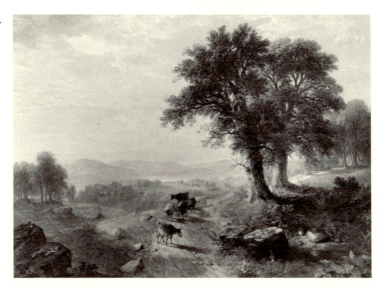

Dutch and Flemish counterparts. Durand's work, especially *River Scene*, in which the cattle move toward the viewer down a road in the center of the composition, increasingly suggests the influence of Barbizon artists like Constant Troyon and Jean François Millet. The paintings were becoming well known in America in the 1850s, often being praised in art journals. Durand may have seen actual Barbizon paintings, rather than relying on prints, for an 1861 article in the *Crayon* mentions paintings by Troyon in three New York private collections.

Yet, while the farm and domestic animals in the works of Troyon and his contemporaries, such as Rosa Bonheur, are heroic and larger than life, Durand's cattle are notably gentle and unthreatening, part of an idyllic depiction of nature. Despite the oak tree from his Swiss sketchbook and the cattle whose presence was probably inspired by French paintings, the blue outlines of the Hudson Highlands in the background and the radiant sky set the overall tone of the painting and establish its American locale.

Oil on canvas, 24 × 34⅛ in. (61 × 86.7 cm.). Signed and dated at lower left: A. B. Durand 1854.
REFERENCES: J. K. Howat, *The Hudson River and Its Painters* (1972), color ill. no. 26, p. 144, says that despite Durand's rejection of European models, this painting "harks back strongly to Dutch and English traditions"; identified view as "toward the southern entrance to the Hudson Highlands from Peekskill Bay" // J. K. Howat, *MMA Bull.* 30 (June–July 1972), color ill., p. 280, p. 281 // D. B. Lawall, *Asher B. Durand* (1978), p. 103, no. 190 // W. M. Winkle, Jr., letter in Dept. Archives, Dec. 26, 1978, provides information on donor's family.
EXHIBITED: Norman Mackenzie Art Gallery, University of Saskatchewan, 1971, *In Search of America*, no. 62, pl. 4 // Queens County Art and Cultural Center, New York, MMA, Memorial Art Gallery of the University of Rochester, N. Y., and Sterling and Francine Clark Art Institute, Williamstown, Mass., traveling exhibition, 1972–1973, *19th Century American Landscape*, cat. by M. Davis and J. K. Howat, ill. 6 // Shizuoka, Okayama, and Kumamoto Prefectural Museums of Art, Japan, 1988, *Nature Rightly Observed*, no. 4, color ill. p. 97, p. 182, discussed.
ON DEPOSIT: Allentown Art Museum, Pa., 1975–1976.
EX COLL.: Edgar Beach Van Winkle, New York, d. 1920; his daughter, Mary Starr Van Winkle, New York, until 1969.
Bequest of Mary Starr Van Winkle, 1970.
1970.58.

In the Woods

In 1855, when this painting, commissioned by Jonathan Sturges (see above), was exhibited at the National Academy of Design, it was the focus of a critical excitement unusual for the times. While it was still in Durand's studio, a writer in the February issue of the *Crayon* called it "a Wood-scene—a passage of wild forest material, [in] which we believe will be found something new in landscape Art." Immediately after the exhibition opened, the painting was praised repeatedly by writers in the same magazine: one called it a "noble picture . . . It is positive knowledge and earnest study everywhere" (March 28); the picture seemed not the work of an artist but "a passage of nature uncommonly beautiful" (April 4); and a picture of "perfect and sublime wilderness" (April 11). This contemporary emphasis on the picture's realism may have been intensified by a response to its somewhat melancholy mood, evoked by the abundance of dead decaying trees.

Unfortunately, these articles were unsigned, but at least some of them were probably by one or the other of the journal's editors, William James Stillman (1828–1901), an artist and friend of Durand, and John Durand, his son. If either of these two were giving praise to the artist, it could have reflected in the one case friendship and in the other filial piety, but as they were both among the more prominent American admirers of Ruskin they would undoubtedly have wished to mount a campaign on behalf of the painting because of Durand's faithful, almost obsessive, obedience to Ruskin's prescription for detailed observation and reproduction of the actual appearance of natural forms.

The critic for the *Knickerbocker*, however, remarking that Durand "does not despise manipulation and care, even to the minutest object; and still he is not a pre-Raphaellite," suggested an important distinction. Although Durand was evidently following Ruskin's insistence on strict adherence to nature, *In the Woods* does not show any of the garish color and esoteric subject matter often found in landscapes by the Pre-Raphaelite painters, whose work Ruskin praised. While such paintings represented a more radical break with the past than *In the Woods*, the latter was immediately recognized in the United States as a repudiation of the work of earlier artists, particularly Cole. Discussing it, a critic for

Putnam's Monthly saw Durand as "working out the problem of his originality," stating that Cole must be classed as a sentimentalist, and inclined both by feeling and study to the masters of the last phase of landscape; while the former [Durand] in all respects conforms to the modern spirit, based on reality and admitting no sentiment which is not entirely drawn from Nature. . . . Durand appears to better advantage than ever before.

An adverse piece of criticism appeared in the *New York Times*, though neither the artist nor the painting was explicitly identified:

It is not by sitting in a wood and depicting trees therein with painful minuteness—that American artists can hope to rival their European brethren, or create a school of their own, with vitality in it. *History, poetry, fable, and the inexhaustable treasures of the imagination, are the subjects of which the preceding should be but adjuncts.* Fidelity to external Nature is but mere mechanism of Art, if it be not accompanied with internal sentiment and poetry (quoted in the *Crayon* 1 [May 9, 1855], p. 299).

This critic understood that the strong objective realism Durand had adopted was a renunciation of the romantic landscape tradition and an espousal of the doctrinaire position expounded by Ruskin.

In the Woods suffers from a certain dryness of execution and lack of variety in color, which may be the result of its realism. In later paintings Durand partially abandoned the meticulous method used here, but the same closed-in format, which he had been developing since at least 1846, was influential in the work of a number of other artists, the most important being JOHN F. KENSETT (for example, *Bash-Bish Falls, South Egremont, Massachusetts*, 1855, MFA, Boston) and WORTHINGTON WHITTREDGE (*The Trout Pool*, 1868, q.v. VOL. 2). His effort to paint a landscape according to Ruskin's ideal may have dictated the choice of a close-up view, and the vertical format may have been simply a response to the nature of his subject matter. The format and composition could also have come from an earlier artistic period. Jacob van Ruisdael and Meindert Hobbema have been mentioned in relation to this painting, but it is probably closer to landscapes by lesser-known seventeenth-century Dutch artists like Herman Saftleven (for example, *Interior of a Forest*, 1647, Bredius Museum, The Hague) and Jan Hackaert (*Stag Hunt*, n.d., Detroit Institute of Arts). In Durand's travels

through Belgium and the Netherlands in 1840, he could have seen the work of such artists and also, while in France the same year, early works by Barbizon painters like Théodore Rousseau. Unfortunately, he recorded very little about the works of art he saw in Europe. Gustave Courbet is the painter whose work *In the Woods* most resembles. The similarity of Courbet's *La Curée, Chasse au Chevreuil dans les Forêts du Grand Jura*, 1857 (MFA, Boston), to Durand's painting may stem from a common source, probably Dutch.

It is highly unusual in Durand's exhibition pictures to find no human figures. Wolfgang Stechow has described the presence of man in Dutch landscapes as tending to prevent an "attempt at a glorification or deification of nature as something beyond man's scope or control" (*Dutch Landscape Painting of the Seventeenth Century* [1966], p. 8), and the landscape *In the Woods* can be seen as both deified and outside human control. The scene is closed in, with only small areas of sky visible. Tall trees, some of them stretching up beyond the viewer's range and leaning inward, produce an arching frame for a brook that emerges from the bottom edge and winds through the picture, leading the eye to a far distant opening at the end. Fallen trees and branches and rotting stumps litter the forest floor. The light is bluish-gray, almost unearthly. Life is present, however, expressed by a woodpecker on a tree trunk, a low-flying hawk, and a squirrel on a log. A connection has been noted by Lawall to poems by William Cullen Bryant, particularly "Inscription for the Entrance to a Wood," with its mood of quiet relaxation, and even such details as the birds. There are other resemblances to Bryant's descriptions of the forest as a place of worship (for example, "A Forest Hymn") in the painting's implication of a Gothic church interior.

Aside from its relationship to these ideas, the tone is more somber than in earlier works like *The Beeches* and especially the oil study *Woodland Interior*, 1854 (Smith College Museum of Art, Northampton, Mass.), on which *In the Woods* is based, and which has relatively few decayed and dying trees. The changes in emotion can possibly be attributed to Durand's personal life and the philosophical climate of the country. As the decade went on, Durand's somewhat naive optimism, as expressed by the benign American landscape, may have been more difficult to sustain. In the early 1850s the artist was troubled

by the severe illness of his wife. In 1854 and 1855, the years during which *In the Woods* was painted, the violent struggles engendered by the Kansas-Nebraska Act made clear the increasingly precarious situation of American politics and society. An inherently cheerful man, Durand did not actually forsake the pleasant, bucolic views that had made him rich and successful. *In the Woods*, painted when he was fifty-nine, does, however, mark the beginning of a more modulated interpretation of the American landscape and a more quietistic, less optimistic, approach to it.

Oil on canvas, 60½ × 49 in. (153.5 × 124.5 cm.). Signed and dated at lower right: A. B. Durand / 1855.

RELATED WORKS: *Woodland Interior*, oil on canvas, 23½ × 16¾ in. (59.7 × 42.5 cm.), Smith College Museum of Art, Northampton, Mass. || *Sketch in the Woods*, oil on canvas, 24⅛ × 8¼ in. (61.3 × 46.3 cm.), 1856, Brandywine River Museum, Chadds Ford, Pa., has a very similar birch tree, but shown in reverse.

REFERENCES: *Crayon* 1 (Feb. 28, 1855), p. 139 (quoted above) || *Crayon* 1 (March 21, 1855), p. 186, says "it is treated with most masterly breadth, and almost pre-Raphaelite truth of detail" || *Albion* 14 (March 24, 1855), p. 141, calls it "wonderfully complete," says it might "savour of mechanical excellencies" were it not for "the abounding space and atmosphere" || *Spirit of the Times* 25 (March 24, 1855), p. 66, says Durand's "Woody dells take us from the dusty streets into the very arcana of nature" || *Crayon* 1 (March 28, 1855), p. 203 (quoted above) || *Home Journal* (March 31, 1855), p. 2, calls it "glorious" || *Crayon* 1 (April 4, 1855), p. 219 (quoted above), (April 11, 1855), p. 234 (quoted above), (April 18, 1855), p. 250, M. N. M. remarks on the "grayish tone, which seems to pervade the whole picture"; p. 251, gives poem "In the Woods" occasioned by this painting ||

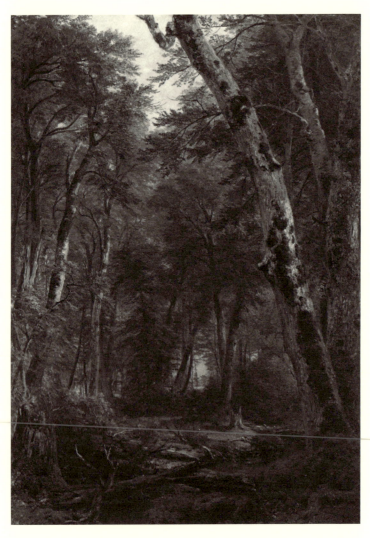

Durand, *Woodland Interior*. Smith College Museum of Art.

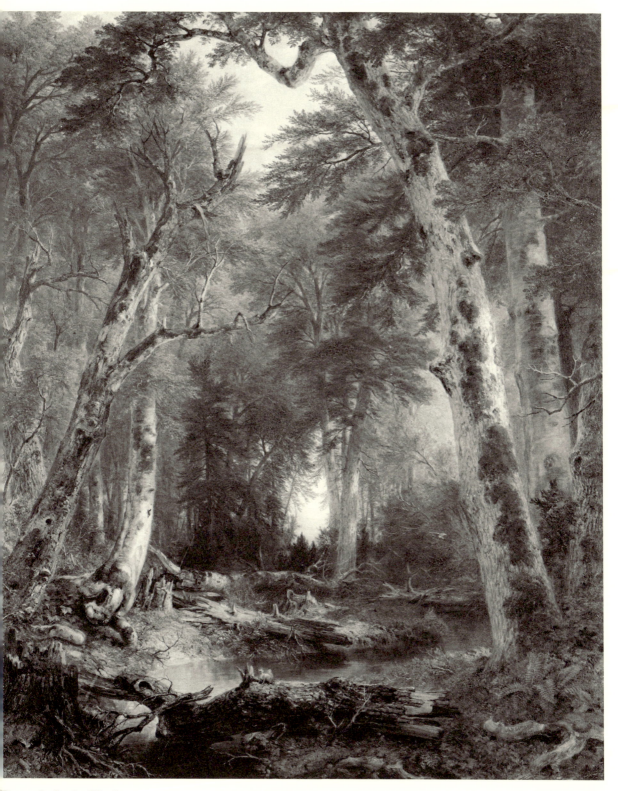

Durand, *In the Woods*.

New-York Daily Tribune (May 7, 1855), p. 7, says "Ashy tints prevail too much and deaden the light, which in the wood should offer broader contrasts, by the opposition of sun and shade" // *Crayon* 1 (May 9, 1855), p. 299, quotes the *Times* (quoted above) and Clarence Cook of the *Independent* as calling Durand "mannered" and "monotonous," saying foliage "entirely wanting in character" in this picture, says Durand "painstaking and conscientious . . . but his ability is very limited" // *Southern Times* (Montgomery, Ala., May 12, 1855), clipping in John Durand Papers, NYPL, quoted in D. B. Lawall, *Asher B. Durand* (1978), p. 109, praises very highly, quotes praise from an unnamed "gentleman of taste and culture" // *Putnam's Monthly* 5 (May 1855), pp. 505-507 (quoted above) and describes it at length // *Knickerbocker* 45 (May 1855), p. 532 (quoted above), calls it "replete with gems" // *Harper's New Monthly Magazine* 10 (May 1855), p. 841, calls it "accurate and conscientious," but complains that this work shows no advance on his earlier paintings // J. Durand to A. B. Durand, July 28, 1855, Asher B. Durand Papers, NYPL, microfilm N20 Arch. Am. Art, forwards check from Sturges, possibly for this painting // *Crayon* 3 (Feb. 1856), p. 8, article on Sturges collection calls it "to our taste, the finest of the artist's works" // J. Sturges to A. B. Durand, May 23, 1857, Asher B. Durand Papers, encloses additional payment for this painting, saying "The trees have grown no more than two hundred Dollars worth since 1855" // T. S. Cummings, *Historical Annals of the National Academy of Design* (1865), p. 141, mentions it as in Sturges collection // H. T. Tuckerman, *Book of the Artists* (1867), pp. 189-190, describes what appears to be this picture, identifies trees, praises it for its realism; p. 195 // F. Leslie, *Report on the Fine Arts, Paris Universal Exposition, 1867* (1868), p. 13, gives title as Autumn in the Woods, calls it "by no means one of his best works" // D. O'C. Townley, *Scribner's Monthly* 2 (June 1871), p. 43, lists as among most praised works // Montezuma [Montague Marks?], *Art Amateur* 15 (Nov. 1886), p. 113, lists it in Jonathan Sturges collection as "one of his best works" // D. Huntington, *Asher B. Durand: A Memorial Address* (1887), p. 34 // Ortgies Art Gallery, New York, *Studies in Oil by Asher B. Durand. . .*, sale cat. (1887), p. 4, lists it among Durand's leading works // J. Durand to C. H. Hart, Jan. 22, 1893, John Durand Papers, NYPL, discusses possibility of borrowing it from Mrs. Sturges for Chicago Columbian Exposition // J. Durand, *The Life and Times of A. B. Durand* (1894), mentions it as "most admired" of "the series of tree-trunk subjects," which included Primeval Forest (now called Woodland Interior), 1854 (Smith College Museum of Art, Northampton, Mass.), and June Shower, 1854 (Manoogian coll., Detroit) // *MMA Bull.*, suppl. to 12 (Oct. 1917), p. 4 // A. T. Gardner, *MMA Bull.* 23 (April 1965), p. 272 // Gardner and Feld (1965), pp. 213-214 // D. B. Lawall, *Asher Brown Durand* (Ph. D. diss.,

Princeton University, 1966; published 1977), pp. 367-368, says based on oil study, Woodland Interior (Smith College Museum), probably related to Primeval Forest and Trees and Brook, both ca. 1855, and Trees and Brook, 1858 (all NYHS); p. 370, gives as an example of culmination of Durand's efforts toward realism; p. 408; pp. 473-485, says related to European works and influenced American contemporaries, illustrates Bryant's poetry, discusses analogy of forest and Gothic church; p. 484, says the painting is "mainly an enlargement of an oil study"; fig. 169 // J. T. Flexner, *Nineteenth Century American Painting* (1970), p. 60, color ill. // B. Novak, *Art in America* 60 (Jan.-Feb. 1972), p. 52 // M. W. Brown, *American Art to 1900* (1977), p. 328, calls it "a most significant step toward the realistic landscape that his followers in the next generation would exploit" // D. B. Lawall, *Asher B. Durand* (1978), p. xxv, says series of studies of plant forms "for the sake of the mystery of the unconscious life of the vegetative soul which they reveal" began with The Beeches and culminates in this painting; p. xxxix, says illustrates "the theme of the continuity of life"; pp. 107-110, quotes extensively from contemporary comments; fig. 102.

EXHIBITED: NAD, 1855, no. 113, lent by J. Sturges // *Exposition Universelle*, Paris, 1867, no. 14 // NAD, Winter 1867, no. 639, lent by J. Sturges // MMA, 1917, *Paintings of the Hudson River School* (see *MMA Bull.*, suppl. to 12, above) // Baltimore Museum of Art, 1940, *Romanticism in America* // Century Association, New York, 1943, *Exhibition of Paintings by Asher B. Durand*, no. 11 // Utah Centennial Exposition, Salt Lake City, 1947, *100 Years of American Painting*, ill. p. 57, no. 2 // MMA, *1970 19th-Century America*, not in cat. // National Gallery, Washington, D. C.; City Art Museum, Saint Louis; and Seattle Art Museum, 1970-1971, *Great American Paintings from the Boston and Metropolitan Museums*, ill. no. 35 // Museum of Modern Art, New York, 1976, *The Natural Paradise*, ill. p. 69 // MMA, 1987, *American Paradise*, color ill. p. 114; pp. 113-115, entry by B. D. Gallati.

EX COLL.: Jonathan Sturges, New York, 1855-d. 1874; Mrs. Jonathan Sturges, New York, 1874-d. 1894; their children, 1895.

Gift in memory of Jonathan Sturges by his children, 1895.

95.13.1.

Summer Afternoon

This landscape was painted in 1865 for Morris K. Jesup, a prominent businessman and philanthropist, who also owned *The Beeches* (see above) by Durand and a number of other important paintings of the Hudson River school. Although it has on occasion been very highly

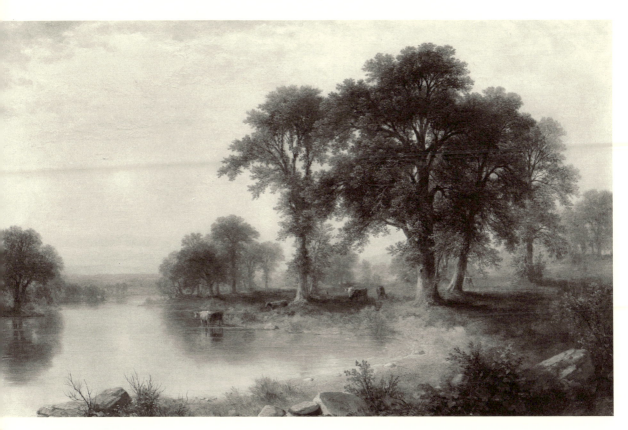

Durand, *Summer Afternoon.*

praised, the picture represents a rigidifying of the artist's style into a formula, the very one that for years the term "Hudson River school" connoted for most of its critics. In comparison to the oil study for it, the finished painting lacks spontaneity and is calculated in concept and execution. In the study, Durand was somewhat painterly in depicting light and shade, and the sky has something of the same beautiful rosy glow he achieved in *The Beeches.* The elements in the finished work show him at his most academic. The chiaroscuro in the right middle ground is dryly painted and unconvincing, the spots of yellow paint looking more like a two-dimensional surface pattern than the effect of light on grass. The sky, too, which, like the right side of the landscape was adapted from the work of J. M. W. Turner (*Liber Studiorum* [1807 or 1808], no. 68), is flat and uninspired, especially in comparison to Turner's. Perhaps the handling of the animals is the most revealing. In the study they are real and anatomically believable, whereas in the finished painting they are vague and unsubstantial forms.

The possible reasons for Durand's decline into formula painting are many. By 1865 the Hudson River school style, or at least that variety of it practiced by Durand, was for the most part exhausted. Even though academic painting would be precisely what to expect from a president of the National Academy, his *American Wilderness* of the previous year (Cincinnati Art Museum), and one of his most somber landscapes, shows none of the formulaic weaknesses of *Summer Afternoon.* Of course, in 1865, the artist may have been suddenly too old at sixty-nine to attain the heights he had reached only a few years before. Yet the most convincing explanation may be a broader one, that Durand shared in the national relief that the Civil War was at last coming to an end, and the painting could have been an unsuccessful effort on his part to return to the pastoral, essentially optimistic, vision of his earlier work.

While not enough information has yet been published about which paintings by Barbizon artists came to this country during the 1860s, *Summer Afternoon* should probably be considered

Asher B. Durand

429

in relation to the works of Théodore Rousseau, who was often fulsomely praised in the *Crayon*. Paintings by Rousseau were shown in New York after about 1859 at Goupil's Gallery and the Crayon Art Gallery on Broadway and Eighth Street run by George Ward Nichols (1837–1885), an artist and art dealer (see P. Bermingham, *American Art in the Barbizon Mood* [1975], pp. 29–30). A comparison of *Summer Afternoon* with Rousseau's *Farm on the Banks of the Oise*, 1852 (coll. George Howard, Yorkshire, ill. in R. L. Herbert, *Barbizon Revisited* [1962], no. 97, p. 188), shows a close relationship in composition and certain details. Rousseau's painting was apparently still in France in 1865, but a very similar landscape by him might well have been exhibited in New York. Furthermore, the rather awkward manner in which Durand applied the paint in the right middle ground and the oddly hot tones of green and yellow suggest an undigested appropriation of Rousseau's style.

Oil on canvas, 22½ × 35 in. (57.2 × 88.9 cm.).
Signed and dated at lower center: A. B. Durand / 1865.
RELATED WORK: *Summer Afternoon*, oil on canvas, 16⅝ × 21 in. (42.2 × 53.3 cm.), ca. 1865, Virginia Museum of Fine Arts, Richmond, color ill. on back cover of *American Art Review* 4 (August 1977).
REFERENCES: H. T. Tuckerman, *Book of the Artists* (1867), p. 195, says "all Durand's rare faculty" appears in the picture and praises it effusively for its charm, truth, and sentiment // B. Burroughs, *MMA Bull.* 10 (April 1915), p. 64, says installed in Jesup's house in dark wood panel over mantel // *MMA Bull.*, suppl. to 12 (Oct. 1917), p. 4, ill. p. 3 // Gardner and Feld (1965), pp. 214–215 // D. B. Lawall, *Asher Brown Durand* (Ph. D. diss., Princeton University, 1966; 2 vols. published, 1977); 3 (unpub.), no. 364, p. 180 // M. W. Brown, *American Art to 1900* (1977), pp. 327–328, calls it "perhaps his greatest and most characteristic painting," says it "sums up both his dependence on Claude and his own particular talent," says reflects Dutch influence, with the Claudian "mode . . . transformed into a contemporary American experience" // D. B. Lawall, *Asher B. Durand* (1978), p. 141, no. 268A, identifies study for it in Virginia Museum of Fine Arts, Richmond // M. Wallace, orally, Dec. 1, 1978, pointed out similarity to Turner print.
EXHIBITED: MMA and NAD, 1876, *Centennial Loan Exhibition of Paintings*, no. 182 // MMA, 1934, *Landscape Paintings*, no. 67 // *Century Association, New York*, 1943, *Exhibition of Paintings by Asher B. Durand*, no. 15 // MMA, 1958–1959, *Fourteen American Masters*, no cat. // Henry Gallery, University of Washington, Seattle, 1968, *The View and the Vision*, cat. by R. B. Stein, p. 24, presumably referring to this painting, says "The late landscapes of Durand often seem to have traded the agitated and often harsh precision of particular 'truth to nature' of Kauterskill Clove for the placid serenity of Barbizon, without quite catching the new tone and vigor of these mid-nineteenth-century radicals"; no. 14 // Saint Peter's College, Centennial Art Gallery, Jersey City, 1972, *Hudson River School of Painting*, checklist, no. 5 // New York State Museum, Albany, 1977–1978, *New York: The State of Art*, no. 7.
ON DEPOSIT: United States Mission to the United Nations, New York, 1973–1976.
EX COLL.: Morris K. Jesup, New York, 1865–1908; his wife, Maria DeWitt Jesup, New York, 1908–1914.
Bequest of Maria DeWitt Jesup, from the collection of her husband, Morris K. Jesup, 1914.
15.30.60.

OLIVER TARBELL EDDY

1799–1868

The engraver, itinerant portraitist, and inventor Oliver Tarbell Eddy was born in Greenbush, Vermont. His father, Isaac, was a copperplate engraver, printer, and manufacturer of printer's inks, and also developed and patented machinery. Eddy probably received his only artistic training from his father while in the printing business. His first known work is a copperplate engraving, *The Death of General Pike*, ca. 1814. A map of New Hampshire with an inset of Bellows Falls that he engraved is dated 1817.

Eddy married Jane Maria Burger, the daughter of a silversmith, in Newburgh, New York, in 1822. She later bore him seven children. It is not known where they lived before 1827, when Eddy is first listed in the New York city directory as a miniature and portrait painter. During the same year he exhibited at the National Academy of Design and the American Academy of the Fine Arts. In about 1830, he moved his growing family to Elizabeth, New Jersey. Apparently he had trouble getting commissions and so abandoned painting for a while. In 1835, however, he advertised in the Elizabeth Town *New Jersey Journal* that: "O.T. Eddy has resumed his former profession of portrait and miniature painting." He moved to Newark that year, for his name appears in that city's 1835 directory. He then began to find considerable success and painted in his best style. After several years, having painted many of the prominent families in Newark, Eddy moved to Baltimore in search of a larger clientele. There he painted prolifically for eight years beginning in 1842. During this period, the work of REMBRANDT PEALE had marked, if short-lived influence on Eddy's style. In 1839, Eddy painted *William Rankin, Sr.* (Newark Museum), five years after the subject had been painted by Peale. The Peale portrait was hanging in the parlor of the Rankin home at the time Rankin sat for Eddy. As a result, Eddy's portrait is softer and less linear than usual. Shortly, however, he returned to his dry, tight style, and his subsequent works show little of Peale's directness and manner. When his commissions began once more to diminish, he became preoccupied with mechanical inventions, much as his father had before him.

In 1850, he received a patent for a typewriter that he called a typographer. The plans were well designed, but the actual construction of the machine was complicated; and he spent several years trying unsuccessfully to perfect it. That year, Eddy moved to Philadelphia and exhibited at the Pennsylvania Academy of the Fine Arts three Talbotype portraits, photographic pictures that he colored by hand. In 1859 he patented an improved coffee pot. He also created a device for raising and lowering the sails on a boat, a machine for making cork linoleum, a barrel maker, and a cartridge belt.

His portraits all show the marked influence of his early years as an engraver—crisp outlines and meticulous attention to detail. Like the work of many other self-taught artists of the nineteenth century, Eddy's portraits are characterized by stilted figures, bold, bright colors, a strong sense of decorative pattern, and lack of perspective. His subjects are delineated in tight brushstrokes and portrayed in a quiet, serious style. His training in engraving, when applied to canvas, produced a curious blend of virtuoso treatment of detail and routine limning. He delighted in rendering clothing, furnishings, and personal belongings. His portraits depicting only one sitter almost invariably are three-quarter length and show the person seated, with gold-fringed, red drapery in the background. More elaborate compositions are excellent documents of early Victorian interiors. He carefully delineated background details, such as Brussels-style floor coverings, Empire furniture, ornate chandeliers, vases of flowers, and architectural features, including fluted columns and elaborate moldings. For group portraits, it is obvious that Eddy made separate studies of each subject as they bear little relation to one another.

Eddy's production during the final years of his life seems to have diminished considerably. Whether this was due to lack of commissions or his preoccupation with inventions is not

certain. He did exhibit two portraits at the Pennsylvania Academy in 1868. He died in Philadelphia the same year.

BIBLIOGRAPHY: Newark Museum, *Oliver Tarbell Eddy, 1799–1810*, exhib. cat. by Edith Bishop (Newark, 1950). Most complete treatment of the artist's life and work // William H. Gerdts, "People and Places of New Jersey," [Newark] *Museum* 15 (Spring-Summer 1963), pp. 7–9.

The Alling Children

Stephen Ball Alling (1808–1861), a partner in the Newark, New Jersey, jewelry firm of Alling, Hall, and Dodd, married Jane H. Weir (1811–1889) of New York in 1830. The Allings had ten children, the first four of whom are the subjects of this painting. From left to right, they are Stephen Ball (1835–1839), Mary Wilder (b. 1836), Cornelia Meigs (b. 1833), and Emma (b. 1831). Emma became the wife of Dr. William A. Durrie of East Orange in 1851, and Cornelia was married to Albert Palmer, also of East Orange, the following year. Mary was married to Dr. Samuel R. Farman of Jersey City in 1860.

The apparent ages of the children in the portrait date it about 1839. The composition, moreover, suggests that the portrait was painted shortly after Stephen's death in 1839. The three girls are set to the right of the canvas, separated both spatially and coloristically from their brother, who stands in a pool of light. Postmortem

Eddy, *The Alling Children*.

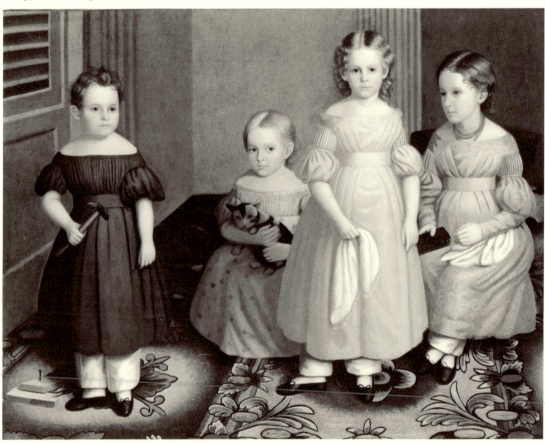

portraits were common in the nineteenth century because families often desired likenesses of departed members. Eddy painted two other such portraits in Newark at approximately this time: *The Rankin Children* of 1838 (Newark Museum) depicts a little girl who was deceased, as does *Two of the Children of Albert Alling and Sarah Canfield Alling* (coll. Mrs. Francis Child; ill. in Newark Museum, *Oliver Tarbell Eddy, 1799–1868* (1959), pl. 16).

Eddy is not known ever to have signed his work, and *The Alling Children* heretofore had only been attributed to him. Circumstantial data and stylistic comparisons, however, are substantial. Not only was he established in Newark at the time the Alling children were growing up, he also painted their cousins: *Grandchildren of David Alling*, ca. 1840 (New Jersey Historical Society), and *Two Children of Albert Alling and Sarah Canfield Alling*, ca. 1838. The crisply delineated subjects, coloring, and meticulous attention to the detail of the costumes, patterned floor cloth, and architectural elements are all very much in the style of Eddy. The cat that Mary is holding is not only similar in handling to the one in *The Rankin Children*, which is a painting documented to be by Eddy, but could easily have come from the same litter. Until Eddy moved to Baltimore, he seems to have painted on wood panel, with the exception of his large-scale group portraits. In these cases, he joined two sheets of canvas vertically, a construction evident in both *The Rankin Children* and *The Alling Children*.

The Alling children are shown in the family parlor. Stephen holds a hammer in one hand and a nail in the other. Placed on the floor next to him are the objects of his industry—two pieces of wood about to be nailed together, perhaps an allusion to the cross that marks his grave. Mary, in a pale yellow dress with tiny red flowers, is seated on a late Empire stool, holding a fat black-and-white calico cat in her lap. Cornelia, who is standing, wears a stylish pink satin off-the-shoulder dress and looks directly at the viewer. In her right hand, she holds a white handkerchief edged in lace. Emma, who wears a gray brocade dress and a red necklace, is seated facing her brother, although she does not appear to be looking at him. A black prayer book is in her right hand and a handkerchief is in her lap. All the children have blue eyes and rose-colored cheeks and wear white pantalettes and black slippers with tiny bows. The Brussels-style floor cloth is colored in shades of brown, yellow, red, and pink. The walls are light brown; fluted columns flank the doorways and the door at the left has bright green louvres.

Eddy's awkward drawing of the figures is characteristic of his work. Emma appears stilted, placed on the very edge of a chair in a semi-seated position, Cornelia is centered over one leg, the cat looks more like a pig, and Stephen's left arm is too short, his sleeve too large. The sensitive and realistic portrayal of the children's faces coupled with the meticulous rendering of the costumes and setting, however, make this an immensely appealing domestic scene and an important documentary source for American mid-nineteenth-century interiors.

Oil on canvas, 47⅛ × 62⅞ in. (119.7 × 159.7 cm.).

Ex COLL.: Edgar William and Bernice Chrysler Garbisch, by 1964.

Gift of Edgar William and Bernice Chrysler Garbisch, 1966.

66.242.21.

UNIDENTIFIED ARTIST

Portrait of a Little Girl Picking Grapes

The representation of girls picking grapes or other fruits or flowers was a formula frequently employed by mid-nineteenth-century portrait painters, both academic and untrained. The latter, however, seemed particularly fond of this iconography. This painting is loosely executed and dominated by shades of green and blue. The attempt to depict the girl in motion, the general composition, and the manner in which the arms and hands as well as the trees in the background are painted resemble a portrait of a girl picking berries (ill. in J. Lipman, *American*

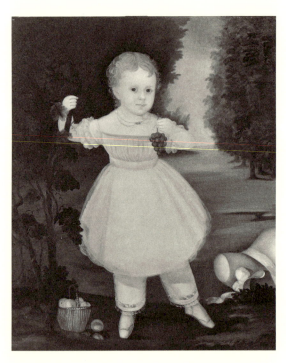

Primitive Painting [1942], pl. 10). Unfortunately, that work too is neither dated nor attributed. Judging from the clothing, it is likely they both date from about 1840 to 1850.

Oil on canvas, 35¾ × 28⅞ in. (91.0 × 73.3 c,.).
ON DEPOSIT: Gracie Mansion, New York, 1974–1975.
Ex COLL.: with David W. McCoy, until 1962; Edgar William and Bernice Chrysler Garbisch, 1962–1973.
Gift of Edgar William and Bernice Chrysler Garbisch, 1973.
1973.323.6.

Unidentified artist,
Portrait of a Little Girl Picking Grapes.

JOHN BRADLEY

active 1832–1847

Although a number of signed and dated paintings by John Bradley exist, not much is known of his life. The inscription "Drawn by I. Bradley / From Great Britton" on five 1834 portraits proves that he was an immigrant; he has tentatively been associated with a John Bradley who came to the United States from Ireland in 1826. His earliest known work, *The Cellist,* 1832 (Phillips Collection, Washington, D. C.), recalls the work of British painter Arthur Devis (1712–1782) in the spareness of its composition and size, which is small for a full-length portrait. Between 1833 and 1834, Bradley painted a series of half-length portraits of Staten Island residents that are characterized by marked attention to likeness and details of dress. Like a number of other provincial artists of this period, Bradley excelled at painting the lace worn by his lady sitters.

In 1836, Bradley advertised himself in the New York city directory as a portrait painter at 56 Hammersley Street. Between 1837 and 1844, he worked at 128 Spring Street; from 1844 to 1847, he lived at number 134. He excelled in painting portraits of children, such as *Girl with Doll,* 1836 (Abby Aldrich Rockefeller Folk Art Center, Williamsburg, Va.), and some of his portraits of adults are extraordinary likenesses. He is also known to have painted miniatures. During his later years in New York, Bradley accommodated himself more and

more to the prevailing academic portrait style he saw around him, muting his colors and adopting more conventional compositions. Bradley is last listed in the New York city directories for 1847 and nothing is known of his career after that date.

BIBLIOGRAPHY: Mary Childs Black and Stuart P. Feld, "Drawn by I. Bradley from Great Britton," *Antiques* 90 (Oct. 1966), pp. 502–509. The most complete work on Bradley to date. Includes a checklist of twenty–two portraits.

Emma Homan

Emma Homan (1842–1908), daughter of George and Emma Homan, was born in New York on February 13, 1842. When Bradley painted her, she was probably about two years old.

According to information given to the previous owners, the portrait was painted in 1843 in Wading River, a small village on the north shore of Long Island some seventy miles from New York. The address included with the signature indicates that the portrait was painted between

Bradley, *Emma Homan.*

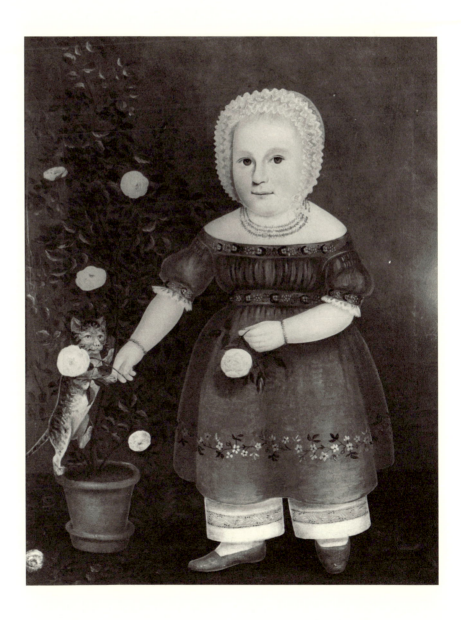

1837 and 1844. From the apparent age of the subject, the latter year is more likely.

Bradley painted at least two other portraits of little girls during the period he lived at 128 Spring Street in New York. The subjects are all posed standing beside rosebushes. The *Little Girl in Lavender*, ca. 1840 (National Gallery of Art, Washington, D.C.), has a cat in the left foreground playing with a rose that has fallen to the floor; the roses in this painting are red, instead of pink as in *Emma Homan*. In the *Child in a Green Dress*, ca. 1837–1844 (private coll., ill. in Sotheby's *Important American Folk Art and Furniture* [Jan. 27, 1979], lot 253), which is very similar to Emma Homan's portrait, the little girl holds a basket and has no cat, but she stands on a carpet much like the one in the museum's portrait in pattern and color. Emma Homan, little more than a baby in her portrait, stands unnaturally still. Her cat, climbing the conveniently thornless rosebush, is oddly pig-like, with fixed, piercing yellow eyes. The unreality of the scene produces a magical charm. As in many of Bradley's paintings, the color has great subtlety and balance, with the orange-red of the mouth and the coral necklace contrasted with the delicate pink cheeks and roses, and the white pantalettes and bright red shoes standing out against the purplish gray dress.

Emma Homan went to Rutgers College and became an artist and a writer. According to *Who Was Who in America* (1942, 1, p. 1225), she studied at the National Academy of Design, where she exhibited her work. In 1876 the academy catalogue lists *On the Watch*, priced at $75, and *Lady Teasle*, at $125, under the name of Emma Homan Graves, with no address given for her home or studio. Her first husband, George A. Graves, died four years after their marriage, and she married Elmer A. Thayer in 1877. She then went to Chicago. An address there at 220 Dearborn Avenue is given with a painting she exhibited at the National Academy in 1882 called *Only Five Cents*, priced at $800. The same year she moved to Colorado and became an authority on wild flowers, publishing *Wild Flowers of Colorado*, from her own watercolor sketches, with brief botanical descriptions, in a limited edition in New York in 1885 and again as *Wild Flowers of the Rocky Mountains* in 1887. Another

book based on her watercolors, *Wild Flowers of the Pacific Coast*, also appeared in 1887. After this, she wrote several novels, among which were *The English American*, published in 1890, *Petronilla: The Sister*, in 1897, and *A Legend of Glenwood Springs*, in 1900. Another line of interest is indicated by *Dorothy Scudder's Science*, which she published in 1901. She died in Denver.

Oil on canvas, 34 × 27⅛ in. (86.4 × 68.9 cm.).

Signed at the lower right: By J. Bradley 128 Spring Street.

REFERENCES: *Antiques* 64 (Nov. 1953), p. 400, as for sale by Argosy Gallery // R. Shevin, letter in Dept. Archives, Oct. 8, 1953, supplies information on subject // C. W. Schaefer, curator of Garbisch coll., letter in Dept. Archives, Sept. 13, 1955, says the portrait was reportedly "Painted in Wading River, L. I., New York 1843" // M. C. Black and S. P. Feld, *National Gallery of Canada Bulletin* 4 (August 1966), p. 1, date Bradley's presence at 128 Spring Street to 1837–1844 by city directory; ill. p. 8 // L. Cannitzer, letter in Dept. Archives, August 6, 1967, says a copy of this painting in an Uruguayan private collection is said to have been purchased in Paris by the end of the last century // S. P. Feld, letter in Dept. Archives, Oct. 5, 1967, refers to Uruguayan painting as a copy // M. C. Black and S. P. Feld, *Antiques* 90 (Oct. 1966), p. 507, no. 20, ill. p. 509.

EXHIBITED: National Gallery of Art, Washington, D. C., 1957, *American Primitive Paintings from the Collection of Edgar William and Bernice Chrysler Garbisch*, part II, ill. p. 62, as painted ca. 1843–1844 // American Federation of Arts, traveling exhibition, 1958–1959, *The Charm of Youth*, no. 2 // Pan American Union, Washington, D. C., 1963, *Primitive Artists of the Americas*, no. 10, p. [2], as lent by Edgar William and Bernice Chrysler Garbisch // Museum Boymans-van Beuningen, Rotterdam, *De Lusthof der Naïeven*, and Musée National d'Art Moderne, Paris, *Le Monde des Naïfs*, 1964, ill. no. 45, compares to similar portrait in the National Gallery.

ON DEPOSIT: National Gallery of Art, Washington, D. C., 1966, lent by Edgar William and Bernice Chrysler Garbisch; Governor's Office, New York, 1975; Staten Island Institute of Arts and Sciences, New York, 1977–1978.

EX COLL.: with Argosy Gallery, New York, 1953; Edgar William and Bernice Chrysler Garbisch, Cambridge, Md., 1953–1966.

Gift of Edgar William and Bernice Chrysler Garbisch, 1966.

66.242.33.

FRANCIS ALEXANDER

1800–1880

Francis Alexander, a portrait, genre, and landscape painter, was born and raised in Killingly, Connecticut. Between the ages of eight and twenty, he worked on his father's modest farm. He attended a country district school until he was seventeen and then, at that same school, taught "the bad pronunciation and bad reading which I had imbibed from my old school-masters" (quoted in Dunlap, p. 427). In the summer of 1820, Alexander fell ill during haying season but not so ill that he could not occupy himself fishing. One day the "beautiful tints and fine forms" of some fish he had caught inspired him to paint them. He was very pleased with the outcome: "they were more like real objects than any paintings I had then seen" (quoted ibid., p. 428). The only art that he had, in fact, seen were two very ordinary portraits at a country inn.

Later that same year, despite the disapproval of family and friends, Alexander went to New York to study painting. For six weeks he was instructed by the drawing teacher Alexander Robertson (1772–1841), the co-proprietor with his brother Archibald (1765–1835) of the Columbia Academy of Painting. When his money ran out, Francis Alexander returned home, where he painted landscapes on the walls of his father's house. His landscapes, however, attracted little interest in the farming community, and he decided to try his hand at portraiture. His first attempts resulted in several local commissions. Before 1822, he made a second trip to New York to study at the Columbia Academy, where he learned to set a palette and borrowed portraits by well-known New York artists to copy. After a few months, his funds exhausted, he went back to Connecticut and "traveled from town to town" seeking commissions. He spent two successful years in Providence, Rhode Island, where his patron, Mrs. James B. Mason, introduced him to people who gave him "constant employ, and from fifteen to twenty five dollars" for his portraits (quoted ibid., p. 432).

Equipped with a letter of introduction from JOHN TRUMBULL and one of his own pictures, Alexander went to see GILBERT STUART in Boston. Stuart was supportive and remarked that though Alexander lacked training, he had a clear insight into human character and the ability to portray it. Indeed, Stuart's enthusiasm prompted Alexander to move to Boston in 1825, and he enjoyed remarkable success there for the next twenty-eight years. The portraits he painted during his first six years in Boston—simple compositions of head and shoulders, strongly modeled, done in delicate warm colors—constitute his best work. The subjects are subtly and charmingly portrayed. Alexander's success was such that by 1831 he had saved enough money to build his parents a new home and to spend a year and a half in Italy.

While in Florence he encountered his good friend THOMAS COLE and went with him to Rome, where they shared Claude Lorrain's former quarters. Together they traveled to Naples, Pompeii, and Paestum to paint landscapes. Alexander also spent seven months in Venice. Among the prominent Americans that he met in Italy were Samuel Swett and his daughter Lucia, of Boston. Lucia's grandfather, William Gray of Salem, was purported to be one of the wealthiest men in America. Alexander painted Lucia's portrait in Florence in 1832 (unlocated), and four years later they were married in Boston.

Alexander returned to Boston in 1833 and the following year he exhibited his European pictures in a joint show with CHESTER HARDING and THOMAS DOUGHTY at the Harding Gallery; but, as H. W. French remarked, Alexander's style had changed substantially, and "though it had more of the world in it, it had deteriorated" (p. 62). His portraits had lost strength both in modeling and character portrayal, and the colors lacked the glow and vibrancy of his earlier work. Backgrounds were no longer painted from nature but were instead fanciful. His formerly crisp brushwork had become rapid and careless.

In 1840 Alexander was made an honorary member of the National Academy of Design in New York, where he exhibited regularly between 1834 and 1845. In 1842 when Charles Dickens visited the United States, he honored Alexander with a request to have his portrait painted. The weak and mannered portrait of Dickens (MFA, Boston) is indicative of Alexander's diminishing talent. His popularity and output decreased during the forties and fifties. In 1853 he returned with his family to Florence and, except for one brief visit to the United States, lived there until his death in 1880. His daughter, Francesca (1837–1917), became a poet and genre painter of Italian subjects. Unlike other artists who went to Italy to paint, Alexander stopped painting altogether shortly after his move. His wife's wealth enabled them to live comfortably, and the last years of his life were spent collecting early Renaissance art and old masters, which he restored himself. When asked by a friend why he no longer painted, he is said to have answered, "What's the use when I can buy a better picture for a dollar and a half than I can paint myself?" (Ball, p. 173).

BIBLIOGRAPHY: William J. Dunlap, *A History of the Rise and Progress of the Arts of Design in the United States* (2 vols., New York, 1834), 2, pp. 426–433 // H. W. French, *Art and Artists of Connecticut* (Boston and New York, 1879), p. 62 // Thomas Ball, *My Three Score Years and Ten* (Boston, 1892), p. 173 // Catherine W. Pierce, "Further Notes on Francis Alexander," *Old Time New England* 56 (Oct.-Dec. 1965), pp. 35–44.

ATTRIBUTED TO FRANCIS ALEXANDER

Leete Farm, West Claremont, New Hampshire

Asa Leete, grandson of William Leete—first governor of Connecticut—moved from Guilford, Connecticut, to Claremont, New Hampshire, in 1769. The Leete farm (now part of West Claremont) consisted of 370 acres nestled between Croydon Mountain and the Sugar River. Francis Alexander probably painted this view of the farm in about 1822, after his second period of study in New York and before he turned almost exclusively to portraiture in 1823. Another landscape attributed to him, *Ralph Wheelock's Farm*, ca. 1822 (National Gallery of Art, Washington, D. C.), is also a haying scene set on a low horizon and is similar in composition, coloring, and treatment of details. While attending the Columbia Academy, he was influenced by both Alexander (1722–1841) and Archibald Robertson (1765–1835). Francis Alexander learned a variety of media techniques from the former, but this landscape and *Ralph Wheelock's Farm* more closely resemble the careful detail of the latter's compositions.

Painted for Asa Leete's grandson, James Leete, who was at that time owner of the farm, the painting later passed to James's great-granddaughter Bertha Leete Gowe. In 1966 she recalled that her grandfather had been born at Leete farm and her father had spent his summer vacations there as a boy. She also told of having been "regaled with stories of the fox hunts, and the Morgan horses they raised plus the peacocks." The subject of this primitive landscape is an activity that was certainly familiar, and mildly

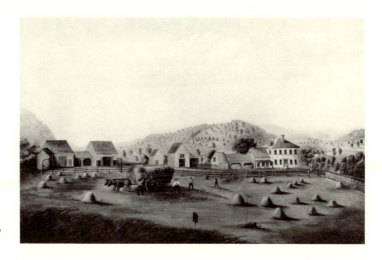

Attributed to Alexander, *Leete Farm, West Claremont, New Hampshire.*

distasteful, to Alexander, who once complained of what hard work haying was. In the foreground three farmers are raking hay while another pitches it onto a wagon and a fifth packs it down. Behind these figures, the house and farm buildings are depicted in a very linear manner. Small houses dot the valley beneath bright green hills with pink and blue mountains beyond. The foreground is framed by tall, dark green hay with red wildflowers amongst the blades that are yet to be cut. The men have hung their coats on a pole driven into the ground, and just to the right stands a rake on its end with a wooden keg, a pitcher, and a mug beside it. "The keg contained 'ginger water' consisting of water, molasses and ginger and very thirst quenching for the haying crew" (B.L. Gowe, 1966).

Surrounding the ox-drawn wagon are small stacks of light green hay. A warm yellow tonality pervades the entire canvas. The sun casts a single shaft of light across the ground, creating a pattern of deep shadows behind the haystacks. A split-rail fence separates the hayfield from the farm buildings, which are attached in a trainlike arrangement common in northern New England. A woman in a red skirt and little girl in blue stand in the doorway of the house where smoke is seen rising from a small chimney. Near the setting sun are tiny pink clouds, and above them white billowy clouds with touches of pink are capped by blue sky.

Oil on canvas, $17 \times 27\frac{1}{4}$ in. (43.2 × 69.2 cm.).
REFERENCES: B. L. Gowe, Limerick, Me., letter in Dept. Archives, July 12, 1966, describes picture (quoted above).
Ex COLL.: James Leete, West Claremont, N. H., and Upton, Mass.; his granddaughter Bertha Leete Gowe, Limmerick, Me., until 1967; Edgar William and Bernice Chrysler Garbisch, 1967–1972.
Gift of Edgar William and Bernice Chrysler Garbisch, 1972.
1972.263.5.

WILLIAM P. CHAPPEL

ca. 1800–1880

William P. Chappel, the main body of whose work—all views of New York— appears below, is believed to be the father of the artist ALONZO CHAPPEL. A native of New York and the son of Huguenots, he was a tinsmith by trade and lived in Manhattan until about 1845 when he took his family to live in Brooklyn. There at an early age his son Alonzo began a

career painting window shades and soon became a prosperous artist. Other sons appear to have been lampmakers.

William P. Chappel's main other work, an oil painting of Tammany Hall (NYHS) is signed on the front: [C]happel Sen[ior]. This and the fact that he is the only William Chappel, listed as William P., living in the area depicted at the dates inscribed are the main grounds for the attribution. If it is correct, he and his son shared an interest in historical scenes. Chappel died at his son's home at Artists' Lake in Middle Island, Long Island, in February 1880 and is buried in the Presbyterian churchyard there.

BIBLIOGRAPHY: Richard J. Koke, *American Landscape and Genre Paintings in the New-York Historical Society* (3 vols., New York, 1982), 1, pp. 170–171 // New York City directories before 1845 and Brooklyn city directories, 1845–1857.

New York Street Scenes

These scenes are akin to the popular prints of street criers, which span at least three centuries. A tinsmith such as Chappel might have used such views to decorate his wares. The first American book of cries, *Cries of Philadelphia*, appeared in 1787; the first *Cries of New York*, in 1808. Chappel's models, however, do not seem to come directly from any of these prints. Crude as his renditions are, they have the feel of being taken from life. The problems with these works center on the dates inscribed on the back—all of which are years earlier than the material they are painted on. While the views reflect the New York of Chappel's childhood, the slate paper he used has been dated after 1825. Had he done such views as a youth, they must have been copied onto the slate paper later. They could, of course, have been done from memory. Most of the names of shops and streets can be substantiated in the city directories for the years indicated on the back, but there are some discrepancies. Moreover, the phrasing of some of the inscriptions indicate that they were added later or that the pictures were done from memory. In *The House Raising*, for example, "Between 3d now Eldrege & Allen St" tells us that the street name had changed. It is thought that there were twenty-nine views, two are missing (nos. 1 and 7).

William P. Chappel is known for only one larger oil painting (on canvas), also a New York view, *The Tammany Society on the Fourth of July, 1814* (NYHS). That work is signed and dated 1869, but the signature is difficult to compare to those on the backs of the small views in the museum's collection. It is also a scene from Chappel's youth in New York but with a definite date of execution, some fifty-five years later. The small views may have been done before or after 1869, possibly around 1876 when the United States centennial celebration made people very conscious of the country's past. As records of early New York, these little pictures can very likely be trusted as scenes of real life. They offer a kind of historical information that is rare. Many of the scenes show ordinary people going about their work, the pedlar, lamplighter, garbage man, as well as how the streets and shops looked. One is struck by the care Chappel has taken to recall the details and the dailiness of life in early nineteenth century New York.

REFERENCES: I. N. Phelps Stokes, *The Iconography of Manhattan Island* (1918), 3, p. 873, mistakenly refers to these paintings as watercolors and says the set originally consisted of twenty-nine pictures // Groce and Wallace (1957), p. 121, mistakenly say these paintings were executed between 1806 and 1813 // M. Shelley, memo in Dept. Archives, appends an earlier conservation report, says the paper support is slate paper which replaced school slates, and dates to second quarter of nineteenth century.

EXHIBITED: Small groups of these scenes have been exhibited at various times.

ON DEPOSIT: Museum of the City of New York, 1940–1963, lent by Edward W. C. Arnold.

EX COLL: Edward W. C. Arnold, New York, until 1954.

The Edward W. C. Arnold Collection of New York Prints. Bequest of Edward W. C. Arnold, 1954.

The Lamp Lighter

The lamplighter is a regular feature of most European and American street cry scenes. Here Chappel places him on Broad Street. This painting has the earliest date in the series.

Oil on slate paper, 6 1/16 × 9 1/8 in. (15.4 × 23.2 cm.). Inscribed and signed on the back: *N° 2 | the Lamp Lighter | in Broad St the Lower End west Side | 1806 N York | W P Chappel.*
54.90.490.

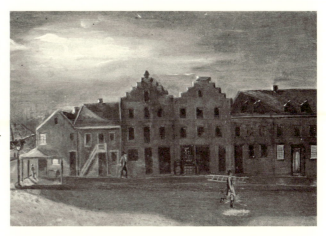

Chappel, *The Lamp Lighter.*

Old Ferry Stairs

The inscription is not completely helpful here. In 1808 there were two ferry stairs for the Brooklyn ferry. The "old ferry" would have been the Fly Market Slip ferry which was on Maiden Lane. This appears to be the Catherine Street ferry, the "new" ferry, because the market to the right across the street is the Catherine Street market.

Oil on slate paper, 6 1/16 × 9 1/8 in. (15.4 × 23.2 cm.). Inscribed on the back: *N° 3 | the Old Ferry Stairs to Brooklyn L I | at the foot of Catharine St N. Y. | 1808.*
54.90.491.

Chappel, *Old Ferry Stairs.*

Fly Market

The Fly Market at the lower part of Maiden Lane at the intersection of Pearl Street was the principal marketplace in the city. It was demolished in 1822 when the Fulton Market opened. The view here is looking east. Longworth's New York directory for 1808 lists J & F Schieffelin as druggists at 193 Pearl Street.

Oil on slate paper, 6 × 9 1/8 in. (15.2 × 23.2 cm.). Inscribed on the front: Drugist. Inscribed and signed on the back: *N° 4 The Old Vly Market in Maiden Lane | & Pearl St N York 1808 | Wm P Chappel.*
54.90.492.

Bull's Head Tavern

The Bull's Head Tavern on the Bowery, close to the slaughter house, was for many years the meeting place of the city's butchers and the drovers from the countryside. It was torn down in 1826. The house is probably that of Colonel Bogerty.

Chappel, *Fly Market.*

Oil on slate paper, 6 $\frac{7}{16}$ × 9 $\frac{1}{8}$ in. (16.4 × 23.2 cm.).
Inscribed and signed on the back: *N⁰ 5 / West side of the Bowery Bulls Head / & Exhibition of fat Cattle At Col Bogarty / House Next to Byard St NY / 1808 / W P Chappel.*
54.90.493.

Baked Pears in Duane Park

Duane Street Park was formed in 1797 at the intersection of Duane and Hudson streets from land acquired from Trinity Church. The baked pear seller is another typical street crier.

Oil on slate paper, 6 × 9 $\frac{1}{8}$ in. (15.2 × 23.2 cm.).
Inscribed and signed on the back: *N⁰ 6 / Baked Pears in Hudson / & Duane St park / 1810 NYork / W P Chappell.*
54.90.494.

Fighting a Fire

Fire was a constant danger in early New York. The inhabitants were ordered to keep leather buckets in their houses for carrying water to fires and could be fined for not having them.

Oil on slate paper, 6 × 9 $\frac{1}{8}$ in. (15.2 × 23.2 cm.).
Inscribed and signed on the back: *N⁰ 8 / Citizens Supplying the Engines With / Water from the pumps in the time of a house on fire / in New York 1809 / W P Chappel.*
54.90.495.

Firemen's Washing Day

Grand Street and the Bowery was about half way between Fire Houses No. 1 and No. 2. There was great rivalry between fire companies so pre-

Chappel, *Bull's Head Tavern.*

Chappel, *Fighting a Fire.*

Chappel, *Baked Pears in Duane Park.*

Chappel, *Firemen's Washing Day.*

sumably aiming water at one another was a bit
of sport. It was the firemen's duty to wash the
company's engine and rules called for this to be
done once every month – thus "Washing Day."

Oil on slate paper, 6 × 9⅛ in. (15.2 × 23.2 cm.).
Inscribed and signed on the back: *N° 9 / The Fire-
mans Washing Day the Meeting of Two / Compys, then
Sports—in the Bowery Corner of / Grand St. NY in 1810 /
The Firemans Washing Day Between / N° 1 & 2 / 1810 /
W P Chappel.*
54.90.496.

Chappel, *Hot Corn Seller*.

Hot Corn Seller

The hot corn seller was a popular pedlar in
New York for many years and a popular Ame-
rican street crier as well. Chappel has also in-
cluded the stage that ran from New York to
Westchester.

Oil on slate paper, 6⅛ × 9 3/16 in. (15.6 × 23.3 cm.).
Inscribed and signed on the back: *N° 10 / Intersec-
tion of Bowery Doyer Chatham & Catherine Sts / Showing
the Old Watch House & the Wench Selling / Hot Corn at the
Corner of Doyer St / also the Stage Waggon By Geo. Hall
from / Tarrytown North Castle By way of Kings bri[d]ge /
NYork 1810 / WP Chappel.*
54.90.497.

Chappel, *Buttermilk Pedlar*.

Buttermilk Pedlar

According to *New York Street Cries of Fifty
Years Ago*, milkmen wove a yoke from each side
of which a large tin kettle filled with milk was
suspended. They went from door to door crying
"Milk, ho!"

Oil on slate paper, 6 3/16 × 9 5/16 in. (15.7 × 23.6 cm.).
Inscribed and signed on the back: *N° 11 / Pedler
of Butter Milk / Showing a Gentle Mans Dwelling &
Coach house / with a Tiled roof / New York 1807 / WP
Chappel.*
54.90.498.

Chappel, *Tea Party*.

Tea Party

By 1812 Foster, a grocer, was listed at Second
Street and Pump. Two Fowlers are listed on the
street in 1812: James, a blacksmith, and Thom-
as, a grocer. What is intriguing in this picture
is where will the tea party of eight pairs of ladies
be held?

William P. Chappel 443

Chappel, *City Watchman*.

Chappel, *The Boot Black*.

Chappel, *Infant Funeral Procession*.

Oil on slate paper, 6⅛ × 9 5/16 in. (15.6 × 23.7 cm.).
Inscribed on the front: 2d St / J Foster (both on corner building); M [?] Fowler (mid-block). Inscribed on the back: *N° 12 / Tea Party / in Second going towards pump St. now forsyth near Canal St / foster's corner grocery. 1809 N York / WP Chappel.*
54.90.499.

City Watchman

The watchman's box is between the Methodist Meeting House and No. 41 Elizabeth Street, which in 1812 was occupied by a cabinetmaker named John Jungerick. Sarah Piggot is listed as a grocer at No. 45 in 1810 and 1812. A George Mount is listed as a cartman.

Oil on slate paper, 6⅛ × 9⅛ in. (15.6 × 23.2 cm.).
Inscribed and signed on the back: *N° 13 / one of the City Watchmen / & his Watch Box in Elisabeth St / West Side house No 41 on the Left Occupyed [illeg.] / Bedstead Maker named John [Jungerick] Next No 43 By / a Mr. Mount an Inspector of Ward No 45 by a / Quaker Lady Named Piggot kept a [illeg.] Grocery at the Present Time is Built the Working Womans [?] House / Little to the Right is the Old Methodist Meeting House / Where [preached?] Lorenzo Dow / 1809 New York / WP Chappel.*
REFERENCE: I. N. P. Stokes, *The Iconography of Manhattan Island* (1928), 6, pl. 92b, as about 1810.
54.90.500.

The Boot Black

The boot black is seen near the stage stop at Franklin Square. The Walton House, 326 Pearl Street (Pearl and Dover intersected at Franklin Square) was built for William Walton (d. 1806) in the middle of the eighteenth century. Something of a city landmark, it stood for 127 years, until 1881, serving as a bank and later a hotel. The Boston and Albany stages stopped opposite the house for many years.

Oil on slate paper, 6 1/16 × 9⅛ in. (15.4 × 23.2 cm.).
Inscribed and signed on the back: *N° 14 / 4th Ward / the Boot Black / in franklyn Square so[u]th side from Dover St / to the Walton House 1808 NY / WP Chappel.*
REFERENCE: I. N. P. Stokes, *The Iconography of Manhattan Island* (1928), 6, p. 92a, as about 1810.
54.90.501.

Infant Funeral Procession

Shown is the site of the Methodist Episcopal Church. The minister at this time was the Rev-

erend William Phoebus. It was the custom for children to wear white for funerals in this period. Infant deaths were commonplace in nineteenth-century New York, especially during these years of the yellow fever epidemic, which took many lives. Next door to the church is Engine House No. 2.

Oil on slate paper, 6 1/16 × 9 3/16 (15.4 × 23.3 cm.).
Inscribed and signed on the back: *N° 15 / infant Funeral 8 young Ladies Born By 8 young Ladies / in White followed By the Widdows & children & [Entering] / Scene in 2d St & Byard / now forsyth St / the Meeting house—Engine house & Corner Store [3] / also the Chain across the Street to prohibit / the Vehicles from Passing in time of Service / Rev Doct Phebus pastor / 1809 / W P Chappel.*
54.90.502.

Chappel, *Adult Funeral Procession.*

Adult Funeral Procession

The inscription below tells us a whole story, including the interesting detail that pallbearers wore white scarfs and gloves. Here is another instance where the notation indicates that the inscription is later, that Leonard Street is now Chrystie Street.

Oil on slate paper, 6 × 9 1/4 in. (15.2 × 23.5 cm.).
Inscribed and signed on back: *N° 16 an Adult [Funeral] Buriel of a Wife / the husband & Children with their Mo[u]rning / weeds on their hats the Pall Bearers with White scarfs / and Gloves in Stanton St NY / & Lenard St / now Christie / 1807 / WP Chappel.*
54.90.489.

Tea Rusk and Brick House

The insurance sign indicates that the Mutual Assurance Company, which was founded about 1796, insured the brick house we see here. Tea rusk was bread baked and then baked again until dry and crisp so it kept longer. Bakers in New York used tall round baskets for bread, tea rusk, hot-cross buns, and gingerbread.

Oil on slate paper, 9 1/8 × 6 in. (23.2 × 15.2 cm.).
Inscribed on the front: MUTUAL / INSURANCE / 1803. Inscribed and signed on the back: *N° 17 / Tea Rusk & Brick House / insured in the Mutual Insurance Co / 1807 / WP Chappel.*
43.90.503.

Chappel, *Tea Rusk and Brick House.*

Tea Water Pump

According to Stokes, *Iconography of Manhattan Island* (1918, 3, p. 873), the old Tea Water pump was on the north side of Chatham (now Park Row) and Roosevelt streets. It was built over a spring, and a park was laid out around it. The water was considered the best drinking water in

Chappel, *Tea Water Pump*.

Chappel, *Chimney Sweeps*.

Chappel, *Strawberry Pedlar*.

the city. Wagons, such as the one shown, were used to bring potable water to other areas, where it was sold. The pump is said to have been removed about 1827.

Oil on slate paper, $6\frac{1}{16} \times 9\frac{5}{16}$ in. (15.4 × 23.7 cm.).
Inscribed on the back: *Nº 18 | Old Tea Water Pump & Cart | Near Corner of Orrang & Chatham St. NY | 1807.*
REFERENCE: I. N. P. Stokes, *The Iconography of Manhattan Island* (1918), 3, pl. 14b.
54.90.504.

Chimney Sweeps

The view of Cherry Street tallies with the period: George Buckmaster was a boatbuilder and city alderman who lived at No. 155; John Wright was a coppersmith at No. 141. Chimney sweeps at this period were licensed. They could not be younger than eleven and were held responsible if fires occurred in any chimney within a month of its sweeping.

Oil on slate paper, $6\frac{1}{16} \times 9\frac{5}{16}$ in. (15.4 × 23.7 cm.).
Inscribed on the front: J WRIGHT Coppersmith | J. LOYD | Chadavoine. Inscribed on the back: *Chimney Sweeps | nº 19 | in Cherry St North Side | Between Georges now Market & Catharine St. | 1st Brick Building Property & dwelling of Alderman | J. Bookmastar 1st store Wm Chardavoine the plumber small house a tin Smith Loyd, the next Mr. J. Wright | Copper Smith | 1810 NY | WP Chappel.*
54.90.505.

Strawberry Pedlar

The strawberry pedlar was a familiar figure on New York streets when the fruit was in season. This is one of the few scenes without a date. Allen, formerly Fourth Street, however, was so named after William Henry Allen in 1817. The buildings of Mr. Allen, according to the 1812 directory, would be those of the coopers John and Leonard Allen at No. 46 Fourth. The Ball Alley seems to have been a kind of bowling alley.

Oil on slate paper, $6\frac{1}{8} \times 9\frac{1}{4}$ in. (15.6 × 23.5 cm.).
Inscribed on the front: Cooper shop. Inscribed on the back: *Straw Berries | Nº 20 | East side of Allen Betwen hester & pump (now Canall) St NY | Showing the Buildings of Mr Allen the Cooper | and the Ball Alley to the right | also — the — Carrying Strawberries to Sell | Straw Berries No. 20.*
54.90.506.

The Garbage Cart

By 1799 the common council of the city employed two men with carts and bells "to go daily through the sections that are not sweeping for the purpose of Collecting the Garbage and Offals from Yards and Kitchens for which purpose they shall Ring the Bell at Suitable Distances to Notify the Inhabitants to bring out the same and put it into the Carts." By 1810 there were some twenty-five cartmen in the city. The inscription "Palmer with his Garbage Cart & Bell" may refer to Thomas Palmer, who is listed in the city directories as a cartman in 1807. William and G. Post were paint manufacturers, established in 1770. The company later became Devoe Paints.

Oil on slate paper, 6⅛ × 9¼ in. (15.6 × 23.5 cm.).
Inscribed on the back: *Nº 21 | No 48–46–42–40–34–32–30 & 28 | East Side of Elisabeth | Corner of pump St Wm S. Groddy posts paint Mill (?) | pot [frye?] Palmer with his Garbage Cart & Bell No. 21.*
54.90.507.

The Sewer

According to Stokes, *Iconography of Manhattan Island* (5 [1926], p. 1342), a common sewer was enclosed on Roosevelt Street about 1797. By 1810 the city council requested that it be opened and regulated "without delay."

Oil on slate paper, 6⅛ × 9¼ in. (15.6 × 23.5 cm.).
Inscribed on the front: J. ROGERS. Inscribed and signed on the back: *Rosavelt & Oak St | Showing the Sewer 1807 | Nº 22 | W. Chappel.*
54.90.509.

Militia Drilling

The militia is seen here at the site of the Arsenal, at the left. The Stone Bridge Garden was presumably attached to the Stone Bridge Hotel at Broadway. According to Stokes, *Iconography of Manhattan Island* (1918, 3, p. 558), the stone bridge was erected during the Revolution to give access to the fortifications at the Collect Pond; by 1811 the bridge appears to have been enlarged. Plans, however, to build a canal at this location never seem to have been carried out.

Oil on slate paper, 6⅛ × 9¼ in. (15.6 × 23.5 cm.).
Inscribed and signed on the back: *Collect ground | Arsnel & Stone Bridge Garden | Militia Drilling | View from*

Chappel, *The Garbage Cart*.

Chappel, *The Sewer*.

Chappel, *Militia Drilling*.

Chappel, *The Baker's Wagon.*

Chappel, *Berg's Ship Yard.*

Chappel, *House Raising.*

The Baker's Wagon

William Marshall is listed as a potter at 116 Hester Street for many years. He produced earthenware, including redware. In 1810 and 1811 the widow Bumstead is listed as living at 110 Hester Street.

Oil on slate paper, 6⅛ × 9¼ in. (15.6 × 23.5 cm.). Inscribed on the front: Third / HESTER / W. BUMSTED / [M]ARSHALL. / [P]OTTER. Inscribed and signed on the back: *Marshalls | Pottery next the Cor | 3d Hester St | 1811 | N° 24 | & the Bakery Waggon | W Chappel.*
54.90.510.

Berg's Ship Yard

From about 1802 to 1815 Christian Bergh is listed as a shipwright on Water Street at Corlaer's Hook. He built several important packet ships. At his death at age eighty-one in 1843, the New York diarist Philip Hone called him "the oldest ship-carpenter in the city, the father of that great system of architecture which has rendered the city of New York famous throughout the world" (Hone, *Diary* [1889 ed.], 2, p. 187).

Oil on slate paper, 6⅛ × 9⅛ in. (15.6 × 23.2 cm.). Inscribed and signed on the back: *No. 25 Bergs Ship Yard | corner of Water & front St | 1809 | NY | N° 25 | W. Chappel.*
54.90.511.

House Raising

Here we see the frame of the broadside of a house being put in place. Typically the side of a house was fastened together on the ground. After long poles were used to lift it into place, the other sides would be put up and the beams, braces, and studding pinned and nailed into place before the rafters were raised for the roof.

The sign across the street, B. Smith, probably indicates the premises of a blacksmith. The phrase in the inscription for this drawing, "Between 3d now Eldrege" suggests that the drawing was done from memory.

Oil on slate paper, 6⅛ × 9⅛ in. (15.6 × 23.2 cm.). Inscribed on the front: B Smith. Inscribed and signed on the back: *N° 26 | House Raising | in Grand St. | Between 3d now Eldrege & Allen St | 1810. NY | WP Chappel.*
54.90.512.

The Dog Killer

Blunt's *Stranger's Guide to the City of New York* (1817) notes that dogs were not "suffered to go at large." Owner's were obliged to register every dog and to pay a tax for each, with high penalties for not paying or dogs caught loose. It was further noted that dogs at large "may be seized and killed . . . and the carcase buried."

In 1811 there was a Daniel Davis at 359 Water St. who had a boarding house. Next door seems to be a maker of children's clothes. Next to the grocery appears to be a sailors' rooming house.

Oil on slate paper, 6⅛ × 9¼ in. (15.6 × 23.5 cm.).
Inscribed on the front: Grocery / Boarding / DAVIS. Inscribed and signed on the back: *N° 27 | The Dog Killer & Cart | in Water Betwen Rosavelt & Dover | New York | 1813 | WP Chappel N° 27.*
54.90.513.

Ex COLL. (54.90.489-54.90.515): Edward W. C. Arnold, New York, by 1918-d. 1954.

The Edward W. C. Arnold, Collection of New York, Prints Maps, and Pictures. Bequest of Edward W. C. Arnold, 1954.

Chappel, *The Dog Killer*.

Bathing Party

In *History of New York Shipyards*, John H. Morrison notes that above the northernmost East River shipyard, beyond Eighth Street, the bank of the river formed a beautiful sandy beach, called Dandy Point. It was a popular bathing place in the summer.

Oil on slate paper, 6⅛ × 9¼ in. (15.6 × 23.5 cm.).
Inscribed and signed on the back: *N° 28 | Bathing Parties | at the foot Stuyvesant East River | N York 1810 | WP Chappel.*
54.90.514.

Chappel, *Bathing Party*.

Baptism

The inscription on this sunrise scene of an adult baptism indicates that it was a standard sight on Sunday mornings at the foot of Water Street on Corlaer's Hook. The area, just south of the shipyards, was close to several churches. The two tall figures flanking the scene in the foreground appear to be in some kind of uniform.

Oil on slate paper, 6⅛×9¼ in. (15.6×23.5 cm.).
Inscribed and signed on the back: *N° 29 | Baptising at the End of Water St/Corlies Hook NYork on Sunday Mornings/1811/ WP Chappel/No 29.*
54.90.515.

William P. Chappel

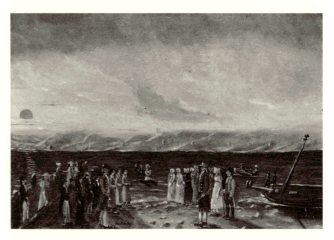

Chappel, *Baptism*.

HENRY INMAN

1801–1846

Henry Inman was born in Utica, New York, the son of English immigrant parents. He had a natural aptitude for drawing, and received lessons from an itinerant drawing master. When his family moved to New York in 1812, he continued his instruction in drawing at a day school. In 1814 JOHN WESLEY JARVIS took him on as an apprentice, and Inman, at this early age, was launched on a career as a portrait painter. He made rapid progress and soon became Jarvis's collaborator. According to WILLIAM DUNLAP, Jarvis "used to receive six sitters a day. A sitting occupied an hour. The picture was then handed to Henry Inman, who painted upon the background and drapery under the master's direction. Thus six portraits were finished each week" (p. 81). The apprenticeship to Jarvis lasted until 1822, the year in which Inman married Jane Riker O'Brien and opened his own studio on Vesey Street. In 1824, he formed a partnership with his student in miniature painting Thomas Seir Cummings (1804–1894). They divided the firm's business, Inman to paint in oils, Cummings to paint miniatures, and this arrangement lasted through 1827. Both men were instrumental in founding the National Academy of Design in 1826; Inman was its first vice-president and Cummings became treasurer in 1827. Little is known about Inman's financial resources at this time, but judging from the large number of portraits he exhibited each year at the National Academy, he was well patronized. His painting style was loose, feathery, and at times very much resembled that of THOMAS SULLY, though he did not possess that painter's gift for brilliant coloring.

In 1831 Inman moved to Philadelphia, where he joined Cephas G. Childs in establishing a lithographic firm. They reproduced many of Inman's portraits, but their venture does not appear to have been a great success, and Inman left the firm in 1832. He returned to New York in late 1834. As his output of portraits increased, his income rose proportionally. During 1837 he is reported to have earned over ten thousand dollars, a very substantial amount for the time. As might be expected of so prolific an artist, his works were not of consistently high quality, though the best among them, such as the portrait of Angelica Singleton Van Buren, 1842 (White House, Washington, D. C.), are very good indeed. During these years, Inman increasingly turned his attention to genre painting. In Tuckerman's phrase, "it is conceded that he was the first American artist who attempted *genre* with success" (p. 237). Paintings such as *The Newsboy*, 1841 (Addison Gallery of American Art, Phillips Academy, Andover, Mass.), *Mumble the Peg*, 1842 (PAFA), and *Dismissal of School on an October Afternoon*, 1845 (MFA, Boston), though not of uniform quality, are landmarks in the history of American genre painting. He was also a talented landscape painter, as revealed in *Trout Fishing in Sullivan County, New York*, ca. 1841 (Munson-Williams-Proctor Institute, Utica, N. Y.), and *Landscape*, 1844 (Wadsworth Atheneum), but this work was not as significant as his portrait and genre painting.

In the spring of 1844, Inman traveled to England with commissions to paint portraits of the poet William Wordsworth (two versions, University of Pennsylvania, Philadelphia,

and Wordsworth House, Sussex), the historian Thomas Babington Macaulay (PAFA), and the Rev. Thomas Chalmers (unlocated). After his return to New York in 1845 his health declined and he found it impossible to work. He died on January 17, 1846, and his funeral was attended by artists, art patrons, and city officials. His friends, of whom he had many, banded together and mounted an exhibition, at the American Art-Union, of one hundred and twenty-six of his works, the proceeds from which went to support his family. It was the first important retrospective exhibition of the works of one man ever held in this country. Henry Inman's son John O'Brien Inman (1828–1896) was also a painter, a student of his father's.

BIBLIOGRAPHY: William Dunlap, *A History of the Rise and Progress of the Arts of Design in the United States* (2 vols., New York, 1834), 2, pp. 348-350 // Henry T. Tuckerman, *Book of the Artists* (New York, 1867), pp. 233–246. A sympathetic account by one of Inman's good friends // Theodore Bolton, "Henry Inman, an Account of His Life and Work," *Art Quarterly* 3 (Autumn 1940), pp. 353–375, and supplement, pp. 401–418. An analytical account of the artist's life with a catalogue of his works // William H. Gerdts, "Henry Inman: Genre Painter," *American Art Journal* 9 (May 1977), pp. 26–48 // National Portrait Gallery, Smithsonian Institution, Washington, D.C., 1987, *The Art of Henry Inman*, exhib. cat. by William H. Gerdts and Carrie Rebora.

William Charles Macready as William Tell

William Charles Macready (1793–1873) was one of the most prominent English actors of the nineteenth century. Born in London, the son of an Irish actor and theater manager, he made his first stage appearance as Romeo with his father's company in Birmingham in 1810. In 1816 he made his London debut as Orestes in *The Distressed Mother* but did not establish himself as a tragedian of the first rank until his appearance as Richard III at Covent Garden in 1819. Three years later he was engaged at Covent Garden for a period of five years and achieved his greatest success there as William Tell in the play by James Sheridan Knowles. He made three tours of the United States, the first in 1826–1827, the second in 1843–1844, and the last in 1848–1849. It was while on this farewell tour, on May 10, 1849, that his rivalry with the American-born tragedian Edwin Forrest erupted into a full-scale riot at Astor Place in New York. Forrest's partisans grew so unruly in their attempt to prevent Macready's performance of Macbeth that the police were forced to summon the soldiers of the Seventh Regiment to their aid. A number of people were killed and hundreds more injured before the disturbance was quelled.

In his day, Macready was among the most keenly intellectual students of drama. He was also a good administrator and managed Covent Garden from 1837 to 1839 and the Drury Lane Theatre from 1841 to 1842. In 1851 he retired from the stage but at times emerged from seclusion to give readings and lecture.

Probably painted in 1826, during Macready's first American tour, this picture was Inman's original sketch from life for a full-length portrait, which for many years hung in the Players Club in New York. Done mostly in shades of brown with considerable deftness and bravura, the sketch is most like Inman's self-portrait of 1834 (PAFA), in which he revealed his considerable talent for quick, bold, painterly execution. This quality in Inman's work is particularly appealing to modern eyes and gives his unfinished works an immediacy and strength that the finished versions often lack. In both portraits Macready is portrayed in the character of William Tell. Only in the larger, full-length picture, however, is the scene evident: William Tell stands shackled in chains beside the castle of Küssnacht, where he was imprisoned. The museum's portrait shows him wrapped in brown fur.

When exhibited at the National Academy of Design in 1827, Inman's full-length painting was attacked in a handbill written and distributed by "Middle-Tint," a self-styled critic and guardian of public taste (actually the sculptor John H. I. Browere). "Middle-Tint" condemned the painting as "a specimen of Art which would disgrace

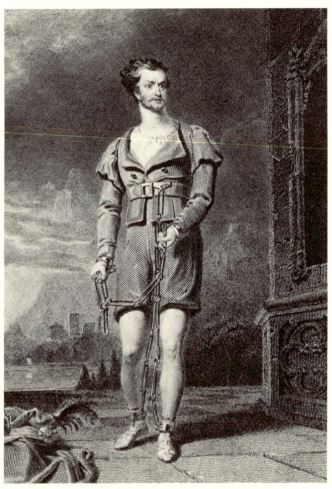

Engraving by Durand of *William Charles Macready
as William Tell.*

a tyro in Anatomical Drawing" and noted that "Mr. Macready sat to Inman for the *Head*—the head *alone* of said portrait—the neck, trunk and lower extremities are not those of Mr. Macready. If we rightly understand, the Secretary of the National Academy of Design [the artist John Ludlow Morton (1792–1871)], and not Mr. Macready, stood for the completion of the whole figure" (quoted in T. S. Cummings, *Historic Annals of the National Academy of Design* (1865), pp. 76–77). Judging by representations of the full-length painting, "Middle-Tint" seems to have had grounds for his complaint. In 1828, when Inman sent the full-length portrait to the exhibition at the Boston Athenaeum, he submitted the portrait sketch to the National Academy, where a critic for the *New-York Mirror* found favor in it:

The original portrait of Macready, which was his study in afterwards completing the full length, that at the last exhibition excited so much applause, deserves to be mentioned. It possesses the same traits of faithful and spirited resemblance with the other; but has evidently been finished with a bolder and more rapid pencil.

The museum's portrait sketch was owned for many years by Macready's good friend the painter and actor Joseph Jefferson (1829–1905).

Oil on canvas, $30\frac{1}{4} \times 25$ in. (76.8×63.5 cm.).
RELATED WORKS: *William Charles Macready as William Tell,* 1827, oil on canvas, formerly coll. Players Club, New York, presently unlocated // Thomas Seir Cummings, *William Charles Macready,* 1826, watercolor on ivory, $3\frac{1}{8} \times 2\frac{5}{8}$ in. (7.93×6.67

Inman, *William Charles Macready as William Tell*.

cm.), coll. Stanton D. Loring // Thomas Seir Cummings, *William Charles Macready*, 1827, oil on canvas, 30¼ × 25½ in. (76.8 × 64.8 cm.), NYHS, ill. *Catalogue of American Portraits in the New-York Historical Society* (1974), 2, p. 508 // Asher B. Durand, *William Tell*, 1828, engraving after Inman, 3⅞ × 2⅝ in. (9.8 × 6.7 cm.), published in *Talisman* 2 (1828), opp. p. 94.

REFERENCES: Middle-Tint, *New York Morning Courier*, May 8, 1828, p. [2], mentions that Inman is exhibiting "the original study of his Macready" at the National Academy // *New-York Mirror* 5 (May 24, 1828), p. 367 (quoted above) // *Century Magazine* 39 (Nov. 1889), ill. p. 20, as in coll. of Joseph Jefferson // *MMA Bull.* 1 (June 1906), p. 105, mistakenly says

Thomas Seir Cummings, *William Charles Macready*. Coll. Stanton D. Loring.

that it shows subject in the character of Macbeth //
DNB (1933; 1961) s.v. Macready, William Charles,
gives information on the subject // T. Bolton, *Art
Quarterly* 3 (1940), p. 363, and suppl. p. 409, lists it //
Gardner and Feld (1965), pp. 219-220.

EXHIBITED: NAD, 1828, no. 80, as *Portrait of
Macready* // Wildenstein Galleries, New York, 1944,
Stars of Yesterday and Today, no. 61 // MMA, 1965,
Three Centuries of American Painting (checklist arranged
alphabetically) // Lytton Gallery, Los Angeles County
Museum of Art; M. H. de Young Memorial Museum,
San Francisco, 1966, *American Paintings from the Metro-
politan Museum of Art*, no. 22 // University of Michigan
Museum of Art, Ann Arbor, 1972, *Art and the Excited
Spirit*, exhib. cat. by D. C. Huntington, no. 99, ill.
(in reverse) // National Portrait Gallery, Smithsonian
Institution, Washington, D. C., 1971, *Portraits of the
American Stage*, exhib. cat. by M. H. Fabian, pp. 36-37.

Ex COLL.: Joseph Jefferson, Buzzards Bay, Mass.,
by 1889-1906 (sale, American Art Association, New
York, April 27, 1906, no. 20, $1,000); with E. Roberts,
as agent, 1906.

Rogers Fund, 1906.

06.195.

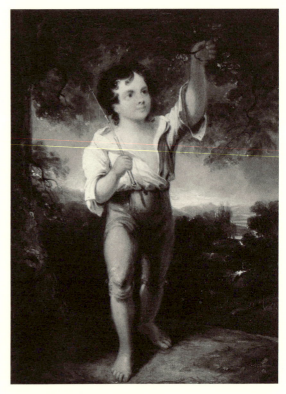

Inman, *The Young Fisherman.*

The Young Fisherman

This is Inman's earliest known genre paint-
ing of major importance. Also called *The Fisher
Boy* and *The Sailor-Boy*, it depicts a boy in the
act of plucking up a caterpillar or insect to bait
his fishing line. The picture seems to have been
painted about 1829 for engraving purposes. In
1830 an engraving of it by George B. Ellis enti-
tled *The Sailor-Boy* was published in *The Atlantic
Souvenir* with a short accompanying essay. Inman
evidently received twenty-five dollars for grant-
ing permission to reproduce the work.

Pink, chubby, happy, and healthy, despite the
shabbiness of his clothes and his bare feet, the
fisher boy recalls the romanticized peasants of
French-rococo pastoral scenes. Inman's paint-
ing, however, is concerned with the innocence
of childhood and not with the amorous license
afforded by an ideal Arcadia. The landscape
vista in the background, with its lush virgin for-
est, distant mountains, and winding river, also
partakes of this sensibility and seems to link the
youth and promise of the nation with the self-
reliant fisher boy. A portrait painter by force of
circumstance rather than by choice, Inman en-
joyed painting such landscape passages and once
noted with regret: "I cannot even get a chance
to paint a landscape, unless I stick it into a por-

trait, where I sometimes manage to crowd in a
bit of sky, or some old tree or green bank. . . .
You see I have not been able to consult my own
inclinations at all" (C. E. Lester, *The Artists of
America* [1846], p. 43).

The engraving after this work was well receiv-
ed and earned the praise of the critic John Neal.
He perceptively noted, however, the anatomical
awkwardness of the boy's chest and correctly
placed the blame on the painter rather than the
engraver. As with other genre paintings of boys
by Inman, for example, *The Newsboy*, 1841 (Addi-
son Gallery of American Art, Phillips Academy,
Andover, Mass.), *The Young Fisherman* was an
early treatment of a theme that found wide pop-
ularity through the medium of engraving and
was subsequently interpreted by a number of
other artists.

Oil on wood, 13¼ × 9⅝ in. (33.7 × 24.5 cm.).

RELATED WORKS: George B. Ellis, *The Sailor-Boy*,
engraving, published in *Atlantic Souvenir* (1830), p. 25 //
Charles Loring Elliott, *The Young Fisherman*, unlocated,
recorded in T. Bolton, *Art Quarterly* 5 (Winter 1942),
p. 83.

REFERENCES: J. Neal, *The Yankee: and Boston Literary Gazette* 2 (Nov. 1829), p. 266, "it is a capital engraving, though wiry. The right foot is exceedingly well done, but the chest is that of a dwarf—such breadth and muscle, however, we should attribute to the painter—for engravers are pretty sure to copy such things faithfully" // A. Burroughs, *Limners and Likenesses* (1936), p. 132, painted "on a tiny scale with meticulous sentiment" // T. Bolton, *Art Quarterly* 3 (Autumn 1940), suppl. p. 415, no. 174, lists Inman painting as Fisher Boy and gives engraver incorrectly as G. B. Hall // H. E. Dickson, ed., *Observations on American Art, Selections from the Writings of John Neal* (1943), p. 65, quotes from 1829 review // Gardner and Feld (1965), pp. 218-219 // W. H. Gerdts, *American Art Journal* 9 (May 1977), pp. 35-38, discusses this work fully and takes notice of Inman's own passion for fishing.

EXHIBITED: MMA, 1945, *William Sidney Mount and His Circle*, no. 25 // Munson-Williams-Proctor Institute, Utica, N. Y., 1948, *Arts of Early Utica*, no cat. // National Portrait Gallery, Washington, D. C., 1987, *The Art of Henry Inman*, exhib. cat. by W. H. Gerdts and C. Rebora, ill. p. 73.

EX COLL.: Samuel P. Avery, New York, by 1895.

Gift of Samuel P. Avery, 1895.

95.17.3.

The Reverend Dr. James Melancthon Mathews

James Melancthon Mathews (1785–1870) was born in Salem, New York. He received a bachelor of arts' degree from Union College, in Schenectady, New York, in 1803. Subsequently he attended the Theological Seminary of the Associated Reformed Dutch Church, from which he graduated in 1807. In 1812 he was appointed associate professor of biblical literature at the seminary founded in New York in 1804 by Dr. John Mitchell Mason, then the leading educator in the Reformed Dutch church. Later, as a founder of the South Reformed Dutch Church in New York, and as its pastor, Mathews occupied an important position in the religious life of the city. During the years 1829 and 1830, he was one of the leading proponents of the establishment of New York University and in 1831 became its first chancellor. In 1837 troubles brought on by the financial panic and the expenses incurred in completing the new Gothic-style university building on Washington Square led Mathews to cut faculty salaries. The stormy period that followed brought out the worst of Mathews's imperious

Henry Inman

temper. His uncle Philip Hone noted in his famous diary on October 1, 1838:

It is greatly to be regretted that an institution which was set in motion with so much spirit and endowed so liberally as New York University should be suffered to fall by reason of the factious spirit which prevails among its officers. . . . Open war exists between the chancellor, Dr. Mathews, and the faculty, and the readers of newspapers are presented almost daily with a column or two of vituperation and recrimination (A. Nevins, ed., *The Diary of Philip Hone* [1927], 1, pp. 344–345).

In his *Recollections of Persons and Events, Chiefly in the City of New York* (1865), Mathews devoted a chapter to the founding of the university and emphasized his support of the fine arts. It was he who appointed SAMUEL F. B. MORSE professor of the literature of the arts of design in 1832, though the position carried no salary. A respected teacher and preacher, Mathews remained active in church affairs until his death, even though he held no pastorate after 1840. He received honorary degrees from Yale and from Rutgers.

This portrait, painted in 1838, demonstrates the stylistic range of which Inman was capable. He avoids the expressive, loose, Sully-like brushwork he used in the portrait of Macready (q.v.)

Inman, *The Reverend Dr. James Melancthon Mathews*.

as well as the overtones of English romantic portraiture that characterize his portrait of Martin Van Buren (q.v.). Instead he adopts a more conservative approach. The relatively tight brushwork, the use of the curtain as a prop, the placement of the head high on the canvas, and the clear depiction of the draperies are more typical of the portrait-painting style best exemplified in New York at this time by WALDO AND JEWETT. Essentially an amalgam of lingering eighteenth-century portrait conventions, a painterly but not too painterly execution, and a kind of uncompromising realism, this style was practiced by a number of American artists. Often, unless such a work is signed, it is difficult to attribute it. Besides the inscription, however, the portrait is identified as his by the similarity to other ecclesiastical portraits, such as *Reverend Henry Croswell*, ca. 1839 (Mead Art Museum, Amherst College). Moreover, the soft but not smooth modeling in the face and the cloud-like treatment of the hair are characteristic of his work.

The year Inman painted this picture, he was at the height of his popularity as a portraitist. The Reverend Dr. Mathews poses in the gown of a doctor of divinity with the Geneva bands of that degree. The portrait came to the museum from his great-grandnephew, the noted American silver collector Alphonso T. Clearwater.

Oil on canvas, 30½ × 25¼ in. (77.5 × 64.1 cm.).
Inscribed and dated on the back, before lining: The Rev.d / Dr. Matthews. / Painted by H. Inman. / N. York. May 1838.
Canvas stamp: PREPARED BY / EDWARD DECHAUX / NEW YORK.
REFERENCES: *MMA Bull.* 26 (May 1931), pp. 130–131, ill. and gives biographical information on the subject // A. T. Clearwater, *MMA Bull.* 26 (July 1931), pp. 174–175, remembers the subject from childhood and clarifies provenance // T. Bolton, *Creative Art* 12 (Feb. 1933), p. 160, lists it incorrectly as Philip Melancthon Matthews; *Art Quarterly* 3 (1940), suppl. p. 409, no. 93, lists it // Gardner and Feld (1965), pp. 220–221 // National Portrait Gallery, Smithsonian Institution, Washington, D. C., 1987, *The Art of Henry Inman*, exhib. cat. by W. H. Gerdts and Carrie Rebora, p. 44.
ON DEPOSIT: MMA, since 1931, lent by A. T. Clearwater // Association of the Bar of the City of New York, 1966–1983 // Gracie Mansion, New York, 1984–present.
EX COLL.: the subject's nephew, Thomas Theunis Clearwater, New Paltz, N. Y., d. 1860; his grandson, Hon. A. T. Clearwater, Kingston, N. Y., d. 1933.

Deposited by Alphonso T. Clearwater, 1931.
L. 3060.

Martin Van Buren

Martin Van Buren (1782-1862), the eighth president of the United States, was born at Kinderhook, in Columbia County, New York. He grew up on his father's farm, attended the local schools, and in 1803 was admitted to the state bar. Early in his legal career Van Buren became interested in politics. By 1820, after serving as surrogate judge of Columbia County and state senator, he had achieved a prominent position in the New York Democratic party organization. From 1821 to 1828, he was United States senator from New York. Though ideologically a populist, he achieved an inconsistent record in the Senate on the vital issues of states' rights, slavery, and internal improvement. Following the election of John Quincy Adams in 1824, Van Buren shifted his support from William H. Crawford to Andrew Jackson, who, after his election to the presidency in 1828, appointed him secretary of state. In 1831, in a demonstration of loyalty, he resigned this post in order to prompt the resignation of other cabinet members and thus give Jackson the opportunity to rid himself of the supporters of John C. Calhoun's nullification doctrine. Now even closer to the president, Van Buren was chosen as Jackson's running mate in 1832, a choice that virtually guaranteed him the vice-presidency.

In 1836 it was again Jackson's influence that gained for Van Buren the Democratic nomination for president. Elected to that office, he attempted to continue Jackson's policies, but the Panic of 1837 and the depression that followed made him an unpopular figure. Perhaps the greatest achievement of his administration was the legislation that led to the establishment of the independent treasury system. In the election of 1840, Van Buren was defeated by the Whig candidate, William Henry Harrison. Following this Van Buren remained active in politics, but at an ever-increasing distance. As an old man, in 1860, he supported the Republican Abraham Lincoln during the secession crisis. He died at his family home in Kinderhook in 1862.

Inman first painted Van Buren's portrait in 1830, a full-length composition for New York's City Hall. During the mid- to late 1830s, he

produced numerous bust-length portraits of Van Buren. The earliest of these, probably from about 1837, appears to be the one now in the New-York Historical Society. Some, such as the example in the Metropolitan, are painted wholly, or almost wholly, by Inman; others exhibit the clumsy execution of less accomplished studio hands. Inman's student Edward Mooney (1813-1887) may have collaborated on some of the Van Buren portraits and is known to have completed at least one copy on his own (unlocated). The quality and spiritedness of the Metropolitan's portrait provides fair assurance that it is almost certainly a replica by Inman. Certain aspects of the work indicate that it is not the artist's first version, and indeed may have been finished by someone in his studio. The lack of detail in the representation of Van Buren's features, the way in which his coat is almost indistinguishable from the background, and the overly mannered, extreme contrast between the brightly lit head and the dense, dark space surrounding it suggest the shortcut methods of the copyist.

Judging from Van Buren's appearance in the portrait, it is likely that he sat to Inman sometime during his term as president, a hypothesis that would also account for the number of surviving versions; for copies of a portrait of Van Buren as president naturally would have been in great demand. The Metropolitan's portrait, closer to the first version than the others, would seem to have been painted about 1837-1838.

Although Inman did not adhere to the portrait-painting style of Sir Thomas Lawrence as closely as did THOMAS SULLY, his pictures often show the influence of the English master. Indeed, Inman's contemporaries did not hesitate to refer to him as the American Lawrence, despite Sully's previous claim on the title. In the case of this portrait, the opposition of the light head against the enveloping blackness, as though it were spotlighted in a completely dark room, repeats a formula employed by Lawrence in a number of his late works. The handling of pigment, however, is tighter and thinner than would have been the case with Lawrence. Also, Inman retains a characteristically American stiffness.

This work was given to the museum by the wife of JACOB HART LAZARUS, Inman's pupil and collaborator during the 1840s. It has been suggested that the portrait is a copy by Lazarus, but a close comparison to his style discloses great differences. (See his portrait of Inman in the Metropolitan Museum, VOL. II, p. 155.) Also, there is little likelihood that he could have produced such an accomplished work so early in his career.

Inman, *Martin Van Buren*.

Oil on canvas, 30¾ × 25½ in. (78.1 × 64.8 cm.).

RELATED WORKS: *Martin Van Buren*, oil on canvas, 30⅛ × 25⅛ in. (76.5 × 63.8 cm.), NYHS, ill. in *Catalogue of American Portraits in the New-York Historical Society* (1974), 2, p. 820 || *Martin Van Buren*, oil on canvas, 29½ × 24½ in. (74.9 × 62.2 cm.), Philipse Manor Hall, Yonkers, N. Y. || *Martin Van Buren*, oil on canvas, 30 × 25 in. (76.2 × 63.5 cm.), Brook Club, New York || *Martin Van Buren*, oil on canvas, 30 × 25 in. (76.2 × 63.5 cm.) private coll.

REFERENCES: Mrs. J. H. Lazarus, letter in MMA Archives, April 12, 1893, says that it was painted by Inman about 1830 || T. Bolton, *Creative Art* 12 (1933), p. 161, lists it || *DAB* (1936; 1958), s.v. Van Buren, Martin, gives biographical information on the subject || Gardner and Feld (1965), pp. 221–222 || *Catalogue of American Portraits in the New-York Historical Society* (1974), 2, p. 820, notes that it is almost identical to their portrait and mistakenly says it was the model for the Wellmore engraving (the model is Inman's 1830 portrait in the coll. of City Hall, New York).

EXHIBITED: Art-Union Rooms, New York, 1846, *Works by the Late Henry Inman*, no. 20, lent by James Lorimer Graham (possibly this picture) || MMA, 1939, *Life in America*, no. 118; 1946, *The Taste of the*

Seventies, no. 127 ‖ M. Knoedler and Company, New York, 1946, *Washington Irving and His Circle*, no. 29 ‖ MMA, 1965, *Three Centuries of American Art*, (checklist arranged alphabetically) ‖ National Portrait Gallery, Smithsonian Institution, Washington, D. C., 1972, "*If Elected. . .*," *Unsuccessful Candidates for the Presidency, 1796–1968*, ill. p. 126.

ON DEPOSIT: Library of Presidential Papers, New York, 1966–1972 ‖ Executive Mansion, Albany, N.Y., 1975–1979 ‖ Gracie Mansion, New York, 1984–present.

EX COLL.: Jacob Hart Lazarus, New York, d. 1891; his wife, Amelia B. Lazarus, New York, 1891–1893.

Gift of Mrs. Jacob H. Lazarus, 1893.
93.19.2.

Gentleman of the Wilkes Family

When this painting was given to the museum it was identified only as a portrait of a member of the Wilkes family by Henry Inman. In 1952 the attribution was changed to CHARLES CROMWELL INGHAM. The sitter was identified as Charles Wilkes (1798–1872), the picturesque naval officer and explorer who was the nephew of New York banker Charles Wilkes (1764–1833), whose portrait by GILBERT STUART was given to the museum by the same donor. In 1965 both the Ingham

Inman, *Gentleman of the Wilkes Family*.

attribution and the identification of the sitter were discarded. The style of the work was found to have little in common with the detailed, tight manner of Ingham, and the likeness of the subject to bear no resemblance to engraved portraits of Charles Wilkes. A more likely subject appears to be the donor's father, George Wilkes (1802–1876), a New York physician and the son of Charles Wilkes the banker. Dr. Wilkes lived for many years at 28 Laight Street before moving with his daughters, his sister Frances, the widow of David Cadwallader Colden (see her portrait by Ingham), and his unmarried sister Ann to 16 Washington Square in 1866. The likenesses of George Wilkes that have been found show him much older and heavier than the man in this portrait. There is a strong resemblance, however, and this could very well be a portrait of him in his youth. He had three brothers, Hamilton (d. 1853), Horatio (d. 1840), and William (1792–1845), good likenesses of whom have not been found, so it cannot really be said with certainty who the sitter is.

It is now difficult to see why, once the obvious discrepancies between the style of the picture and that of Ingham were realized, Inman was not once more considered as the probable artist. The soft, painterly modeling of the face, the rendering of the hair in broad, patchy strokes, the textured quality of the background, and the cursory representation of the coat, the couch, and the view beyond the column are all typical of Inman's facile style. The use of the large column immediately behind the sitter, with its base at shoulder level, is also characteristic of his work and may be observed in his portraits of George Buckham, ca. 1839 (Worcester Art Museum), and John Bishop Hall, 1839 (NYHS). The Worcester portrait, in particular, displays many striking similarities to the Metropolitan portrait in the handling of the face and hair. In addition, though most of Inman's portraits were painted on standard-size canvases, a number of works of the size of this picture and oval in format are known, including the portraits of Abner Buckham, ca. 1839 (Worcester Art Museum), and David Sproat Kennedy, ca. 1840 (NYHS).

This portrait can probably be dated about 1838 to 1840 on the basis of comparison with the above-mentioned portraits and in view of the evidence furnished by the canvas stamp. Philibert Caffé, dealer in artists' canvas, appears in New York city directories only in 1838 and

1839, and it is likely that Inman, who was a quick worker, used whatever canvas he purchased from Caffé during the dealer's working years or shortly thereafter. The sharply focused light and highly naturalistic shading of the face, together with the unusually stiff pose of the sitter, suggest that this portrait bears some relation to photography. In this connection it is interesting to note that in 1839, when the daguerreotype was introduced in New York, Inman was fascinated by the process, and it is possible that this portrait was based on an early daguerreotype.

The painting retains its elaborate original frame, which bears the label of William S. Conely, carver and gilder, 19 Essex Street, New York. He is listed in the city directories at that address from 1833 to 1843.

Oil on canvas, oval, 12 × 10 in. (30.5 × 25.4 cm.).
Canvas stamp: Prepared by / P. CAFFE / New York.

Frame label: WILLIAM [S]. CONELY, / CARVER and GILDER, / 19 E[SS]EX-ST. / NEW-YORK.

REFERENCES: W. Duer to MMA, Dec. 6, 1889, explains that items left to museum by Harriet K. Wilkes are still the property of her aunt Ann and sister Grace Wilkes under the stipulations of the will of George Wilkes // A. T. Gardner, *MMA Bull.* 10 (May 1952), pp. 251–252, identifies this picture as a portrait of Charles Wilkes the explorer and attributes it to C. C. Ingham // Gardner and Feld (1965), p. 169, call it portrait of a gentleman of the Wilkes family by an unidentified painter.

EXHIBITED: MMA, 1946, *The Taste of the Seventies*, exhib. cat. no. 127.

EX COLL.: probably George Wilkes, New York, d. 1876, his sisters Frances (Mrs. David) Colden, New York, d. 1877, and Ann Wilkes, New York, d. 1890, as a life interest; to his daughters Harriet K., d. 1887, and Grace, d. 1922.

Bequest of Grace Wilkes, 1922.
22.45.3.

THOMAS COLE

1801–1848

Thomas Cole was born at Bolton-le-Moor, Lancashire, England on February 1, 1801, the son of a ne'er-do-well woolen manufacturer. The family moved to Chorley, Nottingham, when Cole was still a boy. There he became an engraver of designs at a calico factory, a trade he continued to practice in Liverpool about 1817 when he took employment as a wood engraver's assistant. A born romantic, Cole loved music, poetry, and travel books. During the financial depression that followed the Napoleonic wars, his father, who was searching for opportunities to better his fortune, decided to emigrate. In July 1818 the entire family sailed to this country. They arrived in Philadelphia and shortly after removed to Steubenville, Ohio, then a small frontier town. Cole, who had obtained a job as a wood engraver in Philadelphia, stayed behind. After making a trip to Saint Eustatius in the West Indies early in 1819 he made his way to Steubenville to help in his father's newly established wallpaper manufactory. Because he found this work somewhat tedious, in early 1820, he taught a drawing and painting class and took instruction himself from an itinerant portrait painter, probably John Stein. During 1822, Cole traveled to a number of towns in Ohio, trying to earn a living as an itinerant portraitist. In the spring of 1823 he went to Pittsburgh, where his father had set himself up as a manufacturer of floor cloths. There Cole continued to paint portraits. His earliest surviving landscape drawings date from the summer of 1823 and disclose a keen interest in the minute details of nature. Now determined to become

successful as a landscape painter, Cole returned to Philadelphia in November of the same year. He supported himself by painting comic scenes for sale in barrooms, Japan-ware ornamentation, and occasionally landscapes. It was during this time that the landscape views of THOMAS DOUGHTY and Thomas Birch at the Pennsylvania Academy of the Fine Arts made a deep impression on him.

In 1825 again rejoining his family, Cole moved to New York. Three of his landscapes were purchased by the merchant George W. Bruen, who advanced him the money to make a sketching trip up the Hudson River. The resulting works revolutionized American landscape painting. Priced at twenty-five dollars each, three of them were quickly snapped up by prominent members of the New York art establishment, JOHN TRUMBULL, president of the American Academy of the Fine Arts, WILLIAM DUNLAP, the artist and writer, and ASHER B. DURAND, the engraver, all of whom quickly spread the word of their discovery. "From that time forward," Dunlap wrote, "Cole received commissions to paint landscapes from all quarters" (p. 360). He was an indefatigable draftsman who often traveled great distances in search of scenic beauty. The power of Cole's early landscapes was not just the result of his close observation of nature, but of his attitude toward it. For Cole, the voice of God was best heard in nature. Accordingly, his early representations of native scenery, for example *Kaaterskill Falls*, 1826 (Wadsworth Atheneum, Hartford), and *The Clove, Catskills*, ca. 1827 (New Britain Museum of American Art, New Britain, Conn.), largely dispense with the artificial niceties of eighteenth-century English landscape painting and boldly, if somewhat crudely, glorify the vast and rough American wilderness. In other early works, however, landscape surroundings, sometimes rather fantastic in character, provide a stage for dramatic events intended to teach a lesson, elevate the mind, or illustrate a story, for example, *Scene from "The Last of the Mohicans,"* 1827 (New York State Historical Association, Cooperstown), and *Expulsion from the Garden of Eden*, 1827–1828 (MFA, Boston). What sustained these paintings was a sensibility for epic poetry which Cole, himself something of a poet, could never abandon.

In 1829 Cole left for Europe on a journey that would take him to London, Paris, Florence, and Rome. In these cities he visited artists and made the rounds of galleries and museums. Although he never admitted it, he was an impressionable artist, and during this trip, as his works reveal, he felt the influence of J. M. W. Turner and John Constable and, possibly, one or more of the German artists working in Italy (just as he had already been influenced by engravings after the works of John Martin). His technique improved considerably, and he conceived the idea of painting a series of five pictures illustrating the rise and fall of a society. *The Course of Empire* (NYHS), as he called it, was eventually commissioned by the generous New York collector Luman Reed and was completed in 1836.

After his return from Europe in 1832, Cole, his mind now overflowing with ideas about antiquity, religion, morality, and the passage of time, naturally felt compelled to express them in his art. He could not live up to the public's expectation that he would continually turn out landscapes and nothing else. This passionate desire to make his works speak great truths not only led to paintings with an obvious anecdotal and moralizing content, such as *The Departure* and *The Return*, 1837 (Corcoran Gallery of Art, Washington, D. C.), *The Past* and *The Present*, 1838 (Mead Art Museum, Amherst College, Amherst, Mass.), and the

series *The Voyage of Life*, 1840 (Munson-Williams-Proctor Institute, Utica, N.Y.), but also to "real" landscapes which were pregnant with associations, emotions, and meaning, such as *The Oxbow*, 1836, *View in the Catskills–Early Autumn*, 1837, and *The Mountain Ford*, 1846 (qq.v.). It was, of course, precisely because of this infusion of significance into his views of American scenery that Cole reached a higher level of artistic achievement. It is, therefore, not surprising that Cole's signal contributions to American landscape painting—palpable atmosphere, panoramic composition, effective recession, and an emphasis on inclusiveness—make their appearance in such works, often at the expense of topographical accuracy.

In 1841, now a respected artist with a family and a comfortable house and studio in Catskill, New York, Cole decided to visit Europe again in order to revitalize himself and his art. He stopped in London and Paris but spent most of the time in his beloved Italy. When he returned to the United States in 1842 he was more self-assured than ever. The best of his later works are as adventurous as his earlier ones, but a lusher, more coloristically accomplished technique makes them appear more sophisticated. Many of these works are less agitated: the blasted trees, contorted rocks, and raging storms so typical of his previous works now give way to an appealing sense of quietude. This may be observed in the monumental *Mt. Aetna from Taormina*, 1843 (Wadsworth Atheneum, Hartford), the enormous size of which is in itself an important development, as well as in *Prometheus Bound*, 1846–1847 (Philadelphia Museum of Art), a work whose melodramatic possibilities would have been exploited to the fullest in earlier years, and in more modestly sized works such as *Home in the Woods*, 1845–1846 (private coll.), *The Old Mill at Sunset*, 1844 (Brooklyn Museum), and, especially noteworthy in this group, *American Lake Scene*, 1846 (Detroit Institute of Arts). These last three works already exploit the combinations of still water, distant land, and translucent sky which are associated with the American luminist aesthetic. Thus, before his death from pneumonia in 1848, Cole had already explored most of the territory that would characterize American landscape painting in the decades to follow.

Regarded in his own time as the founder of a native school of landscape painting, Cole's influence cannot be overestimated. His combination of realism and idealism in his landscapes defined the aesthetic parameters of what became known as the Hudson River school and exerted a direct influence on many of its chief figures, including Durand, FREDERIC E. CHURCH, and JOHN F. KENSETT.

BIBLIOGRAPHY: Thomas Cole Papers, New York State Library, Albany, N.Y., microfilm ALC-1 in Arch. Am. Art // William Dunlap, *A History of the Rise and Progress of the Arts of Design in the United States* (2 vols., New York, 1834), pp. 350–367 // Louis L. Noble, *The Life and Works of Thomas Cole* (New York, 1853). The indispensable biography by the artist's close friend; an annotated edition, edited by Elliot S. Vesell, was published in 1964 // Memorial Art Gallery of the University of Rochester, N.Y.; Munson-Williams-Proctor Institute, Utica, N.Y.; Albany Institute of History and Art, Albany, N.Y.; and Whitney Museum of American Art, New York, *Thomas Cole*, exhib. cat. by Howard S. Merritt (1969) // Ellwood C. Parry III, *The Art of Thomas Cole: Ambition and Imagination* (Newark, Del., 1989). A definitive study of the artist's life and work.

Cole, *The Arch of Nero*. Newark Museum.

A View Near Tivoli (Morning)

In February of 1832 Thomas Cole left Florence, where he had been residing for eight months, and went to Rome. There he spent four months which proved to be of crucial importance to his artistic development. He was impressed by the works of Raphael and by the architecture of Saint Peter's, but it was the ancient ruins that captured his imagination. "The things that most affect me in Rome," he wrote to his parents on March 4, "are the antiquities. None but those who can see the remains can form an idea of what Ancient Rome was" (Noble, 1853, p. 157). From Rome he made several excursions to see the sights of the surrounding countryside. He visited Tivoli, Ariccia, and Nemi, all the time making numerous drawings, which he later used

Cole, *The Arch of Nero*. Detroit Institute of Arts.

to paint a number of pictures after his return to Florence in June. Among them was this work, described by him as "a view near Tivoli, representing a bridge, and part of an ancient aqueduct, called 'Il Arco di Nerone': a road passes under the remaining arches: it is a morning scene, with the mists rising from the mountains" (ibid, p. 184).

Cole stated in a letter of September 15, 1834, that this was "not one of those scenes celebrated by travelers or by historical associations . . . [but] merely a picturesque bit that I found in my rambles among the Appenines." This was not, however, really the case. The arch, a fragment of the Claudian Aqueduct, is among the more monumental and best preserved of Roman ruins in the vicinity of Tivoli, and its historical associations are made abundantly clear by the superimposed tower and smaller arch within. These were erected in medieval times and transformed the structure into a fortified gate, intended to regulate the traffic on the road, as well as a watchtower. Now paved and known as the Via Empolitana, the road crosses the Fosso degli Arci, a tributary of the Aniene, immediately behind the arch and proceeds a short distance before bifurcating into branches that lead, respectively, to Castel Madama and to Empiglione. This territory was the scene of a number of military campaigns during the war of the factions of 1389, and it was at this time that the fortification of the arch was carried out (see Francesco Bulgarini, *Notizie Storiche, antiquarie, statistiche ed agronomiche intorno all'antichissima città di Tivoli* [Rome, 1848], p. 106). The bridge in the center of the picture, built over the ruins of another aqueduct, again adapts the remains of a Roman engineering marvel to a more modest modern use. The structures in the painting, therefore, not only contradict Cole's statement but seem particularly calculated to constrast the grandeur of antiquity with the ordinariness of later times.

Cole's approach to the site may be reconstructed from drawings he made on the spot (Sketchbook, Detroit Institute of Arts). He arrived there by taking the road from Tivoli and, while still a good distance away, stepped off the road to make the sketch that appears on page 42 of his sketchbook. This was a quick exploration of the view in broad outline fashion, with numerous color notes and a short sentence recording the time and atmospheric conditions: "It was morning—the distant mountains very

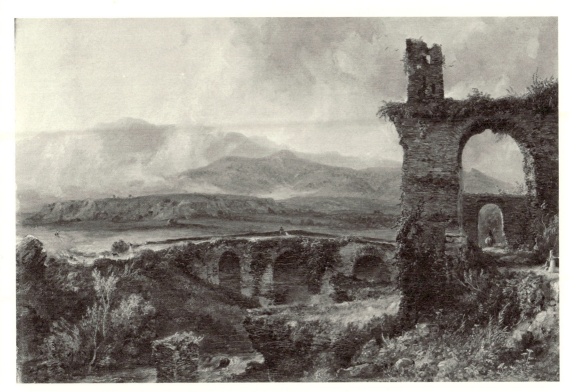

Cole, *A View Near Tivoli (Morning)*.

blue." Cole decided that here indeed was a subject fit for a painting and, still using the dimensions of the sketchbook pages to define the boundaries of the composition, proceeded to make a very detailed drawing on page 43, this time from a point closer to the arch but still off the road. Here he concentrated on obtaining as faithful a transcription of the scene before him as was possible. He noted the relative distance of the mountains by assigning numbers to them (1 being the farthest away and 4 the nearest); he sketched the picturesque figures of the traveling peasants and finally noted that a ploughed field was visible on the far left, even though this caused the drawing on page 43 to spill over onto page 42. Once this drawing was completed, however, Cole noticed that he had not captured the proper relationships between the parts of the arch and wrote: "the proportion of this rather too small, the arch large enough." He titled the drawing "Arch of Nero" and reminded himself to "look at the other arch" and "look over on both sides." He then climbed back onto the road,

walked nearer to the arch and made another sketch, revealing that the bridge was actually almost immediately behind the arch and on the same level with the road (Sketchbook, p. 44). Cole noted that this was "perhaps a better view," but he must have realized that his rendering of the arch was still out of proportion. Accordingly, he turned over his sketchbook and, placing it upright, made the close-up view of the arch, which is, in fact, more in keeping with the actual dimensions of the structure (ibid, p. 111). He executed this drawing in pencil and later, perhaps as late as 1846, went over it with pen and ink; it is this drawing which he relied on for his *The Arch of Nero* of 1846 (Newark Museum). Cole then heeded his own counsel and walked under the arch and across the bridge in order to draw the eastern face of the ruin, again from a position off the road (ibid, p. 110). The mountain against which the arch rests now came into view, but its presence dwarfed the monumentality of the architecture so that it is not surprising that he never used this view.

When Cole arrived back in Florence in June then, he had more than ample visual materials to produce a painting of this subject. For *View of Tivoli*, he chose to use his second rendition of the arch on page 43 of the sketchbook. In retrospect, it is disappointing that instead of carrying out a well-thought-out interpretation of the scene (such as the bolder, more ambitious 1846 painting), he merely turned out a slightly more complex version of his drawing. But perhaps at this time Cole was more interested in being a "fa presto" than an inspired artist. A statement he made to WILLIAM DUNLAP (1834) is practically a confession: "[In Florence] I painted more pictures in three months than I have ever done in twice the time before or since . . . In that three months I painted the Aqueduct picture, the view of the Cascatelles [*sic*] of Tivoli, Mr. Lord's picture of Italian scenery, four small pictures for Mr. Tappan, a small view near Tivoli [this work], and several others.—O that I was there again, and in the same spirit."

The pictorial problems posed by Cole's panoramic intent in the drawing, such as the imbalance in the composition due to the lack of resolution at the left, the ambiguous relationship between the foreground and the bridge (which makes it difficult for the viewer to know which way the stream flows), and the sketchiness of the mountain range in the background, are not satisfactorily dealt with in the picture. One solution would have been to edit the drawing in order to make a better defined statement. This was the option chosen by the German landscape painter Johann Martin von Rohden in his *Ruins of Hadrian's Villa* of about 1810 (Kunsthalle, Hamburg, ill. in F. Novotny, *Painting and Sculpture in Europe, 1780–1880* [1978], p. 222), which is actually a view of aqueduct ruins in the vicinity of the "Arch of Nero" and composed very much like Cole's picture. Cole himself finally did this in his 1846 version of the subject. But in the museum's picture, Cole decided in favor of more rather than less, and, in addition to retaining the multiplicity of elements in the drawing, he proceeded to rely on his imagination, especially in places where the drawing provided no sure guidance. Consequently, he pushed the mountains back into the distance and surrounded them with clouds, giving them more dramatic outlines and making them appear more like the wild Adirondacks than the gently eroded Sabine range. At the extreme left an outcropping of rock was conveniently added in an attempt to close off the composition. Lastly, the bridge was pushed farther behind the arch in order to occupy a more comfortable middle distance. Thus Cole's elaborations and idealizations expand the space represented, make for greater visual complexity, and monumentalize the view. But it is this very all-inclusiveness that prevents the formulation of a clear aesthetic argument. Neither a convincing meditation on antiquity, like the Rohden, nor a well articulated landscape, this picture attempts to be both at the same time, incorporating the genre elements typical of the eighteenth-century *veduta* (compare, e.g., with the view of the site by L. Rossini in *Le Antichità dei Contorni di Roma* [1823]). The result is a conceptually and pictorially cluttered work, the ambitiousness of which is simply not commensurate with its small size and somewhat careless execution. It should be said in favor of this work, however, that it is coloristically accomplished. The sophistication evident in the variations of light and shade is impressive, especially for an American painter at this time.

In 1834 Cole presented the painting to William A. Adams, an old Ohio friend, in satisfaction of a debt of twenty-five dollars incurred ten years previously. Presumably a letter from Cole to Adams inquiring his whereabouts and offering to repay the debt crossed in the mail with one from Adams chiding the artist for his lack of honesty. It is possible, however, that Cole's letter was actually written after he had received Adams's rebuke and was calculated to make Adams think that he had never really forgotten his obligation. Adams's letter to Cole is conveniently missing from the Cole papers, but Cole's letter to Adams survives; it is dated November 4, 1833, but it is clearly postmarked March 25 and the year is 1834 (as is established by the context of the correspondence).

Oil on canvas, 14¾ × 23⅛ in. (37.5 × 58.7 cm.).

Signed, dated and inscribed on the back: T. Cole / Florence / 1832 / Presented to W. A. Adams / by T. Cole / Sep 1834.

RELATED WORKS: On-the-spot drawings, pencil on paper, 8¾ × 12⅜ in. (22.3 × 31.5 cm.), in 1832 Sketchbook (acc. no. 39.565), Detroit Institute of Arts, pp. 42, 43, 44, 110, and 111 (also pen and ink) || *The Arch of Nero*, oil on canvas, 60 × 48 in. (152.4 × 122 cm.), 1846, Newark Museum.

REFERENCES: *New-York Mirror*, May 8, 1833, p. 366: "The painting before us may vie with any thing in the shape of landscape in every part; but its dis-

tance is unrivalled and sets criticism at defiance" ||
T. Cole, to W. A. Adams, Nov. 4, 1833 (?) (post-
marked March 25, 1834); April 7, 23, August 5, and
Sept. 15, 1834; W. A. Adams to T. Cole, August 13
and Nov. 29, 1834, Cole Papers, New York State
Library, Albany (microfilm ALC-1 in Arch. Am. Art),
mention the picture in relation to Cole's debt to
Adams, discuss its content, and give details about
Cole's gift of the picture to Adams || W. Dunlap, *A
History of the Rise and Progress of the Arts of Design in
the United States* (1834), 2, p. 364, has a passage by
Cole mentioning it (quoted above) || L. L. Noble, *The
Course of Empire, Voyage of Life, and Other Pictures of
Thomas Cole, N. A.* (1853), pp. 180–185, gives excerpts
from the correspondence between Cole and W. A.
Adams and asserts that Cole's letter offering to repay
his debt crossed in the mail with Adams's letter rebuk-
ing the painter for his forgetfulness || H. T. Tucker-
man, *Book of the Artists* (1867), p. 232 || D. C. Barck,
ed., *Diary of William Dunlap (1766–1839)* (1931), 3,
p. 640, records on Dec. 26, 1832, that Dunlap thought
Cole's "Tivoli and Roman Aqueduct are very fine" ||
W. H. Gerdts, [Newark] *Museum* 10 (Winter 1958),
pp. 7–11, discusses the Newark Museum picture of
1846, The Arch of Nero, and notes its relationship
to this work; thinks that a watercolor sketch on page
93 of Cole's 1831 sketchbook (Detroit Institute of
Arts, 39.562) is a study for both paintings [this seems
unlikely since this sketch shows two towers and since
the structure in the painting is on top of a hill and does
not rest against the side of a mountain] || Gardner
and Feld (1965), pp. 225–226 || I. Weiss, *American
Art Journal* 9 (Nov. 1977), p. 100, n. 65; p. 101, n.
67, quotes passage from Sanford Gifford's journal
praising Cole's painting The Arch of Nero but erro-
neously thinks that it refers to the Metropolitan's
picture rather than to the 1846 version || W. Craven,
Antiques 114 (Nov. 1978), p. 1018–1019, color ill.
p. 1021, calls it one of Cole's "first attempts to develop
the panoramic pastoral, the elements of which includ-
ed simple, joyous peasants, frequently with sheep or
goats; ancient and overgrown ruins; and a rustic land-
scape, usually suggesting rural Italy by its flora and
general configuration" || E. C. Parry, *The Art of
Thomas Cole* (1989), pp. 132, 135, 152.

EXHIBITED: NAD, 1833, no. 51, as A View near
Tivoli (Morning) || Western Art Union, Cincinnati,
1849, as The Arch of Nero || NAD, 1867–1868, *First
Winter Exhibition*, no. 248, as The Arch of Nero, (pos-
sibly this picture) || World's Columbian Exhibition,
Chicago, 1893, no. 281a, as Roman Aqueduct, lent
by Henry G. Marquand || Dallas Museum of Fine
Arts, 1922, *American Art from the Days of the Colonists
to Now*, no. 15, as Roman Aqueduct || Addison Gal-
lery of American Art, Phillips Academy, Andover,
Mass., 1939, *William Dunlap, Painter and Critic*, exhib.
cat. by W. Ames, pp. 44–45 || Albany Institute of
History and Art, 1941, *Thomas Cole, 1801–1848*, exhib.
cat. by J. D. Hatch, no. 30 || Wadsworth Atheneum,

Hartford, and Whitney Museum of American Art,
New York, 1948–1949, *Thomas Cole, 1801–1848, One
Hundred Years Later*, exhib. cat. by E. Seaver, no. 17,
as The Roman Aqueduct || Detroit Institute of Arts
and Toledo Museum of Art, 1951, *Travelers in Arcadia*,
no. 27, notes that George Inness painted a view of the
same spot in 1870 || E. Nash, Fototeca di Architettura
e Topografia Dell'Italia Antica, to M. Scherer, Jan.
21, 1965, letter in Dept. Archives || Baltimore Mu-
seum of Art, 1965, *Thomas Cole*, no. 10, as Roman
Aqueduct (see Baltimore Museum of Art, *Annual II:
Studies on Thomas Cole* [1967] || Memorial Art Gallery
of the University of Rochester, N. Y.; Munson-Wil-
liams-Proctor Institute, Utica, N. Y.; Albany Insti-
tute of History and Art; Whitney Museum of Amer-
ican Art, New York, 1969, *Thomas Cole*, exhib. cat.
by H. S. Merritt, no. 23, color. ill., p. 52, gives prov-
enance of this picture || National Gallery of Art,
Washington, D. C.; City Art Museum, Saint Louis;
Seattle Art Museum, 1970–1971, *Great American Paint-
ings from the Boston and Metropolitan Museums*, no. 33 ||
MMA and American Federation of Arts, traveling
exhib., 1975–1977, *The Heritage of American Art*, cat.
by M. Davis, no. 30.

EX COLL.: William A. Adams, Zanesville, Ohio,
from 1834 until 1849; Western Art Union, Cincinnati
(gift of W. A. Adams), 1849; N. W. Scarborough,
Cincinnati, by 1850; Daniel Huntington, New York,
probably by 1867; Henry G. Marquand, New York,
by 1893 (sale, American Art Association, New York,
January 23, 1903, no. 81, as A Roman Aqueduct),
with Samuel P. Avery, Jr., 1903.

Rogers Fund, 1903.

03.27.

The Titan's Goblet

The culmination of Cole's romantic fantasies,
The Titan's Goblet has long puzzled students of
American art because of the very qualities that
make it such a fascinating picture. Painted in
1833 at a time when Cole was mostly occupied
with the development of *The Course of Empire*,
1836 (NYHS), and with the production of Italian
landscape views, it is related to other works of
this period both in its depiction of a landscape
derived from Italian scenery and in its attempt
to illustrate themes dealing with the grandeur of
the past, the passage of time, and the encroach-
ment of nature.

Unlike most of Cole's works that include ob-
viously symbolic elements, no explanation by the
artist of the meaning of this picture has come
down to us. Perhaps he gave none, for at least

one reviewer in a respectable journal in 1834 felt justified in thinking that its "conception" was "merely, and gratuitously, fantastical." Later critics of Cole's art, however, have not agreed with this evaluation and have put forward a number of interpretations. A pamphlet published in 1886 by John M. Falconer (1820–1903), a friend of Cole's who then owned the painting, included the following comments by the writer Theophilus Stringfellow, Jr.:

It is a grand picture of symbolic art. What is this vast goblet but the little world of man, which is, as the artist shows, a cosmos, and greater than it seems. The goblet is a man. Its verdure covered foundation, its treelike stem, the vast bowl, the sea within, all together represent and symbolize the world of nature as taken up and metamorphosed in man. The goblet is the microcosm, man. The earth upon which it rests, which stretches beyond, around and beneath it is the vast of nature.

As supporting evidence for his view of the goblet as a world in itself Stringfellow cited the similarities between Cole's goblet and the world-tree of Norse mythology. In 1904 the compiler of the sale catalogue of the Falconer collection picked up on this idea and wrote that *The Titan's Goblet* was:

influenced by the Norse legend of the Tree of Life. Rugged mountains catching the departing gleams of the setting sun form the background for a gigantic cup placed on the projecting point of a rocky headland jutting into a sea, on the shore of which is seen an Eastern city, in the immediate foreground verdure-clad cliffs glowing in the setting sun, an extensive landscape spreading out to the left. The spiritual idea in the centre of the painting, conveying the beautiful Norse theory that life and the world is but as a tree with ramifying branches, is carefully carried out by the painter, the stem of the goblet being a massive tree trunk, the branches of which spread out and hold between them an ocean dotted with sails, surrounded by dense forests and plains, in which appear Greek ruins and a modern Italian building, typical of Ancient and Modern Civilization.

In modern times this interpretation has been either substantially accepted or else completely rejected. Among the earliest doubters was the late Erwin Panofsky, who in 1963 noted that Cole's picture

has, in my opinion, little to do with the Nordic Tree of Life which is described in an entirely different way, reaching from earth to heaven but having three roots beneath each of which a spring bursts forth, one ex-

tending to the realm of the gods, the other to the realm of the giants and the third to the netherworld. Nothing of this is even indicated in Cole's picture.

Instead, Panofsky suggested that the picture might be related to those stories in Nordic mythology which speak of mountains and beaches having been formed by legendary giants accidentally dropping pebbles or sand. In 1972 Ellwood Parry took further issue with the early critics and suggested that the goblet was not a tree but an object made of stone and pointed out that the concepts expressed had more to do with the Mediterranean than with the north. He did not identify a source for Cole's picture but concluded that the artist "had no intention of making a specific cosmological statement in the Titan's Goblet." Parry then went on to establish a number of visual and conceptual parallels between the picture and various impressions the painter must have gathered during his first European journey from 1829 to 1831. Relying on evidence furnished by drawings, Parry concluded that Cole was influenced by J. M. W. Turner's painting of *Ulysses Deriding Polyphemus*, 1829 (National Gallery, London), the story of the colossal statue of Mount Athos, the design of some Italian fountains, and the geological form of the volcanic lakes of Albano and Nemi, both of which Cole visited.

Yet, no overall conclusion regarding the meaning of the picture may be drawn from this debate. The tree of life parallel is only that and cannot withstand a detailed iconographical comparison with Cole's goblet, and the Mediterranean setting of the picture clearly forecloses any relation to the Nordic tales of giants, which, in any case, never mention goblets. Finally, the various links established by Cole's drawings cannot be said to elucidate the meaning of the painting and only partially clarify the question of his visual sources.

In the last analysis, *The Titan's Goblet* may be too original in conception and too eclectic in its transformation of formal precedents to allow a very precise interpretation. That a specific source exists (in art or literature) or that Cole intended to make a specific cosmological statement in it, however, should not be ruled out. In this respect, it may be noted that one element in the picture thus far ignored, the brilliant sun, provides a clue to a fuller understanding of the work. To begin with, the sun was identified in many of the ancient writings as one of the Titans,

while the word titan, in English poetic usage, was commonly understood to refer to the sun. It was in this sense that Shakespeare employed it in *Venus and Adonis* (1593) and it is as such that the word is first glossed in the *Oxford English Dictionary*. Far more to the point, however, are the stories related by a number of classical authors, such as Athenaeus, Mymnermus, and Pherecydes, which deal with the golden goblet of the sun-god Helios. These stories are described by Sir James G. Frazer:

But while the Sun was thus supposed to drive across the sky in a chariot by day, it was imagined that after plunging into the sea in the west he returned by night to his starting-point in the east, floating over the subterranean ocean in a golden goblet. . . . According to Pherecydes, the horses of the Sun were also ferried across the sea by night in the golden goblet; and this seems only reasonable, else how could they have crossed all that stretch of water and been ready to start again the next morning in the east? (*The Worship of Nature* [1926], pp. 465–466.)

But if the main elements of the picture—sun, goblet, landscape, and sea—are explained by making reference to the mythology of the sun in ancient times, other aspects of the picture are not. These are in the nature of further elaborations on the myths and strongly imply that Cole was attempting an interpretation of some kind. The fact that the goblet is overgrown with vegetation and has become an elevated lake suggests that it has fallen into disuse and is now the support for a self-contained classical world (note the Greek temple on the shore; the architecture of the building opposite is not distinguishable), which survives even though removed from the larger world of the surrounding landscape. This wider world is associated with the present by virtue of the Italianate and Eastern architecture of the city by the sea. Direct contact between the two worlds seems impossible, and it is only the water overflowing the goblet that reaches the land below, as if in an ongoing rain.

We may speculate, then, that the goblet is an image for past civilization, made possible by pagan beliefs and mythological tales, which are accepted as reality, and that the landscape stands for the present. The present has no clear perception of antiquity but is nevertheless linked to it by means of its mute remains and by being the recipient of the waters which nourished its culture. The present no longer sees the sun as descending into a goblet for its nightly journey

Cole, *The Titan's Goblet.*

or as a god in a chariot drawn by four horses. It perceives nature realistically and in detail, though not necessarily without religious feeling. Only the artist or the poet in his imagination can gain a loftier perspective to view the past and present in their proper relationship and, perhaps, see that, in the image of the goblet and the sun, another image, that of the chalice and the host, manifests itself.

A work of modest size, apparently executed in haste, *The Titan's Goblet* was not a commissioned work. Cole sent it to Luman Reed, with whom he was arranging terms for the painting of *The Course of Empire*, perhaps on approval, but Reed returned it, probably because it was a little too farfetched for his taste. It was then purchased by the chemist and amateur artist James J. Mapes (1806–1866), who permitted Cole to exhibit it at the National Academy of Design in 1834. Reed's rejection of the picture probably exercised its effect on Cole; for the artist never again attempted a work so fantastic in character.

Oil on canvas, 19⅜ × 16⅛ in. (49.2 × 41 cm.).
Signed and dated at lower right: T Cole. / 1833; Inscribed on paper on the back, recording original

inscription before lining: The Titan's Goblet / T. Cole / 1833.

RELATED WORKS: T. Cole, *Study for the Titan's Goblet*, n.d., black ink over pencil, p. 41, in 1837 Sketchbook, 15½ × 9¼ in. (39.5 × 33.5 cm.), Detroit Institute of Arts, 39.559. Not a study for the picture but a composition thematically related to it.

REFERENCES: T. Cole, List of Financial Transactions with Luman Reed, 1834, Cole Papers, New York State Library, Albany (microfilm ALC-1 in Arch. Am. Art), begins with entry "to Goblet picture 100 By returned Goblet picture 100" // *New York American* (May 22, 1834), p. [2], reviewer comments that "my mind could not accomodate itself to the image it should here have received; I thought only of little children sailing mimic boats upon a table goblet kept for gold fish" // *American Monthly Magazine* 3 (1834), p. 210 // H. T. Tuckerman, *Book of the Artists* (1867), p. 228, says this picture originally belonged to Luman Reed and was then in the possession of J. M. Falconer // J. M. Falconer, ed., *The Titan's Goblet* (Brooklyn, 1886), pp. 2–5, gives quotation from Theophilus Stringfellow, Jr., of Milwaukee, dated September 30, 1885, associating the painting with the world-tree of Scandinavian mythology; also quotes a description of the picture by the Rev. Louis L. Noble, Cole's biographer, which states that within the goblet, "steeped in the golden splendors of a summer retreat, in a little sea from Greece, or Holy Land, with Greek and Syrian life, Greek and Syrian nature looking out upon its quiet waters" // Anderson Auction Company, New York, *Catalogue of the Interesting and Valuable Collection of Oil Paintings, Water-Colors and Engravings Formed by the Late John M. Falconer* (1904), p. 41, no. 407, interpreted as influenced by the Norse legend of the tree of life // E. Panofsky, letter in Dept. Archives, July 1, 1963, rejects Norse tree of life interpretation and suggests it may have more to do with Nordic stories of giants // J. D. Prown, *American Painting* (1964), p. 65, briefly discusses the painting // Gardner and Feld (1965), pp. 226–227 // J. T. Flexner, *Nineteenth Century American Painting* (1970), ill. p. 48 // E. C. Parry, *MMA Journal* 4 (1971), pp. 123–140, discusses the painting at length, relates it to several themes arising from Cole's first European trip and says that Cole had no intention of making a specific cosmological statement // A. A. Davidson, *The Eccentrics and Other American Visionary Painters* (1978), pp. 20–21 // H. A. Weinberg, *Prospects* 8 (1983), pp. 261–280, examines the painting iconographically to establish that it was "peculiarly central to the process of making the American landscape function in a metaphorical way"; describes the subject as "an American Grail" // E. C. Parry, *The Art of Thomas Cole* (1989), pp. 98, 138, ill. p. 139, calls it "the most surrealistic painting of his career" and suggests many sources of inspiration for the subject.

EXHIBITED: NAD, 1834, no. 41, lent by J. J. Mapes, Esq. // Stuyvesant Institute, New York, 1838, *Exhibition of Select Paintings by Modern Artists* (Dunlap Benefit Exhibition), no. 37, lent by J. J. Mapes // Artist's Fund Society, Philadelphia, 1842, no. 5 // Artist's Fund Society, New York, 1863, *Fourth Annual Exhibition*, no. 160, lent by J. M. Falconer // Brooklyn Art Association, 1872, *Chronological Exhibition of American Art*, no. 34 // MMA and NAD, 1880, *Loan Exhibition of Paintings*, no. 48 // Hamilton Club, New York, 1887, *Exhibition of Pictures by American Artists*, no. 15, lent by J. M. Falconer // Museum of Modern Art, New York, 1936, *Fantastic Art*, exhib. cat. by A. H. Barr, no. 105 // Cleveland Museum of Art, 1944, *American Realists and Magic Realists*, no cat. // Art Institute of Chicago and Whitney Museum of American Art, New York, 1945, *The Hudson River School*, no. 70 // Wadsworth Atheneum, Hartford, and Whitney Museum of American Art, New York, 1948–1949, *Thomas Cole, 1801–1848, One Hundred Years Later*, exhib. cat. by E. Seaver, no. 23 and pp. 11–12 // AFA and Whitney Museum of American Art, traveling exhibition, 1954, *American Painting in the Nineteenth Century*, no. 8 // Corcoran Gallery of Art, Washington, D. C., 1959, *The American Muse*, no. 62 // World's Fair, New York, 1964, *The River*, no. 17 // Montreal Museum of Fine Arts, 1967, *The Painter and the New World*, no. 216 // Memorial Art Gallery of the University of Rochester, N. Y., Munson-Williams-Proctor Institute, Utica, N. Y., Albany Institute of History and Art, and Whitney Museum of American Art, New York, 1969, *Thomas Cole*, exhib. cat. by H. S. Merritt, no. 27, accepts the Norse tree of life interpretation and notes the similarities between the painting and the illustration of the tree of life published in Finnur Magnusson's *Eddalaeren* (Copenhagen, 1825), p. 3.

Ex coll.: James J. Mapes, New York, by 1834; John M. Falconer, Brooklyn, by 1863 (sale, Anderson Auction Galleries, New York, April 28–29, 1904, no. 407); Samuel P. Avery, Jr., New York.

Gift of Samuel P. Avery, Jr., 1904.
04.29.2.

View from Mount Holyoke, Northampton, Massachusetts, after a Thunderstorm – The Oxbow

Long known as *The Oxbow*, this painting is one of the generally acknowledged masterpieces of American landscape painting. Its meaning is intimately related to the circumstances of its making. During the fall and winter of 1835 and during the early months of 1836, Thomas Cole was at work on *The Course of Empire*, 1836 (NYHS), for the prominent New York art patron Luman Reed. Toward the end of 1835, however, Cole began to have doubts about the

success of this project. In January or early February of 1836, Reed suggested that he suspend work on *The Course of Empire* and paint a landscape for the National Academy of Design exhibition opening in April. On March 2, 1836, Cole replied:

I have revolved in my mind what subject to take and have found it difficult to select such as will be speedy of execution and popular. Fancy pictures seldom sell and they generally take more time than views, so I have determined to paint one of the latter. I have already commenced a view from Mt. Holyoke—it is about the finest scene I have in my sketchbook and is well known—it will be novel and I think effective.

It was long assumed that Cole drew his inspiration for *The Oxbow* from a visit to the site and that the final appearance of the canvas was determined by what he saw, as recorded in a sketch done on the spot, now in the collection of the Detroit Institute of Arts (Sketchbook no. 8, p. 67). This sketch, mentioned in Cole's letter to Reed of March 2, was probably executed in the summer of 1833 when Cole traveled to Boston.

Cole's consideration of a view of the Connecticut River from Mount Holyoke as a subject for a painting, however, appears to antedate this sketch by some years. Another drawing that once appeared to be a compositional sketch for *The Oxbow* (Detroit Institute of Arts 39.70) may now be dated as far back as 1829, that is, to the time of Cole's stay in London on the first leg of his European tour of 1829 to 1832. Identified in his handwriting as Mount Holyoke, this drawing is not an original creation of Cole's but rather an exact tracing of a view published in Basil Hall's *Forty Etchings Made with the Camera Lucida in North America in 1827 and 1828* (pl. xi). This book appeared in London in 1829 as a companion to Hall's *Travels in North America*, published that same year both in London and Philadelphia.

Since the publication of Hall's book caused a major uproar on both sides of the Atlantic, it seems most probable that Cole made his drawing shortly after the publication of the book. At this time he would have been in London. As an American in England he would have been called upon by friends and acquaintances to respond to Hall's negative assertions regarding America. Of special interest to him would have been Hall's views on American scenery:

All the world over, I suspect the great mass of people care mighty little about scenery, and visit such places merely for the sake of saying they have been there.

I own, however, that I was at first rather taken in with respect to this matter in America; and really fancied, from the flaming descriptions we had given us of the beauties and wonders of the country, that the persons describing it were more than usually sensible to its charms. But we now began to suspect, most grievously, that our friends of whom we were striving with all our might to think well in every point, were like most folks elsewhere, nearly as insensible to the beauties of nature, as we had reason to fear, from their public exhibitions, they were to the graces of art (B. Hall, *Travels*, 1, p. 68).

This argument Hall repeated later in his book (p. 220).

Subsequent events in Cole's career as an artist suggest that he was much disturbed by these issues and that his responses to them are an integral part of the meaning of *The Oxbow*. His answer to the criticisms voiced by Hall and others was first clearly spelled out in *The Essay on American Scenery*, which he delivered before the New York Lyceum on May 16, 1835 (*American Monthly Magazine*, n.s. 1 [Jan. 1836], pp. 1–2). To the indifference of many Americans toward their native scenery, Cole opposed the interest of "a community increasing in intelligence" of which he and his circle were part. To the oft-cited criticism, based on concepts of the picturesque and the sublime, "that American scenery possesses little that is interesting or truly beautiful—that it is rude without picturesqueness, and monotonous without sublimity, "Cole opposed his own characterization of the American land. Thus in America, he wrote, "there is a union of the picturesque, the sublime and the magnificent," where "the traveller . . . cannot but acknowledge that although in some regions of the globe nature has wrought on a more stupendous scale, yet she has nowhere so completely married together *grandeur* and *loveliness*"; where the observer sees "the sublime melting into the beautiful, the savage tempered by the magnificent." Finally, Cole countered what had often been considered the greatest defect in American scenery, the lack of historical associations such as those called to mind by the scenes of the old world. American views, he concluded, did not reveal the hand of the past but the hope of the future:

Seated on a pleasant knoll, look down into the bosom of that secluded valley, begirt with wooded hills through enamelled meadows and wide waving fields of grain; a silver stream winds lingeringly along— here seeking the green shade of trees—there glancing in the sunshine; on its banks are rural dwellings

shaded by elms and garlanded by flowers—from yonder dark mass of foliage the village spire beams like a star. You see no ruined tower to tell of outrage—no gorgeous temple to speak of ostentation; but freedom's offspring—peace, security and happiness dwell there, the spirits of the scene . . . And in looking over the yet uncultivated scene, the mind's eye may see far into futurity—mighty deeds shall be done in the now pathless wilderness: and poets yet unborn shall sanctify the soil.

This almost precise description of the Oxbow in the context of Cole's *Essay* discloses his intentions in the painting. Formally, the division of *The Oxbow* into two clearly discernible areas, the left featuring elements of Salvator Rosa's romantic sublime, and the right emphasizing the Claudian beautiful, is strictly in keeping with the tenets of Cole's new synthesis. The contorted tree trunks, the receding storm, and the wild mountains are effectively juxtaposed with the "silver stream that winds lingeringly along," on whose banks are "rural dwellings shaded by elms."

The inclusion of varied topographic features and atmospheric conditions—mountains, plains, wild forests, cultivated farmlands, a dark storm opposed to a translucent sky, shadow contrasted with light—are all part of the variety Cole identified with American scenery. He defined that scenery not with limiting conditions but with inclusive ones. Moreover, in showing that the American landscape could synthesize the individual features of foreign scenery, Cole pointed to the future prospect of the American nation.

As might be suspected, Cole's arrangement of his landscape is not a strictly topographical one, as is the case with Hall's view executed with the aid of the camera lucida. Comparing Cole's finished painting with his own on-the-spot sketch and Hall's etching, it becomes immediately apparent that if Cole relied on Hall's precedent it was only in a most elementary way. In fact, what the American painter did was transform a commonplace topographical depiction into a boldly composed, vividly colored, and heroically conceived picture that "transcends the mere view to become art" (Novak, 1969, p. 77).

To call attention unequivocally to the nature of this work, Cole included a self-portrait of himself at work, recording the vast panorama stretching before him. The figure bears perpetual testimony to the picture-worthiness of the scenery and relays this message to the viewer. The artist has put himself forward as an American producing American art, in communion with American scenery.

Oil on canvas, $51\frac{1}{2} \times 76$ in. (130.8 × 193 cm.).

Signed and dated at lower left: T. Cole 1836. Signed on the artist's portfolio: T Cole.

RELATED WORKS: *Mount Holyoke/Mass.*, pencil on tracing paper, $4\frac{1}{2} \times 8\frac{3}{8}$ in. (11.4 × 21.3 cm.), ca. 1829–1832, Detroit Institute of Arts (39.70). A tracing of pl. xi in Basil Hall, *Forty Etchings Made With the Camera Lucida in North America in 1827 and 1828* (1829) // *View from Mount Holyoke*, pencil, $8\frac{7}{8} \times 27\frac{1}{2}$ in. (22.5 × 69.9 cm.), 1833, in Sketchbook no. 8, pp. 66–67,

Cole, study for *The Oxbow*. Private collection, photograph courtesy of Kennedy Galleries, New York.

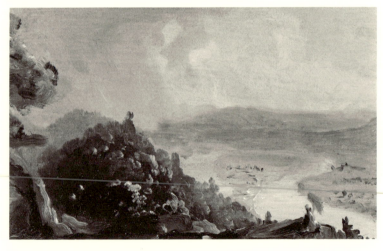

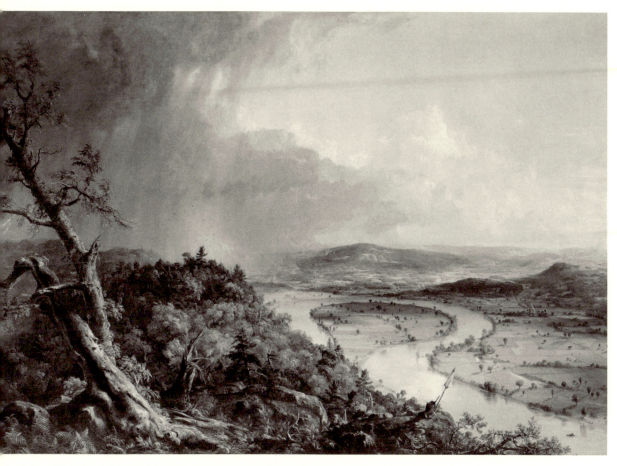

Cole, *View from Mount Holyoke, Northampton, Massachusetts,*
after a Thunderstorm — The Oxbow.

Detroit Institute of Arts (39.566), detailed on-the-spot sketch on which Cole based the painting // *Study for the Oxbow*, oil on board, 5¾ × 9⅝ in. (14.6 × 24.5 cm.), 1835–1836, private coll.

REFERENCES: T. Cole to L. Reed, Feb. 19, 1836, Cole Papers, New York State Library, Albany, microfilm ALC–1 in Arch. Am. Art, says he would rather paint the last picture of *The Course of Empire* and send it to the NAD exhibition // L. Reed to T. Cole, Feb. 26, 1836, ibid., replies that the effect of displaying the entire series at once would be ruined by exhibiting one of the paintings first and suggests that Cole paint a landscape for sale // T. Cole to L. Reed, March 2, 1836, Cole Papers, ibid. (quoted above // G. H. Talbot to T. Cole, July 11, 1836, Cole Papers, ibid., says that Mr. Talbot would be pleased to have Cole alter the painting as regards the umbrella [note: recent X-rays show no repainting in this area of the painting] // *New York Evening Post*, April 27, 1836, p. [2], describes it as "a splendid landscape" // *New York Herald*, May 17, 1836, p. 1, says "in this picture we are presented with a copy of the fresh and living scenery of nature, and must remember that we are not gazing upon the free creations of a poetic mind" // *New-York Mirror* 13 (June 18, 1836), p. 406, calls it "a noble specimen of the judgement in selection and skill in execution which has placed Mr. Cole at the head of the department; yet we have seen, and shall see, works of more merit from his pencil" // *Knickerbocker Magazine* 8 (July 1836), p. 115, says "this is really a fine landscape, although at first it does not appear so. It wants to be studied" // C. Lanman, *Letters from a Landscape Painter* (1845), p. 66 // *Bulletin of the American Art-Union* (Dec. 1, 1851), p. 139, says it shows "strong nationality // L. L. Noble, *The Course of Empire, Voyage of Life, and Other Pictures of Thomas Cole* (1853), pp. 215–216 // E. E. Hale, *Art in America* 4 (1916), pp. 34–37 // Gardner and Feld (1965), pp. 227–229 // B. Novak, *American Paintings of the Nineteenth Century* (1969), pp. 75–77, notes that "light, atmosphere, space, . . . and an awareness of the subtleties of climate and weather make their appearance by the mid-1830's" in this work // E. C. Parry, *Art in America* 59 (Nov.–Dec. 1971), p. 60, points out that the detailed sketch executed by Cole on the spot comes close to the objective centrality of Basil Hall's view made with the aid of a camera lucida but that the final result is a transformation which emphasizes panoramic values // *MMA Bull.* 23 (Winter 1975–1976), p. 202 // O. Rodriguez Roque, *MMA Jour.* 17 (1987), pp. 63–73, more fully advances the interpretation of this work adopted here // E. C. Parry, *The Art of Thomas Cole*, pp. 172–176, ill. p. 175, reasserts his 1971 interpretation and notes that Cole might have traced Hall's view "in 1836 to check the accuracy of his own rendering of the famous Oxbow" // A. Wallach, *Bulletin of the Detroit Institute of Arts* 66 (1990), pp. 34–45, considers Cole's representation of the view

from Mt. Holyoke as an example of "the panoptic sublime."

EXHIBITED: NAD, 1836, no. 149, as View from Mount Holyoke, Northampton, Massachusetts, after a Thunderstorm, for sale // Stuyvesant Institute, New York, 1838, *Exhibition of Select Paintings by Modern Artists* (Dunlap Benefit Exhibition), no. 68, as Landscape, described as view of Mt. Holyoke, lent by Mr. Talbott [*sic*] // American Art Union, New York, 1848, *Exhibition of Paintings of the Late Thomas Cole*, no. 68, as View from Mount Holyoke, Northampton, Massachusetts, after a Thunder Storm // Artists' Fund Society, New York, 1862, *Third Annual Exhibition*, no. 181, as Mount Holyoke // Museum of Modern Art, New York, 1943, *Romantic Painting in America*, no. 54 // Wadsworth Atheneum, Hartford, and Whitney Museum of American Art, New York, 1948–1949, *Thomas Cole, 1801–1848, One Hundred Years Later*, exhib. cat. by E. Seaver, no. 26 // American Federation of Arts and Whitney Museum of American Art, New York, traveling exhibition, 1954, *American Painting in the Nineteenth Century*, no. 9 // MMA, 1965, *Three Centuries of American Painting*, unnumbered checklist // Whitney Museum of American Art, New York, 1966, *Art of the United States, 1670–1966*, exhib. cat. by L. Goodrich, no. 50, pp. 30, 147 // Memorial Art Gallery of the University of Rochester; Munson-Williams-Proctor Institute, Utica, N. Y.; Albany Institute of History and Art; and Whitney Museum of American Art, New York, 1969, *Thomas Cole*, exhib. cat. by H. S. Merritt, no. 31 // MMA, 1970, *Nineteenth Century America*, exhib. cat. by J. K. Howat and N. Spassky, no. 44 // MFA, Boston, 1970, *Masterpieces of Painting in the Metropolitan Museum of Art*, cat. p. 105, color ill. // Pushkin Museum, Moscow, and Hermitage, Leningrad, 1975, *100 Kartin iz muzea Metropoliten* [100 Paintings from the Metropolitan Museum], no. 86 // MMA, 1976, *A Bicentennial Treasury* (see *MMA Bull.* 23 above) // MMA, 1986, *American Paradise*, exhib. cat. entry by O. Rodriguez Roque, pp. 125–127, color ill. p. 125.

EX COLL.: Charles N. Talbot, New York, by June 1836–d. 1874; his estate; Mrs. Russell Sage, New York, until 1908.

Gift of Mrs. Russell Sage, 1908.
08.228.

View on the Catskill—Early Autumn

According to Cole's journal ("Thoughts and Occurrences," May 14, 1837), this painting was executed in the winter of 1836–1837 for the well-known New York collector Jonathan Sturges, who had commissioned it in 1835. It is a fairly accurate view of Catskill Creek looking toward the southwest from a vantage point not far from

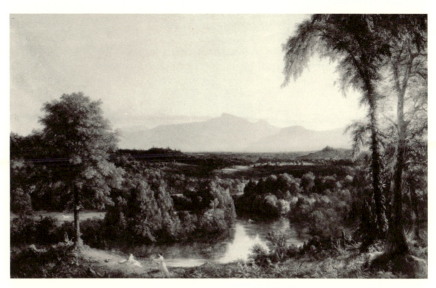

Cole, *View on the Catskill—Early Autumn.*

Cole's Catskill village home. In the distance are seen High Peak (in the center of the picture), Round Top Mountain (the next highest), the clove of the Kaaterskill and, farther to the right, the ledge-like range of hills where the Catskill Mountain House was located (here barely visible). This was the site of one of Cole's favorite walks and provided the subject matter for a series of works, the earliest of which is the *View near Catskill*, 1827 (Fine Arts Museums of San Francisco). Others are *Catskill Creek*, 1833 (NYHS), *Sunset in the Catskills*, 1841 (MFA, Boston, once owned by Jonathan Sturges), and *River in the Catskills*, 1843 (MFA, Boston). Of this group the Metropolitan's is the largest, the best painted, and the most ambitious. Like other works by Cole of this quality, it is the outcome of careful deliberation and deep emotion.

The history of the painting is inextricably connected with the history of the site and its beginnings go back to the spring of 1836 when Cole gave his patron Luman Reed the following account of events along Catskill Creek:

The copper-hearted barbarians are cutting ALL the TREES down in the beautiful valley on which I have looked so often with a loving eye—this throws quite a gloom over my spring anticipations—tell this to Durand, not that I wish to give him pain, but that I want him to join with me in maledictions on all dollar-godded utilitarians (Cole to Reed, March 6, 1836, Cole Papers, New York State Library, Albany, microfilm ALC-1, Arch. Am. Art).

Twenty days later his anger somewhat abated, and probably fearful that Reed, a successful capitalist, might think him too radical, Cole penned a more detailed description of his reaction to the development of the area:

After I had sealed my last letter I was in fear that what I said about the tree-destroyers might be understood in a more serious light than I intended although I despise the miserable creatures who destroy the beautiful works of nature wantonly & for a paltry gain, my "maledictions" are gentle ones—and I do not know that I could wish them anything worse than that barrenness of mind, that sterile desolation of the soul in which sensibility to the beauty of nature cannot take root. Bye and bye, one reason why I am in so gentle a mood is that I am informed that some of the trees will be saved yet—thank them for that—If I live to be *old enough* I may sit down under some bush the last left in the utilitarian world and feel thankful that intellect on its march has spared one vestige of the ancient forest for me to die by (Cole to Reed, March 26, 1836, Cole Papers).

To modern ears language of this kind seems excessive, but in the context of Cole's romanticism it must be regarded as expressive of authentic feelings.

The artist's guarded optimism as embodied in his letter of March 26 turned out to be premature. The deforestation brought about by the construction of the Catskill and Canajoharie Railroad continued apace. By late summer, this part of Catskill Creek, literally just outside Cole's

doorstep, had lost much of its former scenic splendor. Cole's expressions of grief now betrayed a feeling of helplesness:

Last evening I took a walk up the Catskill above Austin's Mill, where the Rail Road is now making— This was once a favourite walk but the charm of quietness and solitude is gone—it is still lovely, man cannot remove the mountains, he has not yet felled ALL the woods & the stream will have its course. If men were not blind and insensible to the beauty of nature the great works necessary for the purposes of commerce might be carried on without destroying it, and at times even contribute to her charms by rendering her more accessible—but it is not so— they desecrate whatever they touch—they cut down the forest with a wantonness for which there is no excuse, even gain, & leave the herbless rocks to glimmer in the burning sun ("Thoughts and Occurrences," August 1, 1836).

There was, of course, nothing the artist could do to reverse this course of events, but it was at least within his power to pay homage to the vanished beauty of Catskill Creek by painting it in the fullness of its grandeur. Thus it seems only natural that in the winter he began a large-scale painting of this spot and that he chose to execute it for Jonathan Sturges, a patron who would be willing to pay the price for such an ambitiously conceived work.

Cole had made drawings of this spot at different times during his career and in order that this attempt to recapture the past should prove convincing, he turned to a sketch of the site he had made in about 1832 or 1833 (Sketchbook no. 8, pp. 44–45, Detroit Institute of Arts). This drawing is not dated but it appears in Cole's sketchbook about twenty leaves before his detailed sketch for *The Oxbow* (q.v.), which was probably executed in the summer of 1833. Many features included in this painting, such as the foreground trees and the figures, are not present in the sketch, but the relationship of the topographically salient points (marked with appropriate numbers to indicate relative distance) and the frieze-like stretch of the mountains across the panoramic view are almost identical.

We do not know what specific comments Cole made to Sturges regarding his program for this picture, but from a letter written by Sturges to Cole in the following spring it is clear that he had explained his intentions in detail and assured Sturges that the painting would be important enough to send to the National Academy exhibition that year:

I shall be happy to possess a picture showing what the valley of the Catskill was before the art of modern improvement found a footing there. I think of it often and can imagine what your feelings are when you see the beauties of nature swept away to make room for avarice—we are truly a destructive people. I have no fears but what *I* shall be satisfied with the picture—I am only anxious that it shall be a picture that people cannot get away from in the academy—I do not know that I ought to expect others to feel as I do about it—the multitude are easily caught by fly traps, and to them a dancing negro has more charms than the most sublime landscape—I do not wonder that an artist's feelings are frozen by such want of feeling for true beauty as they constantly witness (Sturges to Cole, March 23, 1837).

Considering what had happened in his own backyard, Cole saw its wider implications. His response was to paint a picture that would not only evoke a specific memory but also present a programmatic image of harmony between man and nature. This accounts for the presence of the many small-scale figures that at first appear out of place in such a vast landscape. The man in the rowboat, the man chasing after his horses in the meadow, the woman gathering wildflowers, her baby sitting by the banks of the stream, the hunter coming into view at the right, all are symbols of a happy relationship with the environment. The houses in the middle distance, as well as the dam in the stream (suggesting the presence of a mill), are clear signs of man's exploitation of nature, but here the "development" has not spoiled the scenic beauty. This programmatic description is not only socially and politically right (the spirit of harmony is so pervasive that fences defining property lines have broken down); it is also spiritually inspiring. The monumental Catskill Mountains embracing the valley below contribute to this end:

The mountains are before me; the strong chain
That binds to central earth the prostrate plain—
They like high watch-towers o'er the wide spread land
Upon the shore of heaven's ocean stand—
And I have thought that such might landmarks be
To voyaging spirits on th'etherial sea—
And they are still; and stern—with fixed look;
But beautiful like those who have forsook
All earthly thoughts for holiest things on high
And hold alone communion with the sky—

(T. Cole, Lines Written After a Walk on a Beautiful Morning in November, Catskill, 1833, in M. B. Tymm, ed., *Thomas Cole's Poetry* [1972], p. 63).

Yet Cole knew that the scenario he presented here was probably an impossible one and that therefore some indication of what had actually happened to the site ought to be hinted at in the painting. The sun setting behind the trees, the time of the year noted in its title, and the many buzzards circling above a spot in the far distance, all have an ominous quality.

An idea of how this site actually looked when Cole painted this work may be gathered from his later representation of it in *River in the Catskills*, 1843 (MFA, Boston), in which a rather depressing scene of deforestation meets the eye of the viewer. The foreground is littered with felled trees, while on the left a man with an axe surveys the rather bare landscape traversed by a railroad in the middle distance. It is a dispirited performance announcing the victory of the tree-destroyers and is not as impressive a work as *View on the Catskill—Early Autumn*.

Formally, the Metropolitan picture echoes the pastoral landscape formulas of Claude Lorrain, but the detailed realism of the trees, the emphasis on atmospheric space and the pronounced horizontality of the far distance are more in accord with Cole's own style, as he began to define it about this time in such large-size works as *The Oxbow* (q.v.). Among the technical accomplishments evident in this work, the extraordinarily sophisticated use of color should be singled out. The varied hues of the foliage are recorded with great fidelity and the many shades of browns used to represent the far reaches of the plain are masterfully graduated in order to record the long shadows of early evening, the dappled sunlight, and the deep distance. Immediately above, the mountains form a band of dull gray that takes on the quality of an abstract zone of color, well calculated to convey the spiritual qualities Cole associated with them. This area of the picture is visually rather weightless and mediates between the lively, painterly greens, browns, and yellows of the land and the attractive, smoothly painted blues of the sky. In the foreground, the reflections in the water are a bit of a tour-de-force. The painter CHARLES CROMWELL INGHAM, who apparently objected to this passage, later, in a letter of July 10, 1837, retracted his complaint: "On the fourth I went to Philadelphia, on the road I was studying water. I find that my criticisms on the water in your Catskill picture were erroneous, your representation and theory were both correct."

Oil on canvas, 39 × 63 in. (99.1 × 160 cm.).

Signed and dated at lower right: T Cole. / 1837.

RELATED WORKS: *Near Catskill*, on-the-spot sketch of the site in Sketchbook no. 8, pp. 44–45, pencil on paper, 8⅞ × 13¹¹⁄₁₆ in. (22.5 × 34.8 cm.), 1832–1833, Detroit Institute of Arts (39.566). Other drawings of the site are on p. 41 of this sketchbook, in a sketchbook at the Museum of Fine Arts, Boston (59.925), and in a sketchbook at the Art Museum, Princeton University, folio 5 (verso) and folio 6 (recto and verso), but this painting does not appear to have been based on any of these.

REFERENCES: T. Cole, "Commissions for Paintings—July 1835," Cole Papers, New York State Library, Albany (microfilm ALC-1, Arch. Am. Art), lists "For Mr. Sturges—a View" crossed out and marked "painted" // J. Sturges to Cole, Feb. 21, 1837, March 23, 1837 (quoted above), Cole Papers, New York State Library, Albany (microfilm ALC-1, Arch. Am. Art) // Cole to his wife, Maria, April 18, 1837, ibid., "My pictures please very much—but do you know I have been working all this afternoon on the child in Mr. Sturges' picture, I have not done a jot only scraped part of the old one out—the more haste the less speed" // T. Cole, "Thoughts and Occurrences," May 14, 1837, ibid., says it was painted for Sturges // *New-York Mirror* (May 20, 1837), p. 375, reviews it at NAD exhibition: "here instead of the valley of the Arno, and the domes and towers of Florence suggesting ideas of former greatness and present servitude, we have the humble plain of the Catskill, and its river, until now unknown to fame. The sublime mountains of the Catskills are the admiration of every American traveler, and form a conspicuous feature of this magnificent picture—magnificent not in monuments of art, but in forms and colorings of nature. We hesitate which to pronounce best of the two pictures Mr. Cole has placed before us in this exhibition; we wander from one to the other, and 'that' is best before which we, for the time being, stand" (the other painting was View of Florence from San Miniato, 1837, now in the Cleveland Museum of Art) // C. C. Ingham to Cole, July 10, 1837, Cole Papers (quoted above) // L. L. Noble, *The Course of Empire, Voyage of Life, and Other Pictures of Thomas Cole, N.A.* (1853), p. 238, gives excerpt from Cole's "Thoughts and Occurrences" // H. T. Tuckerman, *Book of the Artists* (1867), pp. 230, 267, lists it as owned by Sturges // E. E. Hale, *Art in America* 4 (1916), p. 28 // E. P. Richardson, *American Romantic Painting* (1944), p. 30, no. 98; *Painting in America* (1956), p. 166, calls it "one of the best examples of Cole's treatment of the American landscape . . . a picture which he never surpassed in imaginative realism or lyric sentiment" // Gardner and Feld (1965), pp. 229–231 // J. T. Flexner, *The World of Winslow Homer* (1966), pp. 20–21, color ill. // E. C. Parry, *The Art of Thomas Cole* (1989), pp. 191–192, ill. p. 190, suggests that Cole's wife modeled for the standing figure and that

the mother and child scene "provide what appear to be an autobiographical touch" // K. Maddox, note in Dept. Archives, supplied 1837 quote from Cole to his wife.

EXHIBITED: NAD, 1837, no. 44, as View on the Catskill—Early Autumn // American Art-Union, New York, 1848, *Exhibition of the Paintings of the Late Thomas Cole*, no. 69, as View of the Catskill Mountains // MMA and NAD, 1876, *Centennial Loan Exhibition of Paintings*, no. 260, as Summer Afternoon in the Catskills, lent by Jonathan Sturges // Albany Institute of History and Art, 1941, *Thomas Cole, 1801–1848*, exhib. cat. by J. D. Hatch, no. 11, lists an oil sketch dated June 12 as the original study for this painting // Detroit Institute of Arts, 1944–1945, *The World of the Romantic Artist*, no. 55, as In the Catskills // Art Institute of Chicago and Whitney Museum of American Art, New York, 1945, *The Hudson River School*. no. 55, as In the Catskills // Wadsworth Atheneum, Hartford, and Whitney Museum of American Art, New York, 1948–1949, *Thomas Cole, 1801–1848, One Hundred Years Later*, exhib. cat. by E. Seaver, no. 27, as In the Catskills // Hudson River Museum, Yonkers, N. Y., 1954, *The Hudson River School, 1815–1865*, no. 26 // MMA, 1965, *Three Centuries of American Art* (checklist arranged alphabetically) // Indianapolis Museum of Art, 1970–1971, *Treasures from the Metropolitan*, no. 2 // MMA and American Federation of Arts, traveling exhibition, 1975–1977, *The Heritage of American Art*, cat. by M. Davis, color ill. no. 31 // New York State Museum, Albany, 1977, *New York: The State of Art*, exhib. cat. p. 26 // MMA, 1986, *American Paradise*, exhib. cat. entry by O. Rodriguez Roque, pp. 128–129, color ill. p. 128 // Shizuoka, Okayama, Kumamota Prefectural Museums, Japan, 1988, *Nature Rightly Observed*, exhib. cat. by J. K. Howat and O. Rodriguez Roque, p. 183, color ill. pp. 100–101.

EX COLL.: Jonathan Sturges, New York, 1837–d. 1874; his children, 1874–1895.

Gift in memory of Jonathan Sturges by his children, 1895.

95.13.3.

The Mountain Ford

Although *The Mountain Ford* elicited universal praise for masterful execution and luminous atmospheric effects practically from the time it left the artist's studio, not a word regarding its iconography has come down to us. The suggestion that an as yet unidentified literary source may exist is well taken (Gardner and Feld 1965), though if this were the case it would be difficult to understand why it was never mentioned in contemporary reviews, in comments made by Cole's friends such as Louis L. Noble and WILLIAM SIDNEY MOUNT, or in the catalogue of the Charles Leupp sale. At least the general theme of the work, that of human incursion into the wilderness, however, is readily apparent from the painting and the preparatory drawings.

Contrary to previously expressed views, this work does not appear to be the result of sketches made from nature at any specific site. To be sure, the mountain at the center of the picture, as well as the general aspect of the landscape, recalls some sketches Cole made during his trip to the Genesee Valley in 1839, but this is not significant, for these features also resemble on-the-spot drawings made in the Adirondacks (*Lake Sandford*, 1846, Detroit Institute of Arts, no. 39.129) and in Switzerland (*In the Simmenthal Pass*, 1841, Detroit Institute of Arts, no. 39.322). Furthermore, the earliest drawing which can be securely associated with this work (Detroit Institute of Arts, no. 39.119) is a compositional sketch of about 1845–1846, the kind Cole executed when he was giving shape to ideas in his imagination rather than to possible arrangements of a specific, actual view. The precise framing of the composition in this drawing strongly suggests this, but the fact that the scene is an imaginary one is surely established by the existence of a larger, more elaborate drawing of the same period (Corcoran Gallery of Art, Washington, D.C., no. 52.24) in which Cole has freely changed some features of the topography.

In many ways the drawing at the Corcoran Gallery of Art is only a step away from the final work, but at least two elements in it, absent in the painting, should be noted: one is the rifle carried over the shoulder of the horseman, the other is the tree stump at the lower right corner of the drawing. By eliminating the weapon a portent of conflict disappeared from the composition, while the omission of the tree stump removed the one trace of human intervention. It is as if Cole had deliberately attempted to increase the wild aspect of the scene and at the same time heighten the heroism and fearlessness of the unarmed rider. At the moment depicted, the man is about to undertake the dangerous task of fording the stream, something which seems to have frightened the hesitant horse but which the traveler must risk if he is to arrive at his destination. The image is suggestive and may have had some relation to general events or personal ones in the life of the artist at this time.

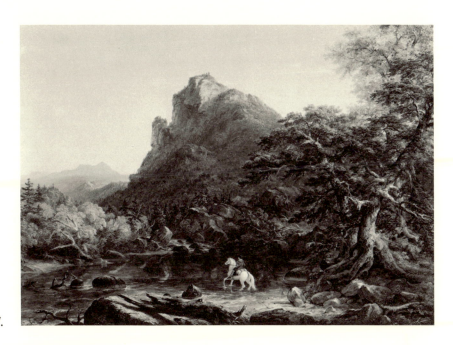

Cole, *The Mountain Ford.*

To begin with, 1845 and 1846 were the years of "manifest destiny," when the Oregon question, the annexation of Texas, the Mexican War, and the possible acquisition of California turned the imagination of Americans to visions of expansion and future greatness. We do not know much of Cole's opinions regarding these issues, but it is likely that he at least partially caught the spirit of the times. We know from a letter he wrote to Robert Cooke in London that he considered the war in Mexico "vile" (July 19, 1846, Cole Papers, microfilm ALC-1 in Arch. Am. Art). Since New York had the greatest concentration of expansion advocates in the country, it would have been difficult for Cole to have remained impervious to this climate, especially since his friends included such prominent men as William Cullen Bryant, the editor of the expansionist *New York Evening Post*. In view of the political context, such elements of *The Mountain Ford* as the heroic traveler mounted on a white steed, the high mountains suggestive of western scenery, and the direction taken by the rider, toward the sun setting behind the large mountain, take on more specific meanings. It should also be remembered that Charles M. Leupp, the painting's first owner, was a banker, entrepreneur, and railroad magnate for whom territorial expansion must have held bright prospects.

Alternatively, it is possible that the episode illustrated in this work refers more to Cole's own experiences at this time. In early 1846, he de-scribed the image of a traveler crossing a stream, albeit in a completely different setting, to symbolize the hazards involved in his undertaking a new series of paintings which he feared would not prove to be very popular.

I long for the time when I can paint whatever my imagination would dictate without fear of running into pecuniary difficulties. This painting for money & to please the many is sadly repulsive to me. Thoughts, conceptions crowd upon me at times that I would fain embody but I am kept from them by necessity. And like one who, travelling through a desert, comes to a deep stream beyond which he sees green fields & fruits & flowers, fears to venture in the rushing waters. But I am about to venture. I have determined to commence in a short time (indeed I have already commenced drawing on the canvasses) a series of Five pictures. The subject is the Cross & the World. I have no commission for the work & my means are scarcely competent for me to accomplish so great an undertaking, but the work I trust is a good one & I will venture in faith & hope ("Thoughts and Occurrences," Jan. 1, 1846, Cole Papers).

Thus, ironically, this work, which by virtue of its subject matter and appealing rendition of nature, was one of those pictures Cole knew would "please the many," may also contain a more personal iconography. The possibility that the rider, whose long sideburns are emphatically delineated, is actually a self-portrait cannot be dismissed. In this eventuality the threatening aspect of the scenery, its solitude and altitude,

would become emblematic of the difficulties encountered by the artist in attempting to reach the heights of artistic achievement he yearned for.

Since early in 1846 Cole must have been at work on *The Pic-Nic*, 1846 (Brooklyn Museum), which was exhibited at the National Academy in the spring. (He seems to have done very little work the previous summer due to a spell of depression.) It would appear that *The Mountain Ford* was executed late in 1846 and may have helped the artist regain his spirits before setting to work on *The Cross and The World* and *Prometheus Bound*.

Compositionally and thematically, this work is prefigured by Cole's *The Notch of the White Mountains*, 1839 (National Gallery of Art, Washington, D.C.). That picture represents a scene set in the wilderness, with a high mountain dominating the center of the canvas and a horseman approaching a forbidding passage (the narrow notch) through which flowed a stream (the Saco River). Whereas the Metropolitan's painting emphasizes the uninhabitable quality of the scene, *The Notch of the White Mountains* includes a house, a cabin, and tree stumps. In that picture, however, we know that Cole was dealing with an actual site, for he made an on-the-spot drawing (see L. Hawes, *Record of the Art Museum, Princeton University* 15 [1956], p. 14).

Although the light in *The Mountain Ford* is implausibly painted as coming from a number of different sources, it is precisely this distribution of highlights that permitted Cole to flood the scene with luminous greens, yellows, and browns applied with evident gusto and self-assurance. William Sidney Mount, who probably saw the picture on exhibition at the Art-Union following Cole's death, considered it "great," and that was indeed the general response.

Oil on canvas, $28\frac{1}{4} \times 40\frac{1}{16}$ in. (71.8 × 101.8 cm.). Signed and dated at lower right: T COLE 1846.

RELATED WORKS: *View of Lake with Mountain Cliff in Background and Large Tree in Foreground*, pencil on paper, $12\frac{1}{2} \times 9\frac{1}{2}$ in. (31.7 × 24.2 cm.), probably about 1845–1846, Detroit Institute of Arts (39.119) // *Landscape*, charcoal and white chalk on green paper, $5\frac{1}{4} \times 7\frac{5}{8}$ in. (13.3 × 19.4 cm.), probably about 1845–1846, Corcoran Gallery of Art, Washington. D. C. (52.24). This is a larger, more detailed drawing, very similar to the painting.

REFERENCES: A. B. Durand to T. Cole, March 11, 1847, Cole Papers, New York State Library, Albany, N. Y., microfilm ALC–1 in Arch. Am. Art, tells Cole that he has already secured C. M. Leupp's permission to exhibit this painting at the 1847 NAD exhibition // *Anglo American* 9 (May 15, 1847), p. 94, reports, "we are glad to say of this, that it is not the usual proportion of Cole's mannerism. It does not look so patchy in the foliage and the dark ground" // *Knickerbocker* 29 (June 1847), p. 572, says it "embodies nearly all Mr. Cole's most felicitous points" // *Literary World* (June 5, 1847), p. 420, states in a review of the 1847 NAD exhibition: "This is painted in Cole's happiest manner. The scene, we believe, is in the Adirondack Mountains. A bold bluff projects into the sky in the middle ground—and the foreground is made up of trees with gnarled fantastic branches and luxuriant foliage, fragments of rock, broken trunks of trees, and a stream of clear water across which a horseman is urging his white steed. Every object in the picture is well expressed, the handling is vigorous, and the color fresh and liquid. We think it is one of the most masterly pictures in the collection" // W. C. Bryant, *A Funeral Oration Occasioned by the Death of Thomas Cole* (1848), p. 33, mentions that it recalls the "original fervour" of Cole's earlier works // W. S. Mount, diary entry, Dec. 29, 1848, in A. Frankenstein, *William Sidney Mount* (1975), p. 199: "The Mountain Ford—great—owned by C. M. Leuppe Esqr." // L. L. Noble, *The Course of Empire, Voyage of Life, and Other Pictures of Thomas Cole* (1853), p. 362: "The Mountain Ford – wonderful for the moisture and clarity of its deep heaven, and the vitality of its atmosphere" // *Crayon* 3 (June 1856), p. 186, in an article on the Leupp collection, notes: "Cole's best picture (to our mind, and by his own declaration), 'The Mountain Ford,' makes a point in the collection which no one studying his works should lose" // E. H. Ludlow and Co., New York, *Catalogue of Valuable Paintings, etc., of the Late Chas. M. Leupp to be sold at auction . . .* (1860), no. 57, gives the following comment: "one of the finest of his pictures; noble in composition and color, and very carefully painted. This is one of the most admired of Cole's works" // T. S. Cummings, *Historic Annals of the National Academy of Design* (1865), p. 278, comments on the Leupp sale and notes: "the highest price paid for any picture was paid for a bold and thorough landscape by Cole, the 'Mountain Ford'. Mr. Bowman Johnson got it for $875" // H. T. Tuckerman, *Book of the Artists* (1867), p. 230 // B. Burroughs, *MMA Bull.* 10 (April 1915), p. 64 // Gardner and Feld (1965), pp. 232–233 // J. T. Flexner, *Nineteenth Century American Painting* (1970), p. 46 // M. Brown, *American Art to 1900* (1977), p. 326, ill. p. 327 // E. L. Parry, *The Art of Thomas Cole* (1989), p. 326, ill. p. 325, discusses it and speculates that Cole finished the painting by late November 1846.

EXHIBITED: NAD, 1847, no. 179, lent by C. M. Leupp // American Art-Union, New York, 1848, *Exhibition of the Paintings of the Late Thomas Cole*, no. 21 // Philadelphia, 1876, *Centennial Exposition*, no. 33 // Newark Museum, 1930–1931, *Development of American Painting, 1700–1900*, no cat. // Wadsworth Atheneum, Hartford, and Whitney Museum of American Art,

New York, 1948–1949, *Thomas Cole, 1801–1848, One Hundred Years Later*, exhib. cat. by E. Seaver, no. 46, says it is based on studies made by Cole in the Genesee Valley in 1839 and in the Adirondacks in 1846 // NAD and American Federation of Arts, traveling exhibition, 1951-1952, *The American Tradition*, no. 27 // MMA, 1965, *Three Centuries of American Painting* (checklist arranged alphabetically) // Lytton Gallery, Los Angeles County Museum of Art, and M. H. de Young Memorial Museum, San Francisco, 1966, *American Paintings from the Metropolitan Museum of Art*, color ill., no. 38 // Memorial Art Gallery of the University of Rochester; Munson-Williams-Proctor Institute, Utica, N.Y.; Albany Institute of History and Art; and Whitney Museum of American Art, New York, 1969, *Thomas Cole*, exhib. cat. by H. S. Merritt, no. 56, col. ill. p. 55 // Queens County Art and Cultural Center, New York; MMA; Memorial Art Gallery of the University of Rochester, N. Y., and Sterling and Francine Clark Art Institute, Williamstown, Mass., 1972-1973, *Nineteenth Century American Landscape*, no. 5 // Shizuoka, Okayama, Kumamota Prefectural Museums of Art, Japan, 1988, *Nature Rightly Observed*, exhib. cat. by J. K. Howat and O. Rodriguez Roque, no. 7, p. 183, color ill. pp. 102-103.

Ex coll: Charles M. Leupp, New York, by 1847 (sale, E. H. Ludlow and Co., New York, Nov. 13, 1860, no. 57, $875); John Taylor Johnston, 1860 (sale, Somerville Art Gallery, New York, Dec. 19, 1876, no. 138, $900); Morris K. Jesup, New York, until 1914.

Bequest of Maria DeWitt Jesup, from the collection of her husband, Morris K. Jesup, 1914.

15.30.63.

JOHN QUIDOR

1801–1881

John Quidor was born in Tappan, New York. At the age of ten he moved with his parents to New York City, where in 1818 he became apprenticed to the successful portrait painter JOHN WESLEY JARVIS. Apparently Jarvis did not pay a great deal of attention to him; for in 1822 Quidor sued him for breach of indenture and won damages of $251.35. The real circumstances behind this incident are obscure, but it is likely that Jarvis neglected Quidor in favor of his other, more gifted apprentice HENRY INMAN. Inman was clearly the outstanding talent in Jarvis's shop, and it is interesting to note that while Quidor's work does not reflect the influence of Jarvis, one of his earliest paintings, *Dorothea*, 1823 (Brooklyn Museum), displays the loose, painterly techniques characteristic of Inman.

From 1827 to 1836 Quidor was listed in the New York city directories as a portrait painter, but, curiously enough, no portraits by his hand are known to have survived. He clearly had difficulties making a living, and it is only natural that he turned to painting signs, banners, and ornamental panels for fire engines and steamboats. About this time, he began to produce the humorous scenes, chiefly drawn from the writings of Washington Irving, for which he was to become famous. His early works in this genre are by and large his best and include such minor masterpieces as *Ichabod Crane Pursued by the Headless Horseman*, 1828 (Yale University, New Haven), *The Money Diggers*, 1832 (Brooklyn Museum), and *Leatherstocking's Rescue* (q.v.). They show the influence of a multiplicity of English sources, including works by Hogarth, Cruikshank, Gillray, Wright of Derby, and Morland. The very broad range of his borrowing, however, establishes Quidor's considerable creativity in picking and choosing his sources and certainly demonstrates his familiarity with English prints. Successful or not, his brand of painting clearly began to attract attention, and it was about this time that

two young men, Thomas Bangs Thorpe (1815–1878) and CHARLES LORING ELLIOTT, became his apprentices.

Long a speculator in western lands, Quidor moved to Quincy, Illinois, perhaps as early as 1834. From 1837 to 1850 his name is absent from the New York city directories, and it is likely that throughout this period he was painting, speculating in land, and perhaps even farming in Illinois. In 1844 he entered into an unusual arrangement by which he agreed to pay for an eight-thousand-dollar farm he had bought by painting eight huge religious canvases. Three of these paintings, presumably based upon engravings of works by BENJAMIN WEST, were exhibited in New York in 1847, but all are now unknown.

From 1851 until his retirement in 1869 Quidor was once more working in New York. But his style of painting had changed for the worse. He thinned his colors with excessive amounts of varnish, making his increasingly stylized figures dissolve into the background, and simplified his compositions. These hazy, monochromatic works did not sell well, and eventually he retired to Jersey City, New Jersey, where his eldest daughter lived. Quidor had never gained much support from art collectors and critics, but the failure of his late works discouraged him from painting during the last years of his life. Because of the lack of enthusiasm for his pictures during his career, he seems to have limited his output relative to other artists who painted for nearly fifty years. Yet he neither gave up his interest in dramatic literary subjects nor altered his rather eccentric style to suit his audience, even when such genre painters as GEORGE CALEB BINGHAM and WILLIAM SIDNEY MOUNT won considerable acclaim for their realistic depictions of everyday life. Quidor's imaginative vision sets him apart from his contemporaries and gives him a unique position in the history of American genre painting.

BIBLIOGRAPHY: Munson-Williams-Proctor Institute, Utica, N.Y., *John Quidor*, exhib. cat. by John I. H. Baur (1965) // David M. Sokol, "John Quidor, Literary Painter," *American Art Journal* 2 (Spring 1970), pp. 60–73 // Ernest Rohdenburg, "The Misreported Quidor Court Case," *American Art Journal* 2 (Spring 1970), pp. 74–80 // Wichita Art Museum, *John Quidor: Painter of American Legend*, exhib. cat. by David M. Sokol (1973) // Christopher K. Wilson, "Engraved Sources for Quidor's Early Work," *American Art Journal* 8 (Nov. 1976), pp. 17–25. Points out Quidor's strong reliance on print sources.

Leatherstocking's Rescue

The scene illustrated in this painting is one of the dramatic high points of James Fenimore Cooper's novel *The Pioneers* (1823). Elizabeth Temple and Louisa Grant, accompanied by Miss Temple's mastiff Brave, had been walking in the woods near Natty Bumppo's cabin when they came upon a female panther with her cub. The cub attacked the dog and was quickly killed, but the aging dog was not equal to the fury of the mother panther, and after a fierce battle the dog died. In the meantime, Louisa Grant had fainted, making an escape impossible.

Elizabeth now lay wholly at the mercy of the beast . . . Miss Temple did not or could not move. Her hands were clasped in the attitude of prayer, but her eyes were still drawn to her terrible enemy—her cheeks were blanched to the whiteness of marble, and her lips were slightly separated with horror. The moment seemed now to have arrived for the fatal termination, and the beautiful figure of Elizabeth was bowing meekly to the stroke, when a rustling of leaves behind seemed to mock the organs, than to meet her ears. "Hist! hist!" said a low voice. "Stoop lower, gal; your bonnet hides the creater's head." It was rather the yielding of nature than compliance with this unexpected order that caused the head of our heroine to sink on her bosom when she heard the report of

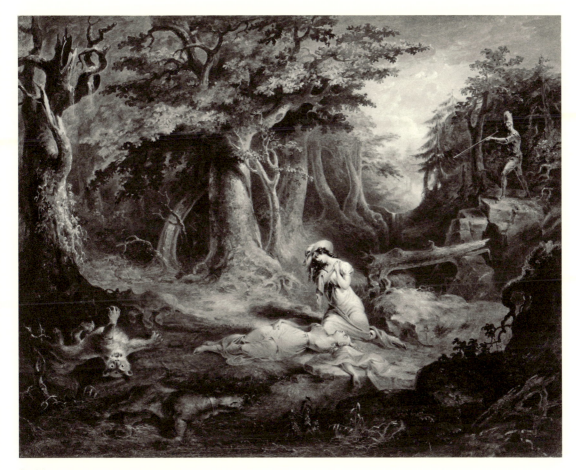

Quidor, *Leatherstocking's Rescue*.

the rifle, the whizzing of the bullet, and the enraged cries of the beast, who was rolling over on the earth biting its own flesh and tearing the twigs and branches within its reach. At the next instant the form of Leatherstocking rushed by her (James Fenimore Cooper, *The Pioneers* [ed. 1964, New American Library], pp. 294–295).

This is one of only two scenes that Quidor chose to illustrate a scene from a work by James Fenimore Cooper. The other one, *Leatherstocking Meets the Law*, 1832 (New York State Historical Association, Cooperstown), is also from *The Pioneers*. In that picture the aging Leatherstocking (the nickname of Natty Bumppo) is heroicized as the last of a vanishing breed of hardy, self-reliant woodsmen. Leatherstocking is merely one among many other interesting characters in *The Pioneers*. Quidor's choice of scenes involving him, therefore, is eclectic and can only be explained

by the popularity of the character as established in Cooper's novels *The Last of the Mohicans* (1826) and *The Prairie* (1827), both of which are more exclusively devoted to him. It has been suggested that Quidor's *Leatherstocking Meets the Law* and *Leatherstocking's Rescue* were created as companion pieces. Visually, it is difficult to conceive of the two scenes as a pair but size, subject matter, and Susan Fenimore Cooper's probable ownership of both pictures do point to such a conclusion.

It is well known that Quidor repeatedly borrowed from engraved sources in conceiving his works. In the case of *Leatherstocking's Rescue*, the figure of Elizabeth appears to be derived from the frontispiece to the edition of *The Pioneers* published by H. Colburn and R. Bentley in London in 1832 (see C. Wilson, 1976, p. 25). More generally, the painterly execution of the

trees, shrubs, and rocks—all barely suggestive of the actual forms and not at all in tune with the values of the nascent Hudson River school—recalls a languid style of late eighteenth-century landscape painting. The most prolific representative of this type of painting in England was George Morland. Quidor's use of glazes and impasto in depicting natural forms in this painting and the overall composition of the scene are reminiscent of Morland's *Gipsy Encampment with Seated Man Breaking Firewood*, 1790 (Detroit Institute of Arts). Morland's works were very popular in their day and were engraved, so that it is likely for Quidor to have known them. It must be admitted, however, that Quidor's work is highly original. Despite his many borrowings, his synthesis of narrative and caricature often achieved, as in the present work, dramatic expression. In this painting, one of Quidor's best executed and preserved, the blend of the serious and the fantastic may be seen at work in the highly stylized natural setting, the carefully painted and melodramatically charged figures of the girls, and the comic-strip figure of Leatherstocking as well as the dead panther and dog.

Oil on canvas, 26 × 34 in. (66 × 86.4 cm.).

Signed and dated at lower center: J. Quidor, Pinxt. / N. Y. 1832. Signed, inscribed, and dated on the back before lining: J. Quidor N. York 1832.

REFERENCES: Brooklyn Museum, *John Quidor, 1801–1881*, exhib. cat. by J. I. H. Baur (1942), p. 56, no. 22, lists it as unlocated and refers to a photograph of it owned by Mrs. A. F. de Forest // Munson-Williams-Proctor Institute, Utica, N. Y., traveling exhibition, *John Quidor*, cat. by J. I. H. Baur (1965), p. 12, says it is still unlocated // C. K. Wilson, *American Art Journal* 8 (Nov. 1976), pp. 23–25, discusses Quidor's reliance on prints and identifies the source for the figure of Elizabeth // C. Mandeles, *American Art Journal* 12 (Summer 1980), pp. 65–74, discusses Quidor's Leatherstocking paintings as interrelated compositions on the theme of "the inherent antinomy between the law of the forest and the law of the town"; ill. p. 66, shows this and a similar painting of the same scene, in the Moss Collection, England.

EXHIBITED: Newhouse Galleries, New York, 1933, *The Forgotten School, First American Genre Exhibition*, no number (possibly this painting) // Bernard Danenberg Galleries, New York, 1970, *Discoveries in Nineteenth Century American Painting*, no. 1 // Wichita Art Museum and Art History Galleries, Department of Art History, University of Wisconsin—Milwaukee, 1973, *John Quidor*, exhib. cat. by D. M. Sokol, pp. 26–27, 44, ill. p. 45, says the picture deviates from Cooper's text.

ON DEPOSIT: Museum of Fine Arts, Springfield, Mass., 1970–1971, lent by Douglas Collins, Longmeadow, Mass.

EX COLL.: possibly Susan Fenimore Cooper, Cooperstown, N. Y., d. 1894; possibly A. F. de Forest, New York; with Bernard Danenberg Galleries, New York, until 1970; Douglas Collins, Longmeadow, Mass., 1970–1972; with Vose Galleries, Boston, 1972–1978.

Gift of the Erving Wolf Foundation, 1978.
1978.262.

The Vigilant Stuyvesant's Wall Street Gate

The presence in this painting of the peg-legged Peter Stuyvesant and of his trumpeter Antony Van Corlear assures us that it is related to Washington Irving's *History of New York . . . by Diedrich Knickerbocker* (1809). The work clearly represents the return of Stuyvesant and Van Corlear from the victorious expedition against the Swedes on the Delaware in 1655:

It was a pleasant and goodly sight to witness the joy of the people of New Amsterdam, at beholding their warriors once more returned, from this war in the wilderness. The old women thronged round Antony Van Corlear, who gave the whole history of the campaign with matchless accuracy . . . The schoolmasters throughout the town gave holliday to their little urchins, who followed in droves after the drums, with paper caps on their heads and sticks in their breeches, thus taking the first lesson in vagabondizing. As to the sturdy rabble, they thronged at the heels of Peter Stuyvesant wherever he went, waving their greasy hats in air and shouting "Hardkoppig Piet forever!" (Washington Irving, *A History of New York . . . by Diedrich Knickerbocker* [1809], 2, p. 162).

A writer for the *Collector* in 1895 noted that Quidor had aspired "to execute a series of pictures illustrating 'Knickerbocker's History of New York' . . . How far he got with these I do not know." The writer then mentions three Quidor paintings on themes from Irving's *History* just acquired by Henry T. Chapman, Jr.: "The Vigilant Stuyvesant's Wall Street Gate" [this picture] (Book V, Chap. 5), "Peter Stuyvesant's Journey up the Hudson River" (Book VI, Chap. 3), and "The Voyage of the Good Oloffe to Hell Gate from Communipaw" [ca. 1861–1866, Wichita Art Museum].

As is the case with many of Quidor's paintings, the use of unstable pigments has caused

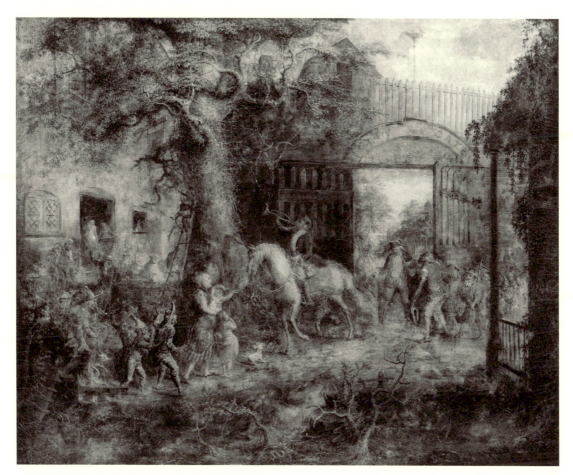

Quidor, *The Vigilant Stuyvesant's Wall Street Gate*.

heavy deterioration of the paint surface of *The Vigilant Stuyvesant's Wall Street Gate*, and little can be done to reverse the process. Because of the condition of the picture, the date in the inscription at the lower center has been variously read as 1833 or 1863. As far back, however, as 1895 the date of the painting was placed in the 1860s. When the work changed hands in 1929, the date recorded in the sale catalogue was 1863. This was corroborated by Alan Burroughs in 1936 and David Sokol in 1973 on the basis of style.

Thinly painted in a somewhat monochromatic manner and lacking the attention to detail (especially in the representation of faces and figures) of Quidor's earlier works, the picture still reveals his considerable ability as a painter of humorous subjects. The throngs of devilish-looking children, the barking dogs, and the parlous appearance of the tobacco-smoking burghers are all in keep-

ing with Irving's satirical intent. They contribute to a lively scene of uproar and disorder that is reminiscent of works by William Hogarth.

An early owner of this painting, the Hon. Thomas B. Carroll, was an enthusiastic admirer of Quidor's works and at one time owned as many as eight pictures by him.

Oil on canvas, $27\frac{1}{8} \times 34\frac{3}{8}$ in. (68.9 × 87.3 cm.).

Signed and dated at lower center: John Quidor, Painter / 18[6]3.

REFERENCES: *Collector* 6 (August 1, 1895), p. 268, discusses series illustrating Irving's History // Anderson Galleries, New York, *Collection of W. E. D. Stokes and Others*, sale cat. (April 9–10, 1929), p. 37, no. 79, states that the painting is dated 1863 // A. Burroughs, *Limners and Likenesses* (1936), p. 154, suggests the composition was influenced by Dutch or Flemish prints; says it is dated 1863 // J. T. Flexner, *That Wilder Image* (1962), p. 25, describes it and points out

the obscure reclining figure and dog in the center foreground // Gardner and Feld, (1965), pp. 216–217, say it is dated 1833 // Vose Galleries, Boston, by phone, May 8, 1989, gave information about purchase of the painting April 1929 and sale to Anderson Galleries Jan. 1930.

EXHIBITED: Brooklyn Museum, 1897, *Opening Exhibition*, no. 552, as The Vigilant Stuyvesant's Wall Street Gate // Ehrich Galleries, New York, 1910, *Exhibition of Early American Paintings*, no. 27, as Vigilant Stuyvesant at Wall Street Gate // Brooklyn Museum, 1942, *John Quidor, 1801–1881*, exhib. cat. by J. I. H. Baur, p. 11 and p. 50, no. 7 // Whitney Museum of American Art, New York; Munson-Williams-Proctor Institute, Utica, N. Y.; Rochester Memorial Art Gallery; and Albany Institute of History and Art, 1965–1966, *John Quidor*, exhib. cat. by J. I. H. Baur, no. 7, p. 12, says that stylistically it resembles Quidor's later work but "provisionally" accepts 1833 date on strength of the inscription // Lytton Gallery, Los Angeles County Museum of Art and M. H. de Young Memorial Museum, San Francisco, 1966, *American Paintings from the Metropolitan Museum of Art*, no. 73 // Wichita Art Museum and Art History Galleries, Department of Art History, University of Wisconsin-Milwaukee, 1973, *John Quidor: Painter of American Legend*, exhib. cat. by D. M. Sokol, pp. 29, 64–65, dates the painting 1863 and calls it "a summation

of the painter's entire career" // MMA and American Federation of Arts, traveling exhibition, 1975–1977, *The Heritage of American Art*, exhib. cat. by M. Davis, no. 32 // William Rockhill Nelson Gallery of Art and Mary Atkins Museum of Fine Arts, Kansas City, Mo., 1977–1978, *Kaleidoscope of American Painting*, no. 36.

ON DEPOSIT: Brooklyn Museum, 1898–1913, as The Vigilant Stuyvesant's Wall Street Gate, lent by Henry T. Chapman.

EX COLL.: Thomas B. Carroll, Saratoga, N. Y. (sale, American Art Association, New York, May 22, 1895, no. 136, as The Wall Street Gate, $72.50); Henry T. Chapman, New York, 1895–1913 (sale, Anderson Galleries, New York, Jan. 27, 1913, no. 165, $85); William Earl Dodge Stokes, New York, 1913-d. 1926; his estate (sale, Anderson Galleries, New York, April 9, 1929, no. 79, as Peter Stuyvesant Entering the Gates of New York, dated 1863, $475); with Vose Galleries, Boston, 1929–1930; with Anderson Galleries, Chicago, 1930; O. P. and M. J. Van Sweringen, Hunting Valley, Ohio (sale, Parke-Bernet, New York, Oct. 27, 1938, no. 825); with Vixseboxse Art Gallery, Cleveland, 1938; John Caldwell Myers, by 1943; Roy Neuberger, New York, 1959–1961.

Gift of Roy Neuberger, 1961.

1961.79.

UNIDENTIFIED ARTIST

Family Group of Four on a Sofa

This group portrait was probably painted by an artist working in the Northeast, where a number of similar portraits have been found. It bears comparison, for example, to *Family Group with a Parrot*, by W. H. BROWNE (q.v.). Judging by the costumes and the Empire sofa, the picture dates from the 1830s. Like most country or folk artists, the painter concentrated on getting close likenesses of his subjects. Lacking knowledge of the idealizing tendency in academic portraiture, the artist painted the faces very carefully and exactly as he saw them. Instead of focusing the parents' and children's gazes in the same direction, each looks off toward a different point. The two children have vacant expressions, perhaps indicating their boredom at having to sit still. The mother stares suspiciously at some-

thing to her right and the father looks almost directly forward. The effect is somewhat unsettling, although the artist probably intended to portray the family at their best. The mother is adorned in a delicate cap and collar of sheer fabric and lace, the children wear fine dresses trimmed in lace, and the father wears a crisp collar and dark coat. The artist paid a good deal of attention to clothing and setting and made special efforts to render such details as the lace, the wood grain and patterned upholstery of the sofa, the placement of the sitters' hands, and the fashionable coiffures of the mother and father. By contrast, the curtain in the background is summarily painted with no attention at all to its texture.

The placement of the children at the lower edge of the composition, which caused their bodies and hands to be cropped in an awkward

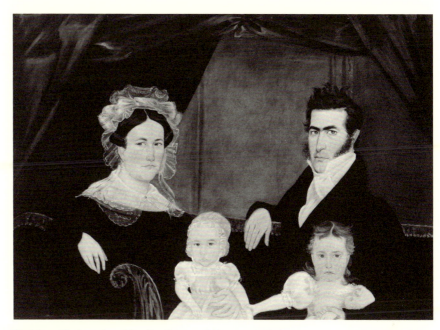

Unidentified artist, *Family Group of Four on a Sofa*.

manner, has led to speculation that the canvas may have been cut down. Examination indicates this is not so. Possibly the artist first painted the parents, who are more completely and carefully rendered, and added the children to the composition later without due consideration for their placement.

Oil on canvas, 36 × 52¼ in. (91.4 × 132.7 cm.).

EXHIBITED: MMA and American Federation of Arts, traveling exhibition, 1975–1977, *The Heritage of American Art*, not in cat. // High Museum of Art,

Atlanta, 1978–1979, *Children in America*, exhib. cat. by R. O. Humm, p. 16, says "we can sense a Puritan restraint, a stiffness of view, a sadness perhaps" in the painting // Center for African Art, New York, 1990, *Likeness and Beyond*, exhib. cat. by Jean M. Borgatti and Richard Brilliant, color ill. p. 142.

ON DEPOSIT: Gracie Mansion, New York, 1980–1981.

EX COLL.: Beatrice K. Day, Fla.; Edgar William and Bernice Chrysler Garbisch, 1962–1970.

Gift of Edgar William and Bernice Chrysler Garbisch, 1970.

1970.283.4.

W. H. BROWNE

active 1838

Only two paintings signed by W. H. Browne are presently known: the museum's group portrait (see below) and a portrait of a man named A. Cook (private coll., ill. in P. H. Tillou, *Where Liberty Dwells* [1976], no. 53). Both of these works are dated 1838, and it seems likely that this was the year in which Browne turned to portrait painting, perhaps as a sideline and only for a brief period of time. It is possible that he may have actually been an ornamental and sign painter; certainly he was not academically trained. His pictures have been

traced to the area around Providence, but so far no one named W. H. Browne living there in the period between 1830 and 1850 can be positively identified as the artist.

Family Group with a Parrot

When it was acquired by the museum, this 1838 painting was said to portray a family from Dorchester, Massachusetts, but this has not been confirmed. Nothing is known about the family depicted. The clothes worn by the parents were very much in fashion when the work was painted, as was the Empire couch on which they sit. The family appears to be a middle-class New England one of fairly comfortable means. The green parrot's striking prominence in the picture has led to the speculation that the father was a sea captain who brought the bird back on one of his voyages. The books lack titles that perhaps could have supplied at least some clue to the family's interests. In Browne's portrait of A. Cook (private coll., ill. in P. H. Tillou, *Where Liberty Dwells* [1976], no. 53), for example, a number of books in the background are identified: a Bible, a biography of Patrick Henry, a copy of Rollin's ancient history, and a volume with "Christ" or "Christian" in the title. The variety of subjects and the fact that he is depicted playing the violoncello do not tell us Cook's profession, but they do tell us about his hobbies.

Cook's portrait, in addition, reveals that Browne could be successfully adventurous in his compositional arrangements. This portrait, on the contrary, is derived from the conventions of the English conversation piece which were often employed by provincial American painters. *Family Group of Four on a Sofa* (q.v.) is a somewhat earlier example of this type. In New England such group portraits were popularized in the early years of the nineteenth century by RALPH EARL, his son RALPH E. W. EARL, and their followers. The elder Earl's *Mrs. Noah Smith and Her Children* (q.v.) and the younger Earl's *Family Portrait*, 1804 (National Gallery of Art, Washington, D.C.), illustrate the beginnings of this tradition.

Oil on canvas, 39⅜ × 53 in. (100 × 134.6 cm.).
Signed and dated on the back before lining: W. H. BROWNE, 1838.
Ex COLL.: with Buchard, Hyannis, Mass.; Sally Turner, Plainfield, N. J., until 1964; Edgar William and Bernice Chrysler Garbisch, until 1973.
Gift of Edgar William and Bernice Chrysler Garbisch, 1973.
1973.323.7.

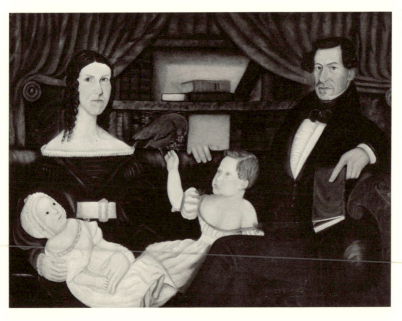

Browne, *Family Group with a Parrot.*

GEORGE LINEN

1802–1888

Linen was born in Greenlaw, Scotland, the youngest of ten children. As a youth, he showed artistic aptitude and was sent to the Royal Scottish Academy in Edinburgh. Later, he established himself in England as a painter of small portraits. His business prospered, and he remained there for about ten years. In 1834, the year after his marriage to Sarah Cartwright Davies of Shropshire, he went to Canada, possibly with his brother John Linnen (ca. 1800–after 1860), who is known to have been working as a portraitist in Toronto at that time. George Linen then moved to New York, where he opened a studio and became successful painting cabinet-size portraits. These small paintings were popular before the advent of photography. Linen's early subjects included SAMUEL WALDO, 1834 (unlocated), Henry Clay, and Daniel Webster (both private coll.), both in 1838.

Between 1837 and 1843, Linen exhibited his works regularly at the Apollo Association and the National Academy of Design, where in 1839 he received a silver medal for his portrait of Clay, "the best specimen of painting exhibited" (*McClure's Magazine* 9 [Sept. 1897], pp. 939–948). In 1843 he moved his home to Newark, New Jersey; and, although he retained a studio in New York until 1848, he exhibited his work infrequently. From the late 1840s through the 1850s, he painted portraits in other cities, including Richmond, Baltimore, Washington, and Alexandria, and in 1860 he was in Terre Haute, Indiana. Between 1855 and 1868, his address was on fashionable Washington Street in Newark, and he once again had a New York studio. The 1868 Newark directory lists him as a landscape painter. There are a few landscapes presently known to be by him—one, owned by his descendants, is a view of the family farm, Glenburn, to which he retired in 1868. The farm was in what is now Riverdale, New Jersey. During his last years, he painted solely for his own pleasure and his family's.

Linen's portraits are usually about ten inches high and painted on paperboard. The subjects are often portrayed by an open window with the curtain drawn back to show an outdoor scene. His delineation of faces was noted for accuracy of expression and detail, but he was not overly meticulous. Skin tones are luminous, and colors clear and harmonious. Linen rarely signed his portraits. Nonetheless, certain characteristics in rendering facial features, such as overly large and somewhat rounded eyes, aid in the identification of his work.

BIBLIOGRAPHY: Obituary: *New York Times*, Sept. 28, 1888, p. 3 // Wilbur D. Peat, *Pioneer Painters of Indiana* (Indianapolis, 1954), p. 41 // *George Linen, 1802–1888: An Exhibition of Portraits* (Madison, N.J., 1982). Checklist for an exhibition held at the Florham-Madison Campus Library of Fairleigh Dickinson University with text by Emma-Joy Linen Dana and Dale T. Johnson.

William Popham

William Popham (1751–1847) was one of twenty-two children born in Bandon, county Cork, to an Irish Presbyterian clergyman. He came with his family to New Jersey in 1760. When of age, Popham was sent to the College of New Jersey (now Princeton) to study for the ministry. His education was interrupted, however, by the War of Independence. He entered

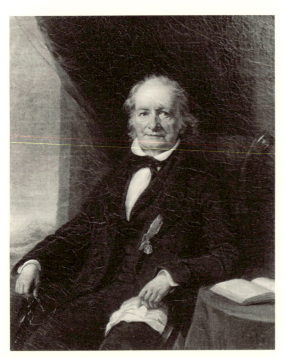

Linen, *William Popham.*

settled his family on a farm in Scarsdale, New York.

A charter member of the Society of the Cincinnati, Popham was elected its seventh president general in 1844, a lifetime appointment. In the portrait, he wears the emblem of that office, a golden eagle adorned with diamonds. It is likely that the honor that had been bestowed upon him prompted the commission of this portrait, dating it about 1845. The picture is detailed but without minute precision. The palette is restrained to dark tones with bright accents of clear color: red drapery and bookbinding, green upholstery and table covering, and the turquoise ribbon holding the medal. The portrait is similar in composition and style to Linen's *Judge Archibald McIntyre* (Museum of the City of New York), painted at approximately the same time. The features of the two men are alike, and, despite their carefully detailed heads, they have misshapen mouths.

the army as a second lieutenant at New Castle, Delaware, in 1775. A year later, during the retreat after the Battle of Long Island, he commanded a detachment of troops that surprised and captured eighteen British soldiers and their leader. Early in 1777 he served in the British campaign against the Indians in western New York and later that year is credited with alerting his superiors to the British advance before the Battle of Brandywine. He reported that the redcoats "looked like strawberries in the field" (H. Hansen, *Scarsdale: From Colonial Manor to Modern Community* [1954], p. 44). In 1778 he became aide-de-camp to Brigadier General James Clinton, commander of the Northern Department. After the Battle of Yorktown, Clinton resigned in pique when General Henry Knox was promoted without consideration for seniority, and Popham was transferred as aide-de-camp to General Baron von Steuben. At the end of the war, Popham was discharged with the rank of brevet major. He took up the study of law at Albany and then set up practice in New York. In 1783, he married Mary Morris, daughter of Chief Justice Richard Morris. By 1800 he had retired and

Oil on canvas, 12 × 9⅞ in. (30.5 × 25 cm.).

Inscribed, on label on the back: HENRY STIDOLPH / owner / PICTURE LINER / RESTORER / 275 Ewen Street / Brooklyn, New York.

RELATED WORKS: Engravings by unidentified artists after Linen appear in the following publications: *Magazine of American History* 10 (Sept. 1883), p. 183 // *American Historical Register and Monthly Gazette* 3 (Oct. 1895), p. 161 // *Portraits of the Presidents General of the Order of the Cincinnati* (1887), unpaged.

REFERENCES: T. Bolton, *Early American Portrait Painters in Miniature* (1921), p. 95, lists this picture // C. N. Durant, August 30, 1943, letter in Dept. Archives, gives information about the sitter and his military record, says he was painted by Stuart (unlocated) // Gardner and Feld (1965), p. 234 // J. E. Newlin, Jan. 9, 1974, a descendant, letter in Dept. Archives, notes that his mother made a copy of the portrait before 1880.

EXHIBITED: MMA, 1895, *Retrospective Exhibition of American Paintings*, no. 142, as Portrait of Colonel Popham, lent by Henry Stidolph, Brooklyn, N. Y. // Museum of the City of New York, 1944, *A List of Portraits and Miniatures on Exhibition in Honor of the 160th Anniversary of the Founding of the Society of the Cincinnati*, unnumbered // Monmouth Museum, N. J., 1969, *Three Centuries of Art in New Jersey*, no. 34.

EX COLL.: with Henry Stidolph, Brooklyn, by 1895; with Samuel P. Avery, New York, by 1897.

Gift of Samuel P. Avery, 1897.

97.29.1.

ROBERT W. WEIR

1803–1889

Robert Weir, historical painter, West Point drawing teacher, and progenitor of artists, was born in New York. His father, a Scotsman who had immigrated to the United States, was a prosperous shipping merchant. But in 1811 French warships seized his cargo, and his business failed. As a result, the family moved out of the city for a time to New Rochelle. His father's fortunes improved, however, and by 1815 he was back in the shipping business in New York. JOHN WESLEY JARVIS's studio was located across the street from the school Weir was attending, and he "frequently lingered about the door to get a glimpse of his art" (quoted in Dunlap, p. 384). Weir's father tried to discourage his son's artistic inclinations and secured a position for him in the offices of an importer. When Weir returned home eighteen months later, he received his first instruction from the little-known British painter in New York Robert Cooke. In 1820 Weir quit the mercantile business altogether, determined to become an artist.

Weir studied independently, borrowing pictures to copy from an art dealer and drawing from plaster casts at the American Academy of the Fine Arts. JOHN TRUMBULL was the president but "as to instruction, or any advice given to the student, such a thing did not exist, Mr. Trumbull was never there" (Weir, p. 9). At the age of eighteen Weir painted his first major work, a monumental depiction of *St. Paul Preaching at Athens*, 1822–1823 (unlocated), measuring eight by ten feet. During the summer of 1823, he exhibited the picture at Washington Hall in New York. Favorable reviews in the newspapers encouraged him to arrange an exhibition in Albany. He recognized, however, that he lacked sufficient knowledge of human anatomy, and so he spent the following winter term studying at the medical school at New York University. The desire for more formal art instruction than he was able to receive in this country took him to Italy at the end of 1824.

Weir spent his first year in Florence studying the works of Michelangelo, Titian, and Raphael and painting religious scenes and landscapes. He left Florence, stopped in Siena to study Pinturicchio's murals, and arrived in Rome in the winter of 1825–1826. There he met Horatio Greenough (1805–1852), the Boston sculptor, and shared rooms with him in a house that had once been occupied by Claude Lorrain. Their days began with "some study in our own room, or [we] went to the French academy and drew from the antique until breakfast time" (quoted in Dunlap, p. 392). Weir studied and copied famous works in the Vatican or private galleries until supper, and then went to the Caffè Greco to meet other foreign artists in Rome. He enjoyed this lifestyle for two years. In 1827, upon returning from a sketching trip to Naples and Paestum, he found Greenough gravely ill from malaria and exhaustion. Weir had hoped to visit France, but cut short his stay to accompany his friend back to New York.

Weir quickly became a leading figure in the city's art circles. He was a member of the Sketch Club, the forerunner of the Century Association, made up of New York's foremost painters, poets, and authors. A publication, *The Talisman*, was an offshoot of this group and

one to which Weir submitted many literary illustrations. He continued to paint Italian scenes which were well received at the National Academy of Design, where he exhibited regularly between 1826 and 1882. His landscapes and figure studies demonstrated his knowledge of composition, careful method of drawing, use of perspective and restrained color. Weir was the National Academy's professor of perspective for six years beginning in 1832, but his duties in New York became sporadic after 1834, when he accepted the appointment of drawing instructor at West Point. He remained in this position until his retirement in 1876. The change from city to country life stimulated his interest in landscape. His romantic scenes place him chronologically and stylistically as an early member of the Hudson River school. THOMAS COLE and ASHER B. DURAND often used Weir's home as headquarters during their sketching trips into the Catskills. Within three years of his appointment to West Point Weir was commissioned by Congress to paint a panel for the Rotunda of the Capitol. *The Embarkation of the Pilgrims*, after copious research and preliminary sketches, was completed in 1843 and was well received.

Weir had sixteen children, two of whom became well-known artists: JOHN FERGUSON WEIR and J. ALDEN WEIR. He married twice, first Louisa Ferguson, whose funeral was the first held in the newly built Church of Holy Innocents at Highland Falls, New York, which Weir had designed. The following year he married Susan Martha Bayard.

After his retirement in 1876, Weir lived for two years in Hoboken, New Jersey, and then moved back to New York, where he spent his last years. He is principally remembered as a history painter, but the variety and scope of his portraiture, landscapes, genre, and literary scenes are great. The museum has a portrait of the artist entitled *The Morning Paper* by his son JOHN FERGUSON WEIR (see VOL. II, p. 567).

BIBLIOGRAPHY: William J. Dunlap, *A History of the Rise and Progress of the Arts of Design in the United States* (2 vols., Boston, 1834) 2, pp. 381-395 // Irene Weir, *Robert W. Weir, Artist* (New York, 1947) // Kent Ahrens, "Portraits by Robert W. Weir," *American Art Journal* 6 (May 1974), pp. 4-17 // Cadet Fine Arts Forum of the United States Corps of Cadets, West Point, *Robert Weir* (1976), exhib. cat. by William H. Gerdts // United States Military Academy Library and West Point Museum, *Robert W. Weir of West Point* (1976), exhib. cat. ed. by Michael E. Moss.

General Winfield Scott

Winfield Scott (1786–1866) was born on his family's plantation near Petersburg, Virginia. He attended the College of William and Mary for a short time but returned to Petersburg and studied law. Incited by Jefferson's proclamation following the outrage committed by H. M. S. *Leopard* on the S. S. *Chesapeake*, Scott set aside the study of law to begin a career in the military.

In 1808 he had reached the rank of captain, but two years later he was suspended for making adverse statements against a superior. In 1812 Scott, then a lieutenant colonel, was taken prisoner in Canada, at Queenstown. He was released during a prisoner exchange and later

promoted to brigadier general. His troops were victorious at the battles at Chippewa and Lundy's Lane, where he was wounded. For his conquests he was breveted major general and given several honors including a gold medal by Congress. Following the War of 1812, he spent a year in France studying military methods. In 1816 he made his home in New York and a year later married the beautiful Maria Mayo whose portrait by ASHER B. DURAND is in the museum's collection.

President Jackson commissioned Scott to go to Charleston during the nullification movement in 1832. He was able to calm the community by tact without resorting to military force. In 1835 he was once more called upon, this time to end

the conflict with the Seminole and Creek Indians in Florida. In 1838 Scott diplomatically settled a brewing border dispute between the United States and Canada. Immediately afterwards he was ordered to South Carolina and Tennessee to pacify the Cherokee Indians, who were enraged at being dispossessed of their lands. After placating them, he accompanied them part of the way to their new territory beyond the Mississippi. He then returned to settle yet another northern border dispute. Although not a West Point graduate, Scott proved a very strong supporter of the academy and of military education in general. At the age of sixty he took command of the war with Mexico. He landed ten thousand men below Veracruz and then, though poorly equipped, fought his way from Veracruz and successfully attacked Mexico City. His glory was of short duration, however, for political enemies spread false accounts of the Mexican campaign that were injurious to him, and he took leave of the army in 1848. Scott remained a popular figure and continued to be active politically. In 1852 the Whigs nominated him for the presidency, but he was overwhelmingly defeated by Franklin Pierce.

Foreseeing eventual war between North and South, Scott wrote President Buchanan in 1860 urging that the federal forts in the South be garrisoned. In 1861 Scott was brought back to Washington, where he oversaw the recruiting and training of a new army. Old and infirm and caught between Union and Southern loyalties, he requested retirement at the beginning of the Civil War. His last years were spent in New York. Shortly before his death, he requested to be taken to West Point, where he died and is buried. Noted for his fine character, Scott was an able general when there were few. He was a scholar as well, and something of an art collector, possessing pictures and sculpture by both American and European artists.

A dignified man of large stature, he is portrayed in this portrait in the full-dress uniform of a general. The pose is typical for Weir: a waist-length figure set against a dark, undefined background. Scott's head is solidly modeled, and his prominent brow, deep-set eyes, small mouth, and protruding chin are carefully and realistically drawn. The restrained palette and rich chiaroscuro are characteristic of Weir's best work. Light color is brushed in with rather painterly strokes to form Scott's wrinkles and the highlights of

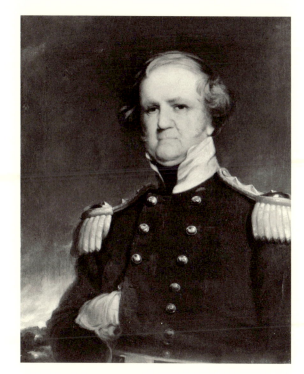

Weir, *General Winfield Scott.*

his uniform. The portrait is one of four Weir is known to have painted of Scott. Two are at West Point: one of them shows Scott slightly younger, and the other, a replica of this picture, is dated 1856. The Metropolitan's portrait is undated, but it was probably done about 1855, the year Congress awarded Scott special honors. The address on the canvas stamp is one that the supplier Schaus is listed at only in 1854 and 1855.

Oil on canvas, 33¾ × 26⅞ in. (85.7 × 68.3 cm.).

Canvas stamp: From / William Schaus / 303 / Broadway / New York / Prints Seller & Artists Colourman.

RELATED WORKS: *Brevet Lieutenant General Winfield Scott*, oil on canvas, 34 × 27 in. (86.4 × 68.6 cm.), United States Military Academy, West Point, N. Y. // *General Scott*, oil on canvas, 34 × 27 in. (86.4 × 68.6 cm.), Julia L. Butterfield Memorial Library, Cold Spring, N. Y.

REFERENCES: D. C. Seitz, *The "Also Rans,"* rev. ed. 1968, ill. opp. p. 125 // F. P. Todd, letter in MMA Archives, Sept. 8, 1964, gives information about the uniform and the West Point portrait // Gardner and Feld (1965), p. 236.

EXHIBITED: MMA, 1895, *Retrospective Exhibition of American Paintings*, no. 196, lent by J. Hampden Robb, New York.

Ex coll.: J. Hampden Robb, New York, by 1895-d. 1911; William B. Isham.

Gift of the heirs of William B. Isham, 1910. 10.54.

Robert W. Weir

FITZ HUGH LANE

1804–1865

Fitz Hugh Lane was born in Gloucester, Massachusetts, on December 19, 1804. First called Nathaniel Rogers Lane, he later changed his name. At the age of eighteen months his legs were paralyzed, probably from polio, and as a result he used crutches throughout his life. Lane is said to have taught himself to draw and paint, and his earliest known work, a watercolor of *The Burning of the Packet Ship "Boston,"* 1830 (Cape Ann Historical Association, Gloucester), done at the age of twenty-six after a drawing by E. D. Knight, is indeed the product of an untrained artist. It is reminiscent of the work of such painters as THOMAS CHAMBERS. During the early 1830s Lane was employed briefly by Clegg and Dodge Lithographers in Gloucester, and around 1832 he became an apprentice in the prominent Boston firm of William S. Pendleton. At first he produced trade cards, advertisements, and sheet-music covers of little distinction but showing increasing assurance. His topographical prints, beginning in 1836, reveal him as a lithographer of genuine ambition and achievement. By 1844 he had set up his own business in partnership with George A. Scott, but during this decade his interests turned more and more to painting. After 1846 he made few prints, but those he did make reveal a significant advancement in his technique.

Lane's earliest paintings date from 1840, and within a year he began exhibiting his work at the Boston Athenaeum and the Apollo Association in New York. By 1844, he had become a remarkably accomplished artist, as demonstrated by his *Gloucester from Rocky Neck* (Cape Ann Historical Association). The scene, a harbor and coast, was to be his main subject for the rest of his career. His rapid mastery of his medium probably owes a good deal to his study of the work of Robert Salmon (ca. 1775–ca. 1845), a British-trained marine painter who lived in Boston from 1828 to 1842, as well as to his awareness of prints after European artists such as J. M. W. Turner.

In 1848, Lane left Boston and moved back to Gloucester, where he remained, except for trips to New York, Maine, Maryland, and perhaps to Puerto Rico. He continued to exhibit paintings in New York and Boston, and judging by press comments and the substantial house he built in Gloucester, his career was a successful one. Certainly his magisterial view of *Boston Harbor at Sunset*, 1850–1855 (MFA, Boston), with its refined colorism, subtle composition, and beautifully painted surface, testifies to his artistic achievement. This painting and others like it, though by no means formally innovative, are among the finest American seascapes. Lane was more radical in his coastal scenes, from which, during the 1850s, he successively purged genre and topographical elements, so much so that, together with MARTIN JOHNSON HEADE, he may well be considered the true avant-garde of American mid-century landscape painting. His increasingly spare landscapes of the 1860s, such as *The Western Shore with Norman's Woe*, 1862 (Cape Ann Historical Association), are formally simple and almost unnaturally calm.

In his late works his sensibility is at its most subtle and refined. His small paintings of *Brace's Rock* from 1864 (Terra Museum of American Art, Chicago; coll. Mr. and Mrs. Harold

Bell; and private coll., ill. in National Gallery of Art, Washington, D.C. [1988], pp. 36–37), are utterly real, but are so pared down and mystical that they seem the work of a visionary.

BIBLIOGRAPHY: John Wilmerding, *Fitz Hugh Lane, 1804–1865: American Marine Painter* (Salem, Mass., 1964). The first monograph published on the artist // *Fitz Hugh Lane: The First Major Exhibition*, De Cordova Museum, Lincoln, Mass., and Colby College Art Museum, Waterville, Me., exhib. cat. by John Wilmerding (1966) // John Wilmerding, *Fitz Hugh Lane* (New York, 1971). The most complete discussion of the artist // Coe Kerr Galleries, New York, *American Luminism*, exhib. cat. by William H. Gerdts (1978). Discusses Lane in relation to other European and American artists. Questions value of term luminism often applied to Lane's work // National Gallery of Art, Washington, D.C., *Paintings by Fitz Hugh Lane*, exhib. cat. by John Wilmerding, et al. (1988). Includes a chronology of his career and five essays focusing on his various scenes and subjects.

The Golden State Entering New York Harbor

The *Golden State*, built in 1852 by Jacob A. Westervelt for Chambers and Heiser of New York, was launched in New York on January 10, 1853. According to O. T. Howe and F. C. Matthews (*American Clipper Ships, 1833–1858* [1926–1927], 1, p. 242), "she had very fine lines, her ends being long and sharp and was a beautiful vessel, alow and aloft. She was a favorite vessel with shippers and also a profitable one to her owners." Recorded as having the longest record of any ship in the China trade, the *Golden State* was an "extreme clipper ship," designed to carry cargo at high speeds. She made a number of exceptionally fast voyages from New York around Cape Horn, stopping in San Francisco on the way to Shanghai and Hong Kong, a few times continuing to England, Ireland, and once to Germany, returning to New York in ballast. After 1883, when she was renamed the *Anne C. Maguire* by her new Canadian owners, she served in the Atlantic trade under the Argentine flag. She went ashore and was wrecked on Cape Elizabeth, Maine, in December 1886.

Lane painted a number of ship portraits and at least four other scenes of New York Harbor. His *New York from Jersey City, New Jersey* and *New York Harbor* (both unlocated), which he exhibited at the American Art-Union in 1849 and 1850, and his *New York Harbor*, 1850 (MFA, Boston), support the speculation that he visited New York at that time. During the mid-1850s, he painted *New York Harbor* (private coll., ill. in National Gallery of Art [1988], p. 99) and *The Golden State Entering New York Harbor*, which share a similar compositional arrangement of ships. In both paintings, Lane delineated the distant city skyline indistinctly, perhaps to avoid making topographical inaccuracies. According to the inscription, which includes an inexplicable variant of the artist's middle name, but is thought to be in his hand, the *Golden State* was painted in Gloucester in 1854. Lane is not known to have been in New York then and may have used sketches from an earlier trip, but these have not been located. He probably did not actually see the *Golden State*, and it is conceivable that he based the ship's portrait on a secondary source. For example, a Chinese export painting of the ship at the Salem Maritime National Historic Site is similar to his rendition. The speculation that Lane was commissioned to paint the new ship's portrait by her owners is supported by two circumstantial details: the picture was painted within a year of the ship's launching, making it a timely commemorative scene, and the ship's name is spelled out prominently, and uncharacteristically for Lane.

In stylistic terms, the *Golden State* reveals Lane's indebtedness to the Anglo-American artist Robert Salmon (ca. 1775–ca. 1845). The tightly executed white-tipped waves and the loosely painted clouds recall such disparate works by Salmon as his *Boston Harbor from Constitution Wharf*, ca. 1829 (United States Naval Academy, Annapolis), and *Aristides Off Liverpool*, ca. 1806 (Mariners Museum, Newport News, Va.). More interesting, the *Golden State* reflects the common source for a number of paintings by Salmon and Lane, namely the work of J. M. W. Turner, whose *Leader Sea Piece* was published in 1808 as part of his *Liber Studiorum*. Lane's borrowing is especially apparent in the ship at the left that proceeds obliquely toward the *Golden State* and in the pattern of clouds at the right.

Oil on canvas, 26 × 48 in. (66 × 122 cm.).

Inscribed on the back before lining: Painted by Fitz Henry Lane. / Gloucester. / Mass. / A. D. 1854. Inscribed on the bow of the ship: GOLDEN STATE.

EXHIBITED: William A. Farnsworth Library and Art Museum, Rockland, Maine, 1974, *Fitz Hugh Lane, 1804–1865*, exhib. cat. by J. Wilmerding, no. 30, color ill. frontis., describes it as an important, newly found work // MMA and American Federation of Arts, traveling exhibition, 1975–1977, *The Heritage of American Art*, no. 33, ill. p. 86, says it reveals influence of Robert Salmon in meticulously rendered waves and high, pale sky // Shizuoka, Okayama, and Kumamoto Prefectural Museums of Art, 1988, *Nature Rightly Observed* (not in catalogue).

EX COLL.: private coll., Chevy Chase, Md., until 1974; with Kennedy Galleries, New York.

Purchase, 1974, Morris K. Jesup Fund, Maria De Witt Jesup Fund, and Rogers Fund.

1974.33.

Stage Fort across Gloucester Harbor

Like the painting described above, this one is also derived from the work of J. M. W. Turner. Here, however, Lane's inspiration is more mediated and eclectic. The original source for his scenes of harbors from the beach was undoubtedly *Medway Sea Piece*, a print from Turner's *Liber Studiorum*, and most evident in *Gloucester Harbor*, 1848 (Virginia Museum of Fine Arts, Richmond). As was the case with the *Golden State*, Lane was also influenced by the work of Robert Salmon (ca. 1775–ca. 1845), whose *Moonlight Fishing Scene* of 1836 (private coll., ill. in J. Wilmerding, *Robert Salmon* [1971], p. 55), is derived from the same print after Turner.

By 1862, when Lane painted this view of Stage Fort (once the site of military fortifications), he had gone far beyond literal borrowing and had achieved a wholly individual style. He was now acquainted with the work of MARTIN JOHNSON HEADE, which was itself a complex amalgam of a number of European styles distilled through a stark and unusual artistic temperament. In *Stage Fort*, Lane introduced a new and radical motif evidently learned from Heade, the arcing form of the land in the middle ground, which is also found in the paintings of other artists familiar with Heade's work, for example *Eaton's Neck, Long Island* by JOHN F. KENSETT (see Vol. II, p. 46). Lane's ambitious attempt to integrate this with his previous style is not entirely successful here. There is a marked disjuncture between the rela-

tively austere, dry foreground and the glowing, lucid middle- and background. Yet the picture marks the beginning of his arrival, very late in life, at what must be considered the highest rank of artistic achievement. In the next three years, before his death in 1865, Lane refined his concept to produce some of the finest landscape paintings in this country. In works like *Brace's Rock, Eastern Point, Gloucester*, about 1863 (MFA, Boston), he achieved, albeit on a smaller scale, a tautness and spareness that have enormous appeal today.

Stage Fort across Gloucester Harbor is in effect a resume of Lane's past and a prospectus of his too brief future. The two men and the boats in the foreground recall his *Entrance of Somes Sound from Southwest Harbor*, 1852 (private coll., color ill. in National Gallery of Art [1988], p. 43), and the boats in the left background bring to mind his *Boston Harbor at Sunset* of the late 1850s (MFA, Boston). Yet the jutting form of land with the fort looks ahead to the radical compositional effects of his last works. The painting is remarkable for its disquieting, preternatural stillness. This, even with the feeling of peace and optimism generated by the pink glow at the left and golden light at the right, projects an elegiac mood.

Oil on canvas, 38 × 60 in. (96.5 × 152.4 cm.). Signed and dated at lower right: Fitz H. Lane / 1862.

REFERENCES: S. Babson, "List of Paintings by Fitz Hugh Lane of Gloucester," typescript in MMA Library, 1938, p. 3, as "Old Fort, foot of Commercial Street" // J. Wilmerding, *Fitz Hugh Lane, 1804–1865* (1964), p. 63, no. 112 // J. Wilmerding, *Fitz Hugh Lane* (1971), p. 181 // J. Wilmerding, letter in Dept. Archives, June 2, 1978, gives provenance, calls it "one of Lane's largest and most impressive pictures," and says it suggests influence of Heade.

EXHIBITED: De Cordova Museum, Lincoln, Mass., and Colby College Art Museum, Waterville, Me., *Fitz Hugh Lane* (1966), no. 52 // National Gallery of Art, Washington, D. C., 1988, *Paintings by Fitz Hugh Lane*, exhib. cat. by J. Wilmerding, et al., cat. no. 16, color ill. p. 38.

EX COLL.: Sargent family, Gloucester, Mass.; Sargent-Murray-Gilman-Hough House, Gloucester, by 1938-until 1978; with Vose Galleries, Boston, 1978.

Purchase, Rogers and Fletcher Funds, Erving and Joyce Wolf Fund, Raymond J. Horowitz Gift, Bequest of Richard de Wolfe Brixey, by exchange, and John Osgood and Elizabeth Amis Cameron Blanchard Memorial Fund, 1978.

1978.203.

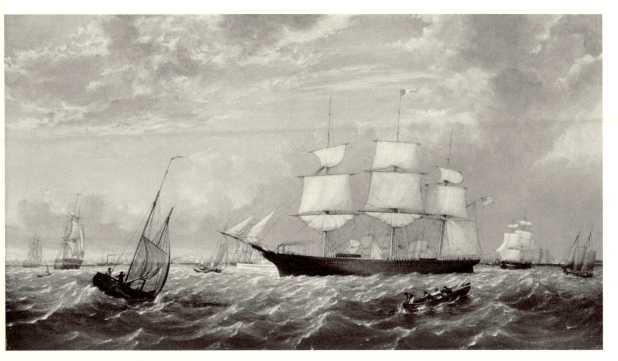

Lane, *The Golden State Entering New York Harbor.*

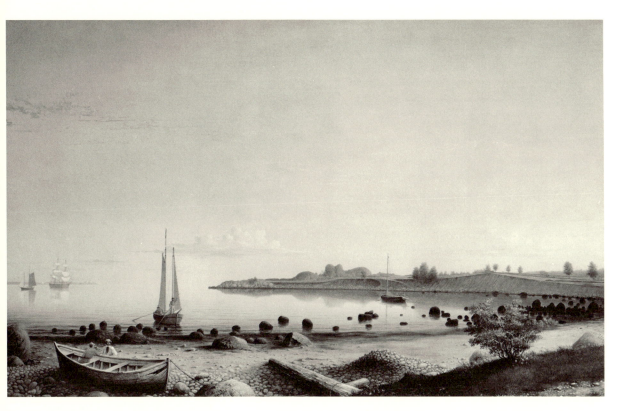

Lane, *Stage Fort across Gloucester Harbor.*

SHEPARD ALONZO MOUNT

1804–1868

Shepard Alonzo Mount was born at Setauket, New York, to Julia Ann Hawkins and Thomas Shepard Mount, who had a farm and kept an inn in that Long Island town. Two of his brothers, Henry Smith Mount (1802–1841) and WILLIAM SIDNEY MOUNT, also became painters. When Thomas Mount died in 1814, the family went to live with Mrs. Mount's family in Stony Brook. In 1821, Shepard was apprenticed to James Brewster, a carriage maker in New Haven, Connecticut, from whom he learned the trade of trimming carriage interiors. The firm opened a business in New York City in 1827, and Shepard Mount came to New York, where he joined his two brothers, Henry, who had an ornamental painting business, and William, who worked with him. All three brothers studied and practiced drawing together. By 1828, Shepard had left Brewster's and was attending drawing classes at the National Academy of Design. In the spring of the following year Shepard and William opened a portrait studio but commissions were few. Shepard passed the time painting still lifes, which he exhibited at the National Academy and American Academy of the Fine Arts. He specialized in fish subjects and may have been one of the earliest American painters of fish trophies. Still, he continued to paint portraits. His style, which shows the influence of HENRY INMAN, earned him an associate membership at the National Academy in 1833.

William soon became a popular genre painter, and was always better known than his brother. Shepard sought portrait commissions on Long Island, where he met Elizabeth Hempstead Elliott, whom he married in 1837. During the next decade, he attracted numerous commissions close to his home in Stony Brook and also painted prominent New Yorkers. In general, his patrons appreciated his honest portrayals. A contemporary critic explained that "the principal merit of [his] portraits is that they are faithful likenesses, and drawn with great care and accuracy" (*Literary World* 1 [May 1847], p. 304).

A sketching trip to Pennsylvania in 1847 seems to have inspired Mount's interest in landscape painting, which he pursued late in his career. His plein-air studies and large, imaginative compositions such as *Hudson River Scene*, 1861 (White House, Washington, D.C.), reveal a sense of spontaneity that is not evident in his portraits. They, however, remained his primary occupation. During the 1850s he combined his landscape and portrait interests in a series of fancy portraits with scenic backgrounds. He often used his children for models. His only daughter, Tutie, was his favorite and appeared in one of his most successful pictures, *Rose of Sharon*, 1850 (Museums at Stony Brook, N.Y.), painted on commission for Goupil and Company. When Tutie died unexpectedly in 1861, Mount painted a rare floral still life, *Rose of Sharon: "Remember Me,"* 1863 (Museums at Stony Brook, N.Y.).

Mount painted portraits and landscapes until the year of his death. In some ways, his career was characterized by his competition with his more famous brother, William, but many of his paintings reveal his unique talent and personality.

BIBLIOGRAPHY: Alden J. Spooner, "Reminiscences of Artists William S. and Sheppard [*sic*] A. Mount," *New York Evening Post*, Dec. 16, 1868, p. 1 // Heckscher Art Museum, Huntington, N.Y.,

Shepard Alonzo Mount, 1804–1868, exhib. cat. by Albert D. Smith (1945) // Museums at Stony Brook, Stony Brook, N.Y., *Shepard Alonzo Mount: His Life and Art*, exhib. cat. by Deborah J. Johnson (1988). The most recent and thorough treatment of his work.

Catherine Brooks Hall

The name of the woman in this portrait was given to the donor as Catherine Brooks Hall. It is possible, but not certain, that she is the Catherine Brooks (1774–1840) of Bridgeport, Connecticut, who was the wife of Benjamin Hall, also of Bridgeport. At the time of her death in 1840 Catherine Brooks Hall was living in Hempstead, Long Island. Her will, dated February 17, 1840, and a genealogy indicate that she had three daughters: Jane Rebecca Hall (Mrs. Isaac Osgood), Ann Maria Hall, and Eliza Lucretia Hall. Mount, of course, painted on Long Island, but he also painted portraits across the sound in Bridgeport. Although the subject appears elderly, she still has very dark hair and could have been in her fifties. The portrait was very likely painted in the 1830s, which would accord with Mount's style at this time.

The portrait is typical of Shepard Alonzo Mount's straightforward depictions. The woman is homely; her mouth is somewhat sunken in from the absence of teeth, but her expression is sharp and alert. Mount makes no attempt to soften her appearance. Sitting in a carved maple chair before a gray masonry wall, the starkly black and white figure of Mrs. Hall is surrounded by color. Out the window to her right is a view of a shore scene with heavy blue-gray storm clouds above a golden yellow horizon. At her left is a bright red drapery. The overall effect is very lively. In the best tradition of American portraiture, Mount has created a strong characterization.

The subject is probably a widow; besides wearing a black dress, she has a jet mourning pin at her bodice and curiously enough wears one black glove. In her ungloved hand she holds a stylus, such as was used at the time for tracing needlework designs. Another example of a woman with a stylus from this period is the exceptionally fine portrait Mount painted of his wife in 1838 (Museums at Stony Brook). In that picture, the function of the stylus is made clearer by the inclusion of a portfolio and an engraving, from which needlework designs were often copied.

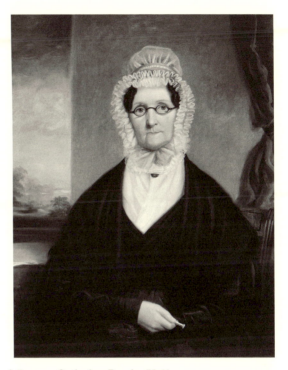

Mount, *Catherine Brooks Hall*.

Oil on canvas 34 × 27 in. (86.4 × 68.6 cm.).

Signed on the back before lining: S A Mount.

REFERENCES: Catherine S. Hall of Hempstead, N. Y., will, Feb. 17, 1840, probated May 19, 1840, Queens County, New York, lists three daughters as heirs // I. Osgood, *A Genealogy of the Descendents of John . . . Osgood* (Salem, Mass., 1894), pp. 170–171, gives dates and offspring of Catherine Brooks Hall // S. P. Feld, letter in Dept. Archives, notes that the painting was acquired with the sitter's name and supplies photograph of the back of the canvas before lining.

EXHIBITED: Museums at Stony Brook, N. Y., 1988, *Shepard Alonzo Mount*, exhib. cat. by D. J. Johnson (not in cat.).

Ex COLL.: Mr. and Mrs. Stuart P. Feld, New York, by 1971.

Gift of Mr. and Mrs. Stuart P. Feld, 1971. 1971.249.

ERASTUS SALISBURY FIELD

1805–1900

Born in Leverett, a small town in north-central Massachusetts, on May 19, 1805, Erastus S. Field was the twin brother of Salome Field; they were named after their parents. Field appears to have painted a few portraits of his family as a very young man, but none has survived. In 1824, at the age of nineteen, Field went to New York, to study with SAMUEL F. B. MORSE, who was then establishing a studio there. Field studied portraiture with Morse for a brief three months and was soon at work as an itinerant portrait painter in New England, probably with Leverett as his home base. His work from this period, however, reveals that the months with Morse had little apparent influence on his style. In composition and execution his portraits are closer to the work of provincial or country artists of the late eighteenth and early nineteenth century, such as AMMI PHILLIPS.

In 1831 Field married Phebe Gilmur (or Gilmore) of Ware, Massachusetts, but he continued to travel. In 1838, for example, he went as far as New Haven, where he painted the missionary Reverend Dyer Ball and his wife Lucy H. Miller Ball (Museum of Fine Arts, Springfield). These two notably fine portraits are strongly frontal and even blunt in their probity of likeness. Both sitters are posed in the eighteenth-century manner at their desks: Ball is writing a letter that in urgent language solicits funds for the mission work he is about to undertake in Singapore; more conventionally his wife has begun to write to her "Dear Parents."

The portrait that is perhaps Field's masterpiece, *Joseph Moore and His Family* (MFA, Boston), was painted in the following year, probably in Ware, Massachusetts, the hometown of Field's wife. Moore was a hatter and in summer a traveling dentist. The Moores and their four children are dressed in black and white, and this coloristic restraint makes the beautiful tones of the red, gold, and green carpet they stand on all the more striking and remarkable. As in all Field's best work, his almost obsessive care in producing an exact likeness of his sitters' faces and clothing results in a degree of precision that is almost hallucinatory in quality.

For a few years Field continued his career as an itinerant artist in New England, but in 1841 he returned to New York, where he learned to make daguerreotypes, perhaps from Samuel F. B. Morse. Except for 1844, Field is listed in city directories from 1841 to 1848 as a painter, portrait painter or artist, but very few portraits can be dated to his second New York period. In about 1844 he produced his first literary painting, *The Embarkation of Ulysses* (Museum of Fine Arts, Springfield). Field left New York in 1848, resumed his travels, and practiced his new trade as a daguerreotypist. Most of his portraits after 1850 were based on his photographs.

The Field family moved frequently during the 1850s. By 1859 they were in North Amherst, where Field's wife, Phebe, died. A newspaper article written after Field's death in 1900 mentions that he painted portraits in Michigan after the Civil War, but he lived primarily with his daughter on a farm owned by the family of Ashley Hubbard in Plumtrees, not far

from Amherst, Massachusetts. Field became increasingly eccentric and painted numerous religious and historical subjects, some quite disturbing due to his distorted perspective, enlarged figures, and obsessive detail. Probably the best and most famous of these is his enormous, visionary *Historical Monument of the American Republic* (Museum of Fine Arts, Springfield, Mass.), which he began in the mid–1860s and completed by 1876 to honor the United States centennial; he altered the picture significantly in 1888 by adding two end towers to his monument. Evidently based on rather eclectic print sources, this tremendous canvas (almost nine by thirteen feet) depicts fantastic interconnected towers with major figures in this country's history either represented as sculpture or portrayed as living figures. With such ambitious and extraordinary works, Field attained an eminence that is unique among American folk artists.

BIBLIOGRAPHY: Erastus S. Field, *Descriptive Catalogue of the Historical Monument of the American Republic* (Amherst, Mass., 1876) // Agnes M. Dods, "A Check List of Portraits and Paintings by Erastus Salisbury Field," *Art in America* 32 (Jan. 1944), pp. 32–40 // Abby Aldrich Rockefeller Folk Art Collection, *Erastus Salisbury Field: A Special Exhibition Devoted to His Life and Work* (Williamsburg, Va., 1963), exhib. cat. by Mary Black // Reginald F. French, "Erastus Salisbury Field, 1805–1900," *Connecticut Historical Society Bulletin* 28 (Oct. 1963), pp. 97–144. The catalogue of an exhibition // Museum of Fine Arts, Springfield, Mass., *Erastus Salisbury Field, 1805–1900* (1984), exhib. cat. by Mary Black. The most thorough work on the artist.

Girl of the Bangs-Phelps Family

When this painting entered the museum's collection in 1963, the sitter was identified as Mary Werner Bangs (1816–1856) and dated about 1830. Subsequently, additional material was published on Erastus Salisbury Field, and the identification of the sitter was changed to Ellen Tuttle Bangs (born 1828) and the painting redated to 1838–1840. In 1973, however, Michael J. Gladstone published a short article on Field in the *Britannica Encyclopedia of American Art* with the interesting observation that Field's paintings of this style had been executed in such a manner as to resemble color photographs. Field is assumed to have learned the art of making daguerreotypes in New York during the years from 1842 to 1848 and this portrait is very likely derived or copied from a photograph. The cloudlike forms that surround the subject probably derive from Field's imitation of a similar effect, termed solarization, that is often found in early photographs.

As this portrait descended in the Phelps family of Springfield, Massachusetts, it probably should be dated after Field's return from New York in 1848, although it could conceivably have been painted in 1845, the one year from 1842 to 1848 that Field does not appear in New York city

directories. This rules out the identification of the subject as Ellen Tuttle Bangs. Since the portrait is known to have descended in the Phelps family, however, it may represent one of Ellen Tuttle Bangs's children after her marriage to William Phelps in 1854. It could also, of course, be a portrait of one of her younger sisters, but then the presence of the portrait in the collection of a descendant of Ellen Tuttle Bangs becomes problematical. Conceivably the portrait could have been painted in 1854 when Field advertised his presence in Palmer, a town very near Springfield.

In any event, the portrait, like a number of Field's works, is more than a trifle odd, and at the same time literal and monumental. Perhaps because the painting was enlarged so much from its original source the image is somewhat fuzzy in detail. Probably also because he based the painting on a photograph, Field depicted his sitter's flesh tones in a curiously flat white almost entirely without modulation. One wonders about the sitter's very large ears; the left one, through some perspectival error, even appears pointed at the top. Her face, though markedly geometrical, is quite expressive; she appears to have been a shy young lady, and the portrait has a subtle poignancy. Coloristically the painting is stark and almost monochromatic, with the large mass of white drapery and the subject's pallid

flesh, both highlighted against a gray background. Except for the brown of her hair and book cover, the red trim at the wrists, and red shoes, color is restricted to the bright yellow, green, red, and blue of the floor covering, probably a painted floor or floor cloth.

Oil on canvas, 58¾ × 30¼ in. (149.2 × 76.8 cm.).
REFERENCES: R. French and A. M. Dods, *Connecticut Historical Society Bulletin* 28 (Oct. 1963), p. 106, identified as Mary Werner Bangs with a date of ca. 1830 // P. Kostoff, letter in Dept. Archives, Feb. 9, 1964, identified as Ellen Tuttle Bangs // Gardner and Feld, 1965, pp. 238–239, identified as Ellen Tuttle Bangs and dated ca. 1830-1840.

Field, *Girl of the Bangs-Phelps Family.*

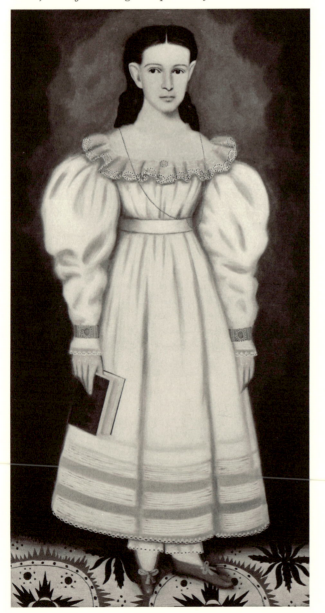

EXHIBITED: Metropolitan Museum of Art and American Federation of Arts, 1961–1964, traveling exhib., *101 Masterpieces of American Primitive Painting from the Collection of Edgar William and Bernice Chrysler Garbisch*, p. 146, no. 49, as Mary Werner Bangs, ca. 1830 // Museum of Fine Arts, Springfield, Mass., 1984, traveling exhib. *Erastus Salisbury Field, 1805–1900*, exhib. cat. by M. Black, p. 94, no. 9, color pl. 2, identified tentatively as Mary Werner Bangs, ca. 1829, and described as "typical of Field's work in the late 1820s."

Ex COLL.: Phelps Family, Springfield, Mass., until 1956; with Peter Kostoff, Springfield, Mass., 1957; Edgar William and Bernice Chrysler Garbisch, 1957–1963.

Gift of Edgar William and Bernice Chrysler Garbisch, 1963.

63.201.4.

Egyptian Scene (possibly Moses and Zipporah)

Field painted a number of biblical scenes, including a series on the plagues of Egypt. According to recent research, he executed the series for the North Amherst Congregational Church. There is no record of how many paintings were in the series, but there are nine surviving works, including *Death of the First Born* (q.v.). This painting, which has been called simply *Egyptian Scene*, is said to be one of them, even though it does not directly relate to the plagues. It was recorded by the previous owners as having the titles *Arranging the Wedding* or *Egyptian Families Discussing the Wedding*, undoubtedly because of the two women in the background admiring or sewing a white dress. It may actually illustrate an episode in the life of Moses: his marriage to Zipporah, the daughter of Jethro (Exodus 2:11–22). After Moses first fled Egypt, having killed an Egyptian who was beating a Hebrew, he went to live in the land of Midian, near present-day Mount Sinai. One day, the seven daughters of Jethro were attempting to water their flocks when shepherds came and drove them away, but Moses came to their aid, drawing water for their sheep. Thus he came to live with Jethro, the priest of Midian, married his daughter Zipporah, and had two sons, Gershom and Eliezer. Moses tended Jethro's flock for a number of years before being called back to Egypt for the familiar struggle with the pharaoh.

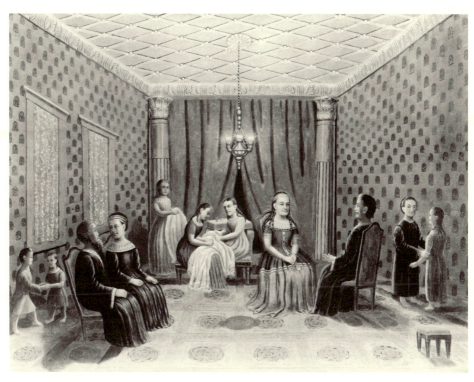

Field, *Egyptian Scene (possibly Moses and Zipporah)*

If this interpretation of the scene is correct, Jethro would be the old man seated at the left speaking to what could be his eldest daughter, and Moses and Zipporah would be the young couple seated facing each other at the right. The remaining five girls would then be Zipporah's younger sisters, and the two small boys might be younger brothers, unmentioned in the Bible. The hieroglyphics on the wall at the left indicate that Field intended to depict a room from biblical times and not an Egyptian revival interior of his own day as was once suggested.

The picture has many of the strange qualities of Field's other biblical scenes. Four of the figures wear the same unnaturally bright blue that he favored, and the light is uncommonly bright. The figures seem motionless, and the two small children on each side, probably meant to be playing, seem to be engaged in an obscure ritual. The faces of most of the figures, which at first glance look contorted with emotion, are probably just distorted by Field's inept drawing. Finally, the inaccurate and abstract pattern of some of the shadows and the harshly lit faces of the

figures, which might seem a deliberate attempt to strengthen the dramatic impact of the scene, are more likely the result of Field's difficulty in portraying effects of light and shade. Like the *Death of the First Born*, this canvas was probably painted between 1865 and 1880.

Oil on canvas, 35 × 46 in. (88.9 × 116.8 cm.).

REFERENCES: Garbisch collection records, 1949, in Dept. Archives, call it Arranging the Wedding, date it 1835–1845 // S. P. Feld, *Antiques* 88 (Jan. 1963), p. 101, as Egyptian Scene, questions whether it is based on a print or other prototype, ill. under caption "unsigned or copy" // A. Tarvest, *Antiques* 88 (March 1963), p. 325, says despite possibility of its being based on a print source, Field "has given us a haunting interpretation of displaced persons in a timeless dimension—an obviously personalized expression" // R. French and A. M. Dods, *Connecticut Historical Society Bulletin* 28 (Oct. 1963), pp. 129–130, no. 260, lists as Egyptian Scene (Seated Figures Converse in Pseudo-Egyptian Interior), ca. 1880 // W. Gerdts, *Antiques* 90 (Oct. 1966), p. 501, as Egyptian Scene, ca. 1880 // Garbisch collection records, Dec. 30, 1966, in Dept. Archives, as Egyptian Families Planning the Wedding, ca. 1850–1875.

The Death of the First Born

This painting was part of a series on the plagues of Egypt and illustrates the tenth and last, in which "the Lord smote all the firstborn in the land of Egypt, from the firstborn of Pharaoh that sat on his throne unto the firstborn of the captive that was in the dungeon; and all the firstborn of cattle" (Exodus 12:29). After this final and most terrible plague the pharaoh allowed the Israelites to leave Egypt.

The scene is set in the royal palace. A figure at the right, presumably the pharaoh, an elaborate crown on the table beside him, raises his arms in alarm or despair, and a number of other crowned figures, perhaps his brothers, mourn the fate of the dead or dying young men. At the extreme right a mysterious figure in black, perhaps a priest, raises his hands in prayer. As in several of the paintings in this series, Field concentrated on the multiplicity of the horrors

Field, *The Death of the First Born.*

involved, almost seeming to relish the bloodiness of the divine vengeance. The eerie, distorted perspective of the giant columns, the overly strong light from the lamps above, and the garishly colored clothing of the figures produce an appearance of phantasmagoria characteristic of Field's other biblical scenes.

Field's choice of subject and composition derive from scenes by English painters such as Richard Westall and John Martin, whose visionary biblical paintings were designed for dramatic effect. In Field's picture the atmosphere seems closed and horrific and the events take on an obsessive quality, as if the violent and vengeful saga of Moses and the release of the Israelites from Egypt had a personal meaning for the artist. Some have suggested that Field, an extreme abolitionist, may have intended to make a parallel between the abolition of slavery and the escape of the Israelites from bondage in Egypt. The painting was probably done between 1865, when Field more or less retired from his combined daguerreotype-painting career, and 1880, when he was about seventy-five.

Oil on canvas, 35 × 46 in. (88.9 × 116.8 cm.).
REFERENCES: V. Barker, *Art in America*, 42 (May 1954) pp. 124–125 as the Seventh Plague of Egypt, ca. 1840 // R. F. French and A. M. Dods, *Connecticut Historical Society Bulletin* 28 (Oct. 1963), p. 128, no. 250, as Death of the First Born (Temple), dates 1865–1880 // M. Black, *Art in America* 54 (Jan.-Feb. 1966), p. 56, as Death of the First Born, ca. 1870 // M. Black and J. Lipman, *American Folk Painting* (1966), p. 174, color pl. 163.

EXHIBITED: Abby Aldrich Rockefeller Folk Art Collection, Williamsburg, Va., 1963, *Erastus Salisbury Field, 1805–1900*, no. 108, as the Plague in the Temple, ca. 1880, says based indirectly on Death of the First Born by Richard Westall, which was published in London in the 1830s in *Illustrations of the Bible* and was often reprinted // Museum of Early American Folk Art, New York, 1966, *Erastus Field in New York*, no. 25, as ca. 1870 // Whitney Museum of American Art, New York, Virginia Museum of Fine Arts, Richmond, and Fine Arts Museums of San Francisco, 1974, *The Flowering of American Folk Art*, p. 80, no. 104, as ca. 1875 // Museum of Fine Arts, Springfield, Mass., *Erastus Salisbury Field, 1805–1900*, p. 110, no. 86, listed as part of "The Plagues of Egypt" series; p. 87, color pl. 27.

EX COLL.: Edgar William and Bernice Chrysler Garbisch, 1949–1966.

Gift of Edgar William and Bernice Chrysler Garbisch, 1966.

66.242.24.

FRANCIS W. EDMONDS

1806–1863

Francis William Edmonds was born at Hudson, New York, the seventh child of Lydia Worth and Samuel Edmonds. His father, a veteran of the revolutionary war, was chiefly a storekeeper in Hudson but also a politician and civil servant: he was a member of the state assembly, high sheriff of the county, and, during the War of 1812, paymaster-general of the New York State Militia. Edmonds displayed an early interest in art and received the encouragement of a family friend, WILLIAM DUNLAP, who in 1812 was assistant paymaster-general of the state militia. Edmonds's father tried to apprentice him to Gideon Fairman of Philadelphia, one of the leading engravers in the country, but Fairman's fee proved too high. In 1823 a maternal uncle, Gorham Worth, offered Edmonds employment as a clerk in the Tradesman's Bank in New York City. This was the beginning of a successful business career and for a time forced Edmonds to abandon his interest in art. In 1826, however, the establishment of the National Academy of Design and its drawing class proved an irresistible

opportunity, and Edmonds enrolled in the Antique School. In 1829, he exhibited his first painting, *Hudibras Capturing the Fiddler* (unlocated), a scene from Samuel Butler's seventeenth-century satirical poem *Hudibras*. Throughout this time Edmonds not only kept his job at the bank but took on further work drawing on wood for engravers, an activity which at times earned him as much as fifteen dollars a day.

In 1830, however, Edmonds was offered an appointment as cashier of the Hudson River Bank and he gave up painting. When he returned to New York in 1832 to work as cashier of the Leather Manufacturers' Bank, he was married and had a child. Thus, he still found it difficult to begin painting again. The bias of his fellow businessmen against his artistic endeavors as well as his continuing involvement with banknote engraving must have dampened his enthusiasm. Not surprisingly, when he began to exhibit again at the National Academy in 1836 it was under the pseudonym of E. F. Williams, a name he continued to use until 1839. The major paintings he exhibited at the academy from 1838 to 1840 show him experimenting with the possibilities of genre painting. In pictures such as *The Epicure*, 1838 (two versions, Wadsworth Atheneum, Hartford, and private coll.), *Commodore Trunnion and Jack Hatchway*, 1839 (Dallas Museum of Art), *Sparking*, 1839, and *The City and the Country Beaux*, ca. 1839 (both Sterling and Francine Clark Art Institute, Williamstown, Mass.), Edmonds took his subjects from literature as well as from contemporary life. His compositions variously reveal the influence of seventeenth-century Dutch genre painting and the works of Sir David Wilkie and WILLIAM SIDNEY MOUNT.

In 1840 the death of his wife precipitated Edmonds's having a nervous breakdown for which his doctors prescribed travel. He left for Europe in November 1840, where his arrival was eagerly awaited by ASHER B. DURAND, JOHN F. KENSETT, JOHN W. CASILEAR, and THOMAS P. ROSSITER, who had sailed in June. They made the usual rounds in England, France, Italy, and Switzerland, and saw the obligatory masterpieces of painting. Edmonds admired the works of Raphael, Michelangelo, Murillo, Reynolds, and Lawrence, but it was his enthusiasm for the genre pictures of Wilkie and the Dutch masters that was subsequently expressed in his own works. Not unexpectedly he made a special point of collecting prints after Dutch artists, such as Teniers, Ostade, and Wouwermans, and of visiting collections known to be strong in Dutch painting.

Edmonds returned home in 1841 and in November of that year married again. From this time until 1855 his artistic and business careers went on successfully. He became a major figure in the cultural life of the city and was instrumental in founding the American Art-Union, managing the National Academy of Design, and helping to organize the New York Crystal Palace exhibition. In 1855 his appointment as city chamberlain led to his expulsion from the banking community. Although the holder of that post was expected to make substantial political contributions, many bankers thought that Edmonds practiced favoritism and gave bank funds too willingly. This incident did not cripple him financially; for by this point Edmonds had become a director of several enterprises and a diversified investor. In 1857 he formed the banknote engraving firm of Edmonds, Jones and Smillie, which in 1860 merged with the American Bank Note Company, of which Edmonds became a director. He died suddenly on February 7, 1863, apparently of a heart attack.

Following his return from Europe, Edmonds had begun to paint subjects derived mainly

or exclusively from contemporary American life. His compositional arrangements were more complex, his figures and their gestures more expressive, and his style, especially his use of color, more sophisticated. *The New Bonnet* (see below) is a good example of his late style and illustrates the combination of narrative interest and pictorial accomplishment that earned him a substantial reputation during his lifetime and established him as one of the masters of American genre painting.

BIBLIOGRAPHY: Henry T. Tuckerman, *Book of the Artists* (New York, 1867), pp. 441–414 // Maybelle Mann, *Francis William Edmonds, Mammon and Art* (New York, 1977). A reprint of the author's 1972 Ph. D. dissertation written for New York University. Dr. Mann literally rescued Edmonds from undeserved oblivion, and her dissertation is a trove of information on him // Francis W. Edmonds, "The Leading Incidents and Dates of My Life" (1844) in *American Art Journal* 13 (Autumn 1981), pp. 5–10. An autobiographical essay that gives many valuable details // H. Nichols B. Clark, *Francis W. Edmonds: American Master in the Dutch Tradition* (Washington, D.C., 1988). Informative catalogue of an exhibition held at the Amon Carter Museum, Fort Worth, and the New-York Historical Society, places Edmonds in the artistic and social context of his time and emphasizes his links to the Dutch tradition.

The New Bonnet

This painting, one of Edmonds's late works and the last he exhibited at the National Academy of Design, is typical of his humorous and gently moralizing approach to genre painting. Generally concerned with aspects of American middle-class life, Edmonds's pictures are good-natured commentaries on both its foibles and concerns. In *The New Bonnet*, it is one of the episodes of that life that is cleverly analyzed. Overly enthused with the fashionable charms of her new purchase, the young woman has incurred the disapproval of her parents who, it seems, think she has spent too much money on a trifling object. They are surprised and question her judgment, but their reactions cannot be taken entirely seriously, for their own frailties are alluded to by a number of visual clues in the painting. That the father is overly fond of drink is made clear by the bottle and the half empty glass resting on the mantelpiece above him as well as by his ruddy complexion. Similarly the face mirror hanging on the wall behind the mother in a room used for the preparation of food and devoted to other household affairs is suggestive of her vanity.

To provide the proper perspective on this confrontation between foolish daughter and foolish parents, Edmonds has included the figure of a delivery girl. Clearly poor and obliged to work for a living even at her young age, the girl eyes the scene with a mixture of apprehension and distrust. Thus the artist emphasizes the disparities in well-being between those able to buy luxury goods and those who can hardly scrape by. The delivery girl is an innocent bystander to a contretemps made possible by moderate wealth. She is sniffed at with suspicion by the household pet, another manifestation of the family's financial security. In this context the girl functions as the outsider who truly deserves the attention of the family but instead receives the sympathy of the viewer in an emotional counterpoint that unmistakably discloses the satirical nature of the work.

In portraying this scene of middle-class American life, Edmonds, like many other genre painters of his time, both here and abroad, relied on the established formulas of the Dutch masters of the seventeenth century. The arrangement of the interior space, the use of a window and door at the sides to let in the light, the inclusion of still-life elements in the foreground to create a convincing sense of depth, the use of a map (here, possibly of North America) as a backdrop, and the strong and varied local colors are certainly derived from Dutch precedents and may be observed in such works as Pieter de Hooch's *The Good Housewife* (Rijksmuseum, Amsterdam) and Quiringh van Brekelenkam's *The Tailor Shop*, 1653 (Worcester Art Museum). Edmonds was an avowed admirer of Dutch genre painting and saw a good deal of it during his travels in Europe.

The development of the theme of the new

Edmonds, *The New Bonnet*.

bonnet during the nineteenth century is problematic. Edmonds's work is an early example and prefigures the painting of the same title by EASTMAN JOHNSON of 1876 (q.v., VOL. II). European renditions of this subject include James Collinson's *The New Bonnet* of about 1850–1860 (destroyed, ill. in G. Reynolds, *Painters of the Victorian Scene* [1953], fig. 41), a work which has parallels with Edmonds's.

It is possible that the figure of the father in this painting may be a portrait of Edmonds's brother Judge John Worth Edmonds and that the view through the door looks out on Irving Place in New York, where Judge Edmonds lived until his death in 1872. Similarly, the figure of the mother recalls that of the elderly lady in Edmonds's *The Speculator*, 1852 (National Museum of American Art, Washington, D. C.), and may have been based on his mother, Lydia (see her portrait by Edmonds, from the late 1830s, Columbia County Historical Society, Kinder-

hook, N. Y.). The same elderly woman also appears in *Bargaining*, ca. 1858 (NYHS), and the little girl shows up in the *Pan of Milk*, 1858 (NYHS).

Oil on canvas, 25 × 30⅛ in. (63.5 × 76.5 cm.). Signed and dated at lower left: F W Edmonds/ 1858.

Labels on frame: SCHAUS / FINE ART / REPOSITORY, / 749 Broadway, / NEW YORK. Inscribed on paper fragment affixed to frame: The [New] Bonnet / F. W. Edm[ond]s

REFERENCES: *Crayon* 6 (Feb. 1859), p. 62, mentions it as being on exhibit in the Tenth Street Studio Building; 6 (May 1859), p. 153; 6 (June 1859), p. 192, praises the "well-drawn, humorous head of an old man" ‖ *Home Journal* (*Town and Country*), no. 25 (June 18, 1859), p. 2, says it is one of Edmonds's "happiest efforts. The story is well told, the characters sharply defined, with a great deal of good detail painting. As a theme of humor and universal sympathy, it arrests attention and provokes mirthful comment" ‖

Critical Guide to the Exhibition at the National Academy of Design (1859), p. 8, says it "lacks the humor and delicacy for which this clever painter is notorious. The old farmer need not put on such a face at the bill, which he seems to regard with horror. The bonnet, certainly, is not from Mrs. Cripps' famous bazaar" // T. S. Cummings, *Historic Annals of the National Academy of Design* (1865), p. 320 // H. T. Tuckerman, *Book of the Artists* (1867), p. 411 // *Appleton's Cyclopedia of American Biography* (1894), 2, p. 304 // M. Mann, Otisville, N.Y., letter in Dept Archives, Jan. 3, 1975, says the old gentleman in the painting bears a striking resemblance to photographs of Judge John Worth Edmonds, believes that the rowhouses visible through the doorway represent Irving Place, where he lived, and thinks the figure of the woman was probably based on the artist's mother; *Francis William Edmonds* (Ph.D. diss., New York University, 1972; published, 1977), p. 152.

EXHIBITED: Tenth Street Studio, New York, Feb. 1859 // NAD, 1859, no. 313, as The New Bonnet // MMA and American Federation of Arts, traveling exhibition, 1975–1977, *The Heritage of American Art*, cat. by M. Davis, no. 35 // Amon Carter Museum, Fort Worth, and NYHS, 1988, *Francis W. Edmonds*, exhib. cat. by H. N. B. Clark, color ill. p. 17; pp. 129–132, describes the scene and interprets the placement of the bonnet against the map as probably a quotation from William Hogarth's *Vrouw Wereld*, or worldly woman, from *The Rake's Progress*; p. 160, lists it.

EX COLL.: private coll., Tucson, 1974, with Berry-Hill Galleries, New York, 1974–1975; with Kennedy Galleries, New York, 1975.

Purchase, Erving Wolf Foundation and Hanson K. Corning Gift, by exchange, 1975.

1975.27.1.

FREDERICK R. SPENCER

1806–1875

One of four children of Mary Pierson and Ichabod Smith Spencer, Frederick R. Spencer was born June 7, 1806, in Lenox, New York, a town between Syracuse and Utica and near Canastota. Most of his early life was spent in the area of Madison County, New York. His father, a lawyer, had become the first postmaster of the town of Canastota. His first contact with painting is said to have been at the age of fifteen when he saw the work of EZRA AMES in Albany. According to WILLIAM DUNLAP, in 1822 Spencer "evinced his love of art by going frequently to Utica . . . to see my scriptural subjects, exhibiting there. . . . He says I at that time gave him some valuable instructions" (2, p. 436). Spencer studied for a while at Middleburg Academy in Genesee County and served as a clerk in his father's law office. In 1825, he went to New York, where he drew from antique casts at the American Academy of the Fine Arts and may have studied with JOHN TRUMBULL. Returning upstate in 1827, he entered the trade of portrait painting. His early works, for example the portrait of Spencer Kellogg, 1830 (Munson-Williams-Proctor Institute, Utica, N.Y.), show the influence of JOHN WESLEY JARVIS, whose work he must have seen while in New York.

In 1831 Spencer went back to the city with his wife, the former Harriet Jacobs of Elbridge, New York, whom he had married in 1828, and in 1832 he was elected an academician at the American Academy. Between 1833 and 1839, he served on the board of directors of that institution. After 1837, he exhibited portraits at the National Academy of Design, where he was elected an academician in 1846 and served as recording secretary from 1849 to 1850. Judging from what he exhibited at both academies, his output consisted almost exclusively of portraits. His extant work from the late 1830s demonstrates his stylistic debt

to HENRY INMAN. In the 1840s, Spencer, like many other portrait painters, came under the influence of the newly popular daguerreotype. *The News-Boy*, 1849 (coll. Mr. and Mrs. Perry T. Rathbone, Cambridge, Mass.), is remarkable for the photographic clarity of the main figure in a conventional genre subject.

Spencer moved back to upstate New York in 1858, perhaps because of marriage problems; for his wife did not accompany him. She later charged him with insanity, but his letters from this period indicate otherwise (Crozier, p. [6]). He continued to paint until his death in 1875.

BIBLIOGRAPHY: William Dunlap, *A History of the Rise and Progress of the Arts of Design in the United States* (2 vols.; New York, 1834), 2, p. 436. Brief, informative, and highly laudatory account of the artist and his work // Laurence B. Goodrich, "A Little-Noted Aspect of Spencer's Art," *Antiques* 40 (Sept. 1966), pp. 361–363. Describes and illustrates a number of Spencer's paintings of genre and literary subjects // Fountain Elms, Utica, N.Y., *A Retrospective Exhibition of the Work of Frederick R. Spencer, 1806–1875*, cat. by Susan C. Crozier (1969). The most complete work on Spencer, it includes a checklist of paintings signed by and attributed to him.

Mary Ann Garrits

When this portrait came to the museum it was identified by a member of the subject's family as Mary Ann Garrits, the daughter of Robert Dugan from the north of Ireland, who was an Episcopal minister in New York. Unfortunately,

Spencer, *Mary Ann Garrits*.

no record has been found of either Mary Ann Garrits or, in church records, of a minister Dugan. A Thomas Dugan, or Duggan (1798–1855), was sexton of Trinity Church from 1835 to 1840, and a Leonard Garrits appears as a merchant in New York directories beginning in 1824 and as a clothier from 1829 to 1848. The lady's unusually elaborate jewelry in the portrait suggests that she enjoyed some degree of prosperity. On her left hand are three rings and on her right at least one; on the front of her dress is a gold chatelaine, a pin with a chain from which hang two little bells; her neckline is adorned with a cameo brooch worn sideways; around her neck is a necklace of coral beads; and from her ears hang cameo earrings. The last three ornaments probably were Italian, like the elaborate comb in her hair.

Except for her plethora of jewelry, the subject is shown in an entirely conventional manner. Behind her is a rich red damask curtain drawn over a landscape, possibly of the Hudson River. Although the face is smoothly painted and probably a flattering likeness, the head is anatomically unconvincing, oddly flat in back. The subject's shoulders have a graceful and almost abstractly curving slope, and the dress is a more or less flat area of black pigment. The style is surprisingly naive.

Oil on canvas, 33 × 26 in. (83.8 × 66 cm.).
Signed on the back: By F. R. Spencer, 1834.
REFERENCES: W. B. Levett (brother-in-law of Sim-

eon Englander), Nov. 27, 1928, MMA Archives, identifies sitter // Gardner and Feld (1965), p. 240.

EXHIBITED: Fountain Elms, Utica, N. Y., 1969, *A Retrospective Exhibition of the Work of Frederick R. Spencer, 1806–1875*, no. 11.

ON DEPOSIT: Bartow-Pell Mansion, New York, 1965–1969.

Ex COLL.: the subject's grandson, Simeon Englander, New York.

Gift of Emma W. Englander, 1928.
28.198.1.

WILLIAM SIDNEY MOUNT

1807–1868

William Sidney Mount, the most important American genre painter of the nineteenth century, was born on Long Island, at Setauket, New York. His father, a prosperous farmer and innkeeper, died when Mount was still young, and the family subsequently moved to the farm of Mrs. Mount's father in Stony Brook. There Mount grew up, and at age seventeen, he began an apprenticeship with his brother Henry S. Mount (1802–1841), an ornamental sign painter in New York. He was ambitious and in 1826 became one of the first students at the National Academy of Design's newly opened school. When not engaged in working for his brother, he drew from casts of antique sculpture and probably copied some paintings. Missing the country life, he returned to Stony Brook the next year. In 1828, he painted his first portrait, a likeness of himself holding a flute, and his first composition, *Christ Raising the Daughter of Jairus* (both at Museums at Stony Brook, N.Y.). They are primitive-looking works which reveal his training as a sign painter. Back in New York in 1829, Mount continued his studies at the academy and set up his own studio at 154 Nassau Street. He was joined in his academic studies by another brother, SHEPARD ALONZO MOUNT, who had recently worked for a carriage maker in New Haven. Both made progress as portrait painters. Like so many other ambitious, young American artists, William Sidney Mount wished to become a history painter; the works he exhibited at the National Academy in 1829, *Crazy Kate* (unlocated) and *Celadon and Amelia* (Museums at Stony Brook), both literary subjects, disclose this interest.

Sometime between 1829 and 1830 Mount decided that "we had materials enough at home to make original painters" (quoted in Frankenstein, 1975, p. 20). From that time on he concentrated on portraits and genre scenes derived from the country life he knew so well. His *Rustic Dance after a Sleigh Ride*, 1830 (MFA, Boston), exhibited at the National Academy of Design in 1830, though still rough in execution and probably adapted from a painting by John Lewis Krimmel (1789–1821) called *Country Frolic and Dance*, 1819 (private coll.), was very favorably reviewed by the press and marked the beginning of Mount's career as a genre painter. In the years between 1830 and 1840 his work reached maturity. The rendition of the figures he included in his paintings—in pose, likeness, and gesture— benefited greatly from his increasing technical ability. Meanwhile the delicate balance of his compositions showed a careful study of geometry and perspective. Among the important pictures he produced at this time are *After Dinner*, 1834 (Yale University, New Haven);

Farmers Nooning, 1836 (Museums at Stony Brook); *Raffling for the Goose*, 1837 (q.v.) and *The Painter's Triumph*, 1838 (PAFA). In the space of only ten years Mount brought American genre painting to its highest level of achievement. Although a great deal of documentation by and about Mount survives, he very seldom wrote about his pictures or discussed them with others. Perhaps because of this it was long assumed that they were straightforward transcriptions of rural life. In recent years, however (see entries on *Cider Making* and *Long Island Farmhouses* below), it has become evident that this view is too limiting. At least some of his works must be viewed as political statements that comment on, and do not simply report, contemporary events.

Like other American painters of his time, such as SAMUEL F. B. MORSE, Mount liked to ponder mechanical problems and invent machines. His most famous product was the hollow-backed violin he patented in 1852, a result of his lifelong interest in music. This interest is manifested in a number of paintings, the most famous of which is *The Power of Music*, 1847 (Cleveland Museum of Art). Another of his inventions was a portable studio he built in 1861. Much like Jean-François Daubigny's houseboat, it was meant to facilitate painting out of doors. Working in the open air was one of Mount's cherished artistic tenets, and a number of palette sketches done on the spot are remarkable for their freshness and color. Certainly, only a careful and direct observation of nature could have produced the amazing representation of light in *Eel Spearing at Setauket*, 1845 (New York State Historical Association, Cooperstown), probably Mount's masterpiece and one of the few American paintings of the time to portray a black person with sympathy and dignity. In this respect Mount's later paintings *The Lucky Throw*, 1850 (unlocated), and *The Banjo Player*, 1856 (Museums at Stony Brook, N.Y.), are especially noteworthy. Their appealing presentation of black people as middle-class freemen rather than as chattels received wide circulation in America and Europe through prints.

After about 1860, Mount's paintings declined in quality, perhaps the result of his poor health. He worked from his portable studio around Stony Brook and Setauket, making numerous sketches and drawings, but his finished works are far below the standards he had previously established. Up to the end of his life he continued to paint portraits to insure an adequate income for himself. He died at his brother Robert's house at Setauket on November 19, 1868.

BIBLIOGRAPHY: William Dunlap, *A History of the Rise and Progress of the Arts of Design in the United States* (2 vols., New York, 1834), 2, pp. 451–452. An early biographical account which considerably boosted Mount's career || Edward P. Buffet, "William Sidney Mount, A Biography," *Port Jefferson* [New York] *Times*, Dec. 1, 1923 to June 12, 1924. This is the first of the modern biographies and still a vital one because it has quotations from many documents that have since been lost (a special copy of newspaper articles plus some photographs were deposited by the author in the MMA library) || Bartlett Cowdrey and Hermann Warner Williams, Jr., *William Sidney Mount, 1807–1868: An American Painter* (New York, 1944) || Alfred Frankenstein, *William Sidney Mount* (New York, 1975). Contains most of the surviving documents relating to Mount.

Mount, *Mrs. Gideon Tucker*.

Mount, *Gideon Tucker*.

Gideon Tucker

Gideon Tucker (1774–1845) was the son of Henry Tucker, a New York politician and supporter of Aaron Burr who later in life became a large landowner in New Jersey. Following in his father's footsteps, Gideon Tucker held a number of important political offices including those of sachem of Tammany Hall, city alderman in New York, and member of the state legislature in 1830. During the War of 1812 he was a member of the Committee of Defense formed to secure New York against attack. He was also an active businessman who owned substantial real estate holdings in New York and New Jersey, and at various times he served as a director of the Chemical Bank and as president of the Mutual Life Insurance Company. He was first married to Sarah Clarke of New Jersey, by whom he had two sons. After her death he married Jemina Brevoort.

This work and its companion, painted two years after Mount's first attempt at portraiture, disclose his remarkable progress in mastering the techniques of portrait painting. Compared with his portrait *Mrs. Charles S. Seabury and Son,*

Charles Edward, 1828 (Museums at Stony Brook), an awkward-looking, provincial affair, the Tucker portraits show greater confidence and an evident awareness of the conventions of the day. Although not typical of his later, more individual style, they are still accomplished attempts to emulate the works of HENRY INMAN and WALDO AND JEWETT, then the leading portrait painters in New York. Thus in the portrait of Gideon Tucker, the softly modeled likeness and the execution of the hair, as well as the organization of the background, recall the style of Henry Inman while the pose of the sitter and the tighter painting of the coat echo the formulas of Waldo and Jewett. At this stage of his career, however, Mount had not quite acquired the competence of these artists: Gideon Tucker sits in an implausibly painted arm chair, and his hands, painted without grace, look like paws.

Oil on canvas, $34\frac{1}{8} \times 27$ in. (86.7 × 68.6 cm.).
Signed and dated on the back before lining: w^Ms. MOUNT / 1830.
REFERENCES: E. Tucker, *Genealogy of the Tucker Family* (1895), pp. 335–336, gives biographical information // Gardner and Feld (1965), pp. 244–245 // A. Frankenstein, *William Sidney Mount* (1975), p. 468.

Exhibited: MMA, 1965, *Three Centuries of American Art* (checklist arranged alphabetically).
On deposit: Gracie Mansion, New York, 1966.
Ex coll.: descended to the subject's great-granddaughter, Helen L. Tucker, d. 1948.
Bequest of Helen L. Tucker, 1949.
49.10.1.

Mrs. Gideon Tucker

This painting depicts the second wife of Gideon Tucker, the former Jemina Brevoort, of whom little is presently known. It is somewhat more darkly painted than the companion portrait of her husband but otherwise shares many of the same qualities. Compositionally, the portrait very much resembles WALDO AND JEWETT's *Portrait of an Old Lady (probably of the Buloid family)* (q.v.), and thus again points to the dominating influence of fashionable New York portraiture on Mount's works at this time.

Oil on canvas, 34⅛ × 27 in. (86.7 × 68.6 cm.).
Signed and dated (on the back before lining): wᴹs. mount. / 1830.
Canvas stamp (before lining): Russian stamp depicting a ship and a double-headed eagle surrounded by arabesques.
References: Gardner and Feld (1965), p. 245 // A. Frankenstein, *William Sidney Mount* (1975), p. 245.
Exhibited: MMA, 1965, *Three Centuries of American Art* (checklist arranged alphabetically).
On deposit: Gracie Mansion, New York, 1966.
Ex coll.: same as preceding entry.
Bequest of Helen L. Tucker, 1949.
49.10.2.

Martin Euclid Thompson

Martin Euclid Thompson (1789–1877) is first listed in the New York city directory for 1816 as a carpenter. Little is known about his early training, but he must have acquired a good reputation as a designer, for in 1822 he was commissioned to draft plans for the second Bank of the United States on Wall Street. This classical building later housed the United States Assay Office. Its marble facade now stands in the courtyard of the American Wing of this museum. In 1824 Thompson was called upon to design the Merchants' Exchange, a building which, when completed in 1827, was one of the most impressive in New York. Two years later he was

Mount, *Martin Euclid Thompson.*

among the twenty-six artists who founded the National Academy of Design.

By 1827 Thompson had formed a partnership with Ithiel Town, whose library of reference books and architectural engravings soon made the firm's office in the Merchants' Exchange a gathering place for architects and artists. From this time on Thompson embraced the Greek revival and the influence of this style was reflected in his Church of the Ascension on Canal Street, which he designed in collaboration with Town. His partnership with Town dissolved about this time, and from then on Thompson worked alone. In the following years he designed the Columbia Grammar School, the facades of the houses on the Murray Street lots of Columbia College, Sailors' Snug Harbor Home, and the house of the merchant Robert Ray at 17 Broadway. He also made plans for an enlargement of City Hall and in all likelihood was responsible for the design of a number of houses built in the northern part of Greenwich Village in the 1840s and 1850s. From 1847 to January 1850 he was street commissioner of the city. Following the death of his wife in 1864 he retired to his daughter's house in Glen Cove, Long Island, where he died on July 24, 1877.

Mount's catalogue of his own pictures notes that in 1830 he painted portraits of Martin E. Thompson, "an early friend with large humanity," and his wife for forty dollars. The portrait of Thompson is painted in much the same manner as that of Gideon Tucker (q.v.), though it is clear that here Mount has worked with greater care. The sitter's likeness is sympathetically and carefully painted as are his coat and neckcloth. His left arm extends out somewhat unnaturally, but this awkwardness more adequately balances the drawing on the left. The drawing represents a classical pediment and alludes to Thompson's profession as well as to the style of his buildings. Overall, the dominant colors are the black of the coat and the brown of the background, an arrangement which sharply sets off the face and the drawing and creates an atmosphere of calm and stability. This, combined with the carefully balanced composition, suggests that in this portrait Mount was deliberately attempting to evoke the neoclassical serenity of the late works of GILBERT STUART and the portraits of JOHN VANDERLYN, in order to complement the aesthetic principles espoused by the sitter and embodied in his buildings.

Oil on canvas, oval, 29¾ × 24½ in. (75.6 × 62.2 cm.).

REFERENCES: W. S. Mount to R. N. Mount, May 29, 1830, states "I am Painting the Portraits of the Rev. Mr. Onderdonk and Mr. Thompson, the Architect," quoted in A. Frankenstein, *William Sidney Mount* (1975), p. 51; "Catalogue of Portraits and Pictures Painted by William Sidney Mount," n.d., year 1830, lists this picture and characterizes Thompson in the passage quoted above, gives price of portrait, quoted in ibid, p. 468 // C. J. Werner, *Historic Miscellanies Relating to Long Island* (1917), pp. 32, 43, lists this painting // Gardner and Feld (1965), pp. 245–246 // *Preservation Notes* [*Society for the Preservation of Long Island Antiquities*] 4 (Oct. 1968), pp. 3–5, notes that Thompson was one of Mount's strong supporters in a campaign organized to have him paint a work for the rotunda of the United States Capitol and states that Thompson's son-in-law, James Price, in whose house at Glen Cove the architect spent his last years, was a good friend of the Mount family, ill. p. 4.

EXHIBITED: NAD, 1831, no. 181, as Portrait of a Gentleman, lent by M. E. Thompson.

EX COLL.: descended to the subject's granddaughter, Susan Louise Thompson, Rye, N. Y.

Bequest of Susan Louise Thompson, 1959. 59.68.

The Raffle (Raffling for the Goose)

This painting depicts six men gathered around a hastily improvised gambling table awaiting the result of the draw that is to determine the winner of the plump goose. A seventh man is at the extreme left, but he does not seem to be an active participant. Such impromptu lotteries (the goose has only recently been killed as is made clear by the blood on the table) seem to have been common at this time on rural Long Island. Since provincial customs are seldom noted in formal historical accounts, information about them is difficult to come by. There is another painting by Mount that more or less deals with the same subject, *The Lucky Throw* (1850, unlocated but known through a lithograph), which tends to support the notion that such lotteries were pervasive. Certainly, all forms of gambling were extremely popular in this country in the early part of the nineteenth century. Patently, the concern in *Raffling for the Goose* is to present this kind of pastime in a sympathetic light. As in many of his pictures, Mount manages to transcend the manifest content of the picture and address general social realities of the time.

Executed in the winter of 1836–1837 and exhibited at the National Academy of Design exhibition in the spring of 1837, the painting was certainly seen as a topical and good-humored reflection of the acute shortages of food typical of those days of economic crisis. On February 13, 1837, New York had witnessed a large-scale riot leading to the destruction of about five hundred barrels of flour at the warehouse of Eli Hart and Company. The placards calling for this assembly declared "Bread, Meat, Rent, Fuel— Their Prices Must Come Down!" Even the wealthy Philip Hone felt the pinch of rising prices when on February 18, 1837, he wrote in his famous diary: "Never yet have I known a market so dear as the Fulton was this morning. It had the appearance of famine, although Saturday when the country always sends in its produce there was plenty of beef at 18 cents per pound, but of poultry and veal and such things there did not appear to be a day's supply for the table of the City Hotel. What is to become of the laboring classes?" (A. Nevins, ed., *The Diary of Philip Hone, 1828–1851* [1927], I, p. 243).

Given this context, the eager looks of the participants become understandable: they are, indeed, playing for high stakes. Further, the clear

Mount, *The Raffle (Raffling for the Goose).*

division of the gamblers into fashionably dressed city types (note that one of the young men wears a traveler's cloak) and poorer country types takes on a clearer meaning. The city versus country distinction is appropriate; for it was in the cities that the depression hit hardest and many city-dwellers were forced to go and live with country relatives in order to survive. On another level, the distinction between common men and wealthy men (they are evenly paired) may well reflect the class frictions generated by the financial policies of the populist Jacksonians. At the center of this struggle were the questions of government deposits in Nicholas Biddle's Bank of the United States (which Jackson halted) and of the re-chartering of the bank (it did not take place). Mount was a conservative Democrat opposed to Jacksonian policies. Thus, it is tempting to associate the dead goose in this picture with the proverbial one that laid the golden eggs— the carcass of Biddle's bank was up for grabs. In fact a cycle of financial gambling and speculation had been unleashed which culminated in the Panic of 1837. But if this is indeed one of the meanings of this picture, Mount's contemporaries do not discuss it. Press reviewers of the National Academy exhibition merely noted its appeal and excellent execution. A later critic, the artist

Charles Lanman (1819–1895), wrote (1845) that the scene represented "a company of loafers in a country bar-room . . . illustrating the proverb, that 'birds of a feather flock together,'" although the building actually looks more like an old barn inhabited by the man at the extreme left. The clothes hanging on a line in the loft above as well as the presence of a small boy, a basket, a coffee pot and a jug in this space suggest that this is his "bachelor's hall," a place where events of dubious legality (or morality) take place from time to time.

Like other works by Mount painted about this time, for example, *The Long Story,* 1837 (Corcoran Gallery of Art, Washington, D.C.), and *The Painter's Triumph,* 1838 (PAFA), *The Raffle* exhibits the pleasing balance of careful, geometrical composition. By means of a complex system of golden section rectangles (1:2) and overlapping squares, the goose is placed at the center of attention as all other elements fall into place around it.

The painting was originally owned by the elder Henry Brevoort, a wealthy New York businessman and proprietor of an extensive tract of land in Greenwich Village. It was engraved as *The Raffle* for *The Gift* of 1842 by Alexander Lawson.

Oil on mahogany, 17 × 23⅛ in. (43.2 × 58.7 cm.). Signed and dated at lower center: wᴹ. ꜱ. ᴍᴏᴜɴᴛ. / 1837.

RELATED WORKS: Alexander Lawson after W. S. Mount, *The Raffle*, engraving, ca. 1841, 3⅛ × 4¼ in. (7.9 × 10.8 cm.), published in the annual *The Gift* for 1842, opp. p. 250 // Attributed to W. S. Mount or A. Lawson, *Raffling for a Goose*, pencil and watercolor on paper, 7 × 4½ in. (17.8 × 11.3 cm.), unlocated, formerly Museums at Stony Brook.

REFERENCES: *Knickerbocker* 9 (June 1837), p. 622, calls it "another admirable picture of rural life and manners . . . although the faces have too much family resemblance" // *New-York Mirror* 14 (June 17, 1837), p. 407, praises this work and expresses hope that Mount's style will remain free of foreign influence // W. S. Mount, catalogue of works, ᴍꜱꜱ at Museums at Stony Brook, quoted in A. Frankenstein, *William Sidney Mount* (1975), p. 469: "Year 1837. The raffle. Painted for Mr. Henry Brevoort of N. York. Size of the picture 17⅛ × 23⅛ in. Painted on mahogany. He gave me three hundred—said I did not charge enough . . . Price of The Raffle $250. Mr. Brevoort kindly gave me 50 dollars extra" // C. Lanman, *Letters from a Landscape Painter* (1845), p. 245 (quoted above) // W. S. Mount, Diary, Dec. 26, 1849, in collection of Museums at Stony Brook, N. Y., quoted in A. Frankenstein, *William Sidney Mount* (1975), p. 200: "When I painted The Raffle in the winter of 1837 I used to walk over to my paint room and make fire before breakfast" // W. A. Jones, *American Whig Review* 14 (1851), p. 124, lists it // *Literary World* 10 (May 8, 1852), p. 333, calls it Raffling for a Goose and says it "once belonged to the late Henry Brevoort" // W. A. Schaus to W. S. Mount, Sept. 1852, in collection of Museums at Stony Brook, quoted in Frankenstein, *William Sidney Mount* (1975), p. 164, says that he would like to publish prints after a number of Mount's paintings, including "Raffling for a Goose" which he thinks is "now in Troy" // W. S. Mount, Diary, Nov. 14, 1852, in collection of Museums at Stony Brook, quoted in Frankenstein, *William Sidney Mount* (1975), p. 249: "The Raffle—and Tough Story—were painted by using two windows" // W. S. Mount to M. O. Roberts, May 27, 1853, quoted in E. P. Buffet, "William Sidney Mount, A Biography," *Port Jefferson Times*, Dec. 1, 1923 to June 12, 1924 (bound volume with all the clippings in MMA library, p. 47), asks for loan of this painting in order to exhibit it at the New York Crystal Palace, 1853, "as I consider it one of my best pictures" (Roberts refused) // W. S. Mount, "Autobiographical Fragment—January 1854," in collection of Museums at Stony Brook, quoted in Frankenstein, p. 29: "Year 1837. The Raffle—painted for the late Henry Brevoort Esqr. Price two hundred and fifty but he generously gave me three hundred dollars and said I did not charge enough. Washington Irving was so much pleased with the raffle that I was introduced to him by Mr. Brevoort at Mr. Irving's

request and he kindly invited me to spend some time at his home, but I regret to say that I could not at that time accept his very kind invitation. 'The Raffle' is now in the possession of Marshall O. Roberts Esqr. He paid four hundred dollars. It was engraved for *The Gift*" // H. T. Tuckerman, *Book of the Artists* (1867), p. 421; p. 626 lists it in Roberts collection, New York // E. Strahan, ed. [E. Shinn], *The Art Treasures of America* (1880), 2, p. 16, lists it as Raffle for a Turkey, in the collection of Mrs. M. O. Roberts // C. J. Werner, *Historic Miscellanies Relating to Long Island* (1917), p. 42 // E. P. Buffet, "William Sidney Mount: A Biography," *Port Jefferson Times* (Dec. 1923– June 1924), bound volume of clippings in MMA library, chapter 13, quotes a review of Mount's paintings in the 1837 NAD exhibition hailing him as "the master spirit of the exhibition" who is better than Teniers // B. Cowdrey and H. W. Williams, Jr., *William Sidney Mount* (1944), pp. 17–18, no. 26 // A. T. Gardner, *MMA Bull.* 3 (Feb. 1945), p. 150 // Gardner and Feld (1965), pp. 246–248 // A. T. Gardner, *MMA Bull.* 23 (April 1965), pp. 272–273 // A. Frankenstein, *William Sidney Mount* (1975), p. 29, 164, 200, 249, 267, 302, 469, in passages quoting Mount's manuscripts.

EXHIBITED: NAD, 1837, no. 285, as The Raffle // Stuyvesant Institute, New York, 1838, *Exhibition of Select Paintings by Modern Artists* (Dunlap Benefit Exhibition), no. 132, as The Raffle // Detroit Institute of Arts, 1922, *Art Before the Machine Age* (no. cat.) // Whitney Museum of American Art, New York, 1935, *American Genre, the Social Scene in Paintings and Prints*, no. 78 // Carnegie Institute, Pittsburgh, 1936, *American Genre Paintings*, no. 72 // Brooklyn Museum, 1942, *William Sidney Mount*, no. 44 // MMA, 1945, *William Sidney Mount and His Circle*, no. 12 // Suffolk Museum, Stony Brook, N. Y., 1947, *The Mount Brothers*, no. 71 // Cincinnati Art Museum, 1955, *Rediscoveries in American Painting*, no. 68 // National Gallery of Art, Washington, D.C.; City Art Museum, Saint Louis; Whitney Museum of American Art, New York; M. H. de Young Memorial Museum, San Francisco, 1968–1969, *William Sidney Mount*, no. 13 // Whitney Museum of American Art, New York; Museum of Fine Arts, Houston; Oakland Museum, 1974–1975, *The Painter's America*, exhib. cat. by P. Hills, p. 26, no. 28 // MMA, 1976, *A Bicentennial Treasury* (checklist arranged alphabetically).

EX COLL.: Henry Brevoort, New York, from 1837, until about 1852; with Williams and Stevens, New York, 1852; Marshall O. Roberts, New York, 1853–1880; his estate (sale, Ortgies and Company, Fifth Avenue Art Galleries, New York, January 19–21, 1897, no. 124, $175); John D. Crimmins, New York.

Gift of John D. Crimmins, 1897.

97.36.

Cider Making

On December 5, 1840, William Sidney Mount noted in a letter to Benjamin F. Thompson, the Long Island historian: "I have a picture on the easel I think you would be pleased to see. The subject is Cider making in the old way. I feel in the spirit of painting and have plenty to do." Commissioned by the prominent New York businessman and Whig political leader Charles Augustus Davis, the picture realistically represents a picturesque aspect of rural life. As J. B. Hudson's research (1975) has convincingly shown, the inspiration for the scene lies in the political realities of the presidential campaign of 1840. In that contest the Whigs successfully defeated the Jacksonian Democrats by adopting a strategy that put forth an image of their candidate, William Henry Harrison, as a common man who would rather live in a log cabin and drink hard cider than occupy the luxurious White House. Issues of substance were avoided, and throughout the country voters were courted with free distributions of hard cider dispensed in log cabins built for the purpose. The Whig objective was to elect a president who would reverse the Jacksonian financial policies that had in effect destroyed the American banking establishment headed by Nicholas Biddle's Bank of the United States and had been largely responsible for the Panic of 1837. Businessmen and merchants looking out after their interests eagerly joined the cause, but the Whigs knew they had to broaden their popular appeal in order to defeat Martin Van Buren, to whom they had lost in 1836. One of the architects of this Whig strategy was Charles Augustus Davis, whose "Jack Downing" letters, folksy reflections on the issues of the day purportedly written by a farmer, appeared in the *New York Daily Advertiser* beginning in June of 1833 and gained a wide popularity. He attacked the financial policies of the Jacksonians and depicted Biddle as a kindly old esquire who had the welfare of the country at heart. Davis himself, as might be expected, had a direct interest in this political battle. Far from being a rural "Jack Downing," he was a sophisticated urban financier who, as it happened, was director of the New York branch of Biddle's bank.

For his part, Mount, though a Democrat, was sympathetic to the anti-Jacksonian cause. He was in the political terminology of the day a conservative Democrat. (It is not known, however, wheth-

er he actually crossed party lines in the election of 1840 and voted for the Harrison-John Tyler ticket, whose familiar slogan was "Tippecanoe and Tyler too!") It was not unnatural for him to have accepted Davis's commission knowing full well that he would be painting a work with political overtones. The date 1840 prominently affixed to the cider barrel in the foreground was certainly intended to make the political implications clear. At least one commentator, a writer in the *New York American* in 1841, got the message and wrote the following thinly veiled interpretation of the picture:

I thought my last letter had embraced all that was left me to describe to you of the charms of "*rural life*;" and that between the period of Harvest Home," and the frosts and snows of *Winter*, little intervened of interest in the country, save preparations to meet the severity of that dreary season, "chopping and drawing wood," "stuffing windows," "repairing the thatch of sheds and hovels," and other similar unsentimental occupations; but, imagine my agreeable surprise, on returning to the "Farm," after a short absence, I found myself in the midst of "*high vintage*,"— and a more joyous and hilarious occupation, it has seldom fallen to my lot to witness.

On calling at the house, I found no one at home save old Mrs. Josslin, who informed me that "all the folks" were "down to the Cider Mill." And then she detailed to me all the incidents of the apple-gathering, and the bright prospects of a *good cider* year. I regretted to hear, however, that my young and roving companion *Amos Josslin* had met with a serious accident, by having, in the occupation of shaking the trees, shaken himself off a limb with the apples, and sprained his wrist, and otherwise injured himself, but had so far recovered as to be able that morning for the first time to stroll out; and he too, though only as a looker-on, had also gone down to the "cider mill." It was Saturday, and all the children who were not old enough to work had been permitted a respite from school, and of course were all "down to the cider mill;" and even "Trim," the favorite companion of Amos, and who generally welcomed me at the bottom of the lane, he too, I suppose, was also at the mill, as I missed his frisking and fawning of welcome.

This language is rich in words and phrases with a political double-meaning: the "younger ones" taking a ride "on the cross beam . . . as a reward for past services," the faithful old mare toiling on because it fears the return of "the whip" who is at the moment tasting "the pure juice" (of victory?), the old esquire (Biddle?) who knows that 1840 was a choice year for "hard cider" and who intends to send a barrel to "Ole

Mount, *Cider Making.*

Tip" (Harrison). Whether this detailed interpretation of the action in the painting, however, in fact constitutes the iconographical program to which the painter adhered is open to question. The story spun here by a Whig partisan is far more anecdotal and politically insinuating than the contents of the picture warrant and must be viewed as a post-facto, and somewhat embellished, reading of the work. Thus it seems likely that the barefoot Fanny could have been the daughter of an esquire, or that it is the painter himself who, like a good conservative Democrat, sits on the fence (a drawing at Museums at Stony Brook by SHEPARD ALONZO MOUNT of William Sidney Mount working on this painting shows that at this time he had a beard whereas the figure on the fence in *Cider Making* does not). Further, it does not appear that any of the carefully painted likenesses are portraits of Davis, Biddle, or any important Whig political figure such as Thurlow Weed. This, of course, does not mean that the political origins of the painting are any less real. Why else would Robert Nelson Mount have written his brother that *Cider Making* should have been painted large and placed in one of the empty spaces in the U.S. Capitol Rotunda in Washington? Nor does it mean that its political implications were any less intended, but it does establish that on balance Mount was more interested in observing the process of cider making than in including iconographic elements that might interfere with the reality he observed. Surviving studies for the painting indicate that, as was his habit, Mount gleaned his visual data from the surrounding countryside and by and large adhered to it. *The American Repertory of Arts, Sciences and Literature* noted in a contemporary review that the composition of *Cider Making*

was "so closely painted to nature that its location is readily discovered to be Suffolk county." The cider mill that Mount painted still stood in Setauket until the early twentieth century.

Oil on canvas, 27 × 34⅛ in. (68.6 × 86.7 cm.).

Signed and dated at lower left: wᴹs, MOUNT. [in black] / 1841 [red]. Inscribed on barrel: 1840. Signed, dated, and inscribed on the back of the canvas: CIDER-MAKING. / Wᵐ. S. Mount. / 1841. / painted for / C. Aug.ᵗ Davis / N. York.

Canvas stamp: PREPARED BY / EDWARD DECHAUX NEW YORK.

RELATED WORKS: *Study for Cider Making*, pencil, 6¾ × 13⅝ in. (17.1 × 34.6 cm.), about 1840, Museums at Stony Brook, N. Y., an on-the-spot sketch showing the cider mill, the horse at the wheel and barrels in the foreground // *Study for Cider Making*, pencil, 5 × 7¾ in. (12.7 × 19.7 cm.), about 1840, unlocated, ill. in Feld, *MMA Bull.* 25 (April 1967), p. 302. Two sketches of the figure pouring cider into the barrel and a sketch of another figure.

REFERENCES: W. S. Mount to B. F. Thompson, Dec. 5, 1840, MSS in Arch. Am. Art, quoted in A. Frankenstein, *William Sidney Mount* (1975), pp. 102–103 (quoted above) // R. N. Mount to W. S. Mount, Jan. 17, 1841, MSS in collection of Museums at Stony Brook, quoted ibid., p. 61: "I think your last picture 'Cider Making' should have been painted large and placed in one of the verdant squares at the Government House in Washington City" // *New-York Mirror* 19 (May 22, 1841), p. 167, admires the group of figures seated on the crossbeam but thinks that the overall effect is wooden // *American Repertory of Arts, Sciences and Literature* 3 (June 1841), p. 358, notes realism of the painting in a favorable review // *Knickerbocker Magazine* 17 (July 1841), p. 87, thinks that "the groups are felicitously chosen and well depicted" but that the color is "harsh and disagreeable" // *New York American*, April 14, 1841, includes anonymous "letter from a 'jaunting gentleman' enjoying rural life to his Friend on the Pavement," which describes the picture in language full of political allusions (quoted above) // C. Lanman to W. S. Mount, Sept. 25, 1841, MSS in collection of Museums at Stony Brook, N. Y., quoted in Frankenstein, *William Sidney Mount* (1975), p. 111, details why he has not yet been able to see the picture // W. S. Mount, "Catalogue of Portraits and Pictures," MSS in collection of Museums at Stony Brook, quoted ibid, p. 470: "Year 1841. Cider Making. Painted for Mr. Chas. A. Davis, N. York. Received two hundred and fifty dollars for the picture, Size of the canvas 27 in. by 34 inches" // C. Lanman, *Letters from a Landscape Painter* (1845), pp. 244–245 // W. A. Jones, *American Whig Review* 14 (August 1851), p. 124, mentions it but does not discuss political significance // W. S. Mount, Diary, entry of Nov. 14, 1852, MSS in collection of Museums at Stony Brook,

quoted in Frankenstein, *William Sidney Mount* (1975), p. 249: "Cider Making—painted on the spot"; "Autobiographical Sketch, January 1854," MSS in collection of Museums at Stony Brook, N. Y., quoted ibid, p. 19: "Year 1841. Cider Making—painted for Chas. A. Davis Esqr. Now in the Crystal Palace" // C. Lanman, *Haphazard Personalities* (1886), p. 171 // *Tenth Year Book, Brooklyn Institute of Arts and Sciences* (1897–1898), p. 451, says that it was exhibited in the Second Loan Exhibition of Paintings at the Brooklyn Museum // C. J. Werner, *Historic Miscellanies Relating to Long Island* (1917), p. 42, lists this painting as having been executed in 1840 // B. F. Thompson, *History of Long Island* (1918), 3, p. 487 // E. P. Buffet, "William Sidney Mount: A Biography" in *Port Jefferson Times*, Dec. 1, 1923 – June 12, 1924, bound volume of clippings in MMA Library, p. 20, quotes an unidentified contemporary review that criticizes the representation of the roof of the cider mill as having no visible means of support, then quotes a review in the *New York Evening Post* stating that the roof is part of the cider press and contributes its weight in the process of squeezing out the juice; p. 33, notes: "An identification of the building that served as Mount's model for his picture of Cider Milling in Long Island has been contributed by Miss Julia Smith of Setauket who writes: 'The old mill was the one standing by the roadside on the road leading to the Macy homestead, in South Setauket, and the young girl was Hannah Howell, the daughter of Youngs Howell, who, at that time, lived in the old house now forming part of the club house, at the golf grounds in South Setauket . . .' " // B. Cowdrey and H. W. Williams, Jr., *William Sidney Mount* (1944), p. 19, no. 34, list it as unlocated; list two pencil sketches noted above // S. P. Feld, *MMA Bull.* 25 (April 1967), pp. 292–307, fully discusses the picture which had been acquired by the museum after a long period when its whereabouts were unknown // J. Biddle, *Antiques* 91 (April 1967), p. 485 // J. B. Hudson, Jr., *MMA Journal* 10 (1975), pp. 107–118, points out the political background of the painting in a convincing interpretation.

EXHIBITED: NAD, 1841, no. 53 // Exhibition of the Industry of All Nations (Crystal Palace), New York, 1853, no. 216 // Brooklyn Museum, 1897, *Opening Exhibition*, no. 394, as The Cider Mill, lent by W. J. Smith // National Gallery of Art, Washington, D. C.; City Art Museum, Saint Louis; Whitney Museum of American Art, New York; and M. H. de Young Memorial Museum, San Francisco, 1968–1969, *Painter of Rural America*, exhib. cat. by A. Frankenstein, no. 19, col. ill. p. 30 // MMA, 1970, *19th-Century America*, exhib. cat. by J. Howat and N. Spassky, no. 53 // National Gallery of Art, Washington, D. C.; City Art Museum, Saint Louis; Seattle Art Museum, 1970–1971, *Great American Paintings from the Boston and Metropolitan Museums*, no. 45 // Pushkin Museum, Moscow, and Hermitage, Leningrad, 1975, *100 Kartin iz Muzea Metropoliten* [100 Paintings from the Metropolitan Mu-

seum], no. 87 // MMA, 1975–1976, *Notable Acquisitions, 1965–1975*, p. 13; 1976–1977, *A Bicentennial Treasury*, no. 46.

ON DEPOSIT: Brooklyn Museum, 1897–1922, lent by William J. Smith; Port Chester Public Library, Port Chester, N. Y., 1931–1937, lent by Ida L. Hume, Port Chester, N. Y.

EX COLL.: Charles Augustus Davis, New York, 1841–d. 1867; William J. Smith, Brooklyn, N. Y., by 1897–1922; his niece, Ida L. Hume, Port Chester, N. Y., 1922–1937; her son, Edwin P. Hume, Port Chester, N. Y., 1937–1965.

Purchase, Charles Allen Munn Bequest, by exchange, 1966.

66.126.

Long Island Farmhouses

This painting has generally been assigned to the years from 1854 to 1860 on the basis of style and because of the Goupil canvas stamp. The style of the work appeared to many Mount scholars to predate 1860 and the Goupil firm was at the 366 Broadway address only between 1854 and 1859. Thus, there seemed little reason to question this dating. It now appears, however, almost certain that *Long Island Farmhouses* was begun in late 1862 and was completed in the spring of 1863. Ignored until recently (see Van Liew [1977], p. 10), Mount's diary entry for November 26, 1862, very likely refers to this work:

I commenced to paint to day (after a careful drawing) a view from my studio window of the residences of John Davis and R. N. Mount as a background to figures in the foreground. Before I commenced the drawing I washed off the canvas with a clean sponge. When dry I rubbed over the surface with kerosene [in margin: Raw oil will do as well] it being an old canvas. I then made my drawing with white chalk first—and lastly corrected the outline with India ink, using hog's gall—it works well.

That Mount here refers to the houses depicted in the museum's painting is clear. Long ago, Edward P. Buffet [1928], Mount's early biographer, identified the one in the background as the residence of the artist's brother Robert Nelson Mount and the one in the foreground as the Brewster homestead, still occupied about that time by a member of the Davis family. (He also noted that the two houses seen through the crotch of the willow tree were originally the seat of St. George's Manor, once owned by Tangier Smith). In addition, Mount's mention of an old canvas

corroborates the information disclosed by the canvas stamp on the back of the picture. In 1862 or 1863 this canvas would have been anywhere from three to nine years old. Equally important is his statement that he began to paint the picture from his studio window. This was not the studio located in the garret of the Mount family house in Stony Brook but rather the portable studio, or painting-room on wheels, which a carriage maker in Port Jefferson had made for him in 1861. In November 1862, the portable studio was moved from Port Jefferson to Setauket by John Denton and John Davis, the neighbor of Mount's brother. From this time on, and especially while staying in Setauket with his brother, Mount worked mostly in the portable studio. It is interesting to note that in a letter to the museum written in 1928 the artist's nephew and frequent companion, John Brewster Mount, son of Robert Nelson Mount, asserted that *Long Island Farmhouses* was painted from the window of the portable studio. All circumstances, then, strongly indicate that the picture, the only one of this subject by Mount known and a work which is not otherwise mentioned in the Mount papers, is indeed the one he referred to in his November 1862 diary entry. If so, it is clear that he never completed it as he had originally intended, that is, with figures in the foreground.

In many ways this revised dating helps us to understand qualities of *Long Island Farmhouses* that have always been singled out as somewhat uncanonical: the absence of genre content and the remarkable luminosity pervading the work. The rather empty appearance of the spacious foreground becomes more intelligible if we assume that Mount had at first intended to place figures there. The intensity of the sunlight takes on a special meaning in the context of the artist's frame of mind in the spring of 1863. That the painting depicts spring is clear: the tree has sprouted new branches and is about to be covered with foliage, numerous robins are perched upon it, the clothing worn by the children indicates that it is just beginning to warm up, snow has melted and there are puddles immediately behind the fence. Thus it would appear that Mount, who, as noted in a diary entry of February 16, 1863, had done little painting since Christmas, returned to the picture he had begun in November 1862 just at this time. In the midst of the horrifying Civil War, the spring of 1863 brought him hope of victory for the Union cause: "March

22nd, 1863. This afternoon is warm and spring like—the people are out sunning themselves and thinking perhaps of the future of their great country and Democracy; like the warmth of the sun cannot be kept down forever" (quoted in Frankenstein [1975], p. 365).

Another document from this period, a letter Mount wrote to Abraham Lincoln, reveals the depth of the painter's sympathy with the Union cause and must be considered jointly with the previous passage in order to perceive the sensibility behind *Long Island Farmhouses*:

Feb. 24th 1863 . . . Sir, The American Flag should wave in every village in the Union. As an American Citizen, I most respectfully request, that you recommend to Congress the "Good old Flag"—"The Star Spangled Banner" to be forever kept *before the people* by hanging it placed upon every Post Office in the City and Country. So that the Stars and Stripes shall forever wave "O'er the land of the free and the home of the brave"—and not be forgotten by our rising generation" (quoted in Frankenstein [1975], p. 373).

Mount went on to say that "even the vessels in our harbors are often destitute of the National Flag." Accordingly, in *Long Island Farmhouses*, the American flag rather unexpectedly waves atop the mast of the modest sailboat moored in front of Robert Nelson Mount's property.

In view of these documents and of the manner in which similar concerns are echoed in this painting, it is now possible to discern Mount's intent in executing it. To him the plain rural dwellings of his Setauket friends *were* "the land of the free and the home of the brave." It is not the manorial seat, the ancestral home of the Smith family, which is the center of attention here but the houses of the yeomanry, that is to say, the houses of those who would in the past have been beholden to the lord of the manor but who now, thanks to democracy, are independent, prospering men. This contrast of house types must have been intended and in the context of the period was particularly appropriate. In *Eel Spearing at Setauket*, 1845 (New York Historical Association, Cooperstown), for example, the manor house is hidden behind trees in order

Mount, *Long Island Farmhouses*

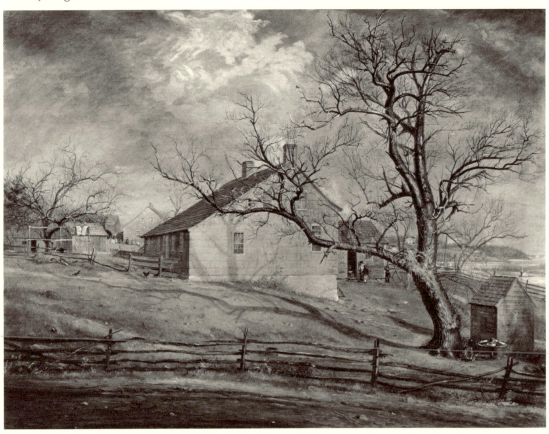

not to interfere with the bucolic mood of the work. It was, after all, precisely the survival of feudalism in the South in the form of slavery and the plantation system (the romantic image of which was, of course, the large white mansion with the columned portico) that was widely perceived in the North to be not only the major cause of the war but also the source of corruption in Southern society. It seems, then, that *Long Island Farmhouses*, in its quiet and undramatic fashion, is actually a strong assertion of the democratic way of life at a time when that way of life was undergoing a political trial which might well result in its disappearance and would certainly, in any event, alter it. Still, Mount was confident of victory, and the warm, bright sunlight of the spring serves as a metaphor. Consequently, light floods his canvas and sharply defines the houses, thus creating a solidity that could not have been greater had he painted structures of stone. The introduction of large figures engaged in some activity or other would have destroyed the quiet eloquence of the picture and would have certainly been inappropriate.

The astonishingly prosaic plainness of *Long Island Farmhouses* is related to other developments in American culture at this time. Like Lincoln's Gettysburg Address, it puts across large and deep sentiments in eloquently clear, but also very simple, tones. As Edmund Wilson noted in *Patriotic Gore* (1962), the trauma of the Civil War resulted in a general "chastening of American prose." In this painting, Mount seems to express just such a sensibility.

Oil on canvas, 21⅞ × 29⅞ in. (55.6 × 75.9 cm.). Signed at lower left: wᴹs. MOUNT.

Canvas stamp: GOUPIL & CO / ARTISTS COLOURMEN / & PRINT SELLERS / 366 / BROADWAY / NEW YORK.

RELATED WORKS: *Detail from Long Island Farmhouses*, ca. 1863, 5 × 4 in. (12.7 × 10.2 cm.), oil on wood, Museums at Stony Brook // *Detail from Long Island Farmhouses (Children Playing by a House)*, ca. 1863, oil on wood, 3⅝ × 4¼ in. (8.9 × 11.4 cm.), Museums at Stony Brook.

REFERENCES: W. S. Mount, Diary, Nov. 26, 1862, in collection of Museums at Stony Brook, N. Y., quoted in A. Frankenstein, *William Sidney Mount* (1975), p. 363 // L. Wickham, letters in MMA Archives, March and April, 1928, supplies provenance // E. P. Buffet, letter in Dept. Archives, May 27, 1928, identifies houses in the painting and notes that a very old man named Davis who occupied the Brewster homestead had only recently died // B. Burroughs, *MMA Bull.* 23 (July 1928), pp. 175–178, says it represents "a mild day of veiled sunlight in early spring," notes that the old cart wheel on its axle fixed table-wise in the ground holds pans of milk set out to sweeten in the fresh air, and thinks that the little boy hiding behind a corner of the house is wearing a child's soldier suit of Civil War times; he thus dates the painting to the time of the Civil War // J. B. Mount, letter in Museum Archives, July 31, 1928, writes: "It may be of interest that I am the *owner* of the artists *portable studio* [and] that 'L. I. Farmhouses' *was* painted from its windows" // J. Lane, *Art Quarterly* 4 (1941), p. 135, suggests that the color may have been influenced by Mount's study of Michel E. Chevreuil's *De la loi du contraste simultane des couleurs* (1839) // H. W. Wehle, memo in Dept. Archives, March 7, 1941, notes painting "is not likely to be more than two or three years after the last year" in which the canvas was stenciled // J. Overton, *Antiques* 41 (Jan. 1942), p. 47, says the old Brewster homestead had always been a favorite stopping place for Mount and that in this painting he recorded it on an early spring day in 1863, but gives no sources for this information // B. Cowdrey and H. W. Williams, Jr., *William Sidney Mount* (1944), p. 26, no. 93, date it about 1854–1860 on the basis of style and canvas stamp // E. P. Richardson, *Painting in America* (1956), p. 174 // A. Frankenstein, *William Sidney Mount* (1975), pp. 324, 479, says that "there is not a word among all the letters and papers by or relating to William Sidney Mount concerning the *Long Island Farmhouses*,"

Mount, *Detail of Long Island Farmhouses*. Museums at Stony Brook.

p. 343 (quoted above) // R. B. Stein, *American Art Review* 3 (March-April 1976), pp. 72–74, discusses its formal structure and concludes that it reflects "the romantic drama between the human will to form, order and enclosure and the openness of nature's space" // J. Wilmerding, *American Art* (1976), p. 117, says it depicts a late autumn afternoon and compares its contemplative mood to the late poetry of Walt Whitman // M. Brown, *American Art to 1900* (1977), p. 344, color pl. 43 // B. F. Van Liew, *Preservation Notes* [Society for the Preservation of Long Island Antiquities] 13 (June 1977), p. 10, notes that Mount's Diary entry for Nov. 27, 1862, refers to this painting.

EXHIBITED: MMA, 1934, *Landscape Paintings*, no. 69; 1939, *Life in America*, no. 114 // Brooklyn Museum, 1942, *William Sidney Mount*, no. 98 // Cleveland Museum of Art, 1944, *American Realists and Magic Realists* (no cat.) // MMA, 1945, *William Sidney Mount and His Circle*, no. 13 // Tate Gallery, London, 1946, *American Paintings*, no. 158 // Suffolk Museum, Stony Brook, N. Y., 1947, *The Mount Brothers*, no. 117 // American Academy of Arts and Letters, New York, 1954, *The Great Decade in American Writing, 1850–1860*, no. 158 // Detroit Institute of Arts, Art Gallery of Toronto, City Art Museum of Saint Louis, Seattle Art Museum, 1951–1952, *Masterpieces from the Metropolitan Museum of Art* (no cat.) // Cincinnati Art Museum, 1955, *Rediscoveries in American Painting*, no. 64 // MMA, 1958–1959, *Fourteen American Masters* (no cat.); 1965, *Three Centuries of American Painting* (checklist arranged alphabetically); 1970, *19th-Century America*, cat. by J. Howat and N. Spassky, no. 55 // Indianapolis Museum of Art, 1970–1971, *Treasures from the Metropolitan*, no. 4 // MMA and American Federation of Arts, traveling exhibition, 1975–1977, *The Heritage of American Art*, exhib. cat. by M. Davis, no. 36 // New York State Museum, Albany, 1977, *New York, the State of Art*, p. 33.

EX COLL.: the artist's niece, Maria Seabury, Setauket, N. Y.; her cousin, William Hull Wickham, New York; his daughter, Louise Floyd Wickham.

Gift of Louise F. Wickham, in memory of her father, William H. Wickham, 1928.

28.104.

THOMAS CHAMBERS

1808 – after 1866

Not much is known of the life of Thomas Chambers. He was born in London in 1808 and came to this country in 1832. His wife, Harriet Shelland Chambers, also from London, followed him two years later. So far there is no evidence that he had artistic training, although he may have had some early experience as a china painter. Judging from the execution of his paintings and his characteristic manner of altering print sources, however, he was probably self-taught. From 1834 to 1837 he is listed in the New York city directories as a landscape painter and then until 1840 as a marine painter, but he never exhibited his work at any of the art organizations of the day. In 1840 he moved to Boston, staying until 1851, when, probably in the spring, he went to Albany. He returned to New York in 1857 or 1858, apparently remaining there for the most part until 1866, the last year in which there is any record of him.

As very few of Chambers's known works are dated, a chronology of his paintings has not been attempted and since he primarily used print sources, it is difficult to consider his stylistic development. His early work is probably the more conventional. Howard S. Merritt tentatively linked him to British landscapists such as Richard Wilson and to the French sea painter Joseph Vernet. More simply, his work seems to reflect the conventions of landscape painting developed in the eighteenth century and extended into the nineteenth by the makers of popular prints. What is peculiar to Chambers, however, is his use of strong colors, which

can be arbitrary and at the same time very beautiful, and his bold use of paint, as seen, for example, in his clouds, which are often strikingly formed masses of paint.

No contemporary reference to Chambers's work has been found. The New York State census of 1855 lists him as living in a house valued at twenty-five hundred dollars, which indicates that he had some means. His works were forgotten for many years until 1942, when an exhibition brought them to light.

BIBLIOGRAPHY: Macbeth Gallery, New York, *T. Chambers, Active 1820–1840, First American Modern* (1942). The first exhibition devoted to the artist // Nina Fletcher Little, "T. Chambers, Man or Myth?" *Antiques* 53 (March 1948), pp. 194–197 // Howard S. Merritt, "Thomas Chambers— Artist," *New York History* 37 (April 1956), pp. 212–222.

The Constitution and the Guerrière

This painting commemorates the first important naval battle of the War of 1812, which took place between the American frigate *Constitution* and the British frigate *Guerrière*. Under the command of Captain Isaac Hull, who had effected her dramatic escape from a British squadron off the New Jersey shore, the *Constitution* slipped out of Boston and came upon the *Guerrière* about six hundred miles east. The ensuing battle was fierce, but the *Constitution*'s fire, directed at the *Guerrière*'s hull, was more accurate, reducing her to such a wreck that she could not be towed into port as a prize and had to be burnt at sea. Tradition has it that the *Constitution* was nicknamed Old Ironsides after one of her gunners saw a shot bounce off the heavy oak planking and shouted "Her sides are made of iron!" Although the battle did not have far-reaching military consequences, it raised American morale considerably.

The closest known source for the painting, which has been tentatively dated about 1845, is an engraving by Cornelius Tiebout after a painting by Thomas Birch (1779–1851) entitled *Engagement Between the Constitution and the Guerrière*, ca. 1813 (MFA, Boston). Chambers made a number of changes from the print, most of which heighten the impact of the scene. The principal change is that the diagonal cloud pattern is opposed to those of the powerful waves below, with the emphatic thrust of the *Constitution*'s yard between. Chambers increased the violence of the encounter by multiplying the holes in the sails of both ships, by showing the *Guerrière*'s mizzenmast completely collapsed, and by adding a lifeboat in the water. He enlarged the three American flags on the *Constitution* and added a fallen British flag on the *Guerrière*. Painted in strong, pure colors, with the water an unusual dark green and the sky a brilliant blue, the composition demonstrated Chambers's originality and force.

Chambers, *The Constitution and the Guerrière*.

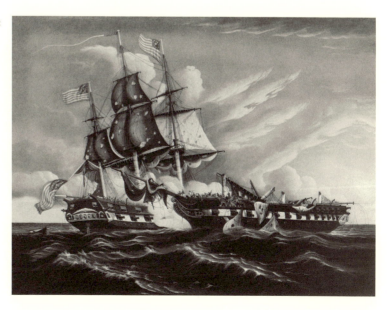

Oil on canvas, 24¾ × 31¼ in. (62.9 × 87.2 cm.).

REFERENCES: Gardner and Feld (1965), p. 278 // J. Wilmerding, *A History of American Marine Painting* (1968), p. 39, ill. p. 41 // T. P. F. Hoving, *Art in America* 58 (March-April 1970), ill. p. 63.

EXHIBITED: MMA, 1962, *101 Masterpieces of American Primitive Painting from the Collection of Edgar William and Bernice Chrysler Garbisch*, p. 148, no. 73 // MMA, 1965, *Three Centuries of American Painting* (checklist arranged alphabetically) // Osaka, 1970, United States Pavilion, Japan World Exposition, *American Paintings* (no cat.) // Whitney Museum of American Art, New York, 1975, *Seascape and the American Imagination*, exhib. cat. by R. B. Stein, no. 18, fig. 32 // Virginia Museum of Fine Arts, Richmond, and Mariners Museum, Newport News, Va., 1976, *American Marine Painting*, ill. no. 18.

EX COLL.: with Macbeth Gallery, New York, 1942; Edgar William and Bernice Chrysler Garbisch, 1962.

Gift of Edgar William and Bernice Chrysler Garbisch, 1962.

62.256.5.

Lake George and the Village of Caldwell

This landscape came into the Metropolitan Museum's collection with the title *Stony Point, New York*. Chambers's source for the composition, however, was a print by Leon Sabatier after Jacques Milbert's *Lake George and the Village of Caldwell*. Chambers used the same print as the source for at least two other paintings, *The Hudson Valley, Sunset* (National Gallery of Art, Washington, D.C.) and *Hudson River Scene* (New York art market, 1986). All three paintings, which probably date from the 1850s, share the same general composition; none includes the men and animals that enliven the foreground of the print. The primary difference between the paintings and the print is that Chambers seems to have changed the time of day. The absence of figures and the long shadows cast over the left side of the scene indicate that it is early evening. Perhaps to enhance the sense of calm in the scene, Chambers also eliminated much of the intricate foliage, especially in the museum's picture, which is characterized by its smooth texture overall. The water has a mirror-like surface that is only broken by sailboats. The scene is an idyllic view of a town, as seen by a traveler descending the road in the foreground.

Oil on canvas, 22½ × 30½ in. (52.1 × 77.6 cm.).

ON DEPOSIT: Gracie Mansion, New York, 1971, 1974–1975, 1981–1984.

EX COLL.: with Henry Coger, 1963; Edgar William and Bernice Chrysler Garbisch, 1963–1966.

Gift of Edgar William and Bernice Chrysler Garbisch, 1966.

66.242.17.

Chambers, *Lake George and the Village of Caldwell.*

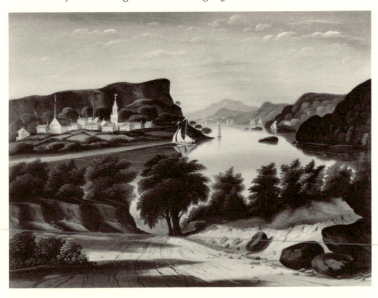

THEODORE SIDNEY MOÏSE

1808–1885

Theodore Sidney Moïse, according to an account written by his son Judge James C. Moïse, was born in Charleston, the son of Cecelia Wolfe and Hyam Moïse. Although he was apparently gifted in drawing and painting since childhood, he did not at first desire to follow an artistic career and refused his uncle's offer to study abroad. For six or seven years he worked as an accountant in a cotton factory, painting portraits on the side that were successful enough to bring him recognition. Persuaded to take up painting professionally, he was described in the *Charleston Courier* in 1835 as a self-taught and capable artist who merited admiration from older, established painters. The following year, however, he had to advertise as a restorer of paintings and ornamental penman for ladies' albums. His portraits at this time are competent and realistic but rather stiff (see, for example, the portrait of Mordecai Cohen, ca. 1834–36, Gibbes Art Gallery, Charleston).

In 1836 Moïse left Charleston, first going to Woodville, Mississippi, before settling in New Orleans in 1842. There he set up a partnership with an artist named Beard, probably James H. Beard (1812–1893). During this period, according to his son, Moïse worked throughout Louisiana and surrounding areas, spending four years in Kentucky, mainly in Louisville and Frankfort, and then one year in New York. He was often accompanied by his pupil Trevor T. Fowler (working 1829–1871), who is said to have painted the backgrounds and drapery of some of his portraits. Moïse's next partnership, from 1859 until the Civil War, was with Benjamin Franklin Reinhart (1829–1885). During the war, Moïse served as a major in the Confederate army. On his return to New Orleans, he became a partner with Paul Poincy (1833–1909) and continued to paint in a studio on Carondelet Street until the end of his life. He died at Natchitoches, Louisiana, the hometown of his wife, Mathilde Vaughn, by whom he had six sons.

Moïse's later works show him to have assimilated the romantic, rather freely painted style of THOMAS SULLY. A large number of his portraits of prominent people still hang in the public buildings of New Orleans. He also painted portraits of racehorses, a predilection shared by two fellow artists with whom he often collaborated, Paul Poincy, his last partner, and Victor Pierson. Two of his paintings are certainly curiosities. One, painted about 1867 with Pierson, called *Life on the Metairie*, 1867 (Fair Grounds Race Track, New Orleans), contains portraits of forty-four well-known citizens enjoying a day at the Metairie Race Course. The other, painted with Pierson and Poincy, *New Orleans Volunteer Fire Department* (Louisiana State Museum, New Orleans), shows sixty-four members of that organization on parade on March 4, 1872.

One of Theodore Moïse's sons, Judge James C. Moïse (1849–1901), was an amateur portrait painter. He wrote that his father was "genial and social in disposition and was esteemed and admired wherever he went. In addition to his many talents he was often summoned before the courts of law as a handwriting expert."

BIBLIOGRAPHY: James C. Moïse, "Theodore S. Moïse," April 1900, MS in Scrap Book No. 100, p. 31, Louisiana State Museum (kindly supplied by John A. Mahé II, curator of the Historic New Orleans Collection // Edna Talbott Whitley, *Kentucky Ante-Bellum Portraiture* (Washington, D.C., 1956) // H. B. Wehle, "A Portrait of Henry Clay Reattributed," *MMA Bull.* 20 (Sept. 1925), pp. 215–216 // Anna Wells Rutledge, *Artists in the Life of Charleston: Through Colony and State from Restoration to Reconstruction* (Philadelphia, 1949), pp. 153, 238. Contains contemporary newspaper references to the artist // Letter from John A. Mahé II, Historic New Orleans Collection, April 21, 1983, Dept. Archives. Includes copies from New Orleans newspapers and city directories with particulars about Moïse's career.

Henry Clay

In January 1843, when Moïse painted this portrait, Henry Clay (1777–1852) was near the height of his fame. In March of the previous year he had resigned his seat in the United States Senate and returned to Ashland, his farm in central Kentucky. He made a series of triumphant visits to other sections of the country that led to his nomination by acclamation as the Whig candidate in the presidential election of 1844, which he lost, however, to James K. Polk.

It is quite possible that Moïse based the painting on life studies of Clay, who arrived in New Orleans with great fanfare in December 1842,

Moïse, *Henry Clay.*

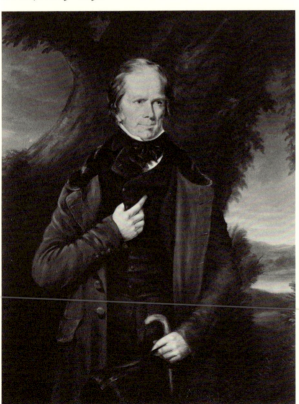

the year Moïse settled there. Clay came to argue a case before the Supreme Court in the city in January 1843, and he greatly impressed the spectators with his oratorical skills. The hills in the landscape background, however, are evidence that the locale is not meant to be New Orleans. Since Clay had made much of his intention of returning to his farm in Kentucky, it is possible that Moïse chose that as the setting.

Clay is shown standing stiffly in front of an enormous tree trunk, his shoulders slanted to an apparently exaggerated degree. His right arm is slightly out of proportion, and in his left hand he holds a walking stick. The loose handling of paint and the use of very dark colors, especially in the foreground, relieved by a few passages of reds, blues, and yellows in the landscape background, are reminiscent of French romantic portraiture of the 1830s and 1840s, particularly of Ary Scheffer, who favored baroque prototypes. Most contemporary American portraitists used far brighter colors. Moïse may have seen French portraits in this dark manner in New Orleans.

The portrait was commissioned by one of Clay's admirers, John Freeland, co-owner of the Orleans Cotton Press. Freeland, who had started as a cotton presser in that business, was at this time living on Carondelet Street, where Moïse's studio was located. For many years the portrait is said to have hung in the house of Freeland's son-in-law, Colonel John Redmon Saxe Lewis, in Lexington, Virginia.

Because of a misreading of the signature, the work came to the museum attributed to SAMUEL F. B. MORSE. It was properly attributed in 1925. There is another portrait of Clay by Moïse in the Tennessee State Museum, Nashville.

Oil on canvas, $51\frac{1}{16} \times 39\frac{1}{2}$ in. (129.7 × 100.3 cm.).

Signed and dated at lower right: Moïse / Jan 7 / 1843.

REFERENCES: *New Orleans Daily Picayune*, Jan. 31, 1843, p. 2, probably describing this portrait, exhibited in the St. Charles Hotel, says Clay is not shown "with the emblems of state surrounding him, but is pictured in that old, snuff-colored overcoat, which all recognize at a glance, with a good firm walking stick—hickory we'll be sworn—in his hand, and the principal feature in the background is a portion of the trunk of a venerable ash tree. . . . The likeness is striking indeed"; April 6, 1843, p. 2, again probably describing this portrait, exhibited in the artist's studio, says "painted to the order of a gentleman of this city" || C. H. Hart, *McClure's Magazine* 9 (Sept. 1897), ill. p. 942, says "signed and dated 'S. F. B. Morse 1841'" || E. L. Morse, ed., *Samuel F. B. Morse, His Letters and Journals* (1914), 1, opp. p. 400, as by Morse || H. B. Wehle, *MMA Bull.* 20 (Sept. 1925), pp. 215–216, corrects attribution || Gardner and Feld (1965), pp. 240–241.

EXHIBITED: Gentlemen's drawing room, St. Charles Hotel, New Orleans, Jan. 1843, probably this portrait || the artist's studio, New Orleans, April 1843, probably this portrait || Toledo Museum of Art, Ohio, 1913, *Perry Victory Centennial Exhibition*, no. 20, as by Morse || MMA, 1939, *Life in America*, ill. no. 127.

ON DEPOSIT: Bar Association of New York, 1952–1983.

EX COLL.: John Freeland, New Orleans, 1843; his son-in-law, John Redmon Saxe Lewis, Lexington, Va., until about 1895; William F. Havemeyer, New York, by 1897; Mrs. William E. Dodge, Jr., New York, by 1909.

Gift of Grace H. Dodge, 1909.

09.24.

JOHN GADSBY CHAPMAN

1808–1889

John Gadsby Chapman was born in Alexandria, Virginia, to Margaret Gadsby and Charles T. Chapman. His father was a businessman from an old Virginia family, and his mother was the daughter of John Gadsby, the owner of successful taverns in Alexandria, Baltimore, and Washington. Chapman's father had hoped that he would study law, but his interest was in drawing. Indeed, he later told Henry T. Tuckerman that he couldn't "remember the time when he did not sketch" (p. 218). This talent was encouraged by his artist friends George Cooke (1793–1849) and Charles Bird King (1785–1862).

In 1827 Chapman began his professional career in Winchester, Virginia, but he quickly realized his need for formal training. A few months working under the Italian drawing master Pietro Ancora (active ca. 1800–1843) and drawing from casts at the Pennsylvania Academy of the Fine Arts sparked his interest in history painting. As he could find no satisfactory instruction in this field at home, Chapman sought and obtained financial backing from friends to study in Italy. In Florence and Rome he made numerous copies of the great masterpieces, among them Guido Reni's *Aurora*, copied for James Fenimore Cooper. Shortly after completing that commission, he embarked on his first major work, *Hagar and Ishmael Fainting in the Wilderness*, which is known today only through an engraving published in 1830.

As Tuckerman noted (p. 217), during the spring and summer of 1830, "Arrayed in a goatskin and untanned shoes of a peasant," Chapman accompanied SAMUEL F. B. MORSE on sketching trips to the Italian countryside east of Rome and to the coastal towns of Naples, Capri, and Amalfi: "Every well-defined outline in the mountain ranges, each graceful shrine, the effective attitude of monk or vintager, the tower of the middle ages, the isolated cornice or pillar . . . the vine-laced terrace or the rocky headland afforded an idea or illustrated an effect which they sketched for future use."

In 1832, one year after Chapman's return from Europe, he married Mary Elizabeth Luckett of Alexandria. They had three children. Chapman taught their two sons to paint, and they became competent artists. John Linton Chapman (1839–1905) gained recognition for his Italian scenes and Conrad Wise Chapman (1842–1913) for his series of paintings on the Civil War.

There was little interest in John G. Chapman's history paintings, so between 1832 and 1833 he traveled throughout Virginia seeking portrait commissions. During this itinerant period, he went to Montpelier and Yorktown, where he painted a group of pictures relating to the lives of James Madison and George Washington. These paintings are considered to be in his best style, showing an absorption in the natural beauty and historical significance of his native countryside. Many of Chapman's paintings from this period were destroyed during the Civil War and are known today only from engravings.

Still unable to find a market for grand historical scenes, Chapman moved in 1834 to New York, where he satisfied his desire for this "higher form" of art by creating pictorial scenes for book illustrations. His first patron was the author James Kirke Paulding, who used several of Chapman's scenes of Virginia in his *Life of Washington*. Seven of these paintings were shown in the spring of 1835 at the National Academy of Design, where Chapman was elected an academician the following year. Tuckerman (p. 218) pointed out Chapman's incredible vitality and facility in a variety of media: "He is familiar with all the processes of the artisan as well as those of the artist; now at work on a mezzotint and now on a woodcut; to-day casting an iron medallion, and to-morrow etching on steel; equally at home at the turning-lathe and the easel, and as able to subdue plaster and bronze, as oils and the crayons, to his uses." Chapman's finest printed illustrations were etchings for Paulding's *A Christmas Gift from Fairy Land* (1838) and *The Poets of America*, edited by John Keese (1840). His most famous illustrations were the fourteen hundred wood engravings that appeared in Harper's *Illuminated Bible*. The *American Drawing-Book*, his favorite project, is still considered by many to be the finest instructive drawing manual. It was published numerous times between 1847 and 1877. Between 1837 and 1840, Chapman worked on one of his most important commissions, *Baptism of Pocahontas*, a monumental history painting that decorates the Rotunda of the United States Capitol.

The demand for his work in New York, mounting pressures from publishers, lack of time for serious painting, and failing health precipitated his move to Europe in 1848. He took his family first to London, then Paris in 1849, and finally Rome in 1850, where he remained for the next thirty-four years. The first years in Europe were spent in relative comfort. The outbreak of the Civil War in the United States, however, sharply reduced the tourist trade, which had provided Chapman's clientele, and, by 1864 he was in dire financial straits. Yet, he remained in Rome for two more decades, except for a brief trip to New York in 1877. He died on Staten Island in 1889.

BIBLIOGRAPHY: Henry T. Tuckerman, *Book of the Artists* (New York, 1867), pp. 216–222 // Georgia Stamm Chamberlain, *Studies on John Chapman: American Artist, 1808–1889* (Annandale, Va, 1963). A series of articles that were published in various magazines between 1957 and 1961 // National Gallery of Art, Washington, D.C. *John Gadsby Chapman: Painter and Illustrator*, exhib. cat. by William P. Campbell (1962).

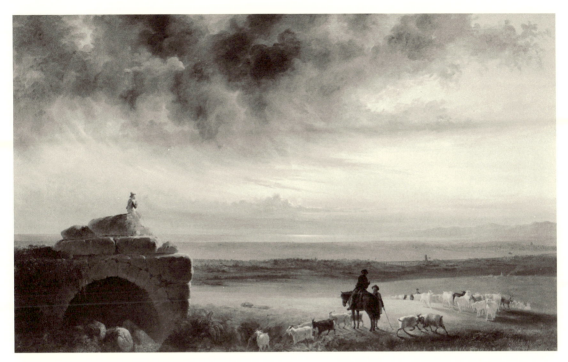

Chapman, *The Roman Campagna*.

The Roman Campagna

From Chapman's first visit to Italy in 1830, the Roman Campagna remained one of his favorite subjects. Four years after the artist's return to Rome in 1850, an anonymous English critic wrote in the *Art Journal*:

Mr. Chapman, an American painter, has great merit and a most suggestive poetic fancy. I much admired some views by him of the Campagna, that exhaustless field for the pencil, with its hourly changes of colour and shade, as the brilliant clouds sail across it,. . . or at the gorgeous sunset (June 1, 1854, p. 186).

Despite such enthusiasm, Chapman found few major commissions and mainly derived his income from painting small scenes of the Italian countryside which he sold as souvenirs to American and English tourists. These views invariably included peasants in bucolic settings with overgrown ruins. He met the increasing demand for these pictures by producing hand-colored etchings of his more successful pictures, such as *Italian Shepherds on the Campagna*, 1857; *Views Out of the Porta Salara over the Lake of Albano* and *The Roman Campagna*, both 1864; and *Harvesting on the Roman Campagna*, 1867.

The Roman Campagna was painted in 1864 and is probably the picture referred to in Tuckerman

Chapman, *Latium from the Alban Hills*, etching. NYPL.

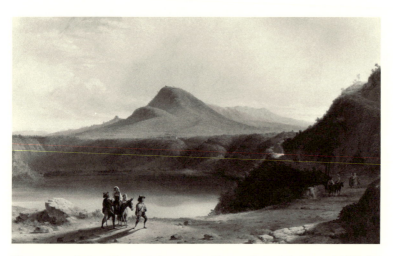

Chapman, *Lake Albano, Going to the Fiesta of the Madonna del 'Tufo*.
Private collection.

(1867) as "a 'Sunset on the Campagna,' very rich in coloring, the higher clouds perhaps a trifle hard." The panoramic view is taken from the Alban Hills overlooking the stark plains of the Campagna. Chapman gives the viewer a vantage point similar to that of the peasant seated on the broken column before a luminous sunset. Two peasants, one on a horse, are seen in silhouette, and their goatherd ascends the hill. In the background Chapman has depicted the Claudian aqueduct. In the distance, on the far right, is the city of Rome; close inspection reveals the dome of Saint Peter's Church. Mountains beyond are included as a compositional device; they form an inlet on the Mediterranean Sea, which spans the horizon. Chapman has rearranged and telescoped elements of Latium in order to include important landmarks. This basic composition was typical for him.

The *Roman Campagna* embodies atmosphere, freshness of coloring, and minute detail. The panoramic composition establishes a romantic aura, which is increased by the hot pink sky, turbulent clouds, and dramatic contrasts of light and shadow caused by the setting sun. The painting has a companion piece, *Lake Albano, Going to the Fiesta of the Madonna del 'Tufo* (private coll., Brookline, Mass.), which, like this painting, was also inscribed to Miss Billings of Boston.

Oil on canvas, $36\frac{1}{8} \times 59\frac{7}{8}$ in. (91.8 × 152.1 cm.). Signed, dated, and inscribed at lower left: J. G. C. / Roma / 1864. Inscribed on the back before lining:

THE ROMAN CAMPAGNA / for MISS BILLINGS – BOSTON. U. S. / by John G. Chapman / Rome. 1872.

RELATED WORKS: Two etchings in *Views and Incidents on the Roman Campagna* (1877). The scene is reproduced in its entirely on contents page. Detail of *The Roman Campagna* showing peasant seated on column, 5 × 12 in. (12.7 × 30.5 cm.), is on title page || *Latium from the Alban Hills*, etching, $4\frac{1}{16} \times 11$ in. (10.3 × 27.9 cm.) is identical to MMA painting but without higher clouds || *Claudian Aqueduct Alban Mountains*, etching, $4\frac{1}{16} \times 11$ in. (10.3 × 27.9 cm.), a closeup of the aqueduct in MMA painting || attributed to Chapman, *Sunset over the Campagna*, oil painting over an etching, 4 × 11 in. (10.2 × 27.9 cm.), Valentine Museum, Richmond, Va., ill. in *Bulletin of the Virginia State Library* 12 (July, October 1919), p. 83, Sheet III, picture 3.

REFERENCES: H. T. Tuckerman, *Book of the Artists* (1867) p. 221, says a recent letter from Rome alludes to a Sunset on the Campagna (quoted above, possibly this painting) || E. P. Richardson, *Painting in America* (1956), p. 172, "his landscapes and color etchings of the Campagna are fresh in color and reveal a sensitive and poetic talent" || Edward F. Heite, *Virginia Cavalcade* (Winter 1968) vol. 17, ill. p. 17, as "one of the several paintings of the Roman Campagna which Chapman painted, probably for sale to American tourists."

EXHIBITIONS: MMA, 1975, *The Heritage of American Art*, exhib. cat. by M. Davis, ill. no. 38, p. 96, and describes this picture.

EX COLL.: the artist, 1864–1872; Miss Billings, Boston, by 1872; with Victor Spark, New York, by 1967.

Gift of Mrs. John C. Newington, 1967.
67.54.

WILLIAM JAMES HUBARD

1809–1862

The nineteenth-century silhouettist, painter, and sculptor William James Hubard was born in Whitchurch, England. His talent was revealed at the age of seven when he cut silhouettes of members of his church. He became exceptionally skilled at this art. In September 1822, a Mr. Smith brought him to Ramsgate, where he billed Hubard as an "infant phenomenon." For the next two years they had a traveling gallery, and Hubard cut silhouettes in England, Scotland, and Ireland. In Glasgow, the Philosophical Society presented Hubard with a silver palette in admiration of his genius.

In 1824 Smith packed up the traveling exhibition, which included works by other silhouettists, and sailed for New York. The Hubard Gallery remained in New York for one year and next appeared in Boston, where Hubard cut hundreds of silhouettes. Hubard, however, tired of producing the cuttings and his interest turned increasingly to oil painting. This caused a disagreement between Hubard and Smith in the spring of 1826. Smith pocketed close to ten thousand dollars which he held as Hubard's manager and left the artist penniless.

Credit for Hubard's introduction to painting has been variously attributed to ROBERT W. WEIR, GILBERT STUART, and THOMAS SULLY. It appears that they all had a part in his advancement. WILLIAM DUNLAP records that Weir "persuaded Hubard to try oil painting, and left him his materials" and that Hubard also "had the advice of Sully" (*A History of the Rise and Progress of the Arts of Design in the United States* [New York, 1834], 2, p. 477). Hubard had probably met Weir in New York during 1824. Evidence of Stuart's assistance appeared in the *Boston News Letter* of April 8, 1826, "Since his [Hubard's] arrival in America, he has conceived a strong passion for painting in oil. We understand Mr. Hubard is now under the instruction of our celebrated Mr. Stuart." Hubard's earliest known painting, about 1826–1827, is a portrait of John Doggett, Jr., of Boston (ill. in *William James Hubard* [1948], p. 17). Doggett family tradition asserts that it was done under Stuart's tutelage and in his studio.

Hubard was in New York during 1828 and in Philadelphia by May 1829, when he studied briefly with Sully and exhibited at the Pennsylvania Academy of the Fine Arts. In 1831 and 1832 he exhibited again at the academy giving his address as Baltimore. Included were portraits of Henry Clay (University of Virginia, Charlottesville) and John C. Calhoun (Corcoran Gallery of American Art, Washington, D.C.), part of a series of statesmen Hubard painted. Other sitters included John Marshall (University of Virginia) and Charles Carroll (see below). The portraits are all cabinet size (about 20 x 14 inches), each man shown seated full length in the approximate center of the composition and surrounded by carefully detailed accessories.

From about 1833 to 1836, Hubard worked in Virginia as an itinerant in Norfolk, Williamsburg, Bremo, Richmond, and Gloucester, where he met Maria Mason Tabb. They married in late 1837 and by early 1838 they were in Europe. He studied the Dutch masters, whose art he found akin to his own tight meticulous style. However, after studying the art

of Raphael in Florence, Hubard's style became bolder. When he returned to Virginia in 1841, he set up a studio in Richmond. His portraits of the forties and early fifties show solid modeling and strong delineation of features. His palette lightened, flesh tones became warmer, and drapery more lustrous. These portraits, which are mainly bust length, often do not exhibit the keen portrayal of character and originality of composition of his earlier ones.

During the 1850s Hubard's interests turned to sculpture; he devoted most of his time and money to casting copies of Jean Antoine Houdon's statue of Washington in the Virginia Capitol. He even set up his own foundry to do this and by 1860 had reproduced six bronze copies. When the Civil War began in April of 1861, there was little market for them, and so he turned to making cannon and munitions at his foundry. In 1862 he was severely injured when a shell accidentally detonated at his plant. He died two days later.

BIBLIOGRAPHY: *A Catalogue of the Subjects Contained in the Hubard Gallery to Which Is Prefixed a Brief Memoir of Master Hubard* (New York, 1824) // Alice Van Leer Carrick, *Shades of Our Ancestors* (Boston, 1928) // Mabel M. Swan, "A Neglected Aspect of Hubard," *Antiques* 20 (Oct. 1931), pp. 222–223. Discusses the artist in context of his painting and sculpture // Valentine Museum, Richmond, *William James Hubard* (1948), exhib. cat. by Helen G. McCormack. A comprehensive catalogue of the artist's work // Sue McKechnie, *British Silhouette Artists and Their Work, 1760–1860* (London, 1978), pp. 236–246. A highly detailed account of the artist's life.

Charles Carroll of Carrollton

Charles Carroll (1737–1832) was the only child born to Charles and Elisabeth Brooke Carroll of Annapolis, Maryland. His grandfather, an Irish nobleman and Roman Catholic, came to Maryland as attorney general in 1688 hoping to find religious freedom. Instead, he found the same discriminatory laws he had left behind. Nonetheless, he stayed and prospered. His financial acumen was inherited by his son, who became the wealthiest man in the country. A very disciplined man, he established an ambitious program for educating his heir in matters intellectual, religious, and social, and felt this could only be accomplished abroad. After a predominately Jesuit education in Maryland, the eleven-year-old Carroll was sent to Europe on an educational odyssey that lasted sixteen years. Following graduation from the Collège of Louis-le-Grand in Paris, he begged to return home, but his father insisted he stay. He studied law in Bourges for four years and then at the Middle Temple in London for five years. On his return to Annapolis in 1765 he took over the operations of Carrollton, the ten-thousand-acre manor, located in what is now Frederick County, which his father had made over to him. Three years later, at the age of thirty-one, he married his cousin Mary Darnall. They eventually had seven children, of which three survived.

Carroll was an early supporter of the colonial cause, for he believed that independence would lead to religious equality. He emerged politically in 1773 when he criticized the government in what became a heated newspaper debate. Active in the nonimportation protests of 1774, he served on the local Annapolis Committee of Correspondence, attended the first Maryland Convention, and was on the Committee of Safety. In 1776 the Continental Congress appointed Carroll along with Benjamin Franklin and Samuel Chase "to promote or form a union" between Canada and the colonies. After that mission failed, he went to the Maryland Convention of 1776, where he was instrumental in the vote to reverse the earlier vote by the Maryland colony to stay with England. At the Continental Congress in Philadelphia, Carroll voted in favor of the Declaration of Independence, signing his name "Charles Carroll of Carrollton" to distinguish himself from his father and cousins of the same name. He served as a state senator from 1777 to 1801 and represented Maryland as a United States Senator from 1789 to 1792. After Jefferson's Democratic party won the election of

1800, Carroll retired to Doghoregan Manor, Howard County, and dedicated himself to his estates—seventy to eighty thousand acres of timber and farmland in Maryland, Pennsylvania, and New York. He advanced the young republic's and his own fortunes by supporting the First and Second Banks of the United States, the Bank of North America, the Baltimore and Ohio Railroad, and the Chesapeake and Ohio Canal.

After Thomas Jefferson and John Adams died in 1826, Carroll was revered as the only surviving signer of the Declaration of Independence. He was honored on numerous ceremonial occasions and divided his time between his manor and the home of his daughter, Mary Caton, in Baltimore. It was in her home that he died at the age of ninety-five.

This cabinet-size portrait is one of the series of statesmen painted by Hubard around 1830, two years before Carroll's death and the last known portrait of him. It was a considerable honor to have Carroll sit for him. Although Carroll had been painted by many leading artists of the day, he had refused another artist's request in 1827, remarking "at my age it is very irksome to set for my picture" (1975, p. 184). In its crispness and direct vitality, this picture is characteristic of Hubard's early style. It embodies the description made by Carroll's contemporary John H. B. Latrobe, who first met him in about 1823:

Below the middle size, weak and emaciated, . . . you saw in him, as he approached to greet you, a very feeble and aged man. His hair was scant and white and silky, and his eyes especially were suggestive of great age. His complexion, however, was healthy His dress was the knee breeches of the old school . . . and I never saw him except in a loose roquelaure, something between a dressing gown and a frock coat. His manners were charming, his countenance pleasant and sprightly, and as one looked at Mr. Carroll, one saw a shadow from past days, when manner was cultivated as essential to a gentleman. (John E. Semmes, *John H. B. Latrobe and His Times, 1803–1891* [1917], p. 215).

The venerable old gentleman is placed in a typical setting for Hubard: seated in a full-length frontal position, he is surrounded by carefully chosen possessions, books, quills, and a Salvador Rosa style landscape which is counterbalanced by a crucifix on a tall draped chest. Despite Hubard's meticulous attention to such details of the setting, the emphasis is on the subject. The artist's predominant dark tones are

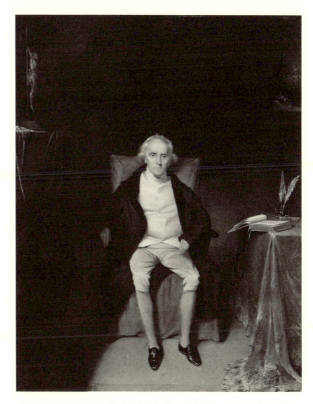

Hubard, *Charles Carroll of Carrollton.*

exquisitely set off by varying hues of deep pink in the tablecloth, slipcover, and floor.

Oil on wood, 18¾ × 14½ in. (47.6 × 36.8 cm.).

RELATED WORKS: Unidentified artist, oil on wood, 19 × 14 in. (48.3 × 35.6 cm.), collection of a descendant in France in 1974 (crucifix and other details are absent and technique is less distinct) // Unidentified artist, ill. in C. W. Bowen, ed., *The History of the Centennial Celebration of the Inauguration of George Washington* (1892) facing p. 97, as coll. of Mary Carroll Acosta (crucifix and landscape absent, detail less distinct; possibly the same painting as above) // Endicott and Swett, *Charles Carroll of Carrollton*, 1832, lithograph, 17 9/16 × 13¼ in. (44.6 × 33.7 cm.) // Endicott and Swett, *Charles Carroll of Carrollton*, lithograph, 4½ × 4⅛ in. (11.4 × 10.5 cm.), head and shoulders only.

REFERENCES: J. T. Scharf, *History of Maryland* (1879) 3, p. 162, woodcut ill. by H. M. Snyder // J. T. Scharf, *History of Baltimore City and County* (1881) 1, woodcut ill. p. 317 // J. T. Scharf, *History of Western Maryland* (1882) 1, woodcut ill. p. 439, // M. M. Swan, *Antiques* 20 (Oct. 1931), p. 223, refers to the painting among others of prominent men painted by Hubard // A. T. E. Gardner, *MMA Bull.* 17 (Summer 1958), pp. 19–23, discusses it, ill. p. 21 // Gardner and Feld (1965), pp. 242–243 // A. C. Van Devanter, *Antiques* 108 (Oct. 1975), p. 742, discusses the painting, ill. p. 743.

EXHIBITED: Metropolitan Opera House, New York, 1889, *Loan Exhibition of Historical Portraits and Relics* [*Centennial of the Inauguration of George Washington*] (not in cat.) // MMA, 1965, *Three Centuries of American Painting* (checklist arranged alphabetically) // Los Angeles County Museum of Art, M. H. de Young Memorial Museum, San Francisco, 1966, *American Paintings from the Metropolitan Museum of Art*, p. 42, ill. no. 26 // Baltimore Museum of Art, 1975, "*Anywhere So Long As There Be Freedom*," exhib. cat. by A. C. Van Devanter, no. 41, p. 105; p. 180, discusses the painting and two related paintings; ill. p. 181; pp. 183–184, discusses related lithographs, ill. p. 183; p. 301, refers to a crucifix that may be the one that appears in the painting // MMA, 1976, *World of Franklin and Jefferson* (not in cat.).

ON DEPOSIT: Maryland Historical Society, Baltimore, 1892–1912.

EX COLL.: the subject, d. 1832; his granddaughter, Emily Caton MacTavish, 1832-d. 1867; her granddaughter, Emily MacTavish, by 1867; her mother, Mrs. Charles Carroll MacTavish, Sr., custodian, deposited at Maryland Historical Society, 1892–1912; her daughter, Virginia Scott MacTavish, Rome, by 1912; her brother, Charles Carroll MacTavish, Jr., 1919–1948; his cousin, Charles Bancroft Carroll, New York, 1948-ca. 1955; Newport, R. I., art market, 1955-1956.

Rogers Fund, 1956.

56.207.

CEPHAS GIOVANNI THOMPSON

1809–1888

Cephas Giovanni Thompson was born in Middleborough, Massachusetts, the oldest son of Olive Leonard and Cephas Thompson (1775–1856), a self-taught portraitist. He learned the rudiments of painting from his father and so did his brother JEROME B. THOMPSON, a genre painter, and his sister, Marietta Thompson (b. 1803), a miniaturist. At the age of eighteen, Thompson set himself up in Plymouth, Massachusetts, where he painted likenesses of sea captains and their families. In 1829, his modest success encouraged him to move to Boston, where he continued to paint portraits and to sharpen his skills. He studied with the illustrator David Claypoole Johnston (1799–1865) and drew from antique casts at the Boston Athenaeum. He spent the early 1830s painting portraits in Bristol, Rhode Island, and Philadelphia, where he became familiar with the works of THOMAS SULLY.

In 1837 Thompson took a studio in the University Building in New York, and for the next ten years he "was more or less the fashionable portrait-painter" in the city (Tuckerman, p. 490). He exhibited semi-annually at the Apollo Association between 1838 and 1841, and his position and affability brought him a circle of literary friends, including William Cullen Bryant, Charles Fenno Hoffman, and Henry T. Tuckerman. Thompson's portraits of these men were exhibited at the National Academy of Design in 1843. The same year, Thompson married Mary Gouveneur Ogden, the daughter of the prominent New York merchant Samuel Gouveneur Ogden. They moved to New Bedford in 1847 and two years later settled in Boston.

In 1852, the Thompsons sailed for Rome, where they lived for seven years. Besides portraits, Thompson copied old masters on commission for various Boston patrons. He also executed a number of genre scenes of Italian life and history paintings drawn from literary subjects. His friend the writer Nathaniel Hawthorne, who was living in Rome at the time, was so impressed by Thompson's *Prospero and Miranda* (unlocated, exhibited NAD, 1861) and

Liberation of Saint Peter (unlocated, exhibited NAD, 1862) that he referred to them in his novel about American expatriate artists in Rome, *The Marble Faun* (1860). Hawthorne sat for a portrait by Thompson, which was later engraved.

Thompson returned to New York in 1859, where he renewed his friendships with the city's authors and artists. The noted art critic James Jackson Jarves wrote that "no one of our artists has brought back with him from Italy a more thorough knowledge and appreciation of the old masters, technically, historically, and aesthetically, than C. G. Thompson. He conscientiously endeavors to infuse their lofty feeling and motives into his own refined manner" (*The Art Idea* [1864; 1960], p. 180). Commissions for history painting were few, but he was talented enough to meet the demand for flattering likenesses and enjoyed considerable success. In 1861 he was elected an associate of the National Academy, where he exhibited almost annually until 1878.

BIBLIOGRAPHY: Henry T. Tuckerman, *Book of the Artists* (New York, 1867), pp. 490–491 // Clara E. Clement and Laurence Hutton, *Artists of the Nineteenth Century and Their Works* (2 vols., Boston, 1880), 2, pp. 289–290 // Obituary: *New York Daily Tribune*, Jan. 7, 1888 // Frederick W. Coburn, *DAB* (1936; 1954), s. v. Thompson, Cephas G. // Groce and Wallace (1957), p. 626.

Spring

Of the existing paintings by Thompson, *Spring* is his masterpiece. In comparison his earlier portraits are more primitive, and the later ones lack the directness and charm. Thompson painted *Spring* in 1838, shortly after his arrival in New York, and he exhibited it with its companion, *Autumn* (unlocated), at the Apollo Association in January 1839. Henry T. Tuckerman (1867) wrote that these "two fancy pieces, idealized likenesses of beautiful young women . . . gained him reputation." *Spring* displays the mid-nineteenth-century vogue for allegorical and romantic portraiture, which can also be seen in the works of CHARLES CROMWELL INGHAM, HENRY INMAN, SAMUEL F. B. MORSE, and THOMAS SULLY. The year previous to painting *Spring*, Thompson was in Philadelphia, where Sully was setting the fashion with his romanticized pictures of genteel ladies. Concurrent with Thompson's arrival in New York in 1837, Morse's romantic portrait of his daughter, Susan Walker Morse (q.v.), was exhibited at the National Academy of Design and praised for "the colour harmonious and flowing; the attitude perfect ease "(*New York Mirror* [May 27, 1837], p. 383). *Spring* has the same sweet, bland features as Ingham's *Amelia Palmer* of about 1828 (q.v.), but is more restrained in its sentimentality.

The subject, an allegory of spring, holds a chain of blossoms and is adorned in the latest style of the season: a white off-the-shoulder dress and wide-brimmed straw hat tied neatly to one side. A floral shawl is draped over the corner of a stone wall. Thompson placed his subject in an atmospheric garden setting enhanced by the requisite neoclassical marble urn. With eyes directed arrestingly at the viewer, she leans forward on one arm, in a relaxed manner, and seems to penetrate the viewer's space

Thompson's soft, delicate modeling, sunny coloring, and skillful handling of light give the picture freshness and a sense of immediacy. It is one of the most captivating portraits of the mid-nineteenth century.

Oil on canvas, 36 × 28¾ in. (91.4 × 73 cm.).

Signed and dated at lower right: C. G. Thompson / Oct. 1838.

REFERENCES: H. T. Tuckerman, *Book of the Artists* (1867) p. 490 (quoted above) // Obituary, *New York Daily Tribune*, Jan. 7, 1888, mentions Spring as one of the artist's best works // C. E. Clement and L. Hutton, *Artists of the Nineteenth Century and Their Works* (1880), p. 290, notes "Charles Sprague, the banker poet owned his [Thompson's] Spring and Autumn" // Parke-Bernet Galleries, New York, *American and English Pewter, Staffordshire, Oriental Lowestoft and Other Porcelains. Oriental Rugs. Collection of Katherine Cole Smith*, sale cat. (March 28, 1940), ill. p. 23; p. 24, no. 108, as Portrait of a Girl // *Antiques* 41 (Feb. 1942), ill. p. 110, as with James Graham and Sons // R. McLanathan,

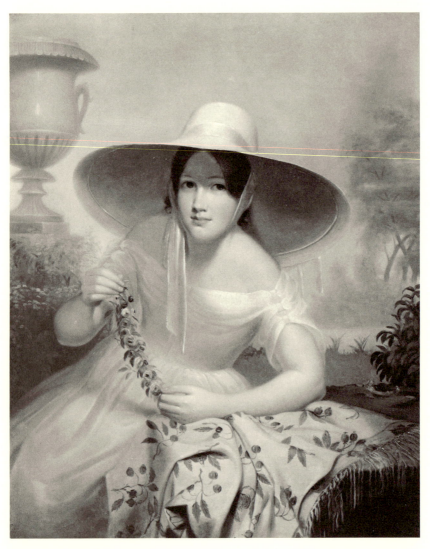

Thompson, *Spring*.

American Portrait and Figure Painting, (n.d., n.p.), notes "An increase in sentiment which was later in the century to dissolve into sentimentality is reflected in such paintings as Cephas G. Thompson's *Spring*" || M. Moore, Falls Church, Va., memo in Dept. Archives, Jan. 16, 1991, identified Stevens in provenance.

EXHIBITIONS: Apollo Association, New York, Jan. 1839, no. 111 || Public Education Association, Knoedler and Co., Hirschl and Adler, and Paul Rosenberg, New York, 1968, *The American Vision*, no. 12, lent by Madeline Thompson Edmonds || MMA, 1970, *19th Century America*, exhib. cat. by J. K. Howat and N. Spassky, no. 63, lent by Mrs. Madeline Thompson Edmonds || MMA, 1972, *Recent Acquisitions* || MMA

and American Federation of the Arts, 1975, *The Heritage of American Art*, exhib. cat. by M. Davis, no. 39.

EX COLL.: Charles Sprague, Boston, d. 1875; William B. Stevens, Jr., Boston, probably at least to 1890; Katherine Cole Smith, Winchester, Mass. (sale, Parke-Bernet Galleries, New York, March 28, 1940, no. 108); with Victor D. Spark, New York, 1940-1942; with James Graham and Sons, New York, 1942-1962; Mrs. Madeline Thompson Edmonds, Northampton, Mass. (granddaughter of the artist's halfbrother), 1962-1971.

Gift of Mrs. Madeline Thompson Edmonds, 1971. 1971.244.

THOMAS WILCOCKS SULLY

1811–1847

Thomas Wilcocks Sully, known as Thomas Sully, Jr., was born on January 3, 1811. His father, the famous Philadelphia painter THOMAS SULLY, taught him to paint portraits and miniatures. Although his works reflect his father's style and technique, he never achieved the elegance and fluidity of the elder Sully. He is perhaps best remembered for a series of portraits of famous actors which were subsequently lithographed by Albert Newsam and published as by Thomas Sully, without the affix "Jr.," an omission responsible for a good deal of misunderstanding in the past. He exhibited at the Artist's Fund Society and the Pennsylvania Academy of the Fine Arts in Philadelphia during the 1830s and 1840s. He died at the age of thirty-six, on April 18, 1847, just when he was beginning to establish his reputation. The extent of his oeuvre is unknown, but good examples of his work may be found in the collections of the Pennsylvania Academy of the Fine Arts and the Historical Society of Pennsylvania.

BIBLIOGRAPHY: Charles H. Hart, *A Register of Portraits Painted by Thomas Sully* (Philadelphia, 1909), p. 13 // Groce and Wallace (1957), p. 615 // Thieme and Becker (Leipzig, 1938), 32, p. 287.

George Washington

When this painting, based on GILBERT STUART's Athenaeum portrait of George Washington (q.v.), came to the museum in 1954 it carried a tentative attribution to THOMAS SULLY. Subsequently, this attribution was accepted as accurate and published as such. For a number of reasons, it is now given to Thomas Sully, Jr.

Although the work betrays the strong influence of Sully's coloring and technique, it resembles far more that of his son. The portrait is too unsophisticated to have been painted by the elder Sully, especially in 1840 when he was at the height of his powers. The masses of color, applied in broad patches, lack the necessary gradations of tone indicative of the elder Sully's work. Then, too, the rendering of the anatomical features of the face reveals a lack of understanding impossible to imagine in so accomplished a portraitist. Further, Sully's register, which is fairly thorough in listing his copies of Washington portraits, does not contain an entry for any such work executed in 1840. In addition, the manner in which the work was signed, T. Sully, is more typical of the son, who usually signed himself T. Sully, Jr., occasionally omitting the junior, than of the father, who habitually employed the monogram TS. Finally, there are grounds for believing that at one time the picture was known as the work of Sully, Jr. John Hill Morgan and Mantle Fielding in their study of the life portraits of Washington list a copy from a "painting by Thomas Sully, Jr., in 1840. Bust, in uniform, wearing badge of the order of the Cincinnati . . . size 25″ × 30.″" They also record that the head in the copy (formerly coll. Army and Navy Club, New York) was of the Stuart Athenaeum type.

The portrait is one of the few existing works depicting Washington wearing the order of the Cincinnati. That organization, formed by Continental army officers in 1783, was among the most controversial groups formed in the infant United States and was heavily criticized by Jeffersonian Democrats as an elitist, aristocratic society. Washington, the American Cincinnatus who after saving his country refused to become king and returned to his farm, was its first president-general. The insignia of this organization, designed by Pierre Charles L'Enfant, the planner of the city of Washington, consisted of a gold eagle suspended by a blue and white ribbon emblematic of the union of the United States and France. At its center, the medal bears an image of the Roman Cincinnatus.

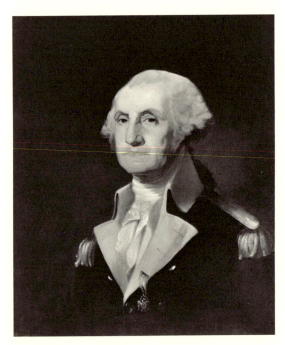

Sully, *George Washington.*

Oil on canvas, 30¼ × 25 in. (76.8 × 63.5 cm.). Signed, dated, and inscribed on the back, before lining: The Head after Stuart / T. Sully / 1840. Canvas stamp, recorded before lining: PREPARED BY / P. CAFFE / NEW YORK.

RELATED WORK: Copy, oil on canvas, 25 × 30 in. (63.5 × 76.2 cm.), formerly coll. Army and Navy Club, New York, listed in J. H. Morgan and M. Fielding, *The Life Portraits of Washington and Their Replicas* (1931), 2, p. 342.

REFERENCES: S. Walker to Miss H. Frick, Dec. 12, 1924, in FARL files, says she acquired it from a New York collector who in turn acquired it from Captain Barr, a Philadelphia dealer who had bought it from Francis Thomas Sully Darley (encloses photograph of what appears to be this picture) // J. H. Morgan and M. Fielding, *The Life Portraits of Washington and Their Replicas* (1931), p. 342, lists copy (quoted above); p. 337, describes a similar picture, attributed to Sully, Jr., that was presented to the New Hampshire chapter of the Cincinnati by Samuel S. Spaulding of Buffalo in 1902 // G. A. Eisen, *Portraits of Washington* (1932), 2, p. 423, describes similar portrait Spaulding presented to the New Hampshire chapter of the Cincinnati as attributed to Sully, Sr., and says that it is definitely not by him, suggests instead Rembrandt Peale; ill. p. 653, reproduces a photograph of the New Hampshire portrait // Gardner and Feld (1965), p. 167, attribute it to Thomas Sully.

EXHIBITED: Scott and Fowles, New York, 1947, *Loan Exhibition of Portraits of George Washington*, as by Sully, Sr., lent by Mrs. George F. Baker.

ON DEPOSIT: Federal Reserve Bank, New York, 1972–.

EX COLL.: probably Francis T. S. Darley, Philadelphia, d. 1914; with a Captain Barr, Philadelphia; Mrs. A. Stewart Walker, New York, from about 1924; Mrs. George F. Baker, New York, by 1947 until 1954.

Gift of Mrs. George F. Baker, 1954.

54.74.

GEORGE CALEB BINGHAM

1811–1879

George Caleb Bingham was born March 20, 1811, on his grandfather's tobacco and grain plantation in the Blue Ridge Mountains, not far from Charlottesville, Virginia. He moved with his family to the town of Franklin in the Missouri Territory in 1819. His father, Henry Vest Bingham, opened up a tavern there, became a partner in a cigar manufactory, and served successively as a county court and circuit court judge before his death in 1823. As a child, Bingham showed a talent for drawing, but at the age of twelve, when his father died, he was forced by circumstances to work on the family farm. In 1828 he was apprenticed to a cabinetmaker named Reverend Jesse Green in Arrow Rock, Missouri, but by 1835 he

had taken up the trade of portrait painter and, like many other American artists, began to travel in search of commissions. In 1836, he married Sarah Elizabeth Hutchison.

Bingham's early portraits, clearly the work of an untrained painter, are rather harsh, linear images. In 1838 he went to Philadelphia, where he studied briefly at the Pennsylvania Academy of the Fine Arts, and painted one of his first genre scenes, *Western Boatmen Ashore*. On his way back to Arrow Rock, he submitted this painting to the Apollo Gallery in New York. That fall, he also sent six paintings to the National Academy of Design. His study of paintings by THOMAS SULLY, SAMUEL F. B. MORSE, and other talented portraitists is evident in the portraits Bingham painted back in Missouri the next year. In these the dry and rigid appearance of his earlier style is somewhat softened. In the fall of 1840 he moved to Washington, where he painted portraits of political figures. It was difficult for him to support his growing family, and by September of 1844 he was back in Missouri, working as an itinerant painter.

The first years after Bingham's return from Washington were among his most artistically innovative. His extraordinary portrait of John Cummings Edwards, 1844 (Missouri Historical Society, Saint Louis), shows the subject in a voluminous black cape looming dramatically against a strikingly lit sky that constitutes almost the entire background. He painted *Fur Traders Descending the Missouri* (see below), acknowledged as his masterpiece, in about 1845. The same year he completed *Cottage Scenery* (Corcoran Gallery of Art, Washington, D.C.), one of his finest landscapes. In 1846 he began painting scenes of life on the river, such as *Boatmen on the Missouri* (Fine Arts Museums of San Francisco) and *The Jolly Flatboatmen* (Manoogian Collection, Detroit). The compositional balance and overall clarity of color, form, and narrative in these pictures are remarkable, especially for an artist who only a few years before had displayed no more than modest skills. Very quickly Bingham had developed into one of the most accomplished painters of his day.

Actively interested in politics since about 1840, Bingham made the first of many races for elective office in 1845 and won a seat the next year in the Missouri legislature. While in office, he continued to paint works illustrating frontier life, including a number of ambitious paintings on the subject of country politicians and elections. He regularly sent his work to the National Academy and the American Art-Union and many of his paintings were engraved in Philadelphia, where he moved in 1852. Four years later, he went to Paris in search of better engravers, and in November of 1856, he moved to Düsseldorf, where his work took on some of the conventional qualities associated with the academy there. After his return from Europe, Bingham painted few of the genre scenes for which he is best known today and concentrated again on portraits. He continued to be active in politics, and for a while during the Civil War he served as treasurer of the state of Missouri and held a number of other offices. In 1877 he was elected professor of art at the University of Missouri, at Columbia, a position he held until his death two years later.

Bingham's reputation as a painter was almost entirely confined to the Missouri region, but, after *Fur Traders* was acquired by this museum in 1933 and an exhibition of his work took place at the Museum of Modern Art in 1935, his art began to be more widely appreciated. Today, he is recognized as being one of the best American genre painters.

BIBLIOGRAPHY: John Francis McDermott, *George Caleb Bingham: River Portraitist* (Norman, Okla., 1959). Solid, well-researched treatment of the artist's life // E. Maurice Bloch, *George Caleb Bingham: The Evolution of an Artist* (Berkeley and Los Angeles, 1967) // Albert Christ-Janer, *George Caleb Bingham: Frontier Painter of Missouri* (New York, 1940; rev. ed. 1975). Lavishly illustrated in color // E. Maurice Bloch, *The Paintings of George Caleb Bingham: A Catalogue Raisonné* (Columbia, Mo., 1986) // Saint Louis Art Museum, *George Caleb Bingham*, exhib. cat. by Michael S. Shapiro, et al. (1990). Five essays include much new research on the artist.

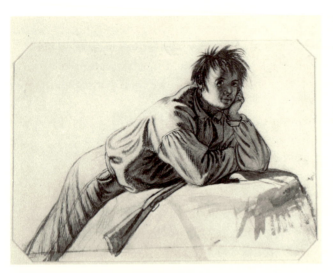

Bingham, *Trapper's Son*, drawing.
Nelson-Atkins Museum of Art.

there is a hint of Bingham's future achievements, *The Mill Boy* does not prepare one for the mastery of *Fur Traders*.

The question of the artistic sources for *Fur Traders* naturally arises. Some European prints and paintings, often wrongly attributed to famous artists, were available to Bingham, but no specific prototype has yet been identified. The similarity between *Fur Traders* and *Eel Spearing at Setauket* by WILLIAM SIDNEY MOUNT (New York State Historical Association, Cooperstown), painted in the same year, has been noted many times. Both of these works have elicited considerable interest in relation to the style called luminism. *Fur*

Bingham, *Fur Trader*, drawing.
Nelson-Atkins Museum of Art.

Fur Traders Descending the Missouri

This is one of the masterpieces of American art. Bingham painted it in time for the 1845 exhibition at the American Art-Union. Done early in his career, the picture is almost inexplicable in terms of Bingham's previous work. In fact, nothing is known of its genesis. After his first years of producing portraits, Bingham exhibited in 1838 a work called *Western Boatmen Ashore*, now unfortunately lost. Several genre and landscape paintings appeared in exhibitions over the next years, but the only extant early work with any relationship to *Fur Traders* is a processional banner for the 1844 Whig convention known as *The Mill Boy* (coll. Mrs. Frances C. Wohler, Aledo, Texas). Both pictures have strongly pyramidal compositions with low horizons, figures that stare directly out at the viewer, and gauzy trees obscured by haze in the background. Although the brushwork is freer and

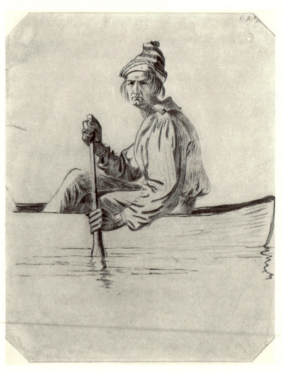

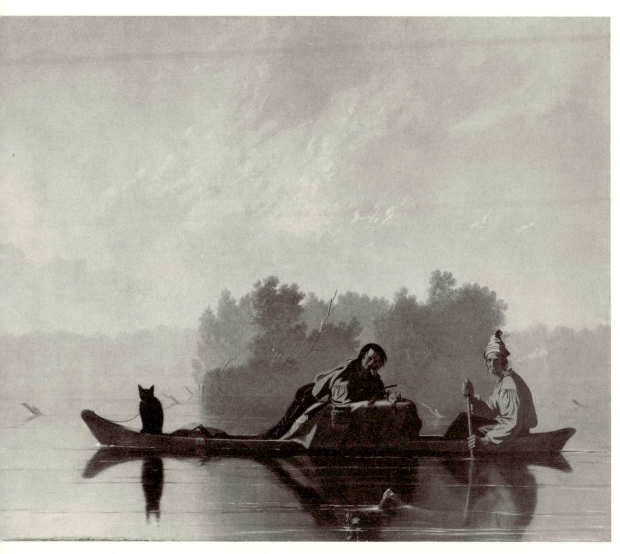

Bingham, *Fur Traders Descending the Missouri.*

Traders was characterized by Barbara Novak (1969) as demonstrating "the unique polarity of luminist vision"; Theodore Stebbins (1975) described *Fur Traders* and Cole's *Lake Scene*, 1844 (Detroit Institute of Arts), as "precedents" for the luminist style; and William H. Gerdts (1978) wrote that neither *Fur Traders* nor Mount's *Eel Spearing* "is a luminist landscape," but that both "reflect luminist interests."

Bingham's *Fur Traders* has a striking appearance. The simplicity of the composition, with its delicate coloristic effects, and the motionlessness of the scene give a sense of extreme quiet and suggest a moment frozen in time. The same feeling was evoked by Mark Twain forty years later when he described Huckleberry Finn moving along the Mississippi:

Not a sound anywheres—perfectly still—just like the whole world was asleep, only sometimes the bullfrogs a-cluttering, maybe. The first thing to see, looking away over the water, was a kind of dull line—that was the woods on t'other side; you couldn't make nothing else out; then a pale place in the sky; then more paleness spreading around; then the river softened up away off, and warn't black any more, but gray . . . and by and by you could see a streak on the water which you know by the look of the streak that there's a snag there in a swift current which breaks on it and makes that streak look that way; and you see the mist curl up off the water, and the east reddens up (ch. 19).

Or again, "It was kind of solemn, drifting down the big, still river, laying on our backs looking up at the stars, and we didn't ever feel like talking loud, and it warn't often that we laughed" (ch. 12).

Like *Huckleberry Finn*, *Fur Traders* depicts a vanished world of innocence and calm on the American frontier, the arena that Americans seem to prefer as a theater for national dramas and a focus for their dreams. Bingham was certainly aware of the popularity of this theme, especially in the Eastern states, and presumably painted this scene with his New York audience in mind. The painting has a deceptively simple subject: a man and his son traveling in a dugout canoe along a tranquil river with a bear cub they have probably tamed for a pet. Bingham drew his viewers into this idyllic Western world by having the figures look directly out of the picture. By positioning the viewer at the very edge of the water, he made it seem as though the viewer were passing by in another boat. Bingham named the picture *French-Trader—Half-breed Son*, a title that specifically identified the racial character of his Western pioneers, but it was given the more generic title of *Fur Traders* before the American Art-Union exhibition opened.

Bingham heightened the impact of this specifically Western scene in one other way. He submitted it to the art union with *The Concealed Enemy*, 1845 (Stark Museum of Art, Orange, Texas), a painting of an Osage warrior poised with his rifle behind a boulder. As opposed to the calm *Fur Traders*, this picture presented an image of savagery and danger, suggesting the wilder side of Western life. As Henry Adams (1983) has suggested, Bingham may have painted these pictures as contrasting companion pieces, one depicting the frontiersman and the other showing his alleged enemy. If hung side by side, the Indian might be seen as taking aim at the traders. Bingham's reassuring version of life in the West, however, favors the pioneers, who show no sign of fear as they float downstream in the warm morning light with their furs safely stowed.

Oil on canvas, 29 × 36½ in. (73.7 × 92.7 cm.).

RELATED WORKS: *Fur Trader*, 11⅞ × 9½ in. (30.2 × 24.1 cm.), 1845, and *Trapper's Son*, 6⅞ × 9⅞ in. (17.5 × 25.1 cm.), 1851, both pencil, ink, and wash, Nelson-Atkins Museum, Kansas City, Mo., ill. in J. F. McDermott, *George Caleb Bingham* (1959), pp. 279–280.

REFERENCES: American Art-Union Management Committee Minutes, NYHS, 1839–1846, Dec. 8, 1845, p. 6, records resolution to purchase French Trader—Halfbreed Son // *Transactions of the American Art-Union* (1845), p. 29, no. 93, lists as Fur Traders descending the Missouri // F. H. Rusk, *George Caleb Bingham, the Missouri Artist* (1917), p. 120, says painted by 1845; p. 32, lists it as unlocated // H. B. Wehle, *MMA Bull.* 28 (June 1933), pp. 120–122, gives information about fur trade and about this picture // A. Christ-Janer, *George Caleb Bingham of Missouri* (1940), p. 37, says it was executed before 1844, probably between 1840 and 1844 // H. B. Wehle, *MMA Bull.* 5 (May 1947), color ill. of detail on cover, described inside front cover // J. F. McDermott, *New-York Historical Society Quarterly* 42 (Jan. 1958), ill. p. 61, and mentions it as exhibited at the American Art-Union; *George Caleb Bingham* (1959), pp. 48–53, discusses it; p. 413, no. 24, dates it 1845 // Gardner and Feld (1965), pp. 251–252 // E. M. Bloch, *George Caleb Bingham* (1967), I, pp. 79–83, mentions possible connection with Washington Irving's *Astoria*, suggests parallels in engraving after Raphael and paintings by Louis Le Nain, relates composition to art instruction books, refers to possible source in print after Copley's Watson

and the Shark; pp. 84, 85, 86, 88, 90, 102, 110, 177, 256; 2, pp. 52–53, no. 136, catalogues it // B. Novak, *American Painting of the Nineteenth Century* (1969), pp. 105–106, 126, 156, 158–159 (quoted above) // A. Christ-Janer, *George Caleb Bingham* (1975), p. 22, color ill. of detail p. 23; pp. 36, 48–49, color ill. pl. 19 // T. E. Stebbins, Jr., *Martin Johnson Heade* (1975), p. 106 (quoted above) // *MMA Bull.* 33 (Winter 1975–1976), color ill. no. 47 // Coe Kerr Gallery, New York, *American Luminism*, exhib. cat. by W. H. Gerdts (1978), p. 4 (quoted above) // S. E. Strickler, *Arts in Virginia* 20 (Spring 1980), pp. 6–9, ill. p. 8, compares it to Going to Market, ca. 1841–1842 (Virginia Museum of Fine Arts, Richmond), in terms of quality of light, compositional structure, and the handling of clothing // J. S. du Mont, copy of letter, Sept. 15, 1983, Dept. Archives, corrects provenance // H. Adams, *Art Bulletin* 65 (Dec. 1983), pp. 675–680, ill. p. 677, argues convincingly that this picture was conceived to hang with The Concealed Enemy, suggesting that Bingham may have attempted to paint opposing compositions using Claudian and Salvatoran modes // C. D. Collins, *Art Bulletin* 66 (Dec. 1984), pp. 678–681, suggests that Charles Deas's watercolor The Trapper and His Family, 1840–1841 (MFA, Boston) is Bingham's source // S. E. Behrendt, *Great Plains Quarterly* 5 (Winter 1985), pp. 24–38, discusses the picture in terms of Bingham's artistic influences and his potential audience // C. K. Wilson, *Art Bulletin* 67 (March 1985), p. 154, offers evidence for identifying the animal as a bear cub // E. M. Bloch, *The Paintings of George Caleb Bingham* (Columbia, Mo., 1986), p. 172, no. 158, catalogues it; color ill. p. xix.

EXHIBITED: American Art-Union, New York, 1845, no. 93, as Fur Traders Descending the Missouri // Detroit Institute of Arts, 1933, *Art Before the Machine Age* (no cat.) // City Art Museum of Saint Louis, 1934, *George Caleb Bingham* (no cat.) // Museum of Modern Art, New York, 1935, *George Caleb Bingham*, ill. no. 3 // MMA, *Life in America*, 1939, no. 132 // Museum of Modern Art, New York, 1943, *Romantic Painting in America*, no. 26 // Tate Gallery, London, 1946, *American Painting*, no. 19 // Brooklyn Museum, 1949, *Westward Ho*, ill. p. [12] // City Art Museum of Saint Louis, 1949, *Mississippi Panorama*, ill. no. 20 // PAFA, 1955, *The One Hundred and Fiftieth Anniversary Exhibition*, ill. no. 53 // William Rockwell Nelson Gallery of Art and Atkins Museum of Fine Arts, Kansas City, Mo., and City Art Museum of Saint Louis, 1961, *Sesquicentennial Exhibition, 1811–1961*, ill. no. 4 // MFA, Boston, 1970, *Masterpieces of Fifty Centuries*, ill. no. 366 // MFA, Boston, 1970, *Masterpieces of Painting in the Metropolitan Museum of Art*, color ill. p. 106 // Tokyo National Museum and Kyoto Municipal Museum, 1972, *Treasured Masterpieces of the Metropolitan Museum of Art*, color ill. no. 112 // Pushkin Museum, Moscow, and Hermitage, Leningrad, 1975, *100 Kartin iz muzeia Metropolitan* [*100 Paintings from the Metropolitan Museum*], no. 88, color ill. p. 242 // MMA, 1976–1977, *A Bicentennial Treasury* (see *MMA Bull.* 33 above) // Saint Louis Art Museum, *George Caleb Bingham*, exhib. cat. by M. E. Shapiro, et al. (1990), color pl. 33; pp. 58–59, discussed by B. Groseclose as companion to The Concealed Enemy; p. 97, described by E. Johns as presenting "a subtle history lesson, keyed to Eastern excitement about Western expansion"; pp. 147, 149, 169, interpreted by M. E. Shapiro as an exemplary use of water as a metaphor for life and as an American adaptation of European landscape style; also compared to Trappers' Return, 1851 (Detroit Institute of Arts); pp. 28, 151, 153, 158, 176.

EX COLL.: American Art-Union, New York, 1845, by lottery to Robert S. Bunker, Mobile, Ala.; his daughter, Josephine (Mrs. Alphonse du Mont); her daughter, Lina du Mont, Point Clear, Ala.; with E. Herndon Smith, New York, as agent, 1932; with John Wise, New York, 1933.

Purchase, Morris K. Jesup Fund, 1933.
33.61.

WILLIAM PAGE

1811–1885

William Page was born in Albany, New York, the son of Levi and Tamer Dunner Gale Page, who moved to New York in 1820. Young Page worked briefly in the law office of Frederick De Peyster, beginning at the age of fourteen, but it soon became apparent that he was determined to be an artist. De Peyster, who was secretary of the American Academy of the Fine Arts, took some of the boy's drawings to its president, JOHN TRUMBULL, who admired

them but recommended that he stay with the law to become rich and famous. Not long afterward, however, Page went to work with the painter James Herring (1799-1867), and during this period made drawings from casts of antique sculpture at the academy. By 1827, at sixteen, Page was studying with SAMUEL F. B. MORSE, and around the same time attending a drawing class at the newly formed National Academy of Design, where he was awarded a silver palette for his proficiency and exhibited his first oil, a still life. A year later, he entered Phillips Academy at Andover with the goal of becoming a minister, but he continued to paint while there, producing miniatures for $20 or $30. One miniature from this period was shown at the National Academy in 1828.

During the early 1830s, Page painted some portraits in upstate New York and continued to show his work at the National Academy, of which he was made an associate member in 1832. That year he entered a history painting of *The Quarrel of Achilles and Agamemnon* (unlocated) and began making a concerted effort to improve his skills beyond portraiture. In early 1834, he wrote to Herring, then secretary of the American Academy, to offer his services as that institution's keeper, so that he could "have the advantage at all times of studying from the fine collection of casts . . . [and] devote all my attention to Historical subjects." Yet, by 1835, when he was elected a director of the American Academy, his reception by the public and press indicates that he had attained a measure of success as a portrait painter. He was elected a full member of the National Academy in 1837 on the merits of his portraits. His sitters have considerable presence. Page's few extant works from these years also testify to his originality as a colorist. He was already experimenting with different techniques, a habit that became almost an obsession for the rest of his career.

In the summer of 1840 Page met James Russell Lowell, at Nantasket Beach, Massachusetts, beginning a friendship with the young poet that was important to him all his life. Encouraged by the association with Lowell and his circle of friends to imbue his work with spirituality, he completed in 1842 the *Young Merchants* (PAFA), a genre painting of two street sellers in which both the unconventional methods of applying paint and the oddly intense expression of the characters testify to the unusual nature of his artistic vision. His *Cupid and Psyche*, 1843 (private coll., ill. in Taylor, fig. 14), is even more unusual for the period, with its strangely off-center composition and erotic subject. Psyche's soft body is seen in half length from behind, in an evidently passionate embrace with Cupid. Despite his membership in the National Academy, the exhibition committee rejected it for its 1843 exhibition because of its suggestive content. Another picture by Page, an Ecce Homo that was accepted for the same exhibition, shocked critics with its color and the total lack of idealization expected in depictions of Christ.

That year, perhaps in search of a new audience, Page left for Boston, where he was well received by a small coterie of friends and art patrons. Margaret Fuller, the feminist and critic, recognized a considerable potential in Page's work: "Should this artist ever be able to unfold his genius in a congenial element, he is able to go a great way and may turn over a new leaf for America" (quoted in Taylor, p. 89). Commissions in Boston, however, were infrequent, and he returned to New York in 1847.

In 1850, Page went to Italy. First in Florence and then in Rome, he painted portraits of some of his American and British colleagues and also produced mythological and biblical

paintings. Robert Browning and Elizabeth Barrett Browning were devoted to him, both as a man and as an artist. Browning called Page's 1854 portrait of him (Baylor University, Waco, Texas) "the wonder of everybody; no such work has been achieved in our time" (quoted in Taylor, p. 135), but the painting in its present unrestorable condition is a good example of how his unusual techniques now make it difficult to evaluate his achievement. In the presence of genuine works by his artistic hero, Titian, Page embarked on ever more radical experiments with his methods of painting. According to the comments of his contemporaries, the results were a great success, but unfortunately within a matter of months the paintings often began to change and darken. Page himself described the transformation: "Some have turned red, some black, some spotted, some have slid off the canvas and all gone as if by spontaneous combustion" (quoted by Taylor, p. 175).

During his years in Italy, the eccentric streak always evident in Page's nature became more marked, in his talk, his obsession with Swedenborgian religion, and his painting techniques. Never very successful financially, he became increasingly idealistic and impractical in his choice of subject matter. His personal life, too, was unconventional. His first two wives, Lavinia Twibill and Sarah Augusta Dougherty, whom he married in 1833 and 1843 respectively, deserted him for other men, and the ensuing divorces resulted in scandal. In 1857 he married Sophia Stevens Hitchcock, a widow with whom he had been living in Rome. Unable to support his family in Italy, which included three daughters from his first marriage, Page tried unsuccessfully to sell his work in London and Paris before returning to New York in 1860. There, despite occasional successes, he fared little better. His increasingly radical paintings, in which color was progressively reduced to the point of monochromy, were not generally well received, and some of his productions, such as the attempt to portray Shakespeare, were almost quixotic. Elected president of the National Academy in 1871, his efforts at reforming it were ended by a stroke in 1872. During his last years he was able to paint and sell very little. He died on October 1, 1885, in Tottenville, Staten Island.

Page is one of the most difficult figures in American art to evaluate. Despite his undoubted talent and originality, his achievements were tainted by his eccentric nature and his often unsuccessful technical experiments. Like WASHINGTON ALLSTON, whom he perhaps resembles most, he failed to fulfill his early promise, but unlike Allston, who may have been to some extent victimized by the shallowness of the contemporary American culture, Page seems to have suffered most from his own romantic notions.

BIBLIOGRAPHY: William Page Papers, 20–27, D312, Arch. Am. Art, a crucial source on the artist and his work // Paul Akers, "Our Artists in Italy: William Page," *Atlantic Monthly* 7 (Feb. 1861), pp. 129–137. Information on and praise from a friend // Susan Nichols Carter, "The President of the National Academy," *Appleton's Journal* 6 (Dec. 2, 1871), pp. 617–620. Useful biographical information // Edgar Preston Richardson, "Two Portraits by William Page," *Art Quarterly* 1 (1938), pp. 91–103. A balanced, scholarly treatment, the first to revive interest in the artist // Joshua C. Taylor, *William Page: The American Titian* (Chicago, 1957). Sympathetic but balanced and judicious account, scholarly and serious, with catalogue raisonné. Bibliography includes artist's writings on art and art theory.

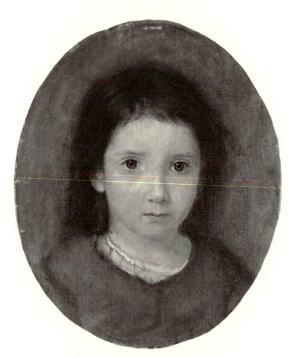

Page, *Daughter of William Page,*
possibly Anne Page.

Daughter of William Page, possibly Anne Page

This portrait almost certainly represents one of the daughters of William Page. On stylistic grounds, Joshua Taylor suggested that it should be dated 1837 or 1838 and thus it would represent Page's first child, Anne, born in 1834. Her mother was Page's first wife, Lavinia Twibill Page, the daughter of a theater manager from Ireland and the sister of the painter George Twibill (ca. 1806–1836). Not much is known of Anne Page's life, but it cannot have been easy. In the summer of 1840, her father left his wife and children behind in New York while he spent the summer in Nantasket Beach, near Boston, and about that time Mrs. Page left her family to live with a Mr. Harrison. Page divorced his wife, and the children were sent first to live with Page's mother in New York and later with the family of the transcendentalists George and Sophia Ripley at Brook Farm, West Roxbury, Massachusetts, the experimental community they founded in 1841. When Page left for Europe in 1850 with his second wife, his children stayed behind in America. In July of 1853, the three girls—Anne was then nineteen—joined their fa-

ther and stepmother in Rome. The following summer, Page, unable to bear the quarrels between his wife and his children, sent them all away to nearby Albano. In the fall Page's second wife left him, fleeing Rome with an Italian count. By 1860, when Page returned to the United States, Anne had married Pietro Fortuna, an Italian singer and voice teacher, and they remained in Rome with their daughter Emma, who bequeathed this painting and the companion portrait (below) to the museum in 1925.

The young child's serious face is direct and has a delicate tonality. Despite the portrait's small size, the sitter has a remarkable presence. The face is delineated with subtle patterns of light. So carefully is her skin painted that the blue of the veins underneath is even faintly perceptible. Her eyes are large and liquid and very expressive. The hair and dress are summarily rendered, and except for the face the painting is really only a sketch. It is an honest, even arresting, portrait of a child, especially interesting in consideration of its period.

Oil on canvas, 14 × 12 in. (35.6 × 30.5 cm.).
Signed on the back: William Page / Pinx.
REFERENCES: *New York Times*, March 17, 1853, review of the Washington Exhibition at the Art-Union mentions a portrait of a child by Page as a "clever sketch of a plain infant" (possibly this picture) // J. C. Taylor, *William Page* (1957), p. 17, says from the "style and the apparent age of the little girl it might well be a portrait of Anne painted about 1837 or 1838 // Gardner and Feld (1965), p. 255.
EXHIBITED: American Art-Union, 1853 (possibly this picture) // MMA, 1946, *The Taste of the Seventies*, no. 143 // Staten Island Institute of Arts and Sciences, New York, 1967, *Staten Island and Its Artistic Heritage* (no cat.).
ON DEPOSIT: Executive Mansion, Albany, 1975–1986.
EX COLL.: possibly the subject, Anne Page Fortuna; her daughter, Emma A. Fortuna.
Bequest of Emma A. Fortuna, 1925.
25.85.2.

Daughter of William Page, possibly Mary Page

Tentatively dated on the basis of style to the early 1840s, this portrait of one of Page's daughters may well represent his second child, Mary, who was born in 1836. The subject appears to be at least five years old. Mary's younger sister

Emma (b. 1839) would probably have been too young. Like her sister Anne (see above), Mary Page's life must have been a difficult one, abandoned as she was by her mother at the age of four and with only an apparently sporadic interest in her on the part of her father. In 1853, Mary, then seventeen, came to Italy with her sisters and lived for a while with her father and his second wife. By 1860, when Page returned to the United States, Mary, who had married the artist Virgil Williams (1830–1886), a young American disciple of Page's, remained in Rome. The couple returned to this country before 1862, when Williams left for San Francisco. He came back to Boston in 1865, and then returned to California in 1871. Williams died there on his ranch near Sonoma in December of 1886. How long, or indeed whether his wife survived him is not known.

Like its companion piece (see above), this portrait is a fine example of Page's subtle use of color. The shades of blue of the hair ribbon, her eyes, and her dress echo each other beautifully, and her hair is filled with rich and subtly painted highlights. The subject's skin demonstrates the painter's unconventional expression of the actual colors he found before him, and her ear, especially, is a masterful study in the effects of light passing through translucent skin. Page presented his daughter with a refreshing lack of sentiment and conventionality, in a manner very unusual for portraits of children in the mid-nineteenth century. Young Miss Page is unexpectedly real and her beauty is affecting and poignant.

Oil on canvas, oval, 14 × 12 in. (35.6 × 30.5 cm.).
REFERENCES: J. C. Taylor, *William Page* (1957), pp. 17–18, says technique close to that used by Page in

Page, *Daughter of William Page, possibly Mary Page.*

early 1840s and that "it would be surprising if this portrait were painted before 1840," p. 270, no. 85, lists the painting and dates it about 1840 // Gardner and Feld (1965), p. 254.

EXHIBITED: MMA, 1946, *The Taste of the Seventies*, no. 144 // Staten Island Institute of Arts and Sciences, 1967, *Staten Island and Its Artistic Heritage* (no cat.).

ON DEPOSIT: Executive Mansion, Albany, 1975–1986.

EX COLL.: Emma A. Fortuna (the probable subject's niece).

Bequest of Emma Fortuna, 1925.
25.85.1.

JOHN W. CASILEAR

1811–1893

The grandson of an immigrant from Barcelona, Casilear was born June 25, 1811, on Staten Island, New York. In 1827, he began an apprenticeship with the engraver Peter Maverick. When Maverick died four years later, Casilear continued his training with ASHER B. DURAND,

who had been Maverick's partner. Casilear soon became a successful and prosperous engraver of banknotes and a partner in a network of engraving firms that eventually joined to form the American Banknote Company. Casilear exhibited several engravings at the National Academy of Design in 1833 and 1834 and a few landscapes in the following years. In 1840, he traveled to Europe with Durand, JOHN F. KENSETT, and THOMAS P. ROSSITER, where he followed the traditional pattern of copying old masters, sketching landscapes, and attending life drawing classes. He remained abroad three years, primarily in England and France, supporting himself for the most part by making engravings for customers back home.

Despite his experience in Europe, Casilear appears to have painted more or less as an amateur in the years after his return to New York. He went on sketching trips with friends such as Kensett and continued to exhibit landscapes at the National Academy, where he became an academician in 1851, and at the American Art-Union. He did not take up painting full time until a few years later. According to the artist, "it was 1854 before I began to paint in earnest, but from the very first I met with every encouragement." It seems that Goupil, the New York art dealers, "would buy almost anything I produced" (unidentified clipping, Casilear Papers). One of the reasons for Casilear's success was probably his lack of artistic originality. His earlier work was heavily influenced by Durand, and after his trip to Europe he began painting in a manner almost indistinguishable from Kensett's, so much so that unsigned paintings by these two artists have sometimes been confused. As Kensett was one of the most popular landscape painters then working in the United States, Casilear tapped a well-developed market. Kensett's style, however, was evolving, and especially in the years just before his death in 1872, he experimented with color schemes and carefully restricted compositions. Here Casilear did not follow, preferring instead to repeat the style Kensett had perfected in his earlier years.

In 1858, Casilear visited Europe again and spent much of his time in Switzerland. His sketches from this trip served as the subject matter for many of his paintings until the late 1880s. In the 1870s, however, as the popularity of the Hudson River school waned and the market for Barbizon and Barbizon-influenced paintings increased, Casilear changed his style to reflect the prevailing fashion. He did not, however, imitate the formal and coloristic experiments of the Barbizon school but chose instead to emulate Constant Troyon, one of the most conservative and earliest of the group's painters. An excellent example of his using Troyon's work as a model is *Distant View of the Catskills* (q.v.).

Casilear, who had become rich from his banknote engraving business, was a man of notably good temperament, much liked by his fellow artists. He remained an active member of the National Academy, as well as the Century Association and the Artists Fund Society, throughout his career. Casilear died at Saratoga Springs, New York, in his eighty-third year.

BIBLIOGRAPHY: John William Casilear Papers, 1832–1962, D177, Arch. Am. Art. A good number of letters together with numerous miscellaneous materials // Henry T. Tuckerman, *Book of the Artists* (New York, 1867), pp. 521–522. Tuckerman knew Casilear well and praises his work // Groce and Wallace (1957).

Casilear, *Lake George*.

Lake George

Lake George was one of Casilear's favorite subjects. He sketched on the spot on several occasions beginning in about 1855 and was reportedly there during August 1856, when he may have taken sketches for this picture and another with the same title also painted in 1857 (Brooklyn Museum). He exhibited three scenes of Lake George at the National Academy during 1857 and 1858; it has not been determined, however, which pictures he showed in these exhibitions. Although each of Casilear's paintings of Lake George shows a different location, they share compositional similarities, with the shoreline defining the foreground, the expansive lake forming the usually hazy middle ground, and mountains in the distance. He probably took this particular view from the western shore of the lake, looking south to Black Mountain.

In execution, this painting demonstrates Casilear's close adherence to the style of JOHN F. KENSETT, especially in the painting of water and distant mountains. The meticulously detailed treatment of the trees at the left, however, is perhaps closest to the work of ASHER B. DURAND. Coloristically duller than Casilear's usual style, the painting demonstrates what could almost be termed the Hudson River school formula: detailed realism combined with the restrained treatment of a calm, rural subject.

Oil on canvas, $20\frac{5}{16} \times 29\frac{7}{8}$ in. (51.6 × 75.9 cm.).
Signed and dated at lower left: JWC (monogram) '57.

REFERENCES: B. Burroughs, *MMA Bull.*, suppl. to 12 (Oct. 1917), p. 7, says foreground and trees so deficient in execution as to appear "to be the work of another and less skillful painter" // Gardner and Feld (1965), p. 256 // R. J. Koke, letter in Dept. Archives, July 10, 1991, identifies the probable site.

EXHIBITED: MMA and NAD, 1876, *Centennial Loan Exhibition of Paintings*, no. 192, lent by Morris K. Jesup // MMA, 1917, *Paintings of the Hudson River School* (see *MMA Bull.*, suppl. to 12, above) // MMA, 1934,

Casilear, *Distant View of the Catskills*.

Landscape Paintings, no. 68 // Hudson River Museum, Yonkers, N. Y., 1954, *The Hudson River School, 1815–1865*, no. 21.

Ex COLL.: Morris K. Jesup, New York, by 1876–1908; his wife, Maria DeWitt Jesup, 1908–1914.

Bequest of Maria DeWitt Jesup, from the collection of her husband, Morris K. Jesup, 1914.

15.30.64.

Distant View of the Catskills

This landscape, dated 1891, was painted when Casilear was in his eighties. An example of his very late adherence to the style of the Hudson River school, it also recalls the work of the first generation of the Barbizon school, revealing in both style and subject matter the influence of such painters as Constant Troyon and Jean Baptiste Camille Corot. Contemporary with the first attempts by the younger generation of American artists to learn from impressionism, the picture reflects an interest in at least a few contemporary developments. To a certain degree

Casilear has abandoned the solidity and detail of his earlier style: the trees give some sense of light shimmering off the leaves, and the clouds have a light, puffy quality absent from his earlier work. Overall, however, the landscape demonstrates that even at his advanced age Casilear had lost none of his skill and was painting with all the dexterity of his younger days.

Oil on canvas, 30⅛ × 54 3/16 in. (76.5 × 137.6 cm.).

Signed and dated at lower left: JWC (monogram) / 91.

Canvas stamp: THEODORE KELLEY / ARTISTS' CANVAS / AND / PICTURE LINEN / 136 E. 13TH ST. N. Y.

REFERENCES: B. Burroughs, *MMA Bull.*, suppl. to 12 (Oct. 1917), p. 8; ill. on cover // Gardner and Feld (1965), pp. 256–257.

EXHIBITED: NAD, 1891, no. 348 // MMA, 1917, *Paintings of the Hudson River School* (see *MMA Bull.*, suppl. to 12, above).

Ex COLL.: the artist's niece, Rebecca A. Goldsmith, Peconic, N. Y., by 1897.

Gift of Rebecca A. Goldsmith, 1897.

97.37.2.

JOHN WOODHOUSE AUDUBON

1812–1862

John Woodhouse Audubon, the younger son of John James Audubon (1785–1851), was born at Henderson, Kentucky, on November 30, 1812. He received some artistic training from his father, who encouraged him and his brother Victor Gifford (1809–1860) to practice drawing from nature. The elder Audubon's travels kept him away from home a great deal, but he sent instructions to his sons in his letters. In 1826, for example, he urged John to "begin a Collection of Drawings . . . and not to destroy one drawing no matter how indifferent" (Audubon to his wife, Lucy, transcribed in H. Corning, ed., *Letters of John James Audubon, 1826–1849* [2 vols., 1930], 1, p. 11). Audubon eventually used John's drawings as the basis for his own, more finished compositions. In 1828, he asked John to "make me a Large Drawing of a fine cotton plant in blooms and buds. . . . Branches of hickory, black nutmegs, and . . . different Oaks when the acorns are on, because I could redraw them and make good drawings" (Audubon to his wife, Feb. 3, 1828, Audubon Collection, American Philosophical Society, Philadelphia). Audubon clearly planned that his sons would be his assistants in the preparation of his projected volumes on American birds and mammals.

By the early 1830s, John was traveling and sketching with his father. During 1832, they toured the coasts of Texas and Florida in search of birds and the following year they journeyed to Labrador. Thereafter, John began to draw from the specimens gathered on these trips. In 1833, he wrote to his brother Victor, "I am working that I may someday become a second Audubon—not to make a fortune. My wish is that I may some day publish some birds or quadrupeds and that my name may stand as does my Father's I have drawn several birds for publication that at least are well done, and I hope to rattle them off as fast as my Father in another year" (Nov. 5, 1833, Audubon Collection, American Philosophical Society).

In 1834, Audubon accompanied his father on an extended trip to London, where Victor had been living for several years. John was impressed with the training his brother had received at the Royal Academy and decided that he, too, should learn to paint portraits and landscapes. He copied portraits by Henry Raeburn, such as *Mrs. James Hamilton of Kames*, 1834 (NYHS), and within a year was receiving sitters in his studio. Yet, even though his portraits might have earned him a living, he continued to paint watercolor studies of birds. He contributed many of the illustrations to his father's *The Birds of America* (1840–1844).

In 1837, Audubon married Maria Rebecca Bachman, daughter of the Reverend John Bachman, the Charleston naturalist who later wrote much of the text for the octavo edition of Audubon's *The Viviparous Quadrupeds of North America* (1849–1854). Audubon and his wife lived in London until 1839, when they moved to New York. During the 1840s and 1850s he exhibited portraits and animal paintings at the National Academy of Design, where he was elected an associate in 1841, the American Art-Union, and the Apollo Association. He spent much of his time traveling in search of specimens for the *Quadrupeds*, which was issued in a chromolithographed folio edition between 1845 and 1848. John Woodhouse Au-

dubon painted over half of the illustrations for this publication in collaboration with Victor, who painted many of the landscape backgrounds. The Audubon brothers also collaborated on other works, such as *Startled Deer—A Prairie Scene* (Brooklyn Museum), which they exhibited at the National Academy in 1848.

During the 1850s, after his father's death, Audubon worked on reducing the *Birds of America* and *Quadrupeds* plates for reproduction in small-size editions. He died at his home just north of New York City on February 21, 1862, two years after his brother. Although he has been largely overshadowed by his famous father, there is little doubt that he was a first-rate painter who deserves wider recognition.

BIBLIOGRAPHY: John Woodhouse Audubon, *Audubon's Western Journal: 1849–1850* (1906). Includes a biographical notice by his daughter, Maria R. Audubon // Alice Ford, *Audubon's Animals: The Quadrupeds of North America* (1951). Describes his contribution to the project and reproduces numerous plates // Alice Ford, *John James Audubon* (1964). Contains much information about John Woodhouse and Victor Gifford Audubon // Grey Art Gallery, New York University, *John James Audubon and His Sons* (1982), exhib. cat. by Gary A. Reynolds. Includes biographical information and illustrates some of his paintings.

Hudson's Bay Lemming

This painting is one of the original works reproduced in *The Viviparous Quadrupeds of North America* (folio edition, 1845–1848; octavo edition with text, 1849–1854). This work was the result of a collaborative effort on the part of John James Audubon and his sons, John Woodhouse and Victor Gifford. The elder Audubon, whose artistic powers declined somewhat toward the end of the project, was responsible for seventy-eight of the plates, while John Woodhouse is credited with the other seventy-two. Victor painted the natural habitats that formed the backgrounds of many of these works.

In this picture, Victor may have painted the landscape setting, which is more broadly painted than the animals. The primary attribution for *Hudson's Bay Lemming*, however, is to John Woodhouse Audubon on the basis of the legend that appears on the published lithograph: "Drawn from nature by J. W. Audubon." The inscription on the back of the canvas, "Oil in Terpentine [*sic*] Dec. 1846," secures the attribution, since Audubon's father executed his illustrations in watercolor and retired from the project before December 1846. John Woodhouse Audubon also produced the oil for the other illustration in *Quadrupeds* of lemmings, *Tawny Lemming and Back's Lemming*, 1848 (Princeton University Library).

The subject, called Hudson's Bay lemming

(Georychus Hudsonius) in *Quadrupeds*, is today commonly known as the collared lemming (Dicrostonyx Hudsonius). Measuring about five inches in length, this small rodent inhabits the Labrador region of Canada between Hudson's Bay and the Atlantic Ocean. Unlike other types of lemming, it is not noted for mass migrations. In summer it burrows under stones, and in winter it lives in a nest made of moss. The species is quite docile and easily tamed. As is indicated in the painting, the animal's coat changes color; the text accompanying the published illustration gives the subtitle "Winter and Summer Pelage." In winter the coat is white, except for black whiskers and some black hairs interspersed along the line of the back and on the hind legs and sides. In summer the hair darkens considerably, becoming deep, reddish brown over most of the body, nearly black along the back, and blending to a pale gray on the underside.

Audubon obviously contrived his composition to show the otherwise unlikely juxtaposition of full-grown, male winter and summer lemmings in the same scene. He did this by using preserved specimens, rather than live animals. In 1846, when this work was painted, both John James and John Woodhouse Audubon were in London, where they obtained permission to study the specimens in the British Museum. The text that accompanies *Hudson's Bay Lemming* in *Quadrupeds* makes it clear that Audubon never saw a live lemming:

Audubon, *Hudson's Bay Lemming*.

Our only acquaintance with this species is through the works of the old writers and the Fauna Boreali Americana, we having failed to meet with it at Labrador. The first specimen we saw of it was in the museum of the Royal College of Surgeons in Edinburgh. Our drawing was made from specimens in the British Museum.

This fact also explains the rather inanimate appearance of the lemmings. Familiarity with the habits and movements of the animals they painted made a definite difference in the quality of the Audubons' designs. This is clear if one compares this work with the masterful portrayal of the common rat executed by the senior Audubon in 1843 in one of its most hospitable American habitats, the City of New York (Pierpont Morgan Library, New York).

Oil on canvas, 14 × 22 in. (35.6 × 55.9 cm.).

Inscribed on the back before lining, at upper right: Hudsonius / Win[ter]; at right center: Hudsonius / Winter & Summer; at right center, below: Painted with / Oil in Terpentine [*sic*] Dec. 1846. Inscribed on original stretcher: Hudson Bay Lemming / Plate CIX. Inscribed on paper attached to stretcher: This is the property of Lucy / Bakewell Audubon.

Canvas stamp: Winsor & Newton / 38 Rathbone Place.

RELATED WORKS: *Hudson's Bay Lemming: Winter and Summer Pelage*, chromolithograph printed by J. T. Bowen, Philadelphia, 22 × 28 in. (55.9 × 71.1 cm.), in *The Viviparous Quadrupeds of North America* (1845–1848), 3, pl. CXIX, incorrectly labeled as CIX.

REFERENCES: J. J. Audubon and J. Bachman, *The Quadrupeds of North America* (3 vols., 1849–1854), 3, p. 83 (quoted above) // A. Ford, *Audubon's Animals*

Lithograph by Bowen for *Hudson's Bay Lemming*. American Museum of Natural History.

(1951), pl. 178, no. 121, identifies the subject as a collared lemming (Dicrostonyx Hudsonius) and discusses specimen // *The Old Print Shop Portfolio* 13 (1954), p. 166, calls this painting the original for plate CIX in the folio edition of the *Quadrupeds* // Gardner and Feld (1965), pp. 258–259.

EXHIBITED: MMA, 1965, *Three Centuries of American Painting* (checklist arranged alphabetically) // M. Knoedler and Co., New York, 1968, *The Artist and the Animal*, no. 80 // Corcoran Gallery of Art, Washington, D. C., 1971, *Wilderness*, no. 11 // MMA and American Federation of Arts, traveling exhibition, 1975–1977, *The Heritage of American Art*, exhib. cat. by M. Davis, no. 40.

EX COLL.: Lucy Bakewell Audubon; with the Old Print Shop, New York, by 1951; with Kennedy Galleries, New York; Mrs. Emily Winthrop Miles, Sharon, Conn., until 1962; Mrs. Darwin Morse, Richmond, Mass., until 1963.

Gift of Mrs. Darwin Morse, 1963.
63.200.5.

John Woodhouse Audubon

CHARLES LORING ELLIOTT

1812–1868

Charles Loring Elliott, a leading New York portraitist of the mid-nineteenth century, was born in Scipio, Cayuga County, New York, to the architect Daniel Elliott and his wife, the former Mehitable Booth. He attended the district school and spent much of his free time in his father's workshop, where he crafted wagons, sleds, and windmills, and began drawing in India ink and crayons and painting in oil. In 1827 the family moved to Syracuse and Elliott entered a school for architectural training. After two years he was capable of producing excellent drawings. He did not, however, care for pure draftsmanship, so his father sent him to an academy of art in Onondaga Hollow, where he learned to paint landscapes. Unhappy with the academy's regime, however, he left after three months.

In 1829, Elliott finally asked for his father's consent to go to New York and become a painter. His father relented and sent him to the American Academy of the Fine Arts with a letter of introduction to JOHN TRUMBULL. After a few months drawing from casts at the academy, Elliott sought advice from JOHN QUIDOR. Quidor gave him easel space in his studio and, according to Elliott's friend Thomas Bangs Thorpe, "that was all the study Elliott ever had as a pupil" (*New York Evening Post*, Sept. 30 and Oct. 1, 1868).

In 1830 Elliott returned to central New York and spent "ten of the brightest and best years of his life" as an itinerant painter (quoted in Lester, 1868, p. 47). He stopped at Hamilton College, Oneida County, for an extended period, where he painted likenesses of faculty members and students including DANIEL HUNTINGTON, who became a portraitist through Elliott's encouragement. According to Henry T. Tuckerman, it was during this itinerant period that Elliott received a portrait by GILBERT STUART in payment for a commission. "In the centre of western New York," Tuckerman explained, "he found his Academy, his Royal College, his Gallery and life-school, in one adequate effort of Gilbert Stuart's masterly hand" (p. 305). For many years Elliott used the picture as a model, and his palette of fresh, clean colors demonstrates the influence of Stuart.

In 1839 Elliott decided that he needed "the electric influence" of the city (Lester, p. 47). During that year he exhibited two portraits at the National Academy of Design and three in 1840. HENRY INMAN was the most sought-after portraitist in New York at the time and Elliott wanted to incorporate some of Inman's techniques with his own. Inman praised Elliott's work, claiming that it "had from the beginning, an air of fidelity, earnestness and truth; there was warm and genial expression and a rich glowing, generous coloring" (Lester, p. 46). Although some of Elliott's portraits show Inman's influence, on the whole his direct style varied considerably from Inman's more sentimental depictions. Thorpe recorded that Inman himself recognized this: "When I am gone that young man will take my place. He has the true idea of portrait painting—if it were possible to live my life over again, in some respects I would change my style . . . Each face should be a study of itself; no aim of a peculiar touch should betray me into a conventional style" (Lester, p. 46).

By 1845 Elliott had gained an international reputation. Though he never visited Europe,

he exhibited his works there; for example, his portrait of Sanford Thayer (1820–1880), a fellow artist, found critical acclaim at the World's Fair in London in 1845. During the same year he sent a portrait of the inventor John Ericsson to the National Academy which critics praised as the best in American portraiture since Stuart. Elected an associate of the academy in 1845, Elliott became an academician in the following year. He was an active member of the Sketch Club and a founder of the Century Association.

After Inman's death in 1846, Elliott became the leading portrait painter of New York. A country boy at heart, the bustle of city life prompted him to move his family to the hills of Hoboken in 1853, although he retained his studio on Broadway. His early development as an artist was influenced by the coloring and draftsmanship of Stuart and the slick, romantic portraiture of Henry Inman. By 1845 Elliott's basic style was fully developed and remained characterized by factualism, simplicity of composition, and crisp handling. This preference can be traced through American portraiture from JOHN SINGLETON COPLEY, CHARLES WILLSON PEALE, and CHESTER HARDING to Elliott. It is not surprising that the advent of the daguerreotype, with its stark realism, had a significant impact on this artist's work, a disastrous one, according to modern critics. As proof, they note that he began using this process as a basis for his later work, the results being uninspired photographic imitations. But the role of the daguerreotype in Elliott's work was more to encourage his natural instincts than to cause a radical alteration or deterioration in his style. Indeed, his later style varied between relentless realism showing "extreme effects of light and shade" as in *Caleb Gasper*, 1852 (q.v.), and a softer, more generalized treatment as in *Mrs. James Clinton Griswold*, 1854 (q.v). In fact the work that is considered his best is strongly photographic, *Mrs. Thomas Goulding*, 1858 (NAD). The meticulous detail, sense of immediacy, and force of clarity and personality in Elliott's portraits raise them well above many of his contemporaries. In 1905, Samuel Isham aptly characterized Elliott's work:

> He was for his time the most skilful portrait painter in the country, and his work shows an even level of excellence, and an unchanging method of work. He painted with a brush well charged with freely flowing paint, without fumbling or working over. The drawing is firm, the color fresh and clean, the likeness well caught, very much like the contemporary work of Winterhalter and his contemporaries in France, and, like that, rather lacking in personal feeling and poetry; but yet a distinct advance on Harding and Inman (*History of American Painting*, 1905, pp. 275–276).

Tuckerman wrote that Elliott painted over seven hundred portraits, but less than a quarter of these have been located. His list of patrons included merchants, financiers, politicians, and scholars. He painted New York governors Washington Hunt, Horatio Seymour, William C. Bouck, William Henry Seward, and Edward D. Morgan; authors James Fenimore Cooper and William Cullen Bryant; as well as artists FREDERIC E. CHURCH, ASHER B. DURAND, and WILLIAM SIDNEY MOUNT.

BIBLIOGRAPHY: Henry T. Tuckerman, *Book of the Artists* (New York, 1867), pp. 300–305 // C. E. Lester, "Charles Loring Elliott," *Harper's Monthly Magazine* 38 (Dec. 1868), pp. 42–50 // Theodore Bolton, "Charles Loring Elliott: An Account of His Life and Work," *Art Quarterly* 5 (Winter 1942), pp. 58–96. Includes a list of his portraits // Philip F. Schmidt, "Charles Loring Elliott," unpublished M.A. thesis, University of Minnesota, 1955.

Portrait of the Artist

There are several known self-portraits of El-
liott. The earliest was painted in 1834 dur-
ing his itinerant days (Everson Museum of
Art, Syracuse). The second is an oil sketch of
about 1845, referred to by Tuckerman as hav-
ing "brought eight hundred dollars at the
Avery sale" (p. 303), and now in a Los Angeles
private collection. In about 1850 he painted this
picture and exhibited it that year at the National
Academy of Design. He painted his last known
self-portrait in 1860 and presented it as a gift
to his friend William T. Walters (Walters Art
Gallery, Baltimore). The Walters painting, in
which the artist portrayed himself in a broad-
brimmed hat, full beard, and voluminous robe,
is reminiscent of a well-known Rubens self-por-
trait. Elliott painted two replicas of the Walters
portrait (Heckscher Museum, Huntington, N.Y.,
and Detroit Institute of Fine Arts); both are un-
dated. This museum owns a portrait of Elliott
by SEYMOUR JOSEPH GUY, painted in 1868 in the
manner of Elliott's photorealistic style and de-
picting him seated in front of his self-portrait for
William T. Walters.

This self-portrait was painted at the height
of Elliott's career. Accordingly, he is represented
in a confident and relaxed manner. He appears
as a man of "genial sensibility," very much as
his friend L. Gaylord Clark described him after
his death: "His whole appearance and manner
were most winning. His handsome face, lighted
up with animation, had the pure red-and-white
complexion, the smoothness and sheen of a
young girl's; and his soft hazel eyes, shaded by
wavy, dark, silken hair" (*Lippincott's Magazine* 2,
1868, p. 652).

From the daguerreotypes of him made by
Mathew Brady around the same time we know
this to be an excellent likeness. It is strongly
modeled with a force of clarity and personality
indicative of his best work.

The year that Elliott painted this self-por-
trait, his close friend WILLIAM SIDNEY MOUNT
wrote:

The beauty of Elliott's coloring depends on his glaz-
ing. . . . In the first sitting he gives the effect of the
head in rather a silvery style of colouring. In the
second sitting he corrects the drawing and effect if it
requires it — in the same style of colouring as the first.
The third and last sitting only requiring the strength
of the palette by glazing with (brush or thumb) — clear
blue, red, and yellow etc as the case may be. Some-

Elliott, *Portrait of the Artist.*

times he improves the high lights after the head is
dry — as the last touches. Elliott told me that in com-
mencing a portrait, he touched on the highest light
(on the forehead) with pure white first — then the next
highest light on the bridge or side of the nose as the
case might be — the next on the upper lip — and the
last on the chin. He then worked from the lights into
the receding shadows, and darks, touching in differ-
ent tints in a spirited manner, observing the reflections
etc. He generally makes his Shadows clear — a great
merit (Alfred Frankenstein, *William Sidney Mount*, p.
238).

This technique enabled Elliott to be a metic-
ulous delineator and, at the same time, to main-
tain an energetic brushstroke. The highlight on
the forehead that Mount refers to is evident in
all of the portraits.

Oil on canvas, 30⅛ × 24½ in. (76.5 × 62.2 cm.).
REFERENCES: C. H. Caffin, *The Story of American
Painting* (1907), p. 95 // F. W. Noxon, "Charles Loring
Elliott," unpublished paper delivered to Onondaga
Historical Association, Syracuse, Oct. 11, 1912, p. 6 //
T. Bolton, *Art Quarterly* 5 (1942), ill. as fig. 1, pp. 80,
81, 88 // P. F. Schmidt, "Charles Loring Elliott" un-
published M.A. thesis, University of Minnesota
(1955), p. 23 // Gardner and Feld (1965), p. 262.
EXHIBITED: NAD, 1850, no. 37 (probably this pic-
ture) // Ortgies Art Galleries, New York, April 28,

1886, *Catalogue of Modern Paintings to be sold by Order of the Executrix of C. N. Fearing*, no. 21 || MMA, 1946, *Taste of the Seventies*, no. 96 || MMA, 1965, *Three Centuries of American Painting* (checklist arranged alphabetically).

Ex COLL.: C. N. Fearing, New York, to 1886; Robert Hoe, Jr., New York, 1886–1887.

Gift of Robert Hoe, Jr., 1887.

87.19.

Preston Hodges

Preston Hodges (1785–1855) was born in Mansfield, Massachusetts, the son of Nathaniel and Hannah Skinner Hodges. He married Lydia Cole, who bore him five children. In 1821 they moved to Providence, Rhode Island, where Hodges opened the Franklin House, which became one of the city's finest hotels. Eleven years later, in 1832, he moved his family to New York. There he and his son, Preston Henry, opened the Clinton Hotel, which occupied part of the newly completed Clinton Hall on the corner of Beekman and Nassau streets. According to Lewis Leland, a reporter for the *New York Tribune*, this location "was exceedingly desirable" (May 1, 1881). The actor George Vandenhoff stayed at the Clinton in 1842 and praised it: "The *table d'hote* set at that house—by no means a large one—far surpassed in excellence and superabundance of good things the tables which we now find even at the best hotels" (*Leaves from an Actor's Note-book* [1860], p. 182).

Elliott painted this portrait in 1850, four years after Hodges retired from the Clinton. Hodges typifies the successful, elderly innkeeper who appears to have enjoyed the "superabundance of good things" as much as his guests. He may have become acquainted with Elliott through his son, who was the proprietor of the Carlton Hotel, where the artist was a boarder. In the 1850 exhibition at the National Academy of Design, one of the twelve portraits by Elliott was a "Portrait of a Gentleman" lent by P. H. Hodges. This very likely was a portrait of Preston Henry Hodges. There is a possibility, however, that it was this portrait of the father. Here Elliott has captured an arresting moment of recognition between the subject and viewer. As Tuckerman wrote:

The vigor and truth of his best likenesses—the character and color which distinguish them are such as

Elliott, *Preston Hodges*.

win for him, the respect and interest due to a master. This is especially true of such of his heads as represent men of strong, practical natures, [who] achieved success through firmness, shrewdness, and self reliance, and whose faces bear the line of this warfare and achievement—all the more effective under the artist's hand, if the complexion is that ruddy hue which Stuart loved to delineate, . . . and with what nature the white hair rests upon the florid temple (*Book of the Artists*, pp. 300–301).

The realistic manner with which Hodges is portrayed is heightened by the strong relief and modeling of every contour. The luminous form of the head juxtaposed against the dark simple background was the most outstanding characteristic of Elliott's paintings. This portrait combines a robustness and sense of immediacy that is in Elliott's best and most personal manner.

Oil on canvas, 27 × 22 in. (68.6 × 55.9 cm.).

Signed, dated, and inscribed on the back: C. L. Elliott / 1850 / New York.

REFERENCES: T. Bolton, *Art Quarterly* 5 (1942), p. 81, fig. 13; p. 89, lists it || P. F. Schmidt, "Charles Loring Elliott," M.A. thesis, University of Minnesota (1955) p. 39, 41, and 42, discusses it || Gardner and Feld (1965), p. 262.

EXHIBITIONS: MMA, 1946, *Taste of the Seventies*, no. 95; 1965, *Three Centuries of American Painting* (check-

list arranged alphabetically) // New York State Council on the Arts, Art and Home Center Exposition Grounds, Syracuse, 1966, *One Hundred and Twenty Five Years of New York State Painting and Sculpture*, no. 20.

Ex coll.: Preston Hodges, 1850–d. 1855; his son, Preston Henry Hodges, 1855–after 1892; his daughter, Marie Diamond Hodges Aspell, after 1892; her daughter, Seddie Boardman Aspell, 1927.

Bequest of Seddie Boardman Aspell, 1927.

27.145.

Caleb Gasper

Caleb Gasper (1790–1877) was born in Ashford, Connecticut. He settled in Marcellus, New York, before 1825, and remained there until his death. His wife, Fanny, whom he married in 1827, bore him three sons and two daughters, one of whom, Laura, married James Clinton Griswold (q.v.).

This picture was painted in 1852, when the sitter would have been forty years old. Gasper, who may have been a farmer, was prematurely wrinkled and looks to have been uncomfortable sitting for his portrait. Elliott was obviously determined to produce a remarkably accurate likeness, recording every wrinkle, bulge, and contour of Gasper's clothing and flesh under intensified light, which suggests that he may have painted the portrait from a daguerreotype. Elliott was enthusiastic about daguerrean art. Thomas Bangs Thorpe recorded the artist's conversation while he was copying James Fenimore Cooper's portrait from a Mathew Brady daguerreotype: "He observed that he never saw a picture made by the process that did not have about it something to admire. He liked Rembrandt better if such a thing were possible, after he had studied daguerreotypes, for they justified his extreme effects in light and shade" (*New York Evening Post*, Sept. 30, 1868, p. 8). Less than two years before this portrait was painted, Brady's *Gallery of Illustrious Americans* appeared in leading bookstores. The book had a profound effect on American portrait painters and on Elliott in particular. His natural inclination had been toward extreme realism, and the photographic process tended to push him further in that direction.

Oil on canvas, 33¼ × 25 in. (84.5 × 63.5 cm.).
Signed and dated at lower right: C. L. Elliott 1852.

Elliott, *Caleb Gasper*.

Canvas stamp: Williams, Stevens, & Williams / Looking Glass Ware Rooms / & Art Repository / Engravings, Art Materials &c. / 353 Broadway, New York

References: F. W. Noxon, "Charles Loring Elliott," unpublished paper delivered to Onondaga Historical Association, Syracuse, Oct. 11, 1912, mentions this portrait, p. 6 // MMA, *Catalogue of Paintings* (1912), p. 88 // T. Bolton, *Art Quarterly* 5 (1942), fig. 7, p. 68, discusses p. 82, lists p. 88 // P. F. Schmidt, "Charles Loring Elliott," unpublished M.A. thesis, University of Minnesota (1955), pp. 3, 39, and 42 // Gardner and Feld (1965), p. 263.

Ex coll.: Caleb Gasper, d. 1877; his daughter, Mrs. James Clinton Griswold, New York, 1877–1897; her daughter-in-law, Katherine Cowdin Griswold (later Mrs. Henry G. Marquand, Jr.), 1897–1900.

Gift of Mrs. Henry G. Marquand, Jr., 1900.

00.17.3.

Mrs. James Clinton Griswold

Laura Gasper (1830–1897) was born in Marcellus, New York, to Fanny and Caleb Gasper (q.v.). In 1849 she married James Clinton Griswold of Fairfield, New York. They settled in New York City where her husband was a partner in the dry goods firm Tefft, Griswold & Com-

558

pany from 1849 until his death in 1876. Elliott painted Mrs. Griswold's portrait in 1854, two years after he painted her father (see above). She is portrayed in the sentimental manner fashionable in the mid-nineteenth century. Elliott avoided his traditional stark background and painted a romantic landscape that serves as a lyrical setting. Though the subject is delineated in solidly modeled forms characteristic of Elliott, the smooth polished surface of her skin is unlike his usual energetic brushwork.

In contrast to the portrait of Mrs. Griswold's father, the affected and sentimental pose seen here is decidedly unphotographic and more directly related to the style of Inman. Elliott's likenesses of young women have never been considered as successful as those of men. An anonymous critic wrote in 1868: "Elliott had more sympathy with strength than with delicacy ... he liked best to paint strongly marked faces, with a full, ruddy complexion, and his method of handling was bold and vigorous" (*Eclectic Magazine* [Nov. 1868], p. 1409).

Elliott, *Mrs. James Clinton Griswold.*

Oil on canvas, 36⅛ × 29¼ in. (91.8 × 74.3 cm.). Signed and dated at lower right: Elliott 1854.

REFERENCES: *Literary World* 10 (April 24, 1852), p. 302, review of the NAD exhibition states that "Elliott has no equal living, and of the grace and beauty of his portraits of ladies anyone can form a judgment by studying No. 53, in which he has been fortunate alike in subject and treatment" // *Knickerbocker* 39 (June 1852), p. 504, review of NAD exhibition includes the comment that "the 'Portrait of a Lady,' No. 53, ... show[s] his peculiarities to the best advantage" // *New York Tribune*, June 7, 1852, p. 5, reviews it in NAD exhibition, "In No. 53, we have one of Mr. Elliott's best portraits ... [that] at first glance would appear from the peculiarity of the position represented, a strange, and even a little grotesque, fixture for the walls of a drawing-room or chamber. It would seem almost an affectation, suggestive of ladies ... in annuals. But this has been naturally and beautifully obviated by the slight bit of landscape introduced. Its rustic ease involuntarily reminds the spectator that the nature indicated is under the circumstances among the most natural and graceful" // F. W. Noxon, "Charles Loring Elliott," unpublished paper delivered to Onondaga Historical Association, Syracuse, Oct. 11, 1912, p. 6 // T. Bolton, *Art Quarterly* 5 (1942), p. 88, lists it // P. F. Schmidt, "Charles Loring Elliott" M.A. thesis, University of Minnesota (1955), p. 36, discusses it // Gardner and Feld (1965), pp. 263–264.

EXHIBITED: NAD, 1852, no. 53, as Portrait of a Lady owned by Jas. C. Griswold (probably this picture).

EX COLL.: Mrs. James Clinton Griswold, New York, 1854–1897; her daughter-in-law, Katherine Cowdin Griswold (later Mrs. Henry G. Marquand, Jr.), 1897–1900.

Gift of Mrs. Henry G. Marquand, 1900.
1900.17.2.

Mathew B. Brady

Mathew B. Brady (1823–1896), pioneer photographer, was born in Warren County, New York, to Andrew and Julia Brady, Irish immigrants of humble origin. His formal education was meager. At the age of fifteen, while visiting in Saratoga, he met WILLIAM PAGE. Page took an interest in Brady and gave him instruction in oil painting and pastels. He later took him to New York and introduced him to SAMUEL F. B. MORSE. Morse had just set up a studio and laboratory of daguerreotypy, a new process he had learned about on a trip to Europe. It was in this studio that Brady, at the age of sixteen, began experimenting with the daguerreotype. Five years later he opened his own studio, in 1844, on the corner of Broadway and Fulton Street. He was an instant success. A tireless in-

Elliott, *Mathew B. Brady.*

On the advent of the Civil War in 1861, Brady was granted permission from General Irvin McDowell to accompany the army and photograph battle and camp scenes. He followed the action with his "Whatizzit Wagon," the forerunner of the newsreel truck, to Bull Run, Petersburg, and Fredericksburg, where he nearly lost his life. In all, he took more than eight thousand photographs of actual conflicts or scenes devastated by gunfire. After the war he proposed that the government purchase the collection, but Congress did not vote the necessary funds until 1875 and then it was for but a fraction of the amount requested. As a result of this delay, Brady was forced to sell much of his New York property in 1869, and one complete set of the plates were claimed by a photographic supply firm when he was unable to pay his bills. The panic of 1873 completed Brady's financial ruin. Not easily defeated, he spent the next twenty years trying to maintain his business and keep up with photographic innovations.

In 1895 an accident confined Brady to a hospital for several months. When he had partially recovered, his lifelong comrades of the Seventh Regiment were planning a testimonial benefit in his honor. Brady wanted to deliver a lecture with the aid of a stereopticon projector and decided to sell the portrait Elliott had painted of him to procure funds for the projector and ease his financial difficulties. But his health grew steadily worse, and he died two weeks before the event was to have taken place. Although Elliott did not date this portrait, Brady stated when he lent it to the Metropolitan Museum in 1895 for an exhibition of American artists that it was done in 1857. He placed it at Wilmurt's store for sale during the fall of 1895 shortly after the exhibition and a few months before his death. When he died, some of his friends bought the painting and gave it to the museum.

Elliott portrayed Brady as a handsome, sensitive, slightly bohemian young man. Painted one year after he had begun making portraits by the "wet plate process," he was at the peak of his career. It is significant that although Elliott occasionally tried to capture the effect of the daguerreotype in his painting, such as his portrait of Caleb Gasper (q.v.), he chose to depict Brady in a much more traditional style. There is little of the forced light and shade one might expect in a picture by Elliott of this well-known photographer.

novator, he soon developed a process of making tinted daguerreotypes on ivory. In 1850 he published his *Gallery of Illustrious Americans*, a photographic compilation with biographical sketches of notable men and women of the period.

The legend "By Brady" on the bottom of a daguerreotype likeness became de rigeur in fashionable circles both in the United States and Europe. In March 1849 Brady had opened a branch gallery in Washington, where he met Julia Handy, whom he soon married. In 1851 they went to the World's Fair in London, where Brady received first prize for his exhibition of forty-eight pictures. In Europe, Brady met Alexander Gardner, who had been working with the new "wet plate process" invented by the English sculptor Frederick Scott Archer. In 1856 Gardner joined Brady in New York, and they began printing the so-called imperial photograph, which measured up to seventeen by twenty inches and sold for as much as seven hundred dollars.

Brady's prestige and talent earned him the honor of being Abraham Lincoln's official photographer. Lincoln first sat for Brady when he was in New York to debate Stephen Douglas. Brady took several pictures, which were in great demand after Lincoln's speech at Cooper Union.

Oil on canvas, 24 × 20 in. (61 × 50.8 cm.).

Canvas stamp: Williams, Stevens, Williams & Co. / Looking Glass Ware Rooms / & Art Repository / Engravings Art Materials &c. / 353 Broadway New York / 24 × 20. Label on frame: T. Wilmurt & Co. / Mirrors & Picture Framers / 54 E. 13th Street.

RELATED WORKS: Richard F. Nagle, Mathew B. Brady, n.d., after Elliott, oil on canvas, 24¼ × 20½ in., NYHS.

REFERENCES: F. W. Noxon, "Charles Loring Elliott," unpublished paper delivered to Onondaga Historical Association, Syracuse, Oct. 11, 1912, p. 6 // T. Bolton, *Art Quarterly* 5 (1942), p. 82; p. 85, lists it; fig. 11 // R. Meredith, *Mr. Lincoln's Camera Man* (1946; 1974), p. 256, ill. p. 149 // J. D. Horan, *Mathew Brady* (1955), pp. 25, 71, fig. 2a // Nancy Vars, *Syracuse Post-Standard Pictorial*, Dec. 26, 1954, p. 8 // Gardner and Feld (1965), p. 264.

EXHIBITIONS: MMA, 1895, *Retrospective Loan Collection of Paintings by American Artists*, no. 160; 1939, *Life in America*, no. 201, p. 151; 1946, *The Taste of the Seventies*, no. 97; 1965, *Three Centuries of American Painting* (checklist arranged alphabetically) // National Portrait Gallery, Oct.-Dec. 1968, Northern Virginia Fine Arts Association Friends of Mathew Brady Society, Sept. 10-Oct. 6, 1972 (no. cat.).

Ex COLL.: Mathew Brady, 1857–1896.

Gift of the Friends of Mathew Brady, 1896.

96.24.

his country home in Bernardsville, New Jersey, in 1883.

In 1859, shortly after his appointment as city chamberlain, there was a temporary shortage of public funds. Stout advanced money from his private funds to pay the police department's wages. In gratitude the police "procured a portrait of A. V. Stout esq., President of the Shoe and Leather Bank, from the pencil of Elliott, which they are about to present to him, as a token of regard and gratitude."

This portrait, painted in the last decade of Elliott's life, shows a handsome, middle-aged, prosperous banker. It embodies the methodical and careful craftsmanship which characterized Elliott's style throughout most of his life.

Oil on canvas, 44 × 37⅝ in. (111.8 × 96 cm.).

Signed and dated lower left: Elliott 1859.

RELATED WORKS: Another version of this portrait is thought to have been done.

REFERENCES: *New York Tribune* (March 12, 1859), quoted above // *New York Times*, Sept. 6, 1883, p. 7, gives information on the sitter.

Ex COLL.: Andrew Varick Stout, New York, 1859–1883; his son, Joseph Suydam Stout, New York, 1883–1904; his son Andrew Varick Stout IV, New York, to 1965.

Gift of Andrew Varick Stout IV, 1965.

65.139.

Andrew Varick Stout

Andrew Varick Stout (1812–1883) was a member of a prominent New York family. Educated in the public schools, he became a teacher at the age of eighteen and rose to become principal of the public school on Madison Street. He was later appointed manager of the New York City Board of Education. At the age of thirty, he turned to mercantile pursuits and established the firm of Stout and Ward, a boot and shoe company, which was very successful. In 1836 he married Almira H. Hanks, who bore him seven children. He founded the Shoe and Leather Bank in 1855 and was its first president, a position he held for twenty-eight years. During this period, he was a director of several banks and insurance companies, served a term as city chamberlain, and was a supporter and trustee of Drew Theological Seminary in New Jersey and Wesleyan University in Connecticut. When the Civil War broke out, he was numbered among the Democrats who favored war and switched to the Republican party. Stout died at

Elliott, *Andrew Varick Stout.*

CHARLES WESLEY JARVIS

1812–1868

Charles Wesley Jarvis was the son of the New York portrait painter JOHN WESLEY JARVIS and his second wife, Betsy Burtis, who was from Oyster Bay, Long Island. A year after Charles was born, his mother died in childbirth, and he and his elder brother, John, were raised by her family. Young Jarvis's experiences as, in effect, an orphan (for his profligate father surely played a very small part in his early life) may not have been very happy. Family tradition records that he "left the wealthy Burtises with half a shirt on his back" (Dickson, p. 319 n). It is almost certain that he never received instruction in painting from his father. About 1828, however, HENRY INMAN offered to train both of Jarvis's sons as painters, apparently as a favor to his former master. Charles became Inman's assistant, first in New York and then from 1831 to 1834 in Philadelphia. He probably accompanied Inman back to New York. At first he boarded in the same house in New York as his partially paralyzed father, assisting him financially and perhaps with his painting as well. At about this time, Charles is said to have married Phileana Croggan Bensol, a widow. They had one child, Emily, who died in an accident at the age of four.

In 1835 Jarvis set up his own studio for painting portraits, and in 1839 he began to exhibit at the National Academy of Design and the Apollo Association. He never became an associate or a full member of the academy and stopped exhibiting there after 1850. By 1854, he had moved to Newark, New Jersey, but maintained a studio in New York up until the time of his death. Most of his work was done in the New York area; he was patronized by several prominent residents living along the Hudson River, including members of the Cruger and Fish families. He is known to have painted in Havana and is said to have restored paintings damaged by fire in New York City Hall.

Now virtually forgotten, Charles Wesley Jarvis appears to have been a competent, if seldom inspired, practitioner of his craft. Although not many works by him are known, it is likely that a good number still exist.

BIBLIOGRAPHY: Harold E. Dickson, *John Wesley Jarvis* (Chapel Hill, N. C., 1949). Includes considerable information on Charles Wesley Jarvis's early years // "Notes on Charles Wesley Jarvis, given to J. Hall Pleasants by the artist's great-niece Mrs. Charles L. Swigert," Jan. 31, 1935, copy in Dept. Archives.

Mrs. Adrian Baucker Holmes

This portrait of a previously unidentified woman is now believed to be Mrs. Adrian Baucker Holmes (ca. 1822–1898), the former Georgiana Duryee. Jarvis's portrait of Mrs. Holmes's children and one of her mother, Eliza Duryee, were given to the Brooklyn Museum in 1916 by Kathryn Holmes Blauvelt, who was also the donor of this portrait. The related correspondence records that Charles Wesley Jarvis painted the group portrait of the four Holmes daughters about 1849 (the youngest daughter in the picture, who had recently died, was painted from a daguerreotype). Kathryn Holmes Blauvelt, one of the daughters, noted that she was seven when the group portrait was painted and remembered "Mr. Charles Jarvis perfectly." The dress and hairstyle of the subject in this portrait indicates a date of about 1850, and her age

Jarvis, *Mrs. Adrian Baucker Holmes.*

and an aunt (age fifty-two). At the time, they lived at 296 West 20th Street in New York. Georgiana Duryee was married to Adrian Baucker Holmes in 1840; in 1850 he is listed in the city directory as an insurance agent with an office on Wall Street. The family moved several times: to Flushing, Newark, and then Brooklyn. Mrs. Holmes was widowed in 1876.

Jarvis shows Mrs. Holmes seated in a red chair against a blue-black evening sky with trees on each side. Her white dress, falling in convincing folds, is well painted, as is her face, in which the cheeks and mouth are of a deep red hue. Jarvis reveals himself here as a competent portrait painter.

Oil on canvas, oval, 30 × 25 in. (76.2 × 63.5 cm.).
REFERENCES: H. W. Kent, copies of letters to donor in MMA Archives, Dec. 9, 1913, acknowledges receipt of three portraits for consideration; Dec. 22, 1913, says the board has accepted the portrait of a young woman and he will return the other two (portrait of a man and portrait of a woman) // Gardner and Feld (1965), p. 260 // T. Carbone, Brooklyn Museum, May 1, 1989, supplies letter from Mrs. Blauvelt, July 23, 1916, Accession record 12702, volume II (quoted above) and a photograph of the portrait of the Holmes children.
ON DEPOSIT: Bartow-Pell Mansion, New York, 1947-present.
EX COLL.: the subject's daughter, Kathryn Holmes (Mrs. J. Harman) Blauvelt, Brooklyn and New York, until 1913.
Gift of Mrs. J. H. Blauvelt, 1913.
13.21.8.

would be consistent with that of Mrs. Holmes in 1850. The Brooklyn portrait of Eliza Duryee is also an oval and is the same size as the Metropolitan portrait.

The 1850 census, which lists Kathryn as seven, includes in the household her parents (father, age thirty, and mother, twenty-eight), two sisters, a grandmother (Eliza Duryee, age fifty),

SAMUEL H. SEXTON

1813–1890

Born in Schenectady, New York, S. H. Sexton, as he invariably signed himself, was the son of a cobbler and may have at first practiced the same trade. By the time he was twenty, however, he was painting portraits. According to a newspaper article of 1835, he was self-taught, and his known early work certainly reflects that statement. Between 1838 and 1840 his work began to show the influence of the currently fashionable style of SAMUEL L. WALDO and WILLIAM JEWETT, suggesting that he may have visited New York. In 1841 he began to exhibit at the National Academy of Design and continued to do so off and on over the next

decade. Most of the paintings were landscapes of the area around Schenectady, but two were portraits, and one was a history painting. None of these is known today.

In *Autobiography of a Journalist* (1901), the critic and artist William J. Stillman (1828–1901) gave the following description of Sexton:

> The friendship between Sexton and myself lasted through his life, and a truer example of the artistic nature never came under my study. All that he knew of painting he got from books, save for an annual visit to the exhibition of the American Academy at New York, but his conception of the nature of art was very lofty and correct, and had his education been in keeping with his natural gifts, he would have taken a high position as a painter. His was one of the most pathetic lives I can recall — a fine, sensitive nature, full of the enthusiasms of the outer world, with rare gifts in the embryonic state and mental powers far above the average, limited in every direction, in facilities, in education, in art, and in letters, and having his lot cast in a community where, except the wife of [Union College] President Nott, there was not a single person who was capable of giving him sympathy or artistic appreciation. Not least in the pathos of his situation was the simplicity and humility with which he accepted himself, with his whole nature yearning towards an ideal which he knew to be as unattainable as the stars, without impatience or bitterness towards men or fate. If he was not content with what was given him, no one could see it, and he was so filled with the happiness that nature and his limited art gave him that he had no room for discontent at the limitations (pp. 110–111).

Judging from the signed portraits extant today, Sexton's patronage from the 1830s until the late 1850s was more or less steady. After that, the number of canvases diminishes sharply, and those that do exist betray the influence of photography. It is not unlikely that the increasing popularity of photographic likenesses contributed to the decline in his commissions. Interviews published in the local press reveal him as a proud man, and he seems to have become a little querulous with the years. From one account (J. B. Clute, cited in Curran [1970], p. 9), Sexton turned his hand to various activities, such as painting stove decorations and plaster statues. In 1890 he produced three landscapes in a style derived from the American Barbizon painters. According to a local historian, he died "an old man in penury" (J. H. Munroe, *Schenectady, Ancient and Modern* [1914], p. 262).

BIBLIOGRAPHY: William James Stillman, *Autobiography of a Journalist* (Boston, 1901), pp. 110–111. The earliest known account of Sexton // Ona Curran, *Samuel Hayden Sexton: 19th Century Schenectady Artist* (Schenectady, N, Y., 1970). Includes all available information on the artist and his career and a catalogue of signed and attributed works and bibliography // Ona Curran, "Samuel Hayden Sexton, Schenectady Painter," *Antiques* 101 (April 1972), pp. 676–679.

Levi Hale Willard

Levi Hale Willard (1823–1883) was a native of Schenectady, New York, born ten years after Sexton. He moved to New York City before 1850, when he was one of the three founding stockholders of the American Express Company, a firm that originated in upstate New York and ultimately made Willard's fortune. He was among the most important early donors to this museum: his bequest provided over $100,000 toward the purchase of architectural models, casts, photographs, and engravings. According to Pierre Le Brun, who headed the museum's Willard Commission and assembled the architecture collection, Willard

really believed that art to be the grandest and most comprehensive of all the fine arts; and it was with the ambition of doing all in his power to cultivate and encourage a popular taste for it, to help such students as were unable to secure the advantages of travel, and to elevate the standard of American work by present-

ing choice selections of masterpieces in all styles, that he desired to found an historical Architecture Collection (quoted in Howe [1918], pp. 209–210).

The collection was assembled by 1894 and was on public view for many years.

Sexton apparently painted two portraits of Willard, and it is conceivable that Willard rejected first one and then the other, for both works were in the artist's possession in 1890, when they were offered for sale to the museum. In November 1890, the artist-illustrator Frederick Dielman (1847–1935) proposed that the museum purchase one or both of Sexton's portraits of Willard to honor the museum's benefactor and to aid an impoverished artist. The offer was referred to the Willard Commission and in December 1890 Le Brun reported that he had seen the portraits and had "failed to detect even a remote resemblance. . . . We can now understand why [Willard's] mother and sister refused to buy them." The following March, Samuel P. Avery, an important art dealer and a benefactor and founding trustee of the museum, wrote to the then director, Louis P. di Cesnola, that DANIEL HUNTINGTON "considers that one of [the portraits] has art merits" and recommended the acquisition. By that time, however, Sexton had died and his brother had written offering the painting as a gift to the museum. John Sexton said that the portrait was "painted many years ago from personal sittings" and that it gave "an Excellent likeness of the gentleman at that time."

Regardless of its success as a likeness, Sexton's portrait of Willard ranks among his most successful works. The dark gray-blue of the background and the blue jacket display Sexton's refined sense of color and provide an effective foil for the subject's face, which is well-painted and expressive. Willard looks out at the viewer with the calm assurance of a businessman confident of his success.

Whether or not this portrait is Sexton's first or second version remains unknown. The unfinished character of Willard's jacket, a highly unusual feature in Sexton's work, suggests that the artist had some difficulty or simply stopped work on the portrait before it was completed.

Sexton, *Levi Hale Willard.*

Oil on canvas, oval, 27 × 21½ in. (68.6 × 54.6 cm.).

Signed and inscribed at lower left: S. H. Sexton. Sch'dy, N. Y. Inscribed on the back: S. H. Sexton / Painter / Schenectady / N. Y. Inscribed on a label on the stretcher: L. H. Willard. Inscribed on a label formerly affixed to the frame: Painted at Schenectady 1857.

REFERENCES: F. Dielman, letter in MMA Archives, Nov. 12, 1890 // J. Q. A. Ward, letter in MMA Archives, Dec. 11, 1890 (quoted above) // J. Sexton, letter in MMA Archives, March 25, 1891 // S. P. Avery, letters in MMA Archives, March 25, 1891 (quoted above), March 26, 1891 // W. Howe, *A History of the Metropolitan Museum of Art* (1918), pp. 208–211 (quoted above) // Gardner and Feld (1965), p. 267 // Ona Curran, *Samuel Hayden Sexton* (1970), p. 38.

Ex COLL.: the artist, Schenectady, New York, 1857–1890; his brother, John Sexton, 1890–1891.

Gift of John Sexton, 1891.

91.32.

JOHN CARLIN

1813–1891

The miniature, genre, and landscape painter John Carlin was born a deaf mute in Philadelphia. In 1820 he entered the new Pennsylvania Institute for the Deaf and Dumb and studied there for four years, until financial circumstances forced him to leave. When he was nineteen, Carlin opened his own ornamental sign-painting business and worked as a house painter. He devoted his spare time to drawing from life and copying engravings. In 1834, he studied portrait painting with JOHN NEAGLE in Philadelphia for four months. Following Neagle's advice, he supplemented this training by taking evening classes with the drawing master John Rubens Smith (1775–1849). During this time, Carlin painted several portraits that met with satisfaction and in December 1834 he left Neagle's studio and set up his own at No. 17 Queen Street. He soon began exhibiting portraits and genre scenes at the Artist's Fund Society.

For the next few years, Carlin mostly painted portrait miniatures. He mastered the meticulous technique and became quite popular for his fine work. In June 1837, he recorded in his credit book that he had painted his one hundred and fiftieth picture, a "Portrait on small ivory for a broatch [sic] of Mrs. Palmer." For nearly the same fee for them as other artists charged for large oil portraits, he produced about thirty miniatures a month.

In May 1838, Carlin decided to further his artistic training and left for London. He continued painting miniatures but devoted most of his time to drawing from antique statues at the British Museum and studying the old masters. At the end of August, he went to Paris and set up his easel in the Louvre, where he also copied paintings. Within months, he entered the studio of the French academic painter Paul Delaroche, where he may have remained as long as three years. The lack of extant history paintings by Carlin makes it difficult to assess the extent of Delaroche's influence on him, but the boldly rendered drawings based on Milton's *Paradise Lost* and Bunyan's *Pilgrim's Progress* in his 1840 sketchbooks (private collection) suggest that he had become competent in figure drawing and had adopted Delaroche's unromanticized approach to historical scenes. These sketches are among Carlin's best work.

Carlin left Europe in the spring of 1841 and set up a studio in New York. Since there was little interest in the sort of allegorical and religious scenes he had learned to paint in Delaroche's studio, he returned to miniature painting, working in Pennsylvania, New York, Connecticut, Massachusetts, and as far south as Baltimore and Washington. Most of his time, however, was spent portraying fashionable and prominent New Yorkers. Between 1841 and 1856 he completed nearly two thousand miniatures. A contemporary critic for the *New York Times* praised his work: "His flesh tints are remarkably pure, and his finish is all that can be desired, while the strong individuality of each face assures us of the faithfulness of the likeness" (quoted in *Biographies of Deaf Persons*, p. 117). When the demand for miniatures diminished in the late 1850s and 1860s, Carlin turned to genre scenes and landscapes. He exhibited his work annually at the National Academy of Design between 1847 and 1886,

although he never became a member. He also entered his work in exhibitions at the American Art-Union and the Pennsylvania Academy of the Fine Arts. His landscapes show the result of careful observation, and his genre scenes are characterized by a humor in everyday situations.

Carlin also wrote poetry, going to great lengths to overcome his lack of hearing, which prevented him from experiencing sound or rhythm. That he succeeded is proven in the poems he published in *Harper's New Monthly Magazine* and various newspapers. He also wrote and illustrated a children's book about monkeys, *The Scratchside Family* (New York, 1868). Carlin's wife, the former Mary Allen Wayland, was also a deaf mute. Their five children, however, were not. Carlin was untiring in his efforts to better the condition of people who shared his affliction. He helped to establish the National Deaf Mute College in Washington, and upon its inauguration in 1864 he was awarded an honorary master's degree. He opened his home in New York to deaf mutes and trained many of them in art. He died in New York of pneumonia at the age of seventy-eight.

BIBLIOGRAPHY: John Carlin Credit Books, 1832–1856, copies on deposit, NYHS // Obituary, *Deaf Mute's Journal* (April 30, 1891) // *Biographies of Deaf Persons* (Albany, n. d.), s. v. Carlin, John // Gardner and Feld (1965), pp. 267–269.

After a Long Cruise

During the middle decades of the nineteenth century, subjects from popular literature and everyday life were in vogue. American genre painting closely paralleled eighteenth-century European prototypes. These sentimental scenes and social satires were often characterized by exaggerated gestures, narrative elements, and moralizing or amusing stories. Bowing to current taste, Carlin's themes turned progressively from those of religion and history to those of everyday life. The tragicomical nature of this scene conforms to the contemporary popularity of buffoonery. The bawdy humor is also reminiscent of satirical paintings and drawings by such British satirists as William Hogarth and Thomas Rowlandson.

This painting, which is dated 1857, entered the museum's collection with the title *Salt's Ashore*, which has since been changed to *After a Long Cruise*, the title it was exhibited with at the National Academy of Design in 1859. While topographical scenes of docks and harbors were fairly common during the nineteenth century, Carlin's particular subject, a comic view of activity on a dock, is unique. A painting by Albertus D. O. Browere (1814–1887) of commotion in front of a shop, *Mrs. McCormick's General Store*, 1844 (New York State Historical Association, Coop-erstown), is somewhat similar in its composition and rowdy humor. In both paintings, the figures stand on stone pavement, are arranged in a compressed space, and display a variety of exaggerated facial expressions and gestures.

The general location for the scene in Carlin's painting is the New York waterfront. The composition has the look of a stage set, with the action in the foreground placed against a relatively flat and calm background of ships and sky. The main characters in the drama are three drunken sailors, who wreak havoc among the other people on the dock. One sailor accosts a black woman, who recoils in fear, while another upsets an apple and peanut vendor by knocking over her stand. Two young boys, taking advantage of the situation, reach for the fallen fruit. The two men who witness the scene keep their distance: a uniformed man behind the sailors has a worried look on his face, while a shopkeeper seated on a stool at the far left looks on in amusement. Carlin's extreme attention to detail, especially on the costumes and ships' rigging, and his use of vibrant colors might be attributed to his French training, but can also be the result of his work as a miniaturist. The painting's overall degree of technical finish and well-conceived narrative give it an unusual charm, which makes up for the sometimes faulty drawing.

Carlin is known to have painted over sixty-

Carlin, *After a Long Cruise.*

five genre scenes, but fewer than ten of them have been located. The best examples include *Playing Dominoes*, 1870 (Clark University, Worcester, Mass.), *The Toll Gate*, 1875 (private coll.), *Little Mischief*, 1875, and *There's a Thief in the House*, 1878 (both New York art market). *After a Long Cruise* is considered one of his best and earliest known genre scenes.

Oil on canvas, 20 × 30 in. (50.8 × 76.2 cm.).

Signed and dated at lower left: J. Carlin 1857.

REFERENCES: *Detroit Free Press*, Oct. 1, 1933, ill. // *Detroit News*, Oct. 1, 1933, ill. // R. Wellman, *Parnassus* 6 (Jan. 1934), ill. p. 14 // E. P. Richardson, *American Romantic Painting* (1944), p. 27 // Gardner and Feld (1965), pp. 267–269 // H. W. Williams, Jr., *Mirror to the American Past* (1973), p. 103, fig. 87 // P. Hills, *The Painter's America* (1974), p. 16, color ill. p. 18.

EXHIBITED: NAD, 1859, no. 297 // Detroit Institute of Arts, 1933, *Nineteenth Century American Artists*, no cat. // Newhouse Galleries, New York, 1933–1934, *American Genre Paintings Depicting the Pioneer Period*, no. 10 // Carnegie Institute, Pittsburgh, 1936, *An Exhibition of American Genre Paintings*, no. 19, lent by McCaughen and Burr // MMA, 1965, *Three Centuries of American Painting* (checklist arranged alphabetically) // Los Angeles County Museum of Art, 1966, *American Paintings from the Metropolitan Museum of Art*, p. 102, ill. no. 86 // Hirschl and Adler Galleries, New York, 1965, *The American Vision*, no. 63 // Cummer Gallery of Art, Jacksonville, Fla., Norfolk Museum of Arts and Sciences, Norfolk, Va., 1969, *American Paintings of Ports and Harbors: 1774–1968*, no. 7 // Hudson River Museum, Yonkers, N. Y., 1970, *American Paintings from the Metropolitan Museum of Art*, no. 6.

EX COLL.: William M. McCaughen, Sr., Saint Louis, by 1910; with McCaughen and Burr, Saint Louis, by 1936–1949.

Maria DeWitt Jesup Fund, 1949.

49.126.

GEORGE P. A. HEALY

1813–1894

George Peter Alexander Healy, nineteenth-century America's artist ambassador at large, was born in Boston, the son of an immigrant Irish sea captain, William Healy. His natural talents were encouraged by his grandmother who painted. In 1830, at age seventeen and virtually self-trained, he opened his first studio on Federal Street in Boston. THOMAS SULLY was in Boston that spring and advised him to go abroad where he would learn more from copying paintings in European galleries. Healy's first important portrait commission came in 1831 from Richard D. Tucker, a Boston merchant who was a founding member of the Boston Athenaeum and also Healy's landlord. That same year Mrs. Harrison Gray Otis, a leading Boston socialite, agreed to sit for Healy and was so impressed with his work that she urged her friends to patronize him. By 1834 he had accumulated sufficient funds to follow Sully's advice and study abroad. After a short time in Paris, Healy entered the atelier of Antoine-Jean Gros, who had studied with Jacques Louis David. Although he was in Gros's studio for only a few months, Healy benefited greatly from this training. His paintings showed solid impasto, excellent tone, and realistic modeling. While there, he met Thomas Couture, who became a devoted friend and influenced his style. During the fall of 1835, Healy studied and copied old masters at the Louvre and received some minor commissions. Toward the end of that year he traveled throughout Italy, where he sketched the landscape and studied the works of Titian, Michelangelo, and Raphael.

The following year he accepted a commission in London from Sir Arthur Faulkner, a friend of Mrs. Otis. Healy's unquestionable talent and great personal charm soon won him a place among prominent members of English society. He rented a studio in London, studied at the Royal Academy, and gradually built up an impressive list of patrons. The year of Queen Victoria's coronation, 1838, brought visitors to London from all over the world. Sully visited with Healy while working on a portrait of Queen Victoria (q.v.). That year, too, Healy met General Lewis Cass, American ambassador to France, who commissioned a portrait of Nicholas Jean de Dieu Soult, marshal of France and representative of Louis Philippe (ill. in de Mare, p. 16). His successful characterization of this authoritative and flamboyant man led to further patronage from Cass, who commissioned portraits of himself, his wife, and others and introduced the artist to Louis Philippe, who agreed to sit for him. The French king was so pleased with the portrait that he requested that Healy copy several portraits for the state collection at Versailles. As part of this commission Healy and his family spent two months at Windsor Castle in 1840 while he made copies of Queen Victoria's pictures.

In 1842 Louis Philippe sent Healy to the United States to paint American presidents and statesmen for his Versailles gallery. Thus began fifty years of trans-Atlantic commuting, at least twenty-five voyages. At home, Healy traveled widely, painting many portraits, including those of leading politicians. Abroad, he was popular in the courts and salons of Europe and had more commissions than he could fill. Healy was working on many portraits for Versailles at the time of the revolution in France that forced Louis Philippe into exile. He

finished these paintings, along with the historical scene *Webster Replying to Hayne*. This picture, completed in 1851, contains over one hundred and thirty portraits, and as Healy hoped, was placed in Faneuil Hall in Boston.

During the 1850s, Healy began to look increasingly toward American commissions. William Butler Ogden, mayor of Chicago, sat for him and persuaded him to move his family there in 1855. During the following decade Healy painted over five hundred portraits, many of Chicagoans. Eventually overexertion began to take its toll, and in 1867 he moved his family back to Europe. No sooner were they settled in Rome, however, than Healy returned to the United States to resume work on the *The Peacemakers*, 1869 (White House, Washington, D. C.), which depicts a conference with Lincoln, Sherman, Grant, and Porter. In Europe, Healy painted portraits of Pope Pius IX; Louis Adolphe Thiers, the first president of the third French Republic; Léon Gambetta, the fourth president; German Chancellor Otto von Bismarck, and other notable sitters. He also collaborated with FREDERIC E. CHURCH and JERVIS MCENTEE on a large painting, the *Arch of Titus*, 1871 (Newark Museum), which portrays Healy and McEntee looking over Church's shoulder as he sketches the view of the Colosseum through the arch. Healy painted prolifically in Europe until 1892, when he returned to Chicago, where he died two years later.

From his earliest stiff and somewhat primitive portraits through the transitional phases from naturalism to the Barbizon and finally impressionist movements, his best work reveals technical virtuosity and psychological insight. Healy's most successful portraits were painted before the influence of photography which caused dryness and insipid coloring in his later work. His popularity was due largely to his adaptable, congenial personality, and the rapidity with which he caught the likenesses of busy statesmen, entrepreneurs, and fashionable women. The quality of his painting fluctuated throughout his career, but in later years his excessive desire for speed and his poor eyesight often resulted in mediocre work.

BIBLIOGRAPHY: George P. A. Healy, *Reminiscences of a Portrait Painter* (Chicago, 1894) // Mary H. Bigot, *Life of George P. A. Healy* [1913] // Marie de Mare, *G. P. A. Healy, American Artist: An Intimate Chronicle of the Nineteenth Century* (New York, 1954). Most complete treatment of the artist's life, written by his granddaughter // Florence Lewison, "G. P. A. Healy, 1815–1894: A Success at Home and Abroad," *American Artist* 32 (Dec. 1968), pp. 54–59 and 69–73 // Louisiana State Museum, New Orleans, *G. P. A. Healy: Famous Figures and Louisiana Patrons*, exhib. cat. (1976) by Vaughn L. Glasgow and Pamela A. Johnson. Includes a bibliography.

Moses Pond

Moses Pond (1800–1870) was born at West Roxbury, Massachusetts, eldest son of Moses and Anne Davis Pond. In 1822 he married Nancy Adams of Boston, who later bore him eleven children. Pond established a tinplate manufacturing business in Boston and became extremely successful as an inventor and producer of hot-air ranges and furnaces. According to his descendants he was a staunch supporter of the antislavery cause. One of his children, George Edward

Pond, became a noted editor and writer.

This portrait was painted in 1832 when Healy was nineteen, shortly after he had taken the likeness of Mrs. Harrison Gray Otis. Pond moved his residence to Salem Street that same year, so presumably the portrait was ordered to grace his new home. One of the self-trained artist's earliest known works, the portrait is exceptionally well executed. It displays strong characterization, which is often lacking in Healy's late works. Pond appears a thoughtful, serious young man in the early stages of a successful career. The

Healy, *Moses Pond.*

Alexander Van Rensselaer

Alexander Van Rensselaer (1814–1878) was the son of Stephen Van Rensselaer (see portrait by CHESTER HARDING) and Cornelia Paterson Van Rensselaer. He was born and raised at Rensselaerswyck, the family manor in Albany, and in 1831, at the age of seventeen, he entered Yale College but left in his sophomore year. At his father's death in 1839 he inherited a portion of the manor property and substantial real estate in New York. He moved to New York, and in 1851 he married Mary A. Howland, who bore him two children before her death in 1855. By his second wife, Louisa Barnewall, he had three more children. He lived in New York throughout his life "devoting his attention entirely to charities," according to an obituary notice, and he "never entered any mercantile pursuit being a man of means and leisure." In later life he was well-known as a yachtsman.

Van Rensselaer was twenty-three when this picture was painted in London during the summer of 1837. Fastidiously dressed in a dark green jacket with brass buttons, he appears an elegant if somewhat affected young gentleman. His affluence is further emphasized by a diamond ring, gold watch fob, and gold-headed cane. Healy had arrived in London in the spring of 1836 at the invitation of Sir Arthur Faulkner, a friend of Mrs. Harrison Gray Otis. In June, Andrew Stevenson, the American ambassador to the court of Saint James's, arrived in London and during the following year introduced a great number of American patrons to the young artist. It is possible that Van Rensselaer was among them.

The careful draftsmanship and bold brushstroke is a vast improvement in Healy's style in the five years since he painted Moses Pond (see above). The palette is lighter, and the paint is more evenly applied. The stiff pose and primitive quality is replaced by a relaxed attitude and the prevalent romantic mode. The portrait's success may have prompted Van Rensselaer to introduce Healy to his sister, Euphemia White Van Rensselaer (see below).

drawing and composition are somewhat naive and the pose is stiff, but the handling of light is competent and the modeling careful. The canvas is thinly painted, which is characteristic of Healy's work before his trip to Europe and his training in the application of paint.

Oil on canvas, 30 × 25 in. (76.2 × 63.5 cm.).

Signed and dated at lower left: G. P. A. Healy / 1832.

REFERENCES: L. G. Burroughs, memo in Dept. Archives, May 1939, gives information on the sitter supplied by his granddaughter Ellen Pond; *MMA Bulletin* 34 (June 1939), pp. 160–161 // M. de Mare, *G. P. A. Healy* (1954), p. 22 // Gardner and Feld (1965), p. 270.

EXHIBITED: Brooklyn Museum, 1917, *Early American Paintings*, no. 33 // Slater Memorial Museum, Norwich, Conn., 1968, *A Survey of American Art*, no. 5, ill., listed.

EX COLL.: Moses Pond, Boston, d. 1870; his wife, Nancy Adams Pond, Boston, d. 1876; her granddaughters Ellen J. Pond and Ellen Pond Dunlap (Mrs. Amos Hopkins, d. 1939), New York, until 1939.

Gift of Mrs. Dunlap Hopkins, 1939.

39.37.

Oil on canvas, 36¼ × 28⅜ in. (91.7 × 71.5 cm.).

Signed and dated at lower right: Geo. P. A. Healy / August 1837 / London.

Canvas stamp: R. Dany / 83 Newman Street / Oxford s[t]. London. 1005.

REFERENCES: S. Van Rensselaer to B. Silliman,

Healy, *Alexander Van Rensselaer.*

August and Dec. 1832, Misc. MSS V, NYHS // Obituary, *New York Times,* May 12, 1878, p. 2 // Gardner and Feld (1965) p. 270.

Ex coll.: Alexander Van Rensselaer, New York, d. 1878; his daughter, Mabel Van Rensselaer Johnson, until 1959.

Bequest of Mabel Van Rensselaer Johnson, 1959. 61.70.

Euphemia White Van Rensselaer

Euphemia White Van Rensselaer (1816–1888) was the daughter of Cornelia Paterson and Stephen Van Rensselaer. She was born at Rensselaerswyck, New York, and inherited a substantial part of her father's extensive estate in 1839. In 1843 she was married to John Church Cruger, a prominent lawyer. They had three children and lived on Cruger's Island in the Hudson River near Barrytown, New York.

Healy painted this picture in Paris in the winter of 1842, five years after he had painted Euphemia's brother Alexander (see above), who may have been instrumental in obtaining this commission for Healy. Portrayed the year before

her marriage, Euphemia Van Rensselaer appears confident and graceful. She wears a stylish black velvet jacket and a velvet and satin stole over a black watered-silk skirt. Her fashionable bonnet is trimmed with bird of paradise feathers, flowers, and satin ribbon. The background suggests that Euphemia Van Rensselaer stands overlooking the Roman Campagna, which she had just visited. Healy had sketched there for several months six years earlier. He has included the arched ruins of the Claudian aqueduct, bare mountains, and a stormy sky.

Throughout his life, Healy's portraits of women not only faithfully rendered the details and textures of their costumes but showed sensitivity and insight into their character. When the subject was also beautiful, the portrait was all the more successful. Of Healy's many portraits of women, this one is perhaps his best. He never surpassed the stunning simplicity, grace, and lively color scheme. The black costume is accented by the green satin lining of the stole, and the yellow bonnet is echoed by a bright yellow in the sky above the mountains. He painted the portrait at the peak of his career, when he had mastered the techniques of brushwork, color, and composition but before the influence of photography had made much of his work routine and overembellished.

The composition and three-quarter-length pose, unusual for Healy, show the influence of the German-born portraitist Franz Xavier Winterhalter. Winterhalter, who had settled in Paris in 1836, was a favorite of Louis Philippe and painted members of the royal family. Healy most likely saw Winterhalter's work at the Versailles gallery as early as 1838. The firm drawing of the subject, lively coloring, and sketchy background strongly resemble Winterhalter's *Queen Victoria,* 1842 (Musée Nationale, Versailles). Euphemia Van Rensselaer, however, is demure, and the pose is less exaggerated and the composition more restrained.

Oil on canvas 45¾ × 35¼ in. (115.1 × 89.2 cm.).

Signed and dated at lower right: G. P. A. Healy Paris 1842.

References: M. C. Bigot, *Life of George P. A. Healy* [1913], p. 101 // *MMA Bull.* 18 (July 1923), no. 7, p. 180; (August 1923), no. 8, ill. p. 185, p. 201 // M. de Mare, *G. P. A. Healy* (1954), pp. 109, 283 // E. P. Richardson, *A Short History of Painting in America* (1963), p. 146, fig. 8–16, p. 148; *Painting in America* (1965), fig. 98, p. 205 // F. Lewison, *American Artist* 32

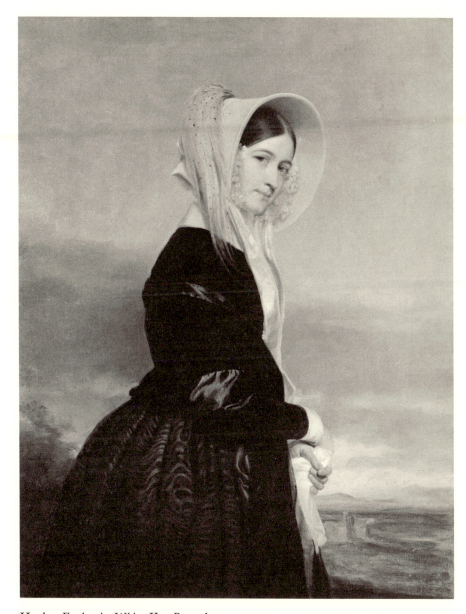

Healy, *Euphemia White Van Rensselaer*.

(Dec. 1968), ill. p. 58, p. 73 // Gardner and Feld (1965), pp. 271–272 // *MMA Bull.* 33 (Winter 1975–1976), ill. p. [240].

EXHIBITED: MMA, 1965, *Three Centuries of American Painting* (checklist arranged alphabetically) // Knoedler and Company, New York, 1968, *The American Vision, 1825–1875*, no. 16 // MMA, 1970, *19th Century America*, by J. K. Howat and N. Spassky, ill. no. 68 // National Gallery of Art, Washington, D. C., City Art Museum, Saint Louis, Seattle Art Museum, 1970–1971, *Great American Paintings from the Boston and Met-* *ropolitan Museums*, exhib. cat. by T. N. Maytham, no. 31, discusses it // Worcester Art Museum, 1973, exhib. cat. by W. J. Hennessy, ill. no 24 // MMA, *A Bicentennial Treasury* (see *MMA Bull.* 33 above).

ON DEPOSIT: White House, Washington, D. C., 1961–1963.

EX COLL.: the subject, d. 1888; her daughter, Cornelia Cruger, by 1923.

Bequest of Cornelia Cruger, 1923.

23.102.

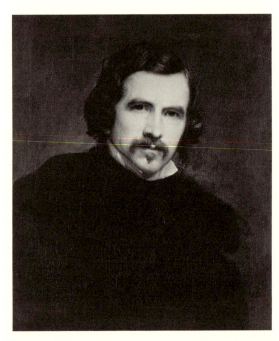

Healy, *Self-portrait.*

Self-portrait

There are eleven known self-portraits of Healy, spanning his career from 1841 (Redwood Library and Atheneum, Newport, R.I.) to 1886 (painted for Eastman Johnson and now in the Brooklyn Museum). His granddaughter claimed: "It was not vanity that led George to make his portrait again and again; of necessity he became his own best model; untiring he practiced tone effects, tried to make the flesh alive, the eyes expressive" (M. de Mare, p. 15). In this portrait, painted in 1851 when he was thirty-eight, much of the optimism and confidence apparent in his self-portrait of 1841 has been replaced by a melancholy perhaps brought on by recent circumstances. An informal portrayal in a highly romantic manner, the portrait shows Healy as a brooding man. Although it was painted the same year he saw the culmination of seven years' work, the installation at Faneuil Hall of his major history painting *Webster Replying to Hayne,* he had reason for sadness. "The Revolution of 1848, which sent Louis Philippe to England and exile," he explained, "deprived me of my royal patron, and ended my fortune in France. My English connection was lost, most of

my kind friends being dead or dispersed" (G. P. A. Healy, *Reminiscences of a Portrait Painter* [1894], p. 124).

Of all his self-portraits this is one of the most flattering. Another one, in the Cleveland Museum, appears to have been painted at the same time, but there his body is turned sharply to the right, making it less engaging. Painted less than ten years after the portrait of Euphemia Van Rensselaer, this self-portrait shows the influence that the advent of photography had on him. Although the brushwork is relatively free, the coloring is nearly monochromatic and the features are delineated more sharply. The portrait also reflects the style of Healy's friend Thomas Couture. The face is solidly modeled while the body is exaggeratedly sketchy and contoured as in Couture's *Portrait of Auguste Mimerel de Roubaix* (ill. in A. Boime, *Thomas Couture and the Eclectic Vision,* p. 48). Healy's admiration for Couture began upon their first meeting at Gros's studio when, according to Healy, Couture pushed him away from his easel, turned over a sheet of paper, and sketched the model. "The outline drawing was so strong, so full of life, so easily done, that I never received a better lesson" (G. P. A. Healy, in *Modern French Painters* [1896], ed. J. C. Van Dyke, p. 3).

Oil on canvas, 24½ × 20½ in. (62.2 × 52.1 cm.). Signed and dated at lower right: G H 1851.

Label on frame: LOOKING GLASSES / PICTURE FRAMES, / ENGRAVINGS, / OIL PAINTINGS. / JAS. S. EARLE & SON / Earles' Galleries, / NO. 816 CHESTNUT ST. / PHILADELPHIA

REFERENCES: J. O'Connor, Jr., *Carnegie Magazine* 28 (June 1954), ill. p. 206, p. 208 // Gardner and Feld (1965), p. 272 // F. Lewison, *American Artist* 32 (Dec. 1968), ill. p. 54.

EXHIBITED: MMA, 1945, *William Sidney Mount and His Circle,* no. 23 // American Federation of Arts, 1947, Centennial Art Gallery, Salt Lake City, Utah, Utah State Fair Grounds, *One Hundred Years of American Paintings from the Collections of the Metropolitan Museum of Art and the Whitney Museum of American Art,* no. 5, p. 6 // MMA, 1965 *Three Centuries of American Painting* (checklist arranged alphabetically) // Florence Lewison Gallery, New York, 1966, *G. P. A. Healy,* no. 2 // Louisiana State Museum, New Orleans, 1976–1977, *G. P. A. Healy,* no. 24, p. 54; p. 56; ill. p. 57.

ON DEPOSIT: U. S. ambassador to the United Nations, New York, 1975–1976.

EX COLL.: Samuel P. Avery, by 1891.

Gift of Samuel P. Avery, 1891.

91.27.2.

Louis Philippe Albert d'Orléans, Comte de Paris

Louis Philippe Albert d'Orléans (1838–1894) was the eldest son of Ferdinand, the duc d'Orléans, who was the eldest son of Louis Philippe and heir to the French throne. Ferdinand died in a carriage accident in 1842. During the revolution in 1848 Louis Philippe abdicated in favor of his ten-year-old grandson, but a republic was set up instead, and the family fled to England.

The young count was educated there by his mother. In 1861 he and his younger brother, the duc de Chartres, went to the United States, where they fought for the Union in the Civil War. Both men served as captains under General George C. McClellan, the count being his aide-de-camp. At the close of the Virginia campaign and the retreat of the Army of the Potomac in June 1862, the brothers returned to Europe. In 1864 the comte de Paris married the daughter of the duc de Montpensier. In 1871 he attempted to gain control of the French government but was thwarted by Louis Adolphe Thiers. He retired from politics and resided at the Chateau d'Eu, which was the home of his wife. Upon the death of Henri de Chambord in 1883, he was acknowledged as head of the house of Bourbon by some legitimists. In 1886, with the passage of the expulsion bill, however, he was forced into exile and left for England. He was the author of *Trade Unions in England* (1869) and the multivolume *History of the Civil War in America* (1857–1888).

This portrait was painted in 1882 at Chateau d'Eu near Dieppe, four years before the count's permanent exile. It was commissioned from Healy by William Henry Hurlbert, journalist, art collector, author of *McClellan and the Conduct of the War* (1864), and at this time editor of the *New York World*.

When Healy requested the sittings from the count, he was invited to Chateau d'Eu. According to his diary, he arrived there on June 23rd and painted this bust portrait on the 24th. He noted that the count found it a striking likeness. Healy's daughter Edith recorded in her diary on June 28, 1882: "The Comte sat on Saturday morning and afternoon. Papa painted an entire bust portrait. It is charming in color, firm and well painted, fresh and bold; I dare say much better than the full-length he means to paint

from it." On the 25th Healy made a full-length sketch. He then returned to Paris with the bust portrait and the sketch from which he planned to paint a full-length portrait for Hurlbert. On June 29 he painted a replica of the bust portrait, which he inscribed "Paris." On July 11 he began work on the full length for Hurlbert but was not satisfied with the outcome and did not resume work on it until the count came to his studio in Paris and sat for him again. The present location of the full-length portrait is unknown, but Healy recorded in his diary on September 13 that it was almost finished. Since the bust portrait was deposited at the Metropolitan by Hurlbert, it is likely that Healy sent him both the finished full length and the original bust and that Hurlbert then kept the full length and lent the bust to the museum.

The Comte de Paris, who was forty-four when he sat for the portrait, appears aristocratic, dapper, and serious. The pose and style are similar to Healy's portrait of his own son-in-law *Tiburce de Mare*, 1870 (ill. in de Mare [1954], p. 27). While the brick red background adds warmth to the otherwise monochromatic coloring, the picture is routine and dull, rather than "fresh

Healy, *Louis Philippe Albert d'Orleans, Comte de Paris.*

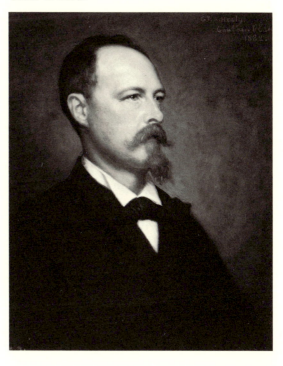

George P. A. Healy

and bold" as his daughter observed. Like many of his works at this time, it was painted in one day. Healy's wife at one point expressed her concern that he accepted too many commissions and that the "portraits lacked life because his hand had stiffened with fatigue" (de Mare, p. 281).

Oil on canvas, 25 × 20⅛ in. (63.5 × 51.2 cm.).
Signed, dated, and inscribed at upper right: G. P. A. Healy / Chateau D'Eau [sic] / 1882.
Canvas stamp: ALEXIS OTTOZ / Felix VOISINOT Succ⟨r⟩ / Mᵃ de Couleurs Fines / Toiles Tableaux / PARIS.

RELATED WORK: *Comte de Paris*, oil on canvas, 1882, 29½ × 25 in. (75.0 × 63.5 cm.), Illinois State Museum, Springfield (FARL 121–14/h3), a replica with an exterior background.
REFERENCES: G. P. A. Healy, typescript of diary, vol. 5 (June 1–Oct. 17, 1882), June 23–29, July 11, Sept. 13, 1882, FARL // E. Healy, diary, June 28, 1882, quoted in M. de Mare, *G. P. A. Healy* (1954), p. 281; pp. 7, 287–288 // Gardner and Feld (1965), p. 273, as the Count of Paris.
EX COLL.: William Henry Hurlbert, until 1883.
Deposited by William Henry Hurlbert, 1883.
L.83.20.

THOMAS H. HINCKLEY

1813–1896

Thomas Hewes Hinckley was born in 1813 in Milton, Massachusetts, the son of Captain Robert Hinckley and his wife Esther. He showed an early talent for drawing animals, which is demonstrated by two skillfully drawn pictures of a pig and a dog, inscribed "T. H. H., aged 4" (Teele, p. 540). His father was opposed to an artistic career for him, so when young Hinckley reached the age of about sixteen he was apprenticed to a merchant in Philadelphia. After a short time in that city, he sought out the drawing instructor William Mason (active 1808–1844) and took evening lessons from him. Hinckley returned to Milton in 1831. His father's death in 1833 removed the last barrier to his pursuit of an artistic career. By 1835 he had set himself up in Boston as an ornamental painter and also took portrait commissions. As Hinckley's skills improved, he turned to the genre he preferred, animal painting. His primary subjects were game dogs and cattle. He was one of the earliest animal painters in this country, and gentlemen farmers and hunters were ready patrons for his scenes of their animals in rural surroundings.

In 1845 Daniel Webster, who lived in nearby Marshfield, invited Hinckley to sketch his prized Ayrshire cattle. These sketches became the basis for a number of paintings, some of which were exhibited and sold at the American Art-Union between 1845 and 1852. Hinckley exhibited at the National Academy of Design only one year, 1846, when he showed two cattle pictures. Henry Tuckerman (1867) wrote of his works: "One of the earliest cattle painters was Hinckley, who produced some excellent specimens, but never seems to have progressed beyond his first successful paintings" (p. 495). Indeed, Hinckley's subject matter, compositions, and technique remained consistent over the course of his career, with very little innovation.

In 1850, Hinckley spent several months sketching deer on Naushon Island, off the coast of Massachusetts. He later continued to make studies of deer in the Adirondacks and at

Moosehead Lake. In 1850 he exhibited his best-known painting at the American Art-Union in New York, *Disputed Game* (National Museum of American Art, Washington, D. C.). Tuckerman relates that this painting along with *Cattle Seeking Shelter from an Approaching Storm* (now unlocated) "were disposed of at great prices" at the sale of the John Wolfe collection in 1863. *Disputed Game* was engraved and appeared in the *Bulletin of the American Art-Union* for 1851.

In 1851, Hinckley made a four-month tour of Europe. He visited England, Holland, Germany, Switzerland, and France. He was greatly interested in seeing the works of the prominent animal painter Sir Edwin Landseer, as well as those of seventeenth-century Dutch still-life and animal painters. In England he made several detailed sketches and upon his return in 1852 painted *Rotherman, Yorkshire, England* (MFA, Boston), an extremely well-executed panoramic view of that town. It is one of the best examples of his keen observation and technical ability. Up to that time, with the exception of *Landscape near Cohasset*, 1847 (Wadsworth Atheneum), landscapes had mainly served as backdrops in Hinckley's works.

In 1852 A. F. TAIT and William Jacob Hays (1830–1875) exhibited animal paintings at the National Academy of Design, each for the first time. That same year, ironically, Hinckley showed in New York for the last time, at the final exhibition of the American Art-Union. Thereafter he exhibited closer to home, at the Boston Athenaeum and Williams and Everett Gallery in Boston. In 1858, however, he exhibited two pictures at the Royal Academy in London. Although his works continued to enjoy wide popularity, contemporary taste favored the more accomplished and sentimental works of Tait, which were reproduced in great number by Currier and Ives.

Hinckley continued to paint animals, but he also turned out farm scenes and depictions of the sea near his home in Milton. In 1870 he traveled west to California, making studies of the landscape and of elk. He seems to have painted up to about 1884, when the last entries were made in his account book. Twelve years later he died at his home in Milton at the age of eighty-three.

BIBLIOGRAPHY: Henry T. Tuckerman, *Book of the Artists* (New York, 1867), p. 495 // Clara Erskine Clement and Laurence Hutton, *Artists of the Nineteenth Century and Their Works* (2 vols., Boston, 1880), 1, p. 358 // A. K. Teele, ed., *The History of Milton, Mass., 1640 to 1887* (Milton, Mass., 1887), pp. 540–541 // Marjorie Shaw, *Thomas Hewes Hinckley, Artist to a Generation* (Milton, Mass., 1985). A biographical account based on letters and the artist's account book from the collections of the Milton Public Library and the Milton Historical Society.

The Rabbit Hunters

This picture was painted near Milton, Massachusetts, in 1850, the year before Hinckley went to Europe. It is listed in his account book as "40 × 52 / The Rabbit Hunters." Game dogs had become one of his favorite themes, and he had exhibited several pictures of them at the American Art-Union: *Setters and Game*, 1847; *Spaniels and Sea Fowl* and *The Retriever*, 1849; and *A Point*, 1850. For these paintings he used various hunting dogs, but his favorite was the yellow terrier named Billy, seen here in the left foreground. Billy appears in several of Hinckley's paintings, including *The Rats amongst the Barley Sheaves* (see below). Shortly after this work was sold at the American Art-Union in 1852, Hinckley wrote (Jan. 17, 1853) the new owner, Smith Thompson Van Buren, of Kinderhook, New York, to whom he had promised an account of Billy.

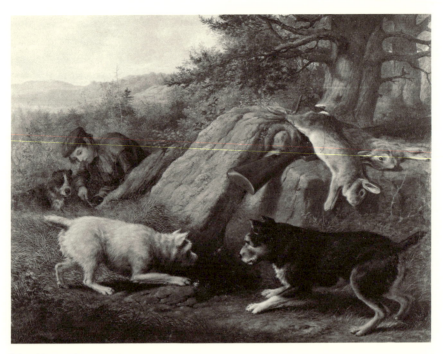

Hinckley, *The Rabbit Hunters.*

When I first saw Billy he was a new born pup in company with some half dozen others of famous pedigree. I selected him on account of his superior sprightliness & comley looks, but was told he was engaged to another . . . I went to the man that had chosed him & offered him a much larger sum . . . he refused . . . but as he [Billy] grew up & became a dog his owner found it impossible to control him, he was a perfect demon of destruction. All Kinds of poultry, geese, ducks, & chickens fell before his ferocious bite in great numbers, & cats . . . gave up their lives after a brief struggle, so that the whole neighborhood were up in arms against him . . . all he wanted was a steady & determined hand with him. I soon got him to understand what to kill & what not to kill & no dog ever understood more readily. For all sorts of virmin [*sic*] I think I never saw his equal. Rats, weazels, minks, skunks, &c. he destroyed in great numbers far and near. And he would course rabbits & hares as surely as [a] beagle hound. I have used him to hunt quails in thick briary & thorny cover in preference to the setter or spaniel[.] He would spring birds from cover that no other dog would go in to, but . . . he had "*one*" fault that I could never break him of viz. the regular terrier bite, a wounded bird was spoil'd when he got hold of it. . . . As a watch dog he never had a superior, he seemed to have an almost human knowledge who to let pass & who to keep out. He knew a loafer immediately & coaxing was wholly lost on him. . . . I could say much more in his praise but

I am afraid that you will think me extravagant in my eulogium. But Billy is dead & I am afraid I shall never find his equal.

Besides the two dogs watching the rabbit hole, Hinckley included dead rabbits and a gun arranged in still-life fashion on the rock above. The hunter is poking a long stick down the rabbit hole to provoke them out in the direction of the dogs. All of the many elements are arranged in a fashion that gives the composition a cluttered and awkward appearance. In 1868 Hinckley painted another version of this scene, *Flushing Wild Game* (ill. in Edward Eberstadt and Sons, sale cat. no. 146 [1958], lot 87), which incorporates the same elements, but the composition of that picture is more successful. The hunter is positioned behind the rocks, and the focus is better directed to the activity in the center of the canvas.

Oil on canvas, 40 × 54¼ in. (101.6 × 137.8 cm.).
Signed and dated at lower right: T. H. Hinckley 1850.
Canvas stamps: J. J. Adams / 99 Washington Street / Boston. G. Rowney & Co / Manufacturers / 51 Rathbone Place / London.
REFERENCES: T. H. Hinckley, "The Account Book

of Thomas H. Hinckley, 1844–1884," Milton Public Library, Milton, Mass., under 1850, lists it as The Rabbit Hunter / unearthing [illegible] a Rabbit / with Terriers // T. Hinckley to S. T. Van Buren, letter in Dept. Archives, Jan. 17, 1853 (quoted above) // A. K. Teele, *History of Milton, Mass., 1640 to 1887* (1887), p. 540, calls this picture The Rabbit-Hunter and states that it had been purchased by the American Art-Union in 1850 // Mrs. F. L. Pell, letter April 9, 1943, notes that Smith Thompson Van Buren, the youngest son of President Martin Van Buren, was her grandfather; May 1947, letter in Dept. Archives, identifies the yellow dog as the "hero" of the picture // Gardner and Feld (1965), pp. 265–266, misidentify Billy as the black dog.

EXHIBITED: American Art-Union, New York, 1852, no. 223, as Rabbit Hunting // MMA, 1965, *Three Centuries of American Painting* (checklist arranged alphabetically) // Lytton Gallery, Los Angeles County Museum of Art; M. H. de Young Memorial Museum, 1966, *American Paintings from the MMA*, p. 12; no. 35, p. 54.

Ex COLL.: American Art-Union, New York, 1852 (sale, Dec. 16, 1852, no. 233, $475) Smith Thompson Van Buren, Kinderhook, N. Y., d. 1876 // probably his wife, d. 1921; their daughter, Mrs. Stuyvesant Fish Morris, New York, by 1921–d. 1929; her estate; her daughter, Ellen (Mrs. F. Livingston) Pell, New York.

Gift of Mrs. F. Livingston Pell, 1943.

43.52.

in the background burrows through sheaves of wheat on the track of yet another rat.

Compared to *The Rabbit Hunters*, the composition of this picture is quite simple. Wooden barrels, stirring rods, and a pan, placed in still-life fashion, serve as the backdrop to the subject. The position of the animals and their common objective serve to unify the scene. The single light source, overall golden hue, and careful draftsmanship combine to make it one of Hinckley's most successful animal paintings.

Oil on canvas, $33\frac{1}{4} \times 40\frac{1}{4}$ (84.5 × 102.2 cm.).

Signed and dated on barrel at center right: T. H. Hinckley, 151.

REFERENCES: Thomas H. Hinckley, "The Account Book of Thomas H. Hinckley, 1844–1884," Milton Public Library, Milton, Mass., listed under Pictures painted in the year 1851 as Rats Amongst the Barley Sheaves, 32 × 40, sold to J. C. Swett, Boston, $200 // A. Umland, Jan. 1988, unpublished paper, Institute of Fine Arts, NYU, copy in Dept. Archives, supplies information from account book and provenance.

Ex COLL.: Joseph Coolidge Swett (named legally changed to J. Swett Coolidge, May 23, 1851), Boston, Mass., 1851–d. 1887; (sale, Phillips, New York, Oct. 12, 1978, ill. no. 88, as The Ratters), the Erving Wolf Foundation, New York, Oct. 1978–1982.

Gift of the Erving Wolf Foundation.

1982.444.

Rats amongst the Barley Sheaves

Hinckley includes the same two terriers in this picture that appear in *The Rabbit Hunters* (see above). *The Rats amongst the Barley Sheaves* was painted in 1851, a year after *The Rabbit Hunters* and within a few months of Hinckley's return from England. The influence of Sir Edwin Landseer is readily apparent in the composition. The dogs seek out their prey in a barn interior, a traditional setting for many of Landseer's animal scenes. Landseer's *Rat Catchers*, ca. 1821 (private coll., ill. in R. Ormond, *Sir Edwin Landseer* [1982], p. 53, no. 16), which was engraved, is particularly close to Hinckley's composition. An important difference in conception, however, is that Hinckley depicts Billy as the "demon of destruction," as he called him, in the act of executing his "regular terrier bite." It seems that one had to see him in action to fully appreciate the description Hinckley wrote of him (quoted above). The black-and-tan terrier spies another victim of prey and is poised, ready to strike. A third dog

Hinckley, *Rats amongst the Barley Sheaves*.

JOHN MIX STANLEY

1814–1872

Best known as a painter of American Indians, John Mix Stanley was born in or near Canandaigua, New York, on January 17, 1814. In 1816, his family moved to Buffalo, where his father, Seth Stanley, Jr., worked at the Farmer's Hotel. According to family records, John Mix Stanley took commissions for sign painting but kept it a secret from his father, who was later angered to find out that his son wanted to be an artist. In 1828, Stanley moved to Naples, New York, where he was apprenticed to a wagonmaker, but by 1832 he was back in Buffalo, working as a house and sign painter.

Little is known about his training as an artist, but in 1834, after his father's death, Stanley moved to Detroit and advertised himself as a portrait painter. His portrait of Benjamin Franklin (unlocated) attracted the attention of the portraitist James Bowman (1793–1842), who helped the young artist improve his painting skills. Stanley worked as an itinerant portraitist between 1836 and 1842, and is known to have spent time in Galena, Illinois, Philadelphia, Baltimore, New York, and Troy, New York, where he met Sumner Dickerman, a local clerk, in 1841. Perhaps inspired by the great portfolio of *The Indian Tribes of North America*, issued by Thomas L. McKenney and James Hall (Philadelphia, 1836–1844), Stanley and Dickerman decided to travel west and document American Indian life. Their route took them into Oklahoma, Texas, and New Mexico. In 1846, after four years of sketching and painting, eighty-three paintings by Stanley were exhibited as the Indian Gallery, including portraits and scenes of domestic life and ritual, such as *Osage Scalp Dance*, 1845 (National Museum of American Art, Washington, D. C.), in Cincinnati and Louisville. The exhibition was accompanied by a *Catalogue of Pictures in Stanley and Dickerman's North American Indian Gallery* (Cincinnati, 1846). Stanley added more pictures based on his travels in California, Oregon, and Hawaii from 1846 to 1849 and arranged exhibitions in Troy, Albany, New York, New Haven, and Hartford in 1850 and 1851. In 1852, he deposited the entire gallery of pictures at the Smithsonian Institution in Washington.

Stanley took his last trip west in 1853 with the North Railroad Survey led by Isaac Ingalls Stevens and settled in Washington, D. C., after his return. He married Alice Caroline English that year. Aside from working on paintings based on his recent sketches, he took portrait commissions and began a panorama of the "Western Wilds" (unlocated). An important member of the Washington art community, Stanley exhibited annually with the Washington Art Association, serving as treasurer of that organization and of the National Art Association, which supported decoration in public buildings, especially the Capitol. He was also a trustee of the National Gallery and School of Arts.

A lack of portrait commissions caused Stanley to offer to sell his Indian Gallery to the Smithsonian in 1857. Congress debated the purchase through 1860, when the Civil War made such an expenditure impractical. For the next few years, Stanley painted and exhibited his "Polemorama," a panorama of the war (unlocated). He moved to Detroit in 1863, where he painted portraits and achieved a considerable reputation. In early 1865, just after the

Michigan state legislature opened discussion of a motion to purchase Stanley's Indian Gallery, a fire at the Smithsonian destroyed all but a few of the canvases. In 1867, Stanley began teaching in his own studio, where he produced chromolithographs of a number of Indian scenes. He founded the Western Art Association in Detroit in 1870.

BIBLIOGRAPHY: Charles R. Tuttle, *General History of the State of Michigan* (Detroit, 1873). The first biography of the artist. // Vernon Kinietz, *John Mix Stanley and His Indian Painting* (Ann Arbor, Mich., 1942) // Julia Ann Schimmel, "John Mix Stanley and Imagery of the West in Nineteenth-Century American Art," Ph.D. diss., Boston University, 1983. A comprehensive study of Stanley's travels and artistic career, with an extensive bibliography.

The Williamson Family

This family portrait, which has recently been attributed to John Mix Stanley on the basis of an early exhibition record, depicts James Abeel Williamson (1816–1897), his wife Mary Louisa Hardenbergh (1816–1902), and their eldest son John W. Aymar Williamson, known as Aymar (1841–1917). James Williamson was born in New Brunswick, New Jersey, and began a mercantile career with the New York firm of Aymar and Company. He named his first son for John Quereau Aymar, one of the founders of the company. By the 1850s, Williamson worked as a shipping and commission merchant for James Bishop and Company, which was in the South American trade.

Williamson married Mary Louisa Hardenbergh, also from New Brunswick, on April 22, 1840, and Aymar was born on January 15, 1841. The Williamsons probably sat for Stanley in late 1841 or early 1842, just before he embarked on his first trip west. During that time, he supported himself by taking portrait commis-

Stanley, *The Williamson Family*.

sions and, although his precise travels from city to city on the East coast are not known, it is probable that he met this family when they lived with Williamson's parents at 203 Madison Avenue, New York. Not only was the portrait exhibited as by Stanley in 1860, but it is stylistically similar to his other portraits as well. A number of his early portraits are small in size. In addition, the meticulous delineation of the figures and the interior bears comparison with his scenes of Indian life.

In general, the painting appears somewhat fanciful, with a stone floor, a view onto an idyllic landscape, and a swag that drapes across the room. Stanley may have derived the composition from an eighteenth-century print, but he apparently took care to depict the family's actual surroundings and possessions. The fashionable interior features Empire and rococo-revival carved furniture, Gothic-revival quatrefoil wainscoting, and an ornately framed landscape painting. Other details convey a sense of status and comfort. Mrs. Williamson wears a stylish Italian micromosaic brooch and rests her foot on a fancy pillow. The spool of thread on the table and

mandolin with a blue ribbon strap suggest her accomplishments in needlework and music. Aymar Williamson pulls an expensive hobby horse and wears a delicate dress of embroidered eyelet, which is now in the museum's Costume Institute (1976.363). The Williamsons' second son, James Rutson, was born in 1846, and three years later the family moved to Jersey City.

Oil on canvas, 27 × 22 in. (68.6 × 55.9).
REFERENCES: J. A. Williamson, comp., *Genealogical Records of the Williamson Family in America* (1896), provides information on the subjects // G. H. Danforth, New York, orally, March 12, 1976, identified the subjects and supplied the provenance.
EXHIBITED: Washington Art Association, 1860, cat. no. 97, as A Family Group lent by J. L. Williamson.
EX COLL.: James Abeel Williamson, New York and Wyoming, N. J., d. 1897; his son John Q. Aymar Williamson, Jersey City, N. J., d. 1917; his grandsons (sons of Elizabeth H. Williamson Danforth, New York) Nicholas Williamson Danforth and George H. Danforth, III, New York, until 1976.
Gift of George H. Danforth, III, 1976.
1976.338.

JEROME B. THOMPSON

1814–1886

Jerome B. Thompson was born on January 30, 1814, the son of the portrait painter Cephas Thompson (1775–1856) of Middleborough, Massachusetts, and Olive Leonard Thompson. His father willingly trained Jerome's older brother CEPHAS GIOVANNI THOMPSON to be a painter but was not disposed to have two of his sons follow that calling. Eager to become an artist, Jerome left home in 1831 with his sister Marietta (b. 1803), who had already learned to paint miniatures, and set himself up as an ornamental and sign painter in Barnstable on Cape Cod. After a few years Thompson went to New York. His name first appears in the New York directories in 1835, the year he exhibited portraits at the American Academy of the Fine Arts and the National Academy of Design. Unfortunately, little is known about his artistic development. It is possible that he was almost entirely self-taught. He continued painting portraits for several years and between 1842 and 1844 traveled through the South, where he attracted a number of commissions.

Thompson exhibited portraits, though infrequently, at the National Academy during the 1840s. In 1850 his submission of *The Rustic Chat* (private coll.) and *Children at a Brook* (un-

located) to the American Art-Union, as well as *The Pick Nick* and *The Artist's Studio* (both unlocated) to the National Academy of Design, signaled a new stage in his career. In 1851, he was elected an associate of the National Academy, and from that time on he concentrated on outdoor genre scenes usually combining landscapes (derived from Hudson River school formulas) with well-executed figure groups. In 1852, he went to England, where, according to a contemporary writer, "from the study of Claude . . ., Turner, and Hogarth, . . . he found that his strength lay even more in country scenes and rustic life" (*Cosmopolitan Art Journal* 1 [1857], p. 129). After his return in 1854 he took a studio in New York and exhibited his outdoor genre scenes. Many of his works from the 1850s reflect his travels in New England, especially in Vermont and the Berkshire area of Massachusetts. A number of these scenes illustrated popular songs and poems, such as *The Old Oaken Bucket*, 1860 (Evansville Museum of Arts and Sciences, Indiana). Some of Thompson's so-called "pencil-ballads" were reproduced as lithographs or chromolithographs.

In the early 1860s Thompson's travels in the West provided subject matter for his art, and during the next decade he produced several allegorical pictures, including a series based on the work of THOMAS COLE. Thompson exhibited very few paintings during this period and by all accounts led a fairly quiet existence. In 1880, however, he resumed sending works to the National Academy of Design exhibitions and did so until 1886, the year in which he died.

Though neglected for some time, and in spite of the fact that not very many of his works are presently known, Thompson is considered an inventive and talented artist whose contribution to American genre painting was substantial (see H. W. Williams, *Mirror to the American Past* [1973], pp. 121–123). A contemporary art critic wrote of Thompson that "no living artist . . . catches the lights and shades of American life and humor; and consequently, none is more popular. . . . He adds that intangible faculty of seizing the most picturesque view of things, and succeeds in producing pictures which literally *talk* with reminiscences and life" (*Cosmopolitan Art Journal* 1 [1857], p. 127).

BIBLIOGRAPHY: "Jerome B. Thompson," *Cosmopolitan Art Journal* 1 (1857), pp. 127–130 // Frederick W. Coburn, *DAB* (1936, 1964), s.v. Thompson, Jerome B. Gives a thorough, though brief, biographical account and comments prophetically: "It is conceivable that there may at some time be a rediscovery of the merits of Jerome Thompson as a painter; at this writing (1935) he is well-nigh forgotten except by collectors of old lithographs" // Donelson F. Hoopes, "Jerome B. Thompson's Pastoral America," *American Art and Antiques* 1 (July-August 1978), pp. 92–99. Reproduces many paintings in color // Lee M. Edwards, "Life and Career of Jerome Thompson," *American Art Journal* 14 (Autumn 1982), pp. 4–30.

The Belated Party on Mansfield Mountain

About 1850, as the exhibition record of the National Academy of Design indicates, Jerome Thompson abandoned portrait painting and began to concentrate on outdoor genre scenes combining landscape vistas with prominent figure groups. Among his earliest efforts in this new manner was a painting entitled *The Pick Nick* (unlocated), which was the first of picnic subjects by him. Thematically and formally, these paintings appear to have been influenced by *The Pic Nic* of 1846 by THOMAS COLE (Brooklyn Museum). But, whereas Cole disliked combining landscape and genre elements, Thompson did so with evident pleasure and even flair.

During the late 1850s, Thompson painted a

Thompson, *The Belated Party on Mansfield Mountain.*

number of scenes of outdoor gatherings at Mount Mansfield in the Green Mountains of Vermont. In March 1857, the *Home Journal* pronounced that Thompson's recently finished *Recreation— A Picnic Scene in Vermont* (Fine Arts Museums of San Francisco) was "his best work" (p. 3). Perhaps inspired by this praise, Thompson returned to Mount Mansfield in 1858. He painted an on-the-spot sketch of this mountain from which he executed *The Belated Party on Mansfield Mountain.* It depicts a group of young men and women gathered for a picnic just below the peak, watching the sun set over the vast Champlain Valley. As Thompson's title and the gesture of the man holding up his watch suggest, they have lingered overly long at the top of the mountain, and, consequently, the picnickers may be overtaken by the coming darkness on their descent. The event is further dramatized by evidence of a strong wind and the alarmed expression of the woman looking at the watch.

Unlike Thompson's other picnic scenes, which present man in harmony with nature, this painting suggests a possible conflict. The artist, in fact, encouraged this interpretation among contemporary viewers by submitting the picture to the National Academy of Design in 1859 along with *The Haymakers, Mount Mansfield, Vermont* (private coll.), a sunny, idyllic composition. A reviewer for the *Home Journal* described the uneasy feeling he sensed when looking at *The Belated Party*: "In the long descent to the valley you feel the urgency of [the young man's] summons for departure, in conflict with the desire to wait and watch the sun disappear beyond the far distant dim line where earth and sky blend in the blaze of light." Thompson successfully expressed the grandeur of the view and, more generally, of nature.

Oil on canvas, 38 × 63¼ in. (96.5 × 160.3 cm.). Signed and dated at lower right: Jerome Thompson / 1858.

RELATED WORKS: Study for *The Belated Party on Mount Mansfield*, oil on canvas, 8¼ × 15 in. (21 × 38.1 cm.), ca. 1858, New York art market, 1990, ill. in

American Art and Antiques 1 (July/August 1978), p. 98.

REFERENCES: *Home Journal* (June 4, 1859), p. 2 (quoted above) // *Cosmopolitan Art Journal* 3 (1859), p. 234, reports that both paintings at the NAD are "works of which any artist in this country might be proud" and *Cosmopolitan Art Journal* 4 (1860), p. 34, notes that the artist's "'Mansfield Mountain,' as a landscape, has won golden opinions" // Leavitt Auctioneers, New York, *Private Gallery . . . of Uriah Allen*, sale cat. (April 5–6, 1876), no. 27, as Belated Party, Mount Mansfield // *MMA Bull.* 28 (May 1970), p. 399 // *American Heritage* 22 (June 1971), pp. 46–47 // D. F. Hoopes, *American Art and Antiques* 1 (July/August 1978), p. 98 (quoted above), color ill. p. 99 // L. M. Edwards, *American Art Journal* 14 (Autumn 1982), p. 15, interprets the painting as "a prophetic evocation (albeit an unconscious one) of a nation on the brink of civil war," ill. p. 16 // K. J. Avery, *American Paradise* (1987), pp. 146–147, describes the site shown in the picture and its popularity as a resort, mentions other artists' views of the area, and compares Thompson's rendition to Sanford R. Gifford's Mansfield Mountain 1859 (private coll.).

EXHIBITED: NAD, 1859, no. 775, as The Belated Party on Mansfield Mountain, lent by H. Anderson // MMA and American Federation of Arts, traveling

Thompson, study for *The Belated Party on Mansfield Mountain*. Private collection, photograph courtesy of Kennedy Galleries, New York.

exhibition, 1975–1977, *The Heritage of American Art*, cat. by M. Davis, no. 41 // MMA, *American Paradise*, 1987.

EX COLL.: H[enry Hill?] Anderson, by 1859; Uriah Allen, Jersey City, N. J., by 1876; Joseph Raiola, Glenolden, Pa., by 1969.

Purchase, Rogers Fund, 1969.
69.182.

GEORGE LORING BROWN

1814–1889

George Loring Brown was born in Boston on February 2, 1814, the third of eight children of Joanna Pratt and Loring Brown. At the age of fourteen he left home, where his artistic proclivities were regarded with little sympathy, and apprenticed himself to the Boston wood engraver Alonzo Hartwell (1805–1873). Brown's interest in painting developed under the tutelage of GEORGE P. A. HEALY, then a young portraitist establishing himself in Boston. It was Healy who probably brought Brown's first landscape to the attention of Isaac P. Davis, a member of the Fine Arts Committee of the Boston Athenaeum. In 1832 Brown exhibited six paintings there, and in July of that year he set off for Europe with money advanced him by a Boston merchant. He landed in Antwerp, quickly ran out of money, and sought the aid of the American engraver John Cheney (1801–1885), who was in London. By the middle of December 1832, both Cheney and Brown were in Paris, where they lodged with the miniaturist Savinien Duborjal while attempting to gain admission to a reputable atelier. Eventually, both became students of Eugène Isabey, whose landscapes and marines were highly regarded and whose loose brushwork certainly influenced Brown. To make ends meet, Brown painted copies after the old masters which he then exported to Boston.

In 1834 he returned to Boston, but the economic hardship caused by the panic of 1833

forced him to travel throughout New England in search of employment as an engraver, illustrator, portrait painter, and miniaturist. In 1839, at Brown's request, WASHINGTON ALLSTON wrote this evaluation of his work: "judging from what you have done, especially your sketches from nature and your copy of Claude, I have every reason to believe that, provided you have the advantage of studying in Europe, you have it in your power to become a first-rate landscape painter" (quoted in *Boston Daily Evening Transcript*, April 25, 1879, p. 6). He followed Allston's advice and decided to make another trip to Europe, where he arrived by September 1840. Brown lived in Italy for almost twenty years and became a well-known member of the American art colonies in Florence and Rome. His landscapes of Italian scenery, largely derived in composition and color from the works of Claude Lorrain, were painted with care but also with a painterly flair. William Cullen Bryant's opinion of them, written in 1845, is representative of the contemporary esteem for his pictures:

> [Brown] possesses great knowledge of detail, which he knows how to keep in its place, subduing it and rendering it subservient to the general effect. I saw in his studio two or three pictures in which I admired his skill in copying the various forms of foliage and other objects, nor was I less pleased to see that he was not content with this sort of merit, but in going back from the foreground, had the art of passing into the appearance of an infinity of forms and outlines which the eye meets with in nature. I could not help regretting that one who copied nature so well, should not prefer to represent her as she appears in our own fresh and glorious land. (W. C. Bryant, *The Picturesque Souvenir* [1850], p. 238).

Brown's Italian landscapes were eagerly purchased by Englishmen and Americans traveling in that country and by Boston collectors who ordered them from abroad. In time his success spoiled him, and many of the paintings he produced during the 1850s are merely repetitions of a well-worn theme turned out with the help of a studio hand. After his return to the United States in 1859, he became one of those artists (like Allston and WILLIAM MORRIS HUNT) who suffered undeservedly from an unfortunate cultural chauvinism prevalent in Boston at this time. His Italian subject matter simply did not interest local collectors. He attempted to concentrate on American scenery but his inability to adapt his style to the native landscape is revealed in such paintings as *The Crown of New England*, 1868 (Dartmouth College, Hanover, N. H.), *Medford Marshes*, 1862 (MFA, Boston), and *View of Norwalk Islands*, 1864 (Addison Gallery of American Art, Phillips Academy, Andover, Mass.,), in which he attempted to emulate the work of FREDERIC E. CHURCH, MARTIN JOHNSON HEADE, and FITZ HUGH LANE. James Jackson Jarves gave Brown his harshest critique in 1864: "His is pictorial slopwork: crude tints, hot, staring, and discordant, loaded on the canvas with the profligate palette-knife dash of a Rembrandt, without the genius that transformed his seeming recklessness into consummate art" (J. J. Jarves, *The Art-Idea* [1864, ed. 1960], pp. 193–194). Yet, in recent years, Brown's talent has gained new appreciation.

BIBLIOGRAPHY: Henry T. Tuckerman, *Book of the Artists* (New York, 1867), pp. 346–354 // Thomas W. Leavitt, "The Life, Work and Significance of George Loring Brown, American Painter," Ph. D. diss., Harvard University, 1957 // Currier Gallery of Art, Manchester, N. H.; Robert Hull Fleming Museum, Burlington, Vt.; and Herbert F. Johnson Museum, Cornell University, Ithaca, N. Y., *George Loring Brown* (1973). Published for a traveling exhibition, it includes a biographical essay by Thomas W. Leavitt that provides the most up-to-date biographical information on Brown as well as discussions of many of his paintings.

Brown, *View at Amalfi, Bay of Salerno.*

View at Amalfi, Bay of Salerno

The subject of this work, the picturesque coast-line that runs from Salerno to Sorrento and takes its name from the small Italian fishing village of Amalfi, was one of the most frequently painted seascape views of the first half of the nineteenth century. Noteworthy in connection with Brown's view are two similarly composed and earlier renditions by the German painter Jakob Alt, 1844 (Kunsthalle, Hamburg), and by his son Rudolf von Alt (coll. Georg Schafer, Schweissfurt). In all likelihood the present work was based on an oil study painted by Brown in 1856 now at the Shelburne Museum, Vermont, although some important variations exist. It is likely that he produced a number of finished paintings from the one sketch and included variations presumably because he did not wish all the finished paintings to appear identical. Another painting of this general location by Brown is known, *Near Sundown, Seacoast near Salerno*, 1854–1855 (University of Kansas Museum of Art,

Lawrence), and there are probably others. During the 1850s, he was so busy producing mementos of famous Italian sites for tourists and for American collectors that he had to hire an assistant to lay in the compositions.

Since Brown was an enthusiastic admirer of Claude Lorrain, it is only natural that the composition and execution of this painting should reveal the influence of Claude's harbor and coast scenes, especially in the placement of the ships and the perspectively rendered architecture at the right (compare, for example, Claude's *The Embarkation of St. Ursula* in the National Gallery, London, to Brown's *Coast Scene* in the Detroit Institute of Arts).

Oil on canvas, $33\frac{1}{4} \times 53\frac{3}{4}$ in. (84.5 × 136.5 cm.).
Signed and dated at lower center: G. L. Brown / Rome 1857.
REFERENCES: T. W. Leavitt, "The Life, Work and Significance of George Loring Brown, American Landscape Painter," Ph.D. diss., Harvard University, 1957, p. 93, relates this painting to the sketch at Shelburne // Gardner and Feld, 1965, p. 276.

Exhibited: Detroit Institute of Arts and Toledo Museum of Art, 1951, *Travelers in Arcadia*, no. 8 // MMA, *Three Centuries of American Painting*, 1965 (checklist arranged alphabetically) // Lytton Gallery, Los Angeles County Museum of Art and M. H. de Young Memorial Museum, San Francisco, 1966, *American Paintings from the Metropolitan Museum*, no. 46 // Currier Gallery of Art, Manchester, N.H.; Robert Hull Fleming Museum, Burlington, Vt., and Herbert F. Johnson Museum, Cornell University, Ithaca, N.Y., 1973, *George Loring Brown*, no. 7.

Ex coll.: Jonathan Sturges, New York, d. 1874; his wife, Mary Pemberton Sturges, New York, d. 1894; her grandson, William Church Osborn, New York, until 1903.

Gift of William Church Osborn, 1903.
03.34.

LOUIS LANG

1814–1893

Louis Lang was born at Waldsee, Württemberg, Germany, on March 29, 1814. As a young man he helped to support his family by painting carriages, designing monuments, and decorating churches; he also sang for the cathedral choir. His father, a historical painter, wanted him to pursue a career in music. Since he displayed a talent for painting early on, however, he was permitted to follow his calling. At age sixteen Lang began to draw portraits in pastel and during the next four years, while residing at Lake Constance, produced nearly a thousand such works. In 1834 he went to Paris to study. Subsequently he established himself at Stuttgart. He arrived in Philadelphia in 1838 and worked there for several years before returning to Europe in 1841. He worked in Bologna, Florence, Rome, Paris, and Venice, where he shared a studio with THOMAS P. ROSSITER. Then in 1845 he returned to the United States, where he was chiefly engaged in painting decorations and modeling plaster figures for ornamental purposes. In 1847 he again visited Rome, remaining there for two years and apparently concentrating on painting. In 1849 he settled in New York. His sweet, sentimental approach to portraiture at this time is reflected in the portraits of Frederick Mead, his wife, and their daughter Julia Augusta in the collection of the New-York Historical Society.

Lang became an associate member of the National Academy of Design in 1852 and a full member in 1853. He exhibited there from 1847 on, mostly genre pictures depicting women. He continued to visit Europe throughout his life and apparently traveled within the United States in search of commissions. In 1855, for example, he was in Washington, D. C., painting portraits of Secretary of the Treasury James Guthrie and other government officials and members of the diplomatic corps (*Crayon* 1 [March 7, 1855], p. 156).

Although the art critic James Jackson Jarves called his works "illustrations of lackadaisical sentimentalism of the most hollow kind, mere soap-bubbles of art," it must be admitted that Lang was an ambitious, prolific, and popular artist (J. J. Jarves, *The Art-Idea* [1864, ed. 1960], p. 204). Not many of his works are now known, but they included such subjects as *The Stolen Child* and *Asleep in Prayer* (both 1869), *An Old Mill at Greenwich, Connecticut* (1870), *Mary Queen of Scots, Dividing Her Jewels*, 1861 (NYPL, on deposit NYHS), and *The Last Supper of Mary Queen of Scots*, exhibited at the National Academy in 1860 and called a "bold

and impressive" work (*Crayon* 7 [Feb. 1860], p. 56). His paintings were perfectly in tune with the times, and this, to a great extent, accounts for the magnitude of his success. An amiable and sociable person, Lang was a close friend of F. O. C. Darley (1822–1888) and JOHN F. KENSETT, with whom he shared a New York studio for nearly twenty-five years. For a long time he was an active member of the Century Association and was credited by WORTHINGTON WHITTREDGE as "the first to introduce in any of the clubs monthly collections of pictures to be lighted up on the occasions of monthly evening meetings. This gave the artists an opportunity of hearing what members of all sorts had to say about their work, and as artists' works are not done to be criticized by artists alone, much advantage was gained by hearing the opinions of those who were not artists" ("The Autobiography of Worthington Whittredge, 1820–1910," ed. by J. I. H. Baur, *Brooklyn Museum Journal* [1942], p. 62). As late as 1875 Lang was reported at work in his studio in Rome on a large number of canvases, including *Cleopatra* and *Cinderella*. It is likely that many of his works are to be found in Europe. He died in New York in 1893.

BIBLIOGRAPHY: *Crayon* 7 (Nov. 1860), p. 319. Gives a short biography // Henry T. Tuckerman, *Book of the Artists* (New York, 1867), pp. 434–435 // Clara Erskine Clement and Laurence Hutton, *Artists of the Nineteenth Century and Their Works* (2 vols., Boston, 1880), 2, p. 38. Summarizes Lang's career up to 1878 and lists a number of his works.

The Basket Maker

This is one of a number of paintings of Italian girls that resulted from Lang's studies in Italy during the early part of his career. Although few of his pictures are well known today, it is fair to conclude from contemporary commentaries and newspaper notices that paintings of appealing

Lang, *The Basket Maker*.

young ladies were a speciality of his. William Cullen Bryant, who visited Lang's studio in Rome in October of 1845, commented on two such works:

At the studio of Lang, a Philadelphia artist, I saw two agreeable pictures, one of which represents a young woman whom her attendants and companions are arraying for her bridal. As a companion piece to this, but not yet finished, he had upon the easel a picture of a beautiful girl, decked for espousals of a different kind, about to take the veil . . . Both pictures are designed for a Boston gentleman, but a duplicate of the first has already been painted for the King of Wirtemberg [sic] (W. C. Bryant to *New York Evening Post* Oct. 5, 1845, in *The Letters of William Cullen Bryant* [1977], ed. by W. C. Bryant II and T. G. Voss, 2, p. 412).

When he returned to the United States, Lang continued painting this subject matter. In 1850, the National Academy of Design exhibited his *The Venetian Bride*, *The Tambourine Girl*, and *Sketch of an Italian Mother and Child* (all unlocated). In a biographical note on Lang, Tuckerman mentions the artist's fondness for "delineating female and infantile beauty, with gay dresses and flowers" (Henry T. Tuckerman, *Book of the Artists* [1867], p. 435). Such pictures were very popular during the nineteenth century, when Lang enjoyed a wide reputation. His works were highly regarded by such American collectors as Nicholas Ludlum, who either commissioned this painting or purchased it shortly after its completion in 1853. Although mainly concerned with depicting female beauty, Lang did not neglect prevailing social mores. Accordingly, the suggestiveness of the basketmaker's off-the-shoulder blouse and submissive feminine look are counterbalanced by her refusal of the cherries offered by her young companion and her continuing attention to the task at hand.

Oil on canvas, $27\frac{1}{4} \times 34\frac{1}{4}$ in. (69.2 × 87 cm.). Signed and dated at lower right: L. Lang 1853.

Canvas stamp: WILLIAMS, STEVENS & WILLIAMS / Looking Glass Ware Rooms / ART REPOSITORY / Engravings, Art Materials &c. / 353 BROADWAY, NEW YORK.

RELATED WORK: *Weaving a Basket*, 1853, oil on canvas, 17 × 21 in. (43.2 × 53.3 cm.), ill. Sotheby's, sale cat. 5141, Jan. 26, 27, 1984, no. 462.

REFERENCES: Gardner and Feld (1965), pp. 274–275 // W. D. Garrett, *MMA Journal* 3 (1970), pp. 319, 320.

EXHIBITED: NAD, 1853, no. 66, as The Basket Maker, owned by N. Ludlum // MMA, 1965, *Three Centuries of American Paintings* (checklist arranged alphabetically).

ON DEPOSIT: Bartow-Pell Mansion, Museum and Garden, Pelham Bay Park, New York, 1961–present.

EX COLL.: Nicholas Ludlum, from 1853–d. 1868; his wife, Sarah Ann Ludlum, New York, 1868–d. 1876.

Bequest of Sarah Ann Ludlum, 1877.

77.3.4.

JOSEPH WHITING STOCK

1815–1855

One of twelve children of Martha Whiting and John Stock, Joseph Whiting Stock was born in Springfield, Massachusetts, where his father was employed in the United States Armory. At the age of eleven, Stock was crippled by an accident he describes in his journal: "My dear brother Isaac, Philos B. Tyler, and myself were standing near the body of an ox-cart, which leaned nearly upright against the barn . . . when suddenly, I perceived it falling, which instead of endeavoring to avoid, I attempted to push back and was crushed under it (p. 3)." Stock's spine was injured, leaving him paralyzed from the waist down. Later, at the suggestion of his doctor and with the hope of finding something he could do to earn a living, Stock took up painting. He received a few lessons from Franklin White, a pupil of CHESTER

HARDING. Then, another doctor, for whom Stock made anatomical illustrations in 1834, fashioned a wheelchair that allowed him to sit upright and to move about. By having his wheelchair placed on a flat railroad car, he was able to travel and work as an itinerant portrait painter.

Between 1836 and 1839, Stock painted portraits in various towns in Massachusetts and Connecticut, completing over one hundred commissions. During that time he also opened a studio in Court Square in Springfield.

During the early 1840s, Stock spent much of his time on the road. On his return stays in Springfield, he set up a portrait and daguerreotype business with his brother-in-law Otis Cooley, a partnership that was formed and dissolved twice between 1844 and 1846. From 1852 to 1855, Stock lived and worked in Middletown, Goshen, and finally Port Jervis, New York, where he was stricken with tuberculosis. He moved back to Springfield shortly before his death in 1855. His journal reveals the tone of an optimistic man: "The week commences with a bright promise of business and I receive encouragement from all quarters and I trust my efforts may be successful and give satisfaction to my friends (p. 4)." When he was not working on portrait commissions, he made banners, decorated objects with shells, carved toys, painted window shades, and organized lotteries whereby he sold his goods.

In his journal, Stock recorded painting nine hundred and twelve works between 1832 and 1846; over fifty of these were genre scenes and landscapes, none of which is known today. He painted miniature and cabinet-sized portraits as well as standard-sized ones, but he is best known for his portraits of children, which are invariably full-length compositions and quite ambitious compared to his portraits of adults. Stock's young sitters usually stand on elaborate Brussels-style carpets. Their clothing is meticulously detailed, and they often have a pet, a doll, or some carved wooden toy close by. Wood graining is carefully delineated on what is often empire furniture. These portraits are excellent documents of interior decoration, childrens' fashions, and toys.

Realistically modeled heads on flat, weightless bodies are characteristic of Stock's portraiture. The subjects confront the viewer with large staring eyes. Their expressions are generally sweet and placid with a particular set to the corner of the mouth. Stock carefully outlined his subjects and used bright colors and strong decorative patterns. As his style evolved, his figures became less stiff and awkward, the compositions more complex. Still, he never lost the primitive qualities of a self-taught artist. During the early fifties, Stock's work shows the adverse effect of copying from daguerreotypes. In the last located work by him, *The Farnum Children* of 1855 (NYHS), the composition is overly elaborate and the characterization borders on the sentimental.

BIBLIOGRAPHY: John Lee Clarke, Jr., "Joseph Whiting Stock, American Primitive Painter (1815–1855)," *Antiques* 33 (August 1938), pp. 82–84 // Juliette Tomlinson, ed., *The Paintings and the Journal of Joseph Whiting Stock* (Middletown, Conn., 1976). Contains a biographical note, a transcription of the journal he kept from 1833 to 1846 (the original is in the Connecticut Valley Historical Museum, Springfield, Mass.), and a checklist of works compiled by Kate Steinway // Smith College Museum of Art, Northampton, Mass., *Joseph Whiting Stock, 1815–1855* (1977). Catalogue for a joint exhibition with the Connecticut Valley Historical Museum includes essays by Betsy B. Jones and Juliette Tomlinson and illustrates forty-four works by Stock.

Stock, *John and Louisa Stock.*

John and Louisa Stock

When the museum acquired this portrait, the subjects were misidentified as the artist's children. A previous owner had described it as by "one Stock of Boston, I believe a portrait of his children, Circa 1840." Stock had no children: he never married and was paralyzed below the waist.

One of the most important factors in identifying the children is the size of the canvas, which is uncommon in Stock's work. According to his journal (published in 1976), he painted only five portraits of this size between 1833 and 1846. He identified one of these large portraits, painted in December 1845, as "John & Louisa

Stock in group." All the other works of this size were either of single subjects or sitters already accounted for. According to the 1850 census for Springfield, John (b. about 1838) and Louisa Stock (b. about 1840), the children of the artist's younger brother Isaac C. Stock and Sarah Hunt Stock of Springfield, would have been about seven and five in 1845. This is consistent with the apparent ages of the children in the portrait. The style of their clothing, when compared to those in other Stock portraits of the period, is also appropriate for the 1845 date. Furthermore, the children bear a strong family resemblance to the Stocks, especially to Joseph's brother Luther, whom he painted in 1840 (Connecticut Valley Historical Museum, Springfield, Mass.). Since Stock's jour-

nal stops after August 1846 and he continued to paint until about 1855, there could still be room to doubt the identity of the children. Yet, given the evidence and the tradition that the subjects are named Stock, the designation seems fairly secure.

Isaac Stock and his family moved back and forth from Springfield to Boston between 1843 and 1852, when they settled in New Haven, Connecticut. There Isaac worked as a conductor for the New Haven Railroad. He is mentioned several times in Joseph Stock's journal, but little information has come to light regarding his children. John is listed intermittently in New Haven directories between 1858 and 1879, as a messenger for the Adams Express, a baker, and a clerk.

Part of this picture's charm is the good-natured appearance of the children. John, seated on a stool, looks up from his book, and Louisa, standing next to him, places one hand affectionately on his shoulder and in the other holds a rose. Both gaze intently at the viewer with dark, button-like eyes.

Stock has modeled the children's heads fairly well and given character to their faces. Their figures, however, show the awkward drawing typical of an untrained artist. There is a keen decorative sense, however, evident in the handling of the carpet or painted floor, the meticulous lace pattern in Louisa's pantalettes, and the wood-grained furniture. Painted at the height of Stock's career, the portrait has fresh, bright colors and strong outlines, and the subjects are presented simply and directly.

Oil on canvas, $50\frac{1}{4} \times 40$ in. (127.6 × 101.6 cm.).

REFERENCES: R. Ray, III, typescript copy of letters in Dept. Archives, Oct. 9, 15, 1949, says the painting was acquired about 1946 from Meredith Galleries in New York // J. Tomlinson, ed., *The Paintings and Journal of Joseph Whiting Stock* (1976), p. 45, transcribes from journal, under 1845, "John & Louisa Stock in group 40 × 50" // E. M. Coty, City Library, Springfield, Mass., letter in Dept. Archives, Jan. 17, 1979, provides information from 1850 Springfield census, which lists the children of Isaac and Sarah Stock, gives John H., age 11, and Louisa M., age 9.

EXHIBITED: Hudson River Museum, Yonkers, N. Y., 1970, *American Paintings from the Metropolitan Museum of Art*, no. 40, as The Artist's Children.

ON DEPOSIT: Federal Reserve Bank, Washington, D. C., 1973.

EX COLL.: with Meredith Galleries, New York, by 1946; with Robert Ray III, New York, by 1949; Edgar William and Bernice Chrysler Garbisch, 1949–1966.

Gift of Edgar William and Bernice Chrysler Garbisch, 1966.

66.242.19.

UNIDENTIFIED ARTIST

Portrait of a Boy with Blond Hair

This portrait, datable about 1840 to 1850 on the basis of the subject's costume, is notable principally for the purity of its color scheme. Reduced in the extreme, it features green in the background, red in the chair and child's dress. The floor covering is predominantly yellow with red and green decoration. Perhaps to balance the rather large areas of bold coloring, the artist has arranged a number of small still-life elements on the chair seat. The patterned black shoes indicate that the child is probably a boy.

Together with black and yellow designs printed on the dress fabric, the gold watch and chain, black book, lemon, and brown seashell considerably enliven the work.

So far no attribution of this work to a known hand has been proven. In terms of composition, it very much resembles a number of portraits by JOSEPH WHITING STOCK of Springfield, Massachusetts. The patterning of the floor, the relationship of the floor to the background, the awkward position of the chair, and the poor anatomy appear to follow Stock's formula, but it is unlikely that he executed it. The picture is thinly painted

Unidentified artist, *Portrait of a Boy with Blond Hair*.

and the outlines of its forms are blurry and indecisive, whereas Stock's works are usually more clearly defined and possess a greater degree of sophistication and realism. It is, however, possible that it was painted by an artist working in the Springfield vicinity who was acquainted with Stock's works.

Oil on canvas, 34½ × 29½ in. (87.6 × 75 cm.).
ON DEPOSIT: Gracie Mansion, New York, 1974–1975.

Ex COLL.: with John Bihler and Henry Coger, by 1962; Edgar William and Bernice Chrysler Garbisch, 1962–1973.

Gift of Edgar William and Bernice Chrysler Garbisch, 1973.

1973.323.5.

JOSEPH KYLE

1815–1863

Despite a fairly long and active career, not much is now known of Joseph Kyle. He was born in Ohio in 1815. By 1834 he was living in Philadelphia, where he studied with Bass Otis (1784–1861) and THOMAS SULLY. His portrait of John Sartain, probably painted about 1836 (Henry Francis du Pont Winterthur Museum, Winterthur, Del.), is the work of a trained artist whose style dimly reflects that of Sully, and perhaps of JOHN NEAGLE, but clearly indicates that he was attempting to develop on his own. He exhibited regularly from 1834 to 1845 in the exhibitions of the Artists' Fund Society in Philadelphia. For the most part he showed portraits, but as the years went by he also sent history paintings, genre scenes, and landscapes, few of which are known today. He moved to New York between 1845 and 1847 and showed pictures at the National Academy of Design and the American Art-Union. Through 1860, he exhibited at the academy, usually portraits and occasionally a genre subject.

Kyle was also interested in painting panoramas. In 1848 he advertised a panorama of the Mississippi and in 1850 exhibited a moving landscape with scenes from John Bunyan's *The Pilgrim's Progress*, which he had painted with Edward Harrison May (1824–1887). This panorama had scenes based on diagrams by such painters as FREDERIC E. CHURCH, JASPER F. CROPSEY, and DANIEL HUNTINGTON. Kyle supposedly produced panoramas in collaboration with other artists as well. Unfortunately, most nineteenth-century panoramas have been destroyed, so there is no way of judging his ability in this form. Kyle's easel paintings, however, show him to have been a highly competent artist. The self-portrait (q.v.) is an accomplished work in a style familiar from the paintings of CHARLES LORING ELLIOTT and GEORGE P. A. HEALY. Kyle died in his forty-eighth year.

BIBLIOGRAPHY: Groce and Wallace (1957), p. 379. The most detailed treatment ∥ Joseph Earl Arrington, *Skirving's Moving Panorama* (1964), pp. 141–142. A brief, informative account of his career ∥ Lee Parry, "Landscape Theater in America," *Art in America* 59 (Nov.-Dec. 1971), pp. 59–60. Discusses Kyle's panorama of *The Pilgrim's Progress*.

Self-portrait

According to Kyle's daughter, who gave the portrait to the Metropolitan Museum, it is "one of his best works," which his friends CHARLES LORING ELLIOTT, JAMES M. HART, WILLIAM MAGRATH, William H. Beard (1824–1900), and others declared to be "an extremely fine specimen of his work." That Elliott liked the portrait is not surprising; it is quite similar in style and technique to his own self-portrait (q.v.). Kyle's self-portrait is also comparable to that of GEORGE P. A. HEALY (q.v.). Kyle's face, which stands out against the dark background and jacket, is the focal point of the composition. The brushwork is finely executed, with the details and light effects meticulously rendered. The overall impression testifies to his effort to compete with photographers. Like Elliott and Healy, Kyle accurately reproduced the details of his subject's appearance, while preserving in a controlled, painterly style his autonomy as an artist.

According to another of Kyle's daughters, who lent the portrait to the museum in 1895, it was painted in 1859.

Kyle, *Self-portrait.*

Oil on canvas, 17 × 14 in. (43.2 × 35.6 cm.).

Canvas stamp: GOUPIL & Co / Artists Colourmen / & PRINT SELLERS / 366 / Broadway / NEW YORK.

REFERENCES: L. S. Kyle letter in MMA Archives, Dec. 25, 1905 // *MMA Bull.* 1 (Feb. 1906), p. 49 // Gardner and Feld (1965), p. 280.

EXHIBITED: MMA, 1895, *Retrospective Exhibition of American Paintings, Loan Collections, and Recent Gifts to the Museum,* no. 200x, lent by Mrs. Mary Kyle Dallas, New York, as portrait of the artist, painted by himself, 1859.

EX COLL.: the artist's daughters, Mary Kyle Dallas, d. 1897, and Louise Sherman Kyle, New York, until 1906.

Gift of Miss Louise Sherman Kyle, 1906.

06.1311.

Portrait of a Lady

When this portrait was exhibited at the Metropolitan Museum in 1895, the owner stated that it was painted in 1861. As such it forms a surprising contrast to Kyle's self-portrait (see above), which is supposed to have been painted two years earlier. In place of the latter's sophisticated brushwork and subtle coloring, this portrait is very broadly, even crudely, painted and may, in fact, be unfinished. Its small size suggests that it could also be an oil sketch made for a full-scale portrait. The subject is not known, but she may have been a relative of the donor, WILLIAM MAGRATH, a fellow artist and friend of Kyle's.

Oil on canvas, 12⅞ × 11 in. (32.7 × 27.8 cm.).

REFERENCE: L. S. Kyle, letter in MMA Archives, Dec. 25, 1905, calls it "insignificant" in comparison to Kyle's self-portrait.

EXHIBITED: MMA, *Retrospective Exhibition of American Paintings, Loan Collections, and Recent Gifts to the Museum,* 1895, no. 257b, as Portrait of a Lady, 1861, lent by William Magrath, New York.

EX COLL.: William Magrath, New York, 1895.

Gift of William Magrath, 1895.

95.20.

Kyle, *Portrait of a Lady.*

DAVID GILMOUR BLYTHE

1815–1865

The son of immigrant parents who came to the United States from Perth, Scotland, David Gilmour Blythe was born on May 9, 1815, in Wellsville, Ohio, and grew up on a homestead farm in nearby East Liverpool. He was apparently an eccentric, bookish child who at an early age showed an interest in art. At age sixteen he was sent to Pittsburgh to learn the trade of wood carving at the firm of Joseph Woodwell, where he also learned carpentry and cabinetmaking. After serving an apprenticeship of three years, he worked as a house carpenter in Pittsburgh until 1835 when he and his brother made a trip down the Mississippi to New Orleans. Back in Pittsburgh the following year, Blythe apparently did not find satisfactory employment due to the economic depression.

In the summer of 1837, he traveled to New York to enlist in the navy, and for the next three years he served aboard the ship *Ontario*, sailing to ports in the Caribbean and to the Gulf of Mexico. During his enlistment, Blythe retained his interest in art and in the winter of 1838–1839, while his ship was docked in Boston, he copied David Teniers's *Interior of an Inn*, ca. 1640 (Cleveland Museum of Art), then in the collection of Charles R. Codman. Blythe's copy, now in the Historical Society of Western Pennsylvania in Pittsburgh, is clearly the work of an amateur but ably translates the spirit of the original (see W. Stechow, *Bulletin of the Cleveland Museum of Art* 55 [Jan. 1968], pp. 28–33).

From 1840 to about 1845, Blythe led the life of an itinerant portrait painter in the area around East Liverpool. About 1846 he settled in Uniontown, Pennsylvania, where he continued to paint portraits and where he met Julia Keffer, whom he married in 1848. Her death two years later from typhoid fever left Blythe in a profoundly dejected state of mind from which he never completely freed himself. For a few more years, he remained based in Uniontown turning out portraits, carving a heroic statue of General Lafayette for the dome of the Fayette County courthouse, and producing a huge panorama of the Allegheny Mountains. He made many on-the-spot sketches, and, by the fall of 1851, the panorama was ready for display. His financial backers arranged shows in many cities throughout Ohio and western Pennsylvania, where the panorama received favorable reviews but never turned a profit. Blythe soon resumed his career as an itinerant portrait painter.

In 1856 Blythe returned to Pittsburgh and entered upon the most interesting period of his career. His political convictions, his wit, and his bittersweet outlook on life now combined with his art in the remarkable genre pictures he painted for the rest of his life. In these works one feels the gentle chiding of the moralizer and, at times, the social reformer. His depictions of street urchins and other city dwellers engaged in common activities are characterized by his uncompromising approach to the harsh realities of everyday life, but they are not devoid of humor, warmth, or understanding. With the coming of the Civil War, Blythe turned his attention to works that gave voice to his political beliefs. Through his paintings, he indicted the judicial system, slavery, and radical abolitionists, and championed Abraham Lincoln.

At the outbreak of the war, Blythe followed the Thirteenth Pennsylvania Regiment to the front and remained with it for three months. From this experience resulted his *General Doubleday Crossing the Potomac*, ca. 1861–1864 (National Baseball Hall of Fame and Museum, Cooperstown, N. Y.), perhaps his most competently executed and ambitious picture.

Little is known about Blythe's artistic education or his working methods. During his apprenticeship in Pittsburgh in the early 1830s, he may have studied the portraits of local artists James Bowman (1793–1842), James Reid Lambdin (1807–1889), and CHESTER HARDING. His works, though often inexpertly painted, reveal a knowledge of traditional technique and compositional vocabulary gleaned from a variety of sources. He is known to have frequented bookstores and print dealers' galleries, where he liberally borrowed ideas from graphic works by British caricaturists such as William Hogarth, George Cruikshank, and Thomas Rowlandson. His work also suggests that he studied prints by Francisco Goya. Blythe's style is one of the most individual of any nineteenth-century American artist and, despite its shoddy aspect, possesses a vigor and directness seldom found in American genre painting. Accordingly, Blythe must be ranked with the strongest—if not as the strongest— painter of American life at this time.

BIBLIOGRAPHY: James Hadden, *History of Uniontown* (1913), pp. 589–604. An early biographical account // Dorothy Miller, *The Life and Work of David G. Blythe* (Pittsburgh, 1950) // Donald D. Keyes and Lisa Taft, "David G. Blythe's War Paintings," *Antiques* 108 (Nov. 1975), pp. 992–997 // Bruce W. Chambers, *The World of David Gilmour Blythe, (1815–1865)* (New York, 1980). The definitive biography with a catalogue of the artist's works and an extensive bibliography.

Corn Husking

Paintings of rural scenes by Blythe are rare. That may be the reason why this work has been associated with subjects painted by him in the early 1850s which are thought to represent the Blythe family farm near East Liverpool, Ohio. It more closely relates, however, to a series of farm scenes painted in 1863 and 1864. The sensibility and sophistication evident in the work also link it with the masterpiece Blythe painted at this time, the well-known and securely dated *Libby Prison*, 1863 (MFA, Boston). Both pictures share a number of formal characteristics, including a convincing sense of spatial recession, a complex but balanced distribution of mass, and schematically painted figures that are based on a close study of poses and gestures and convey great emotion.

Set in an eerie, moonlit night, *Corn Husking* depicts a sudden outbreak of violence among a group of boys engaged in the boring and taxing task of husking recently harvested corn. Contrary to the approach of genre painters such as Alvan Fisher (1792–1863) who portrayed such an ac-

tivity as a pleasant evening diversion by the light of the harvest moon (for example, *Corn Husking Frolic*, 1828–1829, MFA, Boston), Blythe has stripped this work of all sentimentality and bared a scene of discord and bleakness bordering on desperation. The figure of the woman emerging from the door of the house indicates that the presence of an adult will soon halt the quarrel between the boys, but the dilapidated condition of the farm buildings and the carelessness with which the farm implements and other objects are thrown around the property assure us that the impoverished lot of these people will not soon change. In order to shock the viewer into the recognition of an unpleasant reality, Blythe pointedly made poverty and discord the themes of a situation that one would normally associate with abundance and harmony. This concern with informing the spectator without deception or idealization was a major aspect of Blythe's art and is evident in his depictions of urban realities, to which this painting is a rural counterpart. It is also found in his works dealing with the political issues of the Civil War.

Painted in a slapdash but knowing manner

Blythe, *Corn Husking*.

and featuring a silvery blue-green light which casts its color everywhere, *Corn Husking* possesses an intensity of feeling and moral conviction that transforms the painting into a social commentary. The lack of individuality in the children's faces and the emphasis on evocative gestures, poses, and grimaces create figures, which are unrealistic and cartoon-like but which, like the strange inhabitants of Goya's etchings, possess great expressive power.

Oil on canvas, 24 × 33½ in. (61 × 85.1 cm.).

Signed twice at lower left, on fence plank and on ox yoke: Blythe.

REFERENCES: D. Miller, *The Life and Work of David G. Blythe* (1950), pp. 103, 132, lists this picture among Blythe's unlocated paintings // Gardner and Feld (1965), pp. 279–280, date it between 1850 and 1855 // J. T. Flexner, *Nineteenth Century American Painting* (1970), p. 102 // B. Chambers, *The World of David Gilmour Blythe (1815–1865)* (1980), p. 169, dates it 1863–1864.

EXHIBITED: Pittsburgh Public Library, 1879, lent by Dr. John Shallenberger // MMA, 1965, *Three Centuries of American Painting* (checklist arranged alphabetically) // Lytton Gallery, Los Angeles County Museum of Art and M. H. de Young Memorial Museum, San Francisco, 1966, *American Paintings from the Metropolitan Museum of Art*, no. 52 // MMA and American Federation of Arts, traveling exhibition, 1975–1977, *The Heritage of American Art*, no. 42.

EX COLL.: John Shallenberger, Pittsburgh, by 1879; the family of John Shallenberger, Germany, until 1957; with the Old Print Shop, New York, 1957.

Purchase, Catharine Lorillard Wolfe Fund, 1957. 57.19.

UNIDENTIFIED ARTIST

Walking in the Woods

This painting depicts two children walking in the woods in the company of an elderly man, perhaps their grandfather. The boy has taken the girl's purse, and she appears to be pleading with the man to make him return it. A figure of a lady is visible on the path at the left, but it is difficult to tell whether she has anything to do with the principal figures. On the path leading to the house at the right are a number of goats and sheep.

As untrained painters often do, the artist has depicted the figures and animals in an unconvincing manner though not without a certain logic. The relative size of the figures has more to do with their rank and importance than with any attempt to represent them realistically. This principle, which obviously ignores the demands of perspective, even extends to the animals: the sheep and goats are smaller than any of the human figures but, as befits productive livestock, much larger than the pet dog which is accord-

ingly reduced to the size of a mouse. The man is the dominant figure in the painting, physically and in terms of authority. Similarly, the representation of nature as benign, omnipresent, and fertile, in short, an environment in which man can happily exist, embodies an ideal of rural life that is stated unrealistically but with disarming conviction. In this way the painter clearly elucidates the relationships between the children, the adult, and the natural environment with a degree of psychological truth that an academic artist could not have communicated so directly.

In some respects, the landscape setting recalls the compositional devices of Hudson River school paintings, and it may be compared with *Hooker and Company* by FREDERIC E. CHURCH, 1846 (Wadsworth Atheneum, Hartford), simply as a means of establishing the painter's debt to, as well as his departure from, the formulas of American landscape painting of the period from 1840 to 1860. The color scheme, with its excessively loud greens and browns, clearly reveals the artist's untutored eye.

Unidentified artist, *Walking in the Woods*.

Oil on canvas, 36¼ × 44 in. (91.7 × 111.8 cm.).
Inscribed on the back: Willie H. Schitler / From /
Aunt. Sallie. Haines.

Ex COLL.: with Jack Whistance, Kingston, N. Y.;
with John Nicholson, New York, by 1966; Edgar Wil-
liam and Bernice Chrysler Garbisch, 1966–1973.

Gift of Edgar William and Bernice Chrysler
Garbisch, 1973.

1973.323.8.

UNIDENTIFIED ARTIST

Portrait of a Gentleman in a Carriage

When this painting was given to the museum
it was identified as a scene depicting harness rac-
ing. While the similarity between this work and
paintings and prints of this subject is undeniable,
it is more likely a portrait of a gentleman in his
two-wheeled tilbury. Mid-nineteenth-century
representations of harness racing do not usually
feature men wearing top hats and overcoats nor
do they depict carriages so obviously designed
for comfort. Still, it is likely that the unknown
painter of this picture relied on precisely such
works in arriving at the pose of the horse and
in designing the overall composition.

Portraits of gentlemen in their carriages are
not common in American painting. A master-
piece of the type is Edward Troye's self-por-
trait with an unidentified boy, 1852 (Yale Uni-
versity, New Haven, Conn.). At least one artist,
Thomas K. Van Zandt of Albany (active 1844–
1870), is known to have made a specialty of such
subjects. His portrait of *Judge Van Arnam in His
Sleigh*, 1855 (Albany Institute of History and
Art), though it depicts a sleigh rather than a
carriage and is set in a snow-covered landscape,
exhibits a number of similarities with this paint-
ing, including a man dressed in top hat and
overcoat and an almost identically posed horse.
Accordingly, the possibility that the painter of
this picture was influenced by his work may be
considered.

Given the style of the gentleman's costume as

Unidentified artist, *Portrait of a Gentleman in a Carriage*.

well as the dates of the other works discussed
here, it is likely that the painting was executed
about 1850 to 1860.

Oil on canvas, 22⅛ × 29 in. (56.2 × 73.7 cm.).

ON DEPOSIT: United States Mission to the United
Nations, 1974–1979; Denver Art Museum, 1988–
1991.

Ex COLL : with Helena Penrose, until 1957; Edgar
William and Bernice Chrysler Garbisch, 1957–1973.

Gift of Edgar William and Bernice Chrysler
Garbisch, 1973.

1973.323.1.

Kidd, *Ivory-billed Woodpeckers.*

Audubon, *Ivory-billed Woodpecker.* NYHS.

Formerly attributed to John James Audubon; now given to Joseph Bartholomew Kidd (Scotland, 1808–1889)

Ivory-billed Woodpeckers

Based on a certification inscribed on the back of the canvas by Audubon's grandchildren, this painting was once attributed to John James Audubon (1785–1851). It is now quite securely given to the Scottish artist Joseph Bartholomew Kidd (1808–1889). While living in Edinburgh, Audubon met Kidd and at various times between 1827 and 1831 commissioned him to produce oil copies after the watercolors he later published in *The Birds of America* (1826–1839). Kidd's oils, one hundred of which he contracted to paint between November 1830 and May 1831, were intended to form a collection of pictures suitable for "perpetual" exhibition in traveling

shows both in England and the United States. This project, however, never came about, and some of the paintings eventually passed into the hands of Audubon's descendants.

This picture exactly follows Audubon's watercolor (before 1826, NYHS) published as plate 66, except for the landscape background which Kidd probably created on his own. In a letter of June 24, 1831, to Audubon, Kidd stated that he had recently completed the *Ivory-billed Woodpeckers*, of which our picture is the only version in oil. Since the painting is after Audubon's original design, it is unlikely that the statement of Audubon's grandchildren was made with intent

to misrepresent the work, and, in retrospect, it does not seem unreasonable to have so long accepted it as true.

Little is known about Kidd's career. He was a founding member of the Scottish Royal Academy and a landscape painter of some reputation. For some years he seems to have worked in Jamaica in the West Indies. In 1836 a number of views of the British Isles by him were exhibited at the National Academy of Design, and the following year he visited New York.

Oil on canvas, 39¼ × 26¼ in. (99.7 × 66.7 cm.).
Inscribed on the back: Painted by / J. J. Audubon / Certified by Lucy A. Williams / B. P. Audubon.
RELATED WORKS: John James Audubon, *Ivory Billed Woodpecker*, before 1826, watercolor on paper, 39 × 5̊3 in. (99.1 × 34.6 cm.), NYHS.
REFERENCES: J. L. Allen, MMA *Bull.* 36 (Sept. 1941), cover ill., pp. 178–79, discussed as by Audubon // A. T. Gardner, *MMA Bull.* 21 (May 1963), cover ill., pp. 311, 314, discusses Kidd's commission and concludes that "the verification of Audubon's oil copies is complicated ... [and] it is best to accept the certification of Audubon's grandchildren and the traditional attribution // Gardner and Feld, 1965, pp. 182–83, catalogued as by Audubon // A. Ford, *John James Audubon* (Norman, Okla. 1964), ill. p. 442, p. 438, cites June 24, 1831, letter from Kidd to Audubon regarding his copy of Ivory-Billed Woodpeckers // A. Ford, Charlottesville, Va., letters in Dept. Archives, May 14, 1977, and August 17, 1978, states that the painting is clearly documented as by Kidd.
EXHIBITED: Detroit Institute of Arts, 1944, *The World of the Romantic Artist*, cat. no. 37, as by Audubon // MMA, 1965, *Three Centuries of American Painting* (checklist arranged alphabetically), listed under Audubon // Los Angeles County Museum of Art, *American Paintings from the Metropolitan Museum of Art*, p. 12, ill. p. 53, as by Audubon // Bronx County Courthouse, New York, 1971, *Paintings from the Metropolitan*, cat. no. 26, as by Audubon // Grey Art Gallery, New York University, 1982, *John James Audubon and His Sons*, exhib. cat. by Gary Reynolds, cat. no. 67, ill. p. 46, discusses Audubon's commission and gives the painting to Kidd.
EX COLL.: John James Audubon, New York, d. 1851; his family, until 1937; with Knoedler Galleries, New York, 1937; Francis P. Garvan, New York, d. 1937; with Knoedler Galleries, New York, 1941.
Rogers Fund, 1941.
41.18.

INDEX OF FORMER COLLECTIONS

Bunker, Robert S., 543
Burgoyne, Lady Amy, 167
Burgoyne, Lady Katherine, probably, 167
Burgoyne, Sir John Montague, 167
Burr, Aaron, 254
Burr, Mrs. J. H. Ten Eyck. *See* Ledyard, Murray
Burton family, 310
Bush, Donald F., 193
Bush, Mrs. Donald F. *See* Pratt, Harriet

C

Cabell, Mrs. J. Alson. *See* Scott, Ethel
Camp, Arthur G., 130
Carlen, Robert, 310
Carroll, Charles Bancroft, 534
Carroll, Daniel, 188
Carroll family, 188
Carroll, Thomas B., 484
Carroll of Carrollton, Charles, 534
Cazenove, Théophile, 154; estate of, 154
Chandler, Parker C., possibly, 197
Channing, Mrs. William, 177
Channing, William F., 177
Chambers, Eunice, 376
Chapman, Henry T., 484
Chapman, John Gadsby, 530
Chapoton, Mrs. and Mrs. William B., 73
Chase, William Merritt, 276
Church, Angelica Schuyler, 205
Church, Catherine (Mrs. Bertram P. Cruger), 205
Church, John A., 235, 236
Church, Mrs. John. *See* Church, Angelica Schuyler
Clapp and Graham, 325, 326
Clark E., 294
Clark, Mrs., 294
Clarkson, Banyer, 168
Clarkson, David, 168
Clarkson, Helen Shelton, 168
Clarkson, Matthew, 168
Clarkson, Mrs. Banyer. *See* Clarkson, Helen Shelton
Clason, Augustus Washington, 305
Clason, Augustus Wood, 305
Clearwater, Alphonso T. (also Hon. A. T.), 253, 456
Clearwater, Thomas Theunis, 456
Clement, Elizabeth Tylee, 180, 182
Clement, Mrs. Samuel. *See* Anthony, Henrietta Hillegas
Coate, Charlotte Adam, 156
Coe, Mr. and Mrs. Jacques, 167
Coger, Henry, 9, 524
Coger, Henry and John Bihler, 594
Colden, David Cadwallader, 25, 26
Colden, Frances Wilkes (Mrs. David Cadwallader Colden), 25, 26, 175, 217, 398, 459
Colles, Dr. Christopher J., 368
Colles, James Sr., 368
Collins, Douglas, 482

Conant, John Adams, 235, 236
Constable, John, 179
Constable, Mrs. William, 179
Constable, William, 179
Coolidge, Baldwin, 385
Coolidge, Benjamin, 385
Coolidge, J. Swett, 579
Coolidge, Mrs. Thomas Brewster, 385
Cooper, Susan Fenimore, possibly, 482
Corcoran, William Street Eustis, 27
Coster, Harry A., 62
Coster, O. de Lancey, 62
Cowdrey, Elizabeth H. J., 328, 332
Cowdrey, Mrs. Francis. *See* Cowdrey, Elizabeth H. J.
Cox, 104
Cozzens, Abraham M., 417
Crane, Mrs. W. Murray, 280
Cremorne, Lord, 69
Crimmins, John D., 515
Croix-Laval. *See* La Croix-Laval
Crossfield family, descendants of, 47, 113
Cruger, Cornelia, 205, 573
Cruger, John Church, 205
Cruger, Mrs. Bertram P. *See* Church, Catherine
Cruger, Mrs. John Church. *See* Van Rensselaer, Euphemia White
Cutler, Colman Ward, 19
Cutler, Paul C., 19
Cutler, Phebe Ward, 19
Cutts, Edward, 36
Cutts, Edward Holyoke, 36
Cutts, Hannah (Annie) Sherwood (Mrs. Edward H.), 36
Cutts, Hampden, 36
Cutts, Mrs. Hampden, 18
Cutts, Samuel, 36
Cutts, Mrs. Samuel, 36

D

Dallas, Mary Kyle, 596
Dana, Richard Henry Jr., 291–292
Danenberg Galleries, Bernard, 482
Danforth, Elizabeth S. B., 88
Danforth, George H., III, 582
Danforth, Mary, 88
Danforth, Moseley I., 379
Danforth, Mrs. Thomas. *See* Bowers, Elizabeth Sherburne
Danforth, Nicholas Williamson, 582
Darley, Jane Sully, 347, 352, 354, 356
Darley, Francis T. S., 347, 352, 354, 356, 357, probably, 538
Darley, Mrs. William H. W. *See* Darley, Jane Sully
Darley, William H. W., 356
Dart-Roper-Bryan family, 42, 43
Davenport, Grace, 328, 332
Davenport, Henry, 19
Davenport, Mrs. Lawrence. *See* Davenport, Grace
Davis, Charles A., 154

H

Halpert, Edith Gregor, 310

Hamilton, duke of. *See* Archibald, William Alexander and Archibald, William Alexander Louis Stephen

Hamilton, tenth duchess of, 75, 76

Hamilton, Schuyler Van Cortlandt, 241

Hampton, Ann. *See* Thomas, Mrs. William

Hansford, Mrs. Milton. *See* Parks, Mary

Harkness, Edward S., 165

Harkness, Mary Stillman, 165

Harkness, Mrs. Edward S. *See* Harkness, Mary Stillman

Harmon, Andrew Sigourney, 193

Harmon, Martha Sigourney, 193

Harmony Society. See Museum of the Harmony Society

Harris, Edward D., 99

Harris, Mrs., 99

Harrison, Mrs. Matthias. *See* Francis, Rebecca

Harrison, Rebecca. *See* McMurtie, Rebecca

Harvard, Michael, 226

Harwood, Elizabeth. *See* Worthington, Mrs. George Fitzhugh

Harwood, Richard, 118

Harwood, Mrs. Thomas. *See* Strachan, Margaret

Hastings, Mrs. Thomas, 331

Hastings, Mrs. Thomas S. *See* de Groot, Fanny

Hastings, Thomas, 331

Havemeyer, Henry O., 188

Havemeyer, William F., 527

Haven, Frances Appleton Langdon, 190

Hearst, William Randolph, 410

Hennick, Edward Rutter, 233

Hennick, Sarah, 233

Hewitt, Erskine, 325, 326

Hewitt Galleries, 249

Hirschl and Adler Galleries, 148, 214, 297, 298

Hodges, Preston, 558

Hodges, Preston Henry, 558

Hoe, John M., 320

Hoe, Robert, Jr., 302, 557

Hollins, John Knapp, 335

Hollins, Mrs. John Knapp. *See* Hollins, Sallie Hitchings

Hollins, Mrs. Henry B. *See* Knapp, Evelina

Hollins, Sallie Hitchings, 335

Holmes, Kathryn. *See* Blauvelt, Mrs. J. Harman

Hoopes, Mrs. M. Howard, 266

Hopkins, Eustis Langdon, 190

Hopkins, Mrs. Amos. *See* Dunlap, Ellen Pond

Hopkins, Mrs. Dunlap. *See* Dunlap, Ellen Pond

Howard, Anna Holyoke Cutts, 18

Hoyt Family, 140

Hubbard, Helen Ledyard, 186

Huber, Mrs. Joseph Nichols. *See* Mettee, Ida

Hume, Edwin P., 519

Hume, Ida L., 519

Huntington, Collis P., 127

Huntington, Daniel, 465

Huntington, Mrs. Eliza Smith, 148

Huntington, William H., 137

Hurd, Lee M., 52, 53

Hurlbert, William Henry, 576

I

Isham, William B., 491; heirs of, 491

J

Jackson, Rosalie V. Tiers, 60

Janney, Mrs. Charles. *See* Pollock, Anne Lee

Jarvis, Mrs. William, 18

Jáudenes family, 170, 172

Jáudenes y Nebot, Joseph de, 170, 172

Jay, Marguerite Soléliac (Mrs. John), 359

Jefferson, Joseph, 454

Jenckes, Mrs. Joseph Sherburne, 88

Jenckes, Rev. Dr. Joseph Sherburne, 88

Jesup, Maria DeWitt, 417, 430, 479

Jesup, Morris K., 417, 430, 479

Jesup, Mr. and Mrs. Morris K., 144. *See also* Jesup, Maria DeWitt

Johnson, Mabel Van Rensselaer, 572

Johnston, J. Herbert, 284

Johnston, John, 284

Johnston, John Taylor, 218, 284, 479

Johnston, Mrs. J. Herbert, 284

K

Kearney, Mrs. Robert. *See* Reade, Anna

Kearney, Susan Watts. *See* Street, Mrs. William Ingram

Kellogg, Edward, 330, 331

Kellogg, Esther (Mrs. Edward), 330, 331

Kelly, Austin III, 130

Kennedy, E. G., 203

Kennedy Galleries (*see also* Kennedy, E. G.), 130, 410, 494, 507, 553

King, Mary C. (Mrs. R. W.), 18

King, Mrs. William M. *See* Sigourney, Mrs. Andrew John Cathcart

King, Noel Johnston Appleton, 284

Knapp, Evelina, 335

Knapp, Shepherd, 335

Knapp, William Kumbel, 335

Knapton, Rev. Augustus James, 106

Knapton, Augustus L. K., 106

Knapton, Mrs., 106

Knoedler, M. and Co. (also Knoedler Galleries), 78, 94, 97, 165, 170, 172, 218, 249, 603

Kostoff, Peter, 500

Kountze, de Lancey, 62

Kyle, Louise Sherman, 596

L

La Croix-Laval, Christian, comte de, 184

Lage, Charlotte Low, 114

Lathrop (Lothrop), Mrs. John. *See* Bontecou, Mary

Seguin, Clara L. (Mrs. Edward S. R.), 69, 74, 81
Seguin, Maria C., 69, 74, 81
Seligmann, Arnold, Rey and Co., 312
Senate House Museum, Kingston, N. Y., 264
Sexton, John, 565
Sexton, Samuel H., 565
Shallenberger, John, 599; family of, 599
Sharpe, George H., 268; family of, 268
Shelton, George F., 392
Shelton, Theodore B., 392
Sherburne, Joseph, descendants of, 92
Sidell, C. V., 265
Sidell, John A., 265
Sigourney, Andrew John Cathcart, 193
Sigourney, Mrs. Andrew John Cathcart, 193
Simons, Benjamin Bonneau, 134
Simons, Jane Van der Horst. *See* Bowly, Jane Van der
 Horst Simons
Simons, Maria, 134
Simons, Mary Harlbeck, 134
Simons, Mrs. Benjamin (née Ann Dymes Dewick), 134
Simons, Mrs. Robert. *See* Simons, Mary Harlbeck
Simons, Robert, 134
Simpson, Jonathan, 86
Simpson, Miss, 86
Smallen, Clara, 359
Smith, Captain H. N., 167
Smith, E. Herndon, as agent, 543
Smith, Frank Bulkeley, 385, 410
Smith, Katherine Cole, 536
Smith, Thomas, 167
Smith, Mr. and Mrs. Noah, 148
Smith, W. [I.], 74, 81
Smith, William J., 519
Spafford, Lucille, 174
Spafford, Mrs. Edward Elwell. *See* Stevens, Lucille
Sparhawk, Mrs. Nathaniel, 18
Spark, Victor D., 162, 530, 536
Sprague, Charles, 536
Sprigg, Elizabeth Galloway, 49
Sprigg, Richard, 49
Stanfield, Rosa C. (Mrs. Mark M.), 343, 344, 345
Stephens, Ann S., 254, 266; heirs of, 266
Stephens, Mrs. Ann S., 254, 266
Stevens, Ebenezer, 174
Stevens, Frederic W., 189
Stevens, Horatio Gates, 174
Stevens, John Rhinelander, 174
Stevens, Lucille, 174
Stevens, Mrs. Byam Kerby. *See* Gallatin, Frances
Stevens, William B., Jr., 536
Stidolph, Henry, 488
Stockwell, David, 14, 16
Stokes, William Earl Dodge, 484
Stokes, William Earl Dodge, estate of, 484
Story, George H., 197, 320, 321
Stout, Andrew Varick, 561
Stout, Andrew Varick IV, 561
Stout, Joseph Suydam, 561

Strachan, Margaret, 118
Streep, Jon Nicholas, 110
Street, Arthur Frederick, 27
Street, Mrs. William Ingram, 27
Street, William Augustus, 27
Stuart, Jane, 166
Stuart, Mrs. Gilbert (née Charlotte Coates), 166
Sturges, Frederick, 414, 418
Sturges, Frederick, Jr., 399, 417–418
Sturges, Jonathan, 404, 414, 428, 476, 590
Sturges, Jonathan, children of, 428, 476
Sturges, Mary Fuller. *See* Wilson, Mary Fuller Sturges
Sturges, Mary Pemberton, 404, 590
Sturges, Mrs. Jonathan. *See* Sturges, Mary Pemberton
Sturges, Virginia Reed, 404
Sudnam, John, 253
Sudnam, Harrison, 253
Sullivan, Charles, 319, 324
Sullivan, Charles Frank, 319, 324
Sully, Ellen Oldmixon. *See* Wheeler, Mrs. John Hill
Sully, Thomas, 347, 349, 352, 354
Sully family, 346
Sutton, 73
Swartout, Samuel, 304
Swett, Colonel Samuel, 90
Swett, Joseph Coolidge. *See* Coolidge, J. Swett, 579
Swinton, George Sitwell Campbell, 165
Sworde, Peter de Lancey, 62

T

Talbot, Charles N., 472
Talbot, Charles N., estate of, 472
Tams, Frederic, 287, 288
Thacher, Thurston, 371
Thomas, Mrs. William (Ann Hampton), 298
Thomas, Ralph W., 229, 230
Tompkins, Robert Schuyler, 502
Thompson, Mrs. Daniel, 294
Thompson, Susan Louise, 513
Thompson, Thomas, 394
Thompson, Thomas, family of, probably, 273
Thorne, Grace Davenport, 328, 332
Thornton, Mrs. Suzanne W., 8
Tooth Brothers, 76
Trotti and Co., 170, 172
Trout, Anna W. F., 312
Trout, Rosealba, 312
Trumbull, John, 214
Tucker, Helen L., 512
Turner, Sally, 486
Tyler, Mrs. Cornelius Boardman. *See* Tyler, Susan W.
Tyler, Susan W., 146
Tyler, Cornelius Boardman, 146

V

Vail, Elizabeth duBois (Mrs. L. Wolters Ledyard), 186,
 221, 222

Valentine Gallery, 310
Van Buren, Smith Thompson, 579; Mrs., probably, 579
Van Hinsberg, probably, 218
Van Nest, George Willett, 150, 257
Van Rensselaer, Alexander, 572
Van Rensselaer, Euphemia White, 573
Van Swerigen, M. J., 484
Van Swerigen, O. P. , 484
Van Winkle, Edgar Beach, 424
Van Winkle, Mary Starr, 424
Van Wyck, Ann Van Rennselaer (Mrs. Alexander Wells), 241
Van Wyck, Philip Gilbert, 241
Vanderlyn, Catherine, 264, 268
Vanderlyn, John, Jr., 264, 268
Vaughan, Mary Eliot (Mrs. Langdon P. Marvin), 196
Vaughan, Mrs. William W. See Parkman, Ellen T.
Verplanck, Bayard, 94
Verplanck, Mrs. Bayard, 97
Verplanck, Giulian Crommelin, 94
Verplanck, James De Lancey, 96
Verplanck, Matilda C., probably, 96
Verplanck, Samuel, 96
Verplanck, W. E., 94
Verplanck, W. Everett, 94
Verplanck, family, 97
Vixseboxse Art Gallery, 484
Vose Galleries, 29, 36, 225, 482, 484, 494

W

Wait, Mr. and Mrs. Frederick S., 407
Waldo, Deliverance, 319, 324
Waldo, Mrs. Samuel L. See Waldo, Deliverance
Waldo, Samuel L., estate, 320
Waldo, Samuel L., 319, 320, 324; family of, 324
Walker, Mrs. A. Stewart, 538
Walker, Sybil, 346
Walker Galleries, 139
Ward, Ellen Maria, 19
Ward, Mary Colman, 19
Washington, Harriet. See Parks, Mrs. Andrew
Watts, Mrs. David, 67
Watts, Henry Miller, 67
Watts, James De Lancey, 61
Watts, John Schonberger, 67
Watts, Dr. Robert, 61
Webb, Mrs. Joshua, 254
Webbs Art Store, Columbia, S. C., 41, 42
Weitzner, Julius, 78, 184
Wells, Mrs. Alexander. See Van Wyck, Ann Van Rennselaer
West, Benjamin, 69, 73, 74, 78, 81
West, Benjamin (son of the artist), 69, 73, 74, 78, 81
West, Raphael, 69, 73, 74, 78, 81
Western Art Union, 465
Wharton, Henry, Jr., 14, 16

Wharton, Mrs. Henry, 14, 16
Wharton, Mrs. Henry, Jr., 14, 16
Wheeler, Charles Sully, 359
Wheeler, Mrs. Alfred. See Baylis, Elizabeth (Eddie) Thornton
Wheeler, Mrs. John Hill, 359
Wheeler, William D., 359
Wheelwright, Mary Bowers, 92
Whistance, Jack, 601
Whitmore, William H., 52, 53
Wickham, Louise Floyd, 522
Wickham, William Hull, 522
Wilkes, Anne, 25, 26, 175, 217, 398, 459
Wilkes, Charles, 175, 217
Wilkes, Frances. See Colden, Frances Wilkes
Wilkes, George, 175, 217
Wilkes, George, probably, 459
Wilkes, Grace, 25, 26, 175, 217, 398, 459
Wilkes, Harriet K., 25, 26, 175, 217, 398, 459
Wilkes, Mrs. Charles, 175, 217
Willett, Edward M., probably, 257
Willett, Mrs. Edward M., 257
Willett, Marinus, probably, 150
Willett, Mrs. Marinus (née Margaret Bancker), 150, 257
Williams, Elie, 130
Williams, Elizabeth. See Sigourney, Mrs. Andrew
Williams, James Arthur, 42, 43
Williams, Otho Holland, 130
Williams, Sarah S., 130
Williams, Thomas D. and Constance R., 246
Williams and Stevens, 515
Williamson, James Abeel, 582
Williamson, John Q. Aymar, 582
Willing, Ava Lowle (Mrs. John Jacob Astor, later Lady Ribblesdale), 129
Willing, Edward Shippen, 129
Willing, Ellen, 129
Willing, Richard, 129
Willing, Thomas, 129
Wilson, Mary Fuller Sturges, 414
Wilson, Mrs. Orme, 86
Wise, John, 543
Wolf, Erving, Foundation, 579
Woodward, Mrs. Phyllis M., 8
Worthington, Mrs. George Fitzhugh, 118
Worthington, Hobart, 118
Wray, Charles S., 335
Wray, Elsa Welles (Mrs. Charles S.), 335

Y

Yates, Anna Davis, 8
Yates, De Forest, 8

Z

Zabriskie, Christian A., 241

INDEX OF ARTISTS AND TITLES

K

Kellogg, Edward, by Waldo and Jewett, 329–330.

Kellogg, Mrs. Edward, by Waldo and Jewett, 330–331.

Kemmelmeyer, Frederick, 157–162.

Kent, Eliza. See *Montgomery, Mrs. James,* by Sully.

Kidd, Joseph Bartholomew, 602–603.

Knapp, Shepherd, children of. See *Knapp Children, The,* by Waldo and Jewett.

Knapp Children, The, by Waldo and Jewett, 332–335.

Knapp, Gideon Lee. See *Knapp Children, The,* by Waldo and Jewett.

Knapp, Peter Kumbel. See *Knapp Children, The,* by Waldo and Jewett.

Knapp, Shepherd Fordyce. See *Knapp Children, The,* by Waldo and Jewett.

Knapp, William Kumbel. See *Knapp Children, The,* by Waldo and Jewett.

Kyle, Joseph, 595–596; self-portrait by, 595–596.

L

Lady with a Dog, by M. Brown, 225.

Lady with Her Pets (Molly Wales Fobes), by Hathaway, 242–244.

Lafayette, Marquis de, by Rembrandt Peale, 282–284.

Lake George, by Casilear, 549–550.

Lake George and the Village of Caldwell, by Chambers, 524.

Lamp Lighter, The, by Chappel, 441.

Landscape — Scene from "Thanatopsis", by A. B. Durand, 419–422.

Lane, Fitz Hugh, 492–495.

Lang, Louis, 585–587.

Lathrop, Mrs. John. See *Bontecou, Mary,* by J. Durand.

Leatherstocking's Rescue, by Quidor, 480–482.

Lee, Charles, or Gentleman of the Lee Family, by Stuart, 182–183.

Lee family. See *Lee, Charles or Gentleman of the Lee Family,* by Stuart.

Leete Farm, West Claremont, New Hampshire, attributed to Alexander, 438–439.

Leonard, Mrs. Elijah. See *Lady with Her Pets (Molly Wales Fobes),* by Hathaway.

Lind, Mrs. Edward. See *Morse, Susan Walker,* by Morse.

Lindley, Hannah. See *Murray, Mrs. John,* by Trumbull.

Linen, George, 487–488.

Long Island Farmhouses, by W. S. Mount, 519–522.

Lothrop, Mrs. John. See *Bontecou, Mary,* by J. Durand.

Lyde, Deborah. See *Brinley, Mrs. Francis and Her Son Francis,* by Smibert.

M

Macready, William Charles as William Tell, by Inman, 451–454.

Macdonough, Thomas, by Wood, 279–280.

Man in a Green Coat, by Stuart, 164–165.

Manigault, Gabriel, by Theüs, 40–41.

Manigault, Mrs. Gabriel, by Theüs, 41–42.

Mapes, Deliverance. See *Waldo, Mrs. Samuel L.,* by Waldo, 324.

Mare, John, 107–110.

Mathews, Mrs. Katherine, by Sully, 338–339.

Mathews, The Reverend Dr. James Melancthon, by Inman, 455–456.

Mayer, Mrs., and Her Daughter, by Phillips, 372–373.

Mayo, Maria D. See *Scott, Mrs. Winfield,* by A. B. Durand.

McLean, Mrs. Neil (possibly). See *Portrait of a Lady (possibly Hannah Stillman),* by unidentified artist.

Midshipman Augustus Brine. See *Brine, Midshipman Augustus,* by Copley.

Mifflin, Mrs. Samuel and Her Granddaughter Rebecca Mifflin Francis, by C. W. Peale, 121, 123–124.

Mifflin, Rebecca. See *Mifflin, Mrs. Samuel and Her Granddaughter Rebecca Francis Mifflin,* by C. W. Peale.

Mifflin, Samuel, by C. W. Peale, 120–121, 122.

Mifflin, Thomas, by Trumbull, 214–215.

Militia Drilling, by Chappel, 447–448.

Miller, Mrs. Henry. See *Rose, Sarah Ursula,* by West.

Moïse, Theodore Sidney, 525–527.

Monroe, James, by Stuart, 194–195.

Montgomery, Mrs. James, by Sully, 359.

Morse, Samuel F. B., 373–382.

Morse, Susan Walker (The Muse), by Morse, 379–382.

Moses Viewing the Promised Land, by West, 77–78.

Mother and Son, by Sully, 354–356.

Moulthrop, Reuben, 226–230.

Mount, Shepard Alonzo, 496–497.

Mount, William Sidney, 509–522.

Mountain Ford, The, by Cole, 476–479.

Munson, Mrs. Eneas. See *Perit, Mrs. Job,* by Moulthrop.

Murray, John R., by Stuart, 186.

Murray, John, by Trumbull, 220–221.

Murray, Mrs. John, by Trumbull, 221–222.

Muse, The. See *Morse, Susan Walker (The Muse),* by Morse.

Musidora, by Sully, 347–349.

N

Neagle, John, 404–408.

Nevins, Mary Hubbard. See *Blake, Mrs. Francis Stanton,* by Harding.

New Bonnet, The, by Edmonds, 505–507.

New York Street Scenes, by Chappel, 440–449.

Noailles, (Louis Marie), Vicomte de, by Stuart, 183–184, 185.

O

Old Ferry Stairs, by Chappel, 441.

Old Pat, the Independent Beggar, by Waldo, 322–324.

Omnia Vincit Amor, or the Power of Love in the Three Elements, by West, 78–81.

On the Hudson, by Doughty, 389–390.

Orléans, Louis Philippe d', Comte de Paris, by Healy, 575–576.

Sexton, Samuel H., 563–565.
Shaw, Joshua, 273–277.
Sherburne, Joseph, by Copley, 90–92.
Sherburne, Mary. See *Bowers, Mrs. Jerathmael,* by Copley.
Sidell, John A., by J. Vanderlyn, 264–265.
Sigourney, Mrs. Andrew, by Stuart, 193.
Simons, Mrs. Benjamin, by Benbridge, 134.
Slade, Philip, by Phillips, 369–371.
Smibert, John, 12–19.
Smith, Celia. See *Smith, Mrs. Noah and Her Children,* by Earl.
Smith Daniel. See *Smith, Mrs. Noah and Her Children,* by Earl.
Smith, Eliza. See *Smith, Mrs. Noah and Her Children,* by Earl.
Smith, Henry. See *Smith, Mrs. Noah and Her Children,* by Earl.
Smith, Mrs. Noah and Her Children, by Earl, 146–148.
Smith, Noah. See *Smith, Mrs. Noah and Her Children,* by Earl.
Smith, Thomas, by Stuart, 166–167.
Sommers, Henrietta Isabella. See *Dart, Mrs. John,* by Theüs.
Sortie Made by the Garrison of Gibraltar, The, by Trumbull, 205–214.
Spanish Girl in Reverie, The, by Allston, 292–294.
Spencer, Frederick R., 507–509.
Spring, by C.G. Thompson, 535–536.
Spring Landscape, by Doughty, 391–392.
Stage Fort across Gloucester Harbor, by Lane, 494–495.
Stanford, Sarah. See *Perit, Mrs. Job,* by Moulthrop.
Stanley, John Mix, 580–582.
Steward, Joseph, 154–156.
Stewart, Martha. See *Wilson, Martha Stewart,* by J. Peale.
Still Life: Balsam Apple and Vegetables, by J. Peale, 137–139.
Still Life: Peaches, Apple and Pear, by Woodside, 312.
Still Life: Peaches and Grapes, by Woodside, 311–312.
Still Life with Cake, by Raphaelle Peale, 248–249.
Stillman, Hannah. See *Portrait of a Lady (possibly Hannah Stillman),* by unidentified artist.
Stock, John and Louisa, by Stock, 592–593.
Stock, Joseph Whiting, 590–593.
Stock, Louisa. See *Stock, John and Louisa,* by Stock.
Storm, Thomas, by Phillips, 371.
Stoughton, Matilda. See *Jáudenes, Matilda Stoughton de.*
Stout, Andrew Varick, by Elliott, 561.
Strachan, Margaret (Mrs. Thomas Harwood), by C. W. Peale, 117–118.
Strawberry Pedlar, by Chappel, 446.
Stuart, Gilbert, 162–198; copies after, 196–198; self-portrait by, 165–166.
Student (Rosalie Kemble Sully), The, by Sully, 353–354.
Study for Arm and Fist, by Waldo, 318–319.
Study for the Angel Releasing Saint Peter from Prison, by Allston, 290–292.
Study from Life, A, by Allston, 290–292.
Sturges, Jonathan, by A. B. Durand, 418–419.
Sully, Ellen Oldmixon. See *Wheeler, Mrs. John and Her Two Sons,* by Sully.

Sully, Jane Cooper. See *Mother and Son,* by Sully.
Sully, Rosalie Kemble. See *Student (Rosalie Kemble), The,* by Sully.
Sully, Sarah Annis, by Sully, 346–347.
Sully, Thomas, 337–359; self-portrait by, 341–343.
Sully, Thomas, Jr. See Sully, Thomas Wilcocks.
Sully, Thomas Wilcocks, 537–538.
Summer Afternoon, by A. B. Durand, 428–430.
Sylvester, Margaret. See *Chesebrough, Mrs. David,* by Blackburn.
Sylvester, Mary, by Blackburn, 32–33.

T

Tea Party, by Chappel, 443–444.
Tea Rusk and Brick House, by Chappel, 445.
Tea Water Pump, by Chappel, 445–446.
Tell, William. See *Macready, William Charles, as,* by Inman.
Thayer, Mrs. Elmer A. See *Homan, Emma,* by Bradley.
Theüs, Jeremiah, 39–43.
Thomas, Master Rees Goring, atributed to Earl, 142–144.
Thomas, Mrs. William (Ann Hampton), by J. W. Jarvis, 298–301.
Thompson, Cephas Giovanni, 534–536.
Thompson, Jerome B., 582–585.
Thompson, Martin Euclid, by W. S. Mount, 512–513.
Thompson, Thomas, 270–273.
Titan's Goblet, The, by Cole, 465–468.
Trumbull, John, 199–222.
Tucker, Gideon, by Mount, 511–512.
Tucker, Mrs. Gideon, by Mount, 511, 512.

U

U. S. Ship Franklin, with a View of the Bay of New York, The, by Thompson, 271–273.
Unidentified artists, 8–9, 11; 313–314; 336; 394–395; 395–396; 433–434; 484–485; 593–594; 600; 601; after Stuart, 196–198.
Unidentified boy, 11, 593–594.
Unidentified family, 484–485; 486.
Unidentified girl, by M. Brown, 226; attributed to Waldo, 325–326; by unidentified artist, 433–434; by Waldo, 335.
Unidentified man, by Benbridge, 132–133; by C.W. Peale, 119; by Stuart (see *Man in a Green Coat* and *Lee, Charles, or Gentleman of the Lee Family*); by Sully, 345–346; by unidentified artist, 601; by Waldo, 320–321.
Unidentified woman, attributed to Duyckinck, 4–5; by Kyle, 596; by C. W. Peale, 119–120; by unidentified artist, 8; by P. Vanderlyn, 10; attributed to Waldo, 324–325.
Unidentified woman and child, by Earl. See *Williams, Lady, and Child,* by Earl.

V

Van Buren, Martin, by Inman, 456–458.
Van Cortlandt, Philip, by Ames, 241.

INDEX OF AUTHORS

The Plantation	John Caldwell	Portrait of a Little Girl Picking Grapes	Oswaldo Rodriguez Roque
Portrait of a Boy with Blond Hair	Oswaldo Rodriguez Roque	View of New York from Weehawken	Kathleen Luhrs
Portrait of a Gentleman in a Carriage	Oswaldo Rodriguez Roque	View from Staten Island	Kathleen Luhrs
Portrait of a Lady (possibly Hannah Stillman)	John Caldwell	Walking in the Woods	Oswaldo Rodriguez Roque

PAINTINGS NOT INCLUDED
IN VOLUMES I, II & III*

John White Alexander
Repose (1980.224)

Ambrose Andrews
The Children of Nathan Starr (1987.404)

Thomas P. Anshutz
A Rose (1993.324)

G. Baker
New York Harbor with Brooklyn Bridge (1977.258.2)

Gifford Beal
Mayfair (14.72)
The Albany Boat (17.48.1)

Reynolds Beal
Shore at Orient, Long Island (1992.203.2)

W. H. Bean
American Eagle on Red Scroll (1980.360.12)

Albert Bierstadt
Mountain Scene (1979.490.2)
Nevada Falls, Yosemite (1979.490.3)
Sea Cove (1979.490.4)
Canadian Rockies (1982.119.1)

Albert Bierstadt, formerly attributed to
After the Storm (66.214)

William Bradford
An Arctic Summer: Boring Through the Pack in Melville Bay (1982.443.1)
An Incident of Whaling (1990.197.1)
Off Greenland—Whaler Seeking Open Water (1990.197.2)

Matilda Auchincloss Brownell
Spring, Luxembourg Garden (67.55.163)

Bryson Burroughs
Consolation of Ariadne (18.42)
Eurydice Bitten by the Snake (32.27)

John F. Carlson
Snow Flurries (47.46)

John W. Casilear
Mountain Lake Scene (1979.272)

Mary Cassatt
Spring: Margot Standing in a Garden (Fillette dans un jardin) (1982.119.2)

Robert Winthrop Chanler
Porcupines and Nightmare (27.30)

William Merritt Chase
Pink Azalea—Chinese Vase (1979.490.5)

Eanger Irving Couse
The Peace Pipe (17.138.1)

Howard Cushing
Mrs. Ethel Cushing (17.83)

Leon Dabo
The Cloud (12.68)

Joseph Decker
Gooseberries (1980.24)

Louis Paul Dessar
The Wood Cart (09.72.5)

William de Leftwich Dodge
Venus in Atrium (1972.192)

Asher B. Durand, formerly attributed to
View of New York from New Jersey (1977.258.3)

Ralph Earl
Esther Boardman (1991.338)

John F. Francis
Still Life with Fruit (1982.139)

Oliver Fraser, attributed to
Henry Clay (68.222.23)

Frederick Carl Frieseke
The Toilet (La Toilette) (12.42)
Summer (66.171)

Maurice Fromkes
Road to San Andres (67.32)

Wilhelm Heinrich Funk
Sir Casper Purdon Clarke (1970.55)

Anne Goldthwaite
A Window at Night (38.48)
The Green Sofa (44.84)
White Mules on a Bridge (45.158.1)
Garden Gate, Near Ascain #7 (1972.200)

* This list includes American paintings acquired in recent years, paintings by artists born after 1864 and before 1876, as well as problem paintings and overmantel paintings. The Twentieth Century Art Department holds works by American artists born from 1876 on.

Arthur Clifton Goodwin
The Celebration of Armistice Day, 1918 (1970.285)
Louis Kronberg in his Studio in Copley Hall (1975.397)

Albert Lorey Groll
Silver Clouds, Arizona (14.71)

Seymour Joseph Guy
*The Contest for the Bouquet: The Family of Robert Gordon
in Their New York Dining-Room* (1992.128)

Philip Leslie Hale
Niagara Falls (1978.509.4)

J. L. Harding
Portrait of A Lady (28.145)

James M. Hart
From Shifting Shade (1990.197.3)

William Stanley Haseltine
Nature Scene (1980.350)

Childe Hassam
Peach Blossoms—Villiers le Bel (1979.490.9)

Martin Johnson Heade
Hummingbird and Apple Blossoms (1979.490.11)
Newburyport Meadows (1985.117)

Edward Lamson Henry
A Carriage Ride (1979.490.12)

Albert Herter
Portrait of A Russian Nobleman (D. C. Imboden) (23.234)
Courtland Palmer (50.220.2)

Charles Hopkinson
George Blumenthal (33.154)

F. G. W. Hunten
New York Bay (54.90.38)

Eastman Johnson
Christmas-Time, The Blodgett Family (1983.486)

George Inness, formerly attributed to
Landscape (67.187.211)

Alphonse Jongers
Louise (10.64.7)
Arthur Hoppock Hearn (11.116.5)

Theodor Kaufmann
On to Liberty (1982.443.3)

William Sergeant Kendall
The Seer (06.1219)
Psyche (10.14)

Louis Kronberg
The Pink Sash (13.61)

George Cochran Lambdin
Side of a Greenhouse (1979.490.10)

Annie Traquair Lang
Portrait of William Merritt Chase (1977.183.1)

Ernest Lawson
The Bronx River (1979.490.13)
Shadows, Spuyten Duyvil Hill (1992.234)

Charles Robert Leslie
Dr. John Wakefield Francis (96.25)

John Lillie
The Old Factory (33.135)

De Witt McClellan Lockman
Patrick Cardinal Hayes (50.122)
Connie (54.66)

Henry Augustus Loop
John Quincy Adams Ward (1992.407)

Robert MacCameron
The Daughter's Return (10.153)
August Rodin (12.171)

Frederick William MacMonnies
Madonna of Giverny (1983.530)

F. A. Mead
Old Brewery, Five Points Mission, New York (54.90.183)

F. Luis Mora
The National Academy Jury of 1907 (41.58)
Flowers of the Field (67.24)

William Sidney Mount
*Great-Grandfather's Tale of the Revolution—A Portrait of
Reverend Zachariah Greene* (1984.192)

Jerome Myers
The Mission Tent (12.69)
Street Group (34.52)
A North River Recreation Pier (66.47)

Henry Hobart Nichols
The Jade Pool (27.140)
Snow Mountain (46.130)

Leonard Ochtman
Salt Marshes, Connecticut (1979.73.2)

Maxfield Parrish
The Errant Pan (64.192)

William MacGregor Paxton
Tea Leaves (10.64.8)

Jay Campbell Phillips
Dr. Stephen Smith (27.50)

Charles Peale Polk
Joseph Howell, Jr. (1982.373)

Edwin Willis Redfield
Overlooking the Valley (16.150)

Ferdinand Richardt
Underneath Niagara Falls (1980.209)

Albert Pinkham Ryder
Under a Cloud (1988.353)

Chauncey F. Ryder
 Mt. Mansfield, Vermont (22.95)

Robert Salmon
 The Custom House at Greenock Scotland (1979.488)

Walter Elmer Schofield
 Sand Dunes near Lelant, Cornwall, England (09.26.1)

Gilbert Stuart
 George Heathcote (1986.264.1)

Henry Stull
 Ludwig (62.241.20)

August Vincent Tack
 In the House of Matthew (22.103)
 John La Farge (37.74)
 Night Clouds and Star Dust (64.250)

Arthur Fitzwilliam Tait
 On Point (1979.490.6)
 Rabbits on a Log (1979.490.7)
 On the Qui Vive, Buck and Three Does (1979.490.8)

Allen B. Talcott
 Return of the Redwing (09.212)

Edmund Charles Tarbell
 Still Life: Vase of Peonies (1979.490.1)

Stephen Seymour Thomas
 Mrs. S. Seymour Thomas (15.15)

Cephas Thompson
 Mrs. Cephas Thompson (Olivia Leonard) (1985.22)

Jerome B. Thompson
 Summer Flowers (1984.252.1)
 Song of the Waters (1984.252.2)

Jonathan K. Trego and J. L. Williams
 Trappers (1985.354)

Allen Tucker
 Blue and Gold (21.61)
 Headland (32.81.1)
 Winter at Portland (66.74.1)
 Interior (66.74.2)

John H. Twachtman
 Arques-la-Bataille (1991.130)

Elihu Vedder
 Cypress and Poppies (1982.441)
 The Fable of the Miller, His Son, and the Donkey
 (1992.205.1-.9)

A. P. Waite, attributed to
 Harlem Bridge, New York (54.90.154)

J. C. Wales
 New York Bay and Harbor (54.90.106)

J. Alden Weir
 The Factory Village (1979.487)
 Fruit (1980.219)

Catherine D. Wentworth
 Letitia (Mrs. Wentworth, Sr.) (48.177)

James McNeill Whistler, formerly attributed to
 Henry Irving as Philip II of Spain, after 1872 (55.49)

J. L. Williams (*see* Jonathan K. Trego)

Theodore Wores
 A Street in Ikao (1990.32)

Unidentified artists
 Bay and Harbor from near Fort Castle William
 (54.90.9)
 Black Hawk (63.138.4)
 The Deer Hunt (1980.360.7)
 Fight Between the U. S. Frigate President and H. B. M.
 Endymion, January 15, 1814 (46.67.84)
 Harbor Scene (56.108.1)
 Hudson House (1973.323.3)
 The Hunting Party—New Jersey (1979.299)
 Hunting Scene (overmantel) (37.84)
 Landscape (46.67.83)
 Landscape with Wayside Crosses (overmantel)
 (37.27.1)
 Marine (63.138.3)
 Martha Bartlett with Kitten (1980.341.11)
 Miss Foote (07.233.38)
 The Old Oaken Bucket which Hung in the Well
 (1980.360.8)
 Portrait of a Man (55.73.3)
 Portrait of a Man (64.97.4)
 Portrait of a Man (64.97.5)
 Portrait of a Woman with a Muff (62.241.1)
 Sarah Cornell Clarkson (Mrs. William Richmond)
 (23.80.81)
 Seascape Fantasy (overmantel) (1972.263.2)
 Ship in New York Harbor (1973.323.4)
 Tobacco Sign (1980.360.9)
 View of the Battery, New York (54.90.179)
 Washington's Triumphal Entry into New York
 (34.90.177)

CUMULATIVE LIST OF ARTISTS
FOR VOLUMES I, II & III

Edwin Austin Abbey, III
Francis Alexander, I
Henry Alexander, III
John White Alexander, III
Washington Allston, I
Ezra Ames, I
Joseph Alexander Ames, II
Thomas Anshutz, III
John Woodhouse Audubon, I
Joseph Badger, I
George A. Baker, Jr., II
Cecilia Beaux, III
J. Carroll Beckwith, III
Henry Benbridge, I
Frank W. Benson, III
Albert Bierstadt, II
George Caleb Bingham, I
Joseph Blackburn, I
Ralph Blakelock, III
Edwin H. Blashfield, III
Jacob D. Blondel, II
Robert Blum, III
David Gilmour Blythe, I
Otto Boetticher, II
George H. Bogert, III
Frank Boggs, III
William Bradford, II
John Bradley, I
Alfred Thompson Bricher, II
George Loring Brown, I
John G. Brown, II
Mather Brown, I
W. H. Browne, I
George de Forest Brush, III
William Gedney Bunce, II
Dennis Miller Bunker, III
Howard Russel Butler, III
Theodore Earl Butler, III
James H. Cafferty, II
John Carlin, I
Emil Carlsen, III
John W. Casilear, I
Mary Cassatt, II
Jefferson D. Chalfant, III
Thomas Chambers, I
John Gadsby Chapman, I
Alonzo Chappel, II
William P. Chappel, I
William Merritt Chase, III
Frederic E. Church, II
Edmund C. Coates, II

William Coffin, III
Thomas Cole, I
Alfred Q. Collins, III
Samuel Colman, II
Charlotte Buell Coman, II
Nelson Cook, II
Colin Campbell Cooper, III
Alfred Copestick, II
John Singleton Copley, I
Kenyon Cox, III
Caroline Cranch, III
Bruce Crane, III
Jasper F. Cropsey, II
Johan Mengels Culverhouse, II
Elliott Daingerfield, III
William P. W. Dana, II
William Dannat, III
Arthur B. Davies, III
Charles H. Davis, III
Charles Melville Dewey, III
Thomas Dewing, III
Ruger Donoho, III
Thomas Doughty, I
Robert S. Duncanson, II
William Dunlap, I
Asher B. Durand, I
John Durand, I
Frank Duveneck, III
Gerrit Duyckinck, I
Thomas Eakins, II
Ralph Earl, I
Oliver Tarbell Eddy, I
Francis W. Edmonds, I
Jacob Eichholtz, I
Louis Michel Eilshemius, III
Carnig Eksergian, III
Charles Loring Elliott, I
James Guy Evans, II
Joseph Fagnani, II
Robert Feke, I
Erastus Salisbury Field, I
Charles Noël Flagg, III
Ben Foster, III
August R. Franzén, III
James Frothingham, I
George Fuller, II
Ignaz Marcel Gaugengigl, III
Edward Gay, II
Walter Gay, III
Robert Swain Gifford, II
Sanford Robinson Gifford, II

Henry Peters Gray, II
Seymour Joseph Guy, II
John Haberle, III
James Hamilton, II
Chester Harding, I
William Michael Harnett, III
Alexander Harrison, III
James M. Hart, III
William Hart, II
William Stanley Haseltine, II
Childe Hassam, III
Rufus Hathaway, I
Robert Havell, Jr., I
Martin Johnson Heade, II
George P. A. Healy, I
Edward Lamson Henry, II
John Hesselius, I
Edward Hicks, I
Thomas Hicks, II
Joseph H. Hidley, II
John Henry Hill, II
Thomas Hill, II
Thomas Hewes Hinckley, I
George Hitchcock, III
Charles C. Hofmann, II
Winslow Homer, II
Thomas Hovenden, II
William James Hubard, I
Richard William Hubbard, II
William Morris Hunt, II
Daniel Huntington, II
Charles Cromwell Ingham, I
Henry Inman, I
George Inness, II
Charles Wesley Jarvis, I
John Wesley Jarvis, I
William Jennys, I
William Jewett, I
David Johnson, II
Eastman Johnson, II
Joshua Johnston, I
William Johnston, I
Francis Coates Jones, III
H. Bolton Jones, III
Matthew Harris Jouett, I
John Kane, III
William Keith, II
Frederic Kemmelmeyer, I
John F. Kensett, II
Nicholas Biddle Kittell, II
Anna Elizabeth Klumpke, III

Joseph Kyle, I
John La Farge, II
George Cochran Lambdin, II
Fitz Hugh Lane, I
Louis Lang, I
William L. Lathrop, III
Jacob Hart Lazarus, II
Thomas Le Clear, II
Emanuel Leutze, II
George Linen, I
Wilton Lockwood, III
Will H. Low, III
Frederick MacMonnies, III
William Magrath, II
John Mare, I
Homer Dodge Martin, II
Arthur Frank Mathews, III
Francis Blackwell Mayer, II
George Willoughby Maynard, II
Jervis McEntee, II
Gari Melchers, III
Willard Metcalf, III
Louis Remy Mignot, II
Frank Millet, III
Louis Moeller, III
Theodore Sydney Moise, I
Edward Moran, II
Thomas Moran, II
Samuel F. B. Morse, I
Anna Mary Robertson (Grandma)
 Moses, III
Henry Mosler, II
Reuben Moulthrop, I
Shepard Alonzo Mount, I
William Sidney Mount, I
H. Siddons Mowbray, III
J. Francis Murphy, III
John Neagle, I
Robert Loftin Newman, II
Clinton Ogilvie, II
William Page, I
Walter Launt Palmer, III
John Paradise, I
DeWitt Parshall, III
Charles Willson Peale, I
James Peale, I
Raphaelle Peale, I
Rembrandt Peale, I

Charles Sprague Pearce, III
Robert Peckham, I
Enoch Wood Perry, II
John F. Peto, III
Ammi Phillips, I
William Picknell, III
Theodore E. Pine, II
Charles Peale Polk, I
Alexander Pope, III
Matthew Pratt, I
Maurice Prendergast, III
John Quidor, I
Charles S. Raleigh, II
Henry Ward Ranger, III
John Rasmussen, II
Robert Reid, III
Frederic Remington, III
William Trost Richards, II
Theodore Robinson, III
Severin Roesen, II
Charles G. Rosenberg, II
Thomas P. Rossiter, II
Albert Pinkham Ryder, II
Platt Powell Ryder, II
John Singer Sargent, III
William H. Schenck, II
Charles Schreyvogel, III
Schuyler Limner, I
Samuel H. Sexton, I
James J. Shannon, III
Joshua Shaw, I
Alexander Shilling, III
Walter Shirlaw, II
John Smibert, I
George H. Smillie, II
William L. Sonntag, II
Frederick R. Spencer, I
John Mix Stanley, I
Albert Sterner, III
Joseph Steward, I
William Oliver Stone, II
George H. Story, II
Gilbert Stuart, I
M. A. Sullivan, II
Thomas Sully, I
Thomas Wilcocks Sully, I
Gardner Symons, III
Edward Martin Taber, III

Arthur Fitzwilliam Tait, II
Edmund C. Tarbell, III
Abbott H. Thayer, III
Jeremiah Theüs, I
Alfred Wordsworth Thompson, II
Cephas Giovanni Thompson, I
Jerome B. Thompson, I
Thomas Thompson, I
Louis Comfort Tiffany, III
Stacy Tolman, III
John Trumbull, I
Dwight W. Tryon, III
John H. Twachtman, III
Charles Ulrich, III
John Vanderlyn, I
Pieter Vanderlyn, I
Elihu Vedder, II
Douglas Volk, III
Robert Vonnoh, III
Hubert Vos, III
Samuel L. Waldo, I
Henry O. Walker, II
Horatio Walker, III
Frank Waller, II
Charles Caleb Ward, II
Edgar Melville Ward, II
Harry W. Watrous, III
Frederick J. Waugh, III
Edwin Lord Weeks, III
John Ferguson Weir, II
J. Alden Weir, III
Robert W. Weir, I
Adolph Ulrik Wertmüller, I
Benjamin West, I
James McNeill Whistler, II
Edwin White, II
Worthington Whittredge, II
Irving R. Wiles, III
William Williams, I
John Wollaston, I
Joseph Wood, I
Thomas Waterman Wood, II
John A. Woodside, I
Alexander H. Wyant, II
George Henry Yewell, II
Harvey O. Young, II

American Paintings
in the Metropolitan Museum of Art

was designed by Klaus Gemming, New Haven, Connecticut.
It was set in Monotype Baskerville, named for
the English printer and typefounder John Baskerville (1706-1775),
by Stamperia Valdonega, Verona. The book was
printed by The Stinehour Press, Lunenburg, Vermont,
on Mohawk Superfine Softwhite Text and bound
by Acme Bookbinding Company, Charlestown, Massachusetts.

The Metropolitan Museum of Art